Ivan Karp
Art Dealer/Gallery Owner
Page 368

Lori Siebert
Designer
Page 124

Roz Warren
Women's Humor Editor
Page 518

1995
Artist's & Graphic
Designer's Market

1995

Artist's & Graphic Designer's Market

Where & how to sell your illustration, fine art, graphic design & cartoons

Edited by
Mary Cox

Assisted by
Alice P. Buening

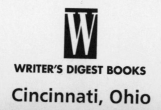

WRITER'S DIGEST BOOKS
Cincinnati, Ohio

Distributed in Canada by McGraw-Hill,
300 Water Street
Whitby Ontario L1N 9B6.
Also distributed in Australia by Kirby Books, Private Bag No. 19, P.O. Alexandria NSW 2015.

Managing Editor, Market Books Department:
Constance J. Achabal;
Supervising Editor: Michael Willins.

International Standard Serial Number
1075-0894
International Standard Book Number
0-89879-675-X

Portrait Artist: Phil Ruxton.
Cover photo: Guildhaus Photographics.

Contents

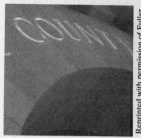

Page 36

The Markets

© 1989 UNISYS

Page 99

© 1993 Dale Kennington

Page 249

From the Editor

For those of you who are new to this book, allow me to give you a brief introduction. This brightly colored, thick volume, loaded with information, is bound to become a close, trusted friend. If by the end of the year it's marked up, highlighted, has coffee rings on the cover, or even has missing pages, we don't mind (unless of course it's a library book!). Market information changes drastically from year to year. That's why we update and publish new and revised editions each year. Market books are meant to be read and *used* between the date they arrive at bookstores in September until the revised edition comes out the following fall.

Those of you who are acquainted with past editions of *Artist's Market* have already noticed something different about this year's book. We have a new name! The reason is simple, and it's been a long time coming. Ever since the first edition of *Artist's Market* in 1974, our goal has been to help fine artists, graphic designers, illustrators and cartoonists market their work. We think our new title more accurately reflects our goal. Our philosophy has remained steadfast. Each year we spend months researching new markets, interviewing art directors, artists, gallery owners, and other industry insiders for the latest and most accurate marketing information we can find. We put it all together in a book and get it in your hands as quickly as possible.

As we researched this year's *Artist's & Graphic Designer's Market*, we were excited to find out what we already suspected. Gallery dealers, art directors and grant-givers are actively looking for artists. If you have the talent, the patience and the drive to work toward your goal, you can make a lot of headway in the coming years. In the 1995 *Artist's & Graphic Designer's Market*, we'll show you how. Inside this year's edition you'll find:

• 2,500 listings containing names and addresses, submission details, pay rates, and tips from buyers to help you submit and sell your work. A whopping 1,000 of those listings are new to this edition.

• Advice on how to market your work. We describe the three most common ways art buyers find artists, illustrators and designers.

• Information on how to submit your work in a professional manner that will fit your budget.

• Articles on the *business* of art, tips on shipping, taxes, copyright, how to price your work and advice on organizing your work space.

As we do every year, we interviewed successful professionals who tell the ins and outs of making it in the art and design fields. As you can see from the portraits on the book's endpapers, we struck gold this year as usual. We hope you enjoy reading about Jane Alexander, Jules Feiffer, Nick Bantock, Ivan Karp and our eight other experts as much as we enjoyed talking to them.

Because we've heard so much about environmental graphic design lately, we asked *HOW* magazine Managing Editor Neil Burns to give us the scoop on this hot new field. Listen in as he talks with a designer who made the transition from print work to signage.

The '90s have been dubbed the "decade of the regional artist" and you'll find that many of our listings are organized by state for that reason. Galleries are anxious to show the work of local artists. Design firms and ad agencies find it easier to work with

local designers. But never limit your sights. Among our articles is one describing how technology is making it easier to work on long-distance assignments.

You'll notice our cover is brighter this year. When our art department envisioned a change for the entire family of nine market books, staff designer Sandy Conopeotis took a conceptual approach. Using words and symbols associated with each book's discipline as a starting point, she selected distinct, vibrant colors for each title. Then she called in Guildhaus Photographics, a Cincinnati-based studio, to weave their magic. To capture the cover's atmospheric quality, Guildhaus pressed type onto upholstery vinyl which they softly bended and curved to create transparent layers of type, adding the illusion of depth. Hard objects, such as the tubes of paint, were sandwiched between the layers of vinyl. Guildhaus built a second set of kodalith representations of words on a glass plate. They achieved the cover's glowing color by shooting the sets through layers of gelled, focused light. The final image was assembled using two 4×5 cameras and multiple exposures.

If you like the cover as much as we do, or have comments or suggestions about *Artist's & Graphic Designer's Market* please write and let us know. We love to hear from our readers and need feedback to make sure we're on the right track. In fact, when we began work on this book, we asked members of North Light Book Club and Graphic Designer's Book Club to participate in a survey to let us know how they use *Artist's & Graphic Designer's Market*. We'd like to thank all the fine and graphic artists who took the time to fill out the three-page questionnaire and to congratulate William A. Barnum, who won his pick of $100 worth of North Light Books in a random drawing of all the responses.

We will be looking at the responses to the questionnaire very closely to make sure *Artist's & Graphic Designer's Market* is meeting your needs. You can be sure we'll use the information to make next year's book even better!

Mary Cox

How to Use Your *Artist's & Graphic Designer's Market*

Artist's & Graphic Designer's Market is compiled with the objective of helping you, the fine artist, freelance illustrator, designer and/or cartoonist, target your work to appropriate markets. The bulk of this book consists of listings for a wide variety of art buyers. Each listing includes a brief description of the buyer, the specific types of materials it seeks, submission procedures, payment information and other helpful tips. Graphic art listings also include information on the percentage of freelance work requiring computer knowledge and the particular software programs used.

In addition to the listings, you'll find a wealth of other useful information in this book that will help you in your professional development and journey toward success. The front of the book contains information on marketing, self-promotion, pricing, taxes, trends and other critical business tips. You'll also find a special section on environmental graphic design. Additionally, each market section opens with an introduction highlighting specifics relating to that area of the industry. For example, the introduction for Magazines contains news and submission information relating to magazine publishing.

Finally, market sections contain Insider Reports, brief interviews with art directors or experienced artists in the field. Look to these for advice and insights into the marketplace you are pursuing.

Where to start

The most efficient way to use this book is to move from the very general to the very specific. The first step is to refer to the sections in the book that correspond to the particular area in which you work. For example, if you are an illustrator, go directly to the major markets for this work: Advertising/Public Relations, Art/Design, Book Publishers, Greeting Cards, Magazines and Record Companies. If you are a fine artist, refer immediately to Galleries, Greeting Cards and, perhaps, to Art Publishers and Distributors. If it is cartooning you do, turn to Magazines and Syndicates. Markets for designers can be found in almost every section of the book, with the exception of Syndicates.

If you are a humorous illustrator and are looking for appropriate markets, take note of the special Humor Index in the back of the book, listing those markets open to such material.

Remember, however, that this is just a preliminary search. You will of course want to take a look at areas you haven't worked in before in order to maximize your sales potential. Don't be too quick to discount any option. Take some time to read through other sections you may not have considered. You may find a perfect place to branch out.

Finding target markets

Once you've determined the market categories you're interested in, the next step is to research within each section and identify individual buyers that will be most receptive to your work.

For the most part, you'll want to check four main items in the listings: location of the market, the type of material they are interested in seeing, submission requirements, and rights and payment policies. Pay close attention to any tips in listings. They provide valuable clues on impressing target markets.

You'll find that many listings have symbols. Those preceded by a solid black square (■) are considered good "first markets" by the *Artist's & Graphic Designer's Market* staff. These are often markets which offer lower payments, pay only in copies, or have expressed an interest in working with newcomers. A bullet (●) within a listing indicates that the editor has a special comment about that particular market. A double dagger (‡) signifies that the listing is new in this edition. A maple leaf (✿) precedes Canadian listings. An asterisk (*) comes before listings located outside of the United States and Canada.

Read each listing very carefully. Art directors, creative directors and gallery directors become irritated when inappropriate samples arrive from artists who are unfamiliar with the needs of their market. Whenever possible, obtain artist's guidelines and conduct further research on your own. For example, if you identify a book publisher that might be interested in your work, it would be wise to first send for a catalog and browse through its titles in a bookstore—before you make contact.

Take note that if you see the acronym "SASE" in a listing, this refers to a self-addressed stamped envelope. You must include a SASE with each submission if you wish to have your work returned to you. If you are making unsolicited submissions, it's a good idea to always include a SASE, regardless of whether or not one has been requested. See the Glossary at the end of this book for complete explanations of other terms that may be unfamiliar to you.

Finally, before taking the plunge and submitting work to any market, be sure to read Marketing 101, page 5 and Successful Self-Promotion, page 15. Also check the introduction to the section in which you found the market for more specific guidelines on submission procedures.

Marketing 101

You've got a copy of *Artist's & Graphic Designer's Market* and you're raring to go. You've probably browsed through the listings and are anxious to submit your work. To get the best results from your efforts, review a few key marketing concepts which will improve your chances for success.

But first here's a quick pop quiz on marketing. Think fast—is "market" a noun or a verb? If you answered "both" give yourself an A+. In the art world your "market" (noun) is the segment of the people who might buy or exhibit your work. The verb "market" means to identify that segment and offer them your finished artwork or professional skills.

There are two key steps, researching and planning, that you must complete *before* approaching your markets. The two will build a solid foundation to support all your marketing efforts.

Market research

There are many markets looking for commercial and fine art. Start out with a little exploratory research by reading the introductions to each section of this book with an open mind. You will probably uncover several markets you weren't aware of.

Read individual listings carefully. The descriptions in each listing offer valuable clues. For example, the client base of an advertising agency will give insight into its freelance needs. A freelancer with experience in designing charts and graphs contacted David Pierce of Tassani & Paglia after reading that the agency had financial companies for clients (see Insider Report, page 66). Similarly, if you excel at illustrating animals or children, look for book publishers, magazines or poster companies specifying needs for those subject matters. Read How to Use Artist's & Graphic Designer's Market on page 3 for tips on pinpointing target markets.

Visit a newsstand to research magazines. Note what types of illustrations they use. Carry a small notebook to jot down names and addresses of new titles. A visit to a gift store can turn up a lot of new greeting card markets. Just look on the back of each card for the company's address. Read magazines associated with your chosen market (see section introductions for titles). Many arts magazines, such as *The Artist's Magazine* have monthly features describing new markets and opportunities.

Market planning

A well thought-out marketing plan can mean the difference between success and failure. Your plan need not be written in stone, but it must be put down in writing. A written plan, forcing you to list and prioritize each step, is a more powerful tool than a set of vague wishes. Referring to it frequently keeps you focused and helps track your progress. Outline your plan as follows:

- **Specify your long-term goal.** Rather than setting the goal "to be a successful artist," fine-tune it. Make your goal clear and specific, as in "to land several illustration assignments from magazines by mailing submissions to 25 listings," or "to have a solo show of my work in a regional gallery." Once you establish your long-term goal you can decide on short-term objectives and strategies.
- **Establish short-term goals.** Break down your long-term goal into reasonable steps

such as planning promotional material, having duplicate slides made, developing a mailing list of target markets, ordering stationery and business cards, composing cover letters, sending out mailings, etc. Set *activity* goals, not production goals. If your daily goals are based on activity you are less likely to fall into a slump.
● **Establish deadlines.** Prioritize short-term goals in the order they need to be finished. Set deadlines for each activity so you can monitor your progress. Setting deadlines creates a challenge and a sense of urgency that spurs you on.

That's it. A marketing plan is basically a glorified "to do" list of marketing activities, but one that is planned carefully to fit your budget, with a final objective and deadlines to keep you on track. Once you get the ball, run with it. When you land a freelance assignment or grab a gallery's interest, follow through consistently and meet deadlines.

Define your niche

Niche marketing means specialization. If a specific aspect of your talent fills a need in the marketplace, you may find success through specializing in a certain style of illustration, like medical or fashion, or becoming known in a specific genre of painting, such as wildlife or marine painting. You could become a designer who is an expert on typefaces, or who knows the ins and outs of CD-ROM.

Specialization can mean that your strength lies in a particular type of work, for example, 3-D illustration or annual report design. If you want to establish a niche market for yourself, design your promotional material around your specialty. If your submissions show only 3-D illustration, art directors will think of you when they need an image in 3-D. You can use niche marketing to get your foot in the door with art directors and galleries and then branch out later.

Passing the "slush pile" test

One of the most tedious, yet potentially rewarding parts of an art director or gallery owner's job is weeding through the piles of submissions which often arrive in stacks of more than 20 bulging envelopes each day. Out of the entire stack, perhaps one will be up to professional standards. That's the submission art buyers file for future consideration, or they contact the artist for a portfolio review. The rest are either tossed or returned in a SASE.

How do you get past the slush file? Well, for starters, send your submission to the current contact person, and be sure to spell his name correctly. Sloppy submissions often end up in the circular file. If an artist doesn't take the time to send to the right name, it's a red flag to art buyers and gallery owners that the person is not responsible in other areas. Be sure to include your name and phone number on the submission. A beautiful self-promotion piece will get tossed if there is no phone number for the artist. (Don't laugh, it happens!) If you're submitting to a listing in this book, be extra careful to read the instructions on submissions and follow them exactly. Include professional self-promotional material as suggested in Successful Self-Promotion, page 15.

The magic three

In compiling the listings for *Artist's & Graphic Designer's Market* we asked art directors and fine art dealers to tell us how they found artists. Their answers were enlighten-

ing. They revealed they find new talent in three basic ways:
- through submissions
- seeing the work in an exhibition or art fair (fine art) or seeing it published in a magazine or sourcebook (graphic art)
- through word of mouth.

This information can give you leverage in your marketing efforts. The trick is to use all three of these methods to grab art buyers' attention. Don't limit your marketing efforts to submitting to high-end magazines or galleries and waiting for a response. Begin getting your work out there where it can be seen. Even a lower paying assignment can be a great way to promote your talents. (Read the Insider Report with Jules Feiffer on page 622 to find out how the "visibility" factor worked for him.)

A gallery director may reject your submission, only to see your work later in a group show and be impressed. A magazine art director may see your work on the cover of a new literary magazine. If you've done great work for one art studio, you'll get referrals. Word travels fast in the art and design community.

Extra credit

After you complete all the activities on your marketing plan, here are some hints to keep yourself motivated until you land that first assignment or portfolio review:
- **Offer yourself a reward.** Whether it's imported watercolor paper, a stack of pancakes, or a night on the town, build a reward into your plan. Once you've accomplished the steps in your marketing plan, you'll deserve it.
- **Keep working.** While waiting for results from submissions, strengthen your portfolio and learn new skills. If you cannot find a paying assignment right away seek out pro bono assignments (see Lori Siebert's Insider Report, page 124) or lower paying markets. If you are a fine artist, read the arts column in your local paper and scan arts publications for opportunities to participate in group shows or competitions. Learn all you can about the business aspect of your career. If you are ignored or rejected at first, realize it's part of the process and keep your enthusiasm.
- **Follow up.** Don't depend on one mailing to launch your career. Artists say it takes several promotional mailings before a cumulative effect kicks in. Keep track of mailings. After a reasonable amount of time has passed without a reply, follow up with a short, courteous phone call to express your interest in assignment work.
- **Evaluate your activities.** Are you getting the results you expect? Start revising and expanding your marketing plan for next year. Consider increasing the quality and frequency of your mailings or advertising in one of the creative directories.

Negotiating the Best Deal

Negotiating the best deal can be a problem, but it is one of the best problems an artist or designer can have. You've already interested an art buyer or gallery in your work, now all you have to do is agree on the terms.

Before you sign on the dotted line, or even give your verbal consent, familiarize yourself with basic copyright and fee-setting information. Take a little time to discuss the terms of your assignment (or show) with your client. Doing so will only improve your image as a professional in the client's eyes. Most importantly, a little communication will protect both you and the client in the long run. The sections that follow will cover some important points to keep in mind during business negotiations.

Reproduction rights

As creator of your artwork, you have certain inherent rights over your work and can control how it is used. When someone buys "rights" to your work, they are buying the right to reproduce your work for a certain duration of time. Unless all rights are purchased, the artwork will be temporarily given to the client in order to make reproductions. The artwork must be returned to you unless otherwise specified. Once the buyer has used the rights purchased, he has no further claim to your work. If he wants to use it a second or third time, he must pay additional fees for that privilege.

The more rights you sell to one client, the more money you should receive. Negotiate this upfront with the art buyer before agreeing on a price. Try to find out how long they intend to use it and where so that you will not relinquish too many rights. If the work is going to be used internationally, for example, you can definitely charge a higher fee. Because the copyright law is frequently misunderstood by both artists and art buyers, it is paramount to know your rights under this law and to make sure every art buyer you deal with understands them too. Here is a list of rights typically sold in the art marketplace:

- **One-time rights**. The artwork is "leased" on a one-time basis. One fee is paid for one use. The buyer has no guarantee he is the first to use the piece. Rights revert back to the creator after use.
- **First rights**. This is generally the same as purchase of one-time rights though the art buyer is paying a bit more for the privilege of being the first to use the image. He may use it only once unless other rights are negotiated.
- **Exclusive rights**. These guarantee the buyer's exclusive right to use the artwork in his particular market or for a particular product. A greeting card company, for example, may purchase these rights to an image with the stipulation that it not be sold to a competing card company for a certain time period. The artist, however, may retain rights to sell the image to other, noncompeting markets.
- **Second serial (reprint) rights**. These give a newspaper or magazine the opportunity to print your work after it has already appeared in another publication.
- **Subsidiary rights**. This category covers a lot of ground, but each right must be specified in the contract. For example, a publisher might want to include the right to use your illustration for the second printing or paperback edition of a book. Most U.S. magazines ask for "first North American serial rights" which gives them the right to publish your work in North America.

- **Promotion rights.** Such rights allow a publisher to use the artist's work for promotion of a publication in which the artwork appeared. The artist should be paid for promotional use in addition to the rights first sold to reproduce the image.
- **Works for hire.** Under the Copyright Act of 1976, section 101, a "work for hire" (as applied to artwork) is defined as: "a work prepared by an employee within the scope of his or her employment; or a work specifically ordered or commissioned for use as a contribution to a collective work, as part of a motion picture or audiovisual work, or as a supplementary work if the parties expressly agree in a written instrument signed by them that the work shall be considered a work made for hire."
- **All rights.** This involves selling or assigning all rights to a piece of artwork for a specified period of time. It differs from work for hire, which means the artist surrenders all rights to an image and any claims to royalties or other future compensation. Terms for all rights — including time period of usage and compensation — should always be negotiated and confirmed in a written agreement with the client.

Copyright specifics

The following questions touch upon the basics of copyright. For further information on copyright, refer to *The Legal Guide for the Visual Artist*, by Tad Crawford and *Make it Legal*, by Lee Wilson (both Allworth Press).

What can you copyright? You can copyright any work that has sprung from your creative efforts and is fixed on paper or any other tangible medium such as canvas or even in computer memory. Reproductions are copyrightable under the category of compilations and derivative works.

What can't be copyrighted? Ideas are not copyrightable. To protect an idea, you must use nondisclosure agreements or apply for a patent. Copyright protects the form but not the mechanical aspects of utilitarian objects. While you can copyright the form of your "Wally the Whale" lamp, you can't stop other people from making lamps. You can also copyright the illustration of Wally painted on the lamp.

What is a copyright notice? A copyright notice consists of the word "Copyright" or its symbol ©, the year of first publication and the full name of the copyright owner. It must be placed where it can easily be seen, preferably on the front of your work. You can place it on the back of a painting as long as it won't be covered by a backing or a frame. Always place your copyright notice on slides or photographs sent to potential clients or galleries. Affix it on the mounts of slides and on the backs of photographs (preferably on a label).

If you omit the notice, you can still copyright the work if you have registered the work before publication and you make a reasonable effort to add the notice to all copies. If you've omitted the notice from a work that will be published, you can ask in your contract that the notice be placed on all copies.

When is a work "published"? Publication occurs when a work is displayed publicly or made available to public view. Your work is "published" when it is exhibited in a gallery; reproduced in a magazine, on a poster or on your promotional pieces.

How do you get copyright protection? Although you will own the copyright from the time your work is expressed in tangible form, you must register your copyright with the U.S. Copyright Office in order to be able to enforce your rights against infringers. While there is no deadline for filing a copyright registration application, you may lose important recourse to infringement if the copyright for an artwork is not registered within 90 days of publication or before infringement begins.

How do I register a work? Write to the Copyright Office, Library of Congress, Washington DC 20559 and ask for form VA (works of visual arts). After you receive the form, you can call the Copyright Office information number, (202)479-0700, if you

need any help. You can also write to the Copyright Office for information, forms and circulars (address your letter to Information and Publications, Section LM-455). After you fill out the form, return it to the Copyright Office with a check or money order for the required amount, a deposit copy or copies of the work and a cover letter explaining your request. For almost all artistic works, deposits consist of transparencies (35mm or 2¼ × 2¼) or photographic prints (preferably 8 × 10). For unpublished works, send one copy; send two copies for published works.

How does registration protect the artist? Patricia A. Felch, a creative arts and entertainment lawyer in Chicago, explains the remedies to infringement in an article written for *The Guild News*, published by the Graphic Artists Guild: "First, copyright owners can prevent infringers from continuing to use infringed works, have the infringing copies destroyed and even have the infringers criminally prosecuted. Second, copyright owners can choose their damages: either 1) actual damages (what would have been earned), plus a percentage of the infringer's profits resulting from the infringement, or 2) statutory damages (for each infringing use, between $200 and $20,000 from innocent infringers or between $500 and $100,000 from willful infringers). Third, the infringers can be forced to pay a copyright owner's legal costs (filing fees, expert deposition fees and transcripts, etc.) and, sometimes, even attorney's fees."

What constitutes an infringement? Anyone who copies a protected work owned by someone else or who exercises an exclusive right without authorization is liable for infringement. In an infringement case, you can sue for an injunction, which means you can stop the infringer from reproducing your work; for damages (you must prove how much money you've lost); and to prevent distribution of the infringing material.

How long does copyright protection last? Once registered, copyright protection lasts for the life of the artist plus 50 years. For works created by two or more people, protection lasts for the life of the last survivor plus 50 years. For works created anonymously or under a pseudonym, protection lasts for 100 years after the work is completed or 75 years after publication, whichever is shorter.

What is a transfer of copyright? Ownership of all or some of your exclusive rights can be transferred by selling, donating or trading them and signing a document as evidence that the transfer has taken place. For example, when you sign an agreement with a magazine for one-time use of an illustration, you are transferring part of your copyright to the magazine. The transfer is called a license. An exclusive license is a transfer that's usually limited by time, place or form of reproduction, such as first North American serial rights. A nonexclusive license gives several people the right to reproduce your work for specific purposes for a limited amount of time. For example, you can grant a nonexclusive license for your polar bear design, originally reproduced on a greeting card, to a manufacturer of plush toys, to an art publisher for posters of the polar bear, or to a manufacturer of novelty items for a polar bear mug.

Special note about the Copyright Reform Act

If you think the paperwork involved in registering your copyright is excessive, you're not alone. A bill passed the House in November, 1993 which will allow artists to receive attorneys' fees and punitive damages without having to formally register work with the Copyright Office. As we go to press, HR897 is before the Senate Judiciary Committee. Watch for updated information in arts publications.

Fee-setting in commercial art markets

It's difficult to make blanket statements about what to charge for illustration and design. Every slice of the industry is somewhat different as is each client. Nevertheless, there is one recurring pattern of note: hourly rates are generally only paid to designers working inhouse on a client's equipment. (Clients are only willing to pay hourly if they are in a position to keep track of the hours being put in by the freelancer.) Designers and illustrators working out of their own studios (this is nearly always the arrangement for illustrators) are almost always paid a flat fee or an advance against royalties. For more information about payment structures in specialized areas of business, refer to the beginning of each market chapter in this book.

Bartering

Take note that cash payment is not the only currency available on the market these days. Bartering is popular and can be advantageous if you find the right deals. You may find it worthwhile at some point to offer your services in exchange for studio space, new equipment, printing services or a number of other benefits.

If you're starting out as a graphic artist and are unsure about what to charge for a job, begin by devising an hourly rate, taking into consideration the cost of your materials and overhead, plus whatever you think your time is worth (if you are a designer, you may want to find out what the average salary would be for a fulltime employee doing the same job). Then estimate how many hours you think the job will take and quote a flat fee to the client based on these calculations. *Setting the Right Price for Your Design & Illustration*, by Barbara Ganim (North Light Books) includes easy-to-use worksheets which can help you set prices for 33 kinds of projects.

Note that there is a distinct difference between giving the client a job estimate vs. a job quotation. An estimate gives the client a "ballpark" figure of what the job will cost, but is subject to change. A quotation, on the other hand, is a set fee which, once agreed upon, is pretty much set in stone. Make sure the client understands upfront which you are negotiating. Estimates are most often used by designers as a preliminary step in itemizing costs for a combination of design services such as concepting, typesetting, photography and printing. Flat quotations, on the other hand, are usually used by illustrators, as there are fewer factors involved in arriving at an illustration fee.

For actual recommendations on what to charge for different services, refer to the Graphic Artists Guild *Handbook of Pricing and Ethical Guidelines*. Also, keep in mind that many artists' organizations have hotlines you can call for advice. Talk with other artists in your area whenever possible and ask what they consider standard payment for the job you're doing.

Keep in mind as you are setting your fees, that certain stipulations will allow you to charge higher rates. Consider some of the following bargaining tools:

- **Usage (rights).** The more exclusive the rights bought, the more you can charge. For example, if the client wishes to make a "buyout" (to buy all rights), you can charge more since you will be relinquishing all rights to future use of your work (and hence will be losing out on resale potential).
- **Turnaround time.** If the client asks you to turn the job around in a short amount

of time, charge more. The rush may mean overtime for you.

● **Budget.** If a client asks you to quote a job, don't be afraid to ask how much they have budgeted for the project. You won't want to charge $500 for a print ad illustration if the ad agency you're working with has a budget of $40,000 for that ad. If the budget is that big, you may be able to ask for higher payment.

● **Reputation.** Naturally, the more well-known you become, the more you'll be able to charge for your creations. As you become more established, periodically raise your rates (in small increments) and see what happens.

Pricing your fine art

One of the questions most frequently asked by artists beginning to market their fine art is "What do I charge?" There are no hard and fast rules for how to price your work. The French have devised a system for working out the price of any given painting by any given artist. A point value is assigned to considerations such as size, subject matter, reputation of artist and medium. The painting is then priced per square inch. Most American artists and galleries base prices on market value, that is, what the buying public is currently paying for similar work. You can learn the market value for certain works by visiting galleries and checking prices of works similar to yours. If you paint impressionistic landscapes, don't compare your prices to Renoir's, but to an emerging talent working in your region. As you study prices, you'll see there are many factors involved in determining price:

● **Medium.** Oils and acrylics generally cost more than watercolors or pastels done by the same artist. Price paintings higher than pencil drawings and sketches.

● **Expense of materials.** Charge more for work done on expensive handmade paper with imported pastels, for instance, than for work of a similar size on a lesser grade paper using crayons. Is the work matted and framed? Build your costs into the price.

● **Size.** Though a larger work isn't necessarily better than a smaller one, it's a rule of thumb that you can charge more for the larger work.

● **Scarcity.** You can charge more for your one-of-a-kind works like paintings and drawings, than for multiples or works printed in an edition, such as lithographs and woodcuts.

● **Status of artist.** Established artists can charge more than lesser-known artists.

● **Status of gallery.** It may not be fair or logical, but the fact remains that prestigious galleries can charge higher prices.

● **Region.** Although this is changing, works sell for more in larger cities like New York and Chicago.

● **Gallery commission.** Remember that the gallery representing you will charge from 30 to 50 percent commission for your work. Your cut must at the very least cover the cost of materials, studio space, taxes and perhaps shipping and insurance, and enough extra to make the venture profitable to you. If the materials for a painting cost you $25, matting and framing cost $37 and you spent 5 hours in the studio working on it, make sure you get at least the cost of material and labor back before the gallery takes their share. Once you set your bottom-line price, maintain the same price structure wherever you show your work. A $500 painting by you should cost a prospective buyer $500 whether it is bought in a gallery or directly from you. To do otherwise is not fair to your gallery and devalues your work.

As you establish a reputation, you can begin to raise your rates—but do so cautiously. Remember that each time you "graduate" to a new price level, you will not be able to come back down.

YOUR BUSINESS LOGO

Agreement of Terms and Conditions

Client Name: _____

Company the Client Represents: _____

Company Address: _____

City/State/Zip: _____

Telephone/Fax Number: _____

Project Name: _____

Project Description: _____

1. The total cost for this project is estimated at: _____ (See attached estimate)
2. All expenses incurred to complete this order shall be the responsibility of the client.
3. Upon receipt of full payment, Designer grants to the Client the following rights in the designs: _____

 All rights not expressly granted in this agreement remain the exclusive property of the Designer. Unless otherwise specified, Designer retains ownership of all original artwork, whether preliminary or final, and Client shall return such artwork within sixty (60) days after use.
4. Payment for this project will be made according to the following schedule:

5. Payment for all invoices are due: _____
6. Designer fees quoted apply only to regular working hours—9 A.M. to 5 P.M., Monday through Friday. If the client requests that project work be performed at times other than the stipulated office hours, additional overtime fees of _____ per hour will be charged, except for corrections made necessary by the designer.
7. All costs are estimates only. Any alterations by the client of project specifications may result in price changes.
8. All additional costs that exceed the original estimate will be quoted to the client, in writing, before the costs are incurred.
9. The designer/design company does not have the authority to exceed this estimate without client approval.
10. The terms and conditions of this agreement are valid for only thirty (30) days.
11. The designer/design company's ability to meet the requirements of the Production Order and Production Schedule (see attached), is totally dependent on the client's delivery at the time specified on the production schedule (see attached) of any and all materials needed to complete the project.
12. If the project is canceled at any time, the client is responsible for all expenses incurred to that point.
13. If a dispute arises between the designer/design company and the client over any term or condition agreed to in this agreement, the client will be subject to pay all reasonable attorney's fees if the dispute requires legal counsel.

I have agreed to the terms and conditions presented in this agreement as it applies to the project named and described above.

Client signature: _____ Date: _____

From *The Designer's Commonsense Business Book*, © 1991, by Barbara Ganim.

Reprinted with permission of North Light Books, a division of F&W Publications, Inc.

Contracts

As the saying goes, "Always get it in writing." Whether you are a fine artist, designer, cartoonist or illustrator, you should have a contract any time you enter into a business agreement. Even if you take an assignment by phone, arrange for the specifics in writing, either requesting a contract or providing your own (see the sample on page 13). A letter stating the terms of agreement signed at the bottom by both parties can serve as an informal contract. There are several excellent books such as *The Artist's Friendly Legal Guide* (North Light Books) which provide sample contracts that you can copy and use. *Business and Legal Forms for Illustrators* by Tad Crawford (Allworth Press) contains negotiation checklists and tear-out forms. With a minimum of legalese, the sample contracts in these books cover practically any situation you might run into from renting your fine art to spelling out royalties in a contract with a book publisher.

Don't let contracts intimidate you. They are simply business tools to make sure everyone is in agreement. The items specified in your contract will vary according to the nature of the business you are dealing with and the complexity of the project. Nevertheless, there are some basic points you'll want to cover.

If you are working on an assignment for a commercial market, your contract should include:

● *A description of the service you are providing.*
● *Deadlines for finished work.*
● *Rights sold.*
● *Your fee.* Hourly rate, flat fee, or royalty.
● *Kill fee.* Compensatory payment to be received by you in the event that the project is cancelled.
● *Changes fees.* Penalty fees to be paid by the client for any last-minute changes (these are most often imposed by designers).
● *Advances.* Any funds paid to you before you begin working on the project.
● *Payment schedule.* When and how often you will be paid for the assignment.
● *Statement regarding expense compensation.* Includes reimbursement for travel, phone calls, materials and the like.
● *Statement regarding return of original art.* Unless you are doing work for hire, your artwork should always be returned to you.

If you are working with a gallery, check your contract for specifics relating to:
● *Terms of acquisition or representation.* Will the work be handled on consignment or purchased outright? If handled on consignment, what is the gallery's commission? If purchased outright, what is the fee? Or is this a co-op arrangement? Will you pay a membership fee?
● *Nature of the show(s).* Will the work be exhibited in group or solo shows or both?
● *Time frames.* At what point will the gallery return unsold works to you? When will the contract cease to be in effect? If a work is sold, when will you be paid?
● *Promotion.* Who will coordinate and pay for promotion? What will this promotion entail? If costs are to be shared, what is the breakdown?
● *Insurance.* Will the gallery insure the work while it is being exhibited?
● *Shipping.* Who will pay for shipping costs to and from the gallery?
● *Geographic restrictions.* If your work is handled by this gallery, will you relinquish the rights to show your work elsewhere in a specified area? If so, what are the boundaries of this area?

Successful Self-Promotion

by Robin Gee

This is a tale of three successful artists: Don is an illustrator whose work has appeared in all the leading newsmagazines and quite a few trade journals. He's also cracked the advertising market with a series of successful ad illustrations for a national lawn care company. Janet is a freelance graphic designer specializing in corporate identity packages. She is currently working on a promotional package for a large hotel chain. Chris works in acrylics and just finished a successful solo show in a large Midwestern city. He's busy putting together work for a traveling exhibit and is finishing up a large piece commissioned for the lobby of a new local office building. What do these three people have in common? They all devote time and care to promoting their work to prospective clients.

Whether you're an illustrator, graphic designer or fine artist, getting noticed is the first step in building a successful freelance or fulltime business. The best way to get noticed is to develop an effective self-promotion campaign. Self-promotion is the art of grabbing attention, an ongoing process of building name recognition and reputation. Not only are you introducing yourself and your work to new clients, but you're also reminding past clients you are still available for work.

Experts suggest artists spend about one-third of each week and up to 10 percent of their gross income on promotion. Whether you decide to spend this much time and expense depends on your resources and the size of your business, but it's important to set aside at least a portion of your time to work on self-promotion. Building this time into your regular working schedule will seem less painful and will help you avoid a "feast or famine" situation.

There are many ways to promote yourself—from word-of-mouth contact with others in the field to full-color advertisements in major creative talent directories. No matter what method of contact you choose, your goal is to get examples of your work into the hands of those most likely to buy it.

The direct mail package

An essential component of any self-promotion plan is the direct mail package. Mailing information and samples of your work to a targeted list of potential clients is the most efficient and cost-effective way to spark the interest that can lead to sales.

To achieve maximum results, it's important first to determine whom you want to reach with your promotion. A few artists rent lists of art buyers from direct mail list companies, but most develop their own mailing list by studying directories, trade publications and by making word-of-mouth contacts. The number of markets you contact depends on your time and budget, as well as the amount of work you want to handle. No matter how many markets you contact, it's essential to keep careful records and to update your lists regularly.

Robin Gee *is a contributing editor and regular marketing columnist for* The Artist's Magazine *and an editor for* Writer's Digest Books.

Timing is an important factor, too. Some artists feel that mailings sent to art directors in the summer may not get a favorable response because many art directors are on vacation. On the other hand, summer tends to be a good time to send to galleries because many are closed or on reduced hours for summer and the director may have more time to look at slides—unless, of course the gallery is in a tourist area. Many artists start by mailing to clients two or four times a year, working up to more frequent, even monthly, mailings. Some use holidays, such as Christmas and Valentine's Day to do special mailings.

"I've found my mailings have a cumulative effect," says Rick Stromoski, cartoonist based in Suffield, Connecticut. "I think of it as sowing seeds. It might take three or four mailings before an art director will use you." A client's interest in your work usually develops over time, so it's important to be consistent, he says. In addition, multiple mailings allow you to show more of your work.

You can spend as little or as much as you want on your direct mail package. Keep in mind, however, that your work is the most important element and it should not be overshadowed by too much fancy packaging or a lot of hard-sell pitches. Let it speak for you. Cleverness, wit and a good idea go a long way in leaving a lasting (and favorable) impression.

Direct mail packages differ depending on whether you are an illustrator, designer or fine artist, but all should contain samples of your best work and information on how to reach you. When you are introducing yourself to a client for the first time, it's also good to include a very brief cover letter.

Direct mail package components

What you send depends on the type of work you do and who you are approaching. If you are an illustrator, you know how busy art directors at magazines, book publishers and ad agencies are. Keep this in mind when sending self-promotion pieces. Illustrators include a short cover letter to new clients along with a flier, brochure or postcard showing examples of their work. Some illustrators send 8 to 12 slides or transparencies. You may also wish to include a business card. Although a poster, or another type of oversize piece will grab attention, it's best to send material that can fit easily into a file folder—something an art director can save. While a résumé or bio sheet is not needed (and is usually thrown away), include a list of clients in your letter and, if possible, on your samples.

For designers, a cover letter and samples that are easy to file are also a good idea. Yet, designers' packages tend to show off their design skills more and may include booklets, specially folded cards or samples with other design elements. Some designers include short commentary with their samples explaining the specific problems they faced and solved with the job. As with illustrators, include a client list and avoid lengthy bios and résumés. You might, however, want to include a paragraph about your educational background or design work experience in your cover letter if it is impressive.

When approaching galleries, fine artists should send 15 to 20 clearly marked slides of their work, along with a cover letter. When possible include a price list with your samples. Some galleries also like to see and file résumés, short artist bios (including exhibits and shows you've had) and an artist's statement. The statement and slides work well to show you are capable of putting together a show based on a well-developed concept or theme. You may also include postcards from shows and reviews with your package.

How you organize your package is up to you, but look at the material you send as a whole package. Coordinated stationery, business card and envelope help give a

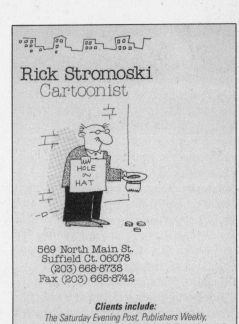

Cartoonist Rick Stromoski grabs art directors' attention with frequent mailings of humorous postcards. The reverse side of each card shows Stromoski's client list.

polished look. Some artists create a logo using their name to tie all the different pieces of their package together. Here are brief descriptions of some of the components you may consider including in your direct mail package:

● **Cover letter.** Many artists choose to include a cover letter with their packages sent to new clients. Avoid a heavy sales pitch and use the letter as a brief means of introduction. You may want to mention your clients or, if you are a fine artist, your recent exhibits or shows. For graphic design and illustration markets, schooling and work history are rarely important unless they are very impressive or relate directly to your work. Your letter should very simply state who you are, what you do, how to reach you and what follow up (if any) you plan to make. Indicate whether your samples may be returned or filed.

● **Business card.** This relatively inexpensive investment may be critical in separating you from the herd. Buyers are much more likely to perceive you as professional if you have a card. Include your card with any follow-up mailings as well as your initial contact.

● **SASE (self-addressed, stamped envelope).** Sending nonreturnable samples is easiest especially when dealing with graphic design markets, but if you want slides or other samples returned, always include a SASE large enough to fit the material and with enough postage. When sending to a market outside your own country, you must send International Reply Coupons for return mail instead of stamps. These are available at most main-branch post offices.

● **Reply card.** If you are sending samples that do not need to be returned, you can encourage the buyer to respond by including a reply card—a small, self-addressed postcard with boxes for the art director or gallery owner to check off and return. The boxes might ask the director to indicate if your samples will be kept on file and whether he or she is interested in receiving future mailings. Keep in mind, however, some art directors are so busy they may prefer to just file your samples and not bother returning the card.

● **Price lists and information sheets.** When sending slides of your work to galleries, send additional information on the work, especially the price of each piece. Sheets should be designed so that potential buyers can read them while viewing your slides with a projector. In addition to price information, briefly include how the piece was created, its media and size, where it was shown and whether it was sold or is still available. For commercial artists sending slides, include information on the assignment, the budget constraints, the lead or turnaround time and how you solved the problem assigned to you.

● **Biography.** Some galleries prefer a brief artist bio instead of a full résumé. You will want to keep it to a few paragraphs about you and your work.

● **Artist's statement.** For galleries, include a short statement about your work, your vision and the themes you are exploring. This works especially well if included with slides of work that demonstrate this vision. Commercial markets, however, are not interested in receiving such statements.

● **Client list.** For commercial markets, include a list of past clients. You may include this list in your cover letter (if it is short), résumé or on a separate sheet of paper. Many illustrators and designers have their list of clients printed on the back of their postcard sample or the bottom of a flier or brochure showing their work.

● **Résumé.** Find out ahead of time if the art director or gallery director you wish to contact likes to receive résumés. Some find them helpful, others find them useless. If you send one, keep it to one page and include only the information pertinent to your career as an artist—art-related education, exhibitions, competitions and awards,

clients, related work experience and activities such as membership in professional art organizations.

Types of samples

Again, the most important part of your direct mail package is your work sample. Some busy illustrators send only a flier or postcard, because, after all, this is the essential part of your package. A few things to keep in mind when selecting and sending samples: Never send original work. Always send your best work and label each piece with your name, address and phone number. You can have this information printed on your flier, brochure or postcard or you can use preprinted labels or a rubber stamp. Also, protect yourself by affixing a copyright symbol with your name to each piece of artwork.

Printed brochures, fliers or postcards need not be expensive. Black and white work is, of course, the least expensive to print because you are using only one color of ink. You can give the illusion of color work by using a dark ink other than black and colored paper. Two-color work such as black and red on white creates an interesting effect as well. Rubber stamps with your logo, address and number using colored ink can also add a colorful touch without the printing expense.

Costs for full, four-color printing have come down over the years. If you cannot afford full-color printing, however, you may want to consider color photocopies. The quality of these copies can be very good. Some artists have solved the color printing dilemma by having color photographs printed and mounted on a card or brochure. This works well only if the mounting looks professional.

Fancy cut-outs, gold stamping and unusual folding will drive the cost of your piece up. To create interest without the expense, experiment with different paper textures. One designer used a hole puncher to add a little inexpensive fun to her piece.

You can cut costs, too, by ganging more than one postcard or other small samples on one piece of paper. Talk to your printer about ways to cut costs and the most economical methods of producing the effects you want. Below are a few types of samples to consider:

- **Postcards.** Fast becoming the most common method of showing your work quickly to art directors, the postcard is an inexpensive way to introduce your work and to remind buyers you are available. You can send a series of cards to prospective buyers at regular intervals to show more than one image.

Illustrator Bob Schuchman of Torrance, California sends a series of 12 different cards and mails about one card every two months. He says color postcards have become less expensive to print over the past few years. Costs for about 1,000 cards is between $350 and $395. There are several national companies who print cards very inexpensively, but Schuchman says working with a local printer gives him more control over the quality of the work.

Be sure to include your name, address and phone number prominently on your postcards. There's room on the back as well to list your clients. Some artists purchase a bulk mail permit which can really cut down on postage costs.

- **Brochure.** A brochure can be a multi-fold printed piece, a one-page flier or a multi-purpose booklet. Take advantage of both sides of the piece and, in addition to contact information, you can use the space to include information on your work and a client list. Although a brochure or flier works well as a solo piece, one included in a larger package can give prospective clients an overview of your work, while smaller, individual samples focus on specific markets.

Since the purpose of the brochure is to give art directors and gallery owners an example of your work to keep on file, avoid sending pieces larger than 8½ × 11. Many

artists use one-page mailers printed with an image or images and contact information on one side. The other side is divided into thirds with two thirds containing client information and a teaser line and one third left blank for the address and stamp. This piece can be used by both fine and commercial artists.

● **Tearsheets.** Most often used by illustrators and designers, tearsheets are examples of work already published. A tearsheet not only tells the art director that you have experience working with other clients, but also shows how well your work will reproduce in print. You may want to laminate your tearsheets and, if you want them returned, include a SASE large enough to accommodate them. Be sure to label the piece with all your contact information. You can affix a label to your laminate.

● **Photocopies and photostats.** It's become quite acceptable to send inexpensive samples such as photocopies or photostats. These work very well for black and white work and the quality of color photocopies has improved greatly in the last few years. Some artists use this method instead of printing to create inexpensive fliers. Again, be sure to label each copy with your contact information.

● **Slides**. A must for sending samples of your work to galleries, slides can also be sent to commercial art markets. Be sure to label each slide clearly. On the front of each slide, indicate your name, size of the original work, medium and title. Also provide arrows pointing toward the top of the image. If your slides are accompanied by a price or information sheet, assign a number to each slide that corresponds with the numbers on the sheet. Submit slides in a protective plastic sleeve labeled with your name and address.

Most artists have slides of their work made professionally. Some prefer to take their own. See *Photographing Your Artwork* by Russell Hart (North Light Books) for more on this important step.

● **Photographs.** Like slides, photographs should be labeled with arrows indicating the top and should be numbered to correspond with an information sheet, if included. Be sure to put your name, address and phone number on each photograph.

The portfolio

Showing your portfolio is another, more personal way to promote your work to prospective clients. Although some portfolio reviews are done by mail, this can be very costly. An in-person review allows you to discuss your work and answer questions about it.

Fine artists are often invited to show their portfolios to gallery directors after they've made initial contact. After sending samples, you may write or call to set up a review. Never visit a gallery to show your portfolio without first setting up an appointment. Not only is it considered rude, but gallery directors are often too busy with clients to stop for impromptu reviews. Let the director schedule a time convenient for the both of you.

This advice applies to illustration and design markets, but many of the larger companies have portfolio drop-off policies. You will not be present for the review and you will be free to pick up your book the following day. To ensure that you are not left empty-handed while your portfolio is being reviewed, be sure to have at least two or three portfolios on hand.

Most businesses are honorable and you don't have to worry about your case being stolen. However, since things do get lost, be sure you've included only duplicates that can be insured at a reasonable cost. Only show originals when you can be present for the review. Remember to label your portfolio with your name, address and phone number.

Packaging and presentation

The overall appearance of your portfolio affects your professional presentation. Your portfolio need not be made of high-grade leather to leave a good impression. Neatness and careful organization are essential whether you are using a three-ring binder or a leather case. The most popular portfolios are simulated leather with puncture-proof sides that allow the inclusion of loose samples.

The size of your portfolio depends on your work, but choose one that can be handled easily by the art director. Avoid the large, "student" size books which are too big and bulky to fit easily on a director's desk. Most artists choose 11×14 or 18×24. Work can be mounted, if appropriate. If you are a fine artist and your work is too large for a portfolio, bring your slides and a few small samples.

Avoid including everything you've done in your portfolio. Select only your best work and choose pieces germane to the company or gallery you are approaching. If you're showing your book to an ad agency, for example, don't bring a lot of greeting card illustrations. Similarly, if you are showing your work to a gallery that specializes in abstract and conceptual work, avoid including realistic or figurative images.

In reviewing portfolios, art directors are looking for consistency of style and skill. They want to be sure your images are solid and you can produce good work on a regular basis. Art directors in commercial markets sometimes like to see work in different stages (roughs, comps and finished pieces) to see the progression of ideas and how you handle certain problems.

Gallery directors are looking for a sense of vision or direction and a body of work to demonstrate this. It's not enough to just skim several subjects briefly and show a collection of unrelated work. You'll need to show you are capable of cultivating an idea into an entire exhibition's worth of work.

When presenting your portfolio, allow your work to speak for itself. It's best to keep explanations to a minimum and be available for questions if asked. Be sure to prepare for the review by taking along notes on each piece. If the buyer asks a question, take the opportunity to talk a little bit about the piece in question. If you're a designer or illustrator, mention the budget, time frame and any problems you faced and solved. If you are a fine artist, talk about how the piece fits into the evolution of a concept, and how it relates to other pieces you've shown.

If you've been called in to talk about a specific job or show, this is the time to find out about its scope, budget and schedule. If, on the other hand, you're introducing your work to the client (or gallery) for future assignments or shows, leave samples (labeled with your name, address and phone number) and your business card. Don't ever walk out of a portfolio review without leaving the buyer something to remember you by. A few weeks after your review, follow up by sending a small promo postcard or other sample as a reminder.

For information on portfolios, see *The Ultimate Portfolio*, by Martha Metzdorf and *The Fine Artist's Guide to Showing and Selling Your Work*, by Sally Prince Davis, both published by North Light Books.

Additional self-promotion strategies

It's a good idea to supplement your direct-mail promotions and portfolio reviews with other forms of self-promotion. Remember self-promotion is not necessarily hard-sell. It's anything you do to make prospective clients aware of you and your work. Consider some of these options:

● **Talent Directories.** Many graphic designers and illustrators buy pages in illustration and design annuals such as *The Creative Black Book*, *The American Showcase* and

RSVP. These go to hundreds of art directors across the country and many keep their directories for up to five years.

For many artists price is a big obstacle. A page in one of these directories can run from $2,000 to $3,500 and you have no control over who receives them – not everyone who buys these books will be a market for your work. Yet, some artists who have bought pages claim they've made their money back and more, up to several times the amount they've spent. One added bonus to these directories is they provide you with up to 2,000 loose pages, depending on the book, to use as samples.

Be sure you are ready for such an investment. It helps to have some professional experience first. You should have developed a consistent style and have a portfolio with enough samples showing that style.

● **Media relations.** The media is always looking for good public interest stories. If you've done something unique with your work, send a press release to magazines, newspapers and radio. This kind of exposure is free and will help increase public awareness of you and your work, even if it doesn't result in immediate sales.

● **Pro bono work.** Creating work for your favorite charity or cause not only makes you feel good and helps your cause, it can be good public relations. These jobs can also help give you added exposure and experience. Certain jobs may present you with an opportunity to reach an audience of potential clients and acquaint them with your work. For example, a poster designed for your local ballet company may put your work in front of area business communicators, gallery directors and shop owners in need of artistic services. If you design a brochure for an upcoming charity event, you'll reach everyone on the charity's mailing list. Generally you only donate free services to nonprofit organizations in need of help – don't give away work to a client who has the means to pay. For more on pro bono work see the Insider Report with Lori Siebert in the Art/Design Studios section of this book.

● **Networking.** Attending seminars, organization meetings, trade shows, gallery openings and fundraisers is a good way to get your name out. Don't be afraid to talk about your work, because you never know when someone might need your services. It doesn't hurt to keep a business card and possibly some postcards on hand. If possible, volunteer to organize some events yourself. This will give you an even better opportunity to meet and work with new people.

● **Contests and juried shows.** Even if you don't win, contests provide good exposure. Judges of design and illustration contests are usually art directors and editors who may need work in the future. Judges of fine art shows are often gallery directors. Entering a juried show will also allow you to show your work to the community.

● **Home shows.** If you are a fine artist and have a body of work nearly complete, go over your mailing list and invite a select number of people to your home to preview the work. Personalized home shows may improve your chances of securing commission work and you retain all the profits of any sales. (Before pursuing this option, however, make sure you are not violating any contracts you already have with galleries).

For more on self-promotion strategies see these books published by North Light: *Creative Self-Promotion on a Limited Budget: For Illustrators and Designers*, by Sally Prince Davis or *The Professional Designer's Guide to Marketing Your Work*, by Mary Yeung. For a variety of promotion ideas see *Promo 2*, edited by Lauri Miller or *Fresh Ideas in Promotion*, edited by Lynn Haller.

Business Nuts & Bolts

Why is it we never hear about "starving dentists" or "starving drugstore managers?" There is such a stereotype about the proverbial starving artist that many creative people assume they will never make it in business, and leave their artistic dreams behind. Sad but true, some of the best and brightest give up early and then grit their teeth when lesser lights find success. Don't buy into the myth. Although business seems the antithesis of the creative spirit, successful artists, designers and illustrators deal with business details on a daily basis. A wise person once said "Successful people do what unsuccessful people are not willing to do." Having a little business savvy will put you head and shoulders above your competition and will increase your self-confidence. You will see yourself as a professional, and others will react to you in kind.

We've already discussed copyright, pricing your work and negotiating fees, yet there are still a few crucial items to cover. In regards to what follows, ignorance is *not* bliss. Not knowing about shipping, billing and taxes can result in lost artwork, time and money, or a visit from the IRS.

Packaging and shipping your work

Your primary goal in packaging is to have your samples, portfolio or finished work arrive undamaged. Flat work can be packaged between heavy cardboard or foam core, or it can be rolled in a cardboard tube. Include your business card or a label with your name and address on the outside of the packaging material in case the outer wrapper becomes separated from the inner packing in transit.

Larger works—particularly those that are matted or framed—should be protected with a strong outer surface, such as laminated cardboard, masonite or light plywood. The actual work should be wrapped in polyfoam, heavy cloth or bubble wrap and cushioned against the outer container with spacers (a spacer can be any object that keeps the work from moving). Whenever possible, ship work before it is glassed. If the glass breaks en route, it may destroy your original image. If you are shipping a particularly large framed work, you may want to contact a museum in your area and ask for more suggestions on packaging.

For the most part, you should send your submissions via first class mail. This makes for quicker service and better handling. The U.S. Postal Service will not automatically insure your work, but you can purchase up to $600 worth of coverage upon request. Artworks exceeding this value should be sent by registered mail. Many artists also use certified mail. Certified packages are logged in at each destination en route. They travel a little slower, but are much easier to track down in the event of a mishap.

If time is of the essence, consider the special services offered by the post office, such as Priority Mail, Express Mail Next Day Service and Special Delivery. For overnight delivery, check to see which air freight services are available in your area (the most familiar of which is probably Federal Express). FedEx automatically insures packages for $100 and will ship art valued up to $500. They also have a 24-hour computer tracking system that will enable you to locate your package at any time.

UPS also automatically insures work for $100, but you can purchase additional insurance for work valued as high as $25,000 for items shipped by air (there is no limit

for items sent on the ground). UPS cannot guarantee the time it will take a package to arrive at its destination but will track lost packages. It also offers Two-Day Blue Label Air Service to any destination in the U.S. and Next Day Service in specific zip code zones.

Before sending any original work, make sure you have a copy (photostat, photocopy, slide or transparency) in your file at home. If your work is lost, you'll at least have a duplicate in some form. To ensure the safe arrival of your submission, always make a quick address check by phone before putting your package in the mail.

Billing

If you are a designer or illustrator, you will be responsible for sending out invoices for your services. Commercial buyers generally will not issue checks without having first received an invoice. Most graphic artists arrange to be paid in thirds and bill accordingly. The first payment is received before starting the project, the second, after the client approves the initial roughs, and the third, upon completion of the project.

If you are a designer, it's wise to have a standard invoice form that allows you to itemize your services. The more you spell out the charges, the easier it will be for your clients to understand what they are paying for—and the more likely they will be to pay on time without arguing. Most designers charge extra for changes made to a project after approval of the initial layout and copy. Keep a separate form for change orders and attach it to your final invoice.

A note about galleries

If you are working with a gallery, you will not need to send invoices. The gallery will be responsible for sending you a check each time one of your pieces is sold (generally within 30 days). To ensure that you are paid promptly, make a point of calling the gallery periodically just to touch base. Let the director or business manager know that you are keeping an eye on your work.

If you are an illustrator, the billing process will be much simpler, as you'll generally only be charging a flat fee. Nevertheless, it may be helpful for you, in determining your original quoted fee, to itemize charges according to time, materials and expenses (the client need not see this itemization—it is for your own purposes). Illustrators generally don't charge fees for changes unless the changes are extensive.

Most businesses will need to have your social security number or tax ID number before they can cut a check for you. You can speed up the process by including this information in your first bill. Also, be sure to put a payment due date on each invoice. Most artists ask for payment within 10-30 days. One way to encourage clients to pay on time is to charge interest on any fees paid after the due date.

Sample invoices for designers are featured in *The Designer's Commonsense Business Book* by Barbara Ganim (North Light Books); an invoice for illustrators is shown in *Business and Legal Forms for Illustrators* by Tad Crawford (Allworth Press).

Record keeping

If you haven't kept good business records, all your talent will mean nothing when it comes time to give an account of your business profitability to the IRS. Remember

that you are an independent businessperson and, like any other entrepreneur, must be financially accountable.

Your bookkeeping system need not be a complicated one. Visit an office supply store to determine which type of journal, ledger or computer software is most suited to your needs. Each time you make a sale or receive an assignment, assign a job number to the project. Then record the date of the project, the client's name, any expenses incurred, sales tax and payments due.

For tax purposes, save all receipts, invoices and canceled checks related to your business. A handy method is to label your records with the same categories listed on Schedule C of the 1040 tax form. This will allow you to transfer figures from your books to the tax form without much hassle. Always make an effort to keep your files in chronological order.

As your business grows, you may find it worthwhile to consult with or hire an expert. If you choose this route, try to find a professional who specializes in working with creative people or small business operators. Find someone who understands your needs and keeps track of current legislation affecting freelance artists.

Taxes

You have the right to take advantage of deducting legitimate business expenses from your taxable income. If your business requires numerous supplies, rental of studio space, advertising and printing costs, these expenses are deductible against your gross art-related income. It is imperative to seek the help of an accountant in preparing your return. In the event your deductions exceed profits, the loss will lower your taxable income from other sources. To guard against taxpayers fraudulently claiming hobby expenses as business losses in order to offset other income, the IRS requires taxpayers to demonstrate a "profit motive." As a general rule, you must show a profit three out of five years to retain a business status. This is a guideline, not a rule. The IRS looks at nine factors when evaluating your status. The IRS looks at losses very closely. If you are ever audited by the IRS, the burden of proof will be on you to demonstrate your work is a business and not a hobby. You must keep accurate records and receipts of all your expenses and sales.

The nine criteria the IRS uses to distinguish a business from a hobby are: the manner is which you conduct your business, expertise, amount of time and effort put into your work, expectation of future profits, success in similar ventures, history of profit and losses, amount of occasional profits, financial status, and element of personal pleasure or recreation. If the IRS rules that you paint for pure enjoyment rather than profit, they will consider you a hobbyist.

Even if you are a "hobbyist," you can deduct expenses such as paint, canvas and supplies on a Schedule A, but you can only take art-related deductions equal to art-related income. That is, if you sold two $500 paintings, you can deduct expenses such as art supplies, art books, magazines and seminars only up to $1,000. You should itemize deductions only if your total itemized deductions exceed your standard deduction. You will not be allowed to deduct a loss from your other source of income.

Document each transaction by keeping all receipts, canceled checks, contracts and records of sale. It is best to keep a journal or diary and record your expenses daily, showing what was purchased, from whom, for whom, for how much and the date. Keep your automobile expenses in a separate log showing date, mileage, gas purchased and reason for trip. Complete and accurate records will demonstrate to the IRS that you take your career seriously.

If your accountant agrees it is advisable to deduct business expenses, he or she will fill out a regular 1040 tax form (not 1040EZ) and prepare a Schedule C. Schedule C

is a separate form used to calculate the profit or loss from your business. The income (or loss) from Schedule C is then reported on the 1040 form. In regard to business expenses, the standard deduction does not come into play as it would for a hobbyist. The total of your business expenses need not exceed the standard deduction.

There is a new, shorter form called Schedule C-EZ which can be used by self-employed people in service industries. It can be applicable to illustrators and designers who have receipts of $25,000 or less and deductible expenses of $2,000 or less. Check with your accountant to see if you can use this shorter form.

Deductible expenses include advertising costs, brochures, business cards, professional group dues, subscriptions to trade journals and arts magazines, legal and professional services, leased office equipment, office supplies, business travel expenses and many other expenses. Your accountant can give you a list of all 100 percent and 50 percent deductible expenses (such as entertainment).

Another reason your accountant is so important is that as a self-employed, "sole proprieter" there is no employer regularly taking tax out of your paycheck. Your taxes must be paid on your income as you earn it. Your accountant will help you put money away to meet your tax obligations, and estimate your tax and file quarterly returns.

Your accountant also will be knowledgeable about another annual tax called the Social Security Self-Employment tax. You must pay this tax if your net freelance income is $400 or more, even if you have other employment.

The fees of tax professionals are relatively low, and they are deductible. To find a good accountant, ask colleagues for recommendations, look for advertisements in trade publications or ask your local Small Business Association. And don't forget to deduct the cost of this book.

You can obtain more information about federal taxes by ordering free publications from the IRS. Some helpful booklets available include Publication 334 — Tax Guide for Small Business; Publication 505 — Tax Withholding and Estimated Tax; and Publication 533 — Self Employment Tax. Order by phone at (800)829-3676.

Independent contractor or employee?

Some companies and agencies automatically classify freelancers as employees and require them to file Form W-4. If you are placed on employee status, you may be entitled to certain benefits, but this will also mean that a portion of your earnings will be withheld by the client until the end of the tax year (and hence not readily available to cover overhead expenses). Moreover, your business expenses will be subject to certain limitations. In short, you may end up taking home less than you would if you were classified as an independent contractor.

The IRS uses a list of 20 factors to determine whether or not a person should be classified as an independent contractor or an employee. This list can be found in Publication 937. Note, however, that your client will be the first to decide whether or not you will be so classified.

The $600 question

Did you receive a 1099 form from that major client? Illustrators and designers take note: if you bill any client in excess of $600, the IRS requires the client to provide independent contractors with a form 1099 at the end of the year. Your client must send one copy to the IRS and a copy to you to attach to your income tax return. Likewise, if you pay a freelancer over $600, you must issue a 1099 form. This procedure is one way the IRS cuts down on unreported income.

Home office deduction

If you are freelancing fulltime from your home, and can devote a separate area to your business, take advantage of a home office deduction. Not only will you be able to deduct a percentage of your rent and utilities, but your business will benefit from deductions on expenses such as office supplies, business-related telephone calls and equipment such as computers and certain furnishings.

The IRS is very strict about home offices and does not allow deductions if the space is used for reasons other than business. In order to deduct expenses for a studio or office in your home the area must meet three criteria:

- *The space must be used exclusively for your business.*
- *The space must be used regularly as a place of business.*
- *The space must be your principle place of business.*

The IRS might question a home office deduction if you are employed full time elsewhere and complete freelance assignments at home. If you do claim a home office, the area must be clearly divided from your living area. A desk in your bedroom will not qualify. To figure out the percentage of your home used for business, divide the total square footage of your home by the total square footage of your office. (To determine square footage, multiply length by width.) This will give you a percentage to work with when figuring deductions. If the home office is 10 percent of the square footage of your home, deduct 10 percent of expenses such as rent, heat and air conditioning.

Note that your total office deduction for the business use of your home cannot exceed the gross income that you derive from its business use. In other words, you cannot take a net business loss resulting from a home office deduction. The law also requires that your business be profitable three out of five years. Otherwise, you will be classified as a hobbyist and will not be entitled to this deduction.

Consult a tax advisor to be certain you meet all of the requirements before attempting to take this deduction, since its interpretations frequently change.

Refer to IRS Publication 587, Business Use of Your Home, for additional information. Homemade Money, *by Barbara Brabec (Betterway Books), provides several formulas for determining percentages for deductions and provides checklists of direct and indirect expenses.*

Sales tax

The good news is, you could be tax exempt when buying art supplies. The bad news is you have to collect and report sales tax.

Most states require a sales tax, ranging from 2 to 7 percent, on artwork you sell directly from your studio, or at art fairs, or on work created for a client, such as finished art for a logo. You are required to register with the state sales tax department, which will issue you a sales permit, or a resale number, and send you appropriate forms and instructions for collecting the tax. Getting a sales permit usually involves filling out a form and paying a small fee. Collecting sales tax is a relatively simple procedure. Record all sales taxes on invoices and in your sales journal. Every three months total the taxes collected and send the tax to the state sales tax department.

The art supplies you buy to create paintings and complete assignments for clients are tax exempt to you. As long as you have the above sales permit number, you can buy materials without paying sales tax. You will probably have to fill out a tax-exempt form with your permit number at the sales desk where you buy materials. The reason you do not have to pay sales tax on your art supplies is that sales tax is only charged on the final product. However, you must then add the cost of materials into the cost of your finished painting or the final artwork for your client. Keep all of your purchase receipts for these items in case of a tax audit. If the state discovers that you have not collected sales tax, you will be liable for tax and penalties.

If you sell all your work through galleries the gallery will charge sales tax, but you will still need a tax exempt number so you can get a tax exemption on supplies.

Investigate the specifics regarding your state's regulations on sales tax. Some states claim that "creativity" is a service rendered and cannot be taxed, while others view it as a product you are selling and therefore taxable. Be certain you understand the sales tax laws to avoid being held liable for uncollected money at tax time. Write to your state auditor for sales tax information.

In most states, if you are selling to a customer outside of your sales tax area, you do not have to collect sales tax. However, check to see if this holds true for your state. You may also need a business license or permit. Call your state tax office to find out what is required.

Background information and further assistance

Depending on the level of your business and tax expertise, you may want to have a professional tax advisor to consult with or to complete your tax form. Most IRS offices have walk-in centers open year-round and offer over 90 free IRS publications containing tax information to help in the preparation of your return. The booklet that comes with your tax return forms contains names and addresses of Forms Distribution Centers by region which you can write for further information. Also the U.S. Small Business Administration offers seminars on taxes, and arts organizations hold many workshops covering business management, often including detailed tax information. Inquire at your local arts council, arts organization or university to see if a workshop is scheduled.

Organizing Your Fine Art Business

by Peggy Hadden

The art world, with its many long-range projects, requires keeping track of details and constant follow-up. It's distracting and frustrating when paperwork steals what little time you have to paint, draw or sculpt. You'll find it easier, even pleasurable, to take care of those details if you take an organized approach. Whether you own a computer, or handle business with less-expensive tools, an organized workspace and system will help you complete those office requirements speedily, freeing you to return to your artwork.

First, everything having to do with the *business* of being an artist should be kept together, by itself—away from your art tools. Nothing is more self-defeating than intending to enter a show and missing the entry deadline because the call for entries is buried under a pile of paint rags. Conversely, nothing can make you appear and feel more professional as an artist than providing visitors to your studio with a price list, current résumé, and other relevant materials when they express interest in your work.

Your office work area does not require a great deal of space. One of the most efficient artist's offices I have seen was built into a closet. By making effective use of the overhead area and painting the whole space one color, the artist achieved an organizational oasis that was a pleasure to see and work in.

Before arranging the space itself, you must spend some time thinking about the business tasks that come up frequently and take more time than necessary. Are misplaced messages and letters causing you problems? Are you always running out at the last minute for envelopes or postage? Analyze the time wasters and then simplify, simplify.

The organized atelier

You will need certain supplies and organizational systems to keep your business functioning smoothly. Assign each item its own space on a shelf or in a filing cabinet. Here are several ideas that work for me:

- Keep a daily desk-size calendar handy. Mark it whenever you submit work so you can follow-up promptly.
- Mailing envelopes that can generously hold your slide packet, cover letter and return envelope are essential supplies. Also stock smaller envelopes and stationery for correspondence.
- Maintain a box of cardboard sheets cut to envelope size for a firm backing to help protect your slides during mailing.
- Get a bound notebook (*important*, as it will get lots of use) and establish a method for tracking your slides. Make columns with these headings: date slides mailed, where

Peggy Hadden, *a graduate of the Parsons School of Design, is a mixed-media artist whose home and studio are in New York City's West Village. She is a regular contributor to* Art Calendar.

they were sent, to whose attention, short response to the work (e.g. "please resubmit in six months"), number of slides or name of series, and if and when slides were returned. By combing these records periodically, you will find contacts with whom you haven't been in touch for some time, or slides that haven't been returned. You can also tell at a glance how many submissions you've mailed this year versus last year. For example, I sent out 84 slide packets in 1993, but only 23 in 1992. This record book should also hold details of your dealings with art consultants and other dealers including your sales records. At tax time, you'll have all the information you need in one place.

● If you don't do your own word processing, it is a good idea to find someone who can do it on a per-project basis. Give them your résumé on disk, so that it can be easily updated. They can make your proposals and art colony applications look polished and professional, too.

● Make a file folder for each piece of your mailing packet, such as résumé, reviews, statements, etc. It will shorten the collating time when you need to put materials together.

● I keep a series of 3×5 index card boxes, each marked for a different category: private dealers and consultants, university galleries and museums, nonprofit exhibition spaces, out-of-town commercial galleries. These hold file cards for every exhibition space where I'm interested in showing. On each card I note the name, address, phone number, and director or curator of a space. I also write everything I hear about a space, even gossip. For instance, they might be interested only in artists with established reputations. All these bits of information can help you decide whether it is worthwhile to pursue a specific gallery or put your energies elsewhere. I mark the card whenever I send a space anything. I also note whenever I attend exhibits and whether I enjoyed them. This information will refresh my memory when making my next contact, and it will make my cover letter more personal and possibly open a dialogue. It also reflects genuine interest on my part. (If you have a computer, this information can be kept on disk.)

● Hang a bulletin board in your art desk area. Post deadlines which will occur during the next year that are relevant to you as an artist. This should include the dates when nonprofit exhibition spaces will be reviewing slides and proposals for future shows. Also post reminder notes a few weeks before the actual deadlines.

● One of my favorite tools for faster communicating is yellow Post-It notes. I prefer the 3×4 size and have my name and telephone number printed on them. Shorter than a full-scale letter, yet able to convey good wishes and a short note, they can help you when time is essential.

● Create file folders for shipping, insurance, and storage information, forms and labels. You might think it isn't a pressing concern now, but wait until you've promised someone that you'll get work to them overnight. Get in the habit of keeping postage stamps on hand.

● A couple of useful paperbacks should be within reach to help your business organization run more smoothly, too. I recommend three in particular: a zip code directory, which can be purchased for $15 at all main post offices and most branches, *Legal Guide for the Visual Artist* by Tad Crawford (Allworth Press, $18.95) and *The Artist's Tax Guide and Financial Planner* by Carla Messman (Lyons & Burford, Publishers, $16.95).

Your one-person public relations office

Finding and staying in touch with those who can buy your work, exhibit or sell it for you, or print kind words in reviews about you could occupy a staff of public relations

professionals. If the "staff" is only you, organizing this part of your career is essential. Start with separate mailing lists for critics, collectors, press and your "cheering section" and keep them current and accurate. By having them typed or on disk, you can transfer them to labels easily and quickly get small mailings out.

The file folders holding copies of your résumé, artist's statement, price list and reviews should be handy, too, as they will help you "introduce" yourself easily to new prospects. You might also want folders for a short bio or copies of articles about your work which have appeared in magazines. (Tip: Always attach a copy of the magazine's cover. Covers are highly recognizable to the public and your work will shine in its proximity to the magazine. Remember, nothing succeeds like success, and any connection between you and anyone or anything successful can benefit you. Watch for opportunities.)

Press releases should go out whenever you receive a large commission, have work acquired by a corporate collector or museum, or receive a grant. Practice writing releases, but if words don't come easily, have a professional write for you. Remember, the way you are presented to others is of very real importance, so this is not a place to skimp.

Expanding your sales

Finding information on opportunities to show your work is essential. Locate and subscribe to newsletters which carry information that you can use. They will generate situations where you can show, sell and expand your audience. Use the classified section of these newsletters to offer services that you can provide for other artists, such as building stretchers or photographing their artwork. This will provide extra income for you.

Being in the right place at the right time to have your work shown and selected is a lot less accidental than it seems. Today's artists must know where to look for opportunities—from the art listing in the local papers to the art-community bulletin boards. Know who your elected officials are and invite them to your exhibitions, even group shows. Send them press releases so that your name will become firmly linked in their mind with the arts. Then, when you request a letter of endorsement for a local arts project, it will be cheerfully forthcoming.

Likewise, become familiar with neighborhood civic groups, which are nonprofit and may sponsor your projects. Even if they are not arts groups they can act as an umbrella group or fiscal agent for you on grants which are not available to individuals. Keep an eye out for large, new construction projects, where the builder or sponsor could use a temporary mural to help convey a positive impression for their project.

Have a folder with the names of talk-radio and TV hosts in your area and include them in press release mailings. Contact them by mail or phone with a brief proposal for you to appear and discuss a project which you are working on. State why this idea is topical and will be of interest to their audience. These appearances can bring sales and inquiries. They will definitely increase attendance at your next open studio event.

You might not think you have reached the stage where you need a separate area devoted to the business side of your career, but I disagree. The more you *feel* like the art professional you intend to become, the more you will *behave* as one. One thing is certain—once you see how much more you accomplish by being organized and treating your work as a business, you'll wonder how you ever managed before.

Forecasting the Future

An article in *Studio* magazine touts the influence of fine art on annual report design. A museum mounts an exhibition of contemporary illustrators. A fine artist documents each step of his process on CD-ROM. Artists design sculptures that purify rainwater and designers urge clients to "go green" with reduced packaging and earth-friendly material. Digital portfolios showcase capabilities and artists share funding opportunities on e-mail.

What an exciting time to be in the business of creating images and ideas! Boundaries between fine and commercial art are blurring. Technology is exploding. We approach the year 2000 and beyond with an incredible learning curve, but with our humanity intact.

Throughout history, artists have paved the way for new ideas to enter the mainstream. Artists have the ability to let their imaginations soar, to visualize concepts and communicate them to others. As society attempts to reach a comfort level with new technologies, environmental concerns and a global economy, the creative community will play a major role in inspiring and cajoling a reluctant public to enter the exciting (and somewhat unsettling) future.

Ahead of your time?

Pat yourself on the back, freelancer; you're ahead of your time. Even if you have a fulltime job and create art on the side, your project-to-project experience will cushion the future shock that's ahead for workers with a strictly nine-to-five mindset. Have you heard all the speculation about the "employment revolution?" According to many economists the corporate culture is undergoing a radical change. We're headed toward an economy with less salaried positions and more "independent contractors" as companies downsize staffs and hire freelancers as needed. Barbara Gordon, New York-based commercial illustration and photography representative, points out "Freelancers have already developed the discipline to work on projects outside of the traditional structure. Without a company to pay a regular salary, provide insurance and put away money in a profit-sharing plan, they've learned to take care of those details themselves."

Telecommunications already enhance the rapport between freelancers and clients, making the independent contractor option more attractive to companies. Graphics computers and modems can connect art directors to a network of freelancers, hand-picked for each project. When discussing an assignment with a freelancer over the phone, an art director can call up a file on his screen to see the changes as they are being made, then quickly place the finished illustration in a layout.

"By using freelancers, I'm able to have hundreds and hundreds of employees with a whole range of skills and styles," says Ron Butwin, owner and principal of Butwin & Associates, an advertising/marketing firm based in Minneapolis. "We have designers who just do layouts, others who do storyboards or keylining. It's a team effort, but it's a team that changes from project to project."

The artist as temp

Because of the trend toward downsizing companies and utilizing freelancers, temporary agencies such as the nationwide Tech/Aid®, a division of Technical Aid Corpo-

ration, are increasingly asked to provide artists and designers for temporary work. There is an increasing demand for the skills of artists and designers in the creative industries, such as entertainment and theme parks. Companies are turning to the temporary agencies to supply them with creative individuals with technical skills. Kathy Golding, contract manager of Tech/Aid, says her firm has expanded its roster to include scenic designers, story board illustrators, set decorators, animators, graphic artists, painters, sculptors, illustrators, model builders and drafters. Tech Aid has 22 offices around the country. Artists who sign up with such agencies have a resource to go to when they're between projects. Temporary agencies handle taxes, workers' compensation, social security and offer optional medical plans.

Cruising the digital highway

Those of us not already on the information superhighway are definitely approaching the on-ramp. The pioneers among us who are daily users of the Internet report terrific networking opportunities through online computer systems. A friendly atmosphere permeates the many chat lines and "bulletin boards," more like neighbors swapping information over the backyard fence than our preconceived notions about cold, computerized data. There are several services on the Internet that are of interest to artists:
• **Arts Wire** is a national computer-based communications network for the arts community. It is designed to help artists and arts organizations across the country share information and coordinate their activities. On Arts Wire, you can find timely summaries of art news, a searchable resource for grant opportunities and competition deadlines, a place to find answers to technical questions, e-mail, a central discussion area and many more services. Any computer that has a modem and communications software can connect to Arts Wire for subscription fees from $3-5 per month plus a $15 per month account fee to Art Wire's host computer system. To receive more information and a registration packet contact: Arts Wire via e-mail:artswire@tmn.com or call (602)829-0815.
• **Digital Art Deli** on Internet showcases the work of independent artists, musicians, writers, filmmakers, performers, CD-ROM authors and software developers. Launched by the Los Angeles-based Kaleidoscope Media, the service is an online electronic catalog on which artists display short excerpts from their projects.

For more information about the Internet and maps to the information superhighway call InterNIC Information Services, a project funded by the National Science Foundation, at 1-800-444-4345.

More time to play

Designer Primo Angeli, principal of the San Francisco design firm Primo Angeli Inc., foresees technology ushering in a brave new world for artists. "The computer will never replace our creativity," says Angeli, "but used as a tool to speed things up it's going to give us much more time to play and to use our imaginations."

Designers and illustrators were among the first to embrace the technology, but an increasing number of fine artists are finding computers an exciting tool as well. Artist McCrystle Wood, who teaches computer graphics at the the University of Cincinnati's College of Design, Architecture, Art and Planning, uses 3-D modeling programs and Adobe Photoshop to create abstract images. "When people say 'Your computer art looks just like your paintings,' I say 'What did you expect?,' " says Wood. The computer is just another medium for artists to use, like pastels or watercolor, she says. The art produced with a computer need not be impersonal and mechanical. Wood believes her computer work is more passionate and vehement than her paintings.

More painters are beginning to use the computers as "virtual sketchbooks" that

enable them to save hours of time when preparing compositional studies for paintings. You can save your work in stages and then return to an earlier version and take the work in another direction. In seconds you can see how a bluer sky could enhance or spoil a landscape, or whether a still life would improve with an added object or a brighter background. When you're satisfied with your choices, the resulting image can be painted in a traditional medium, brush strokes and all.

CD-ROM and the digital frontier

The majority of new computers sold are multimedia capable. Kids already do their homework with interactive encyclopedias and publishers are scurrying to develop books and magazines on CD-ROM. Interactive TV programming is being tested as we speak.

The technology goes way beyond CD-ROM discs that hold 650 million bytes of information. In the future, interactive media more than likely will be delivered through phone lines. "People mistake electronic delivery for CD-ROM," says Michael Sullivan of the Cambridge, Massachusetts design firm Haywood & Sullivan. "That's like calling a floppy disk a computer." In the future, we'll all be connected through fiber-optics. "Digital delivery of ephemeral data is going to be the biggest growth market of the nineties." Sullivan predicts that in 5 to 15 years it will be cheaper to send catalogs and annual reports electronically than to mail them. An added attraction will be that customers and board members alike will be able to interact with documents, clicking "hot buttons" and icons to find specific information they need. "There will be a tremendous need for designers to understand the new technology to create exciting documents which can be easily navigated," says Sullivan. Traditional layouts designed for print will not be sufficient for the new formats. Getting in on the ground floor of the new technology will give designers an edge.

"There will be lots of opportunities for people who are able to harness the new cyberspace," says David Jacobson, president of the Connecticut-based audiovisual firm Effective Communication Arts, Inc. "There is an incredible market opening up for interactive design. Somebody has to put the image on the computer before anybody can interact with it."

The publishers of *American Showcase* have come out with "The Virtual Portfolio," a multimedia index on CD-ROM which was compiled to help buyers find artists, writers, musicians, designers and animators for projects. Art directors and producers can browse through the index by category or artist, and click on the screen to see an artist's work.

The anti-movement

If all this talk of technology makes you want to take a retreat to an Amish farm for some blessed relief, you're not alone. Those of us who still like to read books and love the smell of paint and turpentine can take heart. Another way the computer revolution has affected the art business is that it has unwittingly brought about a backlash. People yearn for the tactile quality of work made by human hands. Brush strokes and torn paper can be a welcome change from pixels and icons.

Maybe that's why crafts and artworks with a handmade feel are so popular. Even some art directors in commercial businesses are making assignments to fine artists for work on ad campaigns and annual reports. Society will always crave brush strokes, textures and even smudges. Amidst all the innovations, inventions and discoveries throughout history and in the future, the human touch is one element we know will *never* go out of style.

Environmental Graphics – Follow the Signs

by Neil Burns

If you have ever considered breaking into the environmental graphic design market (which includes exhibition design), now might just be your golden opportunity. This billion dollar-plus pie is ready to be served and there is plenty for hungry diners.

Just what is environmental design? Years ago when I first crossed its path, I thought it had something to do with, yes, the environment. In a tangible way it does. The field is defined by the Society for Environmental Graphic Design (SEGD) as the "planning, design and specifying of graphic elements in the built and natural environment." Simply put, environmental designers create signage. But it is more complicated than that. This relatively new discipline might best be explained if broken down into seven digestible terms:

- **Identification.** The signage created helps confirm destinations, create landmarks and establish recognition. Picture the "Hollywood" sign, entrances to parking garages, or the familiar exit sign. They are all environmental graphics.
- **Information.** Environmental graphic design communicates knowledge concerning designations, facts and circumstances. Ever read a descriptive label in a museum exhibition? Signage also tells you which bin to toss your recyclables in, and helps you learn about zebras and cockatiels at the zoo.
- **Directional.** Signage guides people through natural and man-made structures such as parks, hospitals, government buildings, shopping malls and hockey stadiums.
- **Interpretation.** The signage must provide verbal and visual explanations. The graphics on restrooms are designed to be interpreted whether or not you can read or speak the language.
- **Orientation.** Signage should provide users with a clear idea of where they are physically. Libraries, shopping malls, hotels and museums have freestanding directories and highly visible signs to assist patrons as they enter rotundas and approach elevators.
- **Regulatory.** From "No Smoking" to "Keep off the Grass," signage displays rules of conduct.
- **Ornamentation.** The signage should beautify or add to its surroundings. The challenge of environmental graphics is "design by subtraction." Designers strive to reduce visual clutter, while presenting essential information.

The Society for Environmental Graphic Design is the principal professional organization for this field. Its numbers are estimated at nearly a thousand. Environmental graphic designers are a close-knit bunch. The SEGD is known for its high level of activity and involvement among its members. The organization hosts an annual conference, drawing designers from around the world. The show offers attendees an opportunity to meet informally with counterparts, and share experiences and information. There are also regional and local gatherings allowing for more frequent contact. What one will find in this field is a friendly support group, for novices and advanced, where

Neil Burns *is managing editor of* HOW *magazine.*

egos are checked at the door. SEGD also has a very active job bank and referral service.

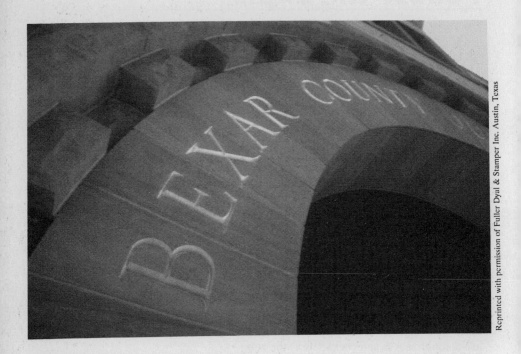

An example of environmental graphic design at work, this majestic arch serves as an entrance way for the Bexar County Justice Center in Bexar County, Texas. The beautiful sandstone arch, featuring lettering in 24-karat gold leaf, was designed by Fuller, Dyal & Stamper, Inc. in Austin, Texas.

One of the growing niches inside environmental graphic design is exhibition design. Exhibition design is not just for museums. The demand for interesting ways to display information is increasing because of the preponderance of conferences and seminars held at convention halls and centers throughout the country. Exhibition designers create necessary elements such as friezes, marques, floor plans and entrance ways.

Finding your way

How does one get into this lucrative field? Let's start with the student. Luckily, environmental graphic design has gained recognition in the overall design field. In the past, few schools offered any kind of career track. However, that has changed. Environmental graphic design (EGD) requires more class variety than traditional design and schools have added classes, such as architecture and fine art, that pertain to this field. So it's now possible for a student to leave school with a better understanding of the industry. Note: SEGD provides American and international students with funds to pursue EGD-related projects of interest to the design and academic communities.

For the mid-level designer who has worked in traditional areas, such as print, the route to EGD assignments is simple. If you own your firm, contact SEGD. They'll

provide an informational packet that outlines the industry, but more importantly, they will provide you with a network.

The key word in environmental design is collaboration. Projects are often so large that many design firms must work together on one assignment, often with deadlines as long as two years. Collaboration is an opportune way to get your foot in the door. At first you may just observe from the sidelines, but eventually you'll get hands-on experience.

If you are a freelancer or work for a firm and want to switch to EGD, do some research. There are a number of books available on the subject. For a good collection of existing signage with short explanations of each (as well as listings of firms—good for contacts) try *Sign Design: Environmental Graphics* published by PBC International. Other good reading includes *Wayfinding, People, Signs and Architecture* by Paul Arthur and Romedi Passini, published by McGraw Hill Ryerson, available through SEGD. This book covers "wayfinding," an industry term referring to the design and implementation of directional systems.

It is also recommended that you familiarize yourself with terminology—there's a lot of it and it is very important. For a good series of introductory articles on the subject, including terminology, pick up *HOW* magazine January/February 1994 issue.

Experienced environmental designers are paid more than print designers because of their specialized knowledge. As you enter the field, you may not benefit from the higher pay scales because of the learning curve involved. The environmental graphic designer must have knowledge about how materials react to weather, how distance affects the visibility of fonts, Braille and audio wayfinding systems for handicapped individuals, compliance with government regulations, zoning laws and the hundreds of other technical details involved in 3-dimensional projects. Despite all the details involved, designers in this field seem to have a lighter attitude. Yet their standards of professionalism are as high as those of traditional designers.

If you are interested in trying environmental graphics, contact the Society of Environmental Graphic Design at (617) 868-3381. They will hook you up with designers in the business who are willing to help you. EGD is a very professional field and very lucrative as well—finding your way in is easy. You may not want to find your way out.

INSIDER REPORT

Diverse Talents Lead to Success in Hot New Field

Paula Rees, principal of Maestri, a Seattle-based environmental graphic design (EGD) firm, jokingly says her interest in design started "when I was four years old." And while Rees is joking, she demonstrates a very common characteristic of the EGD field—humor.

Paula Rees

The prevalence of humor might well be traced to the many "high diversity thinkers" attracted to the field, or it could be the result of an occupational hazard—wandering around too many shopping malls. Environmental graphic design refers to the creation of signage. In other words, environmental designers tell us exactly where to go. They are called upon to create signage for such varied projects as hospitals, hotels and zoos, public parks and food courts. In today's complex environment, society is realizing the importance of signage. Once the domain of architects and sign manufacturers, the field is increasingly designer-driven, and has become a powerful economic and aesthetic force.

If you thrive on multidisciplinary, collaborative projects and are equally attracted to fine art, design, sculpture and architecture, this field could be for you, says Rees, who has always been "very diverse." In school, Rees majored in fine arts, but had interests in design, architecture, theater and printmaking, and dabbled in set design and sculpture. "I thought it was a personality disorder until I realized people in the field had that same kind of interest," Rees says.

After graduating, Rees entered the traditional graphic design field, working about five years, mostly in the design and production of magazines. "It gave me excellent typographic and production skills that carried over into my current work." During that time Rees also worked on projects in fashion and industrial design, which contributed to her knowledge of fabric, texture and material, another necessary element of EGD.

After a move to Seattle, Rees opened her own design firm, Rees Thompson. It was at this time that she first worked on a signage project. "I actually came into the field without knowing that it was actually a field," Rees says. "I had several jobs involving small retail stores or signage components of architectural projects and found I loved looking at the plans and figuring how you would help a person move through a space with how much information at what given point."

EGD has many doors through which one can enter. Freelancers are used because the size of a project requires the work of more than one firm. The best way to get experience, say Rees, is to get a job with a firm that specializes in

EGD. If you are an existing firm and want to get involved, collaborate with someone who has experience and can look at all the issues, from codes to structural concerns, because if you make mistakes, they are very costly. "The networking in the industry is phenomenal." Rees recommends joining professional organizations like the Society for Environmental Graphic Design (read Environmental Graphics—Follow the Signs for more information) which provide opportunities to network with leaders of the industry as well as designers on all levels.

As for the technical knowledge, be prepared to do a lot of reading and research. Not only will you be called upon to design signage, you will be expected to decide what material will be most effective. You must develop a knowledge of materials such as porcelain, fiberglass and various plastics and be aware of their capabilities and limitations. Will the sign hold up under various weather conditions? Can it be seen from a distance? Does the material glare when the sun hits it? You must know who supplies the material, its availability and how much it costs. "Be aware that by the time you spec a certain material it could be discontinued, so you might have to think of something else really quick."

The future of EGD will be "the way we work and design space and reinterpreting what we do with what we already have. Learning how to reuse space and resources and redefine the community. So I think this field is just a baby.

"To be successful in this business you have to love the process of working through solutions," says Rees. "Environmental designers seem to have flatter egos. They understand what it means to work in teams. I think that is the biggest success—collaborating and working with other people."
—*Neil Burns*

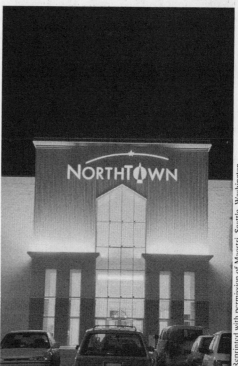

Maestri, Inc. developed a comprehensive identity for Northtown Mall in Spokane, Washington. The exterior graphics, shown here, were echoed in the mall's standing directory and interior signage designed to help shoppers navigate the mall's many shops and restaurants.

Reprinted with permission of Maestri, Seattle, Washington

Jane Alexander: Taking Center Stage for the Arts

Jane Alexander was in the midst of a successful run on Broadway when a team of presidential advisors came calling. The Tony-award-winning actress was having a wonderful time playing the eldest of *The Sisters Rosensweig*. The character of Sara Goode, a sophisticated London banking executive with improbable Brooklyn beginnings, was not easy to give up. "The play was an actor's dream," says Alexander, "a great role, wonderful cast" and it was a comedy, a nice change for an actress known for her dramatic parts. "I was crazy about the play. Had they caught me earlier in the run I probably would have felt differently—but after a year in the same role an actor starts to get itchy." And so for a time, Jane Alexander has been persuaded to leave the stage, and at the request of her country, has taken on an even meatier role.

Jane Alexander

There were 50 others being considered for Chairman of the National Endowment for the Arts. "I really didn't think I was in contention," says Alexander, who made several trips to Washington and answered "lots and lots of questions" before landing the job. When she testified before Congress it was the audition of her life. Alexander spoke from the heart as she described her vision for the arts. Politicians as diverse as Howard Metzenbaum and Jesse Helms were moved by Alexander's testimony, and perhaps a little dazzled by the star's stately presence. Her appointment was approved unanimously. The agreement on all sides was so unusual a senator quipped the hearings were less a confirmation process than a deification process.

Just what is it about Jane Alexander that inspires such trust? Has she always possessed the dignity and intelligence, tempered by warmth, that has led her to be cast as Eleanor Roosevelt and a Supreme Court Justice? Is she like that in real life? The actress explains away her appeal with gentle humor and queenly diction. "My mother always said I was a quality baby."

After her appointment, Alexander embarked on a good will tour, bringing the NEA's message to 50 states and six territories. At a town meeting in Burlington, Vermont, a standing-room-only crowd listened as the actress pledged continued support for the arts in rural areas. She spoke of the 100,000 grants awarded by NEA and their impact on society. Alexander credits the NEA with launching a renaissance in the arts unparalleled in the country's history. Since the agency's founding, she points out, dance companies increased from 37 to more than 250, the number of nonprofit theaters grew from 56 to more than 400, local arts agencies went from 60 to more than 3,000 and the number of opera companies has grown from 27 to more than 100. Major orchestras have grown from 58 in 1965 to a total of 230 orchestras today.

Prior to the Endowment's existence, the arts in the United States were enjoyed primarily by those who could financially afford them. The idea for an endowment

began in 1963 with President Kennedy's larger vision for the arts in society. It was picked up by Senator Jacob Javits of New York, Congressman Frank Thompson of New Jersey and Senator Claiborne Pell from Rhode Island who presented a plan to Congress to continue Kennedy's vision. When The National Endowment for the Arts was created in 1965, its mission was to bring the arts to all Americans. To accomplish its goals, the new agency offered matching funds to states participating in its programs. Within months, regional and state arts councils were created, and they, in turn held out the same offer to local communities. As a result, local arts councils emerged. The NEA also dangled carrots of matching funds for projects raising private monies, encouraging individuals and corporate foundations to support the arts. The seed money offered by NEA quickly grew. Challenge grants of $290 million generated nearly $2.7 billion in matching funds.

"These new partnerships brought about an explosion in the arts in the late '60s and '70s and changed the face of the arts in this country," says Alexander from her office in the Nancy Hanks Center in Washington DC. Without the support of the National Endowment for the Arts we would not have the Vietnam Veteran's Memorial; 200,000 people would have missed out on the Lowell Massachusetts Folk Festival; and major exhibitions such as the Henri Matisse retrospective at the Museum of Modern Art and Camille Pissaro's paintings at the Dallas Museum of Art could not have been mounted. Without support from the NEA, plays originating in nonprofit theater productions, such as *Driving Miss Daisy*, *Jelly's Last Jam* and *A Chorus Line* might never have been produced.

"We should be reading stories about grant recipients and watching them on the nightly news." Instead, says Alexander, "a handful of controversial grants have taken the focus from the thousands upon thousands of grants that have enhanced the lives of millions."

When Alexander appeared before a congressional subcommittee in 1990, she said, "I find it astonishing that after 25 years we are not celebrating the enormous success of the NEA. Rather, we're put in a position of defending it." Alexander's own view of criticisms involving artistic content is a philosophical one. "The artist often taps into the very issues of society that are most sensitive."

NEA's programs cost citizens 68 cents per person per year. The National Endowment for the Arts takes up such a small share of the government's budget that it does not even rate a separate item on the short form of the federal budget. Nevertheless, since the '80s the agency has faced drastic budget cuts — a reduction of 46% since the late '70s — and there are politicians who would like to see it abolished altogether.

But there are encouraging signs. The endowment's challenge grant programs have helped stimulate a dramatic increase in private sector funding for the arts, which now exceeds $9 billion a year. In her speeches throughout the country, Alexander talks about creative ways to develop partnerships to fund projects. You can apply for funds through your city arts council, get additional funds from your state arts council, and have those funds matched by corporate sponsors or foundations. In this way, says Alexander, artists can help the NEA stretch its limited budget.

One way to fight for future budget increases is to build grassroots backing. Artists can help by inviting legislators to arts programs. Attend grant workshops to learn about the funding process. Get in touch with your state and local arts councils and ask for information about available grants. Most important, said Alexander, "Write to your senators and congressmen! Yes — write letters of congratulations for a great agency!"

The Tony-award-winning actress says she has not used her acting skills in her new position. Her dedication to the arts is no act. "What I *have* used is my performance

level—my stamina," she says. Center stage as NEA's chairman takes as much endurance as any Broadway play.
—*Mary Cox*

How to Apply

The NEA awards grants to individual artists for design as well as fine arts. To receive a 25-page booklet of guidelines and an application form, designers should write to the National Endowment for the Arts, Design Arts Program, Room 627, 1100 Pennsylvania Ave., NW, Washington, DC 20506; or call (202)682-5437. Fine artists should write to NEA, Visual Arts Program, Fellowship Guidelines, 1100 Pennsylvania Ave., NW, Washington, DC 20506; or call (202)682-5448. For information about international opportunities for designers and artists call (202)682-5422. Grants are also available in 11 other categories, such as Folk Arts, Media Arts, Dance, Literature and Theater, and are offered to individuals or nonprofit organizations. Information on NEA's programs is also available through regional, state and local arts councils. For general information call the National Endowment for The Arts Public Information Office at (202)682-5400. The TDD Number for Hearing Impaired Persons is (202)682-5496.

Results of Our 1995 Cover Contest

The second *Artist's & Graphic Designer's Market* cover contest received a wealth of great design ideas, but the votes are in and the three winners chosen by Laurel Harper, editor of *HOW* magazine, appear on pages 44-45. Here are the results:

1st place: Ronald Kim of Alexandria, Virginia

2nd place: Gilbert Chavarria of El Paso, Texas

3rd place: Joe Donnelly of Napean, Ontario, Canada

As with a number of our contest entries, two of the winners, including the first place entry, were computer-generated. Although it was expertly designed, we regret we were unable to use Ronald Kim's prize-winning entry to grace the cover of *Artist's & Graphic Designer's Market* this year. As in the past, *Artist's & Graphic Designer's Market* is one of a family of nine market books geared toward artists, writers, photographers and poets. The design for this book must fit in with the look of its sister publications. For this reason, we've decided to put our cover contest on hold for now. But please read on to learn about this year's talented winners.

First Place: Ronald Kim

Although Ronald Kim's winning cover (pictured on page 44) uses traditional artists' tools as its main design elements, this artist's tool of the trade is his Macintosh. Kim, an Advertising Design graduate from the University of Maryland, is a computer graphics specialist at Falcon Microsystems, Inc. in Landover, Maryland and has done work for clients the likes of MECC, TEAMWorks Technologies, Avery and AT&T.

In creating this design, Kim sought to relate it to "artists everywhere," hence his use of essentials such as paint and palette. However, this high-tech artist aimed to depict these traditional tools in a contemporary way. "I wanted to show how the latest technology can manipulate objects easily and quickly to create a better effect than using traditional tools," he says.

To create his winning cover, Kim used Adobe Photoshop and Fractal Design Painter, importing the image into QuarkXPress. He works on a Macintosh Quadra 900 with a 21-inch color monitor.

Ronald Kim took first place with this striking image uniting conventional artist's tools with today's high-tech design devices.

Second Place:
Gilbert Chavarria

Second place was captured by Gilbert Chavarria, a student at the University of Texas at El Paso. This bold black and white repeated-pattern collage in gouache features a splash of color in the hair and tie of the center figure, setting him apart from the others.

Reprinted with permission of Gilbert Chavarria

Third Place:
Joe Donnelly

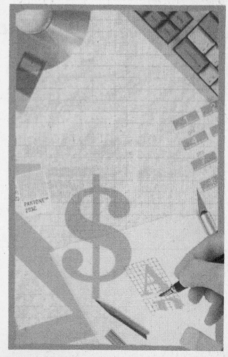

In this design, as in the winning entry, the artist has combined traditional with state of the art. Designer Joe Donnelly depicted common tools such as a pencil, Ex-acto knife and Pantone card in harmony with keyboard, fax dial and CD. Donnelly, a designer at Capital Communications, Inc. in Napean, Ontario, created the cover design on IBM Photostyler.

Reprinted with permission of Joe Donnelly

Important note on the markets

● *The majority of markets listed in this book are those which are actively seeking new talent. Some well-known companies which have declined complete listings are included within their appropriate section with a brief statement of their policies. In addition, firms which for various reasons have not renewed their listings from the 1994 edition are listed in the " '94-'95 changes" lists at the end of each section.*

● *Listings are based on editorial questionnaires and interviews. They are not advertisements (markets do not pay for their listings), nor are listings endorsed by the* Artist's & Graphic Designer's Market *editor.*

● *Listings are verified prior to the publication of this book. If a listing has not changed from last year, then the art buyer has told us that his needs have not changed—and the previous information still accurately reflects what he buys.*

● *Remember, information in the listings is as current as possible, but art directors come and go; companies and publications move; and art needs fluctuate between the publication of this directory and when you use it.*

● Artist's & Graphic Designer's Market *reserves the right to exclude any listing that does not meet its requirements.*

Key to symbols and abbreviations

‡ New listing
■ Good first market
● Comment from *Artist's & Graphic Designer's Market* editor
❧ Canadian listing
* listing outside U.S. and Canada
ASAP As soon as possible
b&w Black and white
IRC International Reply Coupon
P-O-P Point-of-purchase display
SASE Self-addressed, stamped envelope
SAE Self-addressed envelope

The Markets

Advertising, Audiovisual & Public Relations Firms

It may be exciting to see your illustration in a magazine or your design on a book cover, but did you know advertising assignments pay a lot more? You can make more money in this field than in magazines, book publishing or greeting cards. Up to six times as much. However, you will be working within stricter guidelines, and there is less freedom to be creative. In advertising, the bottom line is selling a product or service. When an art director tells you to illustrate a yellow tabby cat, he or she has good reason. In all probability the client shelled out big bucks for market research showing that buyers are more responsive to the yellow tiger stripe cat chomping down on kitty treats than the cute calico of your imagination.

Agencies hire freelancers to do all kinds of projects, from lettering to airbrushing, model making, illustration, charts, production, storyboards, and a myriad of other services. You will most likely be paid by the hour for work done at the advertising agency (inhouse), and by the project if you take the assignment back to your studio. Most checks are issued 40-60 days after completion of assignment. Fees depend on the client's budget, but most agencies are willing to negotiate, taking into consideration the experience of the freelancer, the lead time given, and the complexity of the project. Be prepared to offer a fee estimate for your services before you take an assignment. If you're hoping to retain usage rights to your work, you'll want to discuss this up front as well. You can generally charge more if the client is requesting a buyout. If research and travel are required, make sure you find out ahead of time who will cover these expenses.

The changing face of advertising

The 1980s saw a plethora of mergers and buyouts. Big agencies bought smaller agencies and became mega-agencies offering global service to clients. Some say the resulting structures were too big, causing agencies to drift out of touch with clients. In response, design firms began offering media buying services, something unheard of in the past. Today, hybrids of design firms and ad agencies are springing up, calling themselves marketing communications agencies or integrated marketing firms and offering a proliferation of services from corporate image consultation, to direct marketing, to special events and product design. Some of the giant agencies created in the '80s have either scaled down their services, or created "boutiques" or spin-off agencies in an effort to personalize services. And if you are confused by the difference between ad agencies, design firms and public relations firms, you're not alone. These days, the lines are definitely blurred.

Where you fit in

The good news is the industry is very dependent upon freelancers for both design and illustration. Agencies must respond to clients' needs and cannot predict their work load. Most have become "lean and mean," downsizing their staffs, hiring freelancers on a project by project basis. Here are some tips for breaking into this lucrative field:

Contact local agencies first. Although fax and modem have made it easier for agencies to work with out-of-town illustrators, most prefer to work with local freelancers for design projects.

Research each agency before you submit. Look at the listings in this section and see what type of clients they have. Do they specialize in retail? Perhaps their client base consists of financial institutions, restaurants or healthcare providers. Find agencies whose focus is compatible with your interests and background. Be sure to spell the art directors' names correctly.

Read industry trade publications. If you are at all serious about freelancing for ad agencies it is absolutely imperative that you read at least a few issues of *Advertising Age* and *Adweek*. These magazines will give you a feel for the industry. Current issues can be found in most public libraries.

Become familiar with design annuals. Sometimes called creative service books or sourcebooks, these thick reference books are used by art directors looking for fresh styles. Exploring the sourcebooks will give you a realistic picture of the competition. Though graphic artists pay thousands of dollars to place ads in the commercial sourcebooks like *Showcase*, many of the annuals, like those published yearly by the Society of Illustrators and the American Institute of Graphic Artists (AIGA), showcase the winners of annual competitions. A small entry fee and some innovative designs or illustrations could put your work in front of thousands of art directors. A list of competitions and their deadlines is published in *HOW* magazine's business annual each fall. If you cannot find these books in your public library, a university library should carry them.

If you are an illustrator, aim for consistency in style. "A freelancer should never have more than two styles in one portfolio," advises Patti Harris, art buying manager at Grey Advertising's New York office. "Otherwise it gets too confusing and the person won't be remembered."

Freelance designers must be versatile. Agencies seek jacks-of-all-trades, experienced in design, computer graphics, typesetting and production work. You also should be able to meet tight deadlines.

Learn the lingo. An illustrator or designer is a "creative"; a brochure is just one of many "collateral" pieces; your portfolio is your "book"; your contact at the agency could be an art director or, in the larger agencies, an "art buyer." If you don't already know the meaning of "comp," "rough" and "on spec," check the glossary of this book or pick up a copy of *HOW, Communication Arts* or *Print* and take a crash course.

Get editorial assignments first. It is easier to break into advertising if you can show some tearsheets of previous editorial (magazine or newspaper) work.

Portfolios must be clean, logical and easy to read. Each piece should be accompanied by a brief description of the project: the time it took to produce, the budget constraints and what your instructions were. If you schedule an appointment to show your book, try to find out ahead of time what the art director likes to see. Some may be interested in reviewing different steps of a project (from roughs, to comps, to final product) while others are interested only in the finished piece. Some like to see a

wide variety of work, while others look for a portfolio that's been tailored to their specialties.

Design an attractive self-promotional mailer. After your initial query and portfolio review, keep in touch with your mailing list through promotional mailers. Consider your mailer as an assignment. Create a memorable piece that is a "keeper." Art directors say postcard-size mailers are easy to file or tack onto a bulletin board. Don't depend on one mailing to place your name firmly in art directors' minds. Send out follow-up mailings at least twice a year. Keep a record of all your mailings.

Network with your peers. In most cities there are local chapters of the Art Directors Club, the American Insitute of Graphic Arts (AIGA) and the Graphic Artists Guild (GAG). Join one of these groups and become an *active* member.

Don't put all your eggs in one basket. Send mailings to design studios, magazines, or greeting cards as well as to advertising and public relations agencies. In the advertising field, the work depends more on the state of the economy and may not always be steady, so have some back up work in other areas.

Public relations firms

It's sometimes difficult to distinguish between ad agencies and PR firms. Some ad agencies offer public relations as one item on their menu of services, while other houses specialize only in PR.

The main difference between advertising and public relations work is the mission: it's a matter of hard sell versus soft sell. Advertising urges the public to buy a company's product or service, whereas PR simply encourages the public to feel positively about the company. Thus, PR firms handle a wide variety of tasks, ranging from development of corporate identity systems, to production of public service announcements, and planning community events and fundraisers. This can mean just about anything under the sun for a freelance designer or illustrator.

Audiovisual firms

Many ad agencies offer multimedia production services, but there is also a definite niche in the marketplace for firms that specialize in this type of work. A house working exclusively in audiovisuals may produce instructional motion pictures, filmstrips, special effects, test commercials and corporate slide presentations for employee training and advertising. Computer graphics and electronic design are gaining importance as audiovisual vehicles, and there are a growing number of video houses being established as animation specialists. Closely associated with this trend is television art. Many networks and local television stations need out-of-house help in designing slide shows, news maps, promotional materials and "bumpers" that are squeezed between commercials.

Arizona

‡ARIZONA CINE EQUIPMENT, INC., 2125 E. 20th St., Tucson AZ 85719. (602)623-8268. Vice President: Linda A. Bierk. Estab. 1967. AV firm. Full-service, multimedia firm. Specializes in video. Product specialty is industrial.
Needs: Approached by 5 freelance artists/month. Works with 1 freelance illustrator and 2 freelance designers/month. Prefers local artists. Uses freelance artists mainly for graphic design. Also uses freelance artists for brochure and slide illustration, catalog design and illustration, print ad design, storyboards, animation and retouching. 20% of work is with print ads. Needs computer-literate freelancers for design, illustration, production and presentation. 60% of freelance work demands knowledge of Aldus PageMaker, QuarkXPress, Aldus FreeHand, Adobe Illustrator or Adobe Photoshop.
First Contact & Terms: Send query letter with brochure, résumé, transparencies, photographs and slides. Samples are filed. Reports back to the artist only if interested. Art Director will contact artist for portfolio review if interested. Portfolio should include color thumbnails, final art, tearsheets, slides, photostats, photographs and transparencies. Pays for design by the project, $100-5,000. Pays for illustration by the project, $25-5,000. Buys first rights or negotiates rights purchased.

CHARLES DUFF ADVERTISING, Dept. AM, Suite 2000, 301 W. Osborn Rd., Phoenix AZ 85013. (602)285-1660. Fax: (602)285-1803. Creative Director: Trish Spencer. Estab. 1948. Ad agency. Full-service multimedia firm. Specializes in agri-marketing promotional materials—literature, audio, video, trade literature. Specializes in animal health. Current clients include Farnam, Veterinary Products Inc., Bee-Smart Products.
Needs: Approached by 20 freelance artists/month. Works with 3 illustrators/month. Prefers artists with experience in animal illustration: equine, pets and livestock. Uses freelancers mainly for brochure, catalog and print ad illustration and retouching, billboards and posters. Needs computer-literate freelancers for design, illustration, production and presentation. 25% of freelance work demands knowledge of Aldus PageMaker, Photoshop, QuarkXPress, Aldus FreeHand and Adobe Illustrator. 35% of work is with print ads.
First Contact & Terms Send query letter with brochure, photocopies, SASE, résumé, photographs, tearsheets, slides and transparencies. Samples are filed or are returned by SASE if requested by artist. Reports back within 2 weeks. Reviews portfolios "only by our request." Pays by the project, $100-500 for design; $100-700 for illustration. Buys one-time rights.

FILMS FOR CHRIST, 2628 W. Birchwood Circle, Mesa AZ 85202. Contact: Paul S. Taylor. Motion picture producer and book publisher. Audience: educational, religious and secular. Produces and distributes motion pictures, videos and books.
 • Design and computer work are done by inhouse design staff. Will work with out-of-town illustrators.
Needs: Works with 1-5 illustrators/year. Works on assignment only. Uses illustrators for books, catalogs and motion pictures. Also uses freelancers for storyboards, animation, cartoons, slide illustration and ads.
First Contact & Terms: Send query letter with résumé, photocopies, slides, tearsheets or snapshots. Samples are filed or are returned by SASE. Reports in 1 month. All assignments are on a "work for hire" basis. Originals not returned. Considers complexity of project and skill and experience of artist when establishing payment.

Arkansas

GURLEY ASSOCIATES, Box 1230, 111½ W. Walnut, Rogers AR 72756. (501)636-4037. Fax: (501)636-9457. Art Director: Michelle Serfass. Estab. 1960. Ad agency. Full-service, multimedia firm. Specializes in packaging and print material. Product specialties are toys and sporting goods.
Needs: Approached by 2-3 freelance artists/month. Works with 1-2 illustrators/month. Prefers artists with experience in toys, automotive, military and space products. Works on assignment only. Uses freelancers mainly for illustration for packaging. Also for brochure, catalog and print ad illustration and retouching and posters. Needs computer literate freelancers for design and production. 75% of freelance work demands knowledge of QuarkXPress, Aldus FreeHand, Adobe Illustrator and Photoshop. Needs technical illustration. 8-10% of work is with print ads.
First Contact & Terms: Send query letter with brochure, résumé, photographs and slides. Samples are filed or are returned by SASE only if requested by artist. Does not report back. Artist should "contact by letter." Call for appointment to show portfolio of "whatever best shows the artist's strengths." Pays for design by

How to Use Your **Artist's & Graphic Designer's Market** *offers suggestions for understanding and using the information in these listings. Read this and other articles in the front of this book for important business tips.*

the hour, $50 maximum. Pays for illustration by the project, $250-3,000. Buys all rights.

MANGAN/HOLCOMB & PARTNERS, (formerly MRGH), Suite 911, 320 W. Capitol Ave., Little Rock AR 72201. Contact: Steve Mangan, by mail only. Ad agency. Clients: recreation, financial, tourism, utilities.
Needs: Works with 5 designers and 5 illustrators/month. Assigns 50 jobs and buys 50 illustrations/year. Uses freelancers for consumer magazines, stationery design, direct mail, brochures/flyers, trade magazines and newspapers. Also needs illustrations for print materials. Needs computer-literate freelancers for production and presentation. 30% of freelance work demands knowledge of Macintosh page layout and illustration software.
First Contact & Terms: Query with brochure, flier and business card to be kept on file. Include SASE. Reports in 2 weeks. Call or write for appointment to show portfolio, which should include final reproduction/ product. Pays by the project, $250 minimum.

California

‡THE AD AGENCY, P.O. Box 2316, Sausalito CA 94965. (415)331-9850. Creative Director: Michael Carden. Estab. 1972. Ad agency. Full-service, multimedia firm. Specializes in print, collateral, magazine ads. Client list available upon request.
Needs: Approached by 10-12 freelance artists/month. Works with 10 freelance illustrators and designers/ month. Uses freelance artists mainly for collateral, magazine ads, print ads. Also uses freelance artists for brochure, catalog and print ad design and illustration and mechanicals, billboards, posters, TV/film graphics, lettering and logos. 60% of freelance work is with print ads. Needs computer-literate freelancers for design and illustration. 25% of freelance work demands computer skills.
First Contact & Terms: Send query letter with brochure, photocopies and SASE. Samples are filed or returned by SASE. Reports back in 1 month. Portfolio should include color final art, photostats and photographs. Buys first rights or negotiates rights purchased.
Tips: Finds artists through word of mouth and submissions. "We are an eclectic agency with a variety of artistic needs."

‡ADVANCE ADVERTISING AGENCY, Suite 202, 606 E. Belmont Ave., Fresno CA 93701. (209)445-0383. Art Director: M. Nissen. Estab. 1950. Ad agency. Full-service, multimedia firm. Current clients include Pica Computers, Sound Investment Recording Studio, Howard Leach Auctions, Mr. G's Carpets, Allied Floorcovering, Fresno Dixieland Society. Client list not available.
Needs: Approached by 2-5 freelance artists/month. Prefers local artists with experience in all media graphics and techniques. Works on assignment only. Uses freelance artists mainly for direct mail, cartoons, caricatures. Also uses freelance artists for brochure design and illustration, catalog and print ad design, storyboards, mechanicals, retouching, billboards and logos. 75% of work is with print ads. 25% of freelance work demands computer skills.
First Contact & Terms: Send query letter with résumé, photocopies and SASE. Samples are filed or returned by SASE. Reports back within 2 weeks only if interested. Art Director will contact artist for portfolio review if interested. Portfolio should include roughs, tearsheets and/or printed samples. Pays for design and illustration by the project, rate varies. Buys all rights.
Tips: Finds artists through artists' submissions.

‡ANGLE FILMS, Suite 240, 1341 Ocean Ave., Santa Monica CA 90401. (310)273-0266. President: John Engel. Estab. 1985. AV firm. Motion picture film production. Specializes in feature films and commercials. Client list not available.
Needs: Approached by 5 freelance artists/month. Works with 2 freelance illustrators and 1 freelance designer/month. Prefers artists with experience in feature films, animation and/or visual effects. Works on assignment only. Also uses freelance artists for storyboards, animation, model making, lettering logos and set design. Needs computer-literate freelancers for design, illustration and production. 75% of freelance work demands computer skills.
First Contact & Terms: Send query letter with résumé and photocopies. Samples are filed. Reports back to the artist only if interested. Art Director will contact artist for portfolio review if interested. Pays for design by the hour or by the project. Pays for illustration by the hour. Rights purchased vary according to project.
Tips: Finds artists through agents and word of mouth. "Only artists interested in, and with experience in, feature film (storyboarding or illustration or designing) should write."

ASAP ADVERTISING, P.O. Box 7268, Thousand Oaks CA 91359-7268. (818)707-2727. Fax: (818)707-7040. Owner: Brian Dillon. Estab. 1982. Ad agency. Full-service, multimedia firm. Specializes in print advertising, brochures, sales kits, mailers and PR. Product specialties are high tech, OEM and industrial. Primary clients include Aleph International, American Nucleonics Corp., and Downs Crane & Hoist.

Needs: Approached by 5 artists/month. Works on 1 illustration project/month. Prefers local artists with experience in mechanicals, tight concepts and comps. Currently needs technical illustration. Works on assignment only. No staff art department, uses freelancers for all artwork. Also uses freelance artists for brochure, catalog and print ad design and illustration, retouching, lettering and logos. 60% of work is with print ads.
First Contact & Terms: Send query letter with business card, résumé and photocopies. Samples are filed or are returned by SASE. Reports back within 1 week only if interested. Art Director will contact artist for portfolio review if interested. Portfolio should include thumbnails, roughs and b&w samples showing full range of ability (photocopies OK). Pays for design by the project, $40-200. Pays for illustration by the project, $100-800. Buys all rights.
Tips: Finds artists through creative director's source file of samples.

B&A DESIGN GROUP, 634-C W. Broadway, Glendale CA 91204-1008. (818)547-4080. Fax: (818)547-1629. Creative Director: Barry Anklam. Full-service advertising and design agency providing ads, brochures, P-O-P displays, posters and menus. Product specialties are food products, electronics, hi-tech, real estate and medical. Clients: high-tech, electronic, photographic accessory companies and restaurants. Current clients include Syncor International, California Egg Commission, Neptune Foods, Viktor Benes Continental Pastries, MCA/Universal Merchandising, NTC/National Teleconsultants, Pasadena Tournament of Roses and Unifactor Corp.
Needs: Works with 8 artists/year. Assigns 15-20 jobs/year. Uses freelancers mainly for brochure, newspaper, magazine, ad and editorial illustration and mechanicals, retouching, direct mail packages, lettering and charts/graphs. Needs editorial, technical and medical illustration and editorial cartoons. Needs computer-literate freelancers for design, illustration and production. 95% of freelance work demands knowledge of QuarkXPress, Photoshop and Aldus FreeHand.
First Contact & Terms: Contact through artist's agent or send query letter with brochure showing art style. Samples are filed. Reports back only if interested. To show a portfolio, mail color and b&w tearsheets and photographs. Pays for production by the hour, $20-25. Pays for design by the hour, $75-150; or by the project, $500-2,000. Pays for illustration by the project, $250-3,000. Considers complexity of project, client's budget and turnaround time when establishing payment. Rights purchased vary according to project.
Tips: Finds artists through agents, sourcebooks and sometimes by submissions.

THE BASS GROUP, Dept. AM, 102 Willow Ave., Fairfax CA 94930. (415)455-8090. Producer: Herbert Bass. "A multi-media, full-service production company providing corporate communications to a wide range of clients. Specializes in multi-media presentations video/film, and events productions for corporations."
Needs: Works with numerous artists/year. Prefers solid experience in multi-image and film/video production. Works on assignment only. Uses freelancers for mechanicals, lettering, logos, charts/graphs and multi-image designs. Needs technical illustration, graphic, meeting theme logo and slide design. Needs computer-literate freelancers for design, illustration and production. 90% of freelance work demands knowledge of QuarkXPress, Aldus FreeHand, Adobe Illustrator and Photoshop. Prefers loose or impressionistic style.
First Contact & Terms: Send résumé and slides. Samples are filed and are not returned. Reports back within 1 month only if interested. Art Director will contact artist for portfolio review if interested. Sometimes requests work on spec before assigning a job. Pays by the project. Considers turnaround time, skill and experience of artist and how work will be used when establishing payment. Rights purchased vary according to project.
Tips: Finds illustrators and designers mainly through word-of-mouth recommendations. "Send résumé, samples, rates. Highlight examples in speaker support—both slide and electronic media—and include meeting logo design."

ALEON BENNETT & ASSOC., Suite 212, 13455 Ventura Blvd., Van Nuys CA 91423. President: Aleon Bennett. PR firm.
Needs: Works with 2 artists/year. Works on assignment only. Uses freelancers mainly for press releases and advertisements.
First Contact & Terms: Send query letter. Samples are not filed and are not returned. Portfolio review not required. Does not report back. Pays for design by the project.

‡**CHARTER COMMUNICATIONS**, #127, 4400 Coldwater Canyon, Studio City CA 91604. (818)505-9222. Fax: (818)505-0909. President: Terence J. Kollman. Estab. 1986. Ad agency. Full-service, multimedia firm. Specializes in television but utilizes magazine and newspaper ads. Specialty is direct response products. Client list available upon request.
Needs: Approached by 2 freelance artists/month. Works with 1 freelance designer/month. Prefers local artist with experience in direct response advertising. Works on assignment only. Uses freelance artists mainly for direct response advertising. Also uses freelance artists for brochure design and illustration, print ad design and illustration, storyboards and TV/film graphics. 15% of work is with print ads. Needs computer-literate freelancers for design, illustration, production and presentation. 35% of freelance work demands knowledge of Aldus PageMaker, Adobe Illustrator and/or Aldus FreeHand.

First Contact & Terms: Send query letter with brochure, résumé, photostats, photocopies, photographs, slides or tearsheets. Some samples are filed. Samples are not returned. Reports back to the artist only if interested. Artist should follow-up with call. Portfolio should include b&w and color thumbnails, roughs, final art, tearsheets, slides, photostats, photographs and transparencies. Pays for design by the project, $500 minimum. Pays for illustration by the project, $250 minimum. Buys all rights.
Tips: Finds artists through sourcebooks and artist's submissions.

COAKLEY HEAGERTY, 1155 N. First St., San Jose CA 95112-4925. (408)275-9400. Creative Directors: Susann Rivera and J. D. Keser. Art Directors: Thien Do, Tundra Alex, Ray Bauer and Carrie Schiro. Full-service ad agency. Clients: consumer, high-tech, banking/financial, insurance, automotive, real estate, public service. Client list available upon request.
Needs: Works with 100 artists/year. Assigns 500 jobs/year. Works on assignment only. Uses freelancers for illustration, retouching, animation, lettering, logos and charts/graphs. 10% of freelance work demands knowledge of Adobe Illustrator or Quark XPress.
First Contact & Terms: Send query letter with brochure showing art style or résumé, slides and photographs. Samples are filed or are returned by SASE. Does not report back. Call for an appointment to show portfolio. Pays for design and illustration by the project, $600-5,000.

DIMON CREATIVE COMMUNICATION SERVICES, 3001 N. Fermand Blvd., Burbank CA 91504. (818)845-3748. Fax: (818)954-8916. Art Director: Armin Krumbach. Ad agency/printing firm. Serves clients in industry, finance, computers, electronics, health care and pharmaceutical.
Needs: Needs computer-literate freelancers for design, illustration, production and presentation. 40% of freelance work demands knowledge of Aldus PageMaker, QuarkXPress, Aldus FreeHand, Adobe Illustrator and Photoshop. Need editorial and technical illustration.
First Contact & Terms: Send query letter with tearsheets, finished art samples, photocopies and SASE. Provide brochure, flier, business card, résumé and tearsheets to be kept on file for future assignments. Portfolio should include comps. Pays for design by the hour, $20-50. Pays for illustration by the project, $75 minimum.
Tips: "We have cut staff so we rely more on freelancers to fill in the gaps when work load requires it."

EVANS & PARTNERS INC., 1961 Oxford Ave., Cardiff CA 92007-1636. (619)944-9400. Fax: (619)944-9422. President/Creative Director: David Evans. Estab. 1988. Ad agency. Full-service, multimedia firm. Specializes in marketing communications from strategies and planning through implementation in any media. Product specialties are marketing and graphics design for high-tech, high-tech medical, manufacturing. Current clients include Procare, Novus Technologies, Orincon, Verticle Market Software, various credit unions.
● Very interested in CD-ROM combination photography illustration—typographic work.
Needs: Approached by 3-4 freelance artists/month. Works with 1-2 illustrators and 3-4 designers/month. Works only with artist reps/illustrators. Prefers local artists with experience in listening, concepts, print and collateral. Uses freelance artists mainly for comps, design and production (brochure and print ad design and illustration, storyboards, mechanicals, retouching, billboards, posters, TV/film graphics, lettering and logos). Needs editorial, technical and medical illustration. 40% of work is with print ads. Needs computer-literate freelancers for design, illustration, production and presentation. 90% of freelance work demands knowledge of Aldus PageMaker, Adobe Illustrator, Quark XPress, Aldus FreeHand or Corel Draw.
First Contact & Terms: Send query letter with brochure, photocopies, résumé and photographs. Samples are filed. Reports back to the artist only if interested. Art Director will contact artist for portfolio review if interested. Portfolio should include roughs, photostats, tearsheets, transparencies and actual produced pieces. Very rarely may request work or spec. Pays for design by the project, $100-24,000. Pays for illustration by the project, $100-18,000. Rights purchased vary according to project.
Tips: Finds artists through word of mouth, magazines, submissions, source books and agents.

JUDY GANULIN PUBLIC RELATIONS, 1117 W. San Jose, Fresno CA 93711-3112. (209)222-7411. Fax: (209)226-7326. Owner: Judy Ganulin. Estab. 1984. PR firm. Full-service, multimedia firm. Specializes in brochures. Product specialties are political, nonprofit and small business.
Needs: Approached by 1-2 freelance artists/month. Works with 1 illustrator and 1 designer/month. Prefers local artists only. Works on assignment only. Uses freelance artists mainly for layout, logo development and design. Also uses freelance artists for brochure and print ad design and illustration, billboards, posters, TV/film graphics, lettering and logos. 5% of work is with print ads. Needs computer-literate freelancers for design, editorial illustration, production and presentation. 10% of freelance work demands computer skills.
First Contact & Terms: Send query letter with tearsheets. Samples are returned by SASE only if requested by artist. Reports back within 10 days. Request portfolio review in original query and follow-up with call. Portfolio should include thumbnails, roughs, finished art, color tearsheets. Pays for design and illustration by the hour, $25-60. Negotiates rights purchased.
Tips: Finds artists through word of mouth and cold calls. "In the future I think clients will be very specific about what they will pay for, but they will insist on quality work and excellent service."

‡**GRAFF ADVERTISING INC.**, #100, 1900 Embarcadero Rd., Palo Alto CA 94114. (415)856-4040. Fax: (415)856-2126. Creative Director: Steve Graff. Ad agency. Full-service, multimedia firm. Product specialties are science and medicine, industrial. Current clients include Fuji Medical, Menicon, Microspeed, Fischer Pharmaceuticals and J.H. Baxter. Client list available upon request.
Needs: Approached by 6-10 freelance artists/month. Works with 1-2 freelance illustrators and 2-3 freelance designers/month. Prefers local artists proficient in electronic production. Works on assignment only. Uses freelance artists for concept through final. Also uses freelance artists for brochure, catalog and print ad design and illustration and storyboards, mechanicals, retouching, model making, billboards, posters, TV/film graphics and logos. 50% of work is with print ads. Needs computer-literate freelancers for design, illustration and production. 90% of freelance work demands knowledge of Adobe Illustrator, QuarkXPress, Adobe Photoshop and/or Aldus FreeHand.
First Contact & Terms: Send query letter with résumé and examples of work. Samples are filed or returned by SASE if requested. Does not report back. Artist should follow-up with call. Portfolio should include thumbnails, roughs and final art. Pays for design and illustration by the project. Rights purchased vary according to project.

LINEAR CYCLE PRODUCTIONS, P.O. Box 2608, San Fernando CA 91393-0608. Producer: Rich Brown. Production Manager: R. Borowy. Estab. 1980. AV firm. Specializes in audiovisual sales and marketing programs and also in teleproduction for CATV. Current clients include Katz, Inc. and McDave and Associates.
Needs: Works with 7-15 illustrators and designers/year. Prefers artists with experience in teleproductions (broadcast/CATV/non-broadcast). Works on assignment only. Uses freelancers for storyboards, animation, TV/film graphics, editorial illustration, lettering and logos. 10% of work is with print ads. Needs computer-literate freelancers for illustration and production. 25% of freelance work demands knowledge of in Aldus FreeHand, Photoshop or Tobis IV.
First Contact & Terms: Send query letter with résumé, photocopies, photographs, slides, transparencies, video demo reel and SASE. Samples are filed or are returned by SASE if requested by artist. Reports back to the artist only if interested. To show a portfolio, mail audio/videotapes, photographs and slides; include color and b&w samples. Pays for design and illustration by the project, $100 minimum. Considers skill and experience of artist, how work will be used and rights purchased when establishing payment. Negotiates rights purchased.
Tips: Finds artists through reviewing portfolios and published material. "We see a lot of sloppy work and samples, portfolios in fields not requested or wanted, poor photos, photocopies, graphics etc. Make sure your materials are presentable."

LEE MAGID MANAGEMENT AND PRODUCTIONS, Box 532, Malibu CA 90265. (213)463-5998. President: Lee Magid. Estab. 1963. AV and PR firm. "We produce music specials, videos and recordings."
Needs: Works with 4 illustrators/month. Works on assignment only. Uses freelancers for "anything print." Also uses freelancers for brochure, catalog and print ad design and storyboards, posters, TV/film graphics and logos. 50% of work is with print ads.
First Contact & Terms: Send query letter with brochure, photostats and SASE. Samples are filed or are returned by SASE only if requested by artist. Reports back to the artist only if interested. To show portfolio, mail photostats; include color and b&w samples. Pays for design and illustration by the project. Considers how work will be used when establishing payment. Buys all rights or reprint rights.
Tips: "Send your work in, but keep originals. Send clear copy of work."

MATHEWS & CLARK COMMUNICATIONS, Suite 170, 710 Lakeway, Sunnyvale CA 94086-4013. (408)736-1120. Fax: (408)736-2523. Production Supervisor: Dori Jones. Estab. 1975. Ad/PR firm. Full-service, multimedia firm. Specializes in annual reports, collaterals, ads. Product specialties are high-tech, electronics. Current clients include KLA Instruments, Genus, Tencor Instruments, Johnson Matthey Electronics and ASM Lithography.
Needs: Approached by 4-6 freelance artists/month. Works with illustrators on a project basis. Works with 1-2 freelance designers/month. Prefers artists with experience in high-tech accounts. Works on assignment only. Uses freelance artists mainly for ad concepts, annual reports, collateral. Also uses freelancers for brochure, catalog and print ad design; brochure, technical and print ad illustration; mechanicals; logos and newsletter design. 10% of work is with print ads. Needs computer-literate freelancers for design, illustration and production. 75% of freelance work demands knowledge of Aldus Pagemaker, Adobe Illustrator, QuarkXpress or Aldus Freehand.
First Contact & Terms: Send query letter with brochure. Request portfolio review in original query, follow up with letter. Portfolios may be dropped off on Mondays and Tuesdays at request of firm, and should include b&w and color printed samples. Samples are filed. Sometimes requests work on spec before assigning a job. Pays for design by the hour, $30 minimum or by the project. Pays for illustration by the project. Rights purchased vary according to project.
Tips: Finds artists through word of mouth and sourcebooks.

‡MULTI-IMAGE PRODUCTIONS, 8849 Complex Dr., San Diego CA 92123. (619)560-8383. Fax: (619)560-8465. Graphics Manager: Terry Gardner. Estab. 1976. AV firm. Full-service, multimedia firm. Specializes in corporate business meetings. Current clients include AT&T, American Airlines, Pitney Bowes, Travelodge. Client list available on request.
Needs: Approached by 1-2 freelance artists/month. Works with 3-4 freelance illustrators and 1-2 freelance designers/month. Prefers artists with experience in PC Platform, Targa based. Works on assignment only. Uses freelance artists mainly for graphic creation and design. Also uses freelance artists for brochure design and illustration, storyboards, TV/film graphics and logos. 1% of work is with print ads. Needs computer-literate freelancers for design and production. 95% of freelance work demands knowledge of Digital Arts, Lumena, Inscriber or Targa Tips.
First Contact & Term: Send query letter with brochure, résumé and photocopies. Samples are filed. Reports back ASAP. Art Director will contact artists for portfolio review if interested. Portfolio should include final art. Pays for design by the hour or by the project, "rate depends on project." Buys all rights.

‡NEW & UNIQUE VIDEOS, 2336 Sumac Dr., San Diego CA 92105. (619)282-6126. Fax: (619)283-8264. Estab. 1982. AV firm. Full-service, multimedia firm. Specializes in special interest video titles—documentaries, how-to's, etc. Current clients include Coleman Company, Caribou, DuPont, Canari Cyclewear, Giant Bicycles, Motiv Bicycles. Client list available upon request.
Needs: Prefers artists with experience in computer animation. Works on assignment only. Uses freelance artists mainly for video box covers, video animation. Also uses freelance artists for catalog and print ad design, animation, posters and TV/film graphics. 10% of work is with print ads. Needs computer-literate freelancers for design and illustration. 50% of freelance work demands knowledge of Adobe Illustrator, Adobe Photoshop and/or Aldus FreeHand.
First Contact & Terms: Send query letter with brochure, résumé and SASE. Samples are filed or returned by SASE. Reports back in 1 month only if interested. Art Director will contact artist for portfolio review if interested. Portfolio should include thumbnails, photographs and tearsheets. Pays for design and illustration by the project (negotiated). Buys one-time rights.

ON-Q PRODUCTIONS, INC., 618 E. Gutierrez St., Santa Barbara CA 93103. President: Vincent Quaranta. AV firm. "We are producers of multi-projector slide presentations. We produce computer-generated slides for business presentations." Clients: banks, ad agencies, R&D firms and hospitals.
Needs: Works with 10 artists/year. Assigns 50 jobs/year. Uses freelancers mainly for slide presentations. Also for editorial and medical illustration, retouching, animation and lettering. Needs computer-literate freelancers for design, illustration, production and presentation. 75% of freelance work demands knowledge of QuarkXPress, Aldus FreeHand or Aldus Persuasion 2.1
First Contact & Terms: Send query letter with brochure or résumé. Reports back only if interested. Write for appointment to show portfolio of original/final art and slides. Pays for design and illustration by the hour, $25 minimum; or by the project, $100 minimum.
Tips: "Artist must be *experienced* in computer graphics and on the board. The most common mistakes freelancers make are poor presentation of a portfolio (small pieces fall out, scratches on cover acetate) and they do not know how to price out a job. Know the rates you're going to charge and how quickly you can deliver a job. Client budgets are tight."

‡■PALKO ADVERTISING, INC., Suite 207, 2075 Palos Verdes Dr. N., Lomita CA 90717. (310)530-6800. Art Director: Chuck Waldman. Ad agency. Clients: business-to-business, retail and high-tech.
 • Palko's illustration needs vary widely from fashion to high tech to architectural.
Needs: Uses freelance artists mainly for layout, illustration, paste-up, mechanicals, copywriting and accurate inking. Also uses freelance artists for Mac Production and pre-press. Produces ads, brochures and collateral material.
First Contact & Terms: Prefers local artists. Send query letter with brochure, résumé, business card, "where you saw our address" and samples to be kept on file. Accepts tearsheets, photographs, photocopies, printed material or slides as samples. Samples not filed returned only if requested. Art Director will contact artists for portfolio review if interested. Artist should follow-up with letter after initial query. Sometimes requests work on spec before assigning a job. Pays for design by the hour, $15-30. Pays for illustration by the hour, $15-30; or by the project, $50-1,500. Negotiates rights purchased.
Tips: Finds artists through sourcebooks. "The advertising field continues to be tough, but positive. No end in sight for higher level of service for least amount of money."

PRISCOMM, Suite K, 3188 Airway, Costa Mesa CA 92626. (714)433-7400. Fax: (714)433-7306. Contact: Creative Director. Estab. 1987. Ad agency/PR firm. Full-service, multimedia firm. Specializes in print ads, interactive presentations, collateral, corporate magazines and newsletters. Product specialties are high-tech and audio-video.
 • This agency looks for designers who can carry a project from initial concept through production.
Needs: Approached by 1-2 freelance artists/month. Works with 2-3 illustrators and 2-3 designers/month. Prefers local artists with 3+ years experience in Macintosh computers. Uses freelance artists mainly for

design and production. Also uses freelance artists for brochures and logos. 70% of work is with print ads. Needs computer-literate freelancers with knowledge of Aldus PageMaker, Adobe Illustrator, QuarkXPress, Photoshop, Aldus FreeHand, Macromind Director, Multimedia.

First Contact & Terms: Send query letter with photocopies, SASE, slides and transparencies. Samples are filed and are returned by SASE. Reports back to artist only if interested. Pays for design by the hour. Pays for illustration by the project. Buys all rights.

RED HOTS ENTERTAINMENT, 813 N. Cordova St., Burbank CA 91505-2924. (818)954-0065. Creative Director: Daniel Pomeroy. Estab. 1987. AV firm. Full-service motion picture and music video film production and off-line editing company. Specializes in documentaries, shorts, video long forms, music videos, motion picture development and production. Current clients include A&M Records, Sony Pictures, Pacific Bell, Walt Disney, Warner Bros., Capitol Records, PBS and Universal/MCA Corp.

Needs: Approached by 1-4 freelance artists/year. Works with 1-2 illustrators and 1-3 designers/year. Works only through artist reps. Prefers artists with experience in motion pictures, television and music. Works on assignment only. Uses freelance artists mainly for storyboards, set stills, film promotion, advertising, set designs, etc. Also uses freelancers for print ad design, mechanicals, retouching, posters, TV/film graphics and logos. 10-25% of work is with print ads, depending on motion picture project. 20% of freelance work demands knowledge of Aldus FreeHand.

First Contact & Terms: Contact only through artist rep. Samples are not filed and are returned by SASE. Reports back within 1-3 weeks if interested. Write for appointment to show portfolio of thumbnails, tearsheets and photographs. Pays for design and illustration by the project depending on per project budget allocations. Rights purchased vary according to project.

‡DONALD S. SMITH, P.O. Box 1545, Whittier CA 90609. (310)690-3700. Fax: (310)690-9045. Art Director: Fred Hartson. Estab. 1965. Ad agency. Full-service, multimedia firm. Specializes in magazine ads and collateral. Product specialties are technical services and products. Current clients include Christie Electronics, Preston Scientific, Polara Engineering, Ardrox, Selco Products, Standard Enterprises, National Irrigation Systems.

Needs: Approached by 1-2 freelance artists/month. Works with 2 freelance illustrators/year. Works on assignment only. Uses freelance artists mainly for illustration. Also uses freelance artists for brochure and print ad illustration. 60% of work is with print ads.

First Contact & Terms: Send tearsheets, photographs, slides and transparencies. Samples are filed or are returned by SASE if requested. Reports back to the artist only if interested. Art Director will contact artist for portfolio review if interested. Pays for illustration by the project, $200-1,500. Buys all rights.

Tips: Finds artists through sourcebooks, word of mouth and artists' submissions.

21ST CENTURY VIDEO PRODUCTIONS, 1292 N. Sacramento St., Orange CA 92667. (714)538-8427. Fax: same. Estab. 1986. AV firm. Full-service, multi-media firm. Specializes in video productions. Current clients include IBM, Ronald Reagan, CHSOC and Electro-Plasma.

Needs: Approached by 2 freelance artists/month. Works with 1 illustrator and 1 designer/year. Prefers local artists with experience in video productions. Uses freelance artists mainly for animation, TV/film graphics and logos. 10% of work is with print ads.

First Contact & Terms: Send query letter with video. Samples are filed. Reports back to the artist only if interested. To show a portfolio, mail video. Pays for design by the project. Buys all rights.

‡VISION STUDIOS, 3765 Marwick Ave., Long Beach CA 90808. (310)429-1042. Contact: Arlan H. Boll. Estab. 1990. AV firm. Full-service, multimedia firm. Specializes in audio project studio sound design for all media. Current clients include NBC, AT&T, KLOS, Toyota and Honda. Client list available upon request.

Needs: Approached by 2-4 freelance artists/year. Works with 2-4 freelance designers/year. 50% of freelance work demands knowledge of Aldus PageMaker.

First Contact & Terms: Send query letter with brochure. Samples are filed. Reports back within 10 days.

■VISUAL AID/VISAID MARKETING, Box 4502, Inglewood CA 90309. (310)473-0286. Manager: Lee Clapp. Estab. 1961. Distributor of promotion aids, marketing consultant service, "involved in all phases." Clients: manufacturers, distributors, publishers and graphics firms (printing and promotion) in 23 SIC code areas.

Needs: Works with 3-5 artists/year. Assigns 4 jobs to freelance artists/year. Uses artists for advertising, brochure and catalog design, illustration and layout; product design; illustration on product; P-O-P display;

A bullet introduces comments by the editor of Artist's & Graphic Designer's Market *indicating special information about the listing.*

display fixture design and posters. Buys some cartoons and humorous cartoon-style illustrations. Additional media: fiber optics, display/signage, design/fabrication.

First Contact & Terms: Works on assignment only. Send query letter with brochure, résumé, business card, photostats, duplicate photographs, photocopies and tearsheets to be kept on file. Reports back if interested and has assignment. Write for appointment to show portfolio. Pays for design by the hour, $5-75. Pays for illustration by the project, $100-500. Considers skill and experience of artist and turnaround time when establishing payment.

Tips: "Do not say 'I can do anything.' We want to know the best media you work in (pen & ink, line drawing, illustration, layout, etc.)."

DANA WHITE PRODUCTIONS, INC., 2623 29th St., Santa Monica CA 90405. (310)450-9101. Owner/Producer: Dana C. White. AV firm. "We are a full-service audiovisual production company, providing multi-image and slide-tape, video and audio presentations for training, marketing, awards, historical and public relations uses. We have complete inhouse production resources, including slidemaking, soundtrack production, photography, and AV multi-image programming. We serve major industries, such as GTE, Occidental Petroleum; medical, such as Whittier Hospital, Florida Hospital; schools, such as University of Southern California, Pepperdine University, Clairbourne School; publishers, such as McGraw-Hill, West Publishing; and public service efforts, including fund-raising."

Needs: Works with 4-6 artists/year. Assigns 12-20 freelance jobs/year. Prefers artists local to greater LA, "with timely turnaround, ability to keep elements in accurate registration, neatness, design quality, imagination and price." Uses freelance artists for design, illustration, retouching, characterization/animation, lettering and charts. Needs computer-literate freelancers for design and illustration. 50% of freelance work demands knowledge of Adobe Illustrator or Aldus FreeHand.

First Contact & Terms: Send query letter with brochure or tearsheets, photostats, photocopies, slides and photographs. Samples are filed or are returned only if requested. Reports back within 2 weeks only if interested. Call or write for appointment to show portfolio. Pays by the project. Negotiates payment negotiable by job.

Tips: "These are tough times. Be flexible. Negotiate. Deliver quality work on time!"

Los Angeles

THE ADVERTISING CONSORTIUM, 1315 S. Sycamore, Los Angeles CA 90019. (213)937-5064. Fax: (213)937-3536. Contact: Kim Miyade. Estab. 1985. Ad agency. Full-service, multimedia firm. Specializes in print, collateral, direct mail, outdoor, broadcast. Current clients include Bernini, Meridian Communications, Royal-Pedic Mattress and Lombardo Ltd.

Needs: Approached by 5 freelance artists/month. Works with 1 illustrator and 3 art directors/month. Prefers local artists only. Works on assignment only. Uses freelance artists and art directors for everything (none on staff), including brochure, catalog and print ad design and illustration and mechanicals and logos. 80% of work is with print ads. 100% of freelance work demands knowledge of Aldus PageMaker, QuarkXPress, Aldus FreeHand, Adobe Illustrator and Photoshop.

First Contact & Terms: Send query letter with brochure, résumé and anything that does not have to be returned. Samples are filed. Write for appointment to show portfolio. "No phone calls, please." Portfolio should include original/final art, b&w and color photostats, tearsheets, photographs, slides and transparencies. Pays for design by the hour, $60-75. Pays for illustration by the project, based on budget and scope.

ANCHOR DIRECT MARKETING, Suite 100, 7926 Cowan Ave., Los Angeles CA 90045. (310)216-7855. Fax: (310)337-0542. President: Robert Singer. Estab. 1986. Ad agency. Specializes in direct marketing.

Needs: Prefers local artists with experience in direct response and illustration. Works on assignment only. Uses freelance artists mainly for layout. Needs computer-literate freelancers for design, illustration and production. 80% of freelance work demands knowledge of Aldus PageMaker, Adobe Illustrator, Aldus FreeHand or QuarkXPress.

First Contact & Terms: Call for appointment to show portfolio of direct response work. Sometimes requests work on spec before assigning job. Pays for design and illustration by the project.

BRAMSON (+ ASSOC.), 7400 Beverly Blvd., Los Angeles CA 90036. (213)938-3595. Fax: (213)938-0852. Art Directors: Alex or Gene. Estab. 1970. Advertising agency. Specializes in magazine ads, collateral, I.D., signage, graphic design, imaging, campaigns. Product specialties are healthcare, consumer, business to business. Current clients include Johnson & Johnson, Lawry's, 10 LAB Corp, DBC and Surgin, Inc.

Needs: Approached by 15 freelance artists/month. Works with 2 illustrators and 1-2 designers/month. Prefers local artists. Works on assignment only. Uses freelance artists for brochure and print ad design; brochure, technical, medical and print ad illustration; storyboards; mechanicals; retouching; lettering; logos. 30% of work is with print ads. Needs computer-literate freelancers for design, illustration, production and presentation. 50% of freelance work demands knowledge of Aldus Pagemaker, Adobe Illustrator, QuarkXpress, Photoshop or Aldus Freehand.

First Contact & Terms: Send query letter with brochure, photocopies, résumé, photographs, tearsheets, SASE. Samples are filed. Art Director will contact artist for portfolio review if interested. Portfolio should include roughs, color tearsheets. Sometimes requests work on spec before assigning job. Pays for design by the hour, $15-25. Pays for illustration by the project, $250-2,000. Buys all rights or negotiates rights purchased.
Tips: Finds artists through sourcebooks.

GARIN AGENCY, Suite 614, 6253 Hollywood Blvd., Los Angeles CA 90028. (213)465-6249. Manager: P. Bogart. Ad agency/PR firm. Clients: real estate, banks.
Needs: Works with 1-2 artists/year. Prefers local artists only. Works on assignment only. Uses artists for "creative work and TV commercials."
First Contact & Terms: Send query letter with photostats or tearsheets to be kept on file for one year. Samples not filed are not returned. Does not report back. Pays by the hour (rates negotiable). Considers client's budget and turnaround time when establishing payment. Buys all rights.
Tips: "Don't be too pushy and don't overprice yourself."

GORDON GELFOND ASSOCIATES, INC., 11500 Olympic Blvd., Los Angeles CA 90064. (310)478-3600. Fax: (310)477-4825. Art Director: Barry Brenner. Estab. 1967. Ad agency. Full-service, multimedia firm. Specializes in print campaigns. Product specialties are financial, general, consumer. Current clients include Long Beach Bank, Century Bank and Deluxe Color Labs.
Needs: Works only with artists reps. Uses freelancers for print ad illustration, mechanicals, retouching and lettering. 95% of work is with print ads.
First Contact & Terms: Send query letter with photostats. Art Director will contact artist for portfolio review if interested. Pays for illustration by the project, $200 minimum. Rights purchased vary according to project.

‡RHYTHMS PRODUCTIONS, P.O. Box 34485, Los Angeles CA 90034. President: Ruth White. Estab. 1955. AV firm. Specializes in CD-ROM and music production/publication. Product specialty is educational materials for children. Client list not available.
Needs: Prefers local artists with experience in cartoon animation and graphic design. Works on assignment only. Uses freelance artists mainly for cassette covers, books, character design. Also uses freelance artists for catalog design, animation and album covers. 2% of work is with print ads. Needs computer-literate freelancers for design, illustration and production. Freelancers should be familiar with Adobe Illustrator, Adobe Photoshop or Macromind Director.
First Contact & Terms: Send query letter with brochure, résumé, photocopies, photographs, SASE (if you want material returned) and tearsheets. Samples are returned by SASE if requested. Reports back within 2 months only if interested. Art Director will contact artist for portfolio review if interested. Pays for design and illustration by the project. Buys all rights.
Tips: Finds artists through word of mouth and artists' submissions.

SPEER, YOUNG & HOLLANDER, #2020, 3580 Wilshire Blvd., Los Angeles CA 90010. (213)487-2363. Fax: (213)487-0072. Production Manager: Deborah Neikirk. Associate Creative Director: Linda Umstead. Estab. 1948. Ad agency and PR firm. Full-service, multimedia firm. Specializes in print ads and collateral. Product specialty is business to business.
Needs: Approached by 10 freelance artists/month. Works with 2-3 illustrators and designers/year. Prefers local artists but will work with with others if necessary. Must show quality and professionalism. Uses freelancers mainly for brochure, catalog and print ad illustration and computer mechanicals, storyboards, retouching, posters, TV/film graphics, lettering and logos. 50% of work is with print ads. Needs computer-literate freelancers for illustration and production. 100% of freelance work demands knowledge of QuarkXPress.
First Contact & Terms: Send query letter with résumé, photocopies. Samples are filed and returned by SASE only if requested by artist. Reports back to the artist only if interested. Write for appointment to show portfolio or mail rough, b&w photostats, transparencies and printed pieces. Rights purchased vary according to project. "We operate on hourly rates."

San Francisco

LORD & BENTLEY PERSUASIVE MARKETING, 1800 Cabrillo, San Francisco CA 94121. (415)386-4730 and (415)565-4422. Creative Director: Allan Barsky. Ad and marketing agency.
Needs: Works with 10 artists/year. Prefers experienced local artists only. Works on assignment only. Uses artists for design and illustration of advertisements, brochures, magazines, newspapers, billboards, posters,

Always enclose a self-addressed, stamped envelope (SASE) with queries and sample packages.

direct mail packages and logos. Artists must "understand reproduction process; the job is to enhance copy strategy."

First Contact & Terms: Send 6 photocopies of published/printed work. Samples not filed are not returned. Does not report back. To show portfolio, mail only photocopies of final reproduction/product. Pays for design by the project or hour, $25-100. Pays for illustration by the hour, $50-120. Considers skill and experience of artist when establishing payment. Buys all rights.

Colorado

CINE DESIGN FILMS, Box 6495, Denver CO 80206. (303)777-4222. Producer/Director: Jon Husband. AV firm. Clients: automotive companies, banks, restaurants, etc.
Needs: Works with 3-7 artists/year. Uses artists for layout, titles, animation and still photography. Clear concept ideas that relate to the client in question are important.
First Contact & Terms: Works on assignment only. Send query letter to be kept on file. Reports only if interested. Write for appointment to show portfolio. Pays by the hour, $20-50 average; by the project, $300-1,000 average; by the day, $75-100 average. Considers complexity of project, client's budget and rights purchased when establishing payment. Rights purchased vary according to project.

‡**HAMILTON SWEENEY ADVERTISING**, 707 Sherman St., Denver CO 80203. (303)837-0515. Vice President/ Creative Director: Stacy Edwards. Estab. 1960. Ad agency. Full-service, multimedia firm. Works in a broad range of media and product categories.
Needs: Approached by 3 freelance illustrators/month. Works with 1 freelance illustrator and 1 freelance designer/month. Prefers artists with experience. Uses freelance artists mainly for illustration. Also uses freelance artists for some brochure design and illustration, print ads, storyboards and mechanicals. 50% of work is with print ads.
First Contact & Terms: Send introductory letter with brochure and photocopies. Samples are filed and not returned. Reports back only if interested. To show a portfolio, mail appropriate materials. Negotiates payment for design and illustration. Buys all rights.

Connecticut

DONAHUE, INC., 227 Lawrence St., Hartford CT 06106. (203)728-0000. Fax: (203)247-9247. Art Director: Ellen Myska. Estab. 1979. Ad agency. Full-service, multimedia firm. Specializes in collateral, trade ads, packaging and PR. Product specialties are computer, tool and interior design.
Needs: Approached by 4-5 freelance artists/month. Works with 1-2 illustrators and 3-4 designers/month. Prefers artists with experience in reproduction, tight comps and mechanicals. Uses freelancers mainly for inhouse work: brochure and print ad design, catalog design and illustration, technical and editorial illustration, mechanicals, posters, lettering and logos. 40% of work is with print ads. Needs computer-literate freelancers for design, illustration, production and presentation. 50% of freelance work demands knowledge of QuarkXPress, Aldus FreeHand, Adobe Illustrator or Photoshop.
First Contact & Terms: Send query letter with résumé and tearsheets. Samples are filed. Art Director will contact artist for portfolio review if interested. Portfolio should include thumbnails, roughs, original/final art and tearsheets. Sometimes requests work on spec before assigning job. Pays for design by the hour, $20-65. Pays for illustration by the project, $200-5,000 maximum. Rights purchased vary according to project.

EFFECTIVE COMMUNICATION ARTS, INC., 149 Dudley Rd., P.O. Box 250, Wilton CT 06897-0250. (203)761-8787. Vice President: David Jacobson. Estab. 1965. AV firm. Produces films, videotapes and interactive videodiscs on science, medicine and technology. Specialize in pharmaceuticals, medical devices and electronics. Current clients include ICI Pharma, AT&T, Burroughs Wellcome and SmithKline Beecham.
 ● This president predicts the audiovisual field will see growth of CD-ROM projects and the need for more art.
Needs: Works with 2 illustrators and 4 designers/month. Prefers artists with experience in science and medicine. Works on assignment only. Uses freelancers mainly for animation and computer graphics. Also uses

Market conditions are constantly changing! If you're still using this book and it is 1996 or later, buy the newest edition of Artist's & Graphic Designer's Market *at your favorite bookstore or order directly from Writer's Digest Books.*

freelancers for editorial, technical and medical illustration, brochure design, storyboards, slide illustration, mechanicals and TV/film graphics. Needs computer-literate freelancers for design, illustration and production. 75% of freelance work demands knowledge of computer graphics packages.

First Contact & Terms: Send query letter with résumé, photographs and videotape. Samples are filed or are returned by SASE only if requested by artist. Reports back to the artist only if interested. Portfolio review not required. Pays for design by the project or by the day, $200 minimum. Pays for illustration by the project, $150 minimum. Considers complexity of project, client's budget and skill and experience of artist when establishing payment. Buys all rights.

Tips: "Show good work and have good references."

ESSEX ADVERTISING GROUP, INC., Suite C-23, P.O. Box 5089, 246 Federal Rd., Brookfield CT 06804-5089. (203)775-1515. Fax: (203)775-9563. Vice President: Stephen Messelt. Estab. 1982. Ad agency and PR firm. Full-service, multimedia firm. Specializes in magazine ads, brochures/catalogs and other collateral, and direct mail. Product specialties are business-to-business and high-tech. Current clients include: Society of Plastics Engineers, Majestech Corp., Posalux, Bedoukian Research and Perkin-Elmer Technical Training.

Needs: Approached by 1 freelance illustrator/month. Works with 1-2 designers/month. Prefers artists with experience in high tech and business-to-business. Works on assignment only. Uses freelance artists mainly for collateral, including print ad design, brochure and catalog design and logos. 30% of work is with print ads.

First Contact & Terms: Send query letter with brochure and résumé. Samples are filed or are returned by SASE if requested by artist. Reports back to the artist only if interested. Call or write for appointment to show portfolio of thumbnails, roughs and tearsheets. Pays for design and illustration by the hour, $15-50. Buys all rights.

ERIC HOLCH/ADVERTISING, 49 Gerrish Lane, New Canaan CT 06840. President: Eric Holch. Full-service ad agency. Product specialties are packaging, food, candy, machinery and real estate. Current clients include Raymond Automation, H.L. Thomas, Cotlyn and National Coverage Corp.

Needs: Works with 10 artists/year. Works on assignment only. Uses freelancers mainly for technical and commercial ads and brochure illustration. Prefers food, candy, packages and seascapes as themes. Needs computer-literate freelancers for design and production. 10% of freelance work demands knowledge of Aldus PageMaker.

First Contact & Terms: Send query letter with brochure showing art style or 8½ × 11 samples to be kept on file. Art Director will contact artist for portfolio review if interested. Portfolio should include roughs, photocopies and original/final art. Sometimes requests work on spec before assigning job. Pays for design and illustration by the project, $100-3,000. Negotiates rights purchased depending on project.

Tips: Finds artists through submissions.

LISTENING LIBRARY, INC., 1 Park Ave., Old Greenwich CT 06870-1727. (203)637-3616. Fax: (203)698-1998. Art Director: Deanna Thomas. Produces books on tape for children and adults. Product specialties include catalogs and cassette covers.

Needs: Periodically requires illustrators for covers of 3 catalogs/year. Uses artists for catalog and advertising design and layout, advertising and editorial illustration and direct mail packages. Needs computer-literate freelancers for production. 50% of freelance work demands knowledge of QuarkXPress or Photoshop.

First Contact & Terms: Prefers local Fairfield County (New York City) and Westchester County artists only. Works on assignment only. Send résumé and nonreturnable samples to be kept on file for possible assignments. Art Director will contact artist for portfolio review if interested. "Payment is determined by the size of the job and skill and experience of artist." Buys all rights.

REALLY GOOD COPY CO., 92 Moseley Terrace, Glastonbury CT 06033. (203)659-9487. Fax: (203)633-3238. President: Donna Donovan. Estab. 1982. Ad agency. Full-service, multimedia firm. Specializes in print ads, collateral, direct mail and catalogs. Product specialties are medical/health care, consumer products and services. Current clients include The Music Stand, Tobacco Shed Antiques, Ross-Simons and The Music Sound Exchange.

Needs: Approached by 3-4 freelance artists/month. Works with 1 illustrator and 1-2 designers/month. Prefers local artists. Works on assignment only. Uses freelance artists for all projects. "There are no on-staff artists." Needs editorial illustration—line art and cartoon art. 50% of work is with print ads. 90% of freelance work demands knowledge of QuarkXPress, Adobe Illustrator or PhotoShop.

First Contact & Terms: Send query letter with description of background and experience. Samples are filed or are returned by SASE only if requested. Reports back to the artist only if interested. Portfolio review not required, but portfolio should include roughs and original/final art. Pays for design by the hour, $25-80. Pays for illustration by the project, $100-750.

Tips: "I file interesting samples and call when an appropriate project comes up. The best source of artists for me is word of mouth with others who have been happy with someone's work. Computer access and skills are more important than ever. I think the dog-eat-dog climate in this business has had its day! I hope we're

going to see practitioners becoming more socially and personally responsible and that doing business will be fun again."

Delaware

AB&C MARKETING COMMUNICATIONS, Dept. AM, 1 Riverwalk Center., Wilmington DE 19801. (302)655-1552. Contact: Tom DeSanto. Ad agency. Clients: health care, banks, industry, restaurants, real estate, hotels, businesses, transit systems, government offices. Current clients include Blue Cross, Blue Shield of Delaware and Riddle Memorial Hospital.
Needs: Assigns "many" freelance jobs/year. Works with 3-4 illustrators and 3-4 designers/month. Uses artists for trade magazines, billboards, direct mail packages, brochures, newspapers, stationery, signage and posters.
First Contact & Terms: Prefers local artists only "within reason (Philadelphia, Baltimore)." Send query letter with résumé, business card and slides, photos, photostats, photocopies. Samples "worthy of consideration" are filed; work is returned only if requested. Reports only if interested. Works on assignment only. Call for appointment to show portfolio. Pays for design by the hour, $20-50. Pays for illustration by the hour; or by the project, $250-1,000.

CUSTOM CRAFT STUDIO, 310 Edgewood St., Bridgeville DE 19933. (302)337-3347. Fax: (302)337-3444. AV producer. Vice President: Eleanor H. Bennett.
Needs: Works with 1 illustrator and 1 designer/month. Works on assignment only. Uses freelancers mainly for work on filmstrips, slide sets, trade magazines and newspapers. Also uses freelancers for print finishing, color negative retouching and airbrush work. Prefers pen & ink, airbrush, watercolor and calligraphy. Needs computer-literate freelancers for design and presentation. 10% of freelance work demands knowledge of Adobe Illustrator. Needs editorial and technical illustration.
First Contact & Terms: Send query letter with résumé, slides or photographs, brochure/flyer and tearsheets to be kept on file. Samples returned by SASE. Reports in 2 weeks. Originals not returned. Pays for design and illustration by the project, $25 minimum.

Florida

BEBER SILVERSTEIN & PARTNERS, 3361 SW Third Ave., Miami FL 33145. (305)856-9800. Fax: (305)854-1932. Associate Creative Director: Joseph Perz. Art Directors: James Hale, Bob Geffert. Estab. 1978. Ad agency. Full-service, multimedia firm. Specializes in TV and magazine ads, posters, logos, billboards, direct mail and collateral. Product specialties are consumer, travel and fragrance. Current clients include First National Bank, Florida Power & Light, Floridagold Orange Juice and Coty Fragrances.
Needs: Approached by 4 artists/month. Works with 1-2 illustrators and 1-2 designers/month. Works on assignment only. Uses freelancers mainly for logos and collateral. Also uses freelancers for brochure and catalog design, editorial illustration, storyboards, mechanicals and lettering. 50% of work is with print ads.
First Contact & Terms: Send query letter with photocopies, photographs, slides, tearsheets and transparencies. Samples are filed and are not returned. Reports to the artist only if interested. If asked to show portfolio, mail color tearsheets, photographs, slides and transparencies. Pays for design by the hour, $8-20. Pays for illustration by the project, $200-5,000. Rights purchased vary according to project.
Tips: Finds artists through award show books, direct mail pieces, trade publications and editorial credits.

‡CENTURY III AT UNIVERSAL STUDIOS, 2000 Universal Studios Plaza, Orlando FL 32819-7606. (407)354-1000. Fax: (402)352-8662. Graphics Producer: Byron Cameron. Estab. 1985. Production/post production company. Specializes in film production, post production and graphics. Client list not available.
Needs: Approached by 12 freelance artists/month. Works with 1 freelance designer/month. Prefers artists with experience in 3-D and 2-D animation for commercials and TV IDs. Uses freelance artists mainly for Rotoscoping. Also uses freelance artists for storyboards, animation, retouching, TV/film graphics and logos. 2% of work is with print ads. Needs computer-literate freelancers for design and production. 100% of freelance word demands knowledge of Adobe Illustrator, Adobe Photoshop or WaveFont.
First Contact & Terms: Send query letter. Samples are filed. Does not report back. Artist should call 2 weeks after submitting. Art Director will contact artist for portfolio review if interested. Portfolio should include b&w and color thumbnails, photographs and transparencies. Pays various rates for design and illustration.

CREATIVE RESOURCES, INC., 2000 S. Dixie Hwy., Miami FL 33133. (305)856-3474. Chairman: Mac Seligman. Estab. 1970. PR firm. Specializes in travel and transportation. Current clients include Art Deco Hotels, Ltd. and Aviation Management Services.
Needs: Approached by 2-3 freelance artists/month. Works with 1 illustrator and 1-2 designers/year. Works only with artist reps. Prefers local artists only. Works on assignment only. Uses freelance artists mainly for brochure and collateral design. Also for brochure illustration and mechanicals.

First Contact & Terms: Send query letter with résumé and photostats. "Do not send samples." Call for appointment to show portfolio. Pays for design by the hour, $25-40. Pays for illustration by the project. Buys all rights.

GOLD AND ASSOCIATES, Box 2659, Ponte Vedra Beach, FL 2659-32004. (904)285-5669. Fax: (904)285-1002. Creative Director/President: Keith Gold. Estab. 1988. Ad agency. Full-service, multimedia firm. Specializes in graphic design. Product specialties are health care, communications and fashion.
 • The president of Gold and Associates believes agencies will offer more services than ever before, as commissions are reduced by clients.
Needs: Approached by 10-12 freelance artists/month. Works with 2-3 illustrators and 2-3 designers/month. Works only with artist reps. Works on assignment only. Uses freelancers for brochure, catalog, medical, editorial, technical, slide and print ad illustration; storyboards; animatics; animation; mechanicals; retouching. 50% of work is with print ads. Needs computer-literate freelancers for illustration, production and presentation. 50% of freelance work demands knowledge of Aldus PageMaker, Adobe Illustrator and Quark-XPress.
First Contact & Terms: Contact through artist rep or send query letter with photocopies, tearsheets and capabilities brochure. Samples are filed. Reports back to the artist only if interested. Request portfolio review in original query. Art Director will contact artists for portfolio review if interested. Follow-up with letter after initial query. Portfolio should include tearsheets. Pays for design by the hour, $35-125. "Maximum number of hours is negotiated up front." Pays for illustration by the project, $200-7,500. Buys all rights.
Tips: Finds artists primarily through sourcebooks and reps.

‡**STEVE POSTAL PRODUCTIONS,** P.O. Box 428, Carraway St., Bostwick FL 32007. (904)325-5254. Director: Steve Postal. Estab. 1958. AV firm. Full-service, multimedia firm. Specializes in documentaries, feature films. Product specialty is films and videos. Client list not available.
Needs: Approached by 10 freelance artists/month. Works with 2 freelance artists/month. Prefers artists with experience in advertising, animation, design for posters. Works on assignment only. Uses freelance artists mainly for films and film ads/VHS boxes. Also uses freelance artists for brochure, catalog and print ad design and illustration and animation, TV/film graphics and lettering. 10% of work is with print ads. Needs computer-literate freelancers for production. 10% of freelance work demands knowledge of Aldus FreeHand.
First Contact & Terms: Send query letter with résumé, photostats, photocopies, SASE and tearsheets. Samples are filed. Reports back to the artist only if interested. Artist should follow-up with letter after initial query. Portfolio should include b&w and color final art, tearsheets and photographs. Pays for design and illustration by the project. Buys all rights.
Tips: Finds artists through submissions.

Georgia

‡**THE ASLAN GROUP, LTD.,** 3595 Webb Bridge Rd., Alpharetta GA 30202. (404)442-1500. Fax: (404)442-1844. Senior Art Director: Christopher Farrell. Estab. 1984. Ad agency. Full-service, multimedia firm. Specializes in direct response print advertising, magazine ads and direct mail. Product specialty is software and building products. Current clients include S&S Mills Carpet, Peachtree Software, Zondervan Publishing, Christian Publishing. Client list available upon request.
Needs: Approached by 8-10 freelance artists/month. Works with 1 freelance illustrator and 3-4 freelance designers/month. Prefers local artists only with experience in direct response mailings. Uses freelance artists mainly for production from conceptual sketches. Also uses freelance artists for brochure and print ad design and illustration. 60% of work is with print ads. Needs computer-literate freelancers for design and production. 90% of work demands computer skills in Adobe Illustrator, QuarkXPress or Adobe Photoshop.
First Contact & Terms: Send query letter with résumé and photocopies. Samples are filed or returned by SASE. Reports back to the artist only if interested. Artist should call for an appointment. Portfolios may be dropped off every Friday. Artist should follow-up with call. Portfolio should include color final art and tearsheets. Pays for design by the hour, $20-50; by the day, $120-300. Pays for illustration by the project, $100-1,200. Rights purchased vary according to project.
Tips: "We find designers primarily through referral from freelancers we trust. We will try unfamiliar (new) talent on low-risk work before turning over a priority job. Trust and reliability are paramount, along with speed and initiative."

CINEVISION CORPORATION, 3300 NE Expressway, Atlanta GA 30341. (404)455-8988. President: Steve Newton. Estab. 1972. AV firm providing sales service and rental of professional 16mm/35mm/70mm/vistavision motion picture equipment and screening of motion pictures on location and in screening room facility in Atlanta. Current clients include AT&T, Bell South, Paramount Pictures, Universal Pictures, Warner Bros. and Disney Company.
Needs: Works on assignment only. Seeks experienced freelancers for brochure design. 2% of work is with print ads.

First Contact & Terms: Send query letter with brochure. Samples are filed. Reports back within 10 days. To show portfolio, mail tearsheets. Pays for design and illustration by the project. Considers client's budget when establishing payment.

COMPRO PRODUCTIONS, Suite 114, 2080 Peachtree Industrial Court, Atlanta GA 30341-2281. (404)455-1943. Fax: (404)455-3356. Creative Director: Nels Anderson. Estab. 1977. AV firm. Specializes in film and video. Product specialties are travel industry and airlines.
Needs: Approached by 1-2 freelancers/month. Uses freelancers mainly for animation. Also uses freelancers for brochure and print ad design and storyboards. 5-10% of work is with print ads.
First Contact & Terms: Send query letter with videotape demo reel, VHS, ¾", betacam sp. Samples are filed. Reports back only if interested. Call or write for appointment to show portfolio. Pays for design and illustration by the project. Buys all rights.

GRANT/GARRETT COMMUNICATIONS, INC., Box 53, Atlanta GA 30301. (404)755-2513. President: Ruby Grant Garrett. Estab. 1979. Production and placement firm for print media. Specializes in recruitment advertising and graphics. Clients: banks, organizations, products-service consumer. Client list available for SASE.
• Grant/Garrett Communications predicts there will be more small jobs in the future.
Needs: Assigns 24 jobs/year. Works with 2-3 illustrators and 2 designers/year. "Experienced, talented artists only." Works on assignment only. Uses freelancers for billboards, brochures, signage and posters. 100% of work is with print ads. Needs editorial, technical and medical illustration. Especially needs "help-wanted illustrations that don't look like clip art." Needs computer-literate freelancers for design, illustration and presentation. 30% of freelance work demands knowledge of Aldus PageMaker.
First Contact & Terms: Send query letter with résumé and samples to be kept on file or returned by SASE. Reports within 10 days. Art Director will contact artist for portfolio review if interested. Portfolio should include roughs and tearsheets. "Do not send samples or copies of fine art or paintings." Requests work on spec before assigning a job. Pays for design by the hour, $25-35; or by the project, $75-3,500. Pays for illustration by the project, $35-2,500. Considers client's budget, skill and experience of artist and turnaround time when establishing payment. Negotiates rights purchased.
Tips: Finds artists through submissions and sourcebooks.

GROUPATLANTA CREATIVE, (formerly GroupAtlanta), Box 500725, Atlanta GA 31150. Creative Director: Ralph Broom. Full service advertising, marketing communications and specialty advertising firm. Clients: real estate, banks, health care, radio stations, government agencies, car dealers, fashion, lingerie.
Needs: Works with 20 artists/year. Assigns 400 freelance jobs/year. Works on assignment only. Uses highly experienced freelancers for design, illustration, mechanicals, retouching, animation, direct mail packages, lettering, logos and charts/graphs. Needs architectural and sophisticated, professional cartoon illustration. Would like to see more excellent, professional pencil or pen & ink architectural, and computer illustration. 50% of freelance work demands knowledge of Adobe Illustrator and Photoshop. "Do not want to see entry level or amaturish work."
First Contact & Terms: Send query letter with brochure or tearsheets, photostats, photocopies, slides and photographs. Samples are filed and are not returned. Pays for design and illustration by the project. Considers complexity of project, client's budget and turnaround time when establishing quotes.
Tips: "Send 8½×11 color photocopied samples with amount you charged on each."

J. WALTER THOMPSON COMPANY, One Atlanta Plaza, 950 E. Paces Ferry Rd., Atlanta GA 30326. (404)365-7300. Fax: (404)365-7399. Executive Art Director: Bill Tomassi. Executive Creative Director: Mike Lollis. Ad agency. Clients: mainly financial, industrial and consumer. "This office does creative work for Atlanta and the southeastern US."
Needs: Works on assignment only. Uses freelancers for billboards, consumer and trade magazines and newspapers. Needs computer-literate freelancers for design, production and presentation. 60% of freelance work demands knowledge of Adobe Illustrator, Photoshop or QuarkXPress.
First Contact & Terms: Deals with artists reps only. Send slides, original work, stats. Samples returned by SASE. Reports only if interested. Originals not returned. Call for appointment to show portfolio. Pays by the hour, $20-80; by the project, $100-6,000; by the day, $140-500.
Tips: Wants to see samples of work done for different clients. Likes to see work done in different media, variety and versatility. Artists interested in working here should "be *professional* and do top-grade work."

For a list of markets interested in humorous illustration, cartooning and caricatures, refer to the Humor Index at the back of this book.

EMIL J. WALCEK ASSOCIATES & TRADE PR SERVICE, Dept. AM, Suite D, 1031 Cambridge Square, Alpharetta GA 30201. (404)664-9322. Fax: (404)664-9324. President: Emil Walcek. Estab. 1980. Ad agency. Specializes in magazine ads and collaterals. Product specialty is business-to-business.
Needs: Works with 2 illustrators and 1 designer/month. Prefers local artists only with experience in Mac computer design and illustration and Photoshop expertise. Works on assignment only. Uses freelancers for brochure, catalog and print ad design and illustration; editorial, technical and slide illustration; retouching and logos. 50% of work is with print ads. Needs computer-literate freelancers for design, illustration, production and presentation. 75% of freelance work demands knowledge of Aldus PageMaker, Aldus FreeHand, Adobe Illustrator or Photoshop.
First Contact & Terms: Send query letter with résumé, photostats and slides. Samples are filed or are returned by SASE if requested by artist. Reports back to the artist only if interested. Write for appointment to show portfolio. Portfolio should include thumbnails, roughs, final art, tearsheets. Pays for design by the hour or by the project. Pays for illustration by the project. Buys all rights.

Idaho

CIPRA, Dept. AM, 314 E. Curling Dr., Boise ID 83702. (208)344-7770. President: Ed Gellert. Estab. 1979. Ad agency. Full-service, multimedia firm. Specializes in trade magazines, TV and logos.
Needs: Works with illustrators 2-3 times/year. Prefers artists with experience in airbrushing. Works on assignment only. Uses freelancers mainly for retouching and logos.
First Contact & Terms: Send query letter. Samples are filed for reference. Does not report back unless needed. To show portfolio, mail appropriate materials, including color photocopies. Pays for design and illustration by the project. Payment negotiated for each job. Buys all rights.

‡MEDIA ASSOCIATES ADV., 3808 W. Dorian St., P.O. Box 5791, Boise ID 83705. (208)384-9278. President: Danny Jensen. Estab. 1990. Ad agency. Full-service, multimedia firm. Specializes in electronic media, radio and TV, video corporate and industrial productions. Product specialty is consumer. Client list not available.
Needs: Works with 2-3 freelance illustrators and designers/month. Prefers local artists, but works with out-of-town also. Works on assignment only. Uses freelance artists mainly for commercials. Also uses freelance artists for brochure design, print ad design and illustration, storyboards, slide illustration, animation, billboards, posters and logos. 30% of work is with print ads. Needs computer-literate freelancers for design, illustration and production. 20% of freelance work demands knowledge of Aldus FreeHand.
First Contact & Terms: Send query letter with brochure and photocopies. Samples are filed or returned by SASE. Reports back to the artist only if interested. Pays for design and illustration by the hour, $35-50. Rights purchased vary according to project.

Illinois

BRAGAW PUBLIC RELATIONS SERVICES, 800 E. Northwest Hwy., Palatine IL 60067. (708)934-5580. Fax: (708)934-5596. Principal: Richard S. Bragaw. PR firm. Specializes in newsletters and brochures. Clients: professional service firms, associations and industry. Current clients include Arthur Anderson, KPT Kaiser Precision Tooling, Inc. and Nykiel-Carlin and Co. Ltd.
Needs: Assigns 12 freelance jobs/year. Prefers local artists only. Works on assignment only. Works with 1 freelance illustrator and 1 freelance designer/month. Uses freelancers for direct mail packages, brochures, signage, AV presentations and press releases. Needs computer-literate freelancers for design and production. 90% of freelance work demands knowledge of Aldus PageMaker. Needs editorial and medical illustration.
First Contact & Terms: Send query letter with brochure to be kept on file. Reports only if interested. Pays by the hour, $25-75 average. Considers complexity of project, skill and experience of artist and turnaround time when establishing payment. Buys all rights.
Tips: "We do not spend much time with portfolios."

‡■JOHN CROWE ADVERTISING AGENCY, INC., 1104 S. 2nd St., Springfield IL 62704. (217)528-1076. President: Bryan J. Crowe. Ad/art agency. Specializes in industries, manufacturers, retailers, banks, publishers, insurance firms, packaging firms, state agencies, aviation and law enforcement agencies. Product specialty is creative advertising. Current clients include Systems 2000 Ltd., Silhouette American Health Spas.
Needs: Buys 3,000 illustrations/year. Works with 4 freelance illustrators and 3 freelance designers/month. Works on assignment only. Uses artists for color separation, animation, lettering, paste-up and type specing for work with consumer magazines, stationery design, direct mail, slide sets, brochures/flyers, trade magazines and newspapers. Especially needs layout, camera-ready art and photo retouching. Needs technical illustration. Prefers pen & ink, airbrush, watercolor and marker. Needs computer-literate freelancers for design and illustration. 25% of freelance work demands computer skills.
First Contact & Terms: "Send a letter to us regarding available work at agency. Tell us about yourself. We will reply if work is needed and request samples of work." Prefers tearsheets, original art, photocopies,

brochure, business card and résumé to be kept on file. Samples not filed are returned by SASE. Reports in 2 weeks. Pays for design and illustration by the hour, $15-25. No originals returned to artist at job's completion. No payment for unused assigned illustrations.
Tips: "Current works are best. Show your strengths and do away with poor pieces that aren't your stonghold. A portfolio should not be messy and cluttered. There has been a notable slowdown across the board in our use of freelance artists."

‡**WALTER P. LUEDKE & ASSOCIATES, INC.**, 3150 Landstrom Rd., Rockford IL 61107. (815)398-4207. Fax: (815)398-4239. President: W. P. Luedke. Estab. 1959. Ad agency. Full-service multimedia firm. Specializes in magazine ads, brochures, catalogs and consultation. Product specialty is industry.
Needs: Approached by 2 freelance artists/month. Works with 2 freelance illustrators and 2 freelance designers/month. Prefers artists with experience in technical layout. Works on assignment only. Uses freelance artists mainly for layout and keylines. Also uses freelance artists for brochure, catalog and print ad design and illustration and storyboards, slide illustration, animatics, animation, mechanicals, retouching, billboards, posters, TV/film graphics, lettering and logos. 30% of work is with print ads.
First Contact & Terms: Send query letter with résumé, photographs, tearsheets, photostats and slides. Samples are filed and are not returned. Reports back to the artist only if interested. Call for appointment to show portfolio of thumbnails, roughs, original/final art, b&w and color photostats, tearsheets, photographs or slides. Pays for design and illustration by the hour, by the project or by the day (negotiable). Buys all rights.

‡**OMNI ENTERPRISES, INC.**, 430 W. Roosevelt Rd., Wheaton IL 60187-5072. (708)653-8200. Fax: (708)653-8218. President: Steve Jacobs. Estab. 1962. Ad agency. Specializes in all collateral, ads, AV, marketing consulting, etc. Product specialties include business-to-business and some consumer. Current clients include Viking Travel, Schweppe, Rose Laboratories, Illinois Benedictine College, Thomas Engineering.
Needs: Approached by 10 freelance artists/month. Works with 3 freelance illustrators and 5 freelance designers/month. Prefers local artists only with experience in typesetting, color selection. Uses freelance artists for "all we do. We have no in-house art staff." Also uses freelance artists for brochure, catalog and print ad design and illustration, storyboards, slide illustration, mechanicals, retouching, billboards, posters, TV/film graphics, lettering, logos, displays and P-O-P. 20% of work is with print ads. Needs computer-literate freelancers for design, illustration, production and presentation. 60% of freelance work demands computer skills.
First Contact & Terms: Send query letter and phone for appointment. Samples sometimes filed, returned if not filed. Does not report back. Artist should follow-up with call. Art Director will contact artist for portfolio review if interested. Portfolio should include b&w and color thumbnails, roughs, tearsheets, slides, photostats, photographs and transparencies. Pays for design by the hour, $20-50; by the project. Pays for illustration by the project, $25-15,000. Buys all rights.
Tips: Finds artists through submissions.

Chicago

‡**CLEARVUE, INC.**, 6465 N. Avondale, Chicago IL 60631. (312)775-9433. President: Mark Ventling. AV firm.
Needs: Works with 10-12 freelance artists/year. Works on assignment only. Uses freelance artists mainly for video programs and computer animation. Needs editorial and technical illustration.
First Contact & Terms: Send query letter with SASE to be kept on file. Prefers to review proposal and demo tape. Reports back within 10 days. Write for appointment to show portfolio. Average program is 10-20 minutes long. Considers the complexity of the project and budget when establishing payment. Particularly interested in combining existing archival art and video materials with computer animations. Pays by the project, $50-2,500, depending on the scope of the work. Rights negotiable.
Tips: "Have some knowledge of the educational video marketplace. Review our catalogs. Write a proposal that tells how you fill a need in one or more curricular subject areas."

DeFRANCESCO/GOODFRIEND, Suite 1000, 444 N. Michigan Ave., Chicago IL 60611. (312)644-4409. Fax: (312)644-7651. Partner: John DeFrancesco. Estab. 1985. PR firm. Full-service, multimedia firm. Specializes in marketing, communication, publicity, direct mail, brochures, newsletters, trade magazine ads, AV presentations. Product specialty is consumer home products. Current clients include S-B Power Tool Co., Plantation Baking, ITW Brand Merchandising, Promotional Products Association International.
Needs: Approached by 1-2 freelance artists/month. Works with 1-2 designers/month. Works on assignment only. Uses freelancers mainly for brochures, ads, newsletters. Also for print ad design and illustration, editorial and technical illustration mechanicals, retouching and logos. Needs computer-literate freelancers for

Always enclose a self-addressed, stamped envelope (SASE) with queries and sample packages.

Are You Computer Friendly Yet?

Tassani & Paglia, a bustling full-service marketing communications agency located on Chicago's State Street, has a work station built specifically for freelancers. Equipped with a Macintosh IIci and loaded with Adobe PhotoShop, QuarkXPress, Wacom Drawing Tablet and Adobe Illustrator, the station is up and running. Trouble is, it sits empty much of the time, not for lack of work but because there just aren't enough good designers with polished computer skills.

David Pierce

It's a common scenario created by the sweeping changes in technology in recent years, says David Pierce, Tassani & Paglia's high-energy design director. Most experienced designers don't have up-to-date computer skills and recent graduates have knowledge of the latest programs, but lack design experience. A freelancer who combines computer skills with design know-how can virtually write his or her own ticket.

You could become a computer wiz with one to two years of study on your own time, insists Pierce, who speaks from experience. "I was one of those designers who swore I'd never use a computer. But once I got started, I loved it." It's not that difficult and doesn't take that long to learn. Renting a computer is a good way to start, advises Pierce. Play around with the tutorials, and pick up some instructional videos from the library. Start out with a Mac because, so far, it's more widely used in design than the IBM PC. Try some of the more commonly used software programs like QuarkXPress and Aldus PageMaker.

Computer manuals aren't geared toward design, says Pierce, so get books on the various computer programs written from a designer's point of view. You'll learn all kinds of shortcuts to get the effects you'll need. Magazines like *HOW* and *Step-By-Step Graphics* will keep you inspired and up-to-speed on the latest software. Since technology is constantly being updated, your education must be continuous.

Be willing to part with cherished ways of doing things. It's not easy to let go of hard-earned skills but it is the only way to go. Learn which of your skills will be phased out and replace them with new knowledge. Good "wrists" (experts at drawing roughs and storyboards with markers) will always be in demand, but some techniques—like airbrush—may be used less in the future because computer blends create similar effects. "If you could learn how to operate something as complicated as an airbrush, you can learn to use a computer."

After an initial period of frustration, you'll be creating layouts and designing

brochures. Once you are confident in a popular software, says Pierce, begin approaching art directors for projects. Don't misrepresent your skills to get an assignment. Pierce has been burned before by freelancers claiming to have computer knowledge, who had minimal skills. That meant lost time and money, because staff designers had to scramble to complete the assignment on deadline.

"This is a spontaneous business," says Pierce, whose agency must respond quickly to clients' needs. That's why freelancers are such a valued part of the team. "I don't have time to teach. I want to be able to say 'Do this graph in Adobe Illustrator, in a pie chart format, with a drop shadow' and the freelancer can just run with it. A great freelancer is like a pair of old sweats—comfortable and ready for a workout."

Pierce speaks glowingly of one of his freelancers. He found her, or rather she found him, when she cold-called him one day, described her background and skills, and asked for an appointment. Her design experience combined with some newly acquired computer skills impressed Pierce. She also took the trouble to research the market. She approached Tassani & Paglia after noting their client list includes financial institutions, which fit her experience and skills.

Another quality Pierce looks for is enthusiasm. And that's where newcomers could have an edge. "Their eyes light up when they are talking about an assignment." Somewhere along the line some experienced designers and illustrators lose that sense of excitement. Learning new skills, says Pierce, is one way to keep your enthusiasm. He should know. It works for him.

—*Mary Cox*

Reprinted with permission of Tassani & Paglia, Chicago, Illinois

His hand held up to hearken every word, this character was computer-generated by Eric Donelan to illustrate the concept "More Than Listening" on the cover of Tassani & Paglia's colorful, bold capabilities brochure.

design, illustration, production and presentation. 75% of freelance work demands computer skills.

First Contact & Terms: Send query letter with brochure and résumé. Samples are filed. Does not report back. Request portfolio review in original query. Artist should call within 1 week. Portfolio should include printed pieces. Pays for design by the project, $50 minimum. Pays for illustration by the project, $50 minimum. Rights purchased vary according to project.

Tips: Finds artists "through word of mouth and queries to us. I think there is a slow but steady upward trend in the field. Computerization is adding to fragmentation: many new people opening shop."

‡**KAUFMAN RYAN STRAL INC.**, Suite 370, 101 E. Ontario, Chicago IL 60611. (312)467-9494. Fax: (312)467-0298. Vice President/Creative Director: Robert Ryan. Estab. 1993. Ad agency. Specializes in all materials in print. Product specialty is business-to-business. Client list available upon request.

Needs: Approached by 20 freelance artists/month. Works with 3 freelance illustrators and 6 freelance designers/month. Prefers local artists only. Uses freelance artists for design, production, illustration and computer work. Also uses freelance artists for brochure, catalog and print ad design and illustration and animation, mechanicals, retouching, model making, posters, lettering and logos. 30% of work is with print ads. Needs computer-literate freelancers for design, illustration and production. 75% of freelance work demands knowledge of QuarkXPress, Ventura or Corel Draw.

First Contact & Terms: Send query letter with résumé and photostats. Samples are filed or returned by SASE. Reports back to the artist only if interested. Artist should follow-up with call and/or letter after initial query. Art Director will contact artist for portfolio review if interested. Portfolio should include b&w and color roughs and final art. Pays for design by the hour, $35-75; by the project. Pays for illustration by the project, $75-8,000. Buys all rights.

Tips: Finds artists through sourcebooks, word of mouth and submissions.

MSR ADVERTISING, INC., P.O. Box 10214, Chicago IL 60610-0214. (312)477-4777. Fax: (312)477-2288. President: Marc S. Rosenbaum. Vice President: Phillip A. Ogliore. Estab. 1983. Ad agency. Full-service, multimedia firm. Specializes in collateral. Product specialties are medical, food, industrial and aerospace. Current clients include Baxter Healthcare, Mama Tish's, Pizza Hut, hospitals, healthcare, Helene Curtis, Colgate-Palmolive.

Needs: Approached by 6-12 freelance artists/month. Works with 2-6 illustrators and 2-6 designers/month. Prefers local artists who are "innovative, resourceful and hungry." Works on assignment only. Uses freelancers for creative through boards. Also uses freelancers for brochure, catalog and print ad design and illustration and storyboards, mechanicals, billboards, posters, lettering and logos. 30% of work is with print ads. Needs computer-literate freelancers for design, illustration, production and presentation. 75% of freelance work demands computer skills.

First Contact & Terms: Send query letter with brochure, SASE and résumé. Samples are filed and returned. Reports back within 1-2 weeks. Write for appointment to show portfolio or mail appropriate materials: thumbnails, roughs, finished samples. Artist should follow up with call. Buys all rights.

Tips: Finds artists through submissions and agents. "We maintain a relaxed environment designed to encourage creativity, however, work must be produced timely and accurately. Normally the best way for a freelancer to meet with us is through an introductory letter and a follow-up phone call a week later."

S.C. MARKETING, INC., Suite 402, 101 W. Grand Ave., Chicago IL 60610. (312)464-0460. Fax: (312)464-0463. President: Susie Cohn. Estab. 1990. Ad agency, concentrating on print. Specializes in magazine ads, collateral, and miscellaneous print materials. Product specialty is food service. Current clients include Keebler Co., Bernardi Italian Foods, Original Chili Bowl Co., Golden Tiger Co. and Bri-al, Inc.

Needs: Approached by 1 freelance artist/month. Works with 2 illustrators and 1 designer/month. Prefers artists with experience in food industry. Works on assignment only. Uses freelancers mainly for layout/creative development, type specing, production coordination, photography supervision. Also for brochure, catalog and print ad design and illustration and storyboards, posters, packaging, food illustration, lettering and logos. 40% of work is with print ads. Needs computer-literate freelancers for design, illustration, production and presentation. 30% of freelance work demands computer skills.

First Contact & Terms: Send query letter with résumé, photocopies, photographs and tearsheets. Samples are filed. Art Director will contact artist for portfolio review if interested. Portfolios may be dropped off or mailed. Portfolio should include roughs and b&w or color tearsheets and photographs. Pays for design and illustration by the project. Buys all rights.

Tips: Finds artists through referrals.

‡**TASSANI & PAGLIA**, 515 North State St., Chicago IL 60610. (312)644-2400. Fax: (312)644-1504. Design Supervisors: Bill Marvin and Debora Clark. Estab. 1978. Specializes in annual reports; brand and corporate identity; display, design, direct mail, package and publication design; and signage. Clients: corporations. Current clients include San Doz, Cellular One, Arthur Anderson, American Express, Kemper Financial, Gatx, AT&T, Clintec Nutrition Co., Abbott Labs. Client list available upon request.

• See Insider Report in this section. David Pierce, design director, talks about freelance opportunities for designers.

Needs: Approached by 10-20 freelance graphic artists/year. Works with 10-20 freelance illustrators and 3-4 freelance designers/year. Works on assignment only. Uses illustrators mainly for brochure covers and ads. Uses designers mainly for desktop execution and some layout. Also uses freelance artists for brochure and catalog designand illustration, P-O-P and add illustration, magazine design, mechanicals, airbrushing, audio-visual materials, lettering, logos and charts/graphs. Needs computer-literate freelancers for design and production. 50% of freelance work demands knowledge of QuarkXPress, Adobe Illustrator or Adobe Photoshop.
First Contact & Terms: Contact through artist rep or send query letter with tearsheets, resume and slides. Samples are filed and are not returned. Reports back to the artist only if interested. Artist should follow up with call. Portfolio should include roughs, final art, tearsheets and slides. Pays for design by the hour, $20-30. Pays for illustration by the project, $250-10,000. Rights purchased vary according to project.
Tips: Finds artists through *Blackbook, Chicago Sourcebook, Creative Directory, Showcase*, Reps, direct contact. "Designers must have strong desktop skills. All art should have a price for one time usage and/or a full buy-out (people are becoming confused by usage fees)."

WEBER, COHN & RILEY, 444 N. Michigan Ave., Chicago IL 60611. (312)527-4260. Fax: (312)527-4273. Vice President/Executive Creative Director: C. Welch. Estab. 1960. Ad agency. Full-service, multimedia firm. Specializes in broadcast/print advertising, collateral, direct mail, P-O-P displays.
Needs: Approached by 10 freelance artists/month. Works with 4 illustrators/month. Works on assignment only. Uses freelancers for storyboards, animatics, mechanicals, retouching and TV/film graphics. 70% of work is with print ads.
First Contact & Terms: Send query letter with photocopies and résumé. Samples are filed. Reports back to the artist only if interested. To show portfolio, mail appropriate materials: tearsheets, photographs and transparencies. Pays for design and illustration by the project, $250-4,000. Rights purchased vary according to project.
Tips: "We're still using about the same number of artists that we did in the past. Budgets for illustrations have decreased, however."

Indiana

ADVANCED DESIGNS CORPORATION, 804 N. College Ave., Bloomington IN 47404. (812)333-1922. Fax: (812)333-2030. President: Martin Riess. Estab. 1982. AV firm. Weather radar systems and associated graphics. Specializes in TV news broadcasts. Product specialties are the Doppler Radar and Display Systems.
Needs: Prefers artists with experience. Works on assignment only. Uses freelance graphic artists mainly for TV/film (weather) and cartographic graphics. Needs computer-literate freelancers for production. 100% of freelance work demands knowledge of ADC Graphics.
First Contact & Terms: Send query letter with résumé and SASE. Samples are not filed and are returned by SASE. Pays for design and illustration by the hour, $7 minimum. Art Director will contact artist for portfolio review if interested. Rights purchased vary according to project.
Tips: Finds artists through classifieds.

‡ASHER AGENCY, 511 W. Wayne, Fort Wayne IN 46802. (219)424-3373. Sr. Art Director: Steve Blakey. Estab. 1974. Ad agency and PR firm. Clients: automotive firms, convention centers, financial/investment firms, area economic development agencies, health care providers and fast food companies.
 ● This art director predicts there will be an increase in consulting-only relationships with clients because of their computer/software build-ups but a gradual return to business-as-usual after they learn computers do not a designer make!
Needs: Works with 10 freelance artists/year. Assigns 50 freelance jobs/year. Prefers local artists. Works on assignment only. Uses freelance artists mainly for technical and medical illustration. Also uses freelance artists for design, brochures, catalogs, consumer and trade magazines, retouching, billboards, posters, direct mail packages, logos and advertisements.
First Contact & Terms: Send query letter with brochure showing art style or tearsheets and photocopies. Samples are filed or are returned by SASE. Reports back only if interested. Art Director will contact artist for portfolio review if interested. Portfolio should include roughs, original/final art, tearsheets and final reproduction/product. Pays for design by the hour, $25 minimum. Pays for illustration by the project, $50 minimum. Buys all rights.
Tips: Finds artists usually through word of mouth.

A bullet introduces comments by the editor of Artist's & Graphic Designer's Market *indicating special information about the listing.*

THE OMNI CENTRE FOR PUBLIC MEDIA, INC., (formerly Omni Productions), 655 W. Carmel Dr., Carmel IN 46032. (317)848-3456. President: Sandra Long. Estab. 1987. AV firm. Full-service, multimedia firm. Specializes in video, multi-image, slides. Current clients include "a variety of industrial clients, international."
Needs: Works on assignment only. Uses freelance artists for brochure design and illustration, storyboards, slide illustration, animation, and TV/film graphics. Needs computer-literate freelancers for design, illustration and production. Most of freelance work demands computer skills.
First Contact & Terms: Send résumé. Samples are filed and are not returned. Artist should follow-up with call and/or letter after initial query.
Tips: Finds artists through agents, word of mouth and submissions.

BJ THOMPSON ASSOCIATES, INC., Dept. AM, 201 S. Main St., Mishawaka IN 46544. (219)255-5000. Senior Art Director: Dave Marks. Estab. 1979. "We are a full-service ad/PR firm, with much of our work in print media and collateral." Specializes in RVs, agriculture and home improvement. Current clients include Jayco, Inc., Leer, Inc. and Firan Motor Coach, Inc.
Needs: Works with 6 illustrators and 2 designers/month. Prefers artists with experience in mechanical illustration and airbrush. Works on assignment only. Uses freelancers for all print material. Also uses freelancers for storyboards, slide illustration, retouching, billboards and posters. 70% of work is with print ads. Needs computer-literate freelancers for design, illustration and production. 50% of freelance work demands knowledge of Aldus PageMaker, QuarkXPress, Aldus FreeHand, Adobe Illustrator, Photoshop and other Mac software. Needs editorial and technical illustration and some cartoons.
First Contact & Terms: Send query letter with résumé and slides. Samples are not filed and are returned by SASE if requested by artist. Reports back to the artist only if interested. Write for appointment to show portfolio of color and b&w photostats, tearsheets, final reproduction/product and slides. Pays by the project, $50/hour minimum. Buys all rights.

Iowa

FLEXSTEEL INDUSTRIES INC., 3200 Jackson, Dubuque IA 52004-0877. (319)556-7730. Fax: (319)556-8345. Advertising Manager: Tom R. Baldwin or Lance Rygh. Estab. 1893. Full-service, multimedia firm, manufacturer with full-service in-house agency. Specializes in furniture advertising layouts, price lists, etc. Product specialty is consumer-upholstered furniture.
Needs: Approached by 1 freelance artist/month. Works with 4-6 illustrators/month. Prefers artists who can do both wash and line illustration of upholstered furniture. Uses freelance artists for catalog and print ad illustration, retouching, billboards and posters. Works on assignment only. 25% of work is with print ads.
First Contact & Terms: Send query letter with résumé, tearsheets and samples. Samples are filed or are returned by SASE if requested by artist. Reports back to the artist only if interested. To show a portfolio, mail thumbnails, roughs and b&w tearsheets. Pays for design and illustration by the project. Buys all rights.

HELLMAN ANIMATES, LTD., 1225 W. 4th St., P.O. Box 627, Waterloo IA 50702. (319)234-7055. Animation studio. Specializes in animated TV commercials and programs.
Needs: Approached by 1 freelance artist/month. Works with 3 animators/month. Prefers artists with experience in animation. Works on assignment only. Uses freelancers for storyboards and animatics.
First Contact & Terms: Send query letter with demo reel. Samples are filed or are returned. Reports back to the artist only if interested. Pays by foot of production, $35-135. Buys all rights.

Kansas

BRYANT, LAHEY & BARNES, INC., 5300 Foxridge Dr., Shawnee Mission KS 66202. (913)262-7075. Art Director: Terry Pritchett. Ad agency. Clients: agriculture and veterinary firms.
Needs: Local artists only. Uses artists for illustration and production, including keyline and paste-up; consumer and trade magazines and brochures/flyers.
First Contact & Terms: Query by phone. Send business card and résumé to be kept on file for future assignments. Originals not returned. Negotiates pay.

‡SPRINT INTEGRATED MARKETING SERVICES, #300, 7015 College Blvd., Overland Park KS 66212. (913)491-7000. Creative Director: Karen Segal. Estab. 1990. Ad agency. Full-service, multimedia firm. Specializes in direct response advertising covering all facets of communication from print to broadcast. Product specialty is business-to-business and consumer. Client list not available.
Needs: Approached by 2-3 freelance artists/month. Works with 1 freelance illustrator and 2-3 freelance designers/month. Prefers artists with experience in direct response. Uses freelance artists for brochure, catalog and print ad design and illustration, storyboards, slide illustration, animation, billboards, posters, TV/film graphics, lettering and logos. 50% of work is with print ads. Needs computer-literate freelancers for design, illustration, production and presentation. 95% of freelance work demands knowledge of Aldus

PageMaker, QuarkXPress, Aldus FreeHand, Adobe Illustrator or Adobe Photoshop.
First Contact & Terms: Send query letter with photocopies. Samples are filed. Reports back to the artist only if interested. Art Director will contact artist for portfolio review if interested. Portfolio should include b&w and color thumbnails, final art, tearsheets and slides. Pays for design and illustration by the project, $200-3,000. Buys all rights.
Tips: Finds artists through word of mouth and "go see" interviews with artists.

Kentucky

■**MERIDIAN COMMUNICATIONS**, Suite 200, 444 E. Main St., Lexington KY 40507. (606)252-3350. Fax: (606)254-5511. Senior Vice President, Creative Service: Ave Lawyer. Estab. 1975. Ad agency. Full-service, multimedia firm. Specializes in PR, ads (magazine and newspaper), grocery store handbills, TV and radio spots, packaging, newsletters, etc. Current clients include Toyota, Big Valu, Po Folks, Lexmark and Southern Belle.
Needs: Approached by 6 artists/month. Works with 2 illustrators and 3 designers/month. Prefers local artists. Works on assignment only. Uses freelancers for brochure and catalog design and illustration, print ad illustration, storyboards, animatics, animation, posters, TV/film graphics, logos. 60% of work is with print ads.
First Contact & Terms: Send query letter with résumé, photocopies, photographs and tearsheets. Samples are filed. Reports back within 2 weeks. To show portfolio, mail b&w and color tearsheets and photographs. Pays negotiable rates for design and illustration. Rights purchased vary according to project.

Louisiana

‡**KEATING MAGEE LONG**, 2223 Magazine St., New Orleans LA 70130. (504)523-2221. Fax: (504)525-6647. Art Director: Jennifer Simpson. Production Manager: Sue Sjrachan. Estab. 1981. Ad agency. Full-service, multimedia firm. Client list available upon request.
Needs: Approached by 5-10 freelance artists/month. Works with 2-3 freelance illustrators and designers/month. Works on assignment only. Uses freelance artists mainly for illustration for advertising. Also uses freelance artists for brochure and print ad design and illustration, storyboards, mechanicals, retouching, billboards, posters, TV/film graphics, lettering and logos. 80% of work is with print ads. Needs computer-literate freelancers for design, illustration, production and presentation. 85% of freelance work demands knowledge of Adobe Illustrator, QuarkXPress, Adobe Photoshop or Aldus FreeHand.
First Contact & Terms: Samples are filed. Reports back to the artist only if interested. Artist should follow-up. Art Director will contact artist for portfolio review if interested. Portfolio should include thumbnails, final art and photographs. Pays for design and illustration by the project. Buys all rights or negotiates rights purchased.

‡**PETER O'CARROLL ADVERTISING**, Suite 209, 710 W. Drien Lake Rd., Lake Charles LA 70601. (318)478-7396. Fax: (318)478-0503. Art Director: Kathlene Deaville. Estab. 1977. Ad agency. Specializes in newspaper, magazine, outdoor, radio and TV ads. Product specialty is consumer. Current clients include Players Riverboat Casino, First Federal Savings & Loan, Charter Hospital. Client list available upon request.
Needs: Approached by 2 freelance artists/month. Works with 1 freelance illustrator/month. Prefers artists with experience in computer graphics. Works on assignment only. Uses freelance artists mainly for time consuming computer graphics. Also uses freelance artists for brochure and print ad illustration and storyboards. 65% of work is with print ads. Needs computer-literate freelancers for design and illustration. 50% of freelance work demands knowledge of Adobe Illustrator, Adobe Photoshop or Aldus FreeHand.
First Contact & Terms: Send query letter wtih résumé, transparencies, photographs, slides and tearsheets. Samples are filed or returned by SASE if requested. Reports back to the artist only if interested. Art Director will contact artist for portfolio review if interested. Portfolio should include color roughs, final art, tearsheets, slides, photostats and transparencies. Pays for design by the project, $30-300. Pays for illustration by the project, $50-275. Rights purchased vary according to project.
Tips: Find artists through "viewing portfolios, artists' submissions, word of mouth, district advertising conferences and conventions.

SACKETT EXECUTIVE CONSULTANTS, Dept. AM, Suite 3400, 1001 Howard Ave., New Orleans LA 70113-2036. (504)522-4040. Fax: 524-8839. Art Director: Andrea Pesheret. Estab. 1980. Ad agency and PR firm.

The double dagger before a listing indicates that the listing is new in this edition. New markets are often more receptive to freelance submissions.

Full-service, multimedia firm. Specializes in magazine/newspaper ads, direct mail, audiovisual TV/radio/film productions and political campaigns. Product specialties are retail, political and legal. Current clients include Canupo, Sound Trek and ABC Insurance.

Needs: Approached by 10 artists/month. Works with 2 illustrators and 1 designer/month. Prefers artists with experience in food illustration, architectural rendering and technical illustration. Works on assignment only. Uses freelancers mainly for illustration and presentation (or crash jobs). Also for brochure, catalog and print ad design and illustration and animatics, animation, mechanicals, retouching, billboards, posters, TV/film graphics, lettering and logos. 40% of work is with print ads.

First Contact & Terms: Send query letter with brochure, photocopies, résumé, tearsheets and photostats. Samples are filed and are not returned. Reports back within 1 week. Call for appointment to show portfolio of original/final art, b&w and color photostats. Pays for design by the hour, $10-50; by the project, $100 minimum; by the day, $80-400. Pays for illustration by the project, $500-3,000. Buys first rights and all rights.

Maryland

SAMUEL R. BLATE ASSOCIATES, 10331 Watkins Mill Dr., Gaithersburg MD 20879-2935. Phone/Fax: (301)840-2248. President: Samuel R. Blate. AV and editorial services firm. Clients: business/professional, US government, some private.

Needs: Works with 5 artists/year. Only works with artists in the Washington metro area. Works on assignment only. Uses freelancers for cartoons (especially for certain types of audiovisual presentations), editorial and technical illustrations (graphs, etc.) for 35mm slides, pamphlet and book design. Especially important are "technical and aesthetic excellence and ability to meet deadlines." Needs computer-literate freelancers for design, illustration, production and presentation. 60% of freelance work demands knowledge of Corel Draw, Aldus PageMaker or Harvard Graphics for Windows.

First Contact & Terms: Send query letter with résumé and tearsheets, photostats, photocopies, slides or photographs to be kept on file. "No original art." Samples are returned only by SASE. Reports only if interested. Pays by the hour, $20-40. Rights purchased vary according to project, "but we prefer to purchase first rights only. This is sometimes not possible due to client demand, in which case we attempt to negotiate a financial adjustment for the artist."

Tips: "The demand for technically oriented artwork has increased."

MARC SMITH CO., INC., Box 5005, Severna Park MD 21146. (301)647-2606. Art/Creative Director: Marc Smith. Ad agency. Clients: consumer and industrial products, sales services and PR firms.

Needs: Works with 3 illustrators/month. Prefers local artists only. Uses freelance artists for layout, lettering, technical art, type specing, paste-up and retouching. Also uses freelance artists for illustration and design of direct mail, slide sets, brochures/flyers, trade magazines and newspapers; design for film strips, stationery, multimedia kits. Occasionally buys humorous and cartoon-style illustrations. Needs computer-literate freelancers for design, illustration and production. 50% of freelance work demands computer skills.

First Contact & Terms: Send query letter with brochure showing art style or tearsheets, photostats, photocopies, slides or photographs. Keeps file on artists. Originals not returned. Negotiates payment.

Tips: "More sophisticated techniques and equipment are being used in art and design. Our use of freelance material has intensified. Project honesty, clarity and patience."

Massachusetts

CORNERSTONE ASSOCIATES, 211 Second Ave., Waltham MA 02154. (617)890-3773. Fax: (617)890-8049. Production Manager: Jim Byler. Estab. 1978. "We are an audiovisual company specializing in meetings, multi-media, shows and speaker support slide presentations." Current clients include Bachman, Liberty Mutual Insurance, Thermo. Electron and other local clients.

Needs: Works with 1-2 designers/month. Prefers local artists with experience in slide mechanics and design. Uses freelancers for storyboards and slide illustration. Needs computer-literate freelancers for design, illustration, production and presentation. 98% of freelance work demands knowledge of Aldus PageMaker, Aldus FreeHand, Adobe Illustrator or Photoshop. Needs editorial, technical and medical illustration.

First Contact & Terms: Send query letter with résumé, slides and SASE. Samples are filed or are returned by SASE. Reports back to the artist only if interested. Call for appointment to show portfolio of final reproduction/product, photographs and slides. Sometimes requests work on spec before assigning job. Pays by the hour, $15-35. Rights purchased vary according to project.

Tips: Finds artists through word of mouth and submissions. "Have a strong design sense; show you can execute extremely clean mechanicals; have a portfolio that shows these skills."

COSMOPULOS CROWLEY DALY/CKG, Dept. AM, 250 Boylston St., Boston MA 02116. (617)266-5500. Creative Director: Judy Austin. Advertising and marketing agency. Clients: medical and health care, insurance, restaurants, hotels and resorts, industry, package goods, food and electronics. Current clients include Massa-

chusetts Convention Center Authority and Delta Dental Plan of Massachusetts.

Needs: Works with 6 illustrators and 1 animator/month. Works on assignment only. Uses artists for billboards, P-O-P displays, filmstrips, stationery design, multimedia kits, direct mail, television, slide sets, brochures/flyers, trade and consumer magazines and newspapers. Needs technical, medical and advertising illustration.

First Contact & Terms: Send business card, photostats or slides. Samples not filed are returned by SASE. Reports only if interested. Make an appointment to show portfolio. Originals not returned. Pays for design by the project, $250-2,500. Pays for illustration by the project, $75-4,000.

Tips: "Give a simple presentation of the range of work you can do, including printed samples of actual jobs — but not a lot of samples. I look for specific techniques that an artist may have to individualize the art."

‡THE CRAMER PRODUCTION CENTER, 335 Wood Rd., Braintree MA 02184. Operations Manager: Maura MacMillan. Estab. 1982. AV firm. Specializes in full-service film/video production, events services, AV, multimedia, broadcast commercials, corporate marketing and training. Product specialties are retail, medical, high-tech. Current clients include Boston Scientific, Talbots, Peace Corp. Client list available upon request.

Needs: Approached by 3-4 freelance artists/month. Works with 1 freelance illustrator and designer/month. Prefers local artists only. Works on assignment only. Uses freelance artists mainly for storyboards and set illustrations. Also uses freelance artists for brochure illustration, storyboards, animation and TV/film graphics. 2% of work is with print ads. Needs computer-literate freelancers for design. 40% of freelance work demands computer skills.

First Contact & Terms: Send query letter with samples. Samples are filed or returned by SASE if requested. Does not report back. Artist should follow up within 1-2 weeks. Art Director will contact artist for portfolio review if interested. Portfolio should include thumbnails and tearsheets. Pays for design and illustration by the project, $100 minimum. "Pay really varies depending on the project." Buys all rights.

‡FILM CLASSIC EXCHANGE, 143 Hickory Hill Circle, Osterville MA 02655. (508)428-7198. Fax: (508)428-7198. President: Jeffrey H. Alkman. Estab. 1916. AV firm. Full-service, multimedia firm. Specializes in magazine ads, video/film. Product specialty is motion pictures and video tapes. Current clients include TAM Productions, VIP Video. Client list not available.

Needs: Approached with 10 freelance artists/month. Works with 5 freelance illustrators and designers/month. Works on assignment only. Uses freelance artists mainly for magazine ads. Also uses freelance artists for brochure, catalog and print ad design and illustration and storyboards, slide illustration, animation, mechanicals, retouching, model making, billboards, posters, TV/film graphics and logos. 35% of work is with print ads. Needs computer-literate freelancers for design, illustration, production and presentation. 25% of work demands knowledge of Aldus PageMaker, QuarkXPress, Aldus FreeHand, Adobe Illustrator or Adobe Photoshop.

First Contact & Terms: Send query letter with résumé and tearsheets. Samples are filed or returned by SASE if requested by artist. Reports back to the artist only if interested. Art Director will contact artist for portfolio review if interested. Portfolio should include b&w and color thumbnails, roughs, final art, tearsheets, slides, photostats, photographs and transparencies. Pays for design and illustration by the project, $50 minimum.

Tips: Finds artists through word of mouth and submissions.

FLAGLER ADVERTISING/GRAPHIC DESIGN, Box 1317, Brookline MA 02146. (617)566-6971. Fax: (617)566-0073. President/Creative Director: Sheri Flagler. Specializes in corporate identity, brochure design, ad campaigns and technical illustration. Clients: cable television, finance, real estate, tech and direct mail agencies, infant/toddler manufacturers.

Needs: Works with 10-20 artists/year. Works on assignment only. Uses freelancers for illustration, mechanicals, retouching, airbrushing, charts/graphs and lettering.

First Contact & Terms: Send résumé, business card, brochures, photocopies or tearsheets to be kept on file. Call or write for appointment to show portfolio. Samples not filed are not returned. Reports back only if interested. Pays for design and illustration by the project, $150-2,500. Considers complexity of project, client's budget and turnaround time when establishing payment.

Tips: "Send a range and variety of styles showing clean, crisp and professional work."

‡GREENBAUM & GREENBAUM, One South Ave., Natick MA 01760. (508)651-8158. Fax: (508)655-1637. Estab. 1975. Ad Agency. Specializes in annual reports, corporate identity and publication design. Product specialty is corporate. Current clients include Lite Control, Intrepid Software, Gold Hill, AVP and Faxon.

Needs: Approached by 40-50 freelance artists/month. Works with 3-4 freelance illustrators and 1-2 freelance designers/month. Prefers working through artists' reps. Uses freelance artists mainly for advertising and literature. Also uses artists for brochure and print ad illustration.

First Contact & Terms: Contact through artist rep or send query letter with resume, SASE and photocopies, photographs or slides. Samples are filed or are returned by SASE if requested by artist. Does not report back. Portfolio review not required. Pays for illustration by the project, $500-3,500.

Tips: Finds artists through annuals and sourcebooks.

JEF FILMS INC., 143 Hickory Hill Cir., Osterville MA 02655-1322. (508)428-7198. Fax: (508)428-7198. President: Jeffrey H. Aikman. Vice President: Elsie Aikman. Estab. 1973. AV firm. Full-service, multimedia firm. Specializes in covers for home videotapes, magazine ads (trade and consumer) and movie posters. Current clients include VIP Video, TAM Productions, XTC Video. Client list not available.
Needs: Approached by 400-500 artists/month. Works with 10-12 illustrators and designers/month. Prefers artists with movie and video background. Uses freelancers for all promotional design and editorial and technical illustration. Also uses freelancers for brochure, catalog and print ad design and illustration and slide illustration, storyboards, animatics, animation, mechanicals, retouching, TV/film graphics, lettering and logos. 20% of work is with print ads. Needs computer literate freelancers for design, illustration, production and presentation. 40% of freelance work demands knowledge of Aldus PageMaker, QuarkXPress, Aldus FreeHand, Adobe Illustrator and Adobe Photoshop.
First Contact & Terms: Send query letter with SASE and any of the following: brochure, photocopies, résumé, photographs, photostats, slides, tearsheets and transparencies. Samples are filed or returned by SASE if requested by artist. Reports back only if interested. Art Director will contact artist for portfolio review if interested. Portfolio should include thumbnails, b&w or color photostats, tearsheets, photographs and slides. Sometimes requests work on spec before assigning job. Pays for design and illustration by the project, $50-300. Buys all rights.
Tips: Finds artists through word of mouth, agents, magazines and sourcebooks.

THE PHILIPSON AGENCY, Suite B201, 241 Perkins St., Boston MA 02130. (617)566-3334. Fax: (617)566-3363. President and Creative Director: Joe Philipson. Marketing design firm. Specializes in packaging, collateral, P-O-P, corporate image, sales presentations, direct mail, business-to-business and high-tech.
Needs: Approached by 3-4 freelance artists/month. Works with 1 illustrator and 3 designers/month. Prefers artists with experience in design, illustration, comps and production. Works on assignment only. Uses freelancers mainly for overflow and special jobs. Also uses freelancers for brochure, catalog and print ad design and illustration and packaging, mechanicals, retouching, posters, lettering and logos. Needs editorial illustration. 65% of work is with print ads. Needs computer-literate freelancers for design, illustration and production. 95% of freelance work demands knowledge of Aldus PageMaker, QuarkXPress, Aldus FreeHand, Adobe Illustrator or Photoshop.
First Contact & Terms: Send query letter with brochure, SASE, résumé. Samples are filed or are returned by SASE. Reports back to the artist only if interested. To show a portfolio, mail roughs, photostats, tearsheets, photographs and slides. Pays for design by the hour, $15-50. Pays for illustration by the hour. Buys all rights.

RSVP MARKETING, INC., Suite 5, 450 Plain St., Marshfield MA 02050. (617)837-2804. Fax: (617)837-5389. President: Edward C. Hicks. Direct marketing consultant services—catalogs, direct mail, brochures and telemarketing. Clients: insurance, wholesale, manufacturers and equipment distributors.
Needs: Works with 7-8 artists/year. Prefers primarily local artists with direct marketing skills. Uses freelancers for advertising, copy and catalog design, illustration, layout and technical illustration. Needs line art for direct mail. Needs computer-literate freelancers for design and illustration. 50% of freelance work demands knowledge of Aldus PageMaker.
First Contact & Terms: Send query letter with résumé and finished, printed work to be kept on file. Art Director will contact artist for portfolio review if interested. Sometimes requests work on spec before assigning job. Pays for design and illustration by the hour, $25-70 or; by the project $300-5,000. Considers skill and experience of artist when establishing payment.

‡■TR PRODUCTIONS, 1031 Commonwealth Ave., Boston MA 02215. (617)783-0200. Fax: (617)783-4844. Creative Director: Cary M. Benjamin. Estab. 1947. AV firm. Full-service, multimedia firm. Specializes in slides, collateral, AV shows.
Needs: Approached by 4 freelance artists/month. Works with 2 freelance illustrators and designers/month. Prefers local artists only with experience in slides. Works on assignment only. Uses freelance artists mainly for slides, collateral. Also uses freelance artists for brochure and print ad design and illustration, slide illustration, animation and mechanicals. 5% of work is with print ads. Needs computer-literate freelancers for design, production and presentation. 95% of work demands knowledge of Aldus FreeHand, Adobe Photoshop, Microsoft Powerpoint or Aldus Persuasion.
First Contact & Terms: Send query letter. Samples are filed. Does not report back. Artist should follow-up with call. Art Director will contact artist for portfolio review if interested. Rights purchased vary according to project.

‡TVN-THE VIDEO NETWORK, 31 Cutler Dr., Ashland MA 01721-1210. (508)881-1800. Producer: Gregg McAllister. Estab. 1986. AV firm. Full-service multimedia firm. Specializes in video production for business, broadcast and special events. Product specialties "cover a broad range of categories." Current clients include Marriott, Digital, IBM, Rathoen, National Park Service.
Needs: Approached by 1 freelance artist/month. Works with 1 freelance illustrator/month. Prefers artists with experience in Amiga PC, The Video Toaster, D paint III, 2D and 3D programs. Works on assignment only. Uses freelance artists mainly for video production, technical illustration, flying logos and 3-D work.

Also uses freelance artists for storyboards, animation, TV/film graphics and logos.
First Contact & Terms: Send query letter with videotape or computer disk. Samples are filed or are returned. Reports back within 2 weeks. Art Director will contact artist for portfolio review if interested. Portfolio should include videotape and computer disk (Amiga). Pays for design and illustration by the project, $500-5,000; by the day, $250 minimum. Buys all rights.
Tips: Finds artists through word of mouth, magazines and submissions.

‡**VIP VIDEO,** 143 Hickory Hill Circle, Osterville MA 02655-1322. (508)428-7198. Fax: same. President: Jeffrey H. Aikman. Estab. 1980. AV firm. Full-service, multimedia firm. Specializes in magazine ads, video jackets, brochures. Product specialty is videotapes. Current clients include TAM Productions and USAmericana Films. Client list not available.
Needs: Approached by 10-12 freelance artists/month. Works with 5-6 freelance illustrators and designers/month. Prefers artists with experience in video and film business. Works on assignment only. Uses freelance artists mainly for video covers, brochures. Also uses freelance artists for brochure, catalog and print ad design and illustration and storyboards, slide illustration, animation, retouching, billboards, posters, TV/film graphics, lettering and logos. 50% of work is with print ads. Needs computer-literate freelancers for design, illustration, production and presentation. 25% of work demands knowledge of Aldus PageMaker, QuarkX-Press, Aldus FreeHand, Adobe Illustrator or Adobe Photoshop.
First Contact & Terms: Send query letter with brochure and photographs. Samples are filed or are returned by SASE. Reports back to the artist only if interested. Art Director will contact artist for portfolio review if interested. Portfolio should include b&w and color final art, slides, photographs and transparencies. Pays for design and illustration by the project, $50-300. Buys all rights.
Tips: Finds artists through agents, word of mouth, submissions and sourcebooks.

Michigan

LEO J. BRENNAN, INC. Marketing Communications, Suite 300, 2359 Livernois, Troy MI 48083-1692. (810)362-3131. Fax: (810)362-3131. Vice President: Virginia Janusis. Estab. 1969. Ad agency, PR and marketing firm. Clients: industrial, electronics, robotics, automotive, banks and CPAs.
Needs: Works with 10 artists/year. Prefers experienced artists. Uses freelancers for design, technical illustration, brochures, catalogs, retouching, lettering, keylining and typesetting. 50% of work is with print ads. Needs computer-literate freelancers for design, illustration, production and presentation. 100% of freelance work demands knowledge of IBM software graphics programs.
First Contact & Terms: Send query letter with résumé and samples. Samples not filed are returned only if requested. Reports back to artist only if interested. Call for appointment to show portfolio of thumbnails, roughs, original/final art, final reproduction/product, color and b&w tearsheets, photostats and photographs. Payment for design and illustration varies. Buys all rights.

CLASSIC ANIMATION, 1800 S. 35th St., Galesburg MI 49053-9688. (616)665-4800. Creative Director: David Baker. Estab. 1986. AV firm. Specializes in animation—computer (Topas, Lumena, Wavefront SGI, Rio) and traditional. Current clients include Amway, Upjohn, Armstrong, NBC.
Needs: Approached by 5 freelance artists/month. Works with 3 illustrators and 1 designer/month. Prefers artists with experience in animation. Uses artists mainly for animation and technical, medical and legal illustration. Also uses freelancers for storyboards, slide illustration, animatics, animation, TV/film graphics and logos. 10% of work is with print ads. Needs computer-literate freelancers for design and production. 50% of freelance work demands computer skills.
First Contact & Terms: Send query letter with résumé, photocopies and ½″ VHS. Samples are filed or are returned by SASE. Reports back within 1 week only if interested. Write for appointment to show portfolio or mail appropriate materials. Portfolio should include slides and ½″ VHS. Pays for design and illustration by the hour, $25 minimum; or by the project, $250 minimum. Rights purchased vary according to project.

■**COMMUNICATIONS ELECTRONICS, INC.,** Dept AM, Box 2797, Ann Arbor MI 48106-2797. (313)996-8888. Editor: Ken Ascher. Estab. 1969. Manufacturer, distributor and ad agency (12 company divisions). Specializes in marketing. Clients: electronics, computers.
Needs: Works with approximately 400 illustrators and 100 designers/year. Uses freelancers for brochure and catalog design, illustration and layout and advertising, product design, illustration on product, P-O-P displays, posters and renderings. Needs editorial and technical illustration. Prefers pen & ink, airbrush, charcoal/pencil, watercolor, acrylic, marker and computer illustration. Needs computer-literate freelancers for design and illustration. 30% of freelance work demands knowledge of Aldus PageMaker.
First Contact & Terms: Send query letter with brochure, résumé, business card, samples and tearsheets to be kept on file. Samples not filed are returned by SASE. Reports within 1 month. Art Director will contact artist for portfolio review if interested. Pays for design and illustration by the hour, $15-100; by the project, $10-15,000; by the day, $40-800.

CREATIVE HOUSE ADVERTISING INC., Suite 301, 30777 Northwestern Hwy., Farmington Hills MI 48334. (810)737-7077. Senior Vice President/Executive Creative Director: Robert G. Washburn. Estab. 1964. Advertising/marketing/promotion graphics/display/art firm. Clients: residential and commercial construction, land development, consumer, retail, finance, manufacturing.
Needs: Assigns 20-30 jobs; buys 10-20 illustrations/year. Works with 6 illustrators and 4 designers/year. Prefers local artists. Uses freelancers for work on filmstrips, consumer and trade magazines, multimedia kits, direct mail, television, slide sets, brochures/flyers and newspapers. Most of work involves illustration, design and comp layouts of ads, brochures, catalogs, annual reports and displays. 50-60% of work is with print ads.
First Contact & Terms: Query with résumé, business card and brochure/flier to be kept on file. Artist should follow up with call. Samples returned by SASE. Reports in 2 weeks. Originals not returned. Call or write for appointment to show portfolio of originals, reproductions and published pieces. Pays for design by the project, $250-20,000. Pays for illustration by the project, $200-50,000. Considers complexity of project, client's budget and rights purchased when establishing payment. Reproduction rights are purchased as a buy-out.
Tips: "Flexibility is a necessity; do not send too much of the same style or technique."

PHOTO COMMUNICATION SERVICES, INC., P.O. Box 508, Acme MI 49610-0508. (616)922-3050. Contact: M'Lynn Hartwell. Estab. 1970. Full-service, multimedia AV firm. Specializes in corporate and industrial products.
Needs: Approached by 2-3 freelance artists/month. Works with 1 illustrator/month. Works on assignment only. Uses freelancers mainly for animated illustration. Also uses freelancers for brochure, catalog and print ad design and illustration and storyboards, slide illustration, animation, retouching, lettering and logos. 30% of work is with print ads.
First Contact & Terms: Send query with brochure, SASE and tearsheets. Samples are filed or returned by SASE if requested by artist. Reports back only if interested. To show portfolio, mail tearsheets and transparencies. Pays for design and illustration by the project, $25 minimum. Rights purchased vary according to project.

J. WALTER THOMPSON USA, One Detroit Center, 500 Woodward Ave., Detroit MI 48226-3428. (313)964-3800. Assistant Art Administrator: Maryann Inson. Ad agency. Clients: automotive, consumer, industry, media and retail-related accounts.
Needs: Deals primarily with established artists' representatives and art/design studios.
First Contact & Terms: Contact only through artist's agent. Assignments awarded on lowest bid. Call for appointment to show portfolio of thumbnails, roughs, original/final art, final reproduction/product, color tearsheets, photostats and photographs. Pays for design and illustration by the project.
Tips: "Portfolio should be comprehensive but not too large. Organization of the portfolio is as important as the sample. Mainly, consult professional rep."

Minnesota

‡**ALPINE MARKETING COMMUNICATIONS LTD.,** 3300 Edinborough Way, Minneapolis MN 55435. (612)832-8242. President/CEO: James F. Preste. Estab. 1973. Ad agency. Full-service, multimedia firm. Specializes in sales support material and business-to-business advertising. Product specialties are real estate, finance and manufacturing.
Needs: Approached by 10 freelance artists/month. Works with 7 freelance illustrators and 6 freelance designers/month. Prefers artists with experience in food illustration and real estate renderings. Works on assignment only. Uses freelance artists for special projects. Also uses freelance artists for brochure design, print ad design and illustration, mechanicals, retouching and logos. Needs technical and medical illustration. Needs computer-literate freelancers for design. 60% of freelance work demands knowledge of Aldus PageMaker or QuarkXPress. 45% of work is with print ads.
First Contact & Terms: Send query letter with brochure, résumé, tearsheets and slides. Samples are filed. Reports back only if interested. To show a portfolio, mail roughs, color photostats, photographs and transparencies. Pays for design by the project, $250-5,000. Pays for illustration by the project, $500-7,500. Buys all rights.

The solid, black square before a listing indicates that it is judged a good first market by the Artist's & Graphic Designer's Market editors. Either it offers low payment, pays in credits and copies, or has a very large need for freelance work.

BUTWIN & ASSOCIATES ADVERTISING, INC., Suite 120, 7515 Wayzata Blvd., Minneapolis MN 55426. (612)546-0203. President: Ron Butwin. Estab. 1977. Ad agency. "We are a full-line ad agency working with both consumer and industrial accounts on advertising, marketing, public relations and meeting planning." Clients: banks, restaurants, clothing stores, food brokerage firms, corporations and a "full range of retail and service organizations."

 • This agency offers some unique services to clients, including uniform design, interior design and display design.

Needs: Works with 30-40 illustrators and 20-30 designers/year. Prefers local artists when possible. Uses freelancers for design and illustration of brochures, catalogs, newspapers, consumer and trade magazines, P-O-P displays, retouching, animation, direct mail packages, motion pictures and lettering. 60% of work is with print ads. Prefers realistic pen & ink, airbrush, watercolor, marker, calligraphy, computer, editorial and medical illustration. Needs computer-literate freelancers for design and illustration. 40% of freelance work demands computer skills.

First Contact & Terms: Send brochure or résumé, tearsheets, photostats, photocopies, slides and photographs. Samples are filed or are returned only if SASE is enclosed. Reports back only if interested. Call for appointment to show portfolio. Pays for design and illustration by the project; $25-3,000. Considers client's budget, skill and experience of artist and how work will be used when establishing payment. Buys all rights.

Tips: "Portfolios should include layouts and finished project." A problem with portfolios is that "samples are often too weak to arouse enough interest."

EDWIN NEUGER & ASSOCIATES, 1221 Nicollet Mall, Minneapolis MN 55403. (612)333-6621. President: Ed Neuger. Estab. 1959. "A full-service public relations firm that specializes in investor relations, media relations and publicity, collateral development, and special events." Client list provided upon request.

Needs: Works with 10 artists/year. Assigns 25 jobs/year. Prefers local artists "because of need for close communication and quick turnaround." Uses freelancers for photography, illustration, design and printing.

First Contact & Terms: Samples are filed and are not returned. Does not report back. Call for appointment to show portfolio. Pays by the project. Considers complexity of project, client's budget and skill and experience of artist in determining payment. Buys all rights.

RENNER-BURNS ADVERTISING, INC., Suite 400, 7600 Parklawn Ave., Edina MN 55435. (612)831-7725. Art Director: Mike Christiansen. Estab. 1977. Full service ad agency providing finished materials to client (publication, radio or TV station). Specializes in public utilities and home services. Current clients include Northern States Power Co., Wisconsin Dairyland, R.C. Smith Co., Sedgwick Heating & Air Conditioning, Heigl Mortgage Co. and American Linen.

Needs: Works with 3 illustrators/month. Prefers local artists. Works on assignment only. Uses freelancers mainly for technical and editorial illustration and photography. Also for brochure, catalog and print ad illustration and animation, mechanicals, retouching, TV/film graphics, lettering and logos. 40% of work is with print ads. Does not require computer-literate freelancers.

First Contact & Terms: Send query letter with brochure and photographs. Samples are filed or are returned by SASE if requested by artist. Reports back to the artist only if interested. Call for appointment to show portfolio of original/final art, final reproduction/product, photographs and slides. Include color and b&w samples. Pays for design by the project, $100-1,000. Pays for illustration by the project, $100-2,500. Considers complexity of project, client's budget and turnaround time when establishing payment. Buys all rights.

Tips: Finds artists primarily through agents/artists reps and sourcebooks/mailers. "Have a good track record and fair prices (rates). Show needed style or talent in portfolio or mailed pieces."

Missouri

‡ANGEL FILMS COMPANY, 967 Hwy. 40, New Franklin MO 65274-9778. (314)698-3900. Fax: (314)698-3900. Vice President of Marketing/Advertising: Linda G. Grotzinger. Estab. 1980. Ad agency, AV firm, PR firm. Full-service, multimedia firm. Specializes in "all forms of television and film work plus animation (both computer and art work)." Product specialties are feature films, TV productions, cosmetics. Current clients include Azian, Mesn, Angel One Records.

Needs: Approached by 10-20 freelance artists/month. Prefers artists with experience in graphic arts and computers. Works on assignment only. Uses freelance artists mainly for primary work ("then we computerize the work"). Also uses freelance artists for brochure and print ad design and illustration and storyboards, animation, model making, posters and TV/film graphics. 45% of work is with print ads. Needs computer-literate freelancers for design, illustration and production. 40% of freelance work demands knowledge of Adobe Illustrator, Adobe Photoshop or Corel Draw.

First Contact & Terms: Send query letter with résumé and SASE. Samples are filed. Reports back within 1 month. Art Director will contact artist for portfolio review if interested. Portfolio should include b&w and color slides and computer disks (IBM). Pays for design and llustration by the hour, $8.19 minimum. Buys all rights.

Tips: "People that we work with have read about us in trade publications and contact us to see if we have any work available at the moment."

BRYAN/DONALD, INC. ADVERTISING, Suite 1625, 2345 Grand, Kansas City MO 64108. (816)471-4866. President: Don Funk. Multimedia, full-service ad agency. Clients: food, fashion, pharmaceutical chemicals, insurance, hotels, franchises.
Needs: Works with 4 artists/year. Assigns 35 jobs/year. Works on assignment only. Uses freelancers for design, illustration, brochures, catalogs, books, newspapers, consumer and trade magazines, P-O-P display, mechanicals, retouching, animation, billboards, posters, direct mail packages, lettering, logos, charts/graphs and ads.
First Contact & Terms: Send samples showing your style. Samples are not filed and are not returned. Reports back only if interested. Call for appointment to show portfolio. Considers complexity of project and skill and experience of artist when establishing payment. Buys all rights.

‡MEDIA CONSULTANTS, P.O. Box 130, Sikeston MO 63801. (314)472-1116. Fax: (314)472-3299. President: Rich Wrather. Estab. 1981. Ad agency, AV firm, PR firm. Full-service, multimedia firm. Specializes in print, magazines, AV. Product specialty is business-to-business. Client list not available.
Needs: Works on assignment only. Uses freelance artists mainly for layout and final art. Also uses freelance artists for brochure, catalog and print ad design and illustration and storyboards, animation, billboards, TV/film graphics and logos. 40% of work is with print ads. Needs computer-literate freelancers for design, illustration, production and presentation. 100% of freelance work demands knowledge of Aldus PageMaker, Aldus FreeHand or Adobe Photoshop.
First Contact & Terms: Send query letter with brochure, résumé, photocopies, photographs, SASE and tearsheets. Samples are filed or are returned by SASE. Reports back to the artist only if interested. Art Director will contact artist for portfolio review if interested. Portfolio should include b&w and color roughs, final art, tearsheets, photostats and photographs. Pays for design by the project, $150-1,000. Pays for illustration by the project, $25-250. Buys all rights.
Tips: Finds artists through word of mouth.

PHOENIX FILMS, 2349 Chaffee Dr., St. Louis MO 63146. (314)569-0211. President: Heinz Gelles. Vice President: Barbara Bryant. Clients: libraries, museums, religious institutions, US government, schools, universities, film societies and businesses. Produces and distributes educational films.
Needs: Assigns 20-30 jobs/year. Prefers local artists only. Uses artists for motion picture catalog sheets, direct mail brochures, posters and study guides.
First Contact & Terms: Query with samples (tearsheets and photocopies). Send SASE. Send recent samples of artwork and rates to director of promotions. "No telephone calls please." Reports if need arises. Buys all rights. Keeps all original art "but will loan to artist for use as a sample." Pays for design and illustration by the hour or by the project. Rates negotiable. Free catalog upon written request.

STOBIE BRACE, 240 Sovereign Ct., St. Louis MO 63011. (314)256-9400. Fax: (314)256-0943. Creative Director: Mary Tuttle. Estab. 1935. Ad agency. Full-service, multimedia firm. Product specialties are business-to-business, industrial and consumer services. Current clients include Brown-Forman Co. (Korbel Champagne), Dine-Mor Foods, Star Manufacturing.
Needs: Approached by 5-10 freelance artists/month. Works with 2-3 illustrators and 1-3 designers/month. Uses freelancers for illustration, production and retouching. Also for brochure, catalog, print ad and slide illustration and storyboards, mechanicals and lettering. 40% of work is with print ads. Needs computer-literate freelancers for design, illustration, production and presentation. 20% of freelance work demands knowledge of QuarkXPress or Adobe Illustrator. Needs technical, medical and creative illustration.
First Contact & Terms: Send query letter with résumé, photostats, photocopies, and slides. Samples are filed or are returned by SASE if requested by artist. Reports back to the artist only if interested. Art Director will contact artist for portfolio review if interested. Portfolios may be dropped off Monday-Friday. Portfolio should include thumbnails, roughs, original/final art and tearsheets. Sometimes requests work on spec before assigning job. Pays for design by the project, $150-5,000. Pays for illustration by the project. Negotiates rights purchased.
Tips: Finds artists through word of mouth, reps and work samples.

Nebraska

BAUER, KAHLER & MORSE COMMUNICATIONS, (formerly Kahler, Friendt & Partners), 2407 S. 130th Circle, Omaha NE 68144. (402)334-6900. Vice President Credit Services: Bob Mormann. Ad agency/PR firm. Clients: bank, industry, restaurant, tourist and retail.
Needs: Works on assignment only. Uses artists for consumer and trade magazines, billboards, direct mail packages, brochures, newspapers, stationery, signage, P-O-P displays, AV presentations, posters, press re-

leases, trade show displays and TV graphics. "Freelancing is based on heavy workloads. Most freelancing is paste-up but secondary is illustrator for designed element."
First Contact & Terms: Send query letter with résumé and slides to be kept on file. Samples not filed are returned by SASE. Reports back within 10 days. Write for appointment to show portfolio, "if regional/ national; call if local." Portfolio should include thumbnails, roughs, original/final art, final reproduction/ product, color tearsheets and photostats. Pays by the project, $100-1,500 average. Buys all rights.
Tips: "Be prompt and be able to price your project work accurately. Make quality first."

J. GREG SMITH, Suite 102, Burlington Place, 1004 Farnam St., Omaha NE 68102. (402)444-1600. Senior Art Director: Karen Kehrki. Senior Art Director/Production: Rita Naikelis. Estab. 1974. Ad agency. Clients: financial, banking, associations, agricultural, travel and tourism.
Needs: Works with 3 illustrators and 1 designer/year. Works on assignment only. Uses freelancers mainly for mailers, brochures and projects; also for consumer and trade magazines, catalogs and AV presentations. Needs illustrations of generic scenes, crowds and tourists.
First Contact & Terms: Send query letter with brochure showing art style or photocopies. Reports only if interested. To show portfolio, mail final reproduction/product, color and b&w. Pays for design and illustration by the project, $500-5,000. Buys first, reprint or all rights.

New Hampshire

‡CORPORATE COMMUNICATIONS, INC., Main St. Box 854, N. Conway NH 03860. (603)356-7011. President: Kim Beals. Estab. 1983. Ad agency and PR firm. Full-service, multimedia firm. Specializes in advertising, marketing and public relations. Product specialties are hospitality, sports events, insurance, real estate. Client list not available.
Needs: Approached by 3-5 freelance artists/month. Works with 1-2 freelance illustrators and 2-3 freelance designers/month. Works on assignment only. Uses freelance artists for brochure, catalog and print ad design and illustration and storyboards, mechanicals, billboards, posters, TV/film graphics, lettering and logos. 15% of work is with print ads. Needs computer-literate freelancers for design, illustration, production and presentation. 50% of work demands knowledge of Aldus PageMaker, QuarkXPress, Aldus FreeHand, Adobe Illustrator or Adobe Photoshop. "Freehand skills also required."
First Contact & Terms: Send query letter with brochure, résumé, photocopies, photographs and tearsheets. Samples are filed. Reports back to the artist only if interested. Artist should follow-up with a letter after initial query. Art Director will contact artist for portfolio review if interested. Portfolio should include b&w and color thumbnails, roughs, final art, tearsheets, slides, photostats, photographs and transparencies. Pays for design and illustration by the hour or by the project. "Rates vary." Buys all rights.

New Jersey

‡AM/PM ADVERTISING INC., Suite 26, 345 Claremont Ave., Montclair NJ 07042. (201)824-8600. Fax: (201)824-6631. President: Bob Saks. Estab. 1962. Ad agency. Full-service, multimedia firm. Specializes in national TV commercials and print ads. Product specialties are health and beauty aids. Current clients include J&J, Bristol Myers, Colgate Palmolive. Client list available upon request.
Needs: Approached by 12 freelance artists/month. Works with 3 freelance illustrators and designers/month. Works only with artist reps. Works on assignment only. Uses freelance artists mainly for illustration and design. Also uses freelance artists for brochure and print ad design and illustration, storyboards, slide illustration, animation, mechanicals, retouching, model making, billboards, posters, TV/film graphics, lettering and logos. 30% of work is with print ads. Needs computer-literate freelancers for design, illustration, production and presentation. 50% of work demands knowledge of Aldus PageMaker, QuarkXPress, Aldus FreeHand, Adobe Illustrator or Adobe Photoshop.
First Contact & Terms: Send query letter with brochure, résumé, photostats, transparencies, photocopies, photographs, slides and tearsheets. Samples are filed or returned. Reports back within 10 days. Portfolios may be dropped off every Friday. Artist should follow up after initial query. Portfolio should include b&w and color thumbnails, roughs, final art, tearsheets, photographs and transparencies. Pays for design by the hour, $40-200; by the project, $500-5,000; by the day, $200-1,000. Pays for illustration by the project, $200-5,000. Rights or rights purchased vary according to project.

Market conditions are constantly changing! If you're still using this book and it is 1996 or later, buy the newest edition of Artist's & Graphic Designer's Market at your favorite bookstore or order directly from Writer's Digest Books.

BLOCK ADVERTISING & MARKETING, INC., 33 S. Fullerton Ave., Montclair NJ 07042 (201)744-6900. Fax: (201)744-3864. Senior VP/Creative Director: Karen DeLuca. Estab. 1939. Product specialties are electronics, finance, home fashion, healthcare and industrial manufacturing. Buys 100-200 illustrations/year.
Needs: Works with over 12 illustrators and more than 15 designers/year. Prefers to work with "artists with at least 3-5 years experience in paste-up and 'on premises' work for mechanicals and design." Uses artists for "consumer friendly" technical illustration, layout, lettering, type spec, mechanicals and retouching for ads, annual reports, billboards, catalogs, letterheads, brochures and trademarks. Needs computer-literate freelancers for design and presentation. 50% of freelance work demands knowledge of QuarkXPress, Adobe Illustrator, Type-Styler or Photoshop.
First Contact & Terms: To show portfolio, mail appropriate samples and follow up with a phone call. Include SASE. Reports in 2 weeks. Pays for design by the hour, $15-50. Pays for illustration by the project, $150-5,000.
Tips: "Please send some kind of sample of work. If mechanical artist, send line art printed sample. If layout artist, send composition of some type and photographs or illustrations. We are fortunately busy—we use 4-6 freelancers daily."

CREATIVE ASSOCIATES, Dept. AM, 44 Park Ave., Madison NJ 07044. (201)377-4440. Producer: Harrison Feather. Estab. 1970. AV firm. "We are a multimedia production facility providing photography, video post-production, slide shows, computer graphics, desktop publishing, scriptwriting services for sales meetings, trade shows, speaker support and entertainment." Clients: high-tech, pharmaceutical, computer, R&D labs, engineering and marine. Client list available for SASE.
Needs: Works with 5 artists/year. Assigns 10 jobs/year. Works on assignment only. Uses artists for design, illustration, motion pictures and charts/graphs.
First Contact & Terms: Send query letter with brochure or résumé and slides. Samples are filed or are returned by SASE. Call for appointment to show portfolio of original/final art, slides and video cassette. Pays for design (computer-generated art) by the project, $500 minimum. Pays for illustration by the project, $300 minimum. Rights purchased vary according to project.

NORMAN DIEGNAN & ASSOCIATES, 343 Martens Rd., Lebanon NJ 08833. (908)832-7951. President: N. Diegnan. Estab. 1977. PR firm. Specializes in magazine ads. Product specialty is industrial.
Needs: Approached by 6 freelance artists/month. Works with 2 illustrators and 2 designers/month. Works on assignment only. Uses freelancers for brochure, catalog and print ad design and illustration and story-boards, slide illustration, animatics, animation, mechanicals, retouching and posters. 50% of work is with print ads. Needs computer-literate freelancers for design and illustration. Needs editorial and technical illustration.
First Contact & Terms: Send query letter with brochure and tearsheets. Samples are filed and are not returned. Reports back within 1 week. To show portfolio, mail roughs. Pays for design and illustration by the project. Rights purchased vary according to project.

GARDEN STATE MARKETING SERVICES, INC., Box 343, Oakland NJ 07436. (201)337-3888. Fax: (201)337-8164. President: Jack Doherty. Estab. 1976. Service-related firm providing public relations and advertising services, mailing services and fulfillment. Specializes in direct mail. Clients: associations, publishers, manufacturers.
Needs: Approached by 15 freelance artists/year. Works with 4 illustrators and 4 designers/year. Assigns 10 jobs to freelancers/year. Works on assignment only. Uses freelancers for advertising and brochure design, illustration and layout and display fixture design, P-O-P displays and posters. Needs editorial, medical and technical illustrations, realistic style.
First Contact & Terms: Send query letter with résumé, business card and copies to be kept on file. Samples not filed are returned. Art Director will contact artist for portfolio review if interested. Portfolio should include thumbnails, final reproduction/product, b&w and color tearsheets and photographs. Sometimes requests work on spec before assigning job. Pays for design and illustration by the hour, $25-50; by the project, $100-400. Considers complexity of project, skill and experience of artist and how work will be used when establishing payment.
Tips: Finds artists through word of mouth and submissions.

GREEN, LIND & McNULTY, INC., 1435 Morris Ave., Union NJ 07083. (908)686-7500. Fax: (908)686-4757. Art Director: Barbara Lysko. Estab. 1975. Ad agency. Full-service, multimedia firm. Specializes in print and collateral. Product specialties are healthcare, business-to-business and financial.
Needs: Approached by 2 freelance artists/month. Works with 2 illustrators and 5 designers/month. Prefers local artists with experience in design. Works on assignment only. Uses freelancers mainly for comps. Also uses freelancers for brochure design, print ad illustration, mechanicals, retouching and lettering. 75% of work with print ads. Needs computer-literate freelancers for production. 10% of freelance work demands knowledge of QuarkXPress, Adobe Illustrator and Typestyler.
First Contact & Terms: Send query letter with résumé and tearsheets. Samples are filed or are returned. Reports back only if interested. Write for appointment to show portfolio of b&w or color samples or final

art. Pays for design by the hour, $18-25 or by the project, $100 minimum. Pays for illustration by the project, $35 minimum. Buys all rights.

JANUARY PRODUCTIONS, INC., 210 6th Ave., Hawthorne NJ 07507. (201)423-4666. Fax: (201)423-5569. Art Director: Karen Neulinger. Estab. 1973. AV producer. Serves clients in education. Produces children's educational materials—videos, sound filmstrips and read-along books and cassettes.
Needs: Assigns 1-5 jobs/year. Works with 1-5 illustrators/year. "While not a requirement, an artist living in the same geographic area is a plus." Works on assignment only, "although if someone had a project already put together, we would consider it." Uses freelancers mainly for illustrating children's books. Also uses freelancers for artwork for filmstrips, sketches for books and layout work.
First Contact & Terms: Send query letter with résumé, tearsheets, photocopies and photographs. Art Director will contact artist for portfolio review if interested. "Include child-oriented drawings in your portfolio." Requests work on spec before assigning job. Pays for design and illustration by the project, $20 minimum. Originals not returned. Buys all rights.
Tips: Finds artists through submissions.

KJD TELEPRODUCTIONS, 30 Whyte Dr., Voorhees NJ 08043. (609)751-3500. Fax: (609)751-7729. President: Larry Scott. Estab. 1989. Ad agency/AV firm. Full-service, multimedia firm. Specializes in magazine, radio and television. Current clients include ICI America's and Taylors Nightclub.
Needs: Works with 1-4 illustrators and 1-4 designers/month. Prefers artists with experience in TV. Works on assignment only. Uses freelancers for brochure and print ad design and illustration, storyboards, animatics, animation, TV/film graphics. 70% of work is with print ads.
First Contact & Terms: Send query letter with brochure, résumé, photographs, slides and videotape. Samples are filed or are returned by SASE. Reports back to the artist only if interested. To show portfolio, mail roughs, photographs and slides. Pays for design and illustration by the project; rate varies. Buys first rights or all rights.

MCS, INC., 86 Summit Ave., Summit NJ 07901. (908)273-9626. Fax: (908)273-6487. Executive Vice President/ General Manager: Gail Safian. Estab. 1986. PR firm. Full-service, multimedia firm. Specializes in brochures, videos, monographs, press kits, special events, newsletters. Product specialty is health care. Current clients include Lederle Laboratories, Genentech, Amgen and Zeneca.
Needs: Approached by 2 artists/month. Works with 1 illustrator and 2 freelance designers/month. Prefers local artists with experience in logo design and layout. Works on assignment only. Uses freelancers mainly for design of logos, brochures and collateral material. Also uses freelancers for mechanicals and presentation boards. Needs computer-literate freelancers for design, production and presentation. 50% of freelance work demands computer skills.
First Contact & Terms: Send query letter with brochure, SASE, résumé, photographs and samples. Samples are filed and are returned by SASE only if requested by artist. Does not report back. Artist should follow up. Call for appointment to show portfolio of roughs, final art, b&w and color tearsheets, photographs and printed samples. Sometimes requests work on spec before assigning job. Pays for design and illustration by the project, $500 minimum. Rights purchased vary according to project.
Tips: Finds artists through word of mouth, printers, artists' mailings. "Creative design is going to be more sensitive to the needs of the audience—legibility, color selection."

OXFORD COMMUNICATIONS, INC., 287 S. Main St., Lambertville NJ 08530. (609)397-4242. Fax: (609)397-8863. Creative Director: Chuck Whitmore. Estab. 1986. Ad agency. Full-service, multimedia firm. Specializes in print advertising and collateral. Product specialties are health care, real estate and hightech.
Needs: Approached by 6 artists/month. Works with 1 illustrator and 3 designers every 6 months. Prefers local artists with experience in comping and desktop publishing. Uses freelancers mainly for mechanicals. Also uses freelancers for brochure design and illustration, technical and fashion illustration, print ad illustration, mechanicals, retouching and logos. 75% of work is with print ads.
First Contact & Terms: Send query letter with photocopies and résumé. Samples are filed. Reports back to the artist only if interested. Art Director will contact artist for portfolio review if interested. Portfolio should include b&w and/or color photostats, tearsheets, photographs and slides. Pays for design and illustration by the project, negotiable. Rights purchased vary according to project.

‡SORIN PRODUCTIONS INC., 4400 Route 9 S., Freehold NJ 07728. (908)462-1785. President: David Sorin. Estab. 1982. AV firm. Full-service, multimedia firm. Specializes in corporate video, slides, audio. Current clients include AT&T, First Fidelity Bank, J&J. Client list available upon request.
Needs: Approached by 2-3 freelance artists/month. Works with 1 freelance illustrator and designer/month. Prefers local artists only with experience in graphics for video/slides. Works on assignment only. Uses artists for storyboards, slide illustration, animation, model making and TV/film graphics. 5% of work is with print ads. Needs computer-literate freelancers for design and illustration. 75% of freelance work demands knowledge of Aldus PageMaker, Aldus FreeHand or Lotus Freelance.

First Contact & Terms: Send query letter with brochure. Samples are not filed and are not returned or are returned by SASE if requested. Reports back to the artist only if interested. Art Director will contact artist for portfolio review if interested. Pays for design and illustration by the project. Buys all rights.

‡**SUEDE COMMUNICATION CENTER,** 685 Main St., Hackensack NJ 07601. (201)646-0416. Estab. 1971. AV firm. Full-service, multimedia firm. Specializes in radio and TV documentaries, corporate videos. Current clients include AT&T, IBM. Client list available upon request.
Needs: Works with 1 freelance illustrator/year. Prefers local artists only. Works on assignment only. Uses freelance artists mainly for TV and magazine ads. Also uses freelance artists for brochure and catalog design, print ad illustration, storyboards, slide illustration, TV/film graphics and logos. 20% of work is with print ads. Needs computer-literate freelancers for production and presentation. 90% of freelance work demands knowledge of Aldus PageMaker or Adobe Illustrator.
First Contact & Terms: Contact through artist rep or send query letter. Samples are filed. Reports back within 3 weeks. Request portfolio review in original query. Portfolio should include b&w and color thumbnails, photographs, roughs, transparencies, tearsheets and photostats. Pays for design and illustration by the project. Rights purchased vary according to project.

New York

‡**ATLANTIC FILM PRODUCTION,** 171 Park Lane, Massapequa NY 11758. (516)798-4106. President: Michael Canzoneri. Estab. 1993. AV firm. Specializes in animation and documentaries. Product specialty is automotive.
Needs: Approached by 1 freelance artist/month. Works with 1 freelance illustrator/month. Prefers local artists only. Works on assignment only. Uses freelance artists mainly for titles. Also uses freelance artists for storyboards, animation and model making. 10% of work is with print ads. 10% of work demands computer skills.
First Contact & Terms: Send query letter with brochure, résumé, transparencies and photographs. Samples are filed. Reports back to the artist only if interested. Art Director will contact artist for portfolio review if interested. Portfolio should include b&w and color roughs, photographs and transparencies. Pays for design and illustration by the project, $100-300. Buys one-time rights.
Tips: "We need people who love to draw—especially characters with animal basis."

AUTOMATIC MAIL SERVICES, INC., 30-02 48th Ave., Long Island City NY 11101. (212)361-3091. Contact: Michael Waskover. Manufacturer and service firm. Provides printing and direct mail advertising. Clients: publishers, banks, stores, clubs.
Needs: Works with 5-10 artists/year. Uses freelancers for advertising, brochure and catalog design, illustration and layout.
First Contact & Terms: Send business card and photostats to be kept on file. Call for appointment to show portfolio. Samples not kept on file are returned if requested. Works on assignment only. Pays by the project, $10-1,000 average. Considers skill and experience of artist and turnaround time when establishing payment.

‡**CHANNEL ONE PRODUCTIONS, INC.,** 82-03 Utopia Pkwy., Jamaica Estates NY 11432. (718)380-2525. President: Burton M. Putterman. AV firm. "We are a multimedia, film and video production company for broadcast, image enhancement and P-O-P displays." Clients: multi-national corporations, recreational industry and PBS.
Needs: Works with 25 freelance artists/year. Assigns 100 jobs/year. Prefers local artists. Works on assignment only. Uses freelance artists mainly for work on brochures, catalogs, P-O-P displays, animation, direct mail packages, motion pictures, logos and advertisements. Needs technical illustration. Needs computer-literate freelancers for design, production and presentation. 100% of freelance work demands knowledge of Aldus PageMaker, Aldus FreeHand or Adobe Illustrator.
First Contact & Terms: Send query letter with résumé, slides and photographs. Samples are not filed and are returned by SASE. Reports back within 2 weeks only if interested. Call for appointment to show a portfolio of original/final art, final reproduction/product, slides, video disks and videotape. Pays for design by the project, $400 minimum. Considers complexity of project and client's budget when establishing payment. Rights purchased vary according to project.
Tips: "Our freelance needs have been reduced."

For a list of markets interested in humorous illustration, cartooning and caricatures, refer to the Humor Index at the back of this book.

FASTFORWARD COMMUNICATIONS INC., 401 Columbus Ave., Valhalla NY 10595. (914)741-0555. Fax: (914)741-0597. Vice President: J. Martorano. Estab. 1986. Ad agency/PR firm. Specialties are high technology and entertainment. Current clients include Nynex, AT&T, Chesebrough-Ponds, Farberware and Philip Morris International.

Needs: Approached by 6 freelance artists/month. Works with 1 illustrator and 1-2 designers/month. Works on assignment only. Uses freelancers mainly for Macintosh work. Also uses freelance artists for brochure and catalog design and illustration and TV/film graphics. 90% of work is with printed material. 75% of freelance work demands knowledge of Aldus PageMaker, QuarkXPress, Aldus Freehand, Adobe Illustrator and Photoshop.

First Contact & Terms: Send query letter with samples, rates and résumé. Samples are filed or are returned by SASE. Reports back to the artist only if interested. To show portfolio, mail thumbnails and roughs and b&w or color tearsheets. Pays for design and illustration by the project. Rights purchased vary according to project.

■**FINE ART PRODUCTIONS**, 67 Maple St., Newburgh NY 12550. Phone/Fax: (914)561-5866. Contact: Richie Suraci. Estab. 1990. Ad agency, AV and PR firm. Full-service, multimedia firm. Specializes in film, video, print, magazine, documentaries and collateral. "Product specialties cover a broad range of categories."
 • Fine Art Productions is looking for artists who specialize in science fiction and erotic art for upcoming projects.

Needs: Approached by 24 freelance artists/month. Works with 1-2 illustrators and 1-2 designers/month. "Everyone is welcome to submit work for consideration in all media." Works on assignment only. Uses freelance artists for brochure, catalog and print ad design and illustration and storyboards, slide illustration, animatics, animation, mechanicals, retouching, billboards, posters, TV/film graphics, lettering and logos. Needs editorial, technical, science fiction, jungle, adventure, children's, fantasy and erotic illustration. 20% of work is with print ads. Needs computer-literate freelancers for design, illustration, production and presentation. 20% of freelance work demands knowledge of Aldus PageMaker, QuarkXPress, Aldus FreeHand, Adobe Illustrator or Adobe Photoshop.

First Contact & Terms: Send query letter with brochure, photocopies, résumé, photographs, tearsheets, photostats, slides, transparencies and SASE. Samples are filed or returned by SASE if requested by artist. Reports back in 4-6 months only if interested. Art Director will contact artist for portfolio review if interested. Portfolio should include thumbnails, roughs, b&w and color photostats, tearsheets, photographs, slides and transparencies. Requests work on spec before assigning a job. Pays for design and illustration by the project; negotiable. Rights purchased vary according to project.

Tips: "We need more freelance artists."

‡**GARRITY COMMUNICATIONS, INC.**, 213 N. Aurora St., Ithaca NY 14850. (607)272-1323. Art Director: Debra Engstrom. Estab. 1978. Ad agency, AV firm. Specializes in trade ads, newspaper ads, annual reports, video, etc. Product specialties are financial services, industrial.

Needs: Approached by 8 freelance artists/month. Works with 2 freelance illustrators and 1 freelance designer/month. Works on assignment only. Uses freelance artists mainly for work overflow situations; some logo specialization. Also uses freelance artists for brochure design and illustration, print ad illustration, TV/film graphics and logos. 40% of work is with print ads. Needs computer-literate freelancers for design and production. 90% of freelance work demands knowledge of Aldus PageMaker (IBM) or Corel.

First Contact & Terms: Send query letter with brochure and photocopies. Samples are filed and are not returned. Reports back to the artist only if interested. Art Director will contact artist for portfolio review if interested. Pays for design by the hour, $15-50. Pays for illustration by the project, $150-500. Rights purchased vary according to project.

Tips: Finds artists through sourcebooks, submissions.

IMAC, Inter-Media Art Center, 370 New York Ave., Huntington NY 11743. (516)549-9666. Fax: (516)549-9423. Executive Director: Michael. Estab. 1974. AV firm. Full-service, multimedia firm. Specializes in TV and multimedia productions.

Needs: Approached by 12 artists/month. Works with 3 illustrators and 2 freelance designers/month. Prefers artists with experience in computer graphics. Uses freelancers mainly for animation, TV/film graphics and computer graphics. 50% of work is with print ads.

First Contact & Terms: Send query letter with photographs. Samples are not filed and are not returned. Reports back within 10 days. Rights purchased vary according to project.

PARAGON ADVERTISING, Suite 510, 220 Delaware Ave., Buffalo NY 14202. (716)854-7161. Fax: (716)854-7163. Art Director: Leo Abbott. Estab. 1988. Ad agency. Full-service, multimedia firm. Product specialty is food industry.

Needs: Approached by 2-3 freelance artists/month. Works on assignment only. Uses freelancers mainly for illustrations. Also for lettering. 40% of work is with print ads. Needs computer-literate freelancers for illustration. 20% of freelance work demands knowledge of Adobe Illustrator, QuarkXPress or Photoshop.

First Contact & Terms: Send query letter with résumé, photocopies, photographs, slides, tearsheets and transparencies. Samples are returned by SASE only if requested by artist. Reports back only if interested. Call for appointment to show portfolio of roughs, final art, b&w photostats, transparencies, color tearsheets, photographs, slides. Pays for illustration by the project, $50-2,500. Buys all rights or rights purchased vary according to project.
Tips: "Send creative mailers."

PARTNERS MEANY, 382 Broadway, Albany NY 12207. (518)465-4573. Fax: (518)465-4937. Art Director: Scott Seymour. Ad agency. Full-service, multimedia firm. Specializes in print collateral, advertisements and promotions.
Needs: Approached by 10 freelancers/month. Works with 6-15 illustrators and 2-8 designers/month. Works on assignment only. Uses freelancers mainly for computer-related design—brochure and print ad design and illustration, storyboards, mechanicals, retouching, billboards, posters, lettering and logos. 30% of work is with print ads. Needs computer-literate freelancers for design, illustration and production. 50% of freelance work demands knowledge of QuarkXPress, Aldus FreeHand, Adobe Illustrator and Photoshop.
First Contact & Terms: Send query letter with brochure, résumé, promo piece and photocopies. Samples are filed. Reports back only if interested. Write for appointment to show portfolio of final art. Pays for design by the hour, $15-50. Pays for illustration by the project, $200-5,000. Buys all rights.

JACK SCHECTERSON ASSOCIATES, 5316 251 Place, Little Neck NY 11362. (718)225-3536. Fax: (718)423-3478. Principal: Jack Schecterson. Estab. 1967. Ad agency, packaging, product marketing and design consultants. Specializes in new product introduction business-to-business.
Needs: Works only with artists' and photographers' reps. Prefers local artists only. Works on assignment only. Uses freelancers for package and product design and illustration, brochures, catalogs, retouching, lettering, logos.
First Contact & Terms: Send query letter with SASE and whatever best illustrates work. Samples not filed are returned by SASE only if requested by artist. Request portfolio review in original query. Art Director will contact artist for portfolio review if interested. Portfolio should include appropriate materials including roughs, b&w and color—whatever best illustrates abilities/work. Pays for design and illustration by the project; depends on budget. Buys all rights.

‡SINGER ADVERTISING & MARKETING INC., 1035 Delaware Ave., Buffalo NY 14209. (716)884-8885. Fax: (716)888-7685. Traffic/Production Manager: Kathy Dorey-Pohrte. Estab. 1969. Ad agency. Specializes in advertising (print ads, radio/TV, collateral), telemarketing, public relations services. Product specialties are business and consumer. Current clients include NFL Buffalo Bills, ITT Automotive, Armstrong Pumps, Gollum International, Al Tech Specialty Steel, Re/Max of NY, Inc. Client list available upon request.
Needs: Approached by 2-5 freelance artists/month. Works with 1 freelance illustrator and 2-3 freelance designers/month. Prefers local artists only. Works on assignment only. Uses freelance artists for brochure, catalog and print ad design and illustration. 60% of work is with print ads. Needs computer-literate freelancers for design, illustration and production. 95% of freelance work demands demands knowledge of Aldus PageMaker, QuarkXPress, Aldus FreeHand, Adobe Illustrator or Adobe Photoshop.
First Contact & Terms: Send query letter with tearsheets. Samples are filed. Art Director will contact artist for portfolio review if interested. Portfolio should include b&w and color thumbnails, roughs, final art and tearsheets. Pays for design by the hour or by the project. Pays for illustration by the project. Buys all rights.
Tips: Finds artists through submissions and word of mouth.

STEEN ADVERTISING CORP., 1975 Linden Blvd., Elmont NY 11003. (516)285-3900. President: Norman Steen. Estab. 1960. Ad agency. Full-service, multimedia firm.
Needs: Approached by 3 freelance artists/month. Works with 2 illustrators and 3 designers/month. Prefers local artists only. Works on assignment only. Uses freelancers mainly for print work. Also for brochure, catalog and print ad design and illustration; editorial, technical and general illustration; mechanicals; retouching; TV/film graphics; lettering and logos. 80% of work is with print ads.
First Contact & Terms: Send query letter with brochure, photocopies, photographs and tearsheets. Samples are filed and are not returned. Reports back to the artist only if interested. Request portfolio review in original query. Art Director will contact artist for portfolio review if interested. Portfolio should include roughs and tearsheets. Pays for design and illustration by the project. Buys all rights.

‡STRÜNBERG COMMUNICATION & CONSULTING, (formerly Command Communications), Suite 109, 2500 Westchester Ave., Purchase NY 10577. (914)215-1515. Contact: Studio Manager. Product specialties are direct marketing and internal communicating. Clients: industrial and corporate. Produces video animation, multimedia, slide presentations, videotapes and print materials.
Needs: Assigns 25 jobs/year. Uses artists for design catalogs, corporate brochures, annual reports, slide shows, layouts, mechanicals, illustrations, computer graphics and desk-top publishing.
First Contact & Terms: Prefers local artists only (New York City, Manhattan and Westchester). "Send note on availability and previous work." SASE. Reports in 2 weeks. Provide materials to be kept on file for future

assignments. Originals are not returned at job's completion. Pays $15-25/hour and by the project.
Tips: Finds artists through word of mouth, sourcebooks and submissions.

VISUAL HORIZONS, 180 Metro Park, Rochester NY 14623. (716)424-5300. Fax: (716)424-5313. Estab. 1971. AV firm. Full-service, multimedia firm. Specializes in presentation products. Current clients include US government agencies, corporations and universities. Client list not available.
Needs: Works on assignment only. Uses freelancers mainly for slide illustration. 10% of work is with print ads. Needs computer-literate freelancers for presentation. 100% of freelance work demands knowledge of Aldus PageMaker, Aldus FreeHand, Adobe Illustrator or Arts and Letters.
First Contact & Terms: Send query letter with tearsheets. Samples are not filed and are not returned. Reports back to the artist only if interested. Portfolio review not required. Pays for design and illustration by the hour or project, negotiated. Buys all rights.

New York City

A.V. MEDIA CRAFTSMAN, INC., Dept. AM, Suite 1N, 225 E. 26th St., New York NY 10010. (212)686-2906. President: Carolyn Clark. Estab. 1967. Production company. Full-service, multimedia firm. Specializes in slide shows, training videos and related brochures (educational). Service specialties are consumer and fashion forecasts. Current clients include J.C. Penney Co., DuPont, Mountain Publishers and John Wiley & Co.
Needs: Approached by 20 or more artists/month. Works with 2 illustrators and 2 designers/year. Prefers local artists only with extensive experience in computer slide programs. Works on assignment only. Uses freelancers for brochure illustration.
First Contact & Terms: Send résumé, a few photocopied samples of your work and list of clients. Samples are filed or are not returned. Reports back to the artist only if interested. Pays for design by the hour. Pays for illustration by the project. Rights purchased vary according to project.

‡BENJAMIN & NOVICH INC., ADVERTISING, 461 Park Ave. S., New York NY 10016. (212)779-3640. Fax: (212)779-3644. Vice President: Alan Benjamin. Estab. 1988. Ad agency. Full-service, multimedia firm. Product specialty is food. Current clients include A&P Food Emporium. Client list available upon request.
Needs: Approached by 10-15 freelance artists/month. Works with 2-3 freelance illustrators/month. Prefers local artists with experience in food. Works on assignment only. Uses freelance artists mainly for illustration and design. Also uses freelance artists for brochure, catalog and print ad design and illustration and mechanicals, retouching, billboards, posters, TV/film graphics and lettering. 30% of work is with print ads. Needs computer-literate freelancers for design. Freelancers should be familiar with QuarkXPress.
First Contact & Terms: Send query letter with résumé and photocopies. Samples are filed or are returned by SASE. Reports back to the artist only if interested. Artist should follow up. Portfolio should include b&w and color thumbnails, roughs and tearsheets. Pays for design by the hour, by the project or by the day. Pays for illustration by the project. Rights purchased vary according to project.
Tips: Finds artists through agents, sourcebooks, magazines, word of mouth and submissions.

ANITA HELEN BROOKS ASSOCIATES, PUBLIC RELATIONS, 155 E. 55th St., New York NY 10022. (212)755-4498. President: Anita Helen Brooks. PR firm. Specializes in fashion, "society," travel, restaurant, political and diplomatic and publishing. Product specialties are events, health and health campaigns.
Needs: Works on assignment only. Uses artists for consumer magazines, newspapers and press releases. "We're currently using more abstract designs."
First Contact & Terms: Call for appointment to show portfolio. Reports only if interested. Considers client's budget and skill and experience of artist when establishing payment.
Tips: Artists interested in working with us must provide "rate schedule, partial list of clients and media outlets. We look for graphic appeal when reviewing samples."

■CANON & SHEA ASSOCIATES, INC., Suite 1500, 224 W. 35th St., New York NY 10001. (212)564-8822. Art Buyer: Sal Graci. Estab. 1978. Technical advertising/PR/marketing firm. Specializes in business-to-business and financial services.
Needs: Assigns 20-40 freelance jobs and buys 50-60 freelance illustrations/year. Works with 20-30 illustrators and 2-3 designers/year. Mostly local artists. Uses freelancers mainly for mechanicals and technical illustrations. 85% of work is with print ads.
First Contact & Terms: Send query letter with brochure showing art style or send résumé and tearsheets. Art Director will contact artist for portfolio review if interested. Pays by the hour: $25-35 for animation, annual reports, catalogs, trade and consumer magazines; $25-50 for packaging; $50-250 for corporate identification/graphics; $10-45 for layout, lettering and paste-up.
Tips: Finds artists through art schools, design schools and colleges. "Artists should have business-to-business materials as samples and should understand the marketplace. Do not include fashion or liquor ads. Common mistakes in showing a portfolio include showing the wrong materials, not following up and lacking understanding of the audience."

ERICKSEN/BASLOE ADVERTISING, LTD., 12 W. 37th St., New York NY 10018. Fax: (212)239-3321. Director of Creative Services: Catherine M. Reiss. Full-service ad agency providing all promotional materials and commercial services for clients. Product specialties are promotional, commercial and advertising materials. Current clients include Turner Home Entertainment, Buena Vista Home Video and ABC News International.

Needs: Works with 50 artists/year. Assigns 50 jobs/year. Works on assignment only. Uses freelancers mainly for illustration, advertising, video packaging, brochures, catalogs, trade magazines, P-O-P displays, mechanicals, posters, lettering and logos. "Must be able to render celebrity likenesses." Prefers oils, airbrush, composited and computer-generated artwork.

First Contact & Terms: Contact through artist's agent or send query letter with brochure or tearsheets and slides. Samples are filed and are not returned unless requested with SASE; unsolicited samples are not returned. Reports back within 1 week if interested or when artist is needed for a project. Does not report back to all unsolicited samples. "Only on request should a portfolio be sent. I need to see accurate celebrity likenesses in your portfolio." Pays for illustration by the project, $500-5,000. Buys all rights and retains ownership of original.

Tips: Finds artists through word of mouth, magazines, submissions and sourcebooks. "Advertising artwork is becoming increasingly 'commercial' in response to very tightly targeted marketing in a poor economy (i.e., the artist has to respond to increased creative team input versus the fine art approach of the past—except with style-driven products such as fashion and perfume)."

GREY ADVERTISING INC., 777 3rd Ave., New York NY 10017. Fax: (212)546-2379. Vice President/Art Buying Manager: Patti Harris. Specializes in cosmetics, food, sports, baby products and shoes.
- This company has four art buyers, each of whom makes about 50 assignments per year. Freelancers are needed mostly for photography and illustration, but also for set building, fashion styling and lettering.

Needs: Needs realistic and graphic illustration.

First Contact & Terms: Works on assignment only. Call for appointment at beginning of month to show portfolio of original/final art. Pays by the project, $500 minimum. Considers client's budget and rights purchased when establishing fees.

Tips: "I often find illustrators in sourcebooks and magazines. I also keep promotional material on file by style. We are headed to a computer-generated art world and I think it will continue to grow with CD-ROMs and interactive television. More and more of artwork can now be generated digitally."

GT GROUP, a division of Griffith & Tekushan, Inc., #1000, 630 Ninth Ave., New York NY 10036. (212)246-0154. Fax: (212)581-4827. Estab. 1985. AV firm. Full-service, multimedia firm. Specializes in TV, video, advertising, design and production of promos, show openings and graphics. Current clients include ESPN and CBS.

Needs: Approached by 4 freelance artists/month. Works with 2-3 designers/month. Prefers artists with experience in television or advertising production. Works on assignment only. Uses freelancers mainly for design and production. Also uses freelancers for storyboards, animation, TV/film graphics and logos. Needs computer-literate freelancers for design, production and presentation.

First Contact & Terms: Send query letter with résumé and demo reels. Samples are filed. Art Director will contact artist for portfolio review if interested. Portfolio should include 3/4" video or VHS. Pays for design by the hour, $18; by the project; by the day. Pays for illustration by the project.

Tips: Finds artists through word of mouth.

HILL AND KNOWLTON, INC., Dept. AM, 420 Lexington Ave., New York NY 10017. (212)697-5600. Corporate Design Group: Jim Stanton, Bob Barber and Lorenzo Ottaviani. Incorporated in 1947. PR firm. Full-service, multimedia firm. Specializes in annual reports, collaterals, corporate identity, advertisements.

Needs: Works with 0-10 illustrators/month. Works on assignment only. Uses freelancers for editorial, technical and medical illustration. Also uses freelance artists for storyboards, slide illustration, animatics, mechanicals, retouching and lettering. 10% of work is with print ads. Needs computer-literate freelancers for design and illustration. Freelancers should be familiar with Aldus PageMaker, QuarkXPress, Aldus FreeHand or Adobe Illustrator.

First Contact & Terms: Send query letter with promo and samples. Samples are filed. Does not report back, in which case the artist should "keep in touch by mail—do not call." Call and drop-off only for a portfolio review. Portfolio should include dupe photographs. Pays for illustration by the project, $250-5,000. Negotiates rights purchased.

Tips: Looks for "variety; unique but marketable styles are always appreciated."

KEN LIEBERMAN LABORATORIES, INC., 118 W. 22 St., New York NY 10011. (212)633-0500. Fax: (212)675-8269. Sales Manager: Gail Cohen. Estab. 1972. AV firm. Full-service, multimedia firm. Specializes in custom lab services, prints, dupes and mounting.

Needs: Approached by 60 freelancers/month. Works with 10 illustrators and 10 designers/month. Use freelancers for slide illustration and retouching. 98% of work is with print ads.

First Contact & Terms: Send query letter with photographs, slides and transparencies. Samples are not filed and are returned by SASE only if requested by artist. Portfolio review not required. Pays for design and illustration by the project.

McANDREW ADVERTISING, 2125 St. Raymond Ave., P.O. Box 254, Bronx NY 10462. (718)892-8660. Art/Creative Director: Robert McAndrew. Estab. 1961. Ad agency. Clients: industrial and technical firms. Current clients include Yula Corp. and Electronic Devices.
Needs: Assigns 200 jobs and buys 120 illustrations/year. Works with 5 illustrators and 2 designers/year. Uses mostly local artists. Uses freelancers mainly for design, direct mail, brochures/flyers and trade magazine ads. Needs technical illustration. Prefers realistic, precise style. Prefers pen & ink, airbrush and occasionally markers. 50% of work is with print ads. Needs computer-literate freelancers for design, production and presentation. 5% of freelance work demands computer skills.
First Contact & Terms: Query with photocopies, business card and brochure/flyer to be kept on file. Samples not returned. Reports in 1 month. Originals not returned. Art Director will contact artist for portfolio review if interested. Portfolio should include roughs and final reproduction. Pays for illustration by the project, $35-300. Pays for design by the project. Considers complexity of project, client's budget and skill and experience of artist when establishing payment.
Tips: Finds artists through sourcebooks, word of mouth and business cards in local commercial art supply stores. Artist needs an "understanding of a product and the importance of selling it."

RUTH MORRISON ASSOCIATES, INC., 19 W. 44 St., New York NY 10036. (212)302-8886. Fax: (212)302-5512. Assistant Account Executive: Marinelle Hervas. Estab. 1972. PR firm. Specializes in food, travel, hotel/restaurant, education, non-profit. Assignments include logo/letterhead design, invitations and brochures."
Needs: Prefers local artists only with experience in advertising and publishing. Uses freelancers mainly for brochure design, P-O-P materials and direct mail. Also uses freelancers for catalog and print ad design, mechanicals, editorial illustration, posters, lettering and logos. 5% of work is with print ads. 10% of freelance work demands computer skills.
First Contact & Terms: Send query letter with photocopies. Samples are filed or returned by SASE only if requested by artist. Does not report back. Portfolios may be dropped off every Wednesday. Sometimes requests work on spec before assigning a job. Pays for design and illustration by the project. Rights purchased vary according to project.
Tips: Finds artists through word of mouth, magazines and advertising.

‡NAPOLEON ART STUDIO, 460 W. 42 St., New York NY 10036. (212)967-6655. Fax: (212)268-1548. Director of Art Studio Services: Jane Carter. Estab. 1985. AV firm. Full-service, multimedia firm. Specializes in storyboards, magazine ads, mechanicals. Product specialty is consumer. Current clients include "all major New York City ad agencies." Client list not available.
Needs: Approached by 5 freelance artists/month. Works with 15 freelance illustrators and 2 freelance designers/month. Prefers local artists with experience in advertising art. Works on assignment only. Uses freelance artists for brochure, catalog and print ad design and illustration and storyboards, mechanicals, billboards, posters, TV/film graphics, lettering and logos. 50% of work is with print ads. Needs computer-literate freelancers for design, illustration, production and presentation. 50% of freelance work demands knowledge of Adobe Illustrator or Adobe Photoshop.
First Contact & Terms: Send query letter with photocopies, tearsheets and ¾" or VHS tape. Samples are filed. Reports back to the artist only if interested. Art Director will contact artist for portfolio review if interested. Portfolio should include b&w and color thumbnails. Pays for design and illustration by the project; by the day, $400. Rights purchased vary acording to project.
Tips: Finds artists through word of mouth and submissions.

NOSTRADAMUS ADVERTISING, Suite 1128-A, 250 W. 57th St., New York NY 10107. Creative Director: B.N. Sher. Specializes in book design, publications, signage, fliers, posters, advertising, direct mail and logos. Clients: ad agencies, book publishers, nonprofit organizations and politicians.
Needs: Works with 5 artists/year. Uses freelancers for advertising design, illustration and layout and brochure design, mechanicals, posters, direct mail packages, catalogs, books and magazines. Needs computer-literate freelancers for design and production.
First Contact & Terms: Send query letter with brochure, résumé, business card, samples and tearsheets. Do *not* send slides as samples; will accept "anything else that doesn't have to be returned." Samples not kept on filed are not returned. Reports only if interested. Call for appointment to show portfolio. Pays for design and mechanicals by the hour, $20-30 average. Pays for illustration by the project, $100 minimum. Considers skill and experience of artist when establishing payment.

‡PRO/CREATIVES COMPANY, 25 W. Burda Place, New York NY 10956-7116. President: D. Rapp. Estab. 1986. Ad agency and marketing/promotion/PR firm. Specializes in direct mail, ads, collateral. Product specialties are consumer/trade, goods/services.

Needs: Works on assignment only. Uses freelance artists for brochure and print ad design and illustration. 30% of work is with print ads.

First Contact & Terms: Samples are filed and are returned by SASE. Portfolio review not required. Pays for design and illustration by the project.

PETER ROTHHOLZ ASSOCIATES INC., 380 Lexington Ave., New York NY 10017. (212)687-6565. President: Peter Rothholz. PR firm. Specializes in government (tourism and industrial development), publishing, pharmaceuticals (health and beauty products) and business services.

Needs: Works with 2 illustrators and 2 designers/month. Works on assignment only. Needs editorial illustration.

First Contact & Terms: Call for appointment to show portfolio, which should include résumé or brochure/flyer to be kept on file. Samples returned by SASE. Reports in 2 weeks. Assignments made based on freelancer's experience, cost, style and whether he/she is local. Originals not returned. Sometimes requests work on spec before assigning job. Negotiates payment based on client's budget.

Tips: Finds artists through word of mouth and submissions.

DAVID SCHIFFER DESIGN, INC., 156 Fifth Ave., New York NY 10010. (212)255-3464. President: David Schiffer. Estab. 1986. Ad agency. Specializes in print only: magazine ads, collateral, catalogs. Product specialties are industrial, publishing.

Needs: Approached by 3 freelance artists/month. Works with 1 illustrator and 1 designer/month. Works on assignment only. Uses freelancers mainly for illustration. Also uses freelancers for mechanicals, retouching and desktop publishing. 20% of work is with print ads. Needs computer-literate freelancers for design, illustration and production. 75% of freelance work demands knowledge of QuarkXPress, Adobe Photoshop, Aldus PageMaker, Adobe Illustrator or Aldus FreeHand.

First Contact & Terms: Send query letter with résumé, photographs and tearsheets. Samples are filed. Reports back to the artist only if interested. Write for appointment to show portfolio of roughs or final art. Pays for illustration by the project, $250-2,500. Rights purchased vary according to project.

‡SHADOW LIGHT PRODUCTIONS INC., Suite 1102, 21 W. 46 St., New York NY 10036. (212)221-3616. Fax: (212)755-7192. Director/Producer: Marc Chelnik. AV, film/TV commercials, 3-D computer animation firm. Client list not available.

Needs: Uses freelance artists mainly for illustration, animation and 3-D computer animation. Also uses freelance artists for storyboards, animation, model making, TV/film graphics and logos. Needs computer-literate freelancers for design, illustration and production. Freelancers should be familiar with Adobe Photoshop, Quick Time, HyperCard, Adobe Premiere.

First Contact & Terms: Send query letter with résumé. Samples are not returned. Reports back to the artist only if interested. Artist should follow up with call.

THE SOFTNESS GROUP, INC., 381 Park Ave. S., New York NY 10016. (212)696-2444. Fax: (212)696-2466. Vice President: Laura Russo. Estab. 1960. PR firm. Full-service, multimedia firm. Specializes in brochures, annual reports, ads, display materials, posters. Product specialties are consumer, medical, business. Current clients include GNC, Rit Dye, Fruit of the Loom, Cookin' Good, Key Bank of New York.

Needs: Approached by 1 freelance artist/month. Works with 2 illustrators and 1 designer/month. Prefers local artists with experience in production as well as design. Works on assignment only. Uses freelancers for brochure design and illustration, catalog design and illustration and retouching. 5% of work is with print ads. Needs computer-literate freelancers for design and production. 10% of freelance work demands knowledge of Aldus PageMaker, Adobe Illustrator, QuarkXPress and Aldus FreeHand.

First Contact & Terms: Send query letter with résumé. Reports back to the artist only if interested. Call for appointment to show portfolio. Portfolio should include thumbnails, roughs and final art. Pays flat rate by project. Buys all rights.

‡STRATEGIC COMMUNICATIONS, 276 Fifth Ave., New York NY 10001. (212)779-7240. Fax: (212)779-7248. Estab. 1981. PR firm. Specializes in corporate and press materials, VNRs and presentation materials. Specializes in service businesses.

Needs: Approached by 3-4 freelance artists/month. Works with 3 freelance illustrators and 4 freelance designers/month. Prefers local artists only. Works on assignment only. Uses freelance artists for brochure design and illustration, slide illustration, mechanicals, posters, TV/film graphics, lettering, logos, corporate ID programs, annual reports, collateral and press materials.

First Contact & Terms: Send query letter with brochure, résumé, photographs and nonreturnable samples only. Samples are filed. Does not report back, in which case the artist should send follow-up communication every 6-9 months to keep file active. Portfolio should include original, final art. Pays for design and illustration by the project. Rights purchased vary according to project.

‡■VAN VECHTEN & ASSOCIATES PUBLIC RELATIONS, The Carriage House, 142 E. 30th St., New York NY 10016. (212)684-4646. President: Jay Van Vechten. PR firm. Clients: medical, consumer products, industry. Client list available for SASE.

Needs: Assigns 20 freelance jobs/year. Works with 2 freelance illustrators and 2 freelance designers/month. Works on assignment only. Uses artists for editorial and medical illustration, consumer and trade magazines, brochures, newspapers, stationery, signage, AV presentations and press releases. Needs computer-literate freelancers for presentation. 20% of freelance work demands computer literacy.
First Contact & Terms: Send query letter with brochure, résumé, business card, photographs or photostats. Samples not filed are returned by SASE. Reports back only if interested. Write for appointment to show a portfolio. Pays for design and illustration by the hour, $10-25 average. Considers client's budget when establishing payment. Buys all rights.

‡AL WASSERMAN, %MM&S, Fifth Floor, 440 Park Ave. S., New York NY 10016. (212)683-2100. Fax: (212)696-4795. Designer/Director: Al Wasserman. Estab. 1990. Ad agency. Full-service, multimedia firm. Specializes in magazine ads and all types of collateral. Product specialties are business, industry and real estate. Client list not available.
Needs: Prefers local artists. Uses freelance artists mainly for follow through. Also uses freelance artists for brochure and print ad illustration, animation, mechanicals, retouching, model making, billboards, TV/film graphics and lettering. 75% of work is with print ads. Needs computer-literate freelancers for production. 10% of freelance work demands knowledge of Aldus PageMaker.
First Contact & Terms: Contact only through artist rep. Send query letter with photocopies and tearsheets. Copies are filed or returned by SASE if requested by artist. Reports back to the artist only if interested. Artist should follow up with call and/or letter after initial query. Portfolio should include final art. Pays for illustration by the project, $250-3,000. Rights purchased vary according to project.
Tips: "We find designers from agents, sourcebooks and magazines or other publications such as annual reports."

North Carolina

‡FOGLEMAN & PARTNERS ADVERTISING & MARKETING, 415 1st Ave. NW, Hickory NC 28601. (704)322-7768. Fax: (704)322-4868. Senior Account Executive: Tom Ballus. Estab. 1963. Ad agency and PR firm. Specilizes in all print and broadcast plus full marketing and direct marketing services. Product specialties are furniture, hosiery, travel and trucking. Client list available upon request.
Needs: Approached by 2 freelance artists/month. Works with 1-3 freelance illustrators and designers/month. Prefers artists with experience in business-to-business. Works on assignment only. Uses freelance artists for brochure and print ad design and illustration and billboards and logos. 60% of work is with print ads. Needs computer-literate freelancers for design, illustration and production.

LEWIS ADVERTISING, INC., Dept. AM, 1050 Country Club Rd., Rocky Mount NC 27804. (919)443-5131. Associate Creative Director: Scott Brandt. Senior Art Director: Marty Hardin. Art Directors: Connie Wyche and Calvin Cooper. Ad agency. Clients: fast food, communications, convenience stores, financial. Client list provided upon request with SASE.
Needs: Works with 20-25 artists/year. Works on assignment only. Uses artists for illustration and part-time paste-up. Especially looks for "consistently excellent results, on time and on budget."
First Contact & Terms: Send query letter with résumé, business card and samples to be kept on file. Call for appointment to show portfolio of examples of previous work; include price range requirements and previous employers. Samples not filed are returned by SASE only if requested. Reports only if interested. Pays by the project. Buys all rights.

MORPHIS & FRIENDS, INC., Dept. AM, Drawer 5096, Winston-Salem NC 27113-5096. (910)723-2901. Creative Director: Linda Anderson. Ad agency. Full-service firm. Clients: retail and business-to-business.
Needs: Works on assignment only. Uses freelancers for consumer and trade magazines, editorial and technical illustration, billboards, direct mail packages, brochures and newspapers.
First Contact & Terms: Send query letter with samples and photocopies to be kept on file. Samples not filed are returned only if requested. Art Director will contact artist for portfolio review if interested. Portfolio should include roughs and final reproduction/product. Pays by the project through quote process. Buys all rights.
Tips: Finds artists through word of mouth, sourcebooks, agents and submissions.

‡SMITH ADVERTISING & ASSOCIATES, 321 Arch St., Fayetteville NC 28301. (910)323-0920. Fax: (910)323-3328. Production Manager: Wanda Bullard. Estab. 1974. Ad agency. Full-service, multimedia firm. Specializes in newspaper, magazine, broadcast, collateral, PR, custom presentations. Product specialties are financial, healthcare, manufacturing, business-to-business, real estate, tourism. Current clients include Sarasota CVB, John Koenig Realtors, NC Ports, Southeastern Regional Medical Center, Standard Tobacco Corp. Client list available upon request.
Needs: Approached by 0-5 freelance artists/month. Works with 0-5 freelance illustrators and designers/month. Prefers artists with experience in Macintosh. Works on assignment only. Uses freelance artists mainly

for mechanicals. Also uses freelance artists for brochure, catalog and print ad illustration and animation, mechanicals, retouching, model making, TV/film graphics and lettering. 50% of work is with print ads. Needs computer-literate freelancers for design, illustration, production and presentation. 95% of freelance work demands knowledge of Aldus PageMaker, QuarkXPress, Aldus FreeHand, Adobe Illustrator or Adobe Photoshop.

First Contact & Terms: Send query letter with résumé and copies of work. Samples are returned by SASE if requested by artist. Reports back within 3 weeks. Artist should call. Art Director will contact artist for portfolio review if interested. Portfolio should include b&w and color thumbnails, final art and tearsheets. Pays for design and illustration by the project, $100. Buys all rights.

North Dakota

‡SIMMONS ADVERTISING, 125 S. 4th St., Grand Forks ND 58201. (701)746-4573. Fax: (701)746-8067. Art Director: John Lapsitis. Estab. 1947. Ad agency. Specializes in magazine ads, collateral, documentaries etc. Product specialty is consumer. Client list available upon request.

Needs: Approached by 1 freelance artist/month. Works with 1 freelance illustrator and designer/month. Works on assignment only. Uses freelance artists mainly for illustration. Also uses freelance artists for brochure, catalog and print ad design and illustration and storyboards, billboards and logos. 10% of work is with print ads. 10% of freelance work demands knowledge of Aldus PageMaker or QuarkXPress.

First Contact & Terms: Send query letter with brochure, résumé, slides and tearsheets. Samples are filed or are returned. Reports back within 5 days. Art Director will contact artist for portfolio review if interested. Portfolio should include color thumbnails, roughs, tearsheets, photostats and photographs. Pays for design and illustration by the hour, by the project, or by the day. Rights purchased vary according to project.

Ohio

‡AD ENTERPRISE ADVERTISING AGENCY, INC., Suite 28, 1450 SOM Center Rd., Cleveland OH 44124. (216)461-5566. Art Director: Jim McPherson. Estab. 1953. Ad agency. Full-service, multimedia firm. Specializes in full range of media. Product specialties are industrial and consumer. Client list available upon request.

Needs: Approached by 2 freelance artists/month. Works with 3-4 freelance illustrators and 2-3 freelance designers/month. Prefers local artists with experience in design through finish and knowledge of production. Uses freelance artists mainly for design and finished art. Also uses freelance artists for brochure, catalog and print ad design and illustration and slide illustration, mechanicals, retouching, billboards, posters and logos. 45% of work is with print ads.

First Contact & Terms: Send query letter with résumé. Samples are filed. Reports back within 1 week. Request portfolio review in original query. Portfolio should include thumbnails, roughs, final art and tearsheets. Pays for design by the hour, $25-45. Pays for illustration by the hour, $45-75. Buys all rights.

Tips: Finds artists through word of mouth, and occasionally a search through recommendations of suppliers and artists on staff.

‡BARON ADVERTISING, INC., Suite 645, Hanna Bldg., 1422 Euclid Ave., Cleveland OH 44115-1901. (216)621-6800. Fax: (216)621-6806. President: Selma Baron. Estab. 1956. Ad agency. Specializes in magazine ads and collateral. Product specialties are business-to-business, food, building products, technical products, industrial food service.

Needs: Approached by 30-40 freelance artists/month. Prefers artists with experience in food and technical equipment. Works on assignment only. Uses freelance artists mainly for specialized projects. Also uses freelance artists for brochure, catalog and print ad illustration and retouching. 90% of work is with print ads. Needs computer-literate freelancers for design, illustration and presentation. Freelancers should be familiar with Aldus PageMaker, QuarkXPress, Aldus FreeHand, Adobe Illustrator or Adobe Photoshop.

First Contact & Terms: Send query letter with résumé and photocopies. Samples are filed and are not returned. Does not report back. "Artist should send only samples or copies that do not need returning." Art Director will contact artist for portfolio review if interested. Portfolio should include final art and tearsheets. Pay for design depends on style. Pay for ilustration depends on technique. Buys all rights.

Tips: Finds artists through agents, sourcebooks, word of mouth and submissions.

■BRIGHT LIGHT PRODUCTIONS, INC., Suite 810, 602 Main St., Cincinnati OH 45202. (513)721-2574. Fax: (513)721-3329. President: Linda Spalazzi. Estab. 1976. AV firm. "We are a full-service film/video communications firm producing TV commercials and corporate communications."

Needs: Works on assignment only. Uses artists for editorial, technical and medical illustration and brochure and print ad design, storyboards, slide illustration, animatics, animation, TV/film graphics and logos. Needs computer-literate freelancers for design and production. 50% of freelance work demands knowledge of PageMaker and Photoshop.

First Contact & Terms: Send query letter with brochure and résumé. Samples not filed are returned by SASE only if requested by artist. Request portfolio review in original query. Portfolio should include roughs and photographs. Pays for design and illustration by the project. Negotiates rights purchased.
Tips: Finds artists through recommendations. "Our need for freelance artists is growing."

FREEDMAN, GIBSON & WHITE ADVERTISING, 814 Plum, Cincinnati OH 45202. (513)241-3900. Senior Art Director: Edward Fong. Estab. 1959. Ad agency. Full-service, multimedia firm. Product specialty is consumer.
Needs: Approached by 6 artists/month. Works with 2 illustrators/month. Works only with artist reps. Prefers artists with experience in illustration. Works on assignment only. Uses freelancers for brochure design and illustration, storyboards, slide illustration, animatics, animation, mechanicals and retouching. 80% of work is with print ads.
First Contact & Terms: Send query letter with brochure and résumé. Samples are filed and are not returned. Reports back within 1 week. Call for appointment to show portfolio of thumbnails, roughs, original/final art and b&w transparencies. Pays for design by the hour, $15-20; by the project. Pays for illustration by the project $300-10,000. Buys all rights.

INSTANT REPLAY, Dept. AM, 1349 E. McMillan, Cincinnati OH 45206. (514)861-7065. President: Terry Hamad. Estab. 1977. AV firm. "We are a full-service film production/video production and video post production house with our own sound stage. We also do traditional animation, paintbox animation with Harry, and 3-D computer animation for broadcast groups, corporate entities and ad agencies. We do many corporate identity pieces as well as network affiliate packages, car dealership spots and general regional and national advertising for TV market." Current clients include Procter and Gamble, Whirlpool, General Electric (Jet Engine division), NBC, CBS, ABC and FOX affiliates.
Needs: Works with 1 designer/month. Prefers artists with experience in video production. Works on assignment only. Uses freelancers mainly for production. Also use freelancers for storyboards, animatics, animation and TV/film graphics.
First Contact & Terms: Send query letter with résumé, photocopies, slides and videotape. "Interesting samples are filed." Samples not filed are returned by SASE only if requested by artist. Reports back to the artist only if interested. Call for appointment to show slide portfolio. Pays by the hour, $25-50 or by the project and by the day (negotiated by number of days.) Pays for production by the day, $75-300. Considers complexity of project, client's budget and turnaround time when establishing payment. Buys all rights.

‡CHARLES MAYER STUDIOS INC., 168 E. Market St., Akron OH 44308. (216)535-6121. President: C.W. Mayer, Jr. AV producer. Estab. 1934. Clients: mostly industrial. Produces film and manufactures visual aids for trade show exhibits.
Needs: Works with 1-2 freelance illustrators/month. Uses illustrators for catalogs, filmstrips, brochures and slides. Also uses freelance artists for brochures/layout, photo retouching and cartooning for charts/visuals. In addition, has a large gallery and accepts paintings, watercolors, etc. on a consignment basis, 33%-40% commissions.
First Contact & Terms: Send slides, photographs, photostats or b&w line drawings or arrange interview to show portfolio. Samples not filed are returned by SASE. Reports in 1 week. Provide résumé and a sample or tearsheet to be kept on file. Originals returned to artist at job's completion. Negotiates payment.

‡■MENDERSON & MAIER, INC., 2260 Park Ave., Cincinnati OH 45206. (513)221-2980. Art Director: Barb Phillips. Estab. 1954. Full-service ad agency in all aspects of media.
 • This art director predicts there will be more catalog and brochure work.
Needs: Works with 1-2 freelance illustrators/month. Prefers local artists only. Uses freelancers mainly for editorial, technical, fashion and general line illustrations and production. Also uses freelance artists for brochure, catalog and print ad design and illustration, slide illustration, mechanicals, retouching and logos. Prefers mostly b&w art, line or wash. Needs computer-literate freelancers for design and production. 85% of freelance work demands knowledge of Aldus PageMaker, Aldus FreeHand and Word 4.0. 50% of work is with print ads.
First Contact & Terms: Contact only through artist rep. Send résumé and photocopies. Samples are filed and are not returned. Reports back within 6 days. Art Director will contact artist for portfolio review if interested. Artist should follow up with call. Portfolio should include b&w and color photostats, tearsheets, final reproduction/product and photographs. Sometimes requests work on spec before assigning job. Pays for design by the hour, $12 minimum, or by the project. Pays for illustration by the project. Considers complexity of project and client's budget when establishing payment. Buys all rights.
Tips: Finds artists through résumés and word of mouth. The most effective way for a freelancer to get started in advertising is "by any means that build a sample portfolio."

ART MERIMS COMMUNICATIONS, Suite 1300, Bank One Center, 600 Superior Ave., Cleveland OH 44114-2650. (216)522-1909. Fax: (216)479-6801. President: Arthur M. Merims. Ad agency/PR firm. Current clients include Ohio Pest Control Association, HQ Business Centers, Osborn Engineering, Patrick Douglas, Inc., Woodruff Foundation.

Needs: Assigns 7 freelance jobs/year. Prefers local artists. Works on assignment only. Works with 1-2 illustrators and 1-2 designers/month. Uses freelancers mainly for work on trade magazines, brochures, catalogs, signage, editorial illustrations and AV presentations. Needs computer-literate freelancers for production. 20% of freelance work demands computer skills.

First Contact & Terms: Send query letter with samples to be kept on file. Call for appointment to show portfolio, which should include "copies of any kind" as samples. Sometimes requests work on spec before assigning job. Pays for design and illustration by the hour, $20-60, or by the project, $300-1,200. Considers complexity of project, client's budget and skill and experience of artist when establishing payment.

Tips: Finds artists through contact by phone or mail. When reviewing samples, looks for "creativity and reasonableness of cost."

TELEPRODUCTIONS, C105 Music and Speech Bldg., State Rt. 59, Kent OH 44242. (216)672-2184. Fax: (216)672-2309. Creative Director: Gordon J. Murray. Estab. 1962. "A university-based PBS television production facility that originates and supports programming for two television stations and a campus cable network; also functions as an academic support unit providing instructional television services."

Needs: Works with 2-3 illustrators and 2-3 designers/year. Prefers artists with experience in television, "but not required." Works on assignment only. Uses freelancers mainly for brochure and set design and collateral materials. Also uses freelancers for print design and illustration, storyboards, editorial, technical and medical illustration, animation, mechanicals, posters and TV/film graphics. Needs computer-literate freelancers for design, illustration, production and presentation. 25% of freelance work demands knowledge of Aldus PageMaker, Photoshop, QuarkXPress, Aldus FreeHand, Adobe Illustrator, Dubner, Alias, Cubicomp or Autodesk.

First Contact & Terms: Send query letter with résumé and photocopies. Samples are filed. Reports back to artist only if interested. "We will contact artist about portfolio review." Portfolio should include color and b&w samples, roughs, original/final art, tearsheets, final reproduction/product, photographs, slides. Sometimes requests work on spec before assigning job. Pays for design and illustration by the hour, $18-65. Rights purchased vary according to project.

Tips: Finds artists through *Artist's & Graphic Designer's Market* replies and through Kent State University. "Because of our affiliation with a university with an excellent design program, competition is keen but not exclusive. The diversity of our production often requires the skills of graphic designers, set designers, illustrators, sculptors, cartoonists, paste-up artists and production assistants. We are in the process of building a file of dependable, talented freelancers for future projects. Needs for artists familiar with multimedia/interactive video animation will increase in the years ahead as our clients' needs change to reflect technological advances in these areas."

‡TREEHAUS COMMUNICATIONS, INC., P.O. Box 249, 906 W. Loveland Ave., Loveland OH 45140. (513)683-5716. Fax: (513)683-2882. President: Gerard Pottebaum. Estab. 1973. Publisher. Specializes in books, periodicals, texts, TV productions. Product specialties are social studies and religious education.

Needs: Approached by 1 or 2 freelance artists/month. Works with 1 freelance illustrator/month. Prefers artists with experience in illustrations for children. Works on assignment only. Uses freelance artists for all work. Also uses freelance artists for illustrations and designs for books and periodicals. 5% of work is with print ads. Needs computer-literate freelancers for illustration.

First Contact & Terms: Send query letter with résumé, transparencies, photocopies and SASE. Samples sometimes filed or are returned by SASE if requested by artist. Reports back within 1 month. Art Director will contact artist for portfolio review if interested. Portfolio should include final art, tearsheets, slides, photostats and transparencies. Pays for design and illustration by the project. Rights purchased vary according to project.

Tips: Finds artists through word of mouth, submissions and other publisher's materials.

TRIAD, (Terry Robie Industrial Advertising, Inc.), 7654 W. Bancroft St., Toledo OH 43617-1604. (419)241-5110. Vice President/Creative Director: Janice Robie. Ad agency specializing in graphics and promotions. Product specialties are industrial, consumer and medical.

Needs: Assigns 30 freelance jobs/year. Works with 1-2 illustrators/month and 2-3 designers/month. Works on assignment only. Uses freelancers for consumer and trade magazines, brochures, catalogs, newspapers, filmstrips, stationery, signage, P-O-P displays, AV presentations, posters and illustrations (technical and/or creative).

First Contact & Terms: Send query letter with résumé and slides, photographs, photostats or printed samples. Samples returned by SASE if not filed. Reports only if interested. Write for appointment to show portfolio, which should include roughs, finished art, final reproduction/product and tearsheets. Pays by the hour, $10-60 or by the project, $25-2,500. Considers client's budget and skill and experience of artist when establishing payment. Negotiates rights purchased.

Tips: "We are interested in knowing your specialty."

Oregon

ADFILIATION ADVERTISING & DESIGN, 323 W. 13th Ave., Eugene OR 97401. (503)687-8262. Fax: (503)687-8576. President/Creative Director: Gary Schubert. Media Director/VP: Gwen Schubert. Estab. 1976. Ad agency. "We provide full-service advertising to a wide variety of regional and national accounts. Our specialty is print media, serving predominantly industrial and business-to-business advertisers." Product specialties are forest products, heavy equipment, software, sporting equipment, food and medical.
Needs: Works with approximately 4 freelance illustrators and 2 freelance designers/year. Assigns 20-24 jobs/year. Works on assignment only. Uses freelancers mainly for specialty styles. Also for brochure and magazine ad illustration (editorial, technical and medical), retouching, animation, films and lettering. 80% of work is with print ads. Needs computer-literate freelancers for design, illustration, production and presentation. 80% of freelance work demands knowledge of Adobe Illustrator, QuarkXPress, Aldus FreeHand, MultiMedia, PowerPaint, 3D Renderman or PhotoShop.
First Contact & Terms: Send query letter, brochure, résumé, slides and photographs. Samples are filed or are returned by SASE only if requested. Reports back only if interested. Write for appointment to show portfolio. Pays for design illustration and by the hour, $25-100. Rights purchased vary according to project.
Tips: "We're busy. So follow up with reminders of your specialty, current samples of your work and the convenience of dealing with you. We are looking at more electronic illustration. Find out what the agency does most often and produce a relative example for indication that you are up for doing the real thing! Follow-up after initial interview of samples. Do not send fine art, abstract subjects."

CREATIVE COMPANY, INC., Dept. AM, 3276 Commercial St., SE, Salem OR 97302. (503)363-4433. President/Owner: Jennifer Larsen Morrow. Specializes in corporate identity, packaging and P-O-P displays. Product specialties are local consumer-oriented clients specializing in food products, professionals and trade accounts on a regional and national level.
Needs: Works with 4-6 artists/year. Prefers local artists. Works on assignment only. Uses freelancers for design, editorial illustration, computer production (Mac), retouching, airbrushing, posters and lettering. "Looking for clean, fresh designs!" Freelancers should be familiar with Pagemaker, FreeHand, Illustrator.
First Contact & Terms: Send query letter with brochure, résumé, business card, photocopies and tearsheets to be kept on file. Samples returned by SASE only if requested. Art Director will contact for portfolio review if interested. "We require a portfolio review. Years of experience not important if portfolio is good. We prefer one-on-one review to discuss individual projects/time/approach." Pays for design by the hour, $20-50. Pays for illustration by the hour, $25-60. Considers complexity of project and skill and experience of artist when establishing payment.
Tips: Common mistakes freelancers make in presenting samples or portfolios are: "1) poor presentation, samples not mounted or organized; 2) not knowing how long it took them to do a job to provide a budget figure; 3) not demonstrating an understanding of the printing process and how their work will translate into a printed copy; 4) just dropping in without an appointment; 5) not following up periodically to update information or a résumé that might be on file."

Pennsylvania

‡BLATTNER/BRUNNER, 814 Penn Ave., Pittsburgh PA 15131. (412)263-2979. Fax: (412)263-2126. Associate Creative Director: David Vissat. Estab. 1976. Ad agency. Full-service, multimedia firm. Client list not available.
Needs: Approached by 4 freelance artists/month. Works with 2 freelance illustrators and designers/month. 80% of work is with print ads. Needs computer-literate freelancers for design, illustration, production and presentation. 50% of freelance work demands knowledge of Aldus PageMaker, QuarkXPress, Aldus FreeHand, Adobe Illustrator or Adobe Photoshop.
First Contact & Terms: Send query letter with brochure, résumé, photocopies, photographs and tearsheets. Samples are sometimes filed and are not returned. Reports back to the artist only if interested. Art Director will contact artist for portfolio review if interested. Pays for design by the project.

THE CONCEPTS CORP., Dept. AM, 120 Kedron Ave., Holmes PA 19043. (610)461-1600. Fax: (610)461-1650. Vice President: Frank Hyland, Sr. Estab. 1962. AV firm. Full-service, multimedia firm. Specializes in design, collateral, location and studio photography, computer graphics and special effects photography. Product specialties are computer, medical and industrial. Current clients include Unisys, GE, Westinghouse, Wyeth-Auherst, Franklin Mint, Hercules and DuPont.
Needs: Approached by 8-10 artists/month. Works with 4 illustrators and 4 designers/month. Prefers local artists with experience in collateral and AV design, type-spec, layout, comps and client contact. Uses freelancers mainly for fill-in for overflow and special design illustrator talent. Also for brochure, catalog and print ad design and illustration; storyboards; mechanicals; and TV/film graphics. 25% of work is with print ads.
First Contact & Terms: Send query letter with résumé, slides and referrals. Samples are filed or are returned. Reports back to the artist only if interested. Write for appointment to show portfolio of thumbnails, roughs,

tearsheets and slides. Pays for design by the hour, $10-60; or estimated by the project. Pays for illustration by the project. Buys first rights.

‡CRAWLEY HASKINS & RODGERS PUBLIC RELATIONS, The Bourse Suite 910, Independence Mall East, Philadelphia PA 19106. (215)922-7184. Fax: (215)922-7189. Associate Account Executive: Gayle Gaskin. PR firm. Full-service, multimedia firm. Specializes in "Crawley Haskins & Rodgers is a public relations firm with a marketing orientation." Current clients include American Bay Association, Philadelphia Gas Works, University of Pennsylvania.
Needs: Approached by 10 freelance artists/month. Works with 5 freelance illustrators and designers/month. Prefers local artists only. "African-American and other minorities should be included in any information forwarded." Uses freelance artists mainly for layout and design. Also uses freelance artists for brochure and print ad design, slide illustration, mechanicals and logos. 10% of work is with print ads. Needs computer-literate freelancers for design and production. 90% of work demands knowledge of Aldus PageMaker, Quark-XPress or Aldus FreeHand.
First Contact & Terms: Send query letter with résumé and samples of works. Samples are filed and are not returned. Reports back to the artist only if interested. Artist should follow up with call. Art Director will contact artist for portfolio review if interested. Portfolio should include final art and "a variety of work samples." Pays for design and illustration by the project. Rights purchased vary according to project.
Tips: Finds artists through word of mouth and artist's submissions.

‡GRA-MARK ADVERTISING, P.O. Box 18053, Pittsburgh PA 15236. (412)469-0301. Fax: (412)469-0305. Production Manager: Susan Steider. Estab. 1987. Ad agency. Full-service, multimedia firm. Specializes in brochures, magazine ads, fliers, catalogs. Product specialty is business-to-business. Current clients include Ads-on-Hold, Micropower Systems, USWA. Client list not available.
Needs: Approached by 5-6 freelance artists/month. Works with 2-3 freelance illustrators and 1-2 freelance designers/month. Prefers local artists only. Uses freelance artists mainly for print ad, brochure and logo design. Also uses freelance artists for catalog and print ad design, storyboards, billboards and lettering. 60% of work is with print ads. Needs computer-literate freelancers for design, production and presentation. 90% of work demands knowledge of Aldus PageMaker, QuarkXPress, Aldus FreeHand, Adobe Illustrator, Adobe Photoshop or Corel Draw.
First Contact & Terms: Send query letter with brochure and résumé. Samples are filed. Reports back to the artist only if interested. Artist should follow up with call. Portfolio should include thumbnails, roughs, final art and mechanicals. Pays for design and illustration by the hour or by the project. Buys reprint rights or all rights.
Tips: Finds artists through word of mouth, artist submissions and billboard advertising.

KINGSWOOD ADVERTISING, INC., Cricket Terrace Center, Ardmore PA 19003. Fax: (215)896-9242. Senior Vice President/Creative Director: John F. Tucker, Jr. Executive Art Director: Ed Dahl. Specializes in consumer, industrial, electronics, pharmaceuticals, publishing and scientific products and services.
Needs: Works with 5 illustrators and 5 designers/year. Prefers local artists. Works on assignment only. Uses freelancers mainly for commercial, technical and medical illustration and occasional comps from roughs. Also uses freelancers for technical art, retouching, P-O-P displays, stationery design and newspapers. Needs computer-literate freelancers for design, illustration, production and presentation. 60% of freelance work demands knowledge of Aldus PageMaker, QuarkXPress, Aldus FreeHand, Adobe Illustrator and Photoshop.
First Contact & Terms: Provide business card, brochure/flyer and samples to be kept on file. Prefers roughs through final as samples. Samples returned by SASE. Purchased originals not returned. Request portfolio review in original query. Pays for design by the project, $200-950. Pays for illustration by the project, $250-1,800.
Tips: Finds artists through word of mouth and agents. "Learn a little about our clients' products and their current ad and literature style, and possibly suggest an improvement here and there. Know where your work appeared and what market it addressed. It's getting harder to convince young freelancers that they must first be artists and then technologists. Technology tends to diminish creativity, but an *artist* can control it to everyone's benefit."

The solid, black square before a listing indicates that it is judged a good first market by the Artist's & Graphic Designer's Market editors. Either it offers low payment, pays in credits and copies, or has a very large need for freelance work.

THE NEIMAN GROUP, Harrisburg Transportation Center, 4th and Chesnut St., Harrisburgh PA 17101. (717)232-5554. Fax: (717)232-7998. Art Director: Paul Murray. Estab. 1978. Full-service ad agency specializing in print collateral and ad campaigns. Product specialties are healthcare, banks, retail and industry.
Needs: Works with 4 illustrators and 2 designers/month. Prefers local artists with experience in comps and roughs. Works on assignment only. Uses freelancers mainly for advertising illustration and comps. Also uses freelancers for brochure design, mechanicals, retouching, lettering and logos. 50% of work is with print ads. Needs computer-literate freelancers for design, illustration and production. 75% of freelance work demands knowledge of QuarkXPress, Aldus FreeHand, Adobe Illustrator and Photoshop.
First Contact & Terms: Send query letter with résumé, tearsheets, photostats and photographs. Samples are filed. Art Director will contact artist for portfolio review if interested. Portfolio should include color and b&w samples, thumbnails, roughs, original/final art, photographs. Pays for design and illustration by the project, $300 minimum. Buys all rights.
Tips: Finds artists through sourcebooks and workbooks. "Everybody looks great on paper. Try to get a potential client's attention with a novel concept. Never, ever, miss a deadline. Enjoy what you do. There will be a need for more multimedia and electronic design."

PRIME PRODUCTIONS, INC., (formerly New York Communications, Inc.), Dept. AM, 207 S. State Rd., Upper Darby PA 19082. Fax: (215)352-6225. Contact: Don Creamer. Estab. 1974. Motion picture/TV/marketing consulting firm. Product specialties are TV commercials and corporate videos. Current clients include ABC, WABC-TV, KABC-TV and ALCO Standard Corp.
Needs: Works with 6 illustrators and 3 designers/year. Uses freelancers for storyboards. 5% of work is with print ads. Needs computer-literate freelancers for design, illustration, production and presentation. 90% of freelance work demands knowledge of Aldus PageMaker, QuarkXPress, Aldus FreeHand and Adobe Illustrator.
First Contact & Terms: Send query letter with résumé, business card and sample storyboards that can be kept on file for future assignments. Works on assignment only. Samples not filed are returned by SASE. Originals not returned. Pays for design by the project, $100-1,200. Pays for illustration by the project, $200-2,400. Considers skill and experience of artist and turnaround time when establishing payment.
Tips: Finds artists through word of mouth and submissions. Looks for "the ability to capture people's faces, detail and perspective. Include storyboards in your portfolio or you won't be considered. Don't include page design examples or portraits. Send three samples, plus a query letter and résumé."

‡STEWART DIGITAL VIDEO, 525 Mildred Ave., Primos PA 19018. (610)626-6500. Fax: (610)626-2638. Creative Director: Bob McGrath. Estab. 1989. AV firm, video production facility. Full-service, multimedia firm. Specializes in broadcast programming, commercial, corporate. Client list not available.
Needs: Approached by 1 freelance artist/month. Works with less than 1 freelance illustrator/month. Prefers artists with experience in illustration, computer graphics, graphic design, production. Uses freelance artists mainly for storyboards and computer graphics. Also uses freelance artists for storyboards, animation, mechanicals, model making and TV/film graphics. 20% of work is with print ads. Needs computer-literate freelancers for illustration, production and presentation. 75% of freelance work demands knowledge of Aldus FreeHand or Adobe Photoshop.
First Contact & Terms: Send query letter with résumé, photocopies, photographs, SASE and tearsheets. Samples are filed or returned by SASE if requested by artist. Reports back to the artist only if interested. Art Director will contact artist for portfolio review if interested. Portfolio should include thumbnails, roughs, final art and tearsheets. Pays for design and illustration by the hour, $10-25; by the project, $50-1,000; by the day, $75-500. Buys all rights.
Tips: "We find artists through local schools and contacts in industry."

Tennessee

ARNOLD & ASSOCIATES PRODUCTIONS, 1204 16th Ave. S, Nashville TN 37212-2902. President: John Arnold. AV/video firm.
Needs: Works with 30 artists/year. Prefers local artists, award-winning and experienced. "We're an established, national firm." Works on assignment only. Uses freelancers for multimedia, slide show and staging production.
First Contact & Terms: Send query letter with brochure, tearsheets, slides and photographs to be kept on file. Call for appointment to show portfolio, which should include final reproduction/product and color photographs. Pays for design by the hour, $15-50 or by the project, $500-3,500. Pays for illustration by the project, $500-4,000. Considers complexity of the project, client's budget and skill and experience of artist when establishing payment.

CASCOM INTERNATIONAL, Dept. AM, 806 4th Ave. S., Nashville TN 37210. (615)242-8900. Fax: (615)256-7890. President: Vic Rumore. Estab. 1977. Diversified firm specializing in film graphics and cell animation,

live-action cinematography and stock archival footage for video productions. Also involved in production and distribution of home videos and CD-ROMs.

Needs: Works with 1-2 illustrators and 1-2 designers/month. Prefers artists with experience in film graphics. Works on assignment only. Uses freelancers mainly for print and graphic cell design and layout. Also for brochure, catalog and packaging design and illustration, storyboards, animation, mechanicals and TV/film graphics. 5% of work is with print ads. Freelances should be familiar with Photoshop, etc.

First Contact & Terms: Send query letter with brochure, résumé, photographs, slides and transparencies. Samples are filed or are returned by SASE only if requested by artist. Reports back within 1 month if interested. To show portfolio, mail "anything that shows ability." Pays by the project. Negotiates payment. Considers complexity of project, turnaround time and skill and experience of artist when establishing payment. Buys all rights.

Tips: "Although our business and product line have expanded, we rely 100% on freelancers for our graphics/art needs."

THOMPSON & COMPANY, 65 Union Ave., Memphis TN 38103. Creative Director: Trace Hallowell. Estab. 1981. Full-service ad agency. Current clients include Insituform Technologies, Crews Safety Glasses, Lustrasilla, Seabrook Wallcoverings, Rotary Lift.

Needs: Works with various number of illustrators and designers/month. Works on assignment only. Uses freelancers mainly for ads. Also uses freelancers for brochure design and illustration, slide illustration, storyboards, animatics, animation, mechanicals, retouching, billboards, posters, TV/film graphics, lettering and logos. 80% of work is with print ads.

First Contact & Terms: Send query letter with samples. Samples are filed or are returned by SASE only if requested by artist. Art Director will contact artist for portfolio review if interested. Portfolio should include fresh ideas. Rights purchased vary according to project.

Texas

ARIES PRODUCTIONS, #200, 1110 Avenue H East, Arlington TX 76011. (817)640-9955. Fax: (817)649-2529. President: Wynn Winberg. Estab. 1980. Film/video production company. Specializes in corporate and commercial.

Needs: Uses freelancers mainly for video graphics. Also for storyboards, animatics and TV/film graphics. Needs computer-literate freelancers for production.

‡COOLEY, SHILLINGLAW & DADD, INC., 5613 Star Lane, Houston TX 77057. (713)783-0530. Fax: (713)783-0568. Production Manager: Terri Chin. Estab. 1963. Ad agency. Full-service, multimedia firm. Specializes in magazine ads, data sheets, mailings and brochures. Product specialty is industrial.

Needs: Approached by 5 freelance artists/month. Works with 2 freelance illustrators and 1 freelance designer/month. Prefers artists with experience in industrial design. Works on assignment only. Uses freelance artists for "everything," including brochure, catalog and print ad design; technical and slide illustration; animation; mechanicals; retouching; TV/film graphics; and logos. 40% of work is with print ads.

First Contact & Terms: Send query letter with brochure, résumé and photocopies. Samples are filed. Art Director will contact artist for portfolio review if interested. Portfolio should include thumbnails, roughs, original, final art, b&w and color photographs. Sometimes requests work on spec before assigning job. Pays for design by the project, $500-750. Pays for illustration by the project, $1,200-1,400. Buys all rights.

Tips: Finds artists through referrals from other artists.

DYKEMAN ASSOCIATES INC., 4115 Rawlins, Dallas TX 75219. (214)528-2991. Fax: (214)528-0241. Contact: Alice Dykeman. PR/marketing firm. Specializes in business, industry, sports, environmental, energy, health.

Needs: Works with 5 illustrators/designers per month. Assigns 150 jobs/year. "We prefer artists who can both design and illustrate." Local artists only. Uses freelancers for editorial and technical illustration, design of brochures, exhibits, corporate identification, signs, posters, ads and all design and finished artwork for graphics and printed materials. Needs computer-literate freelancers for design, production and presentation.

First Contact & Terms: Request portfolio review in original query. Pays by the project, $250-3,000 average. "Artist makes an estimate; we approve or negotiate."

Tips: "Be enthusiastic. Present an organized portfolio with a variety of work. Portfolio should reflect all that an artist can do. Don't include examples when you did a small part of the creative work. Have a price structure but be willing to negotiate per project. We prefer to use artists/designers/illustrators who will work with barter (trade) dollars and join one of our associations. We see steady growth ahead."

EMERY & MARTINEZ ADVERTISING, (formerly Emery Advertising), Dept. AM, 1519 Montana, El Paso TX 79902. (915)532-3636. Art Director: Charles C. Fensch. Ad agency. Clients: automotive and architectural firms, banks and restaurants. Current clients include Ford Dealers Association and Speaking Rock Bingo.

Needs: Works with 5-6 artists/year. Uses artists mainly for design, illustration and production. Needs technical illustration and cartoons.

First Contact & Terms: Works on assignment only. Send query letter with résumé and samples to be kept on file. Art Director will contact artist for portfolio review if interested. Prefers tearsheets as samples. Samples not filed are returned by SASE. Reports back. Sometimes requests work on spec before assigning job. Pays for design by the hour, $15 minimum; by the project, $100 minimum; by the day, $300 minimum. Pays for illustration by the hour, $15 minimum; by the project, $100 minimum. Considers complexity of project, client's budget and turnaround time when establishing payment. Rights purchased vary according to project.
Tips: Especially looks for "consistency and dependability."

‡**FUTURETALK TELECOMMUNICATIONS COMPANY, INC.**, P.O. Box 270942, Dallas TX 75227-0942. Contact: Marketing Department Manager. Estab. 1993. Ad agency and PR firm. Full-service, multimedia firm and telecommunications company. Specializes in video phone sales with in-house ad agency (authorized AT&T Sales Agent). Product specialty is telephone equipment and accessories. Current clients include small to medium businesses and individuals. Client list not available.
Needs: Approached by 3-5 freelance artists/month. Works with 1-2 freelance illustrators/month. Prefers artists with experience in computer graphics. Works on assignment only. Uses freelance artists mainly for promotional projects. Also uses freelance artists for brochure and catalog illustration, storyboards, animation, model making, billboards and TV/film graphics. 20% of work is with print ads. Needs computer-literate freelancers for design, illustration and production. 60% of freelance work demands computer skills.
First Contact & Terms: Send query letter with résumé, photocopies, photographs and SASE. Samples are filed or are returned by SASE if requested by artist. Reports back within 3 weeks. Art Director will contact artist for portfolio review if interested. Portfolio should include b&w and color final art, tearsheets and photostats. Pays for design by the hour, $10-25; by the project, $250-2,500; by the day, $250-2,500. Pays for illustration by the hour, $20-40; by the project, $250-2,500; by the day, $250-2,500. Rights purchased vary according to project.
Tips: Finds artists through sourcebooks, word of mouth and artists' submissions.

‡**HEPWORTH ADVERTISING COMPANY**, 3403 McKinney Ave., Dallas TX 75204. (214)526-7785. Manager: S.W. Hepworth. Full-service ad agency. Clients: finance, consumer and industrial firms.
Needs: Works with 3-4 freelance artists/year. Uses artists for brochure and newspaper ad design, direct mail packages, magazine ad illustration, mechanicals, billboards and logos.
First Contact & Terms: Send a query letter with tearsheets. Samples are not filed and are returned by SASE only if requested by artist. Does not report back. Portfolio should include roughs. Pays for design and illustration by the project. Considers client's budget when establishing payment. Buys all rights.
Tips: Looks for variety in samples or portfolio.

KNOX PUBLIC RELATIONS, 608 Peach Orchard Rd., Longview TX 75603. (903)643-2647. President: Donna Mayo Knox. Estab. 1974. PR firm. Specializes in civic, social organizations, private schools and businesses.
Needs: Works with 1-3 illustrators/year. Works on assignment only. Uses freelancers mainly for work on brochures. Also uses freelancers for billboards, stationery design, multimedia kits, direct mail and fliers. 35% of work is with print ads.
First Contact & Terms: Send query letter with brochure showing art style or résumé and samples. Call or write for appointment to show portfolio. Originals returned to artist at job's completion. Pays for illustration by the hour.
Tips: "Business is slowly improving in our area. Please query first. We like variety."

McCANN-ERICKSON WORLDWIDE, Suite 1900, 1360 Post Oak Blvd., Houston TX 77056. (713)965-0303. Creative Director: Jesse Caesar. Ad agency. Clients: all types including consumer, industrial, gasoline, transportation/air, entertainment, computers and high-tech.
Needs: Works with about 20 illustrators/month. Uses freelancers in all media.
First Contact & Terms: Art Director will contact artist for portfolio review if interested. Selection based on portfolio review. Pays for design by the hour, $40 minimum. Pays for illustration by the project, $100 minimum. Negotiates payment based on client's budget and where work will appear.
Tips: Finds artists through word of mouth. Wants to see full range of work including past work used by other ad agencies and tearsheets of published art in portfolio.

‡**McNEE PHOTO COMMUNICATIONS INC.**, 3301 W. Alabama, Houston TX 77098. (713)942-8400. President: Jim McNee. AV/film producer. Serves clients in industry and advertising. Produces slide presentations, videotapes, brochures and films. Also a brokerage for stock photographs.
Needs: Assigns 20 freelance jobs/year. Works with 4 freelance illustrators/month. Prefers local artists with previous work experience. Uses freelance artists for brochures, annual reports and artwork for slides, film and tape.
First Contact & Terms: "Will review samples by appointment only." Provide résumé, brochure/flyer and business card to be kept on file for possible future assignments. Works on assignment only. Reports within 1 month. Method of payment is negotiated with the individual artist. Pays by the hour, $30-60 average.

Considers client's budget when establishing payment. No originals returned after publication. Buys all rights, but will negotiate.

THE SENSES BUREAU, INC., P.O. Box 101107, San Antonio TX 78201-9107. (800)846-5201. President: Fred Weiss. Estab. 1991. Full-service, multimedia firm including an audio and music recording studio and recorded music distribution. Specializes in promotional packages for recording artists (album covers, ads, etc.) and distribution. Specializes in rock music, Latin music and urban/dance music.
Needs: Approached by 4 freelance artists/month. Prefers artists with experience in recorded music industry. Works on assignment only. Uses freelancers mainly for album art. Also uses freelancers for brochure, catalog and print ad design and illustration and storyboards, animation, posters, TV/film graphics, lettering and logos. 60% of work is with print ads.
First Contact & Terms: Send query letter with photocopies, résumé and tearsheets. Samples are filed. Reports back within 2 weeks. Request portfolio review in original query. Pays for design by the hour, $25-50. Pays for illustration by the piece. Rights purchased vary according to project.
Tips: "As a result of economic conditions, we have used fewer illustrators and done more desk-top publishing."

EVANS WYATT ADVERTISING, P.O. Box 18958, Corpus Christi TX 78480-8958. (512)854-1661. Creative Director: E. Wyatt. Estab. 1975. Ad agency. Full-service, multimedia firm. Specializes in general and industrial advertising.
Needs: Approached by 2-4 freelance artists/month. Works with 2-3 illustrators and 5-6 designers/month. Works on assignment only. Uses freelancers for ad design and illustration, brochure and catalog design and illustration, storyboards, retouching, billboards, posters, TV/film graphics, lettering, logos and industrial/technical art. 80% of work is with print ads.
First Contact & Terms: Send a query letter with brochure, photocopies, SASE, résumé and photographs. Samples are filed or are returned by SASE if requested by artist. Reports back within 1 month. Call for appointment to show portfolio or mail thumbnails, roughs and b&w and color photostats, tearsheets and photographs. Pays by the hour, by the project, or by arrangement. Buys all rights.

Utah

BROWNING ADVERTISING, 1 Browning Place, Morgan UT 84050. (801)876-2711, ext. 336. Fax: (801)876-3331. Senior Art Director: Brent Evans. Estab. 1878. Distributor and marketer of outdoor sports products, particularly firearms. Inhouse agency for 3 main clients. Inhouse divisions include non-gun hunting products, firearms and accessories.
Needs: Approached by 50 freelance artists/year. Works with 20 freelance illustrators and 20 freelance designers/year. Assigns 150 jobs/year. Prefers artists with experience in outdoor sports—hunting, shooting, fishing. Works on assignment only. Uses freelancers mainly for design, illustration and production. Also for advertising and brochure layout, catalogs, product rendering and design, signage, P-O-P displays, and posters.
First Contact & Terms: Send query letter with résumé and tearsheets, slides, photographs and transparencies. Samples are not filed and are not returned. Reports back to the artist only if interested. To show portfolio, mail photostats, slides, tearsheets, transparencies and photographs. Pays for design by the hour, $50-75. Pays for illustration by the project. Buys all rights or reprint rights.

ALAN FRANK & ASSOCIATES INC., Dept. AM, 1524 S. 1100 E., Salt Lake City UT 84105. (801)486-7455. Art Director: Kazuo Shiotani. Serves clients in travel, fast food chains and retailing. Mail art with SASE. Reports within 2 weeks.
Needs: Uses freelancers for illustrations, animation and retouching for annual reports, billboards, ads, letterheads, TV and packaging. Minimum payment: $500, animation; $100, illustrations; $200, brochure layout.

Virginia

CARLTON COMMUNICATIONS, INC., 300 W. Franklin St., Richmond VA 23220. (804)780-1701. Fax: (804)225-8036. Account Services Coordinator: Steven White. Estab. 1975. Full-service ad and PR agencies specializing in economic development, hotels, health care, travel, real estate and insurance.
Needs: Works with 2 illustrators and 1 designer/month. Uses freelancers mainly for ads, brochures, direct mail, posters, photography and illustration. Also for catalog design and illustration, storyboards, slide illustration, animatics, animation, mechanicals, retouching, billboards, posters, TV/film graphics, lettering and logos. 50% of work is with print ads. Needs computer-literate freelancers for illustration. 95% of freelance work demands knowledge of QuarkXPress, Adobe Illustrator and Photoshop.
First Contact & Terms: Send query letter with brochure, résumé, tearsheets and photocopies. Samples are filed and are not returned. Reports back to the artist only if interested. Call or write for appointment to

show portfolio of original/final art. Pays for design by the project, $100 minimum. Pays for illustration by the project, $50 minimum. Considers complexity of project and client's budget when establishing payment.
Tips: "The most common mistakes freelancers make in presenting a portfolio is that there is too much work, causing the book to have an unfocused look. Have perseverance and enthusiasm to excel, no matter how small the project."

■**KRISCH HOTELS, INC. KHI Advertising, Inc.,** Box 14100, Roanoke VA 24022. (703)342-4531. Fax: (703)343-2864. Director of Communications: Julie Becker. Estab. 1985. Service-related firm providing all advertising, in-room and P-O-P pieces for service, wholesale and retail businesses for tourists, meetings, conventions and food service (inhouse department). Specializes in hotels/motels, restaurants/lounges, apartment complexes, wholesale businesses and printing firms.
Needs: Approached by 20-30 freelance artists/year. Works with 5-10 illustrators and 2-4 designers/year. Prefers local artists. Works on assignment only. Uses freelancers for advertising and brochure illustration, inroom pieces, direct mail, product illustration, P-O-P display, posters and signage. Prefers pen & ink, airbrush, charcoal/pencil and computer illustration. Needs computer-literate freelancers with knowledge of Aldus PageMaker, QuarkXPress and Aldus FreeHand for design and illustration.
First Contact & Terms: Send query letter with résumé and photocopies. Samples not filed are not returned. Reports only if interested. Call or write for appointment to show portfolio of roughs, original/final art, tearsheets and photostats. Pays for design and illustration by the hour, $10 minimum; by the project, $25 minimum; by the day, $100 minimum.
Tips: "Increased competition in all markets leads to more sophisticated work attitudes on the part of our industry. We predict that the next several years will be extremely competitive, but those who build with the technology on a strong design and art foundation will fare much better. There will be a great many entering the field with either limited computer skills or design background. Artists should know their own abilities and limitations and be able to interact with us to achieve best results. Send a letter of introduction with nonreturnable samples (photocopies are okay). *Please*, no original art."

To convey the spirit of teamwork on a brochure for UNISYS, Saffitz Alpert & Associates enlisted the talents of Forrest Greene. Given a basic visual concept and color considerations, the artist had a few weeks to complete the work in oil, which UNISYS considered successful in relaying information about the company's new division to its audience.

© 1989 UNISYS

‡**SAFFITZ ALPERT & ASSOCIATES,** 8357-B Greensboro Dr., McLean VA 22102. (703)556-9100. Fax: (703)356-4097. Art Director: Robert Grubbs. Estab. 1987. Ad agency and PR firm. Full-service, multimedia firm. Specializes in collateral, magazine ads. Product specialty is high-tech, software marketing. Current clients include Xerox, T. Rowe Price, BNA software, BRS software. Client list available upon request.

Needs: Approached by 10 freelance artists/month. Works with 0-1 freelance illustrators and 1-2 designers/month. Prefers artists with experience in Quark, Illustrator. Works on assignment only. Uses freelance artists mainly for art direction, design. Also uses freelance artists for brochure and print ad design and illustration, retouching, lettering and logos. 80% of freelance work demands knowledge of Adobe Illustrator, QuarkXPress or Adobe Photoshop.

First Contact & Terms: Send query letter with brochure, résumé, transparencies, photocopies, photographs and tearsheets. Samples are filed or are returned by SASE if requested by artist. Reports back to the artist only if interested. Art Director will contact artist for portfolio review if interested. Portfolio should include final art and tearsheets. Pays for design by the hour, $25-60. Pays for illustration by the project, $450-5,000. Rights purchased vary according to project.

Washington

‡AUGUSTUS BARNETT ADVERTISING/DESIGN, 632 St. Helens Ave., Tacoma WA 98402. (206)627-8508. Fax: (206)593-2116. President/Creative Director: Charlie Barnett. Estab. 1981. Ad agency. Specializes in package design, corporate identity, print media. Product specialties are food, consumer, retail, fashion. Current clients include Tree Top, Nalley, Martinac Shipbuilding, Pure-Gar. Client list available upon request.

Needs: Approached by 10 freelance artists/month. Works with 3 freelance illustrators and 2 freelance designers/month. Works on assignment only. Prefers local artists with experience in food related illustration. Uses freelance artists mainly for illustration and production. Also uses freelance artists for brochure, catalog and print ad illustration and storyboards, mechanicals and lettering. 60% of work is with print ads. Needs computer-literate freelancers for design, illustration, production and presentation. 85% of work demands knowledge of QuarkXPress or Aldus FreeHand.

First Contact & Terms: Send query letter with résumé, photocopies and samples. Samples are filed. Reports back within 2 weeks. Portfolios may be dropped off any day except Saturday. Portfolio should include b&w and color thumbnails, roughs and printed samples. Pays for production by the hour, $12-25; "sometimes more on special projects." Pays for illustration by the hour, $20-40. Negotiates rights purchased.

Tips: Finds artists through word of mouth.

KOBASIC FINE HADLEY, Suite 710, 1110 3rd Ave., Seattle WA 98101. (206)623-7725. Fax: (206)623-7723. Creative Director: Cam Green. Art Director: Bruce Stigler. Estab. 1979. Ad agency. Creative shop. Specializes in radio, TV and print (newspaper, outdoor, magazine). Product specialties are health care, banking, business-to-business.

Needs: Approached by 3-5 artists/month. Works with 2-3 illustrators and 1-2 designers/month. Prefers local artists only with agency experience. Uses freelancers for logo design and collateral. Also for brochure and catalog design, illustration and production. Needs editorial and technical illustration. Needs computer-literate freelancers for design, illustration and production. 70% of freelance work demands knowledge of Aldus PageMaker, Quark XPress or Aldus FreeHand. 70% of work is with print ads.

First Contact & Terms: Send query letter with photocopies and résumé. Samples are filed. Reports back to the artist only if interested. Write for appointment to show portfolio of b&w and color roughs and final art. Pays for design and illustration by the project, $50 minimum. Negotiates rights purchased.

West Virginia

GUTMAN ADVERTISING AGENCY, 500 Klos Tower, Wheeling WV 26003-2844. (304)233-4700. President: J. Milton Gutman. Ad agency. Specializes in finance, resort, media, industrial supplies (tools, pipes) and furniture.

Needs: Works with 3-4 illustrators/month. Uses local artists only, except for infrequent and special needs. Uses freelancers for billboards, stationery design, TV, brochures/fliers, trade magazines and newspapers. Also for retouching.

First Contact & Terms: Send materials to be kept on file for possible future assignments. Call for appointment to show portfolio. Originals not returned. Negotiates payment.

Wisconsin

‡GREINKE, EIERS & ASSOCIATES, 2557-C, N. Terrace Ave., Milwaukee WI 53211-3822. (414)962-9810. Fax: (414)352-3233. President: Patrick Eiers. Estab. 1984. Ad agency, PR firm. Full-service multimedia firm. Specializes in special events (large display and photo work), print ads, TV ads, radio, all types of printed material (T-shirts, newsletters, etc.). Current clients include Great Circus Parade, Eastside Compact Disc and Landmark Theatre Chain.

Needs: Approached by 10-12 freelance artists/month. Works with 1 freelance illustrator and 1-2 freelance designers/month. Uses freelance artists for "everything and anything." Also for brochure and print ad illustra-

tion and design, storyboards, slide illustration, retouching, model making, billboards, posters, TV/film graphics, lettering and logos. 40% of work is with print ads. Needs computer-literate freelancers for design, illustration and presentation. 75% of freelance work demands knowledge of Aldus PageMaker, Adobe Illustrator, QuarkXPress, Adobe Photoshop, Aldus Freehand or Powerpoint.

First Contact & Terms: Send samples. Samples are filed and are not returned. Reports back only if interested. Art Director will contact artists for portfolio review if interested. Portfolio should include b&w and color thumbnails, roughs, final art, tearsheets, photographs, transparencies, etc. Pays by personal contract. Rights purchased vary according to project.

Tips: Finds artists through submissions and word of mouth. "We look for stunning, eye-catching work—surprise us!"

Wyoming

‡BRIDGER PRODUCTIONS, INC., P.O. Box 8131, Jackson WY 83001. Phone/Fax: (307)733-7871. Director/Cameraman: Michael J. Emmer. Estab. 1990. AV firm. Full-service, multimedia firm. Specializes in national TV sports programming, national commercials, marketing videos, documentaries. Product specialties are skiing, mountain biking, mountain scenery. Current clients include Life Link International, Crombies, JH Ski Corp., State of Wyoming. Client list available upon request.

Needs: Approached by 2 freelance artists/month. Works with 0-1 freelance illustrator and designer/month. Works on assignment only. Uses freelance artists for everything. Also uses freelance artists for storyborads, animation, model making, billboards, TV/film graphics, lettering and logos. Needs computer-literate freelancers for design, illustration and production. 80% of freelance work demands knowledge of Amiga/Lightwave and other 3-D and paint programs.

First Contact & Terms: Send query letter with film and video work—animations, etc. Samples are filed and are not returned. Reports back to the artist only if interested. Art Director will contact artist for portfolio review if interested. Portfolio should include 16mm, 35mm, motion picture and video work. Pays for design by the project, $150-20,000. Pays for illustration by the project, $150-1,500. Rights purchased vary according to project.

Tips: Finds artists through word of mouth and submissions.

Canada

❦THE CABER FILM & VIDEO CO. LTD., Unit 39, 160 Wilkinson Rd., Brampton, Ontario L6T 4Z4 Canada. (905)454-5141. Fax: (905)454-5936. Producer: Chuck Scott. Estab. 1988. AV firm. Full-service, multimedia firm. Specializes in TV, commercials and corporate videos.

Needs: Approached by 5 artists/month. Works with 2 illustrators and 2 designers/month. Prefers artists with experience in animation, film and video design (graphics). Works on assignment only. Uses freelancers for storyboards, slide illustration, animation, and TV/film graphics. 5% of work is with print ads.

First Contact & Terms: Send query letter with brochure, résumé, photocopies and video reel. Samples are filed or are returned by SASE. Reports back within 1 week. Call for appointment to show portfolio. Pays for design and illustration by the project. Rights purchased vary according to project.

❦NORTHWEST IMAGING & F.X., Suite 100, 2339 Columbia St., Vancouver, British Columbia V5Y 3Y3 Canada. (604)873-9330. Fax: (604)873-9339. General Manager: Alex Tkach. Estab. 1956. AV firm. Specializes in graphics for TV and motion pictures, including storyboards and animation. Product specialties are TV commercials and VHS covers. Current clients include: NBC, CBC, CBS and CTV.

Needs: Approached by 5 artists/month. Works with 2 illustrators and 2 designers/month. Prefers artists with experience in computer design. Works on assignment only. Uses freelancers mainly for backup and computer design. Also uses freelancers for brochure design and illustration, print ad design, storyboards, animatics, animation, TV/film graphics, lettering and logos. 10% of work is with print ads.

First Contact & Terms: Send query letter with résumé. Samples are filed. Reports back within 3 days. Art Director will contact artist for portfolio review if interested. Pays for design by the hour, $10-45; by the project, $100-2,500; also short term contract work by the week and by the day, $100-750. Pays for illustration by the project, $250 minimum. Buys all rights.

Tips: "I look for young, affordable artists we can train on our systems. Attitude pays an important role in their development."

 The maple leaf before a listing indicates that the market is Canadian.

✱WARNE MARKETING & COMMUNICATIONS, Suite 810, 111 Avenue Rd., Toronto, Ontario M5R 3J8 Canada. (416)927-0881. Graphics Studio Manager: John Coljee. Specializes in business-to-business promotion. Current clients: The Raymond Corporation (and dealers), Wellesley Hospital and Johnston Equipment. **Needs:** Works with 8 artists/year. Works on assignment only. Uses freelancers for design, technical and medical illustrations, brochures, catalogs, P-O-P displays, retouching, billboards, posters, direct mail packages, logos. Artists should have "creative concept thinking." Prefers charcoal/pencil, colored pencil and markers. Needs computer-literate freelancers for design. 10% of freelance work demands knowledge of Adobe Illustrator. **First Contact & Terms:** Send query letter with résumé and photocopies. Samples are not returned. Reports only if interested. Pays for design by the hour, $100-150 or by the project, $500-1,000. Pays for illustration by the hour, $100-150. Considers complexity of project, client's budget and skill and experience of artist when establishing payment. Buys all rights.

Advertising, Audiovisual and Public Relations Firms/'94-'95 changes

The following markets were listed in the 1994 edition but do not have listings in this edition. The majority did not respond to our request to update their listings. If a reason was given for exclusion, it appears in parentheses after the market's name.

Sol Abrams Public Relations and Marketing Consultants (per request)
Arnold Advertising Corp.
Baron Video Productions
The Berni Company
Biggs Gilmore Communications
Blixt Associates
Bradford Advertising & Public Relations, Inc.
Caldwell Van Riper, Inc.
Comunications West
Creative Media Development
Deady Advertising
Dolphin Multi-Media Productions, Inc.
The Editing Company
Esrock Advertising Inc.
Richard Falk Assoc.
Fingerote and Fingerote
The Food Group Advertising & Marketing Services
Foremost Communications
Gannon and Company
Goldman & Associates
Good Advertising
Goodman & Associates
Greyfalcon House
Robert Haber Associates
Harper, Bellotti & Company, Inc.
Hayes Orlie Cundall Inc.
Hege, Middleton & Neal, Inc.
Heliotrope Studios Ltd.

The Hitchens Company
Bernard Hodes Advertising
Deke Houlgate Enterprises
Human Relations Media
I/D/E/A Inc.
Image Associates Inc.
William Jenkins Advertising
Kraemer Group
Kruse Corporate Image, Inc.
Kupper Parker Communications, Inc.
Lazar Strickler & Assoc., Advertising, Inc.
Liggett-Stashower
Lister Butler Inc.
Lloyd S. Howard Accos., Inc.
Lohre & Associates
Curt Lowey & Associates
Marina Maher Communications
Marketaide, Inc.
Marketing Mix
Marshfilm Enterprises, Inc.
Martin/Arnold Color Systems
Martin/Siboney, Inc.
Marx Myles Graphics
Media Designs
Media Services Corp.
Messer & Susslin & Others, Inc.
Mills Marketing
Mitchell & Resnikoff
Motivation Media, Inc.
Newmark, Posner & Mitchell, Inc.

Premier Film Video & Recording
Prideaux Sullivan Pattison
Purdom Public Relations
Q1 Productions, inc.
Quin Associates, Inc.
The Riech Group
Reichenstein Advertising Agency
Roberts & Dana Advertising/ Marketing
Shapson Gero & Sommers, Inc.
Shecter & Levine Advertising/ PR
Sherry Wheatley Sacino
Sanchez & Levitan, Inc.
Sawyer Riley Compton
Selz, Seabolt and Associates, Inc.
Richard Siedlecki Marketing
Soter Associates, Inc.
Stranger & Associates
Sweetwater Sound & Video
TAA Inc.
Talco
Taylor Smith
Thompson Advertising Productions, Inc.
Tobol Group, Inc.
Vamcom Advertising
Visage Production Trust Co. (unalbe to contact)
Morton Dennis Wax & Associates, Inc.
ZM Squared

Art/Design Studios

Aspiring designers and illustrators often browse through the sumptuous pages of *HOW, Communication Arts* and *Print* magazines to catch a glimpse inside the country's top art and design studios. Whether sparsely decorated or filled with funky objets d'art, each studio reflects the creativity of its staff. Amidst potted palms or exposed brick walls, in renovated lofts or high tech office spaces, casually dressed designers work at pristine white drafting tables or state-of-the-art computers. Of course not all studios look alike, but all have a certain creative ambiance—and similar goals. And at crunch time most hire talented freelancers, like you, to help them meet deadlines.

What is the difference between an art studio and a design studio? While not a hard and fast rule, art studios specialize in illustration. Design studios offer a range of services including conceptualization and design, illustration and layouts. Increasingly, design studios offer advertising services as well (see the Advertising, Public Relations and Audiovisual introduction).

So where do you fit into the picture? Corporations, small businesses and advertising agencies hire design studios to develop print ads, annual reports, signage, package design, corporate identity, brochures and other projects. An advertising agency might call on an art studio to provide illustrations for a cents-off coupon. A new business might ask a design studio to create a logo, stationery and brochure. Say one of these firms gets backed up with a string of jobs all due at once. If they knew of a talented individual like you who was experienced at layouts and mechanicals, they could ask you to come in and work on the extra Mac, or take some work home. If you are an illustrator, they might ask you to provide the image for a poster or shopping bag.

Design and art studios vary greatly in size. A studio could be one person who turns to freelance help when the workload becomes too heavy; or it could be a larger operation with a staff of account executives looking for a fresh approach or for basic mechanical skills. Like advertising agencies, design firms must react quickly to clients' needs and can't accurately predict their workload. They prefer to maintain a lean staff and call on freelancers on an "as needed" basis.

Targeting your approach

Before sending samples to a prospective studio, find out as much as possible about what they specialize in and who their clients are. If at all possible, try to see some samples of work they have done. Check awards annuals, such as those published by *Print* and *Communication Arts* to see if their work is included. Then customize your sample package so that it fits with their vision. (For more information see Successful Self-Promotion on page 15). Most art directors care less about the type of work you've done (for example, book cover illustration or brochure design) than they do about your individual style, so try to find out ahead of time what styles the studio tends to use most.

Some considerations

Keep in mind that the rules are not the same for designers and illustrators in this business. Most studios that work with freelance designers want local designers who will be available to make presentations to the client, work on inhouse equipment and make last minute changes if the client requires them.

Illustrators, on the other hand, are rarely required to be local, and consequently have much more freedom to pursue assignments outside of their regions. An illustration assignment is usually a one-shot deal, not an ongoing project, so most studios are comfortable communicating instructions for such projects long distance.

Computer competency is also an issue. Designers these days are expected to be Mac-literate and comfortable with the production process. The most popular program by far is QuarkXPress, but knowledge of other programs such as FreeHand, Illustrator and Photoshop will increase your chances of landing an assignment.

For illustrators, computer knowledge can sometimes help, but isn't always necessary. Some studios shun computer-generated work, claiming that "all computer illustration looks the same," while others prefer to use electronic illustration simply to avoid manual paste-up. Investigate a studio's preferences ahead of time to avoid making inappropriate submissions.

Pricing

Like ad agencies, studios generally bill clients by the hour or by the project, and pay their freelancers accordingly. Fees are normally contingent on the client's budget, but there is usually a little room for negotiation. When you are first discussing a project, be sure to ask whether or not you will retain the copyright and receive credit for the work. You can charge more if the client plans to buy all rights.

ADVERTISING DESIGNERS, INC., 7087 Snyder Ridge Rd., Mariposa CA 95338-9642. (209)742-6704. Fax: (209)742-6314. President: Tom Ohmer. Estab. 1947. Specializes in annual reports, corporate identity, ad campaigns, package and publication design and signage. Clients: corporations.
Needs: Approached by 100 artists/year. Works with 2-6 illustrators and 10 designers/year. Works on assignment only. Uses freelancers mainly for editorial and annual reports. Uses designers for annual reports. Also uses artists for brochure design and illustration, mechanicals, retouching, airbrushing, lettering, logos and ad design. Needs computer-literate freelancers for design and illustration. 75% of freelance work demands knowledge of Aldus PageMaker, Quark XPress, Aldus FreeHand or Adobe Illustrator.
First Contact & Terms: Send query letter with résumé and photocopies. Samples are filed. Does not report back, in which case the artist should call. Write for appointment to show portfolio. Pays for design by the hour $35 minimum; by the project, $500-7,500. Pays for illustration by the project, $500-5,000. Rights purchased vary according to project.

■**AHPA ENTERPRISES**, Box 506, Sheffield AL 35660. Marketing Manager: Allen Turner. Estab. 1976. Media products producer/marketer. Provides illustration, fiction, layout, video production, computer-printed material, etc. Specializes in adult male, special-interest material. Clients: limited-press publishers, authors, private investors, etc.
Needs: Approached by 20 freelance artists/year. Works with 5 artists/year. Assigns 40-50 jobs to artists/year. Seeking illustration of realistic original fiction or concepts. Wants only those artists "who can work with us on a long-term intermittent basis." Prefers a tight, realistic style; pen & ink, airbrush, colored pencil and watercolor. Works on assignment only.
First Contact & Terms: Send query letter with résumé and photocopies or tearsheets, photostats, photographs and new sketches to be kept on file. Samples not filed are returned by SASE only if requested. Art Director will contact artist for portfolio review if interested. Pays for illustration by the project, $30-300. Considers complexity of the project and number and type of illustrations ordered when establishing payment. Buys all rights.
Tips: Finds artists through submissions/self-promotion. "This is an excellent place for capable amateurs to 'turn pro' on a part-time, open-end basis. We really respond to artists whose cover letters indicate a willingness to adapt to our particular market needs. We are not inclined to respond to an artist who seems to be 'over-selling' himself."

ALBEE SIGN CO., 561 E. 3rd St., Mt. Vernon NY 10553. (914)668-0201. President: William Lieberman. Produces interior and exterior signs and graphics. Clients are banks and real estate companies.
Needs: Works with 6 freelance artists per year for sign design, 6 for display fixture design, 6 for P-O-P design and 6 for custom sign illustration. Prefers local artists only. Works on assignment only.
First Contact & Terms: Send query letter with samples, SASE, résumé and business card to be kept on file. Pays by job. Previous experience with other firms preferred. Reports within 2-3 weeks. Samples are not returned. Reports back as assignment occurs.

ALPERT AND ALPERT, INC., 8357-B Greensboro Dr., McLean VA 22102. (703)556-8901. Fax: (703)356-4097. Managing Art Director: Robert Grubbs. Estab. 1981. Specializes in annual reports, corporate identity, direct mail and package and publication design. Clients: corporations, associations. Current clients include T. Rowe Price, Xerox, The AES Corporation, BRS Software, BNA Software. Client list available upon request.
Needs: Approached by 15-20 freelance artists/year. Works with 1-2 illustrators and designers/year. Prefers local designers ("illustrators are hired from all around US"). Works on assignment only. Uses illustrators mainly for corporate communication/collateral. Uses designers and illustrators for brochure and ad design and illustration, magazine and direct mail design, retouching, airbrushing, lettering, logos and chart/graphs. Needs computer-literate freelancers for design. 100% of design work demands knowledge of QuarkXPress, Adobe Illustrator or Photoshop.
First Contact & Terms: Send query letter with résumé, tearsheets, photocopies and slides. Samples are filed. Will contact artist for portfolio review if interested. Portfolio should include color slides, tearsheets, photographs and final art. Pays for design by the hour, $25-45. Pays for illustration by the project, $450-5,000. Rights purchased vary according to project.
Tips: Finds artists through word of mouth, mailings and sourcebooks. "The best way for a freelancer to get an assignment is to show a portfolio, do great work and charge a fair price. Designers must have computer skills!"

‡♣ALTERNATIVE DESIGN & ASSOCIATES, 31 Wroxeter Ave., Toronto, Ontario M4K 1J5 Canada. Phone/Fax: (416)462-9536. Art Director: Peter Wong. Estab. 1990. Specializes in annual reports, brand and corporate identity, display and publication design and signage. Clients: corporations, nonprofit organizations and ad agencies. Client list not available.
Needs: Approached by 15-20 freelance graphic artists/year. Works with 4-6 freelance illustrators and 2-3 freelance designers/year. Prefers local artists with experience in Macintosh. Works on assignment only. Uses illustrators mainly for final art, concept. Uses designers mainly for designing of specific items relating to a job. Also uses freelance artists for brochure, catalog, P-O-P, poster and ad illustration and mechanicals, retouching, airbrushing, lettering and charts/graphs. Needs computer-literate freelancers for design, illustration and production. 99% of freelance work demands knowledge of QuarkXPress, Adobe Illustrator or Adobe Photoshop.
First Contact & Terms: Send query letter with tearsheets and résumé. Samples are filed. Reports back to the artist if interested or when appropriate work arises. Request portfolio review in original query. Art Director will contact artist for portfolio review if interested. Portfolio should include b&w and color final art, tearsheets, photographs and 4×5 or 8×10 transparencies. Pays for design by the hour and by the project. Pays for illustration by the project. "Pay depends on experience, length of time and scope of the job." Buys first rights, one-time rights or rights purchased vary according to project.
Tips: Finds artists through sourcebooks, referrals, art/design magazines, artist's mailings. "Knowledge of the computer and software programs is essential, as is willingness to be flexible with time and price in these economic times where pricing for jobs have been eroded and challenged."

&CO., 505 Henry St., Brooklyn NY 11231. (718)834-1843. Fax: (718)834-1843. Contact: Creative Director. Estab. 1983. Specializes in annual reports, direct mail design and brochures. Clients: Fortune 500 corporations. Current clients include NYNEX, AmEx, The Prudential.
Needs: Approached by 5-10 freelance artists/year. Works with 2-5 illustrators and 2-5 designers/year. Works only with artist reps. Prefers local artists only. Uses illustrators for various projects. Uses designers for brochure design and illustration, mechanicals and lettering. Needs computer-literate freelancers for design and illustration. 90% of freelance work demands knowledge of Adobe Illustrator, QuarkXPress, Photoshop and Aldus FreeHand.
First Contact & Terms: Samples are filed. Reports back to the artist only if interested. To show a portfolio, mail appropriate materials. Pays for design by the hour, $20-30. Pays for illustration by the project, $100 minimum. Buys first rights.
Tips: "We are completely Mac-literate."

ANDERSON STUDIO, INC., 2609 Grissom Dr., Nashville TN 37204. (615)255-4807. Fax: (615)255-4812. Contact: Andy Anderson. Estab. 1976. Specializes in T-shirts (designing and printing of art on T-shirts for retail/wholesale market). Clients: business and retail.
Needs: Approached by 4-5 freelance artists/year. Works with 2 illustrators and 2 designers/year. "We use artists with realistic (photorealist) style or approach to various subjects, animals and humor. Also contemporary design and loose film styles accepted." Works on assignment only. Needs illustrators for retail niche markets, resorts, theme ideas, animals, zoos, educational, science and humor-related themes.
First Contact & Terms: Send query letter with color copies. Samples are filed and are returned by SASE if requested by artist. Portfolio should include slides, color tearsheets, transparencies and color copies. Sometimes requests work on spec before assigning a job. Pays for design and illustration by the project, $300-1,000 or in royalties per piece of printed art. Negotiates rights purchased. Considers buying second rights (reprint rights) to previously published work.

Tips: "We're looking for fresh ideas and solutions for art featuring animals, zoos, science, humor and for educational art."

THE ART WORKS, 4409 Maple Ave., Dallas TX 75219. (214)521-2121. Fax: (214)521-2125. Creative Director: Fred Henley. Estab. 1978. Specializes in illustration, brand and corporate identity, packaging, publications and signage. Current clients include Southland, Bennetts Printing Co., Boy Scouts, Interstate Batteries Frito-Lay, E.D.S and many ad agencies. Client list available upon request.
Needs: Approached by 80 artists/year. Works with 30-50 illustrators and 30-50 designers/year. Uses freelancers for editorial and medical illustration; advertising, brochure and catalog design and layout; book, P-O-P displays; mechanicals; retouching; posters; direct mail packages; lettering; and logos. Needs computer-literate freelancers for illustration. 10% of freelance work demands knowledge of Aldus FreeHand.
First Contact & Terms: Send brochure, business card and slides to be kept on file. Samples are returned by SASE only if requested by artist. Reports back within 1 week. Request portfolio review in original query. Pays for design by the hour, $45 minimum; by the project, $250 minimum; by the day, $150 minimum. Pays for illustration by the hour, $45 minimum; by the project; by the day, $150 minimum.
Tips: Finds artists through word of mouth, magazines, artists' submissions/self-promotions, sourcebooks and agents. "We are looking for 2 or 3 illustrators to join our group this year. Do not send school work or work that is repetitive."

‡**ASSISTANTS IN DESIGN SERVICES,** Suite C, 12730 San Pueblo Ave., San Francisco CA 94805-1303. (415)215-5515. President: Edward Tom. Estab. 1975. Specializes in display design, landscape design, interior design, package design and technical illustration. Clients: corporations/private industrial. Current clients include: Chevron Research Co., PMC, and IBM.
Needs: Approached by 1000 freelance artists/year. Works with 20 freelance illustrators and 20 freelance designers/year. Prefers local artists with experience in industrial design. Works on assignment only. Uses freelance illustrators and designers mainly for product design. Also uses freelance artists for brochure, catalog, poster, ad and P-O-P design and illustration; technical and medical illustration; book, magazine, newspaper and direct mail design; mechanicals; retouching; airbrush; lettering; logos; model-making; charts/graphs; audiovisual material.
First Contact & Terms: Send query letter with brochure, résumé, photographs and photocopies. Samples are filed. Art Director will contact for portfolio review if interested. Portfolio should include thumbnails, roughs, b&w and color photostats, slides and photographs. Requests work on spec before assigning job. Pays for design by the project, $2,000-6,000. Pays for illustration by the project, $2,000-6,000. Rights purchased vary according to project.
Tips: Finds artists through submissions.

■**BAILEY SPIKER, INC.,** 805 E. Germantown Ave., Norristown PA 19401. (215)275-4353. Owners/Partners: Christopher Bailey and Paul Spiker. Also contact: Laura Markley, Ken Cahill or Dave Fiedler. Estab. 1985. Specializes in package designs, brand identity, corporate identity, sales promotion materials, corporate communications and signage systems. Clients: corporations (food, drug, health and beauty aids). Current clients include Johnson & Johnson Consumer Products, Kiwi Brands, Freshword Farms, McNeil Consumer Products Company, Regal Communications, Alpo Pet Foods and Binney & Smith.
Needs: Approached by 10-15 freelance artists/year. Works with 4-9 illustrators/year. Uses illustrators mainly for editorial, technical and medical illustration and final art, charts and airbrushing. Uses designers mainly for freelance production (*not* design), or computer only. Also uses freelancers for mechanicals, brochure and catalog design and illustration, P-O-P illustration and model-making.
First Contact & Terms: Send query letter with brochure, résumé, tearsheets and photographs. Samples are filed. Reports back to the artist only if interested. Art Director will contact for portfolio review if interested. Portfolio should include finished art samples, color tearsheets, transparencies and artist's choice of other materials. May pay for illustration by the hour, inhouse $10-15; by the project, $300-3,000. Rights purchased vary according to project.
Tips: Finds artists through word of mouth, self-promotions and sourcebooks.

‡**AUGUSTUS BARNETT ADVERTISING/DESIGN,** Helens Ave., Tacoma WA 98402. (206)627-8508. Fax: (206)593-2116. President: Charlie Barnett. Estab. 1981. Specializes in corporate identity, design and package design. Clients: corporations, manufacturers. Current clients include Tree Top, Inc., I.P. Callison & Sons, Nalleys, Curtice-Burns, Martinac Shipbuilding, Pure-Gar. Client list available upon request.
Needs: Approached by 25 freelance graphic artists/year. Works with 3 freelance illustrators and 2 freelance designers/year. Prefers artists with experience in food work. Works on assignment only. Uses illustrators

The double dagger before a listing indicates that the listing is new in this edition. New markets are often more receptive to freelance submissions.

mainly for product and food illustration. Uses designers mainly for concept development and copy. Also uses freelance artists for brochure design and illustration, airbrushing and lettering. Needs computer-literate freelancers for design and production. 90% of freelance work demands knowledge of QuarkXPress, Aldus FreeHand or Adobe Photoshop. Send query letter with samples, résumé and photocopies. Samples are filed. Reports back within 2 weeks. Portfolios may be dropped off if pre-arranged and should include b&w and color printer samples. Pays for design by the hour, $20-55. Pays for illustration by the hour, $20-45. Rights purchased vary according to project.
Tips: Finds artists through referral and local portfolio review.

BARNSTORM DESIGN/CREATIVE, Suite 100, 3419 W. Colorado Ave., Colorado Springs CO 80904. (719)630-7200. Fax: (719)630-3280. Owner: Douglas D. Blough. Estab. 1975. Specializes in corporate identity, brochure design and publications. Clients: high-tech corporations, nonprofit fundraising, business-to-business and restaurants. Current clients include NCR, USOC, Concept Restaurants, ITT Federal Services Corp., National Systems and Research, General Merchandise Distributors Council.
Needs: Works with 2-4 freelance artists/year. Prefers local, experienced (clean, fast and accurate) artists. Works on assignment only. Uses freelancers mainly for paste-up, editorial and technical illustration and layout. Also uses freelancers for design, mechanicals, retouching and calligraphy. Needs computer-literate freelancers for production. 90% of freelance work demands knowledge of Aldus PageMaker, Adobe Illustrator, QuarkXPress, Photoshop and Aldus FreeHand.
First Contact & Terms: Send query letter with résumé and samples to be kept on file. Prefers "good originals or reproductions, professionally presented in any form" as samples. Samples not filed are returned by SASE. Reports only if interested. Call or write for appointment to show portfolio. Pays for design by the project, $200-300. Pays for illustration by the project, $50 minimum for b&w; $200 for color. Considers client's budget, skill and experience of artist, and turnaround time when establishing payment.
Tips: "Portfolios should reflect an awareness of current trends. We try to handle as much in-house as we can, but we recognize our own limitations (particularly in illustration). Do not include too many samples in your portfolio."

‡BASIC/BEDELL ADVERTISING, (formerly Basic/Bedell Advertising Selling Improvement Corp.), Suite H, 600 Ward Dr., Box 30571, Santa Barbara CA 93130. President: C. Barrie Bedell. Specializes in advertisements, direct mail and how-to manuals. Clients: national and international newspapers, publishers, direct response marketers, retail stores, hard lines manufacturers, software developers, trade associations, plus extensive self-promotion of proprietary advertising how-to manuals.
 • This company's president is seeing "a glut of 'graphic designers,' and an acute shortage of 'direct response' designers."
Needs: Uses artists for publication and direct mail design, book covers and dust jackets and camera-ready computer desktop production.
First Contact & Terms: Especially wants to hear from publishing and "direct response" pros. Portfolio review not required. Pays for design by the project, $100-2,500. Pays for illustration by the project, $25 minimum. Considers client's budget, and skill and experience of artist when establishing payment.
Tips: "There has been a substantial increase in use of freelance talent and increasing need for true professionals with exceptional skills and responsible performance (delivery as promised and 'on target'). It is very difficult to locate freelance talent with expertise in design of advertising and direct mail with heavy use of type. If work is truly professional and freelancer is business-like, contact with personal letter and photocopy of one or more samples of work that needn't be returned."

BEAR CANYON CREATIVE, 6753 Academy Rd. NE, Albuquerque NM 87109. (505)823-9150. Fax: (505)823-9291. Senior Designer: Melanie Wegner. Design Director: Raymond Peña. Estab. 1985. Specializes in graphic and package design. Clients: Audio publishers and corporations.
Needs: Approached by 25 freelance artists/year. Works with 20 illustrators/year. Prefers artists with extensive experience in full color illustration; some children's illustration. Works on assignment only. Uses freelancers mainly for illustration for audio packaging covers.
First Contact & Terms: Send query letter with résumé, tearsheets, photographs, photocopies, photostats, slides or transparencies. Samples are filed or are returned by SASE if requested by artist. Reports back only if interested. Call or write for appointment to show portfolio, or mail appropriate materials. Portfolio should include finished art samples, slides, color tearsheets, transparencies and photographs. Pays by the project, $300-700. Buys only all rights.
Tips: Finds artists mainly through sourcebooks, occasionally through word of mouth and artists' submissions. "Work within our budget. Be highly professional. Be versatile (handle variety of styles). The design field is more competitive—very crowded with new names, new styles."

How to Use Your Artist's & Graphic Designer's Market *offers suggestions for understanding and using the information in these listings. Read this and other articles in the front of this book for important business tips.*

‡**BELYEA DESIGN**, Suite 1007, 1809 7th Ave., Seattle WA 98101. (206)682-4895. Fax: (206)623-8912. Estab. 1980. Specializes in annual reports, brand and corporate identity, marketing materials, in-store P-O-P, design, direct mail, package and publication design. Clients: corporate, manufacturers, retail. Current clients include Weyerhaeuser and Princess Tours. Client list available upon request.

Needs: Approached by 20-30 freelance graphic artists/year. Works with 20 freelance illustrators and 3-5 freelance designers/year. Prefers local artists only. Works on assignment only. Uses illustrators for "any type of project." Uses designers mainly for overflow. Also uses freelance artists for brochure, catalog, poster and ad illustration; and lettering. Needs computer-literate freelancers for design. 100% of freelance work demands knowledge of QuarkXPress, Aldus FreeHand or Adobe Photoshop.

First Contact & Terms: Send query letter. Samples are filed. Reports back to the artist only if interested. Pays for design by the hour, $25-30. Pays for illustration by the project, $125-1,000. Rights purchased vary according to project.

Tips: Finds artists through submissions by mail and referral by other professionals. "Designers must be computer-skilled. Illustrators must develop some styles that make them unique in the marketplace."

BERSON, DEAN, STEVENS, 65 Twining Lane, Wood Ranch CA 93065. (818)713-0134. Fax: (818)713-0417. Owner: Lori Berson. Estab. 1981. Specializes in annual reports, brand and corporate identity and display, direct mail, package and publication design. Clients: manufacturers, ad agencies, corporations and movie studios.

Needs: Approached by 24 freelance artists/year. Works with 4-6 illustrators and 2-3 designers/year. Works on assignment only. Uses illustrators mainly for brochures, packaging and comps. Also uses freelancers for catalog, P-O-P, ad and poster illustration; mechanicals retouching; airbrushing; lettering; logos; and model making. Needs computer-literate freelancers for illustration and production. 50% of freelance work demands knowledge of Aldus PageMaker, Adobe Illustrator, QuarkXpress, Photoshop and Aldus FreeHand.

First Contact & Terms: Send query letter with tearsheets and photocopies. Samples are filed. Art Director will contact artist for portfolio review if interested. Pays for design and illustration by the project. Rights purchased vary according to project. Considers buying second rights (reprint rights) to previously published work.

Tips: Finds artists through word of mouth, submissions/self-promotions, sourcebooks and agents.

BOB BOEBERITZ DESIGN, 247 Charlotte St., Asheville NC 28801. (704)258-0316. Owner: Bob Boeberitz. Estab. 1984. Specializes in graphic design, corporate identity and package design. Clients: retail outlets, hotels and restaurants, textile manufacturers, record companies, professional services, realtor/developers. Majority of clients are manufacturers—business-to-business. Current clients include American Threshold Industries, High Windy Audio and Carolina West, Inc. Client list not available.

• Owner Bob Boeberitz predicts "everything in art design will be done on computer, more electronic clip art, photo image editing and conversions will be used, less commissioned artwork."

Needs: Approached by 50 freelance graphic artists/year. Works with 5 freelance illustrators/year. Works on assignment only. Uses artists primarily for technical illustration and comps. Prefers pen & ink, airbrush and acrylic. Needs computer-literate freelancers for illustration. 50% of freelance work demands knowledge of Aldus PageMaker, Adobe Illustrator, Aldus Photoshop or Corel Draw.

First Contact & Terms: Send query letter with brochure, SASE, photocopies, slides and tearsheets. "Anything too large to fit in file" is discarded. Samples are returned by SASE if requested. Reports only if interested. Art Director will contact artist for portfolio review if interested. Portfolio should include thumbnails, roughs, final art, b&w and color slides and photographs. Sometimes requests work on spec before assigning job. Pays for design and illustration, by the project, $50 minimum. Rights purchased vary according to project. Will consider buying second rights to previously published artwork.

Tips: Finds artists through word of mouth, artists' submissions/self-promotions, sourcebooks, agents. "Show sketches—sketches help indicate how an artist thinks. The most common mistake freelancers make in presenting samples or portfolios is not showing how the concept was developed, what their role was in it. I always see the final solution, but never what went into it. In illustration, show both the art and how it was used. Portfolio should focus on what you do best. Portfolios should be neat, clean and flattering to your work. Show only the most memorable work, what you do best. Always have other stuff, but don't show everything. Be brief. Don't just toss a portfolio on my desk; guide me through it. A 'leave-behind' is helpful, along with a distinctive-looking résumé."

‡∎**THE BOOKMAKERS, INCORPORATED**, 126 S. Franklin St., Wilkes-Barre PA 18701-1189. (717)823-9183. President: John Beck. Specializes in publications and technical illustrations. Current clients include Greenwood, Allyn & Bacon and Hunter College. Majority of clients are book publishers. Client list available upon request.

Needs: Works with 5-10 freelance illustrators/year. Uses artists for editorial, medical and technical illustration and brochures, catalogs, retouching, airbrushing, posters and charts/graphs.

First Contact & Terms: Send query letter with résumé, tearsheets, photostats, photocopies, slides and photographs. Samples not filed are returned by SASE. Reports only if interested. Portfolio review not re-

quired. Pays for design, by the hour, $6-10; by the project, $100-1,200. Pays for illustration by the project, $10-2,500 or more. Buys all rights.

Tips: "We are especially interested in versatility. Don't send too much. Send one good flier or five illustrations of what you do best."

BOOKMAKERS LTD., P.O. Box 1086,Taos NM 87571. (505)776-5435. Fax: (505)776-2762. President: Gayle Crump McNeil. Specializes in publications and related sales promotion and advertising. Clients: trade and educational publishers. Client list not available.

Needs: Approached by 100 artists/year. Works with 20-30 illustrators/year. "We are agents and designers. We represent artists for juvenile through adult markets."

First Contact & Terms: Send query letter with samples showing style (tearsheets, photostats, printed pieces or slides). Samples not filed are returned. Reports within 2 weeks. Considers skill and experience of artist when establishing payment.

Tips: The most comon mistake freelancers make in presenting samples or portfolios is "too much variety— not enough focus. Be clear about what you are looking for and what you can do in relation to the real markets available."

BRAINWORKS DESIGN GROUP, INC., Suite 3, 2335 Hyde St., San Francisco CA 94109-1510. (415)474-6681. Fax: (415)776-2372. Art Director: Al Kahn. Vice President Marketing: Michele Strub. Estab. 1970. Specializes in ERC (Emotional Response Communications), graphic design, corporate identity, direct mail and publication. Clients: colleges, universities, nonprofit organizations, medical and high tech; majority are colleges and universities. Current clients include Marymount College, Iowa Wesleyan, Union University and California Baptist College. Client list available upon request.

Needs: Approached by 80 freelance artists/year. Works with 15 photographers and 18 designers/year. Prefers artists with experience in type, layout, grids, mechanicals, comps and creative visual thinking. Works on assignment only. Uses artists mainly for mechanicals and calligraphy. Also uses freelancers for brochure, direct mail and poster design and mechanicals, lettering and logos. Needs photography. Needs computer-literate freelancers for production. 60% of freelance work demands knowledge of Aldus PageMaker, Quark-XPress, Aldus Freehand and Photoshop.

First Contact & Terms: Send brochure/flyer or résumé, slides, b&w photos and color washes. Samples are filed. Artist should follow up with call and/or letter after initial query. Art Director will contact for portfolio review if interested. Portfolio should include thumbnails, roughs, final reproduction/product and b&w and color tearsheets, photostats, photographs and transparencies. Pays for design by the project, $200-2,000. Considers complexity of project and client's budget when establishing payment. Rights purchased vary according to project.

Tips: Finds artists through sourcebooks and self-promotions. "Creative thinking and a positive attitude are a plus." The most common mistake freelancers make in presenting samples or portfolios is that the "work does not match up to the samples they show." Would like to see more roughs and thumbnails.

THE BRUBAKER GROUP, 10560 Dolcedo Way, Los Angeles CA 90077. (310)472-4766. Estab. 1968. Specializes in brand identity, display, interior and package design and technical illustration. Clients: aircraft and automobile manufacturers, toy and electronic companies and theme parks. Current clients include: Disney, Mattel, Mazda, Exxon, Lear Jet Corp. and CBS. Client list available upon request.

Needs: Approached by 2-10 freelance artists/year. Works with 2-10 illustrators and designers/year. Prefers artists with experience in product, model construction and consumer product design. Works on assignment only. Uses illustrators mainly for theme park environments and product design. Uses designers mainly for product, environmental and auto design. Also for brochure design and illustration, poster illustration and design, model making, charts/graphs and audiovisual materials. Needs computer-literate freelancers for design, illustration, production and presentation. 50% of freelance work demands knowledge of Adobe Illustrator.

First Contact & Terms: Send query letter with tearsheets, photostats, photographs and photocopies. Samples are filed. Samples not filed are not returned. Reports back to the artist only if interested. To show a portfolio, mail b&w photostats and photographs. Pays for design and illustration by the project, $1,000-20,000. Buys all rights.

‡BUGDAL GROUP INC., 7308 S.W. 48 St., Miami FL 33155. (305)665-6686. Fax: (305)663-1387. Vice President: Margarita Spencer. Estab. 1971. Specializes in annual reports, brand and corporate identity, displays signage design. Clients: corporations, public agencies. Current clients include Spillis Candella & Partners, Ampco Products, Odell Associates, Southeast Computer Solutions, Leesfield Leighton Rubio & Hillencamp and Stephen Samson, DDS. Client list available upon request.

Needs: Approached by 50 freelance graphic artists/year. Works with 3 freelance illustrators/year. Prefers local artists with experience in signage and corporate. Works on assignment only. Uses illustrators mainly for print and signage. Also uses freelance artists for brochure, catalog and ad illustration and mechanicals, retouching, airbrushing and charts/graphs. Needs computer-literate freelancers for illustration and produc-

tion. 100% of freelance work demands knowledge of Aldus PageMaker, Aldus FreeHand, Adobe Illustrator or Adobe Photoshop.

First Contact & Terms: Send query letter with brochure, résumé, photographs and transparencies. Samples are filed. Reports back to the artist only if interested. Request portfolio review in original query. Portfolio should include roughs, tearsheets and slides. "Pay depends on the job."

‡**BURCHETTE & COMPANY**, Suite 208, 210 N. Lee, Alexandria VA 22314. (703)684-6066. Fax: (703)684-6180. Creative Director: Karen Casey. Estab. 1985. Specializes in display, package and publication design and corporate identity, advertising and direct mail. Clients: corporations, hi-tech, communications, associations, government agencies. Current clients include DOE, ALPA, Datatel, Inc.

Needs: Approached by 100 freelance artists/year. Works with 3-4 freelance illustrators/year. Works on assignment only. Uses freelance illustrators mainly for direct mail brochure, poster and ad illustration. Also uses freelance artists for retouching, airbrushing and illustration. Needs technical and computer illustration. 25% of freelance work demands knowledge of Quark XPress, Adobe Illustrator, Lightspeed or Pixel Paint.

First Contact & Terms: Send query letter with slides and transparencies. Samples are filed. Reports back to the artist only if interested. Portfolio review not required. Pays for illustration by the project, $125-5,000. Rights purchased vary according to project. Considers buying second rights (reprint rights) to previously published work.

Tips: Finds artists through submissions/self-promotions, sourcebooks and agents. "There is a decreasing need for freelance artists because clients are doing less work requiring illustration."

BYRNE DESIGN, 133 W. 19th St., New York NY 10011. (212)807-6671. Fax: (212)633-6194. Estab. 1976. Specializes in annual reports and collateral material. Clients: financial, telecommunications and industrial. Current clients include Paine Webber, Alliance Capital, Citibank and Dean Witter. Client list available upon request.

Needs: Approached by 100 freelance artists/year. Works with 5-10 illustrators and designers/year. Uses illustrators, photographers and designers mainly for promotional brochures and editorial illustration. Also uses freelancers for mechanicals, lettering, logos and charts/graphs. Needs computer-literate freelancers for design, illustration, production and presentation. 90% of freelance work demands knowledge of Aldus PageMaker, Adobe Illustrator, Photoshop, Quark XPress or Aldus FreeHand.

First Contact & Terms: Send query letter with brochure and résumé. Samples are filed. Reports back only if interested. Portfolio may be dropped off every Wednesday. Pays for design by the hour, $30-60. Pays for illustration by the project, $750-7,500. Rights purchased vary according to project.

Tips: Finds artists through sourcebooks.

CAREW DESIGN, 200 Gate 5 Rd., Sausalito CA 94965. (415)331-8222. Fax: (415)331-7351. President: Jim Carew. Estab. 1975. Specializes in corporate identity, direct mail and package design.

Needs: Works with 15 illustrators and 2-4 designers/year. Prefers local artists only. Works on assignment only. Uses artists for brochure and catalog design and illustration, mechanicals, retouching, airbrushing, direct mail design, lettering, logos and ad illustration. Needs computer-literate freelancers for design, illustration and production. 75% of freelance work demands knowledge of Quark XPress, Aldus FreeHand, Adobe Illustrator or Photoshop. Needs editorial and technical illustration.

First Contact & Terms: Send query letter with brochure, résumé and tearsheets. Samples are filed or are returned only if requested by artist. Reports back only if interested. Call for appointment to show portfolio of roughs and original/final art. Pays for production by the hour, $18-30. Pays for design by the hour, $20-25 or by the project. Pays for illustration by the project, $100-1,500. Buys all rights.

CARNASE, INC., 30 E. 21st. St., New York NY 10010. (212)777-1500. Fax: (212)979-1927. President: Tom Carnase. Estab. 1978. Specializes in annual reports; brand and corporate identity; display, landscape, interior, direct mail, package and publication design; signage and technical illustration. Clients: agencies, corporations, consultants. Current clients include: Clairol, Shiseido Cosmetics, Times Mirror, Lintas: New York. Client list not available.

● President Tom Carnase predicts "very active" years ahead for the design field.

Needs: Approached by 60 freelance artists/year. Works with 2 illustrators and 1 designer/year. Prefers artists with 5 years experience. Works on assignment only. Uses artists for brochure, catalog, book, magazine and direct mail design and brochure and collateral illustration. Needs computer-literate freelancers. 50% of freelance work demands knowledge of QuarkXPress or Adobe Illustrator.

First Contact & Terms: Send query letter with brochure, résumé and tearsheets. Samples are filed. Reports back within 10 days. Art Director will contact artist for portfolio review if interested. Portfolio should include photostats, slides and color tearsheets. Negotiates payment. Rights purchased vary according to project.

Always enclose a self-addressed, stamped envelope (SASE) with queries and sample packages.

Tips: Finds artists through word of mouth, magazines, artists' submissions/self-promotions, sourcebooks, and agents.

‡CARSON & COMPANY, 4701 Teller Ave., Newport Beach CA 92660. (714)833-8435. Fax: (714)833-8463. President: George Carson. Estab. 1980. Specializes in direct mail and package design; corporate identity; and consumer collateral. Clients: manufacturers in automotive, sports, hi-tech industries and food companies; service corporations in financial and legal industries and markets. Current clients include: Bell Brand Snack Foods, Laura Scudder's, Cunningham Rods, Greenbaum & Ferentz, Master Financial, Kool Fit International and North Specialty Products. Client list available upon request.

Needs: Approached by 4-5 freelance graphic artists/year. Works with 2 freelance illustrators and 3 freelance designers/year. Works on assignment only. Uses illustrators for "a variety of jobs – from technical to renderings." Also uses freelance artists for brochure, catalog, magazine, direct mail, P-O-P and ad design; brochure, P-O-P and ad illustration; mechanicals; retouching; airbrushing; audiovisual materials; logos. Needs computer-literate freelancers for design, illustration, production and presentation. 40-60% of work demands knowledge of QuarkXPress or Adobe Illustrator.

First Contact & Terms: Send query letter with résumé and photocopies. Samples are filed. Does not always report back. "Artist should call us or write often, as this industry is one of timeing not product manufacturing." Portfolio should include color thumbnails, roughs, slides and 35mm or 4×5 transparencies. Pays for design by the project, $500-5,000. Pays for illustration by the project, $500-7,000. Rights purchased vary according to project.

Tips: Finds artists through sourcebooks and submissions. "Don't get stuck in any one trend; know how to use trends but keep your own talents strong and visible."

‡■CAS ASSOCIATES, Box 4462, Diamond Bar CA 91765. Editor/President: Carl Schoner. Estab. 1988. Specializes in display, direct mail and publication design and corporate identity, signage and cartoons. Clients: small- to medium-size businesses in retail, wholesale and service-related industries. Does ad layout and design for real estate and mortgage companies, graphic design for sport clothing wholesalers.

Needs: Works with 10-20 freelance illustrators and designers/year. Prefers local artists, "but will consider all talent" with experience in graphic design. Prefers humorous cartoons and "clean" logos. Uses illustrators mainly for ad illustration. Uses designers mainly for logos and ad layout. Also uses artists for brochure, P-O-P and poster illustration and design; direct mail and ad design; charts/graphs; lettering; logos. Especially needs "good cartoonists capable of producing characters for corporate advertising campaigns." Needs computer-literate freelancers for design. 5% of freelance work demands computer literacy.

First Contact & Terms: Send photocopies. Samples are filed or are returned if accompanied by a SASE. Reports back within weeks only if interested. Write to schedule an appointment to show a portfolio, which should include roughs, original/final art and final reproduction/product. Pays for design and illustration by the project, $50 minimum. Considers complexity of project, turnaround time and rights purchased when establishing payment. Negotiates rights purchased.

Tips: "For cartoonists and logo designers, we look for highly imaginative, original artwork coupled with clean lines and only as much detail as is necessary. Original simplicity is the key. We prefer to work with professional graphic artists for logo designs, but we are very open to working with new talent for humorous illustrations and marketing materials."

CLIFF AND ASSOCIATES, 715 Fremont Ave., South Pasadena CA 91030. (818)799-5906. Fax: (818)799-9809. Owner: Greg Cliff. Estab. 1984. Specializes in annual reports, corporate identity, direct mail and publication design and signage. Clients: Fortune 500 corporations and performing arts companies. Current clients include Arco, Times Mirror, Century 21 and Avery Dennison.

Needs: Approached by 20 freelance artists/year. Works with 15 illustrators and 20 designers/year. Prefers local artists and Art Center graduates. Uses illustrators and designers mainly for brochures. Also uses freelancers for technical, "fresh" editorial and medical illustration; mechanicals; lettering; logos; catalog, book and magazine design; P-O-P and poster design and illustration; and model making. Needs computer-literate freelancers for design and production. 90% of freelance work demands knowledge of QuarkXPress, Aldus FreeHand or Adobe Illustrator.

First Contact & Terms: Send query letter with résumé and sample of work. Samples are filed. Art director will contact for portfolio review if interested. Portfolio should include thumbnails and b&w photostats and printed samples. Pays for design by the hour, $15-25. Pays for illustration by the project, $50-3,000. Buys one-time rights.

Tips: Finds artists through sourcebooks. "Make your résumé and samples look like a client presentation. We now have much more computer generated work – especially benefits packages. We continue to use freelance artists, but not as many as before."

CLIFFORD SELBERT DESIGN, 2067 Massachusetts Ave., Cambridge MA 02140. (617)497-6605. Fax: (617)661-5772. Estab. 1982. Specializes in annual reports, corporate identity, displays, landscape design, direct mail and package design and environmental graphics. Clients: colleges, radio stations, corporations, hospitals, computer companies and retailers.

Needs: Approached by "hundreds" of freelance artists/year. Prefers artists with "experience in all types of design and computer experience." Uses freelance artists for brochures, mechanicals, logos, P-O-P, poster and direct mail.

First Contact & Terms: Send query letter with brochure, résumé, tearsheets, photographs, photocopies, slides and transparencies. Samples are filed. Reports back only if interested. Portfolios may be dropped off every Monday through Friday. Artist should follow up with call and/or letter after initial query. Art Director will contact artist for portfolio review if interested. Pays for design by the hour, $15-35; by the project. Pays for illustration by the project. Rights purchased vary according to project.

Tips: Finds artists through word of mouth, magazines, artists' submissions/self-promotions, sourcebooks and agents.

CN COMMUNICATIONS INTERNATIONAL, INC., (formerly CN/Design), 205 W. Milton St., Rahway NJ 07065. (908)382-1066. Fax: (908)382-8559. Creative Director: Brad Manier. Estab. 1978. Specializes in direct mail and package design and annual reports and corporate identity. Clients: Sony Electronic Publishing, Sony Imagesoft, Finex, Prudential Realty Group, New York Cotton Exchange.

Needs: Approached by 30-40 graphic artists/year. Works with 10-12 freelance illustrators and 12-18 freelance designers/year. Works on assignment only. Uses illustrators mainly for packaging illustration. Uses designers mainly for packaging, direct mail, logos. Also uses freelance artists for brochure, catalog, and poster design and illustration; direct mail and ad design; mechanicals; lettering; logos. Needs computer-literate freelancers for design, illustration, production and presentation. 80% of freelance work demands knowledge of QuarkXPress, Adobe Illustrator or Adobe Photoshop.

First Contact & Terms: Send tearsheets, résumé, slides, SASE, photocopies and transparencies. Samples are filed or are returned by SASE. Reports back to the artist only if interested. Art Director will contact artist for portfolio review if interested. Portfolio should include color roughs, final art, tearsheets and transparencies. Pays for design by the hour, $20-45. Rights purchased vary according to project.

Tips: Finds artists through sourcebooks, other publications, artists' submissions. "Computer literacy is a must, particularly Macintosh."

‡CREATIVE WORKS, Suite 200, 1201 US Hwy. One, North Palm Beach FL 33408. (407)775-3800. Owner: Jan Allen. Head Designers: David Wright, Ferany Corbato, Gwynn Cadwaller. Specializes in design, corporate identity, collateral, copywriting, photography, illustration, product and package design and signage.

Nees: Uses local freelancers to work in-house. 75% of freelance work demands knowledge of QuarkXPress, Photoshop, Illustrator or Freehand.

First Contact & Terms: Send query letter with résumé to be kept on file. Samples not kept on file are returned by SASE only if requested. Reports within 1 week. Art Director will contact artist for portfolio review if interested. Sometimes requests work on spec before assigning a job. Pays by the project for drafting and mechanicals. Pays for design and illustration by the hour, $12.50 minimum; by the project, $100 minimum.

Tips: Don't make the mistake of "showing samples that don't accurately represent your capabilities. Send only a distinctive graphic or artistic résumé that is memorable and request an appointment. Artists usually send résumés with words and no pictures."

CRITT GRAHAM & ASSOCIATES, Suite 620, 2970 Clairmont Rd., Atlanta GA 30329. (404)320-1737. Fax: (404)320-1920. Creative Director: Deborah Pinals. Estab. 1979. Specializes in design and production of annual reports, corporate magazines, capabilities brochures and marketing collateral. Clients: primarily major corporations; "7 are members of the Fortune 500." Current clients include Coca-Cola, Eastman Chemical, Harris, Royal Caribbean Cruises, SunTrust Banks.

Needs: Looks for freelancers competent in editorial, technical, medical and map illustration. Also needs photographers, typesetters and computer production designers. All design work is done internally.

First Contact & Terms: Send query letter with résumé and tearsheets. Samples are filed. Art Director will contact artist for portfolio review if interested. Pays for illustration by the project, depending on style. Considers buying second rights (reprint rights) to previously published work.

Tips: Finds artists through word of mouth, magazines, artists' submissions/self-promotions, sourcebooks and agents.

‡JO CULBERTSON DESIGN, INC., 222 Milwaukee St., Denver CO 80206. (303)355-8818. President: Jo Culbertson. Estab. 1976. Specializes in direct mail, packaging, publication and marketing design and annual reports, corporate identity, design and signage. Clients: corporations, not-for-profit organizations. Current clients include Baxa Corporation, Newman & Associates, Colorado Central Station Casino, Great-West Life. Client list available upon request.

Needs: Approached by 15 freelance graphic artists/year. Works with 3 freelance illustrators and 2 freelance designers/year. Prefers local artists only. Works on assignment only. Uses illustrators mainly for corporate collateral pieces. Also uses freelance artists for brochure design and illustration, book and direct mail design, lettering and ad illustration. Needs computer-literate freelancers for design, illustration and production. 50% of freelance work demands knowledge of QuarkXPress, Corel Draw or Ventura Publisher.

First Contact & Terms: Send query letter with résumé, tearsheets and photocopies. Samples are filed. Reports back to the artist only if interested. Artist should follow up with call. Portfolio should include b&w and color thumbnails, roughs and final art. Pays for design by the hour, $15-25; by the project, $250 minimum. Pays for illustration by the hour, $15-25; by the project, $100 minimum.
Tips: Finds artists through file of résumés, samples, interviews.

‡D.A. DESIGN, INC., (formerly Design Associates), 8602 NW 105th Ave., Tamarac FL 33321. (305)726-4453. Fax: (305)726-1229. Contact: Albert Barry. Estab. 1984. Specializes in package design and graphic design for toy industry. Clients: toy and novelty manufacturers. Client list not available.
 ● Albert Barry has a special need for cartoons and humorous illustrations for toy package design. He will work with out-of-town artists.
Needs: Approached by 150 freelance artists/year. Works with 10 freelance illustrators and 15 freelance designers/year. Prefers artists with experience in packaging, cartoon and basic illustration. Works on assignment only. Uses freelance illustrators mainly for packaging and headers. Also uses freelance artists for brochure and P-O-P design, mechanicals and airbrushing. Needs computer-literate freelancers for presentation. 25% of freelance work demands knowledge of Quark XPress.
First Contact & Terms: Call for appointment for portfolio review. Samples are filed. Art Director will contact artist for portfolio review if interested. Portfolio should include original/final art, tearsheets and comps. Pays for design and illustration by the hour, $10-15. Buys all rights.
Tips: Finds artists through art schools and artists' submissions. Will have more need for computer generated art in the future.

D&B GROUP, 386 Park Ave. S., New York NY 10016. (212)532-3884. Fax: (212)532-3921. Contact: Steve Sherman. Estab. 1956. Advertising art studio. Specializes in direct mail response advertising, annual reports, brand and corporate identity and publications. Clients: ad agencies, PR firms, direct response advertisers and publishers.
Needs: Works with 1-2 illustrators and 1-2 designers/month. Prefers local experienced artists only. Uses freelance artwork mainly for video wraps and promotion. Also uses freelancers for consumer magazines, direct mail, brochures/flyers, newspapers, layout, technical art, type spec, paste-up, lettering and retouching. Needs technical and product illustration. Prefers pen & ink, airbrush, watercolor and oil. Needs computer-literate freelancers for production. 60% of freelance work demands knowledge of Adobe Illustrator, Photoshop or QuarkXPress.
First Contact & Terms: Call for interview or send brochure showing art style, fliers, business card, résumé and tearsheets to be kept on file. No originals returned to artist at job's completion. Call for appointment to show portfolio of thumbnails, roughs, 8×10 chromes, original/final art and final reproduction/product. Pays for design by the hour, $25-50; by the project, $200-1,500. Pays for illustration by the project, $75-800. Considers complexity of project and client's budget when establishing payment.
Tips: "We foresee a need for direct response art directors and the mushrooming of computer graphics. Clients are much more careful as to price and quality of work."

JOSEPH B. DEL VALLE, HCR 84, Claverack NY 12513. Fax: (518)851-3857. Director: Joseph B. Del Valle. Specializes in annual reports, publications, book design. Clients: major publishers and museums. Current clients include Metropolitan Museum of Art and Cambridge University Press.
Needs: Works with approximately 6 freelance artists/year. Artists must have experience and be able to work on a job-to-job basis. Uses freelancers for design and mechanicals. Needs computer-literate freelancers for design and production.
First Contact & Terms: Send query letter with résumé. Reports only if interested. Call or write for appointment to show portfolio of final reproduction/product. Pays for design by the hour, $15-25. Considers client's budget and turnaround time when establishing payment.

‡DENTON DESIGN ASSOCIATES, 491 Arbor St., Pasadena CA 91105. (818)792-7141. President: Margi Denton. Estab. 1975. Specializes in annual reports, corporate identity and publication design. Clients: nonprofit organizations and corporations. Current clients include California Institute of Technology, Huntington Memorial Hospital. Client list not available.
Needs: Approached by 12 freelance graphic artists/year. Works with 4 freelance illustrators and 3 freelance designers/year. Prefers local designers only. "We work with illustrators from anywhere." Works on assignment only. Uses designers and illustrators for brochure design and illustration, lettering, logos and charts/graphs.

A bullet introduces comments by the editor of Artist's & Graphic Designer's Market *indicating special information about the listing.*

Needs computer-literate freelancers. 100% of design work demands knowledge of QuarkXPress, Photoshop and Adobe Illustrator.

First Contact & Terms: Send résumé, tearsheets and samples (illustrators just send samples). Samples are filed and are not returned. Reports back to the artist only if interested. Art Director will contact artist for portfolio review if interested. Portfolio should include color samples "doesn't matter what form." Pays for design by the hour, $20-25. Pays for illustration by the project, $250-6,500. Rights purchased vary according to project.

Tips: Finds artists through sourcebooks, AIGA and *Print*.

‡DESIGN & MARKET RESEARCH LABORATORY, 1035 Longford Rd., Oaks PA 19456. (215)935-4038. Fax: (215)935-4100. Director: M. Ryan. Estab. 1945. Specializes in package design. Clients: corporations. Client list available upon request.

Needs: Approached by 20-40 freelance graphic artists/year. Works with 3-5 freelance illustrators and 10-20 freelance designers/year. Prefers local artists only. Uses illustrators and designers mainly for packaging. Also uses freelance artists for brochure and P-O-P illustration and design, mechanicals, retouching, airbrushing, lettering and logos. Needs computer-literate freelancers for design and production. 60% of work demands knowledge of QuarkXPress (mostly), Adobe Illustrator or Adobe Photoshop.

First Contact & Terms: Send query letter with brochure and résumé. Samples are filed. Reports back to the artist only if interested. Request portfolio review in original query. Portfolio should include b&w and color thumbnails, final art and slides. Pays for design by the hour, $18 negotiable. Pays for illustration by the project. Buys all rights.

DESIGN AND PRODUCTION, INC., 711 Rainwater Place, Lorton VA 22079. (703)550-8640. Fax: (703)339-0296. Design Director: G. Evans. Estab. 1949. Specializes in exhibit design. Clients: corporations, museums. Current clients include Federal Reserve Bank of Dallas, Tunghai University, Epcot Center, West Point Military Academy, LBJ Presidential Library. Client list available on request.

Needs: Approached by 20-30 freelance artists/year. Works with 5-10 designers/year. Prefers artists with experience in exhibit design and detailing. Uses designers mainly for exhibition design and rendering. Needs technical and perspective illustration and rendering.

First Contact & Terms: Send résumé and slides. Samples are not filed and are returned. Reports back only if interested. Write for appointment to show portfolio. Artist should follow up with call and/or letter after initial query. Sometimes requests work on spec before assigning job. Pays for design by the hour, $30-75. Pays for illustration by the project, $500-3,000. Buys all rights.

Tips: Finds artists "mainly through sourcebooks—but, hey—wherever. Follow first contact. Be punctual, receptive and flexible." Predicts rosy future ahead for the art design field.

‡DESIGN CONCEPTS, 104 Main St., Box 5A1, RR 1, Unadilla NY 13849. (607)369-4709. Owner: Carla Schroeder Burchett. Estab. 1972. Specializes in annual reports, brand identity, design and package design. Clients: corporations, individuals. Current clients include American White Cross and Private & Natural.

Needs: Approached by 6 freelance graphic artists/year. Works with 2 freelance illustrators and designers/year. Prefers artists with experience in packaging, photography, interiors. Uses freelance artists for mechanicals, poster illustration, P-O-P design, lettering and logos.

First Contact & Terms: Send query letter with tearsheets, photostats, résumé and slides. Samples are filed or are returned by SASE if requested by artist. Reports back. Artists should follow up with letter after initial query. Portfolio should include thumbnails and b&w and color slides. Pays for design by the hour, $10 minimum. Negotiates rights purchased.

Tips: "Artists and designers are used according to talent; team cooperation is very important."

‡DESIGN ELEMENTS, INC., Suite 702, 201 W. Short, Lexington KY 40508. (606)252-4468. President: C. Conde. Estab. 1979. Specializes in corporate identity, package and publication design. "Work directly with end user (commercial accounts)." Client list not available.

Needs: Approached by 6-8 freelance artists/year. Works with 2-3 freelance illustrators and designers/year. Works on assignment only. Uses artists for brochure and P-O-P design and illustration, mechanicals, airbrushing, poster design, lettering and logos.

First Contact & Terms: Send query letter with brochure, résumé, tearsheets and slides. Samples are filed or are returned if requested by artist. Reports back only if interested. Call or write to schedule an appointment to show a portfolio. Pays by the hour, $25 minimum. Considers complexity of project, client's budget and skill and experience of artist when establishing payment. Buys all rights.

Tips: "Freelancers need to be more selective about portfolio samples—show items actually done by person presenting, or explain why not. Send résumé and samples of work first."

DESIGN MOVES, LTD., #1312, 405 N. Wabash, Chicago IL 60611. (312)661-0999. Fax: (312)661-1002. Principal: Laurie Medeiros. Estab. 1988. Specializes in publication, brochure and logo design and annual reports and direct mail. Clients: corporations, financial institutions, marketing agencies, hospitals and associations.

Current clients include Allstate Insurance, Humana—Michael Reese and the American Fund for Dental Health. Client list not available.

Needs: Approached by 25 freelance artists/year. Works with 5 illustrators and 5 designers/year. Works on assignment only. Uses freelance illustrators mainly for hospital publications and Allstate brochures. Uses freelance designers mainly for brochures and comping existing designs. Also uses freelancers for lettering, poster illustration and design, direct mail design and charts/graphs. Needs computer-literate freelancers for design and production. 90% of freelance work demands knowledge of Adobe Illustrator, QuarkXPress and Photoshop. Needs editorial and medical illustration.

First Contact & Terms: Send query letter with brochure, résumé and tearsheets. Samples are filed or are returned by SASE if requested. Request portfolio review in original query. Reports back to the artist only if interested. Portfolio should include thumbnails, tearsheets, photographs and transparencies. Pays for design by the hour, $10-20. Pays for illustration by the project, $50-500. Rights purchased vary according to project.

‡**THE DESIGN OFFICE OF STEVE NEUMANN & FRIENDS**, 2405 Bartlett St., Houston TX 77098. (713)629-7501. Fax: (713)520-1171. Principal: B. Steve Neumann. Specializes in corporate identity and signage. Clients: hospitals, corporations, institutions and developers.

Needs: Works with 20-30 freelance designers/year. Prefers local artists with computer experience. Uses artists for production and design. Also uses freelance designers for brochures, lettering, logos and model making. Needs editorial and technical illustration. Prefers pen & ink, colored pencil and calligraphy. Especially needs full-time and/or part-time production artist. Needs computer-literate freelancers for design, production and presentation. 100% of freelance work demands knowledge of Aldus PageMaker, Aldus FreeHand or Adobe Illustrator.

First Contact & Terms: Send query letter with résumé, references, business card and nonreturnable slides to be kept on file. Call for follow up after 15 days. Pays for design by the hour, based on job contract. Rights purchased vary according to project.

ANTHONY DI MARCO, 2948½ Grand Route St. John, New Orleans LA 70119. (504)948-3128. Creative Director: Anthony Di Marco. Estab. 1972. Specializes in illustration, sculpture and costume design. Clients: Audubon Institute, numerous New Orleans Mardi Gras clubs, churches, agencies. Client list available upon request.

Needs: Approached by 20 or more freelance artists/year. Works with 2-4 illustrators and 2-4 designers/year. Seeks "local artists with ambition. Artists should have substantial portfolios and an understanding of business requirements." Mainly uses artists for fill-in and finish: design, illustration, mechanicals, retouching, airbrushing, posters, model making, charts/graphs. Prefers highly polished, finished art in pen & ink, airbrush, charcoal/pencil, colored pencil, watercolor, acrylic, oil, pastel, collage and marker. 25% of freelance work demands computer skills.

First Contact & Terms: Send query letter with résumé, business card, slides and tearsheets to be kept on file. Samples not kept on file are returned by SASE. Reports back within 1 week if interested. Call or write for appointment to show portfolio. Pays for illustration by the project, $100 minimum.

Tips: "Keep professionalism in mind at all times. Put forth your best effort. Apologizing for imperfect work is a common mistake freelancers make when presenting a portfolio. Include prices for completed works (avoid overpricing). 3-dimensional works comprise more of our total commissions than before."

■**DIAMOND ART STUDIO LTD.**, 11 E. 36th St., New York NY 10016. (212)685-6622. Fax: (212)213-5216. Creative Directors: Gary and Douglas Diamond. Art studio. Clients: agencies, corporations, manufacturers and publishers.

Needs: Works with 10 illustrators/month. Assigns 800 jobs/year. Uses artists for comprehensive illustrations, cartoons, charts, graphs, layout, lettering, logo design, paste-up, retouching, technical art and type specing. Prefers pen & ink, airbrush, colored pencil, watercolor, acrylic, pastel and marker. Needs computer-literate freelancers for design, illustration, production and presentation. 25% of freelance work demands knowledge of Aldus PageMaker, Adobe Illustrator, QuarkXPress, Photoshop, Aldus Freehand.

First Contact & Terms: Send résumé, tearsheets and SASE. Samples are filed. Write for apppointment to show portfolio. Pays for design by the hour. Pays for illustration by the hour or by the project.

Tips: "Leave behind something memorable and well thought out."

DIMENSIONS & DIRECTIONS, LTD., (formerly Helena Frost Associates, Ltd.), Maple Rd., Brewster NY 10509. (914)279-7413; 301 E. 21st St., New York NY 10010. (212)475-6642. President: Helena R. Frost. Estab. 1986. Specializes in packaging, publications and textbooks "at all levels in all disciplines," corporate communications and catalogs. Clients: publishers. Current clients include: Carriage House, Vital and Research Plus.

Needs: Works with more than 50 freelance artists/year. Works on assignment only. Uses freelancers for book design, editorial and technical illustration (prefers realistic style), mechanicals and charts/graphs. Needs computer-literate freelancers for design and illustration. 50-60% of freelance work demands knowledge of Aldus PageMaker, QuarkXPress or Adobe Illustrator.

First Contact & Terms: Send query letter with brochure. Samples are filed or are returned if requested by artist. Does not report back. Write for appointment to show portfolio of roughs, final reproduction/product and tearsheets. Pays for design and illustration by the project. Considers client's budget, turnaround time and rights purchased when establishing payment. Buys one-time rights.

DOCKX DESIGN, 4A Maple St., P.O. Box 1019, Camden ME 04843-1019. (207)236-3144. Fax: (207)236-3208. President/Principal: Russell E. Dockx. Specializes in brand and corporate identity, direct mail and publication design and original lithographs. Clients: corporations, nonprofits, publishers. Current clients include Dow Jones & Co., Inc., *Inc.* Magazine, Children's Television Workshop, Donnelley Marketing, Inc., Lotus Publishing, *PC World*, Hearst, American Express Publishing Corp. and Waterside Gallery. Client list available upon request.
Needs: Approached by 10 freelance artists/year. Works with 3 illustrators and 1 designer/year. Prefers artists with experience in direct mail design.Works on assignment only. Also uses freelancers for brochure, book and direct mail design and editorial illustration, mechanicals, retouching and audiovisual materials. Needs computer-literate freelancers for design and production. 25% of freelance work demands knowledge of Aldus PageMaker, QuarkXPress, Aldus FreeHand, Adobe Illustrator and Photoshop.
First Contact & Terms: Send query letter with brochure and résumé. Samples are filed and are returned. Art Director will contact artist for portfolio review if interested. Portfolio should include thumbnails, roughs and final art and b&w and color tearsheets. Pays for design by the project, $100 minimum. Pays for illustration by the hour, $100-150; by the project, $200-3,000. Rights purchased vary according to project.
Tips: "The graphic arts industry has become overly dependent on electronic software and hardware instead of creative solutions and problem-solving by designers."

‡EHN GRAPHICS, INC., 244 E. 46th St., New York NY 10017. (212)661-5947. President: Jack Ehn. Specializes in promotion, annual reports, book design, corporate identity, direct mail, publications and signage. Current clients include Macmillan and McGraw Hill. Client list available upon request.
Needs: Approached by 20 freelance artists/year. Works with 10-12 freelance artists/year. Uses artists for editorial illustration, books, mechanicals, retouching and direct mail packages.
First Contact & Terms: Send query letter with samples. Samples not filed are returned only if requested. Art Director will contact artist for portfolio review if interested. Portfolio should include original/final art and final reproduction/product. Pays for deisgn and illustration by the project. Considers complexity of project, client's budget, and skill and experience of artist when establishing payment.

EL CRANMER DESIGN ASSOC., 1322 Bell Ave., Tustin CA 92680. (714)259-0717. Fax: (714)259-8879. Owner: El Cranmer. Estab. 1970. Specializes in items related to corporate image and product sales. Clients: small companies and corporations; mostly industrial. Current clients include Reliance Metals, Challenge/RMF, Kizure and Gemini Productions. Client list available upon request.
Needs: Approached by 6 freelance artists/year. Works with 1 illustrator and 1 designer/year. Prefers local artists with experience in industrial work. Works on assignment only. Uses illustrators mainly for airbrush illustration. Uses designers mainly for creative design/layout. Also for brochure, catalog and P-O-P design and illustration; direct mail and ad design; mechanicals; retouching; lettering; logos; and charts/graphs. Needs computer-literate freelancers for design, illustration and production. 50% of freelance work demands knowledge of Aldus PageMaker, Adobe Illustrator, QuarkXPress and Photoshop.
First Contact & Terms: Send query letter with brochure and résumé. Samples are filed. Reports back within 1 week. Call for appointment to show portfolio of thumbnails, roughs, tearsheets, photographs and transparencies. Pays for design and illustration by the hour, $15-30; by the project, $300 minimum; by the day, $300-700. Buys all rights.

RAY ENGLE & ASSOCIATES, 4726 LaVilla Marina, Marina del Rey CA 90292. (310)822-3224. Fax: (310)827-9859. President: Ray Engle. Estab. 1963. Specializes in annual reports, corporate identity, displays, interior design, direct mail, packaging, publications and signage. Clients: corporations, ad agencies, PR firms, direct clients. Current clients include Unocal, IBM, KCET.
Needs: Approached by 200 freelance artists/year. Works with 4 illustrators and 5 designers/year. Prefers local artists; "top quality only." Uses artists mainly for editorial and technical illustration. Also uses freelancers for brochure, catalog, book and magazine design and P-O-P display, mechanicals, retouching, airbrushing, posters, model making, charts/graphs, lettering, and logos. Prefers pen & ink, airbrush, colored pencil, marker and calligraphy. Needs computer-literate freelancers for design, illustration, production and presentation. 80% of freelance work demands knowledge of Quark XPress, Aldus FreeHand, Photoshop or Adobe Illustrator.
First Contact & Terms: Send query letter with brochure showing art style or résumé and tearsheets, photostats, photocopies, slides or photographs. Samples are filed or are returned by SASE. Art Director will contact artist for portfolio review if interested. Portfolio should include b&w and color thumbnails, roughs, original/final art, final reproduction/product, tearsheets, photostats and photographs. Pays for design by the hour, $15-75; by the project, $100 minimum. Pays for illustration by the hour, $20 minimum; by the project, $100 minimum. Rights purchased vary according to project.

Tips: Finds artists through self-promotions, magazines and referrals. "Think of how you can be of service to us—not how we can be of service to you. Send promotional piece, then follow up with a phone call. Be succinct, businesslike. Respect my time."

‡ERVIN ADVERTISING AND DESIGN, 829 Ocean Ave., Seal Beach CA 90740. (310)598-3345. Fax: (310)430-3993. Estab. 1981. Specializes in annual reports and corporate identity and retail, direct mail, package and publication design. Clients: corporations, malls, financial firms, industrial firms and software publishers. Current clients include First American Financial, Interplay, Macerich, Time Warner Interactive, Lakewood Center, Huntington Beach Mall, Sares Regis Group. Client list available upon request.
Needs: Approached by 100 freelance graphic artists/year. Works with 10 freelance illustrators and 3 freelance designers/year. Works on assignment only. Uses illustrators mainly for package designs, annual reports. Uses designers, mainly for annual reports, special projects. Also uses freelance artists for brochure design and illustration, P-O-P and ad illustration, mechanicals, audiovisual materials, lettering and charts/graphs. Needs computer-literate freelancers for production. 99% of freelance work demands knowledge of QuarkXPress or Adobe Photoshop.
First Contact & Terms: Send résumé and photocopies. Samples are filed and are not returned. Reports back to the artist only if interested. Request portfolio review in original query. Portfolio should include color roughs, tearsheets and transparencies. Pays for design by the hour, $15-30; by the project (rate varies); by the day, $120-240. Pays for illustration by the project (rate varies). Buys all rights.
Tips: Finds artists through sourcebooks, résumés submitted, mailings.

EVENSON DESIGN GROUP, 4445 Overland Ave., Culver City CA 90230. (310)204-1995. Fax: (310)204-4879. Production Manager: Catherine Fraser. Estab. 1976. Specializes in annual reports, brand and corporate identity, display design, direct mail, package design and signage. Clients: ad agencies, hospitals, corporations, law firms, record companies, publications, PR firms. Current clients include Apple Computer, Inc., Clean-up Technology, Inc., Capitol Records, Saint Joseph Medical Center, Sony Pictures Entertainment and Warner Bros.
Needs: Approached by 75-100 freelance artists/year. Works with 20-25 illustrators and 10 designers/year. Prefers artists with production experience as well as strong design capabilities. Works on assignment only. Uses illustrators mainly for covers for corporate brochures. Uses designers mainly for logo design, page layouts, all overflow work. Also for brochure, catalog, direct mail, ad, P-O-P and poster design and illustration; mechanicals; lettering; logos; and charts/graphs. Needs computer-literate freelancers for design and production. 80% freelance work demands knowledge of QuarkXPress, Aldus FreeHand, Photoshop or Adobe Illustrator.
First Contact & Terms: Send query letter with résumé. Also has drop-off policy. Samples are filed. Returned by SASE if requested. Reports back to the artist only if interested. Portfolio should include b&w and color photostats and tearsheets and 4×5 or larger transparencies. All work must be printed or fabricated in form of tearsheets, transparencies or actual piece. Pays for design by the hour, $20-35. Rights purchased vary according to project.

FREELANCE EXCHANGE, INC., P.O. Box 1165, Glastonbury CT 06033-6165. (203)677-5700. Fax: (203)677-8342. President: Stella Neves. Estab. 1983. Specializes in annual reports, brand and corporate identity, display, direct mail, package and publication design, illustration (cartoon, realistic, technical, editorial, product and computer). Clients: corporations, nonprofit organizations, state and federal government agencies and ad agencies. Current clients include Lego Systems, Milton Bradley Co., Carrier Corp., Otis Elevator, Duracell Corp., Arthur Andersen Consultants, Phoenix Home Life Insurance Co., State of Connecticut Administrative Service, Weekly Reader Corp. Client list available upon request.
Needs: Approached by 300-500 freelance artists annually. Works with 30-50 illustrators and 45-65 designers/year. Prefers local artists with experience in publications, direct mail, consumer products and desktop publishing. "Computer graphics and illustration are becoming more important and requested by clients." Works on assignment only. Uses illustrators mainly for editorial and computer illustration and cartooning. Design projects vary. Also uses freelancers for brochure, catalog, book, magazine, direct mail, poster, P-O-P and newspaper design; brochure, catalog, P-O-P and poster illustration; mechanicals; audiovisual materials; lettering; logos; and charts/graphs. Needs computer-literate freelancers for design, illustration, production, presentation and animation. 75% of freelance work demands knowledge of Aldus PageMaker, QuarkXPress, Aldus FreeHand, Adobe Illustrator, Photoshop, Persuasion, Powerpoint and animation programs.
First Contact & Terms: Send query letter with résumé, SASE, tearsheets and photocopies. Samples are filed and are returned by SASE. Reports back within 2 weeks. Call or write for appointment to show portfolio of thumbnails, roughs, final art (if appropriate) and b&w and color photostats, slides, tearsheets, photographs. "We prefer slides." Pays for design by the hour, $30 minimum or by the project, $500 minimum. Pays for illustration by the project, $300 minimum. Rights purchased vary according to project.
Tips: "If we choose to include an illustrator in our group, he should send slides of his work on a regular basis. As he completes work, he should send a *new* slide. Portfolios should remain current. Computer graphics are crucial. Artists must learn to use the Mac as another tool. The artists who can't won't survive."

‡**FREELANCE EXPRESS, INC.,** 111 E. 85th St., New York NY 10028. (212)427-0331. Multi-service company. Estab. 1988.
Needs: Uses artists for cartoons, charts, graphs, illustration, layout, lettering, logo design and mechanicals.
First Contact & Terms: Mail résumé and photocopied nonreturnable samples. "Say you saw the listing in *Artist's Market*." Provide materials to be kept on file. No originals returned to artist at job's completion.

FREEMAN DESIGN GROUP, 415 Farms Rd., Greenwich CT 06831. (203)968-0026. President: Bill Freeman. Estab. 1972. Specializes in annual reports, corporate identity, package and publication design and signage. Clients: corporations. Current projects include company magazines. Current clients include Pitney Bowes, Continental Grain Co., IBM Credit, CB Commercial Real Estate. Client list available upon request.
Needs: Approached by 35 artists/year. Works with 5 illustrators and 5 designers/year. Prefers artists with experience in production. Works on assignment only. Uses illustrators for mechanicals, retouching and charts/graphs. Looking for technical illustration and editorial illustration with "montage, minimal statement."
First Contact & Terms: Send query letter with promotional piece showing art style, résumé and tearsheets. Samples are filed or are returned if accompanied by SASE. Does not report back. Call for appointment to show portfolio or mail appropriate materials and tearsheets. Pays for design by the hour, $25 minimum; by the project, $150-3,000.

DAVE FRENCH DESIGN STUDIOS, Suite #108, 4633 E. Broadway Blvd., Tucson AZ 85711. (602)290-8442 or (602)327-8891. Fax: (602)795-6647. Art Director: Dave French. Estab. 1979. Specializes in corporate identity, direct mail and publication design, signage, cartoon illustration, interior and exterior wall graphics systems and newspaper and magazine ads. "We specialize in offering our services to businesses that are just starting up or are interested in re-doing their image. We deal primarily with all types of businesses on a direct basis. Deal with everything from automobile agencies and restaurants to furniture stores and hospitals. We cover just about any industry or business who needs our services." Current clients include Oak & More Furniture Centers, Congressman Jim Kolbe, Jim Click Automotive Group, Tucson Medical Center, Superior Jojoba Oil, Grubb & Ellis, Nationwide Investigations, The Humane Society of Tucson, The Tucson Mall and Tucson Country Nights. Client list available upon request.
Needs: Approached by 75-100 freelance artists/year. Works with 10 illustrators and 15 designers/year. Prefers artists with experience in editorial and technical illustration, cartooning and caricature. Works on assignment only. Uses illustrators mainly for product and fashion promotion. Uses designers mainly for paste up, layout and mechanicals. Also for brochure, ad and newspaper design; brochure, catalog, P-O-P, poster and ad illustration; mechanicals; airbrushing; audiovisual materials; lettering; logos; and charts/graphs. Needs computer-literate freelancers for design, illustration, production and presentation. 35% of freelance work demands knowledge of Aldus PageMaker, Aldus FreeHand or Adobe Illustrator.
First Contact & Terms: Send query letter with brochure, résumé, SASE and transparencies. Samples are filed or are returned by SASE if requested by artist. Art Director will contact artist for portfolio review if interested. Portfolio should include finished art, color tearsheets, photographs and transparencies (35mm or 4×4"). Sometimes requests work on spec before assigning job. Pays for design by the hour, $8.50-15. Pays for illustration by the hour, $20-45. Rights purchased vary according to project. Considers buying second rights (reprint rights) to previously published work.
Tips: Finds artists strictly through word of mouth and telephone solicitation by the artists. "Keep in touch with us on a regular basis and send updated design materials. This will always put you ahead of those who don't. More and more clients are requesting computer aided artwork and the one quality that clients are hungry for is personalized one-on-one service."

‡**STEVE GALIT ASSOCIATES, INC.,** 5105 Monroe Rd., Charlotte NC 28205. (704)537-4071. President: Stephen L. Galit. Specializes in annual reports, corporate identity, direct mail, publications and technical illustrations. Clients: ad agencies and corporations.
Needs: Works with 15 freelance artists/year. Looks for "expertise, talent and capability." Uses freelance artists for brochure, catalog, technical, and editorial illustration; retouching; airbrushing; model making; charts/graphs; lettering.
First Contact & Terms: Send query letter with brochure showing art style or tearsheets, photostats, photocopies, slides or photographs. Samples are filed or are returned if accompanied by a SASE. Art Director will contact artist for portfolio review if interested. Pays for design and illustration by the project, $100-2,000. Considers client's budget, skill and experience of artist and how work will be used. Rights purchased vary according to project. Considers buying second rights (reprint rights) to previously published artwork.
Tips: Finds artists through submissions and sourcebooks.

For a list of markets interested in humorous illustration, cartooning and caricatures, refer to the Humor Index at the back of this book.

‡**GERALD & CULLEN RAPP, INC.**, 108 E. 35th St., New York NY 10016. (212)889-3337. Fax: (212)889-3341. Associate: John Knepper. Estab. 1945. Clients: ad agencies, coporations and magazines. Client list not available.
Needs: Approached by 250 freelance artists/year. Works with 35 freelance illustrators. Works on assignment only. Uses freelance illustrators mainly for advertising illustration. Uses freelance designers mainly for direct mail pieces. Also uses freelance artists for brochure and poster design and illustration; ad and direct mail design; mechanicals; retouching; airbrushing; lettering; and P-O-P illustration.
First Contact & Terms: Send query letter with tearsheets and SASE. Samples are filed or returned by SASE if requested by artist. Reports back within 2 weeks. Call or write for appointment to show portfolio or mail appropriate materials. Pays for design by the project, $500-10,000. Pays for illustration by the project, $500-40,000. Negotiates rights purchased.

GLUCKMAN DESIGN OFFICE, INC., 24 E. Pkwy., Scarsdale NY 10583. (914)723-0088. Fax: (914)472-9854. President: Eric Gluckman. Estab. 1973. Specializes in special interest magazines, corporate identity, direct mail, publications, industrial advertising and promotion, corporate capability brochures and sales promotion (trade) for mostly industrial accounts. "We are a 'general practice' design firm. We usually deal directly with client." Current clients include: Brennan Communications, RJG Inc., NDR Industries
Needs: Works with 20 freelance artists/year. Artists should have 3 years of experience minimum. "All rights to art and photography revert to client." Works on assignment only. Uses artists for brochures, direct mail packages, posters, charts/graphs, lettering, logos and ad design and illustration; mechanicals; retouching; airbrushing. Prefers pen & ink and acrylics. Needs computer-literate freelancers for design and production. 50% of freelance work demands knowledge of Aldus PageMaker, Adobe Illustrator or QuarkXPress. Needs editorial, technical and product illustration.
First Contact & Terms: Send query letter with résumé and samples to be kept on file. No slides as samples. Samples not kept on file returned by SASE. Request portfolio review in original query. Artist should follow up with call. Art Director will contact artist for portfolio review if interested. Pays for design by the hour, $20-50; by the project, $200-2,000. Pays for illustration by the project, $100-5,000. Buys all rights. Considers buying second rights (reprint rights) to previously published artwork.
Tips: Finds artists "by published work and direct mail sent to me. Be professional, make deadlines. Send samples of published artwork, examples of camera ready art and one project from concept to finish (to show thought process). Do not show school projects or material five years old, unless it was an award winner."

■**GODAT/JONCZYK DESIGN CONSULTANTS**, 807 S. 4th Ave., Tucson AZ 85701-2701. (602)620-6337. Partners: Ken Godat and Jeff Jonczyk. Estab. 1983. Specializes in annual reports, marketing communications, publication design and signage. Clients: corporate, retail, institutional, public service. Current clients include Weiser Lock, Rain Bird, IBM and University of Arizona.
Needs: Works with 6-8 freelance designers/year. Freelancers should be familiar with Aldus PageMaker, Aldus FreeHand, Photoshop or Adobe Illustrator. Needs editorial and technical illustration.
First Contact & Terms: Send query letter with samples. Samples are filed. Request portfolio review in original query. Art Director will contact artist for portfolio review if interested. Pays for design by the hour, $15-40 or by the project. Pays for illustration by the project.
Tips: Finds artists through sourcebooks.

GOTTLEIB COMMUNICATIONS, Suite 505, 25 S. Ewing St., Helena MT 59601. Phone/Fax: (406)449-4127. President: Michael Gottleib. Estab. 1979. Specializes in annual reports, corporate identity and collateral, corporate communication programs, strategic planning and marketing and graphics and posters for the sport of Lacrosse. Clients: corporations. Current clients include Sierra Ventures Management Company, D.W. Beary & Associates, Inc., Valley Bank. Client list available upon request. Recently relocated to Montana after 12 years in San Francisco.
Needs: Approached by 12 freelance artists/year. Works with 2 illustrators and 3 designers/year. Prefers local artists only. Works on assignment only. Uses freelance illustrators mainly for spot illustrations. Also uses freelancers for brochure design and illustration, mechanicals, airbrushing, logos and computer design. Needs computer-literate freelancers for design and production. 75% of freelance work demands knowledge of Aldus PageMaker or Adobe Illustrator. Needs editorial illustration.
First Contact & Terms: Send query letter with brochure and résumé. Samples are filed. Reports back to the artist only if interested. Call for appointment to show portfolio of thumbnails, roughs, color original/final art. Pays for design by the hour, $15-35. Pays for illustration by the hour, $15-35; by the project, $200-1,000. Buys one-time rights. Negotiates rights purchased.

GRAPHIC ART RESOURCE ASSOCIATES, 257 W. 10th St., New York NY 10014-2508. (212)929-0017. Fax: (212)929-0017. Owner: Robert Lassen. Estab. 1980. "Provides full range of graphic communications services, including design, editorial, photographic, pre-press and print production, advertising agency and overall graphic communications support." Clients: academia, corporations, institutions and organizations. Current clients include Lopat Enterprises, Disability Income Services, Brooklyn Law School and New York University. Client list "is always in flux."

Needs: Approached by "at least" 60 freelance artists/year. "Traditional freelance artists, for the most part, are being replaced by computerized services because of greater predictability and control of results, speed, price and availability of computerized pre-press. Illustrators, if used, are to provide effects not obtainable through photographic or computerized means."

First Contact & Terms: "Usually work within already established relationships. Rarely, if ever, work with artists more than 50 miles from New York for quality control reasons, although exceptions are made in the case of photographers. Call first. Do not send samples unless asked to do so." Art Director will contact artist for portfolio review if interested. "Usually, appointments are available if we are interested." Pays for design and illustration by the project, $150 maximum. All fees are negotiated. "We do not deal with reps." Considers buying second rights (reprint rights) to previously published artwork.

Tips: Finds artists through self-promotions and sourcebooks. The CEO of this company believes art design will become "mostly budget driven and virtually all computerized. There will be more type, less illustration, photos from high res video, more inhouse and less freelance work.

GRAPHIC DATA, 5111 Mission Blvd., P.O. Box 99991, San Diego CA 92169. (619)274-4511. Fax: (619)274-4511; call first. President: Carl Gerle. Estab. 1971. Specializes in industrial design. Clients: industrial and publishing companies. Client list available upon request.

Needs: Approached by 20 freelance artists/year. Works with 6 sculptors and 4 designers/year. Prefers sculptors and designers with interest in using computer design systems. Works on assignment only. Uses illustrators mainly for architectural, landscape and technical drawing. Uses designers mainly for architectural and publication design. Needs sculptors and designers for miniature gameboard figurines. 60% of freelance work demands computer skills.

First Contact & Terms: Send query letter with brochure, résumé or photostats. Samples are returned if SASE included. Request portfolio review in original query. Sometimes requests work on spec before assigning job. Pays for design and sculpture by the project, $100-1,000 plus royalties. Rights purchased vary according to project.

GRAPHIC DESIGN CONCEPTS, Suite 2, 4123 Wade St., Los Angeles CA 90066. (310)306-8143. President: C. Weinstein. Estab. 1980. Specializes in package, publication and industrial design and annual reports, corporate identity, displays and direct mail. "Our clients include public and private corporations, government agencies, international trading companies, ad agencies and PR firms." Current projects include new product development for electronic, hardware, cosmetic, toy and novelty companies.

Needs: Works with 15 illustrators and 25 designers/year. "Looking for highly creative idea people, all levels of experience." All styles considered. Uses illustrators mainly for commercial illustration. Uses designers mainly for product and graphic design. Also uses freelancers for brochure, P-O-P, poster and catalog design and illustration; book, magazine, direct mail and newspaper design; mechanicals; retouching; airbrushing; model making; charts/graphs; lettering; logos. Needs computer-literate freelancers for design, illustration, production and presentation. 25% of freelance work demands knowledge of Aldus PageMaker, Adobe Illustrator, QuarkXPress, Photoshop or Aldus FreeHand.

First Contact & Terms: Send query letter with brochure, résumé, tearsheets, photostats, photocopies, slides, photographs and/or transparencies. Samples are filed or are returned if accompanied by SASE. Reports back within 10 days with SASE. Portfolio should include thumbnails, roughs, original/final art, final reproduction/product, tearsheets, transparencies and references from employers. Pays for design by the hour, $15 minimum. Pays for illustration by the hour, $50 minimum. Considers complexity of project, client's budget, skill and experience of artist, how work will be used, turnaround time and rights purchased when establishing payment.

Tips: "Send a résumé if available. Send samples of recent work or *high quality* copies. Everything sent to us should have a professional look. After all, it is the first impression we will have of you. Selling artwork is a business. Conduct yourself in a business-like manner."

APRIL GREIMAN, INC., Suite 211, 620 Moulton Ave., Los Angeles CA 90031. (213)227-1222. Fax: (213)227-8651. Design Director: Lorna Turner. Estab. 1980. Specializes in corporate identity, environmental design, publication design, signage. Clients: international corporations, museums, retail and universities. Current clients include: Xerox, MCA, MOMA, Vitra, CBS, Letraset. Client list available upon request.

Needs: Approached by 200 artists/year. Works with 1-4 designers/year. Prefers artists with experience in computers, especially Macintosh. Uses freelance artists for brochure, ad, P-O-P, poster and catalog design and illustration; mechanicals; retouching; airbrushing; lettering; logos; book, magazine direct mail, environmental and newspaper design; model making; charts/graphs; AV materials. Needs architectural illustration. Needs computer-literate freelancers for design, production and presentation. 100% of freelance work demands knowledge of Aldus PageMaker, Quark XPress, Aldus FreeHand and Adobe Illustrator.

Always enclose a self-addressed, stamped envelope (SASE) with queries and sample packages.

First Contact & Terms: Send query letter with résumé and SASE. Samples are filed. Reports back to the artist only if interested. To show portfolio, mail appropriate materials. Payment for design varies.
Tips: All illustration now done inhouse.

HAMMOND DESIGN ASSOCIATES, INC., 206 W. Main, Lexington KY 40507. (606)259-3639. Fax: (606)259-3697. Vice-President: Mrs. Kelly Johns. Estab. 1986. Specializes in direct mail, package and publication design and annual reports, brand and corporate identity, display and signage. Clients: corporations, universities and medical facilities. Client list not available.
Needs: Approached by 35-50 freelance artists/year. Works with 7 illustrators/year. Works on assignment only. Uses illustrators mainly for brochures and ads. Also uses freelancers for editorial, technical and medical illustration and airbrushing, lettering, P-O-P and poster illustration and charts/graphs. 15% of freelance work demands knowledge of Aldus FreeHand.
First Contact & Terms: Send query letter with brochure or résumé. "Sample in query letter a must." Samples are filed or returned by SASE if requested by artist. Reports back only if interested. Art Director will contact artist for portfolio review if interested. Sometimes requests work on spec before assigning job. Pays by the project, $100-10,000. Rights negotiable.

HARRISON DESIGN GROUP, 665 Chestnut St., San Francisco CA 94133. (415)928-6100. Fax: (415)673-0243. Estab. 1980. Specializes in collateral, brand and corporate identity, visual merchandising, package design and signage. Clients: Bay area corporations and businesses, some nonprofits. Current clients include Levi Strauss & Co., Bank of America, Williams-Sonoma and Pacific Telesis. Client list available upon request.
Needs: Approached by 500 freelance artists/year. Works with 20 illustrators and 5 designers/year. Prefers artists with experience in "strong, dramatic images, very sophisticated." Uses illustrators mainly for annual reports and brochures, architectural renderings and computer illustration. Uses designers mainly for project management (all projects), including identity and packaging. Also for brochure and magazine design, lettering, logos, charts/graphs and audiovisual material. Needs editorial and technical illustration and b&w or color line art. Needs computer-literate freelancers for design, illustration, production and presentation. 100% of freelance work demands knowledge of Aldus PageMaker, QuarkXPress, Aldus FreeHand, Adobe Illustrator, Photoshop, also Microsoft Word.
First Contact & Terms: Send query letter with résumé, tearsheets, photographs and photocopies. Samples are filed. Reports back within 3 weeks. Art Director will contact artist for portfolio review if interested. Portfolios may be dropped off any day. Portfolio should include thumbnails, roughs, finished art samples, b&w or color photostats, tearsheets, photographs, slides or transparencies. Pays for design by the project, $300-5,000. Pays for illustration by the project, $200-8,000. Negotiates rights purchased.

‡HARTUNG & ASSOCIATES, LTD., 10279 Field Lane, Forestville CA 95436. (707)887-2825. Fax: (707)887-1214. President: Tim Hartung. Estab. 1976. Specializes in display, direct mail, package and publication design and corporate identity and signage. Clients: corporations. Current clients include Zacson, Crown Transportation, Rand McNally, Readers Digest International Video Network, Exigent, IBM, AT&T. Client list available upon request.
Needs: Approached by 20 freelance graphic artists/year. Works with 5 freelance illustrators and 1 freelance designer/year. Prefers local artists "if possible." Works on assignment only. Uses illustrators and designers mainly for brochures. Also uses freelance artists for brochure and package design and illustration, direct mail design, P-O-P illustration and design, mechanicals, retouching, airbrushing, audiovisual materials, lettering, logos and charts/graphs. 50% of freelance work demands knowledge of QuarkXPress or Adobe Illustrator.
First Contact & Terms: Send query letter with brochure, tearsheets and résumé. Samples are filed. Does not report back. Artist should follow up with call. Portfolio should include b&w and color thumbnails, roughs, final art, photostats and tearsheets. Pays for design by the hour or by the project. Pays for illustration by the project. "Rate depends on size, detail, etc. of project." Buys all rights.
Tips: Finds artists through sourcebooks and artists' submissions.

MARK HEIDEMAN GRAPHIC DESIGN, 9301 Brunson Run, Indianapolis IN 46256. (317)845-4064. Contact: Mark Heideman. Estab. 1985. Specializes in display, direct mail, package and publication design and annual reports, brand identity, corporate identity, signage and technical illustration. Clients: technical and industrial.
Needs: Works with 3 illustrators/year. Works with 2 designers/year. Works on assignment only. Uses artists for brochure, catalog, P-O-P, and poster illustration. Needs computer-literate freelancers for design, illustration, production and presentation. 95% of freelance work demands knowledge of Adobe Illustrator, QuarkXPress or photoshop. Needs editorial and technical illustration.
First Contact & Terms: Send query letter. Samples are filed. Art Director will contact artist for portfolio review if interested. Portfolio should include thumbnails, roughs, original/final art, final reproduction/product and tearsheets. Sometimes requests work on spec before assigning job. Pays for design by the project, $100 minimum. Pays for illustration by the project, $100-2,000. Considers client's budget, skill and experience of artist and turnaround time when establishing payment. Buys all rights; rights purchased vary according to project.

THOMAS HILLMAN DESIGN, 193 Middle St., Portland ME 04101. (207)773-3727. Design Director: Thomas Hillman. Estab. 1984. Specializes in annual reports, corporate identity and package and publication design. Clients: businesses and corporations.
Needs: Approached by 30-50 freelance artists/year. Works with 10-20 illustrators/year. Prefers local artists with experience in illustration. Works on assignment only. Uses illustrators mainly for collateral. Also for medical, technical and editorial illustration and brochure, catalog and poster design. Needs computer-literate freelancers for illustration. 50% of freelance work demands knowledge of Aldus FreeHand or Aldus Illustrator.
First Contact & Terms: Send query letter with tearsheets and photocopies. Samples are filed or are returned by SASE if requested by artist. Reports back only if interested. To show portfolio, call or mail tearsheets and copies. Pays for illustration by the hour, $30-50; by the project, $100-2,500. Rights purchased vary according to project.
Tips: "Our needs are growing."

■**DAVID HIRSCH DESIGN GROUP, INC.**, Suite 622, 205 W. Wacker Dr., Chicago IL 60606. (312)329-1500. President: David Hirsch. Specializes in annual reports, corporate identity, publications and promotional literature. Clients: manufacturing, PR, real estate, financial and industrial firms.
Needs: Works with over 30 freelance artists/year. Uses artists for design, illustrations, brochures, retouching, airbrushing, AV materials, lettering, logos and photography. Needs technical, editorial and spot illustration.
First Contact & Terms: Send query letter with promotional materials showing art style or samples. Samples not filed are returned by SASE. Reports only if interested. Call for appointment to show portfolio of roughs, final reproduction/product, tearsheets and photographs. Pays for design and illustration by the project. Considers complexity of project, client's budget and how work will be used when establishing payment. Interested in buying second rights (reprint rights) to previously published work.
Tips: Finds artists primarily through source books and self-promotions. "We're always looking for talent at fair prices."

‡**HJERMSTAD AND ASSOCIATES**, # 330, 665 Third St., San Francisco CA 94107. (415)974-3646. Fax: (415)974-6577. Art Director: Patria Hjermstad. Estab. 1981. Specializes in corporate and event identity, direct mail and package design. Clients: corporate, nonprofit, national charities, wholesale, manufacturers. Current clients include: March of Dimes, Commonwealth Club of California, S.F. Conservatory of Music. Client list available upon request.
Needs: Approached by "nearly a hundred" freelance graphic artists/year. Works with 6 freelance illustrators and designers/year. Prefers local artists only. Works on assignment only. Uses freelance artists for brochure design and illustration, mechanicals, airbrushing, lettering, ad illustration and charts/graphs. Needs computer-literate freelancers for production and presentation. 50% of freelance work demands knowledge of Aldus PageMaker or QuarkXPress.
First Contact & Terms: Send query letter with brochure and résumé. Samples are filed or are returned. Reports back to the artist only if interested. Art Director will contact artist for portfolio review if interested. Portfolio should include "no more than 10 items of best work." Pays for design and illustration by the hour, $75-100; by the project, $50-75. Rights purchased vary according to project.
Tips: Finds artists through word of mouth and "seeing their work published."

‡**BARRY HOWARD LIMITED**, 29350 Pacific Coast Hwy., Malibu CA 90265. (310)457-1516. Fax: (310)457-6903. Project Manager: Patti Drum. Estab. 1985. Specializes in display design and design. Clients: museums, visitor centers, attractions, expo pavilions. Current clients include Hollywood Entertainment Museum, Steamtown National Historic Site.
Needs: Approached by 5 freelance graphic artists/year. Works with 5 freelance illustrators and 10 freelacne designers/year. Prefers artists with experience in 3-D display/exhibit design. Uses illustrators for storyboards. Uses designers for all facets. Also uses freelance artists for mechanicals, model making, audiovisual materials and logos. Needs computer-literate freelancers design, production and presentation. 50% of freelance work demands knowledge of Aldus PageMaker, QuarkXPress, Aldus FreeHand, Adobe Illustrator or Adobe Photoshop.
First Contact & Terms: Send query letter with brochure and résumé. Samples are filed or returned if requested. Reports back within 30 days. Artist should follow up with letter after initial query. Portfolio should include "whatever is appropriate." Pays for design and illustration by the hour, $15-35. Rights purchased vary according to project.
Tips: Finds artists "usually through word-of-mouth, through some 'technical aid' firms, through artists' submissions."

THE HOYT GROUP, INC., Box 928, Woodstock NY 12495. President: Earl Hoyt. Specializes in corporate identity and packaging, and develops package structures. Clients: Fortune 500 firms.
Needs: Works with 5-10 freelance artists/year. Seeks experienced professionals. Works on assignment only. Uses artists for editorial illustration, design, Mac computer work, mechanicals, airbrushing, model making, lettering and logos.

First Contact & Terms: Send brochure to be kept on file. Send reproductions only as samples—no original art. Art Director will contact artist for portfolio review if interested. Pays for design and illustration by the project, $200-2,000. Considers client's budget, and skill and experience of artist when establishing payment.
Tips: Finds artists through word of mouth and artists' submissions/self-promotions. "Technical advantage of computer layouts will change the profession and attract less artistic people, flooding the field with 'instant' designers. 'Thinking' may be the best defense against technical competence (clients do not know the difference but the artist will)."

HULSEY GRAPHICS, P.O. Box 2981, Gainesville GA 30503. (404)534-6624. Fax: (404)536-6858. President: Clay Hulsey. Estab. 1989. Specializes in annual reports; brand and corporate identity; and direct mail, package and publication design. Clients: advertising agencies, banks, colleges, hospitals, corporations, real estate. Current clients include: Northeast Georgia Medical Center, First National Bancorp, Pittman Dental Laboratories. Client list not available.
Needs: Approached by 17 freelance artists/year. Works with 2 illustrators and 5 designers/year. Prefers local artists with experience in airbrush. Works on assignment only. Uses illustrators and designers mainly for overload work, airbrushing and editorial and technical illustration. Also for brochure, catalog, direct mail, ad and newspaper design; brochure, catalog and ad illustration; mechanicals; retouching; airbrushing; lettering; logos; and charts/graphs. Needs computer-literate freelancers for design and production. 25% of freelance work demands knowledge of QuarkXPress or Aldus FreeHand.
First Contact & Terms: Send query letter with brochure, résumé, tearsheets and non-returnable samples. Samples are filed. Art Director will contact artist for portfolio review if interested. Pays for design and illustration by the hour, $25-40; by the project, $100 minimum. Rights purchased vary according to project.
Tips: Finds artists through word of mouth and artists' submissions. "Send non-returnable samples that can be filed. I will contact the freelancer when I have a project that goes with his/her style or qualifications."

ELLIOT HUTKIN INC., 2253 Linnington Ave., Los Angeles CA 90064. (310)475-3224. Fax: (310)446-4855. Art Director: Elliot Hutkin. Estab. 1982. Specializes in publication design. Clients: corporations and publishers. Current projects include: corporate and travel magazines, miscellaneous corporate publications. Current clients include Xerox Corporation and International Destinations, Inc.
 ● Elliot Hutkin says that computer generated work is up (to 99%); "client-driven" quality is down (client doesn't care; quality exists only with individual designer); fees and income expectation (of freelancers) are down.
Needs: Works with 10 illustrators and 1 designer/year. Works on assignment only. Uses freelancers mainly for editorial illustration. Also for retouching, airbrushing, charts/graphs, lettering and logos. Style is eclectic. Needs computer-literate freelancers for illustration and production. 50% of freelance work demands computer knowledge. "We can work with any program, any system."
First Contact & Terms: Send tearsheets, photocopies and photographs. Samples are filed or are returned by a SASE. Art Director will contact artist for portfolio review if interested. Pays for design by the project, $100; Pays for illustration by the project, $50-5,000. Fee is for first use and retention of art and reprint usage with credit. Additional fee paid for other use. Interested in buying second rights (reprint rights) to single panel cartoons.
Tips: Finds artists through sourcebooks, "cold-call" mailings, published work. "Send samples of work in 8½×11 or 9×12 page format (I file them by style in 3-ring binders). Include *all* styles and b&w. " Provide fax number if available.

‡IDC, Box 312, Farmington CT 06034. (203)678-1111. Fax: (203)793-0293. President: Dick Russell. Estab. 1960. Specializes in industrial design. Clients: corporations. Client list not available.
Needs: Approached by 50 freelance industrial designers/year. Works with 15 freelance designers/year. Prefers local designers. Uses designers mainly for product design. Also uses freelance designers for model making and industrial design. Needs computer-literate freelancers for design. 50% of freelance work demands knowledge of CADKey.
First Contact & Terms: Send résumé. Reports back to the artist only if interested. Artist should follow up with call after initial query. Art Director will contact artist for portfolio review if interested. Portfolio should include thumbnails and roughs. Pays for design by the hour.

IDENTITY CENTER, Suite S, 1340 Remington Rd, Schaumburg IL 60173. President: Wayne Kosterman. Specializes in brand and corporate identity, print communications and signage. Clients: corporations, hospitals, manufacturers and banks.
Needs: Works with 6-10 freelance artists/year. Prefers 3-5 years of experience minimum. Uses artists for editorial and technical illustration, mechanicals, retouching and lettering. Needs computer-literate freelancers for design, illustration and production. 50% of freelance work demands knowledge of QuarkXPress and Adobe Illustrator.
First Contact & Terms: Send résumé and photocopies. Samples are filed or are returned. Reports back within 1 week. To show a portfolio, mail photostats and photographs. Pays for design by the hour, $12-35. Pays for illustration by the project, $200-5,000. Considers client's budget, skill and experience of artist and

INSIDER REPORT

Pro Bono: When Doing Good Is Good for You

Some designers grumble when nonprofit organizations ask for donated design services. They see such requests as a drain on their time and talents. Lori Siebert, president and creative director of Cincinnati's Siebert Design Associates, sees things in a different light. Like many successful designers, Siebert knows that pro bono projects offer creative freedom, and a chance to network—and they're the kind of projects that win awards and generate great publicity.

Lori Siebert

Fresh from the University of Cincinnati's College of Design, Art, Architecture and Planning, with dreams of one day opening her own studio, Siebert was so enthusiastic about design she took advantage of every opportunity to stretch her talents.

One of her first pro bono assignments was a brochure for a new arts organization which was distributed through Cincinnati's museum shops. Siebert's cutting edge layout caught the eye of the publicity director of another nonprofit group, who asked her to design their annual report. While producing it, Siebert worked with members of the business community, who were impressed with her talent and recommended her to paying clients.

While working fulltime as art director for *Visual Merchandising & Store Design*, Siebert built a substantial freelance client list. Though she had estimated it would take five to ten years, Siebert developed a strong enough client base to open her own studio just three years after graduation. Siebert credits the support and advise of her accountant father as well as the interest generated from pro bono work with helping her reach her goals ahead of schedule.

When a pro bono project works well it's a win/win situation for everyone involved. The printer, paper company and designer have a wonderful printed piece to show off, and the nonprofit organization saves money on promotional costs. Follow these guidelines for a successful collaboration.

Be selective. Pro bono work should take up no more than 10-15% of your time, so only work with organizations you believe in, on projects that inspire you. Whenever possible, choose work that will round out your portfolio, or that will show off new capabilities to clients.

Put everything in writing. Make sure the organization knows what is expected of it and what is expected of you. If you want creative control, explain up front it's one of your conditions for accepting the work. Agree on who is responsible for copy and proofreading and set deadlines. Choose one person as liaison for

the organization to prevent design-by-committee.

Barter whenever possible. In exchange for work, Siebert received voice lessons, opera tickets, and a singing group performed at a party for her clients.

Ask that materials be provided. "I used to beg materials and printing services from paper companies and printers, but I stopped because it gives you the reputation of being the one who is always asking for a favor," says Siebert. Give your pro bono clients the specs on the kind of paper you need and recommend printers and paper companies they can approach to ask for donated services.

Enter competitions. Do your best work on your pro bono assignments and then enter them in design competitions. *HOW* magazine prints a chart of competitions and their deadlines every year in the November/December issue.

Know the difference between pro bono and "on spec" work. Pro bono refers to a donation to a cultural or social cause. "On spec" is something completely different, although it, too, implies service for free. Often a prospective paying client will ask you to produce work "on speculation" before deciding to buy. Siebert will not do work "on spec," a practice discouraged by the American Institute of Graphic Artists. "Would you ask a Roto-Rooter man to snake your pipes first and then decide whether or not to pay him?" asks Siebert.

Send an itemized statement. List all donated time and services and what they would cost a paying client. In this way, Siebert says, the pro bono client will realize the value of your gift.

—*Mary Cox*

Even with a busy schedule filled with corporate clients, Siebert's 9-person design team allocates time to support nonprofit organizations like Ensemble Theatre of Cincinnati. Using energetic illustrations and high contrast, this 2-color design, done pro bono, was effective while saving printing costs. The illustrator and printer discounted their regular prices for the project.

Reprinted with permission of Siebert Design Associates, Cincinnati, Ohio

how work will be used when establishing payment. Rights purchased vary according to project.
Tips: "Not interested in amateurs or 'part-timers.'"

INNOVATIVE DESIGN & GRAPHICS, Suite 214, 1234 Sherman Ave., Evanston IL 60202-1375. (708)475-7772.
Contact: Tim Sonder. Clients: magazine publishers, corporate communication departments, associations.
Needs: Works with 3-15 freelance artists/year. Prefers local artists only. Uses artists for editorial and techni-
cal illustration and desktop (Corel, Freehand, Illustrator).
First Contact & Terms: Send query letter with résumé or brochure showing art style, tearsheets, photostats,
slides and photographs. Art Director will contact artist for portfolio review if interested. Pays for illustration
by the project, $100-700 average. Considers complexity of project, client's budget and turnaround time when
establishing payment. Interested in buying second rights (reprint rights) to previously published work.
Tips: "Interested in meeting new illustrators, but have a tight schedule. Looking for people who can grasp
complex ideas and turn them into high-quality illustrations. Ability to draw people well is a must. Do not
call for an appointment to show your portfolio. Send non-returnable tearsheets or self-promos, and we will
call you when we have an appropriate project for you."

‡INTELPLEX, 12215 Dorsett Rd., Maryland Heights MO 63043. (314)739-9996. Owner: Alan E. Sherman.
Estab. 1953. Specializes in corporate identity, display design and package design and signage. Clients: manu-
facturers. Current clients include SLM Corp., Quickpoint, Rubbermaid. Client list not available.
Needs: Works with 3 freelance designers/year. "We prefer persons with a good grasp of technical issues."
Works on assignment only. Uses illustrators mainly for product illustration. Also uses freelance artists for
catalog design and illustration, mechanicals, airbrushing, logos and ad design. Needs computer-literate free-
lancers for design and production. 50% of freelance work demands knowledge of QuarkXPress or AutoCAD.
First Contact & Terms: Send query letter. Samples are filed or are returned. Does not report back. Art
Director will contact artist for portfolio review if interested. Portfolio should include final art. Pays for design
and illustration by the project. Buys all rights.
Tips: Finds artists through submissions and references.

PETER JAMES DESIGN STUDIO, Suite 203, 7520 NW Fifth St., Plantation FL 33317. (305)587-2842. Fax:
(305)587-2866. Creative Director: Jim Spangler. Estab. 1980. Specializes in business-to-business advertising,
package design, direct mail advertising and corporate identity. Clients: manufacturers, corporations and
hospitality companies. Client list available upon request.
Needs: Approached by dozens of freelance artists/year. Works with 6 freelance art directors and designers/
year. Prefers local artists with 7 years experience minimum in corporate design. Also uses artists for technical,
editorial and graphic illustration and mechanicals, retouching, airbrushing, lettering and logo design. Needs
computer-literate freelancers for design, illustration and production. 25% of freelance work demands knowl-
edge of Aldus PageMaker, QuarkXPress, Aldus FreeHand, Adobe Photoshop or Adobe Illustrator.
First Contact & Terms: Send query letter with samples, tearsheets, photocopies and résumé. Samples are
filed or are returned by SASE if requested by artist. Art Director will contact artist for portfolio review if
interested. Pays for inhouse design by the hour, $15-50. Pays for illustration by the project, $50-1,500. Rights
purchased vary according to project. Considers buying second rights (reprint rights) to previously published
work.
Tips: Finds artists through word of mouth, magazines, artists' submissions/self-promotions, sourcebooks and
agents. Jim Spangler thinks "electronic artwork and design will continue to evolve. . . hopefully to be less
mechanical and more inspired."

JENSEN COMMUNICATIONS GROUP, INC., 145 Sixth Ave., New York NY 10013. (212)645-3115. Fax:
(212)645-6232. Designer/Production Manager: Ken Echevarnia. Estab. 1986. Specializes in annual reports,
corporate identity, corporate communications and publication design. Clients: Fortune 50 corporations. Cur-
rent clients include Pepsi Co., Philip Morris, Warner-Lambert Co. and IBM. Client list available upon
request.
Needs: Approached by 300-400 freelance artists/year. Works with 10-15 illustrators, 10-15 photographers
and 3-4 designers/year. Works on assignment only. Uses illustrators, photographers and designers mainly for
corporate communications: brochure, magazine and poster design; brochure and poster illustration; editorial,
technical and corporate illustration mechanicals; model making and audiovisual materials. Needs computer-

How to Use Your Artist's & Graphic Designer's Market *offers
suggestions for understanding and using the information
in these listings. Read this and other articles in the front of
this book for important business tips.*

literate freelancers for design, illustration and production. 100% of freelance work demands knowledge of QuarkXPress, Aldus FreeHand or Photoshop.

First Contact & Terms: Send query letter with résumé and tearsheets. Samples are filed and are not returned. Art Director will contact artist for portfolio review if interested. Pays for design and illustration by the project, $250-50,000. Rights purchased vary according to project.

Tips: Finds artists through work of mouth, mailings and sourcebooks. "Problem-solving skills are as important as technical/artistic skills."

■**JEWELITE SIGNS, LETTERS & DISPLAYS, INC.,** 106 Reade St., New York NY 10013. (212)233-1900. Fax: (212)233-1998. Vice President: Bobby Bank. Produces signs, letters, silk screening, murals, handlettering, displays and graphics. Current clients include Transamerica, Duggal Labs, Steve Horn and MCI.

Needs: Approached by 15+ freelance artists/year. Works with 12 artists/year. Assigns 20+ jobs to freelancers/year. Works on assignment only. Uses artists for handlettering, walls, murals, signs, interior design, architectural renderings, design consulting and model making. 80% of freelance work demands computer skills. Prefers airbrush, lettering and painting.

First Contact & Terms: Call or send query letter. Call for appointment to show portfolio of photographs. Pays for design and illustration by the project, $75 and up. Considers complexity of project and skill and experience of artist when establishing payment.

BRENT A. JONES DESIGN, 328 Hayes St., San Francisco CA 94102. (415)626-8337. Principal: Brent Jones. Estab. 1983. Specializes in corporate identity, brochure and advertising design. Clients: corporations, museums, book publishers, retail establishments. Current clients include San Francisco Symphony, Crown Point Press and the California Academy of Sciences. Client list available upon request.

Needs: Approached by 1-3 freelance artists/year. Works with 2 illustrators and 1 designer/year. Prefers local artists only. Works on assignment only. Uses illustrators mainly for renderings. Uses designers mainly for production. Also uses freelancers for brochure design and illustration, mechanicals, catalog illustration, charts/graphs and ad design and illustration. "Computer literacy a must." Needs computer-literate freelancers for production. 95% of freelance work demands knowledge of Aldus PageMaker, Quark XPress, Adobe Illustrator or Photoshop.

First Contact & Terms: Send query letter with brochure and tearsheets. Samples are filed and are not returned. Reports back within 2 weeks only if interested. Write for appointment to show portfolio of slides, tearsheets and transparencies. Pays for design by the hour, $15-25; or by the project. Pays for illustration by the project. Rights purchased vary according to project.

LARRY KERBS STUDIOS, 18-19 River Rd., Fair Lawn NJ 07410. (201)796-1119. Fax: (201)703-0559. Contact: Larry Kerbs or Jim Lincoln. Specializes in sales promotion design, ad work and placement, annual reports, corporate identity, publications and technical illustration. Clients: industrial, chemical, medical devices, insurance, travel, PR.

Needs: Works with 3 illustrators and 1 designer/month. New York, New Jersey and Connecticut artists only. Uses artists for direct mail, layout, illustration, technical art, paste-up and retouching for annual reports, trade magazines, product brochures and direct mail. Especially board mechanicals and type specification. Combines traditional and computer art. Needs computer-literate freelancers. Needs editorial and technical illustration. Looks for realistic editorial illustration, montages, 2-color and 4-color.

First Contact & Terms: Mail samples or call for interview. Prefers b&w line drawings, roughs and previously published work as samples. Provide brochures, business card and résumé to be kept on file for future assignments. No originals returned at job's completion. Pays by the hour, $20-25 for paste-up; $25-35 for comprehensive layout; $30-40 for design; negotiates payment by the project for illustration.

Tips: "Strengthen typographic knowledge and application; know production and printing in depth to be of service to yourself and to your clients."

LEIMER CROSS DESIGN, 140 Lakeside Ave., Seattle WA 98122. (206)325-9504. Fax: (206)329-9891. Partner: Dorothy Cross. Estab. 1982. Specializes in annual reports, publication design, marketing brochures. Clients: corporations and service companies. Client list not available.

Needs: Approached by 75 freelance artists/year. Works with 10-15 illustrators and 2-3 designers/year. Prefers artists with experience in working for corporations. Works on assignment only. Uses freelance illustrators

The solid, black square before a listing indicates that it is judged a good first market by the Artist's & Graphic Designer's Market editors. Either it offers low payment, pays in credits and copies, or has a very large need for freelance work.

mainly for annual reports, lettering and marketing materials. Uses freelance designers mainly for "layout per instructions," production. Also for brochure illustration, mechanicals, charts/graphs. "Mac/Aldus Pagemaker expertise a must."

First Contact & Terms: Send query letter with résumé, tearsheets and photographs. Samples are filed. Reports back to the artist only if interested. To show a portfolio, mail thumbnails, roughs, tearsheets and photographs. Pays for design by the hour or by the project. Pays for illustration by the project. Rights purchased vary according to project.

LEO ART STUDIO, INC., Suite 610, 276 Fifth Ave., New York NY 10001. (212)685-3174. Fax: (212)685-3170. Studio Manager: Lynn Johnson. Art Director: Robert Schein. Specializes in textile design for home furnishings. Clients: wallpaper manufacturers/stylists, glassware companies, furniture and upholstery manufacturers. Current clients include Burlington House, Blumenthal Printworks, Columbus Coated, Eisenhart Wallcoverings, Victoria's Secret, Town and Country, Fieldcrest-Cannon and Western Textile. Client list available upon request.

Needs: Approached by 25-30 freelance artists/year. Works with 1-2 illustrators and 10-15 designers/year. Prefers artists trained in textile field, not fine arts. Must have a portfolio of original art designs. Should be able to be in NYC on a fairly regular basis. Works both on assignment and speculation. Prefers realistic and traditional styles. Uses artists for design, airbrushing, coloring and repeats. "We are always looking to add fulltime artists to our inhouse staff (currently at 12). We will also look at any freelance portfolio to add to our variety of hands. Our recent conversion to CAD system may require future freelance assistance."

First Contact & Terms: Send query letter with résumé. Do not send slides. Request portfolio review in original query. "We prefer to see portfolio in person. Contact via phone is OK—we can set up appointments with a day or two's notice." Samples are not filed and are returned. Reports back within 5 days. Portfolio should include original/final art. Sometimes requests work on spec before assigning job. Pays for design by the project, $500-1,000. "Payment is generally two-thirds of what design sells for—slightly less if reference material, art material, or studio space is requested." Considers complexity of project, skill and experience of artist and how work will be used when establishing payment. Buys all rights.

Tips: "Do not call if you are not a textile artist. Artists must be able to put design in repeat, do color combinations and be able to draw well on large variety of subjects—florals, Americana, graphics, etc. We will look at student work and advise if it is correct field. We do very little fashion and clothing design."

LESIAK/CRAMPTON DESIGN INC., 600 N. McClurg, Chicago IL 60611. (312)751-8825. Fax: (312)751-9833. President: Lucy. Specializes in book design. Clients: educational publishers. Current clients include Harper Collins Publishers, Scott Foresman, Richard D. Irwin, National Text Book, South-Western Publishing, Wm. C. Brown, Mosby-Year Book. Client list available upon request.

Needs: Approached by 20 freelance artists/year. Works with 5-10 illustrators and 2-3 designers/year. Works on assignment only. Uses illustrators mainly for story or cover illustration, also editorial, technical and medical illustration. Uses designers mainly for text design. Also for book design, mechanicals and logos. Needs computer-literate freelancers for design, production and presentation. 70% of freelance work demands knowledge of Aldus PageMaker, QuarkXPress or Adobe Illustrator.

First Contact & Terms: Send query letter with photocopies. Samples are filed. Art Director will contact artist for portfolio review if interested. Portfolio should include final art, color tearsheets and transparencies. Pays for design by the hour, $30-50. Pays for illustration by the project, $30-3,000. Rights purchased vary according to project.

Tips: Finds artists through agents, sourcebooks and self-promotions.

LESLEY-HILLE, INC., 136 E. 57th St., New York NY 10022. (212)759-9755. President: Valrie Lesley. Specializes in annual reports, corporate identity, publications, advertising and sales promotion. Clients: nonprofit organizations, hotels, restaurants, investment, oil and real estate, financial and fashion firms.

Needs: Seeks "experienced and competent" artists. Uses freelancers for illustration, mechanicals, airbrushing, model making, charts/graphs, AV materials and lettering.

First Contact & Terms: Send query letter with résumé, business card and samples to be kept on file. Accepts "whatever best shows work capability" as samples. Samples not filed are returned by SASE. Reports only if interested. Call or write for an appointment to show portfolio. Payment varies according to project.

Tips: "Designers and artists must be *able to do* what they say they can and agree to do . . . professionally and on time!"

Market conditions are constantly changing! If you're still using this book and it is 1996 or later, buy the newest edition of Artist's & Graphic Designer's Market *at your favorite bookstore or order directly from Writer's Digest Books.*

‡**TOM LEWIS, INC.**, 13070 Viagrimaldi, Del Mar CA 92014. (619)481-7600. Fax: (619)481-3247. Contact: Nancy Cash. Estab. 1982. Specializes in annual reports, corporate identity and publication design. Clients: corporations, publishers. Current clients include Equifax, Miter, Realty Income Corp, Harper Collins Abrams, Harcort Brace & Co. Client list available upon request.
Needs: Approached by 50-60 freelance graphic artists/year. Works with 10 freelance illustrators/year. Uses illustrators mainly for corporate communication. Also uses freelance artists for brochure and ad illustration, poster and P-O-P design and lettering. Needs computer-literate freelancers for illustration and production. 90% of freelance work demands knowledge of Aldus PageMaker, QuarkXPress, Aldus FreeHand, Adobe Illustrator, Adobe Photoshop or 3-D programs.
First Contact & Terms: Send query letter with tearsheets. Samples are filed and are not returned. Reports back within 6 weeks. Art Director will contact artist for portfolio review if interested. Portfolio should include color final art, tearsheets, photographs and transparencies. Pays for illustration by the project, $100-10,000. Rights purchased vary according to project.
Tips: Finds artists through soucebooks, publications and artists' submissions.

LIEBER BREWSTER CORPORATE DESIGN, 324 W. 87 St., New York NY 10024. (212)874-2874. Principal: Anna Lieber. Estab. 1988. Specializes in annual reports, corporate identity, direct mail and package design, publications, exhibits, advertising and signage. Clients: publishing, nonprofits, corporate, financial, foodservice and retail. Client list available upon request.
Needs: Approached by 50 freelance artists/year. Works with 10 illustrators and 10 designers/year. Works on assignment only. Uses illustrators mainly for newsletter and computer illustration. Uses designers mainly for computer layout and comprehensives. Also uses freelancers for mechanicals, retouching, airbrushing, lettering, logos, direct mail design, charts/graphs, audiovisual materials. Needs computer-literate freelancers for design, illustration, production and presentation. 90% of freelance work demands knowledge of Adobe Illustrator, QuarkXPress, Photoshop or Aldus FreeHand. Needs editorial, technical, medical and creative color illustration.
First Contact & Terms: Send query letter with résumé, tearsheets and photocopies. Samples are filed. Art Director will contact artist for portfolio review if interested. Portfolio should include b&w and color work. Pays for design by the hour. Pays for illustration by the project. Rights purchased vary according to project.
Tips: Finds artists through promotional mailings.

LISTER BUTLER INC., 475 Fifth Ave., New York NY 10017. (212)951-6100. Fax: (212)481-0230. President/ Chief Operating Officer: Anita K Hersh. Estab. 1977. Specializes in brand and corporate identity, direct mail, information design, package and publication design and signage. Clients: US and international corporations. Current clients include AT&T, American Express, Citicorp, Nestlé, Kraft General Foods, Seagrams, Prudential-Bache, Chase Manhattan, Bell Atlantic, Ameritech, General Electric. Client list not available.
Needs: Works with 5 illustrators/year. Works on assignment only. Uses illustrators mainly for brochure and P-O-P illustration, mechanicals/electronic, retouching, airbrushing, model making, audiovisual materials and lettering. Needs computer-literate freelancers for design, illustration and production. 100% of freelance work demands expert knowledge of Aldus PageMaker, QuarkXPress, Aldus FreeHand, Adobe Illustrator or Photoshop.
First Contact & Terms: Send query letter with résumé, tearsheets, material that does not need to be returned. "Do not sent original work." Samples are sometimes filed and are not returned. Reports back within 1 month. Write for appointment to show portfolio or mail appropriate materials. Portfolio should include color tearsheets. Pays for design and illustration by the project. Clients buy all rights.

LORENC DESIGN, INC., 724 Longleaf Dr. NE, Atlanta GA 30342-4307. (404)266-2711. President: Mr. Jan Lorenc. Specializes in corporate identity, display, packaging, publication, architectural signage design and industrial design. Clients: developers, product manufacturers, architects, real estate and institutions. Current clients include Gerald D. Hines Interests, MCI, City of Raleigh NC, City of Birmingham AL, HOH Associates. Client list available upon request.
Needs: Approached by 25 freelance artists/year. Works with 5 illustrators and 10 designers/year. Local senior designers only. Uses freelancers for design, illustration, brochures, catalogs, books, P-O-P displays, mechanicals, retouching, airbrushing, posters, direct mail packages, model making, charts/graphs, AV materials, lettering and logos. Needs editorial and technical illustrations. Especially needs architectural signage designers. Needs computer-literate freelancers for design, illustration, production and presentation. 10% of freelance work demands knowledge of QuarkXPress or Aldus FreeHand.
First Contact & Terms: Send brochure, résumé and samples to be kept on file. Prefers slides as samples. Samples not kept on file are returned. Call or write for appointment to show portfolio, which should include thumbnails, roughs, original/final art, final reproduction/product and color photostats and photographs. Pays for design by the hour, $10-50; by the project, $100-10,000; by the day, $80-400. Pays for illustration by the hour, $10-50; by the project, $100-2,000; by the day, $80-400. Considers complexity of project, client's budget, and skill and experience of artist when establishing payment.
Tips: "Sometimes it's more cost-effective to use freelancers in this economy, so we have scaled down permanent staff."

JODI LUBY & COMPANY, INC., 808 Broadway, New York NY 10003. (212)473-1922. Fax: (212)473-2858. President: Jodi Luby. Estab. 1983. Specializes in corporate identity, promotion and direct mail design. Clients: magazines, corporations. Client list not available.

Needs: Approached by 10-20 freelance artists/year. Works with 2-5 illustrators/year. Prefers local artists only. Uses freelancers for brochure and catalog illustration, mechanicals, retouching and lettering. Needs computer-literate freelancers for production. 5% of freelance work demands computer skills.

First Contact & Terms: Send query letter with brochure, résumé, tearsheets and photocopies. Samples are not filed and are not returned. Art Director will contact artist for portfolio review if interested. Portfolio should include thumbnails, roughs, b&w and color printed pieces. Pays for design by the hour, $25 minimum; by the project, $100 minimum. Pays for illustration by the project, $100 minimum. Rights purchased vary according to project.

Tip: Finds artists through word of mouth.

JACK LUCEY/ART & DESIGN, 84 Crestwood Dr., San Rafael CA 94901. (415)453-3172. Contact: Jack Lucey. Estab. 1960. Art agency. Specializes in annual reports, brand and corporate identity, publications, signage, technical illustration and illustrations/cover designs. Clients: businesses, ad agencies and book publishers. Current clients include U.S. Air Force, TWA Airlines, California Museum of Art & Industry, Lee Books, High Noon Books. Client list available upon request.

Needs: Approached by 12 artists/year. Works with 2 designers/year. Uses mostly local artists. Uses artists for lettering for newspaper work. Uses freelancers mainly for type and airbrush.

First Contact & Terms: Query. Prefers photostats and published work as samples. Provide brochures, business card and résumé to be kept on file. Portfolio review not required. No originals returned to artist at job's completion. Requests work on spec before assigning job. Pays for design by the project.

‡SUDI MCCOLLUM DESIGN, 3244 Cornwall Dr., Glendale CA 91206. (818)243-1345. Fax: (818)243-1345. Contact: Sudi McCollum. Specializes in corporate identity and publication design. Majority of clients are small to mid-size business. "No specialty in any one industry." Clients: corporations and small businesses. Current clients include Babcock & Brown, Miracle Method, Pebble Beach Company, DUX.

Needs: Approached by a few graphic artists/year. Works with a couple of freelance illustrators and a couple of freelance designers/year. Works on assignment only. Uses designers mainly for assistance in production. Also uses artists for retouching, airbrushing, catalog, editorial and technical illustration and charts/graphs.

First Contact & Terms: Send query letter with "whatever you have that's convenient." Samples are filed. Reports back to the artist only if interested. Write or call to schedule an appointment to show a portfolio. Portfolio should include tearsheets and original/final art.

MACEY NOYES ASSOCIATES, INC., 232 Danbury Rd., Wilton CT 06897. (203)762-9002. Fax: (203)762-2629. Designer: Dee Cavitt. Estab. 1979. Specializes in package design. Clients: corporations (marketing managers, product managers). Current clients include Duracell, Hanes, BDF, Comstock Western. Majority of clients are retail suppliers of consumer goods.

Needs: Approached by 25 artists/year. Works with 2-3 illustrators and 5 designers/year. Prefers local artists only with experience in package comps, Macintosh and type design. Works on assignment only. Uses technical and product illustrators mainly for ad slick, in-use technical and front panel product. Uses designers for conceptual layouts and product design. Also uses freelancers for mechanicals, retouching, airbrushing, lettering, logos and industrial/structural design. Needs computer-literate freelancers for design, illustration and production. 40% of freelance work demands knowledge of QuarkXPress, Aldus FreeHand, Adobe Illustrator or Photoshop.

First Contact & Terms: Send query letter with résumé. Samples are filed or are returned by SASE if requested by artist. Reports back to the artist only if interested. Art Director will contact artist for portfolio review if interested. Portfolio should include thumbnails, roughs and transparencies. Pays for design by the hour, $18-40. Pays for illustration by the project, $100-2,500. Rights purchased vary according to project.

Tips: Finds new artists through sourcebooks and agents.

MCGUIRE ASSOCIATES, 1234 Sherman Ave., Evanston IL 60202. (708)328-4433. Fax: (708)328-4425. Owner: James McGuire. Estab. 1983. Specializes in annual reports, corporate identity, direct mail design, publication design and signage. Clients: ad agencies, direct with clients and marketing firms.

Needs: Works with 5 freelance illustrators/year. Prefers artists with experience in many areas of illustration. Works on assignment only. Uses illustrators mainly for brochure, newsletters and ads. Also for mechanicals. Needs computer-literate freelancers for design, illustration and production. 80% of freelance work demands knowledge of Adobe Illustrator, QuarkXPress or Photoshop. Needs editorial, technical and humorous illustration and "a wide range of possible needs."

First Contact & Terms: Send query letter with résumé, tearsheet, photostats, slides and photographs. Samples are filed. Samples not filed are returned only if requested by artist. Reports back only if interested. Call or write for appointment to show portfolio of b&w and color tearsheets, photostats, photographs and transparencies. Pays for design by the hour, $10-35. Pays for illustration by the project, $100-2,000. Considers

complexity of project, client's budget, skill and experience of artist and how work will be used when establishing payment. Rights purchased vary according to project.

Tips: Finds artists through word of mouth, magazines, artists' submissions/self-promotions, sourcebooks and agents. "Send samples of work to keep on file for reference. Do not take too long presenting your portfolio by including too many items."

‡MARKETING BY DESIGN, 2212 K St., Sacramento CA 95816. (916)441-3050. Creative Director: Joel Stinghen. Estab. 1977. Specializes in display, direct mail, package and publication design and annual reports, corporate identity and signage. Client: associations and corporations. Client list not available.

Needs: Approached by 50 freelance artists/year. Works with 6-7 freelance illustrators and 1-3 freelance designers/year. Works on assignment only. Uses illustrators mainly for editorial. Also uses freelance artists for brochure and catalog design and illustration, mechanicals, retouching, lettering, ad design and charts/graphs.

First Contact & Terms: Send query letter with brochure, résumé, tearsheets. Samples are filed or are not returned. Does not report back. Artist should follow up with call. Call for appointment to show portfolio of roughs, b&w photostats, color tearsheets, transparencies and photographs. Pays for design by the hour, $10-20; by the project, $50-5,000. Pays for illustration by the project, $50-4,500. Rights purchased vary according to project.

Tips: Finds designers through word of mouth; illustrators through sourcebooks.

DONYA MELANSON ASSOCIATES, 437 Main St., Boston MA 02129. Fax: (617)241-5199. Contact: Donya Melanson. Art agency. Clients: industries, institutions, education, associations, publishers, financial services and government. Current clients include: Hygienetics, Inc., The Seiler Corp., Cambridge College, American Psychological Association, Commonwealth of Massachusettes, Alliance to Save Energy and U.S. Dept. of Agriculture. Client list available upon request.

Needs: Approached by 30 artists/year. Works with 4-5 illustrators/year. Most work is handled by staff, but may occasionally use illustrators and designers. Uses artists for stationery design, direct mail, brochures/flyers, annual reports, charts/graphs and book illustration. Needs editorial and promotional illustration. Needs computer-literate freelancers for design, illustration and production. 50% of freelance work demands knowledge of Adobe Illustrator, QuarkXPress, Photoshop or Aldus FreeHand.

First Contact & Terms: Query with brochure, résumé, photostats and photocopies. Reports in 1-2 months. Provide materials (no originals) to be kept on file for future assignments. Originals returned to artist after use only when specified in advance. Call or write for appointment to show portfolio or mail thumbnails, roughs, final art, final reproduction/product and color and b&w tearsheets, photostats and photographs. Pays for design and illustration by the project, $100 minimum. Considers complexity of project, client's budget, skill and experience of artist and how work will be used when establishing payment.

Tips: "Be sure your work reflects concept development. We would like to see more electronic design and illustration capabilities."

‡MENON ASSOCIATES, 818 S. Travis, Sherman TX 75090. Phone/Fax: (903)893-8989. Owner: Das Menon. Estab. 1982. Specializes in brand and corporate identity, ergonomic and package design and technical illustration. Clients: corporations, businesses. Current clients include Texas Instruments, Southwestern Nameplates, Textile Supply Co., Douglas Distribution. Client list available upon request.

Needs: Approached by 4-6 graphic artists/year. Works with 1 freelance illustrator and 2 freelance designers/year. Prefers artists with minimum 6-8 years of experience. Works on assignment only. Uses illustrators mainly for product illustration. Uses designers for product design. 10% of freelance work demands knowledge of QuarkXPress, Aldus FreeHand or Adobe Illustrator.

First Contact & Terms: Send query letter with résumé and photocopies. Samples are filed. Reports back to the artist only if interested. Portfolio should include thumbnails, roughs and photostats. "Pay for design and illustration work will be negotiated." Buys all rights.

Tips: Finds artists through sourcebooks and references.

MG DESIGN ASSOCIATES INC., 824 W. Superior, Chicago IL 60622. (312)243-3661. Contact: Michael Grivas or design director. Specializes in trade show exhibits, museum exhibits, expositions and commercial interiors. Clients: industrial manufacturers, consumer-oriented product manufacturers, pharmaceutical firms, state and federal government, automotive parts manufacturers, etc.

Needs: Works with 4-6 freelance artists/year. Artists must be local exhibit designers with minimum of five years of experience. Works on assignment only. Uses freelancers for design, illustration, detail drawings and model making, graphic design and CAD.

First Contact & Terms: Send résumé, slides and photocopies to be evaluated. Samples not kept on file are returned only if requested. Write for appointment to show portfolio. Considers complexity of project, client's budget, and skill and experience of artist when establishing payment.

■MIRANDA DESIGNS INC., 745 President St., Brooklyn NY 11215. (718)857-9839. President: Mike Miranda. Estab. 1970. Specializes in "giving new life to old products, creating new markets for existing products,

and creating new products to fit existing manufacturing/distribution facilities." Deals in solving marketing problems, annual reports, corporate identity, direct mail, fashion, packaging, publications and signage. Clients: agencies, manufacturers, PR firms, corporate and retail companies. Current clients include Kings Plaza, Albee Square Mall, Greater New York Savings Bank, Little Things. Client list not available.

Needs: Approached by 30 freelance artists/year. Mainly uses freelancers for editorial, food, fashion and product illustration and design and mechanicals. Works with 20 illustrators and 5 designers/year; at all levels, from juniors to seniors, in all areas of specialization. Works on assignment only. Uses freelancers for catalog design and illustration; brochure, ad, magazine and newspaper design; mechanicals; model making; direct mail packages; and charts/graphs. Uses illustrators for editorial and product illustrations. Needs computer-literate freelancers for design, illustration, production and presentation. 60% of freelance work demands knowledge of Aldus PageMaker, QuarkXPress, Photoshop or Adobe Illustrator.

First Contact & Terms: Send query letter with résumé and photocopies. Samples are filed or are not returned. Art Director will contact artist for portfolio review if interested. Portfolio should include thumbnails, roughs, original/final art and final reproduction/product. Pays for design and illustration by the project, whatever the budget permits." Considers complexity of project, client's budget and skill and experience of artist when establishing payment. Rights purchased vary according to project. Considers buying second rights (reprint rights) to previously published work; depends on clients' needs.

Tips: Finds artists through artists' submissions/self-promotions, sourcebooks and agents. "Be professional. Show a variety of subject material and media."

MITCHELL STUDIOS DESIGN CONSULTANTS, 1111 Fordham Lane, Woodmere NY 11598. (516)374-5620. Fax: (516)374-6915. Principals: Steven E. Mitchell and E.M. Mitchell. Estab. 1922. Specializes in brand and corporate identity, displays, direct mail and packaging. Clients: major corporations.

Needs: Works with 20-25 freelance artists/year. "Most work is done in our studio." Uses artists for design, illustration, mechanicals, retouching, airbrushing, model making, lettering and logos. Needs computer-literate freelancers for design, illustration and production. 80% of freelance work demands computer skills. Needs technical illustration and illustration of food, people.

First Contact & Terms: Send query letter with brochure, résumé, business card, photostats, photographs and slides to be kept on file. Reports only if interested. Call or write for appointment to show portfolio of roughs, original/final art, final reproduction/product and color photostats and photographs. Pays for design by the hour, $25 minimum; by the project, $250 minimum. Pays for illustration by the project, $250 minimum.

Tips: "Call first. Show actual samples, not only printed samples. Don't show student work. Our need has increased—we are very busy."

MIZEREK DESIGN INC., (formerly Mizerek Advertising Inc.), 48 E. 43rd St., New York NY 10017. (212)986-5702. President: Leonard Mizerek. Estab. 1975. Specializes in catalogs, direct mail, jewelry, fashion and technical illustration. Clients: corporations—various product and service-oriented clientele. Current clients include: Rolex, Leslies Jewelry, World Wildlife, Fortune Magazine and Time Life.

Needs: Approached by 20-30 freelance artists/year. Works with 10 designers/year. Works on assignment only. Uses artists for design, technical illustration, brochures, retouching and logos. Needs computer-literate freelancers for illustration. 45-65% of freelance work demands knowledge of Macintosh.

First Contact & Terms: Send query letter with tearsheets and photostats. Art Director will contact artist for portfolio review if interested. Portfolio should include original/final art and tearsheets. Pays for design by the project, $500-5,000. Pays for illustration by the project, $500-3,500. Considers client's budget and turnaround time when establishing payment. Interested in buying second rights (reprint rights) to previously published work.

Tips: Finds artists through sourcebooks and self-promotions. "Let the work speak for itself. Be creative. Show commercial product work, not only magazine editorial. Keep me on your mailing list! The recession is increasing our use of freelancers."

STEWART MONDERER DESIGN, INC., Suite 112, 10 Thacher St., Boston MA 02113. (617)720-5555. Senior Designer: Robert Davison. Estab. 1982. Specializes in annual reports, corporate identity, package and publication design, employee benefit programs, corporate capability brochures. Clients: corporations (hi-tech, industry, institutions, health care, utility, consulting, service). Current clients include Aspen Technology, Vivo Software, Voicetek Corporation, Fidelity and Lesley College. Client list not available.

Needs: Approached by 200 freelance artists/year. Works with 5-10 illustrators and 1-5 designers/year. Works on assignment only. Uses illustrators mainly for corporate communications. Uses designers for design and production assistance. Also uses freelancers for mechanicals and illustration. Needs computer-literate freelancers for design, illustration and production. 50% of freelance work demands knowledge of Aldus PageMaker, Adobe Illustrator, QuarkXPress, Photoshop or Aldus FreeHand. Needs editorial and corporate illustration.

First Contact & Terms: Send query letter with brochure, tearsheets, photographs and photocopies. Samples are filed. Art Director will contact artist for portfolio review if interested. Portfolio should include b&w and color finished art samples. Sometimes requests work on spec before assigning job. Pays for design by the hour, $10-25; by the project. Pays for illustration by the project, $250 minimum. Negotiates rights purchased.

Tips: Finds artists through submissions/self-promotions and sourcebooks.

LOUIS NELSON ASSOCIATES INC., 80 University Place, New York NY 10003. (212)620-9191. Fax: (212)620-9194. President: Louis Nelson. Estab. 1980. Specializes in environmental, interior and product design and brand and corporate identity, displays, packaging, publications, signage, exhibitions and marketing. Clients: corporations, associations and governments. Current clients include Tennessee Aquarium, Korean War Veterans Memorial, Dynacraft Industries, Port Authority of New York & New Jersey and Richter + Ratner Contracting Corporation.

Needs: Approached by 25-30 freelance artists/year. Works with 3-5 illustrators and 10 designers/year. Works on assignment only. Uses freelance artwork mainly for specialty graphics and three-dimensional design. Uses artists for design, mechanicals, model making and charts/graphs. Needs computer-literate freelancers for design, production and presentation. 90% of freelance work demands knowledge of Aldus PageMaker, Quark XPress, Photoshop or Adobe Illustrator. Needs editorial illustration.

First Contact & Terms: Send query letter with brochure showing art style or tearsheets, slides and photographs. Samples are returned only if requested. Reports within 2 weeks. Write for appointment to show portfolio of roughs, color final reproduction/product and photographs. Pays for design by the hour, $10-40; by the project, negotiable.

Tips: "I want to see how the person responded to the specific design problem and to see documentation of the process—the stages of development. The artist must be versatile and able to communicate a wide range of ideas. Mostly, I want to see the artist's integrity reflected in his/her work."

TOM NICHOLSON ASSOCIATES, INC., Suite 805, 295 Lafayette St., New York NY 10012. (212)274-0470. Fax: (212)274-0380. President: Tom Nicholson. Contact: Sean Rooney. Estab. 1987. Specializes in design of interactive computer programs. Clients: corporations, museums, government agencies and multimedia publishers. Client list available upon request.

Needs: Works with 6-10 illustrators and 6 designers/year. Prefers local artists. Uses illustrators mainly for computer illustration and animation. Uses designers mainly for computer screen design and concept development. Also for mechanicals, charts/graphs and AV materials. Needs editorial and technical illustration. Especially needs designers with interest (not necessarily experience) in computer screen design plus a strong interest in information design. 80% of freelance work demands computer skills.

First Contact & Terms: Send query letter with résumé; include tearsheets and slides if possible. Samples are filed or are returned if requested. Art Director will contact artist for portfolio review if interested. Portfolio should include thumbnails, original/final art and tearsheets. Considers complexity of project, client's budget and skill and experience of artist when establishing payment. Rights purchased vary according to project. Interested in buying second rights (reprint rights) to previously published work.

Tips: Finds artists through submissions/self-promotions and sourcebooks. "I see tremendous demand for original content in electronic publishing."

‡ODEN & ASSOCIATES, 5140 Wheelis Dr., Memphis TN 38117. (901)683-8055. Fax: (901)683-2070. Creative Director: Bret Terwilleger. Estab. 1971. Specializes in annual reports, brand and corporate identity, design and package design. Clients: corporations. Current clients include International Paper, Maybeline, Federal Express.

Needs: Approached by 15-20 freelance graphic artists/year. Works with 5-8 freelance illustrators and 4-6 freelance designers/year. Works on assignment only. Uses illustrators and designers mainly for collateral. Also uses freelance artists for brochure design and illustration, mechanicals and ad illustration. Need computer-literate freelancers for design and production. 50% of freelance work demands knowledge of QuarkXPress or Adobe Photoshop.

First Contact & Terms: Send query letter with brochure, photographs, slides and transparencies. Samples are filed and are not returned. Reports back to the artist only if interested. Portfolio review not required. Pays for design by the hour, $55-70; or by the project. Pays for illustration by the project, $500. Rights purchased vary according to project.

Tips: Finds artists through sourcebooks.

‡YASHI OKITA DESIGN, #220, 2325 Third St., San Francisco CA 94107. (415)255-6100. Fax: (415)255-6300. Principal: Yashi Okita. Estab. 1981. Specializes in corporate and product brochures, annual reports; brand and corporate identity; display, direct mail and package design; and signage. Clients: corporations. Current clients include Intel, Levi's, H.P. Richoh, Stanford Hospital. Client list available upon request.

Needs: Approached by 20 freelance graphic artists/year. Works with 8-10 freelance illustrators and 10 freelance designers/year. Works on assignment only. Uses illustrators and designers mainly for corporate brochures. Also uses freelance artists for brochure, poster and ad design and illustration, and direct mail design, mechanicals, model making, lettering, logos and charts/graphs. Needs computer-literate freelancers for design, illustration, production and presentation. 70% of freelance work demands knowledge of QuarkXPress, Adobe Illustrator or Adobe Photoshop.

First Contact & Terms: Send query letter with résumé and tearsheets. Samples are filed. Reports back to the artist only if interested. Portfolios may be dropped off every Monday. Portfolio should include slides,

tearsheets, transparencies, final art and photographs. Pays for design by the hour. Pays for illustration by the project. Rights purchased vary according to project.
Tips: Finds artists through reps and sourcebooks.

PATTERN PEOPLE, INC., 10 Floyd Rd., Derry NH 03038. (603)432-7180. Vice President: Michael S. Copeland. Estab. 1988. Design studio servicing various manufacturers of consumer products. Designs wallcoverings and textiles with "classical elegance and exciting new color themes for all ages."
Needs: Approached by 5-8 freelance artists/year. Works with 10-15 artists/year. Prefers artists with professional experience in various mediums. Uses freelancers mainly for original finished artwork. Also for textile and wallcovering design. "We use all styles but they must be professional." Special needs are "floral (both traditional and contemporary), textural (faux finishes, new woven looks, etc.) and geometric (mainly new wave contemporary)." Needs computer-literate freelancers for design. 20% of freelance work demands knowledge of Aldus PageMaker, Adobe Illustrator, QuarkXPress, Photoshop or Aldus FreeHand.
First Contact & Terms: Send query letter with photocopies, slides and photographs. Samples are filed. Art Director will contact artist for portfolio review if interested. Portfolio should include original/final art and color samples. Sometimes requests work on spec before assigning job. Pays for design by the project, $100-1,000. Buys all rights.
Tips: Finds artists through sourcebooks and other artists. "The best way to break in is by attending the annual Surtex Design show in New York."

‡SAM PAYNE & ASSOCIATES, Suite A, 1471 Elliott Ave. W., Seattle WA 98119. (206)285-2009. Fax: (206)285-2948. Owner: Sam Payne. Estab. 1979. Specializes in brand and corporate identity; direct mail, package and publication design; and signage. Clients: food companies, corporations, small to medium-sized businesses and packaging companies. Current clients include Shurgard Inc., Speciality Seafoods and Liberty Orchards. Client list available upon request.
Needs: Approached by 10-12 freelance artists/year. Works with 2-3 freelance illustrators/year. Prefers local artists with experience in food. Works on assignment only. Uses freelance illustrators mainly for packaging and miscellaneous publications. Also uses freelance artists for ad, brochure, editorial, food, catalog and P-O-P illustration and retouching, airbrushing and lettering.
First Contact & Terms: Send query letter with brochure, résumé and SASE. Samples are filed or are returned by SASE if requested by artist. Art Director will contact artist for portfolio review if interested. Portfolio should include color slides, photographs and finished printed pieces. Pays for design and illustration by the project, $50-5,000. Rights purchased vary according to project. Considers buying second rights (reprint rights) to previously published work.

‡PENULTIMA INC., One Gold Mine Rd., Flanders NJ 07836. (201)691-1819. Fax: (201)691-4260. Estab. 1971. Specializes in display design, trade show exhibition design and management and signage. Clients: corporate and designers. Current clients include Congoleum, Nat West, L'Oréal, Clairol. Client list available upon request.
Needs: Works with 2-3 freelance designers/year. Uses designers mainly for rendering concepts. Also uses freelance artists for P-O-P illustration and design.
First Contact & Terms: Send brochure, tearsheets, résumé, photographs and photocopies. Samples are filed. Does not report back. Artist should call. Portfolio review not required. Pays for design by the project, $1,000 minimum. Pays for illustration by the project, $200 minimum. Buys all rights.
Tips: Finds artists through word of mouth.

QUALLY & COMPANY INC., Suite 3, 2238 Central St., Evanston IL 60201-1457. (708)864-6316. Creative Director: Robert Qually. Specializes in integrated marketing/communication and new product development. Clients: major corporations.
Needs: Works with 20-25 freelance artists/year. "Artists must be good and have the right attitude." Works on assignment only. Uses artists for design, illustration, mechanicals, retouching, lettering and computer graphics.
First Contact & Terms: Send query letter with brochure, résumé, business card and samples. Samples not kept on file are returned by SASE. Reports back within several days. Call or write for appointment to show portfolio.
Tips: Looking for "talent, point of view, style, craftsmanship, depth and innovation" in portfolio or samples. Sees "too many look-alikes, very little innovation."

THE QUARASAN GROUP, INC., 214 W. Huron St., Chicago IL 60610-3613. (312)787-0750. President: Randi S. Brill. Project Managers: Kathy Kasper, Jean LoGrasso and Laura Stanley Thomas. Specializes in books. Clients: educational book publishers. Client list not available.
Needs: Approached by 400 freelance artists/year. Works with 600-700 illustrators/year. Artists with publishing experience preferred. Uses artists for illustration, books, mechanicals, charts/graphs, lettering and production. Needs computer-literate freelancers for illustration and production. 30% of freelance work demands

knowledge of Adobe Illustrator, QuarkXPress, Photoshop or Aldus FreeHand. Needs editorial, technical, medical and scientific illustration.

First Contact & Terms: Send query letter with brochure or résumé and samples addressed to ASD to be circulated and to be kept on file. Prefers "anything that we can retain for our files: photostats, photocopies, tearsheets or dupe slides that do not have to be returned" as samples. Reports only if interested. Pays for illustration by the piece/project, $40-2,000 average. Considers complexity of project, client's budget, how work will be used and turnaround time when establishing payment. "For illustration, size and complexity are the key factors."

Tips: "Our publishers continue to require us to use only those artists willing to work on a work-for-hire basis. This may change in time, but at present, this is a current requirement."

MIKE QUON DESIGN OFFICE, INC., 568 Broadway, New York NY 10012. (212)226-6024. Fax: (212)219-0331. President: Mike Quon. Contact: Dawn Morales. Specializes in corporate identity, displays, direct mail, packaging, publications and technical illustrations. Clients: corporations (fashion, beauty, financial) and ad agencies. Current clients include American Express, HBO, Amtrak, Revlon, Nynex and AT&T. Client list available upon request.

Needs: Approached by 30-50 graphic artists each year. Works with 5-6 illustrators and 4-5 designers/year. Prefers "good/great people; locale doesn't matter." Works by assignment only. Prefers graphic style. Uses artists for design, brochures, P-O-P displays, logos, mechanicals, model making, charts/graphs and lettering. Especially needs computer artists with knowledge of QuarkXPress, Adobe Illustrator and Photoshop.

First Contact & Terms: Send query letter with résumé, tearsheets and photocopies. Samples are filed or are returned if accompanied by SASE. Reports back only if interested. Write for appointment to show portfolio or mail thumbnails, roughs and tearsheets. Pays for design by the hour, $20-45. Pays for illustration by the hour, $20-50; or by the project, $150-500 and up. Rights purchased vary according to project.

Tips: "The introduction of the computer has given us much more control and flexibility in our design and production. It has also allowed us to work much quicker but on the downside, the clients also want it quicker. The economy has made available a larger pool of talent to make our choice from, and has enabled us to recruit more experienced designers and illustrators on a more competitive price scale. This is not only beneficial to us but to our clients."

‡THE RED FLANNEL DESIGN GROUP, INC., Suite 2A, The Office Center, Plainsboro NJ 08536. (609)275-4501. Fax: (609)275-8183. Vice President/Creative Director: Jim Redzinak. Estab. 1987. Specializes in annual reports, corporate identity, publication design and marketing communications. Clients: corporations. Current clients include Schering-Plough. Client list not available.

Needs: Approached by 20 freelance artists/year. Works with 12 freelance illustrators and 3 freelance designers/year. Works on assignment only. Uses freelance illustrators mainly for specific project work. Uses freelance designers mainly for backup of staff and on-site work. Also uses freelance artists for brochure, catalog, ad, P-O-P and poster illustration; retouching; airbrushing; model making; and AV materials.

First Contact & Terms: Send query letter with tearsheets. Samples are filed or are not returned. Reports back to the artist only if interested. To show a portfolio, mail thumbnails, roughs and tearsheets. Pays for design by the hour, $25-50. Pays for illustration by the project, as negotiated. Rights purchased vary according to project.

PATRICK REDMOND DESIGN, P.O. Box 75430, St. Paul MN 55175-0430. (612)646-4254. Designer/Owner/President: Patrick M. Redmond. Estab. 1966. Specializes in book and/or book cover design; logo and trademark design; package, publication and direct mail design; brand and corporate identity; design consulting and education; and posters. Provides design services for more than 100 clients in the following categories: publishing, advertising, marketing, retail, financial, food, arts, education, computer, manufacturing, health care, government and professions. Current clients include Dos Tejedoras Fiber Arts Publications, Mid-List Press, Hauser Artists International, and others.

Needs: Approached by 50 freelance artists/year. Works with 2-4 illustrators and 1-2 designers/year. Uses freelancers mainly for editorial and technical illustration, publications, books, brochures and newsletters. Needs computer-literate freelancers for design, illustration, production and presentation. 60% of freelance work demands knowledge of QuarkXpress and Macintosh.

First Contact & Terms: Send query letter with brochure, résumé, photocopies and SASE. Samples not filed are thrown away. No samples returned. Reports back only if interested. "Artist will be contacted for portfolio review if work seems appropriate for client needs. Patrick Redmond Design will not be responsible for acceptance of delivery or return of portfolios not specifically requested from artist or rep. Samples must be

The double dagger before a listing indicates that the listing is new in this edition. New markets are often more receptive to freelance submissions.

presented in person unless other arrangements are made. Unless specifically agreed to in writing, portfolios should not be sent unsolicited." Pays for design and illustration by the project. Rights purchased vary according to project. Considers buying second rights (reprint rights) to previously published work.
Tips: Finds artists through word of mouth, magazines, artists' submissions/self-promotions, sourcebooks and agents. "I see ahead more diversity; a wider range of styles; innovative creative breakthroughs."

ROY RITOLA, INC., 431 Jackson St., San Francisco CA 94111. (415)788-7010. President: Roy Ritola. Specializes in brand and corporate identity, displays, direct mail, packaging and signage. Clients: manufacturers.
Needs: Works with 6-10 freelance artists/year. Uses freelancers for design, illustration, airbrushing, model making, lettering and logos.
First Contact & Terms: Send query letter with brochure showing art style or résumé, tearsheets, slides and photographs. Samples not filed are returned only if requested. Reports only if interested. To show a portfolio, mail final reproduction/product. Pays for design by the hour, $25-100. Considers complexity of project, client's budget, skill and experience of artist, turnaround time and rights purchased when establishing payment.

‡RITTA & ASSOCIATES, 568 Grand Ave., Englewood NJ 07631. (201)567-4400. Fax: (201)567-7330. Art Director: Steven Scheiner. Estab. 1976. Specializes in annual reports, corporate identity and communications, and publication design. Clients: corporations. Current clients include BMW, Volvo, Bellcore, Hoffman LaRoche, Warner Lambert. Client list available upon request.
Needs: Approached by 50-100 freelance graphic artists/year. Works with 20 freelance illustrators/year. Uses illustrators mainly for corporate publications. Also uses freelance artists for retouching and model making. Needs computer-literate freelancers for illustration and production. 10% of freelance work demands knowledge of QuarkXPress, Adobe Illustrator or Adobe Photoshop.
First Contact & Terms: Send query letter with résumé, tearsheets and printed samples. Samples are filed or are returned by SASE if requested by artist. Reports back to the artist only if interested. Art Director will contact artist for portfolio review if interested. Pays for illustration by the project, $100-2,500. Rights purchased vary according to project.
Tips: Finds artists through sourcebooks, publications, agents and artists' submissions.

RITTER & RITTER, INC., 45 W. 10th St., New York NY 10011. (212)505-0241. Fax: (212)533-0743. Creative Director: Valerie Ritter Paley. Estab. 1968. Specializes in annual reports, corporate identity, book covers, brochures, catalogs and promotion. Clients: publishers, corporations, nonprofit organizations and hospitals. Client list available.
Needs: Approached by 50 artists/year. Works with 2 illustrators and designers/year according to firm's needs. Does not always work on assignment only; "sometimes we need a freelance on a day-to-day basis." Uses freelance artwork mainly for catalogs and brochures. Uses fine artists for covers; graphic designers for brochure design, mechanicals and desktop publishing. Prefers "elegant, understated, sensitive design without self-conscious trendiness." Needs computer-literate freelancers for design. 65% of freelance work demands knowledge of Aldus PageMaker or QuarkXPress. Needs editorial and technical illustration.
First Contact & Terms: Prefers experienced artists, although "talented 'self-starters' with design expertise/education are also considered." Send query letter with brochure, résumé and samples to be kept on file. "Follow up within a week of the query letter about the possibility of arranging an appointment for a portfolio review." Prefers printed pieces as samples. Samples not filed are returned by SASE. Pays for mechanicals and desktop publishing by the hour, $10-25. Pays for design by the hour, $15-25; by the project. Pays for illustration by the project, $50-1,000.
Tips: Finds artists through submissions/self-promotions. "I think the level of design will continue to deteriorate because of the increasing number of people who are not grounded or trained in design but, with the use of computers, function as designers thus lowering the standard of good design."

DEBORAH RODNEY CREATIVE SERVICES, Suite B, 1020 Pico Blvd., Santa Monica CA 90405. (310)450-9650. Fax: (310)450-9793. Owner: Deborah Rodney. Estab. 1975. Specializes in advertising design and collateral. Clients: ad agencies and direct clients. Current projects include advertising for Paul Singer Floor Coverings, Century City Hospital and California Casualty Co.
Needs: Works with 3-5 freelance illustrators/year. Prefers local artists. Uses illustrators mainly for finished art and lettering. Uses designers mainly for logo design. Also uses artists for mechanicals, charts/graphs, ad design and illustration. Especially needs "people who do good marker comps, and work on Macintosh." Needs computer-literate freelancers for production and presentation. 100% of freelance work demands knowledge of QuarkXPress or Photoshop. Needs advertising illustration.
First Contact & Terms: Send query letter with brochure, résumé, tearsheets and photocopies. Request portfolio review in original query. Portfolio should include final reproduction/product and tearsheets or "whatever best shows work." Pays for design by the hour, $30-50; by the project; by the day, $100 minimum. Pays for illustration by the project, $100 minimum. Negotiates rights purchased. Considers buying second rights (reprint rights) to previously published work.
Tips: Finds artists through sourcebooks and referrals. "I do more concept and design work inhouse and hire out production and comps because it is faster, cheaper that way."

‡**RUBY SHOES STUDIO, INC.**, 124 Watertown St., Watertown MA 02172. (617)923-9769. Creative Director: Susan Tyrrell. Estab. 1984. Specializes in corporate identity, direct mail and package and publication design. Client list available upon request.
Needs: Approached by 150-300 freelance artists/year. Works with 5-10 freelance illustrators and 10-20 freelance designers/year. Uses freelance illustrators mainly for brochure illustration. Uses freelance designers mainly for ad design and mechanicals. Also uses freelance artists for brochure and P-O-P design and illustration, mechanicals, airbrushing, lettering, logos, poster and direct mail design and graphs.
First Contact & Terms: Send query letter with tearsheets, résumé and slides. Samples are filed or are returned by SASE. Reports back to the artist only if interested. To show a portfolio, mail roughs, original/final art, b&w and color tearsheets and slides. Pays for design by the hour, $20-30; by the project, $150-1,500. Pays for illustration by the project. Buys first or one-time rights.

‡**RUSSELL, HOWRY & ASSOCIATES**, Suite 2140, 120 Montgomery, San Francisco CA 94104. (415)433-2035. Fax: (415)433-0816. President: Jill Howry. Estab. 1987. Specializes in annual reports and corporate identity. Clients: corporations. Current clients include Chiron Corp., San Francisco Airport, Cygnus, Sciclone Pharmaceuticals, RasterOps, Souctron. Client list available on request.
Needs: Works with 10-15 freelance illustrators and 2-5 freelance designers/year. Works on assignment only. Uses illustrators for "everything and anything that applies." Uses designers mainly for newsletters, brochures, corporate identity. Also uses freelance artists for mechanicals, retouching, airbrushing, poster illustration, lettering, logos and charts/graphs. Needs computer-literate freelancers for design, illustration and production. 100% of design work, 10% of illustration work demands knowledge of QuarkXPress, Adobe Illustrator or Adobe Photoshop.
First Contact & Terms: Samples are filed. Reports back to the artist only if interested. Portfolios may be dropped off every Thursday. Pays for design by the hour, $20-50. Pays for illustration on a per-job basis. Rights purchased vary according to project.
Tips: Finds artists through sourcebooks, samples, representatives.

‡**HENRY SCHMIDT DESIGN**, 3141 Hillway Dr., Boise ID 83702. (208)385-0262. President: Henry Schmidt. Estab. 1976. Specializes in brand and corporate identity, package and publication design and signage. Clients: corporations. Current clients include Universal Frozen Foods, AFI, Inc., Black Diamond Millwork, Life Lessons. Client list available upon request.
Needs: Approached by 25 freelance graphic artists/year. Works with 1-5 freelance illustrators and 1-2 freelance designers/year. Uses illustrators mainly for product illustration, board games. Uses designers mainly for overload. Also uses freelance artists for brochure and catalog illustration, mechanicals and lettering. Needs computer-literate freelancers for design. 100% of freelance work demands knowledge of Aldus PageMaker, QuarkXPress, Adobe Illustrator or Adobe Photoshop.
First Contact & Terms: Send query letter with brochure, résumé, tearsheets, photostats, photographs, slides and photocopies. Samples are filed. Reports back to the artist only if interested. Request portfolio review in original query. Artist should follow up. Portfolio should include b&w and color final art, tearsheets, photographs and transparencies. Pays for design by the hour, $20-40; by the project, $100-1,000. Pays for illustration by the project, $100-1,500. Rights purchased vary according to project.

R. THOMAS SCHORER & ASSOC. INC., 710 Silver Spur Rd., Palos Verdes CA 90274. (213)377-0207. President: Thomas Schorer. Estab. 1971. Specializes in graphic, environmental and architectural design and product development and signage. Client list available upon request.
Needs: Approached by 100 freelance artists/year. Works with 5 illustrators and 10 designers/year. Works on assignment only. Uses designers for all types of design. Uses illustrators for editorial and technical illustration. 50% of freelance work demands knowledge of Aldus PageMaker or QuarkXPress.
First Contact & Terms: Send query letter with all appropriate samples. Samples are not filed and are returned. Art Director will contact artist for portfolio review if interested. Portfolio should include all appropriate samples. Pays for design and illustration by the project. Buys all rights.
Tips: Finds artists through word of mouth, self-promotions, sourcebooks and agents. "Depending on the economy, the future of art design looks pretty poor."

SCHROEDER BURCHETT DESIGN CONCEPTS, 104 Main St., RR 1 Box 5A, Unadilla NY 13849-9703. (607)369-4709. Designer & Owner: Carla Schroeder Burchett. Estab. 1972. Specializes in packaging, drafting and marketing. Clients: manufacturers.
Needs: Works on assignment only. Uses artists for design, mechanicals, lettering and logos. 20% of freelance work demands knowledge of Aldus PageMaker or Adobe Illustrator. Needs technical and medical illustration.
First Contact & Terms: Send résumé. "If interested, we will contact artist or craftsperson and will negotiate." Write for appointment to show portfolio of thumbnails, final reproduction/product and photographs. Pays for illustration by the project. Pays for design by the hour, $10 minimum. "If it is excellent work the person will receive what he asks for!" Considers skill and experience of artist when establishing payment.
Tips: "Creativity depends on each individual. Artists should have a sense of purpose and dependability and must work for long and short range plans."

RICHARD SEIDEN INTERIORS, 238 N. Allen St., Albany NY 12206. (518)482-8600. President: Richard Seiden. Interior design firm. Provides residential (60%) and contract (40%) interior design.
Needs: Works with 4 freelance artists/year for graphic design; 3, signage design; 2, model making; 3, murals; 4, wall hangings; 3, landscape design; 2, charts/graphs; and 2, stained glass. Works on assignment only. Needs editorial illustration.
First Contact & Terms: Send query letter with résumé, tearsheets, photostats and SASE. Provide materials to be kept on file for future assignments. Will contact artist for portfolio review if interested. Pays $150-1,800 for original wall decor; also pays by the project. Pays for design by the hour, $25 minimum. Considers complexity of project, skill and experience of artist and client's budget when establishing payment.
Tips: Finds artists through word of mouth. Prefers photos rather than slides, if possible.

‡✹GAD SHAANAN DESIGN INC., #390, 4480 Cote De Lesse, Montreal Quebec H4N 2R1 Canada. Design Manager: David Harris. Estab. 1980. Specializes in product, interior and package design; brand identity, product development engineering and signage. Client list available upon request.
Needs: Approached by 30-40 freelance graphic artists/year. Works with 2-5 frelance illustrators and 10 freelance designers/year. Prefers artists with experience. "Artist must work on premises." Uses illustrators mainly for retouching and renderings. Uses designers mainly for graphics, packaging and comps. Needs computer-literate freelancers for design, illustration, production, presentation and drafting. 50-100% of free-lance work demands knowledge of Aldus PageMaker, QuarkXPress, Aldus FreeHand, Adobe Illustrator, Adobe Photoshop or Vellum.
First Contact & Terms: Send query letter with résumé, tearsheets, photographs, slides, photocopies, transparencies and samples. Samples are filed. Portfolio may be dropped off. Request portfolio review in original query. Artist should follow up. Portfolio should include b&w and color thumbnails, roughs, final art, photostats, tearsheet, photographs, slides and transparencies. Pays for design by the hour. Pays for illustration by the project. "Rights purchased vary based on clients needs."
Tips: Finds artists through word of mouth.

DEBORAH SHAPIRO DESIGNS, 150 Bentley Ave., Jersey City NJ 07304. (201)432-5198. Owner: Deborah Shapiro. Estab. 1979. Specializes in annual reports, brand and corporate identity, direct mail, signage and publications. Clients: corporations and manufacturers. Client list available upon request.
Needs: Approached by 50 artists/year. Works with 2-3 freelance artists/year. Works on assignment only. Uses freelancers for illustration, retouching, brochures, catalog and poster illustration, model making and AV materials.
First Contact & Terms: Send query letter with brochure and tearsheets. Samples are filed and are not returned. Reports back only if interested. To show a portfolio, mail tearsheets, thumbnails and roughs. Pays for illustration by the project, $100-2,500. Buys one-time rights.
Tips: "We do not want to see student works. Do not send too many samples. Send assignment-oriented pieces."

‡SIGNATURE DESIGN, 2101 Locust, St. Louis MO 63103. (314)621-6333. Fax: (314)621-0179. Owners: Therese McKee and Sally Nikolajevich. Estab. 1988. Specializes in corporate identity and display and exhibit design. Clients: museums, nonprofit institutions, corporations, government agencies, botanical gardens. Current clients include Missouri Botanical Garden, Diagraph Corporation, Huntsville Botanical Garden, U.S. Army Corps of Engineers, Crown Optical, Budget Rent-A-Car. Client list available upon request.
Needs: Approached by 15 freelance graphic artists/year. Works with 1-2 freelance illustrators and 1-2 freelnace designers/year. Prefers local artists only. Works on assignment only. Needs computer-literate freelancers for production. 50% of freelance work demands knowledge of Aldus PageMaker, QuarkXPress, Adobe Illustrator or Adobe Photoshop.
First Contact & Terms: Send query letter with résumé, tearsheets and photocopies. Samples are filed. Reports back to the artist only if interested. Artist should follow up with letter after initial query. Portfolio should include "whatever best represents your work." Pays for design by the hour. Pays for illustration by the project.

WILLIAM SKLAROFF DESIGN ASSOCIATES, 124 Sibley Ave., Ardmore PA 19003. (215)649-6035. Fax: (215)649-6063. Design Director: William Sklaroff. Estab. 1956. Specializes in display, interior, package and publication design and corporate identity and signage. Clients: contract furniture, manufacturers, health care corporations. Current clients include: Kaufman, Halcon Corporation, L.U.I. Corporation, McDonald Products, Baker Furniture, Novikoff and Metrologic Instruments. Client list available upon request.

The maple leaf before a listing indicates that the market is Canadian.

Needs: Approached by 50 freelance artists/year. Works with 2-3 designers/year. Works on assignment only. Uses freelancers mainly for assistance on graphic projects. Also for brochure design and illustration, catalog and ad design, mechanicals and logos.

First Contact & Terms: Send query letter with brochure, résumé and slides to Lori L. Minassian, PR Coordinator. Samples are returned. Reports back within 3 weeks. To show a portfolio, mail thumbnails, roughs, finished art samples and color slides and transparencies. Pays for design by the hour. Rights purchased vary according to project.

Tips: Finds artists through word of mouth and artists' submissions.

SMITH & DRESS, 432 W. Main St., Huntington NY 11743. (516)427-9333. Contact: A. Dress. Specializes in annual reports, corporate identity, display, direct mail, packaging, publications and signage. Clients: corporations.

Needs: Works with 3-4 freelance artists/year. Prefers local artists only. Works on assignment only. Uses artists for illustration, retouching, airbrushing and lettering.

First Contact & Terms: Send query letter with brochure showing art style or tearsheets to be kept on file (except for works larger than 8½×11). Pays for illustration by the project. Considers client's budget and turnaround time when establishing payment.

SMITH DESIGN ASSSOCIATES, 205 Thomas St., Box 190, Glen Ridge NJ 07028. (201)429-2177. Fax: (201)429-7119. Vice President: Larraine Blauvelt. Clients: cosmetics firms, toy manufacturers, life insurance companies, office consultants. Current clients: Popsicle, Good Humor, Breyer's and Schering Plough. Client list available upon request.

Needs: Approached by over 100 freelance artists/year. Works with 10-20 illustrators and 2-3 designers/year. Requires quality and dependability. Uses freelancers for advertising and brochure design, illustration and layout and interior design, P-O-P and design consulting. Needs computer-literate freelancers for design, illustration and production. 90% of freelance work demands knowledge of Adobe Illustrator, QuarkXPress or Photoshop. Needs children's, packaging and product illustration.

First Contact & Terms: Send query letter with brochure showing art style or résumé, tearsheets and photostats. Samples are filed or are returned only if requested by artist. Reports back within 1 week. Call for appointment to show portfolio of color roughs, original/final art and final reproduction. Pays for design by the hour, $25-100; by the project, $175-5,000. Pays for illustration by the project, $175-5,000. Considers complexity of project and client's budget when establishing payment. Buys all rights. Also buys rights for use of existing non-commissioned art.

Tips: Finds artists through word of mouth, self-promotions/sourcebooks and agents. "Know who you're presenting to, the type of work we do and the quality we expect. We use more freelance artists not so much because of the economy but more for diverse styles."

SPECTRUM BOSTON CONSULTING, INC., 85 Chestnut St., Boston MA 02108. (617)367-1008. Fax: (617)367-5824. President: George Boesel. Estab. 1985. Specializes in brand and corporate identity, display and package design and signage. Clients: consumer, durable manufacturers. Client list not available.

Needs: Approached by 50 freelance artists/year. Works with 10-20 illustrators and 2-3 designers/year. All artists employed on work-for-hire basis. Works on assignment only. Uses illustrators mainly for package and brochure work. Also for brochure design and illustration, mechanicals, logos, P-O-P design and illustration and model making. Needs computer-literate freelancers for design, illustration and production. 80% of freelance work demands computer knowledge of Adobe Illustrator, QuarkXPress, Photoshop or Aldus Free-Hand. Needs technical and instructional illustration.

First Contact & Terms: Send query letter with brochure, tearsheets, photographs, fees and terms. Samples are filed. Reports back to the artist only if interested. Call or write for appointment to show portfolio of roughs, original/final art and color slides. Pays for design by the hour, $20-40, depending on assignment and skill level. Pays for illustration by the project, $50-1,500. Buys all rights.

‡SPECTRUMEDIA, INC., 11 Center St., Middletown NY 10940. (914)294-7106. Fax: (914)344-0642. Art Director: Katrina Buckingham. Estab. 1984. Specializes in annual reports, brand and corporate identity, package and publication design, technical illustration, slides, computer video and multi-media. Clients: corporations and small businesses. Client list available upon request.

Needs: Approached by 10-12 freelance artists/year. Works with 3-4 freelance illustrators and 3-4 freelance designers/year. Prefers artists with experience in Macintosh. Works on assignment only. Uses freelance designers and illustrators mainly for brochure, catalog, ad and poster design and illustration; book, direct mail and P-O-P design; retouching; airbrushing; logos; charts/graphs; and audiovisual materials.

First Contact & Terms: Send query letter with brochure, résumé, SASE and any appropriate samples. Samples are filed or are returned by SASE. Reports back within 2 weeks. Call to schedule an appointment to show a portfolio of b&w or color thumbnails, roughs, original/final art, photostats, tearsheets, photographs, slides and/or transparencies. Pays for design and illustration by the project. Rights purchased vary according to project.

‡**SPLANE DESIGN ASSOCIATES,** 10850 White Oak Ave., Granada Hills CA 91344. (818)366-2069. Fax: (818)831-0114. President: Robson Splane. Specializes in display and package design, renderings, model making and phototyping. Clients: small, medium and large companies. Current clients include Teledyne Laars, Pacific Fitness, Hoist Fitness Systems, Baton Labs, Sigma, MGB Clareblend, Ediflex, Superspine, Ovation Body Solutions, Trenmark, Ascii. Client list available upon request.

Needs: Approached by 25-30 freelance graphic artists/year. Works with 1-2 freelance illustrators and 0-4 freelance designers/year. Works in assignment only. Uses illustrators mainly for logos, mailings to clients, renderings. Uses designers mainly for sourcing, drawings, prototyping, modeling. Also uses freelance artists for brochure design and illustration, ad design, mechanicals, retouching, airbrushing, model making, lettering and logos. Needs computer-literate freelancers for design and illustration. 20-50% of freelance work demands knowledge of Aldus FreeHand or Ashlar Vellum.

First Contact & Terms: Send query letter with résumé and photocopies. Samples are filed or are returned. Reports back to the artist only if interested. Art Director will contact artist for portfolio review if interested. Portfolio should include color roughs, final art, photostats, slides and photographs. Pays for design and illustration by the hour, $7-25. Rights purchased vary according to project.

Tips: Finds artists through submissions and contacts.

‡**HARRY SPRUYT DESIGN,** Box 555, Block Island RI 02807. Specializes in design/invention of product, package and device; design counseling service shows "in-depth concern for environments and human factors with the use of materials, energy and time." Clients: product manufacturers, design firms, consultants, ad agencies, other professionals and individuals. Client list available.

Needs: Works on assignment only. Uses artists/designers for accurate perspective drawings of products, devices (from concepts and sketches), design and material research and model making. "Illustrations are an essential and cost effective step of evaluation between our concept sketches and model making." Uses freelancers for product, editorial, medical and technical illustrations. Looks for "descriptive line and shade drawings, realistic color illustrations that show how product/object looks and works in simple techniques." Prefers pencil, watercolor and tempera or other "timeless media." 10% of freelance work demands computer skills.

First Contact & Terms: Art Director will contact artist for portfolio review if interested. "Portfolio may include thumbnails and rough sketches, original/final art, final reproduction/product and color photographs/slides of models. I want to see work samples showing the process leading up to these examples, including models or photos, if appropriate, as well as time estimates. After working relationship is established, we can develop projects by fax, phone and mail." Pays for design and illustration by the hour, $10-40; by the day, $60-200; or royalty plus fee.

Tips: Finds artists through word of mouth, self-promotions and agents. "We want to use our time together effectively by finding out each other's needs quickly and communicating efficiently and caringly. We look for the ability to understand the functioning of three-dimensional object/device/product from perspective sketches and descriptive notes so artist/designer can illustrate accurately and clearly."

STEPAN DESIGN, 1849 Barnhill Dr., Mundelein IL 60060. (708)566-0488. Fax: (708)566-0489. Owner/Designer: J. Stepan. Specializes in annual reports, brand and corporate identity, direct mail, packaging, publications and signage. Clients: corporations, ad agencies, arts organizations and hospitals.

Needs: Works with 4 freelance artists/year. Works on assignment only. Uses artists for illustration, P-O-P displays, mechanicals, retouching, model making, lettering and gift items. Currently seeks production-oriented designers on a freelance basis. Must have Mac/Quark background. 75% of work demands computer skills.

First Contact & Terms: "Must see folio or examples of art for reproduction as well as finished product." Send query letter with brochure, résumé and samples to be kept on file. Call for appointment to show portfolio. Samples not filed are returned by SASE. Reports back within 2 months. Pays for design by the hour, $10-25, average. Pays for illustration by the project, $50-500, average. Considers complexity of project, client's budget, skill and experience of artist, how work will be used, turnaround time and rights purchased when establishing payment.

STUDIO 38 DESIGN CENTER, 38 William St., Amityville NY 11701. (516)789-4224. Fax: (516)789-4234. Vice President: Andrea Reda. Estab. 1972. Self-contained manufacturer of wallpaper for national clients.

Needs: Approached by 30 freelance artists/year. Works with 10 designers and 10 illustrators/year. Uses freelancers for wallpaper design. Assigns 80 jobs/year. Prefers pen & ink, airbrush, colored pencil, watercolor, pastel and marker.

First Contact & Terms: Portfolio should include color geometrics and florals; no figures. Pays for design by the project, $50-600.

Tips: "Call and make an appointment."

STUDIO WILKS, 8800 Venice, Los Angeles CA 90034. (310)204-2919. Fax: (310)204-2918. Estab. 1990. Specializes in print, collateral, packaging, editorial and environmental work. Clients: ad agencies, architects,

corporations and small business owners. Current clients include Gemological Institute of America, Upper-Deck Authenticated and Microgames of America.

Needs: Works with 2-3 illustrators/year. Uses illustrators mainly for editorial illustration. Also uses freelancers for brochures, print ads, packaging, collateral, direct mail and promotions.

First Contact & Terms: Send query letter with tearsheets. Samples are returned by SASE if requested by artist. Art Director will contact artist for portfolio review if interested. Pays for design by the project. Buys all rights. Considers buying second rights (reprint rights) to previously published work.

Tips: Finds artists through *The Workbook* and word of mouth.

■**SYLVOR CO., INC.**, 126 11th Ave., New York NY 10011. (212)929-2728. Fax: (212)691-2319. Owner: Bonnie Sylvor. Estab. 1929. Manufacturer of window displays. Clients: department stores, corporate party planners and shops. Current clients include Saks Fifth Ave., Bloomingdales and Fortunoffs.

Needs: Approached by 20 freelance artists/year. Works with 5 designers/year. Assigns 8 jobs to freelancers/year. Prefers local artists only. Works on assignment only. Uses freelancers mainly for graphic design and overload and rush projects. Prefers high style fashion poster style and flat painting that looks dimensional. Also uses freelance artists for product rendering and design, air brushing, model making and signage.

First Contact & Terms: Send query letter with résumé, slides, photographs, transparencies and other nonreturnable samples. Résumés are filed; samples are not filed. Does not report back. Artist should follow up with call. Call for appointment to show portfolio of b&w photostats, slides and photographs. Pays for design by the hour, $8-10; or by the project, $50-400. Pays for illustration by the project.

■**RENEE TAFOYA DESIGN**, 9 S. Broadway, P.O. Box 1144, Red Lodge MT 59068. (406)446-3939. Principal: Renee Tafoya. Estab. 1987. Specializes in brand and corporate identity and direct mail, package and publication design. Clients: small business, corporations and nonprofit associations. Client list available upon request.

Needs: Approached by 3-5 freelance artists/year. Works with 3-4 illustrators and 2-3 designers/year. Prefers artists with experience in 4-color process printing. Works on assignment only. Uses freelancers mainly for brochure design and illustration, logo design. Also for lettering, poster and ad illustration and charts/graphs. Needs computer-literate freelancers for production. 100% of freelance design work demands computer skills. Freelancer must know at least one drawing and one page layout program. Needs editorial and technical illustration.

First Contact & Terms: Send query letter with résumé, photographs, SASE and photocopies. Samples are filed or are returned by SASE if requested by artist. Reports back within 2 weeks. Pays for design by the hour, $10. Pays for illustration by the project, $60 minimum. Rights purchased vary according to project.

‡**JULIA TAM DESIGN**, 2216 Via La Brea, Palos Verdes CA 90274. (310)378-7583. Fax: (310)378-4589. Contact: Julia Tam. Estab. 1986. Specializes in annual reports, corporate identity and design. Clients: corporations. Current clients include Southern California Gas Co., *Los Angeles Times*, UCLA. Client list available upon request.

Needs: Works with 3-7 freelance illustrators/year. "We look for special styles." Works on assignment only. Uses illustrators mainly for brochures. Also uses freelance artists for brochure design and illustration; catalog and ad illustration, retouching and lettering. Needs computer-literate freelancers for production. 50-100% of freelance work demands knowledge of QuarkXPress, Adobe Illustrator or Adobe Photoshop.

First Contact & Terms: Send query letter with brochure, tearsheets and résumé. Samples are filed. Reports back to the artist only if interested. Artist should follow up. Portfolio should include b&w and color final art, tearsheets and transparencies. Pays for design by the hour, $10-20. Pays for illustration by the project. Negotiates rights purchased.

Tips: Finds artists through *LA Workbook*.

TESSING DESIGN, INC., 3822 N. Seeley Ave., Chicago IL 60618. (312)525-7704. Fax: (312)525-7756. Principals: Arvid V. Tessing and Louise S. Tessing. Estab. 1975. Specializes in corporate identity, marketing promotions and publications. Clients: publishers, educational institutions and nonprofit groups. Majority of clients are publishers.

Needs: Works with 8-12 freelance artists/year. Works on assignment only. Uses freelancers mainly for publications. Also for book and magazine design and illustration, mechanicals, retouching, airbrushing, charts/graphs and lettering. Needs computer-literate freelancers for design, illustration and production. 75% of freelance work demands knowledge of QuarkXPress, Photoshop or Adobe Illustrator. Needs textbook, editorial and technical illustration.

First Contact & Terms: Send query letter with brochure. Samples are filed or are not returned. Request portfolio review in original query. Artist should follow up with letter after initial query. Art Director will contact artist for portfolio review if interested. Portfolio should include original/final art, final reproduction/product and photographs. Pays for design by the hour, $35-50. Pays for illustration by the project, $100 minimum. Rights purchased vary according to project.

Tips: Finds artists through word of mouth, artists' submissions/self-promotions and sourcebooks. "We prefer to see original work or slides as samples. Work sent should always relate to the need expressed. Our advice

for artists to break into the field is as always – call prospective clients, show work and follow up."

THARP DID IT, Suite 21, 50 University Ave., Los Gatos CA 95030. (Also an office in Portland OR). Art Director/Designer: Rick Tharp. Estab. 1975. Specializes in brand identity; corporate, non-corporate and retail visual identity; packaging; and signage. Clients: direct and through agencies. Current clients include BRIO Scanditoy (Sweden), Sebastiani Vineyards, Integrated Media Group, Mirassou Vineyards, LeBoulanger Bakeries, Ramada Hotels and Hewlett-Packard.
Needs: Approached by 250-350 artists/year. Works with 5-10 illustrators and 2 designers/year. Needs advertising/product, food and people illustration. Prefers local designers with experience. Works on assignment only. Needs computer-literate freelance designers for production. 20% of freelance work demands computer skills.
First Contact & Terms: Send query letter with brochure or printed promotional material. Samples are filed or are returned by SASE. Art Director will contact artist for portfolio review if interested. "No phone calls please. We'll call you." Pays for design by the project. Pays for illustration by the project, $100-10,000. Considers client's budget and how work will be used when establishing payment. Rights purchased vary according to project.
Tips: Finds artists through awards annuals and artists' submissions/self-promotions. Rick Tharp predicts "corporate globalization will turn all flavors of design into vanilla, but globalization is inevitable. Today, whether you go to Mall of America in Minnesota or to the Gamla Stan (Old Town) in Stockholm, you find the same stores with the same interiors and the same products in the same packages. The cultural differences are fading quickly. Environmental and communication graphics are losing their individuality. Eventually we'll have to go to Mars to find anything unique or stimulating. But, as long as the dictum of business is 'grow, grow, grow' there will always be a place for the designer."

TIMMERMAN DESIGN, Suite 130, 1500 E. Bethany Home Rd., Phoenix AZ 85014. (602)230-9253. Fax: (602)230-8472. Studio Coordinator: Kent Yunk. Estab. 1987. Specializes in direct mail, package and publication design and annual reports and corporate identity. Clients: corporations, real estate developers, manufacturers and marketing consultants.
Needs: Approached by 30-40 freelance artists/year. Works with 2-15 illustrators and 4-7 designers/year. Prefers artists with experience in design and production. Works on assignment only. Uses illustrators mainly for brochures and lettering. Uses designers mainly for ads, brochures, catalogs, logos and mechanicals. Also uses freelancers for retouching, airbrushing, lettering, P-O-P and poster illustration, model making, charts/graphs and audiovisual materials. Needs computer-literate freelancers for illustration and production. 70% of freelance work demands knowledge of Adobe Illustrator, QuarkXPress and Photoshop.
First Contact & Terms: Send query letter with résumé, tearsheets, photographs, photocopies, photostats and slides. Samples are filed or are returned by SASE if requested by artist. Reports back to the artist only if interested. Artist should follow up with call after initial query. To show a portfolio, mail thumbnails, roughs, photostats, tearsheets, slides, transparencies or printed samples of brochures. Pays for design by the hour, $15-40. Pays for illustration by the hour, $15-70. "Payment depends on nature of project, client's budget, level of skill and market rate." Rights purchased vary according to project.
Tips: Now using more freelancers. "We are cautious when hiring fulltime help."

‡**TOKYO DESIGN CENTER**, Suite 252, 703 Market St., San Francisco CA 94103. Contact: Grace Horikiri. Specializes in annual reports, brand identity, corporate identity, packaging and publications. Clients: consumer products, travel agencies and retailers.
Needs: Uses artists for design and editorial illustration.
First Contact & Terms: Send business card, slides, tear sheets and printed material to be kept on file. Samples not kept on file are returned by SASE only if requested. Art Director will contact artist for portfolio review if interested. Pays for design and illustration by the project, $100-1,500 average. Sometimes requests work on spec before assigning job. Considers client's budget, skill and experience of artist, turnaround time and rights purchased when establishing payment. Interested in buying second rights (reprint rights) to previously published work.
Tips: Finds artists through self-promotions and sourcebooks.

‡**TOLLNER DESIGN GROUP**, Suite 1020, 111 N. Market St. San Jose CA 95113. (408)293-5300. Fax: (408)293-5389. President: Lisa Tollner. Estab. 1980. Specializes in corporate identity, direct mail, package design and collateral. Clients: ad agencies, high tech industry and corporations. Current clients include Cadence and Valley Fair Shopping Center. Client list available upon request.
Needs: Approached by 50 freelance artists/year. Works with 15 freelance illustrators/year. Prefers local artists. Works on assignment only. Uses freelance illustrators for brochure, catalog, P-O-P, poster and ad illustration. Needs computer-literate freelancers for design. Freelancers should be familiar with Quark XPress or Adobe Illustrator.
First Contact & Terms: Send query letter with tearsheets, photographs, photocopies, photostats, slides and transparencies. Samples are filed. Request portfolio review in original query. Art Director will contact artist for portfolio review if interested. Portfolio should include tearsheets, photographs, slides and transparencies.

Pays for design and illustration by the project, $75-3,000. Rights purchased vary according to project. Considers buying second rights (reprint rights) to previously published work.
Tips: Finds artists through self-promotions.

TRIBOTTI DESIGNS, 22907 Bluebird Dr., Calabasas CA 91302-1832. (818)591-7720. Fax: (818)591-7910. Contact: Robert Tribotti. Estab. 1970. Specializes in graphic design, annual reports, corporate identity, packaging, publications and signage. Clients: PR firms, ad agencies, educational institutions and corporations. Current clients include Southwestern University, *LA Daily News*, Northrup Corporation and Knitking.
Needs: Works with 2-3 freelance artists/year. Prefers local artists only. Works on assignment only. Uses freelancers mainly for brochure illustration. Also for catalogs, mechanicals, retouching, airbrushing, charts/ graphs, lettering and ads. Prefers marker, pen & ink, airbrush, pencil, colored pencil and computer illustration. Needs computer-literate freelancers for illustration and production. 50% of freelance work demands knowledge of Aldus PageMaker, Adobe Illustrator, QuarkXPress, Photoshop, Aldus FreeHand or Delta Graph. Needs editorial, technical illustration and for annual reports/brochures.
First Contact & Terms: Send query letter with brochure. Art Director will contact artist for portfolio review if interested. Portfolio should include thumbnails, roughs, original/final art, final reproduction/product and b&w and color tearsheets, photostats and photographs. Pays for design by the hour, $35-85. Pays for illustration by the project, $100-1,000. Rights purchased vary according to project.
Tips: Finds artists through word of mouth and self-promotion mailings. "We will consider experienced artists only. Must be able to meet deadline. Send printed samples and follow up with a phone call."

♨2 DIMENSIONS INC., 260 Sorauren Ave., Toronto, Ontario M6R 2G4 Canada. (416)539-0766. Fax: (416)539-0746. Estab. 1989. Specializes in annual reports; brand and corporate identity; direct mail, package and publication design. Clients: Fortune 500 corporations (IBM, etc.), major distributors and manufacturers (Letraset), most government ministries (Canadian), television (Fox TV, CBC). Partial client list available (does not include confidential clients).
Needs: Approached by 20 freelance artists/year. Works with 10 illustrators and 2 designers/year. Looks for unique and diverse signature styles. Designers must be local, but not illustrators. Works on assignment only (illustrators mostly). Uses illustrators mainly for advertising, collateral. Uses designers mainly for special projects and overflow work. Designers must work under creative director. Also uses freelance artists for brochure and magazine design; brochure, catalog, P-O-P, poster and ad illustration; and charts/graphs. Needs computer-literate freelancers for design. 100% of design work demands knowledge of QuarkXPress, Aldus FreeHand, Photoshop, Microsoft Word or Suitcase. Illustration work does not require computer.
First Contact & Terms: Send query letter with brochure or tearsheets, résumé, SASE. Samples are filed or are returned by SASE if requested by artist. Reports back within 2 weeks. Write for appointment to show portfolio."Don't send portfolio unless we phone. Send tearsheets that we can file." Pays for design by the project, $300-10,000. Pays for illustration by the project, $300-8,000. Negotiates rights purchased.
Tips: "We are looking for diverse signature styles of illustration for specific projects. Send tearsheets for our files. Our creative director refers to these files and calls with assignment offer. We don't normally have time to view portfolios except relative to a specific job. Strong defined styles are what we notice. The economy has reduced some client budgets and increased demand for speculative work. Since we are emphatically opposed to spec work, we do not ask our freelancers to work this way. Generalist artists who adapt to different styles are not in demand. Unique or bold illustrative styles are easier to sell."

‡UNICOM, 9470 N. Broadmoor Rd., Bayside WI 53217. (414)352-5070. Fax: (414)352-4755. Senior Partner: Ken Eichenbaum. Estab. 1974. Specializes in annual reports, brand and corporate identity; display, direct, package and publication design; and signage. Clients: corporations, business-to-business communications, and consumer goods. Client list available upon request.
Needs: Approached by 8-10 freelance artists/year. Works with 3-4 freelance illustrators/year. Works on assignment only. Uses freelance artists for brochure, book, poster, and ad illustration.
First Contact & Terms: Send query letter with brochure. Samples are not filed or returned. Does not report back; artist should not send samples to be returned. Write to schedule an appointment to show a portfolio. Portfolio should include thumbnails, photostats, slides and tearsheets. Pays for illustration by the project, $200-6,000. Rights purchased vary according to project.

UNIT ONE, INC., Suite 101, 616 Washington St., Denver CO 80203. (303)863-7810. Fax: (303)863-7812. President: Chuck Danford. Estab. 1968. Specializes in annual reports, brand and corporate identity, direct mail, publications, package design and signage. Clients: all major industries. Current clients include: Castle Builders, Denver International Airport, AB Hirshfield Press, Coors Technology Center and Western Mobile. Client list available upon request.
Needs: Approached by 15-30 freelance artists/year. Works with 1 or 2 illustrators and 3-5 designers/year. Uses freelancers mainly for computer design and production; brochure and ad design and illustration; direct mail, poster and newspaper design; mechanicals; retouching; airbrushing; audiovisual materials; lettering; logos; charts/graphs; and signage. Needs computer-literate freelancers for design and production. 100% of

freelance work demands knowledge of Aldus PageMaker, Adobe Photoshop, MS Word/Works, QuarkXPress or Aldus FreeHand. Needs editorial and general print illustration.

First Contact & Terms: Send query letter with brochure, tearsheets, photographs, photocopies and résumé. Samples are filed and are returned by SASE if requested. Reports only if interested. Art Director will contact artist for portfolio review if interested. Portfolio should include thumbnails, photographs, slides and transparencies. Pays for design by the hour, $6-25; by the project, $50 minimum; by the day, $48-200. Pays for illustration by the project, $100 minimum. Considers skill and experience of artist when establishing payment. Rights purchased vary according to project.

Tips: "Show printed pieces whenever possible; don't include fine art. Explain samples, outlining problem and solution. If you are new to the business develop printed pieces as quickly as possible to illustrate practical experience."

URBAN TAYLOR & ASSOCIATES, 116 Alhambra Circle., Coral Gables FL 33134. (305)444-1804. Fax: (305)461-2007. Senior Vice President: Terry Stone. Estab. 1976. Specializes in annual reports, corporate identity and communications and publication design. Current clients include IBM, American Express, Polaroid and Office Depot, Inc. Client list available upon request.

Needs: Works with freelance illustrators on as needed basis. Works with artist reps and local artists. Looking for a variety of editorial, technical and corporate communications illustration styles and freelance designers with Mac experience. Works on assignment only. Uses illustrators mainly for brochures and publications. Also uses freelancers for catalog and P-O-P illustration, retouching, airbrushing, lettering and charts/graphs. Needs computer-literate freelancers for design, illustration and production. 90% of freelance work demands knowledge of Aldus PageMaker, QuarkXPress, Aldus FreeHand, Adobe Illustrator, Adobe Photoshop or MicroSoft Word.

First Contact & Terms: Send query letter with SASE and appropriate samples. Samples are filed. Request portfolio review in original query. Art Director will contact artist for portfolio review if interested. Pays for design by the hour $15-25; or by the day, $120-200. Pays for illustration by the project, $250-2,500. "Payment depends on project and quantity printed." Rights purchased vary according to project. Interested in buying second rights (reprint rights) to previously published artwork.

Tips: Finds artists through sourcebooks, direct mail pieces, referral from collegues, clients and reps. "The field is going completely technical—provide all illustrations on Mac compatible disk—and CD-ROM soon.'"

THE VAN NOY GROUP, Dept. AM, 19750 S. Vermont Ave., Torrance CA 90502. (310)329-0800. Fax: (310)538-1435. Vice President: Ann Van Noy. Estab. 1972. Specializes in brand and corporate identity, displays and package design. Clients: corporations. Current clients include Kwikset, Western Digital Equipment, McCulloch and Hiram Walker. Client list available upon request.

Needs: Approached by 1-10 freelance artists/year. Works with 2 illustrators and 3 designers/year. Prefers artists with experience in Macintosh design. Works on assignment only. Uses freelancers for packaging design and technical illustration, Quark production, lettering and model making.

First Contact & Terms: Send query letter with résumé and photographs. Samples are filed. Art Director will contact artist for portfolio review if interested. If does not report back, artist should follow up. Pays for design by the hour, $25-50. Pays for illustration by the hour; by the project at a TBD fee.

Tips: Finds artists through sourcebooks, self-promotions and primarily agents. "I think more and more clients will bet setting up internal art departments and relying less and less on outside designers and talent. The computer has made design accessible to the user who is not design-trained."

‡VARON & ASSOCIATES, INC., 31333 Southfield, Beverly Hills MI 48025. (313)645-9730. Fax: (313)642-1303. President: Jerry Varon. Estab. 1963. Specializes in annual reports; brand and corporate identity; display, direct mail and package design; and technical illustration. Clients: corporations (industrial and consumer). Current clients include Dallas Industries Corp., Enprotech Corp., FEC Corp., Johnstone Pump Corp., Microphoto Corp., PW & Associates. Client list available upon request.

Needs: Approached by 20 freelance graphic artists/year. Works with 7 freelance illustrators and 7 freelance designers/year. Prefers local artists only. Works on assignment only. Uses designers mainly for brochure, catalog, P-O-P and ad design and illustration; direct mail design; mechanicals; retouching; airbrushing; adiovisual materials and charts/graphs. Needs computer-literate freelancers for design, illustration and presentation. 70% of freelance work demands knowledge of Aldus PageMaker, QuarkXPress, Aldus FreeHand or Adobe Illustrator.

First Contact & Terms: Send brochure, samples, slides and transparencies. Samples are filed. Reports back to the artist only if interested. Portfolios may be dropped off every Monday-Friday. Portfolio should include color thumbnails, roughs, final art and tearsheets. Buys all rights.

Tips: Finds artists through submissions.

VISUAL CONCEPTS, 5410 Connecticut Ave., Washington DC 20015. (202)362-1521. Owner: John Jacobin. Estab. 1984. Service-related firm. Specializes in visual presentation, mostly for retail stores. Clients: retail stores, residential and commercial spaces. Current clients include Cafe Paradiso, Highlights, and In Detail.

Needs: Approached by 5-10 freelance artists/year. Works with 3 designers/year. Assigns 10-20 projects/year. Prefers local artists with experience in visual merchandising and 3-D art. Works on assignment only. Uses freelancers mainly for design and installation. Prefers contemporary, vintage or any classic styles. Also uses freelancers for editorial, brochure and catalog illustration; advertising design and layout; illustration; signage; and P-O-P displays.
First Contact & Terms: Contact through artist rep or send query letter with brochure showing art style or résumé and samples. Samples are filed. Reports in 2 weeks. Call for an appointment to show portfolio of thumbnails, roughs and color photographs or slides. Pays for design and illustration by the hour, $6.50-30. Rights purchased vary according to project.

WALLACE CHURCH ASSOCIATES, INC., 330 E. 48th St., New York NY 10017. (212)755-2903. Fax: (212)355-6872. Creative Manager: Susan Wiley. Specializes in package design. Clients: Fortune 500 food companies, personal and home product companies, toy companies and pharmaceutical corporations. Current clients include Kraft, General Foods, Pillsbury, Gillette and Bristol-Myers. Client list available upon request.
Needs: Approached by more than 100 artists/year. Works with more than 125 illustrators and designers/year. Prefers artists with experience in food and personal care rendering. Works on assignment only. Uses illustrators mainly for package art. Uses designers mainly for graphics, package design and mechanicals. Also uses artists for mechanicals, retouching, airbrushing, lettering, logos and model making. Needs computer-literate freelancers for design and production. 75% of freelance work demands knowledge of Aldus Page-Maker, Adobe Illustrator, Quark XPress or Aldus FreeHand.
First Contact & Terms: Send query letter with portfolio. Samples are filed. Reports back only if interested. Portfolio should include "everything." Pays for design by the hour, $15-150. Buys all rights.
Tips: "Computer experience is a strong plus."

WATT, ROOP & CO., 1100 Superior, Cleveland OH 44114. (216)566-7019. (216)566-0857. VP, Design Operations: Tom Federico. Estab. 1981. Specializes in annual reports, corporate identity, direct mail and publication design and capability pieces. Clients: corporate and business-to-business. Current clients include TRW, NCR and AT&T. Client list not available.
Needs: Approached by 60 freelance artists/year. Works with 12 illustrators and 10 designers/year. Prefers local artists. Works on assignment only. Uses illustrators mainly for editorial and newsletter spot illustrations. "Uses designers mainly for completing our designs (follow through)." Also for brochure design and illustration, magazine and direct mail design, mechanicals, retouching and airbrushing. Needs computer-literate freelancers for production. 50% of freelance work demands knowledge of Aldus PageMaker, QuarkXPress or Adobe Illustrator.
First Contact & Terms: Send query letter with brochure and résumé. Samples are filed. Does not report back. Artist should follow up with call. Sometimes requests work on spec before assigning job. Pays for design by the project, $500 minimum. Pays for illustration by the project, $50 minimum. Rights purchased vary according to project. Interested in buying second rights (reprint rights) to previously published artwork.
Tips: "Send samples of work. Usually we are looking for a specific style. Freelancers should know that budgets are generally lower now, due to computers (clients have become somewhat spoiled)."

‡WAVE DESIGN WORKS, 560 Harrison Ave., Boston MA 02118. (617)482-4470. Fax: (617)482-2356. Principal: John Buchholz. Estab. 1986. Specializes in corporate identity and display, package and publication design. Clients: corporations—primarily biotech and software. Current clients include Genzyme, Integrated Genetics, New England Biolabs. Client list not available.
Needs: Approached by 24 freelance graphic artists/year. Works with 1-5 freelance illustrators and 1-5 freelance designers/year. Works on assignment only. Uses illustrators mainly for ad illustration. Also uses freelance artists for brochure, catalog, poster and ad illustration; lettering; and charts/graphs. Needs computer-literate freelancers for design, illustration and production. 70% of freelance work demands knowledge of Aldus PageMaker, QuarkXPress, Aldus FreeHand, Adobe Illustrator or Adobe Photoshop.
First Contact & Terms: Send query letter. Samples are filed. Reports back to the aritst only if interested. Artist should follow up with call and/or letter after initial query. Portfolio should include b&w and color thumbnails and final art. Pays for design by the hour, $12.50-25. Pays for illustration by the project. Rights purchased vary according to project.
Tips: Finds artists through submissions and sourcebooks.

WESCO GRAPHICS, INC., 2034 Research Dr., Livermore CA 94550. (510)443-2400. Fax: (510)443-0452. Art Director: Dawn Hill. Estab. 1977. Service-related firm. Specializes in design, layout, typesetting, paste-up, ads and brochures. Clients: retailers. Current clients include Albertsons, Burlingame Stationers, Fleming Foods, Longs Drugs.
Needs: Approached by 20 freelance artists/year. Assigns 12 freelance jobs/year. Works with 2 designers/year. Prefers local artists with experience in paste-up and color. Works on assignment only. Uses freelancers mainly for overload. Also for ad and brochure layout. Needs computer-literate freelancers for production. 90% of freelance work demands knowledge of Adobe Illustrator, QuarkXPress, Photoshop and Multi Ad Creator.

To mark the 100th anniversary of Cracker Jack, Borden enlisted Wallace Church Associates to design this commemorative collectible tin. Wallace Church chose artist Joe Spencer's art deco stylization for the panel illustrations on the tin, each representing 25 years in the history of Cracker Jack and its consumers.

First Contact & Terms: Send query letter with résumé. Samples are filed. Art Director will contact artist for portfolio review if interested. Artist should follow up with call. Portfolio should include b&w thumbnails, roughs, photostats and tearsheets. Sometimes requests work on spec before assigning job. Pays for design and illustration by the hour, $10-15. Buys all rights.
Tips: Finds artists through word of mouth. "Computer experience necessary."

WEYMOUTH DESIGN, INC., 332 Congress St., Boston MA 02210-1217. (617)542-2647. Fax: (617)451-6233. Office Manager: Judith Hildebrandt. Estab. 1973. Specializes in annual reports and corporate collateral. Clients: corporations and small businesses. Client list not available.
Needs: Approached by "tons" of freelance artists/year. Works with 5 illustrators/year. Prefers artists with experience in corporate annual report illustration. Works on assignment only. Needs editorial, medical and technical illustration mainly for annual reports. Also uses freelance artists for brochure and poster illustration.
First Contact & Terms: Send query letter with résumé or illustration samples. Samples are filed or are returned by SASE if requested by artist. Art Director will contact artist for portfolio review if interested. Pays for design by the hour, $20. Pays for illustration by the project; "artists usually set their own fee to which we do or don't agree." Rights purchased vary according to project.
Tips: Finds artists through magazines and agents. "Because our staff is now computer literate as are our clients, and mechanicals are on disk, we no longer need freelance designers during the busy season."

WILDER●FEARN & ASSOC., INC., Suite 416, 644 Linn St., Cincinnati OH 45203. (513)621-5237. Fax: (513)621-4880. President: Gary Fearn. Estab. 1946. Specializes in annual reports, brand and corporate identity and display, package and publication design. Clients: ad agencies, corporations, packaging. Current clients include Jergens Co., Kenner Toys, Kroger and Kraft. Client list available upon request.
Needs: Approached by 20 freelance artists/year. Works with 5-10 illustrators and 2-5 designers/year. Prefers artists with experience in packaging and illustration comps. Uses freelance illustrators mainly for comps and finished art on various projects. Needs editorial illustration. Uses freelance designers mainly for packaging and brochures.
First Contact & Terms: Send query letter with brochure, résumé and slides. Samples are filed or are returned by SASE if requested by artist. Reports back to the artist only if interested. Call for appointment to show portfolio of roughs, original/final art and color tearsheets and slides. Payment for design and illustration is based upon talent, client and project. Rights purchased vary according to project.

WILLIAMS McBRIDE DESIGN, INC., 182 N. Mill St., Lexington KY 40507. (606)253-9319. Fax: (606)233-0180. Partners: Robin Williams Brohm and Kim McBride. Estab. 1988. Specializes in annual reports, corporate identity, capability brochures, direct mail and publication design. Clients: corporations, hospitals, publishers, public relations firms. Client list available upon request.
Needs: Approached by 7-10 freelance artists/year. Works with 4-5 illustrators and 1-2 designers/year. Works on assignment only. Uses designers mainly for concept sketches. Uses illustrators for editorial, brochure and medical illustration and concept thumbnails, retouching and logos. Needs computer-literate freelancers for design and illustration. 50% of freelance work demands knowledge of QuarkXPress and Adobe Illustrator.
First Contact & Terms: Send query letter with résumé, tearsheets or photocopies. Request portfolio review in original query. Samples are filed. Reports back only if interested. Write for appointment to show portfolio of roughs, final art. Pays for design by the hour, $10-30. Pays for illustration by the project, $100-800. Rights purchased vary according to project.
Tips: "Keep our company on your mailing list; remind us that you are out there, and understand the various rights that can be purchased."

WISNER ASSOCIATES, Advertising, Marketing & Design, 2237 NE Wasco, Portland OR 97232. (503)228-6234. Creative Director: Linda Wisner. Estab. 1979. Specializes in brand and corporate identity, direct mail, packaging and publications. Clients: small businesses, manufacturers, restaurants, service businesses and book publishers. Client list not available.
Needs: Approached by 20-30 freelance artists/year. Works with 7-10 artists/year. Prefers experienced artists and "fast, clean work." Works on assignment only. Uses freelancers for technical and fashion illustration, books, mechanicals, airbrushing and lettering. Needs computer-literate freelancers for illustration and production. 70% of freelance work demands knowledge of Aldus PageMaker, Quark, CorelDraw and other IBM-compatible software.
First Contact & Terms: Send query letter with résumé, photostats, photocopies, slides and photographs. Prefers "examples of completed pieces which show the fullest abilities of the artist." Samples not kept on file are returned by SASE only if requested. Art Director will contact artist for portfolio review if interested. Portfolio should include thumbnails, roughs and final reproduction/product. Pays for illustration by the hour, $20-45 average; by the project by bid. Pays for paste-up/production by the hour, $15-25.
Tips: "Bring a complete portfolio with up-to-date pieces."

‡MICHAEL WOLK DESIGN ASSOCIATES, 2318 NE 2nd Court, Miami FL 33137. (305)576-2898. President: Michael Wolk. Estab. 1985. Specializes in corporate identity, displays, interior design and signage. Clients: corporate and private. Client list available upon request.
Needs: Approached by 10 freelance artists/year. Works with 5 freelance illustrators and 5 freelance designers/year. Prefers local artists only. Works on assignment only. Needs editorial and technical illustration mainly for brochures. Uses designers mainly for interiors and graphics. Also uses artists for brochure design, mechanicals, logos and catalog illustration. Needs "progressive" illustration. Needs computer-literate freelancers for design, production and presentation. 75% of freelance work demands knowledge of Aldus PageMaker, Quark XPress, Aldus FreeHand, Adobe Illustraor or other software.
First Contact & Terms: Send query letter with slides. Samples are not filed and are returned by SASE. Reports back to the artist only if interested. To show a portfolio, mail slides. Pays for design by the hour, $10-20. Rights purchased vary according to project.

‡WYD DESIGN, 61 Wilton Rd., Westport CT 06880. (203)227-2627. Fax: (203)454-1848. President: D. Dunkelberger. Estab. 1984. Specializes in annual reports, corporate identity and publication design. Clients: corporations. Client list not available.
Needs: Approached by 50 freelance artists/year. Works with 15-20 freelance illustrators/year. Uses freelance illustrators mainly for annual reports and school books.
First Contact & Terms: Send query letter with tearsheets and photographs. Samples are filed or are returned by SASE if requested by artist. Reports back to the artist only if interested. Write for appointment to show portfolio of slides, tearsheets and photographs. Pays for illustration by the project. Rights purchased vary according to project.

YAMAGUMA & ASSOCIATES, #120, 255 N. Market St., San Jose CA 95110-2409. (408)279-0500. Fax: (408)293-7819. Estab. 1980. Specializes in corporate identity, displays, direct mail, publication design, signage and marketing. Clients: high technology, government and business-to-business. Current clients include Hewlet Packard, Metra Corp and 50/50 Micro Electronics. Client list available upon request.
Needs: Approached by more than 100 freelance artists/year. Works with 3-4 illustrators and 4-6 designers/year. Works on assignment only. Uses illustrators mainly for 4-color, airbrush and technical work. Uses designers mainly for logos, layout and production. Also uses freelancers for brochure, catalog, P-O-P and poster design and illustration; mechanicals; retouching; lettering; ad design and illustration; book, magazine, model making; direct mail design; charts/graphs; and AV materials. Needs editorial and technical illustration. Needs computer-literate freelancers for design, illustration and production. 85% of freelance work demands knowledge of Aldus PageMaker, QuarkXPress, Aldus FreeHand, Adobe Illustrator, Model Shop or Photoshop.
First Contact & Terms: Send query letter with brochure and other samples. Samples are filed. Art Director will contact artist for portfolio review if interested. Portfolio should include thumbnails, roughs, b&w and color photostats, tearsheets, photographs, slides and transparencies. Sometimes requests work on spec before assigning job. Pays for design by the hour, $15-50. Pays for illustration by the project, $300-3,000. Rights purchased vary according to project.
Tips: Finds artists through self-promotions. Would like to see more Macintosh-created illustrations.

‡CLARENCE ZIERHUT, INC., 2014 Platinum St., Garland TX 75042. (214)276-1722. Fax: (214)272-5570. President: Clarence Zierhut. Estab. 1956. Specializes in display, product and package design and corporate identity. Clients: corporations, museums, individuals. Client list not available.
Needs: Works with by 1-2 freelance graphic artists and 3-4 freelance designers/year. Works on assignment only. Uses illustrators and designers mainly for renderings and graphics. Also uses freelance artists for brochure design and illustration, mechanicals, retouching, airbrushing, model making, lettering and logos. Needs computer-literate freelancers for design and illustration. 100% of freelance work demands knowledge of Aldus PageMaker or Adobe Illustrator.
First Contact & Terms: Send query letter with brochure and résumé. Samples are filed. Reports back to the artist only if interested. Art Director will contact artist for portfolio review if interested. Porfolio should include b&w and color final art and photographs. Pays for design by the hour, $15-35; by the project. Pays for illustration by the hour; by the project; or by direct quote. Buys all rights.
Tips: Finds artists through sourcebooks and word of mouth.

Art/Design Studios/'94-'95 changes

The following markets were listed in the 1994 edition but do not have listings in this edition. The majority did not respond to our request to update their listings. If a reason was given for exclusion, it appears in parentheses after the market's name.

Aaron, Sauter, Gaines & Associates/Direct Marketing
Amberger Design Group
Austin Design, Inc.
Backart Design
BCM Ink, Ltd. Creative Design Services
Barry David Berger & Associates, Inc.
The Chestnut House Group Inc.
Jann Church Partners Advertising
Csoka/Benato/Fleurant, Inc.
Exhibit Builders Inc.
Finn Studio Limited
Tom Graboski Associates Inc.
Graphicus Corporations
Jbach Designs
Jones Medinger Kindschi

Jungclaus & Kreffel Design Studio
Kascom Design
Rusty Kay & Assoc. Inc.
Kelly & Co., Graphic Design, Inc.
Don Klotz Associates
The Kottler Caldera Group
Lekasmiller
The Leprevost Corporation
Lubell Brodsky Inc.
Molly Design Company
Notovitz Design Associates, Inc.
Pageworks + Tri Design
Paos New York
Papagalos and Associates
Peresechini & Co.
Petro Graphic Design Associates

Production Ink
Quadrant Communications Co., Inc.
Arnold Saks Associates
Steven Sessions Inc.
Jack Schecterson Associates
Roger Sherman Partners, Inc.
Smallkaps Associates, Inc.
Spot Design
Gordon Stromberg Design
Studio Graphics
Studio N, Inc.
TMA
Tokyo Design Center
The T-Shirt Gallery Ltd.
Universal Exhibits
James Weaver Graphic Design

Art Publishers

There are endless walls of space in hospital corridors, restaurants, office buildings, hotel lobbies, college dorms and households all over the country. Once you start looking, you'll notice that most of them are covered with decorative works of art. And most of the art is in the form of posters and prints. That's what makes the art publishing industry a billion dollar a year business. The space on those walls is reserved for artists, like you, who take the time to research the art publishing market.

Why posters and prints? That's easy. A hospital or restaurant has walls to cover. Choosing individual paintings would be expensive and time consuming, and the paintings might not complement the already existing decor. In these environments, the artwork is not meant to replicate a museum experience, but to make surroundings more pleasant. Uniform sizes and color schemes make the work easier and cheaper to mat, frame and install and the buyer can rest assured that the artwork won't clash with the carpeting.

Your paintings could be published as prints or posters if you are willing to create artwork with an eye to the market. This section lists art publishers and distributors who might publish your work as a print or poster and market the images to framers, interior decorators and other outlets. In order to be accepted for publication, however, your work must fit in with the current trends in the industry. One artist I know submitted slides of her collages to an art publisher, who suggested she do similar work in different colors. Though some artists may have resented such a suggestion, she welcomed the input and followed the publisher's advice. She is now able to support herself handsomely on the profits from her publishing sales. The market she targeted was a highly commercial one looking for strictly decorative work. There is room for more personal statements if the artist chooses to distribute original prints through fine art galleries, but it is still wise to take the publisher's advice on which images to use.

The publishing process

Art publishers work in much the same way that book publishers do, except they publish images, not words. An art publisher usually contracts with an artist to put a piece of that artist's work in print form, and then pays for and supervises the production and marketing of the work. Sometimes a publisher will agree to run prints of a pre-existing image, while other times the artist will be asked to create a new piece of art for publication purposes. A print will generally be classified as an original print or offset reproduction, depending on how it is produced and where it is sold.

Original prints may be woodcuts, engravings, linocuts, mezzotints, etchings, lithographs or serigraphs. What distinguishes them is that they are produced by hand (and consequently often referred to as handpulled prints). The market for original prints has been growing steadily for the last few years. Although prints have traditionally been sold through specialized print galleries, frame shops and high-end decorating outlets, more and more fine art galleries are now handling them in addition to original artwork. A gallery will often handle prints of an artist with whom it has already established a working relationship.

Original prints are always sold in limited editions and consequently command a higher price. Since plates for original prints are made by hand, and as a result can

only withstand a certain amount of use, the number of prints that can be pulled is limited by the number of impressions that can be made before the plate wears out. Some publishers impose their own limits on the number of impressions to increase a print's value. These limits may be set as high as 700 to 1,000 impressions, but some prints are limited to just 250 to 500, making them highly prized by collectors.

Offset reproductions, also known as posters, are reproduced by photomechanical means. Since plates used in offset reproduction do not wear out, there are no physical limits on the number of prints made. Quantities, however, may still be limited by the publisher in order to add value to the edition.

Prices for reproductions vary widely depending on the quantity available, the artist's reputation, the popularity of the image and the quality of the paper, ink and printing process. Since prices are lower than those for original prints, publishers tend to select images with high-volume sales potential.

A special note about sculpture

Some publishers also handle limited editions of sculptural pieces and market them through fine art galleries. Sculptural editions are made by casting several forms from the same mold. Check the listings in this section for more targeted information about this publishing option.

What's hot

According to *USArt* the three most popular printing methods for original prints these days are etching, serigraphy and lithography. Wildlife subjects remain popular, with ducks, wolves and polar bears capturing the most interest. Other popular subjects include Native American images—especially those with spiritual undertones, African and African-American themes, angels and children. Sports images continue to do well, particularly golf prints. Victorian themes also sell well.

Finding the right publisher

Like any business venture, finding the right publisher requires careful research. Visit galleries, frame shops and other retail outlets that carry prints to see what is selling. You may also want to visit designer showrooms, interior decoration outlets and trade shows such as Art Expo and Art Buyers Caravan to get a sense of what's out there.

Once you've selected a list of potential publishers, send for artist's guidelines or catalogs if they are available. Some larger publishers will not send their catalogs because they are too expensive, but you can often ask to see one at your local poster shop, print gallery or frame shop.

Approaching and working with publishers

To approach a publisher, send a brief query letter, a short bio, a list of galleries that represent your work and 5 to 10 slides. It helps to send printed pieces or tearsheets as samples, as these show publishers that your work can be reproduced effectively and that you have some understanding of the publication process.

The self-publishing option

*If you have some knowledge of the printing process and are a savvy marketer,
you may want to consider finding your own printer and self-publishing your work.
As a self-published artist, you will have complete control over the quality and
treatment of your work and will receive all profits on sales. Keep in mind, however,
that this option also requires a lot of time and effort. Promotion, distribution and
marketing will become your responsibility, and you'll have to make a considerable
financial investment upfront to cover production costs.*

*In addition to art publishers, this section also lists distributors and wholesalers.
Such services do not publish art, but rather serve as marketing teams, delivering
artwork to a network of sales outlets. If you're considering the self-publishing
route, you may want to consider contracting with one such service for added
support.*

A few publishers will buy work outright for a flat fee, but most pay on a royalty
basis. Royalties for handpulled prints are usually based on retail price and range from
5-20 percent, while percentages for offset reproductions are lower (from 2 1/2 to 5
percent) and are based on the wholesale price. Be aware that some publishers may
hold back royalties to cover promotion and production costs. This is not uncommon.

As in other business transactions, make sure you understand all the terms of your
contract before you sign. The publisher should provide a description of the print
ahead of time, including the size, printing method, paper and number of images to
be produced. Other things to watch for include insurance terms, marketing plans, and
a guarantee of a credit line and copyright notice.

Always retain ownership of your original work, and try to work out an arrangement
in which you're selling publication rights only. You'll also want to sell rights only for
a limited period of time. Such arrangements will leave you with the option to sell the
image later as a reprint, or to license it for other use (for example as a calendar or
note card).

Most publishers will arrange for the artist to see a press proof and will give the
artist final approval of a print. The more you know about the printing process and
what can and cannot be done in certain processes, the better. If possible, talk to a
printer ahead of time about your concerns. Knowing what to expect beforehand will
eliminate surprises and headaches for the printer, publisher and you.

AARON ASHLEY, INC., Suite 1905, 230 Fifth Ave., New York NY 10001. (212)532-9227. Fax: (212)481-4214.
Contact: Philip D. Ginsburg or Budd Wiesenburg. Produces unlimited edition, 4-color offset and hand-
colored reproductions for distributors, manufacturers, jobbers, museums, schools and galleries. Clients: major
US and overseas distributors, museums, galleries and frame manufacturers, jobbers. Current clients include:
Freer Gallery of Art and Vanguard Studios.
Needs: Seeking decorative art for designer market. Considers oil paintings and watercolor. Prefers realistic
or representational works. Artists represented include French-American Impressionists, Bierstadt, Russell
Remington, Jacqueline Penney, Ron McKee, Carolyn Blish and Urania Christy Tarbot. Editions created by

working from an existing painting or chrome. Approached by 100 artists/year. Publishes and distributes the work of 12 emerging artists/year. Publishes more than 100 editions/year.

First Contact & Terms: Query with SASE and slides or photos. "Do not send originals." Artist should follow up with call and/or letter after initial query. Reports immediately. Pays royalties or fee. Offers advance. Negotiates rights purchased. Requires exclusive representation for unlimited editions. Provides written contract.

ADDI FINE ART PUBLISHING, Suite 105, 961 Matley Lane, Reno NV 89502. (800)845-2950. Fax: (702)324-4066. Director: Andrejs Van Nostrand. Estab. 1989. Art publisher, distributor and gallery. Publishes posters and limited editions. Clients: galleries and distributors. Current clients include Prints Plus and Endangered Species Stores.

Needs: Seeking art for the serious collector and the commercial market. Considers oil and acrylic. Prefers wildlife, landscapes and marine themes. Artists represented include David Miller, Ken Conragan, Trevor Swanson and Elan Vital. Editions created by collaborating with the artist or by working from an existing painting. Approached by 25 artists/year. Publishes and distributes the work of 1-2 emerging, 1-2 mid-career and 2-3 established artists/year.

First Contact & Terms: Send query letter with slides, photocopies, résumé, transparencies, tearsheets and photographs. Samples are not filed and are returned. Reports back within 1 month. Publisher/Distributor will contact artists for portfolio review if interested. Pays variable royalties. Does not offer advance. Buys reprint rights. Provides promotion, shipping from firm, insurance while work is at firm, a written contract.

Tips: "Submit photos or slides of work presently available. We usually request that originals be sent if we are interested in art."

AKASHA, 2919 Como Ave. SE, Minneapolis MN 55414. (612)379-2781. Fax: (612)379-2251. Contact: Steve Andersen. Fine art printing and publishing workshop with showroom for retail and wholesale sales. Estab. 1977.

Needs: Considers sculpture, original handpulled prints, painting and mixed media. Artists represented include Red Grooms, Wegman, Africano, Ed Moses, Solien. Publishes and distributes the work of 2-3 emerging, 5-10 mid-career and 2-3 established artists.

First Contact & Terms: Write for appointment to show portfolio, which should include slides. Replies only if interested within 1 month. Files résumés and reviews. "Artists are invited to the studio on the merits of their original work to produce an edition or a portfolio of monotypes, etc. The proceeds from the sale of the work are split between the publisher and artist. We are also open to other negotiated deals."

✦KEITH ALEXANDER EDITIONS, 102-1445 W. Georgia St., Vancouver, British Columbia V6G 2T3 Canada. (604)682-1234. President: Barrie Mowatt. Estab. 1978. Art publisher, distributor and gallery. Publishes and distributes limited editions, handpulled originals and posters. Clients: galleries and other distributors.

Needs: Prefers original themes. Publishes and distributes the work of 11 artists/year.

First Contact & Terms: Send query letter with résumé, tearsheets and transparencies. Samples are not filed and are returned. Reports back within 6-12 weeks. Write for appointment to show portfolio of transparencies. Pays flat fee or on consignment basis; payment method is negotiated. Buys all rights. Requires exclusive representation of the artist. Provides insurance, promotion, shipping from firm and a written contract.

Tips: "Present a professional portfolio which accurately reflects the real work. Also have goals and objectives about lifestyle expectations."

‡ALEXANDRE A DU M, P.O. Box 34, Upper Marlboro MD 20773. (301)856-3217. Fax: (301)856-2486. Artistic Director: Walter Mussienko. Estab. 1972. Art publisher and distributor. Publishes and distributes handpulled originals, limited editions and originals. Clients: retail art galleries, collectors and corporate accounts.

Needs: Seeking creative and decorative art for the serious collector and designer market. Considers oil, watercolor, acrylic, pastel, ink, mixed media, original etchings and colored pencil. Prefers landscapes, wildlife, abstraction, realism and impressionism. Artists represented include Cantin, Bourrie and Gantner. Editions created by collaborating with the artist. Approached by 30 artists/year. Publishes the work of 2 emerging, 2 mid-career and 3-4 established artists/year. Distributes the work of 2-4 emerging, 2 mid-career and 24 established artists/year.

First Contact & Terms: Send query letter with résumé, tearsheets and photographs. Samples are filed. Reports back within 4-6 weeks only if interested. Call for appointment to show a portfolio or mail photographs and original pencil sketch. Payment method is negotiated: consignment and/or direct purchase. Offers an advance when appropriate. Negotiates rights purchased. Provides promotion, a written contract and shipping from firm.

Tips: "Artist must be properly trained in the basic and fundamental principles of art and have knowledge of art history. Have work examined by art instructors before attempting to market your work."

‡ALL SALES CO./PRIME PRODUCTS, Suite 110, 1186 Ocean Shore Blvd., Ormond Beach FL 32176. (904)441-6856. Fax: (904)441-6856. Owner: Tim Curry. Art publisher and distributor. Publishes and distributes limited and unlimited editions. Current clients include John Akers, Robert Cook, Della Storms and Barbra Louque.

Needs: Considers oil, watercolor and acrylic. Prefers wildlife, birds (particularly the Manatee and the Rose Ha Spoonbill), sport dogs, florals and golf themes. Editions created by collaborating with the artist. Publishing and distributing 14 new prints this year.

First Contact & Terms: Send query letter with tearsheets, photographs and photocopies. Samples are not filed and are returned. Reports back within 1 month. Call to schedule an appointment to show a portfolio or mail tearsheets and photographs. Payment method is negotiated. Offers advance when appropriate. Negotiates rights purchased.

AMERICAN ARTS & GRAPHICS, INC., 10315 47th Ave. W., Mukilteo WA 98275. Fax: (206)348-6296. Licensing Manager: Tina Gilles. Estab. 1948. Publishes posters for a teenage market; minimum 5,000 run. Clients: mass market retailers. "Our main market is family variety stores, record and tape stores and discount drug stores." Current clients include Walmart, K-Mart, Toys R Us, Fred Meyer, Longs and Osco.

Needs: Seeking decorative art (popular trends). Prefers 16 × 20 originals; full-size posters are 23 × 35. Prefers airbrush, then acrylic and oil. Artists represented include Gail Gastfield, Mark Watts, Kurt C. Burmann, Jonnie Chardonn and Jenny Newland. Editions created by working from an existing painting. Approached by 100 artists/year. Publishes the work of 2-3 emerging, 2-3 mid-career and 3-4 established artists/year. Distributes the work of 20 artists/year. Artist's guidelines available.

First Contact & Terms: Send query letter with tearsheets, photostats, photocopies and production quality duplicate slides; then submit sketch or photo of art. Include SASE. Reports in 2 weeks. Usually pays royalties of 10¢/poster sold and an advance of $500-1,000 against future royalties. Payment schedule varies according to how well known the artist is, how complete the work is and the skill level of the artist.

Tips: "Research popular poster trends; request a copy of our guidelines. Our posters are an inexpensive way to decorate, so art sales during recession don't show any significant decreases."

‡AMERICAN GRAPHIC ARTS, 101 Merrimac St., Boston MA 02114. (800)637-9997. Fax: (617)723-6561. President: Jonathan Pollock. Estab. 1986. Art publisher and gallery. Publishes handpulled originals and "unique works." Clients: other galleries, retail art collectors and dealers in the US and Japan.

Needs: Seeking artwork for the commercial market. Considers oil and acrylic. Prefers traditional and realistic imagery. Artists represented include Ted Jeremenko. Editions created by collaborating with the artist and by working from an existing painting. Approached by 75-100 artists/year.

First Contact & Terms: Send query letter with brochure showing art style or résumé and slides, photographs and transparencies. Samples are filed if interested or are returned by SASE if requested by artist. Reports back only if interested, otherwise materials returned. To show portfolio, mail tearsheets, photographs, slides and transparencies. Payment method is negotiated. Negotiates rights purchased. Requires exclusive representation of artist. Provides in-transit insurance, insurance while work is at firm, promotion, shipping from firm and a written contract.

Tips: "Prefers artists with established reputations and experience with fine art printers. Most publishers are not gambling with new or unusual work"

AMERICAN QUILTING ART, Box S-3283, Carmel CA 93921. (408)659-0608. Sales Manager: Erica Summerfield. Art publisher of offset reproductions, unlimited editions and handpulled originals. Clients: galleries. Current clients include Quilts Ltd. and the Smithsonian.

Needs: Seeking decorative art. Considers watercolor, oil, acrylic, pastel, tempera and mixed media. Prefers traditional and folk art. Artists represented include Mary Rutherford. Publishes/distributes the work of 1 emerging, 1 mid-career and 1 established artist/year.

First Contact & Terms: Send query letter with brochure showing art style or "any available material." Samples are filed or are returned by SASE. Reports back within 2 weeks. Write for an appointment to show portfolio. Payment method is negotiated. Offers advance when appropriate. Buys all rights. Prefers exclusive representation of the artist. Provides in-transit insurance, insurance while work is at firm and shipping from firm.

AMERICAN VISION GALLERY, 520 Broadway, New York NY 10012. (212)925-4799. Fax: (212)431-9267. Contact: Acquisitions. Estab. 1974. Art publisher and distributor. Publishes and distributes posters and limited editions. Clients: galleries, frame shops, museum shops. Current clients include Museum of Modern Art, The Studio Museum, Poster Plus, P&C Art and Reprint Mint.

Needs: Seeking creative, fashionable and decorative art for the serious collector and for the commercial and designer markets. Considers collage, oil, watercolor, pen & ink, acrylic. Prefers African-American genre (at home, work, school; jazz; people; church). Artists represented include Bearden, Lawrence, Jeffrey Glenn

The double dagger before a listing indicates that the listing is new in this edition. New markets are often more receptive to freelance submissions.

Reese, Ellis Wilson, Charles Searles, Ed Clark, Herb Gentry, John Biggers and Raven Williamson. Editions created by collaborating with the artist or by working from an existing painting. Approached by 300 artists/ year. Publishes the work of 4 emerging, 2 mid-career and 8 established artists/year. Distributes the work of 20 emerging, 20 mid-career and 50-100 established artists/year.

First Contact & Terms: Send query letter with slides and bio. Samples are returned by SASE if requested by artist. Reports back only if interested. Pays flat fee, $400-1,500 maximum, or royalties of 10%. Offers advance when appropriate. Negotiates rights purchased. Interested in buying second rights (reprint rights) to previously published artwork.

ANGEL GRAPHICS, A Division of Angel Gifts, Inc., P.O. Box 530, 903 W. Broadway, Fairfield IA 52556. Project Manager: Lauren Wendroff. Estab. 1981. Publisher of wall decor art (photographic and graphic images) in mini poster (16×20) and smaller sizes. Clients: wholesale gift market, international, picture framers.

Needs: Seeking detailed artwork, realistic subjects with general appeal. No abstract surrealism. Prefers African-American, Caribbean, African, Native American, inspirational/religious, Western/cowboy, wildlife, inspirational, fantasy, cute, religious, florals, still life images. Seeking detailed artwork, realistic subjects with general appeal. No abstract or surrealism. Publishes 50-100 new subjects each year.

First Contact & Terms: Send query letter with photographs or slides and SASE. Pays $200-500. Successful published artists can arrange advance on royalties.

Tips: "Send $3 for current catalog to see types of images we publish."

HERBERT ARNOT, INC., 250 W. 57th St., New York NY 10107. (212)245-8287. President: Peter Arnot. Vice President: Vicki Arnot. Art distributor of original oil paintings. Clients: galleries, design firms.

Needs: Seeking creative and decorative art for the serious collector and designer market. Considers oil and acrylic paintings. Has wide range of themes and styles—"mostly traditional/impressionistic, not modern." Artists represented include An He, Malva, Willi Bauer, Gordon, Yoli and Lucien Delarue. Distributes the work of 250 artists/year.

First Contact & Terms: Send query letter with brochure, résumé, business card, slides or photographs to be kept on file. Samples are filed or are returned by SASE. Reports within 1 month. Portfolios may be dropped off every Monday-Friday or mailed. Pays flat fee, $100-1,000. Provides promotion and shipping to and from distributor.

Tips: "Professional quality, please."

‡ART BEATS, INC., 251 S. Floral St., Salt Lake City UT 84111. (801)596-2910. Fax: (801)532-1632. Special Projects: Michelle Lloyd. Estab. 1983. Art publisher. Publishes and distributes unlimited editions, posters, limited editions, offset reproductions and gift/fine art cards. Clients: framers, gallery owners, gift shops. Current clients include Prints Plus, Intercontinental Art.

Needs: Seeking creative, fashionable and decorative art for the commercial and designer markets. Considers oil, watercolor, mixed media, pastel and acrylic. Artists represented include Gary Collins, Nancy Lund, Mark Arian, Robert Duncan and Tracy Taylor. Approached by 1,000 artists/year. Publishes the work of 45 established artists/year.

First Contact & Terms: Send query letter with slides, photocopies, résumé, photostats, transparencies and tearsheets. Samples are not filed and are returned by SASE if requested by artist. Reports back within 1 month. Publisher will contact artist for portfolio review if interested. Portfolio should include photostats, slides, tearsheets, photographs and transparencies; "no originals please." Pays royalties of 10% gross sales. No advance. Buys first rights, one-time rights or reprint rights. Provides promotion and written contract.

Tips: Finds artists through art shows, exhibits, word of mouth and submissions.

‡ART BOOM LIMITED EDITIONS, 3149 Glendale Blvd., Los Angeles CA 90039. (213)666-5986. Fax: (213)666-2367. Publisher: Steve Rinehart. Art publisher. Publishes limited editions. Clients: 1,100 galleries.

Needs: Considers oil, mixed media and acrylic. Prefers representational art. Artists represented include Steve Kushner, Alan Murray. Editions created by collaborating with the artist and working from an existing painting. Approached by 100/year. Publishes the work of 2-3 emerging, 1 mid-career and 6-10 established artists/year. Distributes the work of 1-2 emerging and 1-2 established artists/year.

First Contact & Terms: Send query letter with brochure, slides, photocopies, résumé, transparencies, tearsheets and photographs. Samples are not filed and returned by SASE if requested by artist. Portfolio review not required. Publisher will contact artist for portfolio review if interested. Portfolio should include slides and 4×5 or 8×10 transparencies. Pays royalties of 12-15% or negotiates payment. No advance. Buys reprint rights. Requires exclusive representation of artist. Provides in-transit insurance, promotion, shipping from firm and written contract.

Tips: Finds artists through attending art exhibitions.

ART BROKERS OF COLORADO, 1010 W. Colorado Ave., Colorado Springs CO 80904. (719)520-9177. Contact: Nancy Anderson. Estab. 1990. Art publisher and gallery. Publishes limited editions and offset reproductions. Clients: galleries, commercial and retail.

This image in charcoal entitled **The Carrot,** *by Susan von Borstel, was published by Art Boom Limited Editions. The artist sought to create a "warm realistic image" that conveys "the natural connection existing between children and animals." This was her sixth print for Art Boom, from which she received recognition from several companies and many new clients.*

© 1991 Susan von Borstel

Needs: Seeking decorative art for the serious collector. Prefers oil, watercolor, acrylic and pastel. Open to most themes and styles (no abstract). Editions created by collaborating with the artist or working from an existing painting. Approached by 50-75 artists/year. Publishes and distributes the work of 3 emerging, 2 mid-career and 4 established artists/year.

First Contact & Terms: Send query letter with résumé, slides and photographs. Samples are filed or are returned by SASE if requested by artist. Reports back within 2-4 weeks. Call or write for appointment to show portfolio. Portfolio should include slides and photographs. Payment method is negotiated. Buys all rights. Provides insurance while work is at firm and shipping from firm.

ART DALLAS INC., Suite 1, 1400 Hi Line Dr., Dallas TX 75207. (214)745-1105. Fax: (214)748-5145. President: Judy Martin. Estab. 1988. Art publisher, distributor and gallery. Publishes and/or distributes handpulled originals, offset reproductions. Clients: designers, architects.

Needs: Seeking creative art for the commercial and designer markets. Considers mixed media. Prefers abstract, landscapes. Artists represented include Tarran Caldwell, Jim Colley, Tony Bass. Editions created by working from an existing painting. Approached by 10 artists/year. Publishes the work of 2 and distributes the work of 4 established artists/year.

First Contact & Terms: Send query letter with résumé, photocopies, slides, photographs and transparencies. Samples are filed and are returned. Reports back within 2 weeks. Call for appointment to show portfolio of slides and photographs. Pays flat fee: $50-5,000. Offers advance when appropriate. Negotiates rights purchased.

‡ART EDITIONS, INC., 352 W. Paxton Ave., Salt Lake City UT 84101. (801)466-6088. Contact: Ruby Reece. Art printer for limited and unlimited editions, offset reproductions, posters, advertising materials art labels, business cards, magazine ad set up and art folios. Clients: artists, distributors, galleries, publishers and representatives.

First Contact & Terms: Send photographs, slides, transparencies (size $4 \times 5 - 8 \times 10''$) and/or originals. "Contact offices for specific pricing information. Free information packet available upon request."

ART EMOTION, 26 E. Pipe Lane, Prospect Heights IL 60070. (708)459-0209. Fax: (708)397-0206. President: Gerard V. Perez. Estab. 1977. Art publisher and distributor. Publishes and distributes limited editions. Clients: corporate/residential designers, consultants and retail galleries.

Needs: Seeking decorative art. Considers oil, watercolor, acrylic, pastel and mixed media. Prefers representational, traditional and impressionistic styles. Artists represented include Garcia, Johnson and Sullivan. Editions created by working from an existing painting. Approached by 50-75 artists/year. Publishes and distributes the work of 20 artists/year.

First Contact & Terms: Send query letter with slides or photographs. Samples are filed. Does not report back, "in which case the artist should not contact us." Pays royalties of 10%. Doesn't require exclusive representation of artist.

Tips: "Send visuals and a bio first."

***THE ART GROUP,** 146 Royal College St., London NW1 OTA England. (01)482-3206. Contact: Art Director. Fine art card and poster publisher/distributor handling posters for framers, galleries, museums, department stores and gift shops.

Needs: Considers all media and broad subject matter. Fine art contemporary; abstracts; color photography (no b&w). Publishes the work of 100-200 mid-career and 200-400 established artists/year. Distributes the work of more than 1,000 artists/year.

First Contact & Terms: Send query letter with brochure, photostats, photographs, photocopies, slides and transparencies. Samples are filed or are returned. Reports back within 1 month. Publisher/Distributor will contact artists for portfolio review if interested. Pays royalties of 10% of world distribution price. Offers an advance when appropriate. Does not require exclusive representation of the artist. Provides insurance while work is at firm and a written contract.

ART IMAGE INC., 1400 Everman Pkwy., Ft. Worth TX 76140. (817)568-5222. Fax: (817)568-5254. President: Charles Albany. Publishes and produces unlimited and limited editions that are pencil signed and numbered by the artist. Also distributes etchings, serigraphs, lithographs and watercolor paintings. "We also publish and distribute handmade paper, cast paper, paper weavings and paper construction." All work sold to galleries, frame shops, framed picture manufacturers, interior decorators and auctioneers.

Needs: Seeking decorative art for the designer market and art galleries. "We prefer subject matter in all media in pairs or series of companion pieces." Prefers contemporary, traditional and transitional artists. Artists represented include Robert White, Peter Wong, Larry Crawford, David Olson, Marsha Kramer and Ron Dianno. Editions created by collaborating with the artist. Approached by 36 artists/year. Publishes and distributes the work of 18 emerging, 18 mid-career and 18 established artists/year.

First Contact & Terms: Send query letter with brochure showing art style, tearsheets, slides, photographs and SASE. Reports within 1 month. Write for appointment to show portfolio or mail appropriate materials. Portfolio should include photographs. Negotiates payment. Requires exclusive representation. Provides shipping and a written contract.

Tips: "We are publishing and distributing more and more subject matter from offset limited editions to monoprints, etchings, serigraphs, lithographs and original watercolor paintings. We will consider any work that is commercially acceptable."

ART IN MOTION, Suite 150, 800 Fifth Ave., Seattle WA 98104; or 1612 Ingleton, Burnaby, British Columbia V5C 5R9 Canada. (604)299-8787. Fax: (604)299-5975. President: Garry Peters. Art publisher and distributor. Publishes and distributes limited editions, original prints, offset reproductions and posters. Clients: galleries, distributors world wide and picture frame manufacturers.

• Garry Peters reports that business is up 30%.

Needs: Seeking creative, fashionable, decorative art for the serious collector, commercial and designer markets. Considers oil, watercolor, acrylic, and mixed media. Prefers decorative styles. Artists represented include Marilyn Simandle, Corinne Hartley and Art LaMay. Editions created by collaborating with the artist or by working from an existing painting. Approached by 100 artists/year. Publishes the work of 5-7 emerging, mid-career and established artists/year. Distributes the work of 2-3 emerging and established artists/year.

First Contact & Terms: Send query letter with brochure showing art style or résumé and tearsheets, slides, photostats, photography and transparencies. Samples are filed or are returned by SASE if requested by artist. Reports back within 2 weeks only if interested. If does not report back the artist should call. Call for appointment to show portfolio, or mail photostats, slides, tearsheets, transparencies and photographs. Pays royalties up to 15%. Payment method is negotiated. "It has to work for both parties. We have artists making $200 a month and some that make $10,000 a month or more." Offers an advance when appropriate. Negotiates rights purchased. Requires exclusive representation of artist. Provides in-transit insurance, insurance while work is at firm, promotion, shipping to and from firm and a written contract.

Tips: "We are looking for a few good artists, make sure you know your goals, and hopefully we can help you accomplish them, along with ours."

The maple leaf before a listing indicates that the market is Canadian.

ART RESOURCES INTERNATIONAL, LTD./BON ART, Fields Lane, Brewster NY 10509. (914)277-8888. Fax: (914)277-8602. Vice President: Robin E. Bonnist. Estab. 1980. Art publisher. Publishes unlimited edition offset lithographs and posters. Does not distribute previously published work. Clients: galleries, department stores, distributors, framers worldwide.

Needs: Considers oil, acrylic, pastel, watercolor, mixed media and photography. Artists represented include Allan Teger, Tony Niacchiarllo, Rafael, C.W. Mundy, Guttke, Ken Shotwell, Carlos Rios, Halessie, Pamela Patrick, Hulan Fleming and Nicky Boehme. Editions created by collaborating with the artist or by working from an existing painting. Approached by hundreds of artists/year. Publishes the work of 10-20 emerging, 5-10 mid-career and 5-10 established artists/year.

First Contact & Terms: Send query letter with bio, brochure, tearsheets, slides and photographs to be kept on file. Samples returned by SASE only if requested. Portfolio review not required. Prefers to see slides or transparencies initially as samples, then reviews originals. Reports within 1 month. Appointments arranged only after work has been sent with SASE. Pays flat fee, $250-1,000 or 3-10% royalties. Offers advance in some cases. Requires exclusive representation for prints/posters during period of contract. Provides in-transit insurance, insurance while work is at publisher, shipping to and from firm, promotion and a written contract. Artist owns original work.

Tips: "Please submit decorative, fine quality artwork. We prefer to work with artists who are creative, professional and open to art direction."

ARTHURIAN ART GALLERY, 4646 Oakton St., Skokie IL 60076-3145. Owner: Art Sahagian. Estab. 1985. Art distributor and gallery. Handles limited editions, handpulled originals, bronze, watercolor, oil and pastel. Current clients include Gerald Ford, Nancy Reagan, John Budnik and Dave Powers.

Needs: Seeking creative, fashionable and decorative art for the serious collector and commercial market. Artists represented include Robert Barnum, Nancy Fortunato, Art Sahagian and Christiana. Editions created by collaborating with the artist. Approached by 25-35 artists/year. Publishes and distributes the work of 5-10 emerging, 1-3 mid-career and 2-5 established artists/year.

First Contact & Terms: Send query letter with brochure showing art style and résumé, slides and prices. Samples not filed returned by SASE. Reports within 30 days. Write for appointment to show portfolio. Portfolio should include original/final art, final reproduction/product and color photographs. Pays flat fee of $25-2,500; royalties of 3-5%; or on a consignment basis (firm receives 25% commission). Rights purchased vary. Provides insurance while work is at firm, promotion and a written contract.

Tips: Sees trend toward animal images and bright colors.

ARTHUR'S INTERNATIONAL, Suite 28-88, 101 S. Rainbow, Las Vegas NV 89128. President: Marvin C. Arthur. Estab. 1959. Art distributor handling original oil paintings primarily. Publishes and distributes limited and unlimited edition prints. Clients: galleries, corporate and private collectors, etc.

Needs: Seeking creative art for the serious collector. Considers all types of original work. Artists represented include Wayne Takazono, Wayne Stuart Shilson, Paul J. Lopez, Birdel Eliason and Casimir Gradomski. Editions created by collaborating with the artist or by working from an existing painting. Purchases have been made in pen & ink, charcoal, pencil, tempera, watercolor, acrylic, oil, gouache and pastel. "All paintings should be realistic to view, though may be expressed in various manners."

First Contact & Terms: Send brochure, slides or photographs to be kept on file; no originals unless requested. Artist biographies appreciated. Samples not filed are returned by SASE. Reports back normally within 1 week. "We pay a flat fee to purchase the original. Payment made within 5 days. Then we pay 30% of our net profit made on reproductions. The reproduction royalty is paid after we are paid. We automatically raise artist's flat fee as demand increases."

Tips: "Do not send any original paintings unless we have requested them. Having a track record is nice, but it is not a requirement."

‡ARTISTS' ENTERPRIZES, Box 1274, Kaneohe HI 96744. (808)239-9186. Fax: (808)239-9186. Creative Director: Larry LeDoux. Estab. 1978. Advertising and public relations firm for artists and galleries. Distributes handpulled originals, posters, limited editions and offset reproductions. Clients: artists and art galleries. Past clients include Robert Nelson, Shipstore and Lahaina Galleries. "Only distributes work by advertising/public relations clients who use our consulting services. We do not publish. We assist artists to publish themselves or find investors who will publish their work."

Needs: Seeking creative, fashionable and decorative art for the serious collector, commercial and designer markets. Considers oil, watercolor, acrylic, pastel, pen & ink and mixed media. Editions created by collaborating with the artist and by working from an existing painting. Approached by 15-20 artists/year. Distributes the work of 1-2 emerging artists, 2-4 mid-career and 1-2 established artists/year.

First Contact & Terms: Send query letter with brochure showing art style and résumé with tearsheets, slides and photographs. Samples are filed or are returned by SASE. Reports back within 3 months if interested. Pays on consignment basis; firm receives 10% commission. "Artist receives monies from all sales less sales expenses, including telephone, shipping, sales commission (10%) and firm fee (10%)." Artist retains all rights. Provides promotion, a written contract, consulting, marketing, sales, PR and advertising services.

Tips: "We specialize in helping artists become better known and in helping them fund a promotional campaign through sales. If you are ready to invest in yourself, we can help you as we have helped the Makk family, Robert Lyn Nelson and Andrea Smith. We do not just distribute or sell. We offer a complete marketing package."

ARTISTS' MARKETING SERVICE, 160 Dresser Ave., Prince Frederick MD 20678. President: Jim Chidester. Estab. 1987. Distributor of limited and unlimited editions, offset reproductions and posters. Clients: galleries, frame shops and gift shops.
Needs: Seeking decorative art for the commercial and designer market. Prefers traditional themes: landscapes, seascapes, nautical, floral, wildlife, Americana, impressionistic and country themes. Artists represented include Lena Liu and Barbara Hails. Approached by 200-250 artists/year. Distributes the work of 10-15 emerging artists and 5-10 mid-career artists/year.
First Contact & Terms: Send query letter with brochure, tearsheets and photographs. Samples are filed or returned by SASE if requested by artist. Reports back within weeks. To show portfolio, mail tearsheets and slides. Pays on consignment basis (50% commission). Offers an advance when appropriate. Purchases one-time rights. Does not require exclusive representation of artist.
Tips: "We are only interested in seeing work from self-published artists who are interested in distribution of their prints. We are presently *not* reviewing originals for publication. A trend seems to be larger edition sizes for limited editions prints."

ARTS UNIQ' INC., 1710 S. Jefferson, Box 3085, Cookeville TN 38502. (615)526-3491. Fax: (615)528-8904. Contact: Lou Burns. Estab. 1985. Art publisher. Publishes limited and unlimited editions. Clients: art galleries, gift shops, furniture stores and department stores.
Needs: Seeking creative and decorative art for the designer market. Considers all media. Artists represented include Debbie Kingston, D. Morgan, Gay Talbott and Carolyn Wright. Editions created by collaborating with the artist or by working from an existing painting. Publishes the work of 27 emerging artists/year.
First Contact & Terms: Send query letter with slides or photographs. Samples are filed or are returned by request. Reports back within 1-2 months. Pays royalties. Does not offer an advance. "Our contract for artists is for a number of years for all printing rights." Requires exclusive representation rights. Provides promotion, shipping from firm and a written contract.

ARTS UNIQUE INTERNATIONAL, 24841 Lakefield St., Lake Forest CA 92630. (714)583-1250. Owner: Lynne Spencer. Estab. 1990. Distributor. Distributes handpulled originals, limited and unlimited editions, offset reproductions, posters and originals. Clients: galleries, designers and businesses. Current clients include The Designer's Art Resource, Lido Art Dimensions, Fast Frame and Price Point Microtechnology.
Needs: Seeking creative and decorative art for the commercial and designer markets. Prefers abstraction, mixed media, water-related images. Considers contemporary, marine and sports themes. Artists represented include Scott Kennedy, William Robert Woolery, Larry Taugher and Bjorn Richter. Approached by 10-20 artists/year. Distributes the work of 1-2 emerging artists, 2-3 established artists and 1-2 mid-career artists/year.
First Contact & Terms: Send query letter with brochure showing art style or résumé, tearsheets, slides and photographs. Samples are filed or returned by SASE if requested by artist. Request portfolio review in original query. Reports back only if interested. Pays $50-1,000 on consignment basis (30-50% commission) or royalties of 50%. Does not offer an advance. Negotiates rights purchased. Provides insurance while work is at firm and shipping from firm.

BENJAMANS ART GALLERY, 419 Elmwood Ave., Buffalo NY 14222. (716)886-0898. Fax: (716)886-0546. Estab. 1970. Art publisher, distributor, gallery, frame shop and appraiser. Publishes and distributes handpulled originals limited and unlimited editions, posters, offset reproductions and sculpture. Clients come from every walk of life.
Needs: Seeking creative, fashionable and decorative art for the serious collector and the commercial and designer markets. Considers oil, watercolor, mixed media and sculpture. Prefers traditional to abstract work. Artists represented include J.C. Litz, Mike Hamby and Smadar Livine. Editions created by collaborating with the artist or by working from an existing painting. Approached by 20-30 artists/year. Publishes and distributes the work of 2 emerging, 2 mid-career and 2 established artists/year.
First Contact & Terms: Send query letter with brochure showing art style, slides, photocopies, résumé, photostats, transparencies, tearsheets and/or photographs. Samples are filed. Reports back within 2 weeks. Write for appointment to show portfolio. Pays royalties of 30-50% on consignment basis. No advance. Buys all rights. Sometimes requires exclusive representation of artist. Provides promotion, shipping from firm and insurance while work is at firm.
Tips: "Keep trying to join a group of artists."

BENTLEY HOUSE LIMITED, Box 5551, Walnut Creek CA 94596. (510)935-3186. Fax: (510)935-0213. Director of Artist Relations: Mary Sher. Estab. 1986. Art publisher of limited and unlimited editions, offset reproduc-

tions, posters and canvas transfers. Clients: framers, galleries, distributors in North America and Europe and framed picture manufacturers.

Needs: Seeking decorative art for the residential, commercial and designer markets. Considers oil, watercolor, acrylic, gouache and mixed media. Prefers traditional, classic or contemporary styles, realism and impressionism. Artists represented include B. Mock, J. Pike, C. Valente, L. Raad, E. Dertner, R.J. Zolan and E. Antoaccio. Editions created by collaborating with the artist or by working from an existing painting. Approached by 300 artists/year. Publishes the work of 30 established artists/year.

First Contact & Terms: Send query letter with brochure showing art style or résumé, tearsheets, slides and photographs. Samples are filed or are returned by SASE if requested by artist. Reports back within 2 months. "We will call artist if we are interested." Pays royalties of 10% monthly plus 50 artist proofs of each edition. Does not offer an advance. Buys all reproduction rights. Usually requires exclusive representation of artist. Provides national trade magazine promotion, a written contract, worldwide agent representation, 5 annual trade show presentations, insurance while work is at firm and shipping from firm.

Tips: "Customers know that fine art prints from Bentley are 'from a market leader in decorative art and with the quality they have come to expect.' Bentley is looking for experienced artists to continue filling that need."

BERKSHIRE ORIGINALS, % Marian Helpers, Eden Hill, Stockbridge MA 01263. (413)298-3691. Fax: (413)298-3583. Program Design Assistant: Stephanie Wilcox. Estab. 1991. Art publisher and distributor of offset reproductions and greeting cards.

Needs: Seeking creative art for the commercial market. Considers oil, watercolor, acrylic, pastel and pen & ink. Prefers religious themes, but also considers florals, holiday and nature scenes.

First Contact & Terms: Send query letter with brochure showing art style or other art samples. Samples are filed or are returned by SASE if requested by artist. Reports within 1 month. Write for appointment to show portfolio of slides, color tearsheets, transparencies, original/final art and photographs. Pays flat fee; $50-500. Buys all rights.

Tips: "Good draftsmanship is a must, particularly with figures and faces. Colors must be harmonious and clearly executed."

BERNARD PICTURE COMPANY, Box 4744, Largo Park, Stamford CT 06907. (203)357-7600. Fax: (203)967-9100. Art Director: Rosemary McClain. Estab. 1953. Art publisher and distributor. Publishes unlimited editions and posters. Clients: picture frame manufacturers, distributors, manufacturers, galleries and frame shops.

Needs: Seeking creative, fashionable and decorative art for commercial and designer markets. Considers oil, watercolor, acrylic, pastel, mixed media and printmaking (all forms). Prefers multicultural themes, cultural artifacts, inspirational art, contemporary nonobjective abstracts. Editions created by collaborating with the artist or by working from an existing painting. Artists represented include Bob Bates, Lily Chang, Shelly Rasche, Steven Klein and Ron Jenkins. Approached by hundreds of artists/year. Publishes the work of 8-10 emerging, 10-15 mid-career and 100-200 established artists/year.

First Contact & Terms: Send query letter with brochure showing art style and/or résumé, tearsheets, photostats, photocopies, slides, photographs or transparencies. Samples are returned by SASE. "I will hold potential information only with the artist's permission." Reports back within 2-8 weeks. Call or write for appointment to show portfolio of thumbnails, roughs, original/final art; b&w and color photostats, tearsheets, photographs, slides and transparencies. Pays royalties of 10%. Offers an advance when appropriate. Buys all rights. Usually requires exclusive representation of artist. Provides in-transit insurance, insurance while work is at firm, promotion, shipping from firm and a written contract.

Tips: Finds artists through submissions, sourcebooks, agents, art shows, galleries and word of mouth. "We try to look for subjects with a universal appeal. Some subjects that would be appropriate are landscapes, still lifes, animals in natural settings, religious themes and florals to name a few. Please send enough examples of your work that we can get a feel for your style and technique."

BIG, (Division of the Press Chapeau), Govans Station, Box 4591, Baltimore City MD 21212-4591. (301)433-5379. Director: Elspeth Lightfoot. Estab. 1976. Distributor/catalog specifier of original tapestries, sculptures, crafts and paintings to architects, interior designers, facility planners and corporate curators. Makes individual presentations to clients.

Needs: Seeking art for the serious and commercial collector and the designer market. "We distribute what corporate America hangs in its board rooms; highest quality traditional, landscapes, contemporary abstracts. But don't hesitate with unique statements, folk art or regional themes. In other words, we'll consider all categories as long as the craftsmanship is there." Prefers individual works of art. Editions created by collabo-

rating with the artist. Approached by 50-150 artists/year. Distributes the work of 10 emerging, 10 mid-career and 10 established artists/year.
First Contact & Terms: Send query letter with slides. Samples are filed or are returned by SASE. Reports back within 5 days. Request portfolio review in original query. Artist should follow up with letter after initial query. Pays $500-30,000. Payment method is negotiated (artist sets net pricing). Offers advance. Does not require exclusive representation. Provides in-transit insurance, insurance while work is at firm, promotion, shipping to firm, and a written contract.
Tips: Finds artists through sourcebooks, agents, art galleries and fairs.

THE BILLIARD LIBRARY CO., 1570 Seabright Ave., Long Beach CA 90813. (310)432-8264. Fax: (310)436-8817. Production Coordinator: Darian Baskin. Estab. 1972. Art publisher and distributor. Publishes unlimited and limited editions and posters. Clients: poster print stores, billiard retailers. Current clients include Deck the Walls, Prints Plus, Adventure Shops.
Needs: Seeking creative, fashionable and decorative art for the commercial and designer markets. Considers oil, watercolor, mixed media, pastel, pen & ink and acrylic. Prefers themes that center on billiard-related ideas. Artists represented include Melia Taylor, ProShot Gallery and Lance Slaton. Approached by 10-15 artists/year. Publishes and distributes the work of 3-5 emerging artists/year. Distributes the work of 10 mid-career and 10 established artists/year.
First Contact & Terms: Send query letter with slides, photocopies, résumé, photostats, transparencies, tearsheets and photographs. Samples are filed or are returned by SASE if requested. Reports back within 1 month. Publisher/Distributor will contact artists for portfolio review if interested. Pays flat fee, $500 minimum; or royalties of 10%. Negotiates rights purchased. Provides promotion, insurance while work is at firm and a written contract.
Tips: "The Billiard Library Co. publishes and distributes artwork of all media relating to the sport of pool and billiards. Themes and styles of any type are reviewed with an eye towards how the image will appeal to a general audience of enthusiasts. Will also review any image relating to bowling or darts."

TOM BINDER FINE ARTS, 2218 Main St., Santa Monica CA 90405. (310)452-4095. Fax: (310)452-1260. Owner: Tom Binder. Estab. 1983. Art publisher, distributor and broker. Publishes and distributes handpulled originals and limited editions. Clients: dealers, private collectors, and art galleries.
Needs: Conders oil, watercolor, acrylic, pastel, pen & ink, mixed media. Prefers various contemporary themes. Artists represented include Aldo Luongo and Linnea Pergola. Editions created by working from an existing painting. Approached by 10-20 artists/year. Publishes and distributes the work of 1 emerging, 1 mid-career and 1 established artist/year.
First Contact & Terms: Send query letter with brochure showing art style or résumé and tearsheets, photostats, photocopies, slides, photographs and transparencies. Samples are filed or are returned. Reports back within a few days. Mail appropriate samples. Portfolio should include slides, color tearsheets, transparencies and photographs. Offers advance when appropriate. Negotiates payment and rights purchased. Provides insurance while work is at firm, promotion, shipping to and from firm and a written contract.
Tips: "There is a trend toward higher quality, smaller editions."

‡**WM. BLACKWELL & ASSOCIATES**, 638 S. Governor St., Iowa City IA 52240-5626. (800)366-5208. Fax: (319)338-1247. Contact: William Blackwell. Estab. 1979. Distributor. Distributes handpulled originals. Clients: gallery and design (trade only).
Needs: Seeking decorative art for the designer market. Considers etchings (hand-colored). Prefers traditional and representational. Artists represented include Alice Scott, Jeri Fischer, Charles Leonard, Dan Mitra. Approached by 10-15 artists/year.
First Contact & Terms: Send query letter with photographs, samples of actual impressions. Samples are not filed and are returned by SASE if requested by artist. Reports back within 1 month. Distributor will contact artists for portfolio review if interested. Portfolio should include final art. Pays on consignment basis or buys work outright. No advance. Provides promotion, shipping from firm and distribution (primarily eastern and central US).
Tips: "Artists generally approach us via trade shows, trade ads, or referral."

❖BUSCHLEN MOWATT GALLERY, 111-1445 W. Georgia St., Vancouver, British Columbia V6G 2T3 Canada. (604)682-1234. Fax: (604)682-6004. Gallery Director: Ingunn Kemble. Estab. 1979 (gallery opened 1987). Art publisher, distributor and gallery. Publishes and distributes handpulled originals and limited editions. Clients are beginning to advanced international collectors.
Needs: Seeking creative art for the serious collector. Considers original lithographs, etchings and serigraphs. Prefers contemporary art. Artists represented include Gantner, Cathelin, Sawada, Frankenthaler, Olitski, Buffet, Cassigneul. Editions created by collaborating with the artist and by working from an existing painting "as a starting point, not for reproduction." Approached by 500 artists/year. Publishes the work of 2 emerging and 5 established artists/year. Distributes the work of 4 emerging and 5-10 established artists/year.
First Contact & Terms: Send query letter with résumé and photographs. Do not contact through agent. Samples are filed or are returned by SASE if requested by artist. Reports back within 3 weeks if interested. Portfolio should include photographs. Pays on consignment basis; firm receives 50-60% commission. No advance. Buys all rights. Requires exclusive representation of artist. Provides insurance while work is at firm, promotion and a written contract.
Tips: "Professional presentation is essential. We are not able to take on any new work at this time but might consider something exceptional."

C & M FINE ART, INC., d/b/a Robert Aaron Young, 979 3rd Ave., New York NY 10022. (212)421-2440. Fax: (212)838-7735. Corporate Officers: Carol Taub, Mike Prieto and Bernice Adam. Estab. 1965. Art publisher and gallery. Publishes limited editions. Clients: dealers, decorators and architects. Current clients include Rosenbaum Fine Art (Florida), Atlas Gallery (Illinois).
Needs: Seeking decorative art for the designer market. Considers oil. Prefers traditional, semi abstract and realistic themes and styles. Artists represented include Tunglee, Druschilowsky, Alvarez, Quinn, Eisman and Zuniga. Editions created by working from an existing painting. Approached by 25 artists/year. Distributes the work of 4 mid-career and 5 established artists/year.
First Contact & Terms: Send query letter with slides and photographs. Samples are not filed and are returned. Reports back only if interested. Portfolios may be dropped off every Monday-Friday, or call or write for appointment. Portfolio should include slides, color tearsheets. Pays on consignment basis; 50% commission. Offers advance when appropriate. Negotiates rights purchased. Requires exclusive representation of artist. Provides in-transit insurance, promotion, shipping from firm, insurance while work is at firm and a written contract.
Tips: Finds artists through word of mouth. "Do not ask us what we will pay for the art. Have a price in mind."

❖CANADIAN GALLERY PRINTS LTD., 2720 St. Johns St., Port Moody BC V3H 2B7 Canada. (604)936-3470. Fax: (604)936-3716. President: John de Jong. Art publisher of limited editions, offset reproductions and 'art cards'. Clients: galleries and giftshops.
Needs: Considers oil, watercolor, acrylic and mixed media. Prefers realism. Editions created by working from an existing painting.
First Contact & Terms: Send query letter with tearsheets, slides, photographs and transparencies. Samples are not filed and are returned by SASE. Reports back within 1 month. Payment method is negotiated. Buys all rights. Requires exclusive representation of artist. Provides shipping from firm.
Tips: "Be able to supply commercially viable realism that has proven to be popular to the general public."

‡CHALK & VERMILION FINE ARTS, 200 Greenwich Ave., Greenwich CT 06830. (203)869-9500. Fax: (203)869-9520. Contact: Michael Lisi. Estab. 1980. Art publisher. Publishes handpulled originals, posters, limited editions and offset reproductions. Clients: international retailers, distributors, brokers.
Needs: Publishes creative and decorative art for the serious collector and the commercial and designer markets. Considers oil, watercolor, mixed media, pastel and acrylic. Artists represented include Erte, McKnight, Alex Katz, Hallam, Kiraly, Sally Caldwell Fisher, Echo, Brennan and Robert Williams. Editions created by collaborating with the artist or working from an existing painting. Approached by 500-1,000 artists/year. "At present we publish 9 artists."
First Contact & Terms: Send query letter with slides, résumé and photographs. Samples are filed or are returned by SASE if requested by artist. Reports back within 3 months. Publisher will contact artists for portfolio review if interested. Pay "varies with artist, generally fees and royalties." Offers advance. Requires exclusive representation of artist. Provides in-transit insurance, promotion, shipping from firm, insurance while work is at firm and written contract.
Tips: Finds artists through exhibitions, trade publications, catalogs, submissions.

THE CHASEN PORTFOLIO, 6 Sloan St., South Orange NJ 07079. (201)761-1966. Fax: (201)761-0864. President: Andrew Chasen. Estab. 1983. Art publisher/distributor. Publishes limited editions and originals. Clients: galleries, decorators, designers, art consultants, trade professionals and corporate art buyers.
Needs: Considers oil paintings, acrylic paintings, pastels, watercolor, monoprints, lithographs, serigraphs, etchings and mixed media. Prefers classical, formal look. Artists represented include Rafferty, Amarger, Suchy and Tay. Distributes the work of 50 emerging, 150 mid-career and 100 established artists/year.

First Contact & Terms: Send query letter with brochure or tearsheets, photographs and slides. Samples are filed or are returned by SASE if requested. Publisher/Distributor will contact artists for portfolio review if interested. Portfolio should include original/final art. Payment is on consignment basis; firm receives a varying commission. Negotiates payment and rights purchased. Does not require exclusive representation. Provides in-transit insurance, insurance while work is at firm, promotion, shipping from firm and a written contract.
Tips: Finds artists through word of mouth and visiting art fairs.

CIRRUS EDITIONS, 542 S. Alameda St., Los Angeles CA 90013. President: Jean R. Milant. Produces limited edition handpulled originals for museums, galleries and private collectors.
Needs: Seeking contemporary paintings and sculpture. Prefers abstract, conceptual work. Artists represented include Lari Pittman, Joan Nelson, John Millei, Charles C. Hill and Bruce Nauman. Publishes and distributes the work of 6 emerging, 2 mid-career and 1 established artists/year.
First Contact & Terms: Prefers slides as samples. Samples returned by SASE.

‡**CLASS PUBLICATIONS, INC.**, 71 Bartholomew St., Hartford CT 06106. (203)951-9200. Estab. 1982. Art publisher/distributor of offset reproductions. "We are a major poster publisher looking for images that would appeal to the high school or college market. We prefer humorous work for both women and men."
Needs: Considers oil paintings, acrylic paintings and airbrush. "Our posters are published on 100 lb. text, retailing for $4.50, for the college market. Artwork should be creative using strong colors with good detail. Common areas of humor are very much sought after. Examples of those areas include money, sex, married life." Prefers individual works of art. Publishes the work of 2-3 artists/year.
First Contact & Terms: Send query letter with brochure or slides and transparencies. Samples are not filed or are returned only if requested. Reports back within 2 weeks. To show a portfolio, mail slides. Offers an advance. Buy all rights. Provides promotion, shipping from firm and a written contract.
Tips: "Take a look at the artwork. Does it have a broad market appeal? We look for artwork that will have the qualities of sophistication and mass appeal combined."

THE COLONIAL ART CO., 1336 NW First St., Oklahoma City OK 73106. (405)232-5233. Owner: Willard Johnson. Estab. 1919. Publisher and distributor of offset reproductions for galleries. Clients: Retail and wholesale. Current clients include Osburns, Grayhorse and Burlington.
Needs: Artists represented include Felix Cole, Dennis Martin, John Walch and Leonard McMurry. Publishes the work of 2-3 emerging, 2-3 mid-career and 3-4 established artists/year. Distributes the work of 10-20 emerging, 30-40 mid-career and hundreds of established artists/year. Prefers realism and expressionism— emotional work.
First Contact & Terms: Send sample prints. Samples not filed are returned only if requested by artist. Publisher/Distributor will contact artist for portfolio review if interested. Pays negotiated flat fee or royalties, or on a consignment basis (firm receives 33% commission). Offers an advance when appropriate. Does not require exclusive representation of the artist. Considers buying second rights (reprint rights) to previously published work.
Tips: "The current trend in art publishing is an emphasis on qualty."

‡**COLVILLE PUBLISHING**, Promenade #300, 1315 Third St., Santa Monica CA 90401. (310)451-1030. Fax: (310)458-0575. Chairman: Christian Title. Estab. 1982. Art publisher. Publishes limited edition serigraphs. Clients: art galleries.
Needs: Seeking creative art for the serious collector. Considers oil and pastel. Prefers impressionism and American Realism. Artists represented include John Powell, Henri Plisson and Don Hatfield. Publishes and distributes the work of varying number of emerging, 2 mid-career and 4 established artists/year.
First Contact & Terms: Send query letter with résumé, slides, photographs, transparencies, biography and SASE. Samples are not filed. Reports back within 2 weeks. To show a portfolio, mail appropriate materials. Payment method is negotiated. Does not offer an advance. Requires exclusive representation of artist. Provides in-transit insurance, insurance while work is at firm, promotion, shipping to and from firm and a written contract.

‡**CRAZY HORSE PRINTS**, 23026 N. Main St., Prairie View IL 60069. (708)634-0963. Owner: Ronald Salway. Estab. 1976. Art publisher and gallery. Publishes limited editions, offset reproductions and greeting cards. Clients: Indian art collectors.
Needs: "We publish only Indian authored subjects." Considers oil, pen & ink and acrylic. Prefers Indian and nature themes. Editions created by working from an existing painting. Approached by 10 artists/year. Publishes the work of 2 and distributes the work of 20 established artista/year.
First Contact & Terms: Send résumé and photographs. Samples are filed. Reports back to the artist only if interested. Portfolio review not required. Publisher will contact artist for portfolio review if interested. Portfolio should include photographs and bio. Pays flat fee: $250-1,500 or royalties of 5%. Offers advance when appropriate. Buys all rights. Provides promotion and written contract.
Tips: Finds artists through art shows and artists' submissions.

THE CREATIVE AGE, 2824 Rhodes Circle, Birmingham AL 35205. (205)933-5003. President: Finley Eversole. Estab. 1991. Art publisher. Publishes and distributes unlimited editions. Clients: distributors, ready-framers, frame stores and decorators. Current clients include Paragon, Carolina Mirror, Art Image Inc., Galleries International, Inc., Access Fine Arts, Art in Motion and Minotaur.

Needs: Seeking creative art for the serious collector, commercial and designer markets. Considers oil, watercolor, acrylic, pastel, lithographs and engravings. Prefers animals, children, romantic themes, landscapes, sports, seascapes, marines and florals. Artists represented include Bierstadt, Chase, Moran, Plumb, Bouguereau, Frieske, Renoir, Morisot, Sargent, Hassam, Martin Johnson Heade and Bruce Lakofka. Editions created by collaborating with the artist or working from an existing painting. Publishes the work of 1-2 emerging and 1-2 mid-career artists/year. "I'm more interested in an artist's talents and work than in years of experience. The major criteria are our interest in his/her work and our ability to work together."

First Contact & Terms: Send query letter with résumé and tearsheets, slides, photographs and transparencies. Samples are filed or are returned by SASE if requested by artist. Reports back only if interested. Pays royalties of 10%. Offers advance when appropriate. Negotiates payment and rights purchased. Considers buying second rights (reprint rights) to previously published work. Provides return in-transit insurance, promotion, shipping from firm and a written contract.

Tips: Finds mid-career and emerging artists through submissions. "Work must be of very high quality with good sense of color, light and design. Artist should be willing to grow with young company. Possible commissioned work if we like your art; some work for expert copying. We are looking for work in the styles of 19th century Victorian and French and American Impressionist art."

CUPPS OF CHICAGO, INC., 831-837 Oakton St., Elk Grove IL 60007. (312)593-5655. Fax: (708)593-5550. President: Dolores Cupp. Estab. 1964. Distributor of original oil paintings for galleries, frame shops, designers and home shows.

 • Pay attention to contemporary/popular colors when creating work for this design-oriented market.

Needs: Seeking creative, fashionable and decorative art for the serious collector, commercial and designer markets. Artists represented include Carlos Cavidad and Sonia Gil Torres. Editions created by collaborating with the artist and by working from an existing painting. Considers oil and acrylic paintings in "almost any style—only criterion is that it must be well done." Prefers individual works of art. Approached by 75-100 artists/year. Distributes the work of "many" emerging, mid-career and established artists/year.

First Contact & Terms: Send query letter with brochure showing art style or résumé and photographs. Do not submit slides. Samples are filed or are returned by SASE if requested. Reports back only if interested. Call or write for appointment to show portfolio of original/final art. Pays flat fee or royalties of 10%. Offers an advance when appropriate. Negotiates rights purchased. Provides promotion and a written contract.

Tips: "Work must look professional."

DAUPHIN ISLAND ART CENTER, 1406 Cadillac Ave., Box 699, Dauphin Island AL 36528. Owner: Nick Colquitt. Estab. 1984. Wholesale producer and distributor of marine and nautical decorative art. Clients: West, Gulf and eastern coastline retailers.

Needs: Approached by 12-14 freelance artists/year. Works with 8-10 freelance artists/year. Prefers local artists with experience in marine and nautical themes. Uses freelancers mainly for wholesale items to be retailed. Also for advertising, brochure and catalog illustration.

First Contact & Terms: Send query letter with brochure and samples. Samples not filed are returned only if requested by artist. Reports back within 3 weeks. To show a portfolio, mail final reproduction/product. Pays for design and illustration by the finished piece price. Considers skill and experience of artist and "retailability" when establishing payment. Negotiates rights purchased.

Tips: "Send samples of marine/nautical decorative art suitable for retail."

‡✿DEL BELLO GALLERY, 363 Queen St. W., Toronto, Ontario M5V 2A4 Canada. (416)593-0884. Fax: (416)593-8729. Owner: Egidio Del Bello. Art publisher and gallery handling handpulled originals for private buyers, department stores and galleries.

 • Del Bello is an organizer of the Annual International Exhibition of Miniature Art. Deadline for the 10th annual exhibition is July 22, 1995. Send $2 postage and handling for prospectus.

First Contact & Terms: Send query letter with résumé, photographs and slides. Samples are filed or are returned by SASE within 2 weeks. Call for appointment to show portfolio of original/final art and slides. Payment method is negotiated. Offers an advance when appropriate. Negotiates rights purchased. Provides promotion. Publishes the work of 10 artists/year.

DEVON EDITIONS, 6015 6th Ave. S., Seattle WA 98108. (206)763-9544. Fax: (206)762-1389. Director of Production Development: Buster Morris. Estab. 1987. Art publisher and distributor. Publishes offset reproductions. Clients: architects, designers, specifiers, frame shops.

Needs: Seeking creative and decorative art for the designer market. Considers oil, watercolor, acrylics, pastels, mixed media and photography. "Open to a wide variety of styles." Editions created by collaborating with the artist or by working from an existing painting. Approached by 200 artists.

First Contact & Terms: Send query letter with slides, résumé, transparencies and photographs. Samples are filed or are returned by SASE. Reports back within 6 weeks if SASE enclosed. To show portfolio, mail slides and transparencies. Pays flat fee or royalties and advance. Offers advance when appropriate. Buys first-rights or negotiates rights purchased. Provides in-transit insurance, promotion, shipping from firm, insurance while work is at firm and a written contract.

‡DIRECTIONAL PUBLISHING, INC., 2810 Commerce Square E., Birmingham AL 35210. (205)951-1965. Fax: (205)951-3250. President: David Nichols. Estab. 1986. Art publisher. Publishes limited and unlimited editions and offset reproductions. Clients: galleries, frame shops and picture manufacturers.
Needs: Seeking decorative art for the designer market. Considers oil, watercolor, acrylic and pastel. Prefers floral, sporting, landscapes and still life themes. Artists represented include Evans, Neubauer, M. Parker, A. Nichols, D. Nichols, M.B. Zeitz and N. Raborn. Editions created by working from an existing painting. Approached by 50 artists/year. Publishes and distributes the work of 5-10 emerging, 5-10 mid-career and 3-5 established artists/year.
First Contact & Terms: Send query letter with slides and photographs. Samples are not filed and are returned by SASE. Reports back within 2 months. Pays royalties. Offers an advance when appropriate. Buys all rights. Provides in-transit insurance, insurance while work is at firm, promotion, shipping from firm and a written contract.

‡DODO GRAPHICS, INC., P.O. Box 585, 145 Cornelia St., Plattsburgh NY 12901. (518)561-7294. Fax: (518)561-6720. Manager: Frank How. Art publisher of offset reproductions, posters and etchings for galleries and frame shops.
Needs: Considers pastel, watercolor, tempera, mixed media, airbrush and photographs. Prefers contemporary themes and styles. Prefers individual works of art, 16×20 maximum. Publishes the work of 5 artists/year.
First Contact & Terms: Send query letter with brochure showing art style or photographs and slides. Samples are filed or are returned by SASE. Reports back within 3 months. Write for appointment to show portfolio of original/final art and slides. Payment method is negotiated. Offers an advance when appropriate. Buys all rights. Requires exclusive representation of the artist. Provides a written contract.
Tips: "Do not send any originals unless agreed upon by publisher."

*DUTCH ART STUDIOS BV., 210 Industrieweg 210, 5683 Ch Best, Netherlands. Phone: 01131 4998 97300. Fax: 01131 4998 99660. President: Hem Brekoo. Estab. 1972. Art publisher and distributor. Publishes and distributes handpulled originals, limited and unlimited editions and offset reproductions. Clients: art galleries, art shops. Current clients include: Decorative Expressions.
• Hem Brekoo urges artists to keep up with the latest trends in furniture and upholstery markets and to create work that will lend itself well for decorative purposes. He is particularly interested in publishing print series (4 at a time).
Needs: Seeking fashionable and decorative art for the commercial market. Considers oil, watercolor, acrylic and mixed media. Prefers contemporary interpretation of landscapes, seascapes, florals, townscenes, etc. Artists represented include Corsius, Le Mair, Groeneveld and Hovener. Editions created by collaborating with the artist. Approached by 50 artists/year. Publishes the work of 10 emerging, 10 mid-career and 5 established artists/year. Distributes the work of 20 emerging, 20 mid-career and 15 established artists/year.
First Contact & Terms: Send query letter with brochure showing art style. Samples are filed or are returned by SASE (nonresidents include IRC) if requested by artist. Reports back within 1 month. Artist should follow up with letter after initial query. To show a portfolio, mail photographs and slides. Payment method is negotiated. No advance. Requires exclusive representation of artist. Provides promotion and a written contract.

‡EDELMAN FINE ARTS, LTD., Third Floor, 386 W. Broadway, New York NY 10012. (212)226-1198. Vice President: H. Heather Edelman. Art distributor of original oil paintings. "We now handle watercolors, lithographs, serigraphs and 'works on paper' as well as original oil paintings." Clients: galleries, dealers, consultants, interior designers and furniture stores worldwide.
Needs: Seeking creative and decorative art for the serious collector and designer markets. Considers oil and acrylic paintings, watercolor and mixed media. Especially likes Old World themes and impressionist style. Artists represented include Rembrandt, Chagall, Miro and Picasso. Distributes the work of 150 emerging, 70 mid-career and 150 established artists/year.
First Contact & Terms: Send query letter with brochure, résumé, tearsheets, photographs and "a sample of work on paper or canvas" to be kept on file. Portfolios may be dropped off every Monday-Thursday.

The asterisk before a listing indicates that the market is located outside the United States and Canada.

Portfolio should include original/final art and photographs. Reports as soon as possible. Pays royalties of 40% or works on consignment basis (20% commission). Buys all rights. Provides in-transit insurance, insurance while work is at firm, promotion, shipping from firm and written contract.

EDITIONS LIMITED GALLERIES, INC., Suite 400, 625 Second St., San Francisco CA 94107. (415)543-9811. Fax: (415)777-1390. Director: Michael Ogura. Art publisher and distributor of limited edition graphics and fine art posters. Clients: galleries, framing stores, art consultants and interior designers.
Needs: Seeking creative art for the designer market. Considers oil, acrylic and watercolor painting, monoprint, monotype, photography and mixed media. Prefers landscape and abstract imagery. Artists represented include Peter Kitchell, Elba Alvarez and Jack Roberts. Editions created by collaborating with the artist or by working from an existing painting.
First Contact & Terms: Send query letter with résumé, slides and photographs. Samples are filed or are returned by SASE. Reports back within 2 months. Publisher/Distributor will contact if interested in seeing portfolio. Payment method is negotiated. Offers advance when appropriate. Negotiates rights purchased. Provides in-transit insurance, insurance while work is at firm, promotion, shipping to and from firm and a written contract.
Tips: "We deal both nationally and internationally, so we need work with wide appeal. No figurative or cute animals. When sending slides or photos, send at least six so we can see an overview of the work. We publish artists, not just images."

ELEANOR ETTINGER INCORPORATED, 155 Avenue of the Americas, New York NY 10013. (212)807-7607. Fax: (212)691-3508. President: Eleanor Ettinger. Estab. 1975. Art publisher of limited edition lithographs, limited edition sculpture and unique works (oil, watercolor, drawings, etc.).
Needs: Seeking creative, fashionable and decorative art for the serious collector, commercial collector and designer markets. Considers oil, watercolor, acrylic, pastel, mixed media, pen & ink and pencil drawings. Prefers American realism. Editions created by collaborating with the artist. Approached by 100-150 artists/year. Currently distributes the work of 21 artists.
First Contact & Terms: Send query letter with visuals (slides, photographs, etc.), a brief biography, résumé (including a list of exhibitions and collections) and SASE for return of the materials. Reports within 2 weeks.
Tips: "All lithographs are printed on one of our Voirin presses, flat bed lithographic presses hand built in France over 100 years ago. The work must be unique and non-derivative. We look for artists who can create 35-50 medium to large scale works per year and who are not already represented in the fine art field."

THE FOUNDATION FINE ARTS LTD., 8840 Sesame St. NW, Silverdale WA 98383. (206)698-0396. Fax: (206)692-3019. Director: Christopher Law. Estab. 1972. Art publisher of hands-on original graphics. Clients: fine art collectors.
Needs: Seeking creative art for the serious collector. "We publish the highest quality continuous tone original graphics." Prefers wildlife, African, "both loose and tight styles." Artists represented include Dennis Curry, Valerie Hinz, Al Agnew and Brian Jarvi. Editions created by collaborating with the artist. Approached by 25 artists/year. Publishes and distributes the work of 1 emerging, 4 mid-career and 1 established artists/year.
First Contact & Terms: Send query letter with résumé, slides and transparencies. Samples are filed or are returned by SASE. Reports back within 2 weeks. Request portfolio review in original query. Portfolio should include slides and transparencies. Pays royalties of 10-30%. No advance. Negotiates payment and rights purchased. Provides promotion.
Tips: "Only send the best representation of your work."

FOXMAN'S OIL PAINTINGS LTD., 1550 Carmen Dr., Elk Grove Village IL 60007. (708)427-8555. Fax: (708)427-8594. President: Wayne Westfall. Art distributor of limited and unlimited editions and oil paintings. Clients: galleries, horse shows and national chains.
Needs: Considers oil, airbrush and acrylic. Prefers simple themes: children, barns, countrysides; African-American art and other contemporary themes and styles. Prefers individual works of art. Maximum size 36×48. Artists represented include H. Hargrove, Joel Thompson, Kugler and Hollingworth. Publishes the work of 3-5 emerging, 3-5 mid-career and 3-5 established artists/year. Distributes the work of 30-40 emerging, 30-40 mid-career and 30-40 established artists/year.
First Contact & Terms: Send query letter with résumé, tearsheets, photographs and slides. Samples are not filed and are returned. Reports back within 1 month. Negotiates payment method and rights purchased. Requires exclusive representation. Provides promotion, shipping from firm and a written contract.
Tips: Finds artists through word of mouth.

FRONT LINE GRAPHICS, INC., 9808 Waples St., San Diego CA 92121. (619)552-0944. Creative Director: Todd Haile. Estab. 1981. Publisher/distributor of posters, prints and limited editions. Clients: galleries, decorators, and poster distributors worldwide.
Needs: Seeking fashionable and decorative art for the commercial collector and designer market. Considers oil, acrylic, pastel, watercolor and mixed media. Prefers contemporary interpretations of landscapes, seascapes, florals abstracts and African-American subjects. Prefers pairs. Minimum size 22 × 30. Editions created

by collaborating with the artist. Approached by 300 artists/year. Publishes the work of 20-30 artists/year and distributes the work of 24 artists/year.

First Contact & Terms: Send query letter with slides. Samples not filed are returned if requested by artist. Reports back within 1 month. Call for appointment to show portfolio of original/final art and slides. Payment method is negotiated. Requires exclusive representation of the artist. Provides promotion and a written contract.

Tips: "Front Line Graphics is looking for artists who are flexible and willing to work with us to develop art that meets the specific needs of the print and poster marketplace. We actively seek out fresh new art and artists on an on-going basis."

GALAXY OF GRAPHICS, LTD., 460 W. 34th St., New York NY 10001. (212)947-8989. Art Director: Elizabeth Randazzo. Estab. 1983. Art publisher and distributor of unlimited editions. Clients: galleries, distributors, and picture frame manufacturers. Current clients include Marcel and Crystal Art.

Needs: Seeking creative, fashionable and decorative art for the commerical market. Artists represented include Hal and Fran Larsen, Glenna Kurz and Christa Keiffer. Editions created by collaborating with the artist or by working from an existing painting. Considers any media. "Any currently popular and generally accepted themes." Approached by several hundred artists/year. Publishes and distributes the work of 20 emerging and 20 mid-career and established artists/year.

First Contact & Terms: Send query letter with résumé, tearsheets, slides, photographs and transparencies. Samples are not filed and are returned by SASE. Reports back within 1-2 weeks. Call for appointment to show portfolio. Pays royalties of 10%. Offers advance. Buys rights only for prints and posters. Provides insurance while material is in house and while in transit from publisher to artist/photographer. Provides written contract to each artist.

Tips: "There is a trend toward strong jewel-tone colors."

ROBERT GALITZ FINE ART, 166 Hilltop Court, Sleepy Hollow IL 60118. (708)426-8842. Fax: (708)426-8846. Owner: Robert Galitz. Estab. 1986. Distributor of handpulled originals, limited editions and watercolors. Clients: designers, architects, consultants and galleries – in major cities of seven states.

Needs: Seeking creative, fashionable and decorative art for the serious collector and commercial and designer markets. Considers all media. Prefers contemporary and representational imagery. Editions created by collaborating with the artist. Publishes the work of 1-2 established artists/year. Distributes the work of 100 established artists/year.

First Contact & Terms: Send query letter with slides and photographs. Samples are filed or are returned by SASE. Reports back within 1 month. Call for appointment to show portfolio of original/final art. Pays flat fee of $200 minimum, or pays on consignment basis (firm receives 25-40% commission). No advance. Buys all rights. Provides a written contract.

Tips: Finds artists through galleries, sourcebooks, word of mouth, art fairs. "Be professional. I've been an art broker or gallery agent for 26 years and very much enjoy bringing artist and client together!"

GALLERY IN A VINEYARD, Benmarl Vineyards, Marlboro NY 12542. (914)236-4265. Owner: Mark Miller. Art publisher, gallery and studio handling limited editions, offset reproductions, unlimited editions, hand-pulled originals, posters and original paintings and sculpture. Clients: galleries and collectors.

● The owner started out as a self-published artist, but has expanded to consider work by other artists.

Needs: Considers any media. Prefers contemporary, original themes in illustrative style. Publishes/distributes the work of 1-2 artists/year.

First Contact & Terms: Send appropriate samples. Samples are not filed and returned only if requested. Reports back within 3 weeks only if interested. Pays on consignment basis (firm receives 50% commission). Negotiates rights purchased. Provides a written contract.

Tips: "Subjects related to the 50s and 60s period of illustrative art are especially interesting. There seems to be a renewed interest in nostalgia."

GANGO EDITIONS, 351 NW 12th, Portland OR 97209. (800)852-3662. (503)223-9694. Production Assistant: Elaine Graves. Estab. 1982. Publishes posters. Clients: poster galleries, art galleries, contract framers and major distributors. Current clients include Bruce McGaw Graphics, Graphique de France, Image Conscious and In Graphic Detail.

Needs: Seeking creative and decorative art for the commercial and designer markets. Considers, oil, watercolor, acrylic, pastel and mixed media. Prefers whimsical, abstract and landscape styles. Artists represented include Carol Grigg, Nancy Coffelt, Bill Kucha, Jennifer Winship Mark, Linda Holt, Roberta Nadeau, C.W. Potzz, Gregg Robinson, Lise Shearer, Irana Shepherd. Editions created by working from an existing painting. Approached by more than 100 artists/year. Publishes the work of 5 emerging, 10 mid-career and 80 established artists/year. Distributes the work of 15 emerging, 50 mid-career and 45 established artists/year.

First Contact & Terms: Send query letter with slides and/or photographs. Artist is contacted "if we see potential." Otherwise, samples are returned by SASE. Reports back within 2 weeks. Write for appointment to show portfolio or mail appropriate materials. Pays royalties (or payment method is negotiated). Offers

advance when appropriate. Negotiates rights purchased. Requires exclusive representation of artist. Provides insurance while work is at firm, promotion and a written contract.
Tips: "We are interested in fresh ideas for the poster market rather than reworked old ideas. We are always actively seeking new artists. Artists need to be aware of current fashion colors."

GEME ART INC., 209 W. 6th St., Vancouver WA 98660. (206)693-7772. Art Director: Gene Will. Estab. 1966. Publishes fine art prints and reproductions in unlimited and limited editions. Clients: galleries, frame shops, art museums.
Needs: Considers oil, acrylic, pastel, watercolor and mixed media. Theme work is open. Prefers "mid-America" style. Artists represented include Lois Thayer, Gary Fenske, Crystal Skelley and Susan Scheewe. Publishes and distributes the work of 4 emerging, 10 mid-career and 20 established artists/year.
First Contact & Terms: Query with color slides or photos. Include SASE. Reports only if interested. Publisher will contact artist for portfolio review if interested. Simultaneous submissions OK. Payment is negotiated on a royalty basis. Normally purchases all rights. Provides promotion, shipping from publisher and contract.

GENESIS FINE ARTS, 4808 164th St., SE, Bothell WA 98012. (206)481-1581. Fax: (206)487-6766. Art Consultant: Marcia Strickland. Art publisher handling limited editions (maximum 250 prints), offset reproductions and posters for residential and commercial clients.
Needs: Considers watercolor, mixed media and oil—abstract and traditional landscapes. Prefers individual works of art. Maximum size 38×50. Artists represented include Steve Strickland, Nancy Rankin and Melinda Cowdery. Publishes and distributes the work of 2-3 emerging and 1 mid-career artist/year.
First Contact & Terms: Send query letter with transparencies. Samples not filed are returned. Reports back within 2 months. Payment method is negotiated. Provides promotion, a written contract and shipping. Buys first rights.

GESTATION PERIOD, Box 989, Columbus OH 43216-0989. (800)800-1562. General Manager: John R. Ryan. Estab. 1971. Importer and distributor of unlimited editions and posters. Clients: art galleries, framers, campus stores, museum shops and bookstores.
Needs: Seeking published creative art—especially fantasy and surrealism.
First Contact & Terms: Send query letter with résumé, tearsheets, pricing list and published samples. Samples are filed or returned by SASE. Reports back within 2 months. Negotiates rights purchased. Provides promotion.
Tips: "We are seeking pre-published open edition prints that will retail from $5-30."

THE GRAPHIC EDGE, 911 Hope St., P.O. Box 4669, Stamford CT 06907. (203)353-1147. Fax: (203)348-1240. President: Michael Katz. Art publisher of unlimited editions, posters and offset reproductions. Clients: galleries, framers, distributers, manufacturers worldwide.
 • The Graphic Edge has a sister company called Springdale Graphics.
Needs: Seeking creative and decorative art for the commercial and designer markets. Considers oil, watercolor, mixed media, pastel and acrylic. Artists represented include Silvia Edwards, Herb-Ritts. Editions created by collaborating with artist or by working from an existing painting. Publishes the work of 20 emerging, 50 mid-career and 50 established artists/year. Distributes the work of 5 emerging, 10 mid-career and 10 established artists/year.
First Contact & Terms: Send query letter with brochures showing art style, slides, photocopies, résumé, transparencies, tearsheets and photographs. Samples are returned by SASE if requested. Reports back within 3-4 weeks. Call for appointment to show portfolio of slides, tearsheets and photographs. Pays royalties of 10%. Buys all rights or reproduction rights. Requires exclusive representation of artist. Provides in-transit insurance, promotion, shipping from firm, insurance while work is at firm and a written contract.
Tips: Finds artists through word of mouth, magazines, artists' submissions/self-promotion, sourcebooks, agents, by visiting art galleries and attending art fairs and shows.

‡**GRAPHIQUE DU JOUR, INC.,** 2231 Faulkner Rd., Atlanta GA 30324. President: Daniel Deljou. Estab. 1980. Art publisher/distributor handling limited editions (maximum 250 prints), handpulled originals and monoprints/monotypes and paintings on paper. Clients: galleries, designers, corporate buyers and architects. Current clients include Coca Cola, Xerox, Exxon, Marriott Hotels, General Electric, Charter Hospitals, AT&T and more than 2,000 galleries worldwide.
Needs: Seeking creative and decorative art for the serious and commercial collector and designer market. Considers oil, acrylic, pastel, watercolor and mixed media. Prefers corporate art and transitional contemporary themes. Prefers individual works of art pairs or unframed series. Maximum size 38×50 image of published pieces. Artists represented include Kamy, Lee White, Donna Pinter, Ken Weaver, Michaela Sotillo, Alexa Kelemen, Roxanne Petty, Ralph Groff, Steven Cox, Yasharel, Dex Verner, Denis Assayac, Alex Miles, Cameron Scott, John Davis and T.L. Lange. Editions created by collaborating with the artist and by working from an existing painting. Approached by 100 artists/year. Publishes and distributes the work of 10-15 emerging and 15 mid-career artists/year. Publishes the work of 30 established artists/year.

First Contact & Terms: Send query letter with photographs, slides and transparencies. Samples not filed are returned only if requested by artist. Reports back only if interested. Publisher/Distributor will contact artist for portfolio review if interested. Pays flat fee or royalties; also sells on consignment basis or commission. Payment method is negotiated. Offers an advance when appropriate. Negotiates rights purchased. Requires exclusive representation. Provides promotion, a written contract and shipping from firm.

Tips: Finds artists through visiting galleries. "We would like to add a line of traditional art with a contemporary flair. Jewel-tone colors are in. We need landscape artists, monoprint artists, strong figurative artists, strong abstracts and soft-edge abstracts. We are also beginning to publish sculptures and are interested in seeing slides of such. We have had a record year in sales, but as a whole the industry is suffering."

HADDAD'S FINE ARTS INC., P.O. Box 849, Atwood CA 92601. President: P. Haddad. Produces limited and unlimited edition originals and offset reproductions for galleries, art stores, schools and libraries. Sells to the trade only—no retail.

Needs: Seeking unframed individual works and pairs; all media. Publishes 40-70 artists/year.

First Contact & Terms: Submit slides or photos representative of work for publication consideration. Include SASE. Reports back within 90 days. Buys reproduction rights. Pays royalties quarterly, 10% of base net price. Provides insurance while work is at publisher, shipping from publisher and written contract.

‡*HAR-EL PRINTERS & PUBLISHERS, Jaffa Port, POB 8053, Jaffa Israel 61081. 972-3-6816834/5. Fax: 972-3-6813563. Director: Jaacov Har-El. Estab. 1976. Art publisher/distributor/printers handling limited editions (maximum 350 prints), handpulled originals, serigraphs and etchings.

Needs: Considers oils, pastels and watercolor. Prefers contemporary landscape and seascape themes. Prefers individual works of art. Publishes and distributes the work of 6 artists/year.

First Contact & Terms: To show a portfolio mail original/final art and transparencies. Payment method is negotiated. Offers an advance when appropriate. Negotiates rights purchased. Requires exclusive representation. Provides insurance while work is at firms, promotion, shipping to your firm and a written contract.

ICART VENDOR GRAPHICS, Suite 103, 8512 Whitworth Dr., Los Angeles CA 90035. (310)659-1023. Fax: (310)659-1025. Director: John Pace. Estab. 1972. Art publisher and distributor of limited and unlimited editions of offset reproductions and handpulled original prints. Clients: galleries, picture framers, decorators, corporations, collectors.

Needs: Considers oil, acrylic, airbrush, watercolor and mixed media, also serigraphy and lithography. Seeking unusual, appealing subjects in Art Deco period styles as well as wildlife and African-American art. Prefers individual works of art, pairs, series; 30 × 40 maximum. Artists represented include J.W. Ford, Neely Taugher, Louis Icart and Maxfield Parrish. Publishes the work of 2 emerging, 3 mid-career and 1 established artist/year. Distributes the work of 4 emerging, 20 mid-career and 50 established artists/year.

First Contact & Terms: Send brochure and photographs. Do not send slides. Samples returned by SASE. Reports back within 1 month. Pays flat fee, $500-1,000; royalties (5-10%) or negotiates payment method. Sometimes offers advance. Buys all rights. Usually requires exclusive representation of the artist. Provides insurance while work is at publisher. Negotiates ownership of original art.

Tips: "Be original with your own ideas. Give clean, neat presentations in original or photographic form (no slides). No abstracts please. Popular styles include impressionism and landscapes. Posters are becoming less graphic; more of a fine art look is popular."

‡IMAGE CONSCIOUS, 147 Tenth St., San Francisco CA 94103. (415)626-1555. Creative Director: James Langan. Estab. 1980. Art publisher and distributor of offset and poster reproductions. Clients: poster galleries, frame shops, department stores, design consultants, interior designers and gift stores. Current clients include Z Gallerie, Deck the Walls and Decor Corporation.

Needs: Seeking creative and decorative art for the designer market. Considers oil, acrylic, pastel, watercolor, tempera, mixed media and photography. Prefers individual works of art, pairs or unframed series. Artists represented include Mary Silverwood, Aleah Koury, Doug Keith, Jim Tanaka, Gary Braasch and Lawrence Goldsmith. Editions created by collaborating with the artist and by working from an existing painting. Approached by hundreds of artists/year. Publishes the work of 2-3 emerging, 2-3 mid-career and 4-5 established artists/year. Distributes the work of 50 emerging, 200 mid-career and 700 established artists/year.

First Contact & Terms: Send query letter with brochure, résumé, tearsheets, photographs, slides and/or transparencies. Samples are filed or are returned by SASE. Reports back within 1 month. Publisher/Distributor will contact artist for portfolio review if interested. Payment method is negotiated. Negotiates rights purchased. Provides promotion, shipping from firm and a written contract.

> **The double dagger before a listing indicates that the listing is new in this edition. New markets are often more receptive to freelance submissions.**

Tips: "Research the type of product currently in poster shops. Note colors, sizes and subject matter trends."

IMAGES INTERNATIONAL DIRECT SALES CORPORATION, Suite 0-8, 670 Auahi St., Honolulu HI 96813. (808)531-7051. Fax: (808)521-4341. Vice President: Andrew P. Fisher. Estab. 1977. Art publisher and gallery. Publishes limited editions, offset reproductions and originals. Clients: retail galleries, shows and wholesale galleries. Current clients include Dyansen Galleries and Lahaina Galleries.
Needs: Seeking decorative art for the serious collector and commercial market. Considers oil, watercolor, acrylic and painting on fabric. Prefers oriental themes. Artists represented include Otsuka, Caroline Young and Chan. Editions created by collaborating with the artist or by working from an existing painting. Publishes the work of 1 emerging, 1 mid-career and 2 established artists/year.
First Contact & Terms: Send query letter with brochure showing art style or résumé and photographs. Samples are not filed and are returned by SASE if requested by artist. Reports back within 2 months. Payment method is negotiated. Offers an advance when appropriate. Buys one-time rights. Provides in-transit insurance, insurance while work is at firm, promotion, shipping to firm and a written contract.

IMCON, RR 3, Box, Oxford NY 13830. (607)843-5130. Fax: (607)843-2130. President: Fred Dankert. Estab. 1986. Fine art printer of handpulled originals. "We invented the waterless litho plate, and we make our own inks." Clients: galleries, distributors.
Needs: Seeking creative art for the serious collector. Editions created by collaborating with the artist "who must produce image on my plate. Artist given proper instruction."
First Contact & Terms: Call or send query letter with résumé, photographs and transparencies.
Tips: "Artists should be willing to work with me to produce original prints. We do *not* reproduce; we create new images. Artists should have market experience."

IMPACT, 4961 Windplay Dr., El Dorado Hills CA 95762. (916)933-4700. Fax: (916)933-4717. Contact: Benny Wilkins. Estab. 1975. Publishes calendars, postcards, posters and 5×7, 8×10 and 16×20 prints. Clients: international distributors, poster stores, framers, plaque companies, tourist businesses, retailers, national parks, history associations and theme parks. Current clients inlcude Royal Doulton, Image Conscious, Western Graphics, Prints Plus, Plaquefactory and Deck the Walls.
Needs: Looks for traditional, "trendy" and contemporary artwork. Considers acrylics, pastels, watercolors, mixed media and airbrush. Prefers contemporary, original themes, humor, fantasy, autos, animals, children and suitable poster subject matter. Prefers individual works of art. "Interested in licensed subject matter." Artists represented include Jonnie Kostoff, Tom Kidd, Richard Henson and Scott Wilson. Publishes the work of 5-10 emerging and 2-4 mid-career artists/year.
First Contact & Terms: Send query letter with brochure, tearsheets, photographs, slides and transparencies. Samples are filed. Reports back within 2 weeks. Call or write for appointment to show portfolio, or mail original/final art, tearsheets, slides, transparencies, final reproduction/product, color and b&w. Pays flat fee; $100-700; royalties of 7%; payment method is negotiated. Offers an advance when appropriate. Negotiates rights purchased. Does not require exclusive representation of the aritst. Provides insurance while work is at firm, shipping from firm, a written contract and artist credit.
Tips: "In the past we have been 'trendy' in our art; now we are a little more conservative and traditional. Currently looking for good Western art: Indian scenes, Indian chiefs, mountain men."

‡INSPIRATIONART & SCRIPTURE, P.O. Box 5550, Cedar Rapids IA 52406. (319)365-4350. Fax: (319)366-2573. Division Manager: Lisa Edwards. Produces greeting cards, posters and calendars.
 ● This company produces jumbo-sized posters targeted at pre-teens, teens and young adults, some fine art and some commercial. See their listing in the Greeting Card section for more information.

ARTHUR A. KAPLAN CO. INC., 460 W. 34th St., New York NY 10001. (212)947-8989. Fax: (212)629-4317. Art Director: Elizabeth Randazzo. Estab. 1956. Art publisher of unlimited editions of offset reproduction prints. Clients: galleries and framers.
Needs: Seeking creative and decorative art for the designer market. Considers all media and photography. Artists represented include Lena Liu, Charles Murphy and Gloria Eriksen. Editions created by collaborating with artist or by working from an existing painting. Approached by 1,550 artists/year. Publishes and distributes the work of "as many good artists as we can find."
First Contact & Terms: Send résumé, tearsheets, slides and photographs to be kept on file. Material not filed is returned by SASE. Reports within 2-3 weeks. Call for appointment to show portfolio, or mail appropriate materials. Portfolio should include final reproduction/product, color tearsheets and photographs. Pays a royalty of 5-10%. Offers advance. Buys rights for prints and posters only. Provides insurance while work is at firm and in transit from plant to artist.
Tips: "We cater to a mass market and require fine quality art with decorative and appealing subject matter. Don't be afraid to submit work—we'll consider anything and everything."

LOLA LTD./LT'EE, 1811 Egret St. SW, S. Brunswick Islands, Shallotte NC 28459-9809. (909)754-8002. Owner: Lola Jackson. Art publisher and distributor of limited editions, offset reproductions, unlimited editions and

Inspirationart & Scripture published this image, Greater Love, rendered in oil by César Barberena, in poster form. Lisa Edwards of Inspirationart says the piece was chosen because "the message is strong and meaningful to Christians. The colors are vivid and the style in which César portrays the crucifixion is striking."

GREATER LOVE
has no one than this . . .

©César Barberena

handpulled originals. Clients: art galleries, architects, picture frame shops, interior designers, major furniture and department stores and industry.

Needs: Seeking creative and decorative art for the commercial collector and designer market. "Handpulled graphics are our main area." Also considers oil, acrylic, pastel, watercolor, tempera or mixed media. Prefers unframed series, 30×40 maximum. Artists represented include Doyle, White, Brent, Jackson, Mohn, Baily, Carlson, Coleman and Woody. Editions created by collaborating with the artist. Approached by 100 artists/year. Publishes the work of 5 emerging and 5 mid-career artists/year. Distributes the work of 40 emerging and 40 mid-career artists/year. Publishes and distributes the work of 5 established artists/year.

First Contact & Terms: Send query letter with brochure showing art style or résumé, tearsheets, photostats, photographs, photocopies or transparencies. "Actual sample is best." Samples are filed or are returned only if requested. Reports back within 2 weeks. Payment method is negotiated. "Our standard commission is 50% less 50% off retail." Offers an advance when appropriate. Provides insurance while work is at firm, shipping from firm and a written contract.

Tips: "Send a cover letter, actual samples and the price the artist needs. Example: Retail, less 50, less 50. We do not pay for samples. We have sales reps throughout US to sell for you. We are presently looking for more reps."

BRUCE MCGAW GRAPHICS, INC., 230 Fifth Ave., New York NY 10001. (212)679-7823. Fax: (212)696-4523. Acquisitions: Martin Lawlor. Clients: poster shops, galleries, I.D., frame shops.

Needs: Artists represented include Ty Wilson, Betsy Cameron, Yuriko Takata, Art Wolfe, Diane Romanello, Patricia Wyatt, Donna Lacey-Derstine, Dale Terbush and Terry Rose. Publishes the work of 10 new and 20 established artists/year.

First Contact & Terms: Send slides, transparencies or any other visual material that shows the work in the best light. "We review all types of art with no limitation on medium or subject. Review period is 3 weeks, after which time we will contact you with our decision. If you wish the material to be returned, enclose a SASE. Contractual terms are discussed if work is accepted for publication."

Tips: "We have a tremendous need for decorative pieces, especially new abstracts. We have also seen a return to artwork which deals with back-to-nature subject matter as well as palette."

‡MACH 1, INC., P.O. Box 7360, Chico CA 95927. (916)893-4000. Fax: (916)893-9737. Vice President Marketing: Paul Farsai. Estab. 1987. Art publisher. Publishes unlimited and limited editions and posters. Clients: museums, galleries, frame shops and mail order customers. Current clients include the Smithsonian Museum, the Intrepid Museum, Deck the Walls franchisers and Sky's The Limit.

Needs: Seeking creative and decorative art for the commercial and designer market. Considers mixed media. Prefers aviation related themes. Artists represented include Jarrett Holderby and Jay Haiden. Editions created by collaborating with the artist or by working from an existing painting. Publishes the work of 2-3 emerging, 2-3 mid-career and 2-3 established artists/year.
First Contact & Terms: Send query letter with résumé, slides and photographs. Samples are not filed and are returned. Reports back within 1 month. To show a portfolio, mail slides and photographs. Pays royalties. Offers an advance when appropriate. Requires exclusive representation of the artist. Provides promotion, shipping to and from firm and a written contract.

‡**SEYMOUR MANN, INC.,** Suite #1500, 230 Fifth Ave., New York NY 10001. (212)683-7262. Fax: (212)213-4920. Manufacturer.
Needs: Seeking fashionable and decorative art for the serious collector and the commercial and designer markets. Considers watercolor, mixed media, pastel, pen & ink and 3-D forms. Editions created by collaborating with the artist. Approached by "many" artists/year. Publishes the work of 2-3 emerging, 2-3 mid-career and 4-5 established artists/year.

‡**MIXED-MEDIA, LTD.,** Box 15510, Las Vegas NV 89114. (702)796-8282 or (800)796-8282. Fax: (702)796-8282. Estab. 1969. Distributor of posters. Clients: galleries, frame shops, decorators, hotels, architects and department stores.
Needs: Considers posters only. Artists represented include Will Barnet, G.H. Rothe, Castellon and Cuevas. Distributes the work of hundreds of artists/year.
First Contact & Terms: Send finished poster samples. Samples not returned. Negotiates payment method and rights purchased. Does not require exclusive representation.

MODERNART EDITIONS, 100 Snake Hill Rd., West Nyack NY 10994. (914)358-7605. Publisher and distributor of "top of the line" unlimited edition posters and prints. Clients: galleries and custom frame shops nationwide.
Needs: Prefers fine art landscapes, abstracts, representational, still life, decorative, collage, mixed media. Minimum size 18×24. Artists represented are M.J. Mayer, Carol Ann Curran, Diane Romanello, Pat Woodworth, Jean Thomas and Carlos Rios. Publishes and distributes the work of 10 emerging, 10 mid-career and 10 established artists/year.
First Contact & Terms: Query first; submit slides, photographs of unpublished originals, or samples of published pieces available for exclusive distribution. Pays flat fee plus royalties. Reports within 1 month. Buys reproduction rights (exclusively).

MONTMARTRE ART COMPANY, INC., 24 S. Front St., Bergenfield NJ 07621. (201)387-7313 President: Ann B. Sullivan. Estab. 1959. Wholesale art dealer to trade. Clients: galleries, decorators, designers and art consultants.
Needs: Considers oil, acrylic, watercolor and mixed media. Prefers contemporary, traditional themes in unframed series. Distributes the work of 25 artists/year. Artists represented include Carol Ann Curran, Raul Conti, Laforet, Salizar, Takazi.
First Contact & Terms: Send query letter with brochure showing art style or any of the following: résumé, tearsheets, photostats, photographs, photocopies, slides and transparencies. Samples not filed are returned by SASE. Reports back within 7-10 days. Call for appointment to show portfolio of original/final art, slides and transparencies. Pays flat fee of $50-750 or royalties of 10%. Offers an advance when appropriate. Requires exclusive representation. Provides insurance while work is at firm and shipping from firm.
Tips: Finds artists through word of mouth, artists' submissions/self-promotion, sourcebooks, visiting art galleries, attending art fairs and shows. "Montmartre will work with artists to help make certain works are more saleable to our client market. We also help artists get their work published in the print and poster market." Currently "bright jewel-tone colors" are popular.

MULTIPLE IMPRESSIONS, LTD., 128 Spring St., New York NY 10012. (212)925-1313. Fax: (212)431-7146. President: Elizabeth Feinman. Estab. 1972. Art publisher and gallery. Publishes handpulled originals. Clients: young collectors, established clients, corporate, mature collectors.
Needs: Seeking creative art for the serious collector. Considers oil, watercolor, mixed media and printmaking. Prefers figurative, abstract, landscape. Editions created by collaborating with the artist. Approached by 100 artists/year. Publishes the work of 1 emerging, 1 mid-career and 1 established artist/year.
First Contact & Terms: Send query letter with slides and transparencies. Samples are not filed and are returned by SASE. To show a portfolio, send transparencies. Pays flat fee. Offers advance when appropriate. Buys all rights. Requires exclusive representation of artist.

‡**NAHRGANG COLLECTION,** 1005 First Ave., Silvis IL 61282. (309)792-9180. Manager: Ray Monterastelli. Estab. 1980. Manufacturer of dolls. Clients: retail stores and private collectors.
Needs: Seeking art for the commercial market. Considers doll designs. Artists represented include Jan Nahrgang, Cynthia Dutra. Editions created by collaborating with the artist. Approached by 2-4 artists/year.

Publishes and distributes the work of 3 emerging artists/year. Send brochure and photographs. Samples are filed or are returned by SASE if requested by artist. Reports back within 1 month. Artist should follow up with call. Portfolio should include photographs. Pays flat fee of $1,000 or royalties of 5% (negotiable). Offers advance when appropriate. Rights purchased vary according to project. Provides promotion, shipping from firm, insurance while work is at firm and written contract.
Tips: Finds artists through shows, toy fair (NYC).

NEW DECO, INC., #5, 127 NW 13th St., Boca Raton FL 33432. (407)394-2600 or (800)543-3326. Fax: (407)362-9668. President: Brad Morris. Estab. 1984. Art publisher and distributor of limited editions using lithography and silkscreen for galleries. Also publishes/distributes unlimited editions. Clients: art galleries and designers.
Needs: Interested in contemporary work. Artists represented are Robin Morris, Nico Vrielink and Lee Bomhoff. Needs new designs for reproduction. Publishes and distributes the work of 1-2 emerging, 1-2 mid-career and 1-2 established artists/year.
First Contact & Terms: Send brochure, résumé and tearsheets, photostats or photographs to be kept on file. Samples not kept on file are returned. Reports only if interested. Portfolio review not required. Publisher/Distributor will contact artist for portfolio review if interested. Pays flat fee or royalties of 5-7%. Also accepts work on (firm receives 50% commission). Offers advance. Negotiates rights purchased. Provides promotion, shipping and a written contract. Negotiates ownership of original art.
Tips: "We find most of our artists from *Artist's & Graphic Designer's Market*, advertising, trade shows and referrals."

‡NEW YORK GRAPHIC SOCIETY, Box 1469, Greenwich CT 06836. (203)661-2400. President: Richard Fleischmann. Publisher of offset reproductions, limited editions, posters and handpulled originals. Clients: galleries, frame shops and museums shops. Current clients include Deck The Walls, Ben Franklin.
Needs: Considers oil, acrylic, pastel, watercolor, mixed media and colored pencil drawings. Artists represented include Dan and Pauline Campanelli, Henrietta Milan, David Armstrong. Publishes reproductions, posters, serigraphs, stone lithographs, plate lithographs and woodcuts. Publishes and distributes the work of numerous emerging artists/year.
First Contact & Terms: Send query letter with transparencies, slides or photographs. Write for artist's guidelines. All submissions returned to artists by SASE after review. Reports within 3 weeks. Pays flat fee or royalty. Offers advance. Buys all print reproduction rights. Provides in-transit insurance from firm to artist, insurance while work is at firm, promotion, shipping from firm and a written contract; provides insurance for art if requested.
Tips: Finds artists through submissions/self promotions, magazines, visiting art galleries, art fairs and shows. "We publish a broad variety of styles and themes. We actively seek all sorts of fine decorative art."

NORTH BEACH FINE ART, INC., 9025 131st Place N., Largo FL 34643. (813)587-0049. Fax: (813)586-6769. President: James Cournoyer. Art dealer and importer, handling original graphics, prints, etchings, posters and uniques. Clients: art galleries, architects, interior designers and art consultants.
Needs: Considers mixed media serigraphs, stone lithographs, plate lithographs, etchings, woodcuts and linocuts. Especially likes contemporary, unusual and original themes or styles. Artists represented include Burnett, Bukovnik, Franklin. Looking for artists doing own original graphics and high quality prints to distribute.
First Contact & Terms: Send query letter with brochure, résumé, tearsheets, photostats, photocopies, slides or photographs to be kept on file. Accepts any sample showing reasonable reproduction. Samples returned by SASE only. Reports back within 2 months. To show a portfolio, mail finished art samples, color and b&w tearsheets, photostats and photographs. Provides insurance when work is at firm, promotion and written contract. Markets expressly-select original handmade editions of a small number of contemporary artists.
Tips: Wants "original prints by serious, experienced, career-oriented artists with well-developed and thought-out style. We're not looking to publish! If you make your own prints or have inventory please send photos."

NORTHLAND POSTER COLLECTIVE, Dept. AM, 1613 E. Lake St., Minneapolis MN 55407. (612)721-2273. Manager: Ricardo Levins Morales. Estab. 1979. Art publisher and distributor of handpulled originals, unlimited editions, posters and offset reproductions. Clients: mail order customers, teachers, bookstores, galleries, unions.
Needs: "Our posters reflect themes of social justice and cultural affirmation, history, peace." Artists represented include Ricardo Levins Morales, Ralph Fasanella, Karin Jacobson, Betty La Duke and Lee Hoover. Editions created by collaborating with the artist and working from an existing painting.
First Contact & Terms: Send query letter with tearsheets, slides and photographs. Samples are filed or are returned by SASE. Reports back within months; if does not report back, the artist should write or call to inquire. Write for appointment to show portfolio. Payment method is negotiated. Offers an advance when appropriate. Negotiates rights purchased. Contracts vary but artist always retains ownership of artwork. Provides promotion and a written contract.

Tips: "We distribute work that we publish as well as pieces already printed. We print screen prints inhouse and publish 1-4 offset posters per year."

THE OBSESSION OF DANCE CO., 140 Banks Rd., Easton CT 06612. (203)261-4546. Fax: (203)452-7836. Director: Rose Heindel. Estab. 1987. Art publisher and distributor of handpulled originals, posters and limited editions. Clients: galleries, retail theater shows, frame shops. Current clients include Deck the Walls, Fiesta Frames, One Shubert Alley, Triton Gallery.
Needs: Seeking art for the serious collector and the commercial market. Considers oil, mixed media, pen & ink. Prefers theater, dance and costume design. Artists represented include Carol Matyia, Robert Heindel and Raymond Hughes. Editions created by collaborating with the artist or working from an existing painting. Approached by 10 artists/year. Publishes the work of 3 and distributes the work of 3 established artists/year.
First Contact & Terms: Send query letter with brochure showing art style and tearsheets. Samples are filed. To show a portfolio, mail b&w and color tearsheets and photographs. Pays royalties of 15%. Offers advance when appropriate. Requires exclusive representation of artist. Provides promotion and shipping from firm.
Tips: "We are only interested in dance or theatrical-related material."

OLD WORLD PRINTS, Atlantic Gallery Publications, Dept. AM, 502 Research Rd., Richmond VA 23236. (804)378-7833. Fax: (804)378-7834. President: John Wurdeman. Estab. 1983. Art publisher and distributor of primarily open edition hand printed reproductions of antique engravings. Clients: retail galleries, frame shops and manufacturers. Current clients include Pro Framers, Lodan's.
Needs: Specializes in handpainted prints. Seeking fashionable and decorative art for the commercial and designer markets. Considers "b&w (pen & ink or engraved) art which can stand by itself or be hand painted by our artists or originating artist." Prefers traditional, representational, decorative. Artists represented include Roy Cross and Robert Back. Editions created by collaborating with the artist. Distributes the work of more than 300 artists.
First Contact & Terms: Send query letter with brochure showing art style or résumé and tearsheets and slides. Samples are filed. Reports back within 6 weeks. Write for appointment to show portfolio of photographs, slides and transparencies. Pays flat fee of $100 and royalties of 10% or on a consignment basis: firm receives 50% commission. Offers an advance when appropriate. Negotiates rights purchased. Provides in-transit insurance, insurance while work is at firm, promotion, shipping from firm and a written contract.
Tips: Finds artists through word of mouth. "We are a specialty art publisher, the largest of our kind in the world. We reproduce only in b&w and most of our pieces are hand painted."

PACIFIC EDGE PUBLISHING, INC., Suite 112, 540 S. Coast Hwy., Laguna Beach CA 92651. (714)497-5630. President: Paul C. Jillson Estab. 1988. Art publisher and distributor of handpulled originals.
Needs: Seeking art for the serious collector and commercial market. Prefers contemporary impressionism in oil. Artists represented include Maria Bertrán and Tom Swimm. Editions created by working from an existing painting. Approached by 20 artists/year. Publishes and distributes the work of 1 emerging and 1 mid-career artist/year.
First Contact & Terms: Send query letter with brochure showing art style or résumé with tearsheets and photographs. Samples not filed are returned by SASE if requested by artist. Reports back within 10 days. Call for appointment to show portfolio of photographs. Pays for prints in royalties of 10%; for oils, on a consignment basis (firm receives 50% commission). Negotiates rights purchased. Requires exclusive representation of artist. Provides in-transit insurance, insurance while work is at firm, promotion, shipping from firm and a written contract.

PANACHE EDITIONS LTD, 234 Dennis Lane, Glencoe IL 60022. (312)835-1574. President: Donna MacLeod. Estab. 1981. Art publisher and distributor of offset reproductions and posters for galleries, frame shops, domestic and international distributors. Current clients are mostly individual collectors.
Needs: Considers acrylic, pastel, watercolor and mixed media. "Looking for contemporary compositions in soft pastel color palettes; also renderings of children on beach, in park, etc." Artists represented include Bart Forbes, Peter Eastwood and Carolyn Anderson. Prefers individual works of art and unframed series. Publishes and distrubutes work of 1-2 emerging, 2-3 mid-career and 1-2 established artists/year.
First Contact & Terms: Send query letter with brochure showing art style or photographs, photocopies and transparencies. Samples are filed. Reports back only if interested. To show a portfolio, mail roughs and final reproduction/product. Pays royalties of 10%. Negotiates rights purchased. Requires exclusive representation of the artist. Provides in-transit insurance, insurance while work is at firm, promotion, shipping to and from firm and a written contract.
Tips: "We are looking for artists who have not previously been published (in the poster market) with a strong sense of current color palettes. We want to see a range of style and coloration. Looking for a unique and fine art approach to collegiate type events, i.e. Saturday afternoon football games, Founders Day celebrations, homecomings, etc. We do not want illustrative work but rather an impressionistic style that captures the tradition and heritage of one's university. We are very interested in artists who can render figures."

‡*PORTER DESIGN−EDITIONS PORTER, 19 Circus Place, Bath Avon BA1 2PE, England. (01144)225-424910. Fax: (01144)225-447146. Partner: Mary Dixon. Estab. 1985. Publishes limited and unlimited editions and offset productions and hand-colored reproductions. Clients: distributors, interior designers and hotel contract art suppliers. Current clients include Devon Editions, Art Group and Harrods.
Needs: Seeking fashionable and decorative art for the designer market. Considers watercolor. Prefers 17th-19th century traditional styles. Artists represented include Victor Postolle, Joseph Hooker and Adrien Chancel. Editions created by working from an existing painting. Approached by 10 artists/year. Publishes and distributes the work of 10-20 established artists/year.
First Contact & Terms: Send query letter with brochure showing art style or résumé and photographs. Samples are filed or are returned. Reports back only if interested. To show portfolio, mail photographs. Pays flat fee or royalties. Offers an advance when appropriate. Negotiates rights purchased.

Afternoon Tea, by Richard Boyer, has been a steady seller in Portfolio Graphics' line of prints. The publisher created a fine art poster from the original oil painting, as well as making note/greeting cards from a detail of the painting. Boyer receives 10% royalty on all pieces sold.

PORTFOLIO GRAPHICS, INC., 4060 S. 500 W., Salt Lake City UT 84123. (800)843-0402. Fax: (801)263-1076. Creative Director: Kent Barton. Estab. 1986. Publishes and distributes limited editions, unlimited editions and posters. Clients: galleries, designers and poster distributors.
Needs: Seeking creative, fashionable and decorative art for commercial and designer markets. Considers oil, watercolor, acrylic, pastel, mixed media and photography. Publishes 20-30 new works/year. Artists represented include Dawna Barton, Brooke Morrison, Jodi Jensen and Kent Wallis. Editions created by working from an existing painting or transparency.
First Contact & Terms: Send query letter with résumé, biography, slides and photographs. Samples are not filed. Reports back within months. To show a portfolio, mail slides, transparencies and photographs. Pays $100 advance against royalties of 10%. Buys reprint rights. Provides promotion and a written contract.
Tips: Sees trend toward "stronger, richer colors. We released a new 170-page catalog in March '94, and we'll add new supplemental pages twice yearly."

THE PRESS CHAPEAU, Govans Station, Box 4591, Baltimore City MD 21212-4591. Director: Elspeth Lightfoot. Estab. 1976. Publishes and distributes original prints only, "in our own atelier or from printmaker." Clients: architects, interior designers, corporations, institutions and galleries. Also sells to US government through GSA schedule.
Needs: Considers original handpulled etchings, lithographs, woodcuts and serigraphs. Prefers professional, highest museum quality work in any style or theme. Suites of prints are also viewed with enthusiasm. Prefers unframed series. Publishes the work of 2 emerging, 5 mid-career and 10 established artists/year.
First Contact & Terms: Send query letter with slides. Samples are filed. Samples not filed are returned by SASE. Reports back within 5 days. Write for appointment to show portfolio of slides. Pays flat fee of $100-2,000. Payment method is negotiated. Offers advance. Purchases 51% of edition or right of first refusal. Does not require exclusive representation. Provides insurance, promotion, shipping to and from firm and a written contract.
Tips: Finds artists through agents, art galleries and art fairs. "Our clients are interested in investment quality original handpulled prints. Your résumé is not as important as the quality and craftsmanship of your work."

PRESTIGE ART GALLERIES, INC., 3909 W. Howard St., Skokie IL 60076. (708)679-2555. President: Louis Schutz. Estab. 1960. Art gallery. Publishes and distributes paintings and mixed media artwork. Clients: retail professionals and designers.
● This gallery represents a combination of 18th and 19th century work and contemporary material. Clientele seems to be currently most interested in figurative art and realism.
Needs: Seeking art for the serious collector. Prefers realism and French impressionism in oil. Artists represented are Erte, Simbari, Agam and King. Editions created by collaborating with the artist or by working from an existing painting. Approached by 100 artists/year. Publishes 1 emerging, 1 mid-career and 1 established artist/year. Distributes the work of 5 emerging, 7 mid-career and 15 established artists/year.
First Contact & Terms: Send query letter with résumé and tearsheets, photostats, photocopies, slides, photographs and transparencies. Samples are not filed and are returned by SASE. Reports back within 2 weeks. Pays on consignment (firm receives 50% commission). Offers an advance. Buys all rights. Provides insurance while work is at firm, promotion, shipping from firm and a written contract.
Tips: "Be professional. People are seeking better quality, lower sized editions, less numbers per edition—1/100 instead of 1/750."

‡ROMM ART CREATIONS, LTD., P.O. Box 1426, Maple Lane, Bridgehampton NY 11932. (516)537-1827. Fax: (516)537-1752. Contact: Steven Romm. Estab. 1987. Art publisher. Publishes unlimited editions, posters and offset reproductions. Clients: distributors, galleries, frame shops.
Needs: Seeking decorative art for the commercial and designer markets. Considers oil, watercolor, mixed media, pastel, acrylic and photography. Prefers traditional and contemporary. Artists represented include Tarkay, Wohlfelder, Switzer. Editions created by collaborating with the artist or by working from an existing painting. Publishes the work of 10 emerging, 10 mid-career and 10 established artists/year.
First Contact & Terms: Send query letter with slides and photographs. Samples are not filed and are returned by SASE if requested by artist. Reports back to the artist only if interested. Publisher will contact artist for portfolio review if interested. Pays royalties of 10%. Offers advance. Rights purchased vary according to project. Requires exclusive representation of artist for posters only. Provides promotion and written contract.
Tips: Finds artists through attending art exhibitions, agents, sourcebooks, publications, artist's submissions.

SALEM GRAPHICS, INC., Box 15134, Winston-Salem NC 27103. (919)727-0659. Contact: Susan Dahlen. Estab. 1981. Art publisher and distributor of unlimited editions and limited editions of offset reproductions. Clients: art galleries and frame shops.
Needs: Seeking creative, fashionable and decorative art for the serious collector, commercial and designer markets. Considers oil, watercolor, acrylic and pastel. Artists represented include R.B. Dance, John Forches and Mildred Kratz. Editions created by collaborating with the artist or by working from an existing painting. Approached by 50-100 artists/year. "We publish and/or distribute the work of approximately 15 artists, mostly established."
First Contact & Terms: Send query letter with color tearsheets, slides, samples of existing prints and transparencies. Samples are not filed and are returned only by SASE. Reports back ASAP. Requires exclusive representation of artist. Provides insurance while work is at firm.

‡THE SAWYIER ART COLLECTION, INC., 3445-D Versailles Rd., Frankfort KY 40601. (800)456-1390. Fax: (502)695-1984. President: William H. Coffey. Distributor. Distributes limited and unlimited editions, posters and offset reproductions. Clients: retail art print and framing galleries.
Needs: Seeking fashionable and decorative art. Prefers floral and landscape. Artist represented include Lena Liu, Mary Bertrand. Approached by 100 artists/year. Distributes the work of 10 emerging, 50 mid-career and 10 established artists/year.
First Contact & Terms: Send query letter with tearsheets. Samples are not filed and are returned by SASE if requested by artist. Reports back to the artist only if interested. Distributor will contact artist for portfolio

review if interested. Portfolio should include color tearsheets. Buys work outright. No advance.
Tips: Finds artists through publications (*Decor, Art Business News*), retail outlets.

SCAFA-TORNABENE ART PUBLISHING CO. INC., 100 Snake Hill Rd., West Nyack NY 10994. (914)358-7600. Fax: (914)358-3208. Art Coordinator: Susan Murphy. Produces unlimited edition offset reproductions. Clients: framers, commercial art trade and manufacturers worldwide.
Needs: Seeking decorative art for the wall decor market. Considers unframed decorative paintings, posters, photos and drawings. Prefers pairs and series. Artists represented include T.C. Chiu, Nancy Matthews and Marianne Caroselli. Editions created by collaborating with the artist and by working from a pre-determined subject. Approached by 100 artists/year. Publishes and distributes the work of dozens of artists/year. "We work constantly with our established artists, but are always on the lookout for something new."
First Contact & Terms: Send query letter first with slides or photos and SASE and call approximately 2 weeks from contact. Reports in about 3-4 weeks. Pays $200-350 flat fee for some accepted pieces. Royalty arrangements with advance against 5-10% royalty is standard. Buys only reproduction rights. Provides written contract. Artist maintains ownership of original art. Requires exclusive publication rights to all accepted work.
Tips: "Do not limit your submission. We know what we are looking for better than you do. Sometimes we do not even know until we see it. In submitting, more is better. Please be patient. All inquiries will be answered."

‡SCANDECOR INC., 430 Pike Rd., Southampton PA 18966. (215)355-2410. Fax: (215)364-8737. Vice President Operations: Dan Griffin. Estab. 1968. Produces posters. Target market is young people, infants-teens.
Needs: Seeking illustrations in any media for posters. Approached by 50 artists/year. Publishes the work of 15-20 artists/year.
First Contact & Terms: Send query letter with photographs, photocopies, slides and transparencies. Samples are filed or are returned. Call for appointment to show portfolio, or mail appropriate materials. Rights purchased vary according to project. Originals are returned at job's completion. Payment depends on product.

SEGAL FINE ART, #100, 4760 Walnut St., Boulder CO 80301. (303)939-8930. Fax: (303)783-7902. Artist Liason: Andrea Bianco. Estab. 1986. Art publisher. Publishes limited editions. Clients: galleries.
Needs: Seeking creative and fashionable art for the serious collector and commercial market. Considers oil, watercolor, mixed media and pastel. Artists represented include Ting Shao Kuang, Luy Hong, Sassone. Editions created by working from an existing painting. Publishes and distributes the work of 1 emerging artist/year. Publishes the work of 7 and distributes the work of 3 established artists/year.
First Contact & Terms: Send query letter with slides, résumé and photographs. Samples are not filed and are returned by SASE. Reports back in 2 months. To show a portfolio, mail slides, color photographs, bio and résumé. Offers advance when appropriate. Negotiates payment method and rights purchased. Requires exclusive representation of artist. Provides promotion.

SOMERSET HOUSE PUBLISHING, 10688 Haddington, Houston TX 77043. (713)932-6847. Fax: (713)932-7861. Contact: Daniel Klepper. Estab. 1972. Art publisher of fine art limited editions.
Needs: Seeking mature and creative artwork for the serious collector and art lover. Artists represented include G. Harvey, Charles Fracé, Larry Dyke, L. Gordon, Lee Teter, Adriano Manocchia, Michael Atkinson, M.J. Deas. Editions created by collaborating with the artist and by working from an existing painting.
First Contact & Terms: Send query letter, résumé, slides or photographs with SASE.

SPRINGDALE GRAPHICS, 911 Hope St., Box 4816, Springdale CT 06907. (203)356-9510. Fax: (203)967-9100. President: Michael Katz. Estab. 1985. Art publisher and distributor of unlimited editions and posters. Clients: galleries, museum shops, worldwide distributors, frame shops and design consultants.
Needs: Seeking creative, fashionable and decorative art for the serious collector, commercial and designer markets. Considers oil, watercolor, acrylic, pastel, pen & ink, mixed media and printmaking (all forms). Artists represented include Marcia Burtt, William Hunnum, Chagall, Klee, Miro. Editions created by collaborating with the artist or by working from an existing painting. Approached by hundreds of artists/year. Publishes the work of 6-10 emerging, 15-20 mid-career and 100 established artists/year.
First Contact & Terms: Send query letter with brochure showing art style or résumé and tearsheets, slides, photostats, photographs, photocopies and transparencies. Samples are filed or are returned by SASE. Reports back within 2 weeks. Pays royalties of 10%. Offers an advance when appropriate. Buys all rights.

How to Use Your Artist's & Graphic Designer's Market *offers suggestions for understanding and using the information in these listings. Read this and other articles in the front of this book for important business tips.*

Sometimes requires exclusive representation of the artist. Provides in-transit insurance, insurance while work is at firm, promotion, shipping to firm and a written contract.

Tips: Finds artists through word of mouth, magazines, artists' submissions/self-promotion, sourcebooks, agents, by visiting art galleries and attending art fairs and shows. "We are looking for highly skilled artists with a fresh approach to one or all of the following: painting (all mediums), pastel, collage, printmaking (all forms), mixed media and photography."

STANTON ARTS, INC., P.O. Box 290234, Ft. Lauderdale FL 33329. (305)423-9292. Fax: (305)423-9680. President: Stan Hoff. Estab. 1986. Art publisher handling limited editions, posters and figurines. Clients: galleries, framers, department stores and mass merchandisers.

Needs: Seeking creative art for commercial and designer markets. Considers sculpture, watercolor, oil, pastel, pen & ink and acrylic. Prefers children, sports, professions, celebrities, period costumes, clowns/circus and Western subjects. Artists represented include Leighton-Jones, Mary Vickers, David Wenzel, Daniel Lovatt and Dom Mingolla. Editions created by collaborating with the artist. Approached by 100 artists/year.

First Contact & Terms: Send query letter with brochure, tearsheets, photographs and résumé. Samples are returned by SASE if requested by artist. Call or write for appointment to show portfolio of roughs or original/final art, photostats, tearsheets, slides or transparencies. Payment method is negotiated. Offers an advance when appropriate. Negotiates rights purchased. Provides insurance while work is at firm and a written contract.

‡SULIER ART PUBLISHING, 111 Conn Terrace, Lexington KY 40508. (606)259-1688. Estab. 1969. Art publisher and distributor. Publishes and distributes handpulled originals, limited and unlimited editions, posters, offset reproductions and originals. Clients: design.

Needs: Seeking creative, fashionable and decorative art for the serious collector and the commercial and designer markets. Considers oil, watercolor, mixed media, pastel and acrylic. Prefers impressionist. Artists represented include Judith Webb, Neil Sulier, Eva Marie. Editions created by collaborating with the artist and by working from an existing painting. Approached by 20 artists/year. Publishes and distributes the work of 5 emerging artists/year. Publishes the work of 30 mid-career and 6 established artists/year.

First Contact & Terms: Send query letter with brochure, slides, photocopies, résumé, photostats, transparencies, tearsheets and photographs. Samples are filed and are returned. Reports back only if interested. Request portfolio review in original query. Artist should follow up with call. Publisher will contact artist for portfolio review if interested. Portfolio should include slides, tearsheets, final art and photographs. Pays royalties of 10%, on consignment basis or negotiates payment. Offers advance when appropriate. Negotiates rights purchased (usually one-time or all rights). Provides in-transit insurance, promotion, shipping to and from firm, insurance while work is at firm and written contract.

SUNDAY COMICS STORE™, (formerly The Entertainment Art Company), 47 Euclid Ave., Stamford CT 06902. (203)359-6902. Fax: (203)353-9304. President: Bruce Kasanoff. Estab. 1989. Catalog publisher; operates retail stores. Sells wide variety of merchandise imprinted with artwork.

Needs: Seeking artists who can capture America's favorite cartoon characters. "We assign projects to artists based on their demonstrated abilities."

First Contact & Terms: Send query letter with résumé and tearsheets, slides and photographs. Samples are filed or are returned by SASE if requested by artist. Reports back within 1 week. Call for appointment or show portfolio. Portfolio should include original/final art, slides, photographs and transparencies. No advance. Negotiates rights purchased. Provides insurance while work is at firm, promotion, shipping to firm and a written contract.

Tips: "We hire artists to create art for our licensed properties from movies and/or comics. We value talent, flexibility and responsiveness."

JOHN SZOKE GRAPHICS INC., 164 Mercer St., New York NY 10012. Director: John Szoke. Produces limited edition handpulled originals for galleries, museums and private collectors.

Needs: Original prints, mostly in middle price range, by upcoming artists. Artists represented include: James Rizzi, Jean Richardson, Asoma, Scott Sandell and Bauman. Publishes the work of 2 emerging, 10 mid-career and 2 established artists/year. Distributes the work of 10 emerging, 10 mid-career and 5 established artists/year.

First Contact & Terms: Send slides with SASE. Request portfolio review in original query. Reports within 1 week. Charges commission, negotiates royalties or pays flat fee. Provides promotion and written contract.

VARGAS & ASSOCIATES ART PUBLISHING, INC., Suite 200, 8240 Professional Place, Landover MD 20785. (301)731-5175. Fax: (301)731-5712. President: Elba Vargas-Colbert. Estab. 1988. Art publisher and distributor of serigraphs, limited and open edition offset reproductions. Clients: galleries, frame shops, museums and decorators with worldwide distribution.

Needs: Seeking creative art for the serious collector and commercial market. Considers oil, watercolor, acrylic, pastel pen & ink and mixed media. Prefers ethnic themes. Artists represented include Joseph Holston, Kenneth Gatewood, Tod Haskin Fredericks, Betty Biggs, Norman Williams, Sylvia Walker, James Ransome,

Leroy Campbell, William Tolliver, Kathyrn Wooten and Paul Goodnight. Approached by 100 artists/year. Publishes/distributes the work of about 30 artists.
First Contact & Terms: Send query letter with résumé, slides and/or photographs. Samples are filed. Reports back only if interested. To show portfolio, mail photographs. Payment method is negotiated. Requires exclusive representation of the artist.
Tips: "Vargas & Associates Art Publishing is standing as a major publisher committed to publishing artists of the highest caliber, totally committed to their craft and artistic development."

‡WATERMARK FINE ARTS, Suite 402, Lafayette Ct., Kennebunk ME 04043. (207)985-6134. Fax: (207)985-7633. Publisher: Alexander Bridge. Estab. 1989. Art publisher. Publishes and distributes limited and unlimited editions, posters, offset reproductions and stationery. Clients: framers, galleries.
Needs: Seeking creative art for the commercial market. Considers oil, watercolor, mixed media, pen & ink and acrylic. Prefers realistic. Artists represented include John Gable, Walter Kessel. Editions created by collaborating with the artist. Approached by 2 artists/year. Publishes and distributes the work of 1 mid-career and 1 established artist/year.

JAMES D. WERLINE STUDIO, 119 W. Main St., Amelia OH 45102. (513)753-8004. Partner: Dee A. Werline. Estab. 1978. Art publisher handling limited editions of offset reproductions. Clients: galleries and museums.
Needs: Seeking creative art for the serious collector. Considers oil, acrylic, pastel, watercolor and tempera. Prefers original themes and individual works of art. Artists represented include Debbie Hook, James D. Werline and Don Paul Kirk. Approached by 8-10 artists/year. Publishes the work of 2 established artists/ year.
First Contact & Terms: Send query letter with brochure, résumé, tearsheets and slides. Samples are filed or returned if requested by artist. Reports back within 3-4 weeks. Call for appointment to show portfolio, or mail color tearsheets, slides and final reproduction/product. Pays royalties of 10% (wholesale). Buys reprint rights. Requires exclusive representation. Provides insurance, shipping from firm and a written contract.
Tips: "Be totally dedicated to the promotion of your art."

WILD APPLE GRAPHICS, LTD., HCR 68 Box 131, Woodstock VT 05091. (802)457-3003. Fax: (802)457-3214. Art Director: Laurie Chester. Estab. 1989. Art publisher and distributor of posters and unlimited editions. Clients: frame shops, interior designers and furniture companies. Current clients include Deck the Walls, Pier 1, Natural Wonders, The Nature Company and many catalogue and furniture companies.
Needs: Seeking decorative art for the commercial and designer markets. Considers oil, watercolor, acrylic and pastel. Artists represented include Warren Kimble, Charles Lynn Bragg, Lizzie Riches, Kathy Jakobsen and Coco Dauley. Editions created by working from an existing painting. Approached by 1,000 artists/year. Publishes and distributes the work of 1-4 emerging and mid-career and 6-10 established artists/year.
First Contact & Terms: Send query letter with résumé and slides, photographs or transparencies. Samples are returned by SASE. Reports back within 2 months. Negotiates payment method and rights purchased. Provides in-transit insurance, insurance while work is at firm, promotion, shipping to and from firm and a written contract.
Tips: "We're looking for all art forms from experienced artists. The work must have universal appeal. Wild Apple Graphics has grown quickly and steadily since its beginning three years ago, due to the combination of affordability (prints retail from $10-35) and high quality printing."

WILD WINGS INC., S. Highway 61, Lake City MN 55041. (612)345-5355. Fax: (612)345-2981. Merchandising Manager: Sara Koller. Estab. 1968. Art publisher, distributor and gallery. Publishes and distributes limited editions and offset reproductions. Clients: retail and wholesale.
Needs: Seeking artwork for the commercial market. Considers oil, watercolor, mixed media, pastel and acrylic. Prefers fantasy, military, golf, variety and wildlife. Artists represented include David Maass, Lee Kromschreeder, Ron Van Gilder, Robert Abbett and Nancy Grarter. Editions created by working from an existing painting. Approached by 300 artists/year. Publishes the work of 36 artists/year. Distributes the work of numerous emerging artists/year.
First Contact & Terms: Send query letter with slides and résumé. Samples are filed and held for 6 months then returned. Reports back within 3 weeks if uninterested or 6 months if interested. Publisher will contact artist for portfolio review if interested. Pays royalties for prints. Accepts original art on consignment and takes 40% commission. No advance. Buys first-rights or reprint rights. Requires exclusive representation of artist. Provides in-transit insurance, promotion, shipping to and from firm, insurance while work is at firm and a written contract.

‡WINN ART GROUP, 6015 Sixth Ave. S., Seattle WA 98108. (206)763-9544. Fax: (206)762-1389. Direct Product Develop: Buster Morris. Estab. 1976. Art publisher and wholesaler. Publishes limited editions and posters. Clients: mostly trade, designer, decorators, galleries, poster shops. Current clients include: Pier 1, Homestead House, Designer Picture Framers.

Needs: Seeking decorative art for the designer market. Considers oil, water, mixed media, pastel, pen & ink and acrylic. Artists represented include Buffet, Gunn, Wadlington, Schofield, Schaar. Editions created by working from an existing painting. Approached by 300-400 artists/year. Publishes and distributes the work of 0-3 emerging, 3-8 mid-career and 3-5 established artists/year.

First Contact & Terms: Send query letter with brochure, slides, photocopies, résumé, photostats, transparencies, tearsheets or photographs. Samples are returned by SASE if requested by artist. Reports back within 4-6 weeks. Publisher will contact artist for portfolio review if interested. Portfolio should include "whatever is appropriate to communicate the artist's talents." Pay varies. Offers advance when appropriate. Rights purchased vary according to project. Provides written contract.

Tips: Finds artists through attending art exhibitions, agents, sourcebooks, publications, artists' submissions.

Art Publishers/'94-'95 changes

The following markets were listed in the 1994 edition but do not have listings in this edition. The majority did not respond to our request to update their listings. If a reason was given for exclusion, it appears in parentheses after the market's name.

Addi Fine Art Publishing
Alliance Art Publishing (not taking on new artists)
Art Find
Artistworks Wholesale Inc.
Tamora Banc Gallery (unable to contact)
Colmin Fine Art
Crego Editions
Essence Art.
Genre Ltd. Inc — Art Publishers
Girard/Stephens Fine Art Dealers
Gregory Editions

Guidhall, Inc.
Hadley House Publishing
Image-Crafters
Lawrence Unlimited
Leslie Levy Fine Art Publishing, Inc.
Manor Art Enterprises, Ltd.
The Marks Collection
David Marshall
Metropolitan Art Associates
Moriah Publishing, Inc.
Museum Boutique Intercontinental, Ltd.
George Nock Studios

Northwoods Craftsman
Pearl & Peacock
Premier Art Editions
Prettyman Productions, Inc.
Quantam Mechanics
Simon Art Ltd.
Sports Art Inc.
Star Fine Art Publishers
The Story Agency
Tele Graphics
V.F. Fine Arts, Inc.
Waterline Publications, Inc.

Book Publishers

Book covers don't always spring to mind when a fine artist, illustrator or designer is considering markets. But think about it. Every year thousands of books are published, and each must compete with hundreds of other titles for the public's attention. Though the saying goes "You can't judge a book by its cover," more and more publishers are realizing that an intriguing cover can coax the reader to pick up the book and look inside.

The illustration on the cover (or lack of one) combined with the typography and layout choices of the designer, announce to the prospective reader at a glance the style and content of the book. Is it a wistful romance or science fiction? Are the characters brilliant, brave, sexy or scary? Is it scholarly or full of fun? The inside of a book is important, too. Designers create the page layouts that direct us through the text. This is particularly important in children's books and text books.

Walk into any bookstore and start counting the number of images you see on books and calendars. Publishers don't have enough artists on staff to generate such a vast array of styles. The illustrations you see on covers and within the pages of books are for the most part created by freelance artists.

Before author/illustrator Nick Bantock hit it big with the runaway best seller, *Griffin & Sabine* (see Insider Report on page 194), he designed and illustrated book covers on a freelance basis. Bantock found it was a great way to stretch his talents while supporting his family and pursuing his fine art. Crossover artists such as Gary Kelley and Bascove have also enjoyed working on book projects. If you like to read and work creatively to solve problems, the world of publishing could be a great market for you, too.

Different publishers, different needs

It's important to note that the market for freelance design in book publishing is not nearly as strong as that for illustration. Since major publishers use staff for layouts, designers will have more success approaching small presses. Most do not have inhouse art departments, and tend to use outside designers on a freelance or contract basis. Whether you work for large or small publishers, computer skills are essential for designers. Illustration is open to all styles and media, from computer generated images to mixed media paintings. There is a growing interest—particularly among literary publishers—in hand-rendered, tactile artwork. Many publishers are turning to fine artists for cover work. Among small literary presses the selection of artwork is sometimes an intuitive process, or is sometimes left up to the author. Small presses will often purchase pre-existing artwork from illustrators and give freelance designers a lot of creative freedom with page layout. Commercial publishers, however, are more attuned to marketing considerations. Illustration for commercial houses is always assigned, as it is created to appeal to an intended target audience.

The type of work available depends not only on the vision of the publisher, but also on the nature of the actual book being published. A fiction work for example, may feature only a cover illustration and a fairly simple page layout, whereas a nonfiction book (such as a how-to, cookbook or technical manual) may use interior illustration extensively and incorporate more sidebars, checklists and unique type treatments

into the design. Consequently, it's crucial to be familiar with a publisher's specialties before sending samples.

A special note about children's books

The children's book industry has experienced a boom in recent years, and is a growing hotbed for freelance designers and illustrators. More and more kids' books now include unique design elements such as acetate overlay inserts, textured pages, pop out projects and die cuts. Illustrations, of course, continue to be in high demand as well, simply because more kids' books are being published.

It's important to understand, however, that children's-books work requires a specific set of skills. Illustrators, for example, must have a consistent style and must be able to draw the same characters in a variety of action poses and situations. Refer to Children's Writer's and Illustrator's Market, *published by Writer's Digest Books.*

Finding and approaching book publishers

Careful research is the first step in finding book publishers who will be interested in your work. Read the listings in this section and write for catalogs and artist's guidelines from those publishers who interest you most. Be sure to visit bookstores to keep current on what's out there.

Most publishers keep extensive files of art samples and refer to these files each time they're ready to make an assignment. To stake a place in these files, first target your submission to match the unique style of the publisher you're approaching. You'll want to send 5 to 10 nonreturnable samples along with a brief letter and a SASE. Never send originals. (See Successful Self-Promotion by Robin Gee on page 15). Most art directors prefer samples that are 8½ × 11 or smaller that can fit in file drawers. Bulky submissions are often considered a nuisance.

Fees

A few publishers purchase existing art, but most will make assignments for specific projects. Payment for freelance design and illustration varies depending on the size of the publisher, the type of project and the rights bought. Most publishers pay on a per-project basis, although some publishers of highly illustrated books (such as children's books) pay an advance plus royalties. A few very small presses may only pay in copies.

A.D. BOOK CO., 6th Floor, 10 E. 39th St., New York NY 10157-0002. (212)889-6500. Fax: (212)889-6504. Art Director: Doris Gordon. Publishes hardcover and paperback originals on advertising design and photography. Publishes 12-15 titles/year. Recent titles include disks of *Scan This Book* and *Most Happy Clip Art*; book and disk of *101 Absolutely Superb Icons* and *American Corporate Identity #9*.
Needs: Works with 2-4 designers/year. Uses freelance artists mainly for graphic design.
First Contact & Terms: Send query letter to be filed, and arrange to show portfolio of 4-10 tearsheets. Portfolios may be dropped off Monday-Friday. Samples returned by SASE. Buys first rights. Originals returned to artist at job's completion. Free catalog. Advertising design must be contemporary.
Book Design: Pays $100 minimum.
Jackets/Covers: Pays $100 minimum.
Tips: Finds artists through word of mouth.

AEGINA PRESS, INC., 59 Oak Lane, Spring Valley, Huntington WV 25704. Art Coordinator: Claire Nudd. Estab. 1984. Publishes hardcover and trade paperback originals, and trade paperback reprints. Types of

books include contemporary, experimental, mainstream, historical, science fiction, adventure, fantasy, mystery, young adult and travel. Publishes 25 titles/year. Recent titles include *Time in A Vacuum* (novel), *The Planet of Fire* (novel) and *From The Dragon's Tale* (children's). 50% require freelance illustration. Book catalog available for $3 and 9 × 12 SAE with 4 first-class stamps.

Needs: Works with 30 illustrators/year. Prefers artists with experience in color separations and graphic layouts. Uses freelancers mainly for covers and some interior illustrations. 5% of freelance work demands computer skills. Works on assignment only.

First Contact & Terms: Send query letter with photographs and 8½ × 11 photocopies. Samples are filed and are not returned. Reports back within 2 weeks only if interested. To show portfolio, mail appropriate materials. Buys one-time rights. Originals not returned.

Jackets/Covers: Assigns 20 design jobs and 5 illustration jobs/year. Pays by the project, $60-100.

Text Illustration: Assigns 5 jobs/year. Pays by the project, $25-1,000. Prefers pen & ink.

Tips: Finds artists through referrals and submissions.

ALASKA PACIFIC UNIVERSITY PRESS, 4101 University Dr., Anchorage AK 99508. (907)564-8304. Fax: (907)562-4276. Managing Editor: Laurie McNicholas. Estab. 1963. Small press. Publishes hardcover originals, trade paperback originals and reprints and textbooks. Types of books include contemporary and historical fiction, instructional, adventure, biography, travel, reference, history, humor, mythology, legend and folktale. Specializes in Alaska, Alaska Natives, North Pacific Rim countries and peoples. Publishes 1-4 titles/year. Titles include *Favorite Eskimo Tales Retold*. 100% require freelance illustration; 100% require freelance design. Book catalog free by request.

Needs: Approached by 2 freelance artists/year. Works with 1-2 illustrators and 1-2 designers/year. Buys no more than 10 illustrations/year. Prefers local artists with experience in photography and line drawings. "Whenever possible, preference will be given to Alaskan artists, especially Alaska Native artists." Uses freelancers mainly for cover and interior illustration. Also for jacket/cover and book design. Needs computer-literate freelancers for design, illustration and production. 75% of freelance work demands knowledge of Aldus PageMaker. Works on assignment only.

First Contact & Terms: Send query letter with résumé and SASE. "Do not send samples unless specifically requested to do so." Reports back to the artist within 1 month only if interested. Call or write for appointment to show portfolio of roughs, color dummies and photographs. Rights purchased vary according to project.

Book Design: Assigns 1-4 design jobs/year. Pays by the project. "Projects are negotiated individually using a bid process. Will request 3 bids and make a decision based on those bids."

Jackets/Covers: Assigns 1-4 design and 1-4 illustration jobs/year. Pays by the project. Payment individually negotiated with each artist for each project. Prefers photographs, watercolor line drawings.

Text Illustration: Assigns 1-4 jobs/year. Pays by the project. Payment individually negotiated with each artist depending on project specs. Prefers photographs, line drawings.

Tips: "Be knowledgeable about Alaska issues, locations and people. Let me know you are available by letter, phone, or fax, but let me call you to make arrangements for interviews which might lead to project assignments. Alaska art must be authentic to Alaska. APU press is very small and operates with 2 part-time staff members."

ALLYN AND BACON INC., College Division, 160 Gould St., Needham MA 02194. (617)455-1200. Fax: (617)455-1294. Cover Administrator: Linda Knowles. Publishes more than 150 hardcover and paperback textbooks/year. 50% require freelance cover designs. Subject areas include personal selling, business marketing, education, psychology and sociology.

Needs: Approached by 80-100 freelance artists/year. Needs freelancers experienced in preparing art and mechanicals for print production. Designers must be strong in book cover design and contemporary type treatment. Needs computer-literate freelancers for design, illustration and production. 50% of freelance work demands knowledge of Adobe Illustrator, Photoshop and Aldus FreeHand.

Jackets/Covers: Assigns 100 design jobs and 2-3 illustration jobs/year. Pays for design by the project, $300-750. Pays for illustration by the project, $150-500. Prefers sophisticated, abstract style in pen & ink, airbrush, charcoal/pencil, watercolor, acrylic, oil, collage and calligraphy. "Always looking for good calligraphers."

Tips: "Keep stylistically and technically up to date. Learn *not* to over-design: read instructions, and ask questions. Introductory letter must state experience and include at least photocopies of your work. If I like what I see, and you can stay on budget, you'll probably get an assignment. Being pushy closes the door. We primarily use designers based in the Boston area."

ALYSON PUBLICATIONS, INC., 40 Plympton St., Boston MA 02118. Publisher: Sasha Alyson. Estab. 1977. Book publisher emphasizing gay and lesbian concerns. Publishes 20 titles/year. Recent titles include *Two Moms, the Zark, And Me* and *Afterglow*. For sample catalog, send 9 × 12 SAE with 2 first-class stamps.

First Contact & Terms: Works on assignment only. Send query letter with brochure showing art style or tearsheets, photostats, photocopies and photographs. Samples returned by SASE. Reports only if interested.

Jackets/Covers: Buys 6 cover illustrations/year. Pays $200-500 for b&w, $300-500 for color. **Pays on acceptance.**

Text Illustration: "Illustrator for kids' books usually acts as co-author and is paid royalties."
Tips: "We are planning several children's books a year aimed at the kids of lesbian and gay parents. Many styles will be needed, from b&w drawings to full-color work. Send samples to be kept on file."

AMERICA WEST PUBLISHERS, INC., P.O. Box 3300, Bozeman MT 59772. (406)585-0700. Fax: (406)585-0703. Manager: G. Green. Estab. 1985. Publishes trade paperback originals. Types of books include reference and history. Specializes in history. Publishes 40 titles/year. Recent titles include *Guide to Chiropractic, Chaos in America, Conspirators Hierarchy.* 10% require freelance illustration; 10% require freelance design. Book catalog available by request.
Needs: Approached by 5 freelance artists/year. Works with 2 designers/year. Buys 15 illustrations/year. Uses freelancers for jacket/cover illustration. Works on assignment only.
First Contact & Terms: Send query letter with samples of work, photographs and photocopies. Samples are filed or are returned by SASE if requested by artist. Reports back to the artist only if interested. To show portfolio, mail roughs. Buys all rights. Originals are not returned.
Book Design: Assigns 5 illustration jobs/year. Pays by the project, $200-500.
Jackets/Covers: Assigns 10 design and 10 illustration jobs/year. Prefers 4-color work. Pays by the project, $200-500.
Text Illustration: Assigns 2 design and 2 illustration jobs/year. Prefers b&w illustration. Pays according to contract.

AMERICAN BIOGRAPHICAL INSTITUTE, 5126 Bur Oak Circle, Raleigh NC 27612. (919)781-8710. Fax: (919)781-8712. Executive Vice President: Janet Evans. Estab. 1967. Publishes hardcover reference books and biography. Publishes 5 titles/year. Recent titles include *2,000 Notable American Women; Five Hundred Leaders of Influence.* 75% require freelance illustration and design. Books are "mostly graphic text." Book catalog not available.
Needs: Approached by 4-5 freelance artists/year. Works with 2 illustrators and 2 designers/year. Buys 10 illustrations/year. Prefers artists with experience in graphics and copy design. Uses freelancers mainly for brochures (direct mail pieces). Also uses freelancers for book and direct mail design and jacket/cover illustration. Needs computer-literate freelancers for design, illustration and presentation. 95% of freelance work demands knowledge of QuarkXPress or Photoshop. Works on assignment only.
First Contact & Terms: Send query letter with brochure, résumé, SASE and photocopies. Samples are filed. Art Director will contact artists for portfolio review if interested. Portfolio should include art samples, b&w and color dummies and photographs. Sometimes requests work on spec before assigning job. Originals are not returned.
Book Design: Pays by the hour, $35-50; or by the project, $250-500.
Tips: Finds artists mostly through word of mouth.

AMERICAN EAGLE PUBLICATIONS, INC., P.O. Box 41401, Tucson AZ 85717. (602)888-4957. President: Mark Ludwig. Estab. 1988. Publishes hardcover originals and reprints and trade paperback originals and reprints. Types of books includes historical fiction, history and computer books. Publishes 10 titles/year. Titles include *The Captive; Paul Schneider: The Witness of Buchenwald; The Little Black Book of Computer Viruses.* 100% require freelance illustration and design. Book catalog free for SAE with 2 first-class stamps.
Needs: Approached by 10 freelance artists/year. Works with 2 illustrators and 2 designers/year. Buys 20 illustrations/year. Uses freelancers mainly for covers. Also for text illustration. Needs computer-literate freelancers for design. 90% of freelance work demands knowledge of QuarkXPress. Works on assignment only.
First Contact & Terms: Send query letter with résumé, SASE and photocopies. Samples are filed. Reports back only if interested. Call for appointment to show portfolio, which should include final art, b&w and color photostats, slides, dummies, tearsheets, transparencies and dummies. Buys all rights. Originals are returned at job's completion.
Jackets/Covers: Assigns 10 design and 10 illustration jobs/year. Payment negotiable (roughly $20/hr minimum). "We generally do 2-color or 4-color covers composed on a computer."
Text Illustration: Assigns 7 illustration jobs/year. Pays roughly $20/hr minumum. Prefers pen & ink.
Tips: "Show us good work that demonstrates you're in touch with the kind of subject matter in our books. Show us you can do good, exciting work in 2 colors."

‡**AMHERST MEDIA, INC.,** 418 Homecrest Dr., Amherst NY 14226. Phone/Fax: (716)874-4450. Publisher: Craig Alesse. Estab. 1985. Company publishes trade paperback originals. Types of books include instructional

> *How to Use Your* **Artist's & Graphic Designer's Market** *offers suggestions for understanding and using the information in these listings. Read this and other articles in the front of this book for important business tips.*

and reference. Specializes in photography, videography, how-to. Publishes 8 titles/year. Recent titles include *The Freelance Photographer's Handbook*. 20% require freelance illustration; 50% require freelance design. Book catalog free for 9 × 12 SAE with 3 first-class stamps.

Needs: Approached by 12 freelance artists/year. Works with 3 freelance illustrators and 3 freelance designers/year. Buys 4 freelance illustrations/year. Uses freelance artists mainly for illustration and cover design. Also uses freelance artists for jacket/cover illustration and design and book design. Needs computer-literate freelancers for design and production. 80% of freelance work demands knowledge of QuarkXPress or Adobe Photoshop. Works on assignment only.

First Contact & Terms: Send brochure, résumé and photographs. Samples are filed. Reports back only if interested. Art Director will contact artist for portfolio review if interested. Portfolio should include slides. Rights purchased vary according to project. Originals are returned at job's completion.

Book Design: Assigns 4 freelance design jobs/year. Pays by the project, $200-800.

Jackets/Covers: Assigns 4 freelance design and 4 freelance illustration jobs/year. Pays by the project, $200-750. Prefers computer illustration (Quark/Photoshop).

Text Illustration: Assigns 1 freelance illustration job/year. Pays by the project. Prefers computer illustration (Quark).

Tips: First-time assignments are usually covers. Finds artists through word of mouth.

■**APPLEZABA PRESS**, Box 4134, Long Beach CA 90804. (213)591-0015. Publisher: D.H. Lloyd. Estab. 1977. Specializes in poetry and fiction paperbacks. Publishes 2-4 titles/year. Recent titles include *A Week For All Seasons*. 40% require freelance illustration.

Needs: Approached by 20 freelance artists/year. Works with 1 illustrator/year. Mainly uses art for covers. Works on assignment only.

First Contact & Terms: Send query letter with brochure, tearsheets and photographs to be kept on file. Samples not filed are returned by SASE. Reports back only if interested. Originals returned to artist at job's completion. Art Director will contact artist for portfolio review if interested. Portfolio should include 8-10 samples, such as slides or photocopies of b&w work. Considers project's budget and rights purchased when establishing payment. Rights purchased vary according to project. Sometimes buys second rights (reprint rights) to previously published work.

Jackets/Covers: Assigns 1 design job/year. Prefers pen & ink, collage. Pays by project, $50-300.

Tips: Finds artists through word of mouth and submissions. "Usually use cover art that depicts the book title and contents, b&w and one color."

ARCsoft PUBLISHERS, P.O. Box 179, Hebron MD 21330-0179. (410)742-9009. President: A.R. Curtis. Specializes in original paperbacks, especially in space science, computers and miscellaneous high-tech subjects. Publishes 12 titles/year.

Needs: Works with 5 artists/year. Works on assignment only.

First Contact & Terms: Send query letter with brochure, résumé and non-returnable samples. Samples not filed are not returned. Reports back within 3 months only if interested. Originals are not returned. Considers complexity of project, skill and experience of artist, project's budget and turnaround time when establishing payment. Buys all rights.

Jackets/Covers: Assigns 1 design and 5 illustration jobs/year. Pays by the project.

Text Illustration: Assigns 5 jobs/year. Pays by the project.

Tips: "Artists should not send in material they want back. All materials received become the property of ARCsoft Publishers."

ARDSLEY HOUSE PUBLISHERS, INC., 320 Central Park W., New York NY 10025. (212)496-7040. President: Martin Zuckerman. Publishes college textbooks. Specializes in math and music. Publishes 8 titles/year. Titles include *All That Jazz, A Guide to the TI-85 Graphics Calculator* and *A Mathematics Sampler*. 100% require freelance illustration and design. Book catalog not available.

Needs: Works with 3-4 illustrators and 3-4 designers/year. Prefers experienced local artists. Uses freelancers mainly for cover illustrations and technical drawing. Also for direct mail and book design. Needs computer-literate freelancers for design. 50% of freelance work demands computer skills. Works on assignment only.

First Contact & Terms: Send query letter with brochure and résumé. Samples are not filed and are not returned. Reports back only if interested.

Book Design: Assigns 3-4 design jobs/year. Pays by the project.

Jackets/Covers: Assigns 8 design jobs/year. Pays by the project.

Text Illustration: Assigns 8 jobs/year. Pays by the project.

ARTIST'S & GRAPHIC DESIGNER'S MARKET, (formerly *Artist's Market*), Writer's Digest Books, 1507 Dana Ave., Cincinnati OH 45207. Contact: Editor. Annual hardcover directory of markets for designers, illustrators and fine artists. Buys one-time rights.

Needs: Buys 50-60 illustrations/year. "I need examples of art that have been sold to the listings in *Artist's & Graphic Designer's Market*. Look through the book to see the type of art I'm seeking. The art must have been freelanced; it cannot have been done as staff work. Include the name of the listing that purchased or exhibited

the work, what the art was used for and, if possible, the payment you received. Bear in mind that interior art is reproduced in b&w, so the higher the contrast, the better."

First Contact & Terms: Send printed piece, photographs or photostats. "Since *Artist's & Graphic Designer's Market* is published only once a year, submissions are kept on file for the upcoming edition until selections are made. Material is then returned by SASE." Pays $50 to holder of reproduction rights and free copy of *Artist's & Graphic Designer's Market* when published.

ASIAN HUMANITIES PRESS, Box 3523, Fremont CA 94539. (510)659-8272. Fax: (510)659-0501. Publisher: M.K. Jain. Estab. 1976. Publishes hardcover originals, trade paperback originals and reprints and textbooks. Types of books include reference, instructional, cookbooks, religion and philosophy. Specializes in Asian literature, religions, languages and philosophies. Publishes 10 titles/year. Titles include *The World's Living Religions* and *To Be Human Against All Odds*. Books are "uncluttered, elegant, using simple yet refined art." 25% require freelance illustration; 100% require freelance design. Free book catalog.
Needs: Approached by 50 freelance artists/year. Works with 4 illustrators and designers/year. Buys 8 illustrations/year. Prefers artists with experience in scholarly and literary works relating to Asia. Uses freelancers artists mainly for cover/jacket design. Also for jacket/cover illustration and catalog design.
First Contact & Terms: Send query letter with brochure, résumé, tearsheets and photostats. Samples are filed. Reports back to the artist only if interested. Rights purchased vary according to project. Originals are not returned.
Book Design: Assigns 5 design jobs/year. Pays by the project.
Jackets/Covers: Assigns 10 design and 8 freelance illustration jobs/year. Prefers "camera ready mechanicals with all type in place." Pays by the project, $200-500.
Tips: Expects "a demonstrable knowledge of art suitable to use with Asian subject matter."

THE ASSOCIATED PUBLISHERS, INC., 1407 14th St. NW, Washington DC 20005-3704. (202)265-1441. Fax: (202)328-8677. Managing Director: W. Leanna Miles. Estab. 1920. Textbook publisher. Types of books include history and "all materials pertaining to the Black experience." Publishes about 2 titles/year. Recent titles include *African Roots Explore New Worlds; Pre-Columbus to the Space Age* and *Afro-American Scholars: Leaders, Activists, and Writers*. 25% require freelance illustration; 50% require freelance design. Book catalog available for $2.
Needs: Approached by 3-5 freelance artists/year. Works with 2 illustrators and designers/year. Prefers artists with knowledge of the Black experience. Uses freelancers mainly for annual study kits. Also for jacket/cover and text illustration; book, direct mail and catalog design. Works on assignment only.
First Contact & Terms: Send query letter with brochure and résumé. Samples are filed. Reports back to the artist only if interested. Negotiates rights purchased. Assigns 2-5 design and illustration jobs/year. Pays by the project, $200-1,500. Prefers a mixture of media and style.

ASSOCIATION OF COLLEGE UNIONS-INTERNATIONAL, 400 E. 7th St., Bloomington IN 47405. (812)332-8017. Fax: (812)333-8050. Art Director: Ann Vest. Estab. 1914. Professional education association. Publishes hardcover and trade paperback originals. Specializes in multicultural issues, creating community on campus, union and activities programming, managing staff, union operations, and professional and student development. Titles include *How to Start a Recycling Program*. Book catalog free for SAE with 6 first-class stamps.
• This association also publishes a magazine (see magazines section for listing). Note that most illustration and design are accepted on a volunteer basis. This is a good market if you're just looking to build or expand your portfolio.
Needs: "We are a volunteer-driven association. Most people submit work on that basis." Uses freelance artists mainly for illustration. Needs computer-literate freelancers for illustration. Freelancers should be familiar with CorelDraw. Works on assignment only.
First Contact & Terms: Send query letter with tearsheets. Samples are filed. Reports back to the artist only if interested. Negotiates rights purchased. Originals are returned at job's completion.
Tips: Looking for color transparencies of college student union activities.

‡ASTARA INC., Box 5003, Upland CA 91785. Estab. 1951. Nonprofit religious organization publishing books and materials of interest to those in the metaphysical and philosophical areas. Recent titles include *Ten Steps to Self Fulfillment* and *Beyond Words: A Lexicon of Metaphysical Thought*. Books have a "New Age" look.
Needs: Works with 2 freelance illustrators and 2 freelance designers/year. Assigns 4-6 jobs/year. Prefers local artists only. Works on assignment only. Uses freelance artists mainly for book cover design. Also uses freelancers for advertising and brochure design, illustration and layout.
First Contact & Terms: Send query letter with résumé and tearsheets. Reports back within 2 weeks. Call for appointment to show portfolio of final reproduction/product and original/final art. Pays for design and illustration by the project, $250-1,500; by the illustration, $80-100. Considers complexity of project, skill and experience of artist and turnaround time when establishing payment. Buys all rights.

‡AUGSBURG PUBLISHING HOUSE, Box 1209, 426 S. Fifth St., Minneapolis MN 55440. (612)330-3300. Contact: Coordinator, Graphic Design Services. Publishes paperback Protestant/Lutheran books (45 titles/year), religious education materials, audiovisual resources, periodicals. Titles include *To Pray & To Love*, *Theological Ethics of the New Testament* and *A Home for the Homeless*. Uses freelancers for advertising layout, design, illustration and circulars and catalog cover design.
First Contact & Terms: "Majority, but not all, of the artists are local." Works on assignment only. Reports back on future assignment possibilities in 5-8 weeks. Call, write or send brochure, flier, tearsheet, good photocopies and 35mm transparencies; if artist is not willing to have samples retained, they are returned by SASE. Buys all rights on a work-for-hire basis. May require designers to supply overlays on color work.
Book Design: Assigns 45 jobs/year. Uses designers occasionally for inside illustration, text design. Pays by the project, $250-400.
Jackets/Covers: Uses designers primarily for cover design. Pays by the project, $600-900.
Text Illustration: Negotiates pay for 1-, 2- and 4-color. Generally pays by the project, $25-400.
Tips: Be knowledgeable "of company product and the somewhat conservative contemporary Christian market."

‡AVANYU PUBLISHING INC., P.O. Box 27134, Albuquerque NM 87125. (505)266-6128. President: J. Brent Ricks. Estab. 1984. Company publishes hardcover originals and reprints and trade paperback originals and reprints. Types of books include art, anthropology, history and coffee table books. Specializes in Native American and Southwest Americana. Publishes 4 titles/year. Recent titles include *Kachinas, Spirit Beings of the Hopi*. Book catalog free for 8×12 SAE with 1 first-class stamp.
Needs: Approached by 8 freelance artists/year. Prefers local artists only. Uses freelance artists for jacket/book covers and text illustrations. Needs computer-literate freelancers for illustration and presentation. Freelancers should be familiar with Aldus PageMaker. Works on assignment only.
First Contact & Terms: Send résumé and SASE. Samples are not filed and are returned by SASE if requested by artist. Reports back within 2 weeks. Rights purchased vary according to project. Originals are not returned.
Jackets/Covers: Assigns 2 freelance design jobs/year.

BAEN BOOKS, Box 1403, Riverdale NY 10471. (718)548-3100. Publisher: Jim Baen. Editor: Toni Weisskopf. Estab. 1983. Publishes science fiction and fantasy. Publishes 84-96 titles/year. 75% require freelance illustration; 80% require freelance design. Recent titles include *Mars Plus*, *Man Plus* and *The City Who Fought*. Book catalog free for request.
First Contact & Terms: Approached by 1,000 artists/year. Works with 10 illustrators and 4 designers/year. Buys 64 illustrations/year. Needs computer-literate freelancers for design. 10% of work demands computer skills. Send query letter with slides, transparencies (color only) and SASE. Samples are filed. Originals returned to artist at job's completion. Buys exclusive North American book rights.
Jackets/Covers: Assigns 64 design and 64 illustration jobs/year. Pays by the project, $200 minimum, design; $1,000 minimum, illustration.
Tips: Wants to see samples within science fiction, fantasy genre. "Do not send b&w illustrations or surreal art."

BANDANNA BOOKS, 319B Anacapa St., Santa Barbara CA 93101. Fax: (805)564-3278. Publisher: Sasha Newborn. Estab. 1981. Publishes supplementary textbooks and nonfiction trade paperback originals and reprints. Types of books include language, classics. Publishes 3 titles/year. 25% require freelance illustration.
Needs: Approached by 50 freelance artists/year. Buys 5 illustrations/year. Uses illustrators mainly for woodblock or scratchboard art; also for cover and text illustration.
First Contact & Terms: Send query letter with SASE and samples. Samples are filed and are not returned. Reports back within 6 weeks only if interested. Originals are not returned. To show portfolio mail thumbnails and sample work. Considers project's budget when establishing payment.
Jackets/Covers: Prefers b&w (scratchboard, woodblock, silhouettes). Pays by the project, $50-200.
Text Illustration: Pays by the project, $50-200.

BARBOUR & CO., INC., P.O. Box 719, 1810 Barbour Dr., Uhrichsville OH 44683. (614)922-6045, ext. 125. Fax: (614)922-5948. Managing Editor: Stephen Reginald. Estab. 1981. Publishes hardcover originals and reprints, trade paperback originals and reprints and mass market paperback originals and reprints. Types of books include contemporary and historical fiction, romance, self-help, young adult, reference and juvenile. Publishes 60 titles/year. Recent titles include *That Morals Thing* and *Eyes of the Heart*. 60% require freelance illustration. Book catalog available for $1.

 The double dagger before a listing indicates that the listing is new in this edition. New markets are often more receptive to freelance submissions.

Needs: Approached by 15 freelance artists/year. Works with 5 freelance illustrators/year. Prefers artists with experience in people illustration. Uses freelancers mainly for romance jacket/cover illustration. Needs computer-literate freelancers for design, illustration and production. 20% of freelance work demands computer skills. Freelancers should be familiar with QuarkXPress. Works on assignment only.
First Contact & Terms: Send query letter with brochure. Samples are filed. Reports back within 1 week. Write for appointment to show portfolio of thumbnails, roughs, final art, dummies. Sometimes requests work on spec before assigning a job. Buys all rights. Originals not returned.
Jackets/Covers: Pays by the project, $300-1,000.
Tips: Finds artists through word of mouth, recommendations and placing ads. "Submit a great illustration of people suitable for a romance cover."

BEACON PRESS, 25 Beacon St., Boston MA 02108. (617)742-2110. Fax: (617)742-2290. Design and Production Managers: Sara Eisenman and Dan Ochsner. Estab. 1854. Nonprofit book publisher of hardcover originals and trade paperback originals and reprints. Specializes in feminism, spirituality, contemporary affairs, African-American studies, gay and lesbian concerns and the environment. Publishes 60-75 titles/year. Recent titles include *The Measure of Our Success* and *Gay Ideas*. 5% require freelance illustration; 100% require freelance design. Book catalog available.
Needs: Approached by 100 freelance artists/year. Works with 3-4 illustrators and 20 designers/year. Buys 1-2 illustrations/year. Uses freelancers mainly for book cover/jacket illustration and design. Needs computer-literate freelancers for design, illustration and production. 80% of freelance work demands computer skills. Works on assignment only.
First Contact & Terms: Send query letter with résumé, tearsheets, photocopies and slides. Samples are filed. Reports back within 2-3 weeks. To show portfolio, mail tearsheets, transparencies and photographs. Rights purchased vary according to project. Originals are returned at job's completion.
Book Design: Assigns 40 design and 1-2 illustration jobs/year. Pays by the project, $600-850.
Jackets/Covers: Assigns 40 design and 2-3 illustration jobs/year. Pays by the project, $650-1,000.
Text Illustration: Assigns 1-2 jobs/year. Pays by the project. Prefers line art.
Tips: "Must have trade book industry experience. Cover designs are becoming more and more sophisticated."

BEAVER POND PUBLISHING, P.O. Box 224, Greenville PA 16125. (412)588-3492. Owner: Rich Faler. Estab. 1988. Subsidy publisher and publisher of trade paperback originals and reprints and how-to booklets. Types of books include instructional and adventure. Specializes in outdoor topics. Publishes 20 titles/year. Recent titles include *Primitive Pursuit* and *Bear-Baiting and Trapping Black Bear*. 20% require freelance illustration. Book catalog free by request.
Needs: Approached by 6 freelance artists/year. Works with 3 illustrators/year. Buys 50 illustrations/year. Prefers artists with experience in outdoor activities and animals. Uses freelancers mainly for book covers and text illustration. Works on assignment only.
First Contact & Terms: Send query letter with tearsheets and/or photocopies. Samples are filed. Reports back only if interested. To show portfolio, mail appropriate materials: thumbnails, b&w photocopies. Rights purchased vary according to project. Originals are returned at job's completion (if all rights not purchased).
Jackets/Covers: Assigns 3-4 illustration jobs/year. Pays for covers as package with text art. Prefers pen & ink line art.
Text Illustration: Assigns 3-4 jobs/year. Pays by the project, $100 (booklets)-$1,600 (books). Prefers pen & ink line art.
Tips: "Show an understanding of animal anatomy. We want accurate work."

BEDFORD BOOKS OF ST. MARTIN'S PRESS, 29 Winchester St., Boston MA 02116. (617)426-7440. Fax: (617)426-8582. Advertising and Promotion Manager: Donna Dennison. Estab. 1981. Imprint of St. Martin's Press. Publishes college textbooks. Specializes in English and history. Publishes 20 titles/year. Recent titles include *The Bedford Handbook for Writers*, Fourth Edition; *Elements of Argument*, Fourth Edition; *The Age of McCarthyism*. Books have "contemporary, classic design." 40% require freelance illustration; 100% require freelance design.
Needs: Approached by 25 freelance artists/year. Works with 2-4 illustrators and 6-8 designers/year. Buys 4-6 illustrations/year. Prefers artists with experience in book publishing. Uses freelancers mainly for cover and brochure design. Also for jacket/cover and text illustration and book and catalog design. 100% of design work demands knowledge of Aldus PageMaker, QuarkXPress, Aldus FreeHand or Adobe Illustrator.
First Contact & Terms: Send query letter with brochure, tearsheets, photostats. Samples are filed or are returned by SASE if requested by artist. Reports back only if interested. Request portfolio review in original query. Art Director will contact artists for portfolio review if interested. Portfolio should include roughs, original/final art, color photostats and tearsheets. Rights purchased vary according to project. Interested in buying second rights (reprint rights) to previously published work. Originals are returned at job's completion.
Jackets/Covers: Assigns 20 design jobs and 4-6 illustration jobs/year. Pays by the project, $500-1,500.
Tips: Finds artists through magazines, self-promotion and sourcebooks. "Regarding book cover illustrations, we're usually interested in buying reprint rights for artistic abstracts or contemporary, multicultural scenes."

‡**BEHRMAN HOUSE, INC.,** 235 Watchung Ave., West Orange NJ 07052. (201)669-0447. Fax: (201)669-9769. Projects Editor: Adam Siegel. Estab. 1921. Book publisher. Publishes textbooks. Types of books include preschool, juvenile, young adult, history (all of Jewish subject matter) and Jewish texts and textbooks. Specializes in Jewish books for children and adults. Publishes 12 titles/year. Recent titles include *My Jewish Year, Let's Diesover The Bible* and *Conservative Judaism*. Books are "contemporary with lots of photographs and artwork; colorful and lively. Design of textbooks is very complicated." 50% require freelance illustration; 100% require freelance design. Book catalog free by request.
Needs: Approached by 6 freelance artists/year. Works with 6 freelance illustrators and 6 freelance designers/year. Buys 5 freelance illustrations/year. Prefers artists with experience in illustrating for children; "helpful if Jewish background." Uses freelance artists mainly for textbook illustrations. Also for book design. Needs computer-literate freelancers for design. 25% of freelance work demands knowledge of QuarkXPress. Works on assignment only.
First Contact & Terms: Send query letter with brochure, résumé and tearsheets. Samples are filed. Reports back only if interested. Buys reprint rights. Sometimes requests work on spec before assigning job. Originals are returned at the job's completion.
Book Design: Assigns 6 freelance design, 3 freelance illustration jobs/year. Pays by project, $800-1,500.
Jackets/Covers: Assigns 6 freelance design and 4 freelance illustration jobs/year. Pays by the project.
Text Illustration: Assigns 6 freelance design and 4 freelance illustration jobs/year. Pays by the project.

THE BENJAMIN/CUMMINGS PUBLISHING CO., 390 Bridge Pkwy., Redwood City CA 94065. (415)594-4400. Fax: (415)594-4488. Art/Design Manager: Michele Carter. Specializes in college textbooks in biology, chemistry, anatomy and physiology, computer science, computer information systems, engineering, nursing and allied health. Publishes 40 titles/year. 90% require freelance design and illustration. Recent titles include *Human Anatomy and Physiology*, by Marieb; *Microbiology*, by Tortora; *Biology*, by Neil Campbell; and *Computer Currents*, by George Beekman.
Needs: Approached by 100 freelance artists/year. Works with 30-40 illustrators and 10-20 designers/year. Specializes in 1-, 2- and 4-color illustrations—technical, biological and medical. "Heavily illustrated books tying art and text together in market-appropriate and innovative approaches. Our biologic texts require trained bio/med illustrators. Proximity to Bay Area is a plus, but not essential." Needs computer-literate freelancers for design, illustration, and production. 80% of illustration and 90% of design demands knowledge of QuarkXPress, Photoshop, Aldus FreeHand or Adobe Illustrator. Works on assignment only.
First Contact & Terms: Send query letter with résumé and samples. Samples returned only if requested. Originals not returned.
Book Design: Assigns 40 jobs/year. "From manuscript, designer prepares specs and layouts for review. After approval, final specs and layouts are required." Pays by the project, $1,000-3,500.
Jackets/Covers: Assigns 60 jobs/year. Pays by the project, $800-5,000.
Text Illustration: Pays by the project, $25-1,500.
Tips: "We are moving into digital pre-press for our technical illustrations, for page design and covers. We are producing our first multimedia. We need *good* text designers and illustrators who are computer literate."

ROBERT BENTLEY PUBLISHERS, 1000 Massachusetts Ave., Cambridge MA 02138. (617)547-4170. Publisher: Michael Bentley. Publishes hardcover originals and reprints and trade paperback originals—reference books. Specializes in automotive technology and automotive how-to. Publishes 15-20 titles/year. Titles include *Bosch Fuel Injection and Engine Management Including High Performance Tuning*. 50% require freelance illustration; 80% require freelance design. Book catalog for SAE with 75¢ postage.
Needs: Works with 3-5 illustrators and 10-15 designers/year. Buys 1,000 illustrations/year. Prefers artists with "technical illustration background, although a down-to-earth, user-friendly style is welcome." Uses freelancers for jacket/cover illustration and design, text illustration, book design, direct mail and catalog design. Works on assignment only.
First Contact & Terms: Send query letter with résumé, SASE, tearsheets and photocopies. Samples are filed. Reports in 3-5 weeks. To show portfolio, mail thumbnails, roughs and b&w tearsheets and photographs. Buys all rights. Originals are not returned.
Book Design: Assigns 10-15 design and 20-25 illustration projects/year. Pays by the project.
Jackets/Covers: Pays by the project.
Text Illustration: Prefers ink on mylar or Adobe postscript files.
Tips: "Send us photocopies of your line artwork and résumé."

BLUE BIRD PUBLISHING, Suite 306, 1739 E. Broadway, Tempe AZ 85282. (602)968-4088. Owner/Publisher: Cheryl Gorder. Estab. 1985. Publishes trade paperback originals. Types of books include young adult, reference and general adult nonfiction. Specializes in parenting and home education. Publishes 6 titles/year. Titles include: *Green Earth Resource Guide*. 50% require freelance illustration; 25% require freelance design. Book catalog free for #10 SASE.
Needs: Approached by 12 freelance artists/year. Works with 3 illustrators and 1 designer/year. Buys 20-35 illustrations/year. Uses freelancers for illustration. Also for jacket/cover and catalog design. Works on assignment only.

First Contact & Terms: Send query letter with brochure and photocopies. Samples are filed. Reports in 6 weeks. To show portfolio, mail b&w samples and color tearsheets. Rights purchased vary according to project. Originals not returned.

Jackets/Covers: Assigns 1 design and 1 illustration job/year. Pays by the project, $50-200. Prefers "a modern and geometric style in b&w but will consider alternatives."

Text Illustration: Assigns 3 illustration jobs/year. Pays by the project, $20-250. Prefers line art.

■**BLUE DOLPHIN PUBLISHING, INC.,** 12428 Nevada City Hwy., Grass Valley CA 95945. (916)265-6925. Fax: (916)265-0787. President: Paul M. Clemens. Estab. 1985. Publishes hardcover and trade paperback originals. Types of books include biography, cookbooks, humor and self-help. Specializes in comparative spiritual traditions, lay psychology and health. Publishes 12 titles/year. Recent titles include *The Psychic Within*, *Messages to Our Family* and *The Intuitive Tarot*. Books are "high quality on good paper, with laminated dust jacket and color covers." 10% require freelance illustration; 30% require freelance design. Book catalog for $1 with first-class stamp.

Needs: Works with 5-6 freelance illustrators and designers/year. Uses freelancers mainly for book cover design. Also for jacket/cover and text illustration. Needs computer-literate freelancers for design and illustration. 75% of freelance work demands knowledge of Aldus PageMaker, QuarkXPress, Aldus FreeHand, Adobe Illustrator, Photoshop, CorelDraw and other IBM compatible programs. Works on assignment only.

First Contact & Terms: Send query letter with tearsheets. Samples are filed or are returned by SASE if requested. Reports back within 1-2 months. Originals are returned to artist at job's completion. Sometimes requests work on spec before assigning job. Considers project's budget when establishing payment. Negotiates rights purchased. Considers buying second rights (reprint rights) to previously published work.

Book Design: Assigns 1-2 jobs/year. Pays by the hour, $10-15; or by the project, $300-900.

Jackets/Covers: Assigns 5-6 design and 5-6 illustration jobs/year. Pays by the hour, $10-15; or by the project, $300-900.

Text Illustration: Assigns 1-2 jobs/year. Pays by the hour, $10-15; or by the project, $300-900.

Tips: "Send query letter with brief sample of style of work. We usually use local people, but always looking for something special. Learning good design is more important than designing on the computer, but we are very computer oriented."

‡**BONUS BOOKS, INC.,** 160 E. Illinois St., Chicago IL 60611. (312)467-0580. Fax: (312)467-9271. Editorial Production Manager: Emily Brackett. Imprints include Precept Press, Teach'em. Company publishes textbooks and hardcover and trade paperback originals. Types of books include instruction, biography, self help, cookbooks and sports. Specializes in sports, biography, medical, fundraising. Publishes 40 titles/year. Recent titles include *Shaq Impaq*, *Guerrilla Gambling*. 1% require freelance illustration; 50% require freelance design. Book catalog free by request.

Needs: Approached by 30 freelance artists/year. Works with 0-1 freelance illustrator and 6 freelance designers/year. Buys 0-1 freelance illustration/year. Prefers local artists with experience in "designing on the computer." Uses freelance artists mainly for bookcovers/jackets. Also uses freelance artists for jacket/cover illustration and design and direct mail design. Needs computer-literate freelancers for design. 95% of freelance work demands computer skills. Works on assignment only.

First Contact & Terms: Send query letter with tearsheets, photostats and photocopies. Samples are filed. Reports back only if interested. Artist should follow up with call. Portfolio should include color final art, photostats and tearsheets. Rights purchased vary according to project.

Book Design: Assigns 1 freelance book design job/year.

Jackets/Covers: Assigns 6 freelance design and 0-1 freelance illustration jobs/year. Pays by the project, $250-1,000.

Tips: First-time assignments are usually regional, paperback book covers; book jackets for national books are given to "proven" freelancers. Finds artists through artists' submissions and authors' contacts.

BOOK DESIGN, Box 193, Moose WY 83012. Art Director: Robin Graham. Specializes in hardcover and paperback originals of nonfiction, natural history. Publishes more than 3 titles/year. Recent titles include *Tales of the Grizzly* and *Murder in Jackson Hole*.

Needs: Works with 20 freelance illustrators and 10 freelance designers/year. Works on assignment only. "We are looking for top-notch quality only." Needs computer-literate freelancers for design and production.

The solid, black square before a listing indicates that it is judged a good first market by the Artist's & Graphic Designer's Market *editors. Either it offers low payment, pays in credits and copies, or has a very large need for freelance work.*

10% of freelance work demands knowledge of Aldus PageMaker and Aldus FreeHand.
First Contact & Terms: Send query letter with "examples of past work and one piece of original artwork which can be returned." Samples not filed are returned by SASE if requested. Reports back within 20 days. Originals are not returned. Write for appointment to show portfolio. Negotiates rights purchased.
Book Design: Assigns 6 design jobs/year. Pays by the project, $50-3,500.
Jackets/Covers: Assigns 2 design and 4 illustration jobs/year. Pays by the project, $50-3,500.
Text Illustration: Assigns 26 jobs/year. Prefers technical pen illustration, maps (using airbrush, overlays etc.), watercolor illustration for children's books, calligraphy and lettering for titles and headings. Pays by the hour, $5-20 or; by the project, $50-3,500.

‡**BOYDS MILLS PRESS**, 815 Church St., Honesdale PA 18431. Art Director: Tim Gillner. Estab. 1990. A division of Highlights for Children, Inc. Imprint publishes hardcover originals and reprints. Types of books include fiction, picture book and poetry. Publishes 50 titles/year. Recent titles include *Elliot Fry's Goodbye*, *The Always Prayer Shaw* and *Where is Papa Now*.
Needs: Approached by "hundreds" of freelance artists/year. Works with 60-100 freelance illustrators and 5 freelance designers/year. Prefers artists with experience in book publishing. Uses freelance artists mainly for picture books. Also uses freelance artists for jacket/cover and text illustration, jacket/cover and book design. Needs computer-literate freelancers for design. 25% of freelance work demands knowledge of QuarkXPress. Works on assignment only.
First Contact & Terms: Send query letter with tearsheets, photographs, photocopies, slides and transparencies. Samples are filed or are returned by SASE if requested by artist. Artist should follow up with call. Portfolio should include b&w and color final art, photostats, tearsheets and photographs. Rights purchased vary according to project. Originals are returned at job's completion.
Book Design: Assigns 30 freelance design jobs/year. Pays by the project, fees vary.
Jackets/Covers: Assigns 6 freelance design/illustration jobs/year. Pays by the project, fees vary.
Text Illustration: Pays by the project.
Tips: First-time assignments are usually poetry books (b&w illustrations); picture books are given to "proven" freelancers. Finds artists through agents, sourcebooks, submissions, other publications.

‡**BRIGHTON PUBLICATIONS, INC.**, Suite #5, 151 Silver Lake Rd., St. Paul MN 55112. (612)636-2220. Fax: same. Editor: Sharon Dlugosch. Estab. 1978. Company publishes trade paperback originals. Types of books include instructional and self help. Specializes in business, tabletop, event planning. Publishes 3 titles/year. Recent titles include *Don't Slurp Your Soup*, *Romantic At-Home Dinners*. 10% require freelance illustration; 50% require freelance design. Book catalog free for business sized SAE with 1 first-class stamp.
Needs: Works with 3 freelance illustrators and 3 freelance designers/year. Uses freelance artists for jacket/cover and text illustration, jacket/cover, direct mail, book and catalog design. Needs computer-literate freelancers. 75% of freelance work demands knowledge of QuarkXPress. Works on assignment only.
First Contact & Terms: Send query letter with résumé. Samples are filed. Reports back only if interested. Art Director will contact artist for portfolio review if interested.
Book Design: Assigns 3 freelance design jobs/year.
Jackets/Covers: Assigns 3 freelance design jobs/year.

BROOKE-HOUSE PUBLISHING COMPANY, a division of A.B. Cowles, Inc., Suite 901, 25 W. 31st St., New York NY 10001. (212)967-7700. Fax: (212)967-7779. Publisher: Stephen Konopka. Estab. 1986. Independent book producer/packager of hardcover originals and board books. Types of books include pre-school and juvenile. Specializes in juvenile fiction, board books and "gimmick books for preschoolers." Produces 20 titles/year. Recent titles include Macmillan Train Series and Scholastic Christmas Books. 75% require freelance illustration; 50% require freelance design.
Needs: Approached by 15-20 freelance artists/year. Works with 12 illustrators and 6 designers/year. Buys 240 illustrations/year. Prefers artists with experience in all fields of juvenile interest. Uses freelancers for text illustration. Works on assignment only.
First Contact & Terms: Send query letter with brochure, tearsheets, photocopies and photostats. Samples are filed. Reports back to the artist only if interested. Call for appointment to show portfolio of color tearsheets. Buys all rights. Originals are returned at job's completion.
Book Design: Assigns 20 design jobs/year. Pays by the project.
Text Illustration: Assigns 12 illustration jobs/year. Pays by the project.
Tips: "Show samples of art styles which are conventional and up-market. Board-book art should be gentle, clean, cute and cuddly."

Always enclose a self-addressed, stamped envelope (SASE) with queries and sample packages.

BROOKS/COLE PUBLISHING COMPANY, 511 Forest Lodge Rd., Pacific Grove CA 93950. (408)373-0728. Art Director: Vernon T. Boes. Art Coordinator: Lisa Torri. Estab. 1967. Specializes in hardcover and paperback college textbooks on mathematics, psychology, chemistry and counseling. Publishes 100 titles/year. 85% require freelance illustration. Books are bold, contemporary textbooks for college level.
Needs: Works with 25 freelance illustrators and 25 freelance designers/year. Uses freelance artists mainly for interior illustration. Uses illustrators for technical line art and covers. Uses designers for cover and book design and text illustration. Also uses freelance artists for jacket/cover illustration and design. Works on assignment only.
First Contact & Terms: Send query letter with brochure, résumé, tearsheets, photostats and photographs. Samples are filed or are returned by SASE. Art Director will contact artist for portfolio review if interested. Portfolio should include roughs, photostats, tearsheets, final reproduction/product, photographs, slides and transparencies. Considers complexity of project, skill and experience of artist, project's budget and turnaround time in determining payment. Negotiates rights purchased. Not interested in second rights to previously published work unless first used in totally unrelated market.
Book Design: Assigns 20 design and many illustration jobs/year. Pays by the project, $500-1,000.
Jackets/Covers: Assigns 20 design and many illustration jobs/year. Pays by the project, $500-1,000.
Text Illustration: Assigns 85 freelance jobs/year. Prefers ink/Macintosh. Pays by the project, $20-2,000.
Tips: Finds illustrators and designers through word of mouth, magazines, artists' submissions/self promotion, sourcebooks, and agents. "Provide excellent package in mailing of samples and cost estimates. Follow up with phone call. Don't be pushy. Would like to see more abstract photography/illustration; all age, unique, interactive people photography; single strong, bold images."

WILLIAM C. BROWN COMMUNICATIONS, INC., 2460 Kerper Blvd., Dubuque IA 52001. (319)588-1451. Visual/Design Manager: Faye M. Schilling. Art Manager: Janice Roerig-Blong. Estab. 1944. Publishes hardbound and paperback college textbooks. Produces more than 200 titles/year. 10% require freelance design; 50% require freelance illustration.
Needs: Works with 15-25 freelance illustrators and 30-50 designers/year. Uses artists for advertising. Needs computer-literate freelancers for design, illustration and production. 90% of freelance work demands knowledge of Aldus PageMaker, Adobe Illustrator, QuarkXPress, Photoshop or Aldus FreeHand. Works on assignment only.
First Contact & Terms: Prefers color 35 mm slides and color or b&w photocopies. Send cover letter with emphasis on good portfolio samples. "Do not send samples that are not a true representation of your work quality." Reports back in 1 month. Samples returned by SASE if requested. Reports back on future assignment possibilities. Buys all rights. Pays $35-350 for b&w and color promotional artwork. Pays half contract for unused assigned work.
Book Design: Assigns 50-70 design jobs/year. Uses artists for all phases of process. Pays by the project. Payment varies widely according to complexity.
Jackets/Covers: Assigns 70-80 design jobs and 20-30 illustration jobs/year. Pays $350 average and negotiates pay for special projects.
Text Illustration: Assigns 75-100 jobs/year. Considers b&w and color work. Prefers computer-generated, continuous tone, some mechanical line drawings; ink preferred for b&w. Pays $30-500.
Tips: "In the field, there is more use of color. There is need for sophisticated color skills—the artist must be knowlegeable about the way color reproduces in the printing process. Be prepared to contribute to content as well as style. Tighter production schedules demand an awareness of overall schedules. *Must* be dependable."

BUDDHA ROSE PUBLICATIONS, P.O. Box 548, Hermosa Beach CA 90254. (310)543-9673. Editor-in-Chief: Dr. Scott Shaw. Estab. 1988. Publishes hardcover and trade paperback originals and textbooks. Types of books include contemporary fiction, self-help, reference, biography, history. Specializes in mysticism, poetry, modern lifestyle. Publishes 30 titles/year. Titles include *The Passionate Kiss of Illusion* and *No Kisses for the Sinner*. 1% require freelance illustration.
Needs: Approached by 100 freelance artists/year. Works with 3 illustrators and 3 designers/year. Works with artist reps only. Uses freelancers mainly for covers. Needs computer-literate freelancers for illustration. 15% of freelance work demands knowledge of Aldus FreeHand, Adobe Illustrator and Photoshop. Works on assignment only.
First Contact & Terms: Contact only through artist rep. Samples are filed and are not returned. Reports back within 2 months. To show portfolio, mail final art samples, b&w and color photographs, slides and 8×10 transparencies. Buys all rights. Originals not returned.
Book Design: Assigns 2 design jobs/year. Pays by the project, $100 minimum.
Jackets/Covers: Assigns 3 design and 3 illustration jobs/year. Pays by the project, $500 minimum. Prefers oil and/or acrylic painting on board.

‡**CANTERBURY DESIGNS, INC.**. Box 204060, Martinez GA 30917-4060. (800)241-2732 or (404)860-1674. President: Angie A. Newton. Estab. 1977. Publisher and distributor of charted design books; mainly counted

cross stitch. Clients: needlework specialty shops, wholesale distributors (craft and needlework), department and chain stores.

Needs: Works with 12-20 freelance artists/year. Uses artists mainly for counted cross-stitch design.

First Contact & Terms: Send query letter with samples to be returned. Prefers stitched needlework, paintings, photographs or charts as samples. Samples not filed are returned. Reports within 1 month. Call for appointment to show portfolio. Payment varies. "Some designs purchased outright, some are paid on a royalty basis."

Tips: Would like to see more quality designs. "When sending your work for our review, be sure to photocopy it first. This protects you. Also, you have a copy from which to reconstruct your design should it be lost in mail. Send your work by certified mail to have proof it was actually received."

‡ARISTIDE D. CARATZAS, PUBLISHER, Box 210, 30 Church St., New Rochelle NY 10802. (914)632-8487. Managing Editor: John Emerich. Publishes books about archaeology, art history, natural history and classics for specialists in the above fields in universities, museums, libraries and interested amateurs.

Needs: Works with 6 freelance designers/year. Uses freelance artists mainly for book jacket design. Also uses freelance artists for book design.

First Contact & Terms: Send letter with brochure showing artwork. Request portfolio review in original query. Samples not filed are returned by SASE. Reports only if interested. Buys all rights or negotiates rights purchased. Interested in buying second rights (reprint rights) to previously published work.

Book Design: Pays by the project, $200-3,000.

Jackets/Covers: Pays by the project, $150-600.

‡CCC PUBLICATIONS, 21630 Lassen St., Chatsworth CA 91311. (818)407-1661. Fax: (818)718-7651. Senior Editor: Cliff Carle. Estab. 1984. Company publishes trade paperback originals and manufactures accessories (T-shirts, mugs, caps). Types of books include self help and humor. Specializes in humor. Publishes 20 titles/year. Recent titles include *Sharing the Road With Idiots.* 90% require freelance illustration; 90% require freelance design. Book catalog free for SAE with $1 postage.

Needs: Approached by 200 freelance artists/year. Works with 20-30 freelance illustrators and 10-20 freelance designers/year. Buys 50 freelance illustrations/year. Prefers artists with experience in humorous or cartoon illustration. Uses freelance artists mainly for color covers and b&w interior drawings. Also uses freelance artists for jacket/cover and book design. Needs computer-literate freelancers for design, production and presentation. 50% of freelance work demands knowledge of QuarkXPress.

First Contact & Terms: Send query letter with brochure, résumé, SASE and photocopies. Samples are filed or are returned by SASE if requested by artist. Reports back only if interested. Art Director will contact artist for portfolio review if interested. Portfolio should include b&w and color samples. Rights purchased vary according to project.

Book Design: Assigns 20-30 freelance design jobs/year. Pay negotiated based on artist's experience and notoriety.

Jackets/Covers: Assigns 20-30 freelance design and 20-30 freelance illustration jobs/year. Pay negotiated on project by project basis.

Text Illustration: Assigns 30-40 freelance illustration jobs/year. Pay negotiated.

Tips: First-time assignments are usually b&w text illustration; cover illustration are given to "proven" freelancers. Finds artists through agents and unsolicited submissions.

THE CENTER FOR WESTERN STUDIES, Box 727, Augustana College, Sioux Falls SD 57197. (605)336-4007. Managing Editor: Harry F. Thompson. Estab. 1970. Publishes hardcover originals and trade paperback originals and reprints. Types of books include western history. Specializes in history and cultures of the Northern Plains, especially Plains Indians, such as the Sioux and Cheyenne. Publishes 2-3 titles/year. Recent titles include *Duke's Mixture; The Northern Pacific Railroad And The Selling of the West.* 75% require freelance design. Books are conservative, scholarly and documentary. Book catalog free by request.

Needs: Approached by 4 freelance artists/year. Works with 1-2 designers and 1-2 illustrators/year. Uses freelancers mainly for cover design. Also for book design and text illustration. Needs computer-literate freelancers for design. 25% of freelance work demands knowledge of QuarkXPress. Works on assignment only.

First Contact & Terms: Send query letter with résumé, SASE and photocopies. Samples are filed. Request portfolio review in original query. Reports back only if interested. Portfolio should include roughs and final art. Sometimes requests work on spec before assigning a job. Rights purchased vary according to project. Originals are not returned.

Book Design: Assigns 1-2 design jobs/year. Pays by the project, $500-750.

Jackets/Covers: Assigns 2-3 design jobs/year. Pays by the project, $250-500.

Text Illustration: Pays for text illustration by the project, $100-500.

Tips: Finds illustrators and designers through word of mouth and artists' submissions/self promotion. "We are a small house, and publishing is only one of our functions, so we usually rely on the work of graphic artists with whom we have contracted previously. Send samples."

Find Success Through Self-Expression and Serendipity

If not for a pair of red socks, Nick Bantock's work may have gone undiscovered. Or so the enigmatic artist tells it. On his way to meet an editor about a pop-up book, he packed an art project in his bag under a pair of red socks. He intended to show the project to a friend later. Halfway through the meeting with Chronicle Books Editor Victoria Rock, she asked, "What's that in your bag?" Bantock glanced across the room. "The red socks had literally parted," recalls the artist, "and my project was poking out of the bag." To his embarrassment, she asked for a closer look.

Nick Bantock

At first Bantock refused. The work crafted on his off hours was too personal to be of commercial interest. "In a way I thought it was self-indulgent." But the editor was instantly captivated by the small, handmade volume with its lavishly illustrated envelopes and postcards. Despite objections that the book was not commercial and that the insertion of handwritten letters into envelopes within its pages would be a logistical nightmare, Chronicle printed a cautious first run of 10,000 copies. No one was more surprised than Bantock when the book struck a chord in a faxed-out public yearning for the slowness of a personal letter, or perhaps the voyeuristic thrill of reading someone else's mail.

To date *Griffin & Sabine: An Extraordinary Correspondence*, the book Bantock considered too personal to show anyone but his family and closest friends, has sold more than a million copies and has been optioned by Hollywood. Two more books followed, completing the trilogy Bantock had originally envisioned.

"When success finds you it seems to be random. Just luck. But it is part of a process," says Bantock from his home on Bowen Island, British Columbia. "You push and push and push, then stop, turn a corner, and there it is."

After studying fine art for five years at Maidstone College of Art in Kent, England, Bantock found himself struggling to survive. "Frugal" is the word he uses to describe his life in those days. "I had all this training, but I didn't know what to do with it."

So he got a job in a London betting parlor. "I would play chess with my boss in the morning and post racing results on a chalkboard in the afternoon." A chance encounter with an old friend led to his first freelance assignment doing sketches for an ad agency for a "Save the Children" campaign. Bantock found the work rewarding in both senses of the word. In a matter of days, he made more money than he had all year posting bets on the chalkboard. "Not being

totally stupid, I realized this sort of work would be a good way to survive."

Bantock continued freelancing while pursuing fine art on his own time. During the next 15 years, he designed book covers to support his family. To keep the drier assignments interesting he hid private jokes and personal references within his covers. "You've got to hang on to your soul," advises Bantock. "When taking commercial assignments to get by, and the work is less than challenging, there are ways to fight. By making your designs more meaningful, you become more skilled and the work becomes more intricate."

But the desire to do his own work remained strong. One day he said to himself, " 'Oh, bugger! I'm going to do something that is purely me. I'll see how far I can go with it—really push myself.' I suddenly realized I'd never given myself permission to do what I really wanted to do." He filled his new work with his passion for exotic stamps, Gestalt psychology and letter writing. The result was *Griffin & Sabine*—a collection of postcards and letters exchanged by a London postcard designer and a South Seas stamp maker.

Bantock's journey from starving artist to literary phenomenon was filled with serendipity. Bantock contends such occurrences are not mere coincidence, but synchronicity. "Keep your own voice and never give up." The "red socks," he insists, will always show up to lead the way.

—*Mary Cox*

Reprinted with permission of Chronicle Books

An illustration from The Golden Mean, by Nick Bantock, the third book in the artist's enchanting Griffin & Sabine trilogy.

‡CHARIOT FAMILY PUBLISHING, David C. Cook Publishing, 20 Lincoln Ave., Elgin IL 60120. (708)741-9558, ext. 362. Fax: (708)741-0499. Art Director: Helen H. Lannis. Estab. late 1800s. Imprints include Chariot Publishing, Lion Publishing, Life Journey and Bible Discoveries. Imprint publishes hardcover and trade paperback originals and mass market paperback originals. Types of books include contemporary and historical fiction, mystery, self help, religious, juvenile and pre-school. Specializes in Christian books, mostly for children (picture books about Christian issues). Also some adult-age books and some teen. Recent titles include *Grandma, I'll Miss You*. 100% require freelance illustration; 80% require freelance design. Book catalog not available.

Needs: Approached by dozens of freelance artists/year. Works with 20 freelance illustrators and 10-15 freelance designers/year. Buys 100 freelance illustrations/year. Prefers artists with experience in children's publishing. Uses freelance artists mainly for covers and picture books. Also uses freelance artists for text illustration, jacket/cover and book design. Needs computer-literate freelancers for design and production. 50% of design work demands knowledge of Adobe Illustrator, QuarkXPress, Adobe Photoshop or Aldus FreeHand. Works on assignment only.

First Contact & Terms: Send query letter with résumé, tearsheets and photocopies. "Only send samples you want me to keep." Samples are not returned. Reports back only if interested. Request portfolio review in original query. Artist should follow up with call. Portfolio should include color roughs and final art. Rights purchased vary according to project. Originals are "usually" returned at the job's completion.

Jackets/Covers: Assigns 100 freelance design and 100 freelance illustration jobs/year. Pays by the project, $700-1,500. Prefers computer design for comps, realistic illustration for fiction, cartoon or simplified styles for children's.

Text Illustration: Assigns 50 freelance illustration jobs/year. Pays by the project, $2,000-5,000 buyout for 32-page picture books. "Sometimes we offer royalty agreement." Prefers from simplistic, children's styles to realistic.

Tips: First-time assignments are usually covers only to designers and single titles, smaller print runs to illustrators; book series design and large "A" titles are given to "proven" freelancers. Finds artists through artists' submissions, sourcebooks, word of mouth, agents.

CHARLESBRIDGE PUBLISHING, 85 Main St., Watertown MA 02172. Managing Editor: Elena Wright. Estab. 1980. "Our trade books fall in to two categories: multicultural fiction and nature/science nonfiction. Both require very detailed color realism." Titles include *Wood-Hoopoe Willie*, *At Home in the Coral Reef*, *A Carp for Kimiko* and *Will We Miss Them? Endangered Species*. Books are "realistic art picture books depicting people, outdoor places and animals."

Needs: Works with 4 freelance illustrators/year. Artists should have experience in educational textbooks or children's tradebooks. Works on assignment only.

First Contact & Terms: Send résumé, tearsheets and photocopies. Samples not filed are returned by SASE. Reports back only if interested. Originals are not returned. Considers complexity of project and project's budget when establishing payment. Buys all rights.

Book Design: Works with 2 designers/year. Pays by the project.

Jackets/Covers: Pays by the project.

Text Illustration: Assigns few jobs/year. Pays by the project.

Tips "We are focusing on scientifically accurate art."

CHICAGO REVIEW PRESS, Dept. AM, 814 N. Franklin, Chicago IL 60610. (312)337-0747. Fax: (312)337-5985. Art Director: Fran Lee. Editor: Linda Matthews. Publishes hardcover and paperback originals. Specializes in trade nonfiction: how-to, travel, cookery, popular science, Midwest regional. Publishes 12 titles/year. Recent titles include *The Mole People*, *More Than Moccasins*, *Birthmothers*. Books are clean interesting and inovative. 2% require freelance illustration and 100% require jacket cover design.

Needs: Approached by 50 freelance artists/year. Works with 10 illustrators and 10 designers/year. Uses freelance artists mainly for illustration. Also uses freelance artists for jacket/cover illustration and design, text illustration.

First Contact & Terms: Call or send query letter with résumé and tearsheets. Samples are filed or are returned by SASE. Art Director will contact artist for portfolio review if interested. Call to show portfolio of tearsheets, final reproduction/product and slides. Considers project's budget when establishing payment. Buys one-time rights.

Jackets/Covers: Assigns 10 design and 10 illustration jobs/year. Pays by project, $500-1,000.

Text Illustration: Pays by the project, $500-2,000.

Tips: Finds illustrators and designers through magazines, artists' submissions/self promotion, sourcebooks and galleries. "Design and illustration we use is sophisticated, above average, innovative and unusual. Really inovative work is being done today by very talented artists. Fine Art has become very marketable in the publishing industry."

CHIRON PUBLICATIONS, 400 Linden Ave., Wilmette IL 60091. (708)256-7551. Fax: (708)256-2202. Managing Editor: Siobhan Drummond. Estab. 1984. Publishes trade paperback originals. Specializes in psychology (Jungian) for professional audience. Publishes 8-12 titles/year. Recent titles include *The Queen's Cloak* and

To Speak or Be Silent. 10% require freelance illustration; 100% require freelance design. Books are graphic, serious and attractive. Book catalog free by request.

Needs: Approached by 10 freelance artists/year. Works with 1 illustrator and 4 designers/year. Buys 1 illustration/year. Prefers local artists only. Uses freelancers mainly for cover design. Also uses freelance artists for jacket/cover and text illustration and catalog design. Needs computer-literate freelancers for design. Works on assignment only.

First Contact & Terms: Send query letter with brochure, résumé and tearsheets. Samples are filed or are returned by SASE if requested by artist. Art Director will contact artist for portfolio review if interested. Portfolio should include thumbnails and tearsheets. Buys all rights. Considers buying second rights (reprint rights) to previously published work. Originals not returned.

Text Illustration: Pays by the project, $50-500.

Jackets/Covers: Assigns 8-12 design and 1 illustration jobs/year. Pays by the project: $400-600.

Tips: Finds artists through artists' submissions/self-promotion. "No phone queries, please!"

‡CHRONICLE BOOKS, 275 Fifth St., San Francisco CA 94103. Design Director: Michael Carabetta. Estab. 1979. Company publishes high quality, affordably priced hardcover and trade paperback originals and reprints. Types of books include cookbooks, art design, architecture, contemporary fiction, travel guides, gardening and humor. Publishes approximately 150 titles/year. Recent best-selling titles include the *Griffin & Sabine* trilogy, by Nick Bantock. Book catalog free on request (call 1-800-722-6657).

• Chronicle has a separate children's book division, and has recenttly launched a new division called GiftWorks™, to produce letter boxes and a variety of other gift items.

Needs: Approached by hundreds of freelance artists/year. Works with 15-20 illustrators and 30-40 designers/year. Uses artists for cover and interior design and illustration. Also for GiftWorks™ items. Needs computer-literate freelancers for design and production. 99% of design work demands knowledge of Aldus PageMaker, QuarkXPress, Aldus FreeHand, Adobe Illustrator or Adobe Photoshop; "mostly QuarkXPress—software is up to discretion of designer." Works on assignment only.

First Contact & Terms: Send query letter with tearsheets, color photocopies or printed samples no larger than 8½×11. Samples are filed or are returned by SASE. Reports back only if interested. Art Director will contact artist for portfolio review if interested. Portfolio should include thumbnails, roughs, final art, photostats, slides, tearsheets and transparencies. Buys all rights. Originals are returned at job's completion.

Book Design: Assigns 30-50 freelance design jobs/year. Pays by the project; $750-1,200 for covers; varying rates for book design depending on page count.

Jackets/Covers: Assigns 30 freelance design and 30 freelance illustration jobs/year. Pays by the project, $750-1,200.

Text Illustration: Assigns 15 freelance illustration jobs/year. Pays by the project.

Tips: Finds artists through artists' submissions, *Communication Arts* and sourcebooks. "Please write instead of calling; don't send original material."

‡CIRCLET PRESS, INC., P.O. Box 15143, Boston MA 02215. Phone/Fax: (617)262-5272. Publisher: Cecilia Tan. Estab. 1992. Company publishes trade paperback originals. Types of books include science fiction and fantasy. Specializes in erotic science fiction/fantasy. Publishes 8 titles/year. Recent titles include *Techno Sex, Worlds of Women, Sex Magick.* 100% require freelance illustration. Book catalog free for business size SAE with 1 first-class stamp.

Needs: Approached by 4-5 freelance artists/year. Works with 4-5 freelance illustrators/year. Buys 6-8 freelance illustrations/year. Prefers local artists with experience in b&w science fiction illustration. Uses freelance artists mainly for cover art, interior. Also uses freelance artists for jacket/cover and text illustration. Needs computer-literate freelancers for illustration. 10% of freelance work demands knowledge of Aldus PageMaker, Aldus FreeHand or Adobe Illustrator. Works on assignment only.

First Contact & Terms: Send query letter with photocopies. Samples are filed. Reports back within 2 weeks. Portfolio review not required. Portfolio should include b&w samples. Buys one-time rights or reprint rights. Originals are returned at job's completion.

Jackets/Covers: Assigns 8 freelance illustration jobs/year. Pays by the project, $10-50. Prefers b&w, pen & ink, (no halftones; zip-a-tone OK).

Text Illustration: Assigns 2 freelance illustration jobs/year. Pays by the project, $5-15. Prefers b&w, pen & ink (no halftones).

Tips: First-time assignments are usually front piece, interior illustration; big book jackets, wrap-arounds are given to "proven" freelancers. Finds artists through art shows at science fiction conventions and submission samples.

‡CLARION BOOKS, 11th Floor, 215 Park Ave., New York NY 10003. (212)420-5889. Fax: (212)420-5855. Designer: Tony Kramer. Imprint of Houghton Mifflin Company. Imprint publishes hardcover originals and trade paperback reprints. Specializes in picture books, chapter books, middle grade novels and nonfiction, including historical and animal behavior. Publishes 60 titles/year. Recent titles include *Tuesday,* by David Wiesner; *Eleanor Roosevelt,* by Russell Freedman. 90% of titles require freelance illustration. Book catalog free for SASE.

Needs: Approached by "countless" freelance artists/year. Works with 48 freelance illustrators/year. Uses freelance artists mainly for picture books and novel jackets. Also uses freelance artists for jacket/cover and text illustration.
First Contact & Terms: Send query letter with tearsheets, photocopies and SASE. Samples are filed "if suitable to our needs." Reports back only if interested. Art Director will contact artist for portfolio review if interested. Portfolios may be dropped off every Thursday. Rights purchased vary according to project. Originals are returned at job's completion.
Text Illustration: Assigns 48 freelance illustration jobs/year. Pays by the project.

CLIFFS NOTES INC., Box 80728, Lincoln NE 68501. Contact: Michele Spence. Publishes educational and trade (Centennial Press) books. Titles include *Cliffs SAT I Preparation Guide* (Cliffs Notes).
First Contact & Terms: Approached by 30 freelance artists/year. Works on assignment only. Samples returned by SASE. Reports back on future assignment possibilities. Send brochure, flier and/or résumé. Originals are not returned. Buys all rights.
Text Illustration: Uses technical illustrators for mathematics, science, miscellaneous.

‡**THE CONSULTANT PRESS, LTD.**, #201, 163 Amsterdam Ave., New York NY 10023. (212)838-8640. Fax: (212)873-7065. Editor: Bob Persky. Estab. 1980. Imprints include The Photographic Arts Center, The Photograph Collector. Publishes hardcover and trade paperback originals and textbooks. Types of books include instruction, self help and reference. Specializes in art marketing and sales, photography. Publishes 6 titles/year. Recent titles include *Publishing Your Art As Cards, Posters & Calendars* and *Successful Fine Art Marketing.* 50% require freelance illustration; 50% require freelance design. Book catalog free by request.
Needs: Approached by 20 freelance artists/year. Works with 3 freelance illustrators and 3 freelance designers/year. Buys 6 freelance illustrations/year. Uses freelance artists mainly for jacket/cover illustration. Also uses freelance artists for direct mail, book and catalog design. Needs computer-lterate freelancers for design. 80% of freelance work demands knowledge of Aldus PageMaker or QuarkXPress. Works on assignment only.
First Contact & Terms: Send query letter with tearsheets, résumé and SASE, Samples are not filed and are returned by SASE. Reports back only if interested. Art Director will contact artist for portfolio review if interested. Portfolio should include color tearsheets. Rights purchased vary according to project. Originals are not returned.
Book Design: Assigns 4 freelance design jobs/year. Pays by the project, $500-1,000.
Jackets/Covers: Assigns 6 freelance design and 6 freelance illustration jobs/year. Pays by the project, $350-750.
Text Illustration: Assigns 3 freelance illustration jobs/year. Pays by the project, $100-250.
Tips: First-time assignments are usually text illustration; book covers and jackets are given to "proven" freelancers. Finds artists through word of mouth and submissions.

‡**COOL HAND COMMUNICATIONS, INC.**, Suite #1, 1098 NW Boca Raton Blvd., Boca Raton FL 33432. (407)750-9826. Fax: (407)750-9869. Art Director: Cheryl Nathan. Estab. 1992. Company publishes hardcover, trade paperback and mass market paperback originals and trade paperback reprints. Types of books include contemporary, experimental, mainstream and historical fiction, western, adventure, mystery, biography, travel, self help, history, humor, coffee table books and cookbook. Publishes 15-20 titles/year. Recent titles include *Hit Of The Party*, *How to Figure Out a Man/Woman* and *A Cry For Justice.* 25% require freelance illustration; 10% require freelance design. Book catalog free for 9 × 12 SAE with 4 first-class stamps.
Needs: Approached by 50 freelance artists/year. Works with 10 freelance illustrators and 5 freelance designers/year. Buys 75 freelance illustrations/year. Uses freelance artists for jacket/cover and text illustration, jacket/cover and catalog design, and promotion and advertising. Needs computer-literate freelancers for design, illustration and production. 75% of freelance work demands knowledge of Adobe Illustrator, QuarkXPress, Adobe Photoshop or Aldus FreeHand. Works on assignment only.
First Contact & Terms: Send query letter with brochure, résumé, SASE, tearsheets and photocopies. Samples are filed or returned by SASE if requested by artist. Reports back only if interested. Art Director will contact artist for portfolio review if interested. Portfolio should include roughs, final art, slides, mock-ups, tearsheets, transparencies and photographs. Rights purchased vary according to project. Originals are not returned.
Book Design: Assigns 2-4 freelance design jobs/year. Pays by the project, $100-5,000.
Jackets/Covers: Assigns 2-4 freelance design and 5-10 freelance illustration jobs/year. Pays by the project, $250-1,000. Prefers computer-generated designs for covers or mixed media.

The double dagger before a listing indicates that the listing is new in this edition. New markets are often more receptive to freelance submissions.

Text Illustration: Assigns 5-10 freelance illustration jobs/year. Pays by the project, $100-1,000. Prefers line art, b&w, either hand drawn or computer-generated.
Tips: First-time assignments are usually text illustrations; book jacket designs are given to "proven" freelancers. Finds artists through word of mouth and artist submissions.

■**COUNCIL FOR INDIAN EDUCATION**, 517 Rimrock Rd., Billings MT 59102. (406)252-7451. Editor: Hap Gilliland. Estab. 1970. Publishes trade paperback originals. Types of books include contemporary fiction, historical fiction, instruction, adventure, biography, pre-school, juvenile, young adult and history. Specializes in Native American life and culture. Titles include *Search for Identity* and *Kamache and the Medicine Bead*. Look of design is realistic, Native American style. 80% require freelance illustration. Book catalog free for #10 SASE.
Needs: Approached by 35 freelance artists/year. Works with 1-2 illustrators/year. Buys 10-30 illustrations/year. Uses freelancers for illustrating children's books. Works on assignment only.
First Contact & Terms: Send query letter with SASE and photocopies. Samples are filed. Reports back within 2 months. Buys one-time rights. Originals returned at job's completion.
Text Illustration: Assigns 1-3 freelance illustration jobs/year. Prefers realistic pen & ink.
Tips: "We are a small nonprofit organization publishing on a very small budget to aid Indian education. Contact us only if you are interested in illustrating for $5 per illustration."

‡**THE COUNTRYMAN PRESS, INC.**, Box 175, Woodstock VT 05091. (802)457-1049. Production: Michael Gray. Estab. 1976. Book publisher. Publishes hardcover originals and reprints, and trade paperback originals and reprints. Types of books include contemporary and mainstream fiction, mystery, biography, history, travel, humor, cookbooks and recreational guides. Specializes in mysteries, recreational (biking/hiking) guides. Publishes 35 titles/year. Recent titles include *Full Duty: Vermonters in the Civil War* and *50 Hikes in Northern Virginia*. 10% require freelance illustration. 100% require freelance cover design. Book catalog free by request.
Needs: Works with 4 freelance illustrators and 7 freelance designers/year. Buys 15 freelance illustrations/year. Uses freelance artists for jacket/cover and book design. Works on assignment only. Prefers working with computer-literate artists/designers within the New England/New York area.
First Contact & Terms: Send query letter with appropriate samples. Samples are filed. Reports back to the artist only if interested. To show portfolio, mail best representations of style and subjects. Negotiates rights purchased. Originals are returned at job's completion.
Jackets/Covers: Assigns 20 freelance design jobs/year.

CRC PRESS, INC., 2000 Corporate Blvd. NW, Boca Raton FL 33431. (407)994-0555, ext. 2225. Fax: (407)994-3625. Art & Design Director: Bonnie Rhodes. Estab. 1913. Publishes hardcover and trade originals, reference, textbooks, handbooks. Specializes in engineering, math, life sciences, environmental science and chemistry/physics. Publishes 350 titles/year. Recent titles include *Dorf: The Electrical Engineering Handbook*. 5% require freelance illustration; 15% require freelance cover design. 2% require freelance interior book design. Book catalog not available.
Needs: Works with 5 illustrators and 7-10 designers/year. Prefers artists with experience in scientific and technical book covers. For interior design, experience in math textbooks for graduate level students is required. "We must see examples of your work." Artists must submit all work in Macintosh PageMaker or Freehand (current version). Mainly uses freelancers for book covers and marketing needs. Also for book design and text illustration. Works on assignment only. "We very much need freelancers who know PageMaker who can write type specifications from a visual sample of a design." 100% of freelance work demands computer skills. "We especially need freelancers with experience in writing specs for TEX designs (macros helpful!)."
First Contact & Terms: Send query letter with résumé or call. Include photocopies and at least one color sample of work (no slides). Samples are filed (oversize are discarded) or returned by SASE if requested by artist. Reports back to the artist only if interested. Keeps files indefinately. Appointments are encouraged Call for appointment to show portfolio of roughs, original/final art, tearsheets or photographs. "Disk presentation even better–can mail with inquiry." Must be Macintosh FreeHand or PageMaker." Buys all rights. Originals not returned. Not responsible if originals lost or damaged in shipping.
Book Design: Assigns 5-10 design jobs/year. Pays by the project, $500-1,000.
Jackets/Covers: Assigns 30 design jobs/year. Pays by the project, $100-400, less if quantity contact is agreed upon. Prefers 2-color, on disk; some scanned illustrative elements–largely good use of type and color, abstract design or good development of a scanned image (i.e., a micrograph made into a duotone, etc.). Many of our topics involve less tangible concepts."
Text Illustration: Assigns 100 jobs/year. "These assignments involve re-rendering of author illustrations for publishable quality." Pays by the project (including chemical structures), $10-300. Artist must provide camera-ready copy (not laser-printed) or Macintosh disk. "We do not need medical illustration. We do need chemical/physical sciences illustration. No El-Hi or 'school book' design. No cartoons."
Tips: Also uses freelancers for marketing (mostly brochures and catalog layout). "If you haven't seen our books recently, then check a library for the Engineering handbook above. This is a good example of our

current design (very different from what we used to have). We are looking for freelancers this year. To obtain assignments, it is best to be absolutely reliable on deadlines and quality. We must see color samples before we will try a new person. Macintosh compatibility is a *must*. We have reduced our in-house design capacity, so are seeking freelancers more this year than ever before for interior design, type specification writing (especially), illustration, marketing, and covers."

CRC PUBLICATIONS, 2850 Kalamazoo Ave. SE, Grand Rapids MI 49560. (616)246-0780. Fax: (616)246-0834. Design/Composition Manager: Dean Heetderks. Estab. 1866. Publishes hardcover and trade paperback originals. Types of books include instructional, religious, young adult, reference, juvenile and pre-school. Specializes in religious educational materials. Publishes 8-12 titles/year. Recent titles include *Grabbed by God* and *Too Close for Comfort.* 85% require freelance illustration.
Needs: Approached by 12-15 freelance artists/year. Works with 12-16 illustrators/year. Prefers artists with religious education, cross-cultural experience, resources and sensitivities. Uses freelancers for jacket/cover and text illustration. Needs computer-literate freelancers for illustration. 95% of freelance work demands knowledge of Adobe Illustrator, QuarkXPress, Photoshop or Aldus FreeHand. Works on assignment only.
First Contact & Terms: Send query letter with brochure, résumé, tearsheets, photographs, photocopies, photostats, slides and transparencies. Samples are filed. Reports back within 1 week. Request portfolio review in original query. Portfolio should include thumbnails, roughs, finished samples, color slides, tearsheets, transparencies and photographs. Buys one-time rights. Interested in buying second rights (reprint rights) to previously published artwork. Originals are returned at job's completion.
Jackets/Covers: Assigns 2-3 illustration jobs/year. Pays by the project, $200-1,000.
Text Illustration: Assigns 50-100 illustration jobs/year. Pays by the project, $75-100. "This is high volume work. We publish many pieces by the same artist."
Tips: Finds artists through word of mouth. "Be absolutely professional. Know how people learn and be able to communicate a concept clearly in your art."

‡CROSS CULTURAL PUBLICATIONS, INC., P.O. Box 506, Notre Dame IN 46556. Estab. 1980. Imprint is Cross Roads Books. Company publishes hardcover and trade paperback originals and textbooks. Types of books include biography, religious and history. Specializes in scholarly books on cross-cultural topics. Publishes 10 titles/year. Recent titles include *Asia and the West.* Book catalog free for SASE.
Needs: Approached by 25 freelance artists/year. Works with 2 freelance illustrators/year. Buys 2 freelance illustrations/year. Prefers local artists only. Uses freelance artists mainly for jacket/cover illustration.
First Contact & Terms: Send query letter with résumé and photocopies. Samples are not filed and are not returned. Reports back only if interested. Art Director will contact artist for portfolio review if interested. Portfolio should include b&w samples. Rights purchased vary according to project. Originals are not returned.
Jackets/Covers: Assigns 4-5 freelance illustration jobs/year. Pays by the project.
Tips: First-time assignments are usually book jackets. Finds artists through word of mouth.

CROSSWAY BOOKS, A Division of Good News Publishers, 1300 Crescent St., Wheaton IL 60187. Contact: Arthur Guye. "Please, no phone calls." Nonprofit Christian book publisher. Publishes hardcover and trade paperback originals and reprints. Specializes in Christian fiction (contemporary, mainstream, historical, science fiction, fantasy, adventure, mystery). Also publishes biography, juvenile, young adult, reference, history, self help, humor, and books on issues relevant to contemporary Christians. Publishes 40-50 titles/year. Recent titles include *Prophet, Tell Me the Secrets, Ashamed of the Gospel, The Singreale Chronicles, Always in September, Never Dance With a Bobcat.* 65% require freelance illustration; 35% require freelance design. Book catalog free for 9 × 12 SAE with adequate postage.
Needs: Approached by 150-200 freelance artists/year. Works with 15 illustrators and 8 designers/year. Assigns 26 illustration and 35 design projects/year. Uses freelancers mainly for book cover illustration/design. Also for text illustration (minimal), catalog design, advertising, brochure design, promotional materials, layout and production. Needs computer-literate freelancers for design and production. 20% of freelance work demands knowledge of QuarkXPress, Aldus FreeHand or Adobe Illustrator.
First Contact & Terms: Send query letter with 5-10 nonreturnable samples or quality color photocopies of printed or original art for files. Reports back only if interested. Portfolio review not required. Buys "all book and promotional rights." Considers buying second rights (reprint rights) to previously published work "depending on the original context of the art." Originals are returned at job's completion. Considers complexity of project, proficiency of artist and the project's budget when establishing payment.
Book Design: Pays by the hour, $15 minimum; by the project, $100 minimum.
Jackets/Covers: Assigns 26 illustration and 20 design jobs/year. Prefers realistic and semi-realistic color illustration in all media. Looks for ability to consistently render the same children or people in various poses and situations (as in series books). Pays by the project, $200-2,000. Average budget: $1,000.
Text Illustration: Pays by the project, $100-750.
Tips: Finds artists through word of mouth, magazines, artists' submissions/self promotion, sourcebooks. "We are looking for Christian artists who are committed to spreading the Gospel of Jesus Christ through quality literature. Since we are a nonprofit organization, we may not always be able to afford an artist's 'going rate.' Quality and the ability to meet deadlines are critical. A plus would be a designer who could handle all aspects

of a job from art direction to illustration to final keyline/mechanical. If you are interested in production work (type spec and keylining) please include your hourly rate and a list of references. Also looking for designers who can create imaginative typographic design treatments and inspired calligraphic approaches for covers."

© Dia Calhoun

After submitting several pieces in a direct mail promo package, lettering artist Dia Calhoun was paid a flat fee by Crown Publishers to render this title for a biography of Catherine the Great. Calhoun was given two weeks for sketches and one month to deliver the finished product, in a style evoking "romance, femininity and royalty."

CROWN PUBLISHERS, INC., 201 E. 50th St., New York NY 10022. Design Director: Ken Sansone. Art Director: Jim Davis. Specializes in fiction, nonfiction and illustrated nonfiction. Publishes 250 titles/year. Recent titles include *Lovers*, by Judith Krantz; *A Season in Purgatory*, by Dominick Dunne; *Ageless Body, Timeless Mind*, by Deepak Chopra, M.D.; and *Star Flight* by Phillis Whitney.
Needs: Approached by several hundred freelance artists/year. Works with 50 illustrators and 25 designers/year. Prefers local artists. Needs computer-literate freelancers for design. Freelancers should be familiar with Aldus FreeHand or Aldus PageMaker. Works on assignment only.
First Contact & Terms: Send query letter with samples showing art style. Reports only if interested. Originals are returned at job's completion. Rights purchased vary according to project.
Book Design: Assigns 20-30 design jobs/year. Pays by the project.
Jackets/Covers: Assigns 100 design and/or illustration jobs/year. Pays by the project.
Tips: "There is no single style. We use different styles depending on nature of the book and its perceived market. Become familiar with the types of books we publish. For example, don't send juvenile, sci-fi or romance. Book design is changing to Mac-generated layout."

‡CUSTOM COMIC SERVICES, P.O. Box 1684, Austin TX 78767. Contact: Scott Deschaine. Estab. 1985. Specializes in educational comic books for promotion and advertising for use by business, education and government. "Our main product is full-color comic books, 16-32 pages long." Prefers pen & ink, airbrush and watercolor. Publishes 12 titles/year. Recent titles include *Light of Liberty* and *Visit To a Green Planet*.
First Contact & Terms: Approached by 150 freelance artists/year. Works with 24 freelance artists/year. "We are looking for artists who can produce finished artwork for educational comic books from layouts provided by the publisher. They should be able to produce consistently high-quality illustrations for mutually agreeable

deadlines, with no exceptions." Works on assignment only. Send query letter with business card and nonreturnable samples to be kept on file. Samples should be of finished comic book pages; prefers photostats. Reports within 6 weeks; must include SASE for reply. Considers complexity of project and skill and experience of artist when establishing payment. Buys all rights.

Text Illustration: Assigns 18 freelance jobs/year. "Finished artwork will be b&w, clean, and uncluttered. Artists can have styles ranging from the highly cartoony to the highly realistic." Pays $100-250/comic book page of art.

Tips: "Don't send original artwork. Send only samples of comic book pages. No reply without a SASE."

JONATHAN DAVID PUBLISHERS, 68-22 Eliot Ave., Middle Village NY 11379. (718)456-8611. Fax: (718)894-2818. Production Coordinator: Fiorella de Lima. Estab. 1948. Company publishes hardcover originals. Types of books include biography, religious, young adult, reference, juvenile and cookbooks. Specializes in Judaica, sports, cooking. Publishes 25 titles/year. Recent titles include *Jewish Child's Book of Sports Heroes* and *Traditional Jewish Cooking*. 50% of titles require freelance illustration; 50% require freelance design. Book catalog free by request.

Needs: Approached by 15-20 freelance artists/year. Works with 5 freelance illustrators and 5 freelance designers/year. Prefers local artists with experience in book jacket design. Also uses freelance artists for jacket/cover illustration. Needs computer-literate freelancers for design. 50% of freelance work demands knowledge of Adobe Illustrator, QuarkXPress or Adobe Photoshop. Works on assignment only.

First Contact & Terms: Send query letter with résumé and photocopies. Samples are filed. Reports back within 2 weeks. Production Coordinator will contact artist for portfolio review if interested. Portfolio should include color final art and photographs. Buys all rights. Originals are not returned.

Book Design: Assigns 3 freelance design jobs/year. Pays by the project.

Jackets/Covers: Assigns 4-5 freelance design and 4-5 freelance illustration jobs/year. Pays by the project.

Tips: First-time assignments are usually book jackets, mechanicals and artwork. Finds artists through submissions.

DAW BOOKS, INC., 3rd Floor, 375 Hudson St., New York NY 10014-3658. (212)366-2096. Fax: (212)366-2090. Art Director: Betsy Wollheim. Estab. 1971. Publishes hardcover originals and reprints and mass market paperback originals and reprints. Specializes in science fiction and fantasy. Publishes 72 titles/year. Recent titles include *Foreigner*, by C.J. Cherryh; *The Black Gryphon* by Mercedes Lackey and Larry Dixon; *When True Night Falls* by C.S. Friedman. 50% require freelance illustration. Book catalog free by request.

Needs: Works with several illustrators and 1 designer/year. Buys more than 36 illustrations/year. Works with illustrators for covers. Works on assignment basis only.

First Contact & Terms: Send query letter with brochure, résumé, tearsheets, transparencies and SASE. Samples are filed or are returned by SASE only if requested. Reports back about queries/submissions within 2-3 days. Originals returned at job's completion. Call for appointment to show portfolio of include original/final art, final reproduction/product and transparencies. Considers complexity of project, skill and experience of artist and project's budget when establishing payment. Buys first rights and reprint rights.

Jacket/Covers: Pays by the project, $1,500-8,000. "Our covers illustrate the story."

Tips: "We have a drop-off policy for portfolios. We accept them on Tuesdays, Wednesdays and Thursdays and report back within a day or so. Portfolios should contain science fiction and fantasy color illustrations *only*. We do not want to see anything else."

DELMAR PUBLISHERS INC., 3 Columbia Circle, Box 15015, Albany NY 12212. (518)464-3500. Art Supervisors: Judy Orozco and Russell Schneck. Estab. 1946. Specializes in original hardcovers and paperback textbooks—science, computer, health, mathematics, professions and trades. Publishes 200 titles/year. Titles include *Engineering, Drawing and Design* and *Early Childhood Education*.

Needs: Approached by 200 artists/year. Works with 40 artists/year. Prefers text illustrators and designers, paste-up artists, technical/medical illustrators and computer graphic/AUTOCAD artists. Works on assignment only.

First Contact & Terms: Send query letter with brochure, résumé, tearsheets, photostats, photocopies, slides or photographs. Samples not requested to be returned will be filed for one year. Any material needed back must return via certified mail. Not responsible for loss of unsolicited material. Reports back only if interested. Originals are not returned. Considers complexity of project, budget and turnaround time when establishing payment. Buys all rights.

How to Use Your **Artist's & Graphic Designer's Market** *offers suggestions for understanding and using the information in these listings. Read this and other articles in the front of this book for important business tips.*

Book Design: Assigns 50 design jobs/year. Pays by the project.
Jacket/Covers: Assigns 150 design jobs/year. Pays by the project.
Text Illustration: Assigns up to 25 jobs/year. Prefers ink on mylar or vellum—simplified styles. Two-color application is most common form. Four-color art is needed less frequently but still a requirement. Charts, graphs, technical illustration and general pictorials are common. Pays by the project.
Tips: "Quote prices for samples shown. Quality and meeting deadlines most important. Experience with publishing a benefit." Look of design and illusration used is "basic, clean, conservative, straightforward textbook technical art."

DELPHI PRESS, INC., P.O. Box 1538, Oak Park IL 60304. (708)524-7900. Fax: (708)524-7902. President: Karen Jackson. Estab. 1989. Publishes trade paperback originals and reprints. Specializes in Goddess Spirituality, Pagan Theology, witchcraft. Publishes 10-15 titles/year. Recent titles include *Cauldron of Change* and *Celebrating Life*. 100% require freelance illustration and design. Book catalog free by request.
Needs: Approached by 10-15 freelance artists/year. Works with 8-12 illustrators and 3-4 designers/year. Buys 10-20 illustrations/year. Uses freelancers mainly for covers. Also for text illustration. Works on assignment only.
First Contact & Terms: Send query letter with any samples. Samples are filed. Art Director will contact artist for portfolio review if interested. Portfolio should include thumbnails, roughs, final art. Sometimes requests work on spec before assigning a job. Rights purchased vary according to project. Considers buying second rights (reprint rights) to previously published work. Originals returned.
Book Design: Pays by the project, $250-1,000.
Jackets/Covers: Assigns 10-15 design and 10-15 freelance illustration jobs/year. Pays by the project, $250-750.
Text Illustration: Pays by the project, $150-500.

DIAL BOOKS FOR YOUNG READERS, 375 Hudson St., New York NY 10014. (212)366-2803. Fax: (212)366-2020. Editor: Toby Sherry. Specializes in juvenile and young adult hardcovers. Publishes 80 titles/year. Titles include *Brother Eagle, Sister Sky, Amazing Grace, Ryan White: My Own Story* and *Rosa Parks*. 100% require freelance illustration. Books are "distinguished children's books."
Needs: Approached by 400 freelance artists/year.Works with 40 illustrators and 10 designers/year. Prefers artists with some book experience. Works on assignment only.
First Contact & Terms: Send query letter with brochure, tearsheets, photostats, slides and photographs. Samples are filed and are not returned. Reports back only if interested. Originals are returned at job's completion. Call for appointment to show portfolio of original/final art and tearsheets. Considers complexity of project, skill and experience of artist and project's budget when establishing payment. Rights purchased vary.
Book Design: Assigns 10 design jobs/year. Pays by the project.
Jackets/Covers: Assigns 2 design and 8 illustration jobs/year. Pays by the project.
Text Illustration: Assigns 40 illustration jobs/year. Pays by the project.

DOUBLEDAY, 666 Fifth Ave., New York NY 10103. Does not need freelance artists at this time.

ECLIPSE COMICS, Box 1099, Forestville CA 95436. Fax: (707)887-7128. Editor-in-Chief: Catherine Yronwode. Estab. 1978. Publishes trading cards, comic books and graphic albums. "Most of our comics feature fictional characters in action-adventures. Genres include science fiction, weird horror, detective adventure, literary adaptations, etc. We also publish a line of nonfiction comics (graphic journalism) dealing with current and historic political and social subjects. The emphasis is on drawing the human figure in action. Audience is adolescent to adult." Publishes 10 comics/month on average. Some are monthlies, some bimonthly; others are one-shots or mini-series. Circ. 30,000-100,000, depending on title. Recent titles include *Deadbeats, Elvira* and *Beanworld*. Does not accept previously published material except for reprint collections by famous comic book artists. Original artwork returned after publication. Sample copy $2; art guidelines for SASE. Needs computer-literate freelancers for design and production. Freelancers should be familiar with Photoshop and QuarkXPress.
Needs: Works with 25 freelance illustrators and 25 freelance designers/year. Uses freelance artists mainly for illustrating comics and graphic novels. Also uses freelance artists for jacket/cover illustration and design, book and catalog deisgn, and logo designs.
Cartoons: "We buy entire illustrated stories, not individual cartoons. We buy approximately 6,250 pages of comic book art/year—about 525/month." Interested in realistic illustrative comic book artwork—drawing the human figure in action; good, slick finishes (inking); ability to do righteous 1-, 2- and 3-point perspective required. Formats: b&w line drawings or fully painted pages with balloon lettering on overlays. Send query letter with samples of style to be kept on file. "Send minimum of 4-5 pages of full-size (10×15) photocopies of pencilled *storytelling* (and/or inked too)—no display poses, just typical action layout continuities." Material not filed is returned by SASE. Reports within 2 months by SASE only. Art Director will contact artist for portfolio review if interested. (Portfolios reviewed at conventions, not through the mail.) Buys first rights or reprint rights. Sometimes requests work on spec before assigning job. Pays $100-200/page for b&w; "price

is for pencils plus inks; many artists do only pencil for us, or only ink." Pays $25-35/page for painted or airbrushed coloring of greylines made from line art. **Pays on acceptance** (net 30 days); $200-400/page for fully painted comics.
Illustrations: "We buy 12-15 cover paintings for science fiction and horror books per year." Science fiction paintings: fully rendered science fiction themes (e.g. outer space, aliens); horror paintings: fully rendered horror themes (e.g. vampires, werewolves, etc.). Send query letter with business card and samples to be kept on file. Prefers slides, color photos or tearsheets as samples. Samples not filed are returned by SASE. Reports within 2 months by SASE only. Sometimes requests work on spec before assigning job. Buys first rights or reprint rights. **Pays on acceptance** (net 30 days); $150-400 for b&w, $1,400-1,500 for color cover; $75-200 for b&w, $200-400 for color inside. "We also buy paintings for our popular political, current events and baseball trading card sets; each set consists of 36 or 110 small painted portraits or caricatures." For trading card art **pays on acceptance,** $60-100/painting (net 30 days).
Tips: Finds illustrators and designers through word of mouth, magazines, artists' submissions, newspaper review section and bookstores.

EDITORIAL CARIBE, INC., 9200 S. Dadeland Blvd., Miami FL 33156. (305)670-6763. Production Manager: Sam Rodriguez. Publishes hardcover originals, trade paperback originals and reprints and mass market paperback originals and reprints. Types of books include self-help and religious. Specializes in commentary series and Bibles. Publishes 80 titles/year. Recent titles include Precious Moments Bibles (in Spanish), *La Sangre* and *Piense en Grande*. 90% require freelance illustration; 100% require freelance design. Book catalog free by request.
Needs: Approached by 10 freelance artists/year. Works with 18-25 illustrators and 12 designers/year. Buys 50 freelance illustrations/year. Uses freelancers mainly for cover design. Also uses freelance artists for jacket/cover illustration. Needs computer-literate freelancers for design and illustration. 60% of freelance work demands knowledge of Adobe Illustrator or Aldus FreeHand. Works on assignment only.
First Contact & Terms: Send query letter with brochure and tearsheets. Samples are filed. Reports back within 2 weeks. Artist should follow up with call and/or letter after initial query. Requests work on spec before assigning job. Buys all rights. Interested in buying second rights (reprint rights) to previously published work. Originals not returned.
Book Design: Assigns 80 design jobs/year. Pays by the project, $300-1,200.
Jackets/Covers: Assigns 40 design and 40 illustration jobs/year. Pays by the project, $400-700.
Tips: Finds artists through word of mouth, artists' submissions and work already done. "Show creativity at a reasonable price. Keep in touch with industry and know what is out in the marketplace. Visit a large book store."

■EDUCATIONAL IMPRESSIONS, INC., 210 6th Ave., Hawthorne NJ 07507. (201)423-4666. Fax: (201)423-5569. Art Director: Karen Neulinger. Estab. 1983. Publishes original workbooks with 2-4 color covers and b&w text. Types of books include instructional, juvenile, young adult, reference, history and educational. Specializes in all educational topics. Publishes 4-12 titles/year. Recent titles include *Monsters, Magic And Make-Believe; Under the Fairy Tale Tree;* L.I.T. Guides. Books are bright and bold with eye-catching, juvenile designs/illustrations. Book catalog free by request.
Needs: Works with 1-5 illustrators/year. Prefers artists who specialize in children's book illustration. Uses freelancers for jacket/cover and text illustration. Also uses freelance artists for jacket/cover design. Works on assignment only.
First Contact & Terms: Send query letter with tearsheets, photostats, résumé and photocopies. Samples are filed. Art Director will contact artist for portfolio review if interested. Buys all rights. Interested in buying second rights (reprint rights) to previously published work. Originals not returned. Prefers line art for the juvenile market. Sometimes requests work on spec before designing a job.
Book Design: Pays by the project, $20 minimum.
Jackets/Covers: Pays by the project, $20 minimum.
Text Illustration: Pays by the project, $20 minimum.
Tips: Finds artists through submissions.

ELYSIUM GROWTH PRESS, 700 Robinson Rd., Toranga CA 90290. (310)455-1000. Fax: (310)455-2007. Art Director: Chris Moran. Estab. 1961. Small press. Publishes hardcover originals and reprints and trade paperback originals and reprints. Types of books include travel and self-help. Specializes in nudism/naturism. Publishes 4 titles/year. Recent titles include *Nudist Magazines of the '50s and '60s,* Books 1 and 2. 10% require freelance illustration; 10% require freelance design. Book catalog free for SAE with 2 first-class stamps.
Needs: Approached by 5 freelance artists/year. Works with 2 illustrators and 2 designers/year. Buys 3 illustrations/year. Prefers artists with experience in rendering the human body and clothing. Uses freelance artists mainly for covers and interior illustration. Also uses freelancers for jacket and book design. Needs computer-literate freelancers for illustration. 100% of work demands knowledge of Macintosh. Works on assignment only.
First Contact & Terms: Send query letter with brochure, tearsheets and photocopies. Samples are filed. Reports back within 2 weeks. Artist should follow up with call after initial query. Sometimes requests work

on spec before assigning job. Buys one-time rights. Interested in buying second rights (reprint rights) to previously published artwork.
Book Design: Assigns 1 design job/year. Pays by the hour, $20-50.
Jackets/Covers: Assigns 2 design and 2 illustration jobs/year. Pays by the hour, $20-50.
Text Illustration: Assigns 8 jobs/year. Pays by the hour, $20-50.
Tips: Finds artists through submissions ("nonreturnable color photocopies preferred"). "I think the marketing of a book is becoming more important than 'artistic' merit in the industry."

‡**ENSLOW PUBLISHERS**, Box 777, Bloy St. and Ramsey Ave., Hillside NJ 07205. Production Manager: Brian Enslow. Estab. 1978. Specializes in hardcovers, juvenile young adult nonfiction; science, social issues, biography. Publishes 30 titles/year. Titles include *Kwanzaa* and *Steroids*. 30% require freelance illustration. Book catalog for SASE with $2 postage.
First Contact & Terms: Works with 3 freelance artists/year. Needs computer-literate freelancers for design. Works on assignment only. Send query letter with brochure or photocopies. Samples not filed are not returned. Does not report back. Considers skill and experience of artist when establishing payment. Rights purchased vary according to project.
Book Design: Assigns 3 freelance design jobs/year. Pays by the project.
Jackets/Covers: Pays by the project.
Text Illustration: Assigns 5 freelance jobs/year. Pays by the project.
Tips: "We're interested in b&w india ink work. We keep a file of samples by various artists to remind us of the capabilities of each."

M. EVANS AND COMPANY, INC., 216 E. 49th St., New York NY 10016. (212)688-2810. Fax: (212)486-4544. Managing Editor: Charles deKay. Estab. 1956. Publishes hardcover and trade paperback originals. Types of books include contemporary fiction, biography, young adult, history, self help, cookbooks and western. Specializes in western and general nonfiction. Publishes 40 titles/year. Recent titles include *Feed Your Body Right* and *The Quick & Easy Vegetarian Cookbook*. 50% require freelance illustration and design.
Needs: Approached by 25 freelance artists/year. Works with approximately 3 illustrators and 10 designers/year. Buys 20 illustrations/year. Prefers local artists. Uses freelance artists mainly for jacket/cover illustration. Also uses freelance artists for text illustration and jacket/cover design. Works on assignment only.
First Contact & Terms: Send query letter with brochure and résumé. Samples are filed. Art Director will contact artist for portfolio review if interested. Portfolios may be dropped off every Friday. Portfolio should include original/final art and photographs. Rights purchased vary according to project. Originals returned at job's completion upon request.
Book Design: Assigns 20 jobs/year. Pays by project, $200-500.
Jackets/Covers: Assigns 20 design jobs/year. Pays by the project, $600-1,200.
Text Illustration: Pays by the project, $50-500.

‡**FALCON PRESS PUBLISHING CO., INC.,** 48 N. Last Chance Gulch, Helena MT 59601. (406)442-6597. Fax: (406)442-2995. Editorial Director: Chris Cauble. Estab. 1978. Book publisher. Publishes hardcover originals and reprints, trade paperback originals and reprints, and mass market paperback originals and reprints. Types of books include instruction, pre-school, juvenile, travel and cookbooks. Specializes in recreational guidebooks, high-quality, four-color photo books. Publishes 40 titles/year. Titles include *A is for Animals*, *Nature Conservancy Calendar* and *America on My Mind*. Book catalog free by request.
Needs: Approached by 100 freelance artists/year. Works with 2-5 freelance illustrators/year. Buys 40 freelance illustrations/year. Prefers artists with experience in illustrating children's books. Uses freelance artists mainly for illustrating children's books and map making. Needs computer-literate freelancers for illustration. 40% of freelance work demands knowledge of Aldus FreeHand and Adobe Illustrator.
First Contact & Terms: Send query letter with résumé, tearsheets, photographs, photocopies or photostats. Samples are not filed and are returned by SASE if requested by artist. Reports back to the artist only if interested. To show portfolio, mail thumbnails, roughs, original/final art and b&w photostats, slides, dummies, tearsheets, transparencies and photographs. Buys all rights. Originals are returned at job's completion.
Text Illustration: Assigns approximately 3 freelance design and 3 freelance illustration jobs/year. Pays by the project, $500-1,500. No preferred media or style.
Tips: "Be acquainted with our children's series of books, *Highlights in American History* and *Interpreting the Great Outdoors* and have a good portfolio. If we do use freelance illustrators, it's to illustrate these two series featuring color illustrations of historical events and natural phenomena, flowers, trees, animals, etc."

F&W PUBLICATIONS INC., 1507 Dana Ave., Cincinnati OH 45207. Art Director: Kristi Cullen. Imprints: Writer's Digest Books, North Light Books, Betterway Books, Story Press. Publishes 100-120 books annually for writers, artists and photographers, plus selected trade (lifestyle, home improvement) titles. Recent titles include: *Essential Software for Writers*, *Painting Buildings in Watercolor*, *Homemade Money*, 5th Edition. Books are heavy on type-sensitive design. Book catalog available for 6×9 SASE.
Needs: Works with 10-20 freelance illustrators and 5-10 freelance designers/year. Uses freelancers for text illustration and cartoons. Also for jacket/cover and text illustration; jacket/cover, direct mail and book design.

Needs computer-literate freelancers for design and production. 95% of freelance work demands knowledge of QuarkXPress. Works on assignment only.

First Contact & Terms: Send nonreturnable photocopies of printed work to be kept on file. Art Director will contact artist for portfolio review if interested. Interested in buying second rights (reprint rights) to previously published. "We like to know where art was previously published."

Book Design: Pays by the project, $500-1,000.

Jackets/Covers: Pays for by the project, $400-850.

Text Illustration: Pays by the project, $100 minimum.

Tips: Finds illustrators and designers through word of mouth and artists' submissions/self promotion. "Don't call. Send a brief letter with appropriate samples we can keep. Clearly indicate what type of work you are looking for. If you're looking for design work, don't send illustration samples."

FANTAGRAPHICS BOOKS, INC., 7563 Lake City Way, Seattle WA 98115. Phone/Fax: (206)524-1967. Publisher: Gary Groth. Estab. 1976. Publishes hardcover and trade paperback originals and reprints. Types of books include contemporary, experimental, mainstream, historical, science fiction, young adult and humor. "All our books are comic books or graphic stories." Publishes 100 titles/year. Recent titles include *Love and Rockets*, *The Comic Journal*, *Hate Magazine* and *Eightball*. 15% require freelance illustration. Book catalog free by request.

Needs: Approached by 500 freelance artists/year. Works with 25 illustrators/year. Must be interested in and willing to do comics. Uses freelancers for comic book interiors and covers.

First Contact & Terms: Send query letter addressed to Submissions Editor with résumé, SASE, photocopies and finished comics work. Samples are not filed and are returned by SASE. Reports back to the artist only if interested. Call or write for appointment to show portfolio of original/final art and b&w samples. Buys one-time rights or negotiates rights purchased. Originals returned at job's completion. Pays royalties.

Tips: "We want to see completed comics stories. We don't make assignments, but instead look for interesting material to publish that is pre-existing. We want cartoonists who have an individual style, who create stories that are personal expressions."

FOREST HOUSE PUBLISHING CO., INC. & HTS BOOKS, P.O. Box 738, Lake Forest IL 60045-0738. (708)295-8287. President: Dianne Spahr. Children's book publisher. Types of books include instructional, fantasy, mystery, self-help, young adult, reference, history, juvenile, pre-school and cookbooks. Specializes in early readers, sign language, bilingual dictionaries, Spanish children's titles, moral lessons by P.K. Hallinan and Stephen Cosgrove, history. Publishes 5-10 titles inhouse, and as many as 26 titles with other trade publishers. Titles include *Honor The Flag, Read On Rita, ABCs of Nutrition, Every Kid's Guide to Saving the Earth, The Birthday Present*. 90% require freelance illustration and design. Book catalog free by request.

Needs: Approached by 20 freelance artists/year. Works with 5 illustrators and 5 designers/year. Prefers artists with experience in children's illustration. Uses freelancers for jacket/cover and text illustration, book and catalog design. Needs computer-literate freelancers for design, illustration and production. 25% of freelance work demands computer skills. Works on assignment only.

First Contact & Terms: Send query letter with brochure, résumé, photographs, photocopies and 4-color and b&w illustrations. Samples are not filed and are returned by SASE if requested by artist. Reports back within 2 months only if interested. Call for appointment to show portfolio or mail b&w and color roughs, one piece of final art, dummies. Rights purchased vary according to project. Originals returned at job's completion if requested.

Book Design: Assigns 10 design jobs/year. Pays by the project.

Jackets/Covers: Assigns 10 design and 10 illustration jobs/year. Pays by the project.

Text Illustration: Assigns 10 jobs/year. Pays by the project.

Tips: "Call Toll Free 1-800-394-READ and ask for Dianne Spahr. Forest House will then decide if the artist should deliver, as mentioned above."

■FORWARD MOVEMENT PUBLICATIONS, 412 Sycamore St., Cincinnati OH 45202. (513)721-6659. Fax: (513)421-0315. Associate Director: Sally B. Sedgwick. Estab. 1934. Publishes trade paperback originals. Types of books include religious. Publishes 24 titles/year. Recent titles include *Satan Stalking* and *Encounter With Canterbury*. 75% require freelance illustration. Book illustration is usually suggestive, not realistic. Book catalog free for SAE with 3 first-class stamps.

Needs: Approached by 2 freelance artists/year. Works with 2-4 illustrators and 1-2 freelance designers/year. Uses freelancers mainly for illustrations required by designer. "We also keep original clip art type drawings on file to be paid for as used."

First Contact & Terms: Send query letter with tearsheets, photographs, photocopies and slides. Samples are filed. Art Director will contact artist for portfolio review if interested. Sometimes requests work on spec before assigning a job. Interested in buying second rights (reprint rights) to previously published work. Rights purchased vary according to project. Originals sometimes returned at job's completion.

Jackets/Covers: Assigns 18 design and 6 illustration jobs/year. Pays by the project, $25-175.

Text Illustration: Assigns 1-4 jobs/year. Pays by the project, $10-200; pays $5-25/picture. Prefers pen & ink.

Tips: Finds artists mainly through word of mouth.

‡**FOUR WINDS PRESS**, 866 Third Ave., New York NY 10022. (212)702-2180. Art Director: Christy Hale. Imprint of Macmillan Publishing. Imprint publishes hardcover originals. Types of books include juvenile. Publishes 25 titles/year. Recent titles include *Sukey And The Mermaid*, *Masai And I* and *Odds 'N' Ends Alvy*. 90% require freelance illustration.
Needs: Works with 20 freelance illustrators/year. Uses freelance artists mainly for picture books. Also uses freelance artists for jacket/cover illustration. Works on assignment only.
First Contact & Terms: Send query letter with SASE, tearsheets, photographs, photocopies, photostats, slides and transparencies. Samples are sometimes filed. Does not report back. Request portfolio review in original query. Artist should follow up. Portfolio may be dropped off every Thursday morning. Portfolio should include color tearsheets, transparencies and photographs. Rights purchased vary according to project. Originals are returned at job's completion.
Jackets/Covers: Assigns 4 freelance illustration jobs/year. Pays by the project.
Text Illustration: Assigns 15-20 jobs/year. Pays by the project.
Tips: Finds artists through agents, sourcebooks, publications, word of mouth and artists' submissions.

‡**FRANKLIN WATTS**, 95 Madison Ave., New York NY 10016. (212)951-2650. Fax: (212)689-7803. Art Director: Vicki Fischman. Estab. 1942. Imprint of Grolier, Inc. Imprints include Orchard Books, Scarecrow Press, Grolier Educational. Imprint publishes hardcover and trade paperback originals. Types of books include biography, young adult, reference, history and juvenile. Specializes in history, science and biography. Publishes 150 titles/year. 10% require freelance illustration; 50% require freelance design. Book catalog for 9×12 SAE with $2.90 first-class postage.
Needs: Approached by 100 freelance artists/year. Works with 10 freelance illustrators and 20 freelance designers/year. Buys 10-20 freelance illustrations/year. Uses freelance artists mainly for jacket/cover design and illustration. Also uses freelance artists for text illustration and catalog design. Needs computer-literate freelancers for design. 75% of freelance work demands knowledge of Aldus PageMaker, Adobe Illustrator, QuarkXPress, Adobe Photoshop or Aldus FreeHand. Works on assignment only.
First Contact & Terms: Send query letter with brochure, résumé, SASE and photocopies. Samples are not filed and are returned by SASE if requested by artist. Reports back within 1 month. Art Director will contact artist for portfolio review if interested. Portfolio should include b&w and color thumbnails, roughs, final art, photostats, tearsheets, photographs, slides or transparencies. Rights purchased vary according to project. Originals are returned at job's completion.
Book Design: Assigns 30-50 freelance design jobs/year. Pays by the project.
Jackets/Covers: Assigns 75 freelance design and 30 freelance illustration jobs/year. Pays by the project.
Text Illustration: Assigns 20-30 freelance illustration jobs/year. Pays by the project.
Tips: Finds artists "almost entirely through artists' submissions and word of mouth."

GALLOPADE PUBLISHING GROUP, Suite 100, 359 Milledge Ave., Atlanta GA 30312-3238. Contact: Art Department. Estab. 1979. Publishes hardcover and trade paperback originals, textbooks and interactive multimedia. Types of books include contemporary fiction, western, instructional, mystery, biography, young adult, reference, history, humor, juvenile and sex-education. Publishes 1,000 titles/year. Titles include *Alabama Jeopardy* (and other states), *A Trip to the Beach* (CD-ROM). 20% require freelance illustration; 20% require freelance design.
Needs: Approached by 25 freelance artists/year. Works with 10 illustrators and 10 designers/year. Prefers artists with Macintosh experience. Uses freelancers mainly for state art and logos for all 50 state book series, and design of new book covers for 2,000 titles. Also for direct mail, book and catalog design, art database, CD-ROM. Needs computer-literate freelancers for design, illustration and production. 95% of freelance work demands computer skills. Works on assignment only.
First Contact & Terms: Send non-returnable samples only. Usually buys all rights.

GEM GUIDES BOOK CO., Suite F, 315 Cloverleaf Dr., Baldwin Park CA 91706. (818)855-1611. Fax: (818)855-1610. Editor: Robin Nordhues. Estab. 1964. Book publisher and wholesaler of trade paperback originals and reprints. Types of books include western, instructional, travel, history and regional (Western US). Specializes in travel and local interest (Western Americana). Publishes 6 titles/year. Recent titles include *Where to Find Gold in Southern California* and *Retiring to Arizona*. 75% require freelance illustration and design. Book catalog free for SASE.
Needs: Approached by 24 artists/year. Works with 3 illustrators and 3 designers/year. Buys 12 illustrations/year. Uses freelancers mainly for covers. Also uses freelancers for text illustration and book design. Needs computer-literate freelancers for design, illustration and production. 100% of freelance work demands knowl-

The double dagger before a listing indicates that the listing is new in this edition. New markets are often more receptive to freelance submissions.

edge of Aldus PageMaker, Adobe Illustrator, Appleone Scanner and Omnipage Professional. Works on assignment only.
First Contact & Terms: Send query letter with brochure, résumé and SASE. Samples are filed. Art Director will contact artist for portfolio review if interested. Requests work on spec before assigning a job. Buys all rights. Originals are not returned.
Book Design: Assigns 6 design jobs/year. Pays by the project.
Jackets/Covers: Pays by the project.
Text Illustration: Assigns 2 jobs/year. Pays by the project.
Tips: Finds artists through word of mouth and "our files."

GENEALOGICAL INSTITUTE/FAMILY HISTORY WORLD, Box 22045, Salt Lake City UT 84122. (801)257-6174. Manager: JoAnn Jackson. Estab. 1972. Publishes trade paperback originals and textbooks. Types of books include instructional, self-help and reference. Specializes in genealogy. Publishes 3-5 titles/year. Recent titles include *Virginia 7*, *British Syllabus*, *Huguenot Research Sources* and *Marriages*. 10% require freelance illustration and design. Book catalog free for SAE with 2 first-class stamps.
Needs: Approached by 1 artist/year. Works with 1 illustrator and 1 designer/year. Prefers local artists with experience in maps. Uses freelancers mainly for covers. Also for text illustration. Works on assignment only.
First Contact & Terms: Send query letter with brochure and résumé. Samples are filed. Reports back only if interested. To show portfolio mail copies of final art. Rights purchased vary according to project. Originals not returned.
Jackets/Covers: Assigns 3-5 design and 3-5 illustration jobs/year. Pays by the project.

‡GIBBS SMITH, PUBLISHER, P.O. Box 667, Layton UT 84041. (801)544-9800. Editorial Director: Madge Baird. Estab. 1969. Company publishes hardcover and trade paperback originals, textbooks. Types of books include western, travel, humor, juvenile, coffee table books, cookbooks, design/interior. Specializes in humor, western, architecture and interior design, nature. Publishes 30 titles/year. Titles include *100 Years of Western Wear* and *Frank Lloyd Wright Portfolio Series*. Book catalog available for 6 × 9 SAE with 58¢ first-class postage.
Needs: Approached by 50 freelance artists/year. Works with 10 freelance illustrators and 10 freelance designers/year. Buys 100 freelance illustrations/year. Uses freelance artists mainly for jacket/cover illustrations and interior line illustrations. Also uses freelance artists for text illustration, jacket/cover and book design. Needs computer-literate freelancers for design and production. 75% of freelance work demands knowledge of Aldus PageMaker or QuarkXPress. Works on assignment only.
First Contact & Terms: Send brochure, photocopies and slides. Samples are filed. Reports back only if interested. Art Director will contact artist for portfolio review if interested. Portfolio should include color thumbnails, tearsheets and photographs. Rights purchased vary according to project. Originals returned at job's completion if requested.
Book Design: Assigns 30 freelance design jobs/year. Pays by the project, $500-800.
Jackets/Covers: Assigns 30 freelance design jobs and 5 freelance illustration jobs/year. Pays by the project, $300-500.
Text Illustration: Pays by the project or by the piece, $40-50. Prefers ink or pastel.
Tips: First-time assignments are usually text illustration; book design, jacket/cover are given to "proven" freelancers. Finds artists through submissions and word of mouth.

■C.R. GIBSON, 32 Knight St., Norwalk CT 06856. (203)847-4543. Creative Services Coordinator: Harriet Sullivan. Publishes 100 titles/year. 95% require freelance illustration.
Needs: Works with approximately 70 freelance artists/year. Makes assignments "most of the time."
First Contact & Terms: Send tearsheets, slides and/or published work. Samples are filed or are returned by SASE. Reports back within 1 month only if interested. Considers complexity of project, project's budget and rights purchased when establishing payment. Negotiates rights purchased.
Book Design: Assigns at least 65 design jobs/year. Pay by the project, $1,200 minimum.
Jackets/Covers: Assigns 20 design jobs/year. Pays by the project, $500 minimum.
Text Illustration: Assigns 20 jobs/year. Pays by the hour, $15 minimum; or by the project, $1,500 minimum.

GLENCOE PUBLISHING COMPANY, Dept. AM, 15319 Chatsworth St., Mission Hills CA 91345. (818)898-1391. Fax: (818)837-3668. Design Director: Mel Wanamaker. Estab. 1965. Book publisher. Publishes text-

The solid, black square before a listing indicates that it is judged a good first market by the Artist's & Graphic Designer's Market **editors. Either it offers low payment, pays in credits and copies, or has a very large need for freelance work.**

books. Types of books include foreign language, career education, art and music, religious education. Specializes in most el-hi (grades 7-12) subject areas. Publishes 250 titles/year. Recent titles include *Glencoe Spanish*, *Glencoe French*, *Art in Focus*. 80% require freelance illustration; 40% require freelance design. Book catalog free by request.

Needs: Approached by 50 artists/year. Works with 20-30 freelance illustrators and 10-20 freelance designers/year. Prefers experienced artists. Uses freelance artists mainly for illustration and production. Also uses freelance artists for jacket/cover and text illustration and jacket/cover and book design. Works on assignment only.

First Contact & Terms: Send query letter with brochure, tearsheets, photocopies and slides. Samples are filed. Art Director will contact artist for portfolio review if interested. Sometimes requests work on spec before assigning job. Negotiates rights purchased. Originals are not returned to the artist at job's completion.

Book Design: Assigns 10-20 freelance design and many freelance illustration jobs/year. Pays by the project.

Jackets/Covers: Assigns 5-10 freelance design and 5-20 freelance illustration jobs/year. Pays by the project.

Text Illustration: Assigns 20-30 freelance design jobs/year. Pays by the project.

GLOBE PEQUOT PRESS, 6 Business Park Rd., P.O. Box 833, Old Saybrook CT 06475. (203)395-0440. Production manager: Kevin Lynch. Estab. 1947. Publishes hardcover and trade paperback originals and reprints. Types of books include business, cookbooks, instruction, self-help, history and travel. Specializes in regional subjects: New England, Northwest, Southeast bed-and-board country inn guides. Publishes 100 titles/year. 20% require freelance illustration; 40% require freelance design. Recent titles include *Victory Garden Kids' Book*, *Beautiful Easy Lawns & Landscapes*, *Taming the Bear*. Design of books is "classic and traditional, but fun." Book catalog free.

Needs: Works with 5-10 illustrators and 5-10 designers/year. Uses illustrators mainly for cover design, text design and production. Also for jacket/cover illustration, text illustration and direct mail design. Needs computer-literate freelancers for production. All freelance work demands knowledge of QuarkXPress, Adobe Illustrator or Adobe Photoshop. Works on assignment only.

First Contact & Terms: Send query letter with brochure, résumé and photostats. Samples are filed and not returned. Request portfolio review in original query. Artist should follow up with call after initial query. Art Director will contact artist for portfolio review if interested. Portfolio should include roughs, original/final art, photostats, tearsheets and dummies. Requests work on spec before assigning a job. Considers complexity of project, project's budget and turnaround time when establishing payment. Buys all rights. Originals are not returned.

Book Design: Pays by the hour, $15-25 for production; or by the project, $200-600 for cover design.

Jackets/Covers: Prefers realistic style. Pays by the hour, $20-35; or by the project, $500 maximum.

Text Illustration: Prefers pen & ink line drawings. Pays by the project, $25-100.

Tips: Finds artists through word of mouth, submissions, self-promotion and sourcebooks. "More books are being produced using the Macintosh. We like designers who can use the Mac competently enough that their design looks as if it *hasn't* been done on the Mac."

■**GOSPEL LIGHT PUBLICATIONS**, 2300 Knoll Dr., Ventura CA 93003. (805)644-9721. Fax: (805)644-4729. Creative Director: B. Denzel. Estab. 1932. Book publisher. Publishes hardcover, trade paperback and mass market paperback originals. Types of books include contemporary fiction, instructional, pre-school, juvenile, young adult, reference, self-help and history. Specializes in Christian issues. Publishes 15 titles/year. Recent titles include *Healing America's Wounds*, *The Other Woman in Your Marriage* and *Bible Verse Coloring Pages*. 50% require freelance illustration; 25% require freelance design. Book catalog available for SASE.

Needs: Approached by 72 artists/year. Works with 10 illustrators and 4 designers/year. Buys 10 illustrations/year. Uses freelancers mainly for jacket/cover illustration and design. Also for text illustration, direct mail design and book and catalog design. Works on assignment only.

First Contact & Terms: Send SASE, tearsheets, photographs and samples. Samples are filed or are returned by SASE if requested by artist. Art Director will contact artist for portfolio review if interested. Portfolio should include color photostats, tearsheets, photographs, slides and transparencies. Negotiates rights purchased. Originals are returned to artist at job's completion.

Book Design: Assigns 8 design and 15 illustration jobs/year. Pays by the hour or by the project.

Jackets/Covers: Assigns 5 freelance design and 12 freelance illustration jobs/year. Accepts all types of styles and media for jacket/cover design and illustration. Pays by the project.

Text Illustration: Assigns 6 design and 8 illustration jobs/year. Prefers line art and cartoons. Pays by the project.

Tips: "Computer operators are not necessarily good designers, yet many are designing books. Know the basics of good typography before trying to use the computer."

THE GRADUATE GROUP, 86 Norwood Rd., W. Hartford CT 06117-2236. (203)232-3100. President: Mara Whitman. Estab. 1967. Publishes trade paperback originals. Types of books include instructional and reference. Specializes in internships and career planning. Publishes 25 titles/year. Titles include *Outstanding Résumés of College, Business and Law Graduates;*, *Internships for Law Students* and *Directory of Graduate Law Programs*. 10% require freelance illustration and design. Book catalog free by request.

Needs: Approached by 20 freelance artists/year. Works with 1 illustrator and 1 designer/year. Buys 4 illustrations/year. Prefers local artists only. Uses freelance artists for jacket/cover illustration and design and direct mail, book and catalog design. Needs computer-literate freelancers for illustration and presentation. 5% of freelance work demands computer skills. Works on assignment only.

First Contact & Terms: Send query letter with brochure and résumé. Samples are not filed. Reports back only if interested. Write for appointment to show portfolio.

GRAYWOLF PRESS, 2402 University Ave., St. Paul MN 55114. (612)641-0077. Fax: (612)641-0036. Design and Production Manager: Ellen Foos. Estab. 1985. Publishes hardcover originals and trade paperback originals and reprints of contemporary and experimental literary fiction. Specializes in novels, poetry, essays. Publishes 17 titles/year. Recent titles include *Camellia Street* and *Warrior For Gringostroika.* 60% require freelance design. Books use solid typography, strikingly beautiful and well-integrated artwork. Book catalog free by request.

 • Graywolf is recognized as one of the finest small presses in the nation.

Needs: Approached by 50 freelance artists/year. Works with 5 designers/year. Buys 20 illustrations/year (existing art only). Prefers artists with experience in literary titles. Uses freelancers mainly for text and cover design. Also for direct mail and catalog design. Needs computer-literate freelancers for design, production and presentation. 80% of freelance work demands knowledge of Aldus PageMaker, QuarkXPress or Aldus FreeHand. Works on assignment only.

First Contact & Terms: Send query letter with résumé and photocopies. Samples are returned by SASE if requested by artist. Art Director will contact artist for portfolio review if interested. Portfolio should include b&w, color photostats and tearsheets. Negotiates rights purchased. Interested in buying second rights (reprint rights) to previously published work. Originals are returned at job's completion. Pays by the project, $300-800.

Book Design: Assigns 15 jobs/year. Pays by the project, $400-800.

Jackets/Covers: Assigns 25 design jobs/year. Pays by the project, $400-800. "We use existing art—both contemporary and classical—and emphasize fine typography."

Tips: Finds artists through submissions and word of mouth. "Have a strong portfolio of literary (fine press) design. Desktop needs by small publishers are still in infancy, so designer should be able to provide some guidance."

■**GROSSET & DUNLAP,** 200 Madison Ave., New York NY 10016. (212)951-8736. Art Director: Ronnie Ann Herman. Publishes hardcover, trade paperback and mass market paperback originals and board books for pre-school and juvenile audience (ages 1-10). Specializes in "very young mass market children's books." Publishes 90 titles/year. 100% require freelance illustration; 10% require freelance design.

 • Many books by this publisher feature unique design components such as acetate overlays, 3-D pop-up pages, or actual projects/toys that can be cut out of the book.

Needs: Works with 50 freelance illustrators and 1-2 freelance designers/year. Buys 80 books' worth of illustrations/year. "Be sure your work is appropriate for our list." Uses freelance artists mainly for book illustration. Also for jacket/cover and text illustration.

First Contact & Terms: Send query letter with tearsheets, slides, photocopies and transparencies. Samples are filed. Reports back to the artist only if interested. Call for appointment to show portfolio, or mail slides, color tearsheets, transparencies and dummies. Rights purchased vary according to project. Originals are returned at job's completion.

Book Design: Assigns 20 design jobs/year (mechanicals only). Pays by the hour, $15-22 for mechanicals.

Jackets/Covers: Assigns approximately 10 cover illustration jobs/year. Pays by the project, $1,500-2,500.

Text Illustration: Assigns approximately 80 projects/year. Pays by the project, $4,000-10,000.

Tips: "Create great art that suits our needs: cute kids and animals."

■**GRYPHON PUBLICATIONS,** P.O. Box 209, Brooklyn NY 11228. Publisher: Gary Lovisi. Estab. 1983. Book and magazine publisher of hardcover originals, trade paperback originals and reprints, reference and magazines. Types of books include science fiction, fantasy, mystery and reference. Specializes in crime fiction and bibliography. Publishes 10 titles/year. Recent titles include *Difficult Lives,* by James Sallie; *Vampire Junkies,* by Norman Spinrad. 40% require freelance illustration; 10% require freelance design. Book catalog free for #10 SASE.

 • Also publishes *Hardboiled,* a quarterly magazine of noir fiction and *Paperback Parade* on collectible paperbacks.

Needs: Approached by 12 freelance artists/year. Works with 6 illustrators and 1 designer/year. Buys 10-12 illustrations/year. Prefers artists with "professional attitude." Uses freelancers mainly for book and magazine cover and interior illustrations. Also for jacket/cover, book and catalog design. Works on assignment only.

First Contact & Terms: Send query letter with brochure, résumé, SASE, tearsheets, photographs and photocopies. Samples are filed. Reports back within 2 weeks only if interested. Portfolio should include thumbnails, roughs, b&w tearsheets. Buys one-time rights. "I will look at reprints if they are of high quality and cost effective." Originals are returned at job's completion if requested.

Jackets/Covers: Assigns 2 design and 6 illustration jobs/year. Pays by the project, $25-150.
Text Illustration: Assigns 4 jobs/year. Pays by the project, $10-100. Prefers b&w line drawings.

🍁GUERNICA EDITIONS, P.O. Box 117, Station P, Toronto, Ontario M5S 2S6 Canada. (416)657-8885. Fax: (416)657-8885. Publisher/Editor: Antonio D'Alfonso. Estab. 1978. Book publisher and literary press specializing in translation. Publishes trade paperback originals and reprints. Types of books include contemporary and experimental fiction, biography, young adult and history. Specializes in ethnic/multicultural writing and translation of European and Quebecois writers into English and Italian/Canadian and Italian/American. Publishes 16-20 titles/year. Recent titles include *Benedetta in Guysterland*, by G. Rimanelli; *The Voices We Carry*, edited by M.J. Bona; *The Lion's Mouth*, by Caterina Edwards. 40-50% require freelance illustration. Book catalog available for SAE; nonresidents send IRC.
Needs: Approached by 6 artists/year. Works with 6 illustrators/year. Uses freelancers mainly for jacket/cover illustration.
First Contact & Terms: Send query letter with résumé, SASE (or SAE with IRC), tearsheets, photographs and photocopies. Samples are filed or are returned by SASE if requested by artist. Reports back only if interested. To show portfolio, mail photostats, tearsheets and dummies. Buys one-time rights. Originals are not returned at job completion.
Jackets/Covers: Assigns 10 illustration jobs/year. Pays by the project, $150-200.

■HARMONY HOUSE PUBLISHERS – LOUISVILLE, 1008 Kent Rd., Goshen KY 40026. (502)228-4446. Fax: (502)228-2010. Art Director: William Strode. Estab. 1980. Publishes hardcover originals. Specializes in general books, cookbooks and education. Publishes 20 titles/year. Recent titles include *The Saddlebred – America's Horse of Distinction* and *Sandhurst – The Royal Military Academy*. 10% require freelance illustration. Book catalog not available.
Needs: Approached by 10 freelance artists/year. Works with 2-3 freelance illustrators/year. Prefers artists with experience in each specific book's topic. Uses freelancers mainly for text illustration. Also for jacket/cover illustration. Usually works on assignment basis.
First Contact & Terms: Send query letter with brochure, résumé, SASE and appropriate samples. Samples are filed or are returned. Reports back to the artist only if interested. "We don't usually review portfolios, but we will contact the artist if the query interests us." Buys one-time rights. Sometimes returns originals at job's completion. Assigns 2 design and 2 illustration jobs/year. Pays by the project.

■HARVEST HOUSE PUBLISHERS, 1075 Arrowsmith, Eugene OR 97402. (503)343-0123. Fax: (503)342-6410. Production Manager: Fred Renich. Specializes in hardcover and paperback editions of adult fiction and nonfiction, children's books and youth material. Publishes 95 titles/year. Recent titles include *Donovan's Daughers*; *Wings of the Morning*; and *Addie McCormick & The Computer Pirate*. Books are of contemporary designs which compete with the current book market.
Needs: Works with 10 freelance illustrators and 4-5 freelance designers/year. Uses freelance artists mainly for cover art. Also uses freelance artists for text illustration. Works on assignment only.
First Contact & Terms: Send query letter with brochure, résumé, tearsheets and photographs. Samples are filed. Art Director will contact artist for portfolio review if interested. Requests work on spec before assigning a job. Originals may be returned at job's completion. Buys all rights.
Book Design: Pays by the project, $100 minimum.
Jackets/Covers: Assigns 65 design and 22 illustration jobs/year. Pays by the project, $1,000 minimum.
Text Illustration: Assigns 5 jobs/year. Pays by the project, $25-125.
Tips: Finds artists through word of mouth and artists' submissions/self-promotion.

‡■HEARTLAND SAMPLERS, INC., Suite. P, 5555 W. 78th St., Edina MN 55439. (612)942-7754. Fax: (612)942-6307. Art Director: Nancy Lund. Estab. 1987. Book publisher. Types of products include perpetual calendars, books and inspirational gifts. Publishes 50 titles/year. Recent titles include *Share the Hope* and *Tea Time Thoughts*. 100% require freelance illustration and design. Book catalog for SAE with first-class postage.
Needs: Approached by 4 freelance artists/year. Works with 10-12 freelance illustrators and 2-4 freelance designers/year. Buys 50 freelance illustrations/year. Prefers artists with experience in the gift and card market. Uses freelance artists mainly for illustrations. Also uses freelance artists for jacket/cover illustration and design; direct mail, book and catalog design.
First Contact & Terms: Send query letter with brochure, résumé, SASE, tearsheets, photographs, slides and photocopies. Samples are filed or are returned by SASE if requested by artist. Art Director will contact artist for portfolio review if interested. Portfolio should include thumbnails, roughs, 4-color photographs and

The maple leaf before a listing indicates that the market is Canadian.

dummies. Sometimes requests work on spec before assigning a job. Rights purchased vary according to project.

Book Design: Assigns 12 freelance design jobs/year. Pays by the project, $35-300.

Jackets/Covers: Assigns 15-40 freelance design jobs/year. Prefers watercolor, gouache and acrylic. Pays by the project, $50-350.

Text Illustration: Assigns 2 freelance design jobs/year. Prefers watercolor, gouache and acrylic. Pays by the project, $50-200.

■**HEAVEN BONE PRESS**, Box 486, Chester NY 10918. (914)469-9018. President/Editor: Steve Hirsch. Estab. 1987. Book and magazine publisher of trade paperback originals. Types of books include poetry and contemporary and experimental fiction. Publishes 4-6 titles/year. Titles include *Lines During War: A Collaboration of Word & Image After the Persian Gulf Incident, Dear Empire State Building* and *Red Bracelets*. Design of books is "off-beat, eclectic and stimulating." 80% require freelance illustration. Book catalog available for SASE.

 ● This publisher often pays in copies. Approach this market if you're seeking to build your portfolio and are not concerned with payment.

Needs: Approached by 10-12 freelance artists/year. Works with 3-4 illustrators. Buys 3-15 illustrations/year. Uses freelancers mainly for illustrations for books and *Heaven Bone* magazine. Needs computer-literate freelancers for illustration. 5% of work demands knowledge of QuarkXPress, Aldus FreeHand, Adobe Illustrator or Photoshop.

First Contact & Terms: Send query letter with brochure, tearsheets, photostats, photographs and slides. Samples are filed or returned by SASE. Reports back within 3 months. To show portfolio, mail finished art, photostats, tearsheets, photographs and slides. Rights purchased vary according to project. Originals are returned at job's completion.

Book Design: Assigns 1-2 design jobs/year. Prefers to pay in copies, but has made exceptions.

Jackets/Covers: Prefers to pay in copies, but has made exceptions. Prefers pen & ink, woodcuts and b&w drawings.

Text Illustration: Assigns 1-2 design jobs/year.

Tips: "Know our specific needs, know our magazine and be patient."

‡*HEMKUNT PRESS PUBLISHERS**, A-78 Naraina Indl. Area Ph.I, New Delhi 110028 India. Phone: 505079, 541-0083. Fax: 541-0032. Director: Mr. G.P. Singh. Specializes in educational text books, illustrated general books for children and also books for adults. Subjects include religion and history. Publishes 30-50 titles/year. Recent titles include *Macbeth (Annotated Shakespeare), Teen Guide to Safe Sex* and *Jatak Tales*.

Needs: Works with 30-40 freelance illustrators and 20-30 freelance designers/year. Uses freelance artists mainly for designing covers and illustrations. Also uses freelance artists for jacket/cover illustration. Works on assignment only.

First Contact & Terms: Send query letter with résumé and samples to be kept on file. Prefers photographs and tearsheets as samples. Samples not filed are not returned. Art Director will contact artist for portfolio review if interested. Requests work on spec before assigning a job. Originals not returned to artist. Considers complexity of project, skill and experience of artist and project's budget when establishing payment. Buys all rights. Interested in buying second rights (reprint rights) to previously published artwork.

Book Design: Assigns 40-50 titles/year. Payment varies.

Jackets/Covers: Assigns 30-40 freelance design jobs/year. Payment varies.

Text Illustration: Assigns 30-40 jobs/year. Pays by the project, $50-600.

T. EMMETT HENDERSON, PUBLISHER, 130 W. Main St., Middletown NY 10940. (914)343-1038. Contact: T. Emmett Henderson. Publishes hardcover and paperback local history, American Indian, archaeology and genealogy originals and reprints. Publishes 2-3 titles/year. 100% require freelance design and illustration.

First Contact & Terms: Send query letter and résumé. Reports in 1 month. Buys book rights. Originals returned at job's completion. Works on assignment only. "Check for our most recent titles in bookstores." Artist supplies overlays for cover artwork. No advance. No pay for unused assigned work. Assigns 5 advertising jobs/year; pays $10 minimum.

Jackets/Covers: Assigns 2-4 jobs/year. Uses freelancers for cover art work, some text illustration. Prefers representational style. Pays $20 minimum for b&w line drawings and color-separated work.

Text Illustrations: Pays $10 minimum for b&w. Buys 5-15 cartoons/year. Uses cartoons as chapter headings. Pays $5-12 minimum for b&w.

How to Use Your Artist's & Graphic Designer's Market *offers suggestions for understanding and using the information in these listings. Read this and other articles in the front of this book for important business tips.*

HERALD PRESS, 616 Walnut Ave., Scottdale PA 15683. (412)887-8500, ext. 244. Fax: (412)887-3111. Art Director: James M. Butti. Estab. 1908. Publishes hardcover and paperback originals and reprints. Specializes in inspirational, historical, juvenile, theological, biographical, fiction and nonfiction books. Publishes 24 titles/year. Recent titles include *Ellie* series, *The Great Shalom* and *Bioethics*. Books are "fresh and well illustrated." 60% require freelance illustration. Catalog available.

Needs: Approached by 75-100 freelance artists each year. Works with 6-8 illustrators/year. Prefers oil, pen & ink, colored pencil, watercolor, and acrylic in realistic style. Works on assignment only.

First Contact & Terms: Send query letter with brochure or résumé, tearsheets, photostats, slides and photographs. Samples are not filed and are returned by SASE. Reports back within 2 weeks. Originals are not returned at job's completion "except in special arrangements." To show portfolio, mail photostats, tearsheets, final reproduction/product, photographs and slides and also approximate time required for each project. Considers complexity of project, skill and experience of artist and project's budget when establishing payment. Buys all rights.

Jackets/Covers: Assigns 8 design and 8 illustration jobs/year. Pays by the project, $250-600 minimum.

Text Illustration: Assigns 6 jobs/year. Pays by the project, $200-400.

Tips: "Design we use is colorful, realistic and religious. When sending samples, show a wide range of styles and subject matter—otherwise you limit yourself."

HOLIDAY HOUSE, 425 Madison Ave., New York NY 10017. (212)688-0085. Editorial Director: Margery Cuyler. Specializes in hardcover children's books. Publishes 45 titles/year. 30% require freelance illustration. Recent titles include *The Hero of Bremen* and *Christopher: The Holy Giant*.

Needs: Approached by more than 125 freelance artists/year. Works with 10-15 artists/year. Prefers art suitable for children and young adults. Uses freelance artists mainly for interior illustration. Also uses freelance artists for jacket/cover illustration. Works on assignment only.

First Contact & Terms: Samples are filed or are returned by SASE. Request portfolio review in original query. Artist should follow up with call after initial query. Reports back only if interested. Considers complexity of project, skill and experience of artist and project's budget when establishing payment. Buys one-time rights. Originals are returned at job's completion.

Jackets/Covers: Assigns 10-15 illustration jobs/year. Prefers watercolor, then acrylic and charcoal/pencil. Pays by the project, $900-1,200.

Text Illustrations: Assigns 5-10 jobs/year. Pays royalty.

Tips: Finds artists through artists' submissions, agents and sourcebooks. "Show samples of everything you do well and like to do." A common mistake is "not following size specifications."

‡HOLLOW EARTH PUBLISHING, P.O. Box 1355, Boston MA 02205-1355. (603)433-8735. Fax: (603)433-8735. Publisher: Heilan Yvette Grimes. Estab. 1983. Company publishes hardcover originals and reprints, trade paperback originals and reprints, mass market paperback originals and reprints, textbooks and electronic books and CD-ROMs. Types of books include contemporary, experimental, mainstream, historical and science fiction, instruction, fantasy, travel, and reference. Specializes in mythology, photography, computers (Macintosh). Publishes 5 titles/year. Recent titles include *Norse Mythology*, *Legend of the Niebelungenlied*. 50% require freelance illustration; 50% require freelance design. Book catalog free for #10 SAE with 1 first-class stamp.

Needs: Approached by 50 freelance artists/year. Prefers artists with experience in computer graphics. Uses freelance artists mainly for graphics. Also uses freelance artists for jacket/cover design and illustration, text illustration and book design. Needs computer-literate freelancers for design, illustration, production and presentation. 100% of freelance work demands knowledge of Adobe Illustrator, QuarkXPress, Adobe Photoshop, Aldus FreeHand or rendering programs. Works on assignment only.

First Contact & Terms: Send query letter with brochure, résumé and SASE. Samples are filed or are returned by SASE if requested by artist. Reports back within 1 month. Art Director will contact artist for portfolio review if interested. Portfolio should include color thumbnails, roughs, tearsheets and photographs. Buys all rights. Originals are returned at job's completion.

Book Design: Assigns 12 book and magazine covers/year. Pays by the project, $100 minimum.

Jackets/Covers: Assigns 12 freelance design and 12 freelance illustration jobs/year. Pays by the project, $100 minimum.

Text Illustration: Assigns 12 freelance illustration jobs/year. Pays by the project, $100 minimum.

Tips: First-time assignments are usually article illustrations; covers are given to "proven" freelancers. Finds artists through submissions and word of mouth.

HOMESTEAD PUBLISHING, Box 193, Moose WY 83012. Art Director: Carl Schreier. Estab. 1980. Publishes hardcover and paperback originals. Types of books include nonfiction, natural history, Western art and general Western regional literature. Publishes more than 10 titles/year. Recent titles include *The Complete Guide to the Northwest's Bed and Breakfast Inns* and *Greater Yellowstone's Future*. 75% require freelance illustration. Book catalog free for SAE with 4 first-class stamps.

Needs: Works with 20 freelance illustrators and 10 freelance designers/year. Needs computer-literate freelancers for design and production. 25% of freelance work demands knowledge of Aldus PageMaker or Aldus

FreeHand. Works on assignment only. Prefers pen & ink, airbrush, charcoal/pencil and watercolor.
First Contact & Terms: Send query letter with printed samples to be kept on file or write for appointment to show portfolio. For color work, slides are suitable; for b&w technical pen, photostats. "Include one piece of original artwork to be returned." Samples not filed are returned by SASE only if requested. Reports within 10 days. Rights purchased vary according to project. Originals not returned.
Book Design: Assigns 6 freelance jobs/year. Pays by the project, $50-3,500.
Jackets/Covers: Assigns 2 design and 4 illustration jobs/year. Pays by the project, $50-3,500.
Text Illustration: Assigns 50 jobs/year. Prefers technical pen illustration, maps (using airbrush, overlays, etc.), watercolor illustrations for children's books, calligraphy and lettering for titles and headings. Pays by the hour, $5-20 or by the project, $50-3,500.
Tips: "We are using more graphic, contemporary designs and looking for the best quality."

‡**HOWELL PRESS, INC.**, Suite 2, 1147 River Rd., Charlottesville VA 22901. (804)977-4006. Fax: (804)971-7204. President: Ross Howell. Estab. 1985. Company publishes hardcover and trade paperback originals. Types of books include history, coffee table books, cookbooks, gardening and transportation. Publishes 5-6 titles/year. Recent titles include *Aviation: A History Through Art* and *Sunday Drivers: Nascar Winston Cup Stock Car Racing.* 100% requires freelance illustration and design. Book catalog free by request.
Needs: Approached by 6-8 freelance artists/year. Works with 0-1 freelance illustrator and 1-2 freelance designers/year. Uses freelance artists mainly for graphic design. Also uses freelance artists for jacket/cover, direct mail, book and catalog design. Needs computer-literate freelancers for design and production. 80% of freelance work demands computer skills in Aldus PageMaker, Adobe Illustrator or QuarkXPress.
First Contact & Terms: Send query letter with SASE, tearsheets and slides. Samples are not filed and are returned by SASE if requested by artist. Reports back within 1 month. Art Director will contact artist for portfolio review if interested. Portfolio should include color tearsheets and slides. Negotiates rights purchased. Originals are returned at job's completion.
Book Design: Assigns 5-6 freelance design jobs/year. Pays for freelance design by the hour, $15-25; by the project, $500-5,000.
Tips: Finds artists through submissions.

HUMANICS LIMITED, 1482 Mecaslin St. NW, Atlanta GA 30309. (404)874-2176. Fax: (404)874-1976. Acquisitions Editor: W. Arthur Bligh. Estab. 1976. Publishes soft and hardcover children's books, trade paperback originals and educational activity books. Publishes 12 titles/year. Titles include *Listening is a Way of Loving, Balance of Body, Balance of Mind* and *The Adventure of Paz in the Land of Numbers.* Learning books are workbooks with 4-color covers and line art within; Children's House books are high-quality books with full color; trade paperbacks are 6×9 with 4-color covers. Book catalog for 9×12 SASE. Specify which imprint when requesting catalog: Learning, Children's House or trade paperbacks.
Needs: Works with 3-5 freelance illustrators and designers/year. Needs computer-literate freelancers for design, production and presentation. 75% of freelance work demands knowledge of Aldus PageMaker or Ventura. Works on assignment only.
First Contact & Terms: Send query letter with résumé, SASE, photocopies and slides. Samples are filed or are returned by SASE if requested by artist. Rights purchased vary according to project. Originals not returned.
Book Design: Pays by the project, $250 minimum.
Jackets/Covers: Pays by the project, $150 minimum.
Text Illustration: Pays by the project, $150 minimum.

‡**CARL HUNGNESS PUBLISHING**, Box 24308, Speedway IN 46224. (317)244-4792. Editorial Director: Carl Hungness. Publishes hardcover *automotive* originals. Publishes 2-4 titles/year.
First Contact & Terms: Send query letter with samples and SASE. Reports in 2 weeks. Offers $100 advance. Pays no kill fee. Buys one-time or all rights.

INCENTIVE PUBLICATIONS INC., 3835 Cleghorn Ave., Nashville TN 37215. (615)385-2934. Art Director: Marta Johnson Drayton. Specializes in supplemental teacher resource material, workbooks and arts and crafts books for children K-8. Publishes 15-30 titles/year. Recent titles include *On The Loose with Dr. Suess* and *Thematic Learning Adventures.* 40% require freelance illustration. Books are cheerful, warm, colorful, uncomplicated and spontaneous.
Needs: Works with 3-6 freelance illustrators and 1-2 freelance designers/year. Uses freelancers mainly for covers and text illustraion. Also uses freelance artists for promo items (very occasionally). Works on assignment only primarily with local artists. 25% of freelance work demands knowledge of Adobe Illustrator, QuarkXPress or Aldus FreeHand.
First Contact & Terms: Send query letter with brochure showing art style, résumé, tearsheets and/or photostats. Samples are filed. Samples not filed are returned by SASE. Art Director will contact artist for portfolio review if interested. Portfolio should include original/final art, photostats, tearsheets and final reproduction/product. Sometimes requests work on spec before assigning a job. Considers complexity of project, project's budget and rights purchased when establishing payment. Buys all rights. Originals not returned.

Jackets/Covers: Assigns 4-6 illustration jobs/year. Prefers 4-color covers in any medium. Pays by the project, $200-350.

Text Illustration: Assigns 4-6 jobs/year. Black & white line art only. Pays by the project, $175-1,250.

Tips: "We look for a warm and whimsical style of art that respects the integrity of the child. Freelancers should be aware that in this particular field immediate visual impact and legibility of title are important."

INSTRUCTIONAL FAIR, INC., Box 1650, Grand Rapids MI 49501. Creative Coordinator: Annette Hollister Papp. Publishes supplemental education materials for elementary/middle school levels in all curriculum areas for elementary and middle school teachers, parents and home schoolers.

Needs: Works with several freelance artists/year. Need computer-literate as well as fine art freelancers for illustration and production. 20% of freelance work demands knowledge of Aldus PageMaker, Adobe Illustrator, QuarkXPress or Aldus FreeHand. Works on assignment only.

First Contact & Terms: Send query letter with photostats. Samples are filed or are returned if requested. Reports back within 1-2 months only if interested. Write for appointment to show portfolio, or mail samples. Pays by the project (amount negotiated). Considers client's budget and how work will be used when establishing payment. Buys all rights.

‡INTERCULTURAL PRESS, INC., 16 U.S. Route 1, Yarmouth ME 04096. (207)846-5168. Fax: (207)846-5181. Production Coordinator: Patty Topel. Estab. 1982. Company publishes trade paperback originals. Types of books include contemporary fiction, travel and reference. Specializes in intercultural and multicultural. Publishes 12 titles/year. Recent titles include *Crossing Cultures Through Film*, *Education for the Intercultural Experience*, *L.A. Stories*. 100% require freelance illustration. Book catalog free upon request.

Needs: Approached by 20 freelance artists/year. Works with 10 freelance illustrators/year. Buys 12-15 freelance illustrations/year. Prefers artists with experience in trade books, multicultural field. Uses freelance artists mainly for jacket/cover design and illustration. Also uses freelance artists for book design. Needs computer-literate freelancers for design, illustration and production. 50% of freelance work demands knowledge of Aldus PageMaker or Adobe Illustrator. Works on assignment only.

First Contact & Terms: Send query letter with brochure, tearsheets, résumé and photocopies. Samples are filed or are returned by SASE if requested by artist. Does not report back. Art Director will contact artist for portfolio review if interested. Portfolio should include b&w final art. Buys all rights. Originals are not returned.

Jackets/Coverss: Assigns 10 freelance illustration jobs/year. Pays by the project, $300-500.

Text Illustration: Assigns 1 freelance illustration job/year. Pays "by the piece depending on complexity." Prefers b&w line art.

Tips: First-time assignments are usually book jackets; book jackets and interiors are usually given to "proven" freelancers. Finds artists through submissions and word of mouth.

JALMAR PRESS, Suite 204, 2675 Skypark Dr., Torrance CA 90505-5330. (310)784-0016. Fax: (310)784-1379. President: Bradley L. Winch. Project and Production Director: Jeanne Iler. Art Director: Mario A. Artavia II. Estab. 1971. Publishes books emphasizing positive self-esteem. Recent titles include *Staff Esteem Builders* and *The Learning Revolution*. Books are contemporary, yet simple.

Needs: Works with 3-5 illustrators and 5 designers/year. Uses freelancers mainly for cover design and illustration. Also uses freelance artists for direct mail and book design. Works on assignment only.

First Contact & Terms: Send query letter with brochure showing art style. Samples not filed are returned by SASE. Artist should follow up after initial query. Needs computer-literate freelancers for design and illustration. 80% of freelance work demands knowledge of Aldus PageMaker, Adobe Illustrator and QuarkXPress. Buys all rights. Considers reprints but prefers original works. Considers complexity of project, budget and turnaround time when establishing payment.

Book Design: Pays by the project, $200 minimum.

Jackets/Covers: Pay by the project, $400 minimum.

Text Illustration: Pays by the project, $25 minimum.

Tips: "Portfolio should include samples that show experience. Don't include 27 pages of 'stuff'. Stay away from the 'cartoonish' look. If you don't have any computer design and/or illustration knowledge – get some! If you can't work on computers, at least understand the process of using traditional artwork with computer generated film. For us to economically get more of our product out (with fast turnaround and a minimum of rough drafts), we've gone exclusively to computers for total book design; when working with traditional artists, we'll scan their artwork and place it within the computer generated document."

JSA PUBLICATIONS, INC., Box 37175, Oak Park MI 48237. (810)932-0090. Director: Joe Ajlouny. Estab. 1985. Book producer and packagers. Recent titles include *Love to Hate Madonna Joke Book*, by Joey West (for Pinnacle Books); *101 Things Not to Say During Sex*, by Patti Putnick (for Warner Books); *No Chairs Make for Short Meetings*, by Richard Rybolt (for Dutton). Books are attractive, direct and simple; covers should fully describe contents.

Needs: Works with 25 freelance illustrators and 10 freelance designers/year. Uses freelance artists mainly for illustration. Also uses freelance artists for jacket/cover and book design. Considers greeting cards, comic

strips, map art, caricatures, editorial or political cartoons. Will also accept fully completed book proposals.
First Contact & Terms: Send query letter with résumé and enough samples to accurately express artist's talent and styles. Samples are filed or are returned by SASE only if requested. Art Director will contact artist for portfolio review if interested. Sometimes requests work on spec before assigning a job.
Book Design: Pays by the project, $250-1,000.
Jackets/Covers: Pays by the project, $400-2,000.
Text Illustration: Pay by the project, $25-100/illustration.
Tips: All submissions "must be of professional quality. Have a superior method of expression. Develop a theme and title concept and stick to it. We prefer educational, informational, contemporary submissions. We see a tightening of the market and fewer titles being published."

‡**KALMBACH PUBLISHING CO.,** 21027 Crossroads Circle, P.O. Box 1612, Waukesha WI 53187. (414)796-8776. Fax: (414)796-1142. Books Art Director: Sabine Beaupré. Estab. 1934. Imprints include Greenberg Books. Company publishes hardcover and trade paperback originals. Types of books include instruction, reference and history. Specializes in hobby books. Publishes 26 titles/year. Recent titles include *How to Build Your First Lionel Layout* and *Chasing the Shadow: An Observer's Guide to an Eclipse.* 20-30% require freelance illustration; 10-20% require freelance design. Book catalog free by request.
Needs: Approached by 10 freelance artists/year. Works with 5 freelance illustrators and 2 freelance designers/year. Buys 20 freelance illustrations/year. Prefers artists with experience in the hobby field. Uses freelance artists mainly for book layout, line art illustrations. Also uses freelance artists for book design. Needs computer-literate freelancers for design and illustration. 90% of freelnace work demands knowledge of Adobe Illustrator, QuarkXPress or Adobe Photoshop. Works on assignment only.
First Contact & Terms: Send query letter with résumé, tearsheets and photocopies. Samples are filed. Reports back within 2 weeks. Art Director will contact artist for portfolio review if interested. Portfolio should include slides and final art. Rights purchased vary according to project. Originals are returned at job's completion.
Book Design: Assigns 5 freelance design jobs/year. Pays by the project, $1,000-3,000.
Text Illustration: Assigns 10-20 freelance illustration jobs/year. Pays by the project, $500-2,000.
Tips: First-time assignments are usually text illustration, simple book layout; complex track plans, etc., are given to "proven" freelancers. Finds artists through word of mouth, artists' submissions.

KAR-BEN COPIES, INC., 6800 Tildenwood Lane, Rockville MD 20852. Fax: (301)881-9195. Editor: Madeline Wikler. Estab. 1975. Specializes in hardcovers and paperbacks on juvenile Judaica. Publishes 10-12 titles/year. Recent titles include *Thank You, God*; *Tell Me A Mitzvah*; and *Matzah Ball—A Passover Story.* Books contain "colorful illustraions to appeal to young readers." 100% require freelance illustration. Book catalog free on request.
Needs: Uses 10-12 illustrators/year. Uses freelance artists mainly for book illustration. Also for jacket/cover design and illustration, book design and text illustration.
First Contact & Terms: Send query letter with photostats or tearsheets to be kept on file or returned. Samples not filed are returned by SASE. Reports within 2 weeks only if SASE included. Originals returned at job's completion. Sometimes requests work on spec before assigning a job. Considers skill and experience of artist and turnaround time when establishing payment. Pays by the project, $500-3,000 average, or advance plus royalty. Buys all rights. Considers buying second rights (reprint rights) to previously published artwork.
Tips: "Send samples showing active children, not animals or still life. We are using more full-color as color separation costs have gone down."

ALFRED A. KNOPF, INC., 201 E. 50th St., New York NY 10022. (212)751-2600. Art Director: Virginia Tan. Imprint is Random House. Publishes hardcover originals for adult trade. Specializes in history, art and cookbooks. Publishes 150 titles/year. Recent titles include *Cooking With Master Chefs, Disclosure* and *The Victory Garden Fish and Vegetable Cookbook.*
 • Jackets and covers are done in another department.
Needs: Works with 3-5 freelance illustrators and 3-5 freelance designers/year. Prefers artists with experience in b&w. Uses freelancers mainly for cookbooks and biographies. Also for text illustration and book design.
First Contact & Terms: Send query letter with SASE. Request portfolio review in original query. Artist should follow up. Sometimes requests work on spec before assigning a job. Originals are returned at job's completion.
Book Design: Pays by the hour, $15-30; by the project, $450 minimum.
Text Illustration: Pays by the project, $100-5,000; $50-150/illustration; $300-800/maps.
Tips: Finds artists through submissions, agents and sourcebooks. "Freelancers should be aware that Macintosh/Quark is a must for design and becoming a must for maps and illustration."

LEE & LOW BOOKS, 14th Floor, 228 E. 45th St., New York NY 10017. (212)867-6155. Fax: (212)338-9059. Publisher: Philip Lee. Editor-in-Chief: Elizabeth Szabla. Estab. 1991. Book publisher. Publishes hardcover originals and reprints for the juvenile market. Specializes in multicultural children's books. Publishes 6-10

titles/year. First list published in spring 1993. Recent titles include *Baseball Saved Us* and *Abuela's Weave*. 100% require freelance illustration and design. Book catalog available.

Needs: Approached by 100 freelance artists/year. Works with 6-10 illustrators and 1-3 designers/year. Uses freelancers mainly for illustration of children's picture books. Also for direct mail and catalog design. Needs computer-literate freelancers. Needs 10% of freelance presentation work demands computer literacy. Works on assignment only.

First Contact & Terms: Contact through artist rep or send query letter with brochure, résumé, SASE, tearsheets, photocopies and slides. Samples are filed. Reports back within 1 month. Art Director will contact artist for portfolio review if interested. Portfolio should include b&w and color tearsheets, slides and dummies. Rights purchased vary according to project. Originals returned at job's completion.

Book Design: Pays by the project, $1,500.

Text Illustration: Pays by the project, $3,000.

Tips: "We want an artist who can tell a story through pictures and is familiar with the children's book genre. Lee & Low Books makes a special effort to work with writers and artists of color and encourages new voices."

LEISURE BOOKS, a division of Dorchester Publishing Co., Inc., Suite 1008, 276 Fifth Ave., New York NY 10001. (212)725-8811. Managing Editor: Katherine Carlon. Estab. 1970. Specializes in paperback, originals and reprints, especially mass market category fiction—realistic historical romance, western, adventure, horror. Publishes 144 titles/year. Recent titles include *Roselynde*, *Savage Ember* and *Bittersweet Promises*. 90% require freelance illustration.

Needs: Works with 24 freelance illustrators and 6 freelance designers/year. Uses freelance artists mainly for covers. "We work with freelance art directors; editorial department views all art initially and refers artists to art directors. We need highly realistic, paperback illustration; oil or acrylic. No graphics, fine art or photography." Works on assignment only.

First Contact & Terms: Send samples by mail. No samples will be returned without SASE. Reports only if samples are appropriate and if SASE is enclosed. Call for appointment to drop off portfolio. Portfolios may be dropped off Monday-Thursday. Sometimes requests work on spec before assigning a job. Considers complexity of project and project's budget when establishing payment. Usually buys first rights, but rights purchased vary according to project. Interested in buying second rights (reprint rights) to previously published work "for contemporary romance only." Originals returned at job's completion.

Jackets/Covers: Pays by the project.

Tips: "Talented new artists are welcome. Be familiar with the kind of artwork we use on our covers. If it's not your style, don't waste your time and ours."

LIBRARIES UNLIMITED, Box 6633 Englewood CO 80155-6633. (303)770-1220. Fax: (303)220-8843. Contact: Publicity Department. Estab. 1964. Specializes in hardcover and paperback original reference books concerning library science and school media for librarians, educators and researchers. Also specializes in resource and activity books for teachers. Publishes more than 60 titles/year. Book catalog free by request.

Needs: Works with 4-5 freelance artists/year. Works on assignment only.

First Contact & Terms: Send query letter with résumé and photocopies. Samples not filed are returned only if requested. Reports within 2 weeks. Considers complexity of project, skill and experience of artist, and project's budget when establishing payment. Buys all rights. Originals not returned.

Text Illustration: Assigns 2-4 illustration jobs/year. Pays by the project, $100 minimum.

Jackets/Covers: Assigns 4-6 design jobs/year. Pays by the project, $250 minimum.

Tips: "We look for the ability to draw or illustrate without overly-loud cartoon techniques. Freelancers should have the ability to use two-color effectively, with screens and screen builds. We ignore anything sent to us that is in four-color. We also need freelancers with a good feel for typefaces."

‡LIFETIME BOOKS, 2131 Hollywood Blvd., Hollywood FL 33020. (305)925-5242. President: Donald L. Lessne. Specializes in hardcovers, paperbacks and magazines—mostly trade books. Publishes 20 titles/year. Recent titles include *Kathy: A Case Of Nymphomania*; *Dr. Death: Dr. Jack Kevorkian's Rx: Death*; *How to Make A Great Presentation in Two Hours*. Books have a striking look.

Needs: Works with 3 freelance illustrators and 3 freelance designers/year. Uses freelance artists mainly for cover, jacket and book design. Also uses freelance artists for jacket/cover and text illustration, book and catalog design, tip sheets and direct mail. Prefers local artists only. Needs computer-literate freelancers for

The solid, black square before a listing indicates that it is judged a good first market by the Artist's & Graphic Designer's Market editors. Either it offers low payment, pays in credits and copies, or has a very large need for freelance work.

design, illustration and production. 50% of freelance work demands knowledge of Aldus PageMaker. Works on assignment only.

First Contact & Terms: Send brochure showing art style or photocopies. Samples not filed are returned only if requested. Editor will contact artists for portfolio review if interested. Originals are returned to artist at job's completion unless requested. Considers rights purchased when establishing payment. Rights purchased vary according to project. Interested in buying second rights (reprint rights) to previously published work.

Book Design: Assigns 20 freelance design and 20 freelance illustration jobs/year. Pays by the project, $400-1,000.

Jackets/Covers: Assigns 20 freelance design and a variable amount of freelance illustration jobs/year. Pays by the project, $400-1,000.

Tips: "As the trade market becomes more competitive, the need for striking, attention-grabbing covers increases."

LITTLE AMERICA PUBLISHING CO., 9725 SW Commerce Cir., Wilsonville OR 97070. (503)682-0173. Fax: (503)682-0175. Production Manager: Jacelen Pete. Estab. 1986. Imprint of Beautiful America Publishing Co. Publishes hardcover originals for pre-school and juvenile markets. Recent titles include *Melody's Mystery* and *Journey of Hope* both by Diane Kelsay Harvey and Bob Harvey. 50% require freelance illustration. Book catalog available by request.

Needs: Approached by 20 freelance artists/year. Uses 3 freelance illustators and 2 freelance designers/year. Also uses freelance artists for jacket/cover and text illustration. Works on assignment only.

First Contact & Terms: Send query letter with brochure, résumé, tearsheets and photostats. Samples are filed or are returned by SASE. Art Director will contact artist for portfolio review if interested. Portfolio should include tearsheets and color copies. Sometimes requests work on spec before assigning a job. Generally pays royalty. Negotiates rights purchased. Originals are returned at job's completion.

Tips: Finds artists generally through word of mouth. "Most artists find us."

■**THE LITURGICAL PRESS**, St. John's Abbey, Collegeville MN 56321. (612)363-2213. Fax: (612)363-3278. Art Director: Ann Blattner. Estab. 1926. Publishes hardcover and trade paperback originals and textbooks. Specializes in liturgy and scripture. Publishes 150 titles/year. 50% require freelance illustration and design. Book catalog available for SASE.

Needs: Approached by 100 freelance artists/year. Works with 20 illustrators and 25 designers/year. Buys 100 illustrations/year. Uses freelancers for book cover design, jacket/cover illustration and design and text illustration. 25% of freelance work demands computer knowledge.

First Contact & Terms: Send query letter with brochure, photograph, photocopies and slides. Samples are filed. Reports back to the artist only if interested. To show portfolio, mail b&w photostats and photographs. Rights purchased vary according to project. Originals returned at job's completion.

Jackets/Covers: Assigns 100 design and 50 illustration jobs/year. Pays by the project, $150-450.

Text Illustration: Assigns 25 illustration jobs/year. Pays by the project, $45-250.

‡**LLEWELLYN PUBLICATIONS**, Box 64383, St. Paul MN 55164. Art Director: Christopher Wells. Estab. 1901. Book publisher. Imprint of Llewellyn. Publishes hardcover originals, trade paperback originals and reprints, mass market originals and reprints and calendars. Types of books include reference, self-help, metaphysical, occult, mythology, health, women's spirituality and New Age. Publishes 60 titles/year. Recent titles include *Animal Speak* and *Revealing Hands*. Books have photo realistic painting and computer generated graphics. 60% require freelance illustration. Book catalog available for large SASE and 5 first-class stamps.

Needs: Approached by 200 freelance artists/year. Works with 35 freelance illustrators and 5 freelance designers/year. Buys 150 freelance illustrations/year. Prefers artists with experience in book covers, New Age material and realism. Uses freelance artists mainly for photorealistic paintings and drawings. Also uses freelance artists for jacket/cover desgin and illustration, text illustration and direct mail, book, catalog and magazine design. Needs computer-literate illustrators with knowledge of Adobe Illustrator. Works on assignment only.

First Contact & Terms: Send query letter with brochure, SASE, tearsheets, photographs and photocopies. Samples are filed or are returned by SASE. Art Director will contact artist for portfolio review if interested. Sometimes requests work on spec before assigning a job. Negotiates rights purchased. Interested in buying second rights (reprint rights) to previously published work.

Jackets/Covers: Assigns 40 freelance illustration jobs/year. Pays by the illustration, $150-600. Media and style preferred "are usually realistic, well-researched, airbrush, acrylic, oil, colored pencil. Artist should know our subjects."

Text Illustration: Assigns 15 freelance illustration jobs/year. Pays by the project, or $30-100/illustration. Media and style preferred are pencil and pen & ink, "usually very realistic; there are usually people in the illustrations."

Tips: "Know what we publish and send similar samples. I need artists who are aware of occult themes, knowledgeable in the areas of metaphysics, divination, alternative religions, women's spirituality, and who are professional and able to present very refined and polished finished pieces. Knowledge of history, mythology and ancient civilization are a big plus. Be familiar with desktop art programs, page layout, etc."

LODESTAR BOOKS, an affiliate of Dutton Children's Books, 375 Hudson St., New York NY 10014. (212)366-2626. Senior Editor: Rosemary Brosnan. Publishes young adult fiction (12-16 years) and nonfiction hardcovers; fiction and nonfiction for ages 9-11 and 10-14; and nonfiction and fiction picture books. Publishes 25 titles/year. Recent titles include *The Ancestor Tree* and *Juan Bobo and the Pig.*
Needs: Works with approximately 30 illustrators and 4 designers/year. Uses freelance artists mainly for jackets for middle grade and young adult novels. Especially looks for "knowledge of book requirements, previous jackets, good color, strong design and ability to draw people and action." Needs computer-literate designers. Prefers to buy all rights.
First Contact & Terms: Send samples. Request portfolio review in original query. Art Director will contact artist for portfolio review if interested.
Book Design: Pays by the hour, $20-35; by the project, $2,000-4,000.
Jackets/Covers: Assigns approximately 10-12 jackets/year to freelancers. Pays by the project, $800-1,200 for color.
Text Illustration: Pays royalty.
Tips: "We often work through an artists rep to find new illustrators; occasionally an artist's portfolio is so outstanding that we keep him or her in mind for a project. Book design is becoming bolder and more graphic. Nonfiction jackets usually have a strong single image or a photograph and are often 3-color jackets. Fiction tends to the dramatic and realistic and are always in full color."

‡**LUCENT BOOKS,** Box 289011, San Diego CA 92128-9011. (619)485-7424. Managing Editor: Bonnie Szumski. Estab. 1988. Book publisher. Publishes nonfiction for libraries and classrooms. Specializes in juvenile and young adult. Specializes in controversial issues, discovery and invention, history and biography. Publishes 30 titles/year. Titles include *Telescopes: Encyclopedia of Discovery and Invention* and *Eating Disorders.* Book catalog free for SASE.
First Contact & Terms: Approached by 50-75 freelance artists/year. Works with 1-2 freelance illustrators and 1-2 freelance designers/year. Buys 25-30 freelance illustrations/year. Prefers artists with experience in "young adult books with a realistic style in pen & ink or pencil, able to draw creatively, not from photographs." Uses freelance artists mainly for technical drawings for the Encyclopedia series. Also uses freelance artists for jacket/cover and text illustration. Works on assignment only. Send query letter with résumé, tearsheets and photocopies. Samples are filed. Reports back to the artist only if interested. To show portfolio, mail appropriate materials. Buys all rights. Originals are not returned at job's completion.
Book Design: Pays by the project, $100-1,500.
Jackets/Covers: Pays by the project, $350-600.
Text Illustration: Assigns 8-10 freelance illustration jobs/year. Pays by the project, $100-1,500. Prefers pencil and pen & ink.
Tips: "We have a very specific style in mind and can usually tell immediately from samples whether or not an artist's style suits our needs."

‡**McFARLAND & COMPANY, INC., PUBLISHERS,** Box 611, Jefferson NC 28640. (910)246-4460. Fax: (910)246-5018. Assistant Sales Manager: Chris Robinson. Estab. 1979. Company publishes hardcover and trade paperback originals. Specializes in nonfiction reference and scholarly monographs, including film and sports. Publishes 120 titles/year. Recent titles include *Television Series Revivals, Films by Genre* and *Basic Library Skills.* Book catalog free by request.
Needs: Approached by 50 freelance artists/year. Works with 5-8 freelance illustrators/year. Buys 75 freelance illustrations/years. Prefers artists with experience in catalog and brochure work in performing arts and school market. Uses freelance artists mainly for promotional material. Also uses freelance artists for direct mail and catalog design. Works on assignment only.
First Contact & Terms: Send query letter with résumé, SASE and photocopies. Samples are filed. Reports back within 2 weeks. Portfolio review not required. Buys all rights. Originals are not returned.
Tips: First-time assignments are usually school promotional materials; performing arts promotional materials are given to "proven" freelancers.

■**McKINZIE PUBLISHING COMPANY,** 11000 Wilshire Blvd., P.O. Box 241777, Los Angeles CA 90024-9577. (213)934-7685. Fax: (213)931-7217. Director of Art: Nancy Freeman. Estab. 1969. Publishes hardcover, trade and mass market paperback originals, and textbooks. Publishes all types of fiction and nonfiction. Publishes 15 titles/year. Recent titles include *USMC Force Recons: A Black Hero's Story.* Book catalog for SASE.

The double dagger before a listing indicates that the listing is new in this edition. New markets are often more receptive to freelance submissions.

Needs: Uses freelance artists for jacket/cover design and illustration. Also uses freelance artists for jacket/cover design and illustration, text illustration and direct mail and book catalog design. Works on assignment only.

First Contact & Terms: Send query letter with SASE, photographs and photocopies. Samples are filed or are returned by SASE. Portfolio should include thumbnails and roughs. Sometimes requests work on spec before assigning a job. Buys all rights. Originals are not returned. Pays by the project, negotiated.

Tips: "Looking for design and illustration that is appropriate for the general public. Book design is becoming smoother, softer and more down to nature with expression of love of all — humanity, animals and earth."

MACMILLAN PUBLISHING (COLLEGE DIVISION), 445 Hutchinson Ave., Columbus OH 43235. (614)841-3700. Fax: (614)841-3645. Cover Designer: Cathleen Carbery. Imprint of Macmillan Publishing/Merrill Publishing. Specializes in instructional books in education, business, sciences and other topics. Publishes 300 titles/year.

Needs: Approached by 25-40 freelance artists/year. Works with 30 illustrators/year. Buys 90 illustrations/year. Uses freelancers mainly for book cover illustrations in all types of media. Also for jacket/cover design. Needs computer-literate freelancers for design and illustration. 30% of freelance work demands knowledge of QuarkXPress, Aldus FreeHand, Adobe Illustrator or Photoshop.

First Contact & Terms: Send query letter with tearsheets, slides or transparencies. Samples are filed and portfolios are returned. Reports back within 3 days. To show portfolio, mail tearsheets and transparencies. Rights purchased vary according to project. Originals returned at job's completion.

Book Design: Pays by the project, $400-1,500.

Jackets/Covers: Assigns 90 illustration jobs/year.

Tips: "Send a style that works well with our particular disciplines. Almost all covers are produced with a computer, but the images from freelancers can come in in whatever technique they prefer. We are looking for new art produced on the computer."

MADISON BOOKS, Dept. AM, 4720 Boston Way, Lanham MD 20706. (301)459-5308. Fax: (301)459-2118. Vice President, Design: Gisele Byrd. Estab. 1984. Publishes hardcover and trade paperback originals. Specializes in biography, history and popular culture. Publishes 16 titles/year. Recent titles include *Ships That Changed History, Abandoned* and *The Ambassador From Wall Street.* 40% require freelance illustration; 100% require freelance jacket design. Book catalog free by request.

Needs: Approached by 20 freelance artists/year. Works with 4 illustrators and 12 designers/year. Buys 2 illustrations/year. Prefers artists with experience in book jacket design. Uses freelancers mainly for book jackets. Also for book and catalog design. Needs computer-literate freelancers for design, illustration, production and presentation. 80% of freelance work demands knowledge of Adobe Illustrator, QuarkXPress, Photoshop or Aldus FreeHand. Works on assignment only.

First Contact & Terms: Send query letter with tearsheets, photocopies and photostats. Samples are filed or are returned by SASE if requested by artist. Reports back to the artist only if interested. Call for appointment to show portfolio of roughs, original/final art, tearsheets, photographs, slides and dummies. Buys all rights. Interested in buying second rights (reprint rights) to previously published work.

Book Design: Assigns 2 design jobs/year. Pays by the project, $1,000-2,000.

Jackets/Covers: Assigns 16 design and 2 illustration jobs/year. Pays by the project, $200-500. Prefers typographic design, photography and line art.

Text Illustration: Pays by project, $100 minimum.

Tips: "We are looking to produce trade-quality designs within a limited budget. Covers have large type, clean lines, they 'breathe.' If you have not designed jackets for a publishing house but want to break into that area, have at least five 'fake' titles designed to show ability. I would like to see more Eastern European style incorporated into American design. It seems like typography on jackets is becoming more assertive, as it competes for attention on bookstore shelf. Also, trends are richer colors, use of metallics."

‡MEADOWBROOK PRESS, 18318 Minnetonka Blvd., Deephaven MN 55391. (612)473-5400. Fax: (612)475-0736. Production Manager: Amy Unger. Company publishes hardcover and trade paperback originals. Types of books include instruction, humor, juvenile, pre-school and parenting. Specializes in parenting, humor. Publishes 10-15 titles/year. Recent titles include *New Adventures of Mother Goose, Funny Side of Parenthood* and *Practical Parenting Tips.* 80% requires freelance illustration; 30% requires freelance design. Book catalog free by request.

Needs: Approached by 100 freelance artists/year. Works with 5 freelance illustrators and 3 freelance designers/year. Buys 200 freelance illustrations/year. Uses freelance artists mainly for children's fiction, medical-type illustrations, activity books, spot art. Also uses freelance artists for jacket/cover and text illustration. Needs computer-literate freelancers for design and production. 30% of freelance work demands knowledge of QuarkXPress or Adobe Photoshop. Works on assignment only.

First Contact & Terms: Send query letter with tearsheets, photocopies and business card. Samples are filed and are not returned. Reports back only if interested. Art Director will contact artist for portfolio review if interested. Portfolio should include b&w and color final art and transparencies. Buys all rights. Originals are returned at job's completion.

Book Design: Assigns 2 freelance design jobs/year. "Pay varies with complexity of project."
Jackets/Covers: Assigns 3 freelance design and 6 freelance illustration jobs/year. Pays by the project, $300-600.
Text Illustration: Assigns 6 freelance illustration jobs/year. Pays by the project, $80-150.
Tips: First-time assignments are usually text illustration; cover art is given to "proven" illustrators. Finds artists through agents, sourcebooks and artists' submissions.

‡MERIWETHER PUBLISHING LTD., Box 7710, Colorado Springs CO 80907. (719)594-4422. Contact: Tom Myers. Estab. 1969.
Needs: Approached by 10-20 freelance artists/year. Works with 1-2 freelance illustrators/year. Uses freelance artists for jacket/cover and text illustration.
First Contact & Terms: Send photostats and photographs (Mac files are okay). Rarely needs loose line humorous cartooning. Samples are returned by SASE if requested by artist. Portfolio review not required.
Text Illustration: Negotiable rate.

METAMORPHOUS PRESS, Box 10616, Portland OR 97210-0616. (503)228-4972. Publisher: David Balding. Estab. 1982. Specializes in hardcover and paperback originals; general trade books—mostly nonfiction and self-help. Publishes 2-5 titles/year. Recent titles include *Making The Message Clear* and *Megateaching & Learning*. Books are computer generated. 1% require freelance illustration.
• Freelancers with experience in typography have the best chance of cracking this market.
Needs: Approached by 200 freelance artists/year. Works with 0-1 designers and 0-1 illustrators/year. "We're interested in what an artist can do for us—not experience with others." Needs computer-literate designers. Works on assignment only.
First Contact & Terms: Send query letter with brochure, business card, photostats, photographs and tearsheets to be kept on file. Samples are not returned. Considers complexity of project and project's budget when establishing payment. Rights purchased vary according to project.
Tips: "We rarely, if ever, use freelance illustrators and would probably use a local artist over others. Our book designs are becoming more sophisticated and contemporary, taking on a trade book look."

MILKWEED EDITIONS, Suite 400, 430 First Ave. N., Minneapolis MN 55401. (612)332-3192. Estab. 1979. Publishes hardcover and trade paperback originals of contemporary fiction, poetry, essays and children's novels (ages 8-12). Publishes 12-14 titles/year. Recent titles include *Montana 1948*; *I Am Lavina Cumming*; *Drive, They Said*; and *Transforming a Rape Culture*. 70% require freelance illustration; 20% require freelance design. Books have "colorful, quality" look. Book catalog available for SASE with 2 first-class stamps.
Needs: Works with 10 illustrators and designers/year. Buys 100 illustrations/year. Prefers artists with experience in book illustration. Uses freelancers mainly for jacket/cover illustration and text illustration. Needs computer-literate freelancers for design. Works on assignment only.
First Contact & Terms: Send query letter with résumé, SASE and tearsheets. Samples are filed or are returned by SASE if requested by artist. Editor will contact artists for portfolio review if interested. Portfolio should include best possible samples. Rights purchased vary according to project. Interested in buying second rights (reprint rights) to previously published work. Originals are returned at job's completion.
Jackets/Covers: Assigns 10-14 illustration jobs and 5 design jobs/year. Pays by the project, $250-800 for design. "Prefer a range of different media—according to the needs of each book."
Text Illustration: Assigns 10-14 jobs/year. Pays by the project. Prefers various media and styles.
Tips: "Show quality drawing ability, narrative imaging and interest—call back. Design and production are completely computer-based. Budgets have been cut so any jobs tend to neccesitate experience." Finds artists primarily through word of mouth, artists' submissions and "seeing their work in already published books."

‡MILLS & SANDERSON, PUBLISHERS, Suite 201, 41 North Rd., Bedford MA 01730. (617)275-1410. Fax: (617)275-1713. Publisher: Jan H. Anthony. Estab. 1986. Company publishes trade paperback originals. Types of books include self help and wellness/mental health. Specializes in family problem solving. Publishes 6-8 titles/year. 10% of interior work and 100% of cover work requires freelance illustration. Book catalog free by request "while supplies last."
Needs: Approached by 75 freelance artists/year. Works with 2 freelance illustrators/year. Uses freelance artists mainly for covers. Also uses freelance artists for jacket/cover illustration and design, charts and sketches. Needs computer-literate freelancers for design, illustration and production. 50% of freelance work demands knowledge of Aldus PageMaker or Aldus FreeHand. Works on assignment only.
First Contact & Terms: Send query letter with résumé, SASE, photocopies and pricing guide. Samples are filed or are returned by SASE if requested by artist. Reports back only if interested. Art Director will contact artist for portfolio review if interested. Portfolio should include b&w and color thumbnails, roughs and final art. Originals returned "only if artist has special need."
Jackets/Covers: Assigns 6-8 freelance design and 6-8 freelance illustration jobs/year. Pays by the project, $150-500.

Tips: First-time assignments are usually book covers — 2-color, mechanical only; book cover, back and spine — 2- to 4-color — are given to "proven" freelancers. Finds artists through word of mouth, colleague referral and artist query.

‡**MODERN CURRICULUM PRESS,** 13900 Prospect Rd., Cleveland OH 44136. (216)238-2222. Art Director: Catherine Wahl. Specializes in supplemental text books, readers and workbooks. Publishes 100 titles/year.
Needs: All artwork is freelance. Also needs local artists for advertising and mechanicals. Works on assignment only.
First Contact & Terms: Send résumé and tearsheets of illustrative style to be kept on file; "no slides." Samples not filed are returned by SASE. Reports back only if interested. Buys all rights.
Book Design: Pays by the hour, $12 minimum.
Jackets/Covers: Pays by the project, $50 minimum.
Text Illustration: Prefers animated real life themes, "nothing too cartoony; must be accurate." Pays by the project; payment varies.
Tips: Looks for "professional, serious illustrators who know production techniques and can supply comprehensive sketches through final art within deadlines. Books are competing with video — they need to be more visually stimulating. We look for artists with a more original 'style' — creative solutions to size and color restrictions."

MODERN LANGUAGE ASSOCIATION, 10 Astor Place, New York NY 10003-6981. (212)475-9500. Fax: (212)477-9863. Promotions Coordinator: David Cloyce Smith. Estab. 1883. Non-profit educational association. Publishes hardcover and trade paperback originals, trade paperback reprints and textbooks. Types of books include instructional, reference and literary criticism. Specializes in language and literature studies. Publishes 15 titles/year. Titles include *The Right to Literacy, Literary Research Guide* and *American Indian Literatures.* 5-10% require freelance design. Book catalog free by request.
Needs: Approached by 5-10 freelance artists/year. Works with 2-3 designers/year. Prefers artists with experience in academic book publishing and textbook promotion. Uses freelancers mainly for jackets and direct mail. Also for book and catalog design. 100% of freelance work demands knowledge of QuarkXPress. Works on assignment only.
First Contact & Terms: Send query letter with brochure. Reports back to the artist only if interested. To show portfolio, mail finished art samples and tearsheets. Originals returned at job's completion if requested.
Book Design: Assigns 1-2 design jobs/year. Payment "depends upon complexity and length."
Jackets/Covers: Assigns 3-4 design jobs/year. Pays by the project, $750-1,500.
Tips: "Most freelance designers with whom we work produce our marketing materials rather than our books. We are interested in seeing samples only of direct mail pieces related to publishing. We do not use illustrations for any of our publications."

‡**MOREHOUSE PUBLISHING,** Suite 204, 871 Ethan Allen Hwy., Ridgefield CT 06877. (203)431-3927. Fax: (203)431-3964. Promotion/Production Director: Gail Eltringham. Estab. 1884. Company publishes trade paperback originals and reprints. Books are religious. Specializes in spirituality, religious history, Christianity/contemporary issues. Publishes 20 titles/year. Recent titles include *Approaches to Prayer; The Cruelty of Heresy; Resurrection; The Book of Saints; Journeying with Julian (of Norwich).* 50% require freelance illustration; 40% require freelance design. Book catalog free by request.
Needs: Works with 7-8 freelance illustrators and 7-8 freelance designers/year. Buys 10 freelance illustrations/year. Prefers artists with experience in religious (particularly Christian) topics. Uses freelance artists for jacket/cover illustration and design. Needs computer-literate freelancers for design and illustration. Freelancers should be familiar with Aldus PageMaker, Adobe Illustrator, QuarkXPress, Adobe Photoshop or Aldus FreeHand. Also uses original art — all media. Works on assignment only.
First Contact & Terms: Send query letter with tearsheets, photographs, photocopies and photostats. Samples are filed or are returned. Reports back only if interested but returns slides/transparencies that are submitted. Portfolio review not required. Usually buys one-time rights. Originals are returned at job's completion.
Jackets/Covers: Pays by the hour, $25 minimum; by the project, $450 maximum. "We are looking for diversity in our books covers, although all are of a religious nature."
Tips: Finds artists through freelance submissions, *Literary Market Place* and mostly word of mouth.

‡**MOUNTAIN PRESS PUBLISHING CO.,** P.O. Box 2399, Missoula MT 59806. (406)728-1900. Fax: (406)728-1635. Editor: Kathleen Ort. Estab. 1960s. Company publishes hardcover originals and reprints; trade paperback originals and reprints. Types of books include instruction, biography, history, geology, natural history/nature. Specializes in geology, natural history, history, horses, western topics. Publishes 12 titles/year. Recent titles include Roadside Biology series, Roadside History series, regional photographic field guides. Book catalog free by request.
Needs: Approached by 40 freelance artists/year. Works with 5-10 freelance illustrators and 1-2 freelance designers/year. Buys 10-50 freelance illustrations/year. Prefers artists with experience in book illustration and design, book cover illustration. Uses freelance artists for jacket/cover design and illustration, text illustration and book design. Needs computer-literate freelancers for design and production. Does not need com-

puter-literate freelancers for illustration. 100% of design work demands knowledge of Aldus PageMaker or Aldus FreeHand. Works on assignment only.

First Contact & Terms: Send query letter with brochure, résumé, SASE and any samples. Samples are filed or are returned by SASE. Reports back only if interested. Art Director will contact artist for portfolio review if interested. Buys one-time rights or reprint rights depending on project. Originals are returned at job's completion.

Book Design: Pays by the project.

Jackets/Covers: Assigns 2-3 freelance design and 10-12 freelance illustration jobs/year. Pays by the project.

Text Illustration: Assigns 1-2 freelance illustration jobs/year. Pays by the project. Prefers b&w: pen & ink, scratchboard, ink wash, pencil.

Tips: First-time assignments are usually book cover/jacket illustration or design; text illustration, cover design/ illustration and book design projects are given to "proven" freelancers. Finds artists through submissions, word of mouth, sourcebooks and other publications.

NBM PUBLISHING CO., Suite 1504, 185 Madison Ave., New York NY 10016. (212)545-1223. Publisher: Terry Nantier. Publishes graphic novels for an audience of 18-24 year olds. Types of books include adventure, fantasy, mystery, science fiction, horror and social parodies. Titles include *The Forever War* and *Tales of Oscar Wilde*. Circ. 5-10,000.

Needs: Approached by 60-70 freelance artists/year. Works with 2 designers/year. Uses freelancers for lettering, paste-up, layout design and coloring. Prefers pen & ink, watercolor and oil for graphic novels submissions.

First Contact & Terms: Send query letter with résumé and samples. Samples are filed or are returned by SASE. Reports back within 2 weeks. To show portfolio, mail photocopies of original pencil or ink art. Originals returned at job's completion.

Tips: "We are interested in submissions for graphic novels. We do not need illustrations or covers only!"

THE NEW ENGLAND PRESS, Box 575, Shelburne VT 05482. (802) 863-2520. Managing Editor: Mark Wanner. Specializes in paperback originals on regional New England subjects and nature. Publishes 12 titles/year. Recent titles include *Railroads of Vermont*, Volumes I, II and *Howl Like a Wolf: Animal Proverbs*. 50% require freelance illustration. Books have "traditional, New England flavor."

First Contact & Terms: Approached by 20 freelance artists/year. Works with 3-6 illustrators and 1-2 designers/year. Northern New England artists only. Send query letter with brochure showing art style or résumé. Samples are filed. Reports back only if interested. Considers complexity of project, skill and experience of artist, project's budget and turnaround time when establishing payment. Negotiates rights purchased. Originals not usually returned to artist at job's completion, but negotiable.

Book Design: Assigns 8-10 jobs/year. Payment varies.

Jackets/Covers: Assigns 4-5 illustration jobs/year. Payment varies.

Text Illustration: Assigns 4-5 jobs/year. Payment varies.

Tips: Send a query letter with your work, which should be "more folksy than impressionistic."

NEW SOCIETY PUBLISHERS, 4527 Springfield Ave., Philadelphia PA 19143. (215)382-6543. Contact: Production Manager. Estab. 1980. Publishes trade paperback originals and reprints. Specializes in nonfiction books promoting fundamental social change through nonviolent action. Focus is on feminism, environmentalism, multiculturalism, nonviolence. Publishes 12-14 titles/year. Recent titles include *Democracy in Small Groups*, *Reclaiming Our Cities And Towns* and *Close to Home*. Book catalog free by request.

Needs: Works with 5 freelance cover designers/year. Prefers artists with experience in book publishing, who are able to work for less than the market rate. Uses freelancers mainly for illustrating covers, rarely for text illustration. Works on assignment only.

First Contact & Terms: Send query letter with tearsheets, photographs, photocopies or appropriate samples of book covers. "Include rough schedule of availability and turnaround time." Reports back to the artist only if interested. No portfolio reviews. Sometimes requests work on spec before assigning a job. Interested in buying second rights (reprint rights) to previously published work.

Jackets/Covers: Assigns 8 cover design jobs/year. Pays by the project, $275-500.

Tips: Finds artists through "other publisher's recommendations and contacting designers whose work we like."

‡NORTHLAND PUBLISHING, 2900 N. Fort Valley Rd., Flagstaff AZ 86001. (602)774-5251. Fax: (602)774-0592. Art Director: Trina Stahl. Estab. 1958. Company publishes hardcover and trade paperback originals. Types of books include western, juvenile, natural history, Native American art and cookbooks. Specializes in Native America, Western Americana. Publishes 25 titles/year. Recent titles include *The Three Little Javelinas* and *Survivors in the Shadows: Endangered Mammals of the American West*. 50% require freelance illustration; 25% require freelance design. Book catalog free for 9 × 12 SAE with $1.90 first-class postage.

Needs: Approached by 40-50 freelance artists/year. Works with 5-10 freelance illustrators and 4-6 freelance designers/year. Buys 140 freelance illustrations/year. Prefers artists with experience in illustrating children's titles. Uses freelance artists mainly for children's books. Also uses freelance artists for jacket/cover design and illustration, text illustration and book design. Needs computer-literate freelancers for design and produc-

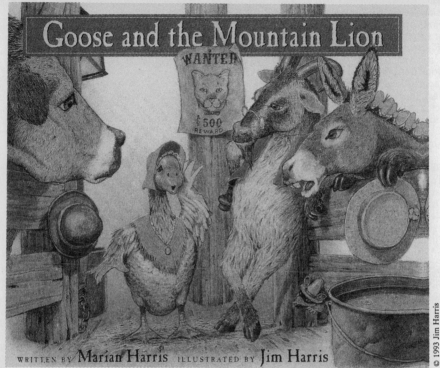

WRITTEN BY Marian Harris ILLUSTRATED BY Jim Harris

© 1993 Jim Harris

Illustrator Jim Harris created this cover, along with 16 interior illustrations, for Goose and the Mountain Lion, by Marian Harris, from Northland Publishing. The artist was given "almost complete freedom to create a concept and final image that would best convey the feeling of the text." The deadline for the project was about three months.

tion. 100% of freelance work demands knowledge of Adobe Illustrator, QuarkXPress, Adobe Photoshop or Aldus FreeHand. Works on assignment only.

First Contact & Terms: Send query letter with résumé, SASE, tearsheets, slides and transparencies. Samples are filed or are returned by SASE if requested by artist. Reports back only if interested. Art Director will contact artist for portfolio review if interested. Portfolio should include color tearsheets and transparencies. Rights purchased vary according to project. Originals are returned at job's completion.

Book Design: Assigns 4-6 freelance design jobs/year. Pays by the project, $500-4,500.

Jackets/Covers: Assigns 4-6 freelance design and 5-10 freelance illustration jobs/year. "We prefer realistic, more representational styles in any medium. We have not used collage styles thus far."

Text Illustration: Assigns 5-10 freelance illustration jobs/year. Pays by the project, $1,000-5,000. Royalties are preferred—gives cash advances against royalties. "We prefer more realistic, representational styles in any medium. We prefer artwork to be bendable so we can scan from original art—no larger than 19×26."

Tips: Finds artists mostly through artists' submissions.

■**NORTHWOODS PRESS**, P.O. Box 298, Thomaston ME 04561. Division of the Conservatory of American Letters. Editor: Robert Olmsted. Estab. 1972. Specializes in hardcover and paperback originals of poetry. Publishes approximately 6 titles/year. Titles include *Dan River Anthology, 1991*, *Broken Dreams* and *Bound*. 10% require freelance illustration. Book catalog for SASE.

● The Conservatory of American Letters now publishes the *Northwoods Journal*, a quarterly literary magazine. They're seeking cartoons and line art and pay cash on acceptance. Send SASE for complete submission guidelines.

Needs: Approached by 40-50 freelance artists/year. Works with 2-3 illustrators and 1-2 designers/year. Uses freelance artists mainly for cover design and illustration. Also uses freelance artists for text illustration.

First Contact & Terms: Send query letter to be kept on file. Art Director will contact artist for portfolio review if interested. Sometimes requests work on spec before assigning a job. Considers complexity of project, skill and experience of artist, project's budget, turnaround time and rights purchased when establishing

payment. Buys one-time rights and occasionally all rights. Originals are returned at job's completion.
Book Design: Pays by the project, $30-200.
Jackets/Covers: Assigns 2-3 design jobs and 4-5 illustration jobs/year. Pays by the project, $30-200.
Text Illustration: Pays by the project, $5-40.
Tips: Portfolio should include "art suitable for book covers — contemporary, usually realistic."

‡O PINYON PRESS, P.O. Box 20513, 68 W. Cortez, Sedona AZ 86341. (602)284-4233. Fax: (602)284-4234. Production Manager: D.A. Boyd. Estab. 1993. Company publishes hardcover and trade paperback originals. Types of books include adventure, travel, reference, history, coffee table books and natural history. Specializes in the Southwest. Publishes 4-6 titles/year. Recent titles include *Verde Valley Gardening, Contemporary Navajo Folk Art.* 20% require freelance illustration; 100% require freelance design. Book catalog not available.
Needs: Approached by 20-30 freelance artists/year. Works with 5 freeelance illustrators and 3-5 freelance designers/year. Buys 15-20 freelance illustrations/year. Prefers local artists with experience in Southwest natural history. Also uses freelance artists for jacket/cover design and illustration, text illustration and book design. Needs computer-literate freelancers for design and illustration. 50% of freelance work demands knowledge of Aldus PageMaker, QuarkXPress, Aldus FreeHand, Adobe Illustrator or Adobe Photoshop. Works on assignment only.
First Contact & Terms: Send query letter with résumé. Samples are filed. Reports back only if interested. Portfolio review not required. Rights purchased vary according to project. Originals are returned at job's completion.
Book Design: Assigns 2-6 freelance design jobs/year. Pays by the hour, $15-25.
Jackets/Covers: Assigns 4 freelance design and "some" freelance illustration jobs/year. Pays by the project, $200-1,000.
Text Illustration: Assigns 2-3 freelance illustration jobs/year. Pays by the hour, $15-25; by the project, $50-500.
Tips: First-time assignments are usually books on natural history of the Southwest; higher level (budget) projects are given to "proven" freelancers.

OCTAMERON PRESS, 1900 Mount Vernon Ave., Alexandria VA 22301. Editorial Director: Karen Stokstod. Estab. 1976. Specializes in paperbacks — college financial and college admission guides. Publishes 10-15 titles/year. Recent titles include *College Match* and *The Winning Edge.*
Needs: Approached by 25 freelance artists/year. Works with 1-2 freelancers/year. Local artists only. Works on assignment only.
First Contact & Terms: Send query letter with brochure showing art style or résumé and photocopies. Samples not filed are returned. Reports within 2 weeks if SASE included. Considers complexity of project and project's budget when establishing payment. Rights purchased vary according to project.
Jackets/Covers: Works with 1-2 designers and illustators/year on 15 different projects. Pays by the project, $300-700.
Text Illustration: Works with variable number of artists/year. Prefers line drawings to photographs. Pays by the project, $35-75.
Tips: "The look of the books we publish is friendly! We prefer humorous illustrations."

‡OREGON HISTORICAL SOCIETY PRESS, 1200 SW Park Ave., Portland OR 97205. (503)222-1741. Fax: (503)221-2035. Director: Bruce Taylor Hamilton. Estab. 1898. Imprints include Eager Beaver Books. Company publishes hardcover originals, trade paperback originals and reprints, maps, posters, plans, postcards. Types of books include biography, travel, reference, history, reprint juvenile and fiction. Specializes in Pacific Northwest history, geography, natural history. Publishes 10-12 biography titles/year. Recent titles include *So Far From Home: An Army Bride on the Western Frontier, Hail, Columbia; Journal of Travels;* and *Oregon Geographic Names,* Sixth Edition. 25% require freelance illustration; 50% require freelance design. Book catalog free by request.
Needs: Approached by 10-50 freelance artists/yaer. Works with 8-10 freelance illustrators and 2-5 freelance designers/year. Buys 0-50 freelance illustrations/year. Prefers local artists only. Uses freelance artists mainly for illustrations and maps. Also uses freelance artists for jacket/cover and text illustration, book design. Needs computer-literate freelancers for design. 20% of freelance work demands knowledge of Aldus PageMaker. Works on assignment only.
First Contact & Terms: Send query letter with brochure, résumé, tearsheets and photocopies. Samples are filed or are returned by SASE. Reports back within 10 days. Art Director will contact artist for portfolio review if interested. Portfolio should include b&w thumbnails, roughs, final art, slides and photographs. Buys one-time rights or rights purchased vary according to project. Originals are returned at job's completion.
Book Design: Assigns 2-5 freelance design jobs/year. Pays by the project.
Jackets/Covers: Assigns 2-5 freelance design and 2-5 freelance illustration jobs/year. Pays by the project.
Text Illustration: Assigns 8-10 freelance illustration jobs/year. Pays by the hour or by the project.

OTTENHEIMER PUBLISHERS, INC., 10 Church Lane, Baltimore MD 21208. (301)484-2100. Art Director: Bea Jackson. Estab. 1890. Book producer. Specializes in mass market-oriented hardcover, trade and paperback originals—cookbooks, children's, encyclopedias, dictionaries, novelty and self-help. Publishes 200 titles/year. Titles include *The Beloved Treasury of Christmas* and *Alice in Wonderland*. 80% require freelance illustration.
Needs: Works with 100 illustrators and 10 designers/year. Prefers professional graphic designers and illustrators. Works on assignment only.
First Contact & Terms: Send query letter with résumé, slides, photostats, photographs, photocopies or tearsheets to be kept on file. Samples not filed are returned by SASE. Reports back only if interested. Call or write for appointment to show portfolio. "I do not want to see unfinished work, sketches, or fine art such as student figure drawings." Considers complexity of project, project's budget and turnaround time when establishing payment. Buys all rights. Originals are returned at job's completion. No phone calls.
Book Design: Assigns 20-40 design jobs/year. Pays by the project, $200-2,000.
Jackets/Covers: Assigns 25 design and 25 illustration jobs/year. Pays by the project, $500-1,500, depending upon project, time spent and any changes.
Text Illustration: Assigns 30 jobs/year. Prefers any full color media with a lesser interest in b&w line work. Prefers graphic approaches as well as very illustrative. "We cater more to juvenile market." Pays by the project, $100-4,000.
Tips: Prefers "art geared towards children—clean work that will reproduce well. I also look for the artist's ability to render children/people well. We use art that is realistic, stylized and whimsical but not cartoony. The more samples, the better."

OXFORD UNIVERSITY PRESS, English Language Teaching (ELT), 24th Floor, 200 Madison Ave., New York NY 10016. Art Buyer: Alexandra F. Rockafellar. Estab. 1478. Specializes in fully illustrated, not-for-profit, contemporary textbooks emphasizing English as a second language. Also produces wall charts, picture cards, CDs and cassettes. Recent titles include *Main Street, Crossroads, Let's Go* and Oxford Picture Dictionaries.
Needs: Approached by 500 freelance artists/year. Works with 100 illustrators and 8 designers/year. Uses freelancers mainly for interior illustrations of exercises. Also uses freelance artists for jacket/cover illustration and design. Needs computer-literate freelancers for illustration. 15% of freelance work demands knowledge of QuarkXPress and Adobe Illustrator. Works on assignment only.
First Contact & Terms: Send query letter with brochure, tearsheets, photostats, slides or photographs. Samples are filed. Art Buyer will contact artist for portfolio review if interested. Sometimes requests work on spec before assigning a job. Considers complexity of project, skill and experience of artist and project's budget when establishing payment. Artist retains copyright. Originals are returned at job's completion.
Jackets/Covers: Pays by the project, $750 minimum.
Text Illustration: Assigns 500 jobs/year. Uses "black line, half-tone and 4-color work in styles ranging from cartoon to realistic. Greatest need is for natural, contemporary figures from all ethnic groups, in action and interaction." Pays for text illustration by the project, $45/spot, $600 maximum/full page.
Tips: Finds artists through submissions; occasionally from work seen in magazines and newspapers, Guild Book, other illustrators. "Please wait for us to call you. You may send new samples to update your file at any time. We would like to see more natural, contemporary, nonwhite people from freelance artists. We do appreciate verve and style—we don't do stodgy texts."

PAPIER-MACHE PRESS, #14, 135 Aviation Way, Watsonville CA 95076. (408)763-1420. Fax: (408)763-1421. Production Editor: Shirley Coe. Estab. 1984. Publishes hardcover and trade paperback originals. Types of books include contemporary fiction, poetry and anthologies. Specializes in women's issues and the art of growing older for both men and women. Publishes 4-6 titles/year. Recent titles include *The Adventures of Stout Mama* and *If I Had My Life to Live Over I Would Pick More Daisies* (sequel to *When I Am an Old Woman I Shall Wear Purple*). Books have fine art on the covers, attractive and accessible designs inside and out. Book catalog and guidelines available for SASE with first-class postage.
Needs: Approached by 10-15 freelance artists/year. Works with 4-6 artists and 1-2 designers/year. Books have fine art on the covers, attractive and accessible designs inside and out. Uses freelancers mainly for covers.
First Contact & Terms: Send query letter with brochure, photocopies or photostats. Samples are filed or are returned by SASE. Art Director will contact artist for portfolio review if interested. Portfolio should include slides, tearsheets, photographs. Buys first rights. Considers buying second rights (reprint rights) to previously published work. Originals are returned at job's completion. "We usually work from transparencies."
Jackets/Covers: Assigns 4-6 design jobs/year. Pays by the project, $350-600. "We are most interested in fine art for reproduction on jacket covers, generally of people."
Tips: Finds artists through artists' submissions author references, and local gallery listings. "After looking at our catalog to see the type of cover art we use, artists should send photocopies of representation pieces for our file. In addition we will put their names on our mailing list for information about future projects."

‡PARADIGM PUBLISHING INC., 280 Case Ave., St Paul MN 55101. (612)771-1555. Production Director: Joan Silver. Estab. 1989. Book publisher. Publishes textbooks. Types of books include business and office,

communications, software-specific manuals. Specializes in basic computer skills. Publishes 40 titles/year. Recent titles include *Keyboarding With WordPerfect* and *Writing: Skill Enhancement*. 100% require freelance illustration and design. Books have very modern high tech design, mostly computer-generated. Book catalog free by request.

Needs: Approached by 50-75 freelance artists/year. Works with 14 freelance illustrators and 20 freelance designers/year. Buys 40 freelance illustrations/year. Uses freelance artists mainly for covers. Works on assignment only.

First Contact & Terms: Send brochure and slides. Samples are filed. Slides are returned. Art Director will contact artist for portfolio review if interested. Portfolio should include b&w and color transparencies. Rights purchased vary according to project. Interested in buying second rights (reprint rights) to previously published work.

Book Design: Assigns 10 freelance design jobs and 30 freelance illustration jobs/year. Pays by the project, $500-1,500.

Jackets/Covers: Assigns 20 freelance design jobs and 20 freelance illustration jobs/year. Pays by the project, $400-1,500.

Text Illustration: Pays $20-75/illustration.

Tips: Finds artists through artist's submission, agents and recommendations. "More work is being generated by the computer."

PEACHPIT PRESS, INC., 2414 6th St., Berkeley CA 94710. (510)548-4393. Fax: (510)548-5991. Estab. 1986. Book publisher. Types of books include instruction and computer. Specializes in desktop publishing and Macintosh topics. Publishes 40-50 titles/year. Recent titles include *The Macintosh Bible* and *The Little PC Book*. 100% require freelance design. Book catalog free by request.

Needs: Approached by 50-75 artists/year. Works with 4 freelance designers/year. Prefers artists with experience in computer book cover design. Uses freelance artists mainly for covers, fliers and brochures. Also uses freelance artists for direct mail and catalog design. Works on assignment only.

First Contact & Terms: Send query letter with résumé, photographs and photostats. Samples are filed. Reports back to the artist only if interested. Call for appointment to show a portfolio of original/final art and color samples. Buys all rights. Originals are not returned at job's completion.

Book Design: Pays by the project, $500-2,000.

Jackets/Covers: Assigns 40-50 freelance design jobs/year. Pays by the project, $1,000-7,000.

‡PEANUT BUTTER PUBLISHING, Dept. AM, 226 2nd Ave. W., Seattle WA 98119. (206)281-5965. Editor: Elliott Wolf. Estab. 1972. Specializes in paperback regional and speciality cookbooks for people who like to dine in restaurants and try the recipes at home. Publishes 30 titles/year. 100% require freelance illustration. Titles include *A Wok with Mary Pang, Lentil and Split Pea Cookbook* and *Miss Ruby's Southern Creole and Cajun Cuisine*. Book catalog free for SASE with 1 first-class stamp.

First Contact & Terms: Approached by 70 freelance artists/year. Works on assignment only. Send brochure showing art style or tearsheets, photostats and photocopies. Samples not filed are returned only if requested. Reports only if interested. To show portfolio, mail appropriate materials.

Book Design: Pays by the hour, $15-25; by the project, $200-3,500.

Jackets/Covers: Pays by the hour, $15-25; by the project, $200-3,000

Text Illustration: Pays by the hour, $15-25; by the project, $200-2,000.

Tips: Books contain pen & ink and 4-color photos. "Don't act as if you know more about the work than we do. Do exactly what is assigned to you."

PELICAN PUBLISHING CO., Box 3110, 1101 Monroe St., Gretna LA 70054. (504)368-1175. Fax: (504)368-1195. Production Manager: Dana Bilbray. Publishes hardcover and paperback originals and reprints. Publishes 60-70 titles/year. Types of books include travel guides, cookbooks and childrens' books. Books have a "high-quality, conservative and detail-oriented" look.

Needs: Approached by 200 freelance artists/year. Works with 20 illustrators/year. Works on assignment only. Needs computer-literate freelancers for illustration. 10% of freelance work demands knowledge of Adobe Illustrator, Aldus FreeHand and Corel Draw.

First Contact & Terms: Send query letter, 3-4 samples and SASE. Samples are not returned. Reports back on future assignment possibilities. Buys all rights. Originals not returned.

Book Design: Pays by the project, $500 minimum.

Jackets/Covers: Pays by the project, $150-500.

Text Illustration: Pays by the project, $50-250.

Tips: Wants to see "realistic detail, more color samples and knowledge of book design."

PENGUIN BOOKS, 375 Hudson St., New York NY 10014. (212)366-2000. Vice President Art Director: Neil Stuart. Publishes hardcover, trade paperback and mass market paperback originals.

Needs: Works with 10-20 freelance illustrators and 10-20 freelance designers/year. Uses freelancers mainly for jackets, catalogs, etc.

First Contact & Terms: Send query letter with tearsheets, résumé, photocopies and SASE. Write for appointment to show portfolio. Rights purchased vary according to project.
Book Design: Pays by the project; amount varies.
Jackets/Covers: Pays by the project; amount varies.
Text Illustration: Pays by the project; amount varies.

THE PILGRIM PRESS/UNITED CHURCH PRESS, 700 Prospect Ave. E., Cleveland OH 44115-1100. (216)736-3724. Production Manager: Cynthia Welch. Art Director: Martha Clark. Estab. 1957. Book publisher of hardcover and trade paperback originals and trade paperback reprints. Types of books include environmental ethics, human sexuality, devotion, women's studies, justice, African-American studies, world religions, Christian education, reference and social and ethical philosophical issues. Specializes in religion. Publishes 20 titles/year. Recent titles include *Psalms From Prison*, *Life/Choice: The Theory of Just Abortion* and *Gay Theology Without Apology*. 75% require freelance illustration; 90% require freelance design. Books are progressive, classic, exciting, sophisticated—conceptually looking for "high design." Book catalog free by request.
Needs: Approached by 15-20 artists/year. Works with 10 illustrators and 20-25 designers/year. Buys 100-125 illustrations/year. Prefers artists with experience in book publishing. Uses freelance artists mainly for covers, catalog and illustration. Also for book design. Works on assignment only.
First Contact & Terms: Send query letter with résumé, tearsheets and photocopies. Samples are filed or are returned by SASE if requested by artist. Art Director will contact artist for portfolio review if interested. Artist should folow up with letter after initial query. Portfolio should include thumbnails, roughs and color tearsheets and photographs. Negotiates rights purchased. Interested in buying second rights (reprint rights) to previously published work based on need, style and concept/subject of art and cost. "I like to see samples." Originals are returned at job's completion.
Book Design: Assigns 6-20 design and 6-20 illustration jobs/year. Pays by the project, $300-500.
Jackets/Covers: Assigns 6-20 design and 6-20 illustration jobs/year. Prefers contemporary styles. Pays by the project, $300-600.
Text Illustration: Assigns 15-20 design and 15-20 illustration jobs/year. Pays by the project, $100 minimum; negotiable, based on artist estimate of job, number of pieces and style.
Tips: Finds artists through agents. "I also network with other art directors/designers for their qualified suppliers/freelancers."

‡PIPPIN PRESS, 229 E. 85th St., Gracie Station Box 1347, New York NY 10028. (212)288-4920. Fax: (908)225-1562. Publisher: Barbara Francis. Estab. 1987. Company publishes hardcover juvenile originals. Publishes 4-6 titles/year. Recent titles include *The Spinner's Daughter*, *The Sounds of Summer* and *Windmill Hill*. 100% require freelance illustration; 50% require freelance design. Book catalog free for SAE with 2 first-class stamps.
Needs: Approached by 50-75 freelance artists/year. Works with 6 freelance illustrators and 2 freelance designers/year. Prefers artists with experience in juvenile books for ages 4-10. Uses freelance artists mainly for book illustration. Also uses freelance artists for jacket/cover illustration and design and book design.
First Contact & Terms: Send query letter with résumé, tearsheets, photocopies. Samples are filed "if they are good" and are not returned. Reports back within 2 weeks. Portfolio should include selective copies of samples and thumbnails. Buys all rights. Originals are returned at job's completion.
Book Design: Assigns 3-4 freelance design jobs/year.
Text Illustration: All text illustration assigned to freelance artists.
Tips: Finds artists "through exhibits, especially children's book illustration exhibits sponsored by the Society of Illustrators, as well as agent's portfolios."

PLAYERS PRESS, Box 1132, Studio City CA 91614. Associate Editor: Marjorie Clapper. Specializes in plays and performing arts books. Recent titles *Corrugated Scenery*, *Historic American Costumes* and *Short Scenes from Shakespeare*.
Needs: Buys up to 10 illustrations/year from freelancers. Works with 3-15 illustrators and 1-3 designers/year. Uses freelance artists mainly for play covers. Also uses freelance artists for text illustration. Works on assignment only.
First Contact & Terms: Send query letter with brochure showing art style or résumé and samples. Samples not filed are returned if SASE is enclosed. Request portfolio review in original query. Art Director will contact artist for portfolio review if interested. Portfolio should include thumbnails, final reproduction/product, tearsheets, photographs and as much information as possible. Sometimes requests work on spec before assigning a job. Buys all rights. Considers buying second rights (reprint rights) to previously published work, depending on usage. "For costume books this is possible."
Book Design: Pays by the project, varies.
Jackets/Covers: Pays by the project, varies.
Text Illustration: Pays by the project, varies.
Tips: "We usually select from those who submit samples of their work which we keep on file. Keep a permanent address so you can be reached."

PLYMOUTH MUSIC CO., INC., 170 NE 33rd St., Ft. Lauderdale FL 33334. (305)563-1844. General Manager: Bernard Fisher. Specializes in paperbacks dealing with all types of music. Publishes 60-75 titles/year. 100% require freelance design and illustrations.
First Contact & Terms: Works with 10 freelance artists/year. Artists "must be within our area." Works on assignment only. Send brochure, résumé and samples to be kept on file. Samples not kept on file are returned. Reports back within 1 week. Call for appointment to show portfolio. Considers complexity of project when establishing payment. Buys all rights. Originals are not returned.
Jackets/Covers: Assigns 5 design and 5 illustration jobs/year. Pays by the project.

‡**PRAKKEN PUBLICATIONS, INC.,** Suite 1, 275 Metty Dr., Box 8623, Ann Arbor MI 48107. (313)769-1211. Fax: (313)769-8383. Production and Design Manager: Sharon Miller. Estab. 1934. Imprints include The Education Digest, Tech Directions. Company publishes textbooks, educator magazines and reference books. Types of books include reference, texts, especially vocational and technical educational. Specializes in vocational, technical education, general education reference. Publishes 2 magazines and 3 new book titles/year. Recent titles include *High School-to-Employment Transition, Vocational Education in the '90s, Managing The Occupational Education Lab.* Book catalog free by request.
Needs: Rarely uses freelancers. Needs computer-literate freelancers for design and production. 50% of freelance work demands knowledge of Aldus PageMaker. Works on assignment only.
First Contact & Terms: Send samples. Samples are filed or are returned by SASE if requested by asrtist. Reports back only if interested. Art Director will contact artist for portfolio review if interested. Portfolio should include b&w and color final art, photostats and tearsheets.

PRICE STERN SLOAN, 6th Floor, 11150 Olympic Blvd., Los Angeles CA 90064. (310)477-6100. Fax: (310)445-3933. Art Director: Sheena Needham. Estab. 1971. Book publisher. Publishes hardcover originals and reprints, trade paperback originals and reprints, and mass market paperback originals and reprints. Types of books include instructional, pre-school, juvenile, young adult, self-help, humor, calendars, novelty and pop-up books. Publishes 80 titles/year. Recent titles include *Number Munch, Fly Away Home, Big Busy Building*. 75% require freelance illustration. 10% require freelance design. Books vary from cute to quirky to illustrative.
Needs: Approached by 300 freelance artists/year. Works with 20-30 freelance illustrators/year. Works with 10-20 freelance designers/year. Prefers artists with experience in book or advertising art. Uses freelance artists mainly for illustration. Also uses freelancers for jacket/cover and book design. Needs computer-literate freelancers for production.
First Contact & Terms: Send query letter with brochure, résumé and photocopies. Samples are filed or are returned by SASE if requested by artist. Art Director will contact artist for portfolio review if interested. Portfolios may be dropped off every Thursday. Portfolio should include b&w and color tearsheets. Rights purchased vary according to project.
Book Design: Assigns 5-10 freelance design jobs and 20-30 freelance illustration jobs/year. Pays by the project.
Jackets/Covers: Assigns 5-10 freelance design jobs and 10-20 freelance illustration jobs/year. Pays by the project, varies.
Text Illustration: Pays by the project and occasionally by participation.
Tips: Finds artists through word of mouth, magazines, artists' submissions, self-promotion, sourcebooks and agents. "Do not send original art. Become familiar with the types of books we publish. We are always looking for excellent book submissions. We are extremely selective when it comes to children's books, so please send only your best work. Any book submission that does not include art samples should be sent to our editorial department. Book design is branching out into new markets—CD-ROM, computers, audio, video."

‡**PRINCETON BOOK PUBLISHERS, DANCE HORIZONS,** 12 W. Delaware Ave., Pennington NJ 08534. Managing Editor: Debi Elfenbein. Estab. 1975. Dance book publisher and dance video distributor. Publishes hardcover originals, trade paperback originals and reprints and textbooks. Types of books include instruction, biography and history. Specializes in dance. Publishes 12-15 titles/year. Titles include *Dance in Poetry* and *Dance: Rituals of Experience*. Books are "trade market, with crossover into university market; not too scholarly, but not too flashy." 3% require freelance illustration. 97% require freelance design. Book catalog free by request.
Needs: Approached by 3-7 freelance artists/year. Works with 2 freelance illustrators and 3-7 freelance designers/year. Needs computer-literate freelancers for design. 5% of freelance work demands knowledge of Aldus PageMaker. Prefers artists with experience in book design and marketing for textbooks and trade books. Uses freelance artists for jacket/cover and book design and dance video covers. Works on assignment only.

Always enclose a self-addressed, stamped envelope (SASE) with queries and sample packages.

First Contact & Terms: Send query letter with résumé, photostats and SASE. Samples are filed. Reports back to the artist only if interested. Write for appointment to show portfolio of original/final art and b&w dummies. Rights purchased vary according to project. Originals are returned at job's completion.
Book Design: Assigns 12 freelance design jobs/year. Pays by the project, $375-500.
Jackets/Covers: Assigns 12 freelance design jobs and 3 freelance illustration jobs/year. Pays by the project, $375-500. Uses mostly photos with an occasional watercolor (4-color) or graphic.
Text Illustration: Assigns 3 freelance design jobs and 3 freelance illustration jobs/year. Pays by the hour, $25; by the project, $50. Prefers pen & ink and realistic figures.
Tips: "Have book design experience. Know what my firm specializes in before we talk."

‡PROLINGUA ASSOCIATES, 15 Elm St., Brattleboro VT 05301. (802)257-7779. Fax: (802)257-5117. President: Arthur A. Burrows. Estab. 1980. Company publishes textbooks. Specializes in language textbooks. Publishes 3-8 titles/year. Recent titles include *Living in Mexico* and *Conversation Strategies*. 100% require freelance illustration. Book catalog free by request.
Needs: Approached by 5 freelance artists/year. Works with 2-3 freelance illustrators/year. Uses freelance artists mainly for pedagogical illustrations of various kinds. Also uses freelance artists for jacket/cover and text illustration. Works on assignment only.
First Contact & Terms: Send photocopies. Samples are filed. Reports back within 1 month. Portfolio review not required. Buys all rights. Originals are returned at job's completion if requested.
Text Illustration: Assigns 5 freelance illustration jobs/year. Pays by the project, $100-1,000.
Tips: Finds artists through word of mouth and submissions.

■PULSE-FINGER PRESS, Box 488, Yellow Springs OH 45387. Contact: Orion Roche or Raphaello Farnese. Publishes hardbound and paperback fiction, poetry and drama. Publishes 5-10 titles/year.
Needs: Prefers local artists. Works on assignment only. Uses freelancers for advertising design and illustration. Pays $25 minimum for direct mail promos.
First Contact & Terms: Send query letter. "We can't use unsolicited material. Inquiries without SASE will not be acknowledged." Reports back in 6 weeks; reports on future assignment possibilities. Samples returned by SASE. Send résumé to be kept on file. Artist supplies overlays for all color artwork. Buys first serial and reprint rights. Originals are returned at job's completion.
Jackets/Covers: "Must be suitable to the book involved; artist must familiarize himself with text. We tend to use modernist/abstract designs. Try to keep it simple, emphasizing the thematic material of the book." **Pays on acceptance;** $25-100 for b&w jackets.

G.P. PUTNAM'S SONS, (Philomel Books), 200 Madison Ave., New York NY 10016. (212)951-8700. Art Director, Children's Books: Cecilia Yung. Assistant to Art Director: Jina Paik. Publishes hardcover and paperback juvenile books. Publishes 100 titles/year. Free catalog available.
Needs: Works on assignment only.
First Contact & Terms: Provide flier, tearsheet, brochure and photocopy or stat to be kept on file for possible future assignments. Samples are returned by SASE. "We take drop-offs on Tuesday mornings. Please call in advance with the date you want to drop of your portfolio." Originals returned at job's completion.
Jackets/Covers: "Uses full-color paintings, painterly style."
Text Illustration: "Uses a wide cross section of styles for story and picture books."

‡RAINBOW BOOKS, INC., P.O. Box 430, Highland City FL 33846-0430. (813)648-4420. Fax: (813)648-4420. Media Buyer: Betsy A. Lampe. Estab. 1979. Company publishes hardcover and trade paperback originals. Types of books include instruction, adventure, biography, travel, self help, religious, reference, history and cookbooks. Specializes in nonfiction, self help and how-to. Publishes 20 titles/year. Recent titles include *One Can Do It: A Guide for the Physically Handicapped*. 10% require freelance illustration. Book catalog available for 9½ × 6½ SAE with 75¢ postage.
Needs: Approached by "less than 3" freelance artists/year. Works with 1-2 freelance illustrators/year. Buys 3-6 freelance illustrations/year. Prefers artists with experience in book cover design and line illustration. Also uses freelance artists for jacket/cover illustration and design and text illustration. Needs computer-literate freelancers for design, illustration and production. 90% of freelance work demands knowledge of Aldus PageMaker, Aldus FreeHand or CorelDraw. Works on assignment only.
First Contact & Terms: Send query letter with SASE, tearsheets, photographs and book covers or jackets. Samples are returned by SASE. Reports back within 2 weeks. Art Director will contact artist for portfolio

How to Use Your Artist's & Graphic Designer's Market offers suggestions for understanding and using the information in these listings. Read this and other articles in the front of this book for important business tips.

review if interested. Portfolio should include b&w and color tearsheets, photographs and book covers or jackets. Rights purchased vary according to project. Originals are returned at job's completion.
Jackets/Covers: Assigns 3-6 freelance illustration jobs/year. Pays by the project, $250 minimum. Prefers electronic illustration.
Text Illustration: Pays by the project. Prefers pen & ink or electronic illustration.
Tips: First-time assignments are usually interior illustration, cover art; complete cover design/illustration are given to "proven" freelancers. Finds artists through word of mouth.

RANDOM HOUSE, INC., (Juvenile), 201 E. 50th St., New York NY 10022. (212)940-7670. Vice President/ Executive Art Director: Cathy Goldsmith. Specializes in hardcover and paperback originals and reprints. Publishes 200 titles/year. 100% require freelance illustration.
Needs: Works with 100-150 freelance artists/year. Works on assignment only.
First Contact & Terms: Send query letter with résumé, tearsheets and photostats; no originals. Samples are filed or are returned. "No appointment necessary for portfolios. Come in on Wednesdays only, before noon." Considers complexity of project, skill and experience of artist, budget, turnaround time and rights purchased when establishing payment. Negotiates rights purchased.
Book Design: Assigns 5 freelance design jobs and 200 illustration jobs/year. Pays by the project.
Text Illustration: Assigns 150 illustration jobs/year. Pays by the project.

■**READ'N RUN BOOKS,** Box 294, Rhododendron OR 97049. (503)622-4798. Publisher: Michael P. Jones. Estab. 1985. Specializes in fiction, history, environment and wildlife books for children through adults. "Books for people who do not have time to read lengthy books." Publishes 2-6 titles/year. Recent titles include *Seven Days in Yemen, Raven and the Flickers* and *Art and Mythology From The Land and Sea.* "Our books, printed in b&w or sepia, are both hardbound and softbound, and are not slick looking. They are home-grown looking books that people love." Accepts previously published material. Art guidelines for #10 SASE.
Needs: Works with 25-50 freelance illustrators and 10 designers/year. Prefers pen & ink, airbrush, charcoal/ pencil, markers, calligraphy and computer illustration. Uses freelancers mainly for illustrating books. Also for jacket/cover, direct mail, book and catalog design.
First Contact & Terms: Send query letter with brochure or résumé, tearsheets, photostats, photocopies, slides and photographs. Samples not filed are returned by SASE. Request portfolio review in original query. Art Director will contact artist for portfolio review if interested. Artist should follow up after initial query. Portfolio should include thumbnails, roughs, final reproduction/product, color and b&w tearsheets, photostats and photographs. Buys one-time rights. Interested in buying second rights (reprint rights) to previously published work. Originals are returned at job's completion. Pays in copies, on publication.
Tips: "Generally, the artists find us by submitting samples—lots of them, I hope. Artists may call us, but we will not return calls. We will be publishing short-length cookbooks. I want to see a lot of illustrations showing a variety of styles. There is little that I actually don't want to see. We have a tremendous need for illustrations on the Oregon Trail (i.e., oxen-drawn covered wagons, pioneers, mountain men, fur trappers, etc.) and illustrations depicting the traditional way of life of Plains Indians and those of the North Pacific Coast and Columbia River with emphasis on mythology and legends. Pen & ink is coming back stronger than ever! Don't overlook this. Be versatile with your work."

■**RIO GRANDE PRESS,** P.O. Box 71745, Las Vegas NV 89170-1745. Editor/Publisher: Rosalie Avara. Estab. 1989. Small press. Publishes trade paperback originals. Types of books include poetry journal and anthologies. Publishes 7 titles/year. (4 editions of *Se La Vie Writer's Journal* and 3 anthologies). 95% require freelance illustration; 90% require freelance design. Book catalog for SASE with first-class postage.
Needs: Approached by 30 freelance artists/year. Works with 5-6 illustrators and 1 designer/year. Buys 150 illustations/year. Prefers artists with experience in spot illustrations for poetry and b&w cartoons about poets, writers, etc. "I have only one cover designer at present." Uses freelance for jacket/cover illustration and design and text illustration.
First Contact & Terms: Send query letter with résumé, SASE, tearsheets, photocopies and cartoons. Samples are filed. Reports back within 1 month. To show portfolio, mail roughs, finished art samples and b&w tearsheets. Buys first rights or one-time rights. Originals are not returned.
Book Design: Assigns 2-3 illustration jobs/year. Pays by the project; $4 or copy.
Jackets/Covers: Pays by the project, $4; or copy.
Text Illustration: Assigns 4 illustration jobs/year. Prefers small b&w line drawings to illustrate poems. Pays by the project; $4 or copy.
Tips: "We have been using portraits of famous poets/writers along with a series of cover articles to go with each issue (Journal)."

‡**ROSS BOOKS,** Box 4340, Berkeley CA 94704. (415)841-2474. Managing Editor: Brian Kluepfel. Estab. 1977. Book publisher. Publishes trade paperback originals, textbooks and hardcover reprints. Types of books include instruction, young adult, reference, self help, cookbooks, adult science, holography and computer books. Specializes in holography and computers. Publishes 7 titles/year. Recent titles include *Holography*

Marketplace 4th edition and *B-Trees for BASIC*. 40% require freelance illustration; 40% require freelance design. Book catalog free for SAE with 2 first-class stamps.

Needs: Approached by 100-300 freelance artists/year. Works with 2-4 freelance illustrators and 1-2 freelance designers/year. Number of freelance illustrations purchased each year varies. Prefers artists with experience in computer generated diagrams and illustration. Also uses freelance artists for jacket/cover illustration, book design, text illustration and direct mail design. Works on assignment only.

First Contact & Terms: Send query letter with résumé and photocopies. Samples are filed. Reports back to the artist only if interested and SASE enclosed. Rights purchased vary according to subject. Originals are returned at job's completion.

Book Design: Assigns 2-4 freelance design jobs and 2-4 freelance illustration jobs/year. Pays by the project, $500 maximum.

Text Illustration: Assigns 2-4 freelance design and 2-4 freelance illustration jobs/year. Pays by the project, $500 maximum.

Tips: "Computer illustration ability—especially Macintosh—should be demonstrated."

‡ROUTLEDGE, (formerly Routledge, Chapman & Hall, Inc.), 29 W. 35th St., New York NY 10001-2291. (212)244-3336. Estab. 1979. Book publisher. Publishes trade paperback originals. Types of books include business, politics and cultural studies. Specializes in science, gay and lesbian studies, women's studies, anthropology, archaeology, literature criticism and statistics. Publishes 1,000 titles/year. Desktop publishing only. Books are text oriented. Book catalog free by request.

Needs: Approached by 20 freelance artists/year. Works with 4-8 freelance designers/year. Prefers artists with experience in catalog and display advertisement design. Uses freelance artists mainly for catalogs, direct mail and print display advertisement. Also uses freelance artists for desktop publishing and book design. Works on assignment only.

First Contact & Terms: Send query letter with brochure to art department. Samples are filed. Reports back to the artist only if interested.

Jackets/Covers: Finds artists through word of mouth. Prefers "either type solutions or simple illustrations."

ST. MARTIN'S PRESS, INC., 175 5th Ave., New York NY 10010. Imprint is Macmillan. Does not need freelance artists at this time.

‡ST. PAUL BOOKS AND MEDIA, 50 St. Paul's Ave., Boston MA 02130. (617)522-8911. Fax: (617)541-9805. Art Director: Sister Mary Joseph, FSP. Estab. 1915. Book publisher. "We also publish 2 magazines and produce audio and video cassettes." Publishes hardcover originals and reprints, trade paperback originals and reprints and textbooks. Types of books include contemporary and historical fiction, instructional, biography, pre-school, juvenile, young adult, reference, history, self-help, prayer and religious. Specializes in religious topics. Publishes 20 titles/year. Titles include *Call Me Jonathan for Short, I Pray with Jesus, Three Religious Rebels* and *Silence of Mary*. 50% require freelance illustration. Book catalog free by request.

Needs: Approached by 50 freelance artists/year. Works with 10-20 freelance illustrators/year. Buys 3-10 freelance illustrations/year for books, 6/year for magazines. Uses freelance artists mainly for children's books and magazines. Also uses freelance artists for jacket/cover and text illustration. Works on assignment only.

First Contact & Terms: Send query letter with brochure, résumé, SASE, tearsheets, photographs, photocopies, photostats, slides and transparencies. Samples are filed or are returned by SASE. Reports back within 1-3 months only if interested. Rights purchased vary according to project. Originals are returned at job's completion.

Jackets/Covers: Assigns 1-2 freelance illustration jobs/year. Pays by the project.

Text Illustration: Assigns 3-10 freelance illustration jobs/year. Pays by the project.

SCHOLASTIC INC., 730 Broadway, New York NY 10003. Art Director: David Tommasino. Specializes in hardcover and paperback originals and reprints of young adult, biography, classics, historical romance and contemporary teen romance. Publishes 250 titles/year. Recent titles include *Goosebumps, Clue* and *Nightmare Hall*. 80% require freelance illustration. Books have "a mass-market look for kids."

Needs: Approached by 100 artists/year. Works with 75 freelance illustrators/year. Works with 2 freelance designers/year. Prefers local artists with experience. Uses freelancers mainly for mechanicals. Also uses freelance artists for jacket/cover illustration and design and book design.

First Contact & Terms: Send query letter with brochure showing art style or tearsheets. Samples are filed or are returned only if requested. Art Director will contact artist for portfolio review if interested. Considers

The double dagger before a listing indicates that the listing is new in this edition. New markets are often more receptive to freelance submissions.

complexity of project and skill and experience of artist when establishing payment. Buys first rights. Originals are returned at job's completion.
Book Design: Pays by the project, $1,000-3,000.
Jackets/Covers: Assigns 200 illustration jobs/year. Pays by the project, $1,800-3,500.
Text Illustration: Pays by the project, $500-1,500.
Tips: Finds artists through word of mouth, *Showcase, RSVP* and Society of Illustrators. "In your portfolio, show tearsheets or proofs only of printed covers. I want to see oil, acrylic tightly rendered; illustrators should research the publisher. Go into a bookstore and look at the books. Gear what you send according to what you see is being used."

SIERRA CLUB BOOKS, Dept. AM, 100 Bush St., San Francisco CA 94104. (415)291-1600. Publisher: Jon Beckmann. Senior Editor: James Cohee. Design Director: Susan Ristow. Publishes books on natural history, science, ecology, conservation issues and related themes, calendars and guides.
Needs: Uses artists for book design and illustration (maps, juvenile art) and jacket design. Works with 10-15 designers/year.
First Contact & Terms: Send query letter with résumé, tearsheets and/or business card to be kept on file. Buys US or world rights.
Book Design: Pays by the project; $700-1,000.
Jackets/Covers: Pays by the project; $700-1,000 for design; $175-500 for illustration.
Text Illustration: Pays by the project; $1,000-2,000.

SILVER BURDETT & GINN, Dept. AM, 250 James St., Morristown NJ 07960. (201)285-8103. Creative Director: Doug Bates. Book publisher. Estab. 1890. Publishes textbooks and nonfiction. Specializes in math, science, social studies, English, music and religion. Publishes approx. 75 titles/year. Books look lively and inviting with fresh use of art and photos. 100% require freelance illustration; 20% require freelance design. Recent titles include *The Music Connection* and *Primary Place.* Book catalog not available.
Needs: Approached by 75-100 artists/year. Works with 25-50 illustrators and 1-5 designers/year. Buys 500 illustrations/year. Uses artists mainly for text illustration and page layout. Also works with artists for jacket/cover illustration and design and book, catalog, packaging and ad design. Needs computer-literate freelancers for design and production. 80% of freelance work demands knowledge of QuarkXPress and Adobe Illustrator. Works on assignment only.
First Contact & Terms: Send query letter with résumé and tearsheets. Samples are filed or are returned by SASE only if requested. Reports back only if interested. Originals are returned to artist at job's completion. Art Director will contact artist for portfolio review if interested. Portfolio should include thumbnails, roughs, final art, tearsheets and final reproduction/product. Sometimes requests work on spec before assigning a job. Considers complexity of project and skill and experience of artist when establishing payment. Considers buying second rights (repint rights) to previously published artwork. Negotiates rights purchased.
Book Design: Assigns approximately 5 design jobs/year. Pays by the hour, $20-30.
Jackets/Covers: Pays by the project, $500-1,000.
Text Illustration: Assigns 1,000 illustration jobs/year. Pays by the project, $350-700.
Tips: "Textbooks have become less traditional in their approach."

SIMON & SCHUSTER, 1230 Avenue of the Americas, New York NY 10020.
● Many things are changing with this publisher since its acquisition by Viacom – including a temporary name change to Paramount Publishing. However, the name Simon & Schuster has been reinstated. Read *Publishers Weekly* for the latest information.

SMITHSONIAN INSTITUTION PRESS, Room 7100, 470 L'Enfant Plaza, Washington DC 20560. Does not need freelance artists at this time.

‡SOUNDPRINTS, P.O. Box 679, 165 Water St., Norwalk CT 06856. (203)838-6009. Fax: (203)866-9944. Assistant Editor: Dana Meachen. Estab. 1989. Company publishes hardcover originals. Types of books include juvenile. Specializes in wildlife. Publishes 12 titles/year. Recent titles include *Summer Coat, Winter Coat* by Doe Boyle, Illustrated by Allen Davis; *Prairie Dog Town*, by Bettye Rogers, illustrated by Deborah Howland. 100% require freelance illustration. Book catalog free for 9×12 SAE with 2 first-class stamps.
Needs: Approached by 15 freelance artists/year. Works with 9 freelance illustrators/year. Prefers artists with experience in realistic wildlife illustration and children's books. Uses freelance artists for illustrating children's books (cover and interior).
First Contact & Terms: Send query letter with tearsheets, résumé, slides and SASE. Samples are filed or returned by SASE if requested by artist. Reports back within 1 month. Art Director will contact artist for portfolio review if interested. Portfolio should include color final art and tearsheets. Rights purchased vary according to project. Originals are returned at job's completion.
Text Illustration: Assigns 12 freelance illustration jobs/year. Prefers watercolor, colored pencil.
Tips: Finds artists through agents, sourcebooks, reference, unsolicited submissions.

THE SPEECH BIN, INC., 1965 25th Ave., Vero Beach FL 32960. Fax: (407)770-0007. Senior Editor: Jan Binney. Estab. 1984. Publishes textbooks and educational games and workbooks for children and adults. Specializes in tests and materials for treatment of individuals with all communication disorders. Publishes 20-25 titles/year. Recent titles include *Talkable Tales, Rewarding Speech* and *Exercise Your Voice to Health*. 75% require freelance illustration; 50% require freelance design. Book catalog available for 8½ × 11 SAE with 98¢ postage.
Needs: Works with 8-10 freelance illustrators and 2-4 freelance designers/year. Buys 1,000 illustrations/year. Work must be suitable for handicapped children and adults. Uses freelancers mainly for instructional materials, cover designs, gameboards, stickers. Also for jacket/cover and text illustration. Occasionally uses freelancers for catalog design projects. Works on assignment only.
First Contact & Terms: Send query letter with brochure, SASE, tearsheets and photocopies. Samples are filed or are returned by SASE if requested by artist. Reports back to the artist only if interested. Do not send portfolio; query only. Usually buys all rights. Considers buying second rights (reprint rights) to previously published work.
Book Design: Pays by the project.
Jackets/Covers: Assigns 10-12 design jobs and 10-12 illustration jobs/year. Prefers b&w line drawings. Pays by the project.
Text Illustration: Assigns 6-10 illustration jobs/year. Prefers b&w line drawings. Pays by the project.
Tips: Finds artists through, word of mouth through our authors and submissions by artists.

‡SPINSTERS INK, P.O. Box 300170, Minneapolis MN 55403-5170. (612)377-0287. Fax: (612)377-1759. Production Manager: Liz Tufte. Estab. 1978. Company publishes trade paperback originals and reprints. Types of books include contemporary fiction, mystery, biography, young women, reference, history of women, humor and feminist. Specializes in "fiction and nonfiction that deals with significant issues in women's lives from a feminist perspective." Publishes 6 titles/year. Recent titles include *The Other Side of Silence, The Solitary Twist, Final Rest* (mysteries), *Trees Call for What They Need, No Matter What, As You Desire* (novels). 50% require freelance illustration; 100% require freelance design. Book catalog free by request.
Needs: Approached by 24 freelance artists/year. Works with 2-3 freelance illustrators and 2-3 freelance designers/year. Buys 2-6 freelance illustrations/year. Prefers artists with experience in "portraying positive images of women's diversity." Uses freelance artists for jacket/cover illustration and design, book and catalog design. Needs computer-literate freelancers for design, illustration, production and presentation. 100% of freelance work demands knowledge of Adobe Illustrator, QuarkXPress or Macintosh FrameMaker. Works on assignment only.
First Contact & Terms: Send query letter with SASE, 3-5 slides or color copies, preferably 8 × 10 or smaller. Samples are filed or are returned by SASE if requested by artist. Reports back within 1 month. Art Director will contact artist for portfolio review if interested. Portfolio should include b&w and color thumbnails, final art and photographs. Buys first rights. Originals are returned at job's completion.
Jackets/Covers: Assigns 6 freelance design and 2-6 freelance illustration jobs/year. Pays by the project, $500-1,000. Prefers "original art with appropriate type treatment, b&w to 4-color. Often the entire cover is computer-generated, with scanned image. Our production department is rapidly moving towards producing the entire book, including cover, electronically."
Text Illustration: Assigns 0-6 freelance illustrations/year. Pays by the project, $75-150. Prefers "b&w line drawings or type treatment that can be converted electronically. We create the interior of books completely using desktop publishing technology on the Macintosh."
Tips: Finds artists through word of mouth and artists' submissions.

STAR PUBLISHING, Box 68, Belmont CA 94002. Managing Editor: Stuart Hoffman. Specializes in original paperbacks and textbooks on science, art, business. Publishes 12 titles/year. 33% require freelance illustration. Titles includes *Microbiology Techniques*.
First Contact & Terms: Works with 15 freelance illustrators and 3-4 designers/year. Send query letter with résumé, tearsheets and photocopies. Samples not filed are returned only by SASE. Reports back only if interested. Rights purchased vary according to project. Originals are not returned.
Book Design: Assigns 12 jobs/year. Pays by the project.
Jackets/Covers: Assigns 5 design jobs/year. Pays by the project.
Text Illustration: Assigns 6 jobs/year. Pays by the project.
Tips: Freelance artists need to be aware of "increased use of graphic elements, striking color combinations, more use of color illustration."

STARBURST PUBLISHERS, P.O. Box 4123, Lancaster PA 17604. (717)293-0939. Editorial Director: Ellen Hake. Estab. 1982. Publishes hardcover originals and trade paperback originals and reprints. Types of books include contemporary and historical fiction, celebrity biography, self help, cookbooks and other nonfiction. Specializes in inspirational and general nonfiction. Publishes 15-20 titles/year. Recent titles include *Stay Well Without Going Broke* and *Beyond the River*. 25% require freelance design; 75% require freelance illustration. Books contain strong, vibrant graphics or artwork. Book catalog available for SAE with 4 first-class stamps.

Needs: Works with 2 freelance illustrators and designers/year. Buys 5 illustrations/year. Prefers artists with experience in publishing and knowledge of mechanical layout. Uses freelancers mainly for jacket/cover design and illustration. Works on assignment only.
First Contact & Terms: Send query letter with brochure, tearsheets, photostats, résumé and SASE. Samples are filed or are returned by SASE. Art Director will contact artist for portfolio review if interested. Sometimes requests work on spec before assigning job. Buys all rights. Considers buying second rights (reprint rights) to previously published artwork. Originals not returned.
Book Design: Assigns 2-5 design and 2-5 illustration jobs/year. Pays by the project, $200 minimum.
Jackets/Cover: Assigns 2-5 jobs/year. Pays by the project, $200 minimum.
Text Illustration: Assigns 2-5 design and 2-5 illustration jobs/year. Pays by the project, $200 minimum.
Tips: "Understand what makes a good competitive book cover and/or an enhancing text illustration."

‡**STONE WALL PRESS INC.**, 1241 30th St. NW, Washington DC 20007. Publisher: Henry Wheelwright. Publishes paperback and hardcover originals; environmental, backpacking, fishing, outdoor themes. Publishes 1-4 titles/year; 10% require freelance illustration. Titles include *Wildlife Extinction* and *Baiji, The Yangtze River Dolphin.*
● This publisher may not be publishing new books this year, but is open to queries.
Needs: Approached by 20 freelance artists/year. Works with 1 freelance illustrator and 1 freelance designer/year. Prefers artists who are accessible. Works on assignment only.
First Contact & Terms: Send query letter with brochure showing art style. Samples returned by SASE. Reports back only if interested. Buys one-time rights. Originals returned to artist at job's completion.
Book Design: Uses artists for composition, layout, jacket design. Prefers realistic style – color or b&w. Artist supplies overlays for cover artwork. **Pays on acceptance** (cash).
Text Illustration: Buys b&w line drawings.
Tips: Looking for "clean, basic, brief, concise, expendable samples."

‡■**SWAMP PRESS**, 323 Pelham Rd., Amherst MA 01002. President: Ed Rayher. Specializes in hardcover and paperback originals of literary first editions. Publishes 2 titles/year.
Needs: Works with 1 freelance artists/year.
First Contact & Terms: Send query letter with four or five photocopies or slides. Samples are filed or are returned by SASE. Reports back within 2 months. To show portfolio, mail photostats, tearsheets and slides. Considers complexity of project and project's budget when establishing payment. Buys one-time rights. Originals are returned to artist at job's completion.
Book Design: Assigns 1 freelance illustration jobs/year. Pays in copies, $50 maximum.
Jackets/Covers: Assigns 1 freelance illustration jobs/year. Pays in copies, $25 maximum.
Text Illustration: Assigns 1 freelance jobs/year. Pays in copies, $50 maximum.
Tips: "Woodcuts, engravings, linocuts are wonderful, especially if we can use your blocks."

TAMBOURINE BOOKS, 1350 Avenue of the Americas, New York NY 10019. (212)261-6500. Art Director: Golda Laurens. Estab. 1989. Imprint of William Morrow & Co., Inc. Publishes hardcover originals and reprints. Types of books include pre-school, juvenile and children's picture books and novels. Publishes 35-50 titles/year. Recent titles include *No Milk!* and *Red Dancing Shoes.* 99% require freelance illustration. "We are interested in highly individual style, strong color, good design." Book catalog for 9 × 12 SASE.
Needs: Works with 30 freelance illustrators/year. Prefers artists with experience in children's books. Uses freelancers for illustrating picture books. Also uses artists for jacket/cover illustration. Works on assignment only.
First Contact & Terms: Send query letter with SASE and (8½ × 11) color photocopies. Samples are filed if appropriate or are returned by SASE. Art Director will contact artist for portfolio review if interested. Rights purchased vary according to project. Originals are returned at job's completion.
Jackets/Covers: Assigns 5 illustration jobs/year. Pays by the project, $1,000; or by artist agreement.
Text Illustration: Assigns 25 illustration jobs/year. Pays by the project, $5,000; or royalty.

✹**THISTLEDOWN PRESS LTD.**, 633 Main St., Saskatoon, Saskatchewan S7H 0J8 Canada. (306)244-1722. Fax: (306)244-1762. Director, Production: Allan Forrie. Estab. 1975. Publishes trade and mass market paperback originals. Types of books include contemporary and experimental fiction, juvenile, young adult and poetry. Specializes in poetry creative and young adult fiction. Publishes 10-12 titles/year. Titles include *The Blue Jean Collection*, *The Mystery of the Missing Will* and *How to Saw Wood with an Angel.* 50% require freelance illustration. Book catalog for SASE.
Needs: Approached by 25 freelance artists/year. Works with 8-10 illustrators/year. Buys 10-12 illustrations/year. Prefers local Canadian artists. Uses freelancers for jacket/cover illustration. Uses only Canadian artists and illustrators for its title covers. Works on assignment only.
First Contact & Terms: Send query letter with résumé, SASE, slides and transparencies. Samples are filed or are returned by SASE. Reports back to the artist only if interested. Call for appointment to show portfolio of original/final art, tearsheets, photographs, slides and transparencies. Buys one-time rights.

Jackets/Covers: Assigns 10-12 illustration jobs/year. Prefers painting or drawing, "but we have used tapestry—abstract or expressionist to representational." Also uses 10% computer illustration. Pays by the project, $250-600.

Tips: "Look at our books and send appropriate material. More young adult and adolescent titles are being published, requiring original cover illustration and cover design. New technology (Adobe Illustrator, Photoshop) has slightly altered our cover design concepts."

‡**TRANSPORTATION TRAILS, National Bus Trader, Inc.**, 9698 W. Judson Rd., Polo IL 61064. (815)946-2341. Fax: (815)946-2347. Editor: Larry Plachno. Production Manager: Joseph Plachno. Estab. 1977. Imprints include National Bus Trader, Transportation Trails Books; also publishes *Bus Tours Magazine*. Company publishes hardcover and mass market paperback originals and magazines. Types of books include "primarily transportation history but some instruction and reference." Publishes 5-7 titles/year. Recent titles include *Breezezs—A Lighthearted History of The Open Trolley Car in America* and *The Steam Locomotive Directory of North America*. Book catalog free by request.

Needs: Approached by 1 freelance artist/year. Works with 3 freelance illustrators/year. Buys 5-15 freelance illustrations/year. Prefers local artists if possible with experience in transportation and rail subjects. Uses freelance artists mainly for covers and chapter logo lines. Also uses freelance artists for text illustration, maps, occasional magazine illustrations, Christmas magazine covers. Works on assignment only.

First Contact & Terms: Send query letter with "any reasonable sample." Samples are returned by SASE if requested by artist. Artist should follow up with letter after initial query. Buys all rights. Originals are not returned.

Jackets/Covers: Assigns 3-6 freelance illustration jobs/year. Pays by the project, $150-700. Prefers b&w pen & ink line drawing of subject with rubylith/amberlith overlays for color.

Text Illustration: Assigns 3-6 freelance illustration jobs/year. Pays by the project, $50-200. Prefers silhouette b&w line drawing approximately 42 picas × 6 picas.

Tips: First-time assignments are usually silhouette text illustrations; book jackets and magazine covers are given to "proven" freelancers.

THE TRUMPET CLUB/MARKETING SERVICES/BANTAM DOUBLEDAY DELL PUBLISHING GROUP, (formerly The Trumpet Club/Bantam Doubleday Dell Publishing Group), 1540 Broadway, New York NY 10036. Senior Designer: Deborah Thoden. Estab. 1985. Mail-order school book club specializing in paperbacks and related promotional material. Publishes juvenile fiction and nonfiction. Books look "child-like and lighthearted; for pre-school-6th grade."

Needs: Works with 20-50 freelance illustrators and 5-10 freelance designers/year. Prefers local computer and non-computer designers and illustrators with children's illustration experience; but out-of-towners okay. Uses freelancers for direct mail and catalog design; poster, sticker, book mark and bookplate illustration; and other original classroom products. Needs computer-literate freelancers for design, illustration and production. 50% of freelance work demands knowledge of Adobe Illustrator, QuarkXPress, Photoshop or Aldus FreeHand.

First Contact & Terms: Send query letter, résumé and tearsheets. Some samples are returned. Reports back only if interested. Art Director will contact artist for portfolio review if interested. "We prefer illustrators with children's book experience, but we will consider others, too." Portfolio should include photostats, final reproduction/product, slides or transparencies. Considers complexity of project and project's budget when establishing payment. Originals are returned at job's completion.

Book Design: Pays by the project.

Jackets/Covers: Pays by the project.

Text Illustration: Pays by the project, based on complexity of the project.

Tips: "We are looking for freelance Macintosh designers and illustrators familiar with QuarkXPress, Adobe Illustrator and Photoshop. Non-computer designers and illustrators are considered as well. We prefer designers who can carry a job through to production."

‡**TWIN PEAKS PRESS**, P.O. Box 129, Vancouver WA 98666. Fax: (206)696-3210. Design Department: Victoria Nova. Estab. 1982. Company publishes hardcover, trade and mass market paperback reprints, trade paperback and mass market paperback originals. Types of books include instruction, travel, self help, reference, humor and cookbooks. Specializes in how-to. Publishes 6 titles/year. Book catalog available for $3.

First Contact & Terms: Send query letter with SASE. Samples are not filed and are not returned. Portfolio review not required.

TYNDALE HOUSE PUBLISHERS, INC., 351 Executive Dr., Wheaton IL 60189. (708)668-8300. Art Buyer: Marlene S. Muddell. Specializes in hardcover and paperback originals on "Christian beliefs and their effect on everyday life." Publishes 80-100 titles/year. Recent titles include *When Nations Die*, *Gates of His Enemies* and *The Eleventh Hour*. 25% require freelance illustration. Books have "classy, highly-polished design and illustration."

Needs: Approached by 50-75 freelance artists/year. Works with 30-40 illustrators and cartoonists/year.

First Contact & Terms: Send query letter, tearsheets and/or slides. Samples are filed or are returned by SASE. Reports back only if interested. Considers complexity of project, skill and experience of artist, project's budget and rights purchased when establishing payment. Negotiates rights purchased. Originals are returned at job's completion except for series logos.

Jackets/Covers: Assigns 40 illustration jobs/year. Prefers progressive but friendly style. Pays by the project, $300-4,000.

Text Illustrations: Assigns 10 jobs/year. Prefers progressive but friendly style. Pays by the project, $300-6,000.

Tips: "Only show your best work. We are looking for illustrators who can tell a story with their work and who can draw the human figure in action when appropriate." A common mistake is "neglecting to make follow-up calls. Be able to leave fileable sample(s). Be available; by friendly phone reminders, sending occasional samples. Schedule yourself wisely, rather than missing a deadline."

UAHC PRESS, 838 Fifth Ave., New York NY 10021. (212)249-0100. Director of Publications: Stuart L. Benick. Produces books, and magazines for Jewish school children and adult education. Recent titles include *My First One Hundred Hebrew Words*, *West of the Hudson* and *A Candle For Grandpa*. Books have "clean" look. Free catalog.

Needs: Approached by 20 freelance artists/year.

First Contact & Terms: Send samples or write for interview. Include SASE. Reports within 3 weeks.

Jackets/Covers: Pays by the project, $250-600.

Text Illustration: Pays by the project, $150-200.

Tips: Seeking "clean and catchy" design and illustration.

UNIVELT INC., Box 28130, San Diego CA 92198. (619)746-4005. Manager: R.H. Jacobs. Publishes hardcover and paperback originals on astronautics and related fields; occasionally publishes veterinary first-aid manuals. Specializes in space. Publishes 10 titles/year; all have illustrations. Recent titles include *Spaceflight Dynamics 1993*. Books have "glossy covers with illustrations." Book catalog free by request.

Needs: Works with 1-2 freelance illustrators/year. Prefers local artists. Uses artists for covers, title sheets, dividers, occasionally a few illustrations. Does not computer-literate freelancers.

First Contact & Terms: Send query letter with résumé, business card and/or flier to be kept on file. Samples not filed are returned by SASE. Reports in 1 month on unsolicited submissions. Buys one-time rights. Originals are returned at job's completion.

Jackets/Covers: Assigns 10 freelance design jobs and 10 freelance illustration jobs/year. Pays $50-100 for front cover illustration or frontispiece.

Text Illustration: Pays by the project, $50-100.

Tips: "Books usually include a front cover illustration and frontispiece. Illustrations have to be space-related. We obtain most of our illustrations from authors and from NASA."

THE UNIVERSITY OF ALABAMA PRESS, Box 870380, Tuscaloosa AL 35487-0380. (205)348-5180. Fax: (205)348-9201. Production Manager: Zig Zeigler. Specializes in hardcover and paperback originals and reprints of academic titles. Publishes 40 titles/year. 5% require freelance design.

Needs: Works with 1-2 freelance artists/year. Requires book design experience, preferably with university press work. Works on assignment only.

First Contact & Terms: Send query letter with résumé, tearsheets and slides. Samples not filed are returned only if requested. Reports back within a few days. To show portfolio, mail tearsheets, final reproduction/product and slides. Considers project's budget when establishing payment. Buys all rights. Originals are not returned.

Book Design: Assigns 1-2 jobs/year. Pays by the project, $250 minimum.

Jackets/Covers: Assigns 1-2 design jobs/year. Pays by the project, $250 minimum.

Tips: Has a very limited freelance budget.

UNLIMITED EDITIONS INTERNATIONAL, Box 1509, Chandler NC 28715. President: Gregory Hugh Leng. Estab. 1982. Independent book producer/packager of trade paperback originals and textbooks. Types of books include instructional, reference and self help. Specializes in photography, business and financial. Produces 30 titles/year. Titles include *How to Make Money in Mail Order*. 50% require freelance illustration and design. Book catalog available for $3.

Needs: Approached by 60-100 freelance artists/year. Works with 12 illustrators and 12 designers/year. Buys 30-60 illustrations/year. Prefers artists with experience in photographic areas and business and educational design. Uses freelancers for text illustration, direct mail and book design and cassette packaging labels. Works on assignment only.

First Contact & Terms: Send query letter with brochure, résumé, SASE and tearsheets. Samples are not filed and are returned by SASE. Reports back within 1 month. To show portfolio, mail tearsheets and slides. Sometimes requests work on spec before assigning a job. Rights purchased vary according to project. Assigns

12 design jobs and 12 freelance illustration jobs/year. Pays by the project, $25-1,000. Originals are returned at job's completion.

Tips: "We use a lot of artwork for self-help cassette courses. We also publish a photographic newsletter called 'Images.' Our company sponsors annual art and design competitions."

■**VALLEY OF THE SUN PUBLISHING**, subsidiary of Sutphen Corp., Box 38, Malibu CA 90265. Art Director: Jason D. McKean. Estab. 1972. Publisher of books and audio, video and music cassettes. Publishes trade and mass market paperback originals. Subjects include self help, metaphysical and New Age. Publishes 30 titles/year. Recent titles include *Lunar Goddess, Sea Odyssey* and *Weight Loss*. 30% require freelance illustration.

Needs: Approached by 30 freelance artists/year. Buys 20 illustrations/year. Uses freelancers mainly for audio and video package cover art. Also for jacket/cover illustration.

First Contact & Terms: Send query letter with 35mm transparencies or self-promotion that can be kept on file. Samples are filed or are returned by SASE. Reports back only if interested. Buys one-time rights.

Jackets/Covers: Assigns 10-20 illustration jobs/year. Pays by the project, $100 minimum.

Tips: "We use surrealistic, fantasy, striking and peaceful illustration, realistic or abstract. I look for eye-catching color."

WARNER BOOKS INC., 1271 Sixth Ave., New York NY 10020. (212)522-7200. Vice President and Creative Director: Jackie Meyer. Publishes mass market paperbacks and adult trade hardcovers and paperbacks. Publishes 350 titles/year. Recent titles include *Slow Waltz in Cedar Bend, Along Came a Spider* and *The General's Daughter*. 20% require freelance design; 80% require freelance illustration.

Needs: Approached by 500 freelance artists/year. Works with 150 freelance illustrators and 30 freelance designers/year. Buys hundreds of designs and illustrations from freelance artists every year. Uses freelance artists mainly for illustration and handlettering. Works on assignment only.

First Contact & Terms: Do not call for appointment or portfolio review. Mail samples only. Send brochure or tearsheets and photocopies. Samples are filed or are returned by SASE. Art Director will contact artist for portfolio review if interested. Pays $800 and up for design; $1,000 and up for illustration. Negotiates rights purchased. Considers buying second rights (reprint rights) to previously published work. Originals are returned at job's completion (artist must pick up). "Check for most recent titles in bookstores."

Jackets/Covers: Uses realistic jacket illustrations. Pays by the project; $1,000-1,500.

Tips: Finds artists through books, mailers, parties, lectures, judging and colleagues. Industry trends include "more graphics and stylized art." Looks for "photorealistic style with imaginative and original design and use of eye-catching color variations." Artists "shouldn't talk too much. Good design and art should speak for themselves."

WEBB RESEARCH GROUP, Box 314, Medford OR 97501. (503)664-4442. Owner: Bert Webber. Estab. 1979. Publishes hardcover and trade paperback originals. Types of books include biography, reference, history and travel. Specializes in the history and development of the Pacific Northwest and the Oregon Trail. Titles include *Rajneeshpuram: Who Were Its People*, a book on American & Japanese relocation in World War II and *Oregon Trail Diaries of Jane Gould*. 5% require freelance illustration. Book catalog for SAE with 2 first-class stamps.

Needs: Approached by more than 30 freelance artists/year, "but most do not read what subject areas we will look at." Uses freelancers for localizing travel maps and doing sketches of Oregon Trail scenes. Also for jacket/cover and text illustration. Works on assignment only.

First Contact & Terms: Send query letter with SASE and photocopied samples of the artists' Oregon Trail subjects. "We will look only at subjects in which we are interested—Oregon history, development and Oregon Trail." Samples are not filed and are only returned by SASE if requested by artist. Reports back to the artist only if interested and SASE is received. Portfolios are not reviewed. Rights purchased vary according to project. Originals often returned at job's completion.

Jackets/Covers: Assigns more than 15 design jobs/year.

Text Illustration: Assigns 6 illustration jobs/year. Payment negotiated.

Tips: "Artist must clearly state his basic or minimum fees expected and must stay within our subjects. No 'modern art' accepted."

SAMUEL WEISER INC., Box 612, York Beach ME 03910. (207)363-4393. Fax: (207)363-5799. Vice President: B. Lundsted. Specializes in hardcover and paperback originals, reprints and trade publications on metaphysics/oriental philosophy/esoterica. Recent titles include *Helping Heaven Happen*, by Donald Curtis and *Comfort to the Sick*, by Brother Aloysius. "We use visionary art or nature scenes." Publishes 20 titles/year. Catalog available for SASE.

Needs: Approached by approximately 15 artists/year. Works with 10-15 illustrators and 2-3 designers/year. Uses freelancers for jacket/cover design and illustration.

First Contact & Terms: Send query letter with résumé, slides, book covers and jackets. "We can use art or photos. I want to see samples I can keep." Samples are filed or are returned by SASE only if requested by artist. Reports back within 1 month only if interested. Originals are returned to artist at job's completion.

This painting in acrylic and oil pastel by Richard Stoddart graced the cover of Finding Your Soulmate, designed by Phillip Augusta, for Samuel Weiser, Inc. "This cover is very popular," says the publisher. "I think it's a combination of art and subject matter."

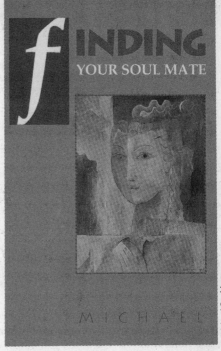

To show portfolio, mail tearsheets and slides. Considers complexity of project, skill and experience of artist, project's budget, turnaround time and rights purchased when establishing payment. Buys one-time nonexclusive rights.

Jackets/Covers: Assigns 20 design jobs/year. Prefers airbrush, watercolor, acrylic and oil. Pays by the project, $100-500.

Tips: Finds most artists through references/word-of-mouth, portfolio reviews and samples received through the mail. "We're interested in artists with professional experience with cover mechanicals — from inception of design to researching/creating image to type design, color-separated mechanicals to logo in place. Don't send us drawings of witches, goblins and demons, for that is not what our field is about. You should know something about us before you send materials."

DAN WEISS ASSOCIATES INC., 33 W. 17th St., New York NY 10011. (212)645-3865. Fax: (212)633-1236. Art Director: Paul Matarazzo. Independent book producer/packager. Publishes mass market paperback originals. Publishes mainstream fiction, juvenile, young adult, self help and humor. Recent titles include *Sweet Valley University* series, *Ocean City* series and *Boyfriends Girlfriends* series. 80% require freelance illustration; 25% require freelance design. Book catalog not available.

Needs: Approached by 50 freelance artists/year. Works with 20 freelance illustrators and 5 freelance designers/year. Only uses artists with experience in mass market illustration or design. Uses freelance artists mainly for jacket/cover illustration and design. Also uses freelance artists for book design. Works on assignment only.

First Contact & Terms: Send query letter with résumé, SASE, tearsheets, photographs and photocopies. Samples are filed or returned by SASE if requested by artist. Reports back to the artist only if interested. To show portfolio, mail original/final art, slides dummies, tearsheets and transparencies. Sometimes requests work on spec before assigning a job. Rights purchased vary according to project. Originals are returned at job's completion.

Jackets/Covers: Assigns 10 freelance design and 50-75 freelance illustration jobs/year. Only criteria for media and style is that they reproduce well.

Tips: "Know the market and have the professional skills to deliver what is requested on time. Book publishing is becoming very competitive. Everyone seems to place a great deal of importance on the cover design as that affects a book's sell-through in the book stores."

WESTERN PUBLISHING CO., INC., 850 3rd Ave., New York NY 10022. (212)753-8500. Fax: (212)371-1091. Art Directors: Dave Werner and Remo Cosentino. Contact: Candice Smilow. Printing company and pub-

lisher. Imprint is Golden Books. Publishes pre-school, juvenile, trade books and young adult and adult nature guides. Specializes in picture books themed for infant to 8 year olds. Publishes 300 + titles/year. Recent titles include *I Love Christmas, Pierrot's ABC Garden, Walt Disney's Aladdin*. 100% require freelance illustration. Book catalog free by request.

Needs: Approached by several hundred artists/year. Works with approximately 100 illustrators/year. Very little freelance design work. Most design is done in-house or by packagers. Buys enough illustration for 250 plus new titles, the majority being licensed character books. Artists must have picture book experience; illustrations are generally full color. Uses freelancers primarily for picture books for young children, and secondarily for natural science guides, pre-teen covers and interiors. Needs computer-literate freelancers for production and paste-up. 35% (more if we could find qualified people) of freelance work demands knowledge of Adobe Illustrator, QuarkXPress, Photoshop or Aldus FreeHand. "Quark is necessity."

First Contact & Terms: Send query letter with SASE and tearsheets. Samples are filed or are returned by SASE if requested by artist. Portfolio drop-off on Thursdays. Will look at original artwork and/or color representations in portfolios, but please do not send original art through the mail. Royalties or work for hire according to project.

Jackets/Covers: All design done in-house or by packagers. Makes outright purchase of cover illustrations.

Text Illustration: Assigns approximately 250 illustration jobs/year. Payment varies.

Tips: "We are open to a much wider variety of styles than in previous years. However, illustrations that have trade and mass market appeal, featuring appealing multicultural children in the vein of Eloise Wilkins will get strongest consideration."

‡WHALESBACK BOOKS, Box 9546, Washington DC 20016. (202)333-2182. Fax: (202)333-2184. Publisher: W.D. Howells. Estab. 1988. Imprint of Howells House. Company publishes hardcover and trade paperback originals and reprints. Types of books include biography, history, art, architecture, social and human sciences. Publishes 2-4 titles/year. 80% require freelance illustration; 80% require freelance design. Book catalog not available.

Needs: Approached by 6-8 freelance artists/year. Works with 1-2 freelance illustrators and 1-3 freelance designers/year. Buys 10-20 freelance illustrations/job. Prefers local artists with experience in color and desktop. Uses freelance artists mainly for illustration and book/jacket designs. Also uses freelance artists for jacket/cover illustration and design; text, direct mail, book and catalog design. Needs computer-literate freelancers for design. 20-40% of freelance work demands knowledge of Aldus PageMaker, Adobe Illustrator or QuarkXPress. Works on assignment only.

First Contact & Terms: Send query letter with brochure, SASE and photocopies. Samples are not filed and are returned by SASE if requested by artist. Reports back only if interested. Art Director will contact artist for portfolio review if interested. Portfolio should include b&w roughs and photostats. Rights purchased vary according to project.

Book Design: Assigns 2-4 freelance design jobs/year. Pays by the project, $300-800.

Jackets/Covers: Assigns 2-4 freelance design jobs/year. Pays by the project, $300-800.

Text Illustration: Assigns 6-8 freelance illustration jobs/year. Pays by the project, $100 minimum.

WILSHIRE BOOK CO., 12015 Sherman Rd., North Hollywood CA 91605. (818)765-8579. President: Melvin Powers. Publishes paperback reprints; psychology, self help, inspirational and other types of nonfiction. Publishes 25 titles/year. Recent titles include *Public Speaking Made Easy* and *Think Like a Winner*. Free catalog.

Needs: Uses freelance artists mainly for book covers. Also uses freelance artists for direct mail design.

First Contact & Terms: Request portfolio review in original query. Buys first, reprint or one-time rights. Interested in buying second rights (reprint rights) to previously published work. Negotiates payment.

Jackets/Covers: Assigns 25 cover jobs/year.

WORD PUBLISHING, Suite 650, 1501 Lyndon B. Johnson Freeway, Dallas TX 75234. (214)488-9673. Fax: (214)488-1311. Art Director: Tom Williams. Estab. 1951. Publishes hardcover, trade paperback and mass market paperback originals. Types of books include contemporary and historical fiction, fantasy, biography, pre-school, juvenile, young adult, self help, humor, Bibles and audio/video tapes. "All books are Christian-oriented, but with strong crossover appeal." Publishes 75 titles/year. Titles include *New World Order* (Pat Robinson) and *Storm Warning* (Billy Graham). 30% require freelance illustration; 100% require freelance design. Books are varied—from typographic to illustration. "We use sophisticated special effects on important titles." Book catalog not available.

Needs: Approached by more than 500 freelance artists/year. Works with 20 illustrators and 25 designers/year. Must have artists with experience in book cover design or illustration. "Designers should be experts at type usage." Uses freelance artists mainly for cover design/illustration. Also uses freelance artists for book design. Needs computer-literate freelancers for design and production. 50% of freelance design demands computer skills. Works on assignment only.

First Contact & Terms: Send query letter with brochure, tearsheets, photocopies and photostats. Samples are filed or are returned by SASE if requested by artist. Reports back to the artist only if interested. "Please

do not call!" Rights purchased vary according to project. Considers buying second rights (reprint rights) to previously published work. Originals are returned.

Book Design: Assigns 2 jobs/year. Pays by the project, $1,500-2,500.

Jackets/Covers: Assigns 75 design and 25-30 illustration jobs/year. Pays by the project, $1,200-2,500.

Text Illustration: Pays by the project, $75-300/b&w illustration.

Tips: To find new artists, "I go to bookstores and get names off jacket/cover credits. You need to already be successful in trade, with impressive credits. Must have experience with book cover design/illustration. Budgets are tighter. We're looking for illustrators/designers who can meet budgets. Also using more computer work with freelancers. Soon all design work will be on disk. Talented newcomers considered. Contact by mail only please. Send best work."

∎**WRITER'S PUBLISHING SERVICE CO.,** 1512 Western Ave., Box 1273, Seattle WA 98111. (206)467-6735. Fax: (206)622-6876. Publisher: William R. Griffin. Estab. 1976. Publishes hardcover originals and reprints, trade paperback originals and textbooks. Types of books include contemporary, experimental, historical, science fiction, instruction, adventure, fantasy, mystery, biography, pre-school, reference, history, self help, humor and cookbooks. Specializes in "all subjects; a separate division does only cleaning and maintenance subjects." Publishes 50 titles/year. Titles include *Living Through Two World Wars*, by Lehman and *How to Sell and Price Contract Cleaning*, by Davis. 90% require freelance illustration; 50% require freelance design.

Needs: Approached by 250 freelance artists/year. Works with 50 illustrators and 20 designers/year. Buys more than 300 freelance illustrations/year. Prefers artists with experience. Uses freelancers mainly for illustration, design, covers. Also for direct mail and catalog design. Works on assignment only.

First Contact & Terms: Send query letter with brochure, résumé, tearsheets, photocopies and other samples of work. Samples are filed. Reports back to the artist only if interested. Call or write for appointment to show portfolio of roughs, dummies and other samples. Rights purchased vary according to project. Originals are returned at job's completion.

Book Design: Assigns 30 design jobs/year. Pays by the hour, $7-30; or by the project, $3-1,500.

Jackets/Covers: Assigns 10 design and 20 illustration jobs/year. Pays by the hour or by the project.

Text Illustration: Assigns 20 illustration jobs/year. Pays by the hour or by the project.

Tips: "We are always looking for cleaning- and maintenance-related art and graphics. Call or write to find out what our current need is. Don't waste your money and our time by sending samples we don't want or need. If you can produce what we want, when we need it and at a reasonable price, your chances are good to sell your work."

‡**WRS GROUP, INC.,** 701 New Rd., Waco TX 76710. (817)776-6461. Fax: (817)776-6321. Art Director: Linda Fitlgo. Estab. 1967. Imprints include WRS Publishing, Health Ed. Co., Childbirth Graphics. Company publishes hardcover, trade paperback and mass market paperback originals, and textbooks. Types of books include instruction, biography, self help, young adult, humor, pre-school and coffee table books. Specializes in health and social issues and art books. Publishes 35 titles/year. Recent titles include *Perez on Medicine* and *The Art of Medicine Today*. Book catalog free for SAE with 2 first-class stamps.

Needs: Approached by 25 freelance artists/year. Works with 5 freelance illustrators and 4 freelance designers/year. Buys 50 freelance illustrations/year. Prefers artists with experience in book illustration. Uses freelance artists mainly for art books. Also uses freelance artists for jacket/cover illustration and design and text illustration. Needs computer-literate freelancers for design and illustration. Freelancers should be familiar with Aldus PageMaker, Adobe Photoshop or Aldus FreeHand. Works on assignment only.

First Contact & Terms: Send query letter with résumé, SASE, tearsheets, photographs, photocopies, slides and transparencies. Samples are filed or are returned by SASE. Reports back within 1 month. Art Director will contact artist for portfolio review if interested. Portfolio should include photostats, slides and tearsheets. Buys all rights. Originals are returned at job's completion.

Book Design: Assigns very few freelance design jobs/year. Pays by the project, $100-5,000.

Jackets/Covers: Assigns 8 freelance design and 4 freelance illustration jobs/year. Pays by the project, $100-5,000. Prefers full-color photography.

Text Illustration: Assigns 5 freelance illustration jobs/year. Pays by the project, $100-5,000. Prefers watercolor, pen & ink, computer.

Tips: First-time assignments are usually children's books; book jackets are given to "proven" freelancers. Finds artists through agents, sourcebooks or other publications, word of mouth, artists' submissions.

ZOLAND BOOKS, INC., 384 Huron Ave., Cambridge MA 02138. (617)864-6252. Design Director: Lori Pease. Estab. 1987. Publishes hardcover and trade paperback originals and reprints. Types of books include literary mainstream fiction, biography, juvenile, travel, poetry, fine art and photography. Specializes in literature. Publishes 6-10 titles/year. Recent titles include *Matron of Honor*, by Sallie Bingham; *Whistling and Other Stories*, by Myra Goldberg. Books are of "quality manufacturing with full attention to design and production, classic with a contemporary element." 10% require freelance illustration; 100% require freelance design. Book catalog with SASE.

Needs: Works with 2 freelance illustrators and 6 freelance designers/year. Buys 3 illustrations/year. Uses freelancers mainly for book and jacket design. Also for jacket/cover illustration and catalog design. Needs

This painting from **Perez on Medicine,** *artist Jose Perez's whimsical collection of 28 works on medical specialties, is part of the private medical art collection owned by Dr. W.R. Spence of WRS Publishing. "We enjoy the satire in his work," says the publisher. "Mr. Perez is a genius."*

computer-literate freelancers for design and production. 100% of design work demands knowledge of Aldus PageMaker. Works on assignment only.

First Contact & Terms: Send query letter with brochure, résumé, tearsheets, photocopies and photostats. Samples are filed or are returned by SASE if requested by artist. Art Director will contact artist for portfolio review if interested. Portfolio should include roughs and tearsheets. Rights purchased vary according to project. Originals are returned at job's completion.

Book Design: Assigns 6-10 jobs/year. Pays by the project, $400 minimum.

Jacket/Covers: Assigns 6-10 design and 1-3 freelance illustration jobs/year. Pays by the project, $500 minimum.

Tips: Finds artists through word of mouth, artists' submissions/self promotion. "We love to see all styles appropriate for a literary publisher."

Book Publishers/'94-'95 changes

The following markets were listed in the 1994 edition but do not have listings in this edition. The majority did not respond to our request to update their listings. If a reason was given for exclusion, it appears in parentheses after the market's name.

Africa World Press, Inc.
American Association of Collegiate Registrars and Admission Officers
American Institute of Chemical Engineering (per request)
April Publications, Inc.
Aquino Productions
Arts End Books

Ashley Publishing (unable to contact)
Don Bosco Multimedia
Carolina Wren Press/Lollipop Power Books
Chatham Press (unable to contact)
China Books & Periodicals
Christian Board of Publication

Clothespin Fever Press
Colonial Press (per request)
Conari Press
Cynthia Publishing
Dark Harvest Books
Demos Publications
T.S. Denison & Co., Inc.
Drama Book Publishers
Elliot & Clark Publishing

Entelek
Facts on File
Fairchild Fashion & Merchandisng Group, Book Division
Farrar, Straus & Giroux, inc.
Firehole Press
J. Flores Publications
Foreign Services Research Institute/Wheat Forders
The Free Press
Gallaudet University Press
The Gestalt Journal Press
Glencoe Publishing Company
Goose Lane Editions Ltd
Grapevine Publications, Inc. (no longer buying art)
Harpercollins
Homestead Publishing

Hunter House Publishers
Inner Traditions International
International Marine Publishing Co.
Kitchen Sink Press
B. Klein Publications, Inc.
Alfred A. Knopf
Kruza Kaleidoscopix Inc
Little, Brown and Company
Minne Ha! Ha!
John Muir Publications
The Noble Press
Oddo Publishing, Inc.
Orchard Books
The Overlook Press
Pacific Press Publishing Association
Paragon House

Pen Notes, Inc.
Penguin Books
Piccadilly Books
Pocket Books
Puffin Books
R.T.A.J. Fry Press/A.I.C
Schanes Products & Services
Thompson & Co. Inc.
Troll Associates
Visual Education Corporation
Weigel Educational Publishers
Westport Publishers, Inc.
Albert Whitman & Company
Woodsong Graphics Inc. (not using freelance work right now)
Ye Galleon Press

Galleries

The '90s has been dubbed the "decade of the regional artist" for good reason. More and more galleries are featuring the work of local artists, and more collectors are realizing that talented artists don't have to be from New York. Retailers, restaurants and downtown councils are finding out that supporting the arts is good for business, and corporations are busy building collections of work by local artists.

In gathering information from the 586 galleries listed in this section, we surveyed galleries across the country. The response was encouraging. Though nobody is exactly singing "We're in the Money," the general tone is optimistic. It looks like signs of recovery are being felt in the arts as well as the rest of the nation's businesses. There are 328 new listings in this section, 157 more new listings than last year.

Venues for artists are springing up everywhere, as new gallery districts emerge to brighten our cities and suburbs. Artists are becoming more entrepreneurial and pro-active, organizing their own galleries and banding together with fellow artists to form co-ops. Established galleries have a more supportive attitude toward new galleries and co-ops. Instead of competing, galleries are boosting their clout by forming associations. Restaurants, bookstores and other businesses team up with the arts communities to sponsor events such as gallery walks, poetry readings, art auctions, street fairs, performance art and other promotional opportunities, attracting business to an entire area. Through local art councils and grants from foundations, artists are renovating old factories, abandoned warehouses and barns to create spaces that revitalize neglected areas.

Now is the time to get involved on a local level. Artists don't have to start at the top. But they must start. By entering group shows and participating in co-op ventures, you can take charge of your career. To find out some of your options, take a look at the listings that follow and those in our Organizations section. But don't limit your browsing. By looking closely at what various galleries and organizations in other cities are doing, you will recognize similar possibilities that could exist in your city. Since most commercial galleries want to show artists who have exhibited before, start by showing your work at nonprofit spaces or join a co-op to gain exposure and experience. Once you've had a few shows under your belt, approach your city's more established galleries. Gallery director Ivan Karp gives advice on approaching galleries in this section's Insider Report on page 368.

Where to start

No matter how talented you are, do not walk into a gallery with your paintings. When we ask gallery directors for pet peeves they always discuss the talented newcomers walking into the gallery with paintings in hand. Send a polished package of about 15 or 20 neatly labeled, mounted slides of your work submitted in plastic slide sheet format (refer to the listings for more specific information on each gallery's preferred submission method). Remember, gallery owners are people who love the arts and enjoy their involvement with artists, but they are also business people. The artists they choose to represent must not only be talented, but experienced and highly professional as well.

It's much easier to begin developing a reputation within a defined region. New

artists rarely burst onto the scene on a national level. If you have never shown your work before, begin by entering your work in a group show. Many galleries, retail spaces and universities conduct group shows regularly in which several artists are featured. In a group show, you'll only be given enough space to show a couple of pieces, but it is a great opportunity to learn about basics like matting and framing your work, hanging the work and deciding what to charge. You can find out about opportunities through university and art school bulletin boards, your public library's art department, artists' magazines and networking with your fellow artists.

Types of galleries

Before you begin your search for the perfect gallery, it's important to understand the different types of spaces and how they operate. There are, of course, advantages and disadvantages to each type of space. The route you ultimately choose will depend on your needs, the type of work you do, your long term goals, and the audience you're trying to reach.

- **Retail or commercial galleries.** The goal of the retail gallery is to sell and promote artists while turning a profit. Work in retail galleries is handled by a professional sales staff, because selling the work is the gallery's major concern. Artwork is either bought outright or handled on consignment. Today, more and more galleries are choosing the consignment option. By avoiding outright purchases, they minimize the risk of having unsold artwork in their inventory.

- **Co-op galleries.** Like retail galleries, co-ops exist to sell and promote artists' work, but they are run by artists, and have no professional sales staff. Members of co-ops are able to exhibit their own work in exchange for a fee, which covers the gallery's overhead. Some co-ops also take a small commission of 20-30% on work sold to cover expenses. It's important to note that this type of arrangement also requires a time commitment. Members share the responsibilities of gallery-sitting, housekeeping and maintenance.

- **Rental galleries.** In this type of arrangement, the artist rents space from an organization or individual in which to display work. The gallery makes its profit primarily through rent and consequently may not take a commission on sales (or will take only a very small commission). Some rental spaces provide publicity for artists, while others do not.

- **Nonprofit galleries.** The mission of the nonprofit gallery is often to provide a forum for public discussion through art. Many nonprofits exist solely for the benefit of the public: to make art and culture accessible to all people. A show in this type of space will provide the artist an opportunity to sell work and gain publicity, but the nonprofit will not market the work aggressively, as its goals are not necessarily sales-oriented. Nonprofits normally take a commission on consignment work, but commissions are less than those taken by commercial galleries.

- **Museums.** Many museums delegate a certain portion of their space for traveling exhibitions and invitational group shows. Like nonprofits, museums focus on public enlightenment and not on sales. Nevertheless, a show in a museum offers great publicity and exposure. Some museums also sell small items through their gift shops. Gift shop items are bought outright or are handled on consignment.

- **Art consultancies.** Generally, art consultants act as liaisons between fine artists and buyers. Most represent artists and take a commission on sales (as would a gallery). Some even maintain small gallery spaces and show work to clients by appointment. Corporate consultants, however, are sometimes paid by the corporations they serve and consequently do not take a cut of the artist's sale.

Asking the right questions

No matter which type of space you seek, there are some basic questions you'll want to find answers to before you commit to a show. Start by visiting a few potential galleries in your area. Then talk to other artists and get their perspective on those galleries. Here are some issues you'll want to investigate ahead of time:

• How long has the gallery been in business? A newer gallery may be more open to new artists but not as financially stable as an established gallery.

• How many artists are represented by the gallery? How often does the gallery sponsor group shows vs. solo shows? If the gallery does lots of group shows, it is good for emerging artists.

• What are the gallery's hours? A few hours of exhibition time on weekends won't get your work the attention it deserves. In tourist towns, the gallery may only be open during certain seasons.

• Does the gallery have a specialty or theme? You'll want to make sure your work is appropriate for the gallery's audience.

• What is the gallery's price range and clientele? Will you be reaching the audience you want in this space?

• How knowledgeable is the sales staff? If they can answer your questions about other artists' work, your work will probably receive the same kind of attention.

After you've identified the galleries that interest you, contact the director at each one (address the person by name, not title) and ask for an appointment to show your portfolio. For more information on how to put together and present a portfolio, refer to page 20.

Pricing your work

In exchange for selling, promoting and publicizing your work, the gallery receives a commission of 40 to 60 percent. Some cooperative galleries take small commissions (20 to 30 percent); others do not charge a commission. Nonprofit galleries sometimes take a small percentage to help cover operational costs of the gallery.

A common question of beginning artists is "What do I charge for my paintings?" There are no hard and fast rules. The better known you become, the more people will pay for your work. Though you should never underprice your work, you must take into consideration what people are willing to pay. (See Negotiating the Best Deal page 8.)

Broadening your scope

Once you have achieved representation on a local level, you are ready to broaden your scope by querying galleries in other cities. Many artists have had success showing in multiple galleries. If you establish a relationship with an out-of-town gallery, be sure that either you or a friend visit the gallery before making any decisions. To develop a sense of which galleries are right for you, look to the myriad of art publications which contain reviews and advertising (the pictures that accompany a gallery's ad can be very illuminating). A few such publications are *ARTnews*, *Art in America*, *The New Art Examiner* and regional publications such as *Artweek* (West Coast), *Southwest Art*, *Dialogue* and *Art New England*. Lists of galleries can be found in *Art in America's Guide to Galleries, Museums and Artists* and *Art Now, U.S.A.'s National Art Museum and Gallery Guide*.

Alabama

CORPORATE ART SOURCE, 2960-F Zelda, Montgomery AL 36106. (205)271-3772. Owner: Jean Belt. Art consultancy. Interested in emerging, mid-career and established artists. "I don't represent artists, but keep a slide bank to draw from as resources." Curates several exhibits/year. Clientele: corporate. 10% private collectors, 90% corporate collectors. Most work sold at $600-2,000.
Media: Considers all media, including woodcuts, wood engravings, linocuts, lithographs and serigraphs. Most frequently uses works on paper (original), paintings on canvas and prints.
Style: Exhibits all styles. Genres include landscapes, Southwestern and figurative work. Prefers contemporary landscapes and mixed media pieces.
Terms: Artwork is accepted on consignment (40% commission). Retail price set by artist. Gallery provides contract, shipping costs from gallery. Prefers artwork unframed.
Submissions: Send query letter with slides and bio. Call for appointment to show portfolio of originals and photographs. Replies in 3 months.

‡FINE ARTS MUSEUM OF THE SOUTH, P.O. Box 8426, Mobile AL 36689. (205)343-2667. Director: Joe Schenk. Clientele: tourists and general public. Sponsors 6 solo and 12 group shows/year. Average display time 6-8 weeks. Interested in emerging, mid-career and established artists. Overall price range: $100-5,000; most artwork sold at $100-500.
Media: Considers all media and all types of print.
Style: Exhibits all styles and genres. "We are a general fine arts museum seeking a variety of style, media and time periods." Looking for "historical significance."
Terms: Accepts work on consignment (20% commission). Retail price set by artist. Exclusive area representation not required. Gallery provides insurance, promotion, contract; shipping costs are shared. Prefers framed artwork.
Submissions: Send query letter with résumé, brochure, business card, slides, photographs, bio and SASE. Write to schedule an appointment to show a portfolio, which should include slides, transparencies and photographs. Replies only if interested within 3 months. Files résumés and slides. All material is returned with SASE if not accepted or under consideration.
Tips: A common mistake artists make in presenting their work is "overestimating the amount of space available." Recent gallery developments are the "prohibitive costs of exhibition – insurance, space, transportation, labor, etc. Our city budget has not kept pace with increased costs."

‡THE STREAM OF CONSCIOUSNESS KOFFIEHUIS, 1128-20th St. S., Birmingham AL 35205. (205)903-6673. Fax: (205)322-2684. Curator, artist, consultant: Kimberly Y. McNair. Coffeehouse. Estab. 1993. Represents/exhibits 12 emerging artists/year. Exhibited artists include Patricia Thompson, Toby Richards, Audra Gray. Sponsors 12 shows/year. Average display time 1 month. Open all year; Monday-Thursday 11 p.m.-12 a.m.; Friday, 11 p.m.-2 a.m.; Saturday, 5 p.m.-2 a.m.; Sunday, 5 p.m.-12 a.m.. Located on the southside; 500 sq. ft.; artistic coffees and desserts. 80% of space for gallery artists. 85% private collectors. Overall price range: $200-2,000; most work sold at $200-1,000.
Media: Considers oil, acrylic, watercolor, pastel, pen & ink, drawing, mixed media, collage, photography, woodcut, engraving, lithograph, mezzotint, serigraphs and etching. Most frequently exhibits paintings, prints and etching, photography.
Style: Exhibits painterly abstraction, postmodern works, realism and imagism. Genres include florals and figurative work. Prefers abstract expression, imagism, figurative.
Terms: Co-op membership fee plus donation of time (15% commission). Retail price set by the artist. Gallery provides promotion and contract; artist pays for shipping costs to and from gallery. Prefers artwork framed.
Submissions: Accepts mostly Southeastern artists. Send query letter with slides, bio and SASE. Call for appointment to show slides. Replies in 3 weeks. Files biographies and résumés.
Tips: Finds artists through word of mouth and artists' submissions. "If at all possible, please have slides available for show."

Alaska

STONINGTON GALLERY, 415 F St., Old City Hall, Anchorage AK 99501. (907)272-1489. Fax: (907)272-5395. Manager: Jane Purinton. Retail gallery. Estab. 1983. Interested in emerging, mid-career and established

How to Use Your Artist's & Graphic Designer's Market offers suggestions for understanding and using the information in these listings. Read this and other articles in the front of this book for important business tips.

artists. Represents 50 artists. Sponsors 9 solo and 15 group shows/year. Average display time 3 weeks. Clientele: 60% private collectors, 40% corporate clients. Overall price range: $100-5,000; most work sold at $500-1,000.

Media: Considers oil, acrylic, watercolor, pastel, mixed media, collage, works on paper, sculpture, ceramic, craft, fiber, glass and all original handpulled prints. Most frequently exhibits oil, mixed media and all types of craft.

Style: Exhibits all styles. "We do not want the Americana, Southwestern, Western and wild, but we have no pre-conceived notions as to what an artist should produce." Prefers landscapes, florals and figurative works. Specializes in original works by artists from Alaska and the Pacific Northwest. "We are the only source of high-quality crafts in the state of Alaska. We continue to generate a high percentage of our sales from jewelry and ceramics, small wood boxes and bowls and paper/fiber pieces. Patrons tend to require that metal, clay and wood items be functional, but not so for paper/fiber or mixed media works."

Terms: Accepts work on consignment (50% commission). Retail price set by artist. Exclusive area representation required. Gallery provides insurance, promotion, contract and shipping costs from gallery. Prefers framed artwork.

Submissions: Send letter of introduction with résumé, slides, bio and SASE. Write for appointment to show portfolio of slides. All material returned if not accepted or under consideration.

Arizona

ARIZONA STATE UNIVERSITY ART MUSEUM, Nelson Fine Arts Center and Matthews Center, Arizona State University, Tempe AZ 85287-2911. (602)965-ARTS. Director: Marilyn Zeitlin. Museum. Estab. 1950. Represents mid-career and established artists. Sponsors 12 shows/year. Average display time 2 months. Open all year. Located downtown Tempe ASU campus. Nelson Fine Arts Center features award-winning architecture, designed by Antoine Predock. "The Matthews Center, located in the center of campus, features the Experimental Gallery, showing contemporary art that explores challenging materials, subject matter and/or content."

Media: Considers all media. Greatest interests are contemporary art, crafts, and work by Latin American and Latino artists.

Submissions: "Interested artists should submit slides to the director or curators."

Tips: "With the University cutbacks, the museum has scaled back the number of exhibitions and extended the average show's length. We are always looking for exciting exhibitions that are also inexpensive to mount."

SUZANNE BROWN GALLERY, Dept. AM, 7160 Main St., Scottsdale AZ 85251. (602)945-8475. Director: Ms. Linda Corderman. Retail gallery and art consultancy. Estab. 1962. "Recently opened a second gallery, specializing in contemporary American art." Interested in established artists. Represents 60 artists. Exhibited artists include Veloy Vigil, Ed Mell and Nelson Boren. Sponsors 6 solo and 2 group shows/year. Average display time 2 weeks. Located in downtown Scottsdale. Clientele: valley collectors, tourists, international visitors. 80% private collectors; 20% corporate clients. Overall price range: $500-20,000; most work sold at $1,000-10,000.

• Though focus is mainly on contemporary interpretations of Southwestern themes, gallery shows work of artists from Idaho, New Jersey and all over the country. Director is very open to 3-dimensional work.

Media: Considers oil, acrylic, watercolor, pastel, drawings, mixed media, collage, sculpture, ceramic, craft, fiber, glass, lithographs, monoprints and serigraphs. Most frequently exhibits oil, acrylic and watercolor.

Style: Exhibits realism, painterly abstraction and postmodern works; will consider all styles. Genres include landscapes, florals and Southwestern and Western themes. Prefers contemporary Western, Southwestern and realism. Likes "contemporary American art, specializing in art of the 'New West.' Our galleries exhibit realistic and abstract paintings, drawings and sculpture by American artists.

Terms: Accepts work on consignment. Retail price set by the gallery and the artist. Exclusive area representation required. Gallery provides insurance, promotion and contract; gallery pays for shipping costs from gallery. Prefers framed artwork.

Submissions: Send query letter with résumé, brochure, slides, photographs, bio and SASE. Replies in 2 weeks. All material is returned with SASE. No appointments are made.

Tips: "Include a complete slide identification list, including availability of works and prices. The most common mistakes are presenting poor reproductions and too much background information."

‡**KAREN CASEY GALLERY,** 118 South Central Ave., Phoenix AZ 85003. (602)271-9119. Retail gallery. Estab. 1992. Represents/exhibits 6 emerging artists/year. Exhibited artists include Elizabeth Cheche. Sponsors 9 shows/year. Average display time 3½ weeks. Open all year; Monday-Friday, 11-6; by appt. Located in downtown Phoenix; 1,300 sq. ft.; contemporary painting, drawing, sculpture. 100% of space for special exhibitions. Clientele: private collectors, other art dealers. 80% private collectors, 20% corporate collectors. Overall price range: $500-10,000.

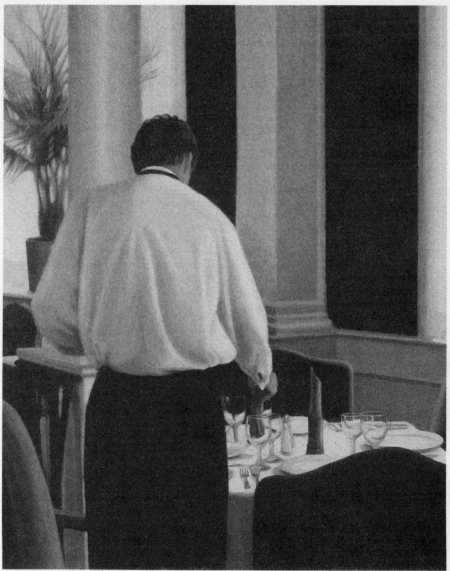

Preparing for the Dinner Crowd *by Dale Kennington has received a positive response from patrons of Suzanne Brown Galleries in Scottsdale, Arizona. "There is a quality that draws the viewer in," says director Linda Corderman. "People guess where the scene is taking place. They seem to create their own narrative."*

Media: Considers oil, acrylic, drawing, mixed media, sculpture and ceramics. Most frequently exhibits oil painting, sculpture, ceramics.

Style: Exhibits expressionism, neo-expressionism, surrealism, imagism and Latin art. Genres include landscapes and figurative work. Prefers figurative work, landscape (nontraditional), still life.

Terms: Accepts work on consignment (50% commission). Retail price set by the gallery and the artist. Gallery provides promotion and contract; artist pays shipping costs to and from gallery. Prefers artwork framed.

Submissions: Send query letter with résumé, brochure, slides, photographs, reviews, bio and SASE. Call or write for appointment to show portfolio of originals, photographs, slides and transparencies. Replies only if interested within 2-3 weeks. Files "work we're interested in."

Tips: Finds artists through agents, visiting exhibitions, word of mouth, art publications and sourcebooks, artists' submissions.

ELEVEN EAST ASHLAND INDEPENDENT ART SPACE, 11 E. Ashland, Phoenix AZ 85004. (602)257-8543. Director: David Cook. Estab. 1986. Represents emerging, mid-career and established artists. Exhibited artists include Erik Foss, Max Rush and Mary MacKenzie. Sponsors 1 juried, 1 invitational and 13 solo and mixed group shows/year. Average display time 3 weeks. Located in "two-story old farm house in central Phoenix, off Central Ave." Overall price range: $100-5,000; most artwork at $100-800.
- Anniversary exhibition is held every year in April and is open to national artists. Work must be submitted by March 1st. Work will not be for sale, but considered for permanent collection and traveling exhibition.

Media: Considers all media. Most frequently exhibits photography, painting, mixed media and sculpture.

Style: Exhibits all styles, preferably contemporary. "This is a non-traditional proposal exhibition space open to all artists excluding Western and Southwest styles (unless contemporary style)."

Terms: Accepts work on consignment (25% commission); rental fee for space covers 1 month. Retail price set by artist. Artist pays for shipping.

Submissions: Accepts proposal in person or by mail to schedule shows 6 months in advance. Send query letter with résumé, brochure, business card, slides, photographs, bio and SASE. Call or write for appointment to show portfolio of slides and photographs. Be sure to follow through with proposal format. Replies only if interested within 1 month. Samples are filed or returned if not accepted or under consideration.

Tips: "Spaces are becoming more diversified."

‡ETHERTON/STERN GALLERY, 135 S. 6th Ave., Tucson AZ 85701. (602)624-7370. Fax: (602)792-4569. Contact: Terry Etherton. Retail gallery and art consultancy. Estab. 1981. Represents 50+ emerging, mid-career and established artists. Exhibited artists include Holly Roberts, Fritz Scholder, James G. Davis and Mark Klett. Sponsors 7 shows/year. Average display time 5 weeks. Open from September to June. Located "downtown; 3,000 sq. ft.; in historic building—wood floors, 16' ceilings." 75% of space for special exhibitions; 10% of space for gallery artists. Clientele: 50% private collectors, 25% corporate collectors, 25% museums. Overall price range: $100-50,000; most work sold at $500-2,000.

Media: Considers oil, acrylic, drawing, mixed media, collage, sculpture, ceramic, all types of photography, original handpulled prints, woodcuts, wood engravings, linocuts, engravings, mezzotints, etchings and lithographs. Most frequently exhibits photography, painting and sculpture.

Style: Exhibits expressionism, neo-expressionism, primitivism, postmodern works. Genres include landscapes, portraits and figurative work. Prefers expressionism, primitive/folk and post-modern. Interested in seeing work that is "cutting-edge, contemporary, issue-oriented, political."

Terms: Accepts work on consignment (50% commission). Buys outright for 50% of retail price (net 30 days). Retail price set by gallery and artist. Gallery provides insurance and promotion; shipping costs are shared. Prefers framed artwork.

Submissions: Only "cutting-edge contemporary—no decorator art." No "unprepared, incomplete works or too wide a range—not specific enough." Send résumé, brochure, slides, photographs, reviews, bio and SASE. Call or write to schedule an appointment to show a portfolio, which should include slides. Replies in 6 weeks only if interested. Files slides, résumés and reviews.

Tips: "Become familiar with the style of our gallery and with contemporary art scene in general."

GALERIA MESA, 155 N. Center, Box 1466, Mesa AZ 85211-1466. (602)644-2242. Owned and operated by the City of Mesa. Estab. 1981. Exhibits the work of emerging, mid-career and established artists. "We only do national juried shows and curated invitationals. We are an exhibition gallery, NOT a commercial sales gallery." Sponsors 9 shows/year. Average display time 4-6 weeks. Closed August. Located downtown; 3,600 sq. ft., "wood floors, 14' ceilings and monitored security." 100% of space for special exhibitions. Clientele: "cross section of Phoenix metropolitan area." 95% private collectors, 5% gallery owners. "Artists selected only through national juried exhibitions." Overall price range: $100-10,000; most artwork sold at $200-400.

Media: Considers all media and original handpulled prints, woodcuts, lithographs, wood engravings, mezzotints, monotypes, serigraphs, linocuts and etchings.

Style: Exhibits all styles and genres. Interested in seeing contemporary work.

Terms: Charges 25% commission. Retail price set by artist. Gallery provides insurance, promotion and contract; pays for shipping costs from gallery. Requires framed artwork.

Submissions: Send a query letter or postcard with a request for a prospectus. "We do not offer portfolio review. Artwork is selected through national juried exhibitions." Files slides and résumés.

Tips: Finds artists through gallery's placement of classified ads in various art publications, mailing news releases and word of mouth. "Have professional quality slides."

THE GALLOPING GOOSE, Dept. AM, 162 S. Montezuma, Prescott AZ 86303. (602)778-7600. Owners: Richard Birtz and Mary Birtz. Retail gallery. Estab. 1987. Represents 200 emerging, mid-career and established artists. Exhibited artists include Bev Doolittle and Maija. Average display time 2 weeks. Open all year. Located in the "SW corner of historic Whiskey Row across from the courthouse in downtown Prescott; newly remodeled with an additional 2,000 sq. ft. of gallery space." 10% of space for special exhibitions. Clients: established art collectors and tourists. 95% private collectors, 5% corporate collectors. Overall price range: $20-5,000; most work sold at $150-1,000.

Media: Considers oil, pen & ink, fiber, acrylic, drawing, sculpture, watercolor, mixed media, ceramic, pastel, original handpulled prints, reliefs, lithographs, offset reproductions and posters. Most frequently exhibits pastel, oil, tempera and watercolor.

Style: Exhibits surrealism, imagism and realism. Genres accepted include landscapes, Americana, Southwestern, Western, wildlife and Indian themes only. Prefers wildlife, Southwestern cowboy art and landscapes.

Terms: Buys outright for 50% of the retail price; net 30 days. Customer discounts and payment by installment are available. Retail price set by the gallery and the artist. Gallery pays for shipping costs to gallery. Prefers artwork unframed.

Submissions: Send query letter with bio, brochure, photographs and business card. To show a portfolio, call for appointment. Gallery prefers written correspondence. Files photographs, brochures and biographies.

Tips: Finds artists through visiting exhibitions, word of mouth and various art publications. "Stop by to see our gallery, determine if artwork would be appropriate for our clientele and meet the owner to see if an arrangement is possible."

‡LANNING/SAPP GALLERY, 431 Hwy. 179, Sedona AZ 86336. (602)282-6865. Fax: (602)282-6865. Owner/Director: Airen Sapp. Retail gallery. Estab. 1990. Represents/exhibits 45 emerging, mid-career and established artists/year. Exhibited artists include Anne Embree, Lawrence Lee. Sponsors 2 shows/year. Average display time 1 month. Open all year; Saturday-Sunday, 10-5:30. Located on Gallery Row; 2,400 sq. ft.; "fabulous Pueblo architecture." 100% of space devoted to special exhibitions twice a year for a month; for gallery artists rest of the year. Clientele: resort guests, tourists, destination art buyers. 2% private collectors, 5% corporate collectors. Overall price range: $100-18,000; most work sold at $3,000-6,000.

Media: Considers oil, acrylic, mixed media, paper, sculpture and ceramics. Most frequently exhibits paintings (oil, acrylic), ceramics, sculpture.

Style: Exhibits expressionism, painterly abstraction, impressionism and imagism. Prefers expressionism, abstraction and impressionism.

Terms: Accepts work on consignment (50% commission). Retail price set by the artist. Gallery provides insurance, promotion and shipping costs from gallery; artist pays shipping costs to gallery. Prefers artwork framed.

Submissions: Prefers only contemporary. Send query letter with résumé, bio, photographs and SASE. Gallery will call if interested. Portfolio should include originals. Replies in 1 month.

Tips: Finds artists through visiting exhibits, artists' submissions and word of mouth. "Please be certain your work is appropriate—compatible with what the gallery shows."

Arkansas

AMERICAN ART GALLERY, 724 Central Ave., Hot Springs National Park AR 71901. (501)624-0550. Retail gallery. Estab. 1990. Represents 22 emerging, mid-career and established artists. Exhibited artists include Stanley Rames and R.L. Michaelis. Sponsors 12 shows/year. Average display time 1 month. Open all year. Located downtown; 4,000 sq. ft. 40% of space for special exhibitions. Clientele: private, corporate and the general public. 85% private collectors, 15% corporate collectors. Overall price range: $50-12,000; most work sold at $250-500.

The double dagger before a listing indicates that the listing is new in this edition. New markets are often more receptive to freelance submissions.

Media: Considers oil, acrylic, watercolor, pastel, pen & ink, sculpture, ceramic, photography, original hand-pulled prints, woodcuts, wood engravings, lithographs and offset reproductions. Most frequently exhibits oil, wood sculpture and watercolor.

Style: Exhibits all styles and genres. Prefers realistic, abstract and impressionistic styles; wildlife, landscapes and floral subjects.

Terms: Accepts work on consignment (55% commission). Retail price set by gallery and the artist. Gallery provides promotion and contract; artist pays for shipping. Offers customer discounts and payment by installments. Prefers artwork framed.

Submissions: Prefers Arkansas artists, but shows 5-6 others yearly. Send query letter with résumé, slides, bio and SASE. Call or write for appointment to show portfolio of originals and slides. Reports in 6 weeks. Files copy of résumé and bio.

Tips: Finds artists through agents, by visiting exhibitions, word of mouth, various art publications and sourcebooks, artists' submissions/self promotions and art collectors' referrals. "We have doubled our floor space and have two floors which allows us to separate the feature artist from the regular artist. We have also upscaled in the quality of art work exhibited. Our new gallery is located between two other galleries."

‡**CANTRELL GALLERY**, 8206 Cantrell Rd., Little Rock AR 72207. (501)224-1335. President: Helen Scott; Director: Cindy Huisman. Wholesale/retail gallery. Estab. 1970. Represents/exhibits 75 emerging, mid-career and established artists/year. Exhibited artists include G.H. Rothe and Robin Morris. Sponsors 6-8 shows/year. Average display time 1 month. Open all year; Monday-Saturday, 10-5. Located in the strip center; 3,500 sq. ft.; "we have several rooms and different exhibits going at one time." Clientele: collectors, retail, decorators. Overall price range: $100-10,000; most work sold at $250-3,000.

Media: Considers oil, acrylic, watercolor, pastel, pen & ink, drawing, mixed media, collage, paper, sculpture, woodcut, engraving, lithograph, wood engraving, mezzotint, serigraphs, linocut, etching. Most frequently exhibits etchings, watercolor, mixed media, oils and acrylics.

Style: Exhibits eclectic, all genres.

Terms: Gallery provides insurance and promotion; shipping costs are shared. Prefers artwork unframed.

Submissions: Send query letter with résumé, slides and bio. Write for appointment to show portfolio of originals. Replies in 4 months. Files all material.

Tips: Finds artists through agents, by visiting exhibitions, word of mouth, art publications and sourcebooks, artists' submissions.

HERR-CHAMBLISS FINE ARTS, 718 Central Ave., Hot Springs National Park AR 71901-5333. (501)624-7188. Director: Malinda Herr-Chambliss. Retail gallery. Estab. 1988. Represents emerging, mid-career and established artists. Sponsors 17 shows/year. Average display time 1 month. Open all year. Located downtown; 3 floors, 5,000-5,500 sq. ft.; "turn-of-the-century building with art-deco remodeling done in 1950." Overall price range: $50-24,000.

Media: Considers oil, acrylic, watercolor, pastel, pen & ink, drawings, mixed media, sculpture, fiber, glass, installation and photography.

Style: Exhibits all styles.

Terms: "Negotiation is part of acceptance of work, generally commission is 40%." Gallery provides insurance, promotion and contract (depends on negotiations); artist pays for shipping to and from gallery. Prefers artwork framed.

Submissions: Prefers painting and sculpture of regional, national and international artists. Send query letter with résumé, slides, bio, brochure, photographs, SASE, business card and reviews. Write for appointment to show portfolio of originals, slides, photographs and transparencies. Replies in 2-3 weeks. Files résumé and slides if available.

Tips: "Slides should include the date, title, medium, size, and directional information. Also, résumé should be succinct and show the number of one-person shows, educational background, group shows, list of articles (as well as enclosure of articles). The neater the presentation, the greater chance the dealer can glean important information quickly. Put yourself behind the dealer's desk, and include what you would like to have for review."

INDIAN PAINTBRUSH GALLERY, INC., Highway 412 W., Siloam Springs AR 72761. (501)524-6920. Owner: Nancy Van Poucke. Retail gallery. Estab. 1979. Represents over 50 emerging, mid-career and established artists. Interested in seeing the work of emerging artists. Exhibited artists include Troy Anderson and Merlin Little Thunder. Sponsors 2-3 shows/year. Average display time 2 weeks. Open all year. Located on bypass; 1,800 sq. ft. 66% of space for special exhibitions. Clientele: Indian art lovers. 80% private collectors, 20% corporate collectors. Overall price range: $5-5,000; most work sold at $5-2,000.

Media: Considers oil, acrylic, watercolor, pastel, pen & ink, drawings, mixed media, works on paper, sculpture, ceramic, woodcuts, lithographs, etchings, posters, serigraphs and offset reproductions. Most frequently exhibits paintings, sculpture, knives, baskets, pottery.

Style: Exhibits Native American. Genres include Americana, Southwestern, Western.
Terms: Accepts work on consignment (60-70% commission). Buys outright for 50% of retail price. Retail price set by gallery. Offers payment by installments. Gallery provides insurance and promotion; artist pays for shipping. Prefers unframed artwork.
Submissions: Send personal information. Call for appointment to show portfolio of "prints, etc." Replies in 2 weeks.
Tips: Finds artists through visiting exhibitions and word of mouth.

PALMER'S GALLERY 800, 800 Central Ave., Hot Springs National Park AR 71901. (501)623-8080. Fax: (501)623-8080. Owner: Linda Palmer. Retail gallery. Estab. 1992. Represents 35 emerging, mid-career and established artists. Exhibited artists include William A. Herring, Leonard Wren, Turner Sculpture, Margaret Speer and Pat Musick. Sponsors 10 shows/year. Average display time 1 month. Open all year, Tuesday-Saturday 11-6, Sunday 1-5. Space is 2,200 sq. ft.; features high ceilings, wide spaces, moveable walls, contemporary decor in an older building. 33⅓% of space for special exhibitions; 66 ⅔% of space for gallery artists. Clientele: 75% private collectors, 25% corporate collectors. Overall price range $500-15,000; most work sold at $500-3,000.
Media: Considers all media. Most frequently exhibits sculpture, oil, pastel, watercolor and mixed media.
Style: All styles and genres. "I'm interested in quality work with strong composition, whether abstract or subjective. Contemporary sculpture—stone, steel, bronze, or mixed media.
Terms: Accepts work on consignment (50% commission). Retail price set by gallery and artist. Customer discounts, and payment by installment are available. Gallery provides promotion and contract; artist pays for shipping costs. Prefers work framed.
Submissions: Send query letter with résumé, slides, photographs, reviews, bio and SASE. Portfolio review requested if interested in artist's work. Replies in 2 months. Files slides and info with artist's permission.
Tips: "Find artists through artists' submissions and art collectors' referrals. The gallery scene in Hot Springs is growing with the downtown area becoming known as 'City of The Arts.' More artists are moving here and opening studios. More galleries are moving here, also."

California

‡ADAMS FINE ARTS GALLERY, 2724 Churn Creek Rd., Redding CA 96002. (916)221-6450. Owner: Susanne Adams. Retail gallery. Estab. 1984. Represents/exhibits 6 mid-career and established artists. May be interested in seeing the work of emerging artists in the future. Exhibited artists include Susan F. Greaves and Janet Turner. Sponsors 2 shows/year. Average display time 3 months. Open all year; Monday-Friday, 10-5:30. Located two blocks from city's largest mall; 1,000 sq. ft. "Our reputation is impeccable. We offer unusual one of a kind items or pieces." 60% of space for special exhibitions; 30% of space for gallery artists. Clientele: upper middle class professionals. 90% private collectors, 10% corporate collectors. Overall price range: $50-300; most work sold at $100-300.
Media: Considers oil, acrylic, watercolor, pastel, sculpture, craft, woodcut, engraving, serigraphs and etching. Most frequently exhibits oil, acrylics, watercolor.
Style: Exhibits expressionism, primitivism, painterly abstraction, impressionism and realism. Genres include landscapes, florals, Americana, Western, country, folk, traditional. Prefers Americana, landscape and Western.
Terms: Accepts work on consignment (50% commission). Retail price set by artist. Gallery provides promotion and contract; artist pays shipping costs to and from gallery. Prefers artwork unframed.
Submissions: Send query letter with bio and photographs. Write for appointment to show portfolio of photographs. Replies only if interested within 2 weeks. Files "only that which we feel may work into our gallery at a future date."
Tips: Finds artists through visiting exhibitions, word of mouth, artists' submissions. "Our gallery is country, traditional, 'folksy,' Americana and antique oriented. Any work other than those styles will not be considered."

‡THE ART SCENE, 4150 Mission Blvd., Pacific Beach CA 92109. (619)483-2740. Manager: Hope Wilts. Cooperative gallery. Estab. 6 years. Represents 75 emerging artists/year. 165 members. Sponsors one show/month. Average display time 1 month. Open all year; closed Mondays; Tuesday-Thursday 12-6; Friday, Saturday, Sunday 12-9. Located 1 block from the beach in Pacific Beach area of San Diego; 650 sq. ft. "We have a lot of wall space and dividers, a nice window display area and the management lets us put up paintings in empty stores." 20% of space for special exhibitions; 80% of space for gallery artists. Clientele: Tourists and restaurant goers. "We have 3 large restaurants in the promenade, but we also have locals who come back time and again." Overall price range: $25-800; most work sold at $50-150.
Media: Considers oil, acrylic, watercolor, pastel, pen & ink, drawing, mixed media, collage, paper, sculpture, ceramics, fiber, glass, photography, lithograph, mezzotint and etching. Most frequently exhibits watercolor, acrylic and collage.

Style: Exhibits painterly abstraction, impressionism and photorealism. Genres include landscapes, florals, Southwestern, wildlife and figurative work. Prefers abstract, landscapes and wildlife.
Terms: Co-op membership fee plus donation of time (20% commission). Rental fee for space; covers 17 months or 1 year. Retail price set by the artist. Gallery provides insurance, promotion and contract; patron pays to ship work. Prefers artwork framed.
Submissions: Accepts only artists from San Diego county. Call manager for appointment to show three pieces of your work to co-op committee. Portfolio should include originals. Replies in 2 weeks.
Tips: Finds artists through published ads in all local papers/magazines, art magazines, papers, etc. "This is a co-op gallery which is very low on commission because the artists run the gallery. Be prepared for a commitment of time to run a gallery and change a show every month."

‡BARLETT FINE ARTS GALLERY, 77 West Angela St., Pleasanton CA 94566. (510)846-4322. Owner: Dorothea Barlett. Retail gallery. Estab. 1981. Represents/exhibits 35-50 emerging, mid-career and established artists/year. Sponsors 6-8 shows/year. Average display time 1 month. Open all year Tuesday-Saturday. Located in downtown Pleasanton; 1,800 sq. ft.; excellent lighting from natural source. 70% of space for special exhibitions; 70% of space for gallery artists. Clientele: "wonderful, return customers." 99% private collectors, 1% corporate collectors. Overall price range: $500-3,500; most work sold at under $1,000.
Media: Considers oil, acrylic, watercolor, pastel, drawing, mixed media, collage, paper, sculpture, ceramics, craft, glass, photography, woodcut, engraving, lithograph, wood engraving, mezzotint, serigraphs, linocut and etching. Most frequently exhibits oil, acrylic, etching.
Style: Exhibits painterly abstraction and impressionism. Genres include landscapes, florals and figurative work. Prefers landscapes, figurative and abstract.
Terms: Accepts work on consignment. Retail price set by the gallery. Gallery provides promotion and contract; artist pays shipping costs to and from gallery.
Submissions: Prefers artists from the Bay Area. Send query letter with slides, bio and SASE. Write for appointment to show portfolio of originals, slides and transparencies. Replies only if interested within 1 month. Files only accepted artists' slides and résumés (others returned).
Tips: Finds artists through word of mouth and "my own canvassing."

CATHY BAUM & ASSOCIATES, 384 Stevick Dr., Atherton CA 94027. (415)854-5668. Fax: (415)854-8522. Principal: Cathy Baum. Art advisor. Estab. 1976. Represents emerging, mid-career and established artists. Keeps files on several hundred artists. Open all year. Clientele: developers, architects, corporations, small businesses and private collectors. 10% private collectors, 90% corporate collectors. Prices are determined by clients' budget requirements.
Media: Considers all media and all types of prints.
Style: Considers all styles and genres.
Terms: Accepts work on consignment (50% commission). Retail price set by artist. Shipping costs are shared. Prefers artwork unframed.
Submissions: Send query letter with résumé, slides, reviews, bio, SASE, retail and wholesale prices. Write for appointment to show portfolio, which should include slides. Replies in 2-3 weeks. Files all accepted material.

CENTRAL CALIFORNIA ART LEAGUE ART CENTER & GALLERY, 1402 I St., Modesto CA 95354. (209)529-3369. Gallery Director: Fred Gaebe. Cooperative, nonprofit sales and rental gallery. Estab. 1951. Represents 66 emerging, mid-career and established artists. Exhibited artists include Beverly Dickerson, Dolores Longbotham, Barbara Brown, Milda Laukkanen and Dale Laitinen. Sponsors 2 shows/year. Average rental and sales display time 3 months. Open all year. Located downtown; 2,500 sq. ft.; in "a historic building, a former county library, consisting of 2 large gallery rooms, entry, large hallway and two classrooms. (Auditorium shared with historical museum upstairs)." 10% of space for special exhibitions, 90% for gallery artists. Clientele: 75% private collectors, 25% corporate clients. Overall price range: $50-1,300; most artwork sold at $300-800.
Media: Considers oil, pen & ink, works on paper, fiber, acrylic, drawing, sculpture, watercolor, mixed media, ceramic, pastel, collage, photography and original handpulled prints. Most frequently exhibits watercolor, oil and acrylic.
Style: Exhibits mostly impressionism, realism. Will consider all styles and genres. Prefers realism, impressionism and photorealism.
Terms: Artwork is accepted on consignment (30% commission), a Co-op membership fee plus a donation of time and a rental fee for space, which covers 3 months. Retail and rental price set by artist. Customer discounts and payment by installment are available. Gallery provides insurance. Prefers framed artwork.

Always enclose a self-addressed, stamped envelope (SASE) with queries and sample packages.

Submissions: Call for information—we are a co-op gallery with all works subject to jury process."Submit 5 works, ready for hanging, by 4:00 p.m. any Tuesday. Judging is done each Wednesday with results by Thursday afternoon." Portfolio review not accepted.
Tips: Finds artists through referrals from other artists.

‡C.L. CLARK GALLERIES, 1818 V St., Bakersfield CA 93301. (805)325-7094. Fax: (805)325-6343. Owner: Lee Clark. Retail gallery. Estab. 1978. Represents/exhibits 35 mid-career artists/year. May be interested in seeing the work of emerging artists in the future. Exhibited artists include Elyse, Gary Bukovnik. Sponsors 9 shows/year. Average display time 5 weeks. Open all year; Tuesday-Friday, 10-4; Saturday, noon-4. Located downtown; 2,400 sq. ft.; restored 1906 brick building, open beam ceilings, surrounded by 3,000 sq. ft. gardens. 15% of space for special exhibitions; 85% of space for gallery artists. Clientele: upper income, professionals, decorators. 85% private collectors, 15% corporate collectors. Overall price range: $450-10,000; most work sold at $900-3,500.
Media: Considers oil, acrylic, watercolor, pastel, mixed media, paper, sculpture, woodcut, engraving, lithograph and serigraphs. Most frequently exhibits oil, watercolor, pastel.
Style: Exhibits expressionism, neo-expressionism, impressionism, photorealism and realism. Genres include landscapes, florals and figurative work.
Terms: Accepts work on consignment (50% commission). Retail price set by the artist. Gallery provides promotion, contract and shipping costs from gallery; artist pays shipping costs to gallery. Prefers artwork framed.
Submissions: Send query letter with résumé, slides and photographs. Write for appointment to show portfolio of photographs and slides. Replies in 3 weeks. Files bio, 1 or 2 slides or photos.
Tips: Finds artists through agents, by visiting exhibitions, word of mouth, various art publications and sourcebooks, artists' submissions.

‡CONTEMPORARY CENTER, 2630 W. Sepulveda Blvd., Torrance CA 90505. (310)539-1933. Director: Sharon Fowler. Retail gallery. Estab. 1953. Represents 150 emerging, mid-career and established artists. Exhibited artists include Terry Erickson Brown, Laura Ross. Open all year; Tuesday-Saturday, 10-6; Sunday 12-5; closed Monday. Space is 5,000 sq. ft. "We sell contemporary American crafts along with contemporary production and handmade furniture." Clientele: private collectors, gift seekers, many repeat customers. Overall price range: $20-800; most work sold at $20-200.
Media: considers paper, sculpture, ceramics, fiber and glass.
Terms: Retail price set by the gallery and the artist.
Submissions: Send query letter with brochure, slides and photographs. Call for appointment to show portfolio of photographs and slides. Replies in 2 weeks.
Tips: Finds artists through word of mouth and attending craft shows. "Please have some type of price in mind for your work. It is helpful to have drawings or photos along with a price list."

‡CREATIVE GROWTH ART CENTER GALLERY, 355 24th St., Oakland CA 94612. (510)836-2340. Fax: (510)836-2349. Executive Director: Irene Ward Brydon. Nonprofit gallery. Estab. 1978. Represents 100 emerging and established artists; 100 adults with disabilities work in our adjacent studio. Exhibited artists include Dwight Mackintosh, Nelson Tygart. Sponsors 10 shows/year. Average display time 5 weeks. Open all year; Monday-Friday, 10-4. Located downtown; 1,200 sq. ft.; classic large white room with movable walls, track lights; visible from the street. 25% of space for special exhibitions; 75% of space for gallery artists. Clientele: private and corporate collectors. 90% private collectors, 10% corporate collectors. Overall price range: $50-4,000; most work sold at $100-250.
 • This gallery concentrates mainly on the artists who work in an adjacent studio, but work from other regional or national artists may be considered for group shows. Only outsider and brut art are shown. Brut art is like Brut champagne—raw and undistilled. Most of the artists have not formally studied art, but have a raw talent that is honest and real with a strong narrative quality.
Media: Considers oil, acrylic, watercolor, pastel, pen & ink, drawing, mixed media, collage, paper, sculpture, ceramics, fiber, woodcut, engraving, lithograph, wood engraving, mezzotint, serigraphs, linocut and etching. Most frequently exhibits (2-D) drawing and painting, (3-D) sculpture, hooked rug/tapestries.
Style: Exhibits expressionism, primitivism, color field, naive, folk art, brut. Genres include landscapes, florals and figurative work. Prefers brut/outsider, contemporary, expressionistic.
Terms: Accepts work on consignment (40% commission). Retail price set by the gallery. Gallery provides insurance, promotion and contract; artist pays shipping costs to and from gallery. Prefers artwork framed.

For a list of markets interested in humorous illustration, cartooning and caricatures, refer to the Humor Index at the back of this book.

Submissions: Prefers only brut, naive, outsider; works by adult artists with disabilities. Send query letter with résumé, slides, bio. Write for appointment to show portfolio of photographs and slides. Replies only if interested. Files slides and printed material.

Tips: Finds artists through agents, by visiting exhibitions, word of mouth, various art publications and source-books, artists' submissions and networking. "Peruse publications that feature brut and expressionistic art (Example: *Raw Vision*)."

CUESTA COLLEGE ART GALLERY, P.O. Box 8106, San Luis Obispo CA 93401. (805)546-3202. Fax: (805)546-3904. Director: Marta Peluso. Nonprofit gallery. Estab. 1965. Exhibits the work of emerging, mid-career and established artists. Exhibited artists include Holly Roberts and Catherine Wagner. Sponsors 7 shows/year. Average display time 3½ weeks. Open all year. Space is 700 sq. ft. 100% of space for special exhibitions. Overall price range: $250-5,000; most work sold at $400-1,200.

Media: Considers all media and all types of prints. Most frequently exhibits painting, sculpture and photography.

Style: Exhibits all styles, mostly contemporary.

Terms: Retail price set by artist. Customer discounts and payment by installment are available. Gallery provides insurance, promotion and contract; shipping costs are shared. Prefers artwork framed.

Submissions: Send query letter with résumé, slides, bio, brochure, SASE and reviews. Call for appointment to show portfolio. Replies in 6 months.

Tips: Finds artists mostly by reputation and referrals, sometimes through slides. "Only submit quality fine art. We have a medium budget, thus cannot pay for extensive installations or shipping."

DEL MANO GALLERY, 33 E. Colorado Blvd., Pasadena CA 91105. (818)793-6648; or 11981 San Vicente Blvd., W. Los Angeles CA 90049. (310)476-8508. Assistant Director: Lisa Spencer. Retail gallery. Estab. 1973. Represents 300+ emerging, mid-career and established artists. Interested in seeing the work of emerging artists. Exhibited artists include Ann Quisty and Josh Simpson. Sponsors 5 shows/year. Average display time 2-6 months. Open 7 days a week in Pasadena; open Tuesday-Sunday in West LA. Located in Old Pasadena (a business district) and San Vicente Blvd. (a scenic corridor). Space is 3,000 sq. ft. in each gallery. 25% of space for special exhibitions; 75% of space for gallery artists. Clientele: professionals and affluent collectors. 20% private collectors, 5% corporate collectors. Overall price range: $50-20,000; most work sold at $250-5,000.

Media: Considers contemporary art in craft media—ceramics, glass, jewelry, wood, fiber. No prints. Most frequently exhibits wood, glass and jewelry.

Style: Exhibits all styles and genres.

Terms: Accepts work on consignment (50% commission) or 30 days net. Retail price set by gallery and artist. Customer discounts and payment by installment are available. 10-mile exclusive area representation required. Gallery provides insurance, promotion and shipping costs from gallery. Prefers artwork framed.

Submissions: Send query letter with résumé, slides, bio and prices. "Please contact Lisa Spencer for details." Portfolio should include slides, price list, artist's statement and bio. Replies in 2 to 6 weeks.

Tips: Finds artists mainly through visiting exhibitions and artists' submissions. "Be professional in your submission."

DEPHENA'S FINE ART, 1027 10th St., Sacramento CA 95814-3517. (916)441-3330. Director: Robert M. Duncan. Retail gallery and art consultancy. Estab. 1984. Represents mid-career artists. Interested in seeing the work of emerging artists. Exhibited artists include A. Wolff, William Tuthill, Reif Erickson and Jan Miskalen. Sponsors 4 shows/year. Average display time 3 months. Open all year. Located downtown; 1,850 sq. ft. 30% for special exhibitions. Clientele: corporate and professional. Overall price range: $200-5,000; most artwork sold at $700-3,000.

Media: Considers oil, pen & ink, works on paper, acrylic, sculpture, watercolor, mixed media, pastel, original handpulled prints, etchings, lithographs, serigraphs and posters.

Style: Exhibits expressionism and realism. Considers very traditional works only. Genres include landscapes, florals, Southwestern, Western, wildlife and portraits. Prefers realism, wildlife and California landscapes.

Terms: Artwork is accepted on consignment (50% commission). Retail price set by artist. Sometimes offers customer discounts and payment by installment. Gallery provides contract; artist pays for shipping. Artwork must be professionally framed.

Submissions: Send query letter with résumé, brochure, slides, photographs and bio. Write for appointment to show portfolio which should include originals, photographs, slides and transparencies. Replies only if interested within 1 month. Files résumé, slides, brochures and photographs.

Tips: Finds artists through artist referrals, word of mouth and sourcebooks. "Be cognizant of the director's time."

DONLEE GALLERY OF FINE ART, 1316 Lincoln Ave., Calistoga CA 94515. (707)942-0585. Fax: (707)942-6657. Also has location at 2933 Grand Ave., Los Olivos CA 93441. (805)686-1088. Owner: Ms. Lee Love. Retail gallery. Estab. 1985. Represents 40 established artists. Exhibited artists include Ralph Love and Mehl Lawson. Sponsors 3 shows/year. Average display time 2 months. Open all year. Located downtown; 3,000

sq. ft.; "warm Southwest decor, somewhat rustic." Clientele: 100% private collectors. Overall price range: $500-24,000; most artwork sold at $1,000-3,500.
Media: Considers oil, acrylic, watercolor and sculpture. Most frequently exhibits oils, bronzes and alabaster.
Style: Exhibits impressionism and realism. Genres include landscapes, Southwestern, Western and wildlife. Interested in seeing American realism. No abstract art.
Terms: Accepts work on consignment (50% commission). Retail price set by gallery. Customer discounts and payment by installment are available. Gallery provides insurance and promotion. Artist pays for shipping. Prefers framed artwork.
Submissions: Accepts only artists from Western states. "No unsolicited portfolios." Portfolio review requested if interested in artist's work. The most common mistake artists make is coming on weekends, the busiest time, and expecting full attention.
Tips: Finds artists through publications, submissions and owner's knowledge. "Don't just drop in—make an appointment. No agents."

DOWNEY MUSEUM OF ART, 10419 Rives, Downey CA 90241. (310)861-0419. Executive Director: Scott Ward. Museum. Estab. 1957. Interested in emerging and mid-career artists. Sponsors 10 shows/year. Average display time: 6 weeks. Open all year. Located in a suburban park: 3,000 sq. ft. Clientele: locals and regional art audience. 60% private collectors, 40% corporate collectors. Overall price range: $100-10,000; most work sold at $400-3,000.
Media: Considers oil, acrylic, watercolor, pastel, pen & ink, drawings, mixed media, collage, works on paper, sculpture, ceramic, craft, fiber, glass, installation, photography, egg tempera, original handpulled prints, woodcuts, wood engravings, linocuts, engravings, mezzotints, etchings, lithographs, pochoir, serigraphs. Most frequently exhibits painting, drawing, and ceramics.
Style: Exhibits all styles and genres. Prefers California-made art in a wide range of styles.
Terms: Accepts work on consignment (30% commission). Retail price set by artist. Sometimes offers customer discounts and payment by installment. Gallery provides insurance and promotion. Artist pays for shipping. Prefers artwork framed.
Submissions: Send query letter with résumé, slides and SASE. Portfolio review requested if interested in artist's work. Files résumé and slides.
Tips: Finds artists through visiting exhibitions and artist's submissions. "Take care not to underestimate your competition. Submit a complete and professional package."

‡EUREKA ART CENTER LTD., (DBA: The Art Center), 211 G. St., Eureka CA 95501. (707)443-7017. Gallery Director: Mary Ann Testagrossa. Retail gallery. Estab. 1972. Represents emerging and established artists; 12-15 ceramic artists; 12-15 artists. Exhibited artists include Peggy Loudon—ceramics; Carrie Grant—photography. Sponsors 9 shows/year. Average display time 1 month. Open all year; Monday-Friday, 9-6; Saturday: 9:30-5:30; Sunday noon-4. Located in Old Town, Eureka; 1,700 sq. ft. 66% of space for special exhibitions; 33% of space for gallery artists. Clientele: local partrons, tourists. 90-100% private collectors. Overall price range: $6-1,000; most work sold at $6-600. "The lower range items are ceramic and glass generally."
Media: Considers oil, acrylic, watercolor, pastel, drawing, mixed media, collage, paper, sculpture, ceramics, craft, fiber, glass, photography, woodcut, engraving, lithograph, serigraphs, linocut and etching. Most frequently exhibits watercolors, ceramics, photography.
Style: Exhibits painterly abstraction, impressionism, photorealism, realism and imagism. Genres include landscapes, florals and figurative work. Prefers landscapes (local), florals (figurative), abstract.
Terms: Accepts work on consignment (40% commission). Retail price set by the artist. Gallery provides insurance and promotion; artist pays shipping to and from gallery. Prefers artwork framed.
Submissions: "Most of the work exhibited is by local artists, with some exceptions." Send query letter with résumé, slides, bio, brochure and photographs. Call for appointment to show portfolio of originals, photographs and slides. Replies in 2 weeks. Files résumé, bio sheets.
Tips: Finds artists through visiting exhibitions and artists' submissions.

‡FRESNO ART MUSEUM GIFT GALLERY, (formerly Fresno Art Museum), 2233 N. First St., Fresno CA 93703. (209)266-5848. Owner: Jean Shore. Gallery. Estab. 1957. Clientele: general public and students; 100% sales to private collectors. Sponsors 13 solo and 12 group shows/year. Average display time is 2 months. Interested in emerging and established artists. Overall price range: $250-25,000; most artwork sold at $300-1,000.
 • A new addition was added to this gallery. It now has a modern look with up-scale art and gift items.
Media: Considers all media.
Style: Considers all styles. "Our museum is a forum for new ideas yet attempts to plan exhibitions coinciding within the parameters of the permanent collection."
Terms: Accepts work on consignment (40% commission). Retail price set by gallery and artist. Offers customer discounts and payment by installments. Exclusive area representation not required. Gallery provides insurance, promotion and contract; shipping costs are shared.
Submissions: Send query letter, résumé, slides and SASE. Call for appointment to show portfolio. All materials are filed.

Tips: "We try to show only local artists. We have a lot of fine local art to choose from."

‡GALERIE CUJAS, 2424 San Diego Ave., San Diego CA 92110. (619)491-0166. Co-Director: Gary Hansmann. Retail gallery. Estab. 1988. Represents 10 emerging, mid-career and established artists. Exhibited artists include Lilly Rosa, Gary Hansmann. Sponsors 4 shows/year. Average display time 2 months. Open all year; Friday-Sunday, 12-7. Located in Old Town, San Diego; 800 sq. ft. 100% of space for gallery artists. 100% private collectors. Overall price range: $100-5,000; most work sold at $400-800.
Media: Considers oil, acrylic, watercolor, pastel, pen & ink, drawing, mixed media, collage, sculpture, prints and monoprints, woodcut, engraving, lithograph, wood engraving, mezzotint, serigraphs, linocut, etching and posters (if original). Most frequently exhibits drawings, prints, paintings.
Style: Exhibits expressionism and figurative. Genres include figurative work. Prefers representational, figurative and expressionistic.
Terms: Accepts work on consignment (50% commission). Retail price set by the artist. Gallery provides some promotion and contract; artist pays shipping costs to and from gallery. Prefers artwork framed.
Submissions: Send query letter with résumé, slides, bio and SASE. Write for appointment to show portfolio of originals, photographs and slides. Replies in 1 month. Files "only interesting work that we may consider in the future."
Tips: Finds artists through personal travel, visiting exhibitions.

‡GALLERY EIGHT, 7464 Girard Ave., La Jolla CA 92037. (619)454-9781. Director: Ruth Newmark. Retail gallery. Estab. 1978. Represents 100 emerging and mid-career artists. Interested in seeing the work of emerging artists. Exhibited artists include Leni Hoch, Thomas Mann. Sponsors 6 shows/year. Average display time 6-8 weeks. Open all year; Monday-Saturday, 10-5. Located downtown; 1,200 sq. ft.; slightly post-modern. 25% of space for special exhibitions; 100% of space for gallery artists. Clientele: upper middle class, mostly 35-60 in age. Overall price range: $5-5,000; most work sold at $25-150.
Media: Considers ceramics, craft, fiber and glass. Most frequently exhibits ceramics, jewelry, other crafts.
Terms: Accepts work on consignment (50% commission) or buys outright for 50% of retail price (net 30 days). Retail price set by the gallery and the artist. Gallery provides insurance, promotion and shipping costs from gallery; artist pays shipping costs to gallery.
Submissions: Send query letter with résumé, slides, photographs, reviews and SASE. Call or write for appointment to show portfolio of photographs and slides. Replies in 1-3 weeks. Files "generally only material relating to work by artists shown at gallery."
Tips: Finds artists through agents, by visiting exhibitions, word of mouth, various art publications and sourcebooks, artists' submissions and juried fairs.

‡GALLERY 57, 204 N. Harbor Blvd., Fullerton CA 92632. (714)870-9194. Director of Membership: William Manning. Nonprofit and cooperative gallery. Estab. 1984. Represents 15-20 emerging artists. Sponsors 11 shows/year. Average display time 1 month. Open all year. Located downtown; 1,000 sq. ft., part of "gallery row" in historic downtown area. 100% of space for special exhibitions; 100% for gallery artists. Clientele: wide variety.
Media: Considers, oil, acrylic, watercolor, pastel, drawings, mixed media, collage, works on paper, sculpture, installation, photography, neon and original handpulled prints. Most frequently exhibits mixed media, painting and sculpture.
Style: Considers all styles. Prefers contemporary works.
Terms: There is a co-op membership fee plus a donation of time. Retail price set by the artist. Gallery provides promotion. Artist pays for shipping.
Submissions: Send query letter with résumé, or bio and slides. Call or write to schedule an appointment to show a portfolio, which should include slides and 1-2 originals. Replies in 1 month. Does not file material.
Tips: "Slides are reviewed by the membership on the basis of content, focus and professionalism. The gallery requires a commitment toward a supportive cooperative experience in terms of networking and support."

‡GALLERY 30, 311 Primrose Rd., Burlingame CA 94010. (415)342-3271. Owner/Director: Ronnie Goldfield. Retail gallery. Estab. 1982. Represents 15-20 mid-career and established artists. May be interested in seeing the work of emerging artists in the future. Exhibited artists include Wolf Kahn, Richard Mayhew. Sponsors 8 shows/year. Average display time 6 weeks. Open all year; Tuesday-Saturday, 10-5; by appointment. Located downtown Burlingame; 2,800 sq. ft. "Our location, a historical building in downtown Burlingame is a two-story English-style residence built in 1931 and home to notable portrait photographer Dorothy M. Crawford. Sensitive remodelling has restored the building and transformed its five galleries lighted with seven skylights into artspace that welcomes the visitor." 30-50% of space for special exhibitions; 50-70% of space for gallery artists. Clientele: "mostly knowledgeable collectors." 95% private collectors; 5% corporate collectors. Overall price range: $500-30,000; most work sold at $3,000-10,000.
Media: Considers oil, acrylic, watercolor, pastel, pen & ink, drawing, mixed media, collage, paper, sculpture, ceramics, glass, furniture art, woodcut, engraving, lithograph, wood engraving, mezzotint, serigraphs, linocut, etching and monotypes. Most frequently exhibits works on paper (etching, lithograph), oils, sculpture (bronze, mixed, ceramic).

Style: Exhibits expressionism, painterly abstraction, surrealism, minimalism, color field, postmodern works, hard-edge geometric abstraction and contemporary. Prefers expressionism, abstract (non-objective and objective), realist.

Terms: Accepts work on consignment (50% commission) or buys outright for a varying percentage of the retail price. Retail price set by the artist "mostly." Gallery provides insurance, promotion and shipping costs from gallery; artists pays shipping costs to gallery. Prefers artwork framed.

Submissions: Send query letter with résumé, slides, bio, photographs and payment information. Write for appointment to show portfolio of photographs, slides and résumé. Replies only if interested within 3 months.

Tips: Finds artists through word of mouth and by visiting exhibitions.

‡**GREENLEAF GALLERY**, 20315 Orchard Rd., Saratoga CA 95070. (408)867-3277. Owner: Janet Greenleaf. Director: Chris Douglas. Collection and art consultancy and advisory. Estab. 1979. Represents 45 to 60 emerging, mid-career and established artists. By appointment only. "Features a great variety of work in diverse styles and media. We have become a resource center for designers and architects, as we will search to find specific work for all clients." Clientele: professionals, collectors and new collectors. 50% private collectors, 50% corporate clients. Prefers very talented emerging or professional fulltime artists — already established. Overall price range: $400-15,000; most artwork sold at $500-8,000.

Media: Considers oil, acrylic, watercolor, pastel, mixed media, collage, works on paper, sculpture, glass, original handpulled prints, lithographs, serigraphs, etchings and monoprints. Most frequently exhibits original oil and acrylic, watercolor and monoprints.

Style: Deals in expressionism, neo-expressionism, painterly abstraction, minimalism, impressionism, realism or "whatever I think my clients want — it keeps changing." Genres include traditional, landscapes, florals, wildlife and figurative work. Prefers all styles of abstract, still lifes (impressionistic), landscapes and florals.

Terms: Artwork is accepted on consignment. "The commission varies." Artist pays for shipping or shipping costs are shared.

Submissions: Send query letter with photographs, résumé, slides, bio, SASE, business card, reviews and "any other information you wish — I do not want just slides and photos." Call or write to schedule an appointment for a portfolio review, which should include originals. If does not reply, the artist should call. Files "everything that is not returned. Usually throw out anything over 2 years old."

Tips: Finds artists through visiting exhibitions, referrals from clients or artists, artists' submissions and self promotions. Mistakes artists make in presenting their work are "not phoning before sending slides, etc. . . . to find what we are currently trying to locate and sending samples that are appropriate; and overpricing their own work."

MICHAEL HIMOVITZ GALLERY, 1020 10th St., Sacramento CA 95814. (916)448-8723. Retail gallery. Estab. 1980. Represents 40 emerging, mid-career and established artists. Interested in seeing the work of emerging artists. Exhibited artists include Clayton Pinkerton and Eleanor Dickinson. Sponsors 12 shows/year. Average display time 1 month. Open Wednesday-Saturday 11:00-4:30 and by appointment. Closed August. Located downtown; 4,500 sq. ft.; 12′ ceilings. four exhibition spaces. 80% of space for special exhibitions; 20% of space for gallery artists. Clientele: 70% private collectors, 30% corporate collectors. Overall price range: $200-80,000; most work sold at $1,500-4,000.

Media: Considers oil, acrylic, drawing, sculpture, watercolor, mixed media, ceramic, pastel, collage, woodcuts, wood engravings, linocuts, engravings and etchings. Most frequently exhibits paintings, drawings and sculpture.

Style: Genres include figurative work. Prefers figurative, narrative.

Terms: Accepts work on consignment (50% commission). Retail price set by gallery and artist. Customer discounts and payment by installment are available. Gallery provides insurance and promotion; artist pays for shipping costs. Prefers artwork framed.

Submissions: Send query letter with résumé, slides, bio, SASE and reviews. Portfolio requested if interested in artist's work. Replies in 3-4 weeks.

Tips: Finds artists through artists' submissions.

‡**IMAGO GALLERIES**, 73-970 El Paseo, Palm Desert CA 92260. (619)776-9890. Fax: (619)776-9891 and Suite 100, 125 E. Tahquitz Canyon, Palm Springs CA 92262. (619)322-7709. Fax: (619)322-3156. Owners: Leisa J. Neal and David Austin. Retail galleries. Estab. 1991. Represents established artists. Interested in seeing the work of emerging artists. Exhibited artists include Dale Chihuly, Tony Berlant. Sponsors 3-4 shows/year. Average display time 6 weeks. Open October 1 thru June; Tuesday-Saturday, 10-5:30; Sunday 1-5:30; Summer 3-4 days per week; closed August. Located downtown, in both locations; 3,900 sq. ft., Palm Desert location; 2,600 sq. ft., Palm Springs location; clean lines, uncluttered, high ceilings, concrete floors. 66% of space for special exhibitions; 33% of space for gallery artists. Clientele: collectors. 80% private collectors, 5% corporate collectors; 15% developers, architects, designers. Overall price range: $1,500-125,000; most work sold at $5,000-40,000.

- 60% of work shown in Imago Galleries is glass. Yet whether cast, blown, laminated, sandcast, carved, hot formed or kiln fired, it must be earthquake safe. The work must be evenly balanced and

there are restrictions on pedestals and other aspects. Gallery commissions respected artists like Dale Chihuly to do installations for corporations.

Media: Considers glass, oil, acrylic, mixed media, collage, sculpture, ceramics and installation. Most frequently exhibits glass (blown, hot formed, cast), large scale contemporary paintings, large scale sculpture in various media, ceramics.

Style: Exhibits painterly abstraction, color field, photorealism and constructivism. Prefers constructivism, color field, painterly abstraction.

Terms: Accepts work on consignment (commission varies). Retail price set by the artist. Gallery provides insurance, promotion and shipping costs from gallery; artists pays shipping costs to gallery.

Submissions: "Work must be stable due to earthquakes." Send query letter with slides, bio, photographs, SASE and reviews. Write for appointment to show portfolio of photographs, slides and transparencies. Files "artist's works which we may be able to use on projects, but do not intend for exhibition in gallery."

Tips: Finds artists through visiting exhibitions, publications and referral from other artists.

INTERNATIONAL GALLERY, 643 G St., San Diego CA 92101. (619)235-8255. Director: Stephen Ross. Retail gallery. Estab. 1980. Represents over 50 emerging, mid-career and established artists. Sponsors 6 solo and 6 group shows/year. Average display time is 2 months. Clientele: 99% private collectors. Overall price range: $15-10,000; most artwork sold at $25-500.

Media: Considers sculpture, ceramic, craft, fiber, glass and jewelry.

Style: "Gallery specializes in contemporary crafts (traditional and current), folk and primitive art, as well as naif art."

Terms: Accepts work on consignment. Retail price set by gallery and artist. Exclusive area representation not required. Gallery provides insurance, promotion and contract; shipping costs are shared.

Submissions: Send query letter, résumé, slides and SASE. Call or write for appointment to show portfolio of slides and transparencies. Resumes, work description and sometimes slides are filed. Common mistakes artists make are using poor quality, unlabeled slides or photography and not making an appointment.

JUDY'S FINE ART CONNECTION, 2880-A Grand Ave., Los Olivos CA 93441-0884. (805)688-1222. Owner: Judy Hale. Retail gallery. Estab. 1987. Represents 30 mid-career and established artists. Exhibited artists include Nancy Phelps, Lori Quarton, Herb Ficher, Angie Whitson and Alice Barrett. Sponsors 4 shows/year. Average display time 6 months. Open all year. Located downtown; 1700 sq. ft.; "the gallery is light and airy, with a woman's touch." 20% of space for special exhibitions which are regularly rotated and rehung. Clientele: homeowners, decorators, collectors. Overall price range: $100-5,000; most work sold at $500-2,000.

Media: Considers oil, acrylic, watercolor, pastel, sculpture, ceramic, fiber, original handpulled prints, offset reproductions, lithographs and etching. Most frequently exhibits watercolor, oil and acrylic.

Style: Exhibits impressionism and realism. Genres include landscapes, florals, Southwestern, portraits and figurative work. Prefers figurative work, florals, landscapes, structure.

Terms: Accepts work on consignment (40% commission). Retail price set by artist. Offers payment by installments. Gallery provides insurance and promotion; artist pays for shipping. Prefers artwork framed.

Submissions: Send query letter with bio, brochure, photographs, business card and reviews. Call for appointment to show portfolio of photographs. Replies in 2 weeks. Files bio, brochure and business card.

Tips: Finds artists through visiting exhibitions, artists' submissions/self-promotions, but "most often artists have come to the gallery and made personal introductions, then set up an appointment. Be sure the work submitted is framed properly, presented professionally."

‡NEEL KANTH GALERIE, 7407 Topanga Canyon Blvd., Canoca CA 91303. (818)710-9599. Fax: (818)718-9620. Retail, wholesale and rental gallery, art consultancy. Estab. 1986. Represents 20 mid-career and established artists/year. May be interested in seeing the work of emerging artists in the future. Exhibited artists include Knox Martin, Krishna Reddy. Sponsors 3 shows/year. Average display time 1 month. Open all year; by appointment. Located in San Fernando Valley, Warner Center; 1,200 sq. ft.; features "museum quality work for beginning and established collectors." 50% of space for special exhibitions; 50% of space for gallery artists. Clientele: collectors, corporate, museum. 50% private collectors, 50% corporate collectors. Overall price range: $300-125,000; most work sold at $1,000-5,000.

Media: Considers oil, acrylic, pen & ink, drawing, mixed media, collage, paper, sculpture, photography, woodcut, engraving, lithograph, wood engraving, mezzotint, serigraphs, linocut, etching, posters and multiples. Most frequently exhibits acrylic, prints, cast paper.

 The double dagger before a listing indicates that the listing is new in this edition. New markets are often more receptive to freelance submissions.

Style: Exhibits expressionism, neo-expressionism, primitivism, painterly abstraction, conceptualism, post-modern works, impressionism, photorealism and realism. Genres include landscapes, florals, wildlife, portraits and figurative work. Prefers figurative, landscapes, portraits.

Terms: Accepts work on consignment (50% commission) or buys outright for 50% of retail price. Retail price set by the gallery and the artist. Gallery provides promotion, contract and shipping costs to and from gallery. Prefers artwork unframed.

Submissions: Send query letter with résumé, slides, photographs and reviews. Write for appointment to show portfolio of originals, photographs, slides and transparencies. Replies in 3 months. Files reviews.

Tips: "Artist should have a past history of museum shows and collections."

‡**LINCOLN ARTS**, 540 F St., P.O. Box 1166, Lincoln CA 95648. (916)645-9713. Arts Administrator: Angela Tahti. Nonprofit gallery and alternative space area coordinator. Estab. 1987. Represents 100 emerging, mid-career and established artists/year. 400 members. Exhibited artists include Bob Arneson, Tommie Moller. Sponsors 19 shows/year (9 gallery, 9 alternative and 1 major month long ceramics exhibition). Average display time 5 weeks. Open all year; Tuesday-Saturday, 10-3, or by appointment. Located in the heart of downtown Lincoln; 900 sq. ft.; housed in a 1926 bungalow overlooking beautiful Beermann Plaza. "Our annual 'Feats of Clay®' exhibition is held inside the 119 year old Gladding McBean terra cotta factory." 70% of space for gallery artists. 90% private collectors, 10% corporate collectors. Overall price range: $90-7,000; most work sold at $150-2,000.

Media: Considers all media including linocut prints. Most frequently exhibits ceramics and mixed media.

Style: Exhibits all styles, all genres.

Terms: Accepts work on consignment (30% commission)."Membership donation (min. $10) is encouraged but not required." Retail price set by the artist. Gallery provides promotion; artist pays shipping costs to and from gallery. Prefers artwork framed.

Submissions: Send query letter with résumé, slides or photographs, bio and SASE. Call or write for appointment to show portfolio of originals (if possible) or photographs or slides. Replies in 1 month. Artist should include SASE for return of slides/photos. Files bio, résumé, review notes. "Scheduling is done minimum one year ahead in August for following calendar year. Request prospectus for entry information for Feats of Clay® exhibition."

Tips: Finds artists through visiting exhibitions, word of mouth, art publications and sourcebooks, artists' submissions.

‡**LIZARDI/HARP GALLERY**, P.O. Box 91895, Pasadena CA 91109. (818)792-8336. Fax: (818)794-0787. Director: Grady Harp. Retail gallery and art consultancy. Estab. 1981. Represents 15 emerging, mid-career and established artists/year. Exhibited artists include Jim Morphesis, Wade Hoefer, Christopher James, Walter Askin, Christopher Piazza, Lyoshikawa, Stephen Freedman and Kirk Pedersen. Sponsors 9 shows/year. Average display time 1 month. Open all year; Monday-Saturday. 80% private collectors, 20% corporate collectors. Overall price range: $900-40,000; most work sold at $2,000-8,000.

Media: Considers oil, acrylic, watercolor, pastel, pen & ink, drawing, mixed media, sculpture, installation, photography, woodcut, lithographs, serigraphs and etchings. Most frequently exhibits works on paper and canvas, sculpture, photography.

Style: Exhibits expressionism, painterly abstraction, postmodern works, photorealism and realism. Genres include landscapes, figurative work, all genres. Prefers figurative, landscapes and experimental.

Terms: Accepts work on consignment (50% commission). Retail price set by the gallery and the artist. Gallery provides insurance, promotion, contract and shipping costs from gallery; artist pays shipping costs to gallery.

Submissions: Send query letter with résumé, slides, bio, photographs, SASE and reviews. Write for appointment to show portfolio of photographs, slides and transparencies. Replies in 3-4 weeks. Files "all interesting applications."

Tips: Finds artists through studio visits, group shows, artist submissions.

MONTEREY PENINSULA MUSEUM OF ART AT CIVIC CENTER, (formerly Monterey Peninsula Museum of Art), 559 Pacific St., Monterey CA 93940. (408) 372-5477. Fax: (408)372-5680. Nonprofit museum. Estab. 1959. Exhibits the work of emerging, mid-career and established artists. Average display time is 3-4 months.
 ● Two new galleries for California historic art and two new galleries for Asian art located 720 Via Mirada, Monterey opened in late Spring 1993.

Media: Considers all media.

Style: Exhibits contemporary, abstract, impressionistic, figurative, landscape, primitive, non-representational, photorealistic, Western, realist, neo-expressionistic and post-pop works. "Our mission as an educational institution is to present a broad range of all types of serious work. Do not submit trendy, faddish derivative commercial work."

Terms: No sales. Museum provides insurance, promotion and contract; shipping costs are shared.

Submissions: Send query letter, résumé, 20 slides and SASE. Portfolio review not required. Resume and cover letters are filed.

Tips: Finds artists through agents, visiting exhibitions, word of mouth, various art publications and source-books, artists' submissions/self promotions, art collectors' referrals. The most common mistake artists make is "trying to second-guess what we want to see – tailoring the work to us. We'd rather see a serious commit-ment to their chosen field, technical proficiency and serious explorations into their aesthetic direction."

OFF THE WALL GALLERY, Suite 11, 2123 Main St., Huntington Beach CA 92648. (714)536-6488. "We also have a location at 3441-B Via Lido, Newport Beach, CA 92663. (714)723-5950." Estab. 1981. Represents 50 emerging, mid-career and established artists. Exhibited artists include Thomas Kinkade, Dave Archer and Howard Behrens. Sponsors 2 shows/year. Average display time 3 weeks. Open all year. Located in outdoor mall; 1,000 sq. ft.; "creative matting and framing with original art hand-cut into mats." 30% of space for special exhibitions. Clientele: 95% private collectors, 5% corporate clients. Overall price range: $10-9,000; most artwork sold at $200-1,000.
Media: Considers mixed media, collage, sculpture, ceramic, craft, original handpulled prints, engravings, etchings, lithographs, pochoir, serigraphs and posters. Most frequently exhibits serigraphs, lithographs and posters.
Style: Exhibits expressionism, primitivism, conceptualism, impressionism, realism and photorealism. Genres include landscapes, florals, Americana, Southwestern and figurative work. Prefers impressionism and realism.
Terms: Accepts work on consignment (50% commission) or buys outright for 50% of retail price (net 30 days). Retail price set by artist. Gallery provides promotion; artist pays for shipping. Prefers framed artwork but will accept unframed art.
Submissions: Send query letter with brochure and photographs. Call for appointment to show portfolio of originals and photographs. "We prefer to see actual art, as we can't use slides." Replies only if interested within 1 week. Files photographs, brochures and tearsheets.

ORANGE COUNTY CENTER FOR CONTEMPORARY ART, Space 111, 3621 MacArthur Blvd., Santa Ana CA 92704. (714)549-4989. Executive Director: Jeffrey Frisch. Cooperative, nonprofit gallery. Exhibits emerging and mid-career artists. 27 members. Sponsors 12 shows/year. Average display time 1 month. Open all year; Wednesday through Sunday 11-4. 1,400 sq. ft. 25% of time for special exhibitions; 75% of time for gallery artists.
Media: Considers all media.
Terms: Co-op membership fee plus a donation of time. Retail price set by artist.
Submissions: Accepts artists generally in and within 50 miles of Orange County. Send query letter with SASE. Replies in 1 week.
Tips: "This is an artist-run nonprofit. Send SASE for application prospectus. Membership means 24 to 30 hours monthly working in and for the gallery and programs; educational outreach; specific theme special exhibitions; hands-on gallery operations and professional career development."

ORLANDO GALLERY, 14553 Ventura Blvd., Sherman Oaks CA 91403. Co-Directors: Robert Gino and Don Grant. Retail gallery. Estab. 1958. Represents 30 emerging, mid-career artists and established. Sponsors 22 solo shows/year. Average display time is 1 month. Accepts only California artists. Overall price range: up to $35,000; most artwork sold at $2,500.
Media: Considers oil, acrylic, watercolor, pastel, pen & ink, drawings, mixed media, collage, works on paper, sculpture, ceramic and photography. Most frequently exhibits oil, watercolor and acrylic.
Style: Exhibits painterly abstraction, conceptualism, primitivism, impressionism, photo-realism, expression-ism, neo-expressionism, realism and surrealism. Genres include landscapes, florals, Americana, figurative work and fantasy illustration. Prefers impressionism, surrealism and realism. Interested in seeing work that is contemporary. Does not want to see decorative art.
Terms: Accepts work on consignment. Retail price set by artist. Offers customer discounts and payment by installments. Exclusive area representation required. Gallery provides insurance and promotion; artist pays for shipping.
Submissions: Send query letter, résumé and slides. Portfolio should include slides and transparencies.
Tips: Finds artists through artists' submissions. "The gallery is internationally known, so we get slides from all over the world."

‡THE MARY PORTER SESNON GALLERY, Porter College, UCSC, Santa Cruz CA 95064. (408)459-2314. Fax: (408)459-3535. Director: Andrea Hesse. University gallery. Estab. 1971. Represents 20 mid-career artists/ year. Sponsors 5-10 shows/year. Average display time 6-8 weeks. Open September-June; Tuesday-Sunday, noon-5. Located on campus; 2,400 sq. ft.; ocean views, recently renovated. 80% of space for special exhibi-tions; 80% of space for gallery artists. Clientele: academic and community-based. 100% private collectors. Overall price range: $30-100,000; most work sold at $30-250.
Media: Considers oil, acrylic, watercolor, pastel, pen & ink, drawing, mixed media, collage, paper, sculpture, ceramics, craft, fiber, glass, installation, photography, woodcut, engraving, lithograph, wood engraving, mez-zotint, serigraphs, linocut, etching and posters. Most frequently exhibits painting, drawing, installation.
Style: Exhibits expressionism, primitivism, painterly abstraction, all styles. Genres include landscapes, por-traits and figurative work. Prefers figurative, conceptual, ethnic.

Terms: "Exhibitions are for educational purposes." Retail price set by the artist. Gallery provides insurance, promotion, contract and shipping costs to and from gallery. Prefers artwork framed.
Submissions: Send query letter with résumé, slides, bio, SASE and reviews. Write for appointment to show portfolio of slides. Replies only if interested within 6 months. "Material is retained for committee review and returned in SASE."
Tips: Finds artists through visiting exhibitions and word of mouth. "Artists should clearly understand the educational mission of the gallery."

‡SAMIMI ART GALLERY, 105 Orinda Way, Orinda CA 94563. (510)254-3994. Fax: (510)254-3994. Director: Ellie Samimi. Retail gallery and art consultancy. Estab. 1991. Represents 10 mid-career and established artists/year. May be interested in seeing the work of emerging artists in the future. Exhibited artists include Mehrdad Samimi, Pam Glover. Sponsors 4-5 shows/year. Average display time 1 month. Open all year; Tuesday-Friday, 11:30-5; Saturday, 11-4; by appointment. Located in Orinda Village across from golf course; 400 sq. ft.; interior decor. warm and cozy. 90% of space for special exhibitions; 90% of space for gallery artists. Clientele: collectors/private collectors. 70% private collectors, 30% corporate collectors. Overall price range: $1,000-15,000; most work sold at $3,000.
• This gallery also accepts commissioned artwork and portraits.
Media: Considers oil, acrylic, watercolor, sculpture and engraving. Most frequently exhibits oil, acrylic and sculpture (bronze).
Style: Exhibits impressionism and realism. Genres include landscapes, florals, portraits and figurative work. Prefers impressionism, realism, representational (also sculptures). Accepts work on consignment (40-50% commission). Retail price set by the gallery and the artist. Gallery provides insurance, promotion, contract and shipping costs from gallery; artist pays shipping costs to gallery. Prefers artwork framed.
Submissions: Prefers only oil. Send query letter with résumé, brochure, slides and photographs. Call for appointment to show portfolio of originals, photographs and slides. Replies only if interested within 2 weeks. Files photos, résumé.
Tips: Finds artists through visiting exhibitions, word of mouth.

‡SMITH/COSBY GALLERIES, P.O. Box 7401, Carmel CA 93921. (408)626-6563. Owner/Director: Sonya Smith. Retail gallery. Estab. 1978. Represents 40 established artists/year. Interested in seeing the work of emerging artists. Exhibited artists include Manuel Cia, John Cosby. Sponsors 6 shows/year. Open all year; 10-6 daily. Located downtown between Ocean and 7th St. (Also have location in Ruidoso NM.); colorful atmosphere, unique contemporary work. 80-85% private collectors, 20-15% corporate collectors. Overall price range: $350-30,000; most work sold at $1,000-5,000.
Media: Considers oil, acrylic, watercolor, pastel, mixed media, sculpture, ceramics and glass. Most frequently exhibits all media, oil-sculpture, acrylics-pastels.
Style: Exhibits expressionism, painterly abstraction, impressionism, representational, realism, all styles. Genres include landscapes, Southwestern, figurative work, all genres. Prefers complex expressionism, Plein-Aire impressionism, representational.
Terms: Retail price set by the artist. Gallery provides promotion; artist pays shipping costs to gallery. Prefers artwork framed. Send query letter with bio, photographs and SASE. Call for appointment to show portfolio of photographs. Replies ASAP. Files photos and bio.
Tips: Finds artists through artists' submissions, exhibitions, word of mouth, art publications.

‡SUSAN STREET FINE ART GALLERY, Studio 100, 444 S. Cedros Ave., Solana Beach CA 92075. (619)793-4442. Fax: (619)793-4491. Gallery Director: Jennifer Faist. Retail and wholesale gallery, art consultancy. Estab. 1984. Represents emerging, mid-career and established artists. Exhibited artists include Kazuko Watanabe, Marcia Burtt. Sponsors 3-4 shows/year. Average display time 1-2 months. Open all year; Monday-Friday, 9:30-5; Saturday, 12-4. Located in North San Diego County coastal; 2,000 sq. ft.; 16 foot ceiling lobby, unique artist-designed counter, custom framing design area. 50% of space for special exhibitions; 50% of space for gallery artists. Clientele: corporate, residential, designers. 30% private collectors, 70% corporate collectors. Overall price range: $125-15,000; most work sold at $400-2,000.
Media: Considers oil, acrylic, watercolor, pastel, pen & ink, mixed media, collage, sculpture, ceramics, glass, photography, woodcut, engraving, lithograph, wood engraving, mezzotint, serigraphs, linocut, etching and posters. Most frequently exhibits painting (oil/acrylic/mixed media), sculpture, ceramics.

Market conditions are constantly changing! If you're still using this book and it is 1996 or later, buy the newest edition of Artist's & Graphic Designer's Market *at your favorite bookstore or order directly from Writer's Digest Books.*

Style: Exhibits all styles, all genres. Prefers post-impressionism, abstract expressionism and minimalism.
Terms: Accepts work on consignment (50% commission). Retail price set by the artist. Gallery provides insurance, promotion, shipping costs from gallery; artist pays shipping costs to gallery. Prefers artwork unframed.
Submissions: Send query letter with résumé, slides, bio, brochure, business card, reviews, price list and SASE. Call for appointment to show portfolio of originals. Replies in 1 month.
Tips: Finds artists through sourcebooks, submissions.

TARBOX GALLERY, 1202 Kettner Blvd., San Diego CA 92101. (619)234-5020. Owner-Director: Ruth R. Tarbox. Retail gallery. Estab. 1969. Represents 75 emerging, mid-career and established artists. Sponsors 5 or 6 solo and group shows alternately/year. Average display time is 1 month."Located in a building with a center built as an open atrium (glass enclosed) beside two award-winning restaurants. Our walls are moveable; acquisition of a second gallery brings total area to 4,000 sq. ft." Clientele: "In addition to tourists who frequently like local landscapes, the majority of our customers are diners at the two top restaurants in the building. So, we try to offer a wide variety of art and subject matter." 60% collectors, 40% corporate clients. Overall price range: $35 poster to $6,000 originals; average sale $1,000.
Media: Considers oil, acrylic, watercolor, pastel, mixed media, collage and sculpture in all media.
Style: Exhibits painterly abstraction, primitivism, impressionism and realism. Genres include landscapes, florals, Southwestern, and figurative work. Prefers landscapes. "Our gallery already has some excellent watercolorists, and we would like to augment these with artists in oil working in contemporary themes."
Terms: Accepts work on consignment (50% commission). Retail price set by gallery and artist. Offers customer discounts and payment by installments. Exclusive area representation required within 10-mile radius. Gallery provides insurance, promotion and contract; shipping costs are shared.
Submissions: Send query letter first, with résumé, slides (signed, sized and described) and SASE. From these the gallery can determine if this work will find a ready market in this area. Indicate pricing and medium. Call or write for appointment to show portfolio of originals (at least 1) and slides. Resumes of promising artists are filed. "Slides are returned, but please include SASE."
Tips: Finds artists through word of mouth and "personal discovery on trips. There is interest in landscapes, pleasing colors and effects. This gallery is always interested in new artists but we are not taking new ones unless we feel they offer something different or the market seems to be improving."

‡THIRD FLOOR GALLERY, California State University, Chico-Bell Memorial Union, Chico CA 95929-0750. (916)898-5079. Fax: (916)898-4717. Gallery Coordinator: Marlys Williams. Owned and operated by Associated Students. Represents emerging, mid-career and established artists. Sponsors 9 shows/year. Average display time 3-4 weeks. Open all year; Monday-Thursday, 7am-midnight; Friday, 7-5; Saturday, 11-5, Sunday, 12-12. Located on downtown campus. 100% of space for special exhibitions.
Media: Considers oil, acrylic, watercolor, pastel, pen & ink, drawing, mixed media, collage, paper, sculpture, ceramics, craft, fiber, glass, photography, woodcut, engraving, lithograph, wood engraving, mezzotint, serigraphs, linocut, etching and posters. Most frequently exhibits oil, acrylic, watercolor, ceramics.
Style: Exhibits all styles, all genres.
Terms: Accepts work on consignment (20% commission). Retail price set by the artist. Gallery provides reception, insurance, promotion, contract, shipping costs from gallery; artist pays shipping costs to gallery. Prefers artwork framed, ready to hang.
Submissions: Send query letter with résumé, slides, brochure, photographs and SASE. Write for appointment to show portfolio of slides. Replies in "spring months only."
Tips: Finds artists through visiting exhibitions, word of mouth, artists' submissions. "Call first."

‡TOWER GALLERY, 1841 El Camino Ave., Sacramento CA 95815. (916)924-1001. Fax: (916)924-1350. Contact: Barry Smith. Retail gallery. Estab. 1983. Represents emerging and established artists. Exhibited artists include Behrens, Otsuka, Parkes, Carle. Sponsors 6 shows/year. Open all year, 7 days a week. Located near downtown; 5,000 sq. ft. Occasionally 25% of space for special exhibitions. 90% private collectors, 10% corporate collectors. Overall price range: $20-5,000.
Media: Considers oil, acrylic, watercolor, pastel, mixed media, lithograph, serigraphs and posters. Most frequently exhibits serigraphs.
Style: Exhibits all styles. Genres include landscapes and figurative work.
Terms: Accepts work on consignment (50% commission) or buys outright for 50% of retail price (net 60 days). Retail price set by the gallery. Gallery provides insurance and promotion.
Submissions: Send query letter with slides, photographs and SASE. Replies only if interested within 2 weeks.

VIEWPOINTS ART GALLERY, 315 State St., Los Altos CA 94303. (415)941-5789. Contact: Carolyn Hofstetter. Cooperative gallery. Estab. 1973. Represents 15 established artists. Is not interested in seeing the work of emerging artists. Exhibited artists include Helen Kunic, Carolyn Hofstetter, Hazel Gibson, Berni Jahnke, Jane Minnick, Barbara von Haunalter and Carol Morrow. Sponsors 5 shows/year. Average display time 1 month. Open all year. Located downtown; 500 sq. ft. 15% of space for special exhibitions, 85% for gallery

artists. Clientele: local residents. 95% private collectors, 5% corporate clients. Accepts only artists living close enough to spend time at the gallery. Overall price range: $35-1,000; most artwork sold at $200-450.
Media: Considers oil, acrylic, watercolor, pastel, pen & ink, drawings, mixed media, collage, sculpture, ceramic, fiber, woodcuts, etchings and serigraphs. Most frequently exhibits watercolor, oil, sculpture and pottery.
Style: Exhibits impressionism and realism. All genres. Prefers landscapes, florals and figurative work.
Terms: Artwork is accepted on consignment (35% commission). Co-op membership fee plus a donation of time (no commission). Retail price set by artist. Sometimes offers customer discounts and payment by installment. Gallery provides promotion. Prefers framed artwork.
Submissions: Send query letter with résumé, slides or photographs. Call for appointment to show portfolio of originals. Replies in 1 month. Files lists of perspective members and résumés and applications.
Tips: "Come in and look us over first. You should decide if your work is right for our gallery or vice versa before discussing application for membership." The most common mistakes artists make in presenting their work is "an incomplete résumé and a spare portfolio."

‡**VLADIMIR SOKOLOV STUDIO GALLERY**, 1540 S. Coast Hwy., Laguna Beach CA 92651. (714)494-3633. Owner: Vladimir Sokolov. Retail gallery. Estab. 1980. Represents 12 mid-career and established artists. May be interested in seeing the work of emerging artists in the future. Exhibited artists include V. Sokolov, Vasa. Sponsors 3-4 shows/year. Average display time 1-3 months. Open all year; Monday-Sunday, 11-5. Located near downtown (south); 700 sq. ft. 75-100% of space for special exhibitions. Clientele: private collectors, tourists. 100% private collectors. Overall price range: $3,000-5,000; most work sold at $3,000-3,800.
Media: Considers oil, acrylic, watercolor, mixed media and sculpture. Most frequently exhibits mixed, acrylic, oil.
Style: Exhibits expressionism, neo-expressionism, painterly abstraction and surrealism. Genres include landscapes, all genres.
Terms: Accepts work on consignment (50% commission) or buys outright for 30% of retail price. Retail price set by the gallery and the artist. Gallery provides insurance and promotion; artist pays shipping costs to and from gallery. Prefers artwork framed.
Submissions: Send query letter with résumé, slides, bio and SASE. Write for appointment to show portfolio of slides and transparencies. Replies only if interested within 2 weeks. Files résumé and slides.
Tips: Finds artists through visiting exhibitions, word of mouth and artists' submissions.

THE WING GALLERY, 13520 Ventura Blvd., Sherman Oaks CA 91423. (818)981-WING and (800)422-WING. Fax: (818)981-ARTS. Director: Robin Wing. Retail gallery. Estab. 1974. Represents 100+ emerging, mid-career and established artists. Exhibited artists include Doolittle and Wysocki. Sponsors 6 shows/year. Average display time 2 weeks-3 months. Open all year. Located on a main boulevard in a charming freestanding building, separate rooms, hardwood floors/carpet, skylights; separate frame design area. 80% of space for special exhibitions. Clientele: 90% private collectors, 10% corporate collectors. Overall price range: $50-50,000; most work sold at $150-5,000.
Media: Considers oil, acrylic, watercolor, pen & ink, drawings, sculpture, ceramic, craft, glass, original handpulled prints, offset reproductions, engravings, lithographs, monoprints and serigraphs. Most frequently exhibits offset reproductions, watercolor and sculpture.
Style: Exhibits primitivism, impressionism, realism and photorealism. Genres include landscapes, Americana, Southwestern, Western, wildlife and fantasy.
Terms: Accepts work on consignment (40-50% commission). Retail price set by gallery and artist. Sometimes offers customer discounts and payment by installments. Gallery provides insurance, promotion and contract; shipping costs are shared. Prefers unframed artwork.
Submissions: Send query letter with résumé, slides, bio, brochure, photographs, SASE, reviews and price list. "Send complete information with your work regarding price, size, medium, etc., and make an appointment before dropping by." Portfolio review requested if interested in artist's work. Replies in 1-2 months. Files current information and slides.
Tips: Finds artists through agents, by visiting exhibitions, word of mouth, various publications, artists' submissions and referrals.

‡**ZANTMAN ART GALLERIES LTD.**, P.O. Box 5818, 6th & Mission, Carmel CA 93921. (408)624-8314. Fax: (408)626-8408. President: Steven A. Huish. Retail gallery with 4 locations in California. Estab. 1959. Represents 50-60 emerging, mid-career and established artists. Exhibited artists include Duane Alt, Luccio Sollazzi. Sponsors 12 shows/year. Average display time 3 weeks. Open all year; daily, 10-5:30. 2 locations in Carmel-By-The-Sea, 1 location in Palm Desert, 1 location in San Francisco; 4,000, 2,500, 3,900, 2,900 sq. ft. respectively. 25% of space for special exhibitions; 75% of space for gallery artists. Clientele: international. 95% private collectors, 5% corporate collectors. Overall price range: $50-100,000 "sometimes higher;" most work sold at $1,500-3,500.
Media: Considers oil, acrylic, watercolor, pastel, pen & ink, mixed media, paper, sculpture, ceramics, craft, fiber, glass, lithograph, mezzotint, serigraphs, etching and posters. Most frequently exhibits oil, acrylic, watercolor.

Style: Exhibits expressionism, neo-expressionism, primitivism, painterly abstraction, surrealism, impressionism, photorealism, hard-edge geometric abstraction and realism. Genres include landscapes, florals, Americana, Southwestern, Western, wildlife, portraits, figurative work, all genres. Prefers landscapes, figurative paintings and sculpture, still life.
Terms: Accepts work on consignment (50% commission). Retail price set by the gallery and the artist. Gallery provides insurance, promotion and shipping costs from gallery; artist pays shipping costs to gallery. Prefers artwork framed.
Submissions: Send query letter with résumé, slides, bio, brochure, photographs, reviews and SASE. Write for appointment to show portfolio of photographs, slides and transparencies. Replies in 3 weeks.
Tips: Finds artists through artists' submissions, travel exhibitions, publications, referrals.

Los Angeles

‡BORITZER/GRAY GALLERY, 1001-B Colorado Ave., Santa Monica CA 90401. (310)394-6652. Fax: (310)394-2604. Owner: Jim Gray. Retail gallery. Estab. 1989. Represents 12 emerging, mid-career and established artists/year. Exhibited artists include Soonja O. Kim, Eric Johnson. Sponsors 8 shows/year. Average display time 4-5 weeks. Open all year; Tuesday-Saturday, 11-6; by appointment. Located Westside; 2,000 sq. ft.; features industrial/end of 20th century art, sculpture. 100% of space for special exhibitions; 100% of space for gallery artists. Clientele: private collectors, consultants, designers, museums, foundations. 70% private collectors, 30% corporate collectors. Overall price range: $200-500,000; most work sold at $3,000.
Media: Considers oil, acrylic, watercolor, pen & ink, drawing, mixed media, paper, sculpture, photography. Most frequently exhibits sculpture, painting, photography.
Style: Exhibits conceptualism, minimalism, color field, postmodern works, hard-edge geometric abstraction. Prefers sculpture.
Terms: Accepts work on consignment; commission varies. Retail price set by the gallery. Gallery provides insurance, promotion and contract; artist pays shipping costs to and from gallery.
Submissions: Send query letter with résumé, slides, bio, brochure, photographs, SASE and reviews. "We will contact if appropriate." Portfolio should include slides. Replies in 2 weeks. Files material relevant to future interest.
Tips: Finds artists through referrals.

‡COUNTY OF LOS ANGELES CENTURY GALLERY, 13000 Sayre St., Sylmar CA 91342. (818)362-3220, 367-8561. Director: Lee Musgrave. Municipal gallery. Estab. 1977. Represents emerging and mid-career artists. Sponsors 7 shows/year. Average display time 1 month. Open all year; Monday-Friday, 10-5. Located in the northeast end of San Fernando Valley; 2,800 sq. ft.
Media: Considers all media and all types of prints.
Style: Exhibits all styles, all genres.
Terms: Accepts work on consignment (20% commission). Retail price set by the gallery and the artist. Gallery provides insurance, promotion and contract; artist pays shipping costs to and from gallery. Prefers artwork framed.
Submissions: Prefers only artists from California. Send query letter with résumé, slides, reviews and SASE. Call for appointment. Replies in 1 month.
Tips: Finds artists through visiting exhibitions, art publications and artists' submissions.

‡CRAFT & FOLK ART MUSEUM (CAFAM), 5800 Wilshire Blvd., Los Angeles CA 90036. (213)937-5544. Fax: (213)937-5576. Director of Exhibition: Marcia Page. Museum. Estab. 1973. Represents emerging, mid-career and established artists. Sponsors 3-4 shows/year. Average display time 2-3 months. Open all year; Tuesday-Saturday, 10-5; Sunday 11-5; closed Monday. Located on Miracle Mile; features design, contemporary crafts, international folk art. 50% of space for special exhibitions; 75% of space for gallery artists.
Media: Considers all media, woodcut and wood engraving. Most frequently exhibits ceramics, found objects, wood, fiber, glass.
Style: Exhibits all styles, all genres. Prefers culturally specific, craft and folk art.
Submissions: Send query letter with résumé, slides and bio. Write for information. Portfolio should include slides.
Tips: Finds artists through written submissions, word of mouth and visiting exhibits.

How to Use Your Artist's & Graphic Designer's Market *offers suggestions for understanding and using the information in these listings. Read this and other articles in the front of this book for important business tips.*

ELECTRIC AVE/SHARON TRUAX FINE ART, (formerly Sharon Truax Fine Art), 1625 Electric Ave., Venice CA 90291. (213)396-3162. Fax: (213)396-3162. Contact: Sharon Truax. Exhibition and project space. Estab. 1987. Exhibits emerging and established artists. Open all year by appointment. 1,500 sq. ft. warehouse; "clean viewing space with 30 ft. ceiling, and intimate salon-viewing area opening to garden." 60% of space for special exhibitions. Clientele: 70% private collectors, 30% corporate collectors. Overall price range: $1,000-125,000; most work sold at $3,000-5,000.
Media: Considers all media. Most frequently exhibits oil on wood panel, canvas, mixed media and paper.
Style: Exhibits painterly abstraction, minimalism and constructivism. Genres include landscape, "styles for eclectic tastes."
Terms: Sometimes offers customer discounts and payment by installment.
Submissions: "Open to unique projects." Send query letter and include only materials which don't need to be returned. Portfolio review requested if interested in artist's work.
Tips: Finds artists through word of mouth, other artists and artists' submissions.

SHERRY FRUMKIN GALLERY, 1440 9th St., Santa Monica CA 90401. (310)393-1853. (213)623-9130. Retail gallery. Estab. 1990. Represents 24 emerging, mid-career and established artists. Interested in seeing the work of emerging artists. Exhibited artists include David Gilhooly and James Strombotne. Sponsors 11 shows/year. Open all year; Tuesday-Saturday 10:30-5:30. 3,500 sq. ft. 25% of space for special exhibitions; 75% of space for gallery artists. Clientele: 85% private collectors, 15% corporate collectors. Overall price range: $600-15,000; most work sold at $2,500-10,000.
Media: Considers oil, acrylic, mixed media, sculpture, ceramic and installation. Most frequently exhibits mixed media/assemblage sculpture, paintings and drawings.
Style: Exhibits all styles.
Terms: Accepts work on consignment (50% commission). Retail price set by gallery and artist. Offers payment by installments. Gallery provides insurance and promotion; artist pays for shipping costs. Prefers artwork framed.
Submissions: Send query letter with résumé, slides and SASE. Portfolio review requested if interested in artist's work. Portfolio should include slides and transparencies. Replies in 1 month. Files résumé and slides.

‡LA LUZ DE JESUS GALLERY, Upstairs, 7400 Melrose Ave., Los Angeles CA 90046. (213)651-4875. Fax: (213)651-0917. Gallery Director: Alix Sloan. Retail gallery, retail store attached with ethnic/religious merchandise. Estab. 1976. Represents emerging, mid-career and established artists. Exhibited artists include Joe Coleman, S. Clay Wilson. Sponsors 12 shows/year; "each show ranges from 1 person to large group (as many as 50)" Average display time 3½ weeks. Open all year; Monday-Thursday, 11-9; Friday and Saturday, 11-midnight; Sunday, noon-8. Located on Melrose Ave. between Fairfax and LaBrea; 4,800 sq. ft.; interesting and colorful shop attached, french windows, light and airy. 100% of space for special exhibitions; 100% of space for gallery artists. Clientele: "mostly young entertainment biz types, celebrities, studio and record company types, other artists, business people, tourists." 95% private collectors, 5% corporate collectors. Overall price range: $100-10,000; most work sold at $200-2,500.
Media: Considers all media. Considers all types of prints, which are usually shown with paintings and drawings by the same artist. Most frequently exhibits acrylic or oil, pen & ink.
Style: Exhibits alternative, underground, comix-inspired. Prefers alternative/underground/cutting-edge, comix-inspired.
Terms: Accepts work on consignment (50% commission). Retail price set by the gallery and the artist."We ask for an idea of what artist thinks and discuss it." Gallery provides insurance, promotion, contract. Gallery pays shipping costs from gallery, artist pays shipping costs to gallery, buyer pays for shipping if piece goes out of town. Prefers artwork framed.
Submissions: Send query letter with résumé, slides, bio, photographs, SASE, reviews and an idea price range for artist's work. Replies in 2 months.
Tips: Finds artists through word of mouth (particularly from other artists), artists' submissions, visiting exhibitions. "Visit the space before contacting us. If you are out of town ask a friend to visit and give you an idea. We are a very different gallery."

LOS ANGELES MUNICIPAL ART GALLERY, Barnsdall Art Park, 4804 Hollywood Blvd., Los Angeles CA 90027. (213)485-4581. Curator: Noel Korten. Nonprofit gallery. Estab. 1971. Interested in emerging, mid-career and established artists. Sponsors 5 solo and group shows/year. Average display time 2 months. 10,000 sq. ft. Accepts primarily Los Angeles artists.
 • LAMAG is funded by the Dept. of Cultural Affairs of the City of Los Angeles. Although mainly interested in Southern California and L.A. artists, a public works program is open to national artists.
Media: Considers oil, acrylic, watercolor, pastel, pen & ink, drawings, contemporary sculpture, ceramic, fiber, photography, craft, mixed media, performance art, collage, glass, installation and original handpulled prints.
Style: Exhibits contemporary works only. "We organize and present exhibitions which primarily illustrate the significant developments and achievements of living Southern California artists. The gallery strives to

Seize the Moment to Activate Your Career

After a long day teaching art to junior high school students in Los Angeles, Cynthia Janet White came home, plopped down her books, clicked on the TV and surveyed a painting in progress on her easel. As she began to paint, she listened to the end of an afternoon talk show. Suddenly the thought hit her: "Oprah Winfrey would love my paintings!" Before her mental critic could censor the idea, White jotted down "Harpo Productions" in her sketch book as the credits rolled, and made a note to send a package of slides the next morning. Two weeks later at the end of another school day, White pressed "play" on her answering machine to find out she had made a sale.

Cynthia Janet White

Seizing the moment comes naturally to White. As an artist, she does it all the time. Friends and students tease her about her ever-present sketch book. She carries it everywhere she goes, whether to faculty meetings, to church services or on a walk down the street. The images White records of relatives, friends, neighbors, students, church-goers and street-corner politicians turn up regularly in monumental paintings that are alive with vivid color, bold shapes and forms.

"Every morning before I leave for school I try to paint. Even if it is just one stroke on the canvas," says White. But if you want to show your work as well as create it, you have to schedule time for entering competitions and submitting your work to galleries. "One of the most important things I learned was to have professional slides taken of my work." You can't just photograph a painting propped up against a wall and expect to be taken seriously. Choose a photographer who understands how to shoot artwork. Get recommendations from other artists, or ask the photographer to show you samples of his or her work. As soon as White finishes a series of paintings, she calls in a photographer. She keeps one set of slides as a permanent reference in plastic slide sleeves in a three-ring binder, and has several other sets ready to send out at a moment's notice.

Seek out every opportunity to show your work, says White, who suggests starting your career by entering group shows and juried competitions. How do you find out about juried shows? Through galleries, "call for entries" columns in art magazines, art school bulletin boards and by talking with other artists at openings. Visit galleries in your city and ask to sign a visitor's book. This will put you on the mailing list to receive invitations to openings and special events.

"Showing with other artists is a great way to start exhibiting your work." says White. The pressure is not as intense as a solo show, and you get to ease into

the experience of showing your work. There is a lot to learn, from planning the invitation to the logistics and expense of matting and framing your art. Group shows provide an opportunity to develop a network of artist friends to share information about everything from art supplies to exhibition opportunities. Gallery owners and people in the art world get to know your name and see your work.

White strongly advises having business cards printed. Gallery owners, art critics and prospective art buyers attending openings of group shows may approach you about your work. It's great to be able to hand them your card.

"An art teacher advised me a long time ago to make my signature legible, and to make it fit in with the rest of the painting. Lots of artists don't sign their work, or else they sign it like a check, with an illegible signature along the lower right-hand corner." It may seem like a small thing, says White, but if someone admires your paintings and can't read your signature, you could be losing sales. White prints her full name in all capital letters on every painting.

By the time gallery owner Daniel Maher saw White's work and offered her a show, the artist was ready. She had developed a mature style and a strong body of work. At the reception for her first solo exhibition, White got a surprise. There is a tradition in art galleries that a red sticker is applied to a painting's label when it is sold. "When I saw all the red dots, my heart leapt," says White. "I knew how much joy the paintings had brought into my life, but I had no idea people would want to buy them."

After the show at Maher Gallery "everything blossomed." These days, White continues to teach art to junior high school students, has two or three shows a year and is working with an agent. Her family, friends and students are her biggest fans. At school she overheard a student say "My art teacher is a *real* artist." She still does not work out of a studio ("I'd feel uncomfortable in one"), preferring to paint at home—close to the TV.
—*Mary Cox*

Hanging Out, *this work in gouache by artist and art teacher Cynthia Janet White, originated from a sketch she made of her students during a between-classes break at their Los Angeles junior high school.*

present works of the highest quality in a broad range of media and styles. Programs reflect the diversity of cultural activities in the visual arts in Los Angeles."

Terms: Gallery provides insurance, promotion and contract. This is a curated exhibition space, not a sales gallery.

Submissions: Send query letter, résumé, brochure, slides and photographs. Slides and résumés arc filed. Submit slides to Dept. of Cultural Affairs, City of Los Angeles.

Tips: Finds artists through submissions to slide registry. "No limits—contemporary only."

‡**DANIEL MAHER GALLERY,** #105, 500 Molino St., Los Angeles CA 90013. (213)617-7891. Owner: Daniel Maher. Retail gallery. Estab. 1973. Exhibits 20 emerging, mid-career and established artists/year. Exhibited artists include Eric Vollrath, Lisa Adams and Cynthia Janet White. Sponsors 6 exhibitions/year. Average display time 6 weeks. Open all year; Monday-Saturday, 11-5. Located downtown in the Artist's Loft District; 1,000 sq. ft., 14-ft. ceilings. "I show good art and support good artists." 100% of space for special exhibitions. "I have shows for individual artists." Clientele: mostly homeowners, a few collectors. Almost 100% private collectors. Overall price range: $500-5,000; most work sold at under $1,000.

Media: : Considers all media and all types of prints, "but no posters and no commercial-style art." Most frequently exhibits paintings, photographs, monoprints and sculpture (steel, wood, paper). "It is due to circumstance, not preference."

Style: Exhibits all genres.

Terms: Accepts work on consignment (45% commission). Retail price set by gallery. Gallery provides promotion and contract; artists pays shipping costs. Prefers artwork framed.

Submissions: Send query letter with résumé and slides. Write for appointment to show portfolio of slides initially, then original art. Replies in a few weeks. Files slides, résumés, articles and reviews.

Tips: Finds artists mostly through referrals form other artists, also through art shows and artists' submissions. "Look at the gallery before you ask for a show. Show me only the work you think is your best, not what you think I might like."

‡**NEWSPACE,** 5241 Melrose Ave., Los Angeles CA 90038. (213)469-9353. Fax: (213)469-1120. Director: Joni Gordon; Assistant Director: Suzanne Vielmetter. Commercial gallery. Estab. 1974. Represents 17 emerging, mid-career and established artists/year. Exhibited artists include Martha Alf, Daniel Wheeler. Sponsors 9-10 shows/year. Average display time 4-5 weeks. Open all year; Tuesday-Saturday, 11-4. Located in Hollywood, next to Paramount studios. 80% of space for special exhibitions; 90% of space for gallery artists. Clientele: private, corporate collectors, museums. 75% private collectors, 25% corporate collectors. Overall price range: $300-30,000; most work sold at $2,000-5,000.

Media: Considers all media and all types of prints. Most frequently exhibits mixed media, oil/acrylic, drawing.

Style: Exhibits painterly abstraction, conceptualism, minimalism, color field, hard-edge geometric abstration, sculpture, all styles.

Terms: Accepts work on consignment (50% commission). Retail price set by the gallery. Gallery provides promotion. Shipping costs are shared. Prefers artwork framed.

Submissions: Accepts only artists from Los Angeles County. Send query letter with résumé, slides, bio and SASE. Replies in 10-12 weeks. Files slides, biographies.

Tips: Finds artists through visiting exhibitions, artists' submissions.

POSNER GALLERY, 6144 Orange St., Los Angeles CA90048. (213)936-3094. Director: Judith Posner. Estab. 1974. Represents 200 emerging, mid-career and established artists. Exhibited artists include Hockney and Wesselmann. Gallery features unique decor. 50% private collectors, 50% corporate collectors. Overall price range: $50-50,000; most work sold at $1,000-10,000.

• Posner Gallery has moved from Milwaukee WI toLos Angeles and the address and phone number given for the office.

Media: Considers oil, acrylic, watercolor, pastel, pen & ink, drawing, mixed media, collage, works on paper, sculpture; original handpulled prints, linocuts, engravings, etchings, lithographs, pochoir, posters and serigraphs. Most frequently exhibits lithographs, serigraphs and paintings (acrylic).

Style: Exhibits painterly abstraction, minimalism, impressionism, realism, photorealism, pattern painting and hard-edge geometric abstraction. All genres. Prefers landscapes, florals and abstract.

Terms: Accepts work on consignment (50% commission). Retail price set by the gallery and the artist. Customer discount and payment by installments. Gallery provides insurance and promotion; artist pays for shipping. Prefers artwork unframed.

Submissions: Send query letter with slides, bio and SASE. Portfolio should include slides. Replies in weeks.

Tips: Finds artists through artists' submissions and art collectors' referrals.

‡**VICTOR SALMONES GALLERY, BEVERLY HILLS, INC.,** 9601 Santa Monica Blvd., Beverly Hills CA 90210. (310)271-1297. Fax: (310)271-4962. Vice President: Travis Hansson. Retail and wholesale gallery. Estab. 1962. Represents 13 emerging, mid-career and established artists/year. Exhibited artists include Victor Salmones, Robert Toll. Sponsors 3 shows/year. Average display time 2 months. Open all year; Monday-Saturday, 10-5. Space is 2,000 sq. ft.; very architectural—showing mainly large sculpture. 100% of space for gallery

artists. Clientele: corporate and private. 85% private collectors, 15% corporate collectors. Overall price range: $1,000-200,000; most work sold at $15,000-75,000.
Media: Considers sculpture. Most frequently exhibits bronze, other metals, stones.
Style: Exhibits all styles, all genres.
Terms: Retail price set by the gallery. Artist pays shipping costs to and from gallery.
Submissions: Send query letter with résumé and photographs. Write for appointment to show portfolio of photographs. Replies only if interested within 1 week. Files only photos.
Tips: Finds artists through agents, by visiting exhibitions, word of mouth, various art publications and source-books, artists' submissions.

SUE SPAID FINE ART, 7454½ Beverly Blvd., Los Angeles CA 90036. (213)935-6153. Director/Owner: Sue Spaid. Retail gallery. Estab. 1990. Represents 13 emerging artists. Exhibited artists include Carole Caroompa, Adam Ross, Nancy Evans, Lynn Aldrich, Theresa Hackett and Jacci Den Hartog. Sponsors 12 shows/year. Average display time 3 weeks. Open all year. Located in Hollywood; 500 sq. ft. Space is "like a studio; artists make work that is site-specific." 85% of space for special exhibitions. Clientele: "top tier collectors." 90% private collectors; 10% corporate collectors. Overall price range: $75-13,000; most work sold at $1,000-2,000.
Media: Considers oil, acrylic, pen & ink drawings, mixed media, collage, works on paper, sculpture, installation and photography. Most frequently exhibits sculpture and process painting.
Style: Exhibits painterly abstraction, conceptualism and minimalism. Prefers minimalism, process painting and image-based styles.
Terms: Accepts work on consignment (50% commission). Retail price set by gallery and artist. Sometimes offers customer discounts and payment by installment. Gallery provides promotion; shipping costs are shared. Prefers artwork unframed.
Submissions: Send query letter with slides, bio and SASE; or come by in person. Portfolio review requested if interested in artist's work. Files "original letter, notes about the work, sometimes a résumé."
Tips: Find artists through visiting shows, meeting artists, getting to know them and their work. "Come by the gallery many times, chat with me, get to know what I'm doing. Don't presume I have a certain logic, pattern or style. It's more complex than it looks!"

‡WELLSPRING GALLERY, Suite 105, 120 Broadway, Santa Monica CA 90401. (310)451-1924. Director/President: Judith Sara Cohen. Retail gallery. Estab. 1991. Represents "up to 40" emerging, mid-career and established artists/year. Exhibited artists include Caryl Bryer Fallert, Therese May. Sponsors 4 shows/year. Average display time 6 months. Open all year; Tuesday-Sunday, noon-6 pm; some evenings. Located downtown in commercial/retail/resort area; 2,000 sq. ft.
Media: Considers fiber. "Our specialty is art quilts. We handle only fine fiber art, no fine craft." Most frequently exhibits art quilts, tapestry, wearable art.
Style: Exhibits all styles, all genres. Prefers figurative/graphic, abstract/contemporary, multimedia.
Terms: Accepts work on consignment (50% commission). Retail price set by the artist. Gallery provides insurance, promotion, contract and pays shipping costs from gallery; artist pays shipping costs to gallery. Prefers artwork unframed.
Submissions: Prefers only fiber art. Send query letter with résumé, slides, bio and SASE. Call for appointment to show portfolio of slides and any good representation. Replies only if interested within 6 months. Files all material not sent with SASE.
Tips: Finds artists "through serendipity."

‡SYLVIA WHITE CONTEMPORARY ARTISTS' SERVICES, 2022 B Broadway, Santa Monica CA 90404. (310)828-6200. Owner: Sylvia White. Retail gallery, art consultancy and career management for visual artists. Estab. 1979. Represents 18 emerging, mid-career and established artists. Exhibited artists include Martin Mull, John White. Sponsors 12 shows/year. Average display time 1 month. Open; Tuesday-Saturday, 10-5. Located in the Santa Monica gallery district; 1,500 sq. ft.
Media: Considers oil, acrylic, watercolor, drawing, mixed media, collage, sculpture, installation and photography. Most frequently exhibits painting and sculpture.
Style: Exhibits painterly abstraction, conceptualism and photorealism.
Terms: "We work on a fee basis and take no commission of sales." Retail price set by the gallery and the artist. Gallery provides insurance, promotion and contract; artist pays shipping costs to and from gallery.
Submissions: Send query letter with résumé, slides and bio. Write for appointment to show portfolio of slides. Replies in 2 weeks. Files slides.

San Francisco

‡AMERICAN INDIAN CONTEMPORARY ARTS, Suite 250, 685 Market St., San Francisco CA 94105-4212. (415)495-7600. Contact: Director of Exhibitions and Programs. Nonprofit gallery. Estab. 1983. Represents 800 emerging, mid-career and established artists. Exhibited artists include Harry Fonseca, Jaune Quick To See Smith. Sponsors 5 shows/year. Average display time 1 month. Open all year; Tuesday-Saturday, 10-5:30;

December, 11-6. Located downtown, 3rd and Market; 2,000 sq. ft.; pre-1906 renovated historic building. 90% of space for special exhibitions. Clientele: individuals. 95% private collectors, 5% corporate collectors. Overall price range: $200-4,000; most work sold at $200-900.
Media: Considers "all media, all types." Most frequently exhibits acrylic and mixed media.
Style: Exhibits all styles, all genres. Prefers abstract and figurative.
Terms: Accepts work on consignment (40% commission). Retail price set by the artist. Gallery provides insurance, promotion, shipping costs from gallery. Artist pays shipping costs to gallery. Prefers artwork framed.
Submissions: Native American artists only. Send query letter with résumé, slides (20) and bio. Call or write for appointment to show portfolio of slides. Files "everything we receive on artists."
Tips: Finds artists through word of mouth, art publications and sourcebooks, artists' submissions.

JOSEPH CHOWNING GALLERY, 1717 17th St., San Francisco CA 94103. (415)626-7496. Fax: (415)863-5471. Director: Joseph Chowning. Retail gallery. Estab. 1972. Represents 19 mid-career and established artists. Exhibited artists include Eduardo Carrillo and Bill Martin. Sponsors 10 shows/year. Average display time 1 month. Open all year; Tuesday-Friday 10:30-5:30, Saturday 12-4. Located south of downtown; 3,600 sq. ft. 50% of space for special exhibitions; 100% of space for gallery artists. Clientele: 80% private collectors, 20% corporate collectors. Overall price range: $100-750,000; most work sold at $100-5,000.
Media: Considers oil, pen & ink, acrylic, sculpture, watercolor, mixed media, ceramic, pastel and original handpulled prints. Most frequently exhibits painting, sculpture, works on paper.
Style: Exhibits synchromy, California contemporary (Bay area). All genres. Prefers contemporary Bay area sculpture and painting, contemporary ceramics.
Terms: Accepts work on consignment (50% commission). Retail price set by gallery. Gallery provides insurance and promotion; shipping costs are shared. Prefers artwork framed.
Submissions: Send slides, bio, SASE and cover letter detailing career/objective. Write for appointment to show portfolio of originals and "whatever is on hand, easiest to transport." Replies in 1-2 weeks. Files cover letters and résumés.

‡EBERT GALLERY, 49 Geart St., San Francisco CA 94108. (415)296-8405. Owner: Dick Ebert. Retail gallery. Estab. 1989. Represents 24 established artists "from this area." Interested in seeing the work of emerging artists. Exhibited artists include Jerrold Ballaine, Boyd Allen. Sponsors 11-12 shows/year. Average display time 1 month. Open all year; Tuesday-Friday, 10:30-5:30; Saturday, 11-5. Located downtown near bay area; 1,200 sq. ft.; one large room which can be divided for group shows. 85% of space for special exhibitions; 15% of space for gallery artists. Clientele: collectors, tourists, art students. 80% private collectors. Overall price range: $500-20,000; most work sold at $500-8,000.
Media: Considers oil, acrylic, watercolor, pastel, pen & ink, drawing, mixed media, collage, paper, sculpture, glass, photography, woodcut, engraving, mezzotint, etching and encostic. Most frequently exhibits acrylic, oils and pastels.
Style: Exhibits expressionism, painterly abstraction, impressionism and realism. Genres include landscapes, figurative work, all genres. Prefers landscapes, abstract, realism.
Terms: Accepts work on consignment (50% commission). Retail price set by the artist. Gallery provides promotion. Shipping costs are shared. Prefers artwork framed.
Submissions: Send query letter with résumé and slides. "We call the artist after slide and résumé review." Portfolio should include originals and slides. Replies in a few weeks.
Tips: Finds artists through referral by professors or stable artists.

HANSON ARTS, 669 Bridgeway, Sausalito CA 94965. (415)332-9352. Fax: (415)927-3406. Director of Acquisitions: Jennifer White. Retail locations in Carmel, New Orleans and Sausalito. Estab. 1974. Represents 20 emerging, mid-career and established artists. Exhibited artists include Peter Max and Mark Kostabi. Sponsors 4-5 shows per gallery/year. Average display time 2-3 weeks. Open all year. Space is approximately 2,000 sq. ft. per gallery. Overall price range: $850-100,000; most work sold at $2,500-7,500.
Media: Considers all media and all types of prints. Most frequently exhibits original oil, serigraphs and sculpture.
Style: Exhibits expressionism, neo-expressionism, painterly abstraction, conceptualism, impressionism, realism and photorealism. Genres include landscapes, portraits and figurative work. Prefers figurative and pop.
Terms: Accepts work on consignment (varied commission). Retail price set by the gallery. Gallery provides insurance, promotion and contract. Artist pays for shipping.
Submissions: Send query letter with résumé, slides, bio, brochure, photographs, SASE, business card and reviews. Write and send slides for appointment to show portfolio, which should include photographs, slides and transparencies. Replies in 2 months.
Tips: "Please send representative illustrations of work and exhibition/biographical history. We do not accept unsolicited original art, nor do we make appointments with artists without first reviewing slides."

INTERSECTION FOR THE ARTS, 446 Valencia, San Francisco CA 94103. (415)626-2787. Gallery Director: Linda Wilson. Alternative space and nonprofit gallery. Estab. 1980. Exhibits the work of 10 emerging and

mid-career artists/year. Sponsors 10 shows/year. Average display time 6 weeks. Open all year. Located in the Mission District of San Francisco; 840 sq. ft.; gallery has windows at one end and cement pillars betwen exhibition panels. 100% of space for special exhibitions. Clientele: 100% private collectors.

• Gallery has been featuring less installation and more wall work.

Media: Considers oil, pen & ink, acrylic, drawings, watercolor, mixed media, installation, collage, photography, site-specific installation, video installation, original handpulled prints, woodcuts, lithographs, posters, wood engravings, mezzotints, linocuts and etchings.

Style: Exhibits all styles and genres.

Terms: Retail price set by artist. Customer discounts and payment by installment are available. Gallery provides promotion; shipping costs are shared. Prefers artwork unframed.

Submissions: Send query letter with résumé, 20 slides, reviews, bio, clippings and SASE. Portfolio review not required. Replies within 6 months only if interested and SASE has been included. Files slides.

Tips: Finds artists through slides sent to gallery director. "Bio info is helpful."

KALA INSTITUTE, 1060 Heinz Ave., Berkeley CA 94710. (510)549-2977. (510)549-2984. Gallery Director: Vickie Jo Sowell. Nonprofit gallery. Estab. 1973. Exhibits 120 emerging, mid-career and established artists. 40 members. Exhibited artists include Leslie Wasserberger and Mirelle Morency. Sponsors 6 shows/year. Average display time 6 weeks. Open all year. 500 sq. ft. 33⅓% of space for special exhibitions; 66⅔% of space for gallery artists. Clientele: 20% private collectors, 40% corporate collectors. Overall price range: $250-1,200; most work sold at $400-700.

• Kala Institute now has an electronic multimedia center.

Media: Considers paper, original handpulled prints, woodcuts, wood engravings, linocuts, engravings, mezzotints, etching, lithographs and serigraphs. Most frequently exhibits prints.

Style: Exhibits all styles. Prefers painterly abstraction, neo-expressionism and imagism.

Terms: Accepts work on consignment (50% commission) or artwork is bought outright. Retail price set by gallery and artist. Sometimes offers customer discounts and payment by installments. Gallery provides promotion and contract; artist pays shipping costs. Prefers artwork unframed.

Submissions: Prefers only printmakers. Must be Art in Red. Call for appointment to show portfolio of slides.

Tips: Finds new artists through word of mouth and exchange exhibitions. "We have many international artists which often lead to exchange shows with other galleries throughout the world."

‡LIMESTONE PRESS: GREVE/HINE, 3857 Tehama St., San Francisco CA 94103. (415)777-2214. Fax: (415)495-2665. Gallery Director: Dede Hine. Retail gallery. Estab. 1975. Represents emerging, mid-career and established artists. Exhibited artists include Richard Tuttle, Georg Baselitz. Sponsors 3 shows/year. Average display time 4 months. Open all year; by appointment. Located south of market; 1,000 sq. ft. 75% of space for special exhibitions; 25% of space for gallery artists.

Media: Considers oil, watercolor, pastel, pen & ink, drawing, mixed media, collage, paper, sculpture, woodcut, engraving, lithograph, wood engraving, mezzotint and etching. Most frequently exhibits prints, sculpture, paintings and drawings.

Style: All styles.

Terms: Retail price set by the gallery and the artist.

Submissions: Portfolio should include slides. Replies only if interested.

Tips: Finds artists through visiting exhibitions.

JUDAH L. MAGNES MUSEUM, 2911 Russell St., Berkeley CA 94705. (510)549-6950. Contact: the curators. Museum. Estab. 1962. Exhibits the work of emerging, mid-career and established artists. Sponsors 9-12 shows/year. Average display time 3 months. Open all year. Located "in a residential area; 1,000+ sq. ft.; renovated mansion with state-of-the-art lighting and climate control." 80% of space for special exhibitions. Clientele: Jewish and non-Jewish, children through seniors. 90-100% private collectors; but "artists' sales are not primary to our purpose." Submission guidelines available.

Media: Considers all media and prints.

Style: Exhibits all styles. Genres include Jewish themes or materials.

Terms: "Standard museum practices." Retail price set by museum shop and artist. Gallery provides insurance and promotion; coverage of shipping costs varies.

Submissions: Prefers primarily Jewish themes/materials. First must send query letter with résumé, slides, bio and SASE.

Tips: Query first. "Curators will review materials at regularly scheduled sessions one or two times per year."

MORPHOS GALLERY, 544 Hayes St., San Francisco CA 94102. (415)626-1936. Fax: (415)626-0368. Owner/ Director: Catharine Clark. Retail gallery. Estab. 1991. Represents 20 emerging and mid-career artists. Exhibited artists include Ted Julian Arnold and Emilie Clark. Sponsors 12 shows/year. Average display time 1 month. Open all year. Located at the Civic Center/Hayes Valley; 1,000 sq. ft. 90% of space for special exhibitions; 10% of space for gallery artists. Clientele: 95% private collectors, 5% corporate collectors. Overall price range: $200-6,000; most work sold at $800-2,200.

Media: Considers oil, acrylic, mixed media, collage, sculpture, installation, photography, woodcuts, wood engravings, linocuts, engravings, mezzotints, etchings and lithographs. Most frequently exhibits mixed media and photography.
Style: Exhibits all styles and genres. Prefers social-surrealist, figurative-expressionism and photography (non-documentary).
Terms: Accepts work on consignment (50% commission). Retail price set by gallery and artist. Offers customer discounts and payment by installments. Gallery provides insurance, promotion and contract; shipping costs are shared. Prefers artwork framed.
Submissions: Send query letter with slides, bio, photographs, reviews and SASE. Reports in 2 months. Portfolio review not required.

OLGA DOLLAR GALLERY, 2nd Fl., 210 Post St., San Francisco CA 94108. (415)398-2297. Fax: (415)398-2788. Retail gallery. Estab. 1989. Represents 60 emerging, mid-career and established artists. Exhibited artists include Francesca Sundsten and David Dornan. Sponsors 16 shows/year. Average display time 6 weeks. Open all year; Tuesday-Saturday 10:30-5:30. Located downtown; 5,400 sq. ft. 50% of space for special exhibitions; 50% of space for gallery artists. Clientele: young-established. 50% private collectors, 50% corporate collectors. Overall price range: $300-15,000; most work sold at $500-3,000.
Media: Considers oil, pen & ink, paper, acrylic, drawing, sculpture, watercolor, mixed media, installation, pastel, collage, photography, mezzotints, etchings, lithographs. Most frequently exhibits paintings, prints, work on paper.
Style: Exhibits painterly abstraction, realism, surrealism, imagism. Genres include landscapes and figurative work. Prefers collage, figurative, realism/surrealism.
Terms: Accepts work on consignment (50% commission). Retail price set by gallery and artist. Gallery provides insurance, promotion, contract, shipping costs from gallery. Prefers artwork framed.
Submissions: Send query letter with résumé, slides, bio. Write for appointment to show portfolio of slides. Replies in 1 month.
Tips: "The artist needs to become more business-like and reasonable with prices."

‡JOHN PENCE GALLERY, 750 Post St., San Francisco CA 94109. (415)441-1138. Proprietor/Director: John Pence. Retail gallery or art consultancy. Estab. 1975. Clientele: collectors, designers, businesses and tourists, 85% private collectors, 15% corporate clients. Represents 16 artists. Sponsors 7 solo and 2 group shows/year. Average display time is 4 weeks. Interested in emerging, mid-career and established artists. Overall price range: $450-65,000; most artwork sold at $4,500-8,500.
 ● Gallery has vast space for exhibitions: 6,000 sq. ft and 17 ft. high ceilings.
Media: Primarily considers oil and pastel. Will occasionally consider watercolor and bronze.
Style: Exhibits painterly abstraction, impressionism, realism and academic realism. Genres include landscapes, florals, Americana, portraits, figurative work and still life. "We deal eclectically. Thus we may deal someone who is the best of a field or someone who could become that. We are *actively involved* with the artist, not merely reps." Looks for "consistency, interesting subjects, ability to do large works."
Terms: Accepts work on consignment (50% commission) or buys outright (33% markup). Retail price is set by gallery and artist. Sometimes offers customer discounts and payment by installment. Exclusive area representation required. Gallery provides insurance and promotion.
Submissions: Call or send for application for portfolio review. Résumés are filed.
Tips: Finds artists through word of mouth, respected artists' recommendations. "Artists need patience, respect for the gallery's artists, respect for the dealer, gentle attitude, cooperative nature and a participatory spirit."

‡SAN FRANCISCO CRAFT & FOLK ART MUSEUM, Bldg. A, Fort Mason Center, San Francisco CA 94123. (415)775-0990. Curator: Carole Austin. Estab. 1983. Represents emerging and mid-career artists. Average display time 2 months. Open all year. Located in a cultural center in a national park; 1,500 sq. ft.; "amidst 4 other museums and many theaters and nonprofits." 100% of space for special exhibitions and museum shop. Clientele: 100% private collectors. Overall price range: $100-3,000. "We are basically a museum and sell only occasionally, so we do not keep statistics on prices."
Media: Considers mixed media, collage, works on paper, sculpture, ceramic, craft, fiber, glass, installation. Most frequently exhibits textile, ceramics and paper.
Style: Exhibits primitivism, folk art, contemporary fine art, tribal and traditional art.
Terms: Sometimes offers customer discounts and payment by installment.
Submissions: Send query letter with résumé, slides, bio, brochure, photographs and SASE. Write to schedule an appointment. Portfolio review not required. Replies in 2 months if SASE included. Does not file material.
Tips: Finds artists through periodicals (craft), announcements, submitted slides, studio visits, word of mouth, galleries.

‡TERRAIH, 165 Jessie, San Francisco CA 94105. (415)543-0656. Fax: (415)543-0584. Partner: Peter Wright. Retail gallery. Estab. 1987. Represents 27 emerging, mid-career and established artists/year. Exhibited artists

include Nancy Spero, Rene De Guzmah. Sponsors 12 shows/year. Average display time 4-5 weeks. Open all year; Tuesday-Saturday, 11-5:30. Located downtown; 1,250 sq. ft. 75% of space for special exhibitions; 25% of space for gallery artists. Clientele: mid-career/mid-income. 90% private collectors; 10% corporate collectors. Overall price range: $350-18,000; most work sold at 1,000-5,000.
Media: Considers oil, acrylic and sculpture. Most frequently exhibits paintings (oil/acrylic), sculpture.
Style: Exhibits expressionism, painterly abstraction, conceptualism, minimalism, postmodern works.
Terms: Accepts work on consignment (50% commission). Retail price set by the gallery. Gallery provides insurance, promotion and contract; shipping costs are shared.
Submissions: Send query letter with résumé, slides, bio and SASE. Write for appointment to show portfolio of slides.

Colorado

BOULDER ART CENTER, 1750 13th St., Boulder CO 80302. (303)443-2122. Fax: (303)447-1633. BAC Board of Directors: Exhibitions Committee. Nonprofit gallery. Estab. 1972. Exhibits the work of emerging, mid-career and established artists. Sponsors 10 shows/year. Average display time is 6 weeks. "Ideal downtown location in a beautiful, historically-landmarked building."
Media: Considers all media.
Style: Exhibits contemporary, abstract, experimental, figurative, non-representational works.
Submissions: Accepts work by invitation only, after materials have been reviewed by Exhibitions Committee. Send query letter, artist statement, résumé, approximately 20 high-quality slides and SASE. Portfolio review requested if interested in artist's work. Reports within 6 months. Press and promotional material, slides and BAC history are filed.

SANDY CARSON GALLERY, 1734 Wazee St., Denver CO 80202. (303)297-8585. Director: Jodi Carson. Retail gallery and art consultancy. Estab. 1974. Represents 200 artists. Sponsors 6-8 group and solo shows/year. Average display time 6 weeks. Interested in emerging, mid-career and established artists. "We have formed a gallery district in a retail location in lower downtown Denver. Many other galleries have followed. We now have more of a New York or Chicago look to our gallery." 3,000 sq. ft. open interior with 2 specific display areas. Clientele: individuals and corporations. 35% private collectors, 65% corporate clients. Overall price range: $125-10,000; most work sold at $2,000.
Media: Considers oil, acrylic, watercolor, pastel, drawings, mixed media, works on paper, sculpture, ceramic, fiber, glass, photography and original handpulled prints.
Style: Exhibits hard-edge geometric abstraction, color field, painterly abstraction, minimalism, conceptualism, post-modernism, pattern painting, primitivism, impressionism, photorealism, expressionism, neo-expressionism and realism. "We carry contemporary serious artwork. It can be abstract to landscape oriented. We tend to stay away from realistic figurative imagery. We have the capability of carrying large scale pieces."
Terms: Accepts work on consignment (50% commission). Retail price set by gallery and artist. Sometimes offers customer discounts and payment by installment. Exclusive area representation required. Gallery provides insurance, promotion and contract; artist pays for shipping.
Submissions: Send query letter, résumé, price list, SASE and slides. Call or write for appointment to show portfolio of originals, slides, price list and transparencies. Résumés are filed.
Tips: Finds artists through referrals from artists and galleries, also by looking when traveling. "I do not want to see commercialized art or copied imagery."

‡COGSWELL GALLERY, 223 Gore Creek Dr., Vail CO 81657. (303)476-1769. Pres./Director: John Cogswell. Retail gallery. Estab. 1980. Represents 40 emerging, mid-career and established artists. Exhibited artists include Steve Devenyns, Frances Donald and Jean Richardson. Sponsors 8-10 shows/year. Average display time 3 weeks. Open all year. Located in Creekside Building in Vail; 3,000 sq. ft. 50% of space for special exhibitions. Clientele: American and international, young and active. 80% private collectors, 20% corporate collectors. Overall price range: $100-50,000; most work sold at $1,000-5,000.
• Cogswell Gallery has recently doubled its size.
Media: Considers oil, acrylic, sculpture, watercolor, ceramic, photography and bronze; lithographs and serigraphs. Most frequently exhibits bronze, oil and watercolor.
Style: Exhibits painterly abstraction, impressionism and realism. Genres include landscapes, Southwestern and Western.
Terms: Accepts work on consignment (50% commission). Retail price set by the artist. Offers customer discounts and payment by installments. Gallery provides insurance and promotion; shipping costs from gallery. Prefers artwork framed.
Submissions: Send query letter with résumé, slides and bio. Call to schedule an appointment to show a portfolio, which should include slides. Replies only if interested within 1 month.

CORE NEW ART SPACE, 1412 Wazee St., Denver CO 80202. (303)571-4831. Coordinator: Tim Hennigan. Cooperative, alternative and nonprofit gallery. Estab. 1981. Exhibits 30 emerging and mid-career artists.

Sponsors 30 solo and 6-10 group shows/year. Average display time: 2 weeks. Open Thursday-Sunday. Open all year. Located "in lower downtown, former warehouse area; 3,400 sq. ft.; large windows, hardwood floor, and high ceilings." Accepts mostly artists from front range Colorado. Clientele: 97% private collectors; 3% corporate clients. Overall price range: $75-1,500; most work sold at $100-600.
Media: Considers all media. Specializes in cutting edge work. Prefers quality rather than marketability.
Style: Exhibits expressionism, neo-expressionism, painterly abstraction, conceptualism; considers all styles and genres, but especially contemporary and alternative (non-traditional media and approach).
Terms: Co-op membership fee plus donation of time. Retail price set by artist. Exclusive area representation not required.
Submissions: Send query letter with SASE. Quarterly auditions to show portfolio of originals, slides and photographs. Request membership or associate membership application. "Our gallery gives an opportunity for emerging artists in the metro-Denver area to show their work. We run four to six open juried shows a year. There is an entry fee charged, but no commission is taken on any work sold. The member artists exhibit in a one-person show once a year. Member artists generally work in more avant-garde formats, and the gallery encourages experimentation. Members are chosen by slide review and personal interviews. Due to time commitments we require that they live and work in the area. There is a yearly Associate Members Show."
Tips: Finds artists through invitations, word of mouth, art publications. "We want to see challenging art. If your intention is to manufacture coffee table and over the couch art for suburbia, we are not a good place to start."

EMMANUEL GALLERY & AURARIA LIBRARY GALLERY, Campus Box 173361, Denver CO 80217-3361. (303)556-8337. Fax: (303)556-3447. Director: Carol Keller. Nonprofit gallery and university gallery. Estab. 1976. Exhibits emerging, mid-career and established artists. Gallery serves 3 colleges. Sponsors 24 shows/year. Average display time 3-4 weeks. Open during semesters all year. Located on the downtown campus; about 1,600 sq. ft.; "the oldest standing church structure in Denver, a historical building built in 1876." 100% of space for special exhibitions. Clientele: private collectors or consultants. Wide price range.
Media: Considers all media and all types of prints. Most frequently exhibits painting, photography and sculpture.
Style: Exhibits neo-expressionism, conceptualism, minimalism, color field, postmodern works, realism, photorealism, installations and all styles and genres.
Terms: It is a nonprofit gallery and there is a consignment during exhibit. A 25% commission donation is accepted. Retail price set by artist. Sometimes offers customer discounts and payment by installment. Gallery provides insurance and promotion; shipping costs are negotiated.
Submissions: Send query letter with résumé, slides, SASE and reviews. Call or write for appointment to show portfolio of slides and résumé. Replies ASAP.
Tips: "Installation exhibits are frequently requested."

GALLERY OF CONTEMPORARY ART, P.O. Box 7150, University of Colorado at Colorado Springs, Colorado Springs CO 80933-7150. (719)593-3567. Director: Gerry Riggs. University museum. Estab. 1981. Exhibits emerging, mid-career and established artists (national, international and regional). Interested in seeing the work of emerging artists. Exhibits 170 artists annually. Sponsors 6 shows/year. Average display time 6 weeks. Open all year; Monday-Friday 10-4 and Saturday 1-4. 2,865 sq. ft. of exhibition space; 15 ft. ceiling, wooden walls, modular partitions. Clientele: members/public. 95%private collectors, 5% corporate collectors. Overall price range: $200-20,000; most work sold at $200-500.
Media: Considers all media and all types of prints. Most frequently exhibits paintings, prints (including photos) 3-D mediums.
Style: Exhibits all styles and mediums of contemporary art. "We are looking for art that is relevant to our viewers, themes that are topical or styles that are current."
Terms: Artwork is accepted on consignment (25% commission). Retail price set by artist. Sometimes offers customer discounts and payment by installment. Gallery provides insurance, promotion and contract; obligation to pay shipping costs varies depending on exhibit. Prefers artwork framed.
Submissions: Send query letter with résumé, slides, reviews and bio. Portfolio review requested if interested in artist's work. Call or write for appointment to show Portfolio should include originals, photographs, slides and transparencies. Files résumé, bio, sample slides (usually 2 or 3 retained).
Tips: Finds artists through agents, exhibits, walk-ins, reading, word of mouth, submissions and referrals, etc. "We do group shows on particular media or themes. Files are retained for matching to exhibits. The gallery likes to show a range of work by as many artists as possible to provide the public with an overview of contemporary art. There are more co-ops in our area. Commercial galleries are having a rough time."

‡**E.S. LAWRENCE GALLERY**, 516 E. Hyman Ave., Aspen CO 81611. (303)920-2922. Fax: (303)920-4072. Director: Ben Vaughn. Retail gallery. Estab. 1988. Represents emerging, mid-career and established artists. Exhibited artists include Zvonimir Mihanovic, Graciela Rodo Boulanger. Sponsors 2 shows/year. Average display time 3 months. Open all year; daily 10-10. Located downtown; 2,500 sq. ft. 100% of space for gallery artists. 95% private collectors, 5% corporate collectors.

Media: Considers oil, acrylic, watercolor, pastel, mixed media, sculpture, glass, lithograph and serigraphs. Most frequently exhibits oil, acrylic, watercolor.
Style: Exhibits expressionism, impressionism, photorealism and realism. Genres include landscapes, florals, Americana, Western, wildlife, figurative work. Prefers photorealism, impressionism, expressionism.
Terms: Accepts artwork on consignment (50% commission). Retail price set by the gallery and the artist. Gallery provides insurance, promotion and contract; artist pays shipping costs to and from gallery "if not sold." Prefers artwork framed.
Submissions: Send query letter with résumé, slides and photographs. Write for appointment to show portfolio of photographs, slides and reviews. Replies in 1 month.
Tips: Finds artists through agents, visiting exhibitions, word of mouth, art publications and artists' submissions.

‡**MACKEY GALLERY,** 2900 West 25th Ave., Denver CO 80216. (303)455-1157. Owner: Mary Mackey. Retail gallery. Estab. 1991. Represents 15 emerging, mid-career and established artists/year. Exhibited artists include Udo Nöger, Russell Beardsley. Sponsors 12 shows/year. Average display time 1 month. Open all year; Tuesday-Friday 1-5, Saturday 12-4. Located 5 minutes from downtown Denver and 5 minutes from I-25; 1,700 sq. ft. plus 1,300 sq. ft. of loft living area where gallery artists are shown. "I have moveable walls and halogen lighting system." 90% of space for special exhibitions; 10% of space for gallery artists. 80% private collectors, 20% corporate collectors. Overall price range: $100-5,000; most work sold at $500-2,000.
Media: Considers oil, acrylic, drawing, mixed media, collage, paper, sculpture, ceramics, photography, monoprint, woodcut, engraving, mezzotint, linocut, etching and monoprints. Most frequently exhibits large canvas/oil/acrylic, sculpture, photography.
Style: Exhibits painterly abstraction, conceptualism, minimalism, postmodern works and non-conceptual abstract. Prefers abstract, figurative and photography.
Terms: Accepts artwork on consignment (50% commission). Retail price set by the gallery and the artist. Gallery provides insurance, promotion and shipping costs from gallery; artist pays shipping costs to gallery. "We offer framing at the gallery."
Submissions: Send query letter with résumé, slides, bio, photographs, reviews and SASE. Call for appointment to show portfolio of originals, photographs, slides and transparencies. Replies in 1 month. Replies if interested within 1 week. Files slides, résumé and any other permanent information.
Tips: Finds artists through attending art exhibitions, various art publications and word of mouth. "I'm mainly looking for abstract artists. Please call to set up an appointment."

‡**MAGIDSON FINE ART,** 525 E. Cooper Ave., Aspen CO 81617. (303)920-1001. Fax: (303)925-6181. Owner: Jay Magidson. Retail gallery. Estab. 1990. Represents 50 emerging, mid-career and established artists. Exhibited artists include Annie Leibovitz, Andy Warhol. Sponsors 5 shows/year. Average display time 3 months. Open all year; December 15-April 15, 10-9 daily; June 15-September 15, 10-9; rest of the year, Tuesday-Sunday, 10-6. Located in central Aspen; 1,500 sq. ft.; exceptional window exposure; free hanging walls; 9½ ft. ceilings. 50% of space for special exhibitions; 50% of space for gallery artists. Clientele: emerging and established collectors. 95% private collectors, 5% corporate collectors. Overall price range: $1,200-75,000; most work sold at $2,500-7,500.
Media: Considers oil, acrylic, watercolor, pastel, pen & ink, drawing, mixed media, collage, paper, sculpture, ceramics, fiber, photography, woodcut, engraving, lithograph, wood engraving, serigraphs, linocut and etching. Most frequently exhibits oil/acrylic on canvas, photography and sculpture.
Style: Exhibits painterly abstraction, surrealism, color field, photorealism, hard-edge geometric abstraction and realism; all genres. Prefers pop, realism and unique figurative (colorful and imaginative).
Terms: Accepts work on consignment (40-60% commission). Retail price set by the gallery. Gallery provides insurance, promotion and shipping costs from gallery; artist pays shipping costs to gallery. Prefers artwork framed.
Submissions: Send query letter with slides, bio, photographs and SASE. Call for appointment to show portfolio of photographs, slides, "never originals!" Replies only if interested in 1 month. Files slides, bios on artists we represent.
Tips: Finds artists through recommendations from other artists, reviews in art magazines, museum shows, gallery shows. "I prefer photographs over slides. No elaborate artist statements or massive résumés necessary."

‡**MASTEN FINE ART GALLERY,** 429 E. 17th Ave., Denver CO 80203. (303)832-6565. Director: Reed Masten. Retail gallery. Estab. 1986. Represents 10-20 mid-career artists. Exhibited artists include Dinah K. Worman, Michael Ome Untiedt. Sponsors 4-6 shows/year. Average display time 6 weeks. Open all year; Tuesday-Friday, 10-6; Saturday, 12-5. Located just east of downtown Denver; 1,000 sq. ft.; intimate traditional gallery in an urban setting. 100% of space for special exhibitions; 100% of space for gallery artists. Clientele: established Denver residents and collectors. 98% private collectors, 2% corporate collectors. Overall price range: $200-4,000; most work gold at $200-800.
Media: Considers oil, acrylic, watercolor, pastel, pen & ink, drawing and "traditional medium and subject matter." Most frequently exhibits oil, pastel, watercolor.

Style: Exhibits impressionism, realism and all traditional styles. Genres include landscapes, florals, Western, figurative work. Prefers landscapes, still lifes.
Terms: Accepts work on consignment (50% commission). Retail price set by the gallery and the artist. Gallery provides promotion and shipping costs from gallery; artist pays shipping costs to gallery. Prefers artwork framed.
Submissions: Prefers only traditional mediums and subject matter. Send query letter with résumé/bio, slides, SASE and retail price list. Write for appointment to show portfolio of originals, photographs, slides and transparencies. Replies in 1 month. Files résumé, photo composite sheets, some slides.
Tips: Finds artists through art magazines and other galleries, referrals, artists contacting gallery.

‡**METROPOLITAN STATE COLLEGE OF DENVER/CENTER FOR THE VISUAL ARTS**, 1701 Wazee, Denver CO 80202. (303)294-5207. Fax: (303)294-5209. Director: Sally L. Perisho. Nonprofit gallery. Estab. 1991. Represents emerging, mid-career and established artists. 400 members. Interested in seeing the work of emerging artists. Sponsors 6 shows/year. Average display time 6 weeks. Open all year; Tuesday-Thursday, 11-5; Friday, 11-8; Saturday, 12-4. Located in lower downtown Denver one block from Union Station; 3,500 sq. ft.; located in a turn-of-the-century brick building. 100% of space for special exhibitions. Clientele: children, adults, seniors and the disadvantaged.
Media: "The Center for Visual Arts' primary goal is to organize and host exhibitions and programs by culturally diverse artists of regional, national and international significance. The exhibition schedule, representing a broad range of subject matter, media, cultures and regions, is designed to attract a new and growing audience as well as sustain the interest of its continued supporters."

‡**ONE WEST ART CENTER**, 201 S. College Ave., Fort Collins CO 80524. (303)482-2787. Executive Director: Wes Pouliot. Nonprofit retail gallery. Estab. 1983. Represents emerging and mid-career artists. 700 members. Exhibited artists include Louis Recchia, Pam Furumo. Sponsors 8 shows/year. Average display time 2 months. Open all year; Wednesday-Saturday, 10-5. Located downtown; 2,500 sq. ft.; 1911 renovated Italian renaissance federal building. 15% of space for special exhibitions; 20% of space for gallery artists. Clientele: community citizens and patrons. 5% private collectors, 5% corporate collectors. Overall price range: $12-6,000; most work sold at $12-500.
Media: Considers all media and all types of prints. Most frequently exhibits oil, acrylic and bronze.
Style: Exhibits all styles, all genres. Prefers impressionism, abstraction and surrealism.
Terms: Accepts work on consignment (40% commission). Retail price set by the artist. Gallery provides insurance and promotion; shipping costs are shared. Prefers artwork framed.
Submissions: Send query letter with résumé, slides, bio and SASE. Write for appointment to show portfolio of originals and slides. Replies in three months. Files slides, résumés.

PINE CREEK ART GALLERY, 2419 W. Colorado Ave., Colorado Springs CO 80904. (719)633-6767. Owners: Liz and Nancy Anderson. Retail gallery. Estab. 1991. Represents 10+ emerging, mid-career and established artists. Exhibited artists include Kirby Sattler, Chuck Mardosz, Don Grzybowski and Zhang Wen Xin. Sponsors 4 shows/year. Average display time 1 month. Open all year. 2,200 sq. ft.; in a National Historic District. 70% of space for special exhibitions. Clientele: middle to upper income. Overall price range: $30-5,000; most work sold at $100-500.
Media: Considers most media, including bronze, pottery and all types of prints.
Style: Exhibits all styles and genres.
Terms: Accepts artwork on consignment (40% commission). Retail price set by gallery and artist. Gallery provides insurance, promotion and shipping costs from gallery. Prefers artwork "with quality frame only."
Submissions: No fantasy or abstract art. Send query letter with slides and photographs. Call or write for appointment to show portfolio or originals, photographs, slides and tearsheets. Replies in 1 week.
Tips: "We like to include a good variety of work, so show us more than 1 or 2 pieces."

SANGRE DE CRISTO ARTS AND CONFERENCE CENTER, 210 N. Santa Fe Ave., Pueblo CO 81003. (719)543-0130. Curator of Visual Arts: Jennifer Cook. Nonprofit gallery and museum. Estab. 1972. Exhibits emerging, mid-career and established artists. Sponsors 25-30 shows/year. Average display time 6 weeks. Open all year. Located "downtown, right off Interstate I-25"; 7,500 sq. ft.; four galleries, one showing a permanent collection of Western art; changing exhibits in the other three. Also a children's museum with changing, interactive exhibits. Clientele: "We serve a 19-county region and attract 200,000 visitors yearly. Most art exhibits are not for sale; however, when they are for sale, anyone can buy." Overall price range: $50-100,000; most work sold at $50-13,000.
Media: Considers all media, but craft. Considers original handpulled prints, woodcuts, wood engravings, linocuts, mezzotints, etchings, lithographs. Most frequently exhibits watercolor, oil on canvas and sculpture.
Style: Exhibits all styles. Genres include Southwestern.
Terms: Accepts work on consignment (30% commission). Retail price set by artist. Gallery provides insurance, promotion, contract and shipping costs. Prefers artwork framed.
Submissions: "There are no restrictions, but our exhibits are booked well in advance." Send query letter with slides. Write or call for appointment to show portfolio of slides. Replies in 2 months.

‡**PHILIP J. STEELE GALLERY AT ROCKY MOUNTAIN COLLEGE OF ART & DESIGN**, 6875 E. Evans Ave., Denver CO 80224. (303)753-6046. Fax: (303)759-4970. Gallery Director: Deborah Horner. Nonprofit college gallery. Estab. 1962. Represents emerging, mid-career and established artists. Exhibited artists include Christo, Jenny Holzer. Sponsors 9 shows/year. Average display time 3 weeks. Open all year; Monday-Friday, 8-6; Saturday, 9-4. Located in southeast Denver; 600 sq. ft.; in very prominent location (art college with 250 students enrolled).
Media: Considers all media and all types of prints.
Style: Exhibits all styles.
Terms: Artists sell directly to buyer; gallery takes no commission. Retail price set by the artist. Gallery provides insurance and promotion; artist pays shipping costs to and from gallery.
Submissions: Send query letter with résumé, slides, bio, SASE and reviews. Write for appointment to show portfolio of originals, photographs and slides. Replies only if interested within 1 month.

TURNER ART GALLERY, 301 University Blvd., Denver CO 80206. (303)355-1828. Owner: Kent Lewis. Retail gallery. Estab. 1929. Represents 12 emerging, mid-career and established artists. Exhibited artists include Scott Switzer and Charles Fritz. Sponsors 6 shows/year. Open all year. Located in Cherry Creek North; 4,200 sq. ft. 50% of space for special exhibitions. Clientele: 90% private collectors. Overall price range: $1,000-10,000.
Media: Oil, acrylic, watercolor, pastel, sculpture and antique prints. Most frequently exhibits oil, watercolor and sculpture.
Style: Exhibits traditional and/or representational. All genres.
Terms: Retail price set by gallery and artist. Gallery provides insurance, promotion, contract and shipping costs from gallery.
Submissions: Call or send slides and bio. Replies in 1 week. Files work of accepted artists.

UNIVERSITY MEMORIAL FINE ARTS CENTER, Campus Box 207, Boulder CO 80309-0207. (303)492-7465. Fax: (303)492-4327. Nonprofit gallery. Estab. 1960. Exhibits 12-15 emerging, mid-career and established artists. Interested in seeing the work of emerging artists. Exhibited artists include John Punning, Sue Bennett, Floyd Tunson and Frank Sampson. Sponsors 12 shows/year. Average display time 3 weeks. Open all year; Monday-Thursday, 9-10, Friday 9-5. Located at University of Colorado, Boulder; 1,144 sq. ft.
 • This gallery is nonprofit and does not make sales.
Media: Considers all media.
Style: Exhibits all styles and genres. "We like artwork that is on the cutting edge."
Terms: Gallery provides insurance, promotion and contract; shipping costs are shared. Prefers artwork framed (except photos).
Submissions: Send query letter with résumé, slides, bio, brochure, photographs and SASE. Portfolio should include slides. Replies only if interested. Files all material submitted.

‡**WHITE HORSE GALLERY**, 1218 Pearl St., Boulder CO 80302. (303)443-6116. Fax: (303)443-9966. Director: Shari Ross. Retail gallery. Estab. 1980. Represents 16 emerging, mid-career and established artists/year. Interested in seeing the work of emerging artists. Exhibited artists include Albert Dreher, Lila Hahn. Sponsors 3-4 shows/year. Average display time 6 months. Open all year; Monday-Saturday, 10-9; Sunday, 12-6. Located on the Pearl St. Pedestrian Mall; 750 sq. ft. "turn-of-the-century building with wonderful old Indian artifacts on display." 100% of space for special exhibitions; 100% of space for gallery artists. Clientele: Western and Indian art collectors. 75% private collectors, 25% corporate collectors. Overall price range: $60-2,000; most work sold at $60-1,500.
Media: Considers all media, all types of print.
Style: Exhibits expressionism, impressionism and realism. Genres include landscapes, Southwestern and Western. Prefers Southwestern, landscape and Western.
Terms: Accepts work on consignment (40% commission). Retail price set by the artist. Gallery provides promotion and shipping costs from gallery; artist pays shipping costs to gallery. Prefers artwork framed.
Submissions: Prefers only Indian or Southwestern subject matter. Send query letter with résumé, slides or photographs and bio. Call for appointment to show portfolio of originals or photographs. Replies in one week. Files bios.
Tips: Finds artists through attending Indian Markets, artists' submissions.

Connecticut

ARTWORKS GALLERY, 30 Arbor St. S., Hartford CT 06106. (203)231-9323. Executive Director: Judith Green. Cooperative nonprofit gallery. Estab. 1971. Exhibits 200 emerging, mid-career and established artists. Interested in seeing the work of emerging artists. 50 members. Sponsors 12 shows/year. Average display time 1 month. Open Tuesday-Friday 11-5, Saturday 12-3. Closed in August. Located in west end of Hartford; 1,500 sq. ft.; large, creative factory space. 20% of space for special exhibitions; 80% of space for gallery artists.

Clientele: 80% private collectors, 20% corporate collectors. Overall price range: $200-5,000; most work sold at $200-1,000.

Media: Considers all media and all types of prints. Most frequently exhibits oil on canvas, photography and sculpture. No crafts or jewelry.

Style: Exhibits all styles and genres, especially contemporary.

Terms: Co-op membership fee plus a donation of time. There is a 30% commission. Retail price set by artist. Offers customer discounts and payment by installments. Gallery provides insurance, promotion and contract. Artist pays for shipping costs. Prefers artwork framed. Accepts only artists from Connecticut for membership. Accepts artists from New England and New York for juried shows.

Submissions: Send query letter with résumé, slides, bio and $10 application fee. Call for appointment to show portfolio of slides. Replies in 1 week.

Tips: Finds artists through visiting exhibitions, various art publications and sourcebooks, artists' submissions, art collectors' referrals, but mostly through word of mouth and juried shows.

‡**B.E.L. GALLERY**, 42 Owenoke Park, Westport CT 06880. (203)227-9215. Director: Barbara E. Lans. Retail gallery. Estab. 1971. Represents 3 or 4 mid-career and established artists/year. May be interested in seeing the work of emerging artists in the future. Sponsors 3 or 4 shows/year. Average display time 1 month. Open all year; Monday-Saturday, 10-5. Located on main thoroughfare. 100% of space for special exhibitions. Clientele: regional/local. 100% private collectors. Overall price range: $100-400.

● Barbara E. Lans has also opened Picture This, part of a frame shop, located at 606 Post Rd. E., in Westport.

Media: Considers oil, acrylic, watercolor, pastel, pen & ink, mixed media, collage, paper, photography and all types of prints.

Style: Exhibits all styles. Genres include landscapes, florals, Americana and abstract.

Terms: Accepts work on consignment (40% commission). Retail price set by the gallery and the artist.

Submissions: Accepts only local artists. Send query letter with résumé, slides, bio, photographs and SASE. Call or write for appointment to show portfolio of originals, slides and transparencies. Replies in 1 month.

Tips: Finds artists through visiting exhibitions, artists' submissions.

MONA BERMAN FINE ARTS, 78 Lyon St., New Haven CT 06511. (203)562-4720. Fax: (203)787-6855. Director: Mona Berman. Art consultancy. Estab. 1979. Represents 50 emerging and mid-career artists. Exhibited artists include Tom Hricko and Juliet Holland. Sponsors 1 show/year. Open all year. Located near downtown; 1,000 sq. ft. Clientele: 5% private collectors, 95% coporate collectors. Overall price range: $200-20,000; most artwork sold at $500-5,000.

Media: Considers all media except installation. Considers all limited edition prints except posters and photolithography. Most frequently exhibits works on paper, painting, relief and ethnographic arts.

Style: Exhibits most styles. Prefers abstract, landscape and transitional. No figurative, little still life.

Terms: Accepts work on consignment (50% commission) or buys outright for 50% of retail price (net 30 days). Retail price is set by gallery and artist. Customer discounts and payment by installment are available. Gallery provides insurance; artist pays for shipping. Prefers artwork unframed.

Submissions: Send query letter, résumé, "plenty of slides," bio, SASE, reviews and "price list – retail only at stated commission." Portfolios are reviewed only after slide submission. Replies in 1 month. Slides and reply returned only if SASE is included.

Tips: Finds artists through word of mouth, art publications and sourcebooks, artists' submissions and self-promotions and other professional's recommendations. "Please understand that we are not a gallery, although we do a few exhibits. We are primarily art consultants. We continue to be busy selling high quality art and related services."

BROOKFIELD/SONO CRAFT CENTER, Brookfield Alley at 127 Washington St., South Norwalk CT 06854. (203)853-6155. Gallery Manager: Judith Russell. Nonprofit gallery. Estab. 1984. Exhibits the work of 300 emerging and established artists. Sponsors 6 solo shows/year. Clientele: 90% private collectors, 10% corporate clients. Overall price range: $25-1,500; most work sold at $25-100.

Media: Considers mixed media, works on paper, sculpture, ceramic, craft, fiber, glass and original handpulled prints. Most frequently exhibits furniture, jewelry, glass and ceramics. "We are especially interested in work that is functional and in the $25-150 range. We do not normally deal with clothing."

Terms: Accepts work on consignment (60% commission). Retail price set by artist. Offers customer discount. Gallery provides insurance and promotion; artist pays for shipping.

Submissions: Send query letter, résumé, brochure, business card, slides, photographs and SASE. Write for appointment to show portfolio.

Tips: Finds artists through publications and craft shows.

MARTIN CHASIN FINE ARTS, 1125 Church Hill Rd., Fairfield CT 06432. (203)374-5987. Fax: (203)372-3419. Owner: Martin Chasin. Retail gallery. Estab. 1985. Represents 40 mid-career and established artists. Interested in seeing the work of emerging artists. Exhibited artists include Katherine Ace and David Rickert. Sponsors 8 shows/year. Average display time 3 weeks. Open all year. Located downtown; 1,000-1,500 sq. ft.

50% of space for special exhibitions. Clientele: "sophisticated." 40% private collectors; 30% corporate collectors. Overall price range: $1,500-10,000; most work sold at $3,000-5,000.

Media: Considers oil, acrylic, watercolor, pastel, pen & ink, drawings, paper, woodcuts, wood engravings, linocuts, engravings, mezzotints, etchings, lithographs, pochoir and serigraphs. "No sculpture." Most frequently exhibits oil on canvas, etchings/engravings and pastel.

Style: Exhibits expressionism, neo-expressionism, color field, postmodern works, impressionism and realism. Genres include landscapes, Americana, portraits, Southwestern and figurative work. Prefers landscapes, seascapes and ships/boating scenes.

Terms: Accepts work on consignment (30-50% commission). Retail price set by artist. Offers payment by installments. Gallery provides insurance, promotion and shipping costs from gallery. Prefers artwork unframed.

Submissions: Send query letter with résumé, slides, bio and SASE. Call or write for appointment to show portfolio of slides and photographs. Replies in 3 weeks. Files future sales material.

Tips: Finds artists through exhibitions, "by artists who write to me and send slides. Send at least 10-15 slides showing all genres of art you produce. Omit publicity sheets and sending too much material. The art scene is less far-out, fewer avant garde works are being sold. Clients want artists with a solid reputation."

‡CHESHIRE FINE ART, INC., 265 Sorghum Mill Dr., Cheshire CT 06410. (203)272-0114. Fax: (203)272-0114. President: Linda Ladden. Retail/wholesale gallery. Estab. 1983. Represents 20 mid-career and established artists/year. Exhibited artists include Emile Gruppe and Bernard Corey. Sponsors 3 shows/year. Average display time 3-6 months. Open all year; daily, by appointment. Located 5 minutes from Town Center; 1,500 sq. ft.; one-to-one personal contact with patrons. 40% of space for special exhibitions; 100% of space for gallery artists. Clientele: collectors looking to assemble related collections. 90% private collectors, 10% corporate collectors. Overall price range: $450-70,000; most work sold at $850-25,000.

Media: Considers oil, watercolor, pastel and gouache. Most frequently exhibits oil, watercolor and pastel.

Style: Exhibits post-impressionism. Prefers landscapes (harbors), genre scenes and floral.

Terms: Accepts work on consignment (negotiable commission). Retail price set by the gallery and the artist. Gallery provides insurance, promotion and shipping costs from gallery; artist pays shipping costs to gallery. Prefers artwork framed.

Submissions: Accepts only artists from New England, or artists who have ties to or paint New England subjects. Send query letter with bio and photographs. Call or write for appointment to show portfolio of photographs. Replies ASAP. Files bio and photos.

Tips: Finds artists through word of mouth and artists' submissions.

CONTRACT ART, INC., P.O. Box 520, Essex CT 06426. (203)767-0113. Fax: (203)767-7247. Senior Project Manager: Victoria Taylor. "We contract artwork for blue-chip businesses, including Disney, Royal Caribbean Cruise Lines and Sheraton." Represents emerging, mid-career and established artists. Approached by hundreds of artists/year. Assigns work to freelance artists based on client needs and preferences. Showroom is open all year to corporate art directors and designers. 1,600 sq. ft. Clientele: 98% commercial. Overall price range: $500-15,000.

Media: Considers all media and all types of prints. Frequently contracts murals.

Style: Uses artists for brochure design, illustration and layout, model making and posters. Exhibits all styles and genres.

Terms: Pays for design by the project, negotiable; 50% up front. Prefers artwork unframed. Rights purchased vary according to project.

Submissions: Send query letter with résumé, slides, bio, brochure, photographs and SASE. If local, write for appointment to show portfolio; otherwise, mail appropriate materials, which should include slides and photographs. "Show us a good range of what you can do. Also, keep us updated if you've changed styles or mediums." Replies in 1 week. Files all samples and information in registry.

Tips: "We exist mainly to solicit commissioned artwork for specific projects."

‡BILL GOFF, INC., Box 977, Kent CT 06757-0977. (203)927-1411. Fax: (203)927-1987. President: Bill Goff. Estab. 1977. Exhibits and publishes baseball art. 95% private collectors, 5% corporate collectors.

Needs: Baseball prints. Realism and photorealism. Represents 10 artists; emerging, mid-career and established. Exhibited artists include Andy Jurinko and William Feldman, Bill Purdom, Bill Williams.

First Contact & Terms: Send query letter with bio and photographs. Write to schedule an appointment to show a portfolio, which should include photographs. Replies only if interested within 2 months. Files photos and bios. Accepts work on consignment (50% commission) or buys outright for 50% of retail price. Overall price range: $95-30,000; most work sold at $125-220. Retail price set by the gallery. Gallery provides insurance and promotion; shipping costs are shared. Prefers artwork unframed.

Tips: "Do not waste our time or your own by sending non-baseball items."

LAWRENCE GALLERIES, Oak Ridge Dr., Meriden CT 06450. (203)686-0000. (800)286-7000 (CT). Art Director: Steve Robichaud. Retail gallery. Estab. 1993. Presently represents 4 emerging, mid-career and established artists. Interested in seeing the work of emerging artists. Open all year; Monday-Friday 9-5, Saturday

10:30-4:30. Located in affluent residential area; 400 sq. ft. "This area has a limited amount of foot traffic from the framing side of the business. It will be mostly a display area or show area for professional people and their clients. Art is exhibited by appointment only for the benefit of interior designers." Clientele: interior designers, architects, corporate accounts.

Media: Considers oil, pen & ink, paper, fiber, acrylic, drawing, sculpture, glass, watercolor, mixed media, ceramic, installation, pastel, collage, craft and photography. All types of prints except posters.

Style: Exhibits all styles and genres.

Terms: Accepts work on consignment (40% commission). Retail price set by gallery and artist. Gallery provides insurance, promotion and contract. Prefers artwork unframed. "We will accept framed artwork as long as it is professionally done and meets our standards. Otherwise we will frame at a discount to the artist and bill accordingly for art that is to be displayed."

Submissions: Send query letter with résumé, slides, bio, brochure, photographs, SASE and reviews. Write for appointment to show portfolio of originals and slides. Replies in 1 month. Files slides and bio.

Tips: "We are not a walk-in gallery. We want to promote your art through the designers and architects of this state. These are the people that will bring your art into the private homes and corporate offices of potential collectors and connoisseurs of fine art and sculpture."

WILDLIFE GALLERY, 172 Bedford St., Stamford CT 06901. (203)324-6483. Fax: (203)324-6483. Director: Patrick R. Dugan. Retail gallery. Represents 72 emerging, mid-career and established artists. Exhibited artists include R. Bateman and R.T. Peterson. Sponsors 4 shows/year. Average display time 6 months. Open all year. Located downtown; 1,200 sq. ft. 30% of space for special exhibitions. Clientele: 20% private collectors, 10% corporate collectors. Overall price range: $300-10,000; most artwork sold at $500-3,000.

Media: Considers oil, acrylic, watercolor, pastel, woodcuts, wood engravings, engravings, lithographs and serigraphs. Most frequently exhibits acrylic, oil and watercolor.

Style: Prefers realism. Genres include landscapes, florals, Americana, Western, wildlife and sporting art. No "impressionism, over-priced for the quality of the art."

Terms: Accepts work on consignment (50% commission). Retail price set by gallery. Sometimes offers customer discounts and payment by installment. Gallery provides promotion and contract; shipping costs are shared. Prefers unframed artwork.

Submissions: Send query letter with photographs, bio and SASE. Write for appointment to show portfolio of originals and photographs. Replies by SASE only if interested within 2 weeks. Files all material, if interested.

Tips: "Must be work done within last six months. Don't send art that is old that you have not been able to sell." Quote prices on first mailing.

Delaware

DELAWARE CENTER FOR THE CONTEMPORARY ARTS, Dept. AM, 103 E. 16th St., Wilmington DE 19801. (302)656-6466. Director: Steve Lanier. Nonprofit gallery. Estab. 1979. Exhibits the work of emerging, mid-career and established artists. "Leaning toward emerging artists." Sponsors 30 solo/group shows/year of both national and regional artists. Average display time is 1 month. 2,000 sq. ft.; 19 ft. ceilings. Overall price range: $50-10,000; most artwork sold at $500-1,000.

Media: Considers all media, including contemporary crafts.

Style: Exhibits contemporary, abstracts, impressionism, figurative, landscape, non-representational, photorealism, realism and neo-expressionism. Contemporary crafts.

Terms: Accepts work on consignment (35% commission). Retail price is set by the gallery and the artist. Exclusive area representation not required. Gallery provides insurance and promotion; shipping costs are shared.

Submissions: Send query letter, résumé, slides and photographs. Write for appointment to show portfolio. Seeking consistency within work as well as in presentation. Slides are filed.

District of Columbia

AARON GALLERY, 1717 Connecticut Ave. NW, Washington DC 20009. (202)234-3311. Manager: Annette Aaron. Retail gallery and art consultancy. Estab. 1970. Represents 35 emerging, mid-career and established artists. Sponsors 18 shows/year. Average display time is 3-6 weeks. Open all year. Located on Dupont Circle; 2,000 sq. ft. Clientele: private collectors and corporations. Overall price range: $100 and up; most artwork sold at $2,000-10,000.

Media: Considers oil, acrylic, watercolor, mixed media, collage, paper, sculpture, ceramic and installation. Most frequently exhibits sculpture, paintings and works on paper. "Aaron Anexus, opened spring 1994, includes functional art: pottery, fibre, glass, wood, metal and jewelry."

Style: Exhibits expressionism, painterly abstraction, imagism, color field, post-modern works, impressionism, realism and photorealism. Genres include florals. Most frequently exhibits abstract expressionism, figurative expressionism and post-modern works.

Terms: Accepts work on consignment (50% commission). Retail price set by gallery and artist. Sometimes offers payment by installment. Exclusive area representation required. Gallery provides promotion and contract; artist pays for shipping.

Submissions: Send query letter, résumé, slides or photographs, reviews and SASE. Slides and photos should be labeled with complete information—dimensions, title, media, address, name and phone number. Portfolio review requested if interested in artist's work. Portfolio should include photographs and, if possible, originals. Slides, résumé and brochure are filed.

Tips: Finds artists through visiting exhibitions, word of mouth, artists' submissions, self-promotions, art collector's referrals. "We visit many studios throughout the country."

‡ARAB AMERICAN CULTURAL FOUNDATION – ALIF GALLERY, 1204 31st St., NW, Washington DC 20007. (202)337-9670. Fax: (202)337-1574. Projects Director: Ms. Lama Dajani-Simpson. Nonprofit gallery. Estab. 1978. Represents emerging, mid-career and established artists. "We do not represent artists on a regular basis. We've exhibited the works of about 90 artists." Exhibited artists include Dia Azzawi, Rashid Diab. Sponsors 6-7 shows/year. Average display time 1 month. Open all year; Monday-Friday, 10-6; Saturday, noon-6. Located downtown (Georgetown); 1,200 sq. ft.; open space, no dividing walls. 90% of space for special exhibitions. Clientele: Arab American Community, Americans interested in the Middle East and art-going public of the Washington DC art scene. 95% private collectors, 5% corporate collectors. Overall price range: $250-10,000; most work sold at $500-3,000.

Media: Considers all media and all types of prints. Most frequently exhibits paintings and prints, photography, sculpture.

Style: Exhibits all styles, all genres. Prefers painterly abstraction, expressionism and postmodern works.

Terms: Accepts work on consignment (40% commission). Retail price set by the gallery and the artist. Gallery provides insurance and promotion; artist pays shipping costs to and from gallery. Prefers artwork framed.

Submissions: Accepts only artists from the Arab World including Arab-American artists or any other artist whose work is related to or inspired by the Arab World. Send query letter with résumé, slides, bio and reviews. Call for appointment to show portfolio of slides or transparencies. "The gallery committee meets once a year in June to review applications." Files all material unless otherwise requested.

Tips: Finds artists through artists' submissions, various art publications and sourcebooks, word of mouth.

ATLANTIC GALLERY OF GEORGETOWN, 1055 Thomas Jefferson St. NW, Washington DC 20007. (202)337-2299. Fax: (202)944-5471. Director: Virginia Smith. Retail gallery. Estab. 1976. Represents 10 mid-career and established artists. Exhibited artists include John Stobart, Tim Thompson, John Gable and Frits Goosen. Sponsors 5 solo shows/year. Average display time is 2 weeks. Open all year. Located downtown; 700 sq. ft. Clientele: 70% private collectors, 30% corporate clients. Overall price range: $100-20,000; most artwork sold at $300-5,000.

Media: Considers oil, watercolor and limited edition prints.

Style: Exhibits realism and impressionism. Prefers realistic marine art, florals, landscapes and historic narrative leads.

Terms: Accepts work on consignment (40% commission). Retail price set by gallery and artist. Exclusive area representation required. Gallery provides insurance, promotion and contract; artist pays for shipping.

Submissions: Send query letter, résumé and slides. Portfolio should include originals and slides.

‡ROBERT BROWN GALLERY, 2030 R St., NW, Washington DC 20009. (202)483-4383. Fax: (202)483-4288. Director: Robert Brown. Retail gallery. Estab. 1978. Represents emerging, mid-career and established artists. Exhibited artists include Joseph Solman, Oleg Kudryashov. Sponsors 6 shows/year. Average display time 6 weeks. Open all year; Tuesday-Saturday, 12-6. Located in Dupont Circle area; 600 sq. ft.; English basement level on street of townhouse galleries. 100% of space for gallery artists. Clientele: local, national and international. Overall price range: $500-20,000.

Media: Considers oil, acrylic, watercolor, pen & ink, drawing, mixed media, collage, paper, photography, woodcut, engraving, lithograph, wood engraving, mezzotint, serigraphs, linocut and etching. Most frequently exhibits works on paper, prints, paintings.

Style: Exhibits all styles.

Terms: Accepts work on consignment (50% commission). Retail price set by the gallery and the artist by agreement. Gallery provides insurance and promotion. Prefers artwork framed.

Submissions: Send query letter with slides, bio, brochure, SASE and any relevant information. No originals. Write for appointment to show portfolio of originals. "Will return information/slides without delay if SASE provided." Files "only information on artists we decide to show."

Tips: Finds artists through exhibitions, word of mouth, artist submissions.

DISTRICT OF COLUMBIA ARTS CENTER (DCAC), 2438 18th St. NW, Washington DC 20009. (202)462-7833. Fax: (202)328-7099. Executive Director: Andrew Mellen. Nonprofit gallery and performance space. Estab. 1989. Exhibits emerging and mid-career artists. Sponsors 7-8 shows/year. Average display time 4-6 weeks. Open Tuesday-Friday 11-6, Thursday-Sunday 7-10, and by appointment. Closed August. Located "in Adams

Morgan, a downtown neighborhood; 132 running exhibition feet in exhibition space and a 52-seat theater."
Clientele: all types. Overall price range: $200-10,000; most work sold at $600-1,400.
Media: Considers all media including fine and plastic art. "No crafts." Most frequently exhibits painting, sculpture and photography.
Style: Exhibits all styles. Prefers "innovative, mature and challenging styles."
Terms: Accepts artwork on consignment (30% commission). Artwork only represented while on exhibit. Retail price set by the gallery and artist. Offers payment by installments. Gallery provides promotion and contract; artist pays for shipping. Prefers artwork framed.
Submissions: Send query letter with résumé, slides, bio and SASE. Portfolio review not required. Replies in 2 months. Files slides, résumés in permanent slide registry. Send for guidelines.
Tips: "We strongly suggest the artist be familiar with the gallery's exhibitions, and the kind of work we show: strong, challenging pieces that demonstrate technical expertise and exceptional vision. Include SASE if requesting reply and return of slides!"

‡**FINE ART AND ARTISTS, INC.**, 4th Floor, 1710 Connecticut Ave. NW, Washington DC 20009. (202)462-2787. Fax: (202)462-3128. President: Judith du Berrier. Retail gallery and art consultancy. Estab. 1990. Represents 50 established artists/year. May be interested in seeing the work of emerging artists in the future. Exhibited artists include Warhol, Lichtenstein, Stella. Sponsors 2 shows/year. Average display time 2 months. Open all year; Monday-Saturday, 12-6. Located in Dupont Circle; 1,700 sq. ft.; skylights, brick walls, Victorian renovated building. 75% of space for special exhibitions; 25% of space for gallery artists. Clientele: corporate, doctors, lawyers, other professionals. 60% private collectors, 40% corporate collectors. Overall price range: $1,500-25,000; most work sold at $3,000-5,000.
Media: Considers oil, acrylic, watercolor, pastel, pen & ink, drawing, mixed media, sculpture, woodcut, engraving, lithograph, wood engraving, serigraphs and linocut. Most frequently exhibits lithograph, serigraph, oil.
Style: Exhibits expressionism, pop, neo-pop.
Terms: Accepts work on consignment (50% commission). Retail price set by the gallery and/or the artist. Gallery provides insurance, promotion, contract and shipping costs from gallery; artist pays shipping costs to gallery. Prefers artwork framed.
Submissions: Prefers only pop; abstract expressionists. Send query letter with photographs and SASE. Write for appointment to show portfolio of photographs. Replies only if interested within 1 month. Files bio, duplicate photos or slides.

FOUNDRY GALLERY, Dept. AM, 9 Hillyer Court, Washington DC 20008. (202)387-0203. Membership Director: Barbara Vogt. Cooperative gallery and alternative space. Estab. 1971. Sponsors 10-20 solo and 2-3 group shows/year. Average display time 3 weeks. Interested in emerging artists. Clientele: 80% private collectors; 20% corporate clients. Overall price range: $100-2,000; most work sold at $100-1,000.
Media: Considers oil, acrylic, watercolor, pastel, pen & ink, drawings, mixed media, collage, paper, sculpture, ceramic, fiber, glass, installation, photography, woodcuts, engravings, mezzotints, etchings, pochoir and serigraphs. Most frequently exhibits painting, sculpture, paper and photography.
Style: Exhibits "expressionism, painterly abstraction, conceptualism and hard-edge geometric abstraction, as well as representational." Prefers non-objective, expressionism and neo-geometric. "Founded to encourage and promote Washington area artists and to foster friendship with artists and arts groups outside the Washington area. The Foundry Gallery is known in the Washington area for its promotion of contemporary works of art."
Terms: Co-op membership fee plus donation of time; 30% commission. Retail price set by artist. Offers customer discounts and payment by installments. Exclusive area representation not required. Gallery provides insurance and a promotion contract. Prefers framed artwork.
Submissions: Send query letter with résumé, slides, and SASE. "Local artists drop off actual work." Call or write for appointment to drop off portfolio. Replies in 1 month.
Tips: Finds artists through artists' submissions. "All works must be delivered by artist."

FOXHALL GALLERY, 3301 New Mexico Ave. NW, Washington DC 20016. (202)966-7144. Director: Jerry Eisley. Retail gallery. Represents emerging and established artists. Sponsors 6 solo and 6 group shows/year. Average display time 3 months. Overall price range: $500-20,000; most artwork sold at $1,500-6,000.
Media: Considers oil, acrylic, watercolor, pastel, sculpture, mixed media, collage and original handpulled prints (small editions).
Style: Exhibits contemporary, abstract, impressionistic, figurative, photorealistic and realistic works and landscapes.
Terms: Accepts work on consignment (50% commission). Retail price set by gallery and artist. Customer discounts and payment by installment are available. Exclusive area representation required. Gallery provides insurance.
Submissions: Send résumé, brochure, slides, photographs and SASE. Call or write for appointment to show portfolio.

Tips: Finds artists through agents, by visiting exhibitions, word of mouth, various art publications and source-books, artists' submissions, self promotions and art collectors' referrals.

GALLERY K, 2010 R St. NW, Washington DC 20009. (202)234-0339. Fax: (202)334-0605. Director: Komei Wachi. Retail gallery. Estab. 1976. Represents 47 emerging, mid-career and established artists. Interested in seeing the work of emerging artists. Exhibited artists include Jody Mussoff and Y. David Chung. Sponsors 10 shows/year. Average display time 1 month. Closed mid July-mid September; Tuesday-Saturday 11-6. Located in DuPont Circle area; 2,500 sq. ft. Clientele: local. 80% private collectors, 10% corporate collectors; 10% other galleries. Overall price range: $100-250,000; most work sold at $200-2,000.
Media: Considers oil, pen & ink, paper, acrylic, drawing, sculpture, watercolor, mixed media, ceramic, pastel, collage, photography, woodcuts, wood engravings, linocuts, engravings, mezzotints, etchings, lithographs and serigraphs. Most frequently exhibits oil, acrylic, drawing.
Style: Exhibits realism and surrealism. Genres include landscapes and figurative work. Prefers surrealism, realism and postmodernism.
Terms: Accepts work on consignment (20-50% commission). Retail price set by gallery and artist. Gallery provides insurance, promotion and contract; artist pays for shipping costs. Prefers artwork framed.
Submissions: Accepts artists mainly from DC area. Send query letter with résumé, slides and SASE. Replies in 4-6 weeks only if SASE enclosed.

GATEHOUSE GALLERY, Mount Vernon College, 2100 Foxhall Rd. NW, Washington DC 20007. (202)331-3416 or 3448. Associate Professor and Gatehouse Gallery/Director: James Burford. Nonprofit gallery. Estab. 1978. Exhibits the work of emerging, mid-career and established artists. Sponsors 7 solo and 2-3 group shows/year. Average display time: 3 weeks. Clientele: college students and professors.
Media: Considers all media. Most frequently exhibits photography, drawings, prints and paintings.
Style: Exhibits all styles and genres. "The exhibitions are organized to the particular type of art classes being offered."
Terms: Accepts work on consignment (20% commission). Retail price set by artist. Exclusive area representation not required. Gallery provides promotion and contract; artist pays for shipping.
Submissions: Send query letter with résumé, brochure, slides or photographs. All material is returned if not accepted or under consideration.

‡MAHLER GALLERY, 406 7th St., NW, 2nd Floor, Washington DC 20004. (202)393-5180. Retail gallery. Estab. 1990. Represents mid-career artists. Exhibited artists include Virginia Daley and Ron Banks. Sponsors 10 shows/year. Open September-July; Wednesday-Friday, 10:30-5; Saturday, 12-5; by appointment. Located downtown on Gallery Row adjacent to Smithsonian Mall and other National Museums; 2,500 sq. ft. Clientele: private and corporate. 75% private collectors, 25% corporate collectors. Overall price range: $750-10,000; most work sold at $1,000-2,000.
Media: Considers oil, acrylic and collage. Most frequently exhibits paintings on canvas and mixed media on paper.
Style: "Very small, selective stable region with strong focus on landscapes. Also represent small number of abstract collage."
Terms: Accepts work on consignment (50% commission). Retail price set by the gallery and the artist. Gallery provides insurance, promotion and contract; artist pays shipping costs to and from gallery.
Submissions: Accepts only artists from Mid-Atlantic region of US. Send query letter with résumé, slides, SASE, price list and description of media. Portfolio should include slides and SASE.
Tips: "We're a small-staff gallery with a very small stable of artists. Therefore, please be sure your mailed material is succinct and efficient and easy for us to re-package and return in your SASE. Also, aside from the small number of abstract collage artists we represent, we're really focusing on adding a small number of exceptional realist painters to our stable."

SPECTRUM GALLERY, 1132 29th St. NW, Washington DC 20007. (202)333-0954. Director: Anna G. Proctor. Retail/cooperative gallery. Estab. 1966. Exhibits the work of 29 mid-career artists. Sponsors 10 solo and 3 group shows/year. Average display time 1 month. Accepts only artists from Washington area. Open year round. Located in Georgetown. Clientele: 80% private collectors, 20% corporate clients. Overall price range: $50-5,000; most artwork sold at $450-900.
Media: Considers oil, acrylic, watercolor, pastel, pen & ink, drawings, mixed media, collage, works on paper, sculpture, ceramic, fiber, woodcuts, mezzotints, etchings, lithographs and serigraphs. Most frequently exhibits acrylic, watercolor and oil.
Style: Exhibits impressionism, realism, minimalism, painterly abstraction, pattern painting and hard-edge geometric abstraction. Genres include landscapes, florals, Americana, portraits and figurative work.
Terms: Co-op membership fee plus donation of time; 35% commission. Retail price set by artist. Sometimes offers payment by installment. Exclusive area representation not required. Gallery provides promotion and contract.
Submissions: Artists must live in the Washington area because of the cooperative aspect of the gallery. Bring actual painting at jurying; application forms needed to apply.

Tips: "A common mistake artists make is not knowing we are a cooperative gallery. We were one of the first cooperatives in the Washington area and were established to offer local artists an alternative to the restrictive representation many galleries were then providing. Each artist is actively involved in the shaping of policy as well as maintenance and operation. The traditional, the abstract, the representational and the experimental can all be found here. Shows change every month and each artist is represented at all times."

STUDIO GALLERY, 2108 R Street NW, Washington DC 20008. (202)232-8734. Director: June Linowitz. Cooperative and nonprofit gallery. Estab. 1964. Exhibits the work of 30 emerging, mid-career and established artists. Sponsors 11 shows/year. Average display time 1 month. Guest artists in August. Located downtown in the Dupont Circle area; 550 sq. ft.; "gallery backs onto a courtyard, which is a good display space for exterior sculpture and gives the gallery an open feeling." 5% of space for special exhibitions. Clientele: private collectors, art consultants and corporations. 85% private collectors; 8% corporate collectors. Overall price range: $300-10,000; most work sold at $500-3,000.
Media: Considers oil, acrylic, watercolor, pastel, pen & ink, drawings, mixed media, collage, works on paper, sculpture, ceramic, fiber, installation, photography, original handpulled prints, woodcuts, engravings, lithographs, wood engravings, mezzotints, monoprints and monotypes, serigraphs, linocuts and etchings. Most frequently exhibits painting, sculpture and prints.
Style: All genres. "Work is exhibited if it is high quality—the particular style varies."
Terms: Co-op membership fee plus a donation of time (30% commission). Offers customer discounts and payment by installments. Gallery provides promotion; artist pays for shipping to gallery; purchaser of work pays for shipping from gallery.
Submissions: Send query letter with SASE. "Artists must be local—or willing to drive to Washington for monthly meetings and receptions. Artist is informed as to when there is a membership opening and a selection review." Files artist's name, address, telephone.
Tips: "This is a cooperative gallery. Membership is decided by the gallery membership. This is peer review. The director does not determine membership. Ask when the next review for membership is scheduled. Do not send slides. Feel free to ask the director questions about gallery operations. Dupont Circle is seeing more and more galleries locating here. It is growing into an exciting gallery row and is drawing more public interest. We are making more of an effort to reach local corporations. We have an outreach program to see to the local businesses and high tech industries."

HOLLIS TAGGART GALLERIES, INC., 3233 P St. NW, Washington DC 20007. (202)298-7676 and 48 E. 73rd St., New York NY 10021. (212)628-4000. Gallery Contact: Elizabeth East. Retail gallery. Estab. 1978. Represents exclusively 7 living artists. Interested in seeing the work of emerging, mid-career and established artists. Sponsors 2 group shows/year. Average display time 4-6 weeks. "Interested only in artists working in contemporary realism." Located in Georgetown. Clientele: 80% private collectors, 10% corporate clients. Overall price range: $1,000-1,000,000; most historical artwork sold at $20,000-500,000; most contemporary artwork sold at $7,000-30,000.
Media: Considers oil, watercolor, pastel, pen & ink and drawings.
Style: Prefers figurative work, landscapes and still lifes. "We specialize in 19th and early 20th century American paintings and contemporary realism. We are interested only in contemporary artists who paint in a realist style. As we plan to handle a limited number of contemporary artists, the quality must be superb."
Terms: Retail price set by gallery and artist. Exclusive area representation required. Insurance, promotion, contract and shipping costs negotiable. Prefers unframed artwork.
Submissions: "Please call first; unsolicited query letters are not preferred. Looks for technical competence."
Tips: "Collectors are more and more interested in seeing traditional subjects handled in classical ways. Works should demonstrate excellent draftsmanship and quality."

TOUCHSTONE GALLERY, 2009 R St. NW, Washington DC 20009. (202)797-7278. Director: Mary Sawchenko. Cooperative gallery. Estab. 1977. Interested in emerging, mid-career and established artists. Represents 44 artists. Sponsors 10 solo and 3 group shows/year. Average display time 3 weeks. Located at the beginning of gallery row, R Street NW, in the Dupont Circle area; two floors with feature shows on the main floor and a continuous group exhibition upstairs. Clientele: 70% private collectors, 30% corporate clients. Overall price range: $200-5,000; most artwork sold at $800-4,500.
Media: Considers all media. Most frequently exhibits paintings, sculpture and prints.
Style: Exhibits all styles and genres. "We show contemporary art from the Washington DC area."
Terms: Co-op membership fee plus donation of time; 40% commission. Retail price set by artist. Exclusive area representation not required. Prefers framed artwork.
Submissions: Send query letter with SASE. Portfolio should include originals and slides. All material is returned if not accepted or under consideration. Artists are juried in by the member artists. A 2/3 majority of positive votes is required for acceptance. Voting is by secret ballot. The most common mistake artists make in presenting their work is "showing work from each of many varied periods in their careers."

This piece by Ken Marlow entitled Three Figs, *was shown at the Hollis Taggert Gallery in Washington, DC. "The gallery was initially attracted to Ken Marlow's work because of the warmth and inner beauty that emanates from his paintings," says a gallery spokesperson. "As well, Ken uses a classical approach while remaining true to the present day." The work is now owned by a private collector.*

Florida

‡ALBERTSON-PETERSON GALLERY, 329 S. Park Ave., Winter Park FL 32789. (407)628-1258. Fax: (407)647-6928. Owner: Judy Albertson. Retail gallery. Estab. 1984. Represents 10-25 emerging, mid-career and established artists/year. Exhibited artists include Carol Bechtel and Frank Faulkner. Sponsors 6 shows/year. Average display time 3 weeks. Open all year; Tuesday-Friday, 10-5:30; Saturday, 11:00-5:30. Located downtown; 3,000 sq. ft.; great visability, lots of glass. 45% of space for special exhibitions (during exhibitions); 95% of space for gallery artists (generally). Clientele: 50% local, 50% tourist. 15-20% private collectors, 40-50% corporate collectors. Overall price range: $200-15,000; most work sold at $500-3,000.

Media: Considers oil, acrylic, watercolor, pastel, mixed media, collage, paper, sculpture, ceramics, craft, fiber, glass, installation, photography, woodcut, engraving, lithograph, wood engraving, mezzotint, serigraphs, linocut and etching. Most frequently exhibits paintings, ceramic, sculpture.

Style: Exhibits all styles. Prefers abstract, contemporary landscape and nonfunctional ceramics.

Terms: Accepts work on consignment (varying commission). Retail price set by the gallery and the artist. Gallery provides insurance, promotion, contract and shipping costs from gallery; artist pays shipping costs to gallery. Prefers artwork unframed.

Submissions: Accepts only artists "exclusive to our area." Send query letter with résumé, slides, bio, photographs, SASE and reviews. Call or write for appointment to show portfolio of photographs, slides and transparencies. Replies within a month.

Tips: Finds artists through exhibitions, art publications and artists' submissions.

‡ATLANTIC CENTER FOR THE ARTS, INC., 1414 Arts Center Ave., New Smyrna Beach FL 32168. (904)427-6975. Contact: Program Director. Nonprofit interdisciplinary artists-in-residence program. Estab. 1979. Represents established artists. Interested in seeing the work of emerging artists. Exhibited artists include Alex Katz, Wm. Wegman, Janet Fish, Mel Chin. Sponsors 5-6 shows/year. Located on secluded bayfront – 3½ miles from downtown; 100 sq. ft.; building made of cedar wood, 30 ft. ceiling, skylights. Clientele: local

community, art patrons. "Most work is not sold—interested parties are told to contact appropriate galleries."
Media: Most frequently exhibits paintings/drawings/prints, video installations, sculpture, photographs.
Style: Contemporary.
Terms: Provides insurance, shipping costs, etc. for exhibiting Master Artists' work.
Submissions: Exhibits only Master Artists in residence. Call for more information.

‡**BAKEHOUSE ART COMPLEX**, 561 N.W. 32 St., Miami FL 33127. (305)576-2828. Contact: D. Sperow. Alternative space and nonprofit gallery. Estab. 1986. Represents 150 emerging and mid-career artists. 150 members. Sponsors 11 shows/year. Average display time 3 weeks. Open all year; Tuesday-Friday, 10-4. Located in Design District; 3,200 sq. ft.; retro fitted bakery preparation area, 17′ ceilings, tile floors. 70% of space for special exhibitions; 40% of space for gallery artists. Clientele: "tall, short, fat, thin, rich, poor, all colors." 80% private collectors, 20% corporate collectors. Overall price range: $500-5,000.
Media: Considers all media and all types of prints.
Style: Exhibits all styles, all genres.
Terms: Co-op membership fee plus donation of time (30% commission). Rental fee for space; covers 1 month. Retail price set by the artist. Gallery provides promotion; shipping costs are shared. Prefers artwork framed.
Submissions: Accepts only artists from juried membership. Send query letter with résumé, slides, bio, reviews. "Must submit work for blind jurying." Write for appointment to show portfolio of slides. Files all accepted members' slides and résumés.
Tips: Finds artists through agents, visiting exhibitions, word of mouth, art publications and sourcebooks, artists' submissions. "Visit facility on open house days (second Sunday of each month) or during openings."

‡**BOCA RATON MUSEUM OF ART**, 801 W. Palmetto Park Rd., Boca Raton FL 33486. (407)392-2500. Fax: (407)391-6410. Curator: Timothy Eaton. Museum. Estab. 1950. Represents established artists. 3,500 members. Exhibits change every 6 weeks. Open all year; Monday-Friday, 10-4; Saturday and Sunday, noon-4. Located one mile east of I-95 on Palmetto Park Road in Boca Raton; 3,000 sq. ft.; three galleries—one shows permanent collection, two are for changing exhibitions. 66% of space for special exhibitions.
Media: Considers all media and all types of prints.
Submissions: "Contact curator." Call.

‡**ALEXANDER BREST MUSEUM/GALLERY**, 2800 University Blvd., Jacksonville University, Jacksonville FL 32211. (904)744-3950 ext. 7371. Fax: (904)744-0101. Director: David Lauderdale. Museum. Estab. 1970. Represents 4-6 emerging, mid-career and established artists/year. Sponsors 4-6 shows/year. Average display time 6 weeks. Open all year; Monday-Friday, 9-4:30; Saturday, 2-5. "We close 2 weeks at Christmas and University holidays." Located in Jacksonville University, near downtown; 800 sq. ft.; 11½ foot ceilings. 20% of space for special exhibitions. "As an educational museum we have few if any sales. We do not purchase work—our collection is through donations."
Media: "We rotate style and media to reflect the curriculum offered at the institution."
Style: Exhibits expressionism, neo-expressionism, primitivism, painterly abstraction, surrealism, all styles, primarily contemporary.
Terms: Retail price set by the artist. Gallery provides insurance and promotion; artist pays shipping costs to and from gallery. "The art work needs to be ready for exhibition in a professional manner."
Submissions: Send query letter with résumé, slides, brochure, business card and reviews. Write for appointment to show portfolio of slides. "Replies fast when not interested. Yes takes longer."
Tips: Finds artists through visiting exhibitions and artist submissions.

‡**CENTER FOR THE FINE ARTS**, 101 W. Flagler St., Miami FL 33130. (305)375-3000. Fax: (305)375-1725. Curator of Exhibitions: Louis Grachos. Museum. Estab. 1984. Represents 12-14 emerging, mid-career and established artists/year. Average display time 6 weeks. Open all year; Tuesday-Saturday, 10-5; Thursday 10-9; Sunday, noon-5 pm. Located downtown; 16,000 sq. ft.; cultural complex designed by Philip Johnson. 100% of space for special exhibitions.
Media: Considers oil, acrylic, watercolor, drawing, mixed media, sculpture, installation, photography, woodcut, engraving, lithograph, wood engraving, mezzotint, serigraphs, linocut and etching. Most frequently exhibits paintings, installation and photography.
Style: Exhibits all styles. Prefers art since 1850, large scale travelling exhibitions, retrospective of internationally known artists.
Terms: Prefers artwork framed.
Submissions: Accepts only artists nationally and internationally recognized. Send query letter with résumé, slides, bio, brochure, photographs, SASE and reviews. Write for appointment to show portfolio of slides. Replies in 2-3 months.
Tips: Finds artists through visiting exhibitions, word of mouth, art publications and artists' submissions.

‡**CLAYTON GALLERIES, INC.**, 4105 S. MacDill Ave., Tampa FL 33611. (813)831-3753. Director: Cathleen Clayton. Retail gallery. Estab. 1986. Represent 28 emerging and mid-career artists. Exhibited artists include

Billie Hightower and Craig Rubadoux. Sponsors 7 shows/year. Average display time 5-6 weeks. Open all year. Located in the southside of Tampa 1 block from the Bay; 1,400 sq. ft.; "post-modern interior with glass bricked windows, movable walls, center tiled platform." 30% of space for special exhibitions. Clientele: 40% private collectors, 60% corporate collectors. Overall price range: $100-15,000; most artwork sold at $500-2,000.
Media: Considers oil, pen & ink, works on paper, fiber, acrylic, sculpture, glass, watercolor, mixed media, ceramic, pastel, craft, photography, original handpulled prints, woodcuts, wood engravings, engravings, mezzotints, etchings, lithographs, collagraphs and serigraphs. Prefers oil, metal sculpture and mixed media.
Style: Considers neo-expressionism, painterly abstraction, post-modern works, realism and hard-edge geometric abstraction. Genres include landscapes and figurative work. Prefers figurative, abstraction and realism—"realistic, dealing with Florida, in some way figurative."
Terms: Accepts work on consignment (50% commission). Retail price set by gallery and the artist. Gallery provides insurance, promotion and contract; artist pays for shipping. Prefers unframed artwork.
Submissions: Prefers Florida or Southeast artists with M.F.A.s. Send résumé, slides, bio, SASE and reviews. Write to schedule an appointment to show a portfolio, which should include photographs and slides. Replies in 6 months. Files slides and bio, if interested.
Tips: Looking for artist with "professional background i.e., B.A. or M.F.A. in art, awards, media coverage, reviews, collections, etc." A mistake artists make in presenting their work is being "not professional, i.e., no letter of introduction; poor or unlabeled slides; missing or incomplete résumé."

CULTURAL RESOURCE CENTER METRO-DADE, 111 NW 1st St., Miami FL 33128. (305)375-4635. Alternative space/nonprofit gallery. Estab. 1989. Exhibits 800 emerging and mid-career artists. Sponsors 10 shows/year. Average display time 3½ weeks. Open all year; Monday-Friday 10-3. Located in Government Center in downtown Miami.
Media: Most frequently exhibits oil, mixed media and sculpture.
Terms: Retail price set by artist. Gallery provides insurance and promotion; artist pays shipping costs. Prefers artwork framed.
Submissions: Accepts only artists from south Florida. Send query letter with résumé, slides, brochure, SASE and reviews. Call for appointment to show portfolio of slides. Replies only if interested within 2 weeks. Files slides, résumés, brochures, photographs.

THE DELAND MUSEUM OF ART INC., 600 N. Woodland Blvd., De Land FL 32720-3447. (904)734-4371. Executive Director: Harry Messersmith. Museum. Exhibits the work of established artists. Sponsors 8-10 shows/year. Open all year. Located near downtown; 5,300 sq. ft.; in The Cultural Arts Center; 18' carpeted walls, two gallery areas, including a modern space. Clientele: 85% private collectors, 15% corporate collectors. Overall price range: $100-30,000; most work sold at $300-5,000.
Media: Considers oil, acrylic, watercolor, pastel, works on paper, sculpture, ceramic, woodcuts, wood engravings, engravings and lithographs. Most frequently exhibits painting, sculpture, photographs and prints.
Style: Exhibits expressionism, surrealism, imagism, impressionism, realism and photorealism; all genres. Interested in seeing work that is finely crafted and expertly composed, with innovative concepts and professional execution and presentation. Looks for "quality, content, concept at the foundation—any style or content meeting these requirements considered."
Terms: Accepts work on consignment (30% donation requested from artist) for exhibition period only. Retail price set by artist. Gallery provides insurance, promotion and contract; shipping costs may be shared.
Submissions: Send résumé, slides, bio, brochure, SASE and reviews. Write for appointment to show portfolio of slides. Replies in 1 month. Files slides and résumé.
Tips: "Artists should have a developed body of artwork and an exhibition history that reflects the artist's commitment to the fine arts. Museum contracts 2-3 years in advance."

‡**DUNCAN GALLERY OF ART**, Campus Box 8269, Stetson University, DeLand FL 32720. (904)822-7266. Fax: (904)822-8832. Gallery Director: Gary Bolding. Nonprofit university gallery. Represents emerging, mid-career and established artists. Sponsors 9 shows/year. Average display time 6 weeks. Open all year except during university holidays and breaks; Monday-Friday, 10-4; Saturday and Sunday, 1-4. Located in the heart of the Stetson University campus, which is adjacent to downtown; 2,400 sq. ft. in main gallery; 144 cu. ft. in glass display cases in foyer; in more than 100-year-old, recently renovated building with Neo-Classical trappings and 16-foot ceilings. 95% of space for special exhibitions. Clientele: students, faculty, community members. 99% private collectors, 1% corporate collectors. Overall price range: $100-35,000.
Media: Considers all media and all types of prints. Most frequently exhibits paintings, ceramics and sculpture.
Style: Exhibits all styles, all genres.
Terms: Accepts work on consignment (25% commission). Retail price set by the artist. Gallery provides insurance and promotion; shipping costs are shared. Prefers artwork framed.
Submissions: "Exhibiting artists tend to be from the Southeast, but there are no restrictions." Send query letter with résumé, slides, SASE and proposal. Write for appointment to show portfolio of originals, photographs, slides or transparencies. Replies in 3-4 months. Files slides, postcards, résumés.
Tips: Finds artists through artists' proposals, visiting exhibitions and word of mouth.

‡**FLORIDA CENTER FOR CONTEMPORARY ART**, 1513 E. Eighth Ave., Tampa FL 33605. Phone/Fax: (813)248-1171. Gallery Director: Patricia Yontz. Alternative space and nonprofit gallery. Estab. 1978. Represents emerging artists. 200 members. Exhibited artists include Carl Chambers, Mark Messersmith. Sponsors 7-8 shows/year. Average display time 2 months. Open all year; Wednesday-Saturday, 1-4. Located in historic art district; 2,200 sq. ft.; old building in historic Ybor City. 90% of space for special exhibitions; 90% of space for gallery artists. 10% private collectors, 15% corporate collectors. Overall price range: $50-7,000; most work sold at $400.
Media: All media accepted.
Style: Experimental, contemporary arts.
Terms: Accepts work on consignment (25% commission). Retail price set by the artist. Gallery provides promotion and contract; shipping costs are shared.
Submissions: Annual call for year's proposals and membership exhibition. Several calls during year for theme exhibitions.
Tips: Finds artists through announcements in Art Papers, Art Calendar and members' mailings.

FLORIDA STATE UNIVERSITY GALLERY & MUSEUM, Copeland & W. Tennessee St., Tallahassee FL 32306-2037. (904)644-6836. Gallery Director: Allys Palladino-Craig. University gallery and museum. Estab. 1970. Shows work by over 100 artists/year; emerging, mid-career and established. Sponsors 12-22 shows/year. Average display time 3-4 weeks. Located on the university campus; 16,000 sq. ft. 50% of space for special exhibitions.
Media: Considers all media, including electronic imaging and performance art. Most frequently exhibits painting, sculpture and photography.
Style: Exhibits all styles. Prefers contemporary figurative and non-objective painting, sculpture, printmaking.
Terms: "Sales are almost unheard of; the gallery takes no commission." Retail price set by the artist. Gallery provides insurance, promotion and shipping costs to and from gallery for invited artists.
Submissions: Send query letter with résumé, slides, bio, brochure, photographs, reviews and SASE. Write for appointment to show portfolio, which should include slides. Faculty and steering committee replies in 6-8 weeks.
Tips: "Almost no solo shows are granted; artists are encouraged to enter our competition—the Florida National (annual deadline for two-slide entries is Halloween). Show is in the spring; curators use national show to search for talent."

‡**FRIZZELL CULTURAL CENTRE GALLERY**, 10091 McGregor Blvd., Ft. Myers FL 33919. (813)939-2787. Fax: (813)939-0794. Contact: Exhibition committee. Nonprofit gallery. Estab. 1979. Represents emerging, mid-career and established artists. 460 members. Exhibited artists include Nat Krate, Gene Fellner. Sponsors 16 shows/year. Average display time 1 month. Open all year; Monday-Saturday, 10-4; Sunday, 1-4. Located in Central Lee County—near downtown; 1,400 sq. ft.; high ceiling, open ductwork—ultra modern and airy. Clientele: local to national. 90% private collectors, 10% corporate collectors. Overall price range: $200-100,000; most work sold at $500-2,500.
Media: Considers all media and all types of print. Most frequently exhibits oil, sculpture and watercolor.
Style: Exhibits all styles, all genres.
Terms: Retail price set by the artist. Gallery provides insurance (limited) and promotion; artist pays shipping costs to and from gallery. Prefers artwork framed.
Submissions: Send query letter with slides, bio and SASE. Write for appointment to show portfolio of photographs and slides. Replies in 3 months. Files "all material unless artist requests slides returned."
Tips: Finds artists through visiting exhibitions, word of mouth and artists' submissions.

GALERIE MARTIN, INC., 417 Town Center Mall, Boca Raton FL 33431. (407)395-3050. Fax: (407)392-8521. Owner/Director: Edith Mallinger. Retail gallery. Estab. 1970. Represents 10 established artists. Interested in seeing the work of emerging artists. Exhibited artists include Leonardo Nierman and Bruno Perino. Sponsors 6 shows/year. Average display time 2 weeks. Open all year. Located in Boca Raton Center; 2,300 sq. ft.; "high-tech architecture with Gothic archway to marble balcony." 50% of space for special exhibitions. Clientele: 75% private collectors; 25% corporate collectors. Overall price range: $100-20,000.
Media: Considers oil, acrylic, mixed media, sculpture, original handpulled prints, lithographs, posters and serigraphs. Most frequently exhibits oil, acrylic and serigraphs.
Style: Exhibits expressionism, neo-expressionism, primitivism, painterly abstraction, impressionism, naive art and realism. Genres include landscapes and figurative work. Prefers impressionism, expressionism and abstraction.
Terms: Accepts artwork on consignment (50% commission). Retail price set by gallery. Gallery provides insurance and promotion; shipping costs are shared.
Submissions: Send query letter with brochure and photographs. Write for appointment to show portfolio of originals. Replies in 2 weeks.

CAROL GETZ GALLERY, Suite 1207, 9 Island Ave., Miami Beach FL 33139. (305)674-1066. Director/Owner: Carol Getz. Retail gallery. Estab. 1987. Represents 12 emerging, mid-career and established artists. Inter-

ested in seeing the work of emerging artists. Exhibited artists include Michelle Spark, Judith Glantzman, Steve Miller, Marilyn Minter and Michael Mogavero. Sponsors 8 shows/year. Average display time 6 weeks. Open fall and spring. "I have moved to my residence as a private dealer, having no formal exhibition space." Clientele: all ages—mostly upper middle class. 85% private collectors, 15% corporate collectors. Overall price range: $400-15,000; most artwork sold at $4,000-6,000.

Media: Considers oil, acrylic, watercolor, pastel, pen & ink, drawings, mixed media, collage, works on paper, woodcuts, linocuts, engravings, mezzotints, etchings, lithographs, pochoir and serigraphs. Most frequently exhibits paintings, prints and drawings.

Style: Exhibits expressionism, neo-expressionism, primitivism, painterly abstraction, conceptualism, minimalism and realism. Prefers new image (combination of object and abstraction) and figurative abstraction.

Terms: Accepts work on consignment (40-50% commission). Retail price set by gallery and artist. Gallery provides insurance, promotion and shipping costs. Prefers unframed artwork.

Submissions: Accepts only artists from New York area (NJ, CT, etc.). Prefers only paintings, drawings and prints. "Artist must have shown before at reputable galleries and have a comprehensive résumé." Send résumé, slides and bio. Call for appointment to show portfolio. Replies in 1 month.

Tips: "Send slides and résumés first with SASE."

‡**GLASS CANVAS GALLERY, INC.,** 233 4th Ave. NE, St. Petersburg FL 33701. (813)821-6767. Fax: (813)821-1775. President: Judy Katzin. Retail gallery. Estab. 1992. Represents 85 emerging and mid-career artists/year. Exhibited artists include Colin Heaney and Mark Eckstrand. Sponsors 6 shows/year. Average display time 6-8 weeks. Open all year; Monday, Tuesday, Wednesday, Friday, 10-6; Thursday, 10-7; Saturday, 10-5; Sunday, 12-5; closed Sunday June-September. Located by the waterfront downtown; 1,800 sq. ft. 25% of space for special exhibition; 75% of space for gallery artists. 5% private collectors, 5% corporate collectors. Overall price range: $20-5,000; most work sold at $100-700.

Media: Considers mixed media, sculpture, glass, engraving, lithograph, linocut, etching and posters. Most frequently exhibits glass, ceramic and mixed.

Style: Exhibits color field. Prefers unique, imaginative, contemporary, colorful and unusual.

Terms: Accepts work on consignment (50% commission) or buys outright for 50% of retail price (net 30 days). Retail price set by the artist. Gallery provides insurance, promotion, contract and shipping costs from gallery; artist pays shipping costs to gallery. Prefers artwork framed.

Submissions: Prefers only glass. Send query letter with résumé, brochure, photographs and business card. Call for appointment to show portfolio of photographs. Replies in 2 weeks. Files all material.

‡**GREENE GALLERY,** Suite 1503, 1541 Brickell Ave., Miami FL 33129. (305)858-7868. President: Barbara Greene. Retail gallery/art consultancy. Average display time: 1 month. Interested in emerging, mid-career and established artists. Open all year. Private dealing by appointment. Clientele: 75% private collectors; 25% corporate clients.

Media: Considers oil, acrylic, watercolor, pastel, pen & ink, drawings, mixed media, collage, works on paper, sculpture, ceramic, woodcuts, wood engravings, linocuts, engravings, etchings, lithographs, pochoir and serigraphs. Most frequently exhibits painting, prints and sculpture.

Style: Exhibits very little realism—mostly contemporary art, minimalism, color field, painterly abstraction, conceptualism, postmodern works and hard-edge geometric abstraction. Genres include landscapes, florals and figurative work. Prefers abstraction, geometric art and post-modernism. "Geometric and abstract art is the gallery's main interest. Interested in seeing work that pushes the limit." Strong interest in Latin art.

Terms: Exclusive area representation required.

Submissions: Send query letter with résumé, slides, SASE, photographs and bio. Call or write to schedule an appointment to show a portfolio, which should include originals, slides, transparencies and photographs. Replies in 1 week. Files slides, photo, bio and reviews.

Tips: "We are not currently looking at the work of unknowns."

THE HANG-UP, INC., 45 S. Palm Ave., Sarasota FL 34236. (813)953-5757. President: F. Troncale. Retail gallery. Estab. 1971. Represents 25 emerging and mid-career artists. Sponsors 6 shows/year. Average display time 1 month. Open all year. Located in arts and theater district downtown; 1,700 sq. ft.; "high tech, 10 ft. ceilings with street exposure in restored hotel." 50% of space for special exhibitions. Clientele: 75% private collectors, 25% corporate collectors. Overall price range: $500-5,000; most artwork sold at $500-1,000.

Media: Considers oil, acrylic, watercolor, mixed media, collage, works on paper, sculpture, original hand-pulled prints, lithographs, etchings, serigraphs and posters. Most frequently exhibits painting, graphics and sculpture.

Style: Exhibits expressionism, painterly abstraction, surrealism, impressionism, realism and hard-edge geometric abstraction. All genres. Prefers abstraction, impressionism, surrealism.

Terms: Accepts artwork on consignment (50% commission). Retail price set by artist. Sometimes offers customer discounts and payment by installment. Gallery provides insurance, promotion and contract; shipping costs are shared. Prefers unframed work. Exhibition costs shared 50/50.

Submissions: Send résumé, brochure, slides, bio and SASE. Write for appointment to show portfolio of originals and photographs. "Come in with more than slides; bring P.R. materials, too!" Replies in 1 week.

‡**HEIM/AMERICA AT FISHER ISLAND GALLERY.** 42102 Fisher Island Dr., Fisher Island FL 33109. (305)673-6809. Fax: (305)532-2789. Director: J.H. Stoneberger. Retail gallery. Estab. 1990. Represents emerging and established artists. Sponsors 4-5 shows/year. Average display time 1 month. Open September 1-July 1; Tuesday-Saturday 11-6. Located in a private community; 1,000 sq. ft. 65% of space for special exhibitions; 65% of space for gallery artists. 50% private collectors, 50% corporate collectors. Overall price range: $800-200,000; most work sold at $10-15,000.
Media: Considers oil, watercolor, pastel, pen & ink, drawing, mixed media, paper and sculpture. Most frequently exhibits oil on canvas, watercolor and drawings.
Style: Exhibits expressionism, painterly abstraction, minimalism, color field, impressionism and realism. Genres include landscapes, florals, portraits, figurative work, all genres. Prefers landscape (realism and post impressionism), abstraction and color field.
Terms: Accepts work on consignment (20-40% commission). Retail price set by the gallery and the artist. Gallery provides insurance, promotion and contract. Artwork framed appropriately.
Submissions: Send query letter with résumé, slides and bio. Write for appointment to show portfolio of photographs. Replies only if interested within 2 months. Will return photos.
Tips: Finds artists through visiting exhibitions and artists' submissions.

‡**THE HENDRIX COLLECTION,** 3170 Commodore Plaza, Coconut Grove FL 33133. (305)446-2182. Owners/Directors: Carolyn and Mike. Retail gallery. Estab. 1986. Represents 50 emerging, mid-career and established artists. Exhibited artists include C.J. Wells and Artie Yellowhorse. Sponsors 1 show/year. Average display time 3 months. Open all year. Located in the village center of Coconut Grove (Miami); 1,300 sq. ft. Clientele: Canadians, Europeans, New Englanders; well-traveled, highly educated. 95% private collectors.
Media: Considers all media, including furniture, jewelry, original handpulled prints, relief, engravings, etchings, lithographs, serigraphs, offset reproductions and posters. Most frequently exhibits oil/acrylic on canvas, alabaster/marble sculpture and sterling/gold jewelry with stones.
Style: Exhibits all styles and Southwestern subjects.
Terms: Accepts artwork on consignment or artwork is bought outright for 50% of the retail price (net 30 days). Requires exclusive area representation. Retail price set by the gallery and the artist. Offers customer discounts and payment by installments. Gallery provides insurance and promotion; shipping costs are shared.
Submissions: Accepts only artists from the West (New Mexico, Colorado, Arizona, etc.). Does not accept artists currently in street festivals/shows. Send query letter with résumé, slides, bio, photographs, SASE and reviews. Portfolio review requested if interested in artist's work. Portfolio should include slides or photographs. Replies only if interested within 3-4 weeks. Files résumé.
Tips: Finds artists mostly through word of mouth. "We specialize in bringing the finest artists of the American West to the East."

IRVING GALLERIES, 332 Worth Ave., Palm Beach FL 33480. (407)659-6221. Fax: (407)659-0567. President: Irving Luntz. Director: Holden Luntz. Retail gallery. Estab. 1959. Represents 15 established artists. Not interested in seeing the work of emerging artists. Exhibited artists include Botero, Frankenthaler, Motherwell, Stella and Pomodovo. Closed for August. Located on main shopping street in town; 2,600 sq. ft. 100% of space for gallery artists. Clientele: "major 20th century collectors." 85% private collectors, 15% corporate collectors. Overall price range: $2,000 and up; most work sold at $20,000 and up.
Media: Considers oil, acrylic, watercolor, pastel, pen & ink, drawings, mixed media, works on paper and sculpture. Most frequently exhibits acrylic, oil, and bronze.
Style: Exhibits expressionism, painterly abstraction, color field, postmodern works and realism. Genres include landscapes, florals and Americana.
Terms: Prefers framed artwork.
Submissions: Send query letter with résumé, slides and bio. Call or write for appointment to show portfolio of slides and transparencies. Replies in 3 weeks.

KENDALL CAMPUS ART GALLERY, MIAMI-DADE COMMUNITY COLLEGE, 11011 SW 104 St., Miami FL 33176-3393. (305)237-2322. Fax: (305)237-2901. Director: Robert J. Sindelir. College gallery. Estab. 1970. Represents emerging, mid-career and established artists. Exhibited artists include Komar and Melamid. Sponsors 10 shows/year. Average display time 3 weeks. Open all year except for 2 weeks at Christmas and 3 weeks in August. Located in suburban area, southwest of Miami; 3,000 sq. ft.; "space is totally adaptable to any exhibition." 100% of space for special exhibitions. Clientele: students, faculty, community and tourists. "Gallery is not primarily for sales, but sales have frequently resulted."
Media: Considers all media, all types of original prints. "No preferred style or media. Selections are made on merit only."
Style: Exhibits all styles and genres.
Terms: "Purchases are made for permanent collection; buyers are directed to artist." Retail price set by artist. Gallery provides insurance and promotion; arrangements for shipping costs vary. Prefers artwork framed.

Submissions: Send query letter with résumé, slides, bio, brochure, SASE, and reviews. Write for appointment to show portfolio of slides. "Artists commonly make the mistake of ignoring this procedure." Replies in 2 weeks. Files résumés and slides (if required for future review).
Tips: "Present good quality slides of works which are representative of what will be available for exhibition."

J. LAWRENCE GALLERY, 1435 Highland Ave., Melbourne FL 32935. (407)259-1492. Fax: (407)259-1494. Director/Owner: Joseph L. Conneen. Retail gallery. Estab. 1980. Represents 65 mid-career and established artists. Exhibited artists include Kiraly and Mari Conneen. Sponsors 10 shows/year. Average display time 3 weeks. Open all year. "Centrally located downtown in a turn-of-the-century bank building in the antique and business district; 2,000 sq. ft.; five individual gallery rooms." 50% of space for special exhibitions. Clientele: 80% private collectors, 20% corporate collectors. Overall price range: $2,000-150,000; most work sold at $2,000-15,000.
Media: Considers oil, acrylic, watercolor, pastel, sculpture, ceramic, glass, original handpulled prints, mezzotints, lithographs and serigraphs. Most frequently exhibits oil, watercolor and silkscreen.
Style: Exhibits expressionism, painterly abstraction, impressionism, realism, photorealism and hard-edge geometric abstraction; all genres. Prefers realism, abstraction and hard-edge works.
Terms: Accepts work on consignment (50% commission). Retail price set by gallery. Customer discounts and payment by installment are available. Gallery provides insurance and promotion; artist pays for shipping.
Submissions: Prefers résumés from established artists. Send résumé, slides and SASE. Write for appointment to show portfolio of originals and slides.
Tips: "The most common mistake artists make is "not making appointments and not looking at the gallery first, to see if their work would fit in. The gallery scene is getting better. The last three years have been terrible."

THE MUSEUM OF ARTS AND SCIENCES, INC., 1040 Museum Blvd., Daytona Beach FL 32114. (904)255-0285. Fax: (904)255-0285, ext. 11. Director: Gary Libby. Museum. Estab. 1971. Exhibits average of 25 mid-career and established artists/year. May consider emerging artists in the future. 6,000 members. Sponsors 12 shows/year in 4 changing galleries. Open all year; Tuesday-Friday 9-4, Saturday and Sunday 12-5. 20,000 sq. ft. in 5 gallery spaces (each space ranges from 500 to 4,000 sq. ft.). "We added two 4,000 sq. ft. galleries and one 1,000 sq. ft. gallery." 40% of space for special exhibitions; 10% of space for gallery artists. Clientele: upper income young retirees and families. Overall price range: $200-10,000; most work sold at $1,000-3,000.
Media: Considers oil, paper, drawing, sculpture, glass, watercolor, ceramic, installation, photography, woodcuts, wood engravings, linocuts, engravings, mezzotints, etchings, lithographs, pochoir, serigraphs. Most frequently exhibits oil, ceramics/glass and works on paper.
Style: Exhibits expressionism, photorealism, neo-expressionism, primitivism, color field, hard-edge geometric abstraction, painterly abstraction, postmodern works, realism, surrealism, impressionism. All genres. Prefers realism, non-objective abstract.
Terms: Terms of representation vary according to exhibit. Retail price set by gallery and artist. Gallery provides insurance, promotion and contract; artist pays for shipping costs. Prefers artwork framed.
Submissions: Send query letter with résumé and slides. Write for appointment to show portfolio of photographs of installations, slides and transparencies. Replies in 2 weeks. Files materials if interested.

‡NORTON GALLERY OF ART, 1451 S. Olive Ave., West Palm Beach FL 33401. (407)832-5196. Fax: (407)655-4689. Senior Curator: David Setford. Museum. Estab. 1941. Represents mid-career and established artists. May be interested in seeing the work of emerging artists in the future. Holds 10 temporary exhibitions per year and several permanent exhibitions. Exhibited artists include Howard Ben Tré and Jonathan Green. Sponsors 10 shows/year. Average display time 5 weeks. Open all year; Tuesday-Saturday, 10-5; Sunday, 1-5. Located downtown; 8,111 sq. ft.; architecture is by Marion Wyeth. 40% of space for special exhibitions; 60% of space for permanent collection.
Media: Considers oil, watercolor, pastel, drawing, sculpture, glass, photography, serigraphs and etching. Most frequently exhibits oil, watercolor and photography.
Style: Exhibits all styles, all genres.
Terms: Gallery provides contract. Prefers artwork framed.
Submissions: Send query letter with résumé, slides, bio, brochure and reviews. Write for appointment to show portfolio of slides and transparencies. "We reply in a timely manner."
Tips: Finds artists through visiting exhibitions, publications, sourcebooks and other curators.

NUANCE GALLERIES, 720 S. Dale Mabry, Tampa FL 33609. (813)875-0511. Owner: Robert A. Rowen. Retail gallery. Estab. 1981. Represents 70 emerging, mid-career and established artists. Sponsors 3 shows/year. Open all year. 3,000 sq. ft. "We've reduced the size of our gallery to give the client a more personal touch. We have a large extensive front window area."
Media: Specializing in watercolor, original mediums including sculpture.
Style: "Majority of the work we like to see are realistic landscapes, escapism pieces, bold images, bright colors and semi tropical subject matter. Our gallery handles quite a selection and it's hard to put us into any one class."

Terms: Accepts work on consignment (50% commission). Retail price set by gallery and artist. Offers customer discounts and payment by installments. Gallery provides insurance and contract; shipping costs are shared.
Submissions: Send query letter with slides and bio. Portfolio review requested if interested in artist's work.
Tips: "Be professional; set prices (retail) and stick with them. There are still some artists out there that are not using conservation methods of framing. As far as submissions we would like local artists to come by to see our gallery and get the idea what we represent. Tampa has a healthy growing art scene and the work has been getting better and better. But as this town gets more educated it is going to be much harder for up and coming artists to emerge."

‡**PAStA PLUS ART (PROFESSIONAL ARTISTS OF ST. AUGUSTINE) GALLERY,** 214 Charlotte St., St. Augustine FL 32084. (904)824-0251. Director/Vice President: Jean W. Troemel. Cooperative nonprofit gallery. Estab. 1984. Represents 18 emerging, mid-career and established artists/year. 18 artist members, 8 craftsmen (guest members). Exhibited artists include Rob Connaway and Jean W. Troemel. Continuous exhibition of members' work plus a featured artist each month. Average display time 2 months. Open all year; Monday-Friday 10:30-4; Saturday and Sunday, 10-5. Located downtown – "South of The Plaza"; 1,250 sq. ft.; a 100-year-old building adjoining a picturesque restaurant and located on a 400-year-old street in our nation's oldest city. 14% of space for special exhibitions; 100% of space for gallery artists. Clientele: tourists and visitors. 100% private collectors.
Overall price range: $10-1,200; most work sold at $10-500.
Media: Considers oil, acrylic, watercolor, pastel, pen & ink, drawing, mixed media, collage, sculpture, ceramics, craft, glass, photography, alkyd, serigraphs and monoprints. Most frequently exhibits watercolor, oil and alkyd.
Style: Exhibits expressionism, primitivism, painterly abstraction, impressionism and realism. Genres include landscapes, florals, portraits and figurative work. Prefers impressionism and realism.
Terms: Co-op membership fee (30% commission). Retail price set by the artist. Gallery provides insurance, promotion and contract; artist pays shipping costs to and from gallery.
Submissions: Accepts only artists from Northeast Florida. Work must be no larger than 48 inches. Send query letter with résumé, slides, bio, brochure, photographs and SASE. Call or write for appointment to show portfolio of originals, photographs and brochures. "New members must meet approval of a committee and sign a 4-month contract with the 1st and 4th month paid in advance." Replies only if interested within 2 weeks.
Tips: Finds artists through visiting exhibitions, word of mouth, artists' submissions.

PENSACOLA MUSEUM OF ART, 407 S. Jefferson, Pensacola FL 32501. (904)432-6247. Director: Carol Malt, Ph.D. Curator: Gail McKenney. Nonprofit museum. Estab. 1954. Interested in emerging, mid-career and established artists. Sponsors 3 solo and 19 group shows/year. Average display time: 6-8 weeks. Open all year. Located in the historic district; renovated 1906 city jail. Clientele: 90% private collectors; 10% corporate clients. Overall price range: $200-20,000; most work sold at $500-3,000.
Media: Considers all media. Most frequently exhibits painting, sculpture, photography, glass and new-tech (i.e. holography, video art, computer art etc.).
Style: Exhibits neo-expressionism, realism, photorealism, surrealism, minimalism, primitivism, color field, postmodern works, imagism; all styles and genres.
Terms: Retail price set by museum and artist. Exclusive area representation not required. Museum provides insurance, promotion and shipping costs.
Submissions: Send query letter with résumé, slides, SASE and/or videotape. Call or write for appointment to show portfolio of originals slides, transparencies and videotape. "A common mistake of artists is making impromptu drop-ins." Replies in 2 weeks. Files guides and résumé.

‡**ANITA L. PICKREN GALLERY,** 33 South Palm Ave., Sarasota FL 34236. (813)954-1800. Curator: Kevin T. O'Keefe. Retail gallery. Estab. 1988. Represents 12-15 established artists/year. Exhibited artists include Gale Fulton-Ross and Otto Neumann. Sponsors 5 shows/year. Average display time 3 weeks. Open all year; Monday-Saturday 10-6. Located downtown in the heart of art gallery district; 3,000 sq. ft.; in national historic register; lobby of an old Victorian hotel; wide open high ceilings. 100% of space for gallery artists. Clientele: upper income. 40% private collectors. Overall price range: $600-40,000; most work sold at $2,500-3,000.
Media: Considers oil, acrylic, watercolor, pastel, mixed media, collage, sculpture and glass. Most frequently exhibits oils, glass and sculpture.

How to Use Your Artist's & Graphic Designer's Market *offers suggestions for understanding and using the information in these listings. Read this and other articles in the front of this book for important business tips.*

Style: Exhibits all styles. Genres include landscapes, florals and figurative work.
Terms: Accepts work on consignment (50% commission). Retail price set by the gallery with approval of the artist. Gallery provides promotion, contract and shipping costs from gallery; artist pays shipping costs to gallery. Prefers oils unframed; decisions are made about works on paper after word is reviewed.
Submissions: Accepts only artists away from Florida. Send query letter with résumé, slides, bio, photographs, SASE and reviews. Write for appointment. Replies only if interested within 1 week. Files slides and bio.
Tips: Finds artists through recommendation by other artists and shows.

SUDDERTH ART INTERNATIONAL, INC., 1170 Third St. S., Unit B110, Naples FL 33940. (813)261-6251. Fax: (813)649-7473. Assistant Director: Dana Groff, Jr. Retail gallery. Estab. 1992. Represents 40 emerging, mid-career and established artists. Exhibited artists include Y.X. Pan and HeNing. Sponsors 2 shows/year. Open all year; Tuesday-Saturday 10-4. Located in downtown Naples Art district. Features contemporary Asian, European and North American artists. Clientele: doctors, lawyers, interior designers. 100% private collectors. Overall price rance: $350-12,500; most work sold at $5,000.
Media: Considers oil, acrylic, mixed media, sculpture, original handpulled prints, lithographs and serigraphs. Most frequently exhibits oil, acrylic and sculpture.
Style: Exhibits painterly abstraction, minimalism, photorealism and contemporary Asian art. Genres include landscapes and florals. Prefers abstract, realism and figurative, Asian and European backgrounds.
Terms: Accepts work on consignment. Retail price set by gallery. Sometimes offers customer discounts. Artist pays for shipping costs. Prefers artwork unframed.
Submissions: Send query letter with résumé, slides and bio. Portfolio review requested if interested in artist's work. Files bios and slides.
Tips: Finds artists through submissions by artists and agents. "Business has diminished considerably. We have chosen to market those artists we have on contract and take on fewer new artists; also fewer shows during the year."

‡UNIVERSITY GALLERY, UNIVERSITY OF FLORIDA, Bldg. B, 102 Fine Arts, Gainesville FL 32611-5803. (904)392-0201. Fax: (904)846-0266. Director: Karen Valdés. Nonprofit gallery. Estab. 1965. Represents 45 emerging, mid-career and established artists/year. Exhibited artists include Velsmann, Arbuckle. Sponsors 8 shows/year. Average display time 4-6 weeks. Open all year; Tuesday, 10-8; Wednesday-Friday, 10-5; Saturday and Sunday, 1-5. Located on University campus; 3,000 sq. ft.; 16-foot ceiling with light grey walls. 100% of space for special exhibitions. Clientele: students, community.
Media: Considers all media and all types of prints. Most frequently exhibits painting, sculpture and photography.
Style: Exhibits all styles, contemporary only.
Terms: Gallery provides insurance and promotion; shipping costs are shared. Prefers artwork framed.
Submissions: Send query letter with résumé, slides and photographs. Write for appointment. Replies in 3 weeks. Files slides and résumés.
Tips: Finds artists through recommendations from other artists.

VALENCIA COMMUNITY COLLEGE ART GALLERIES, 701 N. Econlockhatchee Trail, Orlando FL 32825. (305)299-5000. Fax: (407)299-5000, ext. 2270. Gallery Curator: Robin Ambrose. Nonprofit gallery. Estab. 1982. Interested in emerging, mid-career and established artists. Sponsors 1 solo and 5 group shows/year. "Would also consider installation proposal by groups." Average display time is 6 weeks.
Media: Considers all media. Most frequently exhibits sculpture, paintings, drawings and contemporary crafts.
Style: Considers all styles. Looks for "individuality, passion and technical prowess." Does not want to see commercial work.
Terms: Accepts work on consignment (no commission). Retail price set by artist. Exclusive area representation not required. Gallery provides insurance, shipping costs, promotion and contract.
Submissions: Send query letter with résumé, slides, photographs and SASE. Write for an appointment to show portfolio, which should include slides and transparencies. Resumes and other biographical material are filed.
Tips: "I like to visit artists' studios personally. I need to see the work 'in the flesh,' so to speak. Mostly I learn about new artists by visiting other galleries and museums. Censorship has taken its toll on any innovative works that could be considered for exhibition. I have to be very careful in my selection of exhibitors."

‡WELLINGTON FINE ART, 13152A Quiet Woods Rd., Wellington FL 33414. Phone/Fax: (407)791-0959. Director: Janice Caiazzo. Private dealer and art consultancy. Estab. 1993. Represents established artists. Exhibited artists include Norman Rockwell, Daniel Garber, Andrew Wyeth. Open all year; Monday-Saturday, 9-5. Located 18 miles west of Palm Beach. Overall price range: $1,500-150,000; most work sold at $50,000-95,000.
Media: Considers oil, watercolor, pastel, pen & ink, drawing and mixed media. Most frequently exhibits oil, watercolor and drawing.

Style: Exhibits 19th and early 20th century impressionists. Genres include landscapes, portraits, figurative work, all genres. Prefers figurative, genre and landscape.

‡**WORKS IN PROGRESS GALLERY,** 413B E. Atlantic Ave., Delray Beach FL 33483. (407)274-9286. Fax: (407)394-2541. Director: Sharon L. Tomin. Retail gallery. Estab. 1992. Represents 7 emerging, mid-career and established artists/year. Exhibited artists include David A. Litt and David K. Klarén. Sponsors 12 shows/year. Average display time 1 month. "We keep a representation of gallery artists up year round." Open all year; Monday-Saturday, 10-5; Thursday-Saturday, 7-10 pm. Located downtown – part of art revival community with 8 galleries; 1,000 sq. ft.; high beamed ceilings. 60% of space for special exhibitions; 40% of space for gallery artists. Clientele: very affluent world travelers with a minimum of two residences. 90% private collectors, 10% corporate collectors. Overall price range: $400-8,000; most work sold at $1,500-3,200.
 ● This gallery has a craft gallery annex located at 413A E. Atlantic, Delray Beach.
Media: Considers oil, acrylic, mixed media, sculpture, craft, glass and experimental. Considers any type of print but doesn't handle edition of more than 10. Most frequently exhibits 2-dimensional mixed media, 3 dimensional mixed media and oil.
Style: Exhibits expressionism, painterly abstraction, surrealism, photorealism and imagism. Prefers contemporary image based and experimental media.
Terms: Accepts work on consignment (40-50% commission) or buys outright (for crafts only). Retail price set by the gallery and the artist. Gallery provides insurance, promotion and contract. Prefers artwork framed.
Submissions: Artist can't be with other gallery in area. Send query letter with résumé, slides and SASE. Call or write for appointment to show portfolio of originals (if possible) and slides. Replies in 1 month with SASE. Files résumé and slide or photo.
Tips: Finds artists through visiting exhibitions, word of mouth and submissions. "Works must be large scale, minimum 30″ × 40″."

Georgia

‡**ARIEL GALLERY AT TULA,** 75 Bennett St., NW, Atlanta GA 30309. (404)352-5753. Contact: Director. Cooperative gallery. Estab. 1984. Represents 20 emerging, mid-career and established artists/year. 15 members. Exhibited artists include Phyllis Franco, Debra Lynn Gold. Sponsors 8 shows/year. Average display time 6 weeks. Open all year; Tuesday-Saturday, 11-5. Located downtown; 914 sq. ft. Clientele: upscale, urban. 80% private collectors, 20% corporate collectors. Overall price range: $25-6,000; most work sold at $250-1,500.
Media: Considers all media, all types of prints. Most frequently exhibits paintings, sculpture and fine crafts.
Style: Exhibits primitivism, painterly abstraction and pattern painting.
Terms: Accepts work on consignment (40% commission) or Co-op membership fee plus a donation of time (5% commission). Retail price set by the artist. Gallery provides promotion and contract. "Prefers hand delivery."
Submissions: Accepts only artists from Atlanta area. "Some work taken on consignment. Artist must live outside 50-mile radius of Atlanta." Send query letter with résumé, slides or photographs, and bio. "Applicants for membership are considered at meeting on first Monday of each month." Portfolio should include originals (if possible), photographs or slides. Replies in 2 months.
Tips: Finds artists through visiting exhibitions, word of mouth, artists' submissions, local advertising in arts publications. "Talk with membership chairman or exhibition director and get details. We're approachable and less formal than most."

FAY GOLD GALLERY, Dept. AM, 247 Buckhead Ave., Atlanta GA 30305. (404)233-3843. Owner: Fay Gold. Retail gallery. Estab. 1980. Open all year. Represents 25 emerging and established artists. Sponsors 18 solo and 4 group shows/year. Average display time 1 month. Clientele: 50% private collectors; 50% corporate clients. Overall price range: $200-350,000; most work sold at $2,000-20,000.
Style: Exhibits all styles. Genres include landscapes, Americana and figurative work. Prefers abstracts, landscapes and figurative works. "We specialize in contemporary art of all media."
Terms: Accepts work on consignment (50% commission). Retail price set by gallery and artist. Exclusive area representation required. Gallery provides insurance and promotion.
Submissions: Send query letter with résumé, slides and SASE. Limited review of material. "We contact artists for a portfolio review if we are interested." Replies in 1 month. All material is returned if not accepted or under consideration.

‡**ANN JACOB GALLERY,** 3500 Peachtree Rd. NE, Atlanta GA 30326. (404)262-3399. Director: Yvonne J. Spiotta. Retail gallery. Estab. 1968. Represents 35 emerging, mid-career and established artists/year. Sponsors 4 shows/year. Open all year; Monday-Saturday 10-9; Sunday 12-5:30. Located midtown; 1,600 sq. ft. 100% of space for special exhibitions; 100% of space for gallery artists. Clientele: private and corporate. 80% private collectors, 20% corporate collectors.

Media: Considers oil, acrylic, watercolor, sculpture, ceramics, craft and glass. Most frequently exhibits paintings, sculpture and glass.
Style: Exhibits all styles, all genres.
Terms: Accepts work on consignment (50% commission). Retail price set by the gallery and the artist. Gallery provides promotion; artist pays shipping costs.
Submissions: Send query letter with résumé, slides, bio, brochure, photographs and SASE. Write for appointment. Replies in 2 weeks.

‡NÕVUS, INC., 495 Woodward Way NW, Atlanta GA 30305. (404)355-4974. Fax: (404)355-2250. Vice President: Pamela Marshall. Art dealer. Estab. 1980. Represents 200 emerging, mid-career and established artists. Open all year; daily, 9-5. Located in Buckhead, GA. 50% of space for gallery artists. Clientele: corporate, hospitality, healthcare. 5% private collectors, 95% corporate collectors. Overall price range: $500-20,000; most work sold at $800-5,000.
Media: Considers oil, acrylic, watercolor, pastel, mixed media, collage, paper, sculpture, ceramics, craft, fiber, glass, photography, and all types of prints. Most frequently exhibits mixed/paper and oil/acrylic.
Style: Exhibits all styles. Genres include landscapes, florals and figurative work. Prefers landscapes, abstract and figurative.
Terms: Accepts work on consignment (50% commission). Retail price set by the artist. Gallery provides promotion and contract; shipping costs are shared. Prefers artwork unframed.
Submissions: Artists must have no other representation in our area. Send query letter with résumé, slides, brochure and reviews. Write for appointment to show portfolio of originals, photographs and slides. Replies only if interested within 1 month. Files slides and bio.
Tips: Finds artists through agents, visiting exhibitions, word of mouth, art publications and sourcebooks, artists' submissions. "Send complete information and pricing. Do not expect slides and information back."

Hawaii

THE ART CENTRE AT MAUNA LANI, P.O. Box 6303, 2 Mauna Lani Dr., Kohala Coast HI 96743-6303. (808)885-7779. Fax: (808)885-0025. Director: Julie Bancroft. Retail gallery run by nonprofit organization to fund their activities. Estab. 1988. Represents 25 emerging, mid-career and established artists. Sponsors 6 shows/year. Average display time 2 months. Open all year. Located in the Mauna Lani Resort, Big Island of Hawaii; 2,500 sq. ft. 40% of space for special exhibitions. Clientele: tourists and local residents. 90% private collectors, 10% corporate collectors. Overall price range: $50-30,000.
Media: Considers all media and original handpulled prints, engravings, lithographs, mezzotints and serigraphs. Prefers oil, acrylic and watercolor.
Style: Exhibits all styles and genres, including Oriental art. Prefers photorealism, impressionism and expressionism. "Oriental art and antiques make our gallery unique."
Terms: Accepts artwork on consignment (50% commission). Requires exclusive area representation. Retail price set by gallery and artist. Sometimes offers customer discounts and payment by installment. Gallery provides insurance, promotion and contract; artist pays for shipping. Prefers artwork "properly framed."
Submissions: Send query letter with bio, brochure, photographs and SASE. Portfolio review requested if interested in artist's work.
Tips: "Label all works with size, title, medium and retail price (or range)."

‡MAYOR'S OFFICE OF CULTURE AND THE ARTS, #404, 530 S. King, Honolulu HI 96813. (808)523-4674. Fax: (808)527-5445. Coordinator: Elaine Murphy. Local government/city hall exhibition areas. Estab. 1965. Exhibits group shows coordinated by local residents. Sponsors 57 shows/year. Average display time 3 weeks. Open all year; Monday-Friday, 7:45-4:30. Located at the civic center in downtown Honolulu; 3 galleries— courtyard (3,850 sq. ft.), lane gallery (873 sq. ft.), 3rd floor (536 sq. ft.); Mediterranean-style building, open interior courtyard. "City does not participate in sales. Artists make arrangements directly with purchaser."
Media: Considers all media and all types of prints. Most frequently exhibits oil/acrylic, photo/print and clay.
Terms: Gallery provides promotion; local artists deliver work to site. Prefers artwork framed.
Submissions: "Local artists are given preference." Send query letter with résumé, slides and bio. Write for appointment to show portfolio of slides. "We maintain an artists registry for acquisition review for the art in City Buildings Program."
Tips: "Selections of exhibitions are made through an annual application process."

QUEEN EMMA GALLERY, 1301 Punchbowl St., Honolulu HI 96813. (808)547-4397. Fax: (808)547-4646. Director: Masa Morioka Taira. Nonprofit gallery. Estab. 1977. Exhibits the work of emerging, mid-career and established artists. Average display time 5½ weeks. Located in the main lobby of The Queen's Medical Center; "recently renovated, intimate ambiance allows close inspection." Clientele: M.D.s, staff personnel, hospital visitors, community-at-large. 90% private collectors. Overall price range: $50-5,000.
Media: Considers all media. "Open to innovation and experimental work appropriate to healing environment."

Style: Exhibits contemporary, abstract, impressionism, figurative, primitive, non-representational, photorealism, realism neo-expressionism, landscapes and florals. Specializes in humanities-oriented interpretive, literary, cross-cultural and cross-disciplinary works. Interested in folk art, miniature works and ethnic works. "Our goal is to offer a variety of visual expressions by regional artists. Subject matter and aesthetics appropriate for audience in a healthcare facility is acceptable." Interested in seeing "progressive, honest, experimental works with artist's personal interpretation."

Terms: Accepts work on consignment (30% commission). Retail price set by artist. Offers payment by installments. Exclusive area representation not required. Gallery provides promotion and contract.

Submissions: Send query letter with résumé, brochure, business card, slides, photographs and SASE. Wishes to see a portfolio of slides, blown-up full color reproduction is also acceptable. "Prefer brief proposal or statement or proposed body of works." Preference given to local artists. "Include prices, title and medium information."

Tips: Finds artists through direct inquiries, referral by art professionals, news media publicity. "The best introduction to us is to submit your proposal with a dozen slides of works created with intent to show. Show professionalism, integrity, preparation, new direction and readiness to show. The gallery scene is vastly improved."

‡**THE VILLAGE GALLERY,** 120 Dickenson St., Lahaina HI 96761. (808)661-4402. Owner/Manager: Linda Shue. Retail gallery. Estab. 1970. Represents 100 artists. Interested in emerging and established artists. Sponsors 10 solo and 4 group shows/year. Average display time varies. "We now have 3 locations: Dickenson St., Lahaina; Lahaina Cannery Mall; Ritz-Carlton-Kapalua." Clientele: tourists, return visitors, those with a second home in Hawaii, 85% private collectors, 15% corporate clients. Overall price range: $10-10,000; most work sold at $800-3,000.

Media: Considers oil, acrylic, watercolor, pastel, pen & ink, drawings, mixed media, collage, works on paper, sculpture, ceramic, fiber and glass. Most frequently exhibits oil, watercolor and mixed media.

Style: Exhibits impressionism, realism, color field and painterly abstraction. Genres include landscapes, florals, figurative work; considers all genres. Prefers impressionism, painterly abstraction and realism.

Terms: Accepts work on consignment (50% commission). Retail price set by gallery and artist. Offers payment by installments. Exclusive area representation required. Shipping costs are shared. Prefers artwork framed.

Submissions: Send query letter with résumé, slides, and photographs. Write to schedule an appointment to show a portfolio, which should include originals, slides and photographs. Replies in 2 weeks. All material is returned if not accepted or under consideration.

Tips: "Galleries today must have a broader selection, sizes and price ranges."

‡**VOLCANO ART CENTER,** P.O. Box 104, Hawaii National Park HI 96718. (808)967-7511. Fax: (808)967-8512. Gallery Manager: Natalie Pfeifer. Nonprofit gallery. Estab. 1974. Represents 120 emerging, mid-career and established artists/year. 750 member organization. Exhibited artists include Dietrich Varez and Brad Lewis. Sponsors 25 shows/year. Average display time 1 month. Open all year; daily 9-5. Located Hawaii Volcanoes National Park; 3,000 sq. ft.; in the historic 1877 Volcano House Hotel (gallery uses the entire building). 15% of space for special exhibitions; 90% of space for gallery artists. Clientele: affluent travelers from all over the world. 95% private collectors, 5% corporate collectors. Overall price range: $20-4,500; most work sold at $50-400.

Media: Considers all media, all types of prints. Most frequently exhibits wood, mixed media and ceramics.

Style: Exhibits expressionism, neo-expressionism, primitivism and painterly abstraction. Prefers traditional Hawaiian, contemporary Hawaiian and contemporary crafts.

Terms: "Artists must become Volcano Art Center members." Accepts work on consignment (50% commission) or buys outright for 50% of retail price (net 30 days). Retail price set by the gallery. Gallery provides promotion and contract; artist pays shipping costs to gallery.

Submissions: Prefers only work relating to the area or by Hawaiian artists. Call for appointment to show portfolio. Replies only if interested within 1 month. Files "information on artists we represent."

Idaho

BROWN'S GALLERIES, 1022 Main St., Boise ID 83702. (208)342-6661. Fax: (208)345-5127. Director: Randall Brown. Retail gallery featuring appraisal and restoration services. Estab. 1968. Represents 35 emerging, mid-career and established artists. Exhibited artists include Gerald Merfield and John Horgés. Sponsors 12 shows/year. Average display time 1 month. Open all year. Located downtown; 2,500 sq. ft. Up to 50% of space for special exhibitions. Clientele: mid-to above average income, some tourists. 50% private collectors, 50%

Always enclose a self-addressed, stamped envelope (SASE) with queries and sample packages.

corporate collectors. Overall price range: $10-65,000; most work sold at $1,000-5,000.

Media: Considers oil, acrylic, watercolor, pastel, pen & ink, drawings, mixed media, collage, works on paper, sculpture, ceramic, fiber, glass, original handpulled prints, woodcuts, engravings, lithographs, pochoir, wood engravings, mezzotints, serigraphs, linocuts and etchings. Most frequently exhibits painting, sculpture and glass.

Style: Exhibits all styles, including expressionism, neo-expressionism, painterly abstraction, imagism, conceptualism, color field, postmodern works, impressionism, realism, photorealism, pattern painting and hard-edge geometric abstraction. All genres. Prefers impressionism, realism and abstraction.

Terms: Accepts artwork on consignment (50% commission). Retail price set by artist. Sometimes offers customer discounts and payment by installment. Gallery provides insurance, promotion and contract; artist pays for shipping. Prefers artwork framed.

Submissions: Send query letter with all available information. Portfolio review requested if interested in artist's work. Files all materials.

Tips: "We deal only with professionals. Amateurs frequently don't focus enough on the finish, framing, display, presentation or marketability of their work. We have a second gallery, Brown's Gallery McCall, located in the heart of a popular summer and winter resort town. We carry an electic group of work focusing slightly more on tourists than our first location."

THE GALLERY, 507 Sherman Ave., Coeur d'Alene ID 83814. (208)667-2898. Owner: Donna Yde. Retail gallery. Estab. 1982. Represents 30 emerging, mid-career and established artists. Exhibited artists include Jo Simpson, William Voxman and Donna Yde. Sponsors 4 shows/year. Average display time 3 months. Open all year. Located "in main business district downtown; 2,500 sq. ft.; antique and rustic. 30% of space for special exhibitions. Clientele: middle to upper income. 82% private collectors, 18% corporate collectors. Overall price range: $100-1,400; most work sold at $500.

Media: Considers all media.

Style: Exhibits all styles. Genres include landscapes, florals, Western, wildlife and portraits. Prefers contemporary styles.

Terms: Accepts artwork on consignment (40% commission). Retail price set by gallery and artist. Gallery provides insurance, promotion and contract; artist pays for shipping. Prefers artwork framed.

Submissions: Send query letter with bio, photographs, SASE and business card. Write for appointment to show portfolio of originals and photographs. Replies within 2 weeks only if interested. Files all material for 6 months.

Tips: "The Gallery now has a complete custom frame shop with 23 years experience in framing."

ANNE REED GALLERY, 620 Sun Valley Rd., Ketchum ID 83340. (208)726-3036. Fax: (208)726-9630. Director: Jennifer Gately. Retail Gallery. Estab. 1980. Represents mid-career and established artists. Exhibited artists include Russell Chatham. Sponsors 8 exhibitions/year. Average display time 1 month. Open all year. Located in the Walnut Avenue Mall. 10% of space for special exhibitions; 90% of space for gallery artists. Clientele: 80% private collectors, 20% corporate collectors.

Media: Most frequently exhibits sculpture, wall art and photography.

Style: Exhibits expressionism, abstraction, conceptualism, impressionism, photorealism, realism. Prefers contemporary and landscapes.

Terms: Accepts work on consignment (50% commission). Retail price set by gallery and artist. Sometimes offers customer discounts and payment by installment. Gallery provides insurance, promotion, contract and shipping costs from gallery. Prefers artwork framed.

Submissions: Send query letter with résumé, slides, bio and SASE. Call or write for appointment to show portfolio of originals (if possible), slides and transparencies. Replies in 2 months.

Tips: Finds artists through word of mouth, exhibitions, publications, artists' submissions and collector's referrals.

THE ROLAND GALLERY, 601 Sun Valley Rd., P.O. Box 221, Ketchum ID 83340. (208)726-2333. Fax: (208)726-6266. Owner: Roger Roland. Retail gallery. Estab. 1990. Represents 100 emerging, mid-career and established artists. Sponsors 8 shows/year. Average display time 1 month. Open all year; daily 11-5. 800 sq. ft. 50% of space for special exhibitions; 50% of space for gallery artists. Clientele: 75% private collectors, 25% corporate collectors. Overall price range: $10-10,000; most work sold at $500-1,500.

Media: Considers oil, pen & ink, paper, fiber, acrylic, sculpture, glass, watercolor, mixed media, ceramic, installation, pastel, collage, craft and photography, engravings, mezzotints, etchings, lithographs. Most frequently exhibits glass, paintings and jewelry.

Style: Considers all styles and genres.

Terms: Accepts work on consignment (50% commission) or buys outright for 50% of the retail price (net 30 days). Retail price set by artist. Gallery provides insurance, promotion, shipping costs from gallery. Prefers artwork framed.

Submissions: Send query letter with résumé, slides, bio, brochure, photographs, SASE, business card and reviews. Write for appointment to show portfolio of photographs, slides and transparencies. Replies only if interested within 2 weeks.

STONINGTON GALLERY, 220 East Ave., Ketchum ID 83340. (208)726-4826. Fax: (208)726-4550. Director: Nicki Foster. Retail gallery. Estab. 1974. Represents 36 emerging, mid-career and established artists. Exhibited artists include Nancy Taylor Stonington and Rie Munoz. Sponsors 8 shows/year. Average display time 1 month. Open all year; hours vary by season. Located in central downtown shopping area; 1,000 sq. ft. 15% of space for special exhibitions. Clientele: all types; many tourists and part-time residents. 90% private collectors; 10% corporate collectors. Overall price range: $50-10,000; most work sold at $250-5,000.
Media: Considers oil, acrylic, watercolor, pastel, mixed media, sculpture, ceramic, original handpulled prints, relief, intaglio, offset reproductions, lithographs and serigraphs. Most frequently exhibits watercolor, batik/ mixed media and offset reproductions.
Style: Exhibits primitivism, impressionism, realism and photorealism. Genres include landscapes, florals, Americana and wildlife.
Terms: Accepts artwork on consignment (50% commission). Retail price set by gallery. Sometimes offers customer discounts and payment by installment. Gallery provides insurance and contract; shipping costs are artists responsibility. Prefers artwork framed.
Submissions: Send query letter with résumé, slides, bio and SASE. Portfolio review requested if interested in artist's work. Portfolio should include photographs and slides. Replies in 1 month.
Tips: "Send good, quality slides and always include SASE. We also have galleries in Seattle and Anchorage."

Illinois

ARTCO, INCORPORATED, 3148 RFD, Long Grove IL 60047. (708)438-8420. Fax: (708)438-6464. President: Sybil Tillman. Retail and wholesale gallery, art consultancy and artists' agent. Estab. 1970. Represents 60 mid-career and established artists. Interested in seeing the work of emerging artists. Exhibited artists include Ed Paschke and Gary Grotey. Sponsors 4 shows/year. Average display time 4-6 weeks. Open all year; daily and by appointment. Located "2 blocks outside of downtown Long Grove; 4,500 sq. ft.; unique private setting in lovely estate and heavily wooded area." 50% of space for special exhibitions. Clientele: upper middle income. 65% private collectors, 20% corporate collectors. Overall price range: $500-20,000; most work sold at $2,000-5,000.
Media: Considers paper, sculpture, fiber, glass, original handpulled prints, woodcuts, engravings, pochoir, wood engravings, mezzotints, linocuts, etchings and serigraphs. Most frequently exhibits originals and signed limited editions "with a small number of prints."
Style: Exhibits all styles, including expressionism, abstraction, surrealism, conceptualism, postmodern works, impressionism, photorealism and hard-edge geometric abstraction. All genres. Prefers American contemporary and Southwestern styles.
Terms: Accepts artwork on consignment. Retail prices set by gallery. Customer discounts and payment by installment are available. Gallery provides promotion and contract; artist pays for shipping.
Submissions: Send query letter with résumé, slides, transparencies, bio, brochure, photographs, SASE, business card and reviews. Replies in 2-4 weeks. Files materials sent. Portfolio review required.
Tips: Finds artists through agents, by visiting exhibitions, word of mouth, various art publications and sourcebooks, artists' submissions/self-promotions and art collectors' referrals. "We prefer established artists but will look at all new art."

EVANSTON ART CENTER, 2603 Sheridan Rd., Evanston IL 60201. (708)475-5300. Director: Michele Rowe-Shields. Nonprofit gallery, contemporary art gallery and school. Estab. 1929. Represents emerging, mid-career and established artists. "All exhibitions are temporary—we do not represent specific artists." 1,200 members. Exhibited artists include Donald Lipski, Jin Soo Kim and Paul Sierra. Sponsors 6-8 shows/year. Average display time 6 weeks. Open all year. Located on lakefront property just north of Northwestern University campus; 3,000 sq. ft.; housed in a converted 1927 lakefront mansion; "still maintains the charm of the original home." 100% of space for special exhibitions. Clientele: private collectors, professional artists, students and children. 80% private collectors, 20% corporate collectors. "Sales are not the primary focus of the Art Center." Overall price range: $500-20,000; most work sold at $500-5,000.
Media: Considers all media and all types of prints. Most frequently exhibits installations, paintings, sculpture and video.
Style: Exhibits all styles and genres. "The Evanston Art Center remains sensitive to the currents and trends present in today's art and reflects them in its exhibition program."
Terms: Accepts work on consignment (20% commission). Retail price set by artist. Gallery provides insurance, promotion and contract; arrangements for shipping depend upon the exhibition. Prefers artwork framed.
Submissions: Send query letter with résumé, slides, bio and SASE. Write for appointment to show portfolio of slides. "Our exhibition committee meets bimonthly to review slides and make recommendations." Replies in 6 weeks. Files résumé and bio for future contact.
Tips: "Artists should be familiar with the Art Center and its exhibition program. Professional quality slides are of the utmost importance in order to represent the work accurately."

GALLERY TEN, 514 E. State St., Rockford IL 61104. (815)964-1743. Contact: Jean Apgar. Retail gallery. Estab. 1986. "We are a downtown gallery representing visual artists in all media." Represents emerging, mid-career and established artists. Average display time 6 weeks. Clientele: 50% private collectors, 50% corporate clients. Overall price range: $4-10,000; most artwork sold at $50-300.
Media: Considers all media.
Style: Exhibits fine arts and fine crafts; considers all styles and media. Sponsors national and regional juried exhibits and one-person and group shows. "Part of the gallery is reserved for the sales gallery featuring works by numerous artists and craftspeople and incorporates exhibition space for small shows. All work must be for sale and ready to hang or install."
Terms: Retail price set by artist (40% commission). Offers customer discounts and payment by installments. Exclusive area representation not required. Gallery provides promotion. Prefers artwork framed.
Submissions: Send query letter with slides, photographs and SASE. Portfolio review requested if interested in artist's work. All material is returned by SASE if not accepted or under consideration.
Tips: Finds artists through agents, by visiting exhibitions, word of mouth, various art publications and source-books, artists' submissions/self-promotions, art collectors' referrals; "also through our juried exhibits." Looks for "creative viewpoint—professional presentation and craftsmanship. Common mistakes artists make in their submissions include sloppy presentation, poor quality slides, paper and/or photocopying and errors in spelling and grammar. Quality of work is paramount. We like to try a couple of pieces from an artist in our sales gallery before committing to a larger exhibit."

‡HOWE FINE AND DECORATIVE ART, 241 Driftwood Lane, Bloomingdale IL 60108. (708)529-0787. Owner/Director: Ron Howe. Retail/wholesale gallery. Estab. 1978. Represents 20 emerging, mid-career and established artists/year. Exhibited artists include Harold Altman and Jon Neuse. Sponsors 4 shows/year. Average display time 2 months. Open all year; Tuesday-Saturday, 10-6. Located in a residential area; 1,000 sq. ft.; art nouveau decor. 25% of space for special exhibitions; 75% of space for gallery artists. 90% private collectors, 10% corporate collectors. Overall price range: $100-10,000; most work sold at $1,000-5,000.
Media: Considers oil, acrylic, watercolor, pastel, drawing, ceramics, glass, oil pastel, woodcut, lithograph, wood engraving, mezzotint, linocut and etching. Most frequently exhibits color wood block prints, pastels and watercolors.
Style: Exhibits all styles, impressionism. Genres include landscapes, neighborhood scenes and cityscapes.
Terms: Accepts work on consignment (50% commission). Retail price set by the artist. Gallery provides insurance and promotion; artist pays shipping costs to and from gallery. Prefers oil paintings framed; works on paper unframed but matted.
Submissions: Send query letter with résumé, bio, brochure, SASE, business card and reviews. Call for appointment to show portfolio of originals, photographs, slides and transparencies. Replies only if interested within 1 month. Files all submissions.
Tips: Finds artists by visiting exhibitions, art fairs.

NIU ART MUSEUM, Northern Illinois University, DeKalb IL 60115. (815)753-1936. Fax: (815)753-0198. Acting Director: Peggy Doherty. University museum. Estab. 1970. Exhibits emerging, mid-career and established artists. Sponsors 10 shows/year. Average display time 6 weeks. Open August-May. Located in DeKalb, Illinois. 50% of space for special exhibitions.
Media: Considers all media and all types of prints.
Style: Exhibits all styles and genres.
Terms: "All sales are referred to the artist." Retail price set by artist. Museum provides insurance and promotion; shipping costs are shared.
Submissions: Send query letter with résumé and slides. Replies ASAP. Files "maybes."

THE PEORIA ART GUILD, 1831 N. Knoxville Ave., Peoria IL 61603. (309)685-7522. Director: Ann Conver. Retail gallery for a nonprofit organization. Also has rental program. Estab. 1888. Represents 450 emerging, mid-career and established artists. Sponsored 7 solo and 3 group shows/year. Average display time 6 weeks. Clientele: 50% private collectors, 50% corporate clients. Overall price range: $25-3,000; most work sold at $125-500.
Media: Considers oil, acrylic, watercolor, pastel, mixed media, collage, works on paper, sculpture, ceramic, jewelry, fiber, glass, photography, woodcuts, wood engravings, linocuts, engravings, mezzotints, etchings, lithographs and serigraphs. Most frequently exhibits acrylic/oil, watercolor and etchings/lithographs.
Style: Exhibits all styles. Genres include landscapes, florals and figurative work. Prefers contemporary work, landscapes, realism and painterly abstraction. "Our main gallery supplies all the two-dimensional work to our extensive art rental program. Realistic watercolors, acrylics and oils work into this program easily with painterly abstractions and color field work always a possibility. The main gallery primarily exhibits newly emerging and established Midwestern artists with no restriction to style."
Terms: Accepts work on consignment (40% commission). Retail price set by artist. Offers customer discounts and payment by installments. Gallery provides insurance, promotion and contract. Prefers artwork framed.
Submissions: Send query letter with résumé, slides and SASE. "It's important to include a résumé or an artist's statement." Call for appointment to show portfolio of originals. Replies in 2 months. Files résumé,

slides and statement. All material is returned if not accepted or under consideration.

Tips: Finds artists by visiting exhibitions, word of mouth, artists' submissions/self-promotions and referrals.

‡**PRESTIGE ART GALLERIES**, 3909 W. Howard, Skokie IL 60076. (708)679-2555. President: Louis Schutz. Retail gallery. Estab. 1960. Exhibits 100 mid-career and established artists/year. Interested in seeing the work of emerging artists. Exhibited artists include Jean Paul Avisse. Sponsors 4 shows/year. Average display time 4 months. Open all year; Saturday and Sunday, 11-5; Monday-Wednesday, 10-5. Located in a suburb of Chicago; 3,000 sq. ft. 20% of space for special exhibitions; 50% of space for gallery artists. Clientele: professionals. 20% private collectors, 10% corporate collectors. Overall price range: $100-100,000; most work sold at $1,500-2,000.

Media: Considers oil, acrylic, mixed media, paper, sculpture, ceramics, craft, fiber, glass, lithograph and serigraphs. Most frequently exhibits paintings, glass and fiber.

Style: Exhibits surrealism, impressionism, photorealism and realism. Genres include landscapes, florals, portraits and figurative work. Prefers landscapes, figurative-romantic and floral.

Terms: Accepts work on consignment (50% commission). Retail price set by the gallery and the artist. Gallery provides insurance, promotion and contract; shipping costs are shared. Prefers artwork framed.

Submissions: Send query letter with résumé, slides, bio, SASE and prices/sizes. Call for appointment to show portfolio of photographs. Replies in 2 weeks. "Returns all material if SASE is included."

‡**QUINCY ART CENTER**, 1515 Jersey St., Quincy IL 62301. (217)223-5900. Executive Director: Mariann Barnard. Nonprofit gallery. Estab. 1923. Represents emerging, mid-career and established artists. 650 members. Sponsors 11 shows/year. Average display time 2 months. Open all year; Tuesday-Sunday 1-4. Located in historic district; 3,000 sq. ft.; significant architecture, building built in 1888—addition in 1990. 75% of space for special exhibitions. 100% private collectors. Overall price range: $50-20,000; most work sold at $50-1,500.

Media: Considers all media and all types of prints. Most frequently exhibits paintings, prints and mixed media.

Style: Exhibits all styles, all genres.

Terms: Accepts work on consignment (20% commission). Retail price set by the artist. Gallery provides insurance, promotion and contract; artist pays shipping costs to and from gallery. Prefers artwork framed.

Submissions: Send query letter with résumé and slides. Portfolio should include slides. Replies in 1 month. Files résumé.

Tips: Finds artists through word of mouth, ads for invitationals.

‡**QUINCY UNIVERSITY GRAY GALLERY**, 1800 College, Quincy IL 62301. (217)222-8020, ext. 5371. Gallery Curator/Professor of Art: Robert Mejer. University gallery. Estab. 1968. Represents emerging, mid-career and established artists. 6-8 invited yearly for exhibitions. Exhibited artists include Shelly Thorstensen, Daniel Burke, Robert Nelson and Byron Burford. Sponsors 1 show/year. Average display time 3-4 weeks. Closed July. Located on campus; 111 ft. linear wall space. 100% of space is devoted to special exhibitions of gallery artists. "Hours and location provide viewer intimacy in seeing art." Clientele: "all levels of society." 98% private collectors, 2% corporate collectors. "Location and size of work and shipping are practical considerations." Overall price range $25-2,500; most work sold at $15-500.

● Located in the university library, Gray Gallery has long hours and is accessible to students and the public.

Media: Considers all media, original handpulled prints, woodcuts, engravings, lithographs, pochoir, wood engravings, mezzotints, monotypes, serigraphs, linocuts and etchings. Does not consider glass. Most frequently exhibits works on paper, oil, acrylic and sculpture.

Style: Exhibits all styles and genres. Prefers painterly abstraction, realism, minimalism and pattern painting.

Terms: A small honorarium is given and some transportation is covered. Retail price set by the artist. Offers payment by installments. Gallery provides insurance, promotion and contract. Shipping costs are shared.

Submissions: "Location and size of work and shipping are practical considerations." Send query letter with résumé, slides, bio, brochure and SASE. Portfolio review not required. Replies in 1 month. Files résumé, bio, slides (3) and philosophic statement.

Tips: Finds artists through referrals, slide solicitations, participation in competitive shows, visiting exhibits and meeting artists. "Show work that is current, consistent, representative and qualitive. Slides need to be of high quality. Include a SASE. Be flexible—things can be accomplished/negotiated, satisfying both parties. We make every effort to refer artists to other art centers/galleries if we can't handle or afford them."

LAURA A. SPRAGUE ART GALLERY, Joliet Junior College, 1216 Houbolt Ave., Joliet IL 60436. (815)729-9020. Gallery Director: Joe B. Milosevich. Nonprofit gallery. Estab. 1978. Interested in emerging and established artists. Sponsors 6-8 solo and group shows/year. Average display time is 3-4 weeks.

Media: Considers all media except performance. Most frequently exhibits painting, drawing and sculpture (all media).

Style: Considers all styles.
Terms: Gallery provides insurance and promotion.
Submissions: Send query letter with résumé, brochure, slides, photographs and SASE. Call or write for appointment to show portfolio of originals and slides. Query letters and résumés are filed.

Chicago

A.R.C. GALLERY, 2nd Floor, 1040 W. Huron, Chicago, IL 60622. (312)733-2787. President: Jane Stevens. Nonprofit gallery. Estab. 1973. Exhibits emerging, mid-career and established artists. Interested in seeing the work of emerging artists. 17 members. Exhibited artists include Miriam Schapiro. Average display time 1 month. Closed August. Located in the River West area; 3,500 sq. ft. Clientele: 80% private collectors, 20% corporate collectors. Overall price range $50-40,000; most work sold at $200-4,000.
Media: Considers oil, acrylic, drawings, mixed media, paper, sculpture, ceramic, installation, photography and original handpulled prints. Most frequently exhibits painting, sculpture (installation) and photography.
Style: Exhibits all styles. Genres include landscapes and figurative work. Prefers conceptualism, neo-expressionism and painterly abstraction.
Terms: Rental fee for space. Rental fee covers 1 month. Gallery provides promotion; artist pays shipping costs. Prefers work framed.
Submissions: Send query letter with résumé, slides, bio and SASE. Call for deadlines for review. Portfolio should include slides.

JEAN ALBANO GALLERY, Suite 207, 311 W. Superior St., Chicago IL 60610. (312)440-0770. Director: Jean Albano Broday. Retail gallery. Estab. 1985. Represents 14 mid-career artists. Interested in seeing the work of emerging artists. Exhibited artists include Martin Facey and Jim Waid. Average display time 5 weeks. Open all year. Located downtown in River North gallery district; 1,600 sq. ft. 60% of space for special exhibitions; 40% of space for gallery artists. Clientele: 80% private collectors, 20% corporate collectors. Overall price range: $1,000-20,000; most work sold at $2,500-6,000.
Media: Considers oil, acrylic, sculpture and mixed media. Most frequently exhibits mixed media, oil and acrylic. Prefers non-representational, non-figurative and abstract styles.
Terms: Accepts artwork on consignment (50% commission). Retail price set by gallery and artist; shipping costs are shared.
Submissions: Send query letter with résumé, bio, SASE and well-labeled slides: "size, name, title, medium, top, etc." Write for appointment to show portfolio. Replies in 4-6 weeks. "If interested, gallery will file bio/ résumé and selected slides."
Tips: "We look for artists who make use of non-conventional materials in their work, i.e., diffraction grating or industrial netting and dental acrylic."

‡ARTEMISIA GALLERY, 700 N. Carpenter, Chicago IL 60622. (312)226-7323. Presidents: Sonja Carlborg, Barbara Blades. Cooperative and nonprofit gallery/alternative space. Estab. 1973. 18 members. Sponsors 60 solo shows/year. Average display time 4 weeks. Interested in emerging and established artists. Overall price range: $150-10,000; most work sold at $600-2,500.
Media: Considers oil, acrylic, watercolor, pastel, pen & ink, drawings, mixed media, collage, works on paper, sculpture, ceramic, craft, fiber, glass, installation, photography, egg tempera, woodcuts, wood engravings, linocuts, engravings, mezzotints, etchings, lithographs, pochoir and serigraphs. Prefers paintings, sculpture and installation. "Artemisia is a cooperative art gallery run by artists. We try to promote women artists."
Terms: Co-op membership fee plus donation of time; rental fee for space; rental fee covers 1 month. Retail price set by artist. Exclusive area representation not required. Gallery provides insurance; artist pays for shipping.
Submissions: Send query letter with résumé, slides and SASE. Write to schedule an appointment to show a portfolio, which should include slides. Replies in 6 weeks. All material is returned if not accepted or under consideration.
Tips: "Send clear, readable slides, labeled and marked 'top' or with red dot in lower left corner."

MARY BELL GALLERIES, 215 W. Superior, Chicago IL 60610. (312)642-0202. Fax: (312)642-6672. President: Mary Bell. Retail gallery. Estab. 1975. Represents mid-career artists. Interested in seeing the work of emerging artists. Exhibited artists include Mark Dickson. Sponsors 4 shows/year. Average display time 6 weeks. Open all year. Located downtown in gallery district; 5,000 sq. ft. 25% of space for special exhibitions. Clientele: corporations, designers and individuals. 20% private collectors, 80% corporate collectors. Overall price range: $500-8,000; most work sold at $1,000-3,000.
Media: Considers oil, acrylic, watercolor, pastel, mixed media, collage, paper, sculpture, ceramic, fiber, glass, original handpulled prints, offset reproductions, woodcuts, engravings, lithographs, pochoir, posters, wood engravings, mezzotints, serigraphs, linocuts and etchings. Most frequently exhibits canvas, unique paper and sculpture.

Style: Exhibits expressionism, painterly abstraction, impressionism, realism and photorealism. Genres include landscapes and florals. Prefers abstract, realistic and impressionistic styles. Does not want to see "figurative or bizarre work."

Terms: Accepts artwork on consignment (50% commission). Retail price set by gallery and artist. Offers customer discounts and payment by installments. Gallery provides insurance and contract; shipping costs are shared. Prefers artwork unframed.

Submissions: Send query letter with slides and SASE. Portfolio review requested if interested in artist's work. Portfolio should include slides.

Tips: "Today less expensive works are selling, pieces between $2,000-3,000."

‡**BERET INTERNATIONAL GALLERY,** 3rd Floor, 2211 N. Elston Ave., Chicago IL 60614. (312)489-6518. Director: Ned Schwartz. Alternative space. Estab. 1991. Represents 20 emerging, mid-career and established artists/year. Exhibited artists include Jno Cook and Dennis Kowalski. Sponsors 8 shows/year. Average display time 5 weeks. Open all year; Thursday, 1-7; Friday and Saturday, 1-5; or by appointment. Located near north west Chicago, Bucktown; 2,500 sq. ft.; shows conceptual art, mechanical sculpture. 100% of space for special exhibitions; backrooms for gallery artists. Clientele: "serious art intellectuals." 90% private collectors, 10% corporate collectors. Overall price range: $25-5,000.

Style: Exhibits conceptualism.

Terms: Accepts work on consignment (30% commission). Retail price set by the gallery and the artist. Gallery provides insurance, promotion and contract; artist pays shipping costs to and from gallery.

Submissions: "All art has strong social relevance. No decorative craft." Send query letter with slides, photographs and SASE. Call or write for appointment. Files résumé, slides and photos.

Tips: Finds artists through visiting exhibitions, artists' submissions. "Neo-critics and post-collectors always welcome."

CAIN GALLERY, 111 N. Marion St., Oak Park IL 60301. (708)383-9393. Owners: Priscilla and John Cain. Retail gallery. Estab. 1973. Represents 75 emerging, mid-career and established artists. "Although we occasionally introduce unknown artists, because of high overhead and space limitations, we usually accept only artists who are somewhat established, professional and consistently productive." Sponsors 6 solo shows/year. Average display time 6 months. Open all year. Recent move triples space, features an on-site interior design consultant. Clientele: 80% private collectors, 20% corporate clients. Overall price range: $100-6,000; most artwork sold at $500-1,000.

Media: Considers oil, acrylic, watercolor, mixed media, collage, sculpture, crafts, ceramic, woodcuts, engravings, mezzotints, etchings, lithographs and serigraphs. Most frequently exhibits acrylic, watercolor and serigraphs.

Style: Exhibits impressionism, realism, surrealism, painterly abstraction, imagism and all styles. Genres include landscapes, florals, figurative work. Prefers impressionism, abstraction and realism. "Our gallery is a showcase for living American artists—mostly from the Midwest, but we do not rule out artists from other parts of the country who attract our interest. We have a second gallery in Saugatuck, Michigan, which is open during the summer season. The Saugatuck gallery attracts buyers from all over the country."

Terms: Accepts artwork on consignment. Retail price set by artist. Sometimes offers customer payment by installment. Exclusive area representation required. Gallery provides insurance, promotion, contract and shipping costs from gallery. Prefers artwork framed.

Submissions: Send query letter with résumé and slides. Portfolio review requested if interested in artist's work. Portfolio should include originals and slides.

Tips: Finds artists through visiting exhibitions, word of mouth, artists' submissions/self-promotions and art collectors' referrals. "We are now showing more fine crafts, especially art glass and sculptural ceramics. The most common mistake artists make is amateurish matting and framing."

CHIAROSCURO, 700 N. Michigan Ave., Chicago IL 60611. (312)988-9253. Proprietors: Ronna Isaacs and Peggy Wolf. Contemporary retail gallery. Estab. 1987. Represents over 200 emerging artists. Average display time 3 months. "Located on Chicago's 'Magnificent Mile; 2500 sq. ft. on Chicago's main shopping boulevard, Michigan Ave. Space was designed by award winning architects *Himmel•Bonner* to show art and contemporary crafts in an innovative way." Overall price range: $30-2,000; most work sold at $50-1,000.

Media: All 2-dimensional work—mixed media, oil, acrylic; ceramics (both functional and decorative works); sculpture, art furniture, jewelry. "We moved out of Chicago's gallery district to a more 'retail' environment a year and a half ago because many galleries were closing. Paintings seemed to stop selling, even at the $500-1,000 range, where functional pieces (i.e. furniture) would sell at that price."

Style: "Generally we exhibit bright contemporary works. Paintings are usually figurative works either traditional oil on canvas or to the very non-traditional layers of mixed-media built on wood frames. Other works are representative of works being done by today's leading contemporary craft artists. We specialize in affordable art for the beginning collector, and are focusing on 'functional works' currently."

Terms: Accepts work on consignment (50% commission). Retail price set by gallery and artist. Customer discounts and payment by installment are available. Gallery provides insurance.

Submissions: Send query letter (Attn: Peggy Wolf) with résumé, slides, photographs, price list, bio and SASE. Portfolio review requested if interested in artist's work. All material is returned if not accepted or under consideration.

Tips: Finds artists through agents, by visiting exhibitions and national craft and gift shows, word of mouth, various art publications and sourcebooks, artists' submissions/self-promotions and art collectors' referrals. "Don't be afraid to send photos of anything you're working on. I'm happy to work with the artist, suggest what's selling (at what prices). If it's not right for this gallery, I'll let them know why."

‡CHICAGO CENTER FOR THE PRINT, 1509 W. Fullerton, Chicago IL 60614. (312)477-1585. Fax: (312)477-1851. Owner/Director: Richard H. Kasvin. Retail gallery. Estab. 1979. Represents 100 mid-career and established artists/year. May be interested in seeing the work of emerging artists in the future. Exhibited artists include Hiratsuka, Villar. Sponsors 5-6 shows/year. Average display time 4-6 weeks. Open all year; Tuesday-Saturday, 11-7; Sunday, 12-5. Located in Lincoln Park, Chicago; 2,500 sq. ft.; "we represent works on paper, Swiss graphics and vintage posters." 40% of space for special exhibitions; 60% of space for gallery artists. 90% private collectors, 10% corporate collectors. Overall price range: $300-3,000; most work sold at $500-700.

Media: Considers mixed media, paper, woodcut, engraving, lithograph, wood engraving, mezzotint, serigraphs, linocut, etching and posters. Most frequently exhibits prints and posters.

Style: Exhibits all styles. Genres include landscapes and figurative work. Prefers abstract, figurative and landscape.

Terms: Accepts work on consignment (50% commission) or buys outright for 40-60% of the retail price (30-60 days). Retail price set by the gallery and the artist. Gallery provides promotion; shipping costs are shared. Prefers artwork unframed.

Submissions: Send query letter with résumé, slides and photographs. Write for appointment to show portfolio of originals, photographs and slides. Files everything.

Tips: Finds new artists through agents, by visiting exhibitions, word of mouth, art publications and sourcebooks, artists' submissions.

‡EVA COHON GALLERY, 2057 Green Bay Rd., Highland Park IL 60035 and 301 W. Superior St., Chicago IL 60614. (708)432-7310. Fax: (708)432-7399 (Highland Park); (312)664-3669. Fax: (312)664-8573 (Chicago). Retail gallery. Estab. 1974. Represents 20 emerging, mid-career and established artists/year. Exhibited artists include Aaron Karp, Kikou Saito. Sponsors 11-12 shows/year. Average display time 5-6 weeks. Open all year; Tuesday-Saturday, 10:30-5. Two locations: downtown, suburbs; 1,200 sq. ft. (downtown), 7,200 sq. ft. (Highland Park); "friendly and knowledgeable staff." 75% of space for special exhibitions; 100% of space for gallery artists. Clientele: "North Shore Jewish." 95% private collectors, 5% corporate collectors. Overall price range: $1,000-40,000; most work sold at $4,000-8,000.

Media: Considers oil, acrylic, mixed media, collage, sculpture and fiber. Most frequently exhibits oil on canvas, acrylic on canvas and sculpture.

Style: Exhibits neo-expressionism, painterly abstraction, all styles, color field. Genres include figurative work, all genres. Prefers abstract, neo-expressionism and color field.

Terms: Accepts work on consignment (50% commission) or buys outright for 100% of retail price. Retail price set by the gallery and the artist. Shipping costs are shared. Prefers artwork framed.

Submissions: Send query letter with résumé, slides, bio, photographs and SASE. Write for appointment to show portfolio of originals. Replies in 1 month. "We return unused material."

COLUMBIA COLLEGE ART GALLERY, 72 E. 11th St., Chicago IL 60605. (312)663-1600, ext. 110 or ext. 104. Fax: (312)663-1656. Director: Denise Miller-Clark. Assistant Director: Ellen Ushioka. Nonprofit gallery. Estab. 1984. Exhibits emerging, mid-career and established artists in the Chicago area. Sponsors 3 shows/year. Average display time 2 months. Open September-April. Located downtown in the 11th St. campus of Columbia College, Chicago; 1645 sq. ft. 100% of space for special exhibitions.

Media: Considers oil, acrylic, watercolor, pastel, pen & ink, drawing, mixed media, collage, paper, sculpture, ceramic, craft, fiber, glass and installation.

Style: Exhibits all styles and genres.

Terms: Accepts artwork on consignment (25-30% commission). Retail price set by artist. Shipping costs are shared.

Submissions: Send query letter with résumé, slides, bio, SASE and reviews, if any. "Portfolios are reviewed Friday mornings between 9 a.m. and 1 p.m. The Art Gallery staff offices are located at The Museum of Contemporary Photography of Columbia College Chicago in the main campus building at 600 S. Michigan Ave. Chicago-area residents are asked to deliver portfolios, which may include finished artworks or slide reproductions, to the Museum address by 5 p.m. on the proceding Thursday. Portfolios will be available for pick-up by 1 p.m. on Friday. We suggest you telephone the Museum office to let us know when you will be dropping off a portfolio for review, since we are occasionally out of town, or otherwise unavailable. Visitors to Chicago who will not be in town on a Friday may call Ellen Ushioka at (312)663-5554 to make arrangements for their portfolios to be reviewed on another day." Replies in 1 month. Files slides and bio for future reference, if interested.

Tips: "Portfolio should be of professional quality and show a coherent body of work."

CONTEMPORARY ART WORKSHOP, 542 W. Grant Place, Chicago IL 60614. (312)472-4004. Director: Lynn Kearney. Nonprofit gallery. Estab. 1949. Interested in emerging and mid-career artists. Average display time is 4½ weeks "if it's a show, otherwise we can show the work for an indefinite period of time." Clientele: art-conscious public. 75% private collectors, 25% corporate clients. Overall price range: $300-5,000; most artwork sold at $1,000 "or less."

Media: Considers oil, acrylic, watercolor, mixed media, works on paper, sculpture, installations and original handpulled prints. Most frequently exhibits paintings, sculpture and works on paper.

Style: "Any high-quality work" is considered.

Terms: Accepts work on consignment (33% commission). Retail price set by gallery or artist. "Discounts and payment by installments are seldom and only if approved by the artist in advance." Exclusive area representation not required. Gallery provides insurance and promotion.

Submissions: Send query letter with résumé, slides and SASE. Slides and résumé are filed. "First we review slides and then send invitations to bring in a portfolio based on the slides."

Tips: Finds artists through call for entries in arts papers; visiting local BFA, MFA exhibits; referrals from other artists, collectors. "Looks for a professional approach and a fine art school degree (or higher). Artists a long distance from Chicago will probably not be considered."

‡DEBOUVER FINE ARTS, Suite 15-109 Merchandise Mart, Chicago IL 60654. (312)527-0021. President: Ronald V. DeBouver. Wholesale gallery and art consultancy. Estab. 1981. Clientele: interior designers and wholesale trade only. Represents 200 emerging, mid-career and established artists. Overall price range: $50-8,000; most artwork sold at $500.

Media: Considers oils, acrylics, watercolor, drawings, mixed media, collage, paper and posters. Most frequently exhibits oils, watercolors, graphics.

Style: Exhibits abstraction, color field, painterly abstraction, impressionistic, photorealistic and realism. Genres include landscapes, florals, Americana, English and French school and figurative work. Most frequently exhibits impressionistic, landscapes and floral. Currently seeking impressionistic, realism and abstract work.

Terms: Accepts work on consignment (33-50% commission). Retail price is set by gallery or artist. Offers customer discounts and payment by installments. Exclusive area representation not required.

Submissions: Send résumé, slides, photographs, prices and sizes. Indicate net prices. Portfolio review requested if interested in artist's work. Portfolio should include originals, slides and transparencies. Resume and photos are filed.

Tips: Finds artists through Chicago and New York art expos, art exhibits, word of mouth, artists' submissions and collectors' referrals. "Business has been rather slow in the last year. You must work twice as hard to finalize a sale. Money is very tight."

OSKAR FRIEDL GALLERY, Suite 302, 750 N. Orleans, Chicago IL 60610. (312)337-7550. Fax: (312)337-2466. Assistant Director: George Stahl. Retail gallery. Estab. 1988. Represents 10 emerging, mid-career and established artists. Exhibited artists include Florian Depenthal and Zhou Brothers. Sponsors 8 shows/year. Average display time 6 weeks. Open all year. Located downtown in River North gallery district; 800 sq. ft. "For large scale exhibitions we expand into Suite 303 on the same floor. The additional space is approximately 5,000 sq. ft. and is used for 4 exhibitions a year each running for 6 weeks." Clientele: emerging private collectors. 80% private collectors, 20% corporate collectors. Overall price range: $500-30,000; most work sold at $3,000-8,000.

Media: Considers oil, acrylic, pastel, pen & ink, drawings, mixed media, collage, sculpture and installation. Most frequently exhibits oil, acrylic and sculpture.

Style: Exhibits expressionism, neo-expressionism, conceptualism and painterly abstraction. Prefers contemporay, abstract expressionist and conceptualist styles.

Terms: Accepts artwork on consignment (50% commission). Retail price set by gallery and artist. Gallery provides insurance, promotion, contract and some shipping costs from gallery.

Submissions: Send query letter with résumé, slides, bio, brochure, photographs, SASE and reviews. Portfolio review requested if interested in artist's work. Portolio should include photographs, slides and transparencies. Replies in 2-3 weeks.

Tips: "We have added an additional space (LAYAWAY Visual Arts) where we work exclusively with local artists. All media, all styles—mostly group shows. It is located on North Ave. where many new, young, experimental galleries are springing up."

ROBERT GALITZ FINE ART, 166 Hilltop Court, Sleepy Hollow IL 60118. (708)426-8842. Fax: (708)426-8846. Owner: Robert Galitz. Wholesale representation to the trade. Makes portfolio presentations to corporations. Estab. 1986. Represents 40 emerging, mid-career and established artists. Exhibited artists include Marko Spalatin and Jack Willis. Open by appointment. Located in far west suburban Chicago.

Media: Considers oil, acrylic, watercolor, mixed media, collage, ceramic, fiber, original handpulled prints, engravings, lithographs, pochoir, wood engravings, mezzotints, serigraphs and etchings. "Interested in original works on paper."

Style: Exhibits expressionism, painterly abstraction, surrealism, minimalism, impressionism and hard-edge geometric abstraction. Interested in all genres. Prefers landscapes and abstracts.

Terms: Accepts artwork on consignment (variable commission) or artwork is bought outright (25% of retail price; net 30 days). Retail price set by artist. Customer discounts and payment by installment are available. Gallery provides promotion and shipping costs from gallery. Prefers artwork unframed only.

Submissions: Send query letter with SASE and submission of art. Portfolio review requested if interested in artist's work. Files bio, address and phone.

GRUEN GALLERIES, 226 W. Superior St., Chicago IL 60610. (312)337-6262. Co-Directors: Bradley Lincoln and Renée Sax. Estab. 1959. Represents 20 emerging, mid-career and established artists. Sponsors 9 solo and 3 group shows/year. Average display time is 1 month. Large space with high ceiling. Overall price range: $500-25,000; most artwork sold at $2,500-5,000.

Media: Considers oil, acrylic, paper and contemporary sculpture. Most frequently exhibits acrylic and oil.

Style: Exhibits painterly abstraction. Genres include landscapes and figurative work.

Terms: Accepts work on consignment (50% commission). Retail price set by gallery or artist. Sometimes offers customer discounts and payment by installment. Exclusive area representation required. Gallery provides insurance and promotion; shipping costs are shared.

Submissions: Send query letter, artist's statement, résumé, slides of current work (properly labeled) and SASE. Portfolio review requested if interested in artist's work.

Tips: "I think galleries are moving into undeveloped areas. There is less politically angst-ridden art."

GWENDA JAY GALLERY, 2nd Floor, 301 W. Superior, Chicago IL 60610. (312)664-3406. Director: Gwenda Jay. Retail gallery. Estab. 1988. Represents mainly mid-career artists, but emerging and established, too. Exhibited artists include Richard Hunt and Ruth Weisberg. Sponsors 11 shows/year. Average display time 4 weeks. Open all year. Located in River North area; 2,000 sq. ft.; 60% of space for 1-2 person and group exhibitions. Clientele: "all types—budding collectors to corporate art collections." Overall price range: $500-12,000; most artwork sold at $1,000-6,000.

● The gallery has a small exhibition space but bigger back room, emphasizing more personal contact with collectors and less ambitious group shows.

Media: Considers oil, mixed media and sculpture. "If there is an architectural theme, we may consider prints of limited editions only."

Style: Exhibits various styles and a "personal vision." Genres include landscapes and figurative imagery. Styles are contemporary with classical elements or themes.

Terms: Accepts work on consignment (50% commission). Retail price set by the gallery. Offers customer discounts and payment by installments. Gallery provides insurance, promotion and contract; shipping costs are shared.

Submissions: Send query letter with résumé, slides, bio and SASE. No unsolicited appointments. Replies in 2-4 weeks.

Tips: Finds artists through visiting exhibitions and artists' submissions. "Please send slides with résumé and SASE first. We will reply and schedule an appointment once slides have been reviewed if we wish to see more. Please be familiar with the gallery's style—for example, we don't typically carry abstract art." Looking for "consistent style and dedication to career. There is no need to have work framed excessively. The work should stand well on its own, initially."

HYDE PARK ART CENTER, 5307 S. Hyde Park Blvd., Chicago IL 60615. (312)324-5520. Executive Director: Eileen M. Murray. Nonprofit gallery. Estab. 1939. Exhibits emerging artists. Sponsors 9 group shows/year. Average display time is 4-6 weeks. Located in the historic Del Prado building, in a former ballroom. "Primary focus on Chicago area artists not currently affiliated with a retail gallery." Clientele: general public. Overall price range: $100-10,000.

Media: Considers all media. Interested in seeing "innovative, 'cutting edge' work by young artists; also interested in proposals from curators, groups of artists."

Terms: Accepts work "for exhibition only." Retail price set by artist. Sometimes offers payment by installment. Exclusive area representation not required. Gallery provides insurance and contract.

Submissions: Send query letter with résumé, no more than 6 slides and SASE. Will not consider poor slides. "A coherent artist's statement is helpful." Portfolio review not required. Replies in 3-6 weeks.

A bullet introduces comments by the editor of Artist's & Graphic Designer's Market *indicating special information about the listing.*

Tips: Finds artists through open calls for slides, curators, visiting exhibitions (especially MFA programs) and artists' submissions. Prefers not to receive phone calls. "Do not bring work in person."

ILLINOIS ART GALLERY, (formerly State of Illinois Art Gallery), Suite 2-100, 100 W. Randolph, Chicago IL 60601. (312)814-5322. Fax: (312)814-3891. Assistant Administrator: Jane Stevens. Museum. Estab. 1985. Exhibits emerging, mid-career and established artists. Sponsors 6-7 shows/year. Average display time 7-8 weeks. Open all year. Located "in the Chicago loop, in the State of Illinois Center designed by Helmut Jahn." 100% of space for special exhibitions.
 ● This museum, which was once state funded, is now privately funded.
Media: All media considered, including installations.
Style: Exhibits all styles and genres, including contemporary and historical work.
Terms: "We exhibit work, do not handle sales." Gallery provides insurance and promotion; artist pays for shipping. Prefers artwork framed.
Submissions: Accepts only artists from Illinois. Send résumé, slides, bio and SASE. Write for appointment to show portfolio of slides.

ILLINOIS ARTISANS PROGRAM, James R. Thompson Center, 100 W. Randolph St., Chicago IL 60601. (312)814-5321. Fax: (312)814-3891. Director: Ellen Gantner. Three retail shops operated by the nonprofit Illinois State Museum Society. Estab. 1985. Represents over 1,000 artists; emerging, mid-career and established. Average display time 6 months. "Accepts only juried artists living in Illinois." Clientele: tourists, conventioneers, business people, Chicagoans. Overall price range: $10-5,000; most artwork sold at $25-100.
Media: Considers all media. "The finest examples in all media by Illinois artists."
Style: Exhibits all styles. "Seeks contemporary, traditional, folk and ethnic arts from all regions of Illinois."
Terms: Accepts work on consignment (50% commission). Retail price set by gallery and artist. Sometimes offers customer discounts. Exclusive area representation not required. Gallery provides promotion and contract.
Submissions: Send résumé and slides. Accepted work is selected by a jury. Resume and slides are filed. "The finest work can be rejected if slides are not good enough to assess." Portfolio review not required.
Tips: Finds artists through word of mouth, requests by artists to be represented and by twice yearly mailings to network of Illinois crafters announcing upcoming jury dates.

KLEIN ART WORKS, 400 N. Morgan, Chicago IL 60622. (312)243-0400. Fax: (312)243-6482. Director: Paul Klein and Judith Simon. Retail gallery. Estab. 1981. Represents 20 emerging, mid-career and established artists. Interested in seeing the work of emerging artists. Exhibited artists include Sam Gilliam and Stephanie Weber. Sponsors 10 shows/year. Average display time 5 weeks. Open all year. Located in industrial section of downtown; 4,000 sq. ft.; spacious, with steel floors, no columns and outdoor sculpture garden. 80% of space for special exhibitions; 20% of space for gallery artists. Clientele: 75% private collectors, 25% corporate collectors. Overall price range: $1,000-50,000; most artwork sold at $2,000-10,000.
Media: Considers oil, acrylic, mixed media, sculpture, ceramic, installation and photography. Most frequently exhibits painting and sculpture.
Style: Exhibits abstraction.
Terms: Accepts work on consignment (50% commission). Retail price set by gallery and artist. Gallery provides insurance, promotion and contract; shipping costs are shared.
Submissions: Send query letter with résumé, slides, bio, reviews and SASE. Replies in 2-6 weeks.

MARS GALLERY, 1139 W. Fulton Market, Chicago IL 60607. (312)226-7808. Owner: Barbara Bancroft. Retail gallery. Estab. 1987. Represents 10-15 emerging, mid-career and established artists. Exhibited artists include Peter Mars and Craig Kersten. Sponsors 7 shows/year. Average display time 3-4 weeks. Open all year by appointment only. Located downtown; 2,000 sq. ft. 50% of space for special exhibitions; 50% of space for gallery artists. Clientele: young professionals. 80% private collectors, 20% corporate collectors. Overall price range: $250-5,000; most work sold at $500-1,000.
Media: Considers oil, acrylic, watercolor, pastel, mixed media, collage and original handpulled prints. Most frequently exhibits acrylic, collage and mixed media.
Style: Exhibits pop and outsider art. All genres — especially humorous. Prefers pop outsider and painterly abstraction.
Terms: Accepts work on consignment (50% commission). Retail price set by gallery and artist. Sometimes offers payment by installment. Gallery provides promotion; artist pays shipping costs. Prefers artwork framed only.
Submissions: Send query letter with résumé, brochure, photographs and SASE. Portfolio review requested if interested in artist's work. Portfolio should include originals, photographs and transparencies. Replies in 1 month. Files résumé.
Tips: Finds artists through art collectors' referrals.

‡MASTERS' PORTFOLIO, Suite A, 2214 N. Kenmore, Chicago IL 60614. Contact: Scott B. Johnson. Art consultancy and private dealer. Estab. 1984. Represents 20 established artists/year. Exhibiting artists from

Manet through DeKooning. Sponsors 1 show/year. Average display time 3 months. Open all year; Tuesday-Friday, 10:30-5:30; Saturday, 10:30-2:30. Located north of downtown; 1,000 sq. ft. Clientele: museums, private and corporate collectors. 55% private collectors, 25% corporate collectors.
Media: Considers oil, watercolor, pastel, pen & ink, drawing and sculpture. Most frequently exhibits oil, drawings and watercolor.
Terms: Retail price set by the gallery. Gallery provides promotion and contract. Prefers artwork framed.
Submissions: Send query letter with résumé and slides. Write for appointment to show portfolio of originals and transparencies. Replies only if interested in 1 month.
Tips: Finds artists through visiting exhibitions and word of mouth.

‡**MATRIX GALLERY LTD.**, 4th Floor, 1255 S. Wabash, Chicago IL 60605. (312)554-8868. President: Charles Boone. Cooperative gallery. Estab. 1991. Represents 10-15 emerging and mid-career artists/year. 10 members. Sponsors 12 shows/year. Average display time 1 month. Open all year; Tuesday-Saturday, 1-5. Located on the South Loop; 1,150 sq. ft. 75% of space for special exhibitions. 100% private collectors. Overall price range: $50-5,000; most work sold at $50-1,000.
Media: Considers all media and woodcut, engraving, lithograph, wood engraving, mezzotint, serigraphs, linocut and etching. Most frequently exhibits painting, printmaking and photography.
Style: Exhibits all styles, all genres.
Terms: Co-op membership fee plus a donation of time (30% commission). Retail price set by the artist. Gallery provides promotion; artist pays shipping costs to and from gallery. Prefers artwork framed.
Submissions: Send query letter with résumé, slides, bio and SASE. Call or write for appointment to show portfolio of slides. Replies in 6 weeks.
Tips: Finds artists through artists' submissions and word of mouth.

PETER MILLER GALLERY, 401 W. Superior St., Chicago IL 60610. (312)951-0252. Co-Director: Natalie R. Domchenko. Retail gallery. Estab. 1979. Represents 15 emerging, mid-career and established artists. Sponsors 9 solo and 3 group shows/year. Average display time is 1 month. Clientele: 80% private collectors, 20% corporate clients. Overall price range: $500-20,000; most artwork sold at $5,000 and up.
Media: Considers oil, acrylic, mixed media, collage, sculpture, installations and photography. Most frequently exhibits oil and acrylic on canvas and mixed media.
Style: Exhibits abstraction, conceptual, post-modern, and realism.
Terms: Accepts work on consignment (50% commission). Retail price set by gallery and artist. Exclusive area representation required. Insurance, promotion and contract negotiable.
Submissions: Send slides and SASE. Slides, show card are filed.
Tips: Looks for "classical skills underlying whatever personal vision artists express. Send a sheet of 20 slides of work done in the past 18 months with a SASE."

‡**MORE BY FAR**, 944 N. Noble, Chicago IL 60622-5303. (312)489-4886. Contact: Kimberlie. Alternative space. Estab. 1975. Represents emerging artists. Exhibited artists include: Lydia Kirov, Lloyd Altera and Kimberlie J.K. Rosa. Sponsors 12 shows/year. Work displayed "until it sells." Open all year; Tuesday-Sunday, 11-8. Located "15 minutes from the Loop;" 600 sq. ft. "I continue to present other gallerys and co-ops with emerging artists." 100% of space for special exhibitions. Clientele: lawyers, doctors, white and blue collar. 75% private collectors, 15% corporate collectors. Overall price range: $10-10,000; most work sold at $10-5,000.
Media: Considers oil, acrylic, watercolor, pastel, pen & ink, drawing, mixed media, paper, sculpture, ceramics, fiber, glass, photography, metals, jewelry, woodcut, engraving, lithograph, wood engraving mezzotint, serigraphs, linocut, etching (original or limited editions). Most frequently exhibits metals, stone sculpture, any figurative.
Style: All styles. Genres include landscapes, florals, Americana, Southwestern, Western, wildlife, portraits and figurative work. Prefers realistic.
Terms: Accepts work on consignment (40% commission). Retail price set by the artist. Gallery provides promotion and contract; artist pays shipping to and from gallery.
Submissions: Send query letter with slides, bio, photographs and business card. Call or write for appointment to show portfolio of originals. Replies in 1 month. Files business cards and letters.
Tips: Finds artists through artists' submissions, word of mouth and referrals.

N.A.M.E., 4th Floor, 1255 S. Wabash, Chicago IL 60605. (312)226-0671. Director: Marguerite Perret. Non-profit artists organization. Estab. 1973. Represents emerging, mid-career and established artists. 150 members. Sponsors 8 shows/year. Average display time 5 weeks. Open all year. Located in the South Loop; 2,000 sq. ft.
Media: Considers all media.
Style: Exhibits new work and new genres.
Terms: Gallery takes 20% commission. Retail price set by artist. Gallery provides promotion and shipping costs.

The image of "a shattered, yet intact, figure" was inspired by Marcia Karlin's experiences with her daughter's epilepsy. The idea was transformed into Spellbound, a 76×69 studio art quilt which was exhibited in a one-person show at Vale Craft Gallery. Owner Peter Vale was struck by "the bright colors, strong imagery and unusual techniques" of her work.

Submissions: "No walk-in portfolio reviews." Call gallery for proposal guidelines.
Tips: "Proposals are reviewed on an ongoing basis. They are acknowledged immediately and decided upon within 3 months after review deadline."

‡PHYLLIS NEEDLMAN GALLERY, #2505, 50 E. Bellevue Place, Chicago IL 60611-1170 (312)612-7929. Proprietor: Phyllis Needlman. Retail gallery. Estab. 1976. Represents 6 established artists. "Large selection of Latin American artists, including graphics by Tamayo, Zuniga, Friedeberg." Sponsors 4 solo and 2 group shows/year. Average display time is 1 month. Clientele: 70% private collectors; 30% corporate clients. Overall price range: $500-20,000; most artwork sold at $2,000-3,000.
Media: Considers oils, acrylics, drawings, mixed media, paper, sculpture and glass.
Style: Interested in contemporary and Latin American art.
Terms: Retail price is set by gallery or artist. Exclusive area representation required. Gallery provides insurance and promotion.
Submissions: Send query letter with résumé and slides. Call or write to schedule an appointment to show a portfolio, which should include originals and slides.

NORTHERN ILLINOIS UNIVERSITY ART GALLERY IN CHICAGO, 212 W. Superior, Chicago IL 60610. (312)642-6010. Director: Peggy Doherty. Nonprofit university gallery. Estab. 1984. Exhibits emerging, mid-career and established artists. Sponsors 6 shows/year. Average display time 6-7 weeks. Closed August. Located in Chicago gallery area (near downtown); 1,656 sq. ft. 100% of space for special exhibitions. Overall price range: $100-50,000.
Media: Considers all media.
Style: Exhibits all styles and genres. Interested in seeing contemporary styles.
Terms: "No charge to artist and no commission." Retail price set by artist. Gallery provides insurance and promotion; shipping costs are shared, depending on costs. Prefers artwork framed.

Submissions: Send query letter with résumé, slides, SASE, reviews and statement. Replies "ASAP." Files résumés, bios, statements and paperwork.
Tips: "Always include SASE. Work for exhibition is rarely selected at the first viewing."

‡**PORTIA GALLERY,** 1702 N. Damen, Chicago IL 60647. (312)862-1700. Director:Elysabeth Alfano. Retail gallery. Estab. 1993. Represents 30 emerging, mid-career and established glass artists/year. Average display time 3 months. Open all year; Tuesday-Friday 12-7; Saturday and Sunday 12-5. Located in Chicago's Soho; 180 sq. ft.; glass sculpture, interior decor, high quality paperweights. 100% of space for gallery artists. Clientele: designers, collectors. Overall price range: $50-15,000; most work sold at $300-1,500.
Media: Considers glass only.
Terms: Accepts work on consignment (50% commission). Retail price set by the artist. Gallery provides insurance, promotion, contract and shipping costs from gallery; artist pays shipping costs to gallery.
Submissions: Send query letter with résumé, slides, SASE and reviews (if possible). Replies in 1 month. Files résumé, artist statement, slides — only if accepted.
Tips: "We are very approachable."

RANDOLPH STREET GALLERY, Dept. AM, 756 N. Milwaukee, Chicago IL 60622. (312)666-7737. Fax: (312)666-8986. Contact: Exhibition Committee or Time Arts Committee. Nonprofit gallery. Estab. 1979. Sponsors 10 group shows/year. Average display time is 1 month. Interested in emerging, mid-career and established artists.
Media: Considers all media. Most frequently exhibits mixed media and performance.
Style: Exhibits hard-edge geometric abstraction, painterly abstraction, minimalism, conceptualism, postmodern, feminist/political, primitivism, photorealism, expressionism and neo-expressionism. "We curate exhibitions which include work of diverse styles, concepts and issues, with an emphasis on works relating to social and critical concerns."
Terms: Retail price is set by artist. Exclusive area representation not required. Gallery provides shipping costs, promotion, contract and honorarium.
Submissions: Send résumé, brochure, slides, photographs and SASE. "Live events and exhibitions are curated by a committee which meets monthly." Résumés, slides and other supplementary material are filed.
Tips: "Some of the most common mistakes artists make in presenting their work are not sending slides, not clearly labeling slides and not sending enough written description of work that is difficult to grasp in slide form."

‡**STRUVE GALLERY,** 309 W. Superior St., Chicago IL 60610. (312)787-0563. Fax: (312)787-7268. Owner: Bill Struve. Retail gallery. Estab. 1958. Represents 35 emerging, mid-career and established artists. Exhibited artists include James Winn and William T. Wiley. Average display time 5 weeks. Open all year. Located in River North; 5,000 sq. ft. Overall price range: $100-100,000; most work sold at $2,500-15,000.
Media: Considers oil, acrylic, watercolor, pastel, pen & ink, drawing, mixed media, paper, sculpture, woodcuts, engravings, lithographs, pochoir, wood engravings, mezzotints, linocuts and etchings. Most frequently exhibits painting, drawing and sculpture.
Style: Exhibits painterly abstraction, surrealism, realism and hard-edge geometric abstraction. All genres. Prefers landscape, abstract and figurative.
Terms: Accepts artwork on consignment (50% commission). Buys outright for 50-80% of retail price. Resales on individual basis. Retail price set by the gallery. Gallery provides insurance and promotion and pays for shipping costs from gallery. Prefers artwork framed.
Submissions: Send query letter with slides, bio and SASE. Call to schedule an appointment to show a portfolio, which should include slides, photographs and transparencies. Replies in 2-4 weeks. Files material for special group exhibitions only.

‡**SUBURBAN FINE ARTS CENTER,** 777 Central Ave., Highland Park IL 60035. (708)432-1888. Executive Director: Ann Rosen. Nonprofit gallery. Estab. 1960. Represents "hundreds" of emerging, mid-career and established artists/year. 800 members. Sponsors 12 shows/year. Average display time 1 month. Open all year, Monday-Saturday, 9-4. Located downtown, in Highland Park, a suburb of Chicago; 1,000 sq. ft.; spacious, light and airy. 20% of space for special exhibitions; 20% of space for gallery artists. Clientele: vast array. 100% private collectors. Overall price range: $20-30,000; most work sold at $100.
Media: Considers all media and all types of prints. Most frequently exhibits painting and photography.
Style: Exhibits all styles, all genres. Prefers expressionism, conceptualism and contemporary.
Terms: Accepts work on consignment (35% commission). Retail price set by the artist. Gallery provides insurance, promotion and contract; artist pays shipping costs to and from gallery. Prefers artwork framed.
Submissions: Send query letter with résumé, slides and bio. Call or write for appointment to show portfolio of slides. Replies in 1 week. Files résumé, bio, artist statement.
Tips: Finds artists through agents, visiting exhibitions, word of mouth, art publications and sourcebooks, artists' submissions.

‡VALE CRAFT GALLERY, 207 W. Superior St., Chicago IL 60610. (312)337-3525. Fax: (312)337-3530. Owner: Peter Vale. Retail gallery. Estab. 1992. Represents 40 emerging, mid-career and established artists/year. Exhibited artists include Ellen Anne Eddy and Chet Geiselman. Sponsors 7 shows/year. Average display time 2 months. Open all year; Tuesday-Friday, 10-5; Saturday, 11-5. Located in River North gallery district near downtown; 900 sq. ft.; first floor of Victorian brick building; windows provide natural light and break up wall space. 60% of space for special exhibitions; 40% of space for gallery artists. Clientele: private collectors, 5% corporate collectors. Overall price range; $25-6,000; most work sold at $50-300.
Media: Considers paper, sculpture, ceramics, craft, fiber, glass, metal, wood and jewelry. Most frequently exhibits fiber wall pieces, metal furniture and ceramic sculpture and vessels.
Style: Exhibits contemporary craft. Prefers decorative or ornamental, colorful and natural or organic.
Terms: Accepts work on consignment (50% commission). Retail price set by the artist. Gallery provides insurance, promotion, contract and shipping costs from gallery; artist pays shipping costs to gallery.
Submissions: Accepts only artists from US. Only craft media. Send query letter with résumé, slides, bio, photographs, SASE and reviews if available. Call for appointment to show portfolio of originals and photographs. Replies in 1 month. Files résumés (if interested).
Tips: Finds artists through artists' submissions, art and craft fairs, publishing a call for entries, artists' slide registry and word of mouth.

‡ZAKS GALLERY, 620 N. Michigan Ave., Chicago IL 60611. (312)943-8440. Director: Sonia Zaks. Retail gallery. Represents 25 emerging, mid-career and established artists/year. Sponsors 10 solo shows/year. Average display time is 1 month. Overall price range: $500-15,000.
Media: Considers oil, acrylic, watercolor, drawings, sculpture.
Style: Specializes in contemporary paintings, works on paper and sculpture. Interested in narrative work.
Terms: Accepts work on consignment. Retail price is set by gallery and artist. Exclusive area representation required. Gallery provides insurance and contract.
Submissions: Send query letter with résumé, slides.
Tips: "A common mistake some artists make is presenting badly-taken and unmarked slides. Artists should write to the gallery and enclose a résumé and about one dozen slides."

Indiana

ARTLINK, Suite 202, 437 E. Berry St., Fort Wayne IN 46802-2801. (219)424-7195. Artistic Director: Betty Fishman. Nonprofit gallery. Estab. 1979. Exhibits emerging and mid-career artists. 500 members. Sponsors 8 shows/year. Average display time 5-6 weeks. Open all year. Located 4 blocks from central downtown, 2 blocks from Art Museum and Theater for Performing Arts; in same building as a cinema theater, dance group and historical preservation group; 1,600 sq. ft. 100% of space for special exhibitions. Clientele: "upper middle class." Overall price range: $100-500; most artwork sold at $200.
• Publishes a newsletter, *Genre*, which is distributed to members. Includes features about upcoming shows, profiles of members and other news. Some artwork shown at gallery is reproduced in b&w in newsletter. Send SASE for sample and membership information.
Media: Considers all media, including prints. Prefers work for annual print show and annual photo show, sculpture and painting.
Style: Exhibits expressionism, neo-expressionism, painterly abstraction, conceptualism, color field, postmodern works, photorealism, hard-edge geometric abstraction; all styles and genres. Prefers imagism, abstraction and realism. "Interested in a merging of craft/fine arts resulting in art as fantasy in the form of bas relief, photo/books, all experimental media in non-traditional form."
Terms: Accepts work on consignment only for exhibitions (35% commission). Retail price set by artist. Gallery provides insurance, promotion and contract; shipping costs are shared. Prefers framed artwork.
Submissions: Send query letter with résumé, 6 slides and SASE. Reviewed by 14-member panel. Replies in 2-4 weeks. "Jurying takes place 3 times per year unless it is for a specific call for entry. A telephone call will give the artist the next jurying date."
Tips: Common mistakes artists make in presenting work are "bad slides and sending more than requested — large packages of printed material. Printed catalogues of artist's work without slides are useless." Sees trend of community-wide cooperation by organizations to present art to the community.

CENTRE ART GALLERY, 301B E. Carmel Dr., Carmel IN 46032. (317)844-6421. Fax: (317)844-7875. President: Mark Weintraut. Retail gallery and art consultancy. Estab. 1955. Represents 30 emerging, mid-career and established artists. Exhibited artists include Rosemary Thomas and Ron Parker. Sponsors 5 shows/year. Average display time 1 month. Open all year. Located "on most traveled street in town;" 4,000 sq. ft.; "freestanding building, professionally designed and built as gallery." 50% of space for special exhibitions. Clientele: 80% private collectors, 20% corporate collectors. Overall price range: $300-60,000; most work sold at $1,500-15,000.

© 1993 Nick Bridge

Nick Bridge's **Variation in Brown and Grey** *was inspired by "very striking sunlight effects along the Kennedy Expressway in Chicago." The artist wanted to create "an atmosphere which would complement a sense of monumentality and sculptural spaces." The work was exhibited in a group invitational at Artlink in Fort Wayne, Indiana.*

Media: Considers oil, acrylic, watercolor, pastel, collage, paper, sculpture, ceramic, craft, fiber, glass, original handpulled prints, offset reproductions, engravings, lithographs, mezzotints, serigraphs and etchings.
Style: Exhibits expressionism, painterly abstraction, conceptualism, impressionism and realism. Genres include landscapes, florals, Southwestern and wildlife. Prefers realism, impressionism and abstract.
Terms: Accepts artwork on consignment (50% commission). Retail price set by artist. Gallery provides insurance, promotion, contract and shipping costs from gallery. Prefers artwork unframed.
Submissions: Send query letter with résumé, slides, photographs and SASE. Call for appointment to show portfolio of originals and photographs. Replies in 1 month. Files all accepted work.
Tips: "Be professional in your approach."

ECHO PRESS, 1901 E. Tenth St., Bloomington IN 47403. (812)855-0476. Fax: (812)855-0477. Curator: Pegram Harrison. Retail gallery and contemporary print publishers. Estab. 1979. Represents 22 emerging, mid-career and established artists. Exhibited artists include Steven Sorman, Valerie Jaudon and Sam Gilliam. Average display time 2 months. Open all year. 3,000 sq. ft. 33% of space for special exhibitions. "We are a print workshop with gallery space: ⅔ workshop, ⅓ gallery." Clientele: 40% private collectors, 60% corporate collectors. Overall price range: $200-10,000; most work sold at $1,000-4,000.
Media: Considers lithographs, etchings, original handpulled prints, woodcuts, linocuts, engravings and etchings.
Style: Exhibits neo-expressionism, painterly abstraction and postmodern works.
Terms: "We show our own publications." Retail price set by gallery. Gallery provides insurance and promotion; shipping costs are shared.
Submissions: Send résumé, slides, bio and reviews. Files bio, reproduction and review.

EDITIONS LIMITED GALLERY, 2727 E. 86th St., Indianapolis IN 46240. (317)253-7800. Owner: John Mallon. Director: Marta Blades. Retail gallery. Represents emerging, mid-career and established artists. Sponsors 4 shows/year. Average display time 1 month. Open all year. Located "north side of Indianapolis; track lighting, exposed ceiling, white walls." Clientele: 60% private collectors, 40% corporate collectors. Overall price range: $100-8,500; most artwork sold at $500-2,000.
Media: Considers oil, acrylic, watercolor, pastel, pen & ink, drawings, mixed media, collage, works on paper, sculpture, ceramic, craft, fiber, glass, photography, original handpulled prints, woodcuts, engravings, mezzotints, etchings, lithographs, pochoir and serigraphs. Most frequently exhibits mixed media, acrylic and pastel.
Style: Exhibits all styles and genres. Prefers abstract, landscapes and still lifes.
Terms: Accepts work on consignment (50% commission). Retail price set by gallery. "I do discuss the prices with artist before I set a retail price." Sometimes offers customer discounts and payment by installment. Gallery provides insurance, promotion and contract; shipping costs are shared. Prefers artwork framed.

Submissions: Send query letter with slides, SASE and bio. Portfolio review requested if interested in artist's work. Portfolio should include originals, slides, résumé and bio. Files bios, reviews, slides and photos.
Tips: Does not want to see "hobby art." Please send "a large enough body of work."

INDIAN IMAGE GALLERY, Dept. AM, Suite 108, 100 NW Second St., Evansville IN 47708. (812)464-5703. President: Stephen Falls. Retail gallery. Estab. 1972. Represents 40 emerging, mid-career and established artists. Exhibited artists include Donald Vann and Paladine Roye. Sponsors 3 shows/year. Average display time 3 weeks. Open all year. Located downtown; 1,200 sq. ft.; historic building. 20% of space for special exhibitions. Clientele: business/professional. 95% private collectors, 5% corporate collectors. Overall price range: $30-10,000; most work sold at $100-600.
Media: Considers all media, including original handpulled prints, engravings, lithographs, etchings, serigraphs, offset reproductions and posters. Most frequently exhibits painting, sculpture and jewelry.
Style: Exhibits realism. Genres include Southwestern and Western.
Terms: Accepts artwork on consignment (40% commission) or artwork is bought outright for 50% of the retail price. Retail price set by the gallery and the artist. Gallery provides promotion and contract; shipping costs are shared. Prefers artwork unframed.
Submissions: Send query letter with slides and bio. Call for appointment to show portfolio, which should include slides and photographs. Replies in 2 weeks.

INDIANAPOLIS ART LEAGUE, 820 E. 67th St., Indianapolis IN 46220. (317)255-2464. Fax: (317)254-0486. Exhibitions Curator: Julia Moore. Nonprofit art center. Estab. 1934. Prefers emerging artists. Exhibits approximately 300 artists/year. 1,800 members. Sponsors 8-10 shows/year. Average display time 5 weeks. Open Monday-Friday 9-10, Saturday 9-3, Sunday 12-3. Located in urban residential area; 1,600 sq. ft; "Progressive and challenging work is the norm!" 100% of space for special exhibitions. Clientele: mostly private. 90% private collectors, 10% corporate collectors. Overall price range: $50-15,000; most work sold at $100-1,000.
Media: Considers all media and all types of prints. Most frequently exhibits painting, sculpture and fine crafts.
Style: All styles. Interested in figurative work. "In general, we do not exhibit genre works. We do maintain a referral list, though." Prefers postmodern works, installation works, conceptualism.
Terms: Accepts work on consignment (35% commission). Commission is in effect for 3 months after close of exhibition. Retail price set by artist. Gallery provides insurance, promotion, contract; artist pays for shipping. Prefers artwork framed.
Submissions: "Special consideration for IN, OH, MI, IL, KY artists." Send query letter with résumé, slides, SASE, reviews and artist's statement. Replies in 5-6 weeks.
Tips: "Have slides done by a professional if possible. Stick with one style—no scattershot approaches, please. Have a concrete proposal with installation sketches (if it's never been built). We book 2 years in advance—plan accordingly. Do not call."

‡PATRICK KING GALLERIES, INC., 1726 E. 86th St., Indianapolis IN 46240--2360. (317)580-0400. Contact: Patrick King. Retail gallery and design studio. Estab. 1990. Represents about 15 mid-career artists. Interested in seeing the work of emerging artists. Exhibited artists include David Marsh. Sponsors 5 shows/year. Display is ongoing. Open all year. "We've relocated to 2,700 sq. ft. space in center of city's design corridor. Here are 4 gallery rooms: 2 for decorative arts collection and 2 for special exhibitions." Clientele: private, corporate, architects, designers, museums. 80% private collectors; 20% corporate collectors. Overall price range: $100-5,000.
Media: Considers paper, ceramic, fiber, plastic, wood and metals in applied and decorative arts. Does not consider wearable textiles or jewelry. Most frequently exhibits furniture, textiles, painting and sculpture.
Style: Prefers landscapes and painterly realism. Artist's functional studio furniture sought.
Terms: Accepts artwork on consignment (50% commission). "Retail price is suggested by the gallery." Customer discounts and payment by installment are available. Gallery provides insurance and promotion; shipping costs are shared. Exclusive area representation required.
Submissions: Send query letter with résumé, slides, photographs, SASE and price list. Upon slide review, if interested, gallery will invite artist to show a portfolio. Replies only if interested within 4-6 weeks. Files correspondence and all materials of accepted artists; all other artists' materials returned only by SASE.
Tips: Finds artists through word of mouth from artists and curators and by visiting galleries in other cities. "Have a complete and consistent set of slides; consistency in work is important. Show only works that are available for exhibit or sales. Do not price work on past market prices."

‡MIDWEST MUSEUM OF AMERICAN ART, 429 S. Main St., Elkhart IN 46514. (219)262-3603. Director: Jane Burns. Curator: Brian D. Byrn. Museum. Estab. 1978. Represents mid-career and established artists. May be interested in seeing the work of emerging artists in the future. Sponsors 10-12 shows/year. Average display time 5-6 weeks. Open all year; Tuesday-Friday 11-5; Saturday and Sunday 1-4. Located downtown; 1,000 sq. ft. temporary exhibits; 10,000 sq. ft. total; housed in a renovated neoclassical style bank building; vault gallery. 10% for special exhibitions. Clientele: general public.

Media: Considers all media and all types of prints.

Style: Exhibits all styles, all genres.

Terms: Acquired through donations. Retail price set by the artist "in those cases when art is offered for sale." Gallery provides insurance, promotion and contract; artist pays shipping costs to and from gallery. Prefers artwork framed.

Submissions: Accepts only art of the Americas, professional artists 18 years or older. Send query letter with résumé, slides, bio, reviews and SASE. Write for appointment to show portfolio of slides. Replies in 6 months. Files résumé, bio, statement.

Tips: Finds artists through visiting exhibitions, art submissions, art publications.

‡MOREAU GALLERIES, Saint Mary's College, Notre Dame IN 46556. (219)284-4655. Director: Brett M. Alexander. Nonprofit gallery. Estab. 1968. Sponsors 6 solo and 2 group shows/year. Average display time is 1 month. Interested in emerging, mid-career and established artists. Overall price range: $100-10,000.

Media: Considers all media and original handpulled prints. Most frequently exhibits paintings, drawings, sculpture and ceramic.

Style: Exhibits hard-edge geometric abstraction, color field, painterly abstraction, minimalism, conceptualism, post-modernism, pattern painting, feminist/political works, surrealism, photorealism, expressionism and neo-expressionism. Exhibits all genres. "We are an educational facility. We try to show a variety of styles and media from regional, national and international artists."

Terms: Retail price is set by artist. Exclusive area representation not required. Gallery provides insurance, shipping, promotion and contract.

Submissions: Send query letter, résumé, good-quality slides and SASE. "Gallery board meets each November to screen proposals for following year." Slides, résumés and show flier are filed.

Tips: "We solicit artists to send proposals through ads in artists' magazines and books. We look for stimulating, challenging work. The work must be quality in execution. We generally look for very contemporary work."

‡TURMAN ART GALLERY, INDIANA STATE UNIVERSITY, Terre Haute IN 47809. (812)237-3631. Director: Craig McDaniel. Nonprofit university art gallery. Estab. 1960. Exhibits the work of mid-career and established artists. Interested in seeing the work of emerging artists. Sponsors 10 shows/year. Average display time 3 weeks. Open all year, but reduced schedule in the summer; Tuesday-Friday, 12-4:30; Sunday, 1-5. Located downtown Terre Haute; 3,700 sq. ft.; unique design for gallery. 100% of space for special exhibitions.

Media: Considers "any media—but only of the very highest quality; we have not displayed any work in watercolor. Our emphasis is on advanced, experimental visual art."

Terms: Art works are borrowed for temporary exhibits; not a commercial gallery. Retail price set by the artist. Gallery provides insurance, promotion and shipping costs to and from gallery. Prefers artwork framed.

Submissions: Query first. Send résumé, slides and SASE. Replies in 3 months.

Tips: Finds artists through agents, by visiting exhibitions, word of mouth, art publications and sourcebooks, artists' submissions, etc.

Iowa

ARTS FOR LIVING CENTER, P.O. Box 5, Burlington IA 52601-0005. Located at Seventh & Washington. (319)754-8069. Executive Director: Lois Rigdon. Nonprofit gallery. Estab. 1974. Exhibits the work of mid-career and established artists. May consider emerging artists. 425 members. Sponsors 10 shows/year. Average display time 3 weeks. Open all year. Located in Heritage Hill Historic District, near downtown; 2,500 sq. ft.; "former sanctuary of 1868 German Methodist church with barrel ceiling, track lights." 35% of space for special exhibitions. Clientele: 80% private collectors, 20% corporate collectors. Overall price range: $25-1,000; most work sold at $75-500.

Media: Considers all media and all types of prints. Most frequently exhibits watercolor, intaglio and sculpture.

Style: Exhibits all styles. Prefers landscapes, portraits and abstracts.

Terms: Accepts work on consignment (25% commission). Retail price set by artist. Gallery provides insurance, promotion and contract; artist pays for shipping. Prefers artwork framed.

How to Use Your Artist's & Graphic Designer's Market *offers suggestions for understanding and using the information in these listings. Read this and other articles in the front of this book for important business tips.*

Submissions: Send query letter with résumé, slides, bio, brochure, photographs, SASE and reviews. Call or write for appointment to show portfolio of slides and gallery experience verification. Replies in 1 month. Files résumé and photo for reference if interested.

BLANDEN MEMORIAL ART MUSEUM, Dept. AM, 920 3rd Ave. S., Fort Dodge IA 50501. (515)573-2316. Director: Philip A. LaDouceur. Nonprofit municipal museum. Estab. 1930. Clientele: statewide through international. 75% private collectors, 25% corporate clients. Sponsors 8 solo and 6 group shows/year. Average display time is 2 months. Interested in emerging, mid-career and established artists.
Media: Paintings, drawing, prints, photography, sculpture in various media.
Style: Accepts all work.
Terms: Offers customer discount and payment by installation.
Submissions: Send query letter with résumé, slides and SASE. Slides and résumés are filed.

CORNERHOUSE GALLERY, 2753 First Ave. SE, Cedar Rapids IA 52402. (319)365-4348. Fax: (319)365-1707. Director: Janelle McClain. Retail gallery. Estab. 1976. Represents 125 emerging, mid-career and established artists. Exhibited artists include John Preston, Grant Wood and Stephen Metcalf. Sponsors 2 shows/year. Average display time 6 months. Open all year. 3,000 sq. ft.; "converted 1907 house with 3,000 sq. ft. matching addition devoted to framing, gold leafing and gallery." 15% of space for special exhibitions. Clientele: "residential/commercial, growing collectors." 60% private collectors. Overall price range: $20-75,000; most artwork sold at $400-2,000.
Media: Considers oil, acrylic, watercolor, pastel, drawings, mixed media, collage, works on paper, sculpture, ceramic, fiber, glass, original handpulled prints, woodcuts, wood engravings, linocuts, engravings, mezzotints, jewelry, etchings, lithographs and serigraphs. Most frequently exhibits oil, acrylic, original prints and ceramic works.
Style: Exhibits painterly abstraction, conceptualism, color field, postmodern works and impressionism. All genres. Prefers abstraction, impressionism and postmodern.
Terms: Accepts work on consignment (45% commission). Retail price set by artist and gallery. Offers payment by installments. Gallery provides insurance, promotion and shipping costs from gallery. Prefers artwork unframed.
Submissions: Send résumé, brochure, photographs and bio. Portfolio review requested if interested in artist's work. Replies in 1 month. Files bio and samples.
Tips: Finds artists through word of mouth, art publications, sourcebooks, artists' submissions/self promotions, art collectors' referrals and other artists. Do not stop in unannounced. "Today's buyer is more concerned with 'budget.' Still has money to spend but seems more discriminating."

PERCIVAL GALLERIES, INC., Walnut at Sixth, Firstar Bank Building, Des Moines IA 50309. (515)243-4893. Fax: (515)244-5669. Director: Bonnie Percival. Retail gallery. Estab. 1969. Represents 100 emerging, mid-career and established artists. Exhibited artists include Mauricio Lasansky and Karen Strohbeen. Sponsors 8 shows/year. Average display time is 3 weeks. Open all year. Located in downtown Des Moines; 3,000 sq. ft. 50-75% of space for special exhibitions.
Terms: Accepts work on consignment (50% commission). Retail price set by gallery. Gallery provides insurance and promotion.
Submissions: Send query letter with résumé, slides, photographs, bio and SASE. Call or write for appointment to show portfolio of originals, photographs and slides. Replies in 1 month. Files only items of future interest.

Kansas

‡**GALLERY XII,** #A, 412 E. Douglas, Wichita KS 67202. (316)267-5915. Consignment Committee: Judy Dove. Cooperative nonprofit gallery. Estab. 1977. Represents 50 mid-career and established artists/year. 20 members. Average display time 3 months. Open all year; Tuesday-Friday, 10-5; Saturday, 10-4. Located in historic Old Town which is in the downtown area; 1,300 sq. ft.; historic building. 20% of space for special exhibitions; 80% of space for gallery artists. Clientele: private collectors, corporate collectors, people looking for gifts, tourists. 70% private collectors, 5% corporate collectors. Overall price range: $10-2,000; most work sold at $10-400.
Media: Considers oil, acrylic, watercolor, pastel, drawing, mixed media, paper, sculpture, ceramics, glass, woodcut, engraving, lithograph, wood engraving, mezzotint, serigraphs, linocut and etching.
Style: Exhibits expressionism, neo-expressionism, painterly abstraction, impressionism, realism and imagism. All genres.
Terms: Accepts 3-D work on consignment (35% commission). Co-op membership for 2-D artwork, fee plus a donation of time (15% commission), "but we have limited openings." Retail price set by the artist. Gallery provides promotion and contract; artist pays shipping costs to and from gallery.
Submissions: Send query letter with slides. Write for appointment to show portfolio of photographs or slides. Replies in 3 weeks. "Returns material to artist after viewing."

Tips: Finds artists through visiting exhibitions and word of mouth. "3-D artists need to consider if they can pay shipping both ways for consignment work."

‡**PHOENIX GALLERY TOPEKA**, 2900-F Oakley Dr., Topeka KS 66614. (913)272-3999. Owner: Kyle Garia. Retail gallery. Estab. 1990. Represents 60 emerging, mid-career and established artists/year. Exhibited artists include Dave Archer, Raymond Archer and Louis Copt. Sponsors 6 shows/year. Average display time 6 weeks-3 months. Open all year, 7 days/week. Located downtown; 2,000 sq. ft. 100% of space for special exhibitions; 100% of space for gallery artists. Clientele: upscale. 75% private collectors, 25% corporate collectors. Overall price range: $500-20,000; most work sold at $1,200.
Media: Considers all media and woodcut, engraving, lithograph, wood engraving, mezzotint, serigraphs, linocut and etching. Most frequently exhibits oil, watercolor and ceramic.
Style: Exhibits expressionism and impressionism, all genres. Prefers regional, abstract and 3-D type ceramic.
Terms: Terms negotiable. Retail price set by the gallery and the artist. Prefers artwork framed.
Submissions: Call for appointment to show portfolio of originals, photographs and slides.
Tips: "We are scouting [for artists] constantly."

THE SAGEBRUSH GALLERY OF WESTERN ART, 115 E. Kansas, Medicine Lodge KS 67104. (316)886-5163. Fax: (316)886-5104. Co-Owners: Earl and Kaye Kuhn. Retail gallery. Estab. 1979. Represents up to 20 emerging, mid-career and established artists. Exhibited artists include Garnet Buster, Lee Cable, H.T. Holden and David Vollbracht. Sponsors 4 shows/year. Average display time 3-6 months. Open all year. Located ½ block off Main St.; 1,000 sq. ft. 100% of space for special exhibitions. Clientele: 80% private collectors, 20% corporate collectors. Overall price range: $100-7,000; most work sold at $500-4,000.
Media: Considers oil, acrylic, watercolor, pastel, pen & ink, drawings, mixed media, sculpture, original handpulled prints, lithographs and posters. Most frequently exhibits watercolors, acrylics and bronze sculpture.
Style: Exhibits realism. Genres include landscapes, Southwestern, Western and wildlife. Prefers representational works of contemporary and historical Western.
Terms: Accepts artwork on consignment (25% commission). Retail price set by artist. Offers payment by installments. Gallery provides promotion; artist pays for shipping.
Submissions: Send query letter with résumé, slides, brochure, photographs and SASE. Portfolio review requested if interested in artist's work. Files résumés, bio info and photos.
Tips: Finds artists by any source but the artist's work must speak for itself in quality. "We depend a lot on what fellow artists feel about new artist's work, or how we feel about artist's sincerity. We are careful to screen wildlife and Western livestock to be anatomically correct. Ask about the annual Indian Summer Days Western and Wildlife Art Show Sale."

STRECKER GALLERY, 332 Poyntz, Manhattan KS 66502. (913)539-2139. President: Julie Strecker. Retail gallery. Estab. 1979. Represents 20 emerging and mid-career artists. Exhibited artists include Dean Mitchell and Judy Love. Sponsors 4 shows/year. Average display time 6 weeks. Open all year; Tuesday-Saturday 10-5. Located downtown; 3,000 sq. ft.; upstairs in historic building. 50% of space for special exhibitions; 50% of space for gallery artists. Clientele: university and business. 95% private collectors, 5% corporate collectors. Overall price range: $300-5,000; most work sold at $300-500.
Media: Considers all media and all types of prints (no offset reproductions). Most frequently exhibits watercolor, intaglio, lithograph.
Style: All styles. Genres include landscapes, florals, portraits, Southwestern, figurative work. Prefers landscapes, figurative and floral.
Terms: Accepts work on consignment (40% commission). Retail price set by artist. Sometimes offers payment by installment. Gallery provides promotion; artist pays for shipping costs. Prefers artwork framed.
Submissions: Send query letter with résumé, slides, reviews, bio and SASE. Write for appointment to show portfolio of slides. Replies in 1-2 weeks.
Tips: "I look for uniqueness of vision, quality of craftsmanship and realistic pricing."

TOPEKA & SHAWNEE COUNTY PUBLIC LIBRARY GALLERY, 1515 W. Tenth, Topeka KS 66604-1374. (913)233-2040. Fax: (913)233-2055. Gallery Director: Larry Peters. Nonprofit gallery. Estab. 1976. Exhibits emerging, mid-career and established artists. Sponsors 8-9 shows/year. Average display time 1 month. Open Memorial Day to Labor Day: Monday-Saturday 9-6; Sunday 2-6. Located 1 mile west of downtown; 1,200 sq. ft.; security, track lighting, plex top cases; recently added two moveable walls. 100% of space for special exhibitions. Overall price range: $150-5,000.
Media: Considers oil, fiber, acrylic, sculpture, glass, watercolor, mixed media, ceramic, pastel, collage, metal work, woodcuts, wood engravings, linocuts, engravings, mezzotints, etchings, lithographs. Most frequently exhibits ceramic, oil and watercolor.
Style: Exhibits neo-expressionism, painterly abstraction, postmodern works and realism. Prefers painterly abstraction, realism and neo-expressionism.
Terms: Artwork accepted or not accepted after presentation of portfolio/résumé. Retail price set by artist. Gallery provides insurance; artist pays for shipping costs. Prefers artwork framed.

Submissions: Usually accepts only artists from KS, MO, NE, IA, CO, OK. Send query letter with résumé and slides. Call or write for appointment to show portfolio of slides. Replies in 1-2 months. Files résumé.
Tips: Finds artists through visiting exhibitions, word of mouth and artists' submissions. "Have good quality slides — if slides are bad they probably will not be looked at. Have a dozen or more to show continuity within a body of work. Competition gets heavier each year."

‡**EDWIN A. ULRICH MUSEUM OF ART**, Wichita State University, Wichita KS 67260-0046. (316)689-3664. Fax: (316)689-3898. Director: Donald E. Knaub. Museum. Estab. 1974. Represents mid-career and established artists. May be interested in seeing the work of emerging artists in the future. Sponsors 7 shows/year. Average display time 6-8 weeks. Open Tuesday-Friday, 10-5; Sunday-Saturday, 1-5. Located on campus; 4,000 sq. ft.; high ceilings, neutral space. 75% of space for special exhibitions.
Media: Considers sculpture, installation, neon-light, new media.
Style: Exhibits conceptualism and new media.
Submissions: Send query letter with résumé, slides and SASE. Write for appointment to show portfolio of slides, transparencies and statement of intent. Replies only if interested within 6 weeks.
Tips: Finds artists through word of mouth and art publications.

Kentucky

‡**BROWNSBORO GALLERY**, 4806 Brownsboro Center, Louisville KY 40207. (502)893-5209. Owner: Leslie Spetz; Curator: Patrick Donley. Retail gallery. Estab. 1990. Represents 20-25 emerging, mid-career and established artists. Exhibited artists include Karen and Charlie Berger and Michaele Ann Harper. Sponsors 9-10 shows/year. Average display time 5 weeks. Open all year; Tuesday-Friday, 10-6; Saturday, 10-3; closed Sunday and Monday. Located on the east end (right off I-71 at I-264); 1,300 sq. ft.; 2 separate galleries for artist to display in give totally different feelings to the art; one is a skylight room. 85% of space for gallery artists. Clientele: upper income. 90% private collectors, 10% corporate collectors. Overall price range; $100-2,500; most work sold at $800-1,000.
Media: Considers oil, acrylic, watercolor, pastel, pen & ink, drawing, mixed media, collage, paper, sculpture, ceramics, fiber, glass, installation, photography, woodcut, engraving and etching. Most frequently exhibits oil, mixed (oil or watercolor pastel) and watercolor.
Style: Exhibits painterly abstraction, all styles, color field, postmodern works, impressionism, photorealism and realism. Genres include landscapes, Americana and figurative work. Prefers landscape, abstract and collage/contemporary.
Term: Accepts work on consignment (40% commission). Retail price set by the gallery and the artist. Gallery provides insurance, promotion, contract and shipping costs from gallery; artist pays shipping costs to gallery. Prefers artwork framed.
Submissions: Send query letter with résumé, slides, bio and SASE. Call for appointment to show portfolio of photographs and slides. Replies only if interested within 3-4 weeks.
Tips: Finds artists through word of mouth and artist submissions, "sometimes by visiting exhibitions."

‡**EAGLE GALLERY**, Murray State University, P.O. Box 9, Murray KY 42071-0009. (502)762-6734. Fax: (502)762-6335. Director: Albert Sperath. University gallery. Estab. 1971. Represents emerging, mid-career and established artists. Sponsors 8 shows/year. Average display time 6 weeks. Open Monday, Wednesday, Friday, 8-6; Tuesday, Thursday 8-7:30; Saturday, 10-4; Sunday 1-4; closed during university holidays. Located on campus, small town; 4,000 sq. ft.; modern multi-level dramatic space. 100% of space for special exhibitions. Clientele: "10,000 visitors per year."
Media: Considers all media and all types of prints.
Style: Exhibits all styles.
Terms: "We supply the patron's name to the artist for direct sales. We take no commission." Retail price set by the artist. Gallery provides insurance, promotion and shipping costs from gallery. Prefers artwork framed.
Submissions: Send query letter with résumé and slides. Replies in 1 month.

‡**THE GALBREATH GALLERY**, National City Plaza, 301 E. Main, P.O. Box 2088, Lexington KY 40594-2088. (606)254-4579. Art Dealer/Director: Linda Schwartz. Retail gallery. "Public exhibition space in atrium of National City Plaza. I use this space to exhibit artists I represent. I have an additional 2,000 sq. ft. of conventional gallery space in the same building (Suite 550)." Represents 20 emerging and mid-career artists. Exhibited regional artists include Robert Tharsing and Sheldon Tapley. Sponsors 10 shows/year. Average display time 6-8 weeks. Open all year; atrium: Monday-Friday 10-6; Saturday 10-1; by appointment. Suite 550: daily Monday-Friday; by appointment. Located downtown; "surrounded by two-story windows that help to preview exhibitions to those entering the building as well as to passers-by. The gallery is lit at night — so there is virtually 24 hr. visibility." 100% of space for gallery artists. 40% private collectors, 60% corporate collectors. Overall price range: $1,500-10,000; most work sold at $2,000-8,000.

© 1993 Charlie Berger

Charlie Berger combined photocopy with watercolor, colored pencil, oil pigment and copper foil to create this untitled map, which was displayed in a joint exhibition with his wife Karen, at Louisville's Brownsboro Gallery. The drawing is one of a series developed out of the artist's love of maps and old documents, and took about 75 hours to complete.

Media: Considers oil, acrylic, pastel, mixed media, paper, sculpture, fiber and monotypes. Most frequently exhibits oil and acrylic on canvas, acrylic or pastel on paper and mixed media/sculpture.
Style: Exhibits expressionism, painterly abstraction, conceptualism, hard-edge geometric abstraction, realism and imagism. Prefers abstraction (expressionistic and hard-edge), landscape and conceptual.
Terms: Accepts work on consignment. Retail price set by the gallery and the artist. Gallery provides insurance, promotion and contract; shipping costs are shared. Usually prefers artwork framed.
Submissions: Send query letter with résumé, slides, bio, SASE and reviews. Write for appointment to show portfolio of slides and transparencies. Replies in 1-2 months. Files résumés.

THE GALLERY AT CENTRAL BANK, Kincaid Towers, 300 Vine St., Lexington KY 40507. (800)637-6884 US, (800)432-0721 KY. Fax: (606)253-6244. Curator: John Irvin. Gallery. Estab. 1988. Exhibits emerging, mid-career and established artists. Sponsors 11-12 shows/year. "We have an annual show for University of Kentucky art students that is usually wild!" Average display time 3 weeks. Open all year. Located downtown; 2,000 sq. ft. Overall price range: $75-5,000; most work sold below $1,000.
Media: Considers all media. Most frequently exhibits watercolor, oil and fiber.
Style: Exhibits all styles and genres.
Terms: Artist receives 100% of the sale price. Retail price set by artist. Sometimes offers payment by installment. Gallery provides insurance, promotion, reception and cost of hanging; artist pays for shipping. Prefers artwork framed.
Submissions: Accepts only artists from Kentucky. No nudes. Call for appointment to show portfolio of originals. Replies immediately. Files names, addresses and phone numbers.
Tips: Finds artists through word of mouth; University of Kentucky Art Department and art museum. "Don't be shy, call me. We pay 100% of the costs involved once the work is delivered."

KENTUCKY ART & CRAFT GALLERY, 609 W. Main St., Louisville KY 40202. (502)589-0102. Fax: (502)589-0154. Director of Marketing: Sue Rosen. Retail gallery operated by the private nonprofit Kentucky Art &

Craft Foundation, Inc. Estab. 1984. Represents more than 400 emerging, mid-career and established artists. Exhibiting artists include Arturo Sandoval, Sarah Frederick, Stephen Powell and Rude Osolnik. Sponsors 12 shows/year. Open all year. Located downtown in the historic Main Street district; 5,000 sq. ft.; a Kentucky tourist attraction located in a 120-year-old cast iron building. 33% of space for special exhibitions. Clientele: tourists, the art-viewing public and schoolchildren. 10% private collectors, 5% corporate clients. Overall price range: $3-20,000; most work sold at $25-500.
Media: Considers mixed media, metal, glass, clay, fiber, wood and stone.
Terms: Accepts work on consignment (40% commission). Retail price set by artist. Gallery provides insurance, promotion, contract and shipping costs from gallery.
Submissions: Contact gallery for jury application and guidelines first; then send completed application, résumé and 5 samples. Replies in 2-3 weeks. "If accepted, we file résumé, slides, signed contract, promotional materials and PR about the artist."
Tips: "The artist must live or work in a studio within the state of Kentucky."

‡LOUISVILLE VISUAL ART ASSOCIATION, 3005 Upper River Rd., Louisville KY 40207. (502)896-2146. Fax: (502)896-2148. Gallery Manager: Janice Emery. Nonprofit sales and rental gallery. Estab. 1989. Represents 70 emerging, mid-career and established artists. Average display time 3 months. Open all year; Monday-Friday, 11:30-3:30 and by appointment. Located downtown; 1,500 sq. ft. 10% of space for special exhibitions; 90% of space for gallery artists. Clientele: all ages and backgrounds. 50% private collectors, 50% corporate collectors. Overall price range: $300-4,000; most work sold at $300-1,000.
 • The Louisville Visual Art Association has 3 locations: 1) exhibition and office space are at 3005 Upper River Rd.; 2) sales and rental gallery is at #275 Louisville Galleria; and 3) the MEDIACTR is at Fourth and York. Write or call for more information.
Media: Considers oil, acrylic, watercolor, pastel, pen & ink, drawing, mixed media, collage, paper, sculpture, ceramics, craft (on a limited basis), fiber, glass, photography, woodcut, engraving, lithograph, wood engraving, mezzotint, serigraphs, linocut, etching and some posters. Most frequently exhibits oil, acrylic, watercolor, sculpture and glass.
Style: Exhibits contemporary, local and regional visual art, all genres.
Terms: Accepts work on consignment (40% commission). Membership is suggested. Retail price set by the artist. Gallery provides insurance, promotion and contract (nonexclusive gallery relationship). Artist pays shipping costs to and from gallery. Accepts framed or unframed artwork. Framing is offered. Artists should provide necessary special displays. (Ready-to-hang is advised with or without frames.)
Submissions: Accepts only artists from within a 400-mile radius, or former residents or those trained in KY (university credentials). Send query letter with résumé, slides, bio and reviews. Write for appointment to show portfolio of slides. Replies only if interested within 4-6 weeks. Files up to 20 slides (in slide registry), bio, résumé, brief artist's statement, reviews, show announcement.
Tips: Finds artists through visiting exhibitions, word of mouth, art publications and artists' submissions.

‡MAIN AND THIRD FLOOR GALLERIES, Northern Kentucky University, Nunn Dr., Highland Heights KY 41099. (606)572-5148. Fax: (606)572-5566. Gallery Director: David Knight. University galleries. Program established 1975; new main gallery in fall of 1992; renovated third floor gallery fall of 1993. Represents emerging, mid-career and established artists. Sponsors 10 shows/year. Average display time 1 month. Open Monday-Friday, 9-9; Saturday, Sunday, 1-5; closed major holidays and between Christmas and New Years. Located in Highland Heights KY, 8 miles from downtown Cincinnati; 3,000 sq. ft.; two galleries—one small and one large space with movable walls. 100% of space for special exhibitions. 90% private collectors, 10% corporate collectors. Overall price range; $25-50,000; most work sold at $25-2,000.
Media: Considers all media and all types of prints. Most frequently exhibits painting, printmaking and photography.
Style: Exhibits all styles, all genres.
Terms: Proposals are accepted for exhibition. Retail price set by the artist. Gallery provides insurance, promotion and contract; shipping costs are shared. Prefers artwork framed "but we are flexible."
Submissions: Send query letter with résumé, slides, bio, photographs, SASE and reviews. Write for appointment to show portfolio of originals, photographs and slides. Replies in April of academic school year for following school year. Files résumés and bios.
Tips: Finds artists through agents, visiting exhibitions, word of mouth, art publications and sourcebooks and artists' submissions.

Louisiana

ART BY LAW, 4204 Magazine St., New Orleans LA 70115. (504)897-6666. Director/Owner: Pierre Briant III. Retail gallery. Estab. 1990. Represents 25 emerging artists. Exhibited artists include Tony Henderson and Pierre Briant III. Sponsors 8 shows/year. Average display time 1-2 months. Open all year; Tuesday-Saturday 10-6 or by appointment. Located uptown 1 block off Napolean; indoor 1,500 sq. ft., outdoor 4,500 sq. ft. 65% of space for special exhibitions; 35% of space for gallery artists. Outdoor area is completely devoted to

special exhibitions. "Only outdoor sculpture space in the city." Clientele: 90% private collectors, 10% corporate collectors. Overall price range: $50-7,500; most work sold at $200-1,000.
Media: Considers furniture, woodcuts, engravings, lithographs and etchings. Most frequently exhibits furniture, outdoor sculpture and paints and reliefs.
Style: Exhibits primitivism and painterly abstraction. Includes all genres. Prefers architectural and primative.
Terms: Accepts work on consignment (40% commission). Retail price set by gallery and artist. Gallery provides promotion; artist pays for shipping or shipping costs are shared. Prefers artwork framed.
Submissions: Send query letter with résumé, slides, photographs, SASE and reviews. Call or write for appointment to show portfolio of originals, slides and photographs. Replies only if interested within 1 month. Files current artist slides.
Tips: "We're looking for wood furniture —handcrafted only."

BATON ROUGE GALLERY, INC., 1442 City Park Ave., Baton Rouge LA 70808-1037. (504)383-1470. Director: Kathleen Sunderman. Cooperative gallery. Estab. 1966. Exhibits the work of 50 emerging, mid-career and established artists. 300 members. Sponsors 12 shows/year. Average display time 1 month. Open all year. Located in the city park pavilion; 1,300 sq. ft.; "The building was the original swimming pool pavilion built in 1927." Overall price range: $20-20,000; most work sold at $50-100.
 ● Every Sunday at 4 p.m. the gallery has a multicultural performance. Programs include literary readings, ethnic dance and music by performance artists.
Media: Considers oil, acrylic, watercolor, pastel, video, drawing, mixed media, collage, paper, sculpture, ceramic, fiber, glass, installation, photography, woodcuts, engravings, lithographs, pochoir, wood engravings, mezzotints, serigraphs, linocuts and etchings. Most frequently exhibits painting, sculpture and glass.
Style: Exhibits all styles and genres.
Terms: Co-op membership fee plus donation of time. Gallery takes 33% commission. Retail price set by artist. Artist pays for shipping. Prefers artwork framed.
Submissions: Membership and guest exhibitions are selected by screening committee. Send query letter with résumé and slides. Call for appointment to show portfolio of slides.
Tips: "The screening committee screens applicants on March 4th and October 7th each year. Call for application to be submitted with portfolio and résumé."

‡THE GALLERY, 220 N. Parkerson, P.O. Box 2003, Crowley LA 70526. (318)783-3747. Gallery Coordinator: Jean Oubre. Retail gallery. Estab. 1980. Represents 36 emerging, mid-career and established artists. "The Crowley Art Association with 220 members sponsors The Gallery." Exhibited artists include Bobby Hebert and Dale Pousson. Average display time 3 months. Open all year; Monday-Friday, 10-4. Located downtown— main street; 1,500 sq. ft.; "attractive window displays and the coffee pot is always on." 20% of space for special exhibitions; 80% of space for gallery artists. Clientele: local professionals. 90% private collectors, 10% corporate collectors. Overall price range: $100-300; most work sold at $150 or less.
Media: Considers oil, acrylic, watercolor, pastel, pen & ink, drawing, mixed media, sculpture, ceramics, craft, photography and posters. Most frequently exhibits oil, watercolor and china.
Style: Exhibits primitivism, painterly abstraction, impressionism, photorealism and realism. Genres include landscapes, florals and wildlife. Prefers painterly abstraction, realism and primitivism.
Terms: Accepts work on consignment (20% commission). Co-op membership fee plus a donation of time (20% commission). "We have both working and non-working members." Retail price set by the artist. Gallery provides insurance and promotion; artist pays shipping costs to gallery. Prefers artwork framed.
Submissions: Send query letter with slides, photographs and SASE. Write for appointment to show portfolio of originals. Replies in 2 weeks.
Tips: Finds artists through word of mouth.

GALLERY OF THE MESAS, 2010-12 Rapides Ave., Alexandria LA 71301. (318)442-6372. Artist/Owner: C.H. Jeffress. Retail and wholesale gallery and artist studio. Estab. 1975. Represents 6 established artists. Exhibited artists include Charles H. Jeffress, Peña, Gorman, Atkinson, Doug West and Mark Snowden. Open all year. Located on the north edge of town; 2,500 sq. ft. Features new canvas awnings, large gold letters on brick side of buildings and new mini-gallery in home setting next door. Clientele: 95% private collectors, 5% corporate collectors. Overall price range: $165-3,800.
Media: Considers original handpulled prints, intaglio, lithographs, serigraphs, Indian jewelry, ceramics and drums. Most frequently exhibits serigraphs, inkless intaglio, collage and lithographs.

A bullet introduces comments by the editor of Artist's & Graphic Designer's Market indicating special information about the listing.

Style: Exhibits realism. Genres include landscapes, Southwestern and figurative work.
Submissions: Owner contacts artists he wants to represent. They must be established and well-known nationally.

‡**HALL AND BARNETT GALLERY,** 320 Exchange Alley, New Orleans LA 70130. (504)525-5656. Fax: (504)525-4434. Director: Sjason Prohaska. Retail gallery. Estab. 1989. Represents 45 emerging, mid-career and established artists/year. Exhibited artists include J.L.Steg and John Preble. Sponsors 6-8 shows/year. Average display time 2 months. Open all year; Monday-Saturday, 10-5. Located in the French Quarter between Bienville and Chartres; 5,000 sq. ft. on bottom floor ("recently purchased the building where we are located with 4 floors—each floor containing 2,500 sq. ft."). 80% of space for special exhibitions; 90% of space for gallery artists. Clientele: private collectors, special interest, local collectors. 70% private collectors, 20% corporate collectors. Overall price range: $100-6,000; most work sold at $100-1,200.
 • This gallery is housed in a building erected in 1830 which was the former residence of Degas.
Media: Considers oil, acrylic, watercolor, pastel, pen & ink, mixed media, collage, sculpture, glass, woodcut, engraving and etching. Most frequently exhibits oil painting (landscapes and figure), acrylic (figure and stills) and watercolor (figure and landscape).
Style: Genres include landscapes, figure/stills and abstracts. "We like to think we exhibit poetry rather than prose—no political art."
Terms: Accepts work on consignment (50% commission). Retail price set by the artist. Gallery provides insurance, contract and shipping costs from gallery; artist pays shipping costs to gallery. Prefers artwork framed.
Submissions: Send query letter with résumé, slides, bio, SASE, business card, reviews and artist statement. Call for appointment to show portfolio of originals. Replies in 2 weeks-1 month. "If we are interested we call—we never file without advising the artist first."
Tips: Finds artists through private travel, word of mouth, some publications.

‡**ST. TAMMANY ART ASSOCIATION,** 129 N. New Hampshire, Covington LA 70433. (504)892-8650. Director: Don Marshall. Nonprofit gallery. Estab. 1958. Represents 120 emerging, mid-career and established artists/year. 80 members. Exhibited artists include John Prebble and Jayne Adams. Sponsors 7 shows/year. Average display time 7 weeks. Open all year; Tuesday-Saturday 10-4, Sunday 1-4. Located downtown; 500 sq. ft.; historic home. 100% of space for special exhibitions. Clientele: upper middle class. 100% private collectors. Overall price range: $100-15,000; most work sold at $100-500.
Media: Considers all media, all types of prints. Most frequently exhibits painting (oil or acrylic), watercolor and sculpture.
Style: Exhibits all styles, all genres. Prefers figurative, landscape and abstract.
Terms: Accepts work on consignment (30% commission). Retail price set by the artist. Gallery provides insurance, promotion and contract; shipping costs are shared. Prefers artwork framed.
Submissions: Send query letter with résumé, slides and photographs. Call for appointment to show portfolio of originals, photographs and slides. Replies in 2 months. Files résumé.
Tips: Finds artists through visiting exhibitions.

STILL-ZINSEL, 328 Julia, New Orleans LA 70130. (504)588-9999. Fax: (504)588-9997. Contact: Sam Still. Retail gallery. Estab. 1982. Represents 25 emerging, mid-career and established artists. Sponsors 12 shows/year. Average display time 3 weeks. Open all year. Located in the warehouse district; 4,200 sq. ft.; unique architecture. 40% of space for special exhibitions. Clientele: collectors, museums and businesses.
Media: Considers oil, acrylic, watercolor, pastel, pen & ink, drawings, mixed media, paper, sculpture, glass, installation, photography, original handpulled prints, woodcuts, engravings, wood engravings, mezzotints, linocuts and etchings.
Style: Exhibits neo-expressionism, painterly abstraction, conceptualism, minimalism, color field, postmodern works, impressionism, realism, photorealism and hard-edge geometric abstraction. All genres.
Terms: Accepts work on consignment (50% commission). Retail price set by gallery and artist. Offers customer discounts and payment by installments. Gallery provides promotion and contract; artist pays for shipping.
Submissions: Send query letter with résumé, slides, SASE and reviews. Portfolio review requested if interested in artist's work.
Tips: "Please send clearly labeled slides."

Maine

THE ART GALLERY AT SIX DEERING STREET, 6 Deering St., Portland ME 04101. (207)772-9605. Director/Owner: Elwyn Dearborn. Retail gallery. Estab. 1987. Represents 10-12 emerging, mid-career and established artists/year, none exclusively. Exhibited artists include Betty Lou Schlemm, Edward Minchin, Jonathan Hotz, Ken Pratson, Carl Schmalz, Eliot O'Hara and T.M. Nicholas. Sponsors 8 shows/year. Average display time 3 weeks. Open March through June; September through December. Located downtown, on a residential,

historic street; restored Victorian townhouse, gallery decorated and furnished in period (circa 1868-90). 66% of space for special exhibition. Clientele: local (*not* tourist). 95% private collectors, 5% corporate collectors. Overall price range: $500-1,000; most work sold at $500.

Media: Considers oil, acrylic, watercolor and pastel. Does not consider prints, drawings, sculpture or photographs.

Style: Exhibits expressionism and realism. Genres include landscapes and florals. Prefers "any subject as long as it is basically realism."

Terms: Accepts work on consignment (40% commission). Retail price set by gallery and artist. Gallery provides promotion; artist pays for shipping. Prefers artwork framed.

Submissions: Accepts only artists from the US. Send query letter with résumé, slides, bio, brochure, photographs, SASE and reviews. Write for appointment to show portfolio of originals or photographs, and slides or transparencies. Replies within weeks. Files résumé, brochure and bio.

Tips: "Artists must have been trained at a recognized art institution and preferably have a successful track record."

‡GOLD/SMITH GALLERY, 7 McKown St., BoothBay Harbor ME 04538. (207)633-6252. Owner: Karen Vander. Retail gallery. Estab. 1974. Represents 30 emerging, mid-career and established artists. Exhibited artists include John Vander and Nikki Schumann. Sponsors 6 shows/year. Average display time 6 weeks. Open May-December; Monday-Saturday, 10-6; Sunday, 12-5. Located downtown next to the Memorial Library. 1,500 sq. ft.; traditional colonial house converted to contemporary gallery. 75% of space for special exhibitions; 25% of space for gallery artists. Clientele: residents and visitors. 90% private collectors, 10% corporate collectors. Overall price range: $350-5,000; most work sold at $350-1,500.

● Artists creating traditional and representational work should try another gallery. The work shown here is strong, self-assured and abstract.

Media: Considers oil, acrylic, watercolor, pastel, pen & ink, drawing, mixed media, collage, paper, sculpture, photography, woodcut, engraving, lithograph, wood engraving, mezzotint, serigraphs, linocut and etching. Most frequently exhibits oil, acrylic and watercolor.

Style: Exhibits expressionism, painterly abstraction "emphasis on nontraditional work." Prefers expressionist and abstract landscape, painterly abstraction and surrealism.

Terms: Commission negotiated. Retail price set by the artist. Gallery provides insurance and promotion; artist pays shipping costs to and from gallery. Prefers artwork framed.

Submissions: No restrictions—emphasis on artists from Maine and Northeast. Send query letter with slides, bio, photographs, SASE, reviews and retail price. Write for appointment to show portfolio of originals, Replies in 2 weeks. Artist should write the gallery.

MAINE COAST ARTISTS, P.O. Box 147, Russell Ave., Rockport ME 04856-0147. (207)236-2875. Nonprofit gallery. Estab. 1952. Exhibits the work of approximately 350 emerging, mid-career and established artists per season. 600 members (1,800 artists/subscribers). Exhibited artists include Robert Indiana and Neil Welliver. Sponsors 4-5 shows/year. Open June-October. (Features small, one-person shows in "Executive Gallery" during off-season months, October-May). Located on the seacoast, U.S. Route 1, mid-coast Maine; 5,500 sq. ft.; "1850s livery stable, renovated in 1987; 3 floors; gallery space and administration lower level." 80% of space for special exhibitions. Clientele: residents, tourists and galleries. 85% private collectors, 15% corporate collectors. Overall price range: $200-250,000; most work sold at $500-2,500.

Media: Considers all media, handpulled prints, woodcuts, engravings, lithographs, wood engravings, mezzotints, serigraphs, linocuts and etchings. Most frequently exhibits painting, sculpture and photography.

Style: Exhibits all styles and genres. Prefers painterly abstraction, post-modernism and expressionism.

Terms: Accepts work on consignment (40% commission). Retail price set by artist. Gallery provides insurance, promotion and contract; shipping costs are shared. Prefers artwork framed.

Submissions: Send query letter with résumé, slides and SASE. Write for appointment to show portfolio of originals and for exhibition procedures and guidelines. Replies in 1 month. Files biographical information (résumé), reviews or catalogs and statements.

Tips: "October-April is best time to send query (off-season). Studio visits are easily arranged during this time."

PINE TREE SHOP AND BAYVIEW GALLERY, 33 Bayview St., Camden ME 04843. (207)236-4534. Owner: Betsy Rector. Retail gallery. Estab. 1977. Represents 50 emerging, mid-career and established artists. Exhibited artists include Carol Sebold and Brian Kliewer. Sponsors 12 shows/year. Average display time 1 month. Open all year. Located in downtown; 1,500 sq. ft. 50% of space for special exhibitions. Clientele: 60% private collectors; 40% corporate collectors. Overall price range: $50-5,000; most work sold at $50-500.

Media: Considers oil, acrylic, watercolor, pastel, sculpture, original handpulled prints and offset reproductions. Most frequently exhibits oil, watercolor, pastels and sculpture.

Style: Exhibits primitivism, impressionism and realism. Genres include landscapes, florals, and figurative work. Prefers realism, impressionism and primitivism.

Terms: Accepts work on consignment (45% commission). Retail price set by gallery. Customer discounts and payment by installment are available. Gallery provides insurance, promotion and contract; artist pays for shipping. Prefers artwork framed.

Submissions: Send query letter with résumé, slides, bio, SASE and reviews. Portfolio review not required.

Tips: "Primarily new artists are acquired from their own submissions. We occasionally pursue artists whose work we are custom framing when its quality and nature would be desirable and marketable additions to the gallery. Make sure work is appropriate for gallery. We are showing a slightly broader range of styles, but we need to show a greater percentage of in-state artists to meet the expectations of our market and to maximize press releases. Most of our artists have survived the economy, although we've had to revise our territorial policy in order to allow artists to show elsewhere within our market territory. 90% of our clientele was hit by the economy, forcing us to consider more emerging artists and more modestly priced artwork. Also, as corporate sales are increasing, choices are made more with their trends in mind. Strong, professional work that is evocative of life and landscape of Maine tends to sell best."

‡**ROUND TOP CENTER FOR THE ARTS GALLERY**, Business Rt. 1, P.O. Box 1316, Damariscotta ME 04543. (207)563-1507. Artistic Director: Nancy Freeman. Nonprofit gallery. Estab. 1988. Represents emerging, mid-career and established artists. 1,200 members (not all artists). Exhibited artists include Lois Dodd and Marlene Gerberick. Sponsors 12-14 shows/year. Average display time 1 month. Open all year; Monday-Saturday, 11-4; Sunday, 1-4. Located on a former dairy farm with beautiful buildings and views of salt water tidal river. Exhibition space is on 2 floors 30×60, several smaller gallery areas, and a huge barn. 50% of space for special exhibitions; 25% of space for gallery artists. "Sophisticated year-round community and larger summer population." 25% private collectors. Overall price range: $75-10,000; most work sold at $300-1,000.

Media: Considers all media and all types of prints. Most frequently exhibits watercolor, fiber arts (quilts) and mixed media.

Style: Exhibits all styles. Genres include landscapes, florals, Americana and figurative work. Prefers landscape and historic.

Terms: Accepts work on consignment (25% commission). Retail price set by the artist. Gallery provides insurance, promotion and contract; shipping costs are shared. Prefers artwork simply framed.

Submissions: Send query letter with résumé, slides or photographs, bio and reviews. Write for appointment to show portfolio. Replies only if interested within 2 months. Files everything but slides, which are returned.

Tips: Finds artists through visiting exhibitions, word of mouth and artists' submissions.

THE STEIN GALLERY CONTEMPORARY GLASS, Dept. AM, 20 Milk St., Portland ME 04101. (207)772-9072. Directors: Anne Stein and Philip Stein. Retail gallery. Represents 65 emerging and mid-career artists. Open all year. Located in "old port" area.

Media: Considers glass only.

Submissions: Accepts only artists from the United States. Send query letter with résumé and slides.

Maryland

ARTEMIS, INC., P.O. Box 34574, W. Bethesda MD 20827-0574. (301)365-3788. Owner: Sandra Tropper. Retail and wholesale dealership, art consultancy and art appraisals. Represents more than 100 emerging and mid-career artists. Does not sponsor specific shows. Clientele: 40% private collectors, 60% corporate clients. Overall price range: $100-10,000; most work sold at $500-1,500.

Media: Considers oil, acrylic, watercolor, mixed media, collage, works on paper, sculpture, ceramic, craft, fiber, glass, installations, woodcuts, engravings, mezzotints, etchings, lithographs, pochoir, serigraphs and offset reproductions.

Style: Carries impressionism, expressionism, realism, minimalism, color field, painterly abstraction, conceptualism and imagism. Genres include landscapes, florals and figurative work. "My goal is to bring together clients (buyers) with artwork they appreciate and can afford. For this reason I am interested in working with many, many artists." Interested in seeing works with a "finished" quality.

Terms: Accepts work on consignment (50% commission). Retail price set by dealer and artist. Exclusive area representation not required. Dealer provides insurance and contract; shipping costs are shared. Prefers artwork unframed.

Submissions: Send query letter with résumé, slides, photographs and SASE. Write for appointment to show portfolio of originals, slides, transparencies and photographs. Indicate net and retail prices. Files slides, photos, résumés and promo material. All material is returned if not accepted or under consideration.

Tips: "Many artists have overestimated the value of their work. Look at your competition's prices."

‡**819 GALLERY**, 817 S. Broadway, Fells Point, Baltimore MD 21231. (410)732-4488. Director: Stephen Salny. Retail gallery. Estab. 1986. Represents 25 emerging artists/year. Sponsors 6 shows/year. Average display time 6 weeks. Open all year; Tuesday-Sunday, 12-5. Located on Fells Point; 700 sq. ft.; newly-renovated historic

townhouse near harbor. 100% of space for gallery artists. 100% private collectors. Overall price range: $30-3,200; most work sold at $30-2,000.

Media: Considers oil, acrylic, watercolor, pastel, mixed media, collage, paper, ceramics, craft and monoprint. Most frequently exhibits work on paper.

Style: Exhibits all styles: Prefers contemporary.

Terms: Accepts work on consignment (50% commission). Retail price set by the artist. Gallery provides promotion and contract; artist pays shipping costs to and from gallery. Prefers artwork framed (museum standards).

Submissions: Send query letter with résumé, slides, bio and SASE. Call for appointment to show portfolio of photographs and slides. Replies in 2 months.

Tips: Finds artists through word of mouth and publications.

THE GLASS GALLERY, 4720 Hampden Lane, Bethesda MD 20814. (301)657-3478. Owner: Sally Hansen. Retail gallery. Estab. 1981. Represents 30 emerging, mid-career and established artists. Sponsors 10 shows/year. Average display time 5 weeks. Open all year; Tuesday-Saturday 11-5. Located in metropolitan Washington DC (Bethesda urban district); 1,400 sq. ft. 50% of space for special exhibitions; 50% of space for gallery artists. Clientele: collectors.

Media: Considers sculpture in glass and monoprints (only if they are by glass sculptors who are represented by The Glass Gallery). Also interested in sculpture in glass incorporated with additional materials (bronze, steel etc.). "Focus is on creativity as well as on ability to handle the material well. The individuality of the artist must be evident."

Terms: Accepts work on consignment. Retail price set by artist. Sometimes offers customer discounts and payment by installment. Gallery provides insurance (while work is in gallery), promotion, contract and shipping costs from gallery.

Submissions: Send query letter with résumé, slides, photographs, reviews, bio and SASE. Portfolio review requested if interested in artist's work.

Tips: Finds artists through visits to exhibitions and professional glass conferences, plus artists' submissions and keeping up-to-date with promotion of other galleries (show announcements and advertising). "Send good slides with SASE and clear, concise cover letter and/or description of process. Familiarize yourself with the work of gallery displays to evaluate whether the quality of your work meets the standard."

‡MARLBORO GALLERY, 301 Largo Rd., Largo MD 20772. (301)322-0965-7. Coordinator: John Krumrein. Nonprofit gallery. Estab. 1976. Interested in emerging, mid-career and established artists. Sponsors 4 solo and 4 group shows/year. Average display time 3 weeks. Seasons for exhibition: September-May. 2,100 sq. ft. with 10 ft. ceilings and 25 ft. clear story over 50% of space—track lighting (incandescent) and day light. Clientele: 100% private collectors. Overall price range: $200-16,000; most work sold at $500-700.

● The Marlboro has recently been renovated.

Media: Considers all media. Most frequently exhibits acrylics, oils, photographs, watercolors and sculpture.

Style: Exhibits expressionism, neo-expressionism, realism, photorealism, minimalism, primitivism, painterly abstraction, conceptualism and imagism. Exhibits all genres. "We are open to all serious artists and all media. We will consider all proposals without prejudice."

Terms: Accepts artwork on consignment. Retail price set by artist. Exclusive area representation not required. Gallery provides insurance. Artist pays for shipping. Prefers artwork ready for display.

Submissions: Send query letter with résumé, slides, SASE, photographs, artist's statement and bio. Portfolio review requested if interested in artist's work. Portfolio should include slides and photographs. Replies every 6 months. Files résumé, bio and slides.

Tips: Finds artists through word of mouth, visiting exhibitions and artists' submissions. "Indicate if you prefer solo shows or will accept inclusion in group show chosen by gallery."

MONTPELIER CULTURAL ARTS CENTER, 12826 Laurel-Bowie Rd., Laurel MD 20708. (301)953-1993. Fax: (301)206-9682. Director: Richard Zandler. Alternative space, nonprofit gallery, public arts center. Estab. 1979. Exhibits 1,000 emerging, mid-career, established artists/year. Sponsors 24 shows/year. Average display time 1 month. Open all year; 7 days/week, 10-5. Located midway between Baltimore and Washington on 80 acre estate; 2,500 sq. ft. (3 galleries): cathedral ceilings up to 32′. 85% of space for special exhibitions; 15% of space for gallery artists. Clientele: diverse, general public. Overall price range: $50-50,000; most work sold at $200-300.

Media: Considers oil, pen & ink, paper, fiber, acrylic, drawing, sculpture, glass, watercolor, mixed media, ceramic, installation, pastel, collage, craft, photography, media arts, performance and mail art. Also considers all types of prints.

Style: Exhibits all styles and genres.

Terms: Special exhibitions only. 25% commission on sales during show. Retail price set by artist. Offers customer discount (seniors and members). Gallery provides insurance, promotion, contract and shipping costs from gallery. Prefers artwork framed.

Submissions: "Different shows target different media, theme and region. Call first to understand programs." Send résumé, slides and SASE. Replies only if interested within 8 months. Files résumés and cover letters. Slides are returned.
Tips: Finds artists through visiting exhibitions and artists' submissions.

PYRAMID ATLANTIC, Suite 103, 6001 66th Ave., Riverdale MD 20737. (301)459-7154. Artistic Director: Helen Frederick. Nonprofit gallery/library. Estab. 1985. Represents emerging, mid-career and established artists. Sponsors 6 shows/year. Average display time 2 months. Open all year; 10-6. 15% of space for special exhibitions; 10% of space for gallery artists. Also features research library. Clientele: print and book collectors, general audiences. Overall price range: $1,000-10,000; most work sold at $800-2,500.
Media: Considers watercolor, pastel, pen & ink, drawing, mixed media, collage, paper, sculpture, craft, installation, photography, artists' books and all types of prints. Most frequently exhibits works in and on paper, prints and artists' books and mixed media by faculty who teach at the facility and members of related programs.
Style: Exhibits all styles and genres.
Terms: Accepts work on consignment (50-60% commission). Print subscription series produced by Pyramid; offers 50% to artists. Retail prices set by gallery and artist. Gallery provides insurance, promotion and contract; shipping costs are shared.
Submissions: Send query letter with résumé, slides, bio, brochure, SASE and reviews. Call or write for an appointment to show portfolio, which should include originals and slides. Replies in 1 month. Files résumés.

‡RESURGAM GALLERY, 910 S. Charles St., Baltimore MD 21230. (410)962-0513. Office Manager: P. Randall Whitlock. Cooperative gallery. Estab. 1990. Represents 34 emerging, mid-career and established artists/year. 34 members. Exhibited artists include Ruth Pettus and Beth Wittenberg. Sponsors 14 shows/year. Average display time 3 weeks. Open all year; Wednesday-Saturday, noon-6; closed in August. Located downtown; 600 sq. ft.; in Baltimore's historic Federal Hill district. 100% of space for gallery artists. Clientele: urban professionals. 100% private collectors. Overall price range: $100-1,800; most work sold at $200-800.
Media: Considers oil, acrylic, watercolor, pastel, pen & ink, drawing, mixed media, collage, paper, sculpture, ceramics, craft, fiber, glass, photography and all types of prints. Most frequently exhibits painting, sculpture (mid-sized) and fine crafts.
Style: Exhibits all styles, all genres.
Terms: Co-op membership fee plus donation of time. Retail prices set by the artist. Gallery provides insurance. "Artists are responsible for their own promotion." Artist pays shipping costs to and from gallery. Prefers artwork framed.
Submissions: "Artists must be available to sit in gallery—or pay a sitter—5 days each year." Memberships for calendar year decided in June. Rolling-basis jurying throughout the year. Send query letter with SASE to receive application form. Portfolio should include slides.

‡TOWN CENTER GALLERY, INC., Airrights Center, 7315 Montgomery Ave., Bethesda MD 20814. (301)652-0226. Manager: Connie Woolard. Cooperative gallery. Estab. 1972. Represents 22 emerging, mid-career and established artists. "Gallery offers space to nonmembers. Gallery members' feature shows hang for 1 month, 12 times/year, if no special shows are scheduled." 1,500 sq. ft. in "Metrocenter," direct access from metro stop, "bright, well-lighted, next door to very popular restaurant in retail area of Metro Center's Phase II." Clientele: 90% private collectors; 10% corporate clients. Overall price range: $50-2,500; most artwork sold at $50-500.
Media: Considers oil, acrylic, watercolor, pastel, pen & ink, drawings, mixed media, collage, works on paper, sculpture, ceramic, egg tempera, woodcuts, wood engravings, linocuts, engravings, mezzotints, etchings, lithographs, serigraphs and offset reproductions by artist members. Most frequently exhibits watercolors or acrylics, oils and prints. Also carries computer art.
Style: Exhibits impressionism, expressionism and realism. Genres include landscapes, florals, Americana, wildlife and figurative work. Prefers landscapes, florals and still lifes. "Customers are seeking realism."
Terms: Co-op donation of time; 35% commission. Initial membership fee, rental fee for space; rental fee for nonmembers covers 1 month. Retail price set by artist. Customer discounts and payment by installments are available. Exclusive area representation not required. Prefers framed artwork.
Submissions: Send query letter with résumé, business card, slides, bio and SASE. Call or write to schedule an appointment to show a portfolio, which should include originals, slides, transparencies and photographs. Prefers to see 4 original works, suitably framed, for jurying. Replies in 3 weeks.
Tips: "Nine months a year there are group shows with one large wall featuring a member each month. A *special* nonmember show (3 times a year) might be best consideration for anyone living outside the immediate area, as members are required to give working time, etc., since we are a cooperative gallery." Sees trend toward "a real increased interest in original art; many beginning collectors. We are continually looking for new artists through referrals, artists' submissions and self-promotions."

Massachusetts

BROMFIELD GALLERY, 107 South St., Boston MA 02111. (617)451-3605. Director: Christina Lanzl. Cooperative gallery. Estab. 1974. Represents 20 emerging and mid-career artists. Exhibited artists include Martin Mugar and Tim Nichols. Sponsors 25 shows/year. Average display time 1 month. Open all year; Tuesday-Friday 12-5; Saturday 11-5. Located downtown; 2,500 sq. ft.; sequence of 3 large gallery spaces. 30% of space for special exhibitions; 70% of space for gallery artists. Clientele: 70% private collectors, 30% corporate collectors. Overall price range: $300-6,000; most work sold at $300-2,000.
Media: Considers all media and original handpulled prints. Most frequently exhibits paintings, prints, sculpture.
Style: Exhibits all styles and genres.
Terms: Co-op membership fee plus donation of time (35% commission). For invitational exhibitions, there is a rental fee for space which covers 12 months. Retail price set by artist. Offers customer discounts and payment by installments. Gallery provides promotion and contract; artist pays for shipping costs.
Submissions: Accepts only artists from New England. Send query letter with résumé, slides and SASE. Write for appointment to show portfolio of originals. Replies in 1 month. Files all info on members and visiting artists.
Tips: Finds artists through word of mouth, various art publications and sourcebooks, artists' submissions/self-promotions and referrals.

‡CAMBRIDGE ARTISTS COOPERATIVE, 59A Church St., Cambridge MA 02138. (617)868-4434. Cooperative gallery. Estab. 1988. Represents 150 emerging, mid-career and established artists/year. 22 working members. Exhibited artists include Erin Brayton and Marcia Dean. Sponsors 3 shows/year. Average display time 6-12 months. Open all year; daily, 10-6; Thursday, 10-8; Sunday, 12-5. Located in Harvard Square/Cambridge; 2,000 sq. ft. 35% of space for special exhibitions. Clientele: academics, professionals. Overall price range: $15-1,000; most work sold at $30-100.
Media: Considers all media and all types of prints. Most frequently exhibits jewelry, pottery and fiber.
Terms: Accepts work on consignment (50% commission; 60% in November and December). Retail price set by the artist. Gallery provides insurance, promotion and contract; artist pays shipping costs to gallery.
Submissions: Accepts only artists from US. Send query letter with SASE. Call or write for jury application. Portfolio should include originals and slides. Replies in 1-2 weeks. Files applications, biographies.
Tips: Finds artists through exhibitions, *Crafts Reporter*, word of mouth.

CAPE MUSEUM OF FINE ARTS, Box 2034, 60 Hope Lane, Dennis MA 02638. (508)385-4477. Executive Director: Gregory F. Harper. Museum. Estab. 1981, opened to public in 1985. Represents emerging and established artists, from region or associated with Cape Cod. Located "on the grounds of the historic Cape Playhouse." Sponsors 6 exhibitions/year. Average display time 6 weeks.
Media: "We accept all media." No offset reproductions or posters. Most frequently exhibits oil, sculpture, watercolor and prints.
Style: Exhibits all styles and all genres. "The CMFA provides a year-round schedule of art-related activities and programs for the Cape community: exhibitions, Cinema Club, lectures, bus trips and specially planned events for all ages. The permanent collection of over 700 works focuses on art created by Cape artists from the 1800s to the present."
Submissions: Send query letter with résumé and slides. Write for appointment to show portfolio, which should include originals. The most common mistakes artists make in presenting their work are "dropping off work unannounced and not including bio, reference materials or phone number." All material is returned if not accepted or under consideration.
Tips: "We encourage artist to leave with the Museum their résumé and slides so that we can file them in our archives." Wants to see works by "innovators, creators . . . leaders. Museum-quality works. Artist should be organized. Present samples that best represent your abilities and accomplishments."

CLARK GALLERY, INC., Box 339, Lincoln Station, Lincoln MA 01773. (617)259-8303. Assistant Director: Jennifer Atkinson. Retail gallery. Estab. 1976. Represents 30 emerging and mid-career artists. Sponsors 10 shows/year. Average display time 1 month. Closed August. Located in a suburb of Boston; 1,600 sq. ft.; space large enough for 2 solo exhibitions. 8 shows/year of gallery artists; 2 shows/year include other artists—1 show exclusively of artists not affiliated with the gallery. Clientele: young to established collectors from greater Boston area and craft collectors from across US. Clientele: 90% private collectors, 10% corporate collectors. Overall price range: $400-30,000; most work sold at $500-5,000.
Media: Considers oil, acrylic, drawings, mixed media, collage, works on paper, sculpture, ceramic, craft and glass; original handpulled prints. Most frequently exhibits paintings, furniture and ceramics.
Style: Exhibits painterly abstraction, realism, photorealism and folk art. Genres include landscapes and figurative work. "We are very eclectic, showing 2- and 3-dimensional works in all styles, ranging from abstract to realistic and everything in between."
Terms: Accepts work on consignment (50% commission). Retail price set by gallery. Gallery provides insurance, promotion and contract (sometimes); shipping costs are shared. Artwork may be framed or unframed.

Submissions: "Shows mostly Boston area artists, but others are welcome to submit." Send query letter with résumé, slides and SASE. "Appointment to see original work will be set up only after slide review." Replies in 2 weeks. Files résumés.

‡CLARK WHITNEY GALLERY, 25 Church St., Lenox MA 01240. (413)637-2126. Director: Ruth Kochta. Retail gallery. Estab. 1983. Represents 25 emerging, mid-career and established artists/year. Exhibited artists include Ross Barbera, Suzanne Howes-Stevens. Sponsors 5 shows/year. Average display time 1 month. Open Thursday-Monday, 11-5; closed January and February. Located downtown; 800 sq. ft. "My gallery is in historic Lenox Village in the Berkshire Mountains. It is located in an area very rich in culture, i.e., classical music, dance, opera, Shakespeare, etc." 60% of space for special exhibitions; 100% of space for gallery artists. 90% private collectors, 10% corporate collectors. Overall price range: $200-8,000; most work sold at $200-2,000.
Media: Considers oil, acrylic, mixed media, sculpture, glass and conceptual assemblage. Most frequently exhibits oils, sculpture (bronze, steel, stone) and acrylics.
Style: Exhibits expressionism, neo-expressionism, surrealism, postmodern works, impressionism, realism and imagism. Genres include landscapes, florals and figurative work. Prefers realistic figures in an environment, large scale landscapes and semi-abstracts.
Terms: Accepts work on consignment (40% commission). Retail price set by the artist. Gallery provides insurance. "We do not get involved in shipping." Prefers artwork framed.
Submissions: Accepts only artists who live within 3 hours driving time from Lenox. Send query letter with slides, bio, SASE and price range. Call for appointment to show portfolio of photographs or slides. Replies in 2 weeks. Files bio and copies of slides.
Tips: "I search for uniqueness of concept combined with technical competence."

DE HAVILLAND FINE ART, 39 Newbury St., Boston MA 02116. (617)859-3880. Fax: (617)859-3973. Contact: Gallery Manager. Retail gallery. Estab. 1989. Represents 40 emerging New England artists. Sponsors 10-12 shows/year. Average display time 1 month. Open all year. Located downtown ½ block from the Ritz Hotel; 1,200 sq. ft. 75% of space for special exhibitions. Clientele: 80% private collectors, 20% corporate collectors. Overall price range: $200-5,000.
Media: Considers oil, acrylic, watercolor, pastel, pen & ink, drawing, mixed media and sculpture. Most frequently exhibits oil/acrylic, watercolor/pastel and mixed media. Also special interest in fine art crafts.
Style: Exhibits expressionism, neo-expressionism, primitivism, painterly abstraction, surrealism, postmodern works, impressionism and realism. Genres include landscapes, florals and Americana. Prefers realism, painterly abstraction and impressionism.
Terms: Accepts artwork on consignment (40% commission). Gallery membership; covers 3 months. Retail price set by the gallery and artist. Sometimes offers customer discounts, Gallery provides promotion and contract; artist pays for shipping. Prefers artwork framed.
Submissions: Send query letter with résumé, slides, and SASE or call for application. "We only accept artists who reside in New England." Replies in 2 weeks. Files résumé.

‡DEPOT SQUARE GALLERY, 1837 Massachusetts Ave., Lexington MA 02173. (617)863-1597. Membership Chairman: Penelope Hart. Cooperative gallery. Estab. 1981. Represents emerging, mid-career and established artists. 25 members. Exhibited artists include Gracia Dayton and Natalie Warshawer. Sponsors 10 shows/year. Average display time 1 month. Open all year; Tuesday-Saturday, 10-5; open Sunday, 1-4, (September-June only). Located downtown; 2,000 sq. ft.; 2 floors – street level and downstairs. 100% of space for gallery artists. 10% private collectors, 10% corporate collectors. Overall price range: $100-3,000; most work sold at $100-500.
Media: Considers oil, acrylic, watercolor, pastel, pen & ink, drawing, mixed media, collage, paper, sculpture, ceramics, fiber, glass, woodcut, engraving, wood engraving, mezzotint, serigraphs, linocut and etching. Most frequently exhibits watercolor, oils and prints.
Style: Exhibits all styles, all genres. Prefers realism, impressionism (depends on makeup of current membership).
Terms: Co-op membership fee plus donation of time (40% commission). Retail price set by the artist. Gallery provides promotion. Prefers artwork framed.
Submissions: Accepts only local artists – must attend meetings. help hang shows and work in the gallery. Send query letter with résumé, slides, bio, SASE and reviews. Call for appointment to show portfolio of slides and transparencies. Replies in 6 weeks. Files bio and one slide – "if we want to consider artist for future membership."
Tips: Finds artists through advertising for new members and referrals.

‡FITCHBURG ART MUSEUM, 185 Elm St., Fitchburg MA 01420. (508)345-4207. Fax: (508)345-2319. Curator, Contemporary Exhibitions: Linda Poras. Museum. Estab. 1925. Represents emerging, mid-career and established artists. Sponsors 5 shows/year. Average display time 7 weeks. Open all year; Tuesday-Saturday, 11-4; Sunday, 1-4. Located downtown; 700 sq. ft.; large contemporary galleries – high ceilings. 100% of new wing for special exhibitions.

Media: Considers all media and all types of prints.
Style: Considers all genres.
Terms: Gallery provides insurance and promotion. Prefers artwork framed.
Submissions: Send query letter with résumé, slides, bio, SASE and reviews. "We don't review portfolios." Replies June-August only. Files all material sent.
Tips: Finds artists through agents, visiting exhibitions and word of mouth. Looks for "consistency in selection of work submitted. Photos also are helpful in some cases."

GALLERY NAGA, 67 Newbury St., Boston MA 02116. (617)267-9060. Director: Arthur Dion. Retail gallery. Estab. 1977. Represents 24 emerging, mid-career and established artists. Exhibited artists include Henry Schwartz and Judy Kensley McKie. Sponsors 10 shows/year. Average display time 1 month. Closed August. Located on "the primary street for Boston galleries; 1,500 sq. ft.; housed in an historic neo-gothic church." 10% of space for special exhibitions. Clientele: 90% private collectors, 10% corporate collectors. Overall price range: $500-30,000; most work sold at $2,000-10,000.
Media: Considers oil, acrylic, mixed media, sculpture, photography, studio furniture and monotypes. Most frequently exhibits painting and furniture.
Style: Exhibits expressionism, painterly abstraction, postmodern works and realism. Genres include landscapes, portraits and figurative work. Prefers expressionism, painterly abstraction and realism.
Terms: Accepts work on consignment (50% commission). Retail price set by gallery and artist. Gallery provides insurance and promotion; artist pays for shipping. Prefers artwork framed.
Submissions: "Not seeking submissions of new work at this time."
Tips: "We focus on Boston and New England artists. Become familiar with a gallery to see if your work is appropriate before you make contact."

GROHE GLASS GALLERY, Dock Square, Boston MA 02109. (617)227-4885. Fax: (508)539-0509. Retail gallery. Estab. 1988. Represents 50 mid-career and established artists. Interested in seeing the work of emerging artists. Exhibited artists include Tom Patti, Jon Kuhn and Cissy McCaa. Sponsors 5 shows/year. Average display time 1 month. Open all year. Located downtown in Faneuil Hall marketplace; 750 sq. ft. 75% of space for special exhibitions. Clientele: glass collectors. 90% private collectors, 10% corporate collectors. Overall price range: $1,500-50,000.
Media: Considers glass.
Terms: Accepts work on consignment (50% commission). Retail price set by artist. Gallery provides insurance, promotion and contract; shipping costs are shared.
Submissions: Prefers only glass artists. Send query letter with résumé, slides, bio, photographs and SASE. Write for appointment to show portfolio. Replies in 2 weeks.

‡THE HAND OF MAN—A CRAFT GALLERY, 29 Wendess Ave., Pittsfield MA 02101. (413)443-6033 (office); (413)637-0632 (gallery) Fax: (413)448-2512. Buyer: Marilyn J. Barry. Retail gallery. Estab. 1985. Represents 250-300 emerging, mid-career and established artists/year. Exhibited artists include M. Howard and B. Heise. Sponsors 3-4 shows/year. Average display time 3-4 weeks. Open all year; daily, 10-5. Located in a small town; 300-400 sq. ft.; 120-year-old hotel. 10-20% of space for special exhibitions; 80-90% of space for gallery artists. 10% private collectors, 10% corporate collectors. Overall price range: $25-1,500; most work sold at $25-125.
Media: Considers watercolor, pen & ink, drawing, mixed media, paper, sculpture, ceramics, craft, fiber, glass, photography, woodcut, engraving, lithograph, wood engraving, serigraphs and etching. Most frequently exhibits contemporary craft.
Style: Exhibits fine craft. Prefers contemporary craft.
Terms: Accepts work on consignment (50% commission) or buys outright for 50% of retail price (net 30 days). Retail price set by the artist. Gallery provides promotion; shipping costs are shared. Prefers artwork framed.
Submissions: Prefers only US artists. Send query letter with résumé, slides, bio, brochure, photographs, SASE and business card. Write for appointment to show portfolio of photographs, slides or transparencies. Replies only if interested within 1 month. Files brochure on artist.
Tips: Finds artists through visiting exhibitions, sourcebooks, artists' submissions.

‡KAJI ASO STUDIO/GALLERY NATURE AND TEMPTATION, 40 St. Stephen St., Boston MA 02115. (617)247-1719. Fax: (617)247-7564. Administrator: Kate Finnegan. Nonprofit gallery. Estab. 1975. Represents 40-50 emerging, mid-career and established artists. 35-45 members. Exhibited artists include Kaji Aso and Katie Sloss. Sponsors 10 shows/year. Average display time 3 weeks. Open all year; Tuesday 1-8; Wednesday-Saturday, 1-5; and by appointment. Located in city's cultural area (near Symphony Hall and Museum of Fine Arts); "intimate and friendly." 30% of space for special exhibitions; 70% of space for gallery artists. Clientele: urban professionals and fellow artists. 80% private collectors, 20% corporate collectors. Overall price range: $150-8,000; most work sold at $150-1,000.
Media: Considers oil, acrylic, watercolor, pastel, pen & ink, drawing, ceramics and etching. Most frequently exhibits watercolor, oil or acrylic and ceramics.

Style: Exhibits painterly abstraction, impressionism and realism.

Terms: Co-op membership fee plus donation of time (35% commission). Retail price set by the artist. Gallery provides promotion; artist pays shipping costs to and from gallery. Prefers artwork framed.

Submissions: Send query letter with résumé, slides, bio, photographs and SASE. Write for appointment to show portfolio of originals, photographs, slides or transparencies. Does not reply; artist should contact. Files résumé.

Tips: Finds artists through advertisements in art publications, word of mouth, artists' submissions.

KINGSTON GALLERY, 129 Kingston St., Boston MA 02111. (617)423-4113. Director: Steve Novick. Cooperative gallery. Estab. 1982. Exhibits the work of 11 emerging, mid-career and established artists. Sponsors 11 shows/year. Average display time 1 month. Closed August. Located "in downtown Boston (financial district/ Chinatown); 1,300 sq. ft.; large, open room with 12' ceiling and smaller front room—can accomodate large installation." Overall price range: $100-7,000; most work sold at $600-1,000.

Media: Considers all media but craft. 10% of space for special exhibitions.

Style: Exhibits all styles.

Terms: Co-op membership requires dues plus donation of time. 25% commission charged on sales by members. Retail price set by the artist. Sometimes offers payment by installments. Gallery provides insurance, some promotion and contract. Rental of front gallery by arrangement.

Submissions: Accepts only artists from New England for membership. Artist must fulfill monthly co-op responsibilities. Send query letter with résumé, slides, SASE and "any pertinent information. Slides are reviewed once a month. Gallery will contact artist within 1 month." Does not file material but may ask artist to re-apply in future.

Tips: "Please include thorough, specific information on slides: size, price, etc."

R. MICHELSON GALLERIES, 132 Main St., Northampton MA 01060. (413)586-3964. Also 25 S. Pleasant St., Amherst MA 01002. (413)253-2500. Owner: R. Michelson. Retail gallery. Estab. 1976. Represents 25 emerging, mid-career and established artists/year. Exhibited artists include Barry Moser and Leonard Baskin. Sponsors 5 shows/year. Average display time 1 month. Open all year. Located downtown; Northampton gallery has 1,500 sq. ft.; Amherst gallery has 1,800 sq. ft. 50% of space for special exhibitions. Clientele: 85% private collectors, 15% corporate collectors. Overall price range: $50-50,000; most artwork sold at $300-25,000.

• R. Michelson Galleries is taking on very few new artists at this time.

Media: Considers oil, acrylic, watercolor, pastel, pen & ink, drawings, works on paper, original handpulled prints, woodcuts, wood engravings, linocuts, engravings, mezzotints, lithographs, pochoir, serigraphs and posters. Most frequently exhibits works on paper and paintings.

Style: Exhibits expressionism, neo-expressionism, imagism, realism, photorealism and figurative works. All genres. Prefers realism, photorealism and expressionism.

Terms: Accepts work on consignment or buys outright. Retail price set by gallery and artist. Customer discounts and payment by installment are available.

Submissions: Send query letter with résumé, slides, bio, brochure, SASE and reviews. Portfolio review not required. Files slides.

‡PANORAMIC FINE ART, 76-4 S. Quinsigamono Ave., Shrewsbury MA 01545. (508)797-3585. Fax: (508)798-6606. President: Richard Pano. Art consultancy and architectural art wholesaler. Estab. 1990. Represents emerging, mid-career and established artists. Exhibited artists include Fairchild and Hatfield. Open all year; Monday-Friday, 8-5. Located in a surburb of Massachusetts. Clientele: hospitality and health care corporations. 1% private collectors, 5% corporate collectors. Overall price range: $20-500; most work sold at $45-1,200.

Media: Considers all media and engraving, lithograph, serigraphs, etching and posters.

Terms: Buys outright for 25% of retail price. Retail price set by the gallery. Gallery provides insurance, promotion, contract and shipping costs to and from gallery. Prefers artwork unframed.

Submissions: Send query letter with slides, brochure and photographs. Write for appointment to show portfolio of originals, photographs, slides and transparencies. Replies only if interested within 3 weeks.

Tips: Finds artists through art publications.

‡PEPPER GALLERY, 38 Newbury St., Boston MA 02116. (617)236-4497. Fax: (617)236-4497. Director: Audrey Pepper. Retail gallery. Estab. 1993. Represents 20 emerging, mid-career and established artists/year. Exhibited artists include Roy DeCarava, Edith Vonnegut. Sponsors 9 shows/year. Average display time 6 weeks. Open all year; Tuesday-Saturday, 10-5. Located downtown, Back Bay; 500 sq. ft. 90% of space for special exhibitions; 90% of space for gallery artists. Clientele: private collectors, museums, corporate. 70% private collectors, 15% corporate collectors, 15% museum collectors. Overall price range: $275-15,000; most work sold at $800-4,000.

Media: Considers oil, acrylic, watercolor, pastel, handmade furniture, drawing, mixed media, glass, woodcut, engraving, lithograph, mezzotint, etching and photogravures. Most frequently exhibits oil on canvas, lithos/ etchings and photogravures.

Style: Exhibits painterly abstraction, realism, and other figurative work.
Terms: Accepts work on consignment (50% commission). Retail price set by the gallery and the artist. Gallery provides insurance, promotion and contract.
Submissions: Send query letter with résumé, slides, bio, SASE and reviews. Call for appointment to show portfolio of originals, photographs, slides and transparencies. Replies in 2 months.
Tips: Finds artists through exhibitions, word of mouth, open studios and artists' submissions.

PIERCE GALLERIES, INC., 721 Main St., Rt. 228, Hingham MA 02043. (617)749-6023. Fax: (617)749-6685. President: Patricia Jobe Pierce. Retail and wholesale gallery, art historians, appraisers and consultancy. Estab. 1968. Represents 8 established artists. May consider emerging artists in the future. Exhibited artists include Eric Midttun, Joseph Fontaine, Giovanni De Cünto and Kahlil Gibran. Sponsors 8 shows/year. Average display time 1 month. Open all year. Hours by appointment only. Located "in historic district on major road; 3,800 sq. ft.; historic building with high ceilings and an elegant ambiance." 100% of space for special exhibits. Overall price range: $1,500-400,000; most work sold at $1,500-100,000.
Media: Considers oil, acrylic, watercolor, pastel, pen & ink, drawings and sculpture. Does not consider prints. Most frequently exhibits oil, acrylic and watercolor.
Style: Exhibits expressionism, neo-expressionism, painterly abstraction, surrealism, impressionism, realism, photorealism and social realism. All genres and subjects, including landscapes, florals, Americana, Western, wildlife and figurative work. Prefers impressionism, expressionism and super realism.
Terms: Often buys artwork outright for 50% of retail price; sometimes accepts on consignment (20-33% commission). Retail price set by artist, generally. Sometimes offers customer discounts and payment by installment. Gallery provides insurance and promotion; contract and shipping costs may be negotiated.
Submissions: Send query letter with résumé, slide sheets and SASE. Gallery will contact if interested for portfolio review. Portfolio should include photos or slides of originals. Replies in 48 hours. Files material of future interest.
Tips: Finds artists through referrals, portfolios/slides "sent to me or I see the work in a show or magazine. I want to see consistent, top quality work and techniques – not a little of this, a little of that. Please supply 3 prices per work: price to dealer buying outright, price to dealer for consigned work and a retail price. The biggest mistake artists make is that they sell their own work (secretly under the table) and then expect dealers to promote them! If a client can buy art directly from an artist, dealers don't want to handle the work."

‡THE SOCIETY OF ARTS AND CRAFTS, 175 Newbury St., Boston MA 02116. (617)266-1810. Also, second location at 101 Arch St., Boston MA 02110. (617)345-0033. Gallery Manager: Ms. Randi Lathrop. Retail gallery with for-sale exhibit space. Estab. 1897. Represents 450 emerging, mid-career and established artists. 900 members. Exhibited artists include Grechten Ewert, Clay. Sponsors 6-10 shows/year (in the 2 gallery spaces). Average display time 6-8 weeks. Open all year; main: Monday-Saturday, 10-6; Sunday 12-5; second: Monday-Friday, 11-7. Located in the Copley Square Area; 2nd floor of a brownstone. "The Society is the oldest nonprofit craft gallery in America." 50% of space for special exhibitions; 50% of space for gallery artists. Clientele: corporate, collectors, students, interior designers. 85% private collectors, 15% corporate collectors. Overall price range: $2.50-6,000; most work sold at $100-300.
Media: Considers mixed media, collage, paper, sculpture, ceramics, craft, fiber and glass. Most frequently exhibits wood, clay and metal.
Style: Exhibits contemporary crafts in all mediums, all genres.
Terms: Accepts work on consignment (50% commission). "Exhibiting/gallery artists can become members of the Society for $25 membership fee, annual." Retail price set by the artist; "if assistance is needed, the gallery will suggest." Gallery provides insurance, promotion and contract. Prefers artwork framed.
Submissions: Accepts only artists residing in the US. Send q;uery letter with résumé, slides, bio, brochure, SASE, business card and reviews. Portfolio should include slides or photos (if slides not available). Replies in 6 weeks. Files résumés (given out to purchaser), reviews, visuals.
Tips: Finds artists through networking with artists and other craft organizations, trade shows (ACC Philadelphia, Springfield, Rosen Baltimore), publications (*Niche, American Craft*) and various specialty publications (*Metalsmith, Sculpture, American Woodworking,* etc.), collectors, other galleries, general submissions.

‡THRONJA ORIGINAL ART, 260 Worthington St., Springfield MA 01103. (413)732-0260. Director/Owner: Janice S. Throne. Retail gallery and art consultancy. Estab. 1967. Represents 75 emerging, mid-career and established artists. Exhibited artists include Harold Altman and Robert Sweeney. Sponsors 4-5 shows/year. Open all year; Monday-Friday, 9:30-4:45; Saturday and evenings, by appointment; special holiday hours. Located in downtown Springfield; 1,000 sq. ft.; 2nd floor location overlooking park. 75% of space for special exhibitions; 75% of space for gallery artists. Clientele: corporate, professional, private. 30% private collectors, 70% corporate collectors. Overall price range: $100-15,000; most work sold at $150-1,500.
Media: Considers oil, acrylic, pastel, pen & ink, drawing, mixed media, collage, paper, sculpture, ceramics. fiber, glass, photography and all types of prints. Most frequently exhibits oils, watercolors and prints.
Style: Exhibits expressionism, painterly abstraction, conceptualism, impressionism, photorealism, realism and imagism, all genres. Prefers impressionism, realism and expressionism.

Terms: Accepts work on consignment (50% commission) or buys outright for 50% of retail price (net 30 days).
Retail price set by the gallery and the artist. Gallery provides promotion and contract, "sometimes." Artist pays shipping to and from gallery.
Submissions: Send query letter with résumé, slides, bio, photographs, SASE and reviews. Call or write for appointment to show portfolio of photographs, slides and transparencies. Replies in 1 month. "Follow up with a postcard if you don't hear from us."
Tips: Finds artists through visiting exhibitions at colleges, museums; artists' submissions (a great number); recommendations from museum professionals and art traders; reading art publications.

‡TODD GALLERIES, 572 Washington St., Wellesley MA 02181. (617)237-3434. Owner: Jay Todd. Retail gallery. Estab. 1980. Represents 55 emerging, mid-career and established artists. Sponsors 10 shows/year. Average display time 1 month. Open all year; Tuesday-Saturday, 9:30-5:30; Sunday, 1:00-5:00. Located "in Boston's wealthiest suburb"; 4,000 sq. ft.; vast inventory, professionally displayed. 90% of space for special exhibitions; 90% of space for gallery artists. Clientele: residential and corporate. 70% private collectors, 30% corporate collectors. Overall price range: $100-25,000; most work sold at $500-5,000.
Media: Considers oil, acrylic, watercolor, pen & ink, drawing, mixed media, woodcut, engraving, lithograph, wood engraving, mezzotint, serigraphs, linocut and etching. Most frequently exhibits oils, woodcuts and etchings.
Style: Exhibits primitivism, postmodern works, impressionism and realism. Genres include landscapes, florals, figurative work and still life. Prefers landscapes, figures and still life.
Terms: Accepts work on consignment (negotiable commission). Retail price set by the artist. Gallery provides promotion. Prefers artwork unframed.
Submissions: No abstract work. Send query letter with résumé, slides, bio, photographs and price list. Call or write for appointment to show portfolio of photographs or slides. Replies in 6 weeks. Files "all that is interesting to us."
Tips: Finds artists through agents, visiting exhibitions, word of mouth, art publications and sourcebooks and artists' submissions. "Give us a minimum of 6 works that are new and considered to be your BEST."

‡WENNIGER GALLERY, 19 Mount Pleasant St., Rockport MA 01966. (508)546-8116. Directors/Owners: Mary Ann and Mace Wenniger. Retail gallery and art consultancy. Estab. 1971. Represents 100 emerging, mid-career and established artists. Exhibited artists include Yuji Hiratsuka and Helen Frank. Sponsors 10 shows/year. Average display time 3 weeks. Open all year; Monday-Saturday, 11-5. Located downtown; 500 sq. ft.; on the harbor, attractive cheery building. 100% of space for special exhibitions, 100% of space for gallery artists. Clientele: young professionals. 75% private collectors, 25% corporate collectors. Overall price range: $50-1,000.
Media: Considers woodcut, engraving, lithograph, wood engraving, mezzotint, serigraph, etching and collagraph. Most frequently exhibits collagraph, mezzotint and wood engraving.
Style: Exhibits expressionism, color field and realism. Genres include figurative work.
Terms: Accepts work on consignment (50% commission). Retail prices set by the artist. Gallery provides insurance and shipping costs from gallery; artist pays shipping costs to gallery. Prefers artwork unframed.
Submissions: Send query letter with résumé and slides. Write for appointment to show portfolio of slides and color photocopies. Replies only if interested within 2 months.
Tips: Finds artists through visiting exhibitions.

Michigan

‡THE ART CENTER, 125 Macomb Place, Mount Clemens MI 48043. (810)469-8666. Fax: (810)463-4153. Executive Director: Jo-Anne Wilkie. Nonprofit gallery. Estab. 1969. Represents emerging, mid-career and established artists. 500 members. Sponsors 10 shows/year. Average display time 1 month. Open all year; Tuesday-Friday, 11-5; Saturday 9-2. Located in downtown Mount Clemens; 1,300 sq. ft. The Art Center is housed in the historic Carnegie Library Building, listed in the State of Michigan Historical Register. 100% of space for special exhibitions; 50% of space for gallery artists. Clientele: all types. 100% private collectors. Overall price range: $5-200; most work sold at $50-500.
Media: Considers oil, acrylic, watercolor, pastel, pen & ink, drawing, mixed media, collage, paper, sculpture, ceramics, craft, fiber, glass, all types of prints. Most frequently exhibits oils/acrylics, watercolor and ceramics.

The double dagger before a listing indicates that the listing is new in this edition. New markets are often more receptive to freelance submissions.

Style: Exhibits all styles, all genres.

Submissions: Send query letter with reviews. Call for appointment to show portfolio of photographs, slides and résumé. Files résumé, b&w photos.

Tips: Finds artists through artists submissions, queries, exhibit announcements, word of mouth and membership. "Join the art center as a member, call for placement on our mailing list, enter the Michigan Annual Exhibition."

ART CENTER OF BATTLE CREEK, 265 E. Emmett St., Battle Creek MI 49017. (616)962-9511. Director: A.W. Concannon. Estab. 1948. Represents 150 emerging, mid-career and established artists. 90% private collectors, 10% corporate clients. Represents 150 artists. Exhibition program offered in galleries, usually 6-8 solo shows each year, two artists' competitions, and a number of theme shows. Also offers Michigan Artworks Shop featuring work for sale or rent. Average display time 1 month. "Four galleries, converted from church — handsome high-vaulted ceiling, arches lead into galleries on either side. Welcoming, open atmosphere." Overall price range: $5-1,000; most work sold at $5-300.

Media: Considers oil, acrylic, watercolor, pastel, pen & ink, drawings, mixed media, collage, works on paper, sculpture, ceramic, craft, fiber, glass, photography and original handpulled prints.

Style: Exhibits painterly abstraction, minimalism, impressionism, photorealism, expressionism, neo-expressionism and realism. Genres include landscapes, florals, Americana, portraits and figurative work. Prefers Michigan artists.

Terms: Accepts work on consignment (33⅓% commission). Retail price set by artist. Exclusive area representation not required. Gallery provides insurance, promotion and contract; artist pays for shipping.

Submissions: Michigan artists receive preference. Send query letter, résumé, brochure, slides and SASE. Slides returned; all other material is filed.

Tips: "We need new artists as our market is growing. We are planning a new outlet in downtown marketplace, a retail space near bookstore and other upscale stores. Looking for original work that is well presented."

ART TREE GIFT SHOP/GALLERY II, 461 E. Mitchell, Petoskey MI 49770. (616)347-4337. Manager: Anne Thurston. Retail shop and gallery of a nonprofit arts council. Estab. 1982. Represents emerging, mid-career and established artists. Prefers Michigan artists. Clientele: heavy summer tourism. 99% private collectors, 1% corporate clients. Overall price range: $6-2,000; most work sold at $20-1,000.

• Gallery II has been converted to an exhibit gallery. Monthly thematic exhibits will feature work from the area. All work exhibited will be for sale.

Media: Considers collage, works on paper, sculpture, ceramic, wood, fiber, glass, original handpulled prints, posters, watercolors, oils, acrylics and mixed media.

Style: Seeks "moderately sized work that expresses creativity and fine art qualities."

Terms: "A handler's fee is charged on all gallery sales." Retail price is set by gallery and artist. All work is accepted by jury. Gallery provides insurance and promotion; artist pays for shipping.

Submissions: Call or write for information.

Tips: "Our audience tends to be conservative, but we enjoy stretching that tendency from time to time. A common mistake artists make in presenting their work is not having it ready for presentation." Great need for new work to attract the potential purchaser. "We work from an artist list which is constantly being updated by request, participation or reference."

‡BELIAN ART CENTER, 5980 Rochester Rd., Troy MI 48098. (313)828-7001. Directors: Garared or Zabel Belian. Retail gallery and art consultancy. Estab. 1985. Represents 20 emerging, mid-career and established artists/year. Exhibited artists include Reuben Nakian and Ledward Avesdisian. Sponsors 8-10 shows/year. Average display time 1 month. Open all year; Monday-Saturday, 12-6. Located in a suburb of Detroit; 2,000 sq. ft.; has outdoor area for pool side receptions; different levels of exhibits. 50% of space for special exhibitions; 50% of space for gallery artists. Clientele: 50-60% local, 30% Metropolitan area 10-20% national. 70-80% private collectors, 10-20% corporate collectors. Overall price range: $1,000-20,000.

Media: Considers oil, acrylic, watercolor, pastel, pen & ink, drawing, mixed media, collage, paper, sculpture, ceramics, installation, photography, woodcut, engraving, lithograph, wood engraving, mezzotint and serigraphs. Most frequently exhibits oils, sculptures (bronze) and engraving.

Style: Exhibits expressionism, neo-expressionism, primitivism, painterly abstraction, surrealism, conceptualism, minimalism, color field, postmodern works, impressionism, photorealism, hard-edge geometric abstraction, realism and imagism. Includes all genres. Prefers abstraction, realism, mixed.

Terms: Accepts work on consignment (commission varies) or buys outright for varying retail price. Retail price set by the gallery and the artist. Gallery provides insurance and promotion; shipping costs are shared. prefers artwork framed.

Submissions: Send query letter with résumé, slides, bio, brochure, photographs and reviews. Call or write for appointment to show portfolio of photographs, slides and transparencies. Replies only if interested within 2-3 weeks.

Tips: Finds artists through catalogs, sourcebooks, exhibitions and magazines.

JESSE BESSER MUSEUM, 491 Johnson St., Alpena MI 49707. (517)356-2202. Director: Dennis R. Bodem. Chief of Resources: Robert E. Haltiner. Nonprofit gallery. Estab. 1962. Interested in emerging and established artists. Sponsors 5 solo and 16 group shows/year. Average display time 1 month. Prefers but not limited to northern Michigan artists. Clientele: 80% private collectors, 20% corporate clients. Overall price range: $10-2,000; most artwork sold at $50-250.

Media: Considers oil, acrylic, watercolor, pastel, pen & ink, drawings, mixed media, collage, works on paper, sculpture, ceramic, craft, fiber, glass, installation, photography, original handpulled prints and posters. Most frequently exhibits prints, watercolor and acrylic.

Style: Exhibits hard-edge geometric abstraction, color field, painterly abstraction, pattern painting, primitivism, impressionism, photorealism, expressionism, neo-expressionism, realism and surrealism. Genres include landscapes, florals, Americana, portraits, figurative work and fantasy illustration.

Terms: Accepts work on consignment (25% commission). Retail price set by gallery and artist. Sometimes offers customer discounts and payment by installment. Exclusive area representation not required. Gallery provides insurance, promotion and contract.

Submissions: Send query letter, résumé, brochure, slides and photographs to Robert E. Haltiner. Write for appointment to show portfolio of slides. Letter of inquiry and brochure are filed.

Tips: Finds artists through word of mouth, art publications and sourcebooks, artists' submissions, self-promotions, art collectors' referrals and through visits to art fairs and festivals.

‡WILLIAM BONIFAS FINE ARTS CENTER, 700 First Avenue S., Escanaba MI 49829. (906)786-3833. Fax: (906)786-3840. Executive Director: Vicki Soderberg. Museum. Estab. 1974. Represents 12-24 emerging, mid-career and established artists/year. Sponsors 12-24 shows/year. Average display time 1 month. Open all year; Monday-Friday, 10-5. Located downtown; 2,500 sq. ft.; historic facility. Clientele: community and tourists. 90% private collectors, 10% corporate collectors. Overall price range: $50-3,000; most work sold at $100-300.

Media: Considers all media and all types of prints.

Style: Exhibits all styles, all genres.

Terms: Accepts work on consignment (25% commission). Retail price set by the artist. Gallery provides insurance, promotion and contract. Prefers artwork framed.

Submissions: Send query letter with résumé, slides, bio, brochure and photographs. Call for appointment to show portfolio of photographs and slides. Replies only if interested within 1 year. Files all material.

Tips: Finds artists through artists' submissions, word of mouth, other exhibitions. "We have a waiting list already."

‡DETROIT REPERTORY THEATRE LOBBY GALLERY, 13103 Woodrow Wilson, Detroit MI 48238. (313)868-1347. Fax: (313)868-1705. Gallery Director: Gilda Snowden. Alternative space, nonprofit gallery, theater gallery. Estab. 1965. Represents emerging, mid-career and established artists. Exhibited artists include Carol Ann Carter and Shirley Woodson. Sponsors 4 shows/year. Average display time 6-10 weeks. Exhibits November and June; Thursday-Friday, 8:30-11:30 pm; Saturday-Sunday, 7:30-10:30. Located in midtown Detroit; 750 sq. ft.; features lobby with a wet bar and kitchen; theatre. 100% of space for special exhibitions. Clientele: theatre patrons. 100% private collectors. Overall price range: $50-500; most work sold at $125-300.

Media: Considers oil, acrylic, watercolor, pastel, pen & ink, drawing, mixed media, collage and paper. "Must be two-dimensional; no facilities for sculpture." Most frequently exhibits painting, photography and drawing.

Style: Exhibits all styles, all genres. Prefers figurative painting, figurative photography and collage.

Terms: "No commission taken by gallery; artist keeps all revenues from sales." Retail price set by the artist. Gallery provides insurance and promotion (catalog, champagne reception); artist pays shipping costs to and from gallery. Prefers artwork framed.

Submissions: Accepts only artists from Metropolitan Detroit area. Prefers only two dimensional wall work. Artists install their own works. Send query letter with résumé, slides, bio and SASE. Write for appointment to show portfolio of slides, résumé and bio. Replies in 3 months.

Tips: Finds artists through word of mouth and visiting exhibitions.

THE GALLERY SHOP/ANN ARBOR ART ASSOCIATION ART CENTER, 117 W. Liberty, Ann Arbor MI 48104. (313)994-8004. Gallery Director: Martine Perreault. Estab. 1978. Represents over 200 artists, primarily regional. Clientele: private collectors and corporations. Overall price range: $2,000; most 2-dimensional work sold at $400-800; 3-dimensional work from $25-100. "Proceeds help support the Art Association's exhibits and education programs for all ages."

• Wall surfaces and lighting have been recently upgraded in this gallery and handicapped accessibility improved.

Media: Considers original work in virtually all two- and three- dimensional media, including jewelry, original handpulled prints and etchings, ceramics, glass and fiber.

Style: "The gallery specializes in well-crafted and accessible artwork. Many different styles are represented, including innovative contemporary."

Terms: Accepts work on consignment (40% commission on members' work). Retail price set by artist. Offers customer discounts and payment by installments. Exclusive area representation not required. Gallery provides contract; artist pays for shipping.
Submissions: Send query letter, résumé, brochure, slides and SASE. Materials are considered on a rolling basis. Great Lakes area artists may be called in for one-on-one review.
Tips: Finds artists through visiting exhibitions, networking with graduate and undergraduate schools, word of mouth, artist referral and artists' submissions. "We are particularly interested in new expressions in glass, ceramics, wood and metal at this time."

‡KALAMAZOO INSTITUTE OF ARTS, 314 South Park St., Kalamazoo MI 49007. (616)349-7775. Fax: (616)349-9313. Director of Collections and Exhibitions: Helen Sheridan. Museum. Estab. 1924. Represents mid-career and established artists. Sponsors 25 shows/year. Average display time 4-6 weeks. Closed for two weeks at the end of August. Located in downtown Kalamazoo adjacent to Bronson Park. Features contemporary space designed by Skidmore, Owings & Merrill. 100% of space for special exhibitions. Overall price range: $200-10,000; most work sold at $200-1,500.
Media: Considers all media; original handpulled prints, woodcuts, wood engravings, linocuts, engravings, mezzotints, etchings, lithographs, pochoir and serigraphs. "We are interested in seeing every variety of work produced by contemporary artists but look for balance in the annual schedule of exhibits we produce." Most frequently exhibits paintings (oils, watercolors, acrylics), sculpture, photography and print media.
Style: Exhibits expressionism, neo-exopressionism, painterly abstraction, photorealism, realism, imagism and impressionism. All genres.
Terms: Retail price is set by artist. Offers 10% small discount to members and sometimes offers payment by installment. Gallery provides insurance; shipping costs are shared. Prefers artwork framed.
Submissions: Send query letter, résumé, slides, reviews, bio and SASE. Portfolio review requested if interested in artist's work. Files bios, résumés and reviews.
Tips: "Apply by the first of the month for review that month; replies may be delayed in July and August. There is usually a 1-2 year delay between the time an artist is approved for exhibition and the exhibition itself."

‡RUSSELL KLATT GALLERY, 1467 S. Woodward, Birmingham MI 48009. (810)647-6655. Fax: (810)644-5541. Director: Sharon Crane. Retail gallery. Estab. 1987. Represents 100 established artists/year. Interested in seeing the work of emerging artists. Exhibited artists include Henri Plisson and Mary Mark. Open all year; Monday-Friday; 10-6; Saturday, 10-5. Located on Woodward, 4 blocks north of 14 mile on the east side; 800 sq. ft. 100% private collectors. Overall price range: $800-1,500; most work sold at $1,000.
Media: Considers oil, acrylic, watercolor, pastel, ceramics, lithograph, mezzotint, serigraphs, etching and posters. Most frequently exhibits serigraphs, acrylics and oil pastels.
Style: Exhibits painterly abstraction, impressionism and realism. Genres include landscapes, florals and figurative work. Prefers landscape-impressionism, painterly abstraction and florals.
Terms: Accepts work on consignment (60% commission) or buys outright for 50% of retail price (net 30-60 days). Retail price set by the gallery and the artist. Gallery provides insurance and shipping to gallery; artist pays shipping costs from gallery. Prefers artwork unframed.
Submissions: Send query letter with brochure and photographs. Write for appointment to show portfolio of photographs.
Tips: Finds artists through visiting exhibitions.

‡KRASL ART CENTER, 707 Lake Blvd., St. Joseph MI 49085. (616)983-0271. Fax: (616)983-0275. Director: Dar Davis. Retail gallery of a nonprofit arts center. Estab. 1980. Clientele: community residents and summer tourists. Sponsors 30 solo and group shows/year. Average display time is 1 month. Interested in emerging and established artists. Most artwork sold at $100-500.
Media: Considers oils, acrylics, watercolor, pastels, pen & ink, drawings, mixed media, collage, paper, sculpture, ceramics, crafts, fibers, glass, installations, photography and performance.
Style: Exhibits all styles. "The works we select for exhibitions reflect what's happening in the art world. We display works of local artists as well as major traveling shows from SITES. We sponsor all annual Michigan competitions and construct significant holiday shows each December."
Terms: Accepts work on consignment (25% commission or 50% markup). Retail price is set by artist. Sometimes offers customer discounts. Exclusive area representation required. Gallery provides insurance, promotion, shipping and contract.
Submissions: Send query letter, résumé, slides, and SASE. Call to schedule an appointment to show a portfolio, which should include originals.

‡MIDLAND ART COUNCIL GALLERIES OF THE MIDLAND CENTER FOR THE ARTS, 1801 W. St. Andrews, Midland MI 48640. (517)631-3250. Director: Maria Ciski. Nonprofit gallery and museum. Estab. 1956. Exhibits emerging, mid-career and established artists. Sponsors 10 shows/year. Average display time 5-6 weeks. Open all year, seven days a week, 1-5 pm. Located in a cultural center; "an Alden B. Dow design." 100% of space for special exhibitions.

Media: Considers all media and all types of prints.

Style: Exhibits all styles and genres.

Terms: "Exhibited art may be for sale" (20% commission). Retail price set by the artist. Gallery provides insurance, promotion and contract; shipping costs are shared. Artwork must be exhibition ready.

Submissions: Send query letter with résumé, slides, bio, SASE and proposal. Write to schedule an appointment to show a portfolio, which should include slides, photographs and transparencies. Replies only if interested as appropriate. Files résumé, bio and proposal.

‡**PERCEPTION,** 7 Ionia, S.W., Grand Rapids MI 49503. (616)451-2393. Owner: Kim L. Smith. Retail gallery. Estab. 1989. Represents 20 emerging, mid-career and established artists/year. Exhibited artists include Mathias J. Alten and Jack Smith. Sponsors 4-6 shows/year. Average display time 6-8 weeks. Open all year; Monday-Friday, 10-5:30. Open Saturday, 10-2 from Labor Day to Memorial Day. Located downtown; 2,200 sq. ft.; "open space, unique design." 100% of space for special exhibitions; 100% of space for gallery artists. Clientele: private collectors, dealers. 75% private collectors, 5% corporate collectors. Overall price range: $500-75,000; most work sold at $1,000-4,000.

Media: Considers oil, acrylic, watercolor, pastel, pen & ink, drawing, mixed media, collage, paper, sculpture, ceramics, craft, stone, bronze, woodcut, engraving, lithograph, wood engraving, mezzotint, serigraphs, linocut and etching. Most frequently exhibits oils, etchings and lithographs.

Style: Exhibits all styles; prefers impressionism and realism. Genres include landscapes and figurative work. Prefers American impressionism, contemporary figurative and still life, fine art prints – 1900-present.

Terms: Accepts work on consignment (40% commission) or buys outright for 50% of retail price (net 10 days). Retail prices set by the gallery and the artist. Gallery provides insurance, promotion and shipping costs from gallery; artist pays shipping costs to gallery. Prefers artwork unframed.

Submissions: Send query letter with slides and photographs. Call for appointment to show portfolio of originals and slides. Replies in 1 month. Files bios and résumés.

Tips: Finds artists through visiting exhibitions, word of mouth, artists' submissions. "We are interested in seeing at least 30 to 40 examples and/or pieces that represent work done within a three to four year period."

THE PRINT GALLERY, INC., 29203 Northwestern Hwy., Southfield MI 48034. (313)356-5454. President: Diane Shipley. Retail gallery and art consultancy. Estab. 1979. Represents emerging, mid-career and established artists. Sponsors 4 solo and 4 group shows/year. Average display time 2 months. Clientele: white collar, professional and tourists. 60% private collectors, 40% corporate clients. Overall price range: $100-3,000; most work sold at $600.

Media: Considers oil, acrylic, watercolor, pastel, mixed media, original serigraphs, lithographs and sculpture.

Style: Exhibits painterly abstraction, postmodern works, primitivism, impressionism, photorealism, expressionism and realism. Genres include landscapes, florals, Latin American, portraits and figurative work. "I am leaning toward acquiring more realism and figurative work and Latin American artists."

Terms: Accepts work on consignment (50% commission). Retail price set by gallery and artist. Sometimes offers customer discounts and payment by installment. Gallery provides insurance, shipping and contract.

Submissions: Send query letter and slides. Sometimes portfolio required if interested.

Tips: "Set up an appointment and be able to articulate what kind of work you do."

REFLECTIONS OF COLOR GALLERY, 18951 Livernois Ave., Detroit MI 48221. (313)342-7595. Owners: Carl and Marla Wellborn. Retail gallery. Estab. 1988. Represents 30 emerging, mid-career and established artists. Exhibited artists include Kathleen Wilson and Carl Owens. Average display time 6 weeks. Open all year; Monday-Saturday 11-6, Friday-Saturday 11-7. 30% of space for special exhibitions; 100% of space for gallery artists. Clientele: middle to upper income (professional). 90% private collectors, 10% corporate collectors. Overall price range: $100-3,000; most work sold at $100-200.

Media: Considers oil, acrylic, watercolor, pastel, pen & ink, drawing, mixed media, collage, paper, sculpture, ceramic, fiber, glass, photography, woodcuts, etchings, lithographs, serigraphs and posters. Most frequently exhibits watercolor, pastel and sculpture.

Style: Exhibits conceptualism, photorealism, hard-edge geometric abstraction, realism and surrealism. All genres. Prefers realism, conceptualism and photorealism.

Terms: Accepts work on consignment (40-50% commission). Offers payment by installments. Gallery provides promotion, contract; shipping costs are shared. Prefers artwork framed.

Submissions: "Minority artists only – African-American, Hispanic, African, Native American, East Indian, etc." Send query letter with slides, brochure and photographs. Call or write for appointment to show portfolio of originals, photographs and slides. Replies only if interested within 1 month. Files photos and brochures.

SAPER GALLERIES, 433 Albert Ave., East Lansing MI 48823. (517)351-0815. Fax: (517)351-0815. Director: Roy C. Saper. Retail gallery. Estab. in 1978 as 20th Century Fine Arts; in 1986 designed and built new location and name. Displays the work of 60 artists; mostly mid-career. Exhibited artists include H. Altman and J. Isaac. Sponsors 2-3 shows/year. Average display time 6 weeks. Open all year. Located downtown; 3,700 sq. ft.; "We were awarded *Decor* magazine's Award of Excellence for gallery design." 30% of space for special exhibitions. Clientele: students, professionals, experienced and new collectors. 80% private collec-

tors, 20% corporate collectors. Overall price range: $30-140,000; most work sold at $400-4,000.

Media: Considers oil, acrylic, watercolor, pastel, drawings, mixed media, collage, paper, sculpture, ceramic, craft, glass and original handpulled prints. Considers all types of prints except offset reproductions. Most frequently exhibits intaglio, serigraphy and sculpture. "Must be of highest quality."

Style: Exhibits expressionism, painterly abstraction, surrealism, postmodern works, impressionism, realism, photorealism and hard-edge geometric abstraction. Genres include landscapes, florals, Southwestern and figurative work. Prefers abstract, landscapes and figurative. Seeking artists who will continue to produce excellent work.

Terms: Accepts work on consignment (negotiable commission); or buys outright for negotiated percentage of retail price. Retail price set by gallery and artist. Offers payment by installments. Gallery provides insurance, promotion and contract; shipping costs are shared. Prefers artwork unframed (gallery frames).

Submissions: Send query letter with bio or résumé, brochure and slides or photographs and SASE. Call for appointment to show portfolio of originals or photos of any type. Replies in 1 week. Files any material the artist does not need returned.

Tips: Finds artists through mostly through NY art expo."Artists must know the nature of works displayed already, and work must be of high quality and marketable. Aesthetics are extremely important. Be sure to include prices and SASE."

URBAN PARK–DETROIT ART CENTER, 508 Monroe, Detroit MI 48226. (313)963-5445. Fax: (313)963-2333. Director: Dave Roberts. Retail cooperative gallery. Estab. 1991. Represents 100 emerging and mid-career artists/year. Exhibited artists include Walter Warren and Diana Gamerman. Sponsors 60 shows/year. Average display time 1 month. Open all year; Monday-Thursday, 10-9; Friday-Saturday, 10-11; Sunday 12-7. Located downtown inside Trappers Alley, Greektown; 3,316 sq. ft.; 10 individual exhibit spaces in historic building. 90% of space for special exhibitions; 10% of space for gallery artists. Clientele: mostly beginning collectors, tourists. 90% private collectors, 10% corporate collectors. Overall price range: $50-2,000; most work sold at $50-600.

Media: Considers all media. Most frequently exhibits paintings, sculpture and photography.

Style: Exhibits all styles.

Terms: Co-op membership fee plus donation of time (40% commission). Rental fee for space; covers 1 month. Retail price set by the artist. Gallery provides promotion; shipping costs are shared. Prefers artwork framed.

Submissions: Send query letter with résumé, slides, bio and SASE. Call for appointment to show portfolio of originals, slides and transparencies. Replies in 3 weeks. Files résumé, bio.

Tips: Finds artists through artists' submissions. "Request gallery brochure for specific information."

Minnesota

ANDERSON & ANDERSON GALLERY, Dept. AM, 414 First Ave. N., Minneapolis MN 55401. (612)332-4889. Owners/Directors: John and Sue Anderson. Retail gallery. Estab. 1986. Represents 40 emerging, mid-career and established artists. Exhibited artists include Eugene Larkin and Wayne Potratz. Sponsors 8 shows/year. Average display time 5 weeks. Open all year. Located in downtown gallery district; 35% of space for special exhibitions. Clientele: 65% private collectors, 35% corporate collectors. Overall price range: $150-20,000; most work sold at $1,500.

• This gallery may be moving in the future because current gallery district is declining.

Media: Considers oil, acrylic, watercolor, pastel, pen & ink, drawing, mixed media, works on paper, sculpture, cast metal sculpture, architect-designed furnishings and non-functional ceramic, woodcuts and engravings. Most frequently exhibits painting, cast metal sculpture and works on paper.

Style: Exhibits expressionism, painterly abstraction, imagism, conceptualism, minimalism, impressionism, photorealism, "anything I like—mostly contemporary abstraction." All genres. Prefers abstraction, impressionism and conceptualism.

Terms: Accepts artwork on consignment (50% commission). Retail price set by the gallery and the artist. Offers customer discounts and payment by installments. Gallery provides insurance, promotion and contract; artist pays for shipping. Prefers artwork framed.

Submissions: Send query letter with résumé, slides, bio, SASE and reviews. Portfolio should include slides, transparencies, résumé, price list and SASE. Replies in 2 months. Files résumés if interested.

Tips: "Show professional well-worked slides, a complete résumé and SASE for return of work. Today the works selling are brighter, more colorful and recognizable—very safe."

FLANDERS CONTEMPORARY ART, 400 N. 1st Ave., Minneapolis MN 55401. (612)344-1700. Fax: (612)344-1643. Director: Douglas Flanders. Retail gallery. Estab. 1972. Represents 21 emerging, mid-career and established artists. Exhibited artists include Jim Dine and David Hockney. Sponsors 8 shows/year. Average display time 5 weeks. Open all year; Tuesday-Saturday 10-4. Located in downtown warehouse district; 2,600 sq. ft.; 17' ceilings. Clientele: 100% private collectors. Price range starts as low as $85. Most work sold at $9,500-55,000.

Media: Considers all media and original handpulled prints. Most frequently exhibits sculpture, monotypes and woodblock prints.
Style: Exhibits all styles and genres. Prefers abstract expressionism, impressionism and post-impressionism.
Terms: Accepts work on consignment (50% commission). Gallery provides insurance, promotion and contract; shipping costs are shared. Prefers artwork framed.
Submissions: Send query letter with résumé, slides, bio and SASE. Write for appointment to show portfolio of slides. Replies in 1 week.

‡**GLASSPECTACLE ART GALLERY,** 402 N. Main St., Stillwater MN 55082. (612)439-0757. Manager: Brenda Hanson. Retail gallery. Estab. 1984. Represents 65 emerging, mid-career and established artists/year. Exhibited artists include John Simpson and Steve Maslach. Sponsors 3 shows/year. Average display time 2 months. Open all year; Monday-Saturday, 10-5; Sunday 11-5. Located downtown; 650 sq. ft.; features hand blown art glass, stain and fused only. 30% of space for special exhibitions; 70% of space for gallery artists. Clientele: mid-upper income. 100% private collectors. Overall price range; $10-2,000; most work sold at $80-250.
Media: Considers glass.
Style: Exhibits all styles.
Terms: Accepts work on consignment (60% commission) or buys outright for 50% of retail price (net 30 days). Retail price set by the artist. Gallery pays for shipping costs from gallery; artist pays for shipping costs to gallery.
Submissions: Prefers only glass. Send query letter with slides, photographs and SASE. Call for appointment to show portfolio. Replies in 3 weeks. Files photos, slides and résumé.
Tips: Finds artists through *American Craft*.

J-MICHAEL GALLERIES, 3916 W. 50th St., Edina, MN 55424. (612)920-6070. Gallery Director: Mark Roberts. Estab. 1975. Represents 75-100 emerging, mid-career and established artists. Interested in seeing the work of emerging artists. Exhibited artists include Rose Edin. Sponsors 2-4 shows/year. Average display time 3-6 months. Open all year. 3,500 sq. ft. 10% of space for special exhibitions; 50% of space for gallery artists. Clientele: private homeowners, corporate and designers. 80% private collectors, 20% corporate collectors. Overall price range $10-10,000; most work sold at $400-1,000.
Media: Considers oil, acrylic, watercolor, pastel, mixed media, paper, woodcuts, wood engravings, engravings, mezzotints, etching, lithographs, serigraphs and posters. Most frequently exhibits watercolor, serigraphs/lithographs and offset reproductions.
Style: Exhibits painterly abstraction, impressionism and realism. Genres include landscapes and florals. Prefers landscape, abstract and floral.
Terms: Accepts work on consignment (50% commission). Retail price set by artist. Sometimes offers customer discounts and payment by installment. Gallery provides promotion; artist pays for shipping.
Submissions: Send query letter with résumé, slides, bio, photographs, business card, reviews and SASE. Portfolio review requested if interested in artist's work. Files résumé and card.
Tips: Finds artists through visiting exhibitions, word of mouth and artists' submissions. "The mood of our clients has leaned towards quality, colorful artwork that has an uplifting appeal."

‡**M.C. GALLERY,** #336, 400 First Ave., Minneapolis MN 55401. (612)339-1480. Fax: (612)339-1480-04. Gallery Director: M.C. Anderson. Retail gallery. Estab. 1984. Represents 30 emerging, mid-career and established artists/year. Exhibited artists include Terri Hallman and Tom Grade. Sponsors 8 shows/year. Average display time 5 weeks. Open all year; Tuesday-Saturday, 12-4. Located downtown; 3,500 sq. ft.; in a warehouse with 8 other galleries. 5% of space for special exhibitions; 45% of space for gallery artists. 50% private collectors; 50% corporate collectors. Overall price range: $800-12,000; most work sold at $1,500-3,500.
Media: Considers oil, acrylic, pastel, drawing, mixed media, collage, paper, sculpture, ceramics, fiber, glass, photography and multi media prints. Most frequently exhibits paintings, glass and ceramics.
Style: Exhibits painterly abstraction. Prefers glass and ceramic.
Terms: Accepts work on consignment (50% commission). Retail price set by the artist. Gallery provides promotion and shipping costs from gallery; artist pays shipping costs to gallery. Prefers artwork framed.
Submissions: Send query letter with résumé, slides and bio. Call or write for appointment to show portfolio of slides. Replies if interested "right away."
Tips: Finds artists through agents, visiting exhibitions, word of mouth, art publications and sourcebooks and artists' submissions.

‡**THE CATHERINE G. MURPHY GALLERY,** The College of St. Catherine, 2004 Randolph Ave., St. Paul MN 55105. (612)690-6637. Fax: (612)690-6024. Curator: Kathleen M. Daniels. Nonprofit gallery. Estab. 1973. Represents emerging, mid-career and nationally and regionally established artists. "We have a mailing list of 1,000." Sponsors 6 shows/year. Average display time 5-6 weeks. Open September-June Monday-Friday, 8-8; Saturday, 12-5; Sunday, 12-8. Located on the college campus of the College of St. Catherines; 1,480 sq. ft.

• This gallery also exhibits at art historical and didactic shows of visual significance.

Media: Considers all media and all types of prints.
Style: Exhibits all styles.
Terms: Artwork is loaned for the period of the exhibition. Gallery provides insurance. Shipping costs are shared. Prefers artwork framed.
Submissions: Send query letter with résumé, slides and bio. Write for appointment to show portfolio. Replies in 4-6 weeks. Files résumé and cover letters.

‡**NORTH COUNTRY MUSEUM OF ARTS**, Third and Court Streets, P.O. Box 328, Park Rapids MN 56470. (218)732-5237. Curator/Administrator: Johanna M. Verbrugghen. Museum. Estab. 1977. Interested in seeing the work of emerging and established artists. 100 members. Sponsors 8 shows/year. Average display time 3 weeks. Open May-October Tuesday-Sunday 11-5. Located next to courthouse; 4 rooms in a Victorian building built in 1900 (on Register of Historic Monuments). 50% of space for special exhibitions; 50% of space for gallery artists.
Media: Considers all media and all types of prints. Most frequently exhibits acrylic, watercolor and sculpture.
Style: Exhibits all genres; prefers realism.
Terms: Accepts work on consignment (20% commission). Retail price set by the artist. Artist pays shipping costs to and from gallery. Prefers artwork framed.
Submissions: "Work should be of interest to general public." Send query letter with résumé and slides. Portfolio should include photographs and slides. Replies only if interested within 1-2 months.
Tips: Finds artists through word of mouth.

‡**JEAN STEPHEN GALLERIES**, Suite 401, 800 Nicollet Mall, Minneapolis MN 55402. (612)338-4333. Directors: Steve or Jean Danke. Retail gallery. Estab. 1987. Represents 12 established artists. Interested in seeing the work of emerging artists. Exhibited artists include Jiang, Hart and Max. Sponsors 2 shows/year. Average display time 4 months. Open all year; Monday-Friday, 10-7; Saturday, 10-8; Sunday, 12-5. Located downtown; 1,200 sq. ft. 15% of space for special exhibitions; 85% of space for gallery artists. Clientele: upper income. 90% private collectors, 10% corporate collectors. Overall price range: $600-12,000; most work sold at $1,200-2,000.
Media: Considers oil, acrylic, pastel, pen & ink, drawing, mixed media, collage, paper, sculpture, ceramics, woodcut, engraving, lithograph, wood engraving, mezzotint, serigraphs, linocut and etching. Most frequently exhibits serigraphs, stone lithographs and sculpture.
Style: Exhibits expressionism, neo-expressionism, surrealism, minimalism, color field, postmodern works and impressionism. Genres include landscapes, Southwestern, portraits and figurative work. Prefers Chinese contemporary, abstract and impressionism.
Terms: Accepts work on consignment (50% commission). Retail price set by the gallery. Gallery provides insurance and contract; artist pays shipping costs to and from gallery.
Submissions: Send query letter with résumé, slides and bio. Call for appointment to show portfolio of originals, photographs and slides. Replies in 1-2 months.
Tips: Finds artists through art shows and visits.

‡**THE FREDERICK R. WEISMAN ART MUSEUM**, 333 East River Rd., Minneapolis MN 55455. (612)625-9494. Fax: (612)625-9630. Public Relations Director: Robert B. Bitzan. Museum. Frederick R. Weisman Art Museum opened in November 1993; University of Minnesota Art Museum established in 1934. Represents 13,000 works in permanent collection. Represents established artists. 1,000 members. Sponsors 4-5 shows/year. Average display time 10 weeks. Open all year; Monday-Friday, 10-6; Saturday, Sunday, 12-5. Located at the University of Minnesota, Minneapolis; 11,000 sq. ft.; designed by Frank O. Gehry. 40% of space for special exhibitions.
Media: Considers all media and all types of prints. Most frequently exhibits oil, acrylic and watercolor.
Style: Exhibits all styles, all genres.
Terms: Gallery provides insurance. Prefers artwork framed.
Submissions: "Generally we do not exhibit one-person shows. We prefer thematic exhibitions with a variety of artists. However, we welcome exhibition proposals. Formulate exhibition proposal with a scholarly base. Exhibitions which are multi-disciplinary are preferred."

The double dagger before a listing indicates that the listing is new in this edition. New markets are often more receptive to freelance submissions.

Mississippi

HILLYER HOUSE INC., 207 E. Scenic Dr., Pass Christian MS 39571. (601)452-4810. Owners: Katherine and Paige Reed. Retail gallery. Estab. 1970. Represents emerging, mid-career and established artists: 19 artists, 34 potters, 46 jewelers, 10 glass-blowers. Interested in seeing the work of emerging artists. Exhibited artists include Barbara Wing and Patt Odom. Sponsors 24 shows/year. Average display time 2 months. Open Monday-Saturday 10-5, Sunday 12-5. Open all year. Located beachfront-middle of CBD historic district; 1,700 sq. ft. 50% of space for special exhibitions; 50% of space for gallery artists. Clientele: 80% of clientele are visitors to the Mississippi Gulf Coast, 20% private collectors. Overall price range: $25-700; most work sold at $30-150; paintings $250-700.

• Hillyer House has special exhibitions in all areas.

Media: Considers oil, watercolor, pastel, mixed media, sculpture (metal fountains), ceramic, craft and jewelry. Most frequently exhibits watercolor, pottery and jewelry.

Style: Exhibits expressionism, imagism, realism and contemporary. Genres include aquatic/nautical. Prefers realism, impressionism and expressionism.

Terms: Accepts work on consignment (35% commission); or artwork is bought outright for 50% of the retail price (net 30 days). Retail price set by gallery or artist. Gallery provides promotion and contract; artist pays for shipping. Prefers artwork framed.

Submissions: Send query letter with résumé, slides, bio, brochure, photographs, SASE and reviews. Call or write for appointment to show portfolio of originals and photographs. Replies only if interested within 3 weeks. Files photograph and bio. (Displays photo and bio with each person's art.)

Tips: "Work must be done in last nine months. Watercolors sell best. Make an appointment. Looking for artists with a professional attitude and approach to work. Be sure the work submitted is in keeping with the nature of our gallery."

‡MERIDIAN MUSEUM OF ART, 628 25th Ave., P.O. Box 5773, Meridian MS 39302. (601)693-1501. Acting Director: Terence Heder. Museum. Estab. 1970. Represents emerging, mid-career and established artists. Interested in seeing the work of emerging artists. Exhibited artists include Terry Chaney and Bruce Brady. Sponsors 15 shows/year. Average display time 5 weeks. Open all year; Tuesday-Sunday, 1-5. Located downtown; 1,750 sq. ft.; housed in renovated Carnegie Library building, originally constructed 1912-13. 50% of space for special exhibitions. Clientele: general public. Overall price range: $75-1,000; most work sold at $300-500.

Media: Considers all media, woodcut, engraving, lithograph, wood engraving, mezzotint, serigraphs, linocut and etching. Most frequently exhibits oils, watercolors and sculpture.

Style: Exhibits all styles, all genres.

Terms: Work available for sale during exhibitions (25% commission). Retail price set by the artist. Gallery provides insurance and promotion; shipping costs are shared. Prefers artwork framed.

Submissions: Prefers artists from Mississippi, Alabama and the Southeast. Send query letter with résumé, slides, bio and SASE. Replies in 3 months.

Tips: Finds artists through artists' submissions, word of mouth and visiting exhibitions.

MISSISSIPPI CRAFTS CENTER, Box 69, Ridgeland MS 39158. (601)856-7546. Director: Martha Garrott. Retail and nonprofit gallery. Estab. 1975. Represents 70 emerging, mid-career and established guild members. 200 members. Exhibited artists include Susan Denson and Wortman Pottery. Open all year. Located in a national park near the state capitol of Jackson; 1200 sq. ft.; a traditional dogtrot log cabin. Clientele: travelers and local patrons. 99% private collectors. Overall price range: $2-900; most work sold at $10-60.

Media: Considers paper, sculpture, ceramic, craft, fiber and glass. Most frequently exhibits clay, basketry and metals.

Style: Exhibits all styles. Crafts media only. Interested in seeing a "full range of craftwork — Native American, folk art, naive art, production crafts, crafts as art, traditional and contemporary. Work must be small enough to fit our limited space."

Terms: Accepts work on consignment (40% commission), first order; buys outright for 50% of retail price (net 30 days), subsequent orders. Retail price set by the gallery and the artist. Gallery provides promotion and shipping costs to gallery.

Submissions: Accepts only artists from the Southeast. Artists must be juried members of the Craftsmen's Guild of Mississippi. Ask for standards review application form. Call or write for appointment to show portfolio of slides. Replies in 1 week.

Tips: "All emerging craftsmen should read *Crafts Report* regularly and know basic business procedures. We will probably need more low end work this year."

‡MISSISSIPPI MUSEUM OF ART CORPORATE ART PROGRAM, 201 East Pascagoula St., Jackson MS 39201. (601)960-1515. Fax: (601)960-1505. Director/Associate Curator: Sabrina Comola. Estab. 1986. Represents "hundreds" of emerging, mid-career and established artists/year. Exhibited artists include George Ohr and Steve Moppert. Average display time 3 months. Open all year; Monday-Friday, 9-5. Located in the downtown Arts Center; 500 sq. ft.; represents Mississippi artists exclusively. 85% of space for gallery artists. 100%

corporate collectors. Overall price range: $100-20,000; most work sold at $500-5,000.
Media: Considers oil, acrylic, watercolor, pastel, pen & ink, mixed media, collage, paper, sculpture, ceramics, craft, fiber, glass, installation, photography, woodcut, engraving, lithograph, wood engraving, mezzotint, serigraphs, linocut and etching. Most frequently exhibits oil on canvas, pastel and watercolor.
Style: Exhibits all styles, all genres. Prefers realism, impressionism and primitivism.
Terms: Accepts work on consignment (35% commission). Retail price set by the gallery and the artist. Gallery provides insurance and promotion; shipping costs are shared. Prefers artwork unframed.
Submissions: Accepts only artists Mississippi born or residing. Send query letter with slides, bio, business card and reviews. Call for appointment to show "whatever is available." Replies in 1 week.

Missouri

BARUCCI'S ORIGINAL GALLERIES, 8101 Maryland Ave., St Louis MO 63105. (314)727-2020. President: Shirley Taxman Schwartz. Retail gallery and art consultancy. Estab. 1977. Represents 40 artists. Interested in emerging and established artists. Sponsors 3-4 solo and 4 group shows/year. Average display time is 2 months. Located in "affluent county, a charming area. Clientele: affluent young area. 70% private collectors, 30% corporate clients. Overall price range: $500-5,000.
● This gallery has moved into a corner location featuring 3 large display windows.
Media: Considers oil, acrylic, watercolor, pastel, collage and works on paper. Most frequently exhibits watercolor, oil, acrylic and hand blown glass.
Style: Exhibits painterly abstraction, primitivism and impressionism. Genres include landscapes and florals. Currently seeking contemporary works: abstracts in acrylic and fiber, watercolors and some limited edition serigraphs.
Terms: Accepts work on consignment (50% commission). Retail price set by gallery or artist. Sometimes offers payment by installment. Gallery provides contract.
Submissions: Send query letter with résumé, slides and SASE. Portfolio review requested if interested in artist's work. Slides, bios and brochures are filed.
Tips: "Due to the recession more clients are requesting discounts or longer pay periods."

‡BOODY FINE ARTS, INC., 10701 Trenton Ave., St. Louis MO 63132. (314)423-2255. Retail gallery and art consultancy. "Gallery territory includes 15 Midwest/South Central states. Staff travels on a continual basis, to develop collections within the region." Estab. 1978. Represents 100 mid-career and established artists. Sponsors 6 group shows/year. Clientele: 30% private collectors, 70% corporate clients. Overall price range: $500-300,000.
Media: Considers oil, acrylic, watercolor, pastel, drawings, mixed media, collage, sculpture, ceramic, fiber, metalworking, glass, works on handmade paper, neon and original handpulled prints.
Style: Exhibits color field, painterly abstraction, minimalism, impressionism and photorealism. Prefers nonobjective, figurative work and landscapes.
Terms: Accepts work on consignment or buys outright. Retail price is set by gallery and artist. Customer discounts and payment by installments available. Exclusive area representation required. Gallery provides insurance, promotion and contract; shipping costs are shared.
Submissions: Send query letter, résumé and slides. Write to schedule an appointment to show a portfolio, which should include originals, slides and transparencies. All material is filed.
Tips: Finds artists by visiting exhibitions, word of mouth, artists' submissions and art collectors' referrals. "Organize your slides."

‡GALERIE BONHEUR, 9243 Clayton Rd., St. Louis MO 63124. (314)993-9851. Fax: (314)993-4790. Owner: Laurie Carmody. Private retail and wholesale gallery. Estab. 1980. Represents 60 emerging, mid-career and established artists/year. Exhibited artists include Woodie Long and Justin McCarthy. Sponsors 6 shows/year. Average display time 1 year. Open all year; by appointment. Located in Ladue (a suburb of St. Louis); 1,500 sq. ft.; art is all displayed all over very large private home. 75% of sales to private collectors. Overall price range: $25-25,000; most work sold at $50-1,000.
Media: Considers oil, acrylic, watercolor, pastel, pen & ink, drawing, mixed media, collage, paper, sculpture, ceramics and craft. Most frequently exhibits oil, acrylic and metal sculpture.
Style: Exhibits expressionism, primitivism, impressionism, folk art, self-taught, outsider art. Genres include landscapes, florals, Americana and figurative work. Prefers genre scenes and figurative.
Terms: Accepts work on consignment (50% commission) or buys outright for 50% of retail price. Retail price set by the gallery and the artist. Gallery provides promotion; artist pays shipping costs to and from gallery. Prefers artwork framed.
Submissions: Prefers only self-taught artists. Send query letter with bio, photographs and business card. Write for appointment to show portfolio of photographs. Replies only if interested within 6 weeks.
Tips: Finds artists through agents, visiting exhibitions, word of mouth, art publications and sourcebooks, artists' submissions.

GOMES GALLERY OF SOUTHWESTERN ART, 8001 Forsyth, Clayton MO 63105. (314)725-1808. President: Larry Gomes. Retail gallery. Estab. 1985. Represents 30 emerging, mid-career and established artists. Exhibited artists include R.C. Gorman and Jimmie Lee Brown. Sponsors 3 shows/year. Average display time 2 months. Open all year. Located "downtown, across the street from the St. Louis County Court House; 4,600 + sq. ft.; total Southwestern theme, corner of building with lots of windows." 35% of space for special exhibition during shows. Clientele: upper income. 95% private collectors, 5% corporate collection. Overall price range: $40-8,000; most work sold at $800-4,000.
- This gallery reports that business is up 30%.

Media: Considers oil, acrylic, watercolor, mixed media, sculpture, ceramic, glass, original handpulled prints, offset reproductions, woodcuts, engravings, lithographs, wood engravings, mezzotints, serigraphs, linocuts and etchings. Most frequently exhibits oil, acrylic and watercolor.
Style: Exhibits expressionism, primitivism, painterly abstraction, impressionism and realism. Genres include landscapes, Western, wildlife and Southwestern. Prefers Western/Southwestern themes.
Terms: Accepts artwork on consignment (50% commission); or buys outright for 50% of retail price (net 10-30 days). Retail price set by gallery and artist. Customer discounts and payment by installment are available. Gallery provides insurance, promotion, contract and shipping costs from gallery.
Submissions: Send query letter with slides, medium, price list brochure and photographs. Portfolio review requested if interested in artist's work. Portfolio should include originals, slides, photographs, transparencies and brochure. Replies in 3-4 weeks; or does not reply, in which case the artist should "call and remind."

LEEDY-VOULKOS GALLERY, 2012 Baltimore Ave., Kansas City MO 64108. (816)474-1919. Director: Sherry Leedy. Retail gallery. Estab. 1985. Represents 25-30 emerging, mid-career and established artists. Sponsors 6 two-person, 1 group and 2 solo shows/year. Average display time 6 weeks. 10,000 sq. ft. of exhibit area. Clientele: 50% private collectors, 50% corporate clients. Price range: $500-25,000; most work sold at $5,000.
- Leedy-Voulkos consolidated its two gallery locations into one large art center location to allow more flexibility with exhibitions. There are now several exhibition spaces of varying sizes to accommodate several shows at once. They continue to showcase both nationally and regionally known artists.

Media: Considers oil, acrylic, watercolor, works on paper, mixed media, sculpture, ceramic, glass, installation, photography and original handpulled prints. Most frequently exhibits painting, clay sculpture and glass.
Style: Exhibits abstraction, expressionism and realism. "While we exhibit mature, quality work in all media, our expertise in contemporary ceramics makes our gallery unique."
Terms: Accepts work on consignment (50% commission). Retail price set by gallery and artist. Sometimes offers customer discounts and payment by installment. Exclusive area representation required. Gallery provides insurance, promotion and contract; shipping costs are shared.
Submissions: Send query letter, résumé, good slides, prices and SASE. Call or write for appointment to show portfolio of originals, slides and transparencies. Bio, vita, slides, articles, etc. are filed.
Tips: "We pursue artists that are of interest to us—usually recommended by other artists, galleries and museums. We also find out about artists through their direct inquiries to us—they are usually directed to us by other atists, collectors, museums, etc. Allow 3 months for gallery to review slides."

MORTON J. MAY FOUNDATION GALLERY, Maryville University, 13550 Conway, St. Louis MO 63141. (314)576-9300. Director: Nancy N. Rice. Nonprofit gallery. Exhibits the work of 6 emerging, mid-career and established artists/year. Sponsors 10 shows/year. Average display time 1 month. Open all year. Located on college campus. 10% of space for special exhibitions. Clientele: college community. Overall price range: $100-4,000.
- The gallery is long and somewhat narrow, therefore it is inappropriate for very large 2-D work. There is space in the lobby for large 2-D work but it is not as secure.

Media: Considers oil, acrylic, watercolor, pastel, pen & ink, drawings, mixed media, collage, works on paper, sculpture, ceramic, fiber, installation, photography, original handpulled prints, woodcuts, engravings, lithographs, wood engravings, mezzotints, linocuts and etchings.
All genres.
Terms: Artist receives all proceeds from sales. Retail price set by artist. Gallery provides insurance and promotion; artist pays for shipping. Prefers framed artwork.
Submissions: Prefers St. Louis area artists. Send query letter with résumé, slides, bio, brochure and SASE. Portfolio review requested if interested in artist's work. Portfolio should include slides, photographs and transparencies. Replies only if interested within 3 months.
Tips: Referrals by colleagues, dealers, collectors, etc. "I also visit group exhibits especially if the juror is someone I know and or respect." Does not want to see "hobbyists/crafts fair art."

A bullet introduces comments by the editor of Artist's & Graphic Designer's Market *indicating special information about the listing.*

MARTIN SCHWEIG STUDIO & GALLERY, 4658 Maryland Ave., St. Louis MO 63108. (314)361-3000. Gallery Director: Christine Miller. Retail gallery. Estab. 1956. Represents emerging and mid-career artists. Exhibited artists include Bob Kolbrenner and Yvette Dubinsky. Sponsors 9 shows/year. Average display time 5 weeks. Open Tuesday-Saturday 10-5. Closed February and August. Located central west end district; 560 sq. ft. 100% of space for gallery artists. Clientele: 95% private collectors, 5% corporate collectors. Overall price range: $200-2,500; most work sold at $200-1,000.
Media: Considers photography, oil, acrylic, drawing, mixed media, collage and sculpture. Most frequently exhibits photography, mixed media and oil.
Style: Exhibits all styles. Prefers abstract photography and landscape photography.
Terms: Accepts work on consignment (40% commission). Retail price set by artist (with gallery's input). Artist pays shipping costs.
Submissions: Send query letter with résumé, slides, bio and SASE. Call or write for appointment to show portfolio of originals (photos should be matted). Does not reply. Artist should follow up with phone call in two weeks. Files résumés, bio and sometimes slides.

Montana

‡CUSTER COUNTY ART CENTER, Box 1284, Water Plant Rd., Miles City MT 59301. (406)232-0635. Executive Director: Susan McDaniel. Nonprofit gallery. Estab. 1977. Interested in emerging and established artists. Clientele: 90% private collectors, 10% corporate clients. Sponsors 8 group shows/year. Average display time is 6 weeks. Overall price range: $200-10,000; most artwork sold at $300-500.
 • The galleries are located in the former water holding tanks of the Miles City WaterWorks. The underground, poured concrete structure is listed on the National Register of Historic Places. It was constructed in 1910 and 1924 and converted to its current use in 1976-77.
Media: Considers all media and original handpulled prints. Does not consider crafts. Most frequently exhibits painting, sculpture and photography.
Style: Exhibits painterly abstraction, conceptualism, primitivism, impressionism, expressionism, neo-expressionism and realism. Genres include landscapes, Western, portraits and figurative work. "Our gallery is seeking artists working with traditional and non-traditional Western subjects in new, contemporary ways." Specializes in Western, contemporary and traditional painting and sculpture.
Terms: Accepts work on consignment (30% commission). Retail price is set by gallery and artist. Exclusive area representation not required. Gallery provides insurance, promotion and contract; shipping expenses are shared.
Submissions: Send query letter, résumé, brochure, slides, photographs and SASE. Write to schedule an appointment to show a portfolio, which should include originals, "a statement of why the artist does what he/she does" and slides. Slides and résumés are filed.

HARRIETTE'S GALLERY OF ART, 510 1st Ave. N., Great Falls MT 59405. (406)761-0881. Owner: Harriette Stewart. Retail gallery. Estab. 1970. Represents 20 mid-career artists. Exhibited artists include Brenda Yirsa, Frank Miller, Judy Sleight, Kathleen Thompson and Charlie Haagenson. Sponsors 1 show/year. Average display time 6 months. Open all year. Located downtown; 1,000 sq. ft. 100% of space for special exhibitions. Clientele: 90% private collectors, 10% corporate collectors. Overall price range: $100-10,000; most artwork sold at $200-750.
Media: Considers oil, acrylic, watercolor, pastel, pencils, pen & ink, mixed media, sculpture, original handpulled prints, lithographs and etchings. Most frequently exhibits watercolor, oil and pastel.
Style: Exhibits expressionism. Genres include wildlife, landscape, floral and Western.
Terms: Accepts work on consignment (33⅓% commission); or outright for 50% of retail price. Retail price set by gallery and artist. Sometimes offers customer discounts and payment by installment. Gallery provides promotion; "buyer pays for shipping costs." Prefers artwork framed.
Submissions: Send query letter with résumé, slides, brochure and photographs. Portfolio review requested if interested in artist's work. "Have Montana Room in largest Western Auction in US—The "Charles Russell Auction," in March every year—looking for new artists to display."

HOCKADAY CENTER FOR THE ARTS, P.O. Box 83, Kalispell MT 59903. (406)755-5268. Director: Magee Nelson. Museum. Estab. 1968. Exhibits emerging, mid-career and established artists. Interested in seeing the work of emerging artists. 500+ members. Exhibited artists include Theodore Waddell and David Shaner. Sponsors approximately 20 shows/year. Average display time 6 weeks. Open year round. Located 2 blocks from downtown retail area; 2,650 sq. ft.; historic 1906 Carnegie Library Building with new (1989) addition; wheelchair access to all of building. 50% of space for special exhibitions. Overall price range $500-35,000.
Media: Considers all media, plus woodcuts, wood engravings, linocuts, engravings, mezzotings, etchings, lithographs and serigraphs. Most frequently exhibits painting (all media), sculpture/installations (all media), photography and original prints.

Style: Exhibits all styles and genres. Prefers contemporary art (all media and styles), historical art and photographs and traveling exhibits. "We are not interested in wildlife art and photography, mass-produced prints or art from kits."

Terms: Accepts work on consignment (30% commission). Also houses permanent collection: Montana and regional artists acquired through donations. Sometimes offers customer discounts and payment by installment to museum members. Gallery provides insurance, promotion and contract; shipping costs are shared. Prefers artwork framed.

Submissions: Send query letter with résumé, slides, bio, reviews and SASE. Portfolio should include b&w photographs and slides (20 maximum). "We review *all* submitted portfolios once a year, in spring."

Tips: Finds artists through artists' submissions and self-promotions.

LEWISTOWN ART CENTER, 801 W. Broadway, Lewistown MT 59457. (406)538-8278. Executive Director: Ellen Gerharz. Nonprofit gallery and signature gift shop. Estab. 1971. Represents emerging, mid-career and established artists. Sponsors 12 shows/year. Average display time 1 month. Open all year. Located in historic Courthouse Square; 1,075 sq. ft. (2 separate galleries: 400 sq. ft. in one, 425 sq. ft. in other, plus a reception area that is used as overflow, approximately 250 sq. ft.); historical stone bunk house – 1897 and historical carriage house same era. Clientele: business/professional to agriculture. 75% private collectors, 25% corporate collectors. Overall price range: $45-1,200; most work sold at $200-400.
 ● Even though the Lewistown Art Center is in Montana, its interests in art are much broader than animals, cowboys and Indians.

Media: Considers oil, acrylic, watercolor, pastel, pen & ink, drawings, mixed media, sculpture, ceramic, fiber and glass; all types of prints on consignment only.

Style: Exhibits expressionism, primitivism, conceptualism, postmodern works, impressionism and realism. All genres.

Terms: Accepts work on consignment (35% commission). Retail price set by gallery and artist. Sometimes offers customer discounts and payment by installment. Gallery provides insurance, promotion and contract; artist pays for shipping. Prefers artwork framed.

Submissions: First send query letter with slides and bio. Then later send brochure and reviews. Replies in 2 weeks.

Tips: Finds artists through word of mouth, artists' submissions, traveling shows and visiting and chatting with artists. "Located in the center of Montana, between Great Falls and Billings, the LAC serves Montanans within a 100-mile radius."

Nebraska

ARTISTS' COOPERATIVE GALLERY, 405 S. 11th St., Omaha NE 68102. (402)342-9617. Membership Chair: Robin Davis. Cooperative and nonprofit gallery. Estab. 1974. Exhibits the work of 30-35 emerging, mid-career and established artists. 35 members. Exhibited artists include Carol Pettit, Jerry Jacoby and Patsy Smith. Sponsors 14 shows/year. Average display time 1 month. Open all year. Located in historic old market area; 5,000 sq. ft.; "large open area for display with 25' high ceiling." 20% of space for special exhibitions. Clientele: 85% private collectors, 15% corporate collectors. Overall price range: $20-2,000; most work sold at $20-1,000.

Media: Considers oil, acrylic, watercolor, pastel, drawings, mixed media, collage, paper, sculpture, ceramic, fiber, glass, photography, woodcuts, serigraphs. Most frequently exhibits pastel, acrylic, oil and ceramic.

Style: Exhibits all styles and genres.

Terms: Co-op membership fee plus donation of time. Retail price set by artist. Sometimes offers payment by installment. Artist provides insurance; artist pays for shipping. Prefers artwork framed. No commission charged by gallery.

Submissions: Accepts only artists from the immediate area. "We each work one day a month." Send query letter with résumé, slides and bio. Write for appointment to show portfolio of originals and slides. "Applications are reviewed and new members accepted and notified in August if any openings are available." Files applications.

Tips: "Fill out application and touch base with gallery in July."

‡GALLERY 72, 2709 Leavenworth, Omaha NE 68105. (402)345-3347. Director: Robert D. Rogers. Retail gallery and art consultancy. Estab. 1972. Interested in emerging, mid-career and established artists. Represents 10 artists. Sponsors 4 solo and 4 group shows/year. Average display time is 3 weeks. Clientele: individuals, museums and corporations. 75% private collectors, 25% corporate clients. Overall price range: $750 and up.

Media: Considers oil, acrylic, watercolor, pastel, pen & ink, drawings, mixed media, collage, sculpture, ceramic, installation, photography, original handpulled prints and posters. Most frequently exhibits paintings, prints and sculpture.

Style: Exhibits hard-edge geometric abstraction, color field, minimalism, impressionism and realism. Genres include landscapes and figurative work. Most frequently exhibits color field/geometric, impressionism and realism. .

Terms: Accepts work on consignment (commission varies), or buys outright. Retail price is set by gallery or artist. Gallery provides insurance and promotion; shipping costs are shared.

Submissions: Send query letter with résumé, slides and photographs. Call to schedule an appointment to show a portfolio, which should include originals, slides and transparencies. Vitae and slides are filed.

‡GERI'S ART AND SCULPTURE GALLERY, 7101 Cass St., Omaha NE 68132. (402)558-3030. President: Geri. Retail gallery and art consultancy featuring restrike etchings and tapestry. Estab. 1978. Exhibited artists include Agam and Calder. Open all year. Located in midtown Omaha. Clientele: collectors, designers, residential and corporate. 50% private collectors, 50% corporate collectors. Overall price range: $35-10,000; most work sold at $500-1,000.

Media: Considers watercolor, mixed media, collage, paper, sculpture, ceramic and photography. Considers all types of prints, especially lithographs, serigraphs and monoprints.

Style: Considers all styles and genres. "We carry mostly graphics."

Terms: Artwork is bought outright or leased. Sometimes offers discounts to gallery customers.

Submissions: Portfolio review not required.

Tips: Finds artists through agents, visiting exhibitions, word of mouth, art publications and sourcebooks, artists' submissions, self-promotions and art collectors' referrals.

HAYDON GALLERY, Suite A, 335 N. Eighth St., Lincoln NE 68508. (402)475-5421. Fax: (402)472-9185. Director: Anne Pagel. Nonprofit sales and rental gallery in support of Sheldon Memorial Art Gallery. Estab. 1984. Exhibits 100 mid-career and established artists. Exhibited artists include Karen Kunc and Neil Christensen. Sponsors 12 shows/year. Average display time 1 month. Open all year; Monday-Saturday, 10-5. Located in historic Haymarket District (downtown); 1,100 sq. ft. 85% of space for special exhibitions; 10% of space for gallery artists. Clientele: collectors, corporate, residential, architects, interior designers. 75% private collectors, 25% corporate collectors. Overall price range: $75-20,000; most work sold at $500-3,000.

Media: Considers all media and all types of original prints. Most frequently exhibits paintings, mixed media and prints.

Style: Exhibits all styles. Genres include landscapes, abstracts, still lifes and figurative work. Prefers contemporary realism, nonrepresentational work in all styles.

Terms: Accepts work on consignment (45% commission). Retail price set by gallery and artist. Offers customer discounts and payment by installments. Gallery provides insurance, promotion, contract; artist pays for shipping.

Submission: Accepts primarily Midwest artists. Send query letter with résumé, slides, reviews and SASE. Portfolio review requested if interested in artist's work. Portfolio should include originals, photographs or slides. Replies only if interested within 1 month (will return slides if SASE enclosed). Files slides and other support information.

Tips: Finds artists through submissions, regional educational programs, visiting openings and exhibitions and news media.

ADAM WHITNEY GALLERY, 8725 Shamrock Rd., Omaha NE 68114. (402)393-1051. Manager: Linda Campbell. Retail gallery. Estab. 1986. Represents 350 emerging, mid-career and established artists. Exhibited artists include Valerie Berlin and Christopher Darling. Average display time 3 months. Open all year; Monday-Saturday, 10-5. Located in countryside village; 2,500 sq. ft. 40% of space for special exhibitions. Overall price range: $150-7,000.

Media: Considers oil, paper, fiber, acrylic, sculpture, glass, watercolor, mixed media, ceramic, installation, pastel, collage, craft, jewelry, mezzotints, lithographs and serigraphs. Most frequently exhibits glass, jewelry, 2-dimensional works.

Style: Exhibits all styles and genres.

Terms: Accepts work on consignment (50% commission). Retail price set by gallery and artist. Gallery provides insurance, promotion and contract; shipping costs are shared. Prefers artwork framed.

Submissions: Send query letter with résumé, slides, photographs and reviews. Call or write for appointment to show portfolio of originals, photographs and slides. Files résumé, slides, reviews.

Nevada

‡KNEELAND GALLERY, Suite 21, 4750 W. Sahara, Las Vegas NV 89102. (702)870-5933. Fax: (702)870-7108. Director: Robyn Loggins. Retail gallery. Estab. 1989. Represents 60 mid-career and established artists. Interested in seeing the work of emerging artists. Exhibited artists include Michael King-Prime and Gregg Robinson. Sponsors 10 shows/year. Average display time 4-5 weeks. Open all year; Monday-Friday, 11-6; Saturday, 11-6 or 7; Sunday, 12-4. "The building is surrounded by windows, thereby drawing attention to our displays. The gallery is in a prime location that receives much walk-in traffic." 80% of space for special

exhibitions; 80% for work of gallery artists. Clientele: professionals. 80% private collectors; 20% corporate collectors. Overall price range: $200-8,000; most work sold at $1,300-3,500.

Media: Considers oil, acrylic, watercolor, pastel, mixed media, collage, sculpture, ceramics, engraving, lithograph, serigraphs, etching and posters. Most frequently exhibits oils, watercolors and acrylics.

Style: Exhibits expressionism, color field, impressionism, photorealism, hard-edge geometric abstraction and realism. Genres include landscapes, florals, Southwestern and figurative work. Prefers landscapes, abstracts and southwestern.

Terms: Accepts work on consignment (50% commission). Retail price set by the artist. Gallery provides insurance, promotion, contract and shipping costs from gallery; artist pays shipping costs to gallery. Prefers artwork framed.

Submissions: Send query letter with résumé, slides, bio and photographs. Write for appointment to show portfolio of photographs, slides, transparencies and bio. Replies only if interested in 3 weeks. Files all artists information.

Tips: Finds artists through artists' exhibitions, publications, agents, and artists' submissions.

‡NEVADA MUSEUM OF ART, 160 W. Liberty St., Reno NV 89501. (702)329-3333. Fax: (702)329-1541. Curator: Howard Spencer. Museum. Estab. 1931. Shows the work of emerging, mid-career and established artists. Sponsors 10 solo shows/year. Average display time: 6-8 weeks. Open all year. Located downtown in business district; 5,000 sq. ft.; "the only art museum in the state of Nevada." 80% of space for special exhibitions. Overall price range, $1,000-100,000. "Sales are minimal." "NMA is a nonprofit private art museum with a separate facility, E.L. Wiegand Museum, a new contemporary museum with 8,000+ square feet for all media and format. Museum curates individual and group exhibitions and has active acquisition policy for West/Great Basin artists."

Media: Considers all media and all types of original prints. Most frequently exhibits painting, sculpture, prints and photography.

Style: Exhibits all styles and all genres. Focus is on American art, with special emphasis on Great Basin and West Coast art.

Terms: Acquires art through donation or occasional special purchase. Retail price set by the artist. Gallery provides insurance, promotion and shipping costs to and from gallery. Prefers artwork framed.

Submissions: Send query letter with nonreturnable samples. Include SASE for return of work. Write to schedule an appointment to show a portfolio, which should include originals, photographs, slides, transparencies and "whatever gives a fair impression of your art."

New Hampshire

KILLIAN GALLERY AT SHARON ARTS CENTER, RFD 2, Box 361, Rt 123, Sharon NH 03458. (603)924-7256. Gallery Director: Randall Hoel. Nonprofit gallery. Estab. 1967. Exhibits, emerging, mid-career and established artists. Exhibits 120 juried and 15 invited artists/year. 250 artists; 600 members. Sponsors 9 shows/year. Open all year; Monday-Saturday 10-5 and Sunday 12-5. Located in rural woodland setting; 1,100 sq. ft. Features Killian Gallery for large exhibits, foyer space for solo shows, Laws House Gallery for member artist exhibits. 40% of space for special exhibitions; 60% of space for gallery artists. Clientele: retail. 15% private collectors, 5% corporate collectors. Overall price range: $200-6,000; most work sold at $200-500.

Media: Considers oil, pen & ink, paper, fiber, acrylic, drawing, sculpture, watercolor, mixed media, ceramic, pastel, collage, photography, woodcuts, wood engravings, linocuts, engravings, mezzotints, etchings, lithographs, collagraphs and serigraphs. Most frequently exhibits paintings, prints (most types including photography) and sculptures.

Style: Exhibits all styles and genres. Prefers realism, postmodernism and abstraction.

Terms: Accepts work on consignment (40% commission). Retail price set by artist. Customer discounts and payment by installment are available for center members. Gallery provides insurance, promotion and contract; artist pays for shipping costs. Prefers artwork framed.

Submissions: Send query letter with résumé, slides, bio and SASE. Call for appointment to show portfolio of originals, photographs and slides. Replies in 2 months. Files résumé, bio, slides and photographs.

Tips: "We plan one to one and a half years in advance. Expect a long wait." Finds new artists through visiting exhibitions, word of mouth, art publications, sourcebooks and artist submissions.

‡PERFECTION FRAMING, 213 Rockingham Rd., Londonderry NH 03053. Phone/Fax: (603)434-7939. Owner: Valerie Little. Retail gallery. Estab. 1986. Represents "3 or 4 local/regional," emerging, mid-career and established artists/year. Interested in seeing the work of emerging artists. Exhibited artists include Bateman, Kuck. Sponsors 2-3 shows/year. Average display time 2 months. Open all year; Tuesday-Saturday, 10-6. Located on Route 28; 1,100 sq. ft. 25% of space for special exhibitions; 60% of space for gallery artists. Clientele: residential and corporate. 90% private collectors, 10% corporate collectors. Overall price range: $200-400; most work sold at $300.

Media: Considers all media and all types of prints. Most frequently exhibits limited edition prints, originals and etchings.

Style: Exhibits impressionism and realism. Genres include landscapes, florals, Americana and wildlife. Prefers wildlife, landscapes and Americana.
Terms: Accepts work on consignment (25% commission). Retail price set by the artist. Gallery provides promotion and contract; artist pays shipping costs. Prefers artwork unframed.
Submissions: Accepts only artists from New Hampshire. Send query letter with bio and photographs. Write for appointment to show portfolio of originals and photographs.
Tips: Finds artists through word of mouth.

New Jersey

ARC-EN-CIEL, 64 Naughright Rd., Long Valley NJ 07853. (908)876-9671. Fax: (908)876-4459. Owner: Ruth Reed. Retail gallery and art consultancy. Estab. 1980. Represents 35 mid-career and established artists/year. Exhibited artists include Andre Pierre, Petian Savain. Sponsors 1 or 2 corporate shows/year. Clientele: 50% private collectors, 50% corporate clients. Sponsors 3 group shows/year. Average display time is 6 weeks-3 months. Open by appointment only. Represents emerging, mid-career and established artists. Overall price range: $150-158,000; most artwork sold at $250-2,000.
Media: Considers oil, acrylic, wood carvings, sculpture. Most frequently exhibits acrylic, painted iron, oil.
Style: Exhibits surrealism, minimalism, primitivism and impressionism. "I exhibit country-style paintings, naif art from around the world. The art can be on wood, iron or canvas."
Terms: Accepts work on consignment (50% commission). Retail price is set by gallery and artist. Customer discounts and payment by installment are available. Exclusive area representation required. Gallery provides promotion;shipping costs are shared.
Submissions: Send query letter, photographs and SASE. Portfolio review requested if interested in artist's work. Photographs are filed.
Tips: Finds artists through word of mouth and art collectors' referrals.

ART FORMS, 16 Monmouth St., Red Bank NJ 07701. (201)530-4330. Fax: (201)530-9791. Director: Charlotte T. Scherer. Retail gallery. Estab. 1984. Represents 12 emerging, mid-career and established artists. Exhibited artists include Paul Bennett Hirsch and Sica. Sponsors 7 exhibitions/year. Average display time 1 month. Open all year. Located in downtown area; 1,200 sq. ft.; "art deco entranceway, tin ceiling, Soho appeal." 50% of space for special exhibitions. Clientele: 60% private collectors, 40% corporate collectors. Overall price range: $250-70,000; most work sold at $1,200-4,500.
Media: Considers all media, including wearable art. Considers original handpulled prints, woodcuts, wood engravings, linocuts, engravings, mezzotints, etchings, lithographs, pochoir and serigraphs. Most frequently exhibits mixed media, oil and lithographs.
Style: Exhibits neo-expressionism, expressionism and painterly abstraction. Interested in seeing contemporary representationalism.
Terms: Accepts work on consignment (50% commission). Retail price set by artist. Gallery provides insurance, promotion, contract and shipping costs from gallery. Prefers artwork unframed.
Submissions: Send query letter with résumé, slides, bio and SASE. Write for appointment to show portfolio of originals and slides. Replies in 1 month. Files résumé and slides.

‡BERGEN MUSEUM OF ART & SCIENCE, Ridgewood and Farview Aves., Paramus NJ 07652. (201)265-1248. Director: David Messer. Museum. Estab. 1956. Represents emerging, mid-career and established artists. Exhibited artists include Norman Lundine and Beverly Hallam. Sponsors 10 shows/year. Average display time 2 months. Open all year. Located across from Bergen Pines Hospital in Paramus; 8,000 sq. ft. 65% of space for special exhibitions.
Terms: Payment/consignment terms arranged by case. Retail price set by the artist. Gallery provides promotion; artist pays for shipping. Prefers artwork framed.
Submissions: Send query letter with résumé, bio and photographs. Write to schedule an appointment to show a portfolio, which should include originals, photographs and transparencies. Replies only if interested within 4 weeks.
Tips: Finds artists through word of mouth, artists' submissions and self-promotions. Prefers "upbeat art of quality."

BLACKWELL ST. CENTER FOR THE ARTS, 32-34 W. Blackwell St., Dover NJ 07801. (201)328-9628. Director: Annette Hanna. Nonprofit gallery. Estab. 1987. Exhibits the work of 28 emerging and established artists. Sponsors nine 1-3 person shows and 2-3 group shows/year. Average display time 1 month. Overall price range $100-5,000; most work sold at $150-350.
Media: Considers oil, acrylic, watercolor, pastel, pen & ink, drawings, mixed media, collage, paper, sculpture, ceramics, photography, egg tempera, woodcuts, wood engravings, linocuts, engravings, mezzotints, etchings, lithographs and serigraphs. Most frequently exhibits oil, photography and pastel.

Style: Exhibits all styles and genres. Prefers painterly abstraction, realism and photorealism.
Terms: Membership fee plus donation of time; 25% commission. Retail price set by artist. Sometimes offers payment by installments. Exclusive area representation not required. Artist pays for shipping. Prefers artwork framed.
Submissions: Send query letter with résumé, brochure, slides photographs, bio and SASE. Call or write for appointment to show portfolio of originals and slides. Replies in 1 month. Files slides of accepted artists. All material returned if not accepted or under consideration.
Tips: "The gallery functions as a cultural center and exhibition space for member artists and others. We have 3 categories of artist members. Each pays a fee and participates in the administration of the center. Artists applying for membership are juried. We are seeking visual artists of all types and endeavor to provide the area with exhibitions of high quality art."

CITY WITHOUT WALLS, One Gateway Center, Newark NJ 07102-5311. (201)622-1188. Fax: (201)622-2941. Director: Stephen Sennott. Nonprofit gallery and alternative space. Estab. 1975. Exhibits the work of emerging artists. 225 members. Exhibited artists include Franc Palaia and Willie Cole. Sponsors 8 shows/year. Average display time 6½ weeks. Open all year. Located "downtown, across from Newark Penn Station; 1,000 sq. ft.; very modern, glass-enclosed, art visible 24 hrs." 100% of space for special exhibitions. Clientele: 50% private collectors, 50% corporate collectors. Overall price range: $75-5,000; most work sold at $300-3,000.
Media: Considers all media and prints except posters. Most frequently exhibits mixed media, painting and sculpture.
Style: Exhibits all styles. Genres include contemporary and "experimental in any style or media."
Terms: Accepts work on consignment (30% voluntary commission). Retail price set by artist. Gallery provides insurance, promotion and contract; artist pays for shipping. Prefers artwork framed.
Submissions: Send query letter with résumé, slides and bio. Portfolio should include slides. Replies in 2 weeks. Files résumé and slides.
Tips: "Call and ask for membership information. Over 50% of our artist members are shown each year. Membership only entitles artist to inclusion in slide file, which is reviewed for each exhibition."

‡ESSEX FINE ARTS GALLERY, 13 S. Fullerton Ave., Montclair NJ 07042. (201)783-8666. Fax: (201)783-8613. President/Owner: Diane E. Israel. Retail gallery. Estab. 1987. Represents 35 established artists. May be interested in seeing the work of emerging artists in the future. Exhibited artists include Frank Zuccarelli, Diane Barton. Sponsors 2 shows/year. Average display time 6 months. Open all year; Tuesday-Friday, 10-5:30; Saturday, 10-4:30; Sunday-Monday closed. Located in downtown business district; 600 sq. ft.; old building—"lovely exhibit space." 100% of space for special exhibitions; 100% of space for gallery artists. Clientele: upper class. 90% private collectors, 10% corporate collectors. Overall price range: $50-12,000; most work sold at $200-500.
Media: Considers oil, acrylic, watercolor, pastel, pen & ink, drawing, photography, "all must be representational." Also woodcut, engraving, lithograph, wood engraving, mezzotint, etching "older prints only—1500-1900." Most frequently exhibits watercolor, oil and photography.
Style: Exhibits impressionism, photorealism and realism. Genres include landscapes, florals, wildlife, portraits and figurative work.
Terms: Accepts work on consignment (40% commission). Retail price set by the gallery. Gallery provides promotion; shipping costs are shared. Prefers artwork "gallery matted and framed (acid-free mats only)."
Submissions: Prefers only realistic artworks-no abstracts. Send query letter with photographs, SASE and business card. Write for appointment to show portfolio of photographs. Replies only if interested in 1 month. No material filed.
Tips: Finds artists through visiting local exhibitions.

DAVID GARY LTD. FINE ART, 391 Millburn Ave., Millburn NJ 07041. (201)467-9240. Fax: (201)467-2435. Director: Steve Suskauer. Retail and wholesale gallery. Estab. 1971. Represents 17-20 mid-career and established artists. Exhibited artists include John Talbot and Marlene Lenker. Sponsors 3 shows/year. Average display time 3 weeks. Open all year. Located in the suburbs; 2,500 sq. ft.; high ceilings with sky lights and balcony. Clientele: "upper income." 70% private collectors, 30% corporate collectors. Overall price range: $250-25,000; most work sold at $1,000-15,000.
Media: Considers oil, acrylic, watercolor, drawings, sculpture, pastel, woodcuts, engravings, lithographs, wood engravings, mezzotints, linocuts, etchings and serigraphs. Most frequently exhibits oil, original graphics and sculpture.
Style: Exhibits primitivism, painterly abstraction, surrealism, impressionism, realism and collage. All genres. Prefers impressionism, painterly abstraction and realism.
Terms: Accepts artwork on consignment (50% commission). Retail price set by gallery and artist. Gallery services vary; artist pays for shipping. Prefers artwork unframed.
Submissions: Send query letter with résumé, photographs and reviews. Call for appointment to show portfolio of originals, photographs and transparencies. Replies in 1-2 weeks. Files "what is interesting to gallery."
Tips: "Have a basic knowledge of how a gallery works, and understand that the gallery is a business."

‡**M. THOMPSON KRAVETZ GALLERY,** 517 Main St., Bay Head NJ 08742. Phone/Fax: (908)295-4040. Director: Mary Kravetz. Retail gallery. Estab. 1988. Represents 18 emerging, mid-career and established artists/year. Exhibited artists include Albert Bross Jr., Oscar Sossa. Sponsors 8 shows/year. Average display time 3 weeks. Open all year; Monday-Saturday, 10-5. Located on highway in resort community; 1,200 sq. ft. 80% of space for special exhibitions; 20% of space for gallery artists. Clientele: affluent. 100% private collectors. Overall price range: $200-10,000; most work sold at $800-1,500.

Media: Considers oil, acrylic, watercolor, sculpture, lithograph and serigraphs. Most frequently exhibits oil, acrylics and watercolor.

Style: Exhibits primitivism, impressionism and realism, all genres.

Terms: Accepts work on consignment (negotiable commission). Retail price set by the gallery and the artist. Gallery provides insurance, promotion, contract and shipping costs from gallery; artist pays shipping costs to gallery. Prefers artwork framed.

Submissions: Send query letter with résumé, slides and SASE. Call for appointment to show portfolio of originals or slides and transparencies. Replies in 3 weeks.

Tips: Finds artists through travel.

THE NOYES MUSEUM, Lily Lake Rd., Oceanville NJ 08231. (609)652-8848. Fax: (609)652-6166. Curator of Collections and Exhibitions: Stacy Smith. Museum. Estab. 1982. Exhibits emerging, mid-career and established artists. Sponsors 15 shows/year. Average display time 6 weeks to 3 months. Open all year; Wednesday-Sunday, 11-4. 9,000 sq. ft.; "modern, window-filled building successfully integrating art and nature; terraced interior central space with glass wall at bottom overlooking Lily Lake." 75% of space for special exhibitions. Clientele: rural, suburban, urban mix; high percentage of out-of-state vacationers during summer months. 100% private collectors. "Price is not a factor in selecting works to exhibit."

Media: All types of fine art, craft and folk art.

Style: Exhibits all styles and genres.

Terms: Accepts work on consignment (10% commission). "Artwork not accepted solely for the purpose of selling; we are a nonprofit art museum." Retail price set by artist. Gallery provides insurance. Prefers artwork framed.

Submissions: Send query letter with résumé, slides, photographs and SASE. "Letter of inquiry must be sent; then museum will set up portfolio review if interested." Portfolio should include originals, photographs and slides. Replies in 1 month. "Materials only kept on premises if artist is from New Jersey and wishes to be included in New Jersey Artists Resource File or if artist is selected for inclusion in future exhibitions."

PELICAN ART GALLERIES & FRAMERS, 1 Nasturtium Ave., Glenwood NJ 07418. (914)986-8113 or (201)764-7149. Owner: Thomas F. Prendergast. Art Director: Sean Prendergast. Art consultancy. "Brokers prints at various locations—restaurants, automobile dealers, galleries, dental offices, frame shops and banks." Estab. 1986. Represents emerging, mid-career and established artists. Exhibited artists include Doolittle and Bateman. Sponsors 2 shows/year. Average display time 2 months. Open all year. Clientele: 50% private collectors, 40% other galleries, 10% corporate clients. Overall price range: $150-1,500; most artwork sold at $350-500.

Media: Considers watercolor, pen & ink, woodcuts, lithographs, serigraphs and etchings. Most frequently exhibits original prints and serigraphs. Interested in "portrait art—mostly of famous people."

Style: Exhibits imagism and realism. Genres include landscapes, Americana, Southwestern, Western, marine, aviation and wildlife. Prefers wildlife, Western and Americana. "Interested in seeing good, close-up animal paintings."

Terms: Accepts work on consignment (30% commission). Retail price set by artist. Customer discounts and payment by installment are available. Gallery provides promotion; artist pays for shipping. Prefers artwork framed. "Must be framed with acid-free matting and no cuts or digs on mats. Must be in top shape."

Submissions: Send query letter with résumé and brochure. Call for appointment to show portfolio of originals. Replies in 1 week.

Tips: "Large part of business is sport art prints—baseball, football, hockey, boxing, skiing—signed by artist and autographed by player."

‡**QUIETUDE GARDEN GALLERY,** 24 Fern Rd., East Brunswick NJ 08816. (908)257-4340. Fax: (908)257-1378. Owner: Sheila Thau. Retail/wholesale gallery and art consultancy. Estab. 1988. Represents 60 emerging, mid-career and established artists/year. Exhibited artists include Tom Doyle, Han Van de Boven Kemp. Sponsors 6 shows/year. Average display time 6 weeks. Open April 24-November 1; Wednesday, Thursday, Saturday, Sunday, 11-5. Located in a suburb; 4 acres; unique work exhibited in natural and landscaped, wooded property—each work in its own environment. 25% of space for special exhibitions; 75% of space for gallery artists. Clientele: upper middle class, private home owners and collectors, small corporations. 75% private collectors, 25% corporate collectors. Overall price range: $2,000-50,000; most work sold at $10,000-20,000.

Media: Considers "only sculpture suitable for outdoor (year round) display and sale." Most frequently exhibits metal (bronze, steel), ceramic and wood.

Style: Exhibits all styles.

Terms: Accepts work on consignment. Retail price set by the artist. Gallery provides insurance, promotion and contract; artist pays shipping costs to and from gallery.

Submissions: Send query letter with résumé, slides, bio, photographs, SASE and reviews. Write for appointment to show portfolio of photographs, slides and bio. Replies in 2 weeks. Files "slides, bio of artists who we would like to represent or who we do represent."

Tips: Finds artists through word of mouth, publicity on current shows and ads in art magazines.

SIDNEY ROTHMAN-THE GALLERY, 21st on Central Ave., Barnegat Light NJ 08006. (609)494-2070. Director/Owner: S. Rothman. Retail gallery. Estab. 1958. Represents 50 emerging, mid-career and established artists. Exhibited artists include John Gable and Gregorio Prestopino. Sponsors 1 show/year. Average display time 3 months. Open June-September. Located in the seashore resort area; 256 sq. ft.; on the street floor of owner's home. 100% of space for gallery artists. Clientele: 100% private collectors. Overall price range: $100-20,000.

Media: Considers all media and handpulled prints. No photography or offset reproductions. Most frequently exhibits watercolor, sculpture, acrylic and hand-pulled prints.

Style: Exhibits all styles and genres.

Terms: Accepts work on consignment (33% commission). Retail price set by gallery and artist. Payment by installment available. Gallery provides promotion and shipping costs from gallery.

Submissions: Send query letter with résumé, slides and SASE. Call or write for appointment to show portfolio of originals and slides. "Indicate prices." Replies in 1 month.

Tips: To find artists "I check new galleries, New York City, and catalogs of area artists published in Albuquerque; also word of mouth."

‡BEN SHAHN GALLERIES, William Paterson College, 300 Pompton Rd, Wayne NJ 07470. (201)595-2654. Director: Nancy Eireinhofer. Nonprofit gallery. Estab. 1968. Interested in emerging and established artists. Sponsors 5 solo and 10 group shows/year. Average display time is 6 weeks. Clientele: college, local and New Jersey metropolitan-area community.

Media: Considers all media.

Style: Specializes in contemporary and historic styles, but will consider all styles.

Terms: Accepts work for exhibition only. Gallery provides insurance, promotion and contract; shipping costs are shared.

Submissions: Send query letter with résumé, brochure, slides, photographs and SASE. Write to schedule an appointment to show a portfolio.

Tips: Finds artists through artists' submissions, referrals and exhibits.

WYCKOFF GALLERY, 648 Wyckoff Ave., Wyckoff NJ 07481. (201)891-7436. Director: Sherry Cosloy. Retail gallery. Estab. 1980. Interested in emerging, mid-career and established artists. Sponsors 1-2 solo and 4-6 group shows/year. Average display time 1 month. Clientele: collectors, art lovers, interior decorators and businesses. 75% private collectors, 25% corporate clients. Overall price range: $250-10,000; most artwork sold at $500-3,000.

Media: Considers oil, acrylic, watercolor, pastel, pen & ink, pencil, mixed media, sculpture, ceramic, collage and limited edition prints. Most frequently exhibits oil, watercolor and pastel.

Style: Exhibits contemporary, abstract, traditional, impressionistic, figurative, landscape, floral, realistic and neo-expressionistic works.

Terms: Accepts work on consignment. Retail price set by gallery or artist. Gallery provides insurance and promotion.

Submissions: Send query letter with résumé, slides and SASE. Résumé and biography are filed.

Tips: Sees trend toward "renewed interest in traditionalism and realism."

New Mexico

‡A.O.I. GALLERY (ART OBJECTS INTERNATIONAL), 634 Canyon Rd., Santa Fe NM 87501. (505)982-3456. Fax: (505)982-2040. Director: Frank. Retail gallery. Estab. 1993. Represents 24 emerging and mid-career artists/year. Exhibited artists include Carl Goldhagen, Gary Dodson, Kimiko Fujimura, Michael Kenna, Ernst Haas, Maxine Fine. Sponsors 5 shows/year. Average display time 4-6 weeks. Open daily; 10-6 (summer), 10-4 (winter, closed on Tuesdays). 1,000 sq. ft.; beautiful adobe house, over 100 years old. 100% of space for special exhibitions; 100% of space for gallery artists. Clientele: "Highly sophisticated collectors who are interested in contemporary arts." 50% private collectors. Overall price range: $500-15,000; most work sold at $1,000-3,000.

Media: Considers all types. Most frequently exhibits photography and multi-media work, drawing and painting.

Style: Exhibits all styles. Prefers contemporary art.
Terms: Accepts work on consignment (50% commission). Retail price set by both the gallery and the artist. Gallery provides insurance, promotion and contract; shipping costs are shared. Prefers artwork unframed.
Submissions: Must call first for appointment to show portfolio.

THE ALBUQUERQUE MUSEUM, 2000 Mountain Rd. NW, Albuquerque NM 87104. (505)243-7255. Curator of Art: Ellen Landis. Nonprofit museum. Estab. 1967. Interested in emerging, mid-career and established artists. Sponsors mostly group shows. Average display time is 3-6 months. Located in Old Town (near downtown).
Media: Considers all media.
Style: Exhibits all styles. Genres include landscapes, florals, Americana, Western, portraits, figurative and nonobjective work. "Our shows are from our permanent collection or are special traveling exhibitions originated by our staff. We also host special traveling exhibitions originated by other museums or exhibition services."
Submissions: Send query letter, résumé, slides, photographs and SASE. Call or write for appointment to show portfolio.
Tips: "Artists should leave slides and biographical information in order to give us a reference point for future work or to allow future consideration."

PHILIP BAREISS CONTEMPORARY EXHIBITIONS, 15 Taos Ski Valley, Box 2739, Taos NM 87571. (505)776-2284. Associate Director: Susan Strong. Retail gallery and 3-acre sculpture park. Estab. 1989 at current location "but in business over 10 years in Taos." Represents 21 mid-career and established artists. Exhibited artists include Jim Wagner and Patricia Sanford. Sponsors 8 shows/year. Average display time 2 months. Open all year. "Located in the countryside, close to town next to Taos Pueblo reservation under stunning aspect of Taos Mountain.; 4,000 sq. ft.; gallery is unique metal building with sculptural qualities, walls 10-20 ft. high." Clientele: 99% private collectors, 1% corporate collectors. Overall price range: $250-65,000.
Media: Most frequently exhibits outdoor sculpture, paintings and monotypes.
Styles: Exhibits all styles and genres, including abstract. Interested in seeing original contemporary art, especially outdoor sculpture by artists who are committed to being represented in Taos.
Terms: Accepts work on consignment (varying commission). Gallery provides contract; artist pays for shipping.
Submissions: Currently interested in outdoor sculpture. Send query letter with photographs. Write for appointment to show portfolio of photographs. Replies only if interested. Files résumés and photos only if interested.
Tips: "Do not send material unless your query results in a request for submission. The amount of material a gallery receives from artists can be overwhelming. New artists have to devote more effort to the business side of their careers."

‡COPELAND RUTHERFORD FINE ARTS LTD., 403 Canyon Rd., Santa Fe NM 87501. (505)983-1588. Fax: (505)982-1654. Assistant Director: Samantha P. Furgason. Retail gallery. Estab. 1991. Represents 10 mid-career and established artists. May be interested in seeing the work of emerging artists in the future. Exhibited artists include Doug Coffin, Colette Hosmer. Sponsors 9 shows/year. Average display time 1 month. Open all year; Tuesday-Saturday, 10-5. Located downtown 2 blocks off the plaza; 1,200 sq. ft.; wood floors, 13-foot ceilings; ½ acre outdoor sculpture garden. 95% of space for special exhibitions; 40% of space for gallery artists during exhibitions. Clientele: mid to high end. 95% private collectors, 5% corporate collectors. Overall price range: $500-20,000.
Media: Considers oil, acrylic, watercolor, pastel, pen & ink, drawing, mixed media, collage, paper, sculpture, fiber, glass, installation, photography, mixed media, all types of prints. Most frequently exhibits sculpture, original 2-dimensional, photos, mixed media.
Style: Exhibits painterly abstraction, conceptualism and realism. Genres including cutting edge. Prefers cutting edge contemporary and modern.
Terms: Accepts work on consignment (50% commission). "We do offer space rental for events." Retail price set by the gallery. Gallery provides insurance and promotion; artist usually pays shipping costs to and from gallery. Prefers artwork framed. "We do not accept non-hangable work."
Submissions: Accepts only artists from New Mexico. Send query letter with résumé, slides, bio, brochure, photographs, business card, reviews and SASE. Call or write for appointment to show portfolio of photographs or slides and transparencies. Replies in 2 weeks. Files inexpensive visuals and résumé.
Tips: Finds artists through visiting exhibitions, word of mouth and artists' submissions. "Try to stay in 'cutting edge' focus."

‡FENIX GALLERY, 228-B N. Pueblo Rd., Taos NM 87571. Phone/Fax: (505)758-9120. Director/Owner: Judith B. Kendall. Retail gallery. Estab. 1989. Represents 14 emerging, mid-career and established artists/year. Exhibited artists include Alyce Frank, Earl Stroh. Sponsors 4 shows/year. Average display time 4-6 weeks. Open all year; daily, 10-5; Sunday, 12-5; closed Wednesday during winter months. Located on the main road through Taos; 1,000 sq. ft.; minimal hangings; clean, open space. 100% of space for special exhibitions during

one-person shows; 100% of space for gallery artists during group exhibitions. Clientele: experienced and new collectors. 90% private collectors, 10% corporate collectors. Overall price range: $400-10,000; most work sold at $1,000-2,500.

Media: Considers all media, primarily non-representational, all types of prints except posters. Most frequently exhibits oil, sculpture and paper work/ceramics.

Style: Exhibits expressionism, painterly abstraction, conceptualism, minimalism and postmodern works. Prefers conceptualism, expressionism and abstraction.

Terms: Accepts work on consignment (50% commission). Retail price set by the artist or a collaboration. Gallery provides insurance, promotion and contract; artist pays shipping costs to and from gallery. Prefers artwork framed.

Submissions: Prefers artists from area; "we do very little shipping of artist works." Send query letter with résumé, slides, bio, brochure, photographs, SASE, business card and reviews. Call for appointment to show portfolio of photographs. Replies in 3 weeks. Files "material I may wish to consider later—otherwise it is returned."

Tips: Finds artists through personal contacts, exhibitions, studio visits, reputation regionally or nationally.

FULLER LODGE ART CENTER, Box 790, 2132 Central, Los Alamos NM 87544. (505)662-9331. Director: Patricia Chavez. Retail gallery/nonprofit gallery, museum and rental shop for members. Estab. 1977. Represents over 50 emerging, mid-career and established artists. 388 members. Sponsors 11 shows/year. Average display time 1 month. Open all year. Located downtown; 1,300 sq. ft.; "housed in the original log building from the Boys School that preceded the town." 98% of space for special exhibitions. Clientele: local, regional and international visitors. 99% private collectors, 1% corporate collectors. Overall price range: $50-1,200; most artwork sold at $200-500.

Media: Considers all media, including original handpulled prints, woodcuts, engravings, lithographs, wood engravings, mezzotints, serigraphs, linocuts and etchings.

Style: Exhibits all styles and genres.

Terms: Accepts work on consignment (30% commission). Retail price set by the artist. Gallery provides insurance and promotion; artist pays for shipping. "Work should be in exhibition form (ready to hang)."

Submissions: "Prefer the unique." Send query letter with résumé, slides, bio, brochure, photographs, SASE and reviews. Call for appointment to show portfolio, which should include originals, photographs (if a photographer) and slides. Replies in 2 weeks. Files "résumés, etc.; slides returned only by SASE."

Tips: "Be aware that we never do one-person shows—artists will be used as they fit in to scheduled shows." Should show "impeccable craftsmanship."

GALLERY A, 105 Kit Carson, Taos NM 87571. (505)758-2343. Director: Mary L. Sanchez. Retail gallery. Estab. 1960. Represents 70 emerging, mid-career and established artists. Exhibited artists include Gene Kloss and Carlos Hall. Sponsors 1 show/year. Average display time 2 months. Open all year. Located one block from the plaza; over 3,500 sq. ft; "Southwestern interior decor." 50% of space for special exhibitions. Clientele: "from all walks of life." 98% private collectors. Overall price range: $100-12,000; most artwork sold at $500-5,000.

Media: Considers oil, acrylic, watercolor, pastel, original handpulled prints, serigraphs, etchings and sculpture—bronze, stone or wood. Most frequently exhibits oil, watercolor and acrylic.

Style: Exhibits expressionism, impressionism and realism. Genres include landscapes, florals, Southwestern and Western works. Prefers impressionism, realism and expressionism.

Terms: Accepts work on consignment (40% commission). Retail price set by artist. Sometimes offers customer discounts and payment by installment. Gallery provides promotion; artist pays for shipping. Prefers artwork framed.

Submissions: Send query letter with bio and photographs. Replies only if interested. Portfolio review not required. Files bios.

Tips: Finds artists through word of mouth, visiting exhibitions and artists' submissions.

THE GALLERY LA LUZ, P.O. Box 158, La Luz NM 88337. (505)437-3342. Manager: Barbara Pierce. Cooperative gallery. Exhibits the work of 30 established artists. Interested in seeing the work of emerging artists. Exhibited artists include Ernie Lee Miller and Scott Swen. Sponsors 4 shows/year. Average display time 3 months. Open all year. 1,950 sq. ft.; "adobe walls; all rustic wood." 50% of space for special exhibitions. Clientele: local residents and tourists. Overall price range: $25-800; most work sold at $150-250.

● Gallery La Luz has added handwoven baskets, pottery, clay pieces, furniture and jewelry to its line.

Media: Considers oil, acrylic, watercolor, pastel, pen & ink, drawings, mixed media, collage, sculpture, ceramic, craft, glass, photography, original handpulled prints, woodcuts, engravings, lithographs and serigraphs. Most frequently exhibits watercolor, oil and pen & ink.

Style: Exhibits expressionism, impressionism and realism. Genres include landscapes, florals, Americana, Southwestern, Western, wildlife and portraits.

Terms: Accepts artwork on consignment (30% commission). Co-op membership fee plus donation of time (20% commission). Retail price set by artist. Offers payment by installments. Gallery provides promotion and contract; artist pays for shipping. Prefers artwork framed.

Submissions: Accepts only artists from within 50 miles who are able to put in work hours. Send query letter with résumé, photographs, SASE and reviews. Call for appointment to show portfolio of originals and photographs. Replies in 2 weeks.
Tips: "Write or apply in person for a new member prospectus."

‡**GARLAND GALLERY**, 66 W. Marcy, Santa Fe NM 87501. (505)984-1555. Director: Karen Garland. Retail gallery. Estab. 1990. Represents 25 emerging, mid-career and established artists/year. Exhibited artists include Flo Perkins, Concetta Mason. Sponsors 7 shows/year. Average display time 1 month. Open all year; Monday-Saturday 10-5. Located downtown; 1,000 sq. ft.; specializes in contemporary glass. 50% of space for special exhibitions; 50% of space for gallery artists. Clientele: collectors. 95% private collectors, 5% corporate collectors. Overall price range: $500-23,000; most work sold at $1,800-4,000.
Media: Considers glass. Most frequently exhibits glass.
Style: Exhibits all styles, all genres.
Terms: Accepts work on consignment (50% commission). Retail price set by the artist. Gallery provides insurance, promotion, contract and shipping costs from gallery; artist pays shipping costs to gallery.
Submissions: Prefers only glass. Send query letter with résumé, slides, bio, SASE and reviews. Call for appointment to show portfolio of slides. Replies in 2 weeks.

‡**ELAINE HORWITCH GALLERIES**, 129 W. Palace Ave., Santa Fe NM 87501. (505)988-8997. Fax: (505)989-8702. Director: Kerry J. Sutherland. Retail gallery. Represents 75 emerging, mid-career and established artists/year. Exhibited artists include Tom Palmore, John Fincher. Sponsors 7 shows/year. Average display time 3-4 weeks. Open all year; Monday-Saturday, 9:30-5:30; Sunday 12-5:30 (summer); Tuesday-Saturday, 9:30-5; (winter). Located downtown; 10,000 sq. ft.; varied gallery spaces; upstairs barrel-vaulted ceiling with hardwood floors. 25-30% of space for special exhibitions; 75-70% of space for gallery artists. Clientele: "broad range—from established well-known collectors to those who are just starting." 95% private collectors, 5% corporate collectors. Overall price range: $650-350,000; most work sold at $1,500-15,000.
Media: Considers oil, acrylic, mixed media, sculpture and installation, lithograph and serigraphs. Most frequently exhibits oil, mixed media and acrylic/sculpture.
Style: Exhibits surrealism, minimalism, postmodern works, photorealism, hard-edge geometric abstraction and realism. Genres include landscapes, Southwestern and Western. Prefers realism/photorealism, postmodern works and minimalism.
Terms: Accepts work on consignment (50% commission). Retail price set by the gallery and the artist. Gallery provides insurance, promotion, contract and shipping costs from gallery; artist pays shipping costs to gallery. Prefers artwork framed.
Submissions: Prefers only "artists from the western United States but we consider all artists." Send query letter with résumé, slides or photographs, reviews and bio. "Artist must include self-addressed, stamped envelope if they want materials returned." Call for appointment to show portfolio of originals, photographs, slides or transparencies. Replies in 2 months.
Tips: Finds artists through visiting exhibitions, various art magazines and art books, word of mouth, other artists, artists' submissions.

JORDAN'S MAGIC MOUNTAIN GALLERY, T.A.O.S., (formerly Magic Mountain Gallery), 107 A North Plaza, Taos NM 87571. (505)758-9604. Owner: Marilyn Jordan. Retail gallery. Estab. 1980. Represents 25 mid-career and established artists. Exhibited artists include Jerry Jordan, Philip Moulthrop and James Roybal. Sponsors 1 show/year. Average display time 1 month. Open all year. Located in adobe building in historic Taos Plaza; 1,200 sq. ft. 50% of space for special exhibitions. Clientele: 90% private collectors, 10% corporate collectors. Overall price range: up to $16,000; most work sold at $1,000-5,000.
• This gallery has a new owner and a new name.
Media: Considers oil, sculpture, ceramic, and jewelry. Most frequently exhibits sculpture, oil, ceramic (clay art) and jewelry.
Style: Exhibits expressionism, color field and impressionism. Genres include landscapes and Southwestern (Northern New Mexico subject matter).
Terms: Accepts work on consignment (50% commission). Retail price set by artist. Customer discounts and payment by installments are available. Gallery provides insurance, promotion and contract; shipping costs are shared. Prefers artwork framed.
Submissions: Send query letter with résumé, slides, bio, and photographs. Portfolio review requested if interested in artist's work. Files bio and photos.
Tips: Finds artists through word of mouth and artist's submissions.

EDITH LAMBERT GALLERY, 707 Canyon Rd., Santa Fe NM 87501. (505)984-2783. Fax: (505)983-4494. Contact: Director. Retail gallery. Estab. 1986. Represents 30 emerging and mid-career artists. Exhibited artists include Carol Hoy and Margaret Nes. Sponsors 4 shows/year. Average display time 3 weeks. Open all year. Located in "historic art colony area; 3,100 sq. ft.; historic adobe, Southwestern architecture, lush garden compound." 20% of space for special exhibitions. Clientele: 95% private collectors. Overall price range: $100-4,500; most artwork sold at $500-2,600.

• The Edith Lambert Gallery has doubled its space.

Media: Considers oil, acrylic, watercolor, pastel, mixed media, collage, works on paper, ceramic, craft and glass. Most frequently exhibits watercolor/casein, pastel and oil.

Style: Exhibits expressionism, neo-expressionism and painterly abstraction. Genres include landscapes, Southwestern and figurative work. No portraits or "animal" paintings.

Terms: Accepts work on consignment (50% commission). Exclusive area representation required. Retail price set by gallery. Sometimes offers customer discounts and payment by installments. Provides insurance, promotion and contract; shipping costs are shared. Prefers framed artwork.

Submissions: Send query letter with résumé, slides, bio, SASE and reviews. Call for an appointment to show portfolio, which should include originals and slides. Replies only if interested within 1 month.

Tips: Finds artists through visiting exhibitions, word of mouth, various art publications and sourcebooks, artists' submissions and art collectors' referrals. Looks for "consistency, continuity in the work; artists with ability to interact well with collectors and have a commitment to their career."

MICHAEL McCORMICK GALLERY, 121 B. N. Plaza, Taos NM 87571. (505)758-1372. Assistant Director: Sheila MacDonald. Retail gallery. Estab. 1983. Represents 35 emerging and established artists. Provides 3 solo and 1 group show/year. Average display time 2-3 weeks. "Located in old county courthouse where movie 'Easy Rider' was filmed." Clientele: 90% private collectors, 10% corporate clients. Overall price range: $1,500-85,000; most work sold at $3,500-10,000.

Media: Considers oil, acrylic, watercolor, pastel, pen & ink, drawings, mixed media, collage, works on paper, sculpture, ceramic, craft, photography, woodcuts, wood engravings, linocuts, engravings, mezzotints, etchings, lithographs, pochoir, serigraphs and posters. Most frequently exhibits oil, pottery and sculpture/stone.

Style: Exhibits impressionism, neo-expressionism, surrealism, primitivism, painterly abstraction, conceptualism and postmodern works. Genres include landscapes and figurative work. Interested in work that is "classically, romantically, poetically, musically modern." Prefers figurative work, lyrical impressionism and abstraction.

Terms: Accepts work on adjusted consignment (approximately 50% commission). Retail price set by gallery and artist. Customer discounts and payment by installment are available. Exclusive area representation required. Gallery provides promotion and contract; artist pays for shipping. Prefers artwork framed.

Submissions: Send query letter with résumé, brochure, slides, photographs, bio and SASE. Portfolio review requested if interested in artist's work. Replies in 4-7 weeks.

Tips: Finds artists usually through word of mouth and artists traveling through town. "Send a brief, concise introduction with several color photos. During this last year there seems to be more art and more artists but fewer sales. The quality is declining based on mad, frantic scramble to find something that will sell."

MAYANS GALLERIES, LTD., 601 Canyon Rd., Santa Fe NM 87501; also at Box 1884, Santa Fe NM 87504. (505)983-8068. Fax: (505)982-1999. Director: Ernesto and Leonor Mayans. Retail gallery and art consultancy. Estab. 1977. Represents 10 emerging, mid-career and established artists. Sponsors 2 solo and 2 group shows/year. Average display time 1 month. Clientele: 70% private collectors, 30% corporate clients. Overall price range: $1,000 and up; most work sold at $2,500-7,500.

Media: Considers oil, acrylic, watercolor, pastel, pen & ink, drawings, mixed media, sculpture, photography and original handpulled prints. Most frequently exhibits oil, photography, and lithographs.

Style: Exhibits 20th century American and Latin American art. Genres include landscapes and figurative work. Interested in work "that takes risks and is from the soul."

Terms: Accepts work on consignment. Retail price set by gallery and artist. Exclusive area representation required. Shipping costs are shared.

Submissions: Send query letter, résumé, business card, slides and SASE. Write for appointment to show portfolio of slides and transparencies. Files résumé and business card.

QUAST GALLERIES, TAOS, 229 Kit Carson Rd., P.O. Box 1528, Taos NM 87571. (505)758-7160. Fax: (505)751-0706. Director: E. Waters Olonia. Retail gallery. Estab. 1986. Represents 32 mid-career and established artists. Exhibited artists include J.C. Armstrong, Zhang Wen Xin, Rusty Stecher, Shang Ding and Mark Lundeen. Sponsors 3 shows/year. Open all year. Located a quarter mile east of the town plaza; 1,600 sq. ft.; "old adobe home set under ancient cottonwoods with an outdoor sculpture garden." 100% of space for special exhibitions. Clientele: collectors from across the country and others. 80% private collectors, 20% corporate collectors. Overall price range: $500-150,000; most work sold at $2,000-15,000. Second location: Taos Ski Valley Resort Center. (505)776-1004. "Looks up at the main ski lift; limited exhibition space; but includes sculpture, ceramics and paintings; open Thanksgiving through the end of the ski season." Third location: 133 E. Kit Carson Rd., Taos, NM 87571. (505)758-7779. Fax: (505)758-4079. "2,200 sq. ft. with 12 ft. ceilings. Newly renovated to accomodate large indoor sculptures and paintings. Consists of adobe style bancos, Kiva fireplace and hardwood floors. Spacious and designed for optimal presentation of fine art, traditional style of works—consistent with other two galleries."

Media: Considers oil, watercolor, pastel, drawings and sculpture with an emphasis on bronze. Most frequently exhibits bronze and oil.

Style: Exhibits impressionism and representational work. Genres include landscapes, florals, Southwestern, wildlife, portraits and figurative work. Interested in seeing "collectible works of fine art—nationally recognized 2- and 3-dimensional artists representing contemporary and impressionistic styles."
Terms: Accepts work on consignment. Retail price set by artist. Gallery provides insurance, promotion and contract; artist pays for shipping. Prefers artwork framed.
Submissions: Send query letter with bio, brochure, photographs, SASE, business card, reviews and prices. Write for appointment to show portfolio of originals, slides and photographs. Replies in 2 to 6 weeks.
Tips: "Take time to visit the galleries to see if work would fit in. Make an appointment. Have technical skills and a professional approach to your work."

‡ROSWELL MUSEUM AND ART CENTER, 100 W. 11th St., Roswell NM 88201. (505)624-6744. Fax: (505)624-6765. Director: William D. Ebie. Museum. Estab. 1937. Represents emerging, mid-career and established artists. Sponsors 12-14 shows/year. Average display time 2 months. Open all year; Monday-Saturday, 9-5; Sunday and holidays, 1-5. Closed Thanksgiving, Christmas and New Years Day. Located downtown; 25,000 sq. ft.; specializes in Southwest. 50% of space for special exhibitions; 50% of space for gallery artists.
Media: Considers all media and all types of prints but posters. Most frequently exhibits painting, prints and sculpture.
Style: Exhibits all styles. Prefers Southwestern but some non-SW for context.
Terms: Accepts work on consignment (20% commission). Retail price set by the artist. Gallery provides insurance, promotion and shipping costs to and from gallery. Prefers artwork framed.
Submissions: Accepts only artists from Southwest or SW genre. Send query letter with résumé, slides, bio, brochure, photographs, SASE and reviews. Write for appointment to show portfolio of photographs, slides and transparencies. Replies in 1 week. Files "all material not required to return."
Tips: Finds artists through agents, visiting exhibitions, word of mouth, art publications and sourcebooks, artists' submissions. Looks for "Southwest artists or artists consistently working in Southwest genre."

THE WINTERS GALLERY, P.O. Box 485, St. Francis Plaza, Ranchos De Taos NM 87557. (505)758-0323. Director: Lisa Winters. Artist-owned retail gallery. Estab. 1990. Represents 6 established artists. May consider emerging artists in the future (only 3-dimensional works.) Featured artist is Todd Abbott Winters. Sponsors 1-2 shows/year. Average display time 1 month. Open all year; Monday-Saturday 10-5. Located in historic St. Francis Plaza, outside of Taos NM. Main gallery has 1,500 sq. ft.; studio has 1,000 sq. ft. "150-year old adobe building in historic district of Taos, next to very famous church." 25% of space for special exhibitions. Clientele: "Many first time art buyers and tourists (due to location), plus expert art collectors who are frequenting the area more often." 90% private collectors, 1% corporate collectors. Overall price range: $150-3,000; most work sold at $400-800.
Media: Considers sculpture, watercolor, ceramic, jewelry, lithographs, serigraphs and posters. Most frequently exhibits watercolor, sculpture and jewelry.
Style: Exhibits conceptualism, realism, surrealism. Genres include landscapes, Southwestern. Prefers Southwestern, realism, conceptualism.
Terms: Accepts work on consignment (60% commission). Retail price set by artist. Customer discounts and payment by installment are available. Gallery provides promotion and shipping costs. Prefers artwork framed.
Submissions: Prefers contemporary watercolor. Exclusive on paintings in main gallery, but welcomes other types of work (sculpture, ceramics) in studio gallery. Send query letter with résumé, photographs, bio and SASE. Portfolio review requested if interested in artist's work. Files bios, photographs.
Tips: "Most of the artists we show are longtime friends. Visit the gallery in person. Make sure the gallery feels rights. More artist-owned galleries have emerged than ever before as artists have decided to represent themselves."

New York

‡ADIRONDACK LAKES CENTER FOR THE ARTS, Route 28, Blue Mountain Lake NY 12812. (518)352-7715. Director: Tina Thompson Pine. Nonprofit gallery. Estab. 1967. Represents 700 emerging, mid-career and established artists/year. Sponsors 6-8 shows/year. Average display time 1 month. Exhibits daily Memorial Day-Columbus Day, 9-5; remainder of year Monday-Friday, 9-5. Located on Main Street next to Post Office; 176 sq. ft.; "pedestals and walls are all white and very versatile." Clientele: summer tourists. 90% private collectors, 10% corporate collectors. Overall price range: $100-10,000; most work sold at $100-1,000.
Media: Considers all media and all types of prints. Most frequently exhibits paintings, sculpture and fiber arts.

Always enclose a self-addressed, stamped envelope (SASE) with queries and sample packages.

Style: Exhibits all styles. Genres include landscapes, Americana, wildlife and portraits. Prefers landscapes, wildlife and folk art/crafts (quilts).
Terms: Accepts work on consignment (30% commission). Retail price set by the artist. Gallery provides insurance, promotion and contract; shipping costs are shared. Prefers artwork framed.
Submissions: Send query letter with slides, bio and photographs. Call for appointment to show portfolio of photographs and slides. Replies only if interested within 3 months. Files "slides, photos and bios on artists we're interested in."
Tips: Finds artists through word of mouth, art publications, artists' submissions.

‡**AMERICA HOUSE**, 466 Piermont Ave., Piermont NY 10968. (914)359-0106. President: Susanne Casal. Retail craft gallery. Estab. 1974. Represents 200 emerging, mid-career and established artists. Sponsors 4 shows/year. Average display time 3 months. Open all year; Tuesday-Saturday, 10:30-5:30; Sunday, 12:30-5:30. Located downtown; 1,100 sq. ft.; 1st floor of renovated house. 50% of space for special exhibitions; 50% of space for gallery artists.
Media: Considers mixed media, ceramics, fiber and glass. Most frequently displays jewelry, ceramics and glass.
Terms: Accepts work on consignment (50% commission) or buys outright for 50% of retail price (net 30 days). Retail price set by the artist. Gallery provides insurance, promotion and shipping costs from gallery; artist pays shipping costs to gallery. Prefers artwork framed.
Tips: Finds artists through visiting exhibitions, word of mouth, art publications and sourcebooks.

‡**ANDERSON GALLERY**, Martha Jackson Place, Buffalo NY 14214. (716)834-2579. Fax: (716)834-7789. Retail gallery. Estab. 1952. Exhibits emerging, mid-career and established artists. Exhibited artists include Antoni Tapies, Karel Appel. Presents 8-10 shows/year. Average display time 6 weeks. Open September-July; Thursday-Saturday, 10:30-5:30. Located University Heights; 65,000 sq. ft.; two floors, sculpture atrium; award-winning building. 100% of space for special exhibitions. 75% private collectors, 10% corporate collectors, 5% museums. Overall price range: $100-2,000,000.
Media: Considers oil, acrylic, watercolor, pastel, pen & ink, drawing, mixed media, collage, paper, sculpture, ceramics, installation, all types of prints but posters.
Style: Exhibits neo-expressionism, painterly abstraction, surrealism, conceptualism, minimalism, color field, postmodern works, photorealism, pattern painting, hard-edge geometric abstraction, realism and imagism.
Terms: Accepts work on consignment (commission varies). Retail price set by the gallery. Gallery provides insurance, some promotion and simple contract.
Submissions: Send September-April query letter with résumé, slides and SASE. Replies in 3 months.

‡**CASTELLANI ART MUSEUM OF NIAGARA UNIVERSITY**, Niagara University, Niagara Falls NY 14174. (717)286-8200. Director: Dr. Sandra H. Olsen. University museum. Estab. 1978. Represents 8-100 emerging, mid-career and established artists/year. Exhibited artists include Judy Pfaff, Basquiat. Sponsors 8-15 shows/year. Average display time 4-6 weeks. Open all year. Operates Monday-Friday, 9-5; Saturday, 11-5; Sunday, 1-5. Open to the public Wednesday-Saturday, 11-5; Sunday, 1-5. Located in the center of main campus outside of Niagara Falls; 15,144 sq. ft.; "4,200 square foot exhibition hall with 20-foot-high ceiling provides a unique installation space." 67% of space for special exhibitions.
Media: Considers all media and all types of printmaking. Most frequently exhibits works on paper, photographs, paintings, sculpture and folk arts.
Style: Exhibits all styles.
Terms: Museum pays shipping costs to and from museum. Prefers artwork framed.
Submissions: "We are most interested in ideas for innovative installations in the main exhibition hall, but we welcome all submissions." Send query letter with résumé, slides, bio, photographs and reviews. Call for appointment to show portfolio of originals, slides and transparencies. Replies in 3 months. Files considerations for exhibition.
Tips: Finds artists through exhibitions, gallery and studio visits, publications, artists' submissions.

CEPA (CENTER FOR EXPLORATORY AND PERCEPTUAL ART), 4th Floor, 700 Main St., Buffalo NY 14202. Fax: (716)856-2720. Director/Curator: Robert HIrsch. Alternative space and nonprofit gallery. Interested in emerging, mid-career and established artists. Sponsors 5 solo and 1 group show/year. Average display time 4-6 weeks. Open fall, winter and spring. Clientele: artists, students, photographers and filmmakers. Prefers photographically related work.
Media: Installation, photography, film, mixed media, computer imaging and digital photography.
Style: Contemporary photography. "CEPA provides a context for understanding the aesthetic, cultural and political intersections of photo-related art as it is produced in our diverse society." Interested in seeing "conceptual, installation, documentary and abstract work."
Submissions: Call first regarding suitability for this gallery. Send query letter with résumé, slides, SASE, brochure, photographs, bio and artist statement. Call or write for appointment to show portfolio of slides and photographs. Replies in 6 months.

Tips: "It is a policy to keep slides and information in our file for indefinite periods. Grant writing procedures require us to project one and two years into the future. CEPA does not sell photographs or take commissions. Always provide a good artist statement about the work."

CHAPMAN ART CENTER GALLERY, Cazenovia College, Cazenovia NY 13035. (315)655-9446. Fax: (315)655-2190. Chairman, Center for Art and Design Studies: John Aistars. Nonprofit gallery. Estab. 1978. Interested in emerging, mid-career and established artists. Sponsors 3 solo and 4 group shows/year. Average display time is 3 weeks. Clientele: the greater Syracuse community. Overall price range: $50-3,000; most artwork sold at $100-200.
Media: Considers oil, acrylic, watercolor, pastel, pen & ink, drawings, sculpture, ceramic, fiber, photography, craft, mixed media, collage, glass and prints.
Style: Exhibits all styles. "Exhibitions are scheduled for a whole academic year at once. The selection of artists is made by a committee of the art faculty in early spring. The criteria in the selection process is to schedule a variety of exhibitions every year to represent different media and different stylistic approaches; other than that, our primary concern is quality. Artists are to submit to the committee by March 1 a set of slides or photographs and a résumé listing exhibitions and other professional activity."
Terms: Retail price set by artist. Exclusive area representation not required. Gallery provides insurance and promotion; works are usually not shipped.
Submissions: Send query letter, résumé, 10-12 slides or photographs.
Tips: A common mistake artists make in presenting their work is that the "overall quality is diluted by showing too many pieces. Call or write and we will mail you a statement of our gallery profiles."

‡JAMES COX GALLERY AT WOODSTOCK, 26 Elwyn Lane, Woodstock NY 12498. (914)679-7608. Retail gallery. Estab. 1990. Represents 80 mid-career and established artists. Exhibited artists include Richard Segalman, Mary Anna Goetz. Sponsors 10 shows/year. Average display time 1 month. Open all year; Wednesday-Sunday, 11-6. 6,000 sq. ft.; elegantly restored Dutch barn (200-yrs.-old). 50% of space for special exhibitions; 50% of space for gallery artists. Clientele: New York City and tourists, residents of 50 mile radius. 95% private collectors. Overall price range: $500-50,000; most work sold at $3,000-10,000.
Media: Considers oil, watercolor, pastel, drawing and sculpture. Considers "historic woodstock, fine prints." Most frequently exhibits oil paintings, water colors, sculpture.
Style: Exhibits impressionism, realism and imagism. Genres include landscapes and figurative work. Prefers expressive or evocative realism, painterly landscapes and stylized figurative sculpture.
Terms: Accepts work on consignment (40% commission). Retail price set by the artist. Gallery provides promotion; artist pays shipping costs to and from gallery. Prefers artwork framed.
Submissions: Prefers only artists from New York region. Send query letter with résumé, slides, bio, brochure, photographs, SASE and business card. Replies in 3 months. Files material on artists for special, theme or group shows.

‡THE CRAFTSMAN'S GALLERY LTD., 16 Chase Rd., Scarsdale NY 10583. (914)725-4644. Director: Sybil Robins. Retail fine arts gallery. Estab. 1973. Represents 200 emerging, mid-career and established artists/year. Sponsors 6 shows/year. Average display time 2 months. Open all year; Tuesday-Saturday, 11-6. Located downtown in affluent suburb of New York City; 1,100 sq. ft.; 30% of space for special exhibitions; 70% of space for gallery artists. Clientele: upper middle class, sophisticated professionals. 90% private collectors, 10% corporate collectors. Overall price range: $40-5,000; most work sold at $100-400.
Media: Considers collage, paper, sculpture, ceramics, craft, fiber, glass, jewelry and woodturning. Most frequently exhibits ceramics, jewelry and glass.
Terms: Accepts work on consignment (50% commission). Retail price set by the artist. Gallery provides insurance and promotion; artist pays shipping costs to and from gallery. Prefers framed artwork only.
Submissions: Prefers only clay, wood, metal, fiber, glass, jewelry. Send query letter with résumé, slides, bio, brochure, photographs, SASE, business card and reviews. Portfolio should include photographs, slides, transparencies, reviews and SASE. Files slides, photos, résumés, etc.
Tips: Finds artists through visiting exhibitions, art publications and sourcebooks, artists' submissions, suggestions of other artists.

‡THE FORUM GALLERY, 525 Falconer St., Jamestown NY 14701. (716)665-9107. Fax: (716)665-9110. Nonprofit college gallery. Estab. 1979. Represents 50 emerging, mid-career and established artists/year. Sponsors 5 shows/year. Average display time 6 weeks. Open during academic year; Tuesday-Saturday, 11-5; Thursday, 11-8. Located on campus of Jamestown Community College; 1,000 sq. ft.; white cube—good lighting. 100% of space for special exhibitions. Clientele: students, community members.
Media: Considers mixed media, sculpture, installation, photography. "Primarily interested in nontraditional ideas and approaches." Considers all types of prints. Most frequently exhibits photo-based works, installation oriented works and book works.
Style: Exhibits conceptualism, minimalism and postmodern works.
Terms: "We are not sales oriented, however, if someone is interested in purchasing a piece, we notify the artist and let the artist deal directly with the collector." Retail price set by the artist. Gallery provides

insurance and promotion. "We do catalogs for most exhibitions." Gallery pays shipping costs from gallery; artist pays shipping costs to gallery.

Submissions: Send query letter with résumé, slides and SASE. Replies in 3-4 weeks. Files "anything the artist wishes us to retain."

Tips: Finds artists through visiting exhibitions, word of mouth. "We respond primarily to work that explores new directions in form and content."

GREENHUT GALLERIES, Stuyvesant Plaza, Albany NY 12208. (518)482-1984. Fax: (518)482-0685. President: John Greenhut. Retail gallery and art consultancy. Estab. 1977. Represents 10-20 emerging, mid-career and established artists. Exhibited artists include Frederick Mershimer and John Stockwell. Sponsors 4 shows/year. Average display time 3 weeks. Open all year. Located "near uptown state university campus at beginning of Adirondack Northway"; 2,000-2,500 sq. ft. 25% of space for special exhibitions. Clientele: in banking, industry and health care. 2% private collectors, 50% corporate collectors. Overall price range: $60-20,000; most work sold at $400-2,000.

Media: Considers oil, acrylic, watercolor, pastel, mixed media, collage, paper, sculpture, ceramic, fiber, glass, original handpulled prints, woodcuts, engravings, lithographs, pochoir, wood engravings, mezzotints, linocuts, etchings, serigraphs and posters. Most frequently exhibits graphics, painting and sculpture. Edition sizes of multiples not to exceed 250.

Style: Exhibits expressionism, painterly abstraction, minimalism, color field, postmodern works, impressionism, realism, photorealism and all genres. Prefers landscapes, abstractions and florals.

Terms: Accepts artwork on consignment (50% commission); or buys outright for 50% of retail price (net 30 days). Retail price set by gallery. Gallery provides insurance and promotion; shipping costs are shared. Prefers artwork unframed.

Submissions: Send query letter with résumé, slides, photographs and bio. Call or write for appointment to show portfolio of originals and photographs. Replies in 1-3 months. Files materials of artists represented or previously sold.

Tips: "Try to visit the gallery first to see if we are compatible with you and your work."

HALLWALLS CONTEMPORARY ARTS CENTER, Suite 425, 2495 Main St., Buffalo NY 14214-2103. (716)835-7362. Alternative space. Estab. 1974. Exhibits the work of emerging artists. 600 members. Past exhibited artists include Heidi Kumau, Judith Jackson and Tom Huff. Sponsors 10 shows/year. Average display time 6 weeks. Open all year. Located in downtown Buffalo; "3 galleries, very flexible space." 100% of space for special exhibitions.

Media: Considers all media.

Style: Exhibits all styles and genres. "Contemporary cutting edge work which challenges traditional cultural and aesthetic boundaries."

Terms: "Hallwalls is here for the artist to create work that wouldn't necessarily be accepted in a commercial gallery." Retail price set by artist. Gallery provides insurance.

Submissions: Send query letter with résumé, slides, bio, brochure, photographs, SASE and reviews. Write for appointment to show portfolio of slides. Replies only if interested. Files slides, résumé, statement and proposals.

Tips: "Slides are constantly reviewed for consideration in group shows and solo installations by the staff curators and guest curators. It is recommended that artists leave slides on file for at least a year. We are showing more work by artists based in areas other than NYC and Buffalo."

‡LEATHERSTOCKING GALLERY, Pioneer Alley, P.O. Box 446, Cooperstown NY 13326. (607)547-5942 (Gallery). (607)547-8044 (Publicity). Publicity: Dorothy V. Smith. Retail nonprofit cooperative gallery. Estab. 1968. Represents emerging, mid-career and established artists. 55 members. Sponsors 1 show/year. Average display time 3 months. Open in the summer (mid-June to Labor Day); daily 11-5. Located downtown Cooperstown; 300-400 sq. ft. 100% of space for gallery artists. Clientele: varied locals and tourists. 100% private collectors. Overall price range: $25-500; most work sold at $25-100.

Media: Considers oil, acrylic, watercolor, pastel, pen & ink, drawing, mixed media, collage, paper, sculpture, ceramics, craft, photography, handmade jewelry, woodcut, engraving, lithograph, wood engraving, mezzotint, serigraphs, linocut and etching. Most frequently exhibits watercolor, oil and crafts.

Style: Exhibits impressionism and realism, all genres. Prefers landscapes, florals and American decorative.

Terms: Co-op membership fee plus a donation of time (10% commission). Retail price set by the artist. Gallery provides insurance, promotion and contract; artist pays shipping costs from gallery if sent to buyer. Prefers artwork framed.

Submissions: Accepts only artists from Otsego County; over 18 years of age; member of Leatherstocking Brush & Palette Club. Replies in 2 weeks.

Tips: Finds artists through word of mouth locally; articles in local newspaper.

OXFORD GALLERY, 267 Oxford St., Rochester NY 14607. (716)271-5885. Fax: (716)271-2570. Director: Judy Putman. Retail gallery. Estab. 1961. Represents 50 emerging, mid-career and established artists. Sponsors 10 shows/year. Average display time 1 month. Open all year. Located "on the edge of downtown; 1,000 sq.

ft.; large gallery in a beautiful 1910 building." 50% of space for special exhibitions. Overall price range: $100-30,000; most work sold at $1,000-2,000.

Media: Considers oil, acrylic, watercolor, pastel, pen & ink, drawings, mixed media, collage, paper, sculpture, ceramic, fiber, installation, original handpulled prints, woodcuts, engravings, lithographs, wood engravings, mezzotints, serigraphs, linocuts and etchings.

Styles: All styles.

Terms: Accepts artwork on consignment (50% commission). Retail price set by gallery and artist. Gallery provides insurance, promotion and contract.

Submissions: Send query letter with résumé, slides, bio and SASE. Call for appointment to show portfolio of originals. Replies in 2-3 months. Files résumés, bios and brochures.

Tips: "Have professional slides done of your artwork."

PRINT CLUB OF ALBANY, 140 N. Pearl St., P.O. Box 6578, Albany NY 12206. (518)432-9514. President: Dr. Charles Semowich. Nonprofit gallery and museum. Estab. 1933. Exhibits the work of 60 emerging, mid-career and established artists. Sponsors 1 show/year. Average display time 6 weeks. Open all year. Located in downtown arts district. "We currently have a small space and hold exhibitions in other locations." Clientele: varies. 80% private collectors, 20% corporate collectors.

Media: Considers original handpulled prints, woodcuts, wood engravings, linocuts, engravings, mezzotints, etchings, monoprints, calligraphy, lithographs and serigraphs.

Style: Exhibits all styles and genres. "No reproductions."

Terms: Accepts work on consignment from members. Membership is open internationally; also accepts donations to the permanent collection. Retail price set by artist. Customer discounts and payment by installment are available. Artist pays for shipping. Prefers artwork framed.

Submissions: Prefers only prints. Send query letter. Portfolio review required.

Tips: "We are a nonprofit organization of artists, collectors and others. Artist members exhibit without jury. We hold member shows and the Triannual National Open Competitive Exhibitions. We commission an artist for an annual print each year. Our shows are held in various locations. We are planning a museum (The Museum of Prints and Printmaking) and building. We also collect artists' papers, etc. for our library."

‡PYRAMID ARTS CENTER, 274 N. Goodman St., Rochester NY 14607. (716)461-2222. Fax: (716)461-2223. Program Director: David Pruden. Nonprofit gallery. Estab. 1977. Represents 475 emerging, mid-career and established artists/year. 400 members. Sponsors 50 shows/year. Average display time 2-6 weeks. Open 11 months/year. Business hours Tuesday-Friday, 10-5; gallery hours, Wednesday-Sunday 11-5; closed during August. Located in museum district of Rochester; 17,000 sq. ft.; features 5 gallery spaces, 1 shop, and 2 theater/performance spaces. 80% of space for special exhibitions. Clientele: artists, curators, collectors, dealers. 90% private collectors, 10% corporate collectors. Overall price range: $25-15,000; most work sold at $40-500.

Media: Considers all media, video, film, dance, music, performance art, computer media; all types of prints including computer, photo lithography.

Style: Exhibits all styles, all genres.

Terms: During exhibition a 25% commission is taken on sold works; gallery shop sales are 40% for non-members and 25% for members. Retail price set by the artist. Gallery provides insurance, promotion and contract; shipping costs are shared, "depending upon exhibition, funding and contract." Prefers artwork framed.

Submissions: Prefers artists from upstate New York but includes national artists in thematic shows. Send query letter with résumé and slides. Call for appointment to show portfolio of originals and slides. Replies only if interested within 1 month. "We have a permanent artist archive for slides, bios, résumés and will keep slides in file if artist requests."

Tips: Finds artists through national and local calls for work, portfolio reviews and studio visits. "Present slides that clearly and accurately reflect your work. Label slides with name, title, medium and dimensions."

‡RATHBONE GALLERY, Sage Junior College of Albany, 140 New Scotland Ave., Albany NY 12208. (518)445-1778. Fax: (518)436-0539. Director: Jim Richard Wilson. College Art Gallery. Estab. 1976. Represents 10-20 emerging, mid-career and established artists/year. Sponsors 7 shows/year. Average display time 1 month. Open September-May; Monday-Friday, 10-4:30; Sunday, 1-4; Tuesday, Wednesday, Thursday, 6-8. Located near downtown; 575 sq. ft.; main room approximately 18×28 with 10 foot ceiling; connecting room 12×6 with two walls of UV filter. 100% of space for special exhibitions; 100% of space for gallery artists. Clientele: broad range including college students, faculty, administration and community members. Overall price range: $300-25,000.

Media: Considers all media and all types of prints. Most frequently exhibits drawing, photography and painting.

Style: Exhibits all styles.

Terms: Sales are infrequent, no commission, no fees. Retail price set by the artist. Gallery provides insurance, promotion, contract and shipping costs to and from gallery. Prefers artwork framed.

Submissions: Accepts only artists from outside the Capital Region of New York State. Send query letter with résumé, slides, bio, SASE and reviews. Write for appointment to show portfolio. Replies in 1 month. Files supporting printed materials.

Tips: Finds artists through visiting exhibitions, word of mouth, art publications and sourcebooks, artists' submissions. "We prefer not to deal with agents. Best to send slides and supporting material during autumn. Decisions for following academic year are usually made by preceeding February."

‡**RAVENSONG**, 2132 Seneca St., Lawtons NY 14091. (716)337-3946. Owners: Judi and Ken Young. Retail gallery. Estab. 1990. Represents 25-30 emerging, mid-career and established artists/year. Exhibited artists include Peter Jones, Ben Buffalo. Sponsors 10 shows/year. Average display time 1-5 months. Open all year; Wednesday-Sunday, noon-6; Monday-Tuesday, by appointment. Located 30 miles south of Buffalo, next to the Cattaraugus Indian Reservation; 1,000 sq. ft.; gallery is housed in the former Lawtons Railroad Hotel. 33% of space for special exhibitions; 33% of space for gallery artists. Clientele: collectors, tourists, galleries, local residents. 30% private collectors, 5% corporate collectors. Overall price range: $100-7,500; most work sold at $100-500.

Media: Considers all media including bone and antler carving, leather, silver, beadwork, all types of prints. Most frequently exhibits stone and ceramic sculpture, oil/acrylic paintings, pencil drawings, antler and bone carvings, mixed media.

Style: Exhibits all styles, all genres. Prefers traditional woodland Indian images, contemporary/statement pieces and traditional woodland crafts.

Terms: Accepts work on consignment (30% commission) or buys outright for 50% of retail price (net 30 days). Retail price set by the artist. Gallery provides promotion; shipping costs are shared. Prefers artwork framed.

Submissions: Accepts only artists with Native American tribal membership. Send query letter with résumé, bio, photographs, reviews, tribal affiliation and copy of certification. Call for appointment to show portfolio of photographs or slides. Replies in 2-4 weeks. Files résumé, bio, reviews, tribal certification copy.

Tips: Finds artists through shows, word of mouth, submissions.

ROCKLAND CENTER FOR THE ARTS, 27 S. Greenbush Rd., West Nyack NY 10994. (914)358-0877. Executive Director: Julianne Ramos. Nonprofit gallery. Estab. 1972. Exhibits emerging, mid-career and established artists. 1,500 members. Sponsors 6 shows/year. Average display time 5 weeks. Open September-May. Located in suburban area; 2,000 sq. ft.; "contemporary space." 100% of space for special exhibitions. Clientele: 100% private collectors. Overall price range: $500-50,000; most artwork sold at $1,000-5,000.

Media: Considers oil, acrylic, watercolor, pastel, pen & ink, mixed media, sculpture, ceramic, fiber, glass and installation. Most frequently exhibits painting, sculpture and craft.

Style: Exhibits all styles and genres.

Terms: Accepts work on consignment (33% commission). Retail price set by artist. Gallery provides insurance, promotion and shipping costs to and from gallery. Prefers artwork framed.

Submissions: "Proposals accepted from curators only. No one-person shows. Artists should not apply directly." Replies in 2 weeks.

Tips: "Artist may propose a curated show of 3 or more artists; curator may not exhibit. Request curatorial guidelines. Unfortunately for artists, the trend is toward very high commissions in commercial galleries. Nonprofits like us will continue to hold the line."

‡**THE SCHOOLHOUSE GALLERIES**, Owens Rd., Croton Falls NY 10519. (514)277-3461. Fax: (514)234-7522. Director: Lee Pope. Retail gallery. Estab. 1979. Represents 30 emerging and mid-career artists/year. Exhibited artists include Joseph Keiffer and Michelle Harvey. Average display time 1 month. Open all year; Tuesday-Sunday, 1-5. Located in a suburban community of New York City; 1,200 sq. ft.; 70% of space for special exhibitions; 30% of space for gallery artists. Clientele: residential, corporate, consultants. 50% private collectors, 50% corporate collectors. Overall price range: $75-6,000; most work sold at $350-2,000.

Media: Considers oil, acrylic, watercolor, pastel, pen & ink, drawing, mixed media, collage, paper, sculpture, ceramics, fiber and photography, all types of prints. Most frequently exhibits paintings, prints and sculpture.

Style: Exhibits expressionism, painterly abstraction, impressionism and realism. Genres include landscapes. Prefers impressionism and painterly abstraction.

Terms: Accepts work on consignment (40% commission). Retail price set by the artist. Gallery provides insurance and promotion; shipping costs are shared. Prefers artwork on paper, unframed.

Submissions: Send query letter with slides, photographs and SASE. Call for appointment to show portfolio of photographs and slides. Replies in 1 month. Files slides, bios if interested.

Tips: Finds artists through visiting exhibitions and referrals.

‡**SCHWEINFURTH MEMORIAL ART CENTER**, 205 Genesee St., Auburn NY 13021. (315)255-1553. Director: Lisa Pennella. Museum. Estab. 1981. Represents emerging, mid-career and established artists. Sponsors 15 shows/year. Average display time 2 months. Open Tuesday-Friday, 12-5; Saturday, 10-5; Sunday, 1-5. Closed in January. Located on the outskirts of downtown; 7,000 sq. ft.; large open space with natural and artificial light.

Media: Considers all media, all types of prints.
Style: Exhibits all styles, all genres.
Terms: Retail price set by the artist. Gallery provides insurance and promotion; shipping costs are shared. Prefers artwork framed.
Submissions: Accepts only artists from Central New York. Send query letter with résumé, slides and SASE.

WESTCHESTER GALLERY, County Center, White Plains NY 10606. (914)684-0094. Fax: (914)684-0608. Gallery Coordinator: Jonathan G. Vazquez-Haight. Nonprofit gallery. Exhibits the work of 40 emerging, mid-career and established artists. Exhibited artists include Noreen Halsall and Neil Waldman. Sponsors 6 shows/year. Average display time 3½-4 weeks. Closed holidays and August. Located at County Center and county seat; 400 sq. ft. gallery proper; 300 sq. ft. glass enclosed cabinets; housed in landmark art deco building. 80% of space for special exhibitions. Clientele: 70% private collectors, 30% corporate collectors. Overall price range: $100-160,000; most work sold at $100-3,000.
Media: Considers all media (including video and performance) and all types of prints. Most frequently exhibits paintings, sculpture and photos.
Style: Exhibits all styles and genres. Prefers landscapes, still life and figurative. "Shows work from traditional 'to the absurd.' "
Terms: Accepts work on consignment (33⅓% commission). Retail price set by artist. Sometimes offers payment by installments. Gallery provides insurance, promotion and contract; artist pays for shipping. Will consider art framed or unframed, depending on work.
Submissions: Send query letter with résumé, slides, bio, brochure, photographs or actual work and SASE. Portfolio review requested if interested in artist's work. Portfolio should include originals, slides, photographs and transparencies. Replies in 2-3 months.

New York City

ACTUAL ART FOUNDATION, 7 Worth St., New York NY 10013. (212)226-3109. Director: Valerie Shakespeare. Nonprofit foundation. Estab. 1981. Represents 11 emerging and mid-career artists. Sponsors 2 shows/year. Average display time 3 months. Open all year. Located downtown. Clientele: "community business."
Media: Considers all media.
Style: Exhibits "actual" art. Does not want to see "representational art, old-fashioned art or any style of art already established."
Terms: "We arrange for, curate and sponsor exhibitions in off-site spaces." Retail price set by artist. Customer discounts and payment by installment are available. Gallery provides insurance, promotion and contract; foundation pays for shipping costs to and from site.
Submissions: "Prefers actual artists dealing with effects of time in work." Send query letter with slides, bio and SASE. Portfolio review requested if interested in artist's work. Replies in 1 month. Files "only material requested or interested in."
Tips: Finds artists through visiting exhibitions, word of mouth, various art publications, sourcebooks, artists' submissions/self-promotions and art collectors' referrals. "Work should involve effects of time on materials of the work in some way." Sees trends toward "new concerns with time, with questions of conservation, with awareness among artists."

‡ALTERNATIVE MUSEUM, #402, 594 Broadway, New York NY 10012. (212)966-4444. Fax: (212)226-2158. Curator: Andrew Perchur. Museum. Estab. 1975. Represents emerging, mid-career and established artists. Sponsors 6-8 shows/year. Average display time 6-8 weeks. Open Tuesday-Saturday, 11-6. Closed August. Located in Soho (downtown Manhattan); 4,800 sq. ft. 100% of space for special exhibitions.
Media: Considers all media and all types of prints.
Style: Exhibits all styles, all genres. Prefers works of humanitarian significance that explore issues of social and political concern; works by emerging and mid-career artists who have been under-recognized or disenfranchised because of ideology, race, gender or economic inequality.
Terms: Retail price set by the artist. Gallery provides insurance and promotion. "Shipping costs depend on exhibition funding." Prefers artwork framed.
Submissions: Prefers only artists whose work deals with sound, humanitarian or political issues. Send query letter with résumé, slides, bio and SASE. "Slide review is the first 2 weeks of October." The museum contacts the artist for portfolio review. Files material on upcoming exhibitions.
Tips: Finds artists through agents, visiting exhibitions, word of mouth, art publications and sourcebooks, artists' submissions.

‡THE ART ALLIANCE, 98 Greene St., New York NY 10012. (212)274-1704. Fax: (212)274-1682. President: Leah Poller. Artist agent, curator and consultant. Estab. 1989. Represents 15 mid-career and established artists/year. Exhibited artists include Bernardo Torrens, Mario Murua. Sponsors 3-5 shows in gallery, 10 in outside spaces/year. Average display time 1 month. Open 11-5 by appointment. Closed July and August. Located in Soho loft; 1,200 sq. ft. 70% of space for special exhibitions; 30% of space for gallery artists.

Clientele: international, corporate, major collectors. 80% private collectors, 20% corporate collectors. Overall price range: $1,500-75,000; most work sold at $10,000-20,000.
Media: Considers oil, acrylic, watercolor, pastel, pen & ink, drawing, mixed media, collage and sculpture. Most frequently exhibits oil, sculpture and drawing.
Style: Exhibits expressionism, neo-expressionism, surrealism and realism. Prefers realism—figurative, sculpture—figurative, expressionism/neo-expressionism.
Terms: Accepts work on consignment (50% commission). Retail price set by the artist. Gallery provides insurance, promotion, contract and shipping costs from gallery. Requires artwork framed.
Submissions: Prefers non-American artists; does not accept emerging artists. Send query letter with résumé, slides, bio and SASE. Write for appointment to show portfolio of slides and artist statement. Replies in 1 month.
Tips: Finds artists through art fairs, other artists. "Ask for catalogues on my artists to see quality, bios."

‡**ART INSIGHTS GALLERY,** 161 W. 72nd St., New York NY 10023. (212)724-3715. Fax: (212)769-9194. President: Tom Winer. Retail gallery, art consultancy. Estab. 1988. Represents "many" emerging, mid-career and established artists/year. Exhibited artists include Li Zhong Liang, Ernani Silva. Sponsors 6-8 shows/year. Average display time 1-12 months. Open all year; 10:30-8:00. Located in midtown Manhattan; 3,200 sq. ft.; great variety of artistic styles. 1,200 sq. ft. of space for special exhibitions; 100% of space for gallery artists. Clientele: middle class to upscale. 95% private collectors, 5% corporate collectors. Overall price range: $250-80,000; most work sold at $700-4,000.
Media: Considers all media and all types of prints. Most frequently exhibits works on canvas, original prints, watercolors and 3-D art.
Style: Exhibits all styles, all genres.
Terms: Arrangement is different for each artist. Retail price set by the gallery. Gallery provides insurance and promotion (this varies from project to project). Artist usually pays shipping costs to and from gallery. "Sometimes we participate in shipping." Prefers artwork mostly unframed.
Submissions: Send query letter with photographs and SASE. "We prefer photos, but only send material you don't need back. Please do not call. We'll call if interested."

‡**ARTISTS IN RESIDENCE,** 63 Crosby St., New York NY 10012. (212)966-0799. Associate Director: Nancy Waits. Cooperative nonprofit artist-run women's gallery. Estab. 1972. Represents 23 emerging and established artists/year. 23 members. Sponsors 26 shows/year (2 shows/3 weeks). Average display time 3 weeks. Open Tuesday-Saturday, 11-6. Closed July-August. Located in Soho, downtown; 2,000 sq. ft.; large, lofty space in good Soho location. 20% of space for special exhibitions; 80% of space for gallery artists.
Media: Considers all media, all types of prints.
Style: Exhibits all styles.
Terms: Retail price set by the artist. Gallery provides promotion; artist pays shipping costs to and from gallery.
Submissions: Accepts only women artists. Send query letter with résumé, slides, bio, SASE and reviews. Replies in 1-2 months. Files only accepted artist material, all else is sent back.

‡**BILL BACE GALLERY,** 39 Wooster St., New York NY 10013. (212)219-0959. Retail gallery. Estab. 1989. Represents 15 emerging, mid-career and established artists/year. Exhibited artists include Tom Doyle, Michael A. Smith. Sponsors 10 shows/year. Average display time 5 weeks. Open Tuesday-Saturday, 11-5. Closed in summer. Located in Soho; 2,500 sq. ft. 100% of space for special exhibitions. Clientele: private and corporate collectors. 50% private collectors, 50% corporate collectors. Overall price range: $500-50,000; most work sold at $1,000-5,000.
Media: Considers oil, sculpture, ceramics and photography. Most frequently exhibits sculpture and painting.
Style: Exhibits all styles, all genres.
Terms: Accepts work on consignment (50% commission). Retail price set by the gallery and the artist. Gallery provides promotion and contract; artist pays shipping costs to and from gallery. Prefers artwork framed.
Submissions: The gallery does not review unsolicited material.
Tips: "The gallery does not review unsolicited slides. The gallery works closely with the artists it represents and develops these relationships over a long period of time. Artists are invited to participate in the gallery by attending exhibitions, discussing same with gallery and after some time a working relationship may develop."

‡**BARNARD—BIDERMAN FINE ART,** 22 E. 72nd St., New York NY 10021. (212)772-2352. Fax: (212)921-2058. Director: Isabel Barnard-Biderman. Retail gallery. Estab. 1990. Represents 20 emerging and established artists/year. Exhibited artists include Andres Monreal, Fernando De Szyszlo, Toledo. Sponsors 8 shows/year. Average display time 1 month. Open all year; 12-6. Located uptown; 2,000 sq. ft. 90% of space for special exhibitions; 90% of space for gallery artists. 80% private collectors, 20% corporate collectors. Overall price range: $2,000-18,000; most work sold at $2,000-12,000.
Media: Considers oil, acrylic, engraving, lithograph, mezzotint and etching. Most frequently exhibits oil and acrylic on canvas and mezzotint.

CENTRAL GALLERIES/J.B. FINE ARTS, INC., 420 Central Ave., Cedarhurst NY 11516. (516)569-5686. Fax: (516)569-7114. President: Jeff Beja. Retail gallery. Estab. 1985. Represents 25 emerging, mid-career and established artists. Exhibited artists include Robin Morris and Howard Behrens. Sponsors 2 shows/year. Average display time 1 month. Open all year. Located in Long Island, 5 minutes from JFK airport; 1,800 sq. ft. Clientele: 90% private collectors, 10% corporate collectors. Overall price range: $100-50,000; most work sold at $500-5,000.
Media: Considers oil, acrylic, watercolor, pastel, mixed media, sculpture, original handpulled prints, lithographs, wood engravings, serigraphs and etchings. Most frequently exhibits painting, sculpture and serigraphs.
Style: Exhibits all styles and genres.
Terms: Accepts work on consignment (50% commission). Exclusive area representation required. Retail price set by artist and gallery. Gallery provides insurance and promotion; artist pays for shipping. Prefers artwork framed.
Submissions: Send query letter with résumé, bio, brochure, photographs and SASE. Write for appointment to show portfolio of originals, photographs and transparencies. Replies in 2 weeks.

CERES, Room 306, 584 Broadway, New York NY 10012. (212)226-4725. Administrator: Tamara Damon. Women's cooperative and nonprofit gallery. Estab. 1984. Exhibits the work of emerging, mid-career and established artists. 40 members. Sponsors 11-14 shows/year. Average display time 1 month. Open all year; Tuesday-Saturday, 11-6. Located in Soho, between Houston and Prince Streets; 2,000 sq. ft. 30% of space for special exhibitions; 70% of space for gallery artists. Clientele: artists, collectors, tourists. 85% private collectors, 15% corporate collectors. Overall price range, $300-10,000; most work sold at $350-1,200.
 • Ceres is growing into an alternative culture center with a poetry, dance and music program along with the co-op exhibition program.
Media: All media considered.
Style: All genres considered. "Ceres is dedicated to promoting the art of contemporary living women artists."
Terms: Co-op membership fee plus donation of time. Retail price set by artist. Gallery provides insurance and promotion; artists pay for shipping.
Submissions: Prefers women from tri-state area; "men may show in group/curated shows." Write with SASE for application. Replies in 1-3 weeks.

‡CITYARTS, INC., Suite 911, 225 Lafayette St., New York NY 10012. (212)966-0377. Fax: (212)966-0551. Executive Director: Tsipi Ben-Haim. Art consultancy, nonprofit public art organization. Estab. 1968. Represents 500 emerging, mid-career and established artists. Sponsors 4-8 projects/year. Average display time varies. "A mural or public sculpture will last up to 15 years." Open all year; Monday-Friday, 10-5. Located in Soho; "the city is our gallery. CityArts's 160 murals are located in all 5 boroughs on NYC. We are funded by foundations, corporations, government and membership ('Friends of CityArts')."
Media: Considers oil, acrylic, drawing, sculpture, mosaic and installation. Most frequently exhibits murals (acrylic), mosaics and sculpture.
Style: Exhibits all styles, all genres.
Terms: The artist receives a flat commission for producing the mural or public art work. Retail price set by the gallery. Gallery provides insurance, promotion, contract, shipping costs.
Submissions: "We prefer New York artists due to constant needs of a public art work created in the city." Send query letter with SASE. Call for appointment to show portfolio of originals, photographs and slides. Replies in 1 month. "We reply to original query with an artist application. Then it depends on commissions." Files application form, résumé, slides, photos, reviews.
Tips: Finds artists through recommendations from other art professionals. Also press on CityArts triggers a lot of response.

‡EUGENIA CUCALON GALLERY, 145 E. 72nd St., New York NY 10021 Phone/Fax: (212)472-8741. Gallery Director: Eugenia Cucalon. Retail/wholesale gallery. Estab. 1977. Represents 4 emerging, mid-career and established artists/year. Exhibited artists include Miguel Angel Rios, Yukinor: Yanagi. Sponsors 5-6 shows/year. Average display time 4-6 weeks. Open all year; Tuesday-Saturday, 12-6; closed during August and holidays. Located uptown East Side; 500 sq. ft.

Media: Considers oil, acrylic, watercolor, pastel, pen & ink, drawing, mixed media, collage, paper, sculpture, ceramics, installation, photography, woodcut, lithograph, wood engraving, mezzotint, serigraphs, etching and posters. Most frequently exhibits oil on canvas and works on paper.

Style: Exhibits expressionism, neo-expressionism, painterly abstraction, surrealism, conceptualism, minimalism, color field, postmodern works, impressionism, hard-edge geometric abstraction, realism and imagism. Prefers modern, abstraction and semi-figurative.

Terms: Accepts work on consignment (50% commission) or buys outright for 50% of retail price. Retail price set by the gallery and the artist. Gallery provides insurance, promotion and contract; shipping costs are shared. Prefers artwork framed.

Submissions: Send query letter with résumé, slides and business card. Write for appointment to show portfolio of slides. Replies only if interested. Files slides and résumés.

Tips: Finds artists through word of mouth, publications and sourcebooks, artists' submissions.

‡**DARUMA GALLERIES,** 554 Central Ave., Cedarhurst NY 11516. (516)569-5221. Owner: Linda. Retail gallery. Estab. 1980. Represents about 25-30 emerging and mid-career artists. Exhibited artists include Christine Amarger, Eng Tay, Dorothy Rice, Joseph Dawley and Nitza Flantz. Sponsors 2-3 shows/year. Average display time 1 month. Open all year. Located on the main street; 1,000 sq. ft. 100% private collectors. Overall price range: $150-5,000; most work sold at $250-1,000.

Media: Considers watercolor, pastel, pen & ink, drawings, mixed media, collage, woodcuts, linocuts, engravings, mezzotints, etchings, lithographs and serigraphs. Most frequently exhibits etchings, lithographs and woodcuts.

Style: Exhibits all styles and genres. Prefers scenic (not necessarily landscapes), figurative and Japanese woodblock prints. "I'm looking for beach, land and sea scapes; sailing; pleasure boats."

Terms: 33⅓% commission for originals; 50% for paper editions. Retail price set by the gallery (with input from the artist). Sometimes offers customer discounts and payment by installments. Artist pays for shipping to and from gallery. Prefers unframed artwork.

Submissions: Send query letter with résumé, bio and photographs. Call to schedule an appointment to show a portfolio, which should include originals and photographs. Replies "quickly." Files bios and photo examples.

Tips: Finds artists through agents, visiting exhibitions, word of mouth, various art publications and sourcebooks, artists' submissions/self-promotions and art collectors' referrals. "Bring good samples of your work and be prepared to be flexible with the time needed to develop new talent. Have a competent bio, presented in a professional way. The economy has reduced art buying. Customers are more dollar conscious and looking for quality."

‡**DE LECEA FINE ART/MIGUEL ESPEL GALERIA DE ARTE,** Suite 910, 200 W. 20th St., New York NY 10011. (212)807-7366. Fax: (212)727-8985. Director: Michael De Lecea (US); Miguel Espel (Spain). Retail gallery. Estab. 1975. Represents 2 established artists/year. May be interested in seeing the work of emerging artists in the future. Sponsors 4 shows/year. Average display time 1 month. Open all year except August; Monday-Friday, 11-2 and 5-9. Located in New York and Madrid, Spain; 5,000 sq. ft. 70% of space for special exhibitions; 70% of space for gallery artists. Clientele: private collections and museums. 85% private collectors, 5% corporate collectors. Overall price range: $5,000; most work sold at $1,000.

Media: Considers oil, acrylic, watercolor, pastel, pen & ink, drawing, mixed media, collage, paper, sculpture, ceramics, engraving, lithograph and etching. Most frequently exhibits oil on canvas, watercolor and gouache.

Style: Exhibits surrealism, postmodern works, impressionism and realism. Genres include landscapes, figurative work, all genres. Prefers landscapes, still life and figures.

Terms: Accepts work on consignment (10% commission). Retail price set by the artist. Gallery provides insurance, promotion and contract. Prefers artwork unframed.

Submissions: Send query letter with résumé.

EAST END ARTS COUNCIL, 133 E. Main St., Riverhead NY 11901. (516)727-0900. Visual Arts Coordinator: Patricia Berman. Nonprofit gallery. Estab. 1971. Exhibits the work of 30 emerging, mid-career and established artists. Sponsors 30 solo and 7 group shows/year. Average display time 6 weeks. Prefers regional artists. Clientele: 100% private collectors. Overall price range: $10-10,000; most work sold at under $200.

Media: Considers all media and prints.

Style: Exhibits contemporary, abstract, primitivism, non-representational, photorealism, realism and postpop works. Genres include figurative, landscapes, florals, American and Western. "Being an organization relying strongly on community support, we walk a fine line between serving the artistic needs of our constituency and exposing them to current innovative trends within the art world. Therefore, there is not a particular area of specialization. We show photography, fine craft and all art media."

Terms: Accepts work on consignment (30% commission). Retail price set by gallery and artist. Exclusive area representation not required. Gallery provides insurance, promotion and contract; artist pays for shipping to and from gallery.

Submissions: Send query letter, résumé and slides. All materials returned.
Tips: "When making a presentation don't start with 'My slides really are not very good.' Slides should be great or don't use them."

‡STEPHEN E. FEINMAN FINE ARTS LTD., 448 Broome St., New York NY 10012. (212)925-1313. Contact: S.E. Feinman. Retail/wholesale gallery. Estab. 1972. Represents 10 emerging, mid-career and established artists/year. Exhibited artists include Mikio Watanabe, Johnny Friedlaender, Andre Masson. Sponsors 4 shows/year. Average display time 3 weeks. Open all year; Tuesday-Saturday, 11-6. Located in Soho; 1,000 sq. ft. 100% of space for gallery artists. Clientele: prosperous middle-aged professionals. 90% private collectors, 10% corporate collectors. Overall price range, $300-20,000; most work sold at $1,000-2,500.
Media: Considers oil, acrylic, watercolor, pastel, pen & ink, drawing, mixed media, sculpture, woodcut, engraving, lithograph, mezzotint, serigraphs, linocut and etching. Most frequently exhibits mezzotints, aquatints and oils.
Style: Exhibits painterly abstraction and surrealism, all genres. Prefers abstract, figurative and surrealist.
Terms: Buys outright for % of retail price (net 90-120 days). Retail price set by the gallery. Gallery provides insurance, promotion, contract and shipping costs from gallery; artist pays shipping costs to gallery. Prefers artwork unframed.
Submissions: Send query letter with résumé, slides and photographs. Replies in 2-3 weeks.

‡FIRST PEOPLES GALLERY, 114 Spring St., New York NY 10012. (212)343-0166. Fax: (212)343-0167. Director: Victoria Torrez. Retail gallery. Estab. 1992. Represents 60 mid-career and established artists/year. Interested in seeing the work of emerging artists. Exhibited artists include Ray Tracey, Dan Lomahaftewa, Mirac Creeping Bear. Sponsors 5 shows/year. Average display time 6 weeks. Open all year; Tuesday-Sunday, 11-6. Located in the Soho area of New York City; 2,500 sq. ft. upstairs, 2,000 sq. ft. downstairs; the gallery is in historical area of New York City, turn of century loft, brick building. 60% of space for special exhibitions; 40% of space for gallery artists. Clientele: collectors, walk-in traffic, tourists. 30% private collectors, 10% corporate collectors. Overall price range: $100-1,000 (40%), $1,000-15,000 (10%); most work sold at $3,000 (50%).
Media: Considers oil, acrylic, watercolor, pastel, pen & ink, mixed media, sculpture, pottery (coiled, traditional style only), lithograph, serigraphs and posters. Most frequently exhibits oil and acrylic, Northwest wood carvings, pottery.
Style: Exhibits expressionism, painterly abstraction and realism. Genres includes Southwestern, portraits and figurative work. Prefers expressionism, painterly abstraction and realism.
Terms: Accepts work on consignment (40-50% commission) or buys outright for 50% of retail price (net 30 days). Retail price set by the gallery and the artist. Gallery provides insurance, promotion and contract; artist pays shipping costs to gallery. Prefers artwork framed in wood.
Submissions: Accepts only artists native to North America. Send query letter with résumé, slides, bio, brochure, business card and reviews. Call for appointment to show portfolio. Replies in 3-4 weeks. Replies if interested within 1 week. Files entire portfolio.
Tips: Finds artists through exhibits, submissions, publications and Indian markets.

‡FIRST STREET GALLERY, #402, 560 Broadway, New York NY 10012. (212)226-9127. Contact: Members Meeting. Cooperative gallery. Estab. 1971. Represents emerging and mid-career artists. 30 members. Sponsors 10-13 shows/year. Average display time 3 weeks. Open Tuesday-Saturday, 11-6. Closed in August. Located in the heart of Soho Art District; 2,100 sq. ft.; good combination natural/artificial light, distinguished gallery building. 100% of space for gallery artists. Clientele: collectors, consultants, retail. 50% private collectors, 50% corporate collectors. Overall price range: $500-5,000; most work sold at $1,000-2,500.
 • First Street sponsors an open juried show each spring with a well-recognized figurative artist as judge. Contact them for details.
Media: Considers oil, acrylic, watercolor, pastel, drawing. Considers prints "only in connection with paintings." Most frequently exhibits oil and acrylic on canvas and watercolor on paper.
Style: Exhibits realism. Genres include landscapes and figurative work. "First Street's reputation is based on showing figurative/realism almost exclusively."
Terms: Co-op membership fee plus a donation of time (no commission). "We occasionally rent the space in August for $4,500/month." Retail price set by the artist. Artist pays shipping costs to and from gallery.
Submissions: "We accept figurative/representational work." Send query letter with résumé, slides, bio and SASE. "Artists' slides reviewed by membership at meetings once a month — call gallery for date in any month. We need to see original work to accept a new member." Replies in 1-2 months.

FOCAL POINT GALLERY, 321 City Island, Bronx NY 10464. (718)885-1403. Artist/Director: Ron Terner. Retail gallery and alternative space. Estab. 1974. Interested in emerging and mid-career artists. Sponsors 2 solo and 6 group shows/year. Average display time 3-4 weeks. Clientele: locals and tourists. Overall price range: $175-750; most work sold at $300-500.
Media: Most frequently exhibits photography. Will exhibit painting and etching and other material by local artists only.

INSIDER REPORT

The Art World According to Karp

Pick up any book on the history of contemporary American art and you are likely to find the name Ivan Karp. The ebullient art dealer, dubbed the "Mayor of Soho," is a major player in the New York art scene. The first to show the work of such modern masters as Andy Warhol, Roy Lichtenstein and Tom Wesselmann, Karp has built a reputation on his eye for innovative art.

Ivan Karp

A raconteur who peppers his daily conversation with words like "perspicacious," Karp is a connoisseur who collects antiques, gambles, writes novels, and lectures frequently on art. He is also known for being a maverick. When Karp opened his first gallery in 1969, he named it O.K. Harris Works of Art and hung a sign on the door proclaiming "Established in 1493." Karp liked the idea of having an esteemed ancestor so he dreamed up the name O.K. Harris because it sounded very American—like the work he planned to show in his gallery. In the back office he mischievously hung a 19th century portrait of "Our Founder, Oscar Klondike Harris" a stern-looking man with a full beard. A fictitious proxy, Karp reasoned, would free him up to concentrate on his work and serve as a handy scapegoat in case he made any mistakes. It wasn't long before O.K. Harris began receiving phone calls and invitations to gallery openings, confusing the daylights out of an art world abounding in egos. "Can you believe it? I did not have my name in capitol letters a mile high emblazoned on top my own gallery! How INCREDIBLE!" chuckles Karp.

"That was back when we were one of two galleries in Soho. It was an industrial neighborhood in physical decline." Since then, the area has burgeoned to over 225 galleries and Karp has witnessed cycles of growth, decline and rebirth in the art world. "We've seen in the past few years a recession that is the aftermath of the prosperity of the middle '80s when art was a flourishing enterprise—almost out of control." Lately he has observed signs of a revival and predicts an upturn. Through it all Karp has remained down-to-earth, and generous with his advice to artists. The following are some of "Karp's rules":

● **Visit galleries.** Make a full survey of current exhibitions in your area. Get a feel for each gallery's style.
● **Choose several galleries which show work similar to yours.** Most gallery dealers will express physical or audible agitation when an artist brings in work that is totally inappropriate. Don't bring abstract work to a gallery which shows only figurative art.

- **Make an appointment**. Never walk into a gallery unannounced and expect the gallery director to look at your work.
- **Don't bring in your paintings**. A sure way to annoy a gallery director is to deploy a number of artworks around the exhibition area. Prepare a packet of 10-20 slides or transparencies of current work. Make sure the slides are marked showing topside, media, date of production, and size of work.
- **Choose slides that show technical maturity and consistency in style.** Slides sent in the mail should always be accompanied by a return envelope with proper postage.
- **Have patience**. Even if the gallery director likes your work, he or she may not be able to give you a show right away. Galleries schedule shows far in advance. Be willing to participate in group shows at first.
- **Attend art openings**. It helps a great deal to be visible at the various social events in the art community. In this political arena, it is unfortunate but true that artists make more progress more quickly if they are known in the art community than if they hide away in their studios all day.
- **Be persistent.** Don't be discouraged by the many artists whose work is shallow and merely fashionable, singled out by critics or curators as harbingers of a brave new vision. There is currently a sufficient number of enlightened observers to prevent artists of consequence from being totally ignored.

—*Mary Cox*

Courtesy O.K. Harris Works of Art, New York, New York. Photograph © 1993 D. James Dee

An example of the type of work considered by outlandish gallery director Ivan Karp, Exit Hero, *a work in acrylic by Leonard Dufresne, was shown at O.K. Harris Works of Art in New York City.*

Style: Exhibits all styles and genres. Prefers figurative work, landscapes, portraits and abstracts. Open to any use of photography.
Terms: Accepts work on consignment (30% commission). Exclusive area representation required. Customer discounts and payment by installment are available. Gallery provides promotion. Prefers artwork framed.
Submissions: "Please call for submission information."
Tips: "Do not include résumés. The work should stand by itself. Slides should be of high quality."

‡**14TH STREET PAINTERS**, #2W, 114 W. 14th St., New York NY 10011. (212)627-9893. Alternative space, art consultancy, nonprofit gallery, studio-atelier. Estab. 1987. Represents emerging and mid-career artists. Exhibited artists include Craig Killy, Deborah Greek. Sponsors 2 shows/year. Average display time 3½ weeks. Open all year; daily, noon-7. Located in the West Village; 2,400 sq. ft. (and adding more space). 70% of space for special exhibitions; 70% of space for gallery artists. Clientele: corporate, private, institutional. 40% private collectors, 35% corporate collectors. Overall price range: $300-8,000.
Media: Considers oil, acrylic, watercolor, pastel, drawing, mixed media, collage, paper, sculpture, glass, installation, photography, woodcut, lithograph and serigraphs. Most frequently exhibits painting (2-D works), mixed media and sculpture.
Style: Exhibits expressionism, neo-expressionism, painterly abstraction, color field, postmodern works, all genres.
Terms: Artists, in general, have to work at some time in the studio. Retail price set by the artist. Gallery provides promotion and assistance in art-related problems; artist pays shipping costs to and from gallery. Prefers artwork framed.
Submissions: Send query letter with résumé, slides, photographs and SASE. Write for appointment to show portfolio of photographs and transparencies (no more than 10 images). Replies only if interested within 6 weeks.

GALLERY HENOCH, 80 Wooster, New York NY 10012. (212)966-6360. Director: George Henoch Shechtman. Retail gallery. Estab. 1983. Represents 40 emerging and mid-career artists. Exhibited artists include Caesar Santander and Max Ferguson. Sponsors 10 shows/year. Average display time 3 weeks. Closed August. Located in Soho; 4,000 sq. ft. 50% of space for special exhibitions. Clientele: 90% private collectors, 10% corporate clients. Overall price range: $3,000-40,000; most work sold at $10,000-20,000.
Media: Considers oil, acrylic, watercolor, pastel, pen & ink, drawings, and sculpture. Most frequently exhibits painting, sculpture, drawings and watercolor.
Style: Exhibits photorealism and realism. Genres include landscapes and figurative work. Prefers landscapes, cityscapes and still lifes.
Terms: Accepts work on consignment (50% commission). Retail price set by gallery. Gallery provides insurance and promotion; shipping costs are shared. Prefers artwork framed.
Submissions: Send query letter with slides, bio and SASE. Portfolio should include slides and transparencies. Replies in 3 weeks.
Tips: "We suggest artists be familiar with the kind of work we show and be sure their work fits in with our styles."

‡**GALLERY JUNO**, Suite 604B, 568 Broadway, New York NY 10012. (212)431-1515. Fax: (212)431-1583. Gallery Manager: Gary Timmons. Retail gallery, art consultancy. Estab. 1993. Represents 18 emerging artists/ year. Exhibited artists include Pierre Jacquemon, Michael Craig. Sponsors 12 shows/year. Average display time 1 month. Open all year; Monday-Saturday, 10-6; Sunday, 11-5. Located in Soho; 1,000 sq. ft.; small, intimate space. 50% of space for special exhibitions; 50% of space for gallery artists. Clientele: corporations, private, design. 30% private collectors, 80% corporate collectors. Overall price range: $600-5,000; most work sold at $2,000-5,000.
Media: Considers oil, acrylic, watercolor, pastel, pen & ink, drawing, paper, sculpture, ceramics, glass and photography. Most frequently exhibits painting, sculpture and photography.
Style: Exhibits expressionism, neo-expressionism, painterly abstraction, conceptualism, minimalism, color field, pattern painting and hard-edge geometric abstraction. Genres include landscapes. Prefers contemporary modernism, abstraction and color field.
Terms: Accepts work on consignment (50% commission). Retail price set by the gallery and the artist. Gallery provides insurance, promotion and shipping costs from gallery; artist pays shipping costs to gallery. Prefers artwork framed.
Submissions: Prefers only New York artists. Send query letter with résumé, slides, bio, photographs, SASE, business card and reviews. Write for appointment to show portfolio of originals, photographs and slides. Replies in 3 weeks. Files slides, bio, photos, résumé.
Tips: Finds artists through visiting exhibitions, word of mouth and submissions.

GALLERY NORTH, 90 N. Country Rd., Setauket NY 11733. (516)751-2676. Director: Louise Kalin. Nonprofit gallery. Estab. 1965. Exhibits the work of emerging, mid-career and established artists mainly from the New York metropolitan area. 200 members. Sponsors 9 shows/year. Average display time 4-5 weeks. Open all year. Located in the suburbs, near the State University at Stony Brook; approximately 750 sq. ft.; "in a

renovated Victorian house." 85% of space for special exhibitions. Clientele: university faculty and staff, Long Island collectors and tourists. 95% private collectors. Overall price range: $100-50,000; most work sold at $15-3,000.

• Gallery North is finding its buyers are more conservative and the price scale is lower.

Media: Considers all media and original handpulled prints, woodcuts, wood engravings, linocuts, engravings, mezzotints, etchings, lithographs and serigraphs. Does not consider installation. Most frequently exhibits paintings, prints and crafts, especially jewelry and ceramics.

Style: Exhibits all styles. Prefers realism, abstraction and expressionism and reasonable prices.

Terms: Accepts work on consignment (40% commission). Retail price set by gallery and artist. Sometimes offers customer discounts and payment by installment. Gallery provides insurance, promotion and contract; shipping costs are shared. Prefers well-framed ("simple") artwork.

Submissions: Send query letter with résumé, slides, bio, SASE and reviews. Portfolio review requested if interested in artist's work. Portfolio should include originals, slides or photographs. Replies in 2-4 weeks. Files slides and résumés when considering work for exhibition.

Tips: Finds artists from other exhibitions, slides and referrals. "If possible the artist should visit to determine whether he would feel comfortable exhibiting here. A common mistake artists make is that slides are not fully labeled as to size, medium, which end is up."

‡GALLERY REVEL, 96 Spring St., New York NY 10012. (212)925-0600. Fax: (212)431-6270. Director: Marvin Carson. Retail/wholesale gallery. Estab. 1967. Represents 15 emerging, mid-career and established artists/ year. Exhibited artists include Guy Dessapt, Henry Peeters. Sponsors 4-6 shows/year. Average display time 1-12 months. Open all year; Monday-Friday, 9-6; Saturday, 11-6; Sunday, 12-5. Located in Soho; 6,500 sq. ft.; spacious loft. 100% of space for gallery artists. Clientele: tourists, private collectors, locals. 100% private collectors. Overall price range: $500-30,000; most work sold at $3,500-8,000.

Media: Considers oil and acrylic (on canvas).

Style: Exhibits impressionism, photorealism, realism and imagism. Prefers landscapes, still lifes, figurative work.

Terms: Gallery provides insurance, promotion and contract; artist pays shipping costs to and from gallery. Prefers artwork unframed.

Submissions: Send query letter with slides, photographs and SASE. Write for appointment to show portfolio of photographs, slides and transparencies. Replies in 2-4 weeks.

Tips: Finds artists through artists' submissions.

GALLERY 10, 7 Greenwich Ave., New York NY 10014. (212)206-1058. Director: Marcia Lee Smith. Retail gallery. Estab. 1972. Open all year. Represents approximately 150 emerging and established artists. Clientele: 100% private collectors. Overall price range: $24-1,000; most work sold at $50-300.

Media: Considers ceramic, craft, glass, wood, metal and jewelry.

Style: "The gallery specializes in contemporary American crafts."

Terms: Accepts work on consignment (50% commission); or buys outright for 50% of retail price (net 30 days). Retail price set by gallery and artist.

Submissions: Call or write for appointment to show portfolio of originals, slides, transparencies or photographs.

‡THE GRAPHIC EYE GALLERY of Long Island, 301 Main St., Port Washington NY 11050. (516)883-9668. President: Myrna Turtletaub. Cooperative gallery. Estab. 1974. Represents 25 artists. Sponsors solo, 2- and 3-person and 4 group shows/year. Average display time: 1 month. Interested in emerging and established artists. Overall price range: $35-7,500; most artwork sold at $500-800.

Media: Considers mixed media, collage, works on paper, pastels, photography, paint on paper, woodcuts, wood engravings, linocuts, engravings, mezzotints, etchings, lithographs, serigraphs, and monoprints.

Style: Exhibits impressionism, expressionism, realism, primitivism and painterly abstraction. Considers all genres.

Terms: Co-op membership fee plus donation of time. Retail price set by artist. Offers payment by installments. Exclusive area representation not required. Prefers framed artwork.

Submissions: Send query letter with résumé, SASE, slides and bio. Portfolio should include originals and slides. "When submitting a portfolio, the artist should have a body of work, not a 'little of this, little of that.' " Files historical material.

Tips: Finds artists through visiting exhibitions, word of mouth, artist's submissions and self-promotions. "Artists must produce their *own* work and be actively involved. We have a competitive juried art exhibit annually. Open to all artists who work on paper."

‡GUILD HALL MUSEUM, 158 Main St., East Hampton NY 11937. (516)324-0806. Fax: (516)324-2722. Curator: Christina Mossaiddes Strassfield. Museum. Estab. 1931. Represents emerging, mid-career and established artists. Sponsors 6-10 shows/year. Average display time 6-8 weeks. Open all year; Wednesday-Sunday, 11-5. 500 running feet; features artists who live and work on Eastern Long Island. 85% of space for special exhibitions.

Media: Considers all media and all types of prints. Most frequently exhibits painting, prints and sculpture.
Style: Exhibits all styles, all genres.
Terms: Artwork is donated or purchased. Gallery provides insurance and promotion. Prefers artwork framed.
Submissions: Accepts only artists from Eastern Long Island. Send query letter with résumé, slides, bio, brochure, SASE and reviews. Write for appointment to show portfolio of originals and slides. Replies in 2 months.

O.K. HARRIS WORKS OF ART, 383 W. Broadway, New York NY 10012. Director: Ivan C. Karp. Commercial exhibition gallery. Estab. 1969. Represents 55 emerging, mid-career and established artists. Sponsors 40 solo shows/year. Average display time 3 weeks. Open fall, winter, spring and early summer. "Four separate galleries for 4 separate one-person exhibitions. The back room features selected gallery artists which also change each month." Clientele: 80% private collectors, 20% corporate clients. Overall price range: $50-250,000; most work sold at $12,500-100,000.
Media: Considers all media. Most frequently exhibits painting, sculpture and photography.
Style: Exhibits realism, photorealism, minimalism, abstraction, conceptualism, photography and collectibles. Genres include landscapes, Americana but little figurative work. "The gallery's main concern is to show the most significant artwork of our time. In its choice of works to exhibit, it demonstrates no prejudice as to style or materials employed. Its criteria demands originality of concept and maturity of technique. It believes that its exhibitions over the years have proven the soundness of its judgment in identifying important artists and its pertinent contribution to the visual arts culture."
Terms: Accepts work on consignment (50% commission). Retail price set by gallery. Customer discounts and payment by installment are available. Exclusive area representation required. Gallery provides insurance and limited promotion. Prefers artwork ready to exhibit.
Submissions: Send query letter with slides "labeled with size, medium, top, etc." and SASE. Replies in 1 week.
Tips: "We strongly suggest the artist be familiar with the gallery's exhibitions, and the kind of work we prefer to show. Always include SASE." Common mistakes artists make in presenting their work are "poor quality and unmarked photos (size, material, etc.), submissions without return envelope, utterly inappropriate work. We affiliate about one out of 10,000 applicants."

‡PAT HEARN GALLERY, 39 Wooster St., New York NY 10013. (212)941-7055. Fax: (212)941-7046. Retail gallery. Estab. 1983. Represents 8-10 emerging, mid-career and established artists/year. Exhibited artists include Mary Hellman, Renée Green. Sponsors 7 shows/year. Average display time 5-6 weeks. Open all year; Tuesday-Saturday, 10-6. Located downtown Soho; 1,500 sq. ft.; natural light, clean uninterrupted space. Generally 100% of space for gallery artists. Clientele: all types. 95% private collectors, 5% corporate collectors. Overall price range: $1,000-40,000; most work sold at $6,000-18,000.
Media: Considers all media including video and all types of prints.
Style: Exhibits expressionism, conceptualism, minimalism, color field, postmodern works and video, text, all genres.
Terms: Accepts work on consignment (50% commission). Retail price set by the gallery and the artist. Gallery provides promotion; shipping costs are shared ("this varies").
Submissions: Send query letter with slides and SASE. Portfolio should include slides. Replies in 1-2 months. Files bio only if interested.
Tips: Finds artists through visiting exhibitions, word of mouth.

‡HILLWOOD ART MUSEUM, Long Island University, C.W. Post Campus, Brookville NY 11548. (516)299-2788. Director: Judy Collischan. Deputy Director: Margaret D. Kerswill. Nonprofit gallery. Estab. 1974. Clientele: Long Island residents and university students. Interested in seeing the work of emerging and mid-career artists. Sponsors 1-2 solo and 6-7 group shows/year. Average display time is 6 weeks. Open Monday-Friday 10-5; Sunday 1-5 during semester, if staff available. Located on the north shore of Long Island. 360 running wall ft. Clientele: student population, local and metropolitan residents. "We prefer metropolitan area artists because of transportation costs." Overall price range: $2,000-80,000.
Media: Considers all media. Most frequently exhibits paintings, installation and sculpture.
Style: Exhibits all styles. "Our gallery specializes in work representing the original ideas of artists dedicated to perceiving their world and experiences in a unique and individual manner. Interested in seeing risk-taking, provocative work."
Terms: Accepts work "in the context of invitational/exhibition." If work is sold there is 25% commission. Retail price is set by artist. Gallery provides insurance, promotion and contract; shipping costs are shared.
Submissions: Send query letter, résumé, bio, reviews and slides. Write for appointment to show portfolio. Portfolio should include slides. Replies only if interested in 6 weeks. Selected slides and résumés are filed.
Tips: Finds new artists through visiting exhibitions.

‡HUBERT GALLERY, 1046 Madison Ave., New York NY 10021. Director: Chris Neptune. Retail gallery. Estab. 1988. Represents 5 established living artists/year. Exhibited artists include Matisse, Picasso. Sponsors 5 shows/year. Average display time 1 month. Open all year; Tuesday-Saturday, 11-6. Located uptown; 300 sq.

ft.; smallest gallery in New York. 10% of space for special exhibitions. Clientele: "sophisticated, international collectors." 100% private collectors. Overall price range: $850-95,000; most work sold at $2,000-10,000.
Media: Considers oil, paper, all types of prints. Most frequently exhibits graphics (etchings, aquatint, lithography, silkscreen), drawings and oils.
Style: Exhibits postmodern works and realism. Genres include landscapes. Prefers realism (still life) and landscapes.
Terms: Accepts work on consignment (50% commission). Retail price set by the gallery. Gallery provides insurance; artist pays shipping costs to and from gallery. Prefers artwork framed.
Submissions: Accepts only artists from New York. Send query letter with résumé, slides and bio. Write for appointment to show portfolio of originals and photographs. Replies only if interested within 2 weeks.
Tips: Finds artists through visiting exhibitions, word of mouth.

‡**IMAGES**, 580 Broadway, New York NY 10012. (212)219-8484. Fax: (212)219-9144. Gallery Director: Kati Neiheisel. Retail gallery, art consultancy. Estab. 1993. Represents 10 mid-career and established artists/year. Exhibited artists include George Anthonisen, Yale Epstein. Sponsors 5 shows/year. Average display time 6 weeks. Open all year; Monday-Saturday, 12-5. Located in Soho, gallery district; 1,200 sq. ft.; in historic landmark building. 50% of space for special exhibitions; 50% of space for gallery artists. Clientele: corporate, institutional, retail. 5% private collectors, 95% corporate collectors. Overall price range: $2,000-20,000.
Media: Considers all media except installation and photography, all types of prints. Most frequently exhibits oil painting, lithograph/serigraph, sculpture/tapestry.
Style: Exhibits painterly abstraction, impressionism, photorealism and realism. Genres include landscapes, florals, Americana and figurative work. Prefers color realism, expressionist landscape and figurative sculpture.
Terms: Accepts work on consignment (50% commission). Retail price set by the artist. Gallery provides insurance, promotion and contract; artist pays shipping costs to and from gallery. Prefers artwork unframed.
Submissions: Send query letter with résumé, slides, ("2-3 slides for our permanent file, not to be returned"), brochure and business card. Replies only if interested within 2 months. Files slides, résumés.

JADITE GALLERIES, 415 W. 50th St., New York NY 10019. (212)315-2740. Director: Roland Sainz. Retail gallery. Estab. 1985. Represents 25 emerging and established, national and international artists. Sponsors 10 solo and 2 group shows/year. Average display time 2 weeks. Clientele: 80% private collectors, 20% corporate clients. Overall price range: $500-8,000; most artwork sold at $1,000-3,000.
 • This gallery is affiliated with the Jadite Annex, 413 W. 50th St., New York NY 10019. (212)315-2740. The Annex holds many group exhibitions and offers antique furniture for sale.
Media: Considers oil, acrylic, watercolor, pastel, pen & ink, drawings, mixed media, collage, sculpture and original handpulled prints. Most frequently exhibits oils, acrylics, pastels and sculpture.
Style: Exhibits minimalism, postmodern works, impressionism, neo-expressionism, realism and surrealism. Genres include landscapes, florals, portraits, Western collages and figurative work. Features "national and international emerging artists dealing with contemporary works."
Terms: Accepts work on consignment (40% commission). Retail price set by gallery and artist. Exclusive area representation not required. Gallery provides insurance, promotion and contract; exhibition costs are shared.
Submissions: Send query letter, résumé, brochure, slides, photographs and SASE. Call or write for appointment to show portfolio of originals, slides or photos. Resume, photographs or slides are filed.

‡**KOUROS**, 23 E. 73rd St., New York NY 10021. (212)288-5888. Fax: (212)794-9397. Contact: James Fox. Retail gallery. Represents 15 emerging, mid-career and established artists/year. Exhibited artists include Bruno Romeda, Poul Roussotto. Sponsors 12 shows/year. Average display time 1 month. Open all year; 10-6. Located uptown; 3,500 sq. ft. 75% of space for gallery artists. 80% private collectors, 10% corporate collectors.
Media: Consider oil, acrylic, watercolor, pastel, pen & ink, mixed media, collage, paper and sculpture. Most frequently exhibits oil and sculpture.
Style: Exhibits expressionism, neo-expressionism, painterly abstraction, color field, postmodern works and impressionism.
Terms: Accepts work on consignment (50% commission). Retail price set by the gallery and the artist. Gallery provides insurance and contract; artist pays shipping costs to and from gallery. Prefers artwork framed "or the artist's preference."
Submissions: Send query letter with résumé, slides, brochure, photographs and reviews. Portfolio should include photographs, slides and transparencies. Replies only if interested within 1 month.

LA MAMA LA GALLERIA, 6 E. First St., New York NY 10003. (212)505-2476. Director: Lawry Smith. Nonprofit gallery. Estab. 1981. Exhibits the work of emerging, mid-career and established artists. Sponsors 14 shows/year. Average display time 3 weeks. Open September-June. Located in East Village; 2,500 sq. ft.; "very large and versatile space." 100% of space for special exhibitions. Clientele: 20% private collectors, 20% corporate clients. Overall price range: $1,000-5,000; most work sold at $1,000.

Media: Considers oil, acrylic, watercolor, pastel, pen & ink, drawings, mixed media, collage, sculpture, ceramic, craft, installation, photography, original handpulled prints, woodcuts, engraving and lithograph. Most frequently exhibits oil, installation and collage. "No performance art."

Style: Exhibits expressionism, neo-expressionism, primitivism, painterly abstraction, imagism, conceptualism, minimalism, postmodern works, impressionism, photorealism and hard-edge geometric abstraction.

Terms: Accepts work on consignment (20% commission). Retail price set by gallery. Gallery provides promotion; artist pays for shipping or shipping costs are shared. Prefers artwork framed.

Submissions: Send query letter with résumé, slides and bio. Write for appointment to show portfolio of originals, slides, photographs or transparencies. Replies in 6 weeks. Files slides and résumés.

Tips: Make sure to "include résumé and artist's statement and label slides (size, medium, etc)."

‡**STUART LEVY FINE ARTS**, Suite 303, 588 Broadway, New York NY 10012. (212)941-0009. Fax: (212)941-7987. Retail gallery. Represents emerging, mid-career and established artists. Exhibited artists include Osmo Rauhula, Miro Svolik. Sponsors 6-8 shows/year. Average display time 2 months. Open all year; 10-6 daily. Located downtown; 3,000 sq. ft.

Media: Considers all media, all types of prints.

Style: Exhibits neo-expressionism, primitivism, surrealism and conceptualism. Genres include landscapes.

Terms: Accepts work on consignment (50% commission). Retail price set by the gallery and the artist. Gallery provides insurance, promotion and shipping costs to gallery.

Submissions: Send query letter with résumé, slides, bio and reviews. Write for appointment to show portfolio of photographs, slides, transparencies, bio, press clippings. Replies in 2 weeks. Files "slides and bios we're interested in."

Tips: Finds artists through recommendations, artists' submissions, etc.

‡**LIMNER GALLERY**, 598 Broadway, New York NY 10012. (212)431-1190. Fax: (212)334-8268. Director: Tim Slowinski. "Limner is an artist-owned alternative gallery that combines elements of the retail (consignment) gallery with cooperative, rental gallery in its operational plan." Estab. 1987. Represents 7 emerging and mid-career (permanent) artists; additional artists shown on a rotational basis. Exhibited artists include Slowinski, Eagle, O'Neill. Sponsors 12-13 shows/year. Average display time 3-4 weeks. Open Tuesday-Saturday, 11-6. Closed July 15-August 30. Located in Soho; 1,600 sq. ft.; in a historic landmark cast iron building. 60-80% of space for special exhibitions; 20-40% of space for gallery artists. Clientele: lawyers, real estate developers, doctors, architects. 85% private collectors, 15% corporate collectors. Overall price range: $300-16,000; most work sold at $300-5,000.

Media: Considers all media, all types of prints except posters. Most frequently exhibits painting, sculpture and works on paper.

Style: Exhibits primitivism, surrealism, all styles, postmodern works, all genres. "Gallery exhibits all styles but emphasis is on non-traditional figurative work."

Terms: Accepts work on consignment (50% commission) or buys outright for 50% of retail price (net 15 days). Co-op membership fee plus a donation of time. Rental fee for space per exhibition. Retail price set by the gallery and the artist. Gallery provides promotion and contract; artist pays shipping costs to and from gallery. Prefers artwork framed.

Submissions: Send query letter with résumé, slides, bio and SASE. Call for appointment to show portfolio of originals, photographs, slides and transparencies. Replies in 2-3 weeks. Files slides, résumé.

Tips: Finds artists through word of mouth, art publications and sourcebooks, artists' submissions.

‡**LOFT 101 SOHO INTERNATIONAL PRODUCTION GROUP**, #4, 492 Broome St., New York NY 10013. Phone/Fax: (212)343-2128. Senior Associate: Donna Austin. Cooperative gallery. Estab. 1991. Represents 6 emerging and mid-career artists/year. Exhibited artists include Michael Ricardo, Erik Nissen Johan. Sponsors 5 shows/year. Average display time 3 weeks. Open all year; Tuesday-Saturday, 12-6. Located in Soho; 1,300 sq. ft.; features a small lounge or sitting area used to view artist videos and read original artists' publications. 20% of space for special exhibitions; 80% of space for gallery artists. Clientele: young, north shore Long Islanders. 80% private collectors, 5% corporate collectors. Overall price range: $900-18,000; most work sold at $7,000.

Media: Considers oil, acrylic, watercolor, pen & ink, drawing, mixed media, collage, installation, lithograph and serigraphs. Most frequently exhibits mixed media, acrylic, installation.

 The double dagger before a listing indicates that the listing is new in this edition. New markets are often more receptive to freelance submissions.

Style: Exhibits primitivism, surrealism and conceptualism.
Terms: Accepts work on consignment (50% commission). Co-op membership fee plus donation of time (35% commission). Retail price set by the artist. Gallery provides insurance, promotion and contract; shipping costs are shared. Prefers artwork framed.
Submissions: Send query letter with bio, brochure and reviews. Call or write for appointment to show portfolio of photographs. Replies in 3 weeks. Files photographs.
Tips: "We visit exhibitions in and around New York. We also travel to California and Chicago. Our international affiliates introduce us to artists overseas."

THE JOE & EMILY LOWE ART GALLERY AT HUDSON GUILD, (formerly Hudson Guild Art Gallery), 441 W. 26th St., New York NY 10001. (212)760-9812. Director: Haim Mendelson. Contact: Durriyya Abdullah. Nonprofit gallery. Estab. 1948. Represents emerging, mid-career and established artists. Sponsors 8 shows/year. Average display time 1 month. Open October-June. Located in West Chelsea; 1,200 sq. ft.; a community center gallery in a New York City neighborhood. 100% of space for special exhibitions. Clientele: 100% private collectors.
Media: Considers oil, acrylic, watercolor, pastel, pen & ink, drawings, mixed media, collage, paper, sculpture, original handpulled prints, woodcuts, wood engravings, linocuts, engravings, mezzotints, etchings, lithographs, pochoir and serigraphs. Most frequently exhibits paintings, sculpture and graphics.
Style: Exhibits all styles and genres.
Terms: Accepts work on consignment (20% commission). Retail price set by artist. Sometimes offers payment by installments. Gallery provides insurance; artist pays for shipping. Prefers artwork framed.
Submissions: Send query letter, résumé, slides, bio and SASE. Portfolio should include photographs and slides. Replies in 1 month.
Tips: Finds artists through visiting exhibitions, word of mouth, various art publications and sourcebooks, artists' submissions/self-promotions, art collectors' referrals.

‡MALLET FINE ART LTD., 141 Prince St., New York NY 10012. (212)477-8291. Fax: (212)673-1051. President: Jacques Mallet. Retail gallery, art consultancy. Estab. 1982. Represents 3 emerging and established artists/year. Exhibited artists include Sonntag, Ouattara. Sponsors 1 show/year. Average display time 3 months. Open fall and spring; Tuesday-Saturday, 11-6. Located in Soho; 2,000 sq. ft. 50% of space for special exhibitions; 50% of space for gallery artists. Clientele: private and art dealers, museums. 80% private collectors. Overall price range: $2,000-5,000,000; most work sold at $40,000-400,000.
Media: Considers oil, acrylic, watercolor, pastel, pen & ink, drawing, mixed media, collage, paper, sculpture, engraving, lithograph and etching. Most frequently exhibits oil, works on paper and sculpture.
Style: Exhibits expressionism, surrealism and impressionism.
Terms: Accepts work on consignment (20% commission) or buys outright for 50% of retail price (net 30 days). Retail price set by the gallery. Gallery provides insurance and contract; shipping costs are shared. Prefers artwork framed.
Submissions: Accepts only artists from America and Europe. Send query letter with résumé, slides, bio, photographs and SASE. Write for appointment to show portfolio of transparencies. Replies in 3 weeks.
Tips: Finds artists through word of mouth.

JAIN MARUNOUCHT GALLERY, 560 Broadway, New York NY 10012. (212)274-8087. Fax: (212)274-8284. President: Ashok Jain. Retail gallery. Estab. 1991. Represents 30 emerging artists. Exhibited artists include Fernando Pamalaza and Pauline Gagnon. Sponsors 10 shows/year. Average display time 3 weeks. Open all year; Tuesday-Saturday 11-6. Located in downtown Soho across from new Guggenheim; 3,200 sq. ft. 80% of space for special exhibitions; 20% of space for gallery artists. Clientele: corporate and designer. 50% private collectors, 50% corporate collectors. Overall price range: $1,000-20,000; most work sold at $5,000-10,000.
Media: Considers oil, acrylic and mixed media. Most frequently exhibits oil, acrylic and collage.
Style: Exhibits painterly abstraction. Prefers abstract only.
Terms: Accepts work on consignment (50% commission). Retail price set by artist. Offers customer discount. Gallery provides contract; artist pays for shipping costs. Prefers artwork framed.
Submissions: Send query letter with résumé, brochure, slides, reviews and SASE. Portfolio review requested if interested in artist's work. Portfolio should include originals, photographs, slides, transparencies and reviews. Replies in 1 week.
Tips: Finds artists through referrals and promotions.

NORTHPORT/BJ SPOKE GALLERY, 299 Main St., Huntington NY 11743. (516)549-5106. President: Bernice Taplitz. Membership Director: Rita Calumet. Cooperative and nonprofit gallery. Estab. 1978. Exhibits the work of 22 emerging, mid-career and established artists. Exhibited artists include Betty Cranendonk and Irwin Traugot. Sponsors 2-3 shows/year. Average display time 1 month. Open all year. "Located in center of town; 1,400 sq. ft.; flexible use of space—3 separate gallery spaces." Generally, 66% of space for special exhibitions. Overall price range: $300-2,500; most work sold at $900-1,600. Artist is eligible for a 2-person show every 18 months. Entire membership has ability to exhibit work 11 months of the year.
• Sponsors annual juried show. Deadline December. Send SASE for prospectives.

Media: Considers all media except crafts, all types of printmaking. Most frequently exhibits paintings, prints and sculpture.
Style: Exhibits all styles and genres. Prefers painterly abstraction, realism and expressionism.
Terms: Co-op membership fee plus donation of time (25% commission). Monthly fee covers rent, other gallery expenses. Retail price set by artist. Customer discounts and payment by installment are available. Gallery provides promotion and publicity; artists pay for shipping. Prefers artwork framed; large format artwork can be tacked.
Submissions: For membership, send query letter with résumé, high-quality slides, bio, SASE and reviews. For national juried show send SASE for prospectus and deadline. Call or write for appointment to show a portfolio of originals and slides. Files résumés; may retain slides for awhile if needed for upcoming exhibition.
Tips: "Send slides that represent depth and breadth in the exploration of a theme, subject or concept. They should represent a cohesive body of work."

OWL 57 GALLERIES, 1074 Broadway, Woodmere NY 11598. (516)374-5707. Fax: (516)374-5757. Director: Craig Michel. Retail gallery. Estab. 1970. Represents 50 emerging, mid-career and established artists. Exhibited artists include Secunda and Zacharias. Sponsors 4 shows/year. Average display time 1 month. Open all year. Located in the business district; 1,600 sq. ft. 60% of space for special exhibitions. Clientele: diverse. 80% private collectors, 20% corporate collectors. Overall price range: $500-100,000; most work sold at $1,500-5,000.
Media: Considers oil, acrylic, watercolor, pastel, pen & ink, drawings, mixed media, collage, paper, sculpture, ceramic, craft, fiber, glass and all types of prints. Most frequently exhibits canvases and limited edition prints.
Style: Exhibits diverse range of styles and genres.
Terms: Retail price set by gallery. Shipping costs are shared. Prefers artwork framed.
Submissions: Send query letter with résumé, slides, bio and SASE. Call or write for appointment to show portfolio of originals, photographs and slides. Does not reply. Artist should follow up. Files slides and bios.

‡EVA J. PAPE, 6E, 235 E. 57th St., New York NY 10022. (212)980-1886. Fax: (212)223-2878. Director: Eva J. Pape. Art consultancy working closely with museums and other galleries. Estab. 1976. Represents 12 established artists/year. May be interested in seeing the work of emerging artists in the future. Exhibited artists include Sigmund Menkes Stajewski. Sponsors 3-4 shows/year. Average display time 1 month. Open all year; 10-5. Located in midtown area. Overall price range: $5,000-25,000.
Media: Considers oil, drawing and Polish posters.
Style: Exhibits all styles.
Terms: Retail price set by the artist. Gallery provides promotion and contract; artist pays shipping costs to and from gallery. Prefers artwork framed.
Submissions: Send query letter with SASE. Portfolio should include transparencies.

‡PETZEL/BORGMANN GALLERY, #5A, 591 Broadway, New York NY 10012. (212)334-9466. Fax: (212)219-2027. Contact: Borgmann or Petzel. Retail gallery and office for organization of art events. Estab. 1993. Represents 7 emerging artists/year. Exhibited artists include Paul Nyoda, Keith Edmier, Jorge Pardo. Sponsors 9-10 shows/year. Average display time 1 month. Open September-July; Tuesday-Saturday, 11-6. Located in Soho; 800 sq. ft. 100% of space for gallery artists. 80% private collectors, 20% corporate collectors. Overall price range: $1,000-8,000; most work sold at $4,000.
Media: Considers all media. Most frequently exhibits mixed media.
Terms: Accepts work on assignment (50% commission). Retail price set by the gallery and the artist. Gallery provides promotion, contract and shipping costs to and from gallery. Prefers artwork framed.
Submissions: Send query letter with résumé, slides, bio and reviews. Call for appointment to show portfolio of photographs, slides and transparencies. Replies in 2-3 weeks. Files "only material we are interested in."
Tips: Finds artists through various art publications, word of mouth and studio visits.

THE PHOENIX GALLERY, Suite 607, 568 Broadway, New York NY 10012. (212)226-8711. Director: Linda Handler. Nonprofit gallery. Estab. 1958. Exhibits the work of 32 emerging, mid-career and established artists. 32 members. Exhibited artists include Barbara Londin and Betty Mcgeehan. Sponsors 10-12 shows/year. Average display time 1 month. Open fall, winter and spring. Located in Soho; 180 linear ft.; "We are in a landmark building in Soho, the oldest co-op in New York. We have a movable wall which can divide the gallery into two large spaces." 100% of space for special exhibitions. Clientele: 75% private collectors, 25% corporate clients, also art consultants. Overall price range: $50-20,000; most work sold at $300-10,000.
Media: Considers oil, acrylic, watercolor, pastel, pen & ink, drawings, mixed media, collage, works on paper, sculpture, ceramic, photography, original handpulled prints, woodcuts, engravings, wood engravings, linocuts and etchings. Most frequently exhibits oil, acrylic and watercolor.
Style: Exhibits painterly abstraction, minimalism, realism, photorealism, hard-edge geometric abstraction and all styles. Prefers painterly abstraction, hard-edge geometric abstraction and sculpture.
Terms: Co-op membership fee plus donation of time (25% commission). Retail price set by gallery. Offers customer discounts and payment by installment. Gallery provides insurance, promotion and contract; artist pays for shipping. Prefers artwork framed.

Submissions: Send query letter with résumé, slides and SASE. Call for appointment to show portfolio of slides. Replies in 1 month. Only files material of accepted artists. The most common mistakes artists make in presenting their work are "incomplete résumés, unlabeled slides and an application that is not filled out properly."

Tips: "We find new artists by advertising in art magazines and art newspapers, word of mouth, and inviting artists from our juried competition to be reviewed for membership. Come and see the gallery—meet the director. The New York gallery scene is changing. Many galleries in the Soho area have once again moved to less expensive space further downtown."

‡PRINTED MATTER BOOKSTORE AT DIA, 77 Wooster St., New York NY 10012. (212)925-0325. Fax: (212)925-0464. Director: David Dean. Nonprofit distributor and retailer of artists' books. Estab. 1976. Clientele: international. Represents 2,500 artists. Interested in emerging and established artists. Overall price range: 50 cents-$3,500; most artwork sold at $20.

Media: Considers only artwork in book form in multiple editions.

Terms: Accepts work on consignment (50% commission). Retail price is set by artist. Exclusive area representation not required. Gallery provides promotion and contract; artist pays for shipping.

Submissions: Send query letter and review copy of book. Portfolio review requested if interested in artist's work.

Tips: Finds artists through visiting exhibitions, word of mouth and artists' submissions.

THE REECE GALLERIES, INC., 24 W. 57th St., New York NY 10019. (212)333-5830. Fax: (212)333-7366. President: Shirley Reece. Retail and wholesale gallery and art consultancy. Estab. 1974. Represents 40 emerging and mid-career artists. Exhibited artists include Tsugio Hattori and Sica. Sponsors 5-6 shows/year. Average display time 1 month. Open all year. Located in midtown; 1,500 sq. ft.; gallery is broken up into 3 show areas. 90% of space for special exhibitions. Clientele: corporate, private, architects and consultants. 50% private collectors, 50% corporate collectors. Overall price range: $300-30,000; most work sold at $1,000-15,000.

Media: Considers oil, acrylic, watercolor, pastel, mixed media, collage, paper, original handpulled prints, engravings, mezzotints, etchings, lithographs, pochoir and serigraphs.

Style: Exhibits expressionism, painterly abstraction, color field and impressionism.

Terms: Accepts work on consignment (50% commission). Retail price set by gallery and artist. Gallery provides insurance; artist pays for shipping. Prefers artwork unframed.

Submissions: Prefers only work on canvas and prints. Send query letter with résumé, slides, bio, SASE and prices. Call or write for appointment to show portfolio of slides and photographs with sizes and prices. Replies in 2 weeks.

Tips: "A visit to the gallery (when possible) to view what we show would be helpful for you in presenting your work—to make sure the work is compatible with our aesthetics."

‡ST. LIFER ART EXCHANGE, INC., #21E, 3 Hanover Square, New York NY 10004. (212)825-2059. Fax: (212)825-2582. Director: Jane St. Lifer. Art consultancy and fine art brokers and appraisers. Estab. 1988. Represents established artists. May be interested in seeing the work of emerging artists in the future. Exhibited artists include Miro, Picasso. Open all year by appointment. Located in the Wall Street area. Clientele: national and international contacts. 50% private collectors, 50% corporate collectors. Overall price range: $300-3,000.

Media: Considers oil, acrylic, watercolor, pastel, pen & ink, drawing, woodcut, engraving, lithograph, wood engraving, mezzotint, serigraphs, linocut, etching, posters (original).

Style: Exhibits postmodern works, impressionism and realism. Considers all genres.

Terms: Accepts work on consignment or buys outright. Retail price set by the gallery. Gallery pays shipping costs from gallery; artist pays shipping costs to gallery. Prefers artwork framed.

Submissions: Send query letter with résumé, bio, photographs, SASE and business card. Portfolio should include photographs. Replies in 3-4 weeks. Files résumé, bio.

‡SCULPTORS GUILD, INC., Suite 305, 110 Greene St., New York NY 10012. Phone/Fax: (212)431-5669. President: Barry Parker. Nonprofit gallery. Estab. 1937—office exhibit space; 1993—53 Mercer exhibit spaces. Represents 110 emerging, mid-career and established artists/year. 110 members. Exhibited artists include Dorothy Dehner, Clement Meadmore. Sponsors 5 shows/year. Average display time 1 month. Open all year; Tuesday-Friday 10-5. Located in Soho; office space—700 sq. ft.; 53 Mercer Galleries—548 sq. ft. each; all kinds of sculpture. 100% of space for gallery artists. Clientele: private and corporate collectors. 50% private collectors, 50% corporate collectors. Overall price range: $1,500-40,000; most work sold at $3,000-6,000.

Media: Considers mixed media, sculpture, ceramics, fiber and glass. Most frequently exhibits metal, stone and wood.

Style: Exhibits all styles, all genres.
Terms: Accepts work on consignment (20% commission). Membership fee plus donation of time (20% commission) "We are not a co-op gallery, but an organization with dues-paying members." Retail price set by the artist. Gallery provides promotion; shipping costs are shared.
Submissions: Sculptors only. Send query letter with résumé, slides and SASE. "Once a year we have a portfolio review." Call for application form. Portfolio should include photographs and slides. Replies in 2-3 weeks. Files "information regarding our members."

‡**SCULPTURE CENTER GALLERY**, 167 E. 69th St., New York NY 10021. (212)879-3500. Fax: (212)879-7155. Gallery Director: Marian Griffiths. Alternative space, nonprofit gallery. Estab. 1928. Exhibits emerging and mid-career artists. Sponsors 8-10 shows/year. Average display time 3-4 weeks. Open September-June; Tuesday-Saturday, 11-5. Located upper East side, Manhattan; main gallery, 1,100 sq. ft.; gallery 2,104 sq. ft.; old carriage house with 14 ft. ceilings; 6×3×3 ft. alcove for installations devoted to AIDS. 85% of space for gallery artists. 90% private collectors, 10% corporate collectors. Overall price range: $100-100,000; most work sold at $200-3,000.
Media: Considers drawing, mixed media, sculpture and installation. Most frequently exhibits sculpture, installations and video installations.
Terms: Accepts work on consignment (25% commission). Retail price set by the gallery and the artist. Gallery provides promotion; artist pays shipping costs.
Submissions: Send query letter with résumé, slides and bio. Call for appointment to show portfolio of photographs, slides and transparencies. Replies in 2 months. Files bios, slides.
Tips: Finds artists through artists' and curator's submissions (mostly) and word of mouth.

NATHAN SILBERBERG FINE ARTS, Suite 7-G, 301 E. 63rd St., New York NY 10021. (212)752-6160. Owner: N. Silberberg. Retail and wholesale gallery. Estab. 1973. Represents 10 emerging and established artists. Exhibited artists include Joan Miro, Henry Moore and Nadezda Vitorovic. Sponsors 4 shows/year. Average display time 1 month. Open March-July. 2,000 sq. ft. 75% of space for special exhibitions. Overall price range: up to $50,000; most work sold at $4,000.
Media: Considers oil, acrylic, watercolor, original handpulled prints, lithographs, pochoir, serigraphs and etchings.
Style: Exhibits surrealism and conceptualism. Interested in seeing abstract work.
Terms: Accepts work on consignment (40-60% commission). Retail price set by gallery. Sometimes offers customer discounts. Gallery provides insurance and promotion; shipping costs are shared. Prefers framed artwork.
Submissions: Send query letter with résumé, slides and SASE. Write for appointment to show portfolio of originals, slides and transparencies. Replies in 1 month.
Tips: Finds artists through visiting art schools and studios. "First see my gallery and the artwork we show."

‡**STATEN ISLAND INSTITUTE OF ARTS AND SCIENCES**, 75 Stuyvesant Place, Staten Island NY 10301. (718)727-1135. Fax: (718)273-5683. Vice President: Carol Giuriceo. Museum. Estab. 1881. Represents emerging, mid-career and established artists. "The Museum has biennial juried exhibitions in art and craft." Exhibited artists include Gregory Perillo, Bill Murphy. Sponsors 9 shows/year (in the areas of art, natural science and local history). Average display time 2 months. Open all year; Monday-Saturday, 9-5; Sunday, 1-5. Located in St. George, Staten Island (5 minute walk from the Staten Island Ferry). 3 galleries. Clientele: the general public, school children.
Media: Considers all media. Most frequently exhibits oil, watercolors and photography.
Terms: Retail price set by the artist. Gallery provides insurance and promotion. Prefers artwork framed.

‡**CARLA STELLWEG LATIN AMERICAN & CONTEMPORARY ART**, 87 E. Houston St., New York NY 10012. (212)431-5556. Fax: (212)274-9306. Director: R. Welch. Retail gallery. Estab. 1989. Represents 12 emerging and mid-career artists/year. Exhibited artists include Kukuli Velarde, Jaime Palacios. Sponsors 7 shows/year. Average display time 2 months. Open September-May (or June); Tuesday-Saturday, 11-6. Located in Soho; 2,000 sq. ft.; specializes in Latino/Latin American art. 90% of space for special exhibitions; 90% of space for gallery artists. Clientele: European, American, Latin. 80% private collectors, 20% corporate collectors. Overall price range: $1,000-18,000; most work sold at $3,000-5,000.
Media: Considers oil, acrylic, watercolor, pastel, pen & ink, drawing, mixed media, collage, paper, sculpture, ceramics, installation, photography, woodcut, engraving, lithograph, mezzotint, serigraphs and etching.
Style: Exhibits ritual/figuration.
Terms: Accepts work on consignment (50% commission). Retail price set by the gallery and the artist. Gallery provides insurance, promotion and shipping costs from gallery; artists pays shipping costs to gallery. Prefers artwork framed.
Submissions: Send query letter with résumé, slides and SASE. Write for appointment to show portfolio of slides, catalog, SASE and bio. Replies in 2 weeks.
Tips: Finds artists through other artists, curators, travel-viewing. "We are not looking at new work now since we are in the process of moving and already have a full schedule planned."

‡**THE STUDIO MUSEUM IN HARLEM,** 144 W. 125th St., New York NY 10027. (212)864-4500. Fax: (212)666-5753. Associate Curator: Valerie Mercer. Museum. Estab. 1967. Represents emerging, mid-career and established artists. Exhibited artists include Romare Bearden, Sam Gilliam. Open all year; Wednesday-Friday, 10-5; Saturday, Sunday, 1-6. Located uptown, Harlem; 5,500 sq. ft.; artists' studios, museum shop, sculpture garden. 66-100% of space for special exhibitions; 33% of space for gallery artists. Clientele: individuals interested in collecting, viewing, supporting works by African-American, African and Caribbean artists.
Media: Considers all media, all types of prints. Most frequently exhibits painting, sculpture and installation/multimedia.
Style: Exhibits all styles, all genres.
Terms: Artwork is purchased or donated. Gallery pays shipping costs to and from gallery. Prefers artwork framed.
Submissions: Accepts only African, African-American, Caribbean. Send query letter with résumé, slides, bio, brochure, photographs, SASE, business card and reviews. Write for appointment. Artist will be contacted. Replies in 4-6 weeks. Files slides, résumé, articles, reviews.

‡**STUX GALLERY,** 163 Mercer St., New York NY 10012. (212)219-0010. Fax: (212)219-2243. Owner/Director: Stefan Stux. Retail gallery. Estab. 1980s. Represents mid-career artists. Interested in seeing the work of emerging artists. Exhibited artists include Mark Milloff, Lawrence Carroll. Sponsors 18 or less shows/year. Average display time 4-5 weeks. Open Tuesday-Saturday, 10-6; closed in August. Located in Soho; 3,600 sq. ft.; 4 distinct gallery spaces on 2 floors. 95% of space for special exhibitions. Clientele: major and new collectors. 90% private collectors, 10% corporate collectors. Overall price range: $2,000-35,000; most work sold at $2,000-16,000.
Media: Considers oil, acrylic, watercolor, pen & ink, drawing, mixed media, collage, paper, sculpture, fiber, glass, installation, photography, woodcut, engraving, wood engraving, mezzotint, serigraphs, linocut and etching. Most frequently exhibits painting, photography, sculpture, installation.
Style: Exhibits contemporary.
Terms: Retail price set by the gallery and the artist. Gallery provides insurance, promotion and contract; shipping costs are shared.
Submissions: Send query letter with résumé, slides, bio, brochure, reviews and SASE. Portfolio should include photographs, slides, transparencies. Replies in 3 months.
Tips: Finds artists through agents, visiting exhibitions, word of mouth, art publications and sourcebooks, artists' submissions.

‡**SYNCHRONICITY SPACE,** 55 Mercer St., New York NY 10013. (212)925-8645. Fax: (212)925-0258. Director: John Smith-Amato. Nonprofit gallery. Estab. 1989. Represents 12-16 emerging and established artists. Exhibited artists include Rosalyn Jacobs, John Amato. "We mount 20-25 shows, we sponsor about 40%." Average display time 2 weeks. Open all year; Tuesday-Saturday, noon-6. Located in Soho; 1,200 sq. ft.; high ceilings, "open space connects to our off-Broadway theater, ground level." 50% of space for special exhibitions; 50% of space for gallery artists. Clientele: serious collectors, new investors and art supporters. 75% private collectors, 25% corporate collectors. Overall price range: $350-6,000; most work sold at $3,000-4,000.
Media: Considers oil, acrylic, watercolor, pastel, pen & ink, drawing, mixed media, collage, paper, sculpture, ceramics, photography, woodcut, engraving, lithograph, wood engraving, mezzotint, linocut and etching. Most frequently exhibits oil, photo and sculpture.
Style: Exhibits semi-representational and semi-abstract. Considers all genres. Prefers figurative, landscapes and still life.
Terms: Accepts work on consignment (0% commission). Rental fee for space covers 2 week exhibit: $500 per artist for 2-person exhibit; $1,000 for a solo exhibit. Retail price set by the gallery and the artist. Gallery provides insurance, promotion and contract; artist pays shipping costs to and from gallery. Prefers artwork framed.
Submissions: Send query letter with résumé, photographs and 4×5 transparencies. Call "Wednesday between 12-6 p.m. I review portfolios with the artists being present (otherwise they can drop portfolios off any day 12-6)." Portfolio should include originals, photographs and transparencies. Replies in 2 weeks. "Once an artist is accepted for an exhibit we keep a file open for 3-5 years."

JOHN SZOKE GRAPHICS, INC., 164 Mercer St., New York NY 10012. (212)219-8300. Fax: (212)966-3064. President: John Szoke. Director: Susan Jaffe. Retail gallery and art publisher. Estab. 1974. Represents 30 mid-career artists. Exhibited artists include Janet Fish and Peter Milton. Open all year. Located downtown in Soho; 1,500 sq. ft.; "gallery has a skylight." 50% of space for special exhibitions. Clientele: other dealers and collectors. 20% private collectors, 20% corporate collectors. Overall price range: $1,000-22,000.
 • Gallery has recently increased exhibition space by 40%.
Media: Considers works on paper, multiples in relief and intaglio and sculpture. Most frequently exhibits prints and other multiples.
Style: Exhibits surrealism, minimalism and realism. All genres.
Terms: Buys artwork outright. Retail price set by gallery. Sometimes offers customer discounts and payment by installment. Gallery provides insurance and promotion; artist pays for shipping. Prefers unframed artwork.

Submissions: Send query letter with slides and SASE. Write for appointment to show portfolio, which should include slides. The most common mistake artists make in presenting their work is "sending material without explanation, instructions or reference to our needs." Replies in 1 week. Files all correspondence and slides unless SASE is enclosed.
Tips: Finds artists through word of mouth.

‡**TAMENAGA GALLERY,** 982 Madison Ave., New York NY 10021. (212)734-6789. Fax: (212)734-9413. Director: Partrick O'Connor. Retail gallery. Estab. 1988. Represents 9 emerging artists/year. Exhibited artists include Tom Christopher, Frank Holmes. Sponsors 4 shows/year. Average display time 1 month. Open all year; Tuesday-Saturday, 10-6. Located on Madison Avenue, between 76th & 77th Streets; approximately 3,000 sq. ft. 100% of space for gallery artists. Clientele: private collectors, corporations, tourists. 80% private collectors, 20% corporate collectors. Overall price range: $900-30,000; most work sold at $4,000-10,000.
Media: Considers oil and acrylic. Most frequently exhibits oil on canvas, acrylic on canvas and pencil on paper.
Style: Exhibits realism. Genres include landscapes and figurative work. Prefers figurative realism.
Terms: Accepts work on consignment (50% commission). Retail price set by gallery. Gallery provides insurance. Promotion costs split with artists. Gallery pays shipping costs from gallery; artist pays shipping costs to gallery. Prefers artwork framed.
Submissions: Accepts only artists from US. Prefers only oil or acrylic paintings. Send query letter with résumé, slides, bio and SASE. Call for appointment to show portfolio of photographs and slides. Replies in 2-3 weeks. Files artist's letter, résumé, bio.
Tips: Finds artists through word of mouth and visiting exhibitions, "every once in a while, by artists' submissions. Make sure you fit in with what is shown in the gallery; i.e., figurative realists."

TATYANA GALLERY, 6th Floor, 145 E. 27th St., New York NY 10016. (212)683-2387. Contact: Director. Retail gallery. Estab. 1980. Represents and exhibits work of established artists. Sponsors 2 solo and 2 group shows/year. Open all year. Clientele: 50% private collectors. Overall price range: $200-150,000; most artwork sold at $400-16,000.
Media: Considers oil, watercolor, pastel, pen & ink, drawings, mixed media and works on paper. Most frequently exhibits oil, watercolor and drawings.
Style: Exhibits impressionism and realism. Prefers landscapes, figurative work and portraits. "Our gallery specializes in Russian and Soviet realist art and impressionism."
Tips: Looking for "the best Russian realist paintings I can find in the USA."

‡**THE TEAHOUSE GALLERY AT THE NEW YORK OPEN CENTER,** 83 Spring St., New York NY 10012. (212)677-1954. Gallery Director: Valerie Constantino. Retail gallery, alternative space. Gallery is part of larger organization. Estab. 1990. Represents emerging, mid-career and established artists. "We exhibit one artist/month." Exhibited artists include Maryann Hickey, Gilah Hirsch. Sponsors 10 shows/year. Average display time 1 month. Open all year; Wednesday-Friday, 12-4; or by appointment. Located in Soho; 700 sq. ft.; part of the New York Open Center, "a holistic learning center." 100% private collectors. Overall price range: $400-6,000; most work sold at $400.
Media: Considers oil, acrylic, watercolor, pastel, pen & ink, drawing, mixed media, collage, paper, craft, fiber and photography.

‡**TENRI GALLERY,** 575 Broadway, New York NY 10012. (212)925-8500. Fax: (212)925-8501. Director: Mikio Shinagawa. Nonprofit gallery. Estab. 1991. Represents established artists. Sponsors 7 shows/year. Average display time 6 weeks. Open September-July; Monday-Friday, 12-6, Saturday, 12-5. Located in Soho; 2,200 sq. ft.; interior by Scott Marble. 40% of space for special exhibitions.
Terms: Retail prices set by the gallery and the artist. Gallery provides insurance, promotion and shipping costs. Prefers artwork framed.

TIBOR DE NAGY GALLERY, 41 W. 57th St., New York NY 10019. (212)421-3780. Directors: Andrew H. Arnst and Eric Brown. Retail gallery. Estab. 1950. Represents 18 emerging and mid-career artists. Exhibited artists include Robert Berlind, Gretna Campbell. Sponsors 12 shows/year. Average display time 1 month. Closed August. Located midtown; 3,500 sq. ft. 100% of space for work of gallery artists. 60% private collectors, 40% corporate collectors. Overall price range: $800-30,000; most work sold at $5,000-20,000.
Media: Considers oil, pen & ink, paper, acrylic, drawings, sculpture, watercolor, mixed media, pastel, collage, etchings, and lithographs. Most frequently exhibits oil/acrylic, watercolor and sculpture.
Style: Exhibits representation work as well as abstract painting and sculpture. Genres include landscapes and figurative work. Prefers abstract, painterly realism and realism.
Terms: Accepts work on consignment (50% commission). Retail price set by gallery and artist. Gallery provides insurance, promotion and contract; artist pays for shipping. Prefers artwork framed.
Submissions: Send query letter with résumé, slides, bio, brochure, photographs, SASE and reviews. Call for an appointment to show portfolio of photographs and slides. Replies in 2 weeks. Files résumé and bio.

‡TRIBECA 148 GALLERY, 148b Duane St., New York NY 10013. (212)406-4073. Assistant Director: Roger Warren. Alternative space. Estab. 1992. Represents emerging and mid-career artists. Exhibited 1,600 artists in 2 years. 1,200 members. Sponsors 24 shows/year. Average display time 1 month. Open in summer; Tuesday-Saturday, 12-6. Located downtown Tribeca; 1,700 sq. ft. (plus other renegade and donated spaces); long loft space, and ground floor, high ceilings, interesting vault sub-exhibition space. 90% of space for special exhibitions; 10% of space for gallery artists. Clientele: "The arts community."
Media: Considers oil, acrylic, watercolor, pastel, pen & ink, drawing, mixed media, collage, paper, sculpture, installation and photography. Most frequently exhibits painting, sculpture and photography.
Style: Exhibits all styles, all genres.
Terms: "Work is received for exhibitions; sales are encouraged, but are not our main focus—20% commission."
Submissions: Accepts only professional artists. Send query letter with request for membership information ($30 a year). Portfolio should include slides. "We only receive slides for our slide file as part of the membership service." Files 20 slides, résumé, 3 slides for carousels.
Tips: "We show mostly NYC artists—but do accept artists from out-of-town."

‡VERED GALLERY, 66-68 Park Place Passage, East Hampton NY 11937. (516)324-3303. Fax: (516)324-3303. Estab. 1976. Represents 20 established artists. Interested in seeing the work of emerging artists. Exhibited artists include Milton Avery, Wolf Kahn. Sponsors 10 shows/year. Average display time 3 weeks. Open all year; Thursday-Monday, 11-6. Located across from the movie theater in East Hampton; 2,000 sq. ft.

VIRIDIAN GALLERY, 24 W. 57 St., New York NY 10019. (212)245-2882. Director: Joan Krauczyk. Cooperative gallery. Estab. 1970. Exhibits the work of 34 emerging, mid-career and established artists. Sponsors 13 solo and 2 group shows/year. Average display time is 3 weeks. Clientele: consultants, corporations, private collectors. 50% private collectors, 50% corporate clients. Overall price range: $500-20,000; most work sold at $1,000-8,000.
Media: Considers oil, acrylic, watercolor, pastel, pen & ink, drawings, mixed media, collage, works on paper, sculpture, installation, photography and limited edition prints. Most frequently exhibits oil, sculpture and mixed media.
Style: Exhibits hard-edge geometric abstraction, color field, painterly abstraction, conceptualism, postmodern works, primitivism, photorealism, abstract, expressionism, and realism. "Eclecticism is Viridian's policy. The only unifying factor is quality. Work must be of the highest technical and aesthetic standards."
Terms: Accepts work on consignment (30% commission). Retail price set by gallery and artist. Sometimes offers customer discounts and payment by installment. Exclusive area representation not required. Gallery provides promotion, contract and representation.
Submissions: Send query letter and SASE or call ahead for information on procedure. Portfolio review requested if interested in artist's work.
Tips: "Artists often don't realize that they are presenting their work to an artist-owned gallery where they must pay each month to maintain their represenation. We feel a need to demand more of artists who submit work. Because of the number of artists who submit work our critieria for approval has increased as we receive stronger work than in past years as commercial galleries are closing."

‡WARD-NASSE GALLERY, 178 Prince St., New York NY 10012. (212)925-6951. Director: Robert Curcio. Alternative space, nonprofit gallery. Estab. 1965. Represents emerging, mid-career and established artists. 250 members. Sponsors 10 shows/year. Average display time 3 weeks. Open all year; Tuesday-Saturday, 11-6; Sunday, 1-6 pm. Located in Soho; 2,000 sq. ft.; ground floor, easy access, large front window, very busy street. 95% of space for special exhibitions; 95% of space for gallery artists. Clientele: "all different types." 97% private collectors, 3% corporate collectors. Overall price range: $25-8,000; most work sold at $25-3,000.
Media: Considers all media, all types of prints. Most frequently exhibits painting, sculpture and photography.
Style: Exhibits all styles including installation, video, computer, all genres.
Terms: Accepts work on consignment (15% commission). Retail price set by the gallery and the artist. Gallery provides promotion and contract; artist pays shipping costs to and from gallery. Prefers artwork framed.
Submissions: Send query letter with SASE. "Contact us after reading gallery brochure."
Tips: Finds artists through visiting exhibitions, word of mouth, artists' submissions, ads in local papers, slide libraries. "Do not call with questions until you have sent cover letter and SASE asking for gallery brochure."

‡ELAINE WECHSLER P.D., 5B, 245 W. 104th St., New York NY 10025. (212)222-3619. Contact: Elaine Wechsler. Art consultancy, private dealer. Estab. 1985. Represents 7 emerging, mid-career and established artists/year. Exhibited artists include John Hultberg, Audrey Ushenko. Sponsors 2 shows/year. Average display time 1 month. Open by appointment. Located uptown; 1,500 sq. ft.; pre-war suite—paintings hung as they would be in a home. Clientele: upscale. 80% private collectors, 20% corporate collectors. Overall price range: $800-15,000.
Media: Considers oil, acrylic, watercolor, pastel, mixed media, collage, paper, photography, gouache, lithograph, serigraphs and etching. Most frequently exhibits acrylic, oil, gouache, mixed media (canvas and paper).

Style: Exhibits expressionism, painterly abstraction, surrealism and realism. Genres include landscapes, florals and figurative work. Prefers landscape, abstractions and figurative.
Terms: Accepts work on consignment (40% commission). Retail price set by the gallery and the artist. Gallery provides promotion and contract; shipping costs are shared in some cases. Prefers artwork framed.
Submissions: Send query letter with résumé, slides, bio, brochure, SASE and reviews. Write for appointment to show portfolio of originals, photographs, slides and promotion material. Replies in 3-6 months. Files promotion brochures and bios.
Tips: Finds artists through visiting exhibitions, slide files, referrals, artists' submissions.

‡**L.J. WENDER FINE CHINESE PAINTINGS**, 3 E. 80th St., New York NY 10021. (212)734-3460. Fax: (212)427-4945. Owners: Karen and Leon Wender. Retail gallery. Estab. 1980. Represents established artists. Exhibited artists include Zhu Qizhan, Qi Baishi. Sponsors 4-5 shows/year. Average display time 1 month. Open all year; Monday-Saturday, 10-5. Located on the upper Eastside of New York City; 1,500 sq. ft. 90% of space for special exhibitions. Clientele: private collectors, museums. 95% private collectors, 5% corporate collectors. Overall price range: $400-50,000; most work sold at $2,000-8,000.
Media: Considers watercolor, Chinese ink and color on paper. Most frequently exhibits Chinese ink and color on paper.
Style: Exhibits traditional Chinese painting. Genres include landscapes, florals, wildlife and portraits. Prefers landscapes, flowers, portraits (nonfigurative).
Terms: Retail price set by the gallery. Gallery provides insurance and promotion; artist pays shipping costs to and from gallery. Prefers artwork framed.
Submissions: Accepts only artists from China or overseas Chinese. Prefers only traditional Chinese painting. Send query letter with bio and photographs. Call for appointment to show portfolio of originals and photographs. Replies only if interested within 2 weeks.

‡**WHITEHALL**, 12 White St., New York NY 10013. (212)941-8138. Fax: (212)941-0815. Director: Louis. Retail gallery. Estab. 1985. Represents 12 emerging, mid-career and established artists/year. Exhibited artists include Ana Mercedes Hoyos, Buky Schwartz. Sponsors 6 shows/year. Average display time 6 weeks. Open all year; Tuesday-Thursday, by appointment; Friday, 1-9; Saturday, 11-6. Located in Tribeca; 2,000 sq. ft.; "new concept in space—must be seen." 40% of space for special exhibitions; 60% of space for gallery artists. Clientele: "all types." 90% private collectors, 10% corporate collectors. Overall price range: $1,000-100,000; most work sold at $15,000-25,000.
Media: Considers oil, watercolor, pastel, pen & ink, drawing, mixed media, collage, sculpture, installation, photography, all types of prints. Most frequently exhibits oil, sculpture and mixed media.
Style: Exhibits expressionism, surrealism, all styles, conceptualism. Prefers figurative, conceptual and surrealism.
Terms: Accepts work on consignment (50% commission) or buys outright for 40% of retail price. Retail price set by the gallery. Gallery provides insurance and promotion; shipping costs are shared. Prefers artwork framed.
Submissions: Send query letter with résumé. Write for appointment. Replies in 2 months.
Tips: Finds artists through word of mouth.

‡**YESHIVA UNIVERSITY MUSEUM**, 2520 Amsterdam Ave., New York NY 10033. (212)960-5390. Director: Sylvia A. Herskowitz. Nonprofit museum. Estab. 1973. Interested in emerging, mid-career and established artists. Clientele: New Yorkers and tourists. Sponsors 5-7 solo shows/year. Average display time is 3 months. "4 modern galleries; track lighting; some brick walls." Museum works can be sold through museum shop.
Media: Considers all media and original handpulled prints.
Style: Exhibits post-modernism, surrealism, photorealism and realism. Genres include landscapes, florals, Americana, portraits and figurative work. "We mainly exhibit works of Jewish theme or subject matter or that reflect Jewish consciousness but are somewhat willing to consider other styles or mediums."
Terms: Accepts work for exhibition purposes only, no fee. Pieces should be framed. Retail price is set by gallery and artist. Gallery provides insurance, promotion and contract; artist pays for shipping and framing.
Submissions: Send query letter, résumé, brochure, good-quality slides, photographs and statement about your art. Prefers not to receive phone calls/visits. "Once we see the slides, we may request a personal visit." Resumes, slides or photographs are filed if work is of interest.
Tips: Mistakes artists make are sending "slides that are not identified, nor in a slide sheet." Notices "more interest in mixed media and more crafts on display."

North Carolina

‡**ARTSOURCE CONSULTANTS INC.**, Suite 105, 509 W. Whitaker Mill Rd., Raleigh NC 27608. (919)833-0013. Fax: (919)833-8641. Directors: Nancy McClure and Sharon Tharrington. Retail gallery, art consultancy. Estab. 1990. Represents 60 emerging, mid-career and established artists/year. Exhibited artists include James P. Kerr, Gayle Lowry. Sponsors 4 shows/year. Average display time 6 weeks; consignment period 6 months.

Open all year Monday-Friday, 10-5; Saturday, 12-4. Located in Five Points area (1½ miles from downtown); 1,600 sq. ft. 50% of space for special exhibitions; 50% of space for gallery artists. Clientele: 40% private collectors, 60% corporate collectors. Overall price range: $100-7,500; most work sold at $500-2,000.

Media: Considers oil, acrylic, watercolor, pastel, mixed media, collage, sculpture, ceramics, craft, fiber, glass, lithograph, serigraphs, etching, posters and limited edition prints. Most frequently exhibits oils/acrylics, pastels and watercolors.

Style: Exhibits expressionism, neo-expressionism, painterly abstraction, postmodern works, impressionism, photorealism and realism; Genres include landscapes, florals, Americana and figurative work. Prefers landscapes/seascapes, florals/still lifes, abstraction (soft edge).

Terms: Accepts work on consignment (50% commission). Retail price set by the artist. Gallery provides insurance, promotion and shipping costs from gallery; artist pays shipping costs to gallery. Prefers artwork framed but "can be discussed."

Submissions: Prefers artists from Southeastern region. Send query letter with résumé, slides or photographs, bio and SASE. Call for appointment to show portfolio of originals, photographs, slides and transparencies. Replies in 2 weeks. Files résumé, bio info, reviews, photos (if possible).

Tips: Finds artists through publications, sourcebooks, artists' submissions. "Please send info with pricing and checklist for slides."

‡**ARTSPACE, INC.,** 201 E. Davie St., Raleigh NC 27601. (919)821-2787. Director: Ann Tharrington. Nonprofit gallery. Estab. 1986. Exhibits the work of emerging, mid-career and established artists; 110 member artists. Sponsors 12 shows/year. Average display time 5 weeks. Open all year. Located downtown in the Moore Square Art District in City Market, free on-street parking; 4,000 sq. ft.; "a 30,000 square foot art center for the visual and performing arts; it has two galleries, 22 studios with 39 tenant artists, Raleigh Ensemble Players and a restaurant." 80% of space for special exhibitions. 20% private collectors; 80% corporate collectors. Overall price range: $40-7,500; most work sold at $50-900.

Media: Considers all media and original handpulled prints, woodcuts, wood engravings, mezzotints, etchings and serigraphs. Most frequently exhibits painting, sculpture and fine crafts.

Style: Exhibits all styles and genres. Prefers realism, expressionism and impressionism.

Terms: Accepts artwork on consignment (30% commission). Retail price set by the artist. Gallery provides insurance, promotion and contract; shipping costs are shared. Prefers artwork framed.

Submissions: Send query letter with résumé, slides, bio, brochure, SASE and reviews. Write to schedule an appointment to show a portfolio, which should include photographs. Replies in 3 months. Files résumé.

Tips: "Decisions are made by committee. Please be patient."

‡**ASSOCIATED ARTISTS OF WINSTON-SALEM,** 226 N. Marshall St., Winston-Salem NC 27101. (910)722-0340. Executive Director: Rosemary H. Martin. Nonprofit gallery. Gallery estab. 1982; organization estab. 1956. Represents 500 emerging, mid-career and established artists/year. 375 members. Sponsors 12 shows/year. Average display time 1 month. Open all year; office hours: Monday-Friday, 9-5; gallery hours: Monday-Friday, 9-9; Saturday, 9-6. Located in the historic Sawtooth Building downtown. "Our gallery is 1,000 sq. ft., but we often have the use of 2 other galleries with a total of 3,500 sq. ft. The gallery is housed in a renovated textile mill (circa 1911) with a unique 'sawtooth' roof." 30% of space for special exhibitions; 70% of space for gallery artists. Clientele: "generally walk-in traffic—this is a multi-purpose public space, used for meetings, receptions, classes, etc." 85% private collectors, 15% corporate collectors. Overall price range: $50-3,000; most work sold at $100-500.

Media: Considers oil, acrylic, watercolor, pastel, pen & ink, drawing, mixed media, collage, paper, sculpture, photography, woodcut, engraving, lithograph, wood engraving, mezzotint, serigraphs, linocut and etching (no photo-reproduction prints.). Most frequently exhibits watercolor, oil and photography.

Style: Exhibits all styles, all genres.

Terms: "Artist pays entry fee for each show; if work is sold, we charge 30% commission. If work is unsold at close of show, it is returned to the artist." Retail price set by the artist; artist pays shipping costs to and from gallery. Artwork must be framed.

Submissions: Request membership information and/or prospectus for a particular show. Replies in 1 week to membership/prospectus requests. Files "slides and résumés of our exhibiting members only."

Tips: "We don't seek out artists per se—membership and competitions are generally open to all. We advertise call for entries for our major shows in national art magazines and newsletters."

‡**BLUE SPIRAL 1,** 38 Biltmore Ave., Asheville NC 28801. (704)251-0202. Fax: (704)251-0884. Director: John Cram. Retail gallery. Estab. 1991. Represents emerging, mid-career and established artists. Exhibited artists include Coralie Tweed, Michael Sherrill. Sponsors 10 shows/year. Average display time 6-8 weeks. Open all year; Monday-Saturday, 10-5. Located downtown; 11,000 sq. ft.; historic building, performance/alternative space, sculpture garden (indoor). 85% of space for special exhibitions; 15% of space for gallery artists. Clientele: "across the range." 90% private collectors, 10% corporate collectors. Overall price range: less than $100-50,000; most work sold at $100-2,500.

Media: Considers all media including outsider and contemporary folk art. Most frequently exhibits painting, clay, sculpture and glass.

Style: Exhibits all styles, all genres.

Terms: Accepts work on consignment (50% commission). Retail price set by the artist. Gallery provides insurance, promotion and contract; artist pays shipping costs to and from gallery. Prefers artwork framed.

Submissions: Accepts only artists from Southeast. Send query letter with résumé, slides, prices, bio and SASE. Replies in 3 months. Files slides, name and address.

Tips: Finds artists through word of mouth, referrals, travel.

‡**BROADHURST GALLERY**, 800 Midland Rd., Pinehurst NC 28374. (910)295-4817. Owner: Judy Broadhurst. Retail gallery. Estab. 1990. Represents/exhibits 50 emerging, mid-career and established artists/year. Sponsors about 4 large shows and many smaller shows/year. Average display time 1-3 months. Open all year; Tuesday-Friday 11-5; Saturday 1-4; and by appointment. Located on the main road between Pinehurst and Southern Pines; 3,000 sq. ft.; lots of space, lots of light, lots of parking spaces. 50% of space for special exhibitions; 50% of space for gallery artists. Clientele: people building homes and remodeling, also collectors. 80% private collectors, 20% corporate collectors. Overall price range: $500-10,000; most work sold at $1,000-2,400.

Media: Considers oil, acrylic, watercolor, pastel, mixed media, collage, sculpture, craft and glass. Most frequently exhibits oil, acrylic, sculpture (stone and bronze), watercolor, glass.

Style: Exhibits all styles, all genres.

Terms: Retail price set by the artist. Gallery provides insurance, promotion and contract; shipping costs are shared. Prefers artwork framed.

Submissions: Send query letter with résumé, slides and/or photographs, and bio. Write for appointment to show portfolio of originals and slides. Replies only if interested within 2-3 weeks. Files résumé, bio, slides and/or photographs.

Tips: Finds artists through agents, by visiting exhibitions, word of mouth, various art publications and sourcebooks, artists' submissions.

‡**CARTERET CONTEMPORARY ART**, 1106 Arendell St., Morehead City NC 28557. (919)726-4071. Director: Charles Jones. Retail gallery. Estab. 1992. Represents 85 emerging, mid-career and established artists/year. Exhibited artists include Donna Levinstone, Maria Henle. Sponsors 5 shows/year. Average display time 2½ months. Open all year; Monday-Saturday 10-5. Located downtown; 1,000 sq. ft.; turn-of-the-century free standing building, once a home. 40-60% of space for special exhibitions; 40-60% of space for gallery artists. Clientele: private collectors, tourists. 60% private collectors, 5% corporate collectors. Overall price range: $50-20,000; most work sold at $500-2,500.

Media: Considers oil, acrylic, watercolor, pastel, pen & ink, mixed media, collage, paper, sculpture, ceramics, fiber, glass, photography, woodcut, engraving, lithograph, wood engraving, mezzotint, serigraphs, linocut and etching. Most frequently exhibits oil/acrylic on canvas, watercolor and mixed media.

Style: Exhibits expressionism, neo-expressionism, painterly abstraction, surrealism, minimalism, color field, postmodern works, impressionism, photorealism and realism. Genres include landscapes, florals, portraits and figurative work. Prefers landscape, figurative and abstract/surreal.

Terms: Accepts work on consignment (50% commission). Retail price set by the artist. Gallery provides insurance, promotion, contract and shipping costs from gallery; artist pays shipping costs to gallery. Prefers artwork framed.

Submissions: Send query letter with résumé, brochure, photographs and SASE. Write for appointment to show portfolio of originals and photographs. Replies in 1 month. Files all pertinent material.

Tips: Finds artists through word of mouth, reviews, other galleries, publications.

‡**GREENVILLE MUSEUM OF ART**, 802 S. Evans St., Greenville NC 27834. (919)758-1946. Director: C. Barbour Strickland, III. Museum. Estab. 1939. Represents mid-career and established artists. Interested in seeing the work of emerging artists. 580 members. Sponsors 15-17 shows/year. Average display time 1½-2 months. Open all year; Tuesday-Friday, 10-4:30; Sundays, 1-4. Located downtown; 2,500 sq. ft.

Media: Considers oil, acrylic, watercolor, pastel, pen & ink, drawing, mixed media, collage, paper, sculpture, ceramics, installation, woodcut, engraving, lithograph, mezzotint, serigraphs and etching. Most frequently exhibits oil, acrylic and sculpture.

Style: Exhibits expressionism, neo-expressionism, primitivism, all styles, minimalism, impressionism and realism, all genres.

Terms: Prefers artwork framed.

Submissions: Send query letter with résumé, slides, bio, SASE and reviews. Write for appointment. Replies only if interested within 2 months.

LITTLE ART GALLERY, North Hills Mall, Raleigh NC 27609. (919)787-6317. Co-Presidents: Ruth Green and Roseanne Minick. Retail gallery. Estab. 1968. Represents 50 emerging, mid-career and established artists. Exhibited artists include Francoise Gilot and Tarkay. Sponsors 4 shows/year. Average display time 1 month. Open all year. Located in a suburban mall; 2,000 sq. ft.; small balcony for mini-shows. 20% of space for special exhibitions. 90% private collectors, 10% corporate clients. Overall price range: $200-2,000; most artwork sold at $500-1,000.

Media: Considers oil, acrylic, watercolor, mixed media, collage, ceramic and all types of original handpulled prints. Most frequently exhibits watercolor, oil and original prints.

Style: Exhibits painterly abstraction, realism and abstracted realism. Genres include landscapes and figurative work. Prefers realism and abstracted realism.

Terms: Accepts work on consignment (50% commission). "Will buy outright in certain circumstances." Retail price set by artist. Gallery provides insurance and promotion. Prefers artwork unframed.

Submissions: Send query letter with photographs. Call or write for appointment to show portfolio. Replies in 1 week. Files bios and 1 photo.

Tips: Most common mistake artists make is "presenting the whole range of work they have done instead of concentrating on what they are currently doing and are interested in."

‡**RALEIGH CONTEMPORARY GALLERIES,** 134 E. Hangett St., Raleigh NC 27601. (919)828-6500. Director: Rory Parnell. Retail gallery. Estab. 1984. Represents 20-25 emerging and mid-career artists/year. Exhibited artists include Walter Piepke, Nancy Baker. Sponsors 6 shows/year. Average display time 2-3 months. Open all year; Tuesday-Friday, 11-4. Located downtown; 1,300 sq. ft.; architect-designed; located in historic property in a revitalized downtown area. 70% of space for special exhibitions; 30% of space for gallery artists. Clientele: corporate and private. 35% private collectors, 65% corporate collectors. Overall price range: $500-5,000; most work sold at $1,200-2,500.

Media: Considers oil, acrylic, watercolor, pastel, pen & ink, drawing, woodcut, engraving and lithograph. Most frequently exhibits oil/acrylic paintings, drawings and lithograph.

Style: Exhibits all styles. Genres include landscapes and florals. Prefers landscapes, realistic and impressionistic; abstracts.

Terms: Accepts work on consignment (50% commission). Retail price set by the gallery and the artist. Gallery provides insurance, promotion and contract; shipping costs are shared.

Submissions: Send query letter with résumé, slides, bio, SASE and reviews. Call or write for appointment to show portfolio of slides. Replies in 1 month.

Tips: Finds artists through exhibitions, word of mouth, referrals.

SPIRIT SQUARE CENTER FOR THE ARTS, 345 N. College St., Charlotte NC 28202. (704)372-9664. Fax: (704)377-9808. Exhibitions Coordinator: Donna Devereaux. 6 nonprofit galleries. Estab. 1983. Exhibits emerging, mid-career and established artists. Sponsors 45-50 shows/year. Average display time 2 months. Overall price range: $3,500-60,000.

Tips: Looks for qualities "dealing with issues important to the development of contemporary art. Temporary exhibitions only."

Media: Considers all media.

Terms: Sometimes offers customer discounts if they are members and purchase in excess of $1,000.

Submissions: Send query letter with artist's statement, artist's process, résumé, full sheet of slides ("in focus!") and SASE. Call for an appointment to show portfolio.

Tips: Finds artists through visiting exhibitions, word of mouth, artists' submissions, and research into particular topics or themes.

North Dakota

‡**GANNON & ELSA FORDE GALLERIES,** 1500 Edwards Ave., Bismarck ND 58501. (701)224-5520. Fax: (701)224-5550. Gallery Director: Michelle Lindblom. College gallery. Represents 12 emerging, mid-career and established artists per school year. Sponsors 6 shows/year. Average display time 6 weeks. Open all year; Monday-Thursday, 9-9; Friday, 9-4; Saturday, 1-5; Sunday, 6-9. Summer exhibit is college student work (May-August). Located Bismarck State College Campus; high traffic areas on campus. Clientele: all. 80% private collectors, 20% corporate collectors. Overall price range: $50-10,000; most work sold at $50-3,000.

Media: Considers oil, acrylic, watercolor, pastel, drawing, mixed media, collage, paper, sculpture, ceramics, fiber, photography, woodcut, engraving, lithograph, wood engraving, mezzotint, serigraphs, linocut and etching. Most frequently exhibits painting media (all), mixed media and sculpture.

Style: Exhibits expressionism, neo-expressionism, painterly abstraction, surrealism, impressionism, photorealism, hard-edge geometric abstraction and realism, all genres. Prefers figurative, landscapes and abstract.

Terms: Accepts work on consignment (20% commission). Retail price set by the artist. Gallery provides insurance on premises, promotion, contract and shipping costs from gallery; artist pays shipping costs to gallery. Prefers artwork framed.

Submissions: Send query letter with résumé, slides, bio and SASE. Call or write for appointment to show portfolio of photographs and slides. Replies in 2 months. Files résumé, bio, photos if sent.

Tips: Finds artists through word of mouth, art publications, artists' submissions, visiting exhibitions. "Because our gallery is a University gallery, the main focus is not just selling work but exposing the public to art of all genres. However, we do sell work, occasionally."

HUGHES FINE ART CENTER ART GALLERY, Department of Visual Arts, University of North Dakota, Grand Forks ND 58202-7099. (701)777-2257. Director: Brian Paulsen. Nonprofit gallery. Estab. 1979. Exhibits emerging, mid-career and established artists. Sponsors 5 shows/year. Average display time 3 weeks. Open all year. Located on campus; 96 running ft. 100% of space for special exhibitions.
 ● Director states gallery is interested in "well-crafted, clever, sincere, fresh, inventive, meaningful, (not another Ansel Adams!), unique, well-designed compositions—surprising, a bit shocking, etc."
Media: Considers all media. Most frequently exhibits painting, photographs and jewelry/metal work.
Style: Exhibits all styles and genres.
Terms: Retail price set by artist. Gallery provides "space to exhibit work and some limited contact with the public and the local newspaper." Gallery pays for shipping costs. Prefers artwork framed.
Submissions: Send query letter with slides and résumé. Portfolio review not required. Replies in 1 week. Files "duplicate slides, résumés."
Tips: Finds artists through submissions from *Artist's & Graphic Designer's Market* listing, *Art in America* listing in their yearly museum compilation; as an art department listed in various sources as a school to inquire about; the gallery's own poster/ads. "We have a video we send out by request. Send slides and approximate shipping costs."

MINOT ART GALLERY, Box 325, Minot ND 58702. (701)838-4445. Executive Director: Judith Allen. Nonprofit gallery. Estab. 1970. Represents emerging, mid-career and established artists. Sponsors 9 shows/year. Average display time 1-2 months. Open all year. Located at North Dakota state fairgrounds; 1,600 sq. ft.; "2-story turn-of-the-century house." 100% of space for special exhibitions. Clientele: 100% private collectors. Overall price range: $50-2,000; most work sold at $100-400.
Media: Considers oil, acrylic, watercolor, pastel, pen & ink, drawings, mixed media, collage, works on paper, sculpture, ceramic, fiber, glass, photography, woodcuts, engravings, lithographs, serigraphs, linocuts and etchings. Most frequently exhibits watercolor, acrylic and mixed media.
Style: Exhibits all styles and genres. Prefers figurative, Americana and landscapes. No "commercial style work." Interested in all media (minimal photography).
Terms: Accepts work on consignment (30% commission). Retail price set by artist. Offers discounts to gallery members and sometimes payment by installments. Gallery provides insurance, promotion and contract; pays shipping costs from gallery or shipping costs are shared. Requires artwork framed.
Submissions: Send query letter with résumé and slides. Write for appointment to show portfolio of good quality photographs and slides. "Show variety in your work." Replies in 1 month. Files material interested in.
Tips: Finds artists through visiting exhibitions, word of mouth, artists' submissions of slides and members' referrals. "Do not call for appointment. We are seeing many more photographers wanting to exhibit."

‡NORTHWEST ART CENTER, Minot State University, 500 University Ave. W., Minot ND 58707. (701)857-3264 or 3836. Fax: (701)839-6933. Director: Linda Olson. Nonprofit gallery. Estab. 1970. Represents emerging, mid-career and established artists. Sponsors 15-25 shows/year. Average display time 4-6 weeks. Open all year. Two galleries: Hartnett Hall Galleries; Monday-Friday, 8-5; The Library Gallery; Monday-Friday, 8-10. Located on University campus; 1,000 sq. ft. 100% of space for special exhibitions. 100% private collectors. Overall price range: $100-40,000; most work sold at $100-4,000.
Media: Considers all media and all types of prints except posters.
Style: Exhibits all styles, all genres.
Terms: Retail price set by the artist. Gallery provides insurance, promotion and contract; shipping costs are shared. Prefers artwork framed.
Submissions: Send query letter with résumé, slides, bio, SASE and artist statement. Call for appointment to show portfolio of originals, photographs, slides and transparencies. Replies in 1-2 months. Files all material.
Tips: Finds artists through artists' submissions, visiting exhibitions, word of mouth.

Ohio

‡ACME ART COMPANY, 737 N. High St., Columbus OH 43215. (614)299-4003. Art Director: Lori McCargish. Nonprofit gallery. Estab. 1986. Represents 300 emerging and mid-career artists/year. 250 members. Exhibited artists include Rick Borg, Eric Lubkeman. Sponsors 12 shows/year. Average display time 1 month. Open all year; Wednesday-Saturday, 1:00-7:00. Located in Short North District; 1,200 sq. ft.; 3 gallery areas: main gallery, spotlight gallery, bathroom series, basement for performance. 70% of space for special exhibitions;

A bullet introduces comments by the editor of Artist's & Graphic Designer's Market *indicating special information about the listing.*

70% of space for gallery artists. Clientele: avante-garde collectors, private and professional. 85% private collectors, 15% corporate collectors. Overall price range: $30-5,000; most work sold at $50-1,000.
Media: Considers all media and all types of prints except posters. Most frequently exhibits painting, installations and sculpture.
Style: Exhibits all styles, prefers avante-garde and cutting edge. Genres include all types of experimental and emerging art forms. Prefers experimental, socio/political and avante-garde.
Terms: Accepts work on consignment (30% commission). Retail price set by the gallery and the artist. Gallery provides promotion and contract; shipping costs are shared. Prefers artwork framed.
Submissions: Prefers only "artists who push the envelope, who explore new vision and materials of presentation." Send query letter with résumé, slides, bio, SASE and reviews. Write for appointment to show portfolio of originals if possible, slides or transparencies. Call for following fiscal year line-up ("we work 1 year in advance"). Files bio, slides, résumé and other support materials sent by artists.
Tips: Finds artists through art publications, slides from call-for-entries, minority organizations, universities and word of mouth.

‡ART SALES AND RENTAL SERVICE OF CLEVELAND CENTER FOR CONTEMPORARY ART, 8501 Carnegie Ave., Cleveland OH 44106. (216)421-8671. Fax: (216)421-0737. Museum rental shop. Estab. 1986. Represents 100 emerging, mid-career and established artists/year. Interested in seeing the work of emerging local artists. Exhibited artists include John Pearson, La Wilson. Sponsors 6 shows/year. Average display time 7 weeks. Open all year: Tuesday-Wednesday, 11-6; Thursday-Friday, 11-8:30; Saturday, 12-5; Sunday 1-4. Located in University Circle, Cleveland, Ohio. 50% of space for special exhibitions; 50% of space for gallery artists. Clientele: gallery visitors and members, corporate. 70% private collectors, 30% corporate collectors. Overall price range: $300-100,000; most work sold at $600-2,000.
Media: Considers oil, acrylic, watercolor, pastel, pen & ink, drawing, mixed media, collage, paper, sculpture, ceramics, glass, photography, woodcut, engraving, lithograph, wood engraving, mezzotint, serigraphs, linocut and etching. Most frequently exhibits prints, paintings, works on paper.
Style: Exhibits all styles (contemporary). Genres include abract, minimalist.
Terms: Accepts work on consignment. Retail price set by the artist. Gallery provides insurance and promotion; artist pays shipping costs to and from gallery. Prefers artwork framed.
Submissions: Send query letter with résumé, slides and SASE. Call for appointment to show portfolio of slides. Replies in 2 months. Files slides of interest.
Tips: Finds artists through studio and gallery visits, referrals from artists, slides.

TONI BIRCKHEAD GALLERY, 324 W. Fourth St., Cincinnati OH 45202. (513)241-0212. Director: Toni Birckhead. Retail gallery and art consultancy. Estab. 1979. Represents 40 mid-career and established artists. Sponsors 4 solo and 2 group shows/year. Average display time is 6-7 weeks. Clientele: 25% private collectors, 75% corporate clients. Overall price range: $500-5,000; most work sold at $500-1,000.
• Gallery Director Toni Birckhead likes to promote regional artists and has helped local artists get their work in corporate collections.
Media: Considers oil, acrylic, watercolor, pastel, pen & ink, drawings, mixed media, collage, works on paper, sculpture, ceramic, installation, photography and original handpulled prints. Most frequently exhibits painting, sculpture and works on paper.
Style: Exhibits hard-edge geometric abstraction, color field, painterly abstraction, minimalism, conceptual post-modernism, neo-expressionism and realism.
Terms: Accepts work on consignment (50% commission). Retail price is set by gallery and artist. Exclusive area representation required. Gallery provides insurance, promotion and contract; shipping expenses are shared.
Submissions: Send query letter, résumé, slides and SASE. Call or write to schedule an appointment to show a portfolio, which should include originals and slides. Slides, résumés and reviews are filed.

C.A.G.E., 344 W. Fourth St., Cincinnati OH 45202. (513)381-2437. Director: Krista Campbell. Nonprofit gallery. Estab. 1978. Represents emerging, mid-career and established artists. Sponsors 10-15 solo/group shows/year. Average display time 5 weeks. Approximately 1,300 sq. ft. of exhibition space: lower gallery 13×60 with 8' ceiling; upper gallery 13×60 with 12' ceiling; window space 7×10 with 12' ceiling. Clientele: 99.9% private collectors, .1% corporate clients. Overall price range: $100-5,000; most work sold at $100-500.
• The art shown at C.A.G.E. tends to be on the cutting edge, often controversial and politically left of center.
Media: Considers all media. Most frequently exhibits paintings, mixed media and installation/video/performance.
Style: Considers all styles; "experimental, conceptual, political, media/time art, public art and artists' projects encouraged. Proposals from artists are accepted and reviewed in the fall (deadline September 15) for exhibition 9-20 months from deadline. A panel of peer artists and curators selects the exhibitions."
Terms: Retail price set by artist. Exclusive area representation not required. Gallery provides insurance, promotion and contract.

Submissions: Send query letter with SASE for prospectus. Portfolio review not required.
Tips: Finds artists through various art publications and sourcebooks, artists' submissions and self-promotions. "Some of the most common mistakes artists make are presenting badly or incorrectly labeled slides and unclear proposals."

CLEVELAND STATE UNIVERSITY ART GALLERY, 2307 Chester Ave., Cleveland OH 44114. (216)687-2103. Fax: (216)687-9366. Director: Robert Thurmer. University gallery. Exhibits 50 emerging, mid-career and established artists. Exhibited artists include Ellen Phelan and Kay Walkingstick. Sponsors 6 shows/year. Average display time 1 month. Open Monday-Friday 10-4. Closed Saturday, Sunday and holidays. Located downtown: 4,500 sq. ft. (250 running ft. of wall space). 100% of space for special exhibitions. Clientele: students, faculty, general public. 85% private collectors, 15% corporate collectors. Overall price range: $250-50,000; most work sold at $300-1,000.
Media: Considers all media and all types of prints. Prefers painting, sculpture and new genres work.
Style: Exhibits all styles and genres. Prefers contemporary, modern and postmodern. Looks for challenging work.
Terms: 25% suggested donation to gallery. Sales are a service to artists and buyers. Gallery provides insurance, promotion, shipping costs to and from gallery; artists handle crating. Prefers artwork framed.
Submissions: Send query letter with résumé and slides. Portfolio review requested if interested in artist's work. Files résumé and slides.
Tips: Finds artists through visiting exhibitions, artists' submissions, publications and word of mouth. Submission guidelines available for SASE.

THE A.B. CLOSSON JR. CO., 401 Race St., Cincinnati OH 45202. (513)762-5564. Fax: (513)762-5515. Director: Phyllis Weston. Retail gallery. Estab. 1866. Represents emerging, mid-career and established artists. Average display time 3 weeks. Clientele: general. Overall price range: $600-75,000.
Media: Considers oil, watercolor, pastel, mixed media, sculpture, original handpulled prints and limited offset reproductions.
Style: Exhibits all styles and genres.
Terms: Accepts work on consignment or buys outright. Retail price set by gallery and artist. Customer discounts and payment by installment are available. Exclusive area representation required. Gallery provides insurance and promotion; shipping costs are shared.
Submissions: Portfolio review requested if interested in artist's work. Portfolio should include originals.
Tips: Finds artists through agents, visiting exhibitions, word of mouth, various art publications, sourcebooks, artists' submissions/self-promotions and art collectors' referrals.

‡**SPANGLER CUMMINGS**, Suite 106, 641 N. High St., Columbus OH 43215. (614)224-4484. Fax: (614)224-4483. Owner: Spangler Cummings. Retail gallery. Estab. 1987, reopened 1993. Represents 12 emerging, mid-career and established artists. Sponsors 5 shows/year. Average display time 2 months. Open all year; Tuesday-Saturday, 11-5. Located arts district north of downtown; 800 sq. ft.; "Duchamps meets Gehry" office and storage. 100% of space for gallery artists. Clientele: corporate and private. 75% private collectors, 25% corporate collectors. Overall price range: $250-8,000; most work sold at $250-3,500.
Media: Considers oil, acrylic, watercolor, pastel, pen & ink, drawing, mixed media, collage, sculpture, photography, woodcut, engraving and etching. Most frequently exhibits paintings, sculpture and drawings.
Style: Exhibits expressionism, neo-expressionism, painterly abstraction, minimalism, color field, impressionism and photorealism. Prefers color field, expressionism and painterly abstraction, all contemporary.
Terms: Accepts work on consignment (negotiated commission). Retail price set by the artist. Gallery provides insurance, promotion and contract; artist pays shipping costs to and from gallery.
Submissions: Send query letter with résumé, slides, bio, SASE and reviews. Replies in 1 month.
Tips: Files "only material from artists we may be interested in in the future." Finds artists through visiting exhibits, various art publications, other galleries, art league and community art shows and international art fairs.

‡**EMILY DAVIS GALLERY**, School of Art, University of Akron, Akron OH 44325. (216)972-5950. Director: Rod Bengston. Nonprofit gallery. Estab. 1974. Clientele: persons interested in contemporary/avant-garde art. 12 shows/year. Average display time is 3½ weeks. Interested in emerging and established artists. Overall price range: $100-65,000; "no substantial sales."
Media: Considers all media.
Style: Exhibits contemporary, abstract, figurative, non-representational, photorealistic, realistic, avant-garde and neo-expressionistic works.
Terms: Retail price is set by artist. Exclusive area representation not required. Gallery provides insurance, shipping costs, promotion and contract.
Submissions: Send query letter with résumé, brochure, slides, photographs and SASE. Write for an appointment to show a portfolio. Résumés are filed.
Tips: Finds artists through visiting exhibitions, word of mouth, various art publications, sourcebooks and artist's submissions/self-promotions.

‡**THE DAYTON ART INSTITUTE,** 456 Belmonte Park N., Dayton OH 45405-4700. (513)223-5277. Fax: (513)223-3140. Assistant Director for Collections and Programs: Marianne Lorenz. Museum. Estab. 1919. Represents established artists. Sponsors 4-5 shows/year. Average display time 7 weeks. Open all year; Tuesday-Sundays and holidays, 12-5; closed Mondays. Located near downtown Dayton; 5,450 sq. ft. for special exhibition, 140 sq. ft. for print, 380 sq. ft. for photo, 29,375 sq. ft. for permanent gallery. Museum is in an historic building with beautiful architectural details. 17% of space for special exhibitions. Clientele: female, upper income.
Media: Considers all media, all types of prints. Most frequently exhibits paintings, photographs and sculptures.
Style: Exhibits all styles, all genres.
Terms: Gallery provides promotion and shipping costs to and from gallery (set amount). Prefers artwork framed.
Submissions: Send query letter with résumé, slides, bio and photographs. Write for appointment to show portfolio of photographs, slides and transparencies. Replies only if interested.
Tips: Finds artists through artists' submissions, other museums, agents.

EAST/WEST ALTERNATIVE GALLERY, 13127 Shaker Blvd., Cleveland OH 44120. Contact: Director. Cooperative/consignment gallery. Estab. 1990. Interested in seeing the work of all artists. Sponsors 8 shows/year. Average display time 6 weeks. Open all year. Located in historic Shaker Square; 3,500 sq. ft. 40% of space for special exhibitions. Clientele: 90% private collectors, 10% corporate collectors. Overall price range: $30-3,000; most work sold at $30-750.
Media: Considers all media and all types of prints except posters and offset reproductions. Most frequently exhibits paintings, sculpture and ceramics.
Style: Exhibits all styles and genres. Prefers expressionism, color field and 3-D bronze.
Terms: Co-op membership fee plus donation of time (80% commission). Retail price set by artist. Sometimes offers customer discounts and payment by installment. Gallery provides promotion. Prefers artwork framed.
Submissions: Send query letter with résumé and bio. Write for appointment to show portfolio of slides. Replies in 1 month. Files résumé and letter of acceptance or rejection.
Tips: Looking for "financial ability to split rent, time to gallery sit and most importantly, quality artwork and commitment."

IMAGES GALLERY, 3154 Markway Rd., Toledo OH 43606. (419)537-1400. Fax: (419)537-1477. Owner: Frederick D. Cohn. Retail gallery. Estab. 1970. Represents 75 emerging, mid-career and established artists. Exhibited artists include Motherwell, Welliver, Carol Summers and Larry Zox. Sponsors 8-10 shows/year. Average display time 1 month. Open all year. Located in a small suburban mall; 4,500 sq. ft.; gallery is 2 stories with a balcony and brilliant white space. 50% of space for special exhibitions. Clientele: 50% private collectors, 25% corporate clients. Overall price range: $300-20,000; most work sold at $1,000-1,500.
Media: Considers oil, acrylic, watercolor, pastel, drawings, mixed media, collage, sculpture, glass, woodcuts, etchings, lithographs and serigraphs. Most frequently exhibits original prints and acrylic on canvas.
Style: Exhibits expressionism, painterly abstraction, color field, postmodern works, realism and photorealism. Genres include landscapes, florals and Americana. Interested in seeing "something new and refreshing in approach and technique."
Terms: Accepts work on consignment (50% commission). Retail price set by gallery and artist. Customer discounts and payment by installment are available. Gallery provides promotion and shipping costs from gallery. Unframed work only.
Submissions: Send query letter with résumé, slides, bio, brochure, photographs and reviews. Portfolio review requested if interested in artist's work.
Tips: Finds artists through trips to East and West coasts. "Work must be original, not derivative. I am not interested in surreal esoteric work that is only intelligible to the artist—it must be readily intelligible to the sophisticated eye."

‡**KUSSMAUL GALLERY,** 103 N. Prospect St., Granville OH 43023. (614)587-4640 or 1(800)587-4640. Owner: James Young. Retail gallery. Estab. 1989. Represents 2-12 emerging, mid-career and established artists/year. Exhibited artists include James Young, Greg Murr. Sponsors 1-2 shows/year. Average display time 4-5 weeks. Open all year; Monday-Friday, 10-5; Saturday, 10-3 (holidays, Monday-Saturday, 10-7; Sunday 11-3). Located downtown; 1.600 sq. ft.; restored building erected 1830—emphasis on interior brick walls and hand hewn beams, skylights with contemporary track lighting. 20-90% of space for special exhibitions; 40% of space for gallery artists. Clientele: upper-middle. 80% private collectors, 20% corporate collectors. Overall price range: $25-5,000; most work sold at $75-250.
Media: Considers oil, acrylic, watercolor, pen & ink, drawing, mixed media, ceramics, glass, all types of prints. Most frequently exhibits pen & ink architectural prints, acrylic—mixed media, watercolor.
Style: Exhibits expressionism, neo-expressionism, primitivism, painterly abstraction, conceptualism, minimalism, impressionism, realism, all genres. Prefers expressionism, impressionism.

Terms: Accepts work on consignment (40% commission) or buys outright. Retail price set by the gallery. Gallery provides insurance and promotion; artist pays shipping costs to and from gallery. Prefers artwork unframed.

Submissions: Send query letter with résumé, slides or photographs, bio and SASE. Call for appointment to show portfolio of originals, photographs and transparencies. Replies only if interested within 1 month. Files slides, bio.

Tips: Finds artists through networking, talking to emerging artists, visiting art colleges. "Don't overprice your work, be realistic. Have large body of work representing your overall talent and changes in style, periods etc."

MALTON GALLERY, 2709 Observatory, Cincinnati OH 45208. (513)321-8614. Director: Donald Malton. Retail gallery. Estab. 1974. Represents about 75 emerging, mid-career and established artists. Exhibits 12 artists/year. Exhibited artists include Kendall Jan Jubb and Barbara Young. Sponsors 6 shows/year. Average display time 1 month. Open all year; Monday-Saturday, 10-5. Located in high income neighborhood shopping district. 1,700 sq. ft. "Friendly, non-intimidating environment." Two person shows alternate with display of gallery artists. Clientele: private and corporate. Overall price range: $250-10,000; most work sold at $400-2,500.

Media: Considers oil, acrylic, drawing, sculpture, watercolor, mixed media, pastel, collage and original hand-pulled prints.

Style: Exhibits all styles. Genres include landscapes, florals and figurative work.

Terms: Accepts work on consignment (50% commission). Retail price set by artist (sometimes in consultation with gallery). Gallery provides insurance, promotion, contract and shipping costs from gallery; artist pays shipping costs to gallery. Prefers framed works for canvas; unframed works for paper.

Submissions: Send query letter with résumé, slides or photographs, reviews, bio and SASE. Replies in 2-4 weeks. Files résumé, review or any printed material. Slides and photographs are returned.

Tips: "Never drop in without an appointment. Be prepared and professional in presentation. This is a business. Artists themselves should be aware of what is going on, not just in the 'art world,' but with everything."

THE MIDDLETOWN FINE ARTS CENTER, 130 N. Verity Pkwy., P.O. Box 441, Middletown OH 45042. (513)424-2416. Contact: Peggy Davish. Nonprofit gallery. Estab. 1957. Represents emerging, mid-career and established artists. Sponsors 5 solo and/or group shows/year. Average display time 3 weeks. Clientele: tourists, students, community. 95% private collectors, 5% corporate clients. Overall price range: $100-1,000; most work sold at $150-500.

Media: Considers all media except prints. Most frequently exhibits watercolor, oil, acrylic and drawings.

Style: Exhibits all styles and genres. Prefers realism, impressionism and photorealism. "Our gallery does not specialize in any one style or genre. We offer an opportunity for artists to exhibit and hopefully sell their work. This also is an important educational experience for the community. Selections are chosen 2 years in advance by a committee."

Terms: Accepts work on consignment (30% commission). Retail price set by artist. Sometimes offers customer discounts and payment by installment. Exclusive area representation not required. Gallery provides insurance and promotion; artist pays for shipping. Artwork must be framed and wired.

Submissions: Send query letter with résumé, brochure, slides, photographs and bio. Write for an appointment to show portfolio, which should include originals, slides or photographs. Replies in 3 weeks-3 months (depends when exhibit committee meets.). Files résumé or other printed material. All material is returned if not accepted or under consideration.

Tips: Finds artists through word of mouth, artists' submissions and self promotions. "Decisions are made by a committee of volunteers, and time may not permit an on-the-spot interview with the director."

MILLER GALLERY, 2715 Erie Ave., Cincinnati OH 45208. (513)871-4420. Fax: (513)871-4429. Co-Directors: Barbara and Norman Miller. Retail gallery. Estab. 1960. Interested in emerging, mid-career and established artists. Represents about 50 artists. Sponsors 5 solo and 4 group shows/year with display time 1 month. Located in affluent suburb. Clientele: private collectors. Overall price range: $100-25,000; most artwork sold at $300-10,000.

• The gallery has added 500 square feet of exhibition space, a 400 sq. ft. room, more storage space, and another display window on the street (store adjacent moved).

Media: Considers, oil, acrylic, mixed media, collage, works on paper, ceramic, fiber, glass and original handpulled prints. Most frequently exhibits oil or acrylic, glass and sculpture.

Style: Exhibits impressionism, realism and painterly abstraction. Genres include landscapes, interior scenes and still lifes. "Everything from fine realism (painterly, impressionist, pointilist, etc.) to beautiful and colorful abstractions (no hard-edge) and everything in between. Also handmade paper, collage, fiber and mixed mediums."

Terms: Accepts artwork on consignment (50% commission). Retail price set by artist and gallery. Sometimes offers payment by installment. Exclusive area representation is required. Gallery provides insurance, promotion and contract; shipping and show costs are shared.

Submissions: Send query letter with résumé, brochure, slides or photographs with sizes, wholesale (artist) and selling price and SASE. "Material of interest is filed or is returned by SASE."

Tips: Finds artists through agents, visiting exhibitions, word of mouth, various art publications and sourcebooks, artists' submissions/self-promotions, art collectors' referrals, and *Artist's and Graphic Designer's Market.* "Artists often either completely omit pricing info or mention a price without identifying their percentages or selling price."

‡REINBERGER GALLERIES, CLEVELAND INSTITUTE OF ART, 11141 E. Blvd., Cleveland OH 44106. (216)421-7407. Fax: (216)421-7438. Director: Bruce Checefsky. Nonprofit gallery, college. Estab. 1882. Represents established artists. 8 gallery committee members. Sponsors 9 shows/year. Average display time 4-6 weeks. Open all year; Sunday 1-4, Monday 9-4, Tuesday-Saturday, 9:30-9. Located University Circle; 5,120 sq. ft.; largest independant exhibit facility in Cleveland (for college or university). 100% of space for special exhibitions. Clientele: students, faculty and community at large. 80% private collectors, 30% corporate collectors. Overall price range: $50-75,000; most work sold under $1,000.

Media: Considers all media. Most frequently exhibits prints, drawings, paintings, sculpture, installation, fiber and experimental.

Style: Exhibits all styles, all genres.

Terms: 15% commission. Retail price set by the artist. Gallery provides insurance, promotion, contract and shipping costs.

Submissions: Send query letter with résumé, slides, bio, photographs, SASE and reviews. Call or write for appointment to show portfolio of originals, photographs, slides and transparencies. Replies in 6 months. Files bio and slides when applicable.

© 1992 M. Todd Muskopf

Landscape #86, by M. Todd Muskopf, "was painted on an early fall morning just after the fog had risen. There was a fresh crisp feeling about the lake that day," says the artist, who paints on site. His collection of landscapes in oil were shown at Rutledge Gallery in Dayton.

‡RUTLEDGE GALLERY, 1964 N. Main St., Dayton OH 45405. (513)278-4900. Director: Jeff Rutledge. Retail gallery, art consultancy. Estab. 1991. Represents 80 emerging and mid-career artists/year. Exhibited artists include Pat Antonic, Chris Shatzby and M. Todd Muskopf. Sponsors 12 shows/year. Average display time 2 months. Open all year; Tuesday-Saturday, 11-6. Located 1 mile north of downtown in Dayton's business

district; 2800 sq. ft. "We specialize in sculpture and regional artists. We also offer commissioned work and custom framing." 70% of space for special exhibitions; 70% of space for gallery artists. Clientele: residential, corporate, private collectors, institutions. 65% private collectors, 35% corporate collectors.

Media: Considers oil, acrylic, watercolor, pastel, pen & ink, drawing, mixed media, paper, sculpture, ceramic, craft, glass, jewelry, woodcuts, engraving, lithographs, linocuts, etchings and posters. Most frequently exhibits paintings, drawings, prints and sculpture.

Style: Exhibits expressionism, painterly abstraction, surrealism, color filed, impressionism and realism. Considers all genres. Prefers contemporary (modern), geometric and abstract.

Terms: Accepts work on consignment (40% commission). Retail price set by gallery. Gallery provides insurance, promotion and contract; artist pays shipping costs. Prefers artwork framed.

Submissions: Send query letter with résumé, brochure, slides and photographs. Call for appointment to show portfolio of originals, photographs, slides and transparencies. Replies only if interested within 1 month. Files "only material on artists we represent; others returned if SASE is sent or thrown away."

Tips: "Be well prepared, be professional, be flexible on price and listen."

‡**SPACES**, 2220 Superior Viaduct, Cleveland OH 44113. (216)621-2314. Alternative space. Estab. 1978. Represents emerging artists. Has 300 members. Sponsors 10 shows/year. Average display time 1 month. Open all year. Located downtown Cleveland; 6,000 sq. ft.; "loft space with row of columns." 100% private collectors.

Media: Considers all media. Most frequently exhibits installation, painting and sculpture.

Style: Exhibits all styles.

Terms: 20% commission. Retail price set by the artist. Sometimes offers payment by installment. Gallery provides insurance, promotion and contract.

Submissions: Send query letter with résumé, slides and SASE. Annual deadline in spring for submissions.

‡**THE ZANESVILLE ART CENTER**, 620 Military Rd., Zanesville OH 43701. (614)452-0741. Fax: (614)452-0741. Director: Charles Dietz Ph.D. Nonprofit gallery, museum. Estab. 1936. Represents emerging, mid-career and established artists. "We usually hold 3 exhibitions per month." Sponsors 25-30 shows/year. Average display time 1 month. Open all year; daily 1-5; closed Mondays and major holidays. Located edge of town; 1,152 sq. ft. 50% of space for special exhibitions; 50% of space for gallery artists. Clientele: artists of distinguished talent. 25% private collectors, 25% corporate collectors. Overall price range: $25-5,000; most work sold at $300-600.

Media: Considers all media and all types of prints including mono prints. Most frequently exhibits water media, oil, collage, ceramics, sculpture and children's art.

Style: Exhibits expressionism, neo-expressionism, painterly abstraction, all styles, impressionism, photorealism, realism. Genres include landscapes, florals, Americana, figurative non-objective work, all genres.

Terms: Accepts work on consignment (15% commission on sales). Retail price set by the artist. Gallery provides insurance and promotion; artist responsible for shipping costs to and from gallery. Prefers artwork framed.

Submissions: Send query letter with résumé, slides, bio, brochure, photographs and reviews. Call or write for appointment to show portfolio of originals, photographs, slides, bio or résumé. Replies in 2 weeks. Artist should follow up after query letter or appointment. Files bio or résumé.

Tips: Finds artists through visiting exhibitions, word of mouth, various art publications, artists' submissions.

Oklahoma

CARRIAGE HOUSE GALLERIES, 402 N. Kemp, Tishomingo OK 73460. (405)371-3814. Owner/Director: Melody Johnson. Retail gallery, art supply shop, formal instruction space. Estab. 1991. Represents 14 artists. Exhibited artists include Helen Hooser, SWS; Ruth Hastings, SWS; Polly Erzinger, SWS; and Aurthor Terry. Sponsors 2 shows/year. Open all year. Located on Hwy. 377 & 99 in a small town; 650 sq. ft.; "rock face structure, newly remodeled with lots of personality – quaint feeling." 60% of space for work of gallery artists. Overall price range $200-300; most work sold at $40-300.

Media: Considers oil, acrylic, watercolor, pastel, pen & ink, drawings, mixed media, works on paper, sculpture, ceramic, glass, posters, linocuts and etchings. Most frequently exhibits watercolor, oil and ceramics.

Style: Genres include landscapes, florals, Americana, Western and wildlife. Prefers realism, impressionism and color field.

Terms: Accepts work on consignment (30% commission). Retail price set by gallery. Customer discounts and payment by installment available. Gallery provides insurance and promotion; artist pays for shipping. Prefers artwork framed.

Submissions: Send query letter with résumé, slides, brochure and photographs. Portfolio review requested if interested in artist's work. Portfolio should include originals, slides and photographs.

Tips: Finds artists through visiting exhibitions and word of mouth.

FIREHOUSE ART CENTER, 444 S. Flood, Norman OK 73069. (405)329-4523. Contact: Gallery Committee. Nonprofit gallery. Estab. 1971. Exhibits emerging, mid-career and established artists. 400 members. Sponsors

10-12 group and solo shows/year. Average display time 3-4 weeks. Open all year. Located in former fire station; 629.2 sq. ft. in gallery; consignment sales gallery has additional 120 sq. ft. display area; handicapped accessible community art center offering fully equipped ceramics, painting, sculpture, jewelry and fiber studios plus b&w photography lab. Classes and workshops for children and adults are offered quarterly. Clientele: 99% private collectors, 1% corporate collectors.
Media: Most frequently exhibits functional and decorative ceramics and sculpture, jewelry and wood.
Style: All styles and fine crafts. All genres. Prefers realism and impressionism.
Terms: Accepts work on consignment (35% commission). Offers discounts to gallery members. Gallery provides insurance and promotion for gallery exhibits and consignment sales; artist pays for shipping. Prefers artwork framed.
Submissions: Accepts only artists from south central US. Send query letter with résumé, bio, artist's statement, 20 slides of current work and SASE. Portfolio review required. Replies in 4 months.
Tips: Finds artists through word of mouth, art publications, and art collector's referrals. "The Firehouse is a community art center and accepts work appropriate for display to all ages."

‡GALERIE EUROPA/FLYING COLOURS, 203 N. Main, Tulsa OK 74103. (918)592-2787. Fax: (918)592-7869. Owner: Amadeo Richardson. Retail gallery. Estab. 1992. Represents 40 emerging, mid-career and established artists/year. Exhibited artists include Bodo Kloes, Reinhard Wiedenbeck. Sponsors 6 shows/year. Average display time 1 month. Open all year; 2 locations; airport—Monday-Friday, 7-7; Saturday-Sunday, 10-6; downtown—Tuesday-Friday, 2-6; Saturday-Sunday, 2-5. Located in Tulsa International Airport and downtown; 2,000 sq. ft.; galleries housed in busy airport concourse and turn-of-the-century downtown building. Up to 70% of space for special exhibitions; up to 70% of space for gallery artists. Clientele: tourists, business people. 80% private collectors, 20% corporate collectors. Overall price range: $100-3,000; most work sold at $100-1,000.
Media: Considers oil, acrylic, watercolor, pastel, pen & ink, drawing, mixed media, collage, paper, sculpture, photography, all types of prints. Most frequently exhibits oil, mezzotint and photography.
Style: Exhibits expressionism, neo-expressionism, postmodern works and photorealism.
Terms: Accepts work on consignment (50% commission). Retail price set by the gallery and artist. Gallery provides insurance, promotion and contract; shipping costs are shared.
Submissions: "Art with European focus or relevance receives top consideration." Send query letter with résumé, slides, bio, brochure, photographs and reviews. Call or write for appointment to show portfolio of photographs and slides. Replies only if interested in 1 month. Files all material that is submitted.
Tips: Finds artists through visiting exhibits, artist's contact. "Local artists are more likely to get accepted at our airport location. European influenced work is desired downtown."

‡GUSTAFSON GALLERY, 9606 N. May, Oklahoma City OK 73120. (405)751-8466. President: Diane. Retail gallery. Estab. 1973. Represents 15 mid-career artists. Exhibited artists include D. Norris Moses and Downey Burns. Sponsors 1 show/year. Average display time 2 months. Open all year. Located in a suburban mall; 1,800 sq. ft. 100% of space for special exhibitions. Clientele: upper and middle income. 60% private collectors, 40% corporate collectors. Overall price range: $4,000 maximum.
Media: Considers oil, acrylic, pastel, mixed media, collage, works on paper, sculpture, ceramic, fiber, offset reproductions, lithographs, posters and serigraphs. Most frequently exhibits acrylic, pastel and serigraphs.
Style: Exhibits primitivism and painterly abstraction. Genres include landscapes, Southwestern and Western. Prefers contemporary Southwestern art.
Terms: Artwork is accepted on consignment (40% commission); or buys outright for 50% of the retail price; net 30 days. Retail price set by the the artist. Gallery provides promotion; Shipping costs are shared.
Submissions: Send query letter with résumé, brochure, photographs, business card and reviews. Call to schedule an appointment to show a portfolio, which should include originals and photographs. Replies in 1 month.

‡FRED JONES JR. MUSEUM OF ART, THE UNIVERSITY OF OKLAHOMA, (formerly The University of Oklahoma Museum of Art), 410 W. Boyd St., Norman OK 73019-0525. (405)325-3272. Director: Thomas R. Toperzer. Museum. Estab. 1936. Represents emerging, mid-career and established artists. Exhibited artists include Jesus Morales and Joe Andoe. Sponsors 6-8 shows/year. Average display time 4-6 weeks. Open all year; Tuesday, Wednesday, Friday 10-4:30; Thursday 10-9; Saturday and Sunday 1-4:30. Located on campus; 13,000 sq. ft.; large exhibition space. 50% of space for special exhibitions; 50% of space for permanent collection.
Media Considers all media and all types of prints. Most frequently exhibits paintings, sculptures and photographs.
Style: Exhibits all styles.
Terms: Gallery provides insurance, promotion and contract.
Submissions: "We do not 'represent' artists, only exhibit work." Send query letter with slides. Write for appointment to show portfolio of photographs and slides. Replies only if interested.
Tips: Finds artists through visiting exhibitions, word of mouth and artists' submissions.

‡**LACHENMEYER ARTS CENTER,** 700 S. Little, P.O. Box 586, Cushing OK 74023. (918)225-7525. Director: Rob Smith. Nonprofit gallery. Estab. 1984. Represents 35 emerging and mid-career artists/year. Exhibited artists include Dale Martin. Sponsors 4 shows/year. Average display time 2 weeks. Open in August, September, December, Monday, Wednesday, Friday, 9-5; Tuesday, Thursday, 5-9; Saturday, 9-12. Located inside the Cushing Youth and Community Center; 550 sq. ft. 80% of space for special exhibitions; 80% of space for gallery artists. 100% private collectors.
Media: Considers oil, acrylic, watercolor, pastel, pen & ink, drawing, mixed media, collage, paper, sculpture, ceramics, fiber, photography, woodcut, engraving, lithograph, wood engraving, mezzotint, serigraphs, linocut and etching. Most frequently exhibits oil, acrylic and works on paper.
Style: Exhibits all styles. Prefers landscapes, portraits and Americana.
Terms: Accepts work on consignment (0% commission). Retail price set by the artist. Gallery provides promotion; shipping costs are shared. Prefers artwork framed.
Submissions: Send query letter with résumé, slides, SASE and reviews. Call or write for appointment to show portfolio of originals. Replies in 1 month. Files résumés.
Tips: Finds artists through visiting exhibits, word of mouth, other art organizations. "We are booked 1-2 years in advance."

‡**NO MAN'S LAND MUSEUM,** P.O. Box 278, Goodwell OK 73939-0278. (405)349-2670. Fax: (405)349-2302. Director: Kenneth R. Turner. Museum. Estab. 1934. Represents emerging, mid-career and established artists. Sponsors 12 shows/year. Average display time 1 month. Open all year; Tuesday-Saturday, 9-12 and 1-5. Located adjacent to university campus. 10% of space for special exhibitions. Clientele: general, tourist. 100% private collectors. Overall price range: $20-1,500; most work sold at $20-500.
Media: Considers all media and all types of prints. Most frequently exhibits oils, watercolors and pastels.
Style: Exhibits primitivism, impressionism, photorealism and realism. Genres include landscapes, florals, Americana, Southwestern, Western and wildlife. Prefers realist, primitive and impressionist.
Terms: "Sales are between artist and buyer; museum does not act as middleman." Retail price set by the artist. Gallery provides promotion and shipping costs to and from gallery. Prefers artwork framed.
Submissions: Send query letter with résumé, brochure, photographs and reviews. Call or write for appointment to show portfolio of photographs. Replies only if interested within 3 weeks. Files all material.
Tips: Finds artists through art publications, exhibitions, news items, word of mouth.

‡**THE WINDMILL GALLERY,** Suite 103, 3750 W. Robinson, Norman OK 73072. (405)321-7900. Director: Andy Denton. Retail gallery. Estab. 1987. Represents 20 emerging, mid-career and established artists. Exhibited artists include Rance Hood and Doc Tate Neuaquaya. Sponsors 4 shows/year. Average display time 1 month. Open all year. Located in northwest Norman (Brookhaven area); 900 sq. ft.; interior decorated Santa Fe style: striped aspen, adobe brick, etc. 30% of space for special exhibitions. Clientele: "middle-class to upper middle-class professionals/housewives." 100% private collectors. Overall price range $50-15,000; most artwork sold at $100-2,000.
Media: Considers oil, acrylic, watercolor, pastel, pen & ink, drawings, mixed media, works on paper, sculpture, craft, original handpulled prints, offset reproductions, lithographs, posters, cast-paper and serigraphs. Most frequently exhibits watercolor, tempera and acrylic.
Style: Exhibits primitivism and realism. Genres include landscapes, Southwestern, Western, wildlife and portraits. Prefers Native American scenes (done by Native Americans), portraits and Western-Southwestern and desert subjects.
Terms: Artwork is accepted on consignment (40% commission). Retail price set by the artist. Customer discounts and payment by installments available. Gallery provides insurance and promotion. Shipping costs are shared. Prefers framed artwork.
Submissions: Send query letter with slides, bio, brochure, photographs, SASE, business card and reviews. Replies only if interested within 1 month. Portfolio review not required. Files brochures, slides, photos, etc.
Tips: Finds artists through agents, visiting exhibitions, word of mouth, art publications and sourcebooks, artists' submissions/self-promotions and art collectors' referrals. Accepts artists from Oklahoma area; Indian art done by Indians only. "Call, tell me about yourself, try to set up appointment to view works or to hang your works as featured artist. Fairly casual—but must have bios and photos of works or works themselves! Please, no drop-ins!"

 The double dagger before a listing indicates that the listing is new in this edition. New markets are often more receptive to freelance submissions.

Oregon

‡**APPLERIDGE ART GALLERY AND FLORES FIOL STUDIO**, 36250 SE Douglass Rd., Eagle Creek OR 97022. (503)637-3373. Director: Lynn Butler. Retail/wholesale/rental gallery. Estab. 1988. Represents 7 emerging, mid-career and established artists/year. Exhibited artists include Flores Fiol, Lynn Butler Flores. Sponsors 7-10 shows/year. Average display time 3 weeks. Open all year; daily, 10-4:30 "unless we are having a show in Hawaii." It is the last gallery before the Cascades Mountains; 1,000 sq. ft. 15% of space for special exhibitions; 100% of space for gallery artists. Clientele: Europeans, and Americans from all over the USA including Hawaii (also clients from Japan, Singapore, etc.). 20% private collectors, 10% corporate collectors. Overall price range: $200-7,000; most work sold at $780.
Media: Considers oil, watercolor, mixed media and paper. Most frequently exhibits oils, watercolors.
Styles: Exhibits primitivism, all styles, impressionism. Genres include landscapes, florals, Americana, Southwestern and portraits. Prefers impressionism.
Terms: Accepts work on consignment (40% commission). Retail price set by the artist. Gallery provides insurance, promotion and contract; artist pays shipping costs to and from gallery. Prefers artwork framed.
Submissions: Prefers oils, watercolors. Send query letter with SASE. Write for appointment to show portfolio of photographs. Files catalogs.
Tips: Finds artists through exhibitions. "Good presentation and quality framing is a must."

ARTWORKS GALLERY, P.O. Box 216, 175 Second St., Bandon OR 97411. (503)347-9358. Manager: Linda Montgomery. Retail gallery. Estab. 1992. Represents 85 emerging, mid-career and established artists. Sponsors 2 shows/year. Average display time 3 months. Open all year; 7 days a week, 10-6. Located in "Old Town" along waterfront near ocean; 1,200 sq. ft. 30% of space for special exhibitions; 70% of space for gallery artists. Clientele: tourists. 80% private collectors, 20% corporate collectors. Most work sold at $30-250.
Media: Considers oil, acrylic, watercolor, pastel, pen & ink, mixed media, collage, paper, sculpture, ceramic, fiber, glass, batik and all types of prints. Most frequently exhibits pottery, woodworking and watercolors.
Style: Exhibits all styles. Includes all genres with particular emphasis on ocean themes.
Terms: 40% commission. Retail price set by gallery or artist. Customer discounts and payment by installments are available. Gallery provides contract; shipping costs are shared. Prefers artwork framed.
Submissions: Send query letter with résumé, slides, bio, photographs, business card and reviews. Replies in 2 weeks. Portfolio review not required. Files all material if interested.
Tips: Finds artists through agents, visiting exhibitions, word of mouth, art publications and source books, artists' submissions/self-promotions, art collectors' referrals. "We look for quality art that is unique. New and emerging artists don't worry about long résumés. Just make sure your presentation of your art is well prepared."

BLACKFISH GALLERY, 420 NW 9th Ave., Portland OR 97209. (503)224-2634. Director: Cheryl Snow. Retail cooperative gallery. Estab. 1979. Represents 24 emerging and mid-career artists. Exhibited artists include Carolyn Wilhelm and Stephan Soihl. Sponsors 12 shows/year. Open all year. Located downtown, in the "Northwest Pearl District; 2,500 sq. ft.; street-level, 'garage-type' overhead wide door, long, open space (100' deep)." 70% of space for feature exhibits, 15-20% for gallery artists. Clientele: 80% private collectors, 20% corporate clients. Overall price range: $250-12,000; most artwork sold at $900-1,400.
Media: Considers oil, acrylic, watercolor, pastel, pen & ink, drawings, mixed media, collage, sculpture, ceramic, photography, woodcuts, wood engravings, linocuts, engravings, mezzotints, etchings, lithographs, pochoir and serigraphs. Most frequently exhibits paintings, sculpture and prints.
Style: Exhibits expressionism, neo-expressionism, painterly abstraction, surrealism, conceptualism, minimalism, color field, postmodern works, impressionism and realism. Prefers neo-expressionism, conceptualism and painterly abstraction.
Terms: Accepts work on consignment from invited artists (50% commission); co-op membership includes monthly dues plus donation of time (40% commission on sales). Retail price set by artist with assistance from gallery on request. Customer discounts and payment by installment are available. Gallery provides insurance, promotion and contract, and shipping costs from gallery. Prefers artwork framed.
Submissions: Accepts only artists from northwest Oregon and southwest Washington ("unique exceptions possible"); "must be willing to be an active cooperative member—write for details." Send query letter with résumé, slides, SASE, reviews and statement of intent. Write for appointment to show portfolio of photographs and slides. "We review throughout the year." Replies in 1 month. Files material only if exhibit invitation extended.
Tips: Finds artists through agents, visiting exhibitions, word of mouth, various art publications and source-books, artists' submissions/self-promotions and art collectors' referrals. "Understand—via research—what a cooperative gallery is. Call or write for information packet. Do not bring work or slides to us without first having contacted us by phone or mail."

‡**BUSH BARN ART CENTER**, 600 Mission St. SE, Salem OR 97302. (503)581-2228. Gallery Director: Peter Held. Nonprofit gallery. Represents 125 emerging, mid-career and established artists/year. Sponsors 18 shows/year. Average display time 5 weeks. Open all year; Tuesday-Friday, 10-5; Saturday-Sunday, 1-5. Lo-

cated near downtown in an historic park near Mission and High Streets in a renovated historic barn—the interior is very modern. 50% of space for special exhibitions; 50% of space for gallery artists. Overall price range: $10-2,500.
Media: Considers oil, acrylic, watercolor, pastel, pen & ink, drawing, mixed media, collage, paper, sculpture, ceramics, fiber, glass, installation, photography, all types of prints.
Style: Exhibits all styles.
Terms: Accepts work on consignment (40% commission). Gallery provides contract. Prefers artwork framed.
Submissions: Send query letter with résumé, slides and bio. Write for appointment.

WILSON W. CLARK MEMORIAL LIBRARY GALLERY, 5000 N. Willamette Blvd., Portland OR 97203-5798. (503)283-7111. Fax: (503)283-7491. Director: Joseph P. Browne. Nonprofit gallery. Estab. 1959. Interested in emerging and established artists. Sponsors 7 solo and 4 group shows/year. Average display time 1 month. Clientele: students and faculty. Overall price range: $75-750.
Media: Considers oil, acrylic, watercolor, pastel, pen & ink, drawings, mixed media, collage, photography and prints. Most frequently exhibits watercolor, acrylics and mixed media.
Style: Exhibits all styles and genres.
Terms: Accepts work on consignment (10% commission). Retail price set by artist. "We are strictly an adjunct to the University library and have sold only 1 work in the past 8 or 10 years." Exclusive area representation not required. Gallery provides insurance and promotion.
Submissions: Send query letter, résumé, brochure and photographs. Write for appointment to show portfolio of photographs.

COGLEY ART CENTER, 4035 South Sixth St., Klamath Falls OR 97603. (503)884-8699. Owner/Manager: Sue Cogley. Retail gallery. Estab. 1985. Represents 17 emerging and mid-career artists. Exhibited artists include Katheryn Davis, Guy Pederson, Stacy Smith Rowe, Tom Cogley and Suzanne Cogley. Sponsors 2 major shows and 3-4 smaller "feature" shows/year. "Display time is ongoing." Open all year. Located in a suburban area on the main business street; 800 sq. ft.; "contemporary in feeling—all wall space (no windows), movable panels and track lighting." 25% of space for special exhibitions. Clientele: middle to upper end. 100% private collectors. Overall price range: $150-1,500; most work sold at $300-1,200.
Media: Considers oil, acrylic, watercolor, pastel, pen & ink, drawings, mixed media, collage, works on paper, sculpture, ceramic, fiber, glass, mosaic, original handpulled prints, woodcuts, etchings and serigraphs. Most frequently exhibits watercolor, oil, monotype and glass.
Style: Exhibits all styles, "leaning toward contemporary." Prefers impressionism, painterly abstraction and contemporary realism. "We are not locked into any subject, media or style. Rather we look for an emotional response and involvement of the artist in the work, a creative, innovative, spontaneous approach, not "a story of hard work."
Terms: Accepts work on consignment (40% commission). Retail price set by artist. Customer discounts and payment by installment are available. Gallery provides insurance, promotion and contract; artist pays for shipping. Prefers artwork framed, "but we can work with unframed."
Submissions: "Quality of work is more important than artist's location." Send query letter with current bio and high-quality photographs or slides (a minimum of 3 pieces) and SASE. Portfolio review requested if interested in artist's work. Files bio and photos of artists of future interest.
Tips: "Some of our artists have been found by seeing their work in galleries in other areas, some by word of mouth, some by submissions to a locally held national juried show, and some by artists' submissions. Our space is limited but if we find an artist we are excited about we will make room. Presently we need additional artists working in fine crafts."

‡EMU GALLERY, University of Oregon, % Emu Cultural Forum, University of Oregon, 1222 E. 13th, Eugene OR 97403. (503)346-4373. Fax: (503)346-4400. Contact: Visual Arts Coordinator. Nonprofit gallery. Represents emerging, mid-career and established artists, 1 artist at a time. Exhibited artists include Jeanne Jackson, Laura Willits. Sponsors 12 shows/year. Average display time 1 month. Open all year; Monday-Friday 8-6. Located on the University of Oregon campus; 800 sq. ft.; unsupervised (but alarmed) space with glass cases. Clientele: students and professionals.
Media: Considers all media, all types of prints. Most frequently exhibits photography, painting and mixed media.
Style: Exhibits all styles, all genres.
Terms: "There are no fees or commissions." Retail price set by the artist. Gallery provides insurance and promotion; shipping costs are shared.
Submissions: Send query letter with résumé, slides, bio, photographs and SASE. Write for appointment to show portfolio of photographs, slides and transparencies. Replies only if interested within 1 month. Files reference material from shows.
Tips: Finds artists through word of mouth, artists' submissions.

THE MAUDE KERNS ART CENTER, 1910 E. 15th Ave., Eugene OR 97403. (503)345-1571. Artistic Director: Nancy Frey. Nonprofit gallery. Estab. 1963. Exhibits hundreds of emerging, mid-career and established

artists. Interested in seeing the work of emerging artists. 650 members. Sponsors 8-10 shows/year. Average display time 6 weeks. Open all year. Located in church bulding on Historic Register. 4 renovated galleries with over 2,000 sq. ft. of modern exhibit space. 100% of space for special exhibitions. Clientele: 50% private collectors, 50% corporate collectors. Overall price range: $200-20,000; most work sold at $500-1,000.
Media: Considers all media and original handpulled prints. Most frequently exhibits oil/acrylic, mixed media and sculpture.
Style: Contemporary artwork.
Terms: Accepts work on consignment (40% commission). Retail price set by artist. Offers customer discounts and payment by installments. Gallery provides insurance and contract; artist pays for shipping. Prefers artwork framed.
Submissions: Send query letter with résumé, slides, bio and SASE. Call for appointment to show portfolio of photographs, slides and transparencies. Files slide bank, résumé and statement.
Tips: Finds artists through "Calls to Artists," word of mouth, and local arts council publications. "Call first! Come visit to see exhibits and think about whether the gallery suits you."

LANE COMMUNITY COLLEGE ART GALLERY, 4000 E. 30th Ave., Eugene OR 97405. (503)747-4501. Gallery Director: Harold Hoy. Nonprofit gallery. Estab. 1970. Exhibits the work of emerging, mid-career and established artists. Sponsors 7 solo and 2 group shows/year. Average display time 3 weeks. Most work sold at $100-2,000.
Media: Considers all media.
Style: Exhibits contemporary works. Interested in seeing "contemporary, explorative work of quality. Open in terms of subject matter."
Terms: Retail price set by artist. Sometimes offers customer discounts. Exclusive area representation not required. Gallery provides insurance, promotion and contract; shipping costs are shared. "We retain 25% of the retail price on works sold."
Submissions: Send query letter, résumé and slides with SASE. Portfolio review required. Resumes are filed.

LAWRENCE GALLERY, Box 187, Sheridan OR 97378. (503)843-3633. Director: Gary Lawrence. Retail gallery and art consultancy. Estab. 1977. Represents 150 emerging, mid-career and established artists. Sponsors 7 two-person and 1 group shows/year. "We have developed a landscaped sculpture garden adjacent to the gallery building, in which we are showing sculpture." Clientele: tourists, Portland and Salem residents. 80% private collectors, 20% corporate clients. Overall price range: $10-50,000; most work sold at $1,000-5,000.
Media: Considers oil, acrylic, watercolor, pastel, pen & ink, drawings, mixed media, collage, sculpture, ceramic, fiber, glass, jewelry and original handpulled prints. Most frequently exhibits oil, watercolor, metal sculpture and ceramic.
Style: Exhibits painterly abstraction, impressionism, photorealism and realism. Genres include landscapes, florals and Americana. "Our gallery features beautiful art-pieces that celebrate life."
Terms: Accepts work on consignment (50% commission). Retail price set by artist. Offers payment by installments. Exclusive area representation required. Gallery provides insurance, promotion and contract; artist pays for shipping.
Submissions: Send query letter, résumé, brochure, slides and photographs. Portfolio review required if interested in artists' work. Files résumés, photos of work, newspaper articles, other informative pieces and artist's statement.
Tips: Find artists through agents, visiting exhibitions, word of mouth, art publications and sourcebooks, artists' submissions/self-promotions, art collectors' referrals. "Do not bring work without an appointment."

‡MINDPOWER GALLERY, 417 Fir Ave., Reedsport OR 97467. (503)271-2485. Manager: Tamara Szalewski. Retail gallery. Estab. 1989. Represents 21 emerging and mid-career artists/year. Exhibited artists include Rose Szalewski, Jean McKendree. Sponsors 12 shows/year. Average display time 6-12 months. Open all year; Tuesday-Saturday, 10-6, November 1-May 29; open 7 days a week (same hours) Memorial Day to Halloween. Located in "Oldtown" area—front street is Hwy. 38; 5,000 sq. ft.; 8 rooms with 500' of wall space. 20% of space for special exhibitions; 80% of space for gallery artists. Clientele: ⅓ from within 90 miles, ⅓ from state, ⅓ travelers. 100% private collectors. Overall price range: $50-7,500; most work sold at $100-2,500.
Media: Considers oil, acrylic, watercolor, pastel, mixed media, paper, sculpture, all types of prints. Most frequently exhibits, sculpture, acrylic/oil, watercolor, pastel.
Style: Exhibits all styles, all genres. "We pride ourselves on having the choicest selection of fine art and work hard at maintaining a wide selection of art styles."
Terms: Accepts work on consignment (33⅓% commission). Retail price set by the artist. Gallery provides promotion and contract; artist pays shipping costs to and from gallery. Prefers artwork framed or shrink-wrapped.
Submissions: "Preference given to local artists over other artists with same style." Send query letter with résumé, slides, photographs. "Artist selection committee meets to review photos/slides with résumés on 20th of every month." Replies 1 week after review on the 20th of the month. Files résumés.
Tips: Finds artists through artists' submissions, visiting exhibitions, word of mouth.

‡**RICKERT ART CENTER AND GALLERY,** 620 N. Hwy. 101, Lincoln City OR 97367. (503)994-0430. Fax: (503)1-800-732-8842. Manager/Director: Lee Lindberg. Retail gallery. Represents more than 20 emerging, mid-career and established artists/year. Exhibited artists include Sharon Rickert, Nikki Lindner. Sponsors 7 shows/year. Average display time 1 week. Open all year; daily, 9:30-5:30. Located south end of town on main street; 2,300 sq. ft.; 50-year-old building. 20% of space for special exhibitions; 60% of space for gallery artists. Overall price range: $200-6,000; most work sold at $800-3,000.
Media: Considers oil, acrylic, watercolor, pastel, pen & ink, mixed media, sculpture, photography, lithograph, serigraphs and posters. Most frequently exhibits oil, acrylic, watercolor and pastel.
Style: Exhibits all styles. Genres include landscapes, florals, Southwestern, Western, wildlife, portraits, figurative work, seascapes. Prefers seascapes, florals, landscapes.
Terms: Accepts work on consignment (50% commission). Retail price set by the gallery or the artist. Gallery provides promotion; artist pays shipping costs to and from gallery. Prefers artwork unframed.
Submissions: Send query letter with résumé and photographs. Call or write for appointment to show portfolio of originals. Artist should follow up with call.

‡**ROGUE GALLERY,** 40 S. Bartlett, Medford OR 97501. (503)772-8118. Executive Director: Nancy Jo Muller. Nonprofit rental gallery. Estab. 1961. Represents emerging, mid-career and established artists. Sponsors 8 shows/year. Average display time 6 weeks. Open all year; Tuesday-Friday 10-5, Saturday 10-4. Located downtown; main gallery 240 running ft. (2,000 sq. ft.); rental/sales and gallery shop, 1,800 sq. ft.; classroom facility, 1,700 sq. ft. "This is the only gallery/art center/exhibit space of its kind in region, excellent facility, good lighting." 33% of space for special exhibitions; 33% of space for gallery artists. 95% private collectors. Overall price range: $100-5,000; most work sold at $300-600.
Media: Considers all media and all types of prints. Most frequently exhibits mixed media, drawing, painting, sculpture, watercolor.
Style: Exhibits all styles, all genres. Prefers figurative work, collage, landscape, florals.
Terms: Accepts work on consignment (35% commission). Retail price set by the artist. Gallery provides insurance, promotion and contract; in the case of main gallery exhibit, gallery assumes cost for shipping 1 direction, artist 1 direction.
Submissions: Send query letter with résumé, slides, bio and SASE. Call or write for appointment. Replies in 1 month.

Pennsylvania

‡**AFRO-AMERICAN HISTORICAL AND CULTURAL MUSEUM,** 701 Arch St., Philadelphia PA 19107. (215)574-0381. Fax: (215)574-3110. Director of Exhibitions: Richard Watson. Museum. Estab. 1976. Represents established artists. May be interested in seeing the work of emerging artists in the future. Exhibited artists include Louis Sloan, Paul Keene Jr. Sponsors 4 shows/year. Average display time 3 months. Open all year; Tuesday-Sunday. Located downtown; 8,000 sq. ft. 50% of space for special exhibitions; 50% of space for gallery artists.
Media: Considers all media, all types of prints. Most frequently exhibits painting, sculpture and photography.
Style: Exhibits all styles, all genres.
Terms: Gallery provides insurance, promotion, contract and shipping costs to and from gallery. Prefers artwork framed.
Submissions: Accepts only artists from the Delaware Valley region. Send query letter with résumé, slides and bio. Call or write for appointment to show portfolio of originals. Replies in 1 month. Files slides, résumés.
Tips: Finds artists through artists' submissions, etc.

ALBER GALLERIES, Suite 5111, 3300 Darby Rd., Haverford PA 19041. (215)896-9297. Owners: Howard and Elaine Alber. Wholesale gallery/art consultancy. Represents 33 emerging, mid-career and established artists. Clientele: 20% private collectors, 80% corporate clients, cooperating with affiliated galleries. Overall price range: $25-10,000; most work sold at $150-800.
Media: Considers oil, acrylic, watercolor, pastel, pen & ink, drawings, mixed media, collage, works on paper, sculpture, fiber, photography, woodcuts, wood engravings, linocuts, engravings, mezzotints, etchings, lithographs and serigraphs.
Style: Exhibits impressionism, realism, photorealism, minimalism, color field, painterly abstraction, conceptualism. Considers all styles. Genres include landscapes, Americana and figurative work. Prefers small sculpture, illustration, print editions or photographs for the slide registry. "We're a contributor to the sales and rental gallery of the Philadelphia Museum of Art."
Terms: Accepts work on consignment (40% commission). Retail price set by gallery and artist. Exclusive area representation not required.
Submissions: Presently, only accepting work requested by clients (search material).

‡**THE ART BANK,** 3028 N. Whitehall Rd., Norristown PA 19403-4403. Phone/Fax: (610)539-2265. Director: Phyllis Sunberg. Retail gallery, art consultancy, corporate art planning. Estab. 1985. Represents 40-50 emerg-

ing, mid-career and established artists/year. Exhibited artists include Lisa Fedon, Bob Koffler. Average display time 3-6 months. Open all year; by appointment only. Located in a Philadelphia suburb; 1,000 sq. ft.; Clientele: corporate executives and their corporations. 20% private collectors, 80% corporate collectors. Overall price range: $300-35,000; most work sold at $500-1,000.

Media: Considers oil, acrylic, watercolor, pastel, pen & ink, mixed media, collage, sculpture, glass, installation, holography, exotic material, lithography, serigraphs. Most frequently exhibits acrylics, serigraphs and sculpture.

Style: Exhibits expressionism, painterly abstraction, color field and hard-edge geometric abstraction. Genres include landscapes. Prefers color field, hard edge abstract and impressionism.

Terms: Accepts work on consignment (40% commission). Shipping costs are shared. Prefers artwork unframed.

Submissions: Prefers artists from the region (PA, NJ, NY, DE). Send query letter with résumé, slides, brochure, SASE and prices. Write for appointment to show portfolio of originals (if appropriate), photographs and corporate installation photos. Replies only if interested within 2 weeks. Files "what I think I'll use – after talking to artist and seeing visuals."

Tips: Finds artists through agents, by visiting exhibitions, word of mouth, art publications and sourcebooks, artists' submissions.

‡**CAT'S PAW GALLERY,** 31 Race St., Jim Thorpe PA 18229. (717)325-4041. Director/Owner: John and Louise Herbster. Retail gallery. Represents 100 emerging, mid-career and established artists/year. Exhibited artists include Shelley Buonaiuto, Nancy Giusti. Sponsors 1 or 2 shows/year. Average display time 1 month. Open all year; April-December, Wednesday-Sunday, 11-5; January-March, by chance or appointment. Located in historic downtown district; 400 sq. ft.; in one of 16 "Stone Row" 1848 houses built into mountainside. 40% of space for special exhibitions; 60% of space for gallery artists. Clientele: collectors, tourists, corporate. 50% private collectors. 5% corporate. Overall price range: $2-2,000; most work sold at $20-200.

Media: Considers oil, acrylic, watercolor, pastel, pen & ink, drawing, mixed media, collage, paper, sculpture, ceramics, craft, fiber, glass, original hand-pulled prints. Most frequently exhibits ceramics, sculpture and jewelry.

Style: Exhibits all styles. Only domestic feline subjects.

Terms: Accepts work on consignment (40% commission) or buys outright for 50% of retail price (net 30 days). "We usually purchase, except for major exhibits." Retail price set by the artist. Gallery provides insurance, promotion and contract; shipping costs are shared. Prefers artwork framed.

Submissions: Accepts artists from throughout the US ("please specify region"). Send query letter with résumé, slides or photographs, bio, brochure and reviews. Call or write for appointment to show portfolio of photographs. Replies only if interested within 1 week. Files all material of interest.

Tips: Finds artists through visiting exhibitions and trade shows, word of mouth, artists' submissions, collectors, art publications. "Submit only studio work depicting the domestic feline.We are not interested in cutsey items aimed at the mass market. We will review paintings and graphics, but are not currently seeking them."

‡**CENTER GALLERY OF BUCKNELL UNIVERSITY,** Elaine Langone Center, Lewisburg PA 17837. (717)524-3792. Fax: (717)524-3760. Assistant Director: Cynthia Peltier. Nonprofit gallery. Estab. 1983. Represents emerging, mid-career and established artists. Sponsors 6 shows/year. Average display time 6 weeks. Open all year; Monday-Friday, 11-6; Saturday-Sunday, 1-4. Located on campus; 3,000 sq. ft. plus 40 movable walls.

Media: Considers all media, all types of prints. Most frequently exhibits painting, prints and photographs.

Style: Exhibits all styles, all genres. Prefers landscape, Western, figurative.

Terms: Retail price set by the artist. Gallery provides insurance, promotion (local) and contract; artist pays shipping costs to and from gallery. Prefers artwork framed.

Submissions: Send query letter with résumé, slides and bio. Write for appointment to show portfolio of originals. Replies in 2 weeks. Files bio, résumé, slides.

Tips: Finds artists through occasional artist invitationals/competitions.

THE CLAY PLACE, 5416 Walnut St., Pittsburgh PA 15232. (412)682-3737. Fax: (412)681-1226. Director: Elvira Peake. Retail gallery. Estab. 1973. Represents 50 emerging, mid-career and established artists. Exhibited artists include Warren MacKenzie and Kirk Mangus. Sponsors 12 shows/year. Open all year. Located in small shopping area; "second level modern building with atrium." 2,000 sq. ft. 50% of space for special exhibition. Overall price range: $10-2,000; most work sold at $40-100.

● The Clay Place doubled its space by adding a showroom next door.

Media: Considers sculpture, ceramic, glass and craft. Most frequently exhibits clay, glass and enamel.

Terms: Accepts artwork on consignment (50% commission), or buys outright for 50% of retail price (net 30 days). Retail price set by artist. Sometimes offers customer discounts and payment by installments. Gallery provides insurance, promotion and shipping costs from gallery.

Submissions: Prefers only clay, some glass and enamel. Send query letter with résumé, slides, photographs, bio and SASE. Write for appointment to show portfolio. Portfolio should include actual work rather than slides. Replies in 1 month. Does not reply when busy. Files résumé.

Tips: Finds artists through visiting exhibitions and art collectors' referrals. "Functional pottery sells well. Emphasis on form, surface decoration. Some clay artists have lowered quality in order to lower prices. Clientele look for quality, not price."

‡**THE COMMUNITY GALLERY OF LANCASTER COUNTY,** 135 N. Lime St., Lancaster PA 17602. (717)394-3497. Executive Director: Ellen Rosenholtz. Assistant Director: Audra Thompson. Nonprofit gallery. Estab. 1965. Represents 12 emerging, mid-career and established artists/year. 500 members. Exhibited artists include Margrit Schmidtke, Tom Lacagnini. Sponsors 12 shows/year. Average display time 1 month. Open all year; Monday-Saturday 10-4; Sunday 12-4. Located downtown Lancaster; 4,000 sq. ft.; neoclassical architecture. 100% of space for special exhibitions. 100% of space for gallery artists. Clientele: children, upper middle class adults, retired adults, handicapped. 100% private collectors. Overall price range: $100-5,000; most work sold at $100-800.
Media: Considers all media, all types of prints. Most frequently exhibits watercolor, oil/acrylic, pen & ink/drawing.
Style: Exhibits primitivism, painterly abstraction, postmodern works, impressionism, photorealism and realism, all genres. Prefers painterly abstraction, realism and primitivism.
Terms: Accepts work on consignment (30% commission). Retail price set by the artist. Gallery provides insurance; shipping costs are shared. Prefers artwork framed.
Submissions: Send query letter with résumé, slides and photographs. Replies in 3 months. Files slides, résumé, artist's statement.
Tips: Finds artists through word of mouth, other galleries and "many times the artist will contact me first."

‡**DESIGN ARTS GALLERY,** College of Design Arts, Drexel University, Philadelphia PA 19104. (215)895-2386. Gallery Coordinator: Lydia Hunn. Nonprofit gallery. Exhibits the work of emerging, mid-career and established artists. Clientele: students, artists and Philadelphia community. Sponsors 5 solo and 3 group shows/year. Display time 1 month. 440 sq. ft.; "terrazzo floor, center glass door, first floor access."
Media: Considers all media.
Style: Exhibits all styles and genres. Prefers narrative, political and design oriented work. "Our gallery is a teaching tool for a design arts college whose students are instructed in visual communication. Our shows are designed to be the best examples of these categories."
Terms: Exclusive area representation not required. Offers customer discount. Gallery provides insurance and promotion. Prefers artwork framed.
Submissions: Send query letter with résumé, project description, slides and SASE in October for consideration for the following season. Portfolio review not required. All material is returned if not accepted or under consideration.
Tips: "Some work is simply too large for our limited space."

‡**EVERHART MUSEUM,** Nay Aug Park, Scranton PA 18510. (717)346-8370. Curator: Barbara Rothermel. Museum. Estab. 1908. Represents mid-career and established artists. Interested in seeing the work of emerging artists. 1,500 members. Sponsors 10 shows/year. Average display time 2-3 months. Open all year; Tuesday-Friday, 10-5; Saturday-Sunday, 12-5; closed Monday. Located in urban park; 300 linear feet. 20% of space for special exhibitions.
Media: Considers all media.
Style: Exhibits all styles, all genres. Prefers regional, Pennsylvania artists.
Terms: Gallery provides insurance, promotion and shipping costs. Prefers artwork framed.
Submissions: Send query letter with résumé, slides, bio, brochure and reviews. Write for appointment. Replies in 1-2 months. Files letter of query, selected slides or brochures, other information as warranted.
Tips: Finds artists through agents, by visiting exhibitions, word of mouth, art publications and sourcebooks, artists' submissions.

‡**THE FABRIC WORKSHOP AND MUSEUM,** 5th Floor, 1315 Cherry St., Philadelphia PA 19107. (215)922-7303. Fax: (215)922-3791. Founder/Artistic Director: Marion Boulton Stroud. Alternative space, nonprofit gallery, museum, museum sales shop. Estab. 1977. Exhibits emerging, mid-career and established artists. 15-20 artists participate in residency program per year; 8-10 exhibitions. Exhibited artists include Ann Hamilton, Felix Gonzalez-Torres. Average display time 1-3 months. Open all year; Monday-Friday 9-6, Saturday noon-4. Located Center City Philadelphia; gallery is 61.5×35.
Media: Considers all media, all types of prints.
Submissions: Send query letter with résumé, slides, bio, SASE and reviews. Portfolio should include slides.

FREEDMAN GALLERY, ALBRIGHT COLLEGE, Box 15234, Reading PA 91612-5234. (610)921-7616. Fax: (610)921-2350. Director: Jill Snyder. Nonprofit gallery. Estab. 1976. Represents emerging, mid-career and established artists. Sponsors 5 solo and 3 group shows/year. Average display time 4-6 weeks. 2,500 sq. ft.; "new building, 2 contiguous rooms, designed by architect Adele Santos and artist Mary Miss; 22 ft. ceiling in main gallery; 15 ft. ceiling in 2nd gallery (white walls and concrete floor)." Clientele: college community and general public.

Media: Considers all media, including performance art, video and prints. Most frequently exhibits painting, sculpture and photography.
Style: Considers all styles. Seeks "work that is substantive in content, innovative in form, and provocative in impact."
Terms: 20% commission on sales. Retail price set by artist. Exclusive area representation not required. Gallery provides insurance, shipping costs, promotion and contract.
Submissions: Send query letter with résumé, slides and SASE. "Submit a cohesive body of work." Files résumé and slides "when appropriate."
Tips: Looks for "imaginative, developed personal identity and professional commitment."

‡GALLERY 500, Church & Old York Rds., Elkins Park PA 19117. (215)572-1203. Fax: (215)572-7609. Owner: Rita Greenfield. Retail gallery. Estab. 1969. Represents emerging, mid-career and established artists/year. Sponsors 8-10 shows/year. Average display time 3 weeks. Open all year; Monday-Saturday, 10-5:30. Located in York Town Inn Courtyard of Shops; 3,000 sq. ft.; 30% of space for special exhibitions; 70% of space for gallery artists. 20% private collectors, 30% corporate collectors. Overall price range: $50-6,000; most work sold at $200-1,000.
Media: Considers oil, acrylic, watercolor, pastel, pen & ink, drawing, mixed media, collage, paper, sculpture, ceramics, craft, fiber and glass. Most frequently exhibits jewelry, sculpture and painting.
Style: Exhibits primitivism, painterly abstraction, color field, postmodern works, pattern painting and hard-edge geometric abstraction. Genres include Southwestern and figurative work. Prefers abstract exprssionism and abstract figurative.
Terms: Accepts work on consignment (50% commission) or buys outright for 50% of retail price (net 30 days). Retail price set by the gallery and the artist. Gallery provides insurance, promotion, contract and shipping costs from gallery; artist pays shipping costs to gallery. Prefers artwork framed.
Submissions: Accepts only artists from US. Send query letter with résumé, slides, bio, brochure and SASE. Call for appointment to show portfolio of photographs and slides. Replies in 2 weeks. Files all materials pertaining to artists who are represented.
Tips: Finds artists through craft shows, travel to galleries.

‡THE GALLERY SHOP AT ABINGTON ART CENTER, 515 Meetinghouse Rd., Jenkintown PA 19046. (215)887-4882. Gallery Shop Coordinator: Marian Emery. Retail store. Exhibits 100-200 artists; emerging, mid-career and established. Average display time 6 months. Open all year. 20×30. Clientele: members of AAC and Philadelphia area residents.
Media: Considers ceramic, contemporary craft and glass. Most frequently exhibits jewelry and ceramic.
Style: Interested in seeing work that is "contemporary, fine, saleable and well-made."
Terms: Accepts work on consignment (40% commission) or buys outright for 50% of retail price. Retail price set by the artist. Offers discounts to AAC members. Shipping costs are shared on consignment work.
Submissions: Send query letter with résumé, well-marked slides, bio, photographs, SASE and business card. Portfolio review requested if interested in artist's work. Portfolio should include photographs and slides. Replies only if interested. Likes to see "followup from artists once agreement is reached."
Tips: Finds artists through craft markets and shows, word of mouth and artists' submissions.

‡LEN GARON ART STUDIOS, 1742 Valley Greene Rd., Paoli PA 19301. (215)296-3481. Director of Marketing: Phil Hahn. Wholesale gallery. Estab. 1982. Represents 21 emerging, mid-career and established artists. Exhibited artists include Len Garon and Anna Chen. "I sell previously published prints, lithographs, etchings, etc., plus test market original paintings prior to printing the image to press image." Clientele: galleries, frameshops, designers and furniture stores. Most artwork sold at $50-3,500.
Media: Considers original handpainted prints, offset reproductions, woodcuts, lithographs, posters, mezzotints, serigraphs, etchings and original paintings.
Style: Exhibits expressionism, painterly abstraction, impressionism and realism. Genres include landscapes, florals, Americana, Southwestern, Western, wildlife and figurative work. Prefers landscapes, florals and Americana. Not interested in avante-garde.
Terms: "I sell from samples, then purchase outright." Retail price set by the artist. Customer discounts and payment by installment available. Gallery pays for shipping costs from gallery. Prefers unframed but matted artwork.

Market conditions are constantly changing! If you're still using this book and it is 1996 or later, buy the newest edition of Artist's & Graphic Designer's Market at your favorite bookstore or order directly from Writer's Digest Books.

Submissions: Send query letter with photographs, SASE, reviews and samples of prints. Portfolio review requested if interested in artist's work. Portfolio should include slides, photographs and samples of prints. Replies in 2 weeks.

Tips: Finds artists through agents, visiting exhibitions, word of mouth, various art publications, sourcebooks, artist's submissions/self-promotions and art collectors' referrals. "Send prints that are most commercially saleable. Painting with the color trends helps sell work to the 3 markets: corporate art, home interior art (decorative) and investor and collectible art."

‡■INTERNATIONAL GALLERY OF CONTEMPORARY PRINTMAKING, 39 N. Third St., Philadelphia PA 19106. Phone/Fax: (215)627-3772. Director: Deborah L. Stern. Retail gallery, art consultancy. Estab. 1992. Represents 200 emerging, mid-career and established artists/year. Exhibited artists include Alda Maria Armagni (Argentina), Max Allon (Israel). Sponsors 6-12 shows/year. Average display time 1-2 months. Open all year; Tuesday-Saturday, 12-6. Located downtown art district (Old City); 1,100 sq. ft.; located in 230-year-old restored, historically certified building. 100% of space for gallery artists. 20% private collectors, 80% corporate collectors. Overall price range: $200-2,000; most work sold at $400-1,000.

Media: Considers woodcut, engraving, lithograph, wood engraving, mezzotint, serigraphs, linocut and etching.

Style: Exhibits all styles, all genres.

Terms: Accepts work on consignment (50% commission). Retail price set by the gallery. Gallery provides insurance, promotion, contract and shipping costs from gallery; artist pays shipping costs to gallery. Prefers artwork unframed.

Submissions: Send query letter with résumé, slides, bio and SASE. Write for appointment to show portfolio of slides. Replies in 1 month. Files slides/bio.

Tips: Finds artists "primarily through artist submissions and our own agents. We specialize in small edition, original prints. We have previously limited our artists to printmakers from outside the US, but we are now recruiting US printmakers. We especially encourage emerging artists to apply."

‡GILBERT LUBER GALLERY, 1220 Walnut St., Philadelphia PA 19107. (215)732-2996. Fax: (215)546-2210. Co-owner: Shirley Luber. Retail gallery. Estab. 1971. Represents mid-career and established artists. Exhibited artists include Shigeki Kuroda, Kazutoshi Sugiura. Sponsors 6 shows/year. Average display time 6 weeks. Open all year; Monday-Saturday, 11-30-5:30. Located Center City; 1,000 sq. ft.; Asian art. 50% of space for special exhibitions; 50% of space for gallery artists. Clientele: collectors, decorators. 50% private collectors. Overall price range: $5-15,000; most work sold at $200-500.

Media: Considers watercolor, mixed media, paper, craft, woodblock, woodcut, engraving, lithograph, mezzotint, serigraphs and etching. Most frequently exhibits woodblock, silkscreen and mezzotints.

Style: Exhibits all styles, all genres. Prefers landscapes, floral and actor prints.

Terms: Artwork is bought outright. Retail price set by the gallery. Gallery provides insurance, promotion and shipping costs to and from gallery. Prefers artwork unframed.

Submissions: Accepts only artists from Asia. Prefers only works on paper. Send query letter with résumé and photographs. Call for appointment to show portfolio of originals.

Tips: Finds artists through agents, exhibitions and word of mouth.

‡NEWMAN GALLERIES, 1625 Walnut St., Philadelphia PA 19103. (215)563-1779. Fax: (215)563-1614. Manager: Terrence C. Newman. Retail gallery. Estab. 1865. Represents 40-50 emerging, mid-career and established artists/year. Exhibited artists include Tim Barr and Philip Jamison. Sponsors 2-4 shows/year. Average display time 1 month. Open all year; Monday-Friday, 9-5:30; Saturday, 10-4:30. Located in Center City Philadelphia. 4,000 sq. ft. "We are the largest and oldest gallery in Philadelphia." 50% of space for special exhibitions; 100% of space for gallery artists. Clientele: traditional. 50% private collectors, 50% corporate collectors. Overall price range: $1,000-100,000; most work sold at $2,000-20,000.

Media: Considers oil, acrylic, watercolor, pastel, mixed media, sculpture, woodcut, wood engraving, linocut, engraving, mezzotint, etching, lithograph, serigraphs and posters. Most frequently exhibits watercolor, oil/acrylic, and pastel.

Style: Exhibits expressionism, impressionism, photorealism and realism. Genres include landscapes, florals, Americana, wildlife, portraits and figurative work. Prefers landscapes, Americana and figurative work.

Terms: Accepts work on consignment (45% commission). Retail price set by gallery and artist. Gallery provides insurance and promotion; shipping costs are shared. Prefers oils framed; prints, pastels and watercolors unframed but matted.

Submissions: Send query letter with résumé, slides, bio and SASE. Call to schedule an appointment to show a portfolio, which should include originals, photographs and transparencies. Replies in 2-4 weeks. Files "things we may be able to handle but not at the present time."

Tips: Finds artists through agents, visiting exhibitions, word of mouth, art publications, sourcebooks and artists' submissions.

OLIN FINE ARTS GALLERY, Washington and Jefferson College, Washington PA 15301. (412)223-6110. Gallery Chairman: P. Edwards. Nonprofit gallery. Estab. 1982. Exhibits emerging, mid-career and established

artists. Exhibited artists include Mary Hamilton and Jack Cayton. Sponsors 9 shows/year. Average display time 3 weeks. Open all year. Located near downtown (on campus); 1,925 sq. ft.; modern, air-conditioned, flexible walls, secure. 100% of space for special exhibitions. Clientele: mostly area collectors and students. 95% private collectors, 5% corporate collectors. Most work sold at $300-500.

● This gallery describes its aesthetic and subject matter as "democratic."

Media: Considers all media, except installation, offset reproductions and pochoir. Most frequently exhibits oil, acrylic and watercolor.

Style: Exhibits all styles and genres. Prefers realism/figure, landscapes and abstract.

Terms: Accepts work on consignment (20% commission). Retail price set by artist. Sometimes offers customer discounts. Gallery provides insurance and promotion; artist pays for shipping. Prefers artwork framed.

Submissions: Send query letter with résumé, slides, bio and SASE. Portfolio review not required. "A common mistake artists make is sending unprofessional material." Replies in 2-4 weeks.

Tips: Finds artists through word of mouth, artists' submissions and self-promotions. Values "timely follow-through!"

THE RITTENHOUSE GALLERIES, (formerly Goforth Rittenhouse Galleries), 1524 Walnut St., Philadelphia PA 19102. (215)735-1921. Fax: (215)735-1905. Executive Director: H.W. Kramer. Retail gallery. Estab. 1985. Represents 80 emerging and established artists. Exhibited artists include Morris Blackburn (permanently exhibited) and Vita Solomon. Sponsors 12 shows/year. Average display time 1 month. Open all year. Located in center city; 3,000 sq. ft. 50% of space for special exhibitions; 50% of space for gallery artists. Clientele: middle to upper income, corporate. 65% private collectors, 35% corporate collectors. Overall price range: $100-25,000; most work sold at $3,000-5,000.

Media: Considers oil, acrylic, watercolor, pastel, pen & ink, mixed media, collage, ceramic, woodcuts, engravings, etchings, lithographs and serigraphs. Prefers oil on canvas, acrylic and watercolor.

Style: Exhibits expressionism, surrealism, impressionism, hard-edge geometric abstraction and realism. Genres include landscapes, florals, Southwestern, portraits and figurative work. Prefers landscapes, figurative, florals, and Philadelphia subject matter.

Terms: Accepts work on consignment (45% commission). Retail price set by artist. Offers customer discounts and payment by installments. Gallery provides insurance, promotion and contract; artist pays for shipping. Artwork must be framed.

Submissions: Send query letter with résumé, slides, bio, brochure, photographs and SASE. Call or write for appointment to show portfolio of photographs, slides and transparencies. Replies in 4-6 weeks. Files all materials.

Tips: Finds artists through word of mouth, gallery reputation and sometimes by visiting other exhibits.

‡ROSENFELD GALLERY, 113 Arch St., Philadelphia PA 19106. (215)922-1376. Owner: Richard Rosenfeld. Retail gallery. Estab. 1976. Represents 35 emerging and mid-career artists/year. Sponsors 18 shows/year. Average display time 3 weeks. Open all year; Wednesday-Saturday, 10-5; Sunday, noon-5. Located downtown, "Old City"; 2,200 sq. ft.; ground floor loft space. 85% of space for gallery artists. 80% private collectors, 20% corporate collectors. Overall price range: $200-6,000; most work sold at $1,500-2,000.

Media: Considers oil, acrylic, watercolor, pastel, drawing, mixed media, paper, sculpture, ceramics, craft, fiber, glass, woodcut, engraving, lithograph, monoprints, wood engraving and etching. Most frequently exhibits works on paper, sculpture and crafts.

Style: Exhibits all styles. Prefers painterly abstraction and realism.

Terms: Accepts work on consignment (50% commission). Retail price set by the gallery. Gallery provides insurance and promotion; shipping costs are shared. Prefers artwork framed.

Submissions: Send query letter with slides and SASE. Call or write for appointment to show portfolio of photographs and slides. Replies in 2 weeks.

Tips: Finds artists through visiting exhibitions, word of mouth, various art publications and artists' submissions.

SAINT JOSEPH'S UNIVERSITY GALLERY, 5600 City Line Ave., Philadelphia PA 19131. Assistant Gallery Director: Timothy W. Shea. Nonprofit gallery. Represents emerging, mid-career and established artists. Sponsors 5 solo and 1 group shows/year. Average display time 1 month.

Media: Considers all media.

Style: Exhibits all styles and genres.

Terms: Accepts work on consignment (15% commission). Retail price set by artist. Gallery provides insurance and promotion; artist pays for shipping. Artwork must be framed.

Submissions: Send query letter with résumé, slides, bio and SASE. Write for appointment to show portfolio. Replies in 4 months. All material returned if not accepted or under consideration.

THE STATE MUSEUM OF PENNSYLVANIA, Third and North St., Box 1026, Harrisburg PA 17108-1026. (717)787-4980. Contact: Senior Curator, Art Collections. The State Museum of Pennsylvania is the official museum of the Commonwealth, which collects, preserves and exhibits Pennsylvania history, culture and natural heritage. The Museum maintains a collection of fine arts, dating from 1645 to present. Current

collecting and exhibitions focus on works of art by contemporary Pennsylvania artists. The Archives of Pennsylvania Art includes records on Pennsylvania artists and continues to document artistic activity in the state by maintaining records for each exhibit space/gallery in the state. Estab. 1905. Sponsors 9 shows/year. Accepts only artists who are Pennsylvania natives or past or current residents. Interested in emerging and mid-career artists.

• Plans are underway for a new fine arts gallery on the museum's ground floor.

Media: Considers all media including oil, works on paper, photography, sculpture, installation and crafts.
Style: Exhibits all styles and genres.
Submissions: Send query letter with résumé, slides, SASE and bio. Replies in 1-3 months. Retains résumé and bio for archives of Pennsylvania Art. Photos returned if requested.
Tips: Finds artists through professional literature, word of mouth, Gallery Guide, exhibits, all media and unsolicited material.

‡**SANDE WEBSTER GALLERY**, 2018 Locust St., Philadelphia PA 19102. (215)732-8850. Fax: (215)732-7850. Director: Gerard Brown. Retail gallery. Estab. 1969. Represents emerging, mid-career and established artists. "We exhibit from a pool of 40 and consign work from 200 artists." Exhibited artists include Charles Searles, Moe-Brooker. Sponsors 12-14 shows/year. Average display time 1 month. Open all year; Monday-Friday, 10-6; Saturday, 11-4. Located downtown; 2,000 sq. ft.; "We have been in business in the same location for 25 years." 50% of space for special exhibitions; 50% of space for gallery artists. Clientele: art consultants, commercial and residential clients. 30% private collectors, 70% corporate collectors. Overall price range: $25-25,000; most work sold at $1,000-2,000.
Media: Considers oil, acrylic, watercolor, drawing, mixed media, collage, sculpture, fiber, photography, woodcut, engraving, lithograph, wood engraving, mezzotint, serigraphs, linocut and etching.
Style: Exhibits work in all styles, all genre. Prefers non-objective painting and sculpture and abstract painting.
Terms: Accepts work on consignment (50% commission). Retail price set by agreement. Gallery provides insurance, promotion, contract and shipping costs from gallery; artist pays shipping costs to gallery. "We also own and operate a custom frame gallery."
Submissions: Send query letter with résumé, slides, bio, SASE and retail PR. Call for appointment to show portfolio of slides. "All submissions reviewed from slides with no exceptions." Replies within 2 months. Files "slides, résumés of persons in whom we are interested."
Tips: Finds artists through referrals from artists seeing work in outside shows, and unsolicited submissions.

‡**RUTH ZAFRIR SCULPTURE GALLERY**, 13 S. Second St., Philadelphia PA 19106. (215)627-7098. Sculptor: Ruth Zafrir. Rental gallery. Estab. 1988. Represents 10 emerging, mid-career and established artists/year. Exhibited artists include Kart Karhumaa, Dorothy Stephenson. Sponsors 8 shows/year. Average display time 2 months. Open all year by appointment. Located Olde City Philadelphia; 600 sq. ft.; sculpture only. 100% of space for special exhibitions; 100% of space for gallery artists. Clientele: collectors and private clients. 80% private collectors. Overall price range: $350-5,000.
Media: Considers sculpture and ceramics.
Style: Exhibits all styles, all genres. Prefers representational, realism, modern.
Terms: Accepts work on consignment (40% commission). Retail price set by the artist. Gallery provides promotion; artist pays shipping costs to and from gallery.
Submissions: Send query letter with résumé, slides and photographs. Call or write for appointment to show portfolio of slides. Replies in 2 months. Files résumé and slides.
Tips: Finds artists through word of mouth, artists' submissions. "Personal interview preferred."

ZOLLER GALLERY, Penn State University, 102 Visual Arts Building, University Park PA 16802. (814)865-0444. Contact: Exhibition Committee. Nonprofit gallery. Estab. 1971. Exhibits 250 emerging, mid-career and established artists. Interested in seeing the work of emerging artists. Sponsors 8 shows/year. Average display time 4-6 weeks. Closed in May. Located on Penn State University campus; 2,200 sq. ft. 100% of space for special exhibitions. Overall price range: $50-10,000; most work sold at $300-500.

• This campus gallery features artists' lectures, installation art, visual artists' residencies and interdisciplinary events.

Media: Considers all media, styles and genres.
Terms: "We charge no commission." Retail price set by artist. Gallery provides insurance and promotion; shipping costs are shared. Prefers artwork framed.
Submissions: "We accept proposals once a year. Deadline is February 1." Send query letter with résumé, slides, reviews and SASE. Replies by April 1. Files résumés.

Rhode Island

ARNOLD ART, 210 Thames, Newport RI 02840. (401)847-2273. President: Bill Rommel. Retail gallery. Estab. 1870. Represents 30-40 mid-career and established artists. Sponsors 8-10 solo or group shows/year. Average

display time 2 weeks. Clientele: tourists and Newport collectors. 95% private collectors, 5% corporate clients. Overall price range: $150-12,000; most work sold at $150-750.

Media: Considers oil, acrylic, watercolor, pastel, pen & ink, drawings, mixed media, limited edition offset reproductions, color prints and posters. Most frequently exhibits oil, acrylic and watercolor.

Style: Exhibits painterly abstraction, primitivism, photorealism and realism. Genres include landscapes and florals. Specializes in marine art and local landscapes.

Terms: Accepts work on consignment. Retail price set by gallery or artist. Exclusive area representation not required. Gallery provides insurance, promotion and contract.

Submissions: Send query letter with résumé and slides. Call for appointment to show portfolio of originals. Files résumé and slides.

BANNISTER GALLERY/RHODE ISLAND COLLEGE ART CENTER, 600 Mt. Pleasant Ave., Providence RI 02908. (401)456-9765 or 8054. Gallery Director: Dennis O'Malley. Nonprofit gallery. Estab. 1978. Represents emerging, mid-career and established artists. Sponsors 9 shows/year. Average display time 3 weeks. Open September-May. Located on college campus; 1,600 sq. ft.; features spacious, well-lit gallery space with off-white walls, gloss black tile floor; two sections plus one with 9 foot and 12 foot ceilings. 100% of space for special exhibitions. Clientele: students and public.

Media: Considers all media and all types of original prints. Most frequently exhibitis painting, photography and sculpture.

Style: Exhibits all styles.

Terms: Artwork is exhibited for educational purposes—gallery takes no commission. Retail price set by artist. Gallery provides insurance, promotion and limited shipping costs from gallery. Prefers artwork framed.

Submissions: Send query letter with résumé, slides, bio, brochure, SASE and reviews. Files addresses, catalogs and résumés.

HERA EDUCATIONAL FOUNDATION, HERA GALLERY, P.O. Box 336, 327 Main St., Wakefield RI 02880. (401)789-1488. Director: Linda DeFusco. Nonprofit gallery. Estab. 1974. Located in downtown Wakefield, a rural resort Northeast area (near Newport beaches). Exhibits the work of emerging and mid-career artists. 15 members. Exhibited artists include Grace Bentley-Sheck. Sponsors 16 shows/year. Average display time 3 weeks. Open all year. Located downtown; 1,200 sq. ft. 40% of space for special exhibitions.

Media: Considers all media and original handpulled prints.

Style: Exhibits expressionism, neo-expressionism, painterly abstraction, surrealism, conceptualism, postmodern works, realism and photorealism. "We are interested in innovative, conceptually strong, contemporary works that employ a wide range of styles, materials and techniques." Prefers "a culturally diverse range of subject matter which explores contemporary social and artistic issues important to us all."

Terms: Co-op membership fee plus donation of time. Retail price set by artist. Sometimes offers customer discount and payment by installments. Gallery provides promotion; artist pays for shipping, or sometimes shipping costs are shared.

Submissions: Send query letter with résumé, slides and SASE. Portfolio required for membership; slides for invitational/juried exhibits. Deadlines June 30 and December 31. Files résumé.

Tips: Finds artists through word of mouth, advertising in art publications, and referrals from members. " Be sensitive to the cooperative nature of our gallery. Everyone donates time and energy to assist in installing exhibits and running the gallery. Please write for membership guidelines, and send SASE."

‡WHEELER GALLERY, 228 Angell St., Providence RI 02906. (401)421-9230. Director: Sue L. Carroll. Nonprofit gallery. "This is our fourth year in our new space." Represents emerging, mid-career and established artists. "We don't have a stable of artists which we show. We have an open jury each year to select the 5 exhibitions for the year." Sponsors 5 shows/year. Average display time 3 weeks. Open fall, winter, spring; Tuesday-Saturday, 12-5; Sunday, 3-5. Located in a university and residential area; 1,250 sq. ft.; award-winning architectural design. 100% of space for special exhibitions. 50% private collectors, 50% corporate collectors. Overall price range: $100-25,000.

Media: Considers all media, all types of prints except posters. Most frequently exhibits oil and acrylic painting, sculpture and glass.

Style: Exhibits all styles, all genres.

Terms: Accepts work on consignment (33% commission). Retail price set by the artist. Gallery provides insurance, promotion and contract; artist pays shipping costs to and from gallery.

Submissions: Prefers artists from New England area. Send query letter with SASE. Write for appointment to show portfolio of slides. Replies in 1 month.

Tips: Finds artists through word of mouth, various art publications and artists' submissions. "We also mail out a 'call for slides' notice in late winter."

South Carolina

‡ART GALLERY-HORACE C. SMITH BUILDING, 800 University Way, University of South Carolina-Spartanburg, Spartanburg SC 29303. (803)599-2256. Associate Professor of Art: John R. Caputo. Nonprofit gallery.

Estab. 1989. Represents emerging, mid-career and established artists. "We are an educational institute. We do not actively pursue sales." Sponsors 6 shows/year. Average display time 1 month. Open September-May. Located on campus; rural area off of interstate; 900 sq. ft., 70 ft. of wallspace; "neutral carpeted walls, ties in visually with Performing Arts Center." 100% of space for special exhibitions. Clientele: university and community. Overall price range: $500-3,000; most work sold at $500.
Media: Considers oil, acrylic, drawing, mixed media, collage, paper, sculpture, ceramic, photography, woodcuts, linocuts, etchings, lithographs and serigraphs. Most frequently exhibits paintings, drawings and prints.
Style: Exhibits expressionism, neo-expressionism, primitivisim, painterly abstraction, minimalism, color field, postmodern works, pattern painting, hard-edge geometric abstraction. "We generally do not show genre art. We have no preference on style. All judgments are made on the quality of the work."
Terms: "Artwork is exhibited for a fixed period. No percentage of commission is taken." Retail price set by the artist. Gallery provides insurance, promotion and contract; "$100 is provided to defray the shipping costs." Prefers artwork framed.
Submissions: Send query letter with résumé, slides, bio, SASE and reviews. Write to schedule an appointment to show a portfolio, which should include photographs and transparencies. Replies in 1-2 months. Files résumés and photographs.

ARTS CENTER—THE ARTS PARTNERSHIP, (formerly Arts Council of Spartenburg), 385 S. Spring St., Spartanburg SC 29306. (803)583-2776. Fax: (803)948-5353. Director of Special Projects: Ava J. Hughes. Nonprofit gallery. Estab. 1968. Represents emerging, mid-career and established artists. Sponsors 30 shows/year. Average display time 4-6 weeks. Open all year. Located downtown, in historic neighborhood; 2,500 sq. ft.; total space 44,000 sq. ft. 17% of space for special exhibitions. Overall price range: $150-20,000; most work sold at $150-800.
Media: Considers oil, acrylic, watercolor, pastel, pen & ink, drawings, mixed media, collage, works on paper, sculpture, ceramic, craft, fiber, glass, installation and photography. Most frequently exhibits watercolor, oil and ceramic.
Style: Exhibits all styles and genres.
Terms: Accepts artwork on consignment (33⅓% commission). Retail price set by artist. Gallery provides insurance and promotion; shipping costs are negotiable. Prefers artwork framed.
Submissions: Send query letter with résumé, slides, bio, brochure, SASE and reviews. Write for appointment to show portfolio of slides. Replies in 4-6 weeks. Files bio, résumé and brochure.

CECELIA COKER BELL GALLERY, College Ave., Hartsville, SC 29550. (803)332-1381. Director: Larry Merriman. "A campus-located teaching gallery which exhibits a great diversity of media and style to expose students and the community to the breadth of possibility for expression in art. Exhibits include regional, national and international artists with an emphasis on quality. Features international shows of emerging artists and sponsors competitions." Estab. 1984. Interested in emerging and mid-career artitsts. Sponsors 5 solo shows/year. Average display time 1 month. "Gallery is 30×40, located in art department; grey carpeted walls, track lighting."
Media: Considers oil, acrylic, drawings, mixed media, collage, works on paper, sculpture, installation, photography, performance art, graphic design and printmaking. Most frequently exhibits painting, sculpture/installation and mixed media.
Style: Considers all styles. Not interested in conservative/commercial art.
Terms: Retail price set by artist (sales are not common). Exclusive area representation not required. Gallery provides insurance, promotion and contract; shipping costs are shared.
Submissions: Send résumé, good-quality slides and SASE by November 1. Write for appointment to show portfolio of slides.

BROOKGREEN GARDENS, US 17 South, Murrells Inlet SC 29576. (803)237-4218. Fax: (803)237-1014. Vice President of Academic Affairs and Curator: Robin Salmon. Museum. Estab. 1931. Outdoor sculpture garden. Represents 235 emerging, mid-career and established artists. Clientele: tourists and local residents. Places permanent installations. Accepts only sculpture by American citizens.
Style: Exhibits realism and figurative work. Prefers figurative and wildlife. Gallery shows work by "American sculptors by birth or naturalization; figurative sculpture in permanent materials such as non-ferrous metals or hardstone such as marble, limestone or granite. We suggest you obtain a copy of *A Century of American Sculpture: Treasures from Brookgreen Gardens*." Interested in seeing figurative and representative work. "We do not collect abstract forms and are not interested in site-specific sculpture."
Terms: Buys outright. Accepts donations.
Submissions: Send query letter with résumé and photographs. Guidelines are available on request. Replies in 6 months. Files all material.
Tips: Artists seem to "think Brookgreen Gardens is wealthy. It is not!"

‡PICKENS COUNTY MUSEUM, Pendelton and Johnson, Pickens SC 29671. (803)898-5963. Director: Olivia G. Fowler. Nonprofit museum located in old county jail. Estab. 1976. Interested in emerging, mid-career

and established artists. Sponsors 5 art exhibits/year. Average display time is 3 months. Clientele: artists and public. Overall price range: $200-700; most artwork sold at $200.

Media: Considers oil, acrylic, watercolor, pastel, pen & ink, drawings, sculpture, ceramics, fiber, photography, crafts, mixed media, collage and glass.

Style: Exhibits contemporary, abstract, landscape, floral, primitive, non-representational, photo-realistic and realism.

Terms: Accepts work on consignment (20% commission). Retail price is set by artist. Sometimes offers customer discounts. Exclusive area representation not required. Gallery provides insurance, promotion and contract.

Submissions: Send query letter with résumé, photographs (5) and SASE. Portfolio review required. Call or write, "no drop-ins."

Tips: Find artists by visiting exhibitions, reviewing submissions, and slide registries and word of mouth. "We are interested in work produced by artists who have worked seriously enough to develop a signature style."

PORTFOLIO ART GALLERY, 2007 Devine St., Columbia SC 29205. (803)256-2434. Owner: Judith Roberts. Retail gallery and art consultancy. Estab. 1980. Represents 40-50 emerging, mid-career and established artists. Exhibited artists include Sigmund Abeles and Joan Ward Elliott. Sponsors 4-6 shows/year. Average display time 3 months. Open all year. Located in a 1930s shopping village, 1 mile from downtown; 500 sq. ft. plus 1,100 sq. ft.; features 12 foot ceilings. 100% of space for work of gallery artists. "We have added exhibition space by opening second location (716 Saludo Ave.) around the corner from our 12-year location. The new space has excellent visibility and accomodates large pieces. A unique feature is glass shelves where matted and medium to small pieces can be displayed without hanging on the wall." Clientele: professionals, corporations and collectors. 40% private collectors, 40% corporate collectors. Overall price range: $150-12,500; most work sold at $200-1,500.

Media: Considers oil, acrylic, watercolor, pastel, mixed media, collage, works on paper, sculpture, ceramic, craft, fiber, glass, photography, original handpulled prints, woodcuts, wood engravings, linocuts, engravings, mezzotints, etchings, lithographs and serigraphs. Most frequently exhibits watercolor, oil and monotypes.

Style: Exhibits neo-expressionism, painterly abstraction, imagism, minimalism, color field, impressionism, realism, photorealism and pattern painting. Genres include landscapes and figurative work. Prefers landscapes/seascapes, painterly abstraction and figurative work. "I especially like mixed media pieces, original prints and oil paintings. Pastel medium and watercolors are also favorites. Kinetic sculpture and whimsical clay pieces."

Terms: Accepts work on consignment (40% commission). Retail price set by gallery and artist. Offers payment by installments. Gallery provides insurance, promotion and contract; artist pays for shipping. Artwork may be framed or unframed.

Submissions: Send query letter with slides, bio, brochure, photographs, SASE and reviews. Write for appointment to show portfolio of originals, slides, photographs and transparencies. Replies only if interested within 1 month. Files tearsheets, brochures and slides.

Tips: Finds artists through visiting exhibitions and referrals. "The most common mistake beginning artists make is showing all the work they have ever done. I want to see only examples of recent best work—unframed, originals (no copies)—at portfolio reviews."

South Dakota

GALLERY 306, 102 S. Dakota Ave., Sioux Falls SD 57102. (605)335-3728. Owner: Jocelyn Hanson. Retail gallery and art consultancy. Estab. 1981. Represents 35 established artists. Interested in seeing the work of emerging artists. Exhibited artists include Bill Wheeler, Linda Kall, Sheldon Hage and Robert Aldern. Sponsors 4 shows/year. Average display time 5-6 weeks. Open all year; Monday-Friday 10-5. Located downtown; 1,000 sq. ft. 80% corporate collectors. Overall price range: $185-6,000; most work sold at $800.

Media: Considers all media and all types of prints. Prefers paintings, prints and posters.

Submissions: Send query letter with résumé, slides, photographs and bio. Write for appointment to show portfolio of photographs and slides. Replies in 1 month. Files bio and résumé.

THE HERITAGE CENTER, INC., Red Cloud Indian School, Pine Ridge SD 57770. (605)867-5491. Fax: (605)867-1291. Director: Brother Simon. Nonprofit gallery. Estab. 1984. Represents emerging, mid-career and established artists. Sponsors 6 group shows/year. Accepts only Native Americans. Average display time 10 weeks. Clientele: 80% private collectors. Overall price range: $50-1,500; most work sold at $100-400.

Media: Considers oil, acrylic, watercolor, pastel, pen & ink, drawings, sculpture and original handpulled prints.

Style: Exhibits contemporary, impressionism, primitivism, Western and realism. Genres include Western. Specializes in contemporary Native American art (works by Native Americans). Interested in seeing pictographic art in contemporary style. Likes clean, uncluttered work.

Terms: Accepts work on consignment (20% commission). Retail price set by artist. Customer discounts and payment by installments are available. Exclusive area representation not required. Gallery provides insurance and promotion; artist pays for shipping.

Submissions: Send query letter, résumé, brochure and photographs Wants to see "fresh work and new concepts, quality work done in a professional manner." Portfolio review requested if interested in artist's work.

Tips: Finds artists through word of mouth, publicity in Native American newspapers. "Show art properly matted or framed. Good work priced right always sells. We still need new Native American artists if their prices are not above $300. Write for information about annual Red Cloud Indian Art Show."

Tennessee

BELL●ROSS FINE ART GALLERY, Dept. AM, Suite 118, 6150 Poplar Ave., Memphis TN 38119. (901)682-2189. Owner/Director: Diane Bell. Retail gallery. Estab. 1987. Represents 200 mid-career and established artists. Interested in seeing the work of emerging artists. Exhibited artists include Jack Roberts and Zvonimir Mihanovic. Sponsors 6-7 shows/year. Open all year. Located in East Memphis; 2,600 sq. ft.; "with handcarved furniture, shelving and jewelry cases for our fine art jewelry." 50% of space for special exhibitions. Clientele: 60% private collectors, 40% corporate collectors. Overall price range: $150-20,000; most work sold at $1,500-3,000.

Media: Considers oil, acrylic, watercolor, pastel, mixed media, works on paper, sculpture, ceramic, fiber, glass, bronze and marble sculpture, original handpulled prints, engravings, lithographs, etchings, collagraphs and serigraphs. Most frequently exhibits oil/canvas, glass and jewelry.

Style: Exhibits painterly abstraction, surrealism, minimalism, postmodern works, impressionism, realism, photorealism and hard-edge geometric abstraction. Genres include landscapes, florals, Southwestern and figurative work. Prefers abstraction, impressionism and naive/folk.

Terms: Accepts artwork on consignment (50% commission). Retail price set by the gallery and the artist. Provides insurance, promotion, contract and shipping costs from gallery. Prefers artwork framed.

Submissions: Send query letter with résumé, slides, bio, photographs, SASE and reviews. Write for appointment to show portfolio, which should include originals, slides and photographs. Replies in 2-3 weeks. Files bio, résumé and slides.

Tips: "All work must be high-quality and unique; the artist must also bring some original and personal level of sophistication to his or her work. Do not send work in experimental phases you have not allowed time (years) to develop. We also have an affiliated seasonal gallery in Harbor Springs, Michigan (a sailing and skiing resort community)."

BENNETT GALLERIES, Dept. AM, 4515 Kingston Pike, Knoxville TN 37919. (615)584-6791. Director: Marga Hayes. Owner: Rick Bennett. Retail gallery. Represents 50 emerging, mid-career and established artists. Exhibited artists include Richard Jolley and Jim Tormey. Sponsors 10 shows/year. Average display time 1 month. Open all year. Located in West Knoxville; "gallery space is new, contemporary and done in neutral gray and white; our doors are 100-year-old burgundy and gold-leafed pub doors." Clientele: 70% private collectors; 30% corporate collectors. Overall price range: $200-20,000; most work sold at $2,000-4,000.

Media: Considers oil, acrylic, watercolor, pastel, drawing, mixed media, works on paper, sculpture, ceramic, craft, glass, original handpulled prints, woodcuts, engravings, lithographs, pochoir, wood engravings, mezzotints, serigraphs, linocuts and etchings. Most frequently exhibits painting, ceramic/clay and wood.

Style: Exhibits primitivism, abstraction, figurative, non-objective, impressionism and realism. Genres include landscapes, still life and interiors. Prefers interpretive realism, abstraction and primitivism.

Terms: Accepts artwork on consignment (50% commission). Retail price set by the gallery and the artist. Sometimes offers customer discounts and payment by installments. Gallery provides insurance, promotion, contract from gallery. "We are less willing to pay shipping costs for unproven artists." Prefers artwork framed.

Submissions: Send query letter with résumé, slides, bio, photographs, SASE and reviews. Portfolio review requested if interested in artist's work. Portfolio should include originals, slides, photographs and transparencies. Replies in 6 weeks. Files samples and résumé.

Tips: Finds artists through agents, visiting exhibitions, word of mouth, various art publications, sourcebooks, artist's submissions/self-promotions and art collectors' referrals.

‡THE COLLECTOR'S GALLERY, 6602 Hwy. 100, Nashville TN 37205. (615)356-0699. Director: Mark Kelly. Retail gallery. Estab. about 1965. Represents 30 emerging, mid-career and established artists/year. Sponsors 6 shows/year. Average display time 6-8 weeks. Open all year; Tuesday-Saturday, 10-4. Located west of city in suburban retail area; 1,500 sq. ft.; one of Nashville's oldest retail galleries. 50-70% of space for special exhibitions; 30-50% of space for gallery artists. Clientele: private collectors, corporate collectors. 70% private collectors, 30% corporate collectors. Overall price range: $25-15,000; most work sold at $100-1,000.

Media: Considers oil, acrylic, watercolor, pastel, pen & ink, drawing, mixed media, collage, paper, sculpture, ceramics, craft, glass, woodcut, engraving, lithograph, wood engraving, mezzotint, serigraphs, linocut and etching. Most frequently exhibits oil on canvas (or acrylic), watercolor and mixed media on paper.

Style: Exhibits all styles, all genres.
Terms: Accepts work on consignment. Retail price set by the artist. Gallery provides insurance, promotion, contract and shipping costs from gallery; artist pays shipping costs to gallery.
Submissions: Send query leter with résumé, slides, bio, photographs and reviews. Replies only if interested within 1 month "but will return slides or photos (upon request) if not interested."
Tips: Finds artists through regional exhibitions and artists' submissions.

CUMBERLAND GALLERY, 4107 Hillsboro Circle, Nashville TN 37215. (615)297-0296. Director: Carol Stein. Retail gallery. Estab. 1980. Represents 35 emerging, mid-career and established artists. Sponsors 6 solo and 2 group shows/year. Average display time 5 weeks. Clientele: 60% private collectors, 40% corporate clients. Overall price range: $450-15,000; most work sold at $1,000-5,000.
Media: Considers oil, acrylic, watercolor, pastel, mixed media, collage, works on paper, sculpture, photography, woodcuts, wood engravings, linocuts, engravings, mezzotints and etchings. Most frequently exhibits painting, drawings and sculpture.
Style: Exhibits realism, photorealism, minimalism, painterly abstraction, postmodernism and hard-edge geometric abstraction. Prefers landscapes, abstraction, realism and minimalism. "We have always focused on contemporary art forms including paintings, works on paper, sculpture and multiples. Approximately half of the artists have national reputations and half are strongly emerging artists. These individuals are geographically dispersed." Interested in seeing "work that is technically accomplished, with a somewhat different approach, not derivative."
Tips: "I would hope that an artist would visit the gallery and participate on the mailing list so that he/she has a sense of what we are doing. It would be helpful for the artist to request information with regard to how we prefer work to be considered for inclusion. I suggest slides, résumé, prices, recent articles and a SASE for return of slides. We are currently not actively looking for new work but always like to review work that may be appropriate for our needs."

PAUL EDELSTEIN GALLERY, 519 N. Highland, Memphis TN 38122-4521. (901)454-7105. Owner/Director: Paul Edelstein. Retail gallery. Estab. 1985. Represents 30 emerging, mid-career and established artists. Exhibited artists include Walter Anderson and Carroll Cloar. Sponsors 1-2 shows/year. Average display time 6 weeks. Open all year. Located in East Memphis; 2,000 sq. ft.; 80% of space for special exhibitions. Clientele: 95% private collectors, 5% corporate collectors. Overall price range: $500-200,000; most work sold at $300-800.
Media: Considers oil, acrylic, watercolor, pastel, pen & ink, drawings, mixed media, collage, paper and photography; woodcuts, wood engravings, linocuts, etchings, lithographs and serigraphs. Most frequently exhibits oil, acrylic and watercolor.
Style: Exhibits primitivism, painterly abstraction and color field. Prefers contemporary and established artists from the 1950s. Interested in seeing contemporary, modern and folk art. Prefers contemporary work maintaining antiquity with modern in each work.
Terms: Accepts work on consignment (30% commission). Retail price set by gallery. Offers customer discounts and payment by installments. Gallery provides insurance, promotion and contract; artist pays for shipping. Prefers artwork unframed.
Submissions: Send query letter with résumé, slides, bio, brochure, photographs, SASE and business card. Portfolio review not required. Replies in 2 months. Files all material.
Tips: Finds artists mostly through word of mouth, *Art in America*, and also in publications like *Artist's & Graphic Designer's Market*.

THE PARTHENON, Centennial Park, Nashville TN 37201. (615)862-8431. Fax: (615)862-8414. Museum Director: Miss Wesley Paine. Nonprofit gallery in a full-size replica of the Greek Parthenon. Estab. 1931. Exhibits the work of emerging and mid-career artists. Clientele: general public, tourists. 50% private collectors, 50% corporate clients. Sponsors 8 solo and 3 group shows/year. Average display time 6 weeks. Overall price range: $300-2,000; most work sold at $750.
Media: Considers "nearly all" media.
Style: Exhibits contemporary works and American impressionism. Currently seeking contemporary works. "Interested in both objective and non-objective work, although our clientele respond more favorably to representational work. Sick of barns and sunsets."
Terms: Accepts work on consignment (20% commission). Retail price set by artist. Gallery provides a contract and limited promotion. The Parthenon does not represent artists on a continuing basis.
Submissions: Send query letter with résumé and good-quality slides that show work to best advantage. Portfolio review required.

SLOCUMB GALLERIES, East Tennessee State University, Department of Art, Box 70708, Johnson City, TN 37614-0708. (615)461-7078. Director: Ann Ropp. Nonprofit university gallery. Estab. 1960. Interested in emerging, mid-career and established artists. Sponsors 2-3 solo and 5 group shows/year. Average display time 1 month. Overall price range: $100-5,000; most work sold at $500.

Media: Considers all media.

Style: Exhibits contemporary, paintings, prints, photography and sculpture.

Submissions: Send query letter with résumé and slides. Call or write for appointment to show portfolio. Slides and résumés are filed.

‡**UNIVERSITY GALLERY, The University of the South,** 735 University Ave., Sewanee TN 37383. (615)598-1223. Director: Steven Michael Uroom. Nonprofit gallery, museum. Estab. 1960. Represents emerging, mid-career and established artists. Exhibited artists include Imogen Cunningham, Pradip Malde. Sponsors 5 shows/year. Average display time 6 weeks. Open during academic year; Tuesday-Sunday, noon-5. Located Georgia Ave., Guerry Mall; 240 sq. ft.; two levels, climate controlled, exceptional security. 100% of space for gallery artists. Clientele: academic community. 95% private collectors, 5% corporate collectors. Overall price range: $50-5,000; most work sold at $3,500-4,000.

Media: Considers oil, acrylic, pen & ink, drawing, mixed media, collage, paper, sculpture, installation, photography, woodcut, engraving, lithograph, wood engraving, mezzotint, serigraphs, linocut, etching and posters. Most frequently exhibits photography, painting and prints.

Style: Exhibits all styles, all genres. Prefers Fluxus—mail art, Dada, contemporary prints.

Terms: Accepts work on consignment (20% commission). Retail price set by the artist. Gallery provides insurance, promotion, contract and shipping costs to and from gallery. Prefers artwork framed.

Submissions: Send query letter with résumé, slides, bio, brochure, photographs, SASE, business card and reviews. Write for appointment to show portfolio of photographs, slides and transparencies. Replies in 7 weeks.

Tips: Finds artists through the College Art Association. "Put your proposal in essay form."

Texas

ART LEAGUE OF HOUSTON, 1953 Montrose Blvd., Houston TX 77006. (713)523-9530. Executive Director: Linda Haag Carter. Nonprofit gallery. Estab. 1948. Represents emerging and mid-career artists. Sponsors 12 individual/group shows/year. Average display time 3-4 weeks. Located in a contemporary metal building; 1,300 sq. ft., specially lighted; smaller inner gallery/video room. Clientele: general, artists and collectors. Overall price range: $100-5,000; most artwork sold at $100-2,500.

Media: Considers all media.

Style: Exhibits contemporary avant-garde, socially aware work. Features "high-quality artwork reflecting serious aesthetic investigation and innovation. Additionally the work should have a sense of personal vision."

Terms: Accepts work on consignment (20% commission). Retail price set by artist. Exclusive area representation not required. Gallery provides insurance, promotion and contract; artist pays for shipping.

Submissions: Must be a Texas resident. Send query letter, résumé and slides that accurately portray the work. Portfolio review not required. Submissions reviewed once a year in mid-April and exhibition agenda determined for upcoming year.

THE ART STUDIO, INC., 720 Franklin St., Beaumont TX 77701. (409)838-5393. Executive Director: Greg Busceme. Assistant Director: Terri Fox. Cooperative, nonprofit gallery "in the process of expanding into multicultural arts organization." Estab. 1983. Exhibits 20 emerging, mid-career and established artists. Sponsors 10 shows/year. Average display time 1 month. No shows July through August. Artist space open and sales gallery open. Located in the downtown industrial district; 14,000 sq. ft.; 1946 brick 2-story warehouse with glass brick accents. Overall price range: $25-500; most work sold at $50-250.

Media: Considers all media and all types of prints. Most frequently exhibits painting, ceramics and collage.

Style: Exhibits all styles. Prefers contemporary, painterly abstraction and photorealism.

Terms: Co-op membership fee plus donation of time (25% commission). Retail price set by artist. Gallery provides contract; artist pays for shipping. Prefers artwork framed.

Submissions: Send query letter with résumé and slides. Write for appointment to show portfolio of slides. Replies only if interested within 2 months. Files résumé and slides.

Tips: "Send résumé stating style and reason for choosing the Art Studio."

‡**ARTHAUS GALERIE,** Suite 136, 11520 N. Central Expwy., Dallas TX 75243. (214)681-3229 or (214)343-9559. Fax: (214)324-3416. Director: C. Ann Sousa. Associate Director: Tim O'Neill. Retail gallery, art consultancy. Estab. 1991. Represents 10 emerging, mid-career and established artists/year. Exhibited artists include Michael Cross, Joerg Fercher. Sponsors 9 shows/year. Average display time 3 weeks. Open all year; Thursday-Saturday, 1-4; by appointment. Located north Dallas, near park cities; 1,000 sq. ft.; large glass-front showroom facing skylighted atrium. 40% of space for special exhibitions; 60% of space for gallery artists. Clientele: international collectors of contemporary art. 60% private collectors, 40% corporate collectors. Overall price range: $600-15,000; most work sold at $700-3,500.

Media: Considers oil, acrylic, mixed media, sculpture, installation, woodcut and linocut. Most frequently exhibits mixed media, acrylic and oil.

© 1992 Joerg Fercher

© 1992 Michael Cross

These pieces, by abstract artists Joerg Fercher and Michael Cross, were shown in separate group shows at Arthaus Gallery in Dallas. According to Tim O'Neill, associate director, the reaction to the pieces was enthusiastic. "The piece by Fercher, Secant One, has attracted attention and inquires from collectors in Germany and South America," he says. "Cross's Red Flag/Smoke Signals and another piece from the series sold immediately."

Style: Exhibits painterly abstraction, minimalism and postmodern works. Genres include landscapes and figurative work. Prefers painterly abstraction, minimalism and figurative work.
Terms: Accepts work on consignment (40% commission; variable commission with promotion fee for new artists). Retail price set by the gallery. Gallery provides promotion and contract; shipping costs are shared.
Submissions: Send query letter with résumé, slides, bio and photographs. Call or write for appointment to show portfolio of photographs, slides and works from the past 2-3 years. Replies in 1 month. Files bio and slides.
Tips: Finds artists through artists' submissions.

‡**BARNARDS MILL ART MUSEUM,** 307 SW. Barnard St., Glen Rose TX 76043. (817)897-7494. Directors: Teresa Westmoreland, Steve Igou. Museum. Estab. 1989. Represents 30 mid-career and established artists/ year. Interested in seeing the work of emerging artists. Sponsors 2 shows/year. Open all year; Saturday, 10-5; Sunday, 1-5. Located 2 blocks from the square. "Barnards Mill is the oldest structure (rock exterior) in Glen Rose. 20% of space for special exhibitions; 80% of space for gallery artists.
Media: Considers oil, acrylic, watercolor, pastel, pen & ink, drawing, mixed media, collage, paper, sculpture, ceramics, fiber, glass, installation, photography, woodcut, engraving, lithograph, wood engraving, mezzotint, serigraphs, linocut and etching. Most frequently exhibits oil, pastel and watercolor.
Style: Exhibits experssionism, postmodern works, impressionism and realism, all genres. Prefers realism, impressionism and Western.
Terms: Gallery provides promotion. Prefers artwork framed.
Submissions: Send query letter with résumé, slides or photographs, bio and SASE. Write for appointment to show portfolio of photographs or slides. Replies only if interested within 3 months. Files résumés, photos, slides.

‡**BLUE STAR ART SPACE,** 116 Blue Star, San Antonio TX 78204. (210)227-6960. Fax: (210)229-9412. Director: Jeffrey Moore. Nonprofit gallery and museum store. Estab. 1986. Represents emerging, mid-career and

established artists. 3,000 members. Sponsors 6 or 7 shows/year. Average display time 6-8 weeks. Open all year; Wednesday-Sunday, 12-6. Located downtown; 10,000 sq. ft.; warehouse space.
Media: Considers all media and all types of prints.
Style: Exhibits all styles.
Terms: Retail price set by the artist. Gallery provides insurance and shipping costs to and from gallery.
Submissions: Send query letter with slides and SASE. Call or write for appointment to show portfolio of slides, "whatever is necessary to properly show work." Replies in weeks-months. Files slides (mainly), résumé, other material.
Tips: Finds artists through artists' submissions.

BRIDGE CENTER FOR CONTEMPORARY ART, 127 Pioneer Plaza, El Paso TX 79907. (915)532-6707. Fax: (915)532-3408. Executive Director: M.E. Sorrell. Nonprofit gallery. Estab. 1987. Exhibits 12-20 emerging, mid-career and established artists. 250-300 members. Sponsors 6 shows/year. Average display time 7 weeks. Open all year; Tuesday-Saturday 11-6. Located downtown; 4,000 sq. ft.; all hardwood floors in historic district building.
Media: Considers only proposals for curated or juried exhibits.
Terms: Gallery provides insurance and promotion; shipping costs are shared.
Submissions: Send proposals with all necessary information. Replies in 2-4 months.

CONTEMPORARY GALLERY, 4152 Shady Bend Dr., Dallas TX 75244. (214)247-5246. Director: Patsy C. Kahn. Private dealer. Estab. 1964. Interested in emerging and established artists. Clientele: collectors and retail.
Media: Considers oil, acrylic, drawings, sculpture, mixed media and original handpulled prints.
Style: Contemporary, 20th-century art—paintings, graphics and sculpture.
Terms: Accepts work on consignment or buys outright. Retail price set by gallery and artist; shipping costs are shared.
Submissions: Send query letter, résumé, slides and photographs. Write for appointment to show portfolio.

D-ART VISUAL ART CENTER, 2917 Swiss Ave., Dallas TX 75204. (214)821-2522. Fax: (214)821-9103. Director: Katherine Wagner. Nonprofit gallery. Estab. 1981. Represents emerging, mid-career and established artists. Sponsors 20 shows/year. Average display time 3 weeks. Open all year. Located "downtown; 24,000 sq. ft.; renovated warehouse." Provides information about opportunities for local artists, including resource center.
Media: Considers all media.
Style: Exhibits all styles and genres.
Terms: Invitational, juried and rental shows available. Rental fee for space. Retail price set by artist. Gallery provides promotion; artist pays for shipping. Prefers artwork framed.
Submissions: Supports Dallas area artists. Send query letter with résumé, slides, bio and SASE.
Tips: "We offer a lot of information on grants, commissions and exhibitions available to Texas artists. We are gaining members as a result of our inhouse resource center and non-lending library. Our Business of Art seminar series provides information on marketing artwork, presentation, museum collection, tax/legal issues and other related business issues."

‡DEBUSK GALLERY, 3813 N. Commerce, Ft. Worth TX 76106. (817)625-8476. Owner: Barrett DeBusk. Retail/wholesale gallery, alternative space. Estab. 1987. Represents 5 emerging artists/year. Exhibited artists include Barrett DeBusk, Sue Davis. Sponsors 4 shows/year. Average display time 6 weeks. Open all year; hours vary. Located industrial area; 1,000 sq. ft.; in DeBusk's avant-garde studio. Clientele: mostly wholesale. 90% private collectors, 10% corporate collectors. Overall price range: $20-10,000; most work sold at $500-1,000.
Media: Considers oil, acrylic, sculpture, photography, woodcut, engraving, lithograph and serigraphs. Most frequently exhibits sculpture, painting and performance.
Style: Exhibits expressionism, primitivism, conceptualism and impressionism. Prefers figurative sculpture, expressionist painting and performance.
Terms: Accepts work on consignment (50% commission). Retail price set by the gallery and the artist. Shipping costs are shared.
Submissions: Send query letter with résumé and slides. Write for appointment to show portfolio of photographs and slides.
Tips: Finds artists through word of mouth, exhibitions.

‡DOUGHERTY ART CENTER GALLERY, 1110 Barton Springs Rd., Austin TX 78704. (512)397-1472. Curator: Jerry DeFrese. Nonprofit gallery. Represents emerging, mid-career and established artists. Exhibited artists include Steve Brudniak, Doug Jaques. Sponsors 12 shows/year. Average display time 1 month. Open all year; Monday-Thursday, 9-9:30; Friday 9-5:30; Saturday 10-2. Located central Austin—downtown; 1,800 sq. ft.; open to all artists. 100% of space for special exhibitions. Clientele: citizens of Austin and central Texas. Overall price range: $100-5,000.

Media: Considers all media, all types of prints. Most frequently exhibits flat work.
Style: Exhibits all styles, all genres. Prefers contemporary.
Terms: "Gallery does not handle sales or take commissions. Sales are encouraged but must be conducted by the artist or his/her affiliate." Rental fee for space; covers 1 month. Retail price set by the artist. Gallery provides insurance and promotion; artist pays shipping costs to and from gallery. Prefers artwork framed.
Submissions: Accepts only regional artists, central Texas. Send query letter with résumé and slides. Write for appointment to show portfolio of photographs and slides. Replies in 1 month. Files résumé, slides.
Tips: Finds artists through visiting exhibitions, publications, artists' submissions. "The gallery sponsors 3 call-for-entry exhibitions per year and there are 9 exhibitions by group or individuals chosen annually through applications (applications reviewed March every year)."

‡500 X GALLERY, 500 Exposition, Dallas TX 75226. (214)828-1111. President: Tom Sime. Cooperative gallery. Estab. 1978. Represents emerging artists. 11 regular, 8 associate board members. Exhibited artists include Robert McAn, Robert Moore. Sponsors 16 shows/year. Average display time 1 month. Open all year; Saturday and Sunday, 12-5. Located downtown (Deep Ellum); "very large"; studio lofts surround gallery which is an old warehouse of bricks and wood beams by train tracks. 50% of space for special exhibitions; 50% of space for gallery artists. Clientele: established and first time collectors. 75% private collectors, 25% corporate collectors. Overall price range: $50-3,500; most work sold at $250-500.
Media: Considers all media but crafts, all types of prints but posters. Most frequently exhibits oil paintings, sculpture/assemblage and photography.
Style: Exhibits painterly abstraction, conceptualism, minimalism and postmodern works. Prefers post modern, minimalism and conceptualism.
Terms: Co-op membership fee plus a donation of time (30% commission). Rental fee for space; covers 1 month. Retail price set by the artist. Gallery provides promotion; artist pays shipping costs to and from gallery.
Submissions: Prefers only artists from north Texas. Send query letter with résumé, slides, bio, SASE, reviews and artist's statement. Write for appointment to show portfolio of slides. Replies in 1-2 weeks. Files slides, résumé, artist's statement.
Tips: Finds artists through agents, visiting exhibitions, word of mouth, art publications and sourcebooks, artists' submissions, friends of members.

FLORENCE ART GALLERY, 2500 Cedar Springs at Fairmount, Dallas TX 75201. (214)754-7070. Director: Estelle Shwiff. Contact: Kim Radtke or Janice Meyers. Retail gallery. Estab. 1975. Represents 10-15 emerging and established artists. Exhibited artists include Simbari, H. Claude Pissarro, private collection of Viadan Stiha. Sponsors 2 shows/year. Average display time 2 months. Open all year; Monday-Friday, 10-5; Saturday 11-4. Located 5 minutes from downtown/arts and antique area. "We have expanded to include 4 new rooms in space beside original gallery location. 'New' rooms contain more traditional art." 20% of space for special exhibitions. Clientele: international, US, local. 90% private collectors, 10% corporate collectors.
Media: Considers oil, acrylic, watercolor, pastel, pen & ink, mixed media, collage, paper, sculpture, bronze, original handpulled prints, woodcuts, etchings, lithographs, seriagraphs. Most frequently exhibits oils, bronzes and graphics.
Style: Exhibits all styles and genres. Prefers figurative, landscapes and abstract. Interested in seeing contemporary, impressionist, figurative oils.
Terms: Accepts work on consignment. Retail price set by gallery and artist. Sometimes offers payment by installment. Gallery provides insurance, promotion and contract; shipping costs are shared. Prefers artwork framed.
Submissions: Send query letter with photographs and bio. Does not want to see slides. Call for appointment to show portfolio of photographs. Replies in 2 weeks. Files artists accepted in gallery.
Tips: "Usually we are contacted by new and upcoming artists who have heard of the gallery through word of mouth or in various art publications. Local artists are recommended to come into the gallery with their original works. If they are not available, they may bring in photos. Slides are not acceptable. For out-of-town artists, send query letter with photos and biography. Please call for appointments. Have a complete body of representative work. We always need to see new artists."

GALERIA SIN FRONTERAS, 1701 Guadalupe, Austin TX 78701-1214. (512)478-9448. Fax: (512)477-4668. Director: Susana Monteverde. Retail gallery. Estab. 1986. Represents 45 emerging and mid-career artists. Exhibited artists include Carmen Lomas Garza and Cesar Martinez. Sponsors 5 shows/year. Average display

How to Use Your Artist's & Graphic Designer's Market *offers suggestions for understanding and using the information in these listings. Read this and other articles in the front of this book for important business tips.*

time 10 weeks. Open all year. 1,500 sq. ft.; located in building built in 1930. 60% of space for special exhibitions; 40% of space for gallery artists. Clientele: 90% private collectors, 10% corporate collectors. Overall price range: $100-10,000; most work sold at $200-1,000.

Media: Considers oil, acrylic, drawings, mixed media, paper, photography, original handpulled prints, woodcuts, wood engravings, linocuts, engravings, mezzotints, etchings, lithographs, monotypes and serigraphs. Most frequently exhibits oil/acrylic on canvas, prints (litho, serigraph and monotype) and drawings (charcoal, pen & ink).

Style: Exhibits neo-expressionism, conceptualism, postmodern works and imagism. Genres include figurative work and Chicano and Latin American.

Terms: Accepts work on consignment (50% commission). Retail price set by gallery and artist. Customer discounts and payment by installment are available. Gallery provides insurance, promotion, contract and frame shop; shipping costs are shared.

Submissions: Prefers artists from Latin American background. Send query letter with résumé, slides, bio and SASE. Write for appointment to show portfolio of slides. Replies in 1 month. Files résumé, bio and slides.

Tips: "We specialize in Chicano artwork, which tends to be heavily geared towards socio-political commentary. Most of the work tends to be figurative while deeply rooted in modern and postmodern aesthetics."

GALLERY 1114, 1114 N. Big Spring, Midland TX 79701. (915)685-9944. President: Travis Beckham. Cooperative gallery and alternative space. Estab. 1983. Represents 12-15 emerging, mid-career and established artists. 10 members. Sponsors 8 shows/year. Average display time 6 weeks. Closed during August. Located at edge of downtown; 900-950 sq. ft.; special features include one large space for featured shows, smaller galleries for members and consignment—"simple, elegant exhibit space, wood floors, and white walls." 60% of space for special exhibitions. Clientele: "younger." Almost 100% private collectors. Overall price range: $10-8,000; most work sold at $50-350.

Media: Considers all media. Interested in all original print media. Most frequently exhibits painting, ceramics and drawing.

Style: Exhibits all styles and all genres—"in a contemporary sense, but we are not interested in genre work in the promotion sense."

Terms: Accepts work on consignment (40% commission). Retail price set by gallery. Customer discounts and payment by installment are available. Gallery provides promotion and shipping costs from gallery. Prefers artwork framed.

Submissions: Send query letter, résumé, slides, bio, reviews and SASE. Call or write for appointment to show portfolio of slides. Replies in 3-6 weeks. Files all material of interest. "We schedule up to 2-3 years in advance. It helps us to keep material. We do not file promotional material."

Tips: "Make a neat, sincere, consistent presentation with labeled slides and SASE. We are interested in serious work, not promotion. We are an alternative space primarily for central US. We are here to give shows to artists working in a true contemporary or modernist context: artists with a strong concern for formal strength and originality and an awareness of process and statement."

‡GREMILLION & CO. FINE ART, INC., 2501 Sunset Blvd., Houston TX 77005. (713)522-2701. Fax: (713)522-3712. Director: Christopher Skidmore. Retail gallery. Estab. 1981. Represents 25 mid-career and established artists. May be interested in seeing the work of emerging artists in the future. Exhibited artists include John Pavlicek and Knox Martin. Sponsors 8-10 shows/year. Average display time 4-6 weeks. Open all year. Located "West University" area; 4,000 sq. ft. 50% of space for special exhibitions. 60% private collectors; 40% corporate collectors. Overall price range: $500-150,000; most work sold at $3,000-10,000.

Media: Considers oil, acrylic, watercolor, pastel, pen & ink, drawing, mixed media, collage, works on paper, sculpture, original handpulled prints, woodcuts, engravings, lithographs, wood engravings, mezzotints, linocuts, etchings and serigraphs. Most frequently exhibits oil, acrylic and collage.

Style: Exhibits painterly abstraction, minimalism, color field and realism. Genres include landscapes and figurative work. Prefers abstraction, realism and color field.

Terms: Accepts artwork on consignment (varying commission). Retail price set by the gallery and artist. Sometimes offers customer discounts and payment by installment. Gallery provides insurance and promotion; shipping costs are shared. Prefers artwork unframed.

Submissions: Call to schedule an appointment to show a portfolio, which should include slides, photographs and transparencies. Replies only if interested within 1-3 weeks. Files slides and bios.

Tips: Finds artists through submissions and word of mouth.

HUMMINGBIRD ORIGINALS, INC., 4319 Camp Bowie Blvd., Ft. Worth TX 76107. (817)732-1549. President: Carole Alford. Retail gallery. Estab. 1983. Represents 50 mid-career and established artists. Exhibited artists include Gale Johnson and Robert Rohm. Sponsors 2-5 shows/year. Open all year. Located 2 miles west of downtown in the cultural district; 1,600 sq. ft. 20% of space for special exhibitions, 80% for gallery artists. Clientele: 80% private collectors, 20% corporate collectors. Overall price range: $50-10,000; most work sold at $300-2,500.

● The Hummingbird Gallery is in its eleventh year in the same location.

Media: Considers oil, acrylic, watercolor, pastel, drawings, mixed media, collage, works on paper, sculpture, ceramic, craft, fiber, glass and original prints. Most frequently exhibits watercolor, oil and acrylic.

Style: Exhibits painterly abstraction, surrealism, conceptualism, minimalism, impressionism, realism and all styles. Genres include landscapes, florals, Americana, Southwestern, Western and wildlife. Prefers impressionism, abstraction and realism.

Terms: Accepts work on consignment (40-50% commission). Retail price set by gallery and artist. Offers customer discounts and payment by installments, only with artist's approval. Gallery provides insurance, promotion and contract; shipping costs are shared. Prefers artwork unframed.

Submissions: Send query letter with résumé, slides, bio, brochure, photographs, SASE, business card and reviews. Call or write for appointment to show portfolio of originals, slides, photographs and transparencies. Replies only if interested within 2 weeks. Files material useful to clients and future exhibit needs.

Tips: Finds artists through art publications, offers from artists and exhibitions to see work, occasional referrals and/or agents. "Be prepared. Know if your work sells well, what response you are getting. Know what your prices are. Also understand a gallery, its role as an agent and its needs."

‡**LONGVIEW ART MUSEUM,** 102 W. College St., Longview TX 75601. (903)753-8103. Director: Shannon Gilliland. Museum. Estab. 1967. Represents 80 emerging, mid-career and established artists/year. 600 members. Exhibited artists include Jan Stratman. Sponsors 6-9 shows/year. Average display time 6 weeks. Open all year; Tuesday-Saturday, 10-4. Located near downtown; interesting old building. 75% of space for special exhibitions. Clientele: members, visitors (local and out-of-town). 100% private collectors. Overall price range: $200-2,000; most work sold at $200-800.

Media: Considers all media, all types of prints. Most frequently exhibits oil, acrylic and photography.

Style: Exhibits all styles and genres. Prefers contemporary and realistic American art and photography.

Terms: Accepts work on consignment (30% commission). Retail price set by the artist. Offers customer discounts to museum members. Gallery provides insurance and promotion. Prefers artwork framed.

Submissions: Send query letter with résumé and slides. Portfolio review not required. Replies in 1 month. Files slides and résumés.

Tips: Finds artists through art publications, and shows in other areas.

LYONS MATRIX GALLERY, 1712 Lavaca St., Austin, TX 78701. (512)479-0068. Fax: (512)479-6188. President: Camille Lyons. Retail gallery. Estab. 1981. Represents 40 mid-career and established artists. May consider emerging artists in the future. Exhibited artists include David Everett and Robert Willson. Sponsors 6 shows/year. Average display time 2 months. Open all year. 2,500 sq. ft. 65% of space for special exhibitions; 100% of space for gallery artists. Clientele: 75% private collectors, 25% corporate collectors. Overall price range: $200-12,000; most work sold at $750-2,500.

Media: Considers oil, acrylic, mixed media, sculpture, ceramic, glass, photography, woodcuts, wood engravings, linocuts and etchings. Most frequently exhibits glass sculpture, original handpulled prints and oil on canvas.

Style: Exhibits expressionism, painterly abstraction, postmodern works, photorealism, realism and imagism. Genres include figurative work. "We generally have 3 solo exhibits at a time and try to show 1 glass artist, 1 painter and 1 photographer and printmaker or sculptor concurrently."

Terms: Accepts work on consignment (50% commission). Retail price set by artist. Gallery provides insurance, promotion and contract; shipping costs are shared. Prefers prints framed, paintings unframed.

Submissions: Prefers artists from Southwestern region. Send query letter with résumé, photographs and reviews. Call for appointment to show portfolio of photographs. Replies in 6 weeks. Files résumés and brochures.

‡**NOT JUST ART GALLERY,** #125, 1250 Capital of Texas Hwy. S, Austin TX 78746. (512)329-2092. Owner: Deborah Roberts. Retail gallery. Estab. 1989. Represents 3 emerging and established artists/year. Exhibited artists include Deborah Roberts. Sponsors 3 shows/year. Average display time 3 weeks. Open all year. Located west of downtown, 1,290 sq. ft.; "The gallery has 8 free standing walls and is surrounded by glass." 85% of space for gallery artists. Clientele: age 27-45, upper middle class. 85% private collectors. Overall price range: $150-2,000; most work sold at $2,000.

Media: Considers oil, acrylic, watercolor, pastel, pen & ink, drawing, mixed media, paper, sculpture, woodcut, engraving, lithograph, serigraphs and posters. Most frequently exhibits watercolor, pastel and mixed media.

Style: Exhibits all styles, all genres. Prefers Americana and figurative.

Terms: Accepts work on consignment (40% commission). Retail price set by the artist. Gallery provides insurance, promotion and contract; artist pays shipping costs to gallery. Prefers artwork framed.

Submissions: Send query letter with bio and brochure. Write for appointment to show portfolio of photographs. Replies in 2 weeks. Files bio and brochure.

OLGA PINA'S EL TALLER GALLERY, Suite A, 1221 W. Sixth St., Austin TX 78703. (512)480-0100 or (800)234-7362. Owner: Olga Piña. Director: Art Gonzales. Retail gallery. Estab. 1982. Represents 21 emerging, mid-career and established artists. Exhibited artists include Amado Pena, Jr., Michael Atkinson and R.C. Gorman. Sponsors 12 shows/year. Average display time 3 months. Open all year. Located in historic West End

© 1992 James B. Janknegt

James Janknegt's colorful, figurative piece, Three Visitors, *was shown at Lyons Matrix Gallery in Austin, and was also used on the gallery's 1993 exhibition invitation. It has since sold to a private collector. "I hated to let this piece go," says Gallery Director Camille Lyons. "It was one of my favorite works that Jim has done."*

area; 3,000 sq. ft.; Southwestern architecture. 30% of space for special exhibitions. Clientele: 50% private collectors, 20% corporate collectors. Overall price range: $50-35,000; most work sold at $250-3,500.

Media: Considers oil, acrylic, watercolor, pastel, pen & ink, drawing, mixed media, collage, works on paper, sculpture, ceramic, original handpulled prints, woodcuts, engravings, lithographs, pochoir, wood engravings, mezzotints, serigraphs, linocuts, etchings, offset reproductions and posters. Most frequently exhibits mixed media, acrylic and ceramic.

Style: Genres include landscapes, Western, Southwestern pottery and contemporary, bronzes and figurative work.

Terms: Accepts artwork on consignment. Retail price set by the artist. Sometimes offers customer discounts and payment by installment. Gallery provides promotion; artist pays for shipping.

Submissions: Send query letter with slides, bio, brochure and photographs. If no reply, the artist should call. Portfolio review requested if interested in artist's work. Portfolio should include originals, photographs and slides.

Tips: Finds artists through agents, by visiting exhibitions, word of mouth, various art publications, sourcebooks, artists' submissions/self-promotions and art collectors' referrals. "We will not see walk-ins."

ROBINSON GALLERIES, 3514 Lake St., Houston TX 77098. (713)526-0761. Fax: (713)526-0763. Director: Thomas V. Robinson. Retail and wholesale gallery. Estab. 1969. Represents 10 emerging, mid-career and established artists. Sponsors 4 solo and 6 group shows/year. Average display time 5 weeks. Clientele: 90% museum and private collectors, 10% corporate clients. Overall price range: $100-100,000; most work sold at $1,000-25,000.

Media: Considers all media, including egg tempera, woodcuts, wood engravings, linocuts, engravings, mezzotints, etchings, lithographs and serigraphs. Most frequently exhibits oil/acrylic paintings, works on paper, wood and bronze.

Style: Exhibits expressionism, realism, photorealism, surrealism, primitivism and conceptualism. Genres include landscapes, art of the Americas and figurative work. Prefers figurative and representational work and social commentary. "I am interested in artists that are making a statement about the human condition.

Looking for abstraction based on the figure or nature, but not pure abstraction."
Terms: Accepts work on consignment (50% commission) or buys outright for 50% retail price (net 10 days). Retail price set by gallery and artist. Exclusive area representation required. Gallery provides insurance, promotion and shipping costs from gallery. Prefers artwork framed.
Submissions: Send query letter with résumé, brochure, slides, photographs, bio and SASE. Write for appointment to show portfolio of originals, slides, transparencies and photographs. Replies in 1 week. Files résumé and slides. All material returned if not accepted or under consideration, "only by SASE."
Tips: The most common mistake artists make is that "they do not know, nor do they seem to be concerned with the direction of the prospective gallery. Artists should do their homework and predetermine if the gallery and the work it shows and promotes is compatible with the work and career objectives of the artist."

SELECT ART, 10315 Gooding Dr., Dallas TX 75229. (214)353-0011. Fax: (214)350-0027. Owner: Paul Adelson. Private art gallery. Estab. 1986. Represents 25 emerging, mid-career and established artists. Exhibited artists include Barbara Elam and Larry Oliverson. Open all year; Monday-Saturday 9-5 by appointment only. Located in North Dallas; 2,500 sq. ft. "Mostly I do corporate art placement." Clientele: 15% private collectors, 85% corporate collectors. Overall price range: $200-7,500; most work sold at $500-1,500.
Media: Considers oil, fiber, acrylic, sculpture, glass, watercolor, mixed media, ceramic, pastel, collage, photography, woodcuts, linocuts, engravings, etchings and lithographs. Prefers monoprints, paintings on paper and photography.
Style: Exhibits photorealism, minimalism, painterly abstraction, realism and impressionism. Genres include landscapes. Prefers abstraction, minimalism and impressionism.
Terms: Accepts work on consignment (50% commission). Retail price set by consultant and artist. Sometimes offers customer discounts. Provides contract (if the artist requests one). Consultant pays shipping costs from gallery; artist pays shipping to gallery. Prefers artwork unframed.
Submissions: "No florals or wildlife." Send query letter with résumé, slides, bio and SASE. Call for appointment to show portfolio of slides. Replies only if interested within 1 month. Files slides, bio, price list.
Tips: Finds artists through word of mouth and referrals from other artists. "I occasionally run ads."

‡SPICEWOOD GALLERY & DESIGN STUDIO, 1206 W. 38th St., Austin TX 78705. (512)458-6575. Fax: (512)458-8102. Owner: Jackie Depew. Retail gallery. Estab. 1978. Represents 100 mid-career and established artists/year. May be interested in seeing the work of emerging artists in the future. Exhibited artists include Ken Muenzenmayer, Bobbie Kilpatrick. Sponsors 10 shows/year. Average display time 1 month. Open all year; Monday-Saturday, 10-6. Located in a retail specialty shopping center; 3,895 sq. ft.; airy, built around large atrium. 25% of space for special exhibitions; 75% of space for gallery artists. Clientele: middle-upper class, professionals, well educated. 95% private collectors, 5% corporate collectors. Overall price range: $300-30,000; most work sold at $750-2,000.
Media: Considers oil, acrylic, watercolor, pastel, drawing, mixed media, collage, paper, sculpture, ceramics, craft and glass. Most frequently exhibits oil, watercolor and mixed media.
Style: Exhibits expressionism, neo-expressionism, painterly abstraction, surrealism and impressionism. Genres include landscapes, florals, Americana, Southwestern and figurative work. Prefers landscapes and floral.
Terms: Accepts work on consignment (50% commission). Retail price set by the artist. Gallery provides promotion and contract; artist pays shipping costs to and from gallery. Prefers artwork framed.
Submissions: Accepts only artists from Southwest. Prefers only oil, watercolor, acrylic, mixed media, pastel. Send query letter with résumé, slides, bio, brochure, photographs and SASE. Call for appointment to show portfolio of originals, photographs and slides. Replies only if interested within 1 month. Files résumé, bio, brochure, photos.
Tips: Finds artists through agents by visiting exhibitions, word of mouth, various art publications and sourcebooks, artists' submissions.

WEST END GALLERY, 5425 Blossom, Houston TX 77007. (713)861-9544. Owner: Kathleen Packlick. Retail gallery. Estab. 1991. Exhibits emerging and mid-career artists. Exhibited artists include Kathleen Packlick and Suzanne Decker. Sponsors 6 shows/year. Average display time 6 weeks. Open all year; Saturday 12-4. Located 5 mintues from downtown Houston; 800 sq. ft.; "The gallery shares the building (but not the space) with West End Bicycles." 75% of space for special exhibitions; 25% of space for gallery artists. Clientele: 100% private collectors. Overall price range: $30-2,200; most work sold at $300-600.
Media: Considers oil, pen & ink, acrylic, drawings, watercolor, mixed media, pastel, collage, woodcuts, wood engravings, linocuts, engravings, mezzotints, etchings, lithographs and serigraphs. Prefers collage, oil and mixed media.
Style: Exhibits conceptualism, minimalism, primitivism, postmodern works, realism and imagism. Genres include landscapes, florals, wildlife, Americana, portraits and figurative work. Prefers figurative and conceptual.
Terms: Accepts work on consignment (40% commission). Retail price set by artist. Customer discounts and payment by installment are available. Gallery provides promotion; artist pays shipping costs. Prefers artwork framed.

Submissions: Accepts only artists from Houston area. Send query letter with slides and SASE. Portfolio review requested if interested in artist's work.

‡**WICHITA FALLS MUSEUM & ART CENTER,** #2 Eureka Circle, Wichita Falls TX 76308. (817)692-0923. Fax: (817)696-5358. Director: Lin Purtle. Museum. Estab. 1965. Represents 200-300 mid-career and established artists/year. May be interested in seeing the work of emerging artists in the future. 1,000 members. Sponsors 15-20 shows/year. Average display time 6 weeks. Open all year; Tuesday-Saturday, 10-5; Sunday, 1-5. Located near university; 4,000 sq. ft.; clean contemporary space. 50% of space for gallery artists.
Media: Considers any media, all types of prints. Most frequently exhibits prints and paintings.
Style: Exhibits all styles including historically oriented/early works, all genres. Prefers contemporary, early 20th century and pre-20th.
Terms: Work is bought outright for museum's permanent collection only. Shipping costs are shared. Prefers artwork framed.
Submissions: Prefers only American prints for purchase. Send query letter with résumé, slides, bio, brochure, SASE and reviews.
Tips: Finds artists through galleries and dealers.

Utah

APPLE YARD ART, 3096 S. Highland Dr., Salt Lake City UT 84106. (801)467-3621. Manager: Sue Valentine. Retail gallery. Estab. 1981. Represents 15 established artists. Interested in seeing the work of emerging, mid-career and established artists. Average display time 3 months. "We have added European pine antiques and home accessories to compliment our art." Clientele: 70% private collectors, 30% corporate clients. Overall price range: $150-2,000; most artwork sold at $450.
Media: Most frequently exhibits watercolor, serigraphs and limited edition lithographs.
Style: Exhibits impressionisim. Genres include landscapes and florals. Prefers impressionistic watercolors.
Terms: Accepts work on consignment (40% commission). Retail price set by artist. Gallery provides insurance, promotion and contract; artist pays for shipping.
Submissions: Send query letter, résumé and slides. Write for appointment to show portfolio of well-matted and framed originals.
Tips: Looks for "fresh, spontaneous subjects, no plagiarism." The most common mistakes artists make in presenting their work are "poor framing, no established prices, wanting us to tell them what to sell it for. The artists should establish their prices and have a professional portfolio."

‡**BRAITHWAITE FINE ARTS GALLERY,** 351 West Center, Cedar City UT 84720. (801)586-5432. Director: Mandy Brooks. Nonprofit gallery. Estab. 1976. Represents emerging, mid-career and established artists. Has "100 friends (donors)." Exhibited artists include Jim Jones and Milford Zornes. Sponsors 17 shows/year. Average display time 1 month. Open all year. Located on "college campus; 1,500 sq. ft. (275 ft. running wall); historic—but renovated—building." 100% of space for special exhibitions. Clientele: local citizens, visitors for Shakespeare festival during summer. Clientele: 100% private collectors. Overall price range: $100-8,000; most work sold at $100-500.
Media: Considers oil, acrylic, watercolor, pastel, pen & ink, drawings, mixed media, collage, works on paper, sculpture, ceramic, fiber, glass, installation, photography, original handpulled prints, woodcuts, wood engravings, linocuts, engravings, mezzotints, etchings, lithographs, serigraphs. Most frequently exhibits oil, watercolor and ceramic.
Style: Exhibits all styles and genres.
Terms: Accepts work on consignment (25% commission). Retail price set by the artist. Customer discounts and payment by installment are available. Gallery provides insurance, promotion and contract (duration of exhibit only); shipping costs are shared. Ready to hang artwork only.
Submissions: Send query letter with résumé, slides, bio and SASE. Write to schedule an appointment to show a portfolio, which should include slides and transparencies. Replies in 3-4 weeks. Files bios, slides, résumé (only for 2 years).
Tips: "Know our audience! Generally conservative; during summer (Shakespeare festival) usually loosens up. We look for broad stylistic vision and content. Artists often send no slides, no bio, no artist statement."

DOLORES CHASE FINE ART, 260 S. 200 W St., Salt Lake City UT 84101. (801)328-2787. Fax: (801)364-1102. Contact: Dolores Chase. Retail gallery. Estab. 1985. Represents 15 mid-career artists. Exhibited artists include Edie Roberson and Lee Deffebach. Sponsors 4-6 shows/year. Average display time 6-8 weeks. Open all year. Located in downtown Salt Lake City; 2,000 sq. ft.; gallery features a diagonal exhibit wall through large room, with smaller side galleries. 35% of space for special exhibitions. Clientele: skiers and other visitors from out of town, locals, business people and collectors. 70% private collectors, 30% corporate collectors. Overall price range: $500-25,000; most work sold at $1,000-5,000.
Media: Considers oil, acrylic, pastel, watercolor, mixed media, sculpture, ceramic and glass. No prints. Most frequently exhibits acrylic, oil and mixed media.

Style: Exhibits expressionism, painterly abstraction, surrealism, color field and realism. All genres. Prefers contemporary art, abstraction, surrealism and realism.

Terms: Accepts work on consignment (50% commission). Retail price set by gallery and artist. Customer discounts and payment by installment are available. Gallery provides insurance, contract and shipping costs from gallery.

Submissions: Send query letter with résumé, slides, bio, SASE, reviews and price list. Prefers art under $2,000. Portfolio review requested if interested in artist's work. Replies in 3-5 weeks.

Tips: Finds artists through visits to universities and other nonprofit shows, word of mouth from other artists. Looks for "dramatic use of color, unique subject matter. I am appalled by shallow commercial-design art and copycat artists. Only serious artists with a fresh, honest appeal. Narrative art is very appealing, as is good abstract work." The most common mistake artists make in presenting their work is "too high a regard/price on untried artwork. My collectors know quality and price."

MARBLE HOUSE GALLERY, 44 Exchange Place, Salt Lake City UT 84111. (801)532-7338. Owner: Dolores Kohler. Retail gallery and art consultancy. Estab. 1987. Represents 20 emerging, mid-career and established artists. Sponsors 6 solo or 2-person shows and 2 group shows/year. Average display time 1 month. Located in the historic financial district; modern interior, marble facade, well lit; 6,000 sq. ft. Clientele: 70% private collectors, 30% corporate clients. Overall price range $100-10,000; most work sold at $200-5,000.

• Now carries limited edition prints from Greenwich Workshop and Somerset House Publishing.

Media: Considers oil, acrylic, watercolor, pastel, pen & ink, mixed media, collage, sculpture, ceramic, photography, egg tempera, woodcuts, wood engravings, linocuts, engravings, mezzotints, etchings, lithographs, pochoir and serigraphs. Most frequently exhibits oil, watercolor, sculpture and limited editions.

Style: Exhibits impressionism, expressionism, realism, surrealism, painterly abstraction and postmodern works. Genres include landscapes, florals, Americana, Southwestern, Western, portraits, still lifes and figurative work. Prefers abstraction, landscapes and florals. Looking for "artwork with something extra: landscapes with a center of interest (people or animals, etc.); abstracts that are well designed; still life with a unifying theme; subjects of interest to viewers."

Terms: Accepts work on consignment (50% commission) or buys outright (net 30 days.) Retail price set by gallery and artist. Customer discounts and payment by installment are available. Exclusive area representation required. Gallery provides promotion and contract; shipping costs are shared.

Submissions: Send query letter with résumé, slides, photographs, bio and SASE. Portfolio review requested if interested in artist's work. Portfolio should include originals, slides, transparencies and photographs. Files slides, résumé and price list. All material returned if not accepted or under consideration.

Tips: Finds artists through agents, associations, artists' submissions and referrals. "No crude, suggestive subjects. We look for professionalism and steady production in artists. We have a Gallery Stroll on the 3rd Friday of each month. About 15 galleries participate."

TIVOLI GALLERY, 255 S. State, Salt Lake City UT 84111. (801)521-6288. Fax: (801)363-3528. Director: Dane Traeden. Retail gallery. Estab. 1966. Represents 30 mid-career and established artists. Interested in seeing the work of emerging artists. Exhibited artists include Elva Malin and Rod Serbousek. Sponsors 6 shows/year. Average display time 6 months. Open all year. Located "downtown; 25,000 sq. ft. (largest in the country); Utah's first burlesque theater, has 20 ft. ceilings." 20% of space for special exhibits. Clientele: all types. 60% private collectors, 40% corporate collectors. Overall price range: $50-15,000; most work sold at $600-1,200.

Media: Considers oil, acrylic, watercolor, pastel, sculpture and ceramic. Does not consider prints. Most frequently exhibits oil, watercolor and acrylic.

Style: Exhibits expressionism, painterly abstraction, imagism, impressionism, realism and hard-edge geometric abstraction. Genres include landscapes, florals, Southwestern, Western and figurative work. Prefers landscapes and expressionism. Work is 50% traditional, 50% modern expressionist.

Terms: Accepts work on consignment (50% commission) or buys outright for 25% of retail price (net 60 days). Retail price set by gallery and artist. Customer discounts and payment by installment are available. Gallery provides promotion, contract and shipping costs from gallery.

Submissions: Accepts only artists from Western regions. Send query letter with slides, photographs and bio. Call or write for appointment to show portfolio of originals or photographs or slides. Replies in 2 weeks. Files slides, photos and bios.

Tips: "Don't be intimidated. We like to talk to all artists!"

Vermont

COTTONBROOK GALLERY, 1056-13 Mt. Rd., Stowe VT 05672. (802)253-8121. Owner: Vera Beckerhoff. Retail gallery and custom frame shop. Estab. 1981. Average display time 3 weeks. Clientele: upscale second homeowners. Overall price range: $50-3,000; most work sold at $100-200.

Media: Considers oil, watercolor, drawings, mixed media and sculpture. Most frequently exhibits watercolor and oil.

Style: Exhibits painterly abstraction, primitivism and impressionism. Shows are thematic.
Terms: Work accepted on consignment. Retail price set by gallery or artist. Exclusive area representation required. Shipping costs are shared.
Submissions: Send query letter with résumé, slides and SASE. Write for appointment to show portfolio of originals.

LA PETITE GALERIE, Suite 6, 236 S. Union St., Burlington VT 05401-4514. (802)865-3057. Director: Jean Johnson. Retail gallery. Estab. 1990. Represents 30 emerging and established artists. Exhibited artists include Ruth Rumney and Ken Budd. Sponsors 11 shows/year. Closed August. Located downtown; 1,700 sq. ft.; "interior is country French." Clientele: tourists (Canada). 30% private collectors, 70% corporate collectors. Overall price range: $300-10,000; most work sold at $1,000.
Media: Considers oil, pen & ink, acrylic, drawings, sculpture, watercolor, mixed media, ceramic sculptures on wheel, pastel, original handpulled prints, woodcuts, engravings and etchings. Most frequently exhibits bronze sculpture, acrylics (framed), wood and ceramic sculptures.
Style: Exhibits painterly abstraction impressionism, realism, photorealism, pattern painting, and hard-edge geometric abstraction. Genres include landscapes, florals, Southwestern, wildlife and figurative work. Prefers figurative, abstract and impressionistic.
Terms: Accepts work on consignment (40% commission; Vermont artists 20% commission). Retail price set by artist. Offers customer discount. Gallery provides promotion; artist pays for shipping. Prefers artwork framed.
Submissions: Send query letter with résumé, brochure, business card, slides, photographs, reviews, bio, SASE, video if possible, and price list. Write for appointment to show portfolio of originals, photographs and transparencies. Replies in 1 week. Files slides, photos and bio.
Tips: Finds artists through visiting exhibitions, word of mouth, artists' submissions and art collectors' referrals. "Artists should send all materials at one time, i.e. slides, a minimum of 10 (sleeve preferred) and an artist's statement. A good presentation reduces need for personal interview."

PARADE GALLERY, Box 245, Warren VT 05674. (802)496-5445. Owner: Jeffrey S. Burnett. Retail gallery. Estab. 1982. Represents 15-20 emerging, mid-career and established artists. Clientele: tourist and upper middle class second-home owners. 98% private collectors. Overall price range: $20-2,500; most work sold at $50-300.
Media: Considers oil, acrylic, watercolor, pastel, mixed media, collage, works on paper, sculpture and original handpulled prints. Most frequently exhibits etchings, silkscreen and watercolor. Currently looking for oil/acrylic and watercolor.
Style: Exhibits primitivism, impressionistic and realism. "Parade Gallery deals primarily with representational works with country subject matter. The gallery is interested in unique contemporary pieces to a limited degree." Does not want to see "cutesy or very abstract art."
Terms: Accepts work on consignment (33⅓% commission) or occasionally buys outright (net 30 days). Retail price set by gallery or artist. Sometimes offers customer discounts and payment by installment. Exclusive area representation required. Gallery provides insurance and promotion.
Submissions: Send query letter with résumé, slides and photographs. Portfolio review requested if interested in artist's work. A common mistake artists make in presenting their work is having "unprofessional presentation or poor framing." Biographies and background are filed.
Tips: Finds artists through customer recommendations, shows, magazines or newspaper stories and photos. "We need to broaden offerings in price ranges which seem to offer a good deal for the money."

WOODSTOCK GALLERY OF ART, Gallery Place, Route 4 E., Woodstock VT 05091. (802)457-1900. Fax: (802)457-3022. Director: Charles Fenton. Retail gallery. Estab. 1972. Represents 70 emerging and mid-career artists. Exhibited artists include Cynthia Price and Jerome Couelle. Sponsors 8-10 shows/year. Average display time 1 month. Open all year. Located 1 mile east of town; 1,600 sq. ft.; gallery features large wall space, cathedral ceilings, wooden staircase. 50-75% of space for special exhibitions. Clientele: 75% private collectors, 25% corporate collectors. Overall price range: $100-25,000.
Media: Considers all media; monoprints. Most frequently exhibits acrylic/oil paintings, photo/etching and sculpture.
Style: Exhibits expressionism, neo-expressionism, surrealism, painterly abstraction and realism. Will consider all styles and genres. Prefers expressionism and painterly and figurative abstraction.
Terms: Accepts work on consignment (50% commission). Retail price set by gallery and artist. Offers customer discounts and payment by installments. Gallery provides insurance, promotion and contract; artist pays for shipping. Prefers artwork framed.
Submissions: Send query letter with résumé, brochure, slides, photographs, business card, reviews, bio and SASE. Write to schedule appointment to show portfolio of originals. Replies in 2 weeks. Files résumés and bio sheets.
Tips: "Send an organized packet including items listed above under submissions. Artists with honesty and commitment, please apply."

Virginia

‡**ALLEGHANY HIGHLANDS ARTS AND CRAFTS CENTER**, 439 Ridgeway St., Box 273, Clifton Forge VA 24422. (703)862-4447. Chairman, Exhibition Committee: Bess Caton. Retail and nonprofit gallery. Estab. 1984. Represents 86 artists and 227 craftspeople; emerging, mid-career and established. 389 members. Exhibited artists include Jeanne Shepherd and Geneva Welch. Sponsors 12 shows/year. Average display time 1 month. Open all year. Located downtown; 428 sq. ft. in one gallery, 397 sq. ft in second adjoining space — "can be used together. Also 59 running feet in shop area; spacious, well lit, comfortable to children and adults, handicapped accessibility." 55% of space for special exhibitions. Clientele: tourists from all 50 states and several foreign counties annually, as well as regional visitors. 99% private collectors, 1% corporate collectors. Overall price range: $25-500; most work sold at $125-250.

• Jurying here is very stringent, but they do make an effort to communicate with artists the reasons for rejection.

Media: Considers all media; original handpulled prints, woodcuts, wood engravings, linocuts, engravings, mezzotints, etchings, lithographs and serigraphs. Most frequently exhibits oil and watercolor, drawings/prints and sculpture.

Style: Exhibits expressionism, primitivism, painterly abstraction, postmodern works, impressionism, realism. All genres. Prefers realism, impressionism and painterly abstraction. "Our only real preference is for quality work."

Terms: Accepts work on consignment (30% commission). Retail price set by the artist. Sometimes offers customer discounts and payment by installment. Gallery provides insurance and promotion; artist pays for shipping. Prefers artwork framed. "While we prefer framed work, we have some space for matted shrink wrapped pieces."

Submissions: "We focus on artists from the region (150 mile radius)." Send query letter with résumé, slides, bio, SASE and "brief reviews, please." Portfolio review required. "We will look at slides, however we will make final decisions based on seeing actual work, presentation ready." Files résumés, representations of work and brief reviews.

Tips: Finds artists through visiting exhibitions; word of mouth referrals from other artists, patrons, and other arts administrators/curators. "We also have a number of artists who self-promote. We work to present all media and styles as the Center is an educational facility. We also see many tourists, particularly from May-December."

ART AND AUTHORS GALLERY, 202 Clarke Court, Fredericksburg VA 22407. (703)898-9107. Owner/Curator/Artist: Anne Brauer. Retail gallery. Estab. 1989. Represents local artists. Exhibited artists include Anne Brooks Brauer, D. Green, Van Anderson. Closed February and August. Located in commercial area just outside of city limits in Baltimore-Washington DC area; 576 sq. ft.; "redecorated one-story garden gallery with skylights, divided into 2 galleries for openness." 50% of space for special exhibitions. Clientele: professionals, collectors and the general public. 90% private collectors. Overall price range: $50-650; most work sold at $150-300.

• Fredericksburg receives many tourists from the Baltimore-Washington metropolitan area.

Media: Considers oil, acrylic, watercolor, pen & ink, mixed media, collage and sculpture. Most frequently exhibits oil, watercolor and mixed media. "Will accept no art on anything except canvas and canvas boards (watercolors matted)."

Style: Exhibits expressionism, primitivism, painterly abstraction, impressionism and realism. Genres include landscapes, florals, Americana and portraits. "The public in general still wants originals of familiar things: landscapes, flowers, animals, children, scenes and subdued colors that blend with surroundings."

Terms: Accepts work on consignment (40% commission). Retail price set by artist. Offers customer discounts and payment by installments. Gallery provides promotion; artist pays for shipping. "Artwork must be original."

Submissions: Accepts only artists from within 50-mile radius. "Come by the gallery so we can meet you and see your work." Call for appointment to meet curator. Files photographs of work.

Tips: Finds artists through self-promotion of gallery and news articles in local paper which attract artists. "Be sure you feel your work is saleable. The curator has final word in accepting any art to be displayed. The gallery also sells local authors' works, and some locally handpainted greeting cards and note paper."

THE ART LEAGUE, INC., 105 N. Union St., Alexandria VA 22314. (703)683-1780. Executive Director: Cora J. Rupp. Gallery Director: Nancy Saulnier. Cooperative gallery. Estab. 1953. Interested in emerging, mid-career and established artists. 1,000-1,100 members. Sponsors 10 solo and 16 group shows/year. Average display time 1 month. Located in The Torpedo Factory Art Center. Accepts artists from metropolitan Washington area, northern Virginia and Maryland. Clientele: 75% private collectors, 25% corporate clients. Overall price range: $50-4,000; most work sold at $150-500.

• The Art League is celebrating its 42nd year.

Media: Considers oil, acrylic, watercolor, pastel, pen & ink, drawings, mixed media, collage, works on paper, sculpture, ceramic, fiber, glass, photography and original handpulled prints. Most frequently exhibits watercolor, all printmaking media and oil/acrylic.

Style: Exhibits all styles and genres. Prefers impressionism, painted abstraction and realism. "The Art League is a membership organization open to anyone interested."
Terms: Accepts work on consignment (33⅓% commission) and co-op membership fee plus donation of time. Retail price set by artist. Offers customer discounts (designers only) and payment by installments (if requested on long term). Exclusive area representation not required.
Submissions: Portfolio review requested if interested in artist's work.
Tips: "Artists find us and join/exhibit as they wish within framework of our selections jurying process."

‡**ART MUSEUM OF WESTERN VIRGINIA**, 1 Market Square, Roanoke VA 24011. (703)342-5760. Fax: (703)342-5798. Assistant Curator: Carissa South. Museum. Estab. 1951. Represents emerging, mid-career and established artists. 800 members. Sponsors 10 shows/year. Average display time 3 months. Open all year; Tuesday-Saturday, 10-5; Sunday, 1-5. Located downtown; 60,000 sq. ft.; in facility with 4 other museum organizations. 70% of space for rotating/temporary special exhibitions; 30% of space for permanent collection. Clientele: tourists, educators and classes.
 • AMWV also has a children's art center, Artventure, with its own gallery space for exhibitions of special interest to children.
Media: Considers all media, including photography.
Style: Exhibits all styles, all genres.
Terms: Gallery provides insurance and promotion; shipping costs are shared. Prefers artwork framed.
Submissions: Prefers only artists from southern mountain region of US. Send query letter with résumé, slides, bio. Write for appointment to show portfolio of slides and transparencies. Replies in 6-8 weeks. Files 1-2 slides from regional artists, résumé.
Tips: Finds artists through visiting exhibitions, word of mouth and artists' submissions. "Slide submission *strongly* encouraged!"

‡**FINE ARTS CENTER FOR NEW RIVER VALLEY**, 21 W. Main St., Pulaski VA 24301. (703)980-7363. Director: Michael Dowell. Nonprofit gallery. Estab. 1978. Represents 75 emerging, mid-career and established artists and craftspeople. Sponsors 10 solo and 2 group shows/year. Average display time is 1 month (gallery); 3-6 months (Art Mart). Clientele: general public, corporate, schools. 80% private collectors, 20% corporate clients. Overall price range: $20-500; most artwork sold at $20-100.
 • Downtown Pulaski is enjoying a new growth in the arts, music and antiques areas thanks to an active and successful main street revitalization program.
Media: Considers all media. Most frequently exhibits oil, watercolor and ceramic.
Style: Exhibits hard-edge/geometric abstraction, painterly abstraction, minimalism, post-modernism, pattern painting, feminist/political works, primitivism, impressionism, photorealism, expressionism, neo-expressionism, realism and surrealism. Genres include landscapes, florals, Americana, Western, portraits and figurative work. Most frequently exhibits landscapes, abstracts, Americana.
Terms: Accepts work on consignment (25% commission). Retail price is set by gallery or artist. Sometimes offers payment by installments. Exclusive area representation not required. Gallery provides insurance (80% of value), promotion and contract.
Submissions: Send query letter with résumé, brochure, clearly labeled slides, photographs and SASE. Slides and résumés are filed. Portfolio review requested if interested in artist's work. "We do not want to see unmatted or unframed paintings and watercolors."
Tips: Finds artists through visiting exhibitions and art collectors' referrals. "In the selection process, preference is often (but not always) given to regional and Southeastern artists. This is in accordance with our size, mission and budget constraints."

GALLERY WEST, LTD., 205 S. Union St., Alexandria VA 22314. (703)549-7359. Director: Craig Snyder. Cooperative gallery and alternative space. Estab. 1979. Exhibits the work of 30 emerging, mid-career and established artists. Sponsors 17 shows/year. Average display time 3 weeks. Open all year. Located in Old Town; 1,000 sq. ft. 60% of space for special exhibitions. Clientele: individual, corporate and decorators. 90% private collectors, 10% corporate collectors. Overall price range: $100-2,000; most work sold at $150-400.
Media: Considers all media.
Style: All styles and genres.
Terms: Co-op membership fee plus a donation of time. (25% commission.) Retail price set by artist. Sometimes offers customer discounts and payment by installments. Gallery assists promotion; artist pays for shipping. Prefers artwork framed.

A bullet introduces comments by the editor of Artist's & Graphic Designer's Market *indicating special information about the listing.*

Submissions: Send query letter with résumé, slides, bio and SASE. Call for appointment to show portfolio of slides. Replies in 3 weeks. Files résumés.

‡**GILPIN GALLERY, INC.**, 817 S. Washington St., Alexandria VA 22314. (703)549-2040. President: Maryanne Kowalesky. Retail gallery. Estab. 1982. Represents 25 emerging and established artists. Sponsors 4 solo shows/year. 90% of total space devoted to special exhibitions. 80% private collectors, 20% corporate clients.
Media: Considers paintings, drawings, wearable prints and sculpture.
Style: Exhibits representational, impressionist, expressionist and abstract works.
Terms: Accepts work on consignment (50% commission). Buys outright (50% retail price). Retail price set by gallery and artist. Exclusive area representation not required. Gallery provides insurance, some promotion, contract and shipping from gallery. Prefers artwork framed.
Submissions: Send query letter with brochure and bio. Call or write to schedule an appointment to show a portfolio, which should include originals and photographs. Replies only if interested within 1 month. Files all material. All material is returned if not accepted or under consideration.
Tips: "Do not approach us on weekends or holidays. We prefer appointments."

HERNDON OLD TOWN GALLERY, 720 Lynn St., Herndon VA 22070. (703)435-1888. Membership chairman: Lassie Corbett. Cooperative gallery. Estab. 1984. Represents 10 member artists. Interested in mid-career artists. Sponsors 4 solo and 8 group shows/year. Average display time 2 months. Recently altered space to allow more room for small pieces and matted work. 90% private collectors, 10% corporate clients. Overall price range: $25-1,000; most work sold at $150-350.
• The gallery is now part of a small art school in the same location.
Media: Considers oil, acrylic, watercolor, pastel, pen & ink, drawings, mixed media, collage, photography, egg tempera, original handpulled prints and offset reproductions. Most frequently exhibits watercolor, acrylic, oil and drawings.
Style: Exhibits impressionism, realism and oriental brush; considers all styles. Genres include landscapes, florals, Americana, wildlife, figurative work; considers all genres. Prefers impressionism, realism (local scenes) and oriental brush. "We are more interested in quality than type of style."
Terms: 10% commission. Retail price set by artist. Customer discounts and payment by installment are available. Exclusive area representation not required. Gallery provides promotion; artist pays for shipping. Prefers artwork framed.
Submissions: Send query letter with résumé, slides and SASE. Call or write for appointment to show portfolio of originals, slides or photographs. Replies in 1 week. All material is returned if not accepted or under consideration. Contact for guidelines.
Tips: "We find most of our artists through artists' submissions. Watch your presentation; don't want to see sloppy or dirty mats, damaged frames, etc."

MARSH ART GALLERY, University of Richmond, Richmond VA 23173. (804)289-8276. Fax: (804)287-6006. Director: Richard Waller. Museum. Estab. 1967. Represents emerging, mid-career and established artists. Sponsors 10 shows/year. Average display time 1 month. Open all year; with limited summer hours June-August. Located on University campus; 1,800 sq. ft. 100% of space for special exhibitions.
Media: Considers all media and all types of prints. Most frequently exhibits painting, sculpture, photography and drawing.
Style: Exhibits all styles and genres.
Terms: Work accepted on loan for duration of special exhibition. Retail price set by the artist. Gallery provides insurance, promotion, contract and shipping costs. Prefers artwork framed.
Submissions: Send query letter with résumé, slides, brochure, SASE, reviews and printed material if available. Write for appointment to show portfolio of photographs, slides, transparencies or "whatever is appropriate to understanding the artist's work." Replies in 1 month. Files résumé and other materials the artist does not want returned (printed material, slides, reviews, etc.).

‡**THE PRINCE ROYAL GALLERY**, 204 S. Royal St., Alexandria VA 22314. (703)548-5151. Director: John Byers. Retail gallery. Estab. 1977. Interested in emerging, mid-career and established artists. Sponsors 6 solo and 1 group shows/year. Average display time 3-4 weeks. Located in middle of Old Town Alexandria. "Gallery is the ballroom and adjacent rooms of historic hotel." Clientele: primarily Virginia, Maryland & Washington DC residents. 95% private collectors, 5% corporate clients. Overall price range: $75-8,000; most artwork sold at $700-1,200.
Media: Considers oil, acrylic, watercolor, pastel, mixed media, sculpture, egg tempera, engravings, etchings and lithographs. Most frequently exhibits oil, watercolor and bronze.
Style: Exhibits impressionism, expressionism, realism, primitivism and painterly abstraction. Genres include landscapes, florals, portraits and figurative work. "The gallery deals primarily in original, representational art. Abstracts are occasionally accepted but are hard to sell in northern Virginia. Limited edition prints are accepted only if the gallery carries the artist's original work."
Terms: Accepts work on consignment (40% commission). Retail price set by artist. Customer discounts and payment by installment are available, but only after checking with the artist involved and getting permission.

Exclusive area representation required. Gallery provides insurance, promotion and contract. Prefers framed artwork.

Submissions: Send query letter with résumé, brochure, slides and SASE. Call or write to schedule an appointment to show a portfolio, which should include originals, slides and transparencies. Replies in 1 week. Files résumés and brochures. All other material is returned.

Tips: "Write or call for an appointment before coming. Have at least 6 pieces ready to consign if accepted. Can't speak for the world, but in northern Virginia collectors are slowing down. Lower-priced items continue OK, but sales over $3,000 are becoming rare. More people are buying representational rather than abstract art. Impressionist art is increasing."

‡RESTON ART GALLERY, 11400 Washington Plaza W, Reston VA 22090. (703)481-8156. Publicity: Pat Macintyre. Estab. 1988. Represents 6 artists. Interested in emerging artists. Sponsors 10 solo and 2 group shows/year. Average display time 2 months. 75% private collectors, 25% corporate clients. Overall price range: $25-1,750; most work sold at $150-350.

• This gallery offers some artist's working studios and exhibition space.

Media: Considers all media and prints. Most frequently exhibits oil, acrylic, watercolor, photos and graphics.
Style: Exhibits all styles and genres. Prefers realism and painterly abstraction. The gallery's purpose is to "promote local artists and to educate the public. Gallery sitting and attendance at meetings are required."
Terms: Some consignment (33⅓ commission). Retail price set by artist. Customer discounts and payment by installments are available. Exclusive area representation not required. Gallery provides promotion; artist pays for shipping.
Submissions: Send query letter with résumé, slides, photographs, bio and SASE. Portfolio review requested if interested in artist's work. Portfolio should include originals, slides and photographs. Replies in 1 week. All material is returned if not accepted or under consideration.
Tips: Finds artists through visiting exhibitions and word of mouth.

‡1708 GALLERY, 103 E. Broad St., P.O. Box 12520, Richmond VA 23241. (804)643-7829. Contact: Exhibitions Chair. Alternative space, nonprofit gallery. Estab. 1978. Represents emerging and mid-career artists. 24 members. Sponsors 18 shows/year. Average display time 1 month. Open all year; Tuesday-Sunday, 1-5 pm. Located downtown; one gallery space is 2,000 sq. ft., additional gallery space, 600 sq. ft.; 16 ft. ceilings, art deco staircase. 60% of space for special exhibitions; 40% of space for gallery artists. Clientele: broad cross-section of community. 70% private collectors, 30% corporate collectors. Overall price range: $50-7,000; most work sold at $250-800.
Media: Considers oil, acrylic, watercolor, pastel, pen & ink, drawing, mixed media, collage, sculpture, ceramics, installation, photography, "all contemporary media," woodcut, engraving, lithograph, wood engraving, mezzotint, serigraphs, linocut, etching, "all original print media." Most frequently exhibits painting and works on paper, sculpture and installations.
Style: Exhibits expressionism, neo-expressionism, painterly abstraction, surrealism, conceptualism, minimalism, postmodern works, realism, imagism, "no additional academic."
Terms: Work is for sale during exhibition only. Retail price set by the artist. Gallery provides insurance, promotion and contract; artist pays shipping costs. Prefers artwork framed.
Submissions: Send SASE for proposal form then send query letter with résumé, slides, bio, SASE and form. Reports in 2-3 months.
Tips: Open call for proposals annually.

Washington

‡BRUSKIN GALLERY, 820 Water, Port Townsend WA 98368. (206)385-6227. Contact: Kathleen Bruskin. Retail gallery. Estab. 1985. Repersents 200 established artists/year. Sponsors 12 shows/year. Average display time 1 month. Open all year; daily, 10-4:30. Located downtown. 100% of space for special exhibitions. Clientele: upper middle class. 100% private collectors. Overall price range: $200-900; most work sold at $350-500.
Media: Considers oil, acrylic, watercolor, pastel, mixed media, collage, sculpture and photography. Most frequently exhibits oil, watercolor and mixed media.
Style: Exhibits all styles, all genres. Prefers landscapes, figures, abstractions.
Terms: Accepts work on consignment (33⅓% commission). Retail price set by the gallery and the artist. Gallery provides promotion and contract; artist pays shipping costs to and from gallery. Prefers artwork framed.
Submissions: Send query letter with slides and photographs. Write for appointment to show portfolio of originals, photographs, slides and transparencies. Replies in 2 weeks.
Tips: Finds artists through visiting exhibitions and artists' submissions.

‡THE COLLECTION GALLERY, 118 S. Washington, Seattle WA 98104. (206)682-6184. Owner: Joyce Bronson. Retail gallery. Estab. 1987. Represents 30-40 emerging, mid-career and established artists/year. Exhibited

artists include Terry Cody, Bruce Morrow. Sponsors 6 shows/year. Average display time 5 weeks (for exhibition), 6 months (for gallery display). Open all year; Monday-Saturday, 10:30-5:30. Located downtown Pioneer Square, Seattle; 1,650 sq. ft.; historic brick building, 20 ft. high walls, open space. 25% of space for special exhibitions; 75% of space for gallery artists. Clientele: all types. 90% private collectors, 10% corporate collectors. Overall price range: $20-3,000; most work sold at $20-500.

Media: Considers oil, acrylic, watercolor, pen & ink, drawing, mixed media, collage, paper, ceramics, craft, fiber, photography, woodcut, lithograph and serigraph. Most frequently exhibits oil/acrylic, craft and furniture.

Style: Exhibits all styles, all genres.

Terms: Accepts work on consignment (50% commission). Retail prices set by the gallery and the artist. Gallery provides insurance, promotion and contract; artist pays shipping costs to and from gallery. Prefers artwork framed.

Submissions: Send query letter with slides, bio, photographs and SASE. Call or write for appointment to show portfolio of originals and photographs. Replies in 1-8 weeks. Files photos if interested for future.

Tips: Finds artists through artists' submissions, art publications.

‡**COMMENCEMENT ART GALLERY,** 902 Commerce, Tacoma WA 98402-4407. (206)593-4331. Fax: (206)591-2002. Coordinator: Ben Meeker. Alternative space, art consultancy and nonprofit gallery run by Tacoma Arts Commission. Estab. 1993. Represents 12 emerging or under-shown artists/year. Exhibited artists include Vivian Kendall. Sponsors 11-12 shows/year. Average display time 1 month. Open all year; Tuesday-Saturday, 11-5. Located downtown theater district; 600 sq. ft. (main gallery), 600 ft. performance/installation space, 2 large window display cases. "We occupy the basement of a 19th century theater." 10% of space for special exhibitions; 90% of space for gallery artists. Clientele: full range of Tacoma's population, poor to rich. 100% private collectors. Overall price range: $100-3,500; most work sold at $300-500.

Media: Considers all media, all types of prints. Most frequently exhibits painting/print/photo (2D), sculpture (3D) and installation/performance (4D).

Style: Exhibits all styles, all genres. Prefers cynicism, altruism and didacticism.

Terms: "We act as noncommissioned agent liason for artists." Retail price set by the artist. Gallery provides promotion; artist pays shipping costs to and from gallery.

Submissions: Accepts only emerging or under-shown artists from Puget Sound area (Tacoma, Seattle, Olympia). Send query letter with résumé, slides, bio. Call for appointment to show portfolio of originals and slides. Replies only if interested within 1-2 weeks. Files slides, résumé, bio.

Tips: Finds artists through annual juried slide competition open to all.

‡**FOSTER/WHITE GALLERY,** 311½ Occidental Ave. S., Seattle WA 98104. (206)622-2833. Fax: (206)622-7606. Owner/Director: Donald Foster. Retail gallery. Estab. 1973. Represents 90 emerging, mid-career and established artists/year. Interested in seeing the work of local emerging artists. Exhibited artists include Chihuly, Tobey, George Tsutakawa. Average display time 1 month. Open all year; Monday-Saturday, 10-5:30; Sunday, 12-5. Located historic Pioneer Square; 2,900 sq. ft. Clientele: private, corporate and public collectors. Overall price range: $300-35,000; most work sold at $2,000-8,000.

Media: Considers oil, acrylic, watercolor, pastel, pen & ink, drawing, mixed media, collage, paper, sculpture, ceramics, craft, fiber, glass and installation. Most frequently exhibits glass sculpture, works on paper and canvas and ceramic and metal sculptures.

Style: Contemporary Northwest art. Prefers contemporary Northwest abstract, contemporary glass sculpture.

Terms: Gallery provides insurance, promotion and contract.

Submissions: Accepts only artists from Pacific Northwest. Send query letter with résumé, slides, bio and reviews. Write for appointment to show portfolio of slides. Replies in 3 weeks.

‡**GALLERY ONE,** 408½ N. Pearl St., Ellensburg WA 98926. (509)925-2670. Director: Eveleth Green. Nonprofit gallery. Estab. 1968. Represents emerging, mid-career and established artists. 400 members. Sponsors 10 shows/year. Average display time 3½ weeks. Open all year; Monday-Saturday, 11-5. Located in the heart of downtown business district; 5,000 sq. ft.; entire upper floor of 1889 building (Stewart Bldg.) listed in National Historical Directory. "In addition to 5 exhibit areas, we have 3 sales rooms. The atrium and 4 rooms have original skylights which result in special lighting for artwork." 75% of space for special exhibitions; 100% of space for gallery artists. Clientele: general public, tourists, foreign visitors. Overall price range: $25-10,000; most work sold at $75-500.

Media: Considers all media including jewelry, woodcut, engraving, lithograph, wood engraving, mezzotint, serigraphs, linocut and etching. Most frequently exhibits oil, watercolor and ceramics.

Style: Exhibits expressionism, primitivism, painterly abstraction, surrealism, conceptualism, minimalism, impressionism, photorealism, hard-edge geometric abstraction and realism, all genres. Sells mainly landscapes, florals and wildlife, but tries "to introduce every style of art to the public."

Terms: Accepts work on consignment (30% commission). Retail price set by the artist. Gallery provides insurance and promotion; shipping costs are shared. Prefers artwork framed.

Submissions: Send query letter with résumé, slides or photographs and bio. Call or write for appointment to show portfolio of originals, photographs or slides. Replies only if interested within 2 weeks. Files "everything, if interested in artist and work."
Tips: Finds artists through visiting exhibitions, art publications, sourcebooks, artists' submissions, references from other artists, referrals and recommendations.

‡**LINDA HODGES GALLERY,** 410 Occidental Ave. S., Seattle WA 98112. (206)624-3034. Fax: (206)627-9730. Owner: Linda Hodges. Retail gallery. Estab. 1983. Represents 27 mid-career and established artists/year. Interested in seeing the work of emerging artists. Exhibited artists include Gaylen Hansen, Tom Fawkes. Sponsors 12 shows/year. Average display time 1 month. Open all year; Tuesday-Sunday, 11-5. Located Old Town/Pioneer Square; 1,600 sq. ft.; large exhibition space. 100% of space for gallery artists. Clientele: corporate, private. 70% private collectors, 30% corporate collectors. Overall price range: $300-12,000; most work sold at $700-2,500.
Media: Considers oil, acrylic, watercolor, pastel, pen & ink, drawing, mixed media, collage, paper, sculpture, ceramics, fiber, glass and photography, all types of prints except posters. Most frequently exhibits oil, acrylic and mixed media, all on canvas/board/paper.
Style: Exhibits all styles. Genres include landscapes.
Terms: Accepts work on consignment (50% commission). Retail price set by the gallery. Gallery provides promotion and contract; artist pays shipping costs to and from gallery. Prefers artwork framed.
Submissions: Prefers Northwest regional artists, but open. Send query letter with résumé, slides. Call or write for appointment to show portfolio of slides. Replies in 2 weeks.
Tips: Finds artists through word of mouth, inquiries.

KIRSTEN GALLERY, INC., 5320 Roosevelt Way NE, Seattle WA 98105. (206)522-2011. Director: R.J. Kirsten. Retail gallery. Estab. 1975. Represents 60 emerging, mid-career and established artists. Exhibited artists include Birdsall and Daiensai. Sponsors 10 shows/year. Average display time 1 month. Open all year. 3,500 sq. ft.; outdoor sculpture garden. 40% of space for special exhibitions; 60% of space for gallery artists. 90% private collectors, 10% corporate collectors. Overall price range: $75-15,000; most work sold at $75-2,000.
Media: Considers oil, acrylic, watercolor, mixed media, sculpture, glass and offset reproductions. Most frequently exhibits oil, watercolor and glass.
Style: Exhibits surrealism, photorealism and realism. Genres include landscapes, florals, Americana. Prefers realism.
Terms: Accepts work on consignment (50% commission). Retail price set by artist. Offers payment by installments. Gallery provides promotion; artist pays shipping costs.
Submissions: Send query letter with résumé, slides and bio. Write for appointment to show portfolio of photographs and/or slides. Replies in 2 weeks. Files bio and résumé.
Tips: Finds artists through visiting exhibitions and word of mouth. "Keep prices down. Be prepared to pay shipping costs both ways. Work is not insured (send at your own risk). Send the best work—not just what you did not sell in your hometown."

‡**LIDTKE FINE ART,** 316 Occidental Ave., Seattle WA 98104. (206)623-5082. Director: Kurt Lidtke. Retail gallery. Estab. 1992. Represents 15 mid-career and established artists/year. Interested in seeing the work of emerging artists. Exhibited artists include Morris Graves, Mark Toby. Sponsors 10 shows/year. Average display time 1½ months. Open all year; Thursday-Saturday 10-5:30 and by appointment. Located historic Pioneer Square, 1,000 sq. ft. 95% of space for special exhibitions; 95% of space for gallery artists. Clientele: collectors. 100% private collectors. Overall price range: $1,000-80,000; most work sold at $5,000-15,000.
Media: Considers oil, acrylic, watercolor, pastel, pen & ink, drawing, tempera, gouache. Most frequently exhibits tempera, oil, acrylic.
Style: Exhibits neo-expressionism, painterly abstraction and surrealism. Prefers figurative/modern, figurative abstraction and abstraction.
Terms: Accepts work on consignment (50% commission). Retail price set by the gallery and the artist. Gallery provides insurance, promotion, contract and shipping costs to gallery; artist pays shipping costs from gallery. Prefers artwork framed.
Submissions: Send query letter with bio, SASE and reproductions. Write for appointment to show portfolio of photographs, slides and transparencies. Replies in 1 month. Files bio and one reproduction.
Tips: Finds artists through art publications, word of mouth.

The double dagger before a listing indicates that the listing is new in this edition. New markets are often more receptive to freelance submissions.

PAINTERS ART GALLERY, 30517 S.R. 706E, Ashford WA 98304-0106. Owner: Joan Painter. Retail gallery. Estab. 1972. Represents 30 emerging, mid-career and established artists. Exhibited artists include Jolene Thompson, Joan Painter and Nancy Acosta. Open all year. Located 5 miles from the entrance to Mt. Rainier National Park; 800 sq. ft. 75% of space for work of gallery artists. Clientele: collectors and tourists. Overall price range $10-5,500; most work sold at $300-2,500.

• The gallery has 100 people on consignment. It is very informal, outdoors atmosphere.

Media: Considers oil, acrylic, watercolor, pastel, pen & ink, drawings, mixed media, sculpture (bronze), photography, stained glass, original handpulled prints, reliefs, offset reproductions, lithographs, serigraphs and etchings. "I am seriously looking for bronzes, totem poles and outdoor carvings." Most frequently exhibits oil, pastel and acrylic.

Style: Exhibits primitivism, surrealism, imagism, impressionism, realism and photorealism. All genres. Prefers Mt. Rainier themes and wildlife. "Indians are a strong sell."

Terms: Accepts artwork on consignment (30% commission on prints and bronzes; 40% on paintings). Retail price set by gallery and artist. Gallery provides promotion; artist pays for shipping. Prefers artwork framed.

Submissions: Send query letter or call. "I can usually tell over the phone if artwork will fit in here." Portfolio review requested if interested in artist's work. Does not file materials.

‡PHINNEY CENTER GALLERY, 6532 Phinney Ave. N., Seattle WA 98103. (206)783-2244. Fax: (206)783-0851. Arts Coordinator: Diana Gawle. Nonprofit gallery. Estab. 1982. Represents 10-12 emerging artists/year. Sponsors 10-12 shows/year. Average display time 1 month. Open all year; Monday-Friday, 10-9; Saturday, 10-1. Located in a residential area; 92 sq. ft.; in 1800s building—hard wood floors, high ceilings. 20% of space for special exhibitions; 80% of space for gallery artists. 50-60% private collectors. Overall price range: $50-4,000; most work sold at $50-200.

Media: Considers oil, acrylic, watercolor, pastel, pen & ink, drawing, mixed media, collage, paper, sculpture, ceramics, installation, photography, all types of prints. Most frequently exhibits painting, sculpture and photography.

Style: Exhibits painterly abstraction, all genres.

Terms: Accepts work on consignment (25% commission). Rental fee for space; covers 1 month. Retail price set by the gallery. Gallery provides promotion and contract; artist pays shipping costs to and from gallery. Prefers artwork framed.

Submissions: Send query letter with résumé, bio and SASE. Call or write for appointment to show portfolio of slides. Replies in 2 weeks.

Tips: Finds artists through calls for work in local and national publications.

‡POTLATCH GALLERY, 18830 B Front St., Paulsbo WA 98370. (206)779-3377. Co-owners: Lisa Lund and Lynn Malde. Retail gallery. Estab. 1989. Represents 100 emerging and mid-career artists/year. Average display time 6 months. Open all year; daily, 10-5. Located downtown; 6 sq. ft.; represents Northwest artists. 90% of space for gallery artists. Clientele: "all kinds—lots of tourists." 95% private collectors, 5% corporate collectors. Overall price range: $2-1,500; most work sold at $65-100.

Media: Considers oil, acrylic, watercolor, pastel, pen & ink, drawing, mixed media, collage, paper, sculpture, ceramics, glass, photography, engraving, lithograph, serigraphs and etching. Most frequently exhibits serigraphs, jewelry and pottery.

Style: Exhibits all styles. Genres include landscapes, florals, wildlife and figurative work. Prefers landscapes, Native American work and florals.

Terms: Accepts work on consignment (40% commission). Retail price set by the artist. Gallery provides insurance and contract; shipping costs are shared.

Submissions: Accepts only artists from Northwest. Send query letter with brochure. Call or write for appointment to show portfolio of originals and photographs. Replies in 2 weeks.

Tips: Finds artists through artists' submissions.

PRO ART OF GIG HARBOR, 6677 Kimball Dr., Gig Harbor WA 98335. (206)851-3440. Fax: (206)858-6514. Owner: John Sutch. Retail gallery. Estab. 1983. Represents 22 emerging, mid-career and established artists. Exhibited artists include Tom Lynch, Russell Chatham. Sponsors 6 shows/year. Average display time 2 months. Open all year; Monday-Friday, 9-6; Saturday, 10-5. Located near Gig Harbor City Center; 1,950 sq. ft.; cathedral ceiling, beamed, skylighted. 75% of space for special exhibitions; 25% of space for gallery artists. Clientele: upscale, affluent. 80% private collectors; 20% corporate collectors. Overall price range: $50-100,000; most work sold at $500-30,000.

• The gallery has added a second location (Pro Art of Tacoma, 1201 Pacific Ave., Tacoma WA 98402). It is very upscale and contemporary.

Media: Considers oil, acrylic, watercolor, pastel, pen & ink, drawings, mixed media, collage, sculpture, fiber, glass, original handpulled prints, lithograph, mezzotint and serigraph. Most frequently exhibits watercolor, original lithograph and sculpture.

Style: Exhibits expressionism and photorealism. All genres. Prefers landscapes, florals and Southwestern.

Terms: Accepts work on consignment (50% commission); or buys outright for 65% of retail price (net 30 days). Retail price set by artist. Gallery provides insurance, 50% promotion and shipping costs from gallery. Prefers artwork framed.

Submissions: Send query letter with résumé, slides, bio, brochure, SASE and reviews. Portfolio review requested if interested in artist's work. Files artist information and media.

Tips: Finds artists through word of mouth, various art publications, artists' submissions/self-promotions and art collectors' referrals. "Be prepared and professional."

RUNNINGS GALLERY, 301 Occidental Ave. S., Seattle WA 98104. (206)682-8625. Fax: (206)682-8625. Owner: Gloria Runnings. Retail gallery. Estab. 1989. Represents 30 emerging, mid-career and established artists. Exhibited artists include Pierce Milholland and Hans Schiebold. Sponsors 6 shows/year. Average display time 3 weeks. Open all year. Located in Pioneer Square, at Occidental and Main; 1,900 sq. ft. 75% of space for special exhibitions. Clientele: residential. 10% private collectors, 10% corporate collectors. Overall price range: $1,000-7,000; most work sold at 2,000-5,000.

Media: Considers oil, acrylic, watercolor, pastel, mixed media, sculpture, ceramic and glass. Most frequently exhibits oil, watercolor and pastel.

Style: Exhibits impressionism and realism. Genres include landscapes, florals and figurative work. Prefers realism, impressionism and sculpture.

Terms: Accepts artwork on consignment (50% commission). Retail price set by gallery and artist. Offers payment by installments. Gallery provides insurance, promotion, contract and shipping costs from gallery to client. Prefers artwork framed.

Submissions: Accepts artists from the Northwest, including Canada and northern California. Send query letter with résumé, slide, brochure, photographs, business card and bio. Write for appointment to show portfolio of slides and transparencies. Replies in 4 weeks.

‡TOMORROW'S TREASURES, 801 Washington St., Vancouver WA 98660. (206)695-2130. Owner: Debra Peden. Retail gallery. Estab. 1988. Represents 8-10 mid-career artists/year. May be interested in seeing the work of emerging artists in the future. Sponsors 3 shows/year. Average display time 2-3 months. Open all year; Monday-Friday, 10-5:30; Saturday, 11-4. Located downtown; 1,000 sq. ft. of wall; gallery, 2,200 sq. ft.; turn-of-the-century building with a warm feel. 50% of space for special exhibitions; 25% of space for gallery artists. Clientele: middle-upper income, 75% men. 100% private collectors. Overall price range: $500-2,500; most work sold at $500.

Media: Considers oil, watercolor, pastel, pen & ink, mixed media, paper, sculpture, engraving, lithograph, wood engraving, serigraphs and etching. Most frequently exhibits oil, prints and bronze.

Style: Exhibits photorealism and realism. Genres include Western, wildlife. Prefers wildlife.

Terms: Accepts work on consignment (35% commission). Retail price set by the artist. Gallery provides insurance and promotion; artist pays shipping costs to and from gallery. Prefers artwork unframed.

Submissions: Send query letter with résumé, slide, brochure and SASE. Write for appointment to show portfolio of originals and photographs. Replies in 1 month.

WALSDORF GALLERY, 516 W. First Ave., Spokane WA 99204. (509)838-5847. Fax: (509)747-6970. President: Don Walsdorf. Retail gallery, art consultancy and major art show producer. Estab. 1988. Represents 34 emerging, mid-career and established artists. Exhibited artists include Carl Funseth and John McKinnon. Sponsors 8 1- or 2-artist shows and 2 large group shows/year. Average display time 6 weeks. Open all year. Located downtown in Westcoast Ridpath Hotel; 2,000 sq. ft. 20% of space for special exhibitions. Clientele: collectors, hotel guests and tourists. 70% private collectors, 30% corporate collectors. Overall price range $200-250,000; most work sold at $500-3,000.

Media: Considers all media except craft. Also considers original handpulled prints of any media form. Most frequently exhibits oils, bronze/stone/woodcarvings and watercolor.

Style: Considers primitivism, impressionism, realism and photorealism. Interested in all genres. Prefers Northwestern, wildlife and Americana.

Terms: Accepts artwork on consignment (variable commission, 20-40%). Retail price set by gallery and artist. Customer discounts and payment by installments are available. "Gallery does not accept work beyond its capacity to sell." Gallery provides promotion and shipping costs to gallery. Prefers artwork framed.

Submissions: Send query letter with bio, brochure and photographs. Portfolio review requested if interested in artist's work. Files biography and brochures.

Tips: "Artists who are considering approaching the Walsdorf Gallery must be fulltime artists."

WATERWORKS GALLERY, P.O. Box 28, 315 Spring St., Friday Harbor WA 98250. (206)378-3060. Owner/Director: Ruth Offen-Pearson. Retail gallery. Estab. 1985. Represents 22 emerging, mid-career and established artists. Exhibited artists include Gary Bukounik and Trevor Southey. Sponsors 5 shows/year. Average display time 5-6 weeks. Open all year. Located downtown (on an island); 1,600 sq. ft. 75% of space for special exhibitions. Clientele: 90% private collectors, 10% corporate collectors. Overall price range: $250-5,000; most work sold at: $1,500-2,500.

Media: Considers oil, acrylic, watercolor, pastel, mixed media, collage, sculpture, ceramic, glass, monotypes, original handpulled prints, woodcuts, engravings, lithographs, mezzotints, linocuts, etchings and monoprints. Most frequently exhibits watercolor, lithography and etchings.
Style: Exhibits expressionism, primitivism, painterly abstraction and impressionism. Genres include landscapes, florals and figurative work.
Terms: Accepts artwork on consignment (50% commission). Retail price set by gallery and artist. Sometimes offers customer discounts and payment by installment. Gallery provides insurance, promotion, contract and shipping costs from gallery.
Submissions: Accepts only artists from the Pacific Northwest. Send query letter with photos, preferably, also résumé, slides, bio, business card, reviews and SASE. "We wish to see actual work after reviewing slides or photos." Replies in 1 month, or artist should follow up with a phone call. Files résumé and some slides or photos.
Tips: "Be professional and able to deliver consistent work. We demand more finished and professional work, and are developing a body of oil painters in both figurative and abstract forms."

West Virginia

THE ART STORE, 1013 Bridge Rd., Charleston WV 25314. (304)345-1038. Director: E. Schaul. Retail gallery. Estab. 1980. Represents 16 mid-career and established artists. Sponsors 4 shows/year. Average display time 1 month. Open all year. Located in a suburban shopping center; 2,000 sq. ft. 50% of space for special exhibitions. Clientele: professionals, executives, decorators. 50% private collectors, 50% corporate collectors. Overall price range: $200-8,000; most work sold at $1,800.
Media: Considers oil, acrylic, watercolor, pastel, mixed media, works on paper, ceramic, woodcuts, engravings, linocuts, etchings, and monoprints. Most frequently exhibits pastel, mixed media and watercolor.
Style: Exhibits expressionism, painterly abstraction, color field and impressionism.
Terms: Accepts artwork on consignment (40% commission). Retail price set by gallery and artist. Gallery provides insurance, promotion and shipping costs from gallery. Prefers artwork unframed.
Submissions: Send query letter with résumé, slides, SASE and announcements from other galleries if available. Gallery makes the contact after review of these items; replies in 4-6 weeks.

SUNRISE MUSEUM, 746 Myrtle Rd., Charleston WV 25314. (304)344-8035. Fax: (304)344-8038. Deputy Director of Exhibitions: Ric Ambrose. Museum. Estab. 1974. Represents emerging, mid-career and established artists. Sponsors 6 shows/year. Average display time 2-3 months. Open all year. Located in the South Hills, residential area; 2,500 sq. ft.; historical mansion.
Media: Considers oil, acrylic, watercolor, pastel, pen & ink, drawings, mixed media, collage, works on paper, sculpture, installations, photography and prints.
Style: Considers all styles and genres.
Terms: Retail price set by artist. Gallery pays shipping costs. Prefers artwork framed.
Submissions: Send query letter with résumé, slides, brochure, photographs, reviews, bio and SASE. Write for appointment to show portfolio of slides. Replies only if interested within 2 weeks. Files everything or returns in SASE.

Wisconsin

‡ART INDEPENDENT GALLERY, 623 Main St., Lake Geneva WI 53147. (414)248-3612. Owner: Joan O'Brien. Retail gallery. Estab. 1969. Represents 100 mid-career and established artists/year. May be interested in seeing the work of emerging artists in the future. Exhibited artists include Peg Sindelar. Sponsors 4 shows/year. Average display time 6-8 weeks. Open February-March: Thursday/Friday/Saturday, 10-5; Sundays, 12-5. April-May: daily 10-5; Sundays 12-5; closed Tuesday. June-August: daily, 10-5; Sundays 12-5. September-December: daily 10-5; Sundays, 12-5; closed Tuesday. Closed month of January. 3,000 sq. ft.; loft-like 1st floor, location in historic building. 25% of space for special exhibitions; 100% of space for gallery artists. Clientele: collectors, tourists, designers. 90% private collectors, 10% corporate collectors. Overall price range: $2-2,400; most work sold at $200-600.
Media: Considers oil, acrylic, watercolor, pastel, pen & ink, mixed media, collage, paper, sculpture, ceramics, fiber, glass, photography, jewelry, woodcut, engraving, serigraphs, linocut and etching. Most frequently exhibits paintings, ceramics and jewelry.
Style: Exhibits expressionism and painterly abstraction. Genres include landscapes, florals, Southwestern, portraits and figurative work. Prefers abstracts, impressionism and imagism.
Terms: Accepts work on consignment (50% commission). Retail prices set by the artist. Gallery provides insurance, promotion, contract and shipping costs from gallery; artist pays shipping costs to gallery. Prefers artwork framed.
Submissions: Send query letter with résumé, slides, bio and SASE. Call or write for application. Portfolio should include slides and transparencies. Replies in 2-4 weeks. Files bios and résumés.

Tips: Finds artists through visiting exhibitions, word of mouth, shows/art fairs.

DAVID BARNETT GALLERY, 1024 E. State St., Milwaukee WI 53202. (414)271-5058. Fax: (414)271-9132. Office Manager: Milena Marich. Retail and rental gallery and art consultancy. Estab. 1966. Represents 300-400 emerging, mid-career and established artists. Exhibited artists include Claude Weisbuch and Carol Summers. Sponsors 12 shows/year. Average display time 1 month. Open all year. Located downtown at the corner of State and Prospect; 6,500 sq. ft.; "Victorian-Italianate mansion built in 1875, 3 floors of artwork displayed." 25% of space for special exhibitions. Clientele: retail, corporations, interior decorators, private collectors, consultants, museums and architects. 20% private collectors, 10% corporate collectors. Overall price range: $50-375,000; most work sold at $1,000-50,000.
Media: Considers oil, acrylic, watercolor, pastel, pen & ink, drawings, mixed media, collage, sculpture, ceramic, fiber, glass, photography, bronzes, marble, woodcuts, engravings, lithographs, wood engravings, serigraphs, linocuts, etchings and posters. Most frequently exhibits prints, drawings and oils.
Style: Exhibits expressionism, neo-expressionism, primitivism, painterly abstraction, surrealism, imagism, conceptualism, minimalism, postmodern works, impressionism, realism and photorealism. Genres include landscapes, florals, Southwestern, Western, wildlife, portraits and figurative work. Prefers old master graphics, contemporary and impressionistic.
Terms: Accepts artwork on consignment (50% commission). Retail price set by gallery and artist. Sometimes offers customer discounts and payment by installment. Gallery provides insurance and promotion; artist pays for shipping. Prefers artwork framed.
Submissions: Send query letter with slides, bio, brochure and SASE. "We return everything if we decide not to carry the artwork."
Tips: Finds artists through agents, word of mouth, various art publications, sourcebooks, artists' submissions and self-promotions.

CROSSMAN GALLERY, Center for the Arts, University of Wisconsin-Whitewater, 800 W. Main St., Whitewater WI 53190. (414)472-5708. Director: Susan Walsh. Nonprofit university gallery. Estab. 1979. Exhibits emerging, mid-career and established artists. Exhibited artists include Sam Gilliam and Sue Coe. Sponsors 1 and 2 person shows, invitations, student exhibitions. Sponsors 6-7 shows/year, separate from student shows. Average display time 3-4 weeks. Open all year. Located on the edge of campus, 70 miles from Milwaukee, 100 miles from Chicago; 2,600 sq. ft.; open exhibition space is available in atrium for large works such as bronze sculpture or suspended fibers.
Media: Considers all media and original handpulled prints. Most frequently exhibits painting, sculpture and mixed media/new technology.
Style: Exhibits all styles. Genres include landscapes and Americana. Prefers imagism, naturalism and new technology (surrealism).
Terms: "Will put artist in contact with interested parties in terms of sales." Gallery provides insurance and promotion; shipping costs from gallery for smaller works; shipping costs are shared for large sculpture especially. Prefers artwork framed.
Submissions: Send query letter with résumé, slides, bio, photographs, SASE and reviews. Portfolio should include photographs, slides and transparencies. Replies in 1-2 months. Files résumés, sample slides and photos.
Tips: "Grant money helpful from artist to foot certain expenses (audio equipment, etc.)."

‡GALLERY OF THE AMERICAS, 1028 S. Ninth, Milwaukee WI 53204. (414)384-3100 ext. 61. Fax: (414)649-4411. Visual Artist Specialist: Robert Cisneros. Nonprofit gallery. Represents emerging, mid-career and established artists. Sponsors 6 individual to group exhibitions/year. Average display time 2 months. Open all year; Monday-Friday, 10-4. Located in the near southeast side of Milwaukee; 1,200 sq. ft.; one-time church. 50% of space for special exhibitions; 40% of space for gallery artists. Clientele: the general Hispanic community. Overall price range: $100-2,000.
Media: Considers all media, all types of prints. Most frequently exhibits original 2- and 3-dimensional works and photo exhibitions.
Style: Exhibits all styles, all genres. Prefers artifacts of Hispanic cultural and educational interests.
Terms: "At this point no commission is taken for works sold, our function is to promote cultural awareness." Retail price set by the artist. Gallery provides insurance, promotion, contract, shipping costs to gallery; artist pays shipping costs from gallery. Prefers artwork framed.
Submissions: Send query letter with résumé, slides, bio, business card and reviews. Call or write for appointment to show portfolio of photographs and slides. Replies in 2 weeks.
Tips: Finds artists through recruiting, networking, advertising and word of mouth.

‡THE FANNY GARVER GALLERY, 230 State St., Madison WI 53703. (608)256-6755. Vice President: Jack Garver. Retail Gallery. Estab. 1972. Represents 100 emerging, mid-career and established artists/year. Exhibited artists include Harold Altman and Josh Simpson. Sponsors 11 shows/year. Average display time 1 month. Open all year; Monday-Saturday. Located downtown; 3,000 sq. ft.; older refurbished building in unique downtown setting. 33% of space for special exhibitions; 95% of space for gallery artists. Clientele: private

collectors, gift-givers, tourists. 40% private collectors, 10% corporate collectors. Overall price range: $10-10,000; most work sold at $30-200.

Media: Considers oil, pen & ink, paper, fiber, acrylic, drawing, sculpture, glass, watercolor, mixed media, ceramics, pastel, collage, craft, woodcut, wood engraving, linocuts, engraving, mezzotint, etchings, lithograph and serigraphs. Most frequently exhibits watercolor, oil and glass.

Style: Exhibits all styles. Prefers landscapes, still lifes and abstraction.

Terms: Accepts work on consignment (40% commission) or buys outright for 50% of retail price (net 30 days). Retail price set by gallery. Gallery provides promotion and contract, shipping costs from gallery; artist pays shipping costs to gallery. Prefers artwork framed.

Submissions: Send query letter with résumé, slides, bio, brochure, photographs and SASE. Write for appointment to show portfolio, which should include originals, photographs and slides. Replies only if interested within 1 month. Files announcements and brochures.

‡KATIE GINGRASS GALLERY, Milwaukee, 241 N. Broadway, Milwaukee WI 53202. (414)289-0855. Coordinators: Sarah Gingrass, Elaine Hoth and David Schaefer. Retail gallery. Estab. 1984. Represents 150 emerging and established artists. Sponsors 5-6 group shows/year. Average display time 6-8 weeks. Clientele: 40% private collectors, 60% corporate clients. Overall price range: $50-10,000; most artwork sold at $300-3,000.

Media: Considers oil, acrylic, watercolor, pastel, drawings, mixed media, collage, works on paper, sculpture, ceramic, craft, fiber, glass, photography, woodcuts, wood engravings, linocuts, engravings, mezzotints, etchings, lithographs and serigraphs. Most frequently exhibits paintings, pastel and craft.

Style: Exhibits impressionism, expressionism, realism, photorealism, painterly abstraction and postmodern works. Genres include landscapes, florals and figurative work. Prefers realism, abstraction and impressionism. Specializes in contemporary American paintings, sculptures, drawings and fine crafts.

Terms: Accepts work on consignment (50% commission). Retail price set by gallery and artist. Sometimes offers customer discounts and payment by installments. Exclusive area representation required. Gallery provides insurance, promotion, contract and shipping costs from gallery.

Submissions: Send query letter with résumé, slides, photographs, bio and SASE. Portfolio review requested if interested in artist's work. Portfolio should include originals, slides and prices. Replies in 2 months. Files résumés, biographies and slides. All material is returned if not accepted or under consideration.

Tips: "We usually have new artists contact us because of advertising we have done or connection with other artists." Looks for "art without angst in realistic, abstract and craft work."

PELTZ GALLERY, 1119 E. Knapp St., Milwaukee WI 53202. (414)223-4278. Director: Cissie Peltz. Retail gallery. Estab. 1989. Represents 40 mid-career and established artists. Interested in seeing the work of emerging artists. Exhibited artists include John Sayers and Mark Mulhern. Sponsors 6 shows/year. Average display time 2 months. Closed August. Located on the east side of Milwaukee, near lake and Art Museum; "1885 Victorian landmark house, 8 rooms." 50% of space for special exhibitions. Clientele: corporate and residential Midwestern. 65% private collectors, 35% corporate collectors. Overall price range: $100-15,000; most work sold at $400-3,000.

Media: Considers oil, acrylic, watercolor, pastel, drawing, mixed media, sculpture (small, only), original handpulled prints, woodcuts, engravings, lithographs, linocuts and etchings. Prefers original color prints. Most frequently exhibits paintings, monotypes and original prints.

Style: Exhibits expressionism, neo-expressionism, painterly abstraction, realism and photorealism. Genres include landscapes, florals, figurative work, abstracts, cityscapes, still lifes. Prefers realism, expressionism and abstraction.

Terms: Accepts artwork on consignment (50% commission). Retail price set by gallery and artist. Customer discounts and payment by installments are available. Gallery provides insurance and promotion; if shown, gallery pays for shipping costs from gallery.

Submissions: Send query letter with résumé, slides, photographs and SASE. Replies in 1 month. Portfolio review not required. Files slides, if interested.

Tips: Finds artists through artists' submissions and from museum and university shows. "Many of our artists teach at college level."

SANTA FÉ GALLERY, 2608 Monroe St., Madison WI 53711. (608)233-4223. Fax: (608)276-3171. Owner: John Sveum. Retail gallery. Estab. 1988. Represents 12 emerging, mid-career and established artists. Exhibited artists include Francisco Zuniga and Francisco Mora. Sponsors 5 shows/year. Open all year; Tuesday-Saturday, 10-5. 1,200 sq. ft. Clientele: professional. 95% private collectors, 5% corporate collectors. Overall price range: $35-8,000; most work sold at $800-2,000.

Media: Considers oil, acrylic, sculpture, watercolor, mixed media, ceramic, pastel, collage, original handpulled prints, etchings, lithographs and serigraphs. Prefers lithograph, serigraph, watercolor and acrylic.

Style: Exhibits all styles. Prefers contemporary, Latin American and Southwestern. Accepts work on consignment (50% commission) or buys outright for 50% of retail price. Retail price set by artist. Customer discounts and payment by installments are available. Gallery provides insurance, promotion, contract and shipping costs to gallery.

Submissions: Send query letter with résumé, slides, photographs and bio. Portfolio review requested if interested in artist's work.

Tips: Finds artists through art expos, visiting other galleries and publications.

CHARLES A. WUSTUM MUSEUM OF FINE ARTS, 2519 Northwestern Ave., Racine WI 53404. (414)636-9177. Associate Curator: Caren Heft. Museum. Estab. 1941. Represents about 200 emerging, mid-career and established artists. Sponsors 12-14 shows/year. Average display time 6 weeks. Open all year. Located northwest of downtown Racine; 3,000 sq. ft.; "an 1856 Italianate farmhouse on 13 acres of parks and gardens." 100% of space for special exhibitions. "75% private collectors from a tri-state area between Chicago and Milwaukee, and 25% corporate collectors." Overall price range: $100-10,000; most work sold at $300-1,000.

Media: "We show all media, including video, but specialize in 20th-century works on paper, craft and artists' books." Considers original handpulled prints, woodcuts, wood engravings, linocuts, engravings, mezzotints, etchings, lithographs and pochoir. Most frequently exhibits works on paper, ceramics, fibers.

Style: Exhibits all styles and genres. Most frequently exhibits abstraction, realism and surrealism. "We are interested in good craftsmanship and vision."

Terms: Accepts work on consignment (40% commission). Retail price set by artist. Gallery provides insurance, promotion, contract and shipping costs from gallery (for group); artist pays for shipping (for solo). Prefers artwork framed.

Submissions: Museum reviews artists' requests on an ongoing basis. Must submit 10-20 slides, current résumé and a statement about the work. Must also enclose SASE for return of slides. Files résumés and statements for future reference.

Tips: "I want to see evidence of a consistent body of work. Include a letter telling me why you are sending slides. The most common mistake artists make is sloppy presentation—no slide info sheet, no résumé, no SASE, etc."

Wyoming

‡CENTER STREET GALLERY, P.O. Box 4059, 172 Center St., Jackson WY 83001. (307)733-1115. Owner/Director: Beth Overcast. Retail gallery. Estab. 1987. Represents 30 emerging, mid-career and established artists. Exhibited artists include Malcolm Furlow and Mary Jane Schmidt. Sponsors 4 shows/year. Average display time 2 weeks. Open all year. Located in downtown Jackson; 4,000 sq. ft. 25% of total space for special exhibitions. Clientele: "cosmopolitan, active." 95% private collectors; 5% corporate collectors. Overall price range: $500-20,000; most work sold at $3,000-7,000.

Media: Considers oil, acrylic, watercolor, pastel, mixed media, works on paper, sculpture, fiber, original handpulled prints, lithographs, serigraphs and etchings. Most frequently exhibits acrylic on canvas, oil pastel and sculpture..

Style: Exhibits expressionism and painterly abstraction. Genres include Southwestern and figurative work. Prefers abstract expressionism, "colorful work of a looser feel."

Terms: Accepts artwork on consignment (40-50% commission) or buys outright for 50% of retail price (net 30 days). Retail prices set by the artist. Sometimes offers customer discounts and payment by installments. "There seem to be more galleries discounting for sales and thus clients expect it and are quite insistent." Gallery provides insurance, promotion and shipping costs to gallery. Prefers artwork unframed.

Submissions: Send query letter with bio, brochure and photographs. Portfolio review requested if interested in artist's work. Portfolio should include slides and photographs, promotional material, news and magazine articles and list of current representations. Files photos, biography and slides.

Tips: Finds artists through word of mouth and occasionally art publications. "I travel around to keep abreast of art trends and new emerging artists. Look for a current list of artists represented to make sure your style would fit in. If the material is to be returned, include SASE."

CROSS GALLERY, Box 4181, 180 N. Center, Jackson Hole WY 83001. (307)733-2200. Fax: (307)733-1414. Director: Mary Schmidt. Retail gallery. Estab. 1982. Represents 10 emerging and established artists. Exhibited artists include Penni Anne Cross and Kennard Real Bird. Sponsors 2 shows/year. Average display time 1 month. Open all year. Located at the corner of Center and Gill; 1,000 sq. ft. 50% of space for special

exhibitions. Clientele: retail customers and corporate businesses. Overall price range: $20-35,000.
Media: Considers oil, acrylic, watercolor, pastel, pen & ink, drawings, mixed media, sculpture, original handpulled prints, engravings, lithographs, pochoir, serigraphs and etchings. Most frequently exhibits oil, original graphics, alabaster, bronze, metal and clay.
Style: Exhibits realism and contemporary styles. Genres include Southwestern, Western and portraits. Prefers contemporary Western and realist work.
Terms: Accepts artwork on consignment (33⅓% commission) or buys outright for 50% of retail price. Retail price set by gallery and artist. Offers payment by installments. Gallery provides insurance, promotion and contract; shipping costs are shared. Prefers artwork unframed.
Submissions: Send query letter with résumé, slides and photographs. Portfolio review requested if interested in artist's work. Portfolio should include originals, slides and photographs. Samples not filed are returned by SASE. Reports back within "a reasonable amount of time."
Tips: "We are seeking artwork with creative artistic expression for the serious collector. We look for originality. Presentation is very important."

‡HALSETH GALLERY—COMMUNITY FINE ARTS CENTER, 400 C, Rock Springs WY 82901. (307)362-6212. Fax: (307)382-4640. Director: Gregory Gaylor. Nonprofit gallery. Estab. 1966. Represents 12 emerging, mid-career and established artists/year. Sponsors 8-10 shows/year. Average display time 1 month. Open all year; Monday, 12-9; Tuesday and Wednesday, 10-5; Thursday, 12-9; Friday, 10-5; Saturday, 12-5. Located downtown—on the Rock Springs Historic Walking Tour route; 2,000 ground sq. ft. and 100 running sq. ft.; recently remodeled to accommodate painting and sculpture. 50% of space for special exhibitions; 50% of space for gallery artists. Clientele: community at large. 100% private collectors. Overall price range: $100-1,000; most work sold at $200-600.
Media: Considers all media, all types of prints. Most frequently exhibits oil/watercolor/acrylics, sculpture/ceramics, and installation.
Style: Exhibits all styles, all genres. Prefers neo-expressionism, realism and primitivism.
Terms: "We require a donation of a work." Retail price set by the artist. Gallery provides promotion; artist pays shipping costs to and from gallery. Prefers artwork framed.
Submissions: Send query letter with résumé, slides, bio, brochure, photographs, SASE, business card, reviews, "whatever available." Call or write for appointment to show portfolio of slides. Replies only if interested within 1 month. Files all material sent.
Tips: Finds artists through artists' submissions.

‡NICOLAYSEN ART MUSEUM, 400 E. Collins Dr., Casper WY 82601. (307)235-5247. Director: Sam Gappmayer. Community museum. Estab. 1967. Average display time 2 months. Interested in emerging, mid-career and established artists. Sponsors 10 solo and 10 group shows/year. Open all year. Clientele: 90% private collectors, 10% corporate clients.
Media: Considers all media.
Style: Exhibits all subjects.
Terms: Accepts work on consignment (30% commission). Retail price set by artist. Exclusive area representation not required. Gallery provides insurance, promotion and shipping costs from gallery.
Submissions: Send query letter with slides. Write to schedule an appointment to show a portfolio, which should include originals or slides. Replies in 2 months.

Puerto Rico

GALERIA BOTELLO INC., 208 Cristo St., Old San Juan Puerto Rico 00901. (809)723-9987. Owner: Juan Botello. Retail gallery. Estab. 1952. Represents 10 emerging and established artists. Sponsors 3 solo and 2 group shows/year. Average display time 3 months. Accepts only artists from Latin America. Clientele: 60% tourist and 40% local. 75% private collectors, 30% corporate clients. Overall price range: $500-30,000; most work sold at $1,000-5,000.
Media: Considers oil, acrylic, watercolor, pastel, drawings, mixed media, collage, sculpture, ceramic, woodcuts, wood engravings, linocuts, engravings, mezzotints, etchings, lithographs and serigraphs. Most frequently exhibits oil on canvas, mixed media and bronze sculpture. "The Botello Gallery exhibits major contemporary Puerto Rican and Latin American artists. We prefer working with original paintings, sculpture and works on paper."
Style: Exhibits expressionism, neo-expressionism and primitivism. Genres include Americana and figurative work. Prefers expressionism and figurative work.
Terms: Accepts work on consignment or buys outright. Retail price set by artist. Exclusive area representation required. Gallery provides insurance and contract; artist pays for shipping. Prefers artwork framed.
Submissions: Send query letter with résumé, brochure, slides and photographs. Call for appointment to show portfolio of originals. Replies in 2 weeks. Files résumés.
Tips: "Artists have to be Latin American or major European artists."

Canada

✸**OPEN SPACE**, 510 Fort St., Victoria, British Columbia V8W 1E6 Canada. (604)383-8833. Director: Sue Donaldson. Alternative space and nonprofit gallery. Estab. 1971. Represents emerging, mid-career and established artists. 311 members. Sponsors 8-10 shows/year. Average display time 2½ weeks. Open all year. Located downtown; 1,500 sq. ft.; "multi-disciplinary exhibition venue." 100% of space for gallery artists. Overall price range: $300-8,000.
Media: Considers oil, acrylic, watercolor, pastel, pen & ink, drawing, mixed media, collage, works on paper, sculpture, ceramic, installation, photography, video, performance art, original handpulled prints, woodcuts, wood engravings, linocuts, engravings, mezzotints and etchings.
Style: Exhibits all styles and all contemporary genres.
Terms: "No acquisition. Artists selected are paid exhibition fees for the right to exhibit their work." Retail price set by artist. Gallery provides insurance, promotion, contract and fees; shipping costs are shared. Only artwork "ready for exhibition."
Submissions: "Non-Canadian artists must submit by September 30 in order to be considered for visiting foreign artists' fees." Send query letter with résumé, 10-20 slides, bio, SASE (with IRC, if not Canadian), reviews and proposal outline. "No original work in submission." Replies in 1 month.
Tips: Artists should be aware of the trend of "de-funding by governments at all levels."

International

*ABEL JOSEPH GALLERY, 32 Rue Fremicourt, Paris France 75015. 33-1-45671886. Co-directors: Kevin and Christine Freitas. Retail gallery and alternative space. Estab. 1989. Represents 10 emerging and established artists. Exhibited artists include Diane Cole and Régent Pellerin. Sponsors 6-8 shows/year. Average display time 5 weeks. Open all year. Located in Paris; currently no exhibition space but working at home. 100% of space for work of gallery artists. Clientele: varies from first time buyers to established collectors. 80% private collectors; 20% corporate collectors. Overall price range: $500-10,000; most work sold at $1,000-3,000.
Media: Considers most media except craft. Original handpulled prints, woodcuts, engravings, lithographs, etchings and serigraphs. Most frequently exhibits sculpture, painting/drawing and installation (including active-interactive work with audience—poetry, music, etc.).
Style: Exhibits painterly abstraction, conceptualism, minimalism, pattern painting, post-modern works and imagism. "Interested in seeing all styles and genres." Prefers abstract, figurative and mixed-media.
Terms: Accepts artwork on consignment (50% commission). Retail price set by the gallery with input from the artist. Customer discounts and payment by installments are available. Gallery provides insurance, promotion and contract; shipping costs are shared.
Submissions: Send query letter with résumé, slides, bio, SASE and reviews. Portfolio review requested if interested in artist's work. Portfolio should include slides, photographs and transparencies. Replies in 1 month. Files résumé, bio and reviews.
Tips: "I think galleries have gotten a little more honest, looking out for the artist instead of the money. Budgets are tighter, causing galleries to be more creative for sales, clients, shows, publicity. Aesthetically, I think its more diverse; anything goes now; everything is valid; but we are losing a critical foundation to judge. Gallery districts are starting to spread out. Artists are opening galleries in their own studios."

Galleries/'94-'95 changes

The following galleries were listed in the 1994 edition but do not have listings in this edition. The majority did not respond to our request to update their listings. If a reason was given for a gallery's exclusion, we have included it in parentheses after the gallery's name.

A.K.A. Skylight Gallery of Beacon Hill
Alan Gallery
Alex Gallery
Alias Gallery (carries art of one artist)
Alon Gallery/Art Services
American West Gallery
Anderson County Arts Council
Archway Gallery
The Arkansas Arts Center
The Art Collector
Art in the Atrium
Art Space Gallery
The Arts Center

The Atlanta College of Art Gallery
Barron Arts Center
Beacon Street Gallery & Theatre
Bengert-Macrae Gallery
Bent Gallery and Museum
Joy Berman Galleries
Bingham Gallery
Bird-in-Hand Bookstore & Gallery
Blondies Contmeporary Art
Boston Corporate Art
Bowery Gallery
Broadway Windows

Brookfield Craft Center Gallery
Brookfield Gallery of Fine Art
J.J. Brookings Gallery
Bryant Galleries
Buckley Center Gallery, University of Portland
Burchfield Art Center
Amy Burnett Fine Art Gallery
Caje Art Gallery
Carlsten Art Gallery
Caron County Square House Museum
Case Art Gallery
Casell Gallery

City Arts Center
Claudia Chapline Gallery
Coast Galleries
Coco Bien Objiet D'Art
The Collector's Exchange
Congress Square Gallery (gallery closed)
Converse College Milliken Gallery
Corporate Art Source Inc.
Patricia Correia Gallery
Cudahy's Gallery
The Davidson County Art Guild
Davidson Galleries
Dawson Gallery
Deblois Gallery
Delaware Art Museum Art Sales & Rental Gallery
Detroit Artists Market
Devorzon Gallery
Doshi Center for Contemporary Art
Downtown Gallery
Eagles Roost Gallery
Eastern Shore Art Center
Easton Limited Gallery
Eaton Gallery
Edelstein/Dattel Art Investments
Fayette Art Museum
Fava (Firelands Assoc. for the Visual Arts)
Fenway Gallery
Field Art Studio
Fine Art Gallery of SW Louisiana
Fishbach Gallery
Florida Art Center & Gallery
The Fort Wayne Museum of Art Sales and Rental Gallery
Freeport Art Museum and Cultural Center
Sherry Frumpkin Gallery
Gadsden Museum of Arts
Galerie Internaitonale
Galesburg Civic Art Center
Gallery G
Gallery West
Gallery Yakir
Galman Lepow Associates, Inc.
Stephen Gill Gallery (per request)
John Good Gallery
Gordon Gallery
Lenore Gray Gallery, Inc.
Wellington B. Gray Gallery, East Carolina University
Gray Matters
Greater Lafayette Museum of Art
Grove St. Gallery
Haggerty Museum of Art
Haines Fine Arts Gallery
Hana Coast Gallery
Sally Hawkins Gallery
Haymarket Art Gallery
Henley's Gallery on the Sea Ranch
Hetzel Union Art Galleries
The Hopkins Gallery
Hughley Gallery & Objects

Hulsey Gallery, Norick Art Center, Oklahoma City University
Holly Ross Gallery
Honolulu Academy of Arts
A Houberbocken, Inc.
Houston Center for Photography
Images International Art Gallery
Indigo Gallery
Michael Ingbar Gallery of Architectural Art
Inkfish Gallery
Institute for Design and Experimental Art (IDEA)
Intar Latin American Gallery
International Images, Ltd
Islip Art Museum
Jessel Gallery
Charlotte Crosby Kemper/Kansas City Art Institute (per request)
Kerygma Gallery
Robert L. Kidd
Kirkland Art Center
Laconner Gallery
Laguna Gloria Art Museum
Martin Lawrence Limited Editions
Lite Rail Gallery
Le Mieux Galleries
Leon Loard Gallery of Fine Arts
The Loring Gallery
Los Angeles Municipal Art Association
Dene M. Louchheim Galleries, Fleisher Art Memorial
R.H. Love Contemporary
Lysographics Fine Art
McGowan Fine Art, Inc.
McMurtrey Gallery
Main Line Center of the Arts
Eve Mannes Galery
Mari Galleries of Westchester, Ltd.
Markel/Sears Fine Art
Marlboro Gallery
Andrea Marquit Fine Arts
Maveety Gallery
Jerald Melberg Gallery Inc.
Mendelson Gallery
Merritt Gallery
Mia Gallery
Middle Street Gallery
Mindscape Gallery
Mind's Eye Gallery
Morningstar Gallery, Ltd.
Munson Gallery (per request)
Museum of Church History and Art
Museum of Neon Art
Nab Gallery
Nabisco Foods Group
Neville-Sarpent Gallery
New Ground Gallery (gallery closed)
New Harmony Gallery of Contemporary Art.
A New Leaf Garden Gallery
New Visions Gallery, Inc.
Newhouse Center for Contem-

porary Art
Normandale College Center Gallery
Oates Gallery
Objects of Art
Oliver Art Center
Organization of Independent Artists
Panache Craft Gallery
Paper Press
Park Shore Gallery
Mary Peachin's Art Company
Pro-Art
Bernard Pucker Gallery, Inc.
Queens College Art Center
Radix Gallery
Raydon Gallery
Red Mountain Gallery
Reiss Gallery
Rosicrucian Museums Contemporary Art Gallery
The Rossi Gallery
The Ernest Rubenstein Gallery
Rubiner Gallery
San Angelo Museum of Fine Art
San Francisco Art Institute, Walter/McBean Gallery
San Gabriel Fine Arts Gallery
Santa Fe East Gallery
Scherer Gallery
Sculpture Point
Seraphin Orange Village Art Gallery
Shorney Gallery of Fine Art
Small Space Gallery
Somerhill Gallery
Soundview Art Gallery Ltd.
Southport Gallery
Sunbird Gallery
Jon Taner Gallery
The Tartt Gallery
Tempe Arts Center
Towne Gallery
Union Galleries, University of Arizona (gallery closed)
University Art Gallery, New Mexico State University
University of Illinois at Chicago — Campus Programs
Univeristy of Maine Museum of Art
Valperine Gallery
Mario Villa Gallery
Von Kolb Studio/Gallery and Assocaited Works
Washington Printmakers Gallery
Washington Project for the Arts
White Columns
White Gallery
Wichita Art Museum Shop and Gallery
Wiesner Gallery
Wilkes Art Gallery
Philip Williams Posters
Willowtree Gallery
The Works Gallery
Yeiser Art Center Inc.
Zephyr Gallery

Greeting Cards, Gift Items and Paper Products

Every year Americans buy more than 5 billion dollars' worth of greeting cards. Last year, for example, 2.6 billion Christmas cards were sent; over 950 million Valentine's Day cards were purchased; 155 million Mother's Day and 800,000 mother-in-law cards were mailed. There are cards for every holiday on the calendar. But with today's humorous alternative and studio cards, who needs an occasion?

According to industry leaders, about 40 percent of all greeting cards will require freelance artwork. The greeting card market is one that is especially open to crossover artists, that is, fine artists and illustrators looking for additional outlets for their work. The doors are open for every artistic style, medium and technique. Traditionally the most popular painting mediums are watercolor and designer's gouache. Though cards appear in every size and shape, most follow a vertical format, the standard size being $4\frac{5}{8} \times 7\frac{1}{2}$.

In addition to greeting card companies, firms who hire artists for calendars, T-shirts, collectibles, mugs, balloons, wrapping paper, desk accessories and other gifts are also listed in this section. Licensing agents have developed a multi-billion dollar business matching artists with manufacturers looking for unique, marketable products. Through licensing their designs, many greeting card artists are able to resell their work to other companies who produce peripheral products such as mugs, plates and school items.

Greeting card companies pride themselves in keeping up with social changes and changing demographics. Consequently, trends are fairly easy to spot and anticipate in this business. The multicultural movement has fostered greater interest in ethnic art. We're seeing cards celebrating Kwanzaa, an African-American holiday, alongside Christmas and Hanukkah greetings. Current popular images include Americana motifs, like quilts, folkart and Amish-based designs; African-inspired batiks; and florals paired with stripes, paisleys and small prints. Mosaics, blue and white delft, bandanna and Western imagery, and angels are also in style. Trends change as quickly as consumer interests change, so be on the lookout for what's new.

Study the market

It's important to note that the industry is still dominated by the big three: Hallmark, American Greetings and Gibson. Together, these corporations control 85% of the market share. But in spite of the shadow cast by these giants, there are approximately 1,500 smaller publishers doing quite well in the business too. Large firms have extensive inhouse art staffs but they also work with hundreds of freelance artists each year. Smaller firms are experiencing the most rapid growth within the industry and many rely solely on freelance artwork.

Research the market carefully before approaching greeting card firms. Small companies are all different. Each has carved out its own specific niche in the field. The best way to research card or stationery firms is to visit your local card or gift shop. Grocery stores and pharmacies also devote aisle space to greeting cards. Look at the various cards and try to find those featuring artwork similar to your style. Take a

notebook along and jot down the name of the company off of the back of the card. Study the listings in this book carefully to find out what publishers are looking for.

The next step is to send for a catalog or artist's guidelines. Some companies have very specific guidelines for artist submissions, so it's worth it to get the rules ahead of time. Most of the listings in this section indicate whether guidelines are available.

It may also be worth your while to visit a regional or national trade show if possible. This will give you the opportunity to meet art buyers in person and to see what's hot off the press in the industry. *Party and Paper Retailer* magazine features a calendar of events in every issue, highlighting upcoming trade shows and their locations.

Once you've narrowed your search, you'll be ready to approach buyers individually. Generally, art directors at card companies prefer to receive samples in the mail first. They then schedule portfolio reviews, or ask to see more work if their interest is sparked.

Begin by sending in 3-5 color samples of your work. These can be slides, photos, tearsheets or final reproductions, but they should be color. Card companies rarely take an interest in black and white work—simply because it can't compete on the shelves with bright color work. If you have an idea for a card design that requires pop-ups, die cuts or special folds, you may want to include a dummy card with your submission. Keep in mind that most card designs are vertical, so your samples should be vertical too.

As you're preparing your submissions, think not only in terms of individual card ideas, but also in terms of entire lines and related gift items. Like any other company, a card company wants to create an identity for itself and build brand loyalty among its buyers. Consequently, many companies look for artistic styles that they can build into an entire line of products.

Setting fees

Although payment rates for card design are comparable to those given for magazine and book illustration, price is not normally negotiable in this business. Most card and paper companies have set fees or royalty rates that they pay for design and illustration. What has recently become negotiable, however, is rights. In the past, card companies almost always demanded full rights to work, but now some are willing to negotiate for other arrangements, such as greeting card rights only. Keep in mind, however, that if the company has ancillary plans in mind for your work (for example, calendars, stationery, party supplies or toys) they will probably want to buy all rights. In such cases, you may be able to bargain for higher payment.

Help along the way

The Greeting Card Creative Network (GCCN) is an organization designed to help writers and artists in the greeting card field. The group provides access to a network of industry professionals, including publishers and licensing agents and acts as a clearinghouse for information on design and marketing trends, and legal and financial concerns within the industry. Artists' membership fees in GCCN range from $50 for students to $90 for professional artists. For more information contact GCCN, Suite 760, 1200 G St. NW, Washington DC 20005. (202)393-1780.

To keep current with the greeting card industry, consult *Greetings* magazine and *Party and Paper. The Complete Guide to Greeting Card Design & Illustration* by Eva Szela (from North Light Books) features published samples, tips and inside information on creating successful card designs.

‡**ABEL LOVE, INC.**, Dept. AM, 20 Lakeshore Dr., Newport News VA 23602. (804)877-2939. Buyer: Abraham Leiss. Estab. 1985. Distributor of books, gifts, hobby, art and craft supplies and drafting material. Clients:

retail stores, libraries and college bookstores. Current clients include Hampton Hobby House, NASA Visitors Center, Temple Gift Shops, Hawks Hobby Shop and Army Transportation Museum.
Needs: Approached by 100 freelance artists/year. Works with 10 freelance illustrators and 1 freelance designer/year. Uses freelance artists for catalog design, illustration and layout.
First Contact & Terms: Send query letter with slides, photographs and transparencies. Samples are filed. Reports back ASAP. Art director will contact artist for portfolio review if interested. Pays 10% royalties. Rights purchased vary according to project.

ACME GRAPHICS, INC., 201 3rd Ave. SW, Box 1348, Cedar Rapids IA 52406. (319)364-0233. Fax: (319)363-6437. President: Stan Richardson. Estab. 1913. Produces printed merchandise used by funeral directors, such as acknowledgments, register books and prayer cards.
Needs: Approached by 30 freelance artists/year. Considers pen & ink, watercolor and acrylic. Looking for religious, church window, floral and nature art. Needs computer-literate freelancers for illustration. 10% of freelance work demands knowledge of Aldus PageMaker.
First Contact & Terms: Send brochure. Samples are not filed and are returned by SASE. Reports back within 10 days. Call or write for appointment to show portfolio of roughs. Originals are not returned. Requests work on spec before assigning a job. Pays by the project or flat fee of $50. Payment varies. Buys all rights.
Tips: "Send samples or prints of work from other companies. No modern art or art with figures. Some designs are too expensive to print."

ADVANCE CELLOCARD CO., INC., 1259 N. Wood St., Chicago IL 60622. (312)235-3403. Fax: (312)235-1799. President: Ron Ward. Estab. 1960. Produces greeting cards.
Needs: Considers watercolor, acrylic, oil and colored pencil. Produces material for Valentine's Day, Mother's Day, Father's Day, Easter, graduation, birthdays and everyday.
First Contact & Terms: Send query letter with brochure. Samples not filed are returned by SASE. Reports back within weeks. Originals are not returned. Pays average flat fee of $75-150/design. Buys all rights.
Tips: "Send letter of introduction, and samples or photostats of artwork."

ALASKA MOMMA, INC., 303 Fifth Ave., New York NY 10016. (212)679-4404. Fax: (212)696-1340. President: Shirley Henschel. "We are a licensing company representing artists, illustrators, designers and established characters. We ourselves do not buy artwork. We act as a licensing agent for the artist. We license artwork and design concepts to toy, clothing, giftware, stationery and housewares manufacturers and publishers."
Needs: Approached by 100 or more artists/year. Needs illustrators. "An artist must have a distinctive and unique style that a manufacturer can't get from his own art department. We need art that can be applied to products such as posters, cards, puzzles, albums, etc."
First Contact & Terms: "Artists may submit work in any form as long as it is a fair representation of their style." Prefers to see several multiple color samples in a mailable size. No originals. "We are interested in artists whose work is suitable for a licensing program. We do not want to see b&w art drawings. What we need to see are slides or color photographs or color photocopies of finished art. We need to see a consistent style in a fairly extensive package of art. Otherwise, we don't really have a feeling for what the artist can do. The artist should think about products and determine if the submitted material is suitable for product. Please send SASE so the samples can be returned. We work on royalties that run from 5-10% from our licensees. We require an advance against royalties from all customers. Earned royalties depend on whether the products sell."
Tips: "Publishers of greeting cards and paper products have become interested in more traditional and conservative styles. There is less of a market for novelty and cartoon art. We need freelance artists more than ever as we especially need fresh talent in a difficult market."

ALEF JUDAICA, INC., 3384 Motor Ave., Los Angeles CA 90034. (310)202-0024. Fax: (310)202-0940. President: Guy Orner. Estab. 1979. Manufacturer and distributor of a full line of Judaica, including menorahs, Kiddush cups, greeting cards, giftwrap, tableware, etc.
Needs: Approached by 15 artists/year. Works with 10 artists/year. Buys 75-100 freelance designs and illustrations/year. Prefers local artists with experience. Works on assignment only. Uses freelancers for new designs in Judaica gifts (menorahs, etc.) and ceramic Judaica. Also for calligraphy, pasteup and mechanicals. All designs should be upper scale Judaica.
First Contact & Terms: Mail brochure, photographs of final art samples. Art director will contact artist for portfolio review if interested, or portfolios may be dropped off every Friday. Sometimes requests work on spec before assigning a job. Pays $300 for illustration/design; pays royalties of 10%. Considers buying second rights (reprint rights) to previously published work.

‡**ALL STAR PAPER COMPANY**, #7, 3150 Skokie Valley Rd., Highland Park IL 60035. (708)926-8466. Fax: (708)926-8490. President/Owner: Fran Greenspon. Produces greeting cards, giftwrap, stationery, T-shirts, books. "All product, currently, geared to the Judaic Market with contemporary designs being most important."

Elisse Jo Goldstein was given three months to complete this light-hearted watercolor of a matza bakery in Jerusalem for a "Happy Passover" card for All Star Paper Co. Fran Greenspon of All Star says the card sells very well. The inside copy by Lisa Jaffe reads "On Passover we eat only matza . . . On all other days we eat bagels!"

© 1994 Hanucraft, Inc.

Needs: Works with 12-15 freelance artists/year. Buys 125-150 illustrations/year. Prefers artists with experience in greeting cards. Works on assignment only. Uses freelance artists mainly for cards. Also uses freelance artists for calligraphy and paste-up. Considers any media. Produces material for Rosh Hashanah, Hanukkah, Passover and Bar/Bat Mitzvah. Submit seasonal material 8 months in advance.

First Contact & Terms: Send query letter with brochure, résumé, SASE, tearsheets, photographs and photocopies. Samples are filed or returned by SASE if requested by artist. Reports back to the artist only if interested. Art Director will contact artist for portfolio review if interested. Portfolio should include color final art. Originals are returned at job's completion. Pays $200-250. Rights purchased vary according to project.

‡PATRICIA ALLEN & COMPANY, 139 Heather Glen, Kathleen GA 31047. (912)988-1069. Fax: (912)923-8286. Owner: Patricia Allen. Estab. 1986. Produces greeting cards and humorous books. Produces "humorous books/cards directed toward middle age women – tongue-in-cheek."

Needs: Approached by 10 freelance artists/year. Works with 1 freelance artist/year. Prefers artists with ability to capture the '90s look of women. Works on assignment only. Uses freelance artists mainly for funny illustrations. Looking for women of the '90s – sophisticated style. Needs computer-literate freelancers for illustration.

First Contact & Terms: Send query letter with photographs and photocopies. Samples are filed. Reports back to the artist only if interested. Portfolio review not required. Originals are returned at job's completion. Rights purchased vary according to project. Pays by the project, $75 minimum.

AMBERLEY GREETING CARD CO., 11510 Goldcoast Dr., Cincinnati OH 45249-1695. (513)489-2775. Fax: (513)489-2857. Vice President: Ned Stern. Estab. 1966. Produces greeting cards. "We are a multi-line company directed toward all ages. Our cards are conventional and humorous."

● This publisher avoids niche marketing. Card ideas should appeal to a general, non-specific audience.
 It is sometimes best to use animal characters instead of people.

Needs: Approached by 20 freelance artists/year. Works with 10 freelancers/year. Buys 200 designs and illustrations/year. "We use local artists exclusively." Works on assignment only. Considers any media.

First Contact & Terms: Samples are not filed and are returned by SASE if requested by artist. Reports back to artist only if interested. Call for appointment to show portfolio of original/final art. Pays by the project, $75-80. Buys all rights.

AMCAL, Bldg. 500, 2500 Bisso Lane, Concord CA 94520. (510)689-9930. Fax: (510)689-0108. Publishes calendars, notecards, Christmas cards and other book and stationery items. "Markets to better gift, book and department stores throughout US. Some sales to Europe, Canada and Japan. We look for illustration and design that can be used many ways—calendars, note cards, address books and more so we can develop a collection. We buy art that appeals to a widely female audience. No gag humor or cartoons. Needs freelancers for design and production.
Needs: Prefers work in horizontal format. Send photos, slides, color photocopies or published work.
First Contact & Terms: Send samples. Art director will contact artist for portfolio review if interested. Pay for illustration by the project, advance against royalty.
Tips: Finds artists through word of mouth, magazines, artists' submissions/self-promotions, sourcebooks, visiting artist's exhibitions, art fairs and artists' reps. "Know the market. Go to gift shows and visit lots of stationery stores. Read all the trade magazines. Talk to store owners to find out what's selling and what isn't."

‡APPLE ORCHARD PRESS, P.O. Box 240, Riddel OR 97469. Art Director: Gordon Lance. Estab. 1988. Produces greeting cards and books. "We manufacture our products in our own facility and distribute them nationwide. We make it a point to use the artist's name on our products to help them gain recognition. Our priority is to produce products of the highest quality that are beautiful to look at."
Needs: Works with 4-8 artists/year. Buys 50-75 designs/year. Uses freelance artists mainly for note cards and book covers and dividers. Considers all media, but prefers watercolor and colored pencil. Looking for florals, cottages, gardens, gardening themes, fruits and vegetable recipe art, Christmas themes and animals. "We usually produce 4 or more images from an artist on the same theme at the same time." Produces material for Christmas, Easter, Valentine's Day and everyday. Submit seasonal material 9-12 months in advance, "but will always be considered for the next release of that season's products whenever it's submitted."
First Contact & Terms: Send query letter with SASE and photos or slides. "Samples are not filed unless we're interested." Reports back within 1-2 months. Company will contact artist for portfolio review if interested. Portfolio should include slides and/or photographs. Pays one-time flat fee/image; amount varies. Rights purchased vary according to project.
Tips: "Please do not send pictures of pieces that are not available for reproduction. We must eventually have access to either the original or an excellent quality transparency. If you must send pictures of pieces that are not available in order to show style, be sure to indicate clearly that the piece is not available. We work with pairs of images. Sending quality pictures of your work is a real plus."

THE ASHTON-DRAKE GALLERIES, 9200 N. Maryland Ave., Niles IL 60618. (708)581-8107. Procurement Manager: Andrea Ship. Estab. 1985. Direct response marketer of collectible dolls. Clients: consumers, mostly women of all age groups.
Needs: Approached by 300 freelance artists/year. Works with 250 freelance doll artists, sculptors, costume designers and illustrators/year. Works on assignment only. Uses freelancers for concept illustration, wigmaking, porcelain decorating, shoemaking, costume design, collectible design, prototype specifications and sample construction. Prior experience in giftware design, doll design, greeting card and book illustration a plus. Subject matter includes children and mothers, animals and nostalgia scenes. Prefers "cute, realistic and natural human features; animated poses."
First Contact & Terms: Send query letter with résumé and copies of samples to be kept on file. Prefers photographs, tearsheets or photostats as samples. Samples not filed are returned. Reports within 7 weeks. Pays by the hour, $40-50; by the project, $50-300. Concept illustrations are done "on spec." Sculptors receive contract for length of series on royalty basis with guaranteed advances.
Tips: The most common mistake freelancers make in presenting samples or a portfolio is "sending actual products, ribbons and awards and too many articles on their work." Especially looking for doll artists who work in clay or sculptors, costume designers and concept illustrators.

ATHENA INTERNATIONAL, Box 918, Edinburgh Way, Harlow Essex CM20 2DU England. Phone: 0279 641125. Fax: 0279 635672. Group Publishing Director: Mr. Roger Watt. Produces greeting cards, postcards,

How to Use Your **Artist's & Graphic Designer's Market** *offers suggestions for understanding and using the information in these listings. Read this and other articles in the front of this book for important business tips.*

posters, prints, pop and personality products, stationery, calendars and T-shirts.
Needs: Produces material for everyday, special occasions, Christmas, Valentine's Day, Mother's Day, Father's Day and Easter, plus quality artwork for prints and posters.
First Contact & Terms: Send query letter with brochure, photostats, photocopies and slides. Samples not filed are returned. Reports back within 30 days. To show portfolio, mail roughs, photostats and photographs. Originals returned after job's completion. Pay royalties or pays by the project. Negotiates rights purchased.

THE AVALON HILL GAME CO., 4517 Harford Rd., Baltimore MD 21214. (410)254-9200. Fax: (410)254-0991. Art Director: Jean Baer. Estab. 1958. "Produces strategy, sports, family, role playing and computer games for adults."
 • This company also publishes the magazine *Girls' Life.*
Needs: Approached by 30 artists/year. Works with 10 artists/year. Buys 30-50 designs and illustrations from freelancers/year. Prefers artists with experience in realistic military and/or fantasy art. Works on assignment only. Uses freelancers mainly for cover and interior art. Also for fantasy illustration. Considers any media. "The styles we are looking for vary from realistic to photographic to fantasy."
First Contact & Terms: Send query letter with tearsheets, slides, SASE and photocopies. Samples are filed or returned by SASE if requested by artist. Reports back within 2-3 weeks. If Art Director does not report back, the artist should "wait. We will contact the artist if we have an applicable assignment." Art Director will contact artist for portfolio review if interested. Original artwork is not returned at the job's completion. Sometimes requests work on spec before assigning a job. Pays by the project, $500 average, according to job specs. Buys all rights. Considers buying second rights (reprint rights) to previously published work.
Tips: Finds artists through word of mouth and submissions.

‡BALLOON WHOLESALERS INTERNATIONAL, Suite 104, 1735 E St., Fresno CA 93720. (209)266-1318. Fax: (209)266-3944. Vice President: T. Adishian. Estab. 1983. Manufacturer of balloons for adults and children.
Needs: Approached by 2-3 freelance artists/year. Uses freelance artists mainly for balloon and gift design. Prefers bright, contemporary, upbeat styles. Also uses freelance artists for P-O-P displays, package and header card displays.
First Contact & Terms: Send query letter with brochure showing art style or résumé, tearsheets, photostats, photographs and SASE. Samples are filed or are returned by SASE only if requested by artist. Reports back within 4-6 weeks. Request portfolio review in original query. Art Director will contact artist for portfolio review if interested. Portfolio should include roughs, photostats, tearsheets and dummies. Requests work on spec before assigning a job. Rights purchased vary according to project.

BARTON-COTTON INC., 1405 Parker Rd., Baltimore MD 21227. (301)247-4800. Contact: Art Buyer. Produces religious greeting cards, commercial Christmas cards, wildlife designs and spring note cards. Free guidelines and sample cards; specify area of interest (religious, Christmas, spring, etc.).
Needs: Buys 150-200 freelance illustrations/year. Submit seasonal work any time.
First Contact & Terms: Send query letter with résumé, tearsheets, slides and photographs. Submit full-color work only (watercolor, gouache, pastel, oil and acrylic). Previously published work and simultaneous submissions accepted. Reports in 1 month. Pays average flat fee of $400-500 for illustration and design. **Pays on acceptance.**
Tips: "Good draftsmanship is a must, particularly with figures and faces. Spend some time studying current market trends in the greeting card industry. There is an increased need for creative ways to paint traditional Christmas scenes with up-to-date styles and techniques."

■ANITA BECK CARDS, 3409 W. 44th St., Minneapolis MN 55410. President: Cynthia Anderson. "We manufacture and distribute greeting cards, note cards, Christmas cards and related stationery products through a wholesale and direct mail market."
Needs: Uses freelance artists mainly for card designs; photographs are *not* used.
First Contact & Terms: Send query letter with brochure and photographs of artwork. Samples are filed or are returned only if requested by artist. Reports back within 3 months. Call or write for appointment to show portfolio. Pays for design by the project, $50 minimum. Buys all rights.

FREDERICK BECK ORIGINALS, 20644 Superior St., Chatsworth CA 91311. (818)988-0323. Fax: (818)998-5808. Contact: Ron Pardo, Gary Lainer or Richard Aust. Estab. 1953. Produces silk screen printed Christmas cards, traditional to contemporary.
 • This company is under the same umbrella as Gene Bliley Stationery. One submission will be seen
 by both companies, so there is no need to send two mailings. Frederick Beck designs are a little more
 high end than Gene Bliley designs. The cards are sold through stationery and party stores, where
 the customer browses through thick binders to order cards, stationery or invitations imprinted with
 customer's name. Though many of the same cards are repeated or rotated each year, both companies
 are always looking for fresh images.
Needs: Approached by 6 artists/year. Works with 10 artists/year. Buys 25 designs/illustrations/year. Prefers artists with experience in silk screen printing. Uses freelancers mainly for silk screen Christmas card designs.

Looking for "artwork compatible with existing line; shape and color are important design elements." Prefers 5⅜ × 7⅞. Produces material for Christmas. Submit 1 year before holiday.

First Contact & Terms: Send query letter with simple sketches. Samples are filed. Reports back within 2 weeks if interested. Portfolio review not required. Usually purchases all rights. Original artwork is not generally returned at job's completion "but could be." Sometimes requests work on spec before assigning a job. Pays by the project, average flat fee of $175 for illustration/design.

Tips: Finds artists through word of mouth and artists' submissions/self-promotions.

BEISTLE COMPANY, 1 Beistle Plaza, Box 10, Shippensburg PA 17257. (717)532-2131. Fax: (717)532-7789. Product Manager: C.M. Luhrs-Wiest. Estab. 1900. Manufacturer of paper and plastic decorations, party goods, gift items, tableware and greeting cards. Targets general public, home consumers through P-O-P displays, specialty advertising, school market and other party good suppliers.

• The Beistle Company is expanding and has added gift items, tableware and greeting cards to its line.

Needs: Approached by 15-20 freelance artists/year. Prefers artists with experience in designer gouache illustration—fanciful figure work. Looks for full-color, camera-ready artwork for separation and offset reproduction. Works on assignment only. Uses freelance artists mainly for product rendering and brochure design and layout. Prefers designer gouache and airbrush technique for poster style artwork. Needs computer-literate freelancers for design and illustration. Freelancers should be familiar with QuarkXPress, Aldus FreeHand, Adobe Illustrator, Photoshop or Fractal Design PAINTER.

First Contact & Terms: Send query letter with résumé and the following samples: tearsheets, photostats, photocopies, slides, photographs, transparencies. Samples are filed or returned by SASE. Art Director will contact artist for portfolio review if interested. sometimes requests work on spec before assigning a job. Pays average flat fee of $325; or pays by the hour, $25-35; by the project $600-1,200. Considers buying second rights (reprint rights) to previously published work.

Tips: Finds artists through word of mouth, magazines, artists' submissions/self-promotions, sourcebooks, agents, visiting artist's exhibitions, art fairs and artists' reps. "Our primary interest is in illustration; often we receive freelance propositions for graphic design—brochures, logos, catalogs, etc. These are not of interest to us as we are manufacturers of printed decorations. Send color samples rather than black & white. There is a move toward brighter, stronger designs with more vibrant colors and bolder lines. We have utilized more freelance artists in the last few years than previously. We predict continued and increased consumer interest—greater juvenile product demand due to recent baby boom and larger adult market because of baby boom of the '50s."

BEPUZZLED, 22 E. Newberry Rd., Bloomfield CT 06002. (203)769-5700. Fax: (203)769-5799. Art Director: Brian Cavallaro. Estab. 1987. Produces games and puzzles for children and adults. "BEPUZZLED mystery jigsaw games challenge players to solve an original whodunit thriller by matching clues in the mystery with visual clues revealed in the puzzle."

Needs: Works with 8-16 freelance artists/year. Buys 20-40 designs and illustrations/year. Prefers local artists with experience in children's book and adult book illustration. Uses freelancers mainly for box cover art, puzzle images and character portraits. All illustrations are done to spec. Considers many media.

First Contact & Terms: Send query letter with brochure, résumé, SASE, tearsheets, photographs and transparencies. Samples are filed. Reports back within 2 months. Art Director will contact artist for portfolio review if interested. Portfolio should include original/final art and photographs. Original artwork is returned at the job's completion. Sometimes requests work on spec before assigning a job. Pays by the project, $300-3,000.

Tips: Finds artists through word of mouth, magazines, artists' submissions, sourcebooks, agents, galleries, reps, etc. Prefers that artists not "ask that all material be returned. I like to keep a visual in my files for future reference. New and fresh looking illustration styles are key."

BERGQUIST IMPORTS, INC., 1412 Hwy. 33 S., Cloquet MN 55720. (218)879-3343. Fax: (218)879-0010. President: Barry Bergquist. Estab. 1948. Produces paper tableware products, mugs and tile. Wholesaler of mugs, decorator tile, plates and dinnerware.

Needs: Approached by 5 artists/year. Works with 5 artists/year. Buys 50 design and illustrations/year. Prefers artists with experience in Scandinavian and wildlife designs. Works on assignment only. Uses freelancers for calligraphy. Produces material for Christmas, Valentine's Day and everyday. Submit seasonal material 6-8 months in advance.

First Contact & Terms: Send query letter with brochure, tearsheets and photographs. Samples are not filed and are returned. Reports back within 2 months. Request portfolio review in original query. Artist should follow-up with a letter after initial query. Portfolio should include roughs, color tearsheets and photographs. Rights purchased vary according to project. Originals are returned at job's completion. Requests work on spec before assigning a job. Pays by the project, $50-300; average flat fee of $50 for illustration/design; or royalties of 5%.

Tips: Finds artists through word of mouth, artists' submissions/self-promotions and art fairs.

GENE BLILEY STATIONERY, 20644 Superior St., Chatsworth CA 91311. (818)998-0323. Fax: (818)998-5808. General Manager: Gary Lainer. Sales Manager: Ron Pardo. Estab. 1967. Produces stationery, family-oriented birth announcements and invitations for most events and Christmas cards.

* This company also owns Frederick Beck Originals (see listing). One submission will be seen by both companies.

Needs: Approached by 4-10 freelance artists/year. Works with 2-3 freelancers/year. Buys 15-60 designs and illustrations/year. Prefers local artists. Uses freelancers mainly for invitation and photo card designs. Also for calligraphy, paste-up and mechanicals. Considers any color media, except photography and oil. Produces material for Christmas, graduation, birthdays, Valentine's Day and Mother's Day. Submit Christmas material 1 year in advance; others reviewed year round.

First Contact & Terms: Send query letter with résumé and color tearsheets, photographs or photocopies. Samples are filed. Portfolio review not required. Original artwork not returned at job's completion. Sometimes requests work on spec before assigning a job. Pays flat fee of $100 per design on average. Buys all rights.

Tips: "We are open to new ideas and different approaches within our niche. Our most consistent need is designs for Christmas invitations and photo cards. Familiarize yourself with the marketplace."

‡**BLUE SKY PUBLISHING**, Penthouse M, 6395 Gunpark Dr., Boulder CO 80301. (303)530-4654. Fax: (303)530-4627. Art Director: Theresa Brown. Estab. 1989. Produces greeting cards and stationery. "At Blue Sky Publishing, we are committed to producing contemporary fine art greeting cards that communicate reverence for nature and all creatures of the earth, that share different cultural perspectives and traditions, and that remain true to the artists' visions of their work."

Needs: Approached by 100 fine artists/year. Works with 20 fine artists/year. Licenses 40 fine art pieces/year. Works with artists from all over US. Prefers artists with experience in fine art media: oils, oil pastels, watercolor, fine art photography. "We primarily license existing pieces of art or photography. We rarely commission work." Uses freelance artists mainly for greeting card artwork. Also uses freelance artists for calligraphy, mechanicals, computer layout/design. Looking for colorful, contemporary images (expressing human feelings). 50% of work demands knowledge of Aldus PageMaker and Adobe Illustrator. Produces cards for Christmas, birthdays, Thanksgiving, everyday, Mother's Day, New Year, sympathy, congratulations, baby, anniversary, thank you. Submit seasonal material 1 year in advance.

First Contact & Terms: Send query letter with résumé, SASE, photographs, slides, photocopies or transparencies. Samples are filed. Reports back within 2-3 months if returning artwork. Reports back to the artist only if interested if not returning art. Art Director will contact artist for portfolio review if interested. Portfolio should include color photographs, slides or 4×5 transparencies. Transparencies are returned at job's completion. Pays royalties of 3% with upfront license fee of $250 per image. Buys greeting card rights for 5 years (standard contract; sometimes this is negotiated).

Tips: "We're interested in seeing personal art work that touches you deeply. Since we are licensing existing works of art, this is critical for us. Holiday cards are what we produce in biggest volume. We are looking for 'happy' images and cards dealing with relationships. *Color is key!*"

‡**THE BRADFORD EXCHANGE**, 9333 Milwaukee Ave., Niles IL 60714. (708)581-8204. Fax: (708)581-8770. Art Acquisition Manager: Maureen Case. Estab. 1973. Produces and markets collectible plates. "Bradford produces limited edition collectors plates featuring various artists' work which is reproduced on the porcelain surface. Each series of 6-8 plates is centered around a concept, rendered by one artist, and marketed internationally."

Needs: Approached by thousands of freelance artists/year. Works with approximately 100 freelance artists/year. Prefers artists with experience in rendering painterly, realistic, "finished" scenes; best mediums are oil and acrylic. Uses freelance artists for all work including border designs, sculpture. Considers oils, watercolor, acrylic and sculpture. Traditional representational style is best, depicting scenes of children, pets, wildlife, homes, religious subjects, fantasy art, florals or songbirds in idealized settings. Produces material for all holidays and seasons, Halloween, Christmas, Easter, Valentine's Day, Thanksgiving, Mother's Day. Submit seasonal material 6-9 months in advance.

First Contact & Terms: Send query letter with brochure, résumé, tearsheets, photographs, photocopies or slides. Samples are filed and are not returned. Art Director will contact artist only if interested. Originals are returned at job's completion. Pays royalties, upfront fee or a combination of both. Rights purchased vary according to project.

∎**BRILLIANT ENTERPRISES**, 117 W. Valerio St., Santa Barbara CA 93101. Art Director: Ashleigh Brilliant. Publishes postcards.

Needs: Buys up to 300 designs/year. Artists may submit designs for word-and-picture postcards, illustrated with line drawings.

First Contact & Terms: Submit 5½×3½ horizontal b&w line drawings and SASE. Reports in 2 weeks. Buys all rights. "Since our approach is very offbeat, it is essential that freelancers first study our line. Ashleigh Brilliant's books include *I May Not Be Totally Perfect, But Parts of Me Are Excellent*; *Appreciate Me Now and Avoid the Rush*; and *I Want to Reach Your Mind. Where Is It Currently Located?* We supply a catalog and

© 1994 Sandra Bierman

Blue Sky Publishing licensed Yin & Yang, by Sandra Bierman, as part of their fine art line of note cards. The artist received a flat fee and royalties for use of her oil painting, in which she sought to portray love and a nurturing spirit. The original work has since sold to a collector.

sample set of cards for $2 plus SASE." Pays $50 minimum, depending on "the going rate" for camera-ready word-and-picture design.
Tips: "Since our product is highly unusual, familiarize yourself with it by sending for our catalog. Otherwise, you will just be wasting our time and yours."

BRISTOL GIFT CO., INC., P.O. Box 425, 6 North St., Washingtonville NY 10992. (914)496-2821. Fax: (914)496-2859. President: Matt Ropiecki. Estab. 1988. Produces posters and framed pictures for inspiration and religious markets.
Needs: Approached by 5-10 freelance artists/year. Works with 2 freelancers/year. Buys 15-30 freelance designs and illustrations/year. Works on assignment only. Uses freelance artists mainly for design. Also for calligraphy, P-O-P displays and mechanicals. Prefers 16 × 20 or smaller. Needs computer-literate freelancers for design, illustration and production. 15% of work demands knowledge of Aldus PageMaker or Adobe Illustrator. Produces material for Christmas, Mother's Day, Father's Day and Graduation. Submit seasonal material 6 months in advance.
First Contact & Terms: Send query letter with brochure and résumé. Samples are filed and are returned. Reports back within 2 weeks. Company will contact artist for portfolio review if interested. Portfolio should include roughs. Requests work on spec before assigning a job. Originals are not returned. Pays by the project or royalties of 5-10%. Rights purchased vary according to project. Interested in buying second rights (reprint rights) to previousy published artwork.

BURGOYNE, INC., 2030 E. Byberry Rd., Philadelphia PA 19116. (215)677-8962. Fax: (215)677-6081. Creative Director: Jeanna Lane. Estab. 1907. Produces greeting cards. Publishes Christmas greeting cards geared towards all age groups. Style ranges from traditional to contemporary to old masters' religious.
• Burgoyne has expanded its operation and purchased Curtis Swann (see listing).
Needs: Approached by 150 freelance artists/year. Works with 25 freelancers/year. Buys 50 designs and illustrations/year. Prefers artists with experience in all styles and techniques of greeting card design. Uses freelancers mainly for Christmas illustrations. Also for lettering/typestyle work. Considers watercolor and pen & ink. Produces material for Christmas. Accepts work all year round.
First Contact & Terms: Send query letter with slides, transparencies, photocopies and SASE. Samples are filed. Art Director will contact artist for portfolio review if interested. Payment depends on project. Buys first rights or all rights. Sometimes requests work on spec before assigning job. Interested in buying second rights (reprint rights) to previously published work.

‡CAPE SHORE, INC., 42 N. Elm St., Yarmouth ME 04996. (207)846-3726. Art Director: Joan Jordan. Estab. 1947. "Cape Shore is concerned with seeking, manufacturing and distributing a quality line of gifts and stationery for the souvenir and gift-market."
Needs: Approached by 50-75 freelance artists/year. Works with 30-40 freelance artists/year. Buys 75-80 freelance designs and illustrations/year. Prefers artists with experience in illustration. Uses freelance artists mainly for illustrations for boxed notes and Christmas card designs. Considers watercolor, gouache, acrylics, tempera, pastel, markers, colored pencil. Looking for traditional subjects rendered in a realistic style with strong attention to detail. Prefers final artwork on flexible stock for reproduction purposes.
First Contact & Terms: Send query letter with photocopies and slides. Samples are filed or are returned by SASE. Art Director will contact artist for portfolio review if interested. Portfolio should include slides, finished samples, printed samples. Pays by the project, $150 minimum. Buys reprint rights or varying rights according to project.
Tips: "Cape Shore is looking for realistic detail, good technique, bright clear colors and fairly tight designs of traditional themes."

J.F. CAROLL PUBLISHING, 215 Park Ave. S., New York NY 10003. (212)387-7938. Art Director: Glen Hunter. Estab. 1982. Produces greeting cards, games, stationery, paper tableware products, calendars, giftwrap and posters. Manufactures gift items and New York City area products.
Needs: Approached by 40 freelance artists/year. Works with 4 freelance artists/year. Buys 100 designs and illustrations/year. "We are looking for good work that is consumer oriented." Uses freelancers for P-O-P displays, paste-up, mechanicals and color and b&w cartoons. Style must be accessible to those viewing. Produces material for all holidays and seasons.
First Contact & Terms: Send query letter with brochure, résumé, SASE and any type of art sample. Samples are filed or are returned. Reports back within 2 weeks. To show portfolio, mail appropriate materials:

The double dagger before a listing indicates that the listing is new in this edition. New markets are often more receptive to freelance submissions.

thumbnails, roughs, printed samples, b&w or color dummies and photographs. Pays by the project. Rights purchased vary according to project.
Tips: "Call if you have project ideas you'd like to have published for New York area products, calendars or maps."

JOHN C.W. CARROLL, 1723 Noe St., San Francisco CA 94131. (415)826-5735. Fax: (415)826-8478. Owner: John Carroll. Estab. 1990. Produces greeting cards, stationery, calendars and collectibles on contract for other manufacturers. "My company is an independent creative resource, operating on behalf of a range of gift and stationery trade clients. A team-tailored approach provides complete product development services: planning, design/art/editorial and production."
Needs: Approached by 100 freelance artists/year. Works with 10-15 freelancers/year. Buys 50-100 freelance designs and illustrations/year. Works on assignment only. Uses freelancers mainly for design and illustration. Also for calligraphy. Considers all media. "No fluorescents. Our needs list is updated periodically." Needs computer-literate freelancers for design. 15% of freelance work (including in-house) demands knowledge of Aldus PageMaker, Adobe Illustrator, QuarkXPress or Aldus FreeHand. Produces material for all holidays and seasons, birthdays and everyday. Submit seasonal material 18 months in advance.
First Contact & Terms: Send query letter with SASE. Samples are filed or are returned by SASE. Reports back within 1 month. Artist should follow-up with call and/or letter after initial query. Portfolio should include roughs, tearsheets, photographs and slides. No original art. Originals are returned at job's completion. Pays average flat fee of $250 for illustration/design (negotiable), by the project, $250-350 average (per image); or 5% royalties. Rights purchased vary according to project.
Tips: Finds artists through word of mouth. Keep presentation simple and concise.

H. GEORGE CASPARI, INC., 35 E. 21st St., New York NY 10010. (212)995-5710. Contact: Lucille Andriola. Publishes greeting cards, Christmas cards, invitations, giftwrap and paper napkins. "The line maintains a very traditional theme."
Needs: Buys 80-100 illustrations/year. Prefers watercolor and other color media. Produces seasonal material for Christmas, Mother's Day, Father's Day, Easter and Valentine's Day.
First Contact & Terms: Send samples to Lucille Andriola to review. Prefers unpublished original illustrations, slides or transparencies. Art Director will contact artist for portfolio review if interested. **Pays on acceptance;** negotiable. Pays flat fee of $400 for design.
Tips: Finds artists through word of mouth, magazines, artists' submissions/self-promotions, sourcebooks, agents, visiting artist's exhibitions, art fairs and artists' reps. "Caspari and many other small companies rely on freelance artists to give the line a fresh, overall style rather than relying on one artist. We feel this is a strong point of our company. Please do not send verses."

‡CEDCO PUBLISHING CO., 2955 Kerner Blvd., San Raphael CA 94901. Contact: Art Deptartment. Estab. 1982. Produces 155 upscale calendars and books.
Needs: Approached by 500 freelance artists/year. Works with 5 freelance artists/year. Buys 48 freelance designs and illustrations/year. "We never give assignment work." Uses freelance artists mainly for stock material and ideas. "We use either 35mm slides or 4×5s of the work."
First Contact & Terms: "No phone calls accepted." Send query letter with brochure, tearsheets and photostats. Samples are filed. "Send non-returnable samples only." Reports back to the artist only if interested. To show portfolio, mail thumbnails and b&w photostats, tearsheets and photographs. Original artwork is returned at the job's completion. Pays by the project. Buys one-time rights. Interested in buying second rights (reprint rights) to previously published work.
Tips: Finds artists through art fairs and licensing agents. "Full calendar ideas encouraged!"

CENTRIC CORP., 6712 Melrose Ave., Los Angeles CA 90038. (213)936-2100. Fax: (213)936-2101. Vice President: Neddy Okdot. Estab. 1986. Produces fashion watches, clocks, mugs, non-holographic 3-D posters and stand-ups for ages 18-55.
Needs: Approached by 40 freelance artists/year. Works with 6-7 freelance artists/year. Buys 30-40 designs and illustrations/year. Prefers local artists only. Works on assignment only. Uses freelancers mainly for watch and clock dials, posters, mugs and packaging. Also for mechanicals. Considers graphics, computer graphics, cartoons, pen & ink, photography. Needs computer-literate freelancers for design. 70% of freelance work demands knowledge of QuarkXPress, Adobe Illustrator or Adobe Paintbox.
First Contact & Terms: Send query letter with photographs. Samples are filed if interested. Reports back to the artist only if interested. Originals are returned at job's completion. Requests work on spec before assigning a job. Pays by the project. Rights purchased vary according to project.
Tips: Finds artists through artists' submissions/self-promotions, sourcebooks, agents and artists' reps.

CHESAPEAKE CONSUMER PRODUCTS CO., 1200 S. Perkins St., Appleton WI 54912-1039. (414)739-8233. Fax: (414)730-4880. Creative Manager: Dave Butzen. Produces paper tableware products. "Chesapeake provides upscale quality consumer disposable paper tableware. With the ability to print 6-color flexo napkins, plates and table covers, Chesapeake has become the preferred resource in the mass market industry."

Needs: Approached by 6-12 freelance artists/year. Works with 15 freelancers/year. Buys 30 designs and illustrations/year. Prefers artists with experience in paper tableware products (but this is not a prerequisite). Uses freelancers for concept and design. "Style and look depend mainly on the market category being filled. This information is available through contact with the creative manager." Prefers 9½" circle image size. Needs computer-literate freelancers for design and illustration. 50% of freelance work demands knowledge of Aldus PageMaker, QuarkXPress, Aldus FreeHand, Adobe Illustrator, Photoshop. Produces material for Christmas, Valentine's Day, Easter, Graduation, Thanksgiving, New Year, Halloween, birthdays, everyday, St. Patrick's Day, weddings, showers, patriotic occasions, parties. Submit seasonal material 9 months in advance.

First Contact & Terms: Send query letter with résumé, SASE, tearsheets, photocopies. Samples are filed and are returned by SASE if requested by artist. Art Director will contact artist for portfolio review if interested. Portfolio should include thumbnails, roughs, finished art samples and color photostats, tearsheets, photographs and dummies. Rights purchased vary according to project. Interested in buying second rights (reprint rights) to previously published work. Originals are returned at job's completion. Requests work on spec before assigning a job. Pays by the project, $200-2,000; average flat fee of $1,000 for illustration/design; or royalties of 4%.

Tips: Finds artists through art fairs and artist reps. "We are interested in trend setting, as well as traditional concepts and designs. Contact should be made with the creative manager, via a letter containing a résumé and style samples. Often we receive designs with no prior contact that do not fit what we do. This wastes our time and the designer's."

‡CLASSIC OILS, Box 33, Flushing NY 11367. (718)426-4960 or (718)261-5402. Contact: Roy Sicular. Estab. 1978. Produces greeting cards and posters."I publish scenes of New York City—watercolor, collages, b&w."
Needs: Approached by 5 freelance artists/year. Works with 0-1 freelance artists/year. Buys 0-1 freelance design and illustration/year. Considers all media.
First Contact & Terms: Send query letter with photocopies. Samples are not filed and are returned. Reports back to the artist only if interested. Portfolio review not required. Originals are returned at job's completion. Pays $100-300 for reproduction rights. Buys reprint rights.

CLOUD 9, 3532 Greenwood Blvd., St. Louis MO 63143. (314)644-3500. Fax: (314)644-1589. President/Creative Director: Pamela Miller. Produces greeting cards.
Needs: Works with 12 freelance artists/year. Buys 150-200 designs and illustrations/year. Seeks artists with strong look that can be shown as a stand alone line. "We want creativity that strikes a chord and mirrors the sentiments and emotions of present day society." Looking for humorous, whimsical and photographic work. Prefers final art 5×7. Produces material for all holidays and seasons.
First Contact & Terms: Send query letter with brochure, color photocopies and slides. Samples are filed or are returned by SASE within 2 months. Artist should follow-up after initial query. Pays flat fee of $200 for illustration/design; or royalty of 5%. Considers buying second rights (reprint rights) to previously published work.
Tips: Finds artists through word of mouth, magazines, artists' submissions, visiting artist's exhibitions and art fairs.

‡COLORS BY DESIGN, 7723 Densmore Ave., VanNuys CA 91406. Creative Director: Tamara Niemerow. Produces greeting cards, giftwrap, stationery, imprintables, invitations, desk top accessories, notecards. "Our current products are bright, bold, whimsical, watercolors using calligraphy and quotes and collage cards using gold ink. We are open to new lines, new looks, including humor cards, photo cards and cards that fit into our current line."
Needs: Works with 20-25 freelance artists/year. Buys 100-200 freelance designs and illustrations/year. Uses freelance artists for all products. Considers all media. "Looking for humor cards, photo cards, cards that fit into our current line." Cards are 5×7. Produces material for all holidays and seasons. "Anytime we welcome everyday submissions; in June, submit Mother's Day, Father's Day, Easter, graduation and Valentine's Day; in January, submit Christmas, New Year's, Hanukkah, Passover, Thanksgiving, Halloween, Rosh Hashanah."
First Contact & Terms: "Please write for our submission guidelines and catalogue." Samples are returned by SASE. Reports back within 6 weeks. Art Director will contact artist for portfolio review if interested. Portfolio should include color roughs, final art and photographs. Originals are not returned. Pays royalties of 3-5% and $350 advance against royalties/piece. Buys all rights or negotiates rights purchased, reprint rights.
Tips: "Phone calls are discouraged."

■COMSTOCK CARDS, INC., Suite 15, 600 S. Rock Blvd., Reno NV 89502. (702)856-9400. Fax: (702)856-9406. Production Manager: Gene Romaine. Estab. 1987. Produces greeting cards, notepads, invitations and magnets. Styles include alternative and adult humor, outrageous, shocking and contemporary themes; specializes in fat, age and funny situations. No animals or landscapes. Target market predominately professional females, ages 25-55.

Needs: Approached by 250-350 artists/year. Presently working with 10-12 artists/year. "Especially seeking artists able to produce outrageous adult-oriented cartoons." Uses freelancers mainly for cartoon greeting cards. No verse or prose. Gaglines must be brief. Prefers 5×7 final art. Needs computer-literate freelancers for illustration in Aldus PageMaker or Adobe Illustrator. Produces material for Christmas, Hanukkah, Easter, birthdays, Valentine's Day, Thanksgiving, Halloween, Mother's Day, Father's Day, anniversaries, as well as everyday. Submit holiday concepts 11 months in advance.
First Contact & Terms: Send query letter with SASE, tearsheets, sample illustrations, slides or transparencies. Samples are not usually filed and are returned by SASE if requested. Reports back only if interested. Portfolio review not required. Originals are not returned. Pays by the project, $50 minimum; may negotiate other arrangements. Buys all rights

■❀**CONTENOVA GIFTS, INC.,** 1239 Adanac St., Vancouver, British Columbia V6A 2C8 Canada. (604)253-4444. Fax: (604)253-4014. Creative Director: Russ Morris. Estab. 1965. Produces impulse gift merchandise and ceramic greeting mugs.
Needs: Buys 100 freelance designs/year for mugs. Prefers artists with experience in full color work and fax capabilities. Works on assignment only. Looking for humorous cartoon work, cute animals and caricatures. Produces material for Father's Day, Christmas, Easter, birthdays, Valentine's Day, Mother's Day and everyday.
First Contact & Terms: Send query letter with brochure, tearsheets, SASE and photocopies. Samples are not filed and are returned by SASE. Art Director will contact artist for portfolio review if interested. Portfolio should include roughs, photostats, slides, color tearsheets and dummies. Sometimes requests work on spec before assigning a job. Pays by the project, $400-500. Buys all rights.
Tips: Finds artists through submissions/self-promotions and word of mouth. "We see steady growth for the future."

‡**COURAGE CENTER,** 3915 Golden Valley Rd., Golden Valley MN 55422. (612)520-0211. Fax: (612)520-0299. Art & Production Manager: Fran Bloomfield. Greeting cards from original art first produced in 1970. "Courage Center produces holiday notecards and Christmas cards. Cards are reproduced from fine art aquired through nationwide Art Search. Courage Center is a nonprofit rehabilitation and independent living center helping children and adults with physical, communication and sensory disabilities."
Needs: Approached by 300-500 freelance artists/year. "We prefer that art arrives as a result of our Art Search announcement." Works with 5-10 freelance artists/year. Buys 0-10 freelance designs and illustrations/year. Prefers artists with experience in holiday/Christmas designs. Considers all media (no 3-D). Produces material for Christmas, birthdays, Thanksgiving, everyday. "Information is sent in September with mid-January deadline the following year."
First Contact & Terms: Send query letter with SASE. Samples are not filed and are returned by SASE if requested by artist. Acknowledgment of receipt of artwork is sent immediately. Decisions as to use are made 6-8 weeks after deadline date. Portfolio review not required. Originals are returned at job's completion. Pays $350 honorarium.

CPS CORPORATION, 1715 Columbia Ave., Franklin TN 37065. (615)794-8000. Creative Director: Francis Huffman. Manufacturer producing Christmas and all-occasion giftwrap.
Needs: Approached by 75 artists/year. Assigns 75-100 jobs/year. Uses freelancers mainly for giftwrap design. Computer work not necessary but acceptable for design and illustration.
First Contact & Terms: Send query letter with résumé, tearsheets, photostats and slides. Samples are filed or are returned by SASE. Reports back only if interested. Call or write for appointment to show portfolio of roughs, original/final art, final reproduction/product, tearsheets and photostats. Pays average flat fee of $400 for illustration/design; or by the hour, $15 and up. Considers complexity of project and skill and experience of artist when establishing payment. Negotiates rights purchased.
Tips: "Designs should be appropriate for one or more of the following categories: Christmas, wedding, baby shower, birthday, masculine/feminine and abstracts. Understand our market—giftwrap is not nice illustration, but surface texture design with ability to repeat."

CREATE-A-CRAFT, Box 330008, Fort Worth TX 76163-0008. (817)292-1855. Contact: Editor. Estab. 1967. Produces greeting cards, giftwrap, games, calendars, posters, stationery and paper tableware products for all ages.
Needs: Approached by 500 freelance artists/year. Works with 3 freelancers/year. Buys 3-5 freelance designs and illustrations/year. Prefers artists with experience in cartooning. Works on assignment only. Uses freelancers mainly for greetings cards and T-shirts. Also for calligraphy, P-O-P display, paste-up and mechanicals. Considers pen & ink, watercolor, acrylic and colored pencil. Prefers humor and "cartoons that will appeal to families. Must be cute, appealing, etc. No religious, sexual implications or offbeat humor." Produces material for all holidays and seasons; submit seasonal material 6 months before holiday.
First Contact & Terms: Contact only through artist's agent. "No phone calls from freelancers accepted." Samples are filed and are not returned. Reports back only if interested. Write for appointment to show portfolio of original/final art, final reproduction/product and color and b&w slides and tearsheets. Originals

are not returned. Pays by the hour, $6-8; or by the project, $100-200. Pays royalties of 3% for exceptional work on one year basis. "Payment depends upon the assignment, amount of work involved, production costs, etc." Buys all rights.
Tips: "Demonstrate an ability to follow directions exactly. Too many submit artwork that has no relationship to what we produce. Sample greeting cards are available for $2.50 and a #10 SASE. Write, do not call. We cannot tell what your artwork looks like from a phone call."

CREATIF LICENSING, 31 Old Town Crossing, Mount Kisco NY 10549. President: Stan Cohen. Licensing Manager. "Creatif is a licensing agency that represents artists and concept people."
Needs: Looking for unique art styles and/or concepts that are applicable to multiple products. "The art can range from fine art to cartooning."
First Contact & Terms: "If you have a style that you feel fits our qualifications please send photocopies or slides of your work with SASE. If we are interested in representing you, we will present your work to the appropriate manufacturers in the clothing, gift, publishing, home furnishings, paper products (cards/giftwrap/party goods, etc.) areas with the intent of procuring a license. We try to obtain advances and/or guarantees against a royalty percentage of the firm's sales. We will negotiate and handle the contracts for these arrangements, show at several trade shows to promote your style and oversee payments to insure that the requirements of our contracts are honored. Artists are responsible for providing us with materials for our meetings and presentations and for copyrights, trademarks and protecting their ownership (which is discretionary). For our services, as indicated above, we receive 50% of all the deals we negotiate as well as renewals. There are no fees if we are not productive."
Tips: Common mistakes illustrators make in presenting samples or portfolios are "sending oversized samples mounted on heavy board and not sending appropriate material. Color photocopies and photos are best."

CREATIVE PAPERS BY C.R. GIBSON, The C.R. Gibson Co., 32 Knight St., Norwalk CT 06856. (203)847-4543. Vice President Creative Papers: Steven P. Mack. Publishes stationery, note paper, invitations and giftwrap.
Needs: Buys 100-200 freelance designs/year. Especially needs new 4-color art for note line and invitations. "We need designs that relate to current fashion and home furnishing trends as well as a wide variety of illustrations suitable for boxed note cards. We constantly update our invitation line and can use a diverse selection of ideas." Humorous illustrations for invitation line only. "We buy a broad range of artwork with assorted themes. The only thing we don't buy is very contemporary or avant-garde." Prefers gouache, watercolor, acrylic, oil and collage. Needs computer-literate freelancers for design and illustration. 15% of freelance work demands knowledge of in Adobe Illustrator, QuarkXPress or Aldus FreeHand. Speculation art has no size limitations. Finished size of notes is 4×5½ or 3¾×5; folded invitations, 3¾×5; card style invitations, 4⅜×6; and giftwrap repeat, 9×9 minimum.
First Contact & Terms: "Before any work can be reviewed we require a signed copy of our submission agreement form. Call or write to Eileen Mulkerin to request artists' guidelines and a submission agreement form." Prefers 4-6 samples (slides or chromes of work or originals), published or unpublished, brochures showing art style or résumé, photocopies or slides. Include SASE. Previously published, photocopied and simultaneous submissions OK, if they have not been published as cards and the artist has previous publishers' permissions. Reports in 6 weeks. Call or write for appointment to show portfolio of thumbnails, roughs, original/final art and tearsheets. Pays $35-50 for rough sketch. Pays average flat fee of $200-300; or by the hour, $20-25 average; or royalties of 5-6%. Negotiates payment. Usually buys all rights; sometimes buys limited rights.
Tips: "Almost all of our artists are professional in that they have a background of other professional assignments and exhibits as well as a good art education. Even our few 'discoveries' have been at it for a number of years and have a very distinctive style with complete understanding of printing specifications and mechanicals. Keep your presentation neat and don't send very large pieces of art. Keep the submission as varied as possible. Show us diversity! Everything we print is in full color. Two to three designs are sufficient to get across a stationery collection concept. Designs should be somewhat sophisticated without being limiting. Classic designs do well."

CREEGAN CO., INC., 510 Washington St., Steubenville OH 43952. (614)283-3708-09. Fax: (614)283-4117. President: Dr. G. Creegon. Estab. 1961. Produces animations, costume characters, mall displays and audio-animatronic characters. "The Creegan Company designs and manufactures animated characters, costume characters and life-size air-driven characters. The products are custom made from beginning to end."
Needs: Approached by 10-30 freelance artists/year. Works with 3 freelancers/year. Prefers local artists with experience in sculpting, latex, oil paint, molding, etc. Artists sometimes work on assignment basis. Uses freelancers mainly for design comps. Also for mechanicals. Produces material for all holidays and seasons, Christmas, Valentine's Day, Easter, Thanksgiving, Halloween and everyday. Submit seasonal material 1 month in advance.
First Contact & Terms: Send query letter with résumé. Samples are filed. Does not report back. Write for appointment to show portfolio of final art, photographs. Originals not returned. Rights purchased vary according to project.

THE CROCKETT COLLECTION, Rt. 7A N., Box 1428, Manchester Center VT 05255. (802)362-2913. Fax: (802)362-5590. President: Sharon Scheirer. Estab. 1929. Publishes mostly traditional, some contemporary, humorous and whimsical Christmas and everyday greeting cards, postcards, note cards and bordered stationery on recycled paper. Christmas themes are geared to sophisticated, upper-income individuals. Artist's guidelines available for SASE.
Needs: Approached by 225 artists/year. Buys 25 designs/year. Produces products by silk screen method exclusively. Considers gouache, poster paint, cut and pasted paper and acrylic.
First Contact & Terms: Send query letter with SASE. Request guidelines which are mailed out once a year in February, 1 year in advance of printing. Submit unpublished, original designs only. Art should be in finished form. Art not purchased is returned by SASE. Pays flat fee of $90-140 for illustration/design. Buys all rights.
Tips: "Designs must be suitable for silk screen process. Airbrush, watercolor techniques and pen & ink are not amenable to this process. Bold, well-defined designs only. Our look is traditional, mostly realistic and graphic. Request guidelines and submit work according to our instructions."

‡THE CRYSTAL TISSUE COMPANY, 3120 S. Verity Pkwy., Middletown OH 45044. (513)423-1512. Fax: (513)423-8207. Product Design Specialist: Amy Reis-Booth. Estab. 1894. Produces giftwrap, tissue paper and gift boxes. Crystal Tissue's products are directed toward all age groups for everyday, as well as special occasions. They are purchased mostly by adult women.
Needs: Approached by 10 freelance artists/year. Works with 20-30 freelance artists/year. Buys 100 freelance designs and illustrations/year. Prefers artists with experience in greeting cards and designing for repeats. Works on assignment only. Uses freelancers mainly for gift bag and tissue design. Also for calligraphy. Considers watercolor, gouache, cut paper, acrylic, flat line art, ink, pastels, etc. Looking for contemporary and traditional (but not trendy) designs for everyday; traditional, Old World, contemporary or graphic repeat tissue designs for Christmas. Needs computer-literate freelancers for design and illustration. 20% of freelance work demands knowledge of QuarkXPress, Adobe Illustrator and Adobe Photoshop. Produces seasonal material for Christmas, Valentine's Day, Mother's Day, Father's Day, Easter, Hanukkah, graduation, Halloween, birthdays and everyday. "We need a variety of styles from contemporary to traditional—florals, geometric, tropical, whimsical, cartoon, upscale, etc." Submit seasonal material 6 months in advance.
First Contact & Terms: Send query letter with brochure, résumé, tearsheets, photographs, photocopies, slides, transparencies. Samples are filed or are returned by SASE if requested by artist. Company will contact artist for portfolio review if interested. Portfolio should include thumbnails, roughs and final art. Originals are not returned unless requested. Pays by the project, $500-1,000; negotiable. Negotiates rights purchased.
Tips: "I have information available on designing for repeats. The gift bag market is much the same as the greeting card market. We like to work in a particular theme or style and do several pieces in that one direction. We like to have a tissue that coordinates with at least one bag design. We like bags that have a dominant image and possibly framed in a sub-dominant design that can be a matching tissue."

‡CUSTOM STUDIOS INC., 6116 N. Broadway St., Chicago IL 60660-2502. (312)761-1150. President: Gary Wing. Estab. 1960. Custom T-shirt manufacturer. "We specialize in designing and screen printing custom T-shirts for schools, business promotions, fundraising and for our own line of stock."
Needs: Works with 20 freelance illustrators and 20 freelance designers/year. Assigns 50 freelance jobs/year. Especially needs b&w illustrations (some original and some from customer's sketch). Uses artists for direct mail and brochures/flyers, but mostly for custom and stock T-shirt designs.
First Contact & Terms: Send query letter with résumé, photostats, photocopies or tearsheets. "We will not return originals." Reports in 3-4 weeks. Call or write for appointment to show portfolio or mail b&w tearsheets or photostats to be kept on file. Pays for design and illustration by the hour, $28-35; by the project, $50-150. Considers turnaround time and rights purchased when establishing payment. For designs submitted to be used as stock T-shirt designs, pays 5-10% royalty. Rights purchased vary according to project.
Tips: "Send 5-10 good copies of your best work. We would like to see more black & white, camera-ready illustrations—copies, not originals. Do not get discouraged if your first designs sent are not accepted."

DECORAL INC., 165 Marine St., Farmingdale NY 11735. (516)752-0076 or (800)645-9868. Fax: (516)752-1009. President: Walt Harris. Produces decorative, instant stained glass, as well as sports and wildlife decals.
Needs: Buys 50 designs and illustrations from freelance artists/year. Uses freelancers mainly for greeting cards and decals; also for P-O-P displays. Prefers watercolor.
First Contact & Terms: Send query letter with brochure showing art style or résumé and samples. Samples not filed are returned. Art Director will contact artist for portfolio review if interested. Portfolio should include final reproduction/product and photostats. Originals are not returned. Sometimes requests work on spec before assigning a job. Pays flat fee of $400 minimum. Buys all rights.
Tips: Finds artists through word of mouth, magazines, artists' submissions/self-promotions, sourcebooks, agents, visiting artist's exhibitions, art fairs and artists' reps. "We predict a steady market for the field."

‡DESIGN HOUSE INC., 185 W. Englewood Ave., Teaneck NJ 07666. (201)837-2260. Fax: (201)833-2178. Product Designer: Cynthia Braisted. Estab. 1976. Produces calendars. "Design House Inc. carries several

lines of appointment books, address books and calendars directed at the business community. Design House also has a strong back to school line for elementary, junior high, senior high and college. We have a line of products designed specifically for home use as well, and keep expanding every day!"

Needs: Approached by 10 freelance artists/year. Works with 5 freelance artists/year. Buys 10 freelance designs and illustrations/year. Prefers artists with experience in graphic design. Works on assignment only. Uses freelance artists mainly for "graphic design and illustration for cover and insert design on appointment books and address books. We also use illustration and photography on our calendars." Also uses freelance artists for P-O-P displays, paste-up and mechanicals. Considers photography, pen & ink, watercolor, etc. Looking for styles targeted to the following consumers: executive male, executive female age over 30, "Home" products, college, high school, junior high school kids, younger children age 6. Prefers final art smaller than 19×24. Needs computer-literate feelancers for design. 10% of freelance work demands knowledge of Aldus PageMaker, QuarkXPrss, Aldus FreeHand, Adobe Illustrator or Adobe Photoshop.

First Contact & Terms: Send query letter with brochure, résumé, tearsheets, photographs and slides. Samples are filed or are returned. Reports back to the artist only if interested. Art Director will contact artist for portfolio review if interested. Portfolio should include b&w and color roughs, final art, slides and photographs. Originals are not returned. Pays by the hour, $16-40; by the project, $100-1,000. Rights purchased vary according to project.

Tips: "We begin to set our new product lines in January. This is the best time to approach Design House Inc. However, we are always looking for fresh ideas! Our product introductions are seasonal; we introduce in April, September, and December and are usually looking for work 4 months before each introduction."

DESIGNER GREETINGS, INC., Box 140729, Staten Island NY 10314. (718)981-7700. Art Director: Fern Gimbelman. Produces greeting cards and invitations. Produces general, informal, inspirational, contemporary, juvenile, soft-line and studio cards.

Needs: Works with 16 freelancers/year. Buys 100-150 designs and illustrations/year. Works on assignment only. Also uses artists for calligraphy, P-O-P displays and airbrushing. Prefers pen & ink and airbrush. No specific size required. Produces material for all seasons; submit seasonal material 6 months before holiday.

First Contact & Terms: Send query letter with brochure or tearsheets and photostats or photocopies. Samples are filed or are returned only if requested. Reports back within 3-4 weeks. Call or write for appointment to show portfolio of original/final art, final reproduction/product, tearsheets and photostats. Originals are not returned. Pays flat fee. Buys all rights.

Tips: "We are willing to look at any work through the mail (photocopies, etc.). Appointments are given after I personally speak with the artist (by phone)."

DIEBOLD DESIGNS, Box 236, High Bridge Rd., Lyme NH 03768. (603)795-4422. Fax: (603)795-4422. Principle: Peter Diebold. Estab. 1978. Produces greeting cards. "We produce special cards for special interests and greeting cards for businesses — primarily Christmas. We have now expanded our Christmas line to include 'photo mount' designs, added designs to our everyday line for stockbrokers and are ready to launch a line for boaters."

Needs: Approached by more than 100 freelance artists/year. Works with 5-10 freelancers/year. Buys 10-20 designs and illustrations/year. Prefers professional caliber artists. Works on assignment only. Uses freelancers mainly for greeting card design, calligraphy and mechanicals. Also for paste-up. Considers all media. "We market 5×7 cards designed to appeal to individual's specific interest — golf, tennis, etc." Prefers an upscale look. Submit seasonal ideas 6-9 months in advance.

First Contact & Terms: Send query letter with SASE and brief sample of work. Samples are filed or are returned by SASE. Reports back to artist only if interested. Portfolio review not required. Pays flat fee of $200 minimum. Rights purchased vary according to project. Interested in buying second rights (reprint rights) to previously published work, if not previously used for greeting cards.

Tips: Finds artists through word of mouth, exhibitions and *Artist's & Graphic Designer's Market*. "It's important that you show us samples *before* requesting submission requirements. There's a 'bunker' mentality in business today and suppliers (including freelancers) need to understand the value they add to the finished product in order to be successful. Consumers are getting more for less every day and demanding more all the time. We need to be more precise every day in order to compete."

‡THE DUCK PRESS, 216 Country Garden Lane, San Marcos CA 92069. (619)471-1115. Fax: (619)591-0990. Owner: Don Malm. Estab. 1982. Produces greeting cards, calendars and posters for the golfing market only.

Needs: Approached by 12 freelance artists/year. Works with 5 freelance artists/year. Buys 50-100 freelance designs and illustrations/year. Prefers artists with experience in humorous sport art — especially golf. Works on assignment only. Uses freelance artists mainly for illustrations for greeting cards. Considers all media. Looking for full color illustration. Prefers final art scaled to 5×7. Produces material for Christmas and Father's Day. Submit 6 months before holiday.

First Contact & Terms: Send query letter with brochure, tearsheets, photostats and photographs. Samples are not filed and are returned. Reports back within 2 weeks. To show portfolio, mail thumbnails, roughs and color tearsheets. Original artwork is not returned at job's completion. Pays royalties of 4-6%. Negotiates rights purchased.

E.F. MUSICAL GREETING CARDS, Room 24, 370 Wadsworth Ave., P.O. Box 544, New York NY 10040. (212)568-5990. Fax: (212)795-5563. President: Edward Fernandes. Estab. 1983. Produces greeting cards for ages 25-45.
Needs: Approached by 10-15 artists/year. Works with 5-10 artists/year. Prefers artists with experience in birthday, wedding, baby and anniversary cards. Uses freelancers mainly for flowers, children's images and some cartoons. Also for calligraphy, paste-up and mechanicals. Needs computer-literate freelancers for production. 20-40% of freelance work demands knowledge of Aldus PageMaker or QuarkXPress, Aldus FreeHand or Adobe Illustrator. Produces material for wedding, get well, anniversary, baby, pop-ups, Christmas, Valentine's Day, Mother's Day, birthdays and everyday. Submit seasonal material 10 months in advance.
First Contact & Terms: Send query letter with brochure, résumé, SASE and photocopies. Samples are filed or are returned by SASE if requested by artist. Reports back only if interested. Art Director will contact artist for portfolio review if interested. Portfolio should include finished art. Pays by the project, $100-400. Rights purchased vary according to project.

‡**ENVIRONMENTAL PRESERVATION INC. (EPI Marketing)**, 250 Pequot Ave., Southport CT 06490. (203)255-1112. Fax: (203)255-3313. Vice President Marketing: Merryl Lambert. Estab. 1989. Produces greeting cards, posters, games/toys, educational children's gifts.
Needs: Works with "many" freelance artists/year. Buys "many" freelance designs and illustrations/year. Prefers artists with experience in nature images and sports. Works on assignment only. Uses freelance artists for P-O-P displays and mechanicals. Needs computer-literate freelancers for design, production and presentation. Freelancers should be familiar with Aldus PageMaker, QuarkXPress, Adobe Illustrator or Adobe Photoshop.
First Contact & Terms: Send query letter with brochure, tearsheets and slides. Samples are filed and are not returned. Reports back to the artist only if interested. Art Director will contact artist for portfolio review if interested. Originals are returned at job's completion. Negotiates rights purchased.

EUROPEAN TOY COLLECTION/CROCODILE CREEK, 6643 Melton Rd., Portage IN 46368. (219)763-3234. Fax: (219)762-1740. President: Mel Brown. Estab. 1984. Produces "high quality, well-designed toys, children's gifts, books and decorative accessories. Works with all major museums, catalogs, department stores and specialty stores. An innovative, creative company committed to imaginative well-designed children's products. Listed in INC 500 as one of the fastest growing small companies in the US. Winner of several Parents' Choice Awards."
Needs: Approached by 100 freelance artists/year. Works with 10 freelancers/year. Buys 10-20 designs and illustrations/year. Prefers artists with experience in a variety of media. "Over the next few years we plan on expanding and broadening our product development and creative department significantly." Uses freelancers mainly for product development and P-O-P and show display. "Artists can contact us for a free catalog — to get some ideas of our current products."
First Contact & Terms: Send query letter with photographs. Samples are filed. Reports back only if interested. "We currently will contact artist for portfolio review after they've made initial inquiry." Portfolio should include color tearsheets and photographs. Sometimes requests work on spec before assigning a job. Rights purchased vary according to project. Interested in buying second rights (reprint rights) to previously published work.
Tips: Finds artists through networking, artists' submissions and exhibitions. "There are many opportunities for original, creative work in this field."

THE EVERGREEN PRESS, INC., 3380 Vincent Rd., Pleasant Hill CA 94523. (415)933-9700. Art Director: Malcolm K. Nielsen. Publishes greeting cards, giftwrap, stationery, quality art reproductions, Christmas cards and postcards.
Needs: Approached by 750-1,000 freelance artists/year. Buys 200 designs/year from freelance artists. Uses freelancers mainly for greeting cards, Christmas cards and giftwrap and product design. Uses only full-color artwork in any media. Seeks unusual designs, sophisticated art and humor or series with a common theme. No super-sentimental Christmas themes, single greeting card designs with no relation to each other, or single-color pen or pencil sketches. Roughs may be in any size to get an idea of work; final art must meet size specifications. Would like to see nostalgia, ecology, sports scenes and fine-arts-oriented themes. Produces seasonal material for Christmas, Easter, Mother's Day and Valentine's Day. "We examine artwork at any time of the year to be published for the next following holiday."
First Contact & Terms: Send query letter with brochure showing art style or slides and actual work; write for art guidelines. Samples returned by SASE. Reports within 2 weeks. Originals are returned at job's completion. Negotiates rights purchased. "We usually make a cash down payment against royalties; royalty to be negotiated." Pays on publication.
Tips: Sees "trend toward using recycled paper for cards and envelopes and subject matter involving endangered species, the environment and ecology. Spend some time in greeting card stores and become familiar with the 'hot' cards of the moment. Try to find some designs that have been published by the company you approach."

‡**EVERTHING METAL IMAGINABLE, INC. (E.M.I.)**, 401 E. Cypress, Visalia CA 93277. (209)732-8126. Contact: Deborah Lopez. Estab. 1967. Wholesale manufacturer. "We manufacture lost wax bronze sculpture. We do centrifugal white metal casting and resin casting (cold cast bronze, alabaster walnut shell, clear resin etc.)." Clients: wholesalers, premium incentive consumers, retailers.
Needs: Approached by 10 freelance artists/year. Works with 20 freelance designers/year. Assigns 5-10 jobs to freelance artists/year. Prefers artists that understand centrifugal casting, bronze casting and the principles of mold making. Uses artists for figurine sculpture and model making. Prefers a tight, realistic style.
First Contact & Terms: Send query letter with brochure or résumé, tearsheets, photostats, photocopies and slides. Samples not filed are returned only if requested. Reports back only if interested. Call for appointment to show portfolio of original/final art and photographs "or any samples." Pays for design by the project, $500-20,000. Buys all rights.
Tips: "Artists must be conscious of detail in their work, be able to work expediently and under time pressure and be able to accept criticism of work from client. Price of program must include completing work to satisfaction of customers."

FOTOFOLIO, INC., 536 Broadway, New York NY 10012. (212)226-0923. Fax: (212)226-0072. Editorial Coordinator: Lisa Adelson. Estab. 1976. Produces greeting cards, calendars, posters, T-shirts and postcards.
 • Fotofolio has a new line of products for children including a photographic book, Kieth Haring coloring books and notecards.
Needs: Buys 5-60 freelance designs and illustrations/year. Reproduces existing works. Primarily interested in photography. Produces material for Christmas, Valentine's Day, Birthday and everyday. Submit seasonal material 8 months in advance.
First Contact & Terms: Send query letter with SASE. Samples are filed or are returned by SASE if requested by artist. Art Director will contact artist for portfolio review if interested. Originals are returned at job's completion. Pays by the project, 7½-15% royalties. Rights purchased vary according to project.
Tips: Finds artists through word of mouth, magazines, artists' submissions/self-promotions, sourcebooks, agents, visiting artist's exhibitions, art fairs and artists' reps.

FRAVESSI GREETINGS, INC., 11 Edison Place, Springfield NJ 07081. (201)564-7700. Fax: (201)376-9371. Art Director: Janet Thomassen. Estab. 1930. Produces greeting cards, gift wrap, packaged goods, notes.
 • Fravessi has added some contemporary styles to its usual traditional look.
Needs: Approached by 25 freelance artists/year. Works with 12 freelance artists/year. Buys 500-1,000 freelance designs and illustrations/year. Uses freelancers for greeting card design. Also for calligraphy. Considers watercolor, gouache, and pastel. Especially needs seasonal and everyday designs; prefers cute and whimsical imagery. Produces seasonal material for Christmas, Mother's Day, Father's Day, Thanksgiving, Easter, Valentine's Day, St. Patrick's Day, Halloween, graduation, Jewish New Year and Hanukkah.
First Contact & Terms: Send query letter and samples of work. Submit seasonal art 1 year in advance. Include SASE. Reports in 2-3 weeks. Provide samples to be kept on file for possible future assignments. Art Director will contact artist for portfolio review if interested. Originals not returned. Requests work on spec before assigning a job. Pays flat fee of $125-200 illustration/design. **Pays on acceptance.** Buys all rights.
Tips: Finds artists through word of mouth and artists' submissions. Must now implement, "tighter scheduling of seasonal work to adapt to changing tastes. There is an emphasis on lower priced cards. Check the marketplace for type of designs we publish." No cartoons.

G.A.I. INCORPORATED, Box 30309, Indianapolis IN 46230. (317)257-7100. President: William S. Gardiner. Licensing agents. "We represent artists to the collectibles and gifts industries. Collectibles include high-quality prints, collector's plates, figurines, bells, etc. There is no up-front fee for our services. We receive a commission from any payment the artist receives as a result of our efforts." Clients: Lenox, Enesco, The Bradford Exchange and The Hamilton Group.
Needs: Approached by 100 artists/year. Works with 50 illustrators and 5 designers/year. Works on assignment only. "We are not interested in still lifes or modern art. A realistic—almost photographic—style seems to sell best to our clients. We are primarily looking for artwork featuring people or animals. Young animals and children usually sell best. Paintings must be well done and should have broad emotional appeal."
First Contact & Terms: Send query letter with résumé and color photographs; do *not* send original work. Request portfolio review in original query. Samples not kept on file are returned by SASE. Reports in 1-3 months. Payment: "If we are successful in putting together a program for the artist with a manufacturer, the artist is usually paid a royalty on the sale of the product. This varies from 4-10%. Payment is negotiated individually for each project."

 A bullet introduces comments by the editor of Artist's & Graphic Designer's Market *indicating special information about the listing.*

Tips: Finds artists through word of mouth, magazines, artists' submissions/self-promotions, sourcebooks, agents, visiting artist's exhibitions, art fairs and artists' reps.

GALISON BOOKS, 36 W. 44th St., New York NY 10036. (212)354-8840. Fax: (212)391-4037. Design Director: Heather Zscholl. Estab. 1978. Produces greeting cards, journals and puzzles; "museum gift products aimed at a general market. Products are geared toward children, families."
Needs: Approached by 25 freelance artists/year. Works with 10-15 freelance artists/year. Buys 5-10 designs and illustrations/year. Works on assignment only. Uses freelancers mainly for illustration. Considers all media. Also produces material for Christmas and New Year. Submit seasonal material 6-12 months in advance.
First Contact & Terms: Send query letter with brochure, résumé and tearsheets (no unsolicited original artwork). Samples are filed. Reports back to the artist only if interested. Request portfolio review in original query. Art Director will contact artist for portfolio review if interested. Portfolio should include color photostats, slides, tearsheets and dummies. Originals are returned at job's completion. Rights purchased vary according to project.
Tips: Finds artists through word of mouth, magazines and artists' reps.

‡GOES LITHOGRAPHING COMPANY SINCE 1879, 42 W. 61st St., Chicago IL 60621-3999. (312)684-6700. Fax: (312)684-2065. Contact: W.J. Goes. Estab. 1879. "We produce holiday/Christmas stationery/letterheads to sell to printers and office product stores."
Needs: Approached by 1-2 freelance artists/year. Works woth 2-3 freelance artists/year. Buys 4-30 freelance designs and illustrations/year. Uses freelance artists mainly for designing holiday letterheads. Considers pen & ink, color, acrylic, watercolor. Prefers final art 17×22. Produces material for Halloween, Christmas, Easter, Valentine's Day, Thanksgiving, mainly Christmas.
First Contact & Terms: Contact W.J. Goes. "I will send examples for your ideas." Samples are not filed and are returned by SASE. Reports back within 1-2 months. Pays $125 minimum on final acceptance. Buys first rights and reprint rights.

GREAT AMERICAN PUZZLE FACTORY INC., 16 S. Main St., S. Norwalk CT 06854. (203)838-4240. Fax: (203)838-2065. President: Pat Duncan. Estab. 1975. Produces jigsaw puzzles for adults and children.
Needs: Approached by 100 artists/year. Works with 50 artists/year. Buys 60 designs and illustrations/year. Uses freelancers mainly for puzzle material. Looking for "fun, involved and colorful" work. Needs computer-literate freelancers for box design.
First Contact & Terms: Send query letter with brochure and photocopies. Samples are filed or are returned. Art Director will contact artist for portfolio review if interested. Original artwork is returned at the job's completion. Pays royalties of 5%. Rights purchased vary according to project. Interested in buying second rights (reprint rights) to previously published work.

‡GREAT ARROW GRAPHICS, 1685 Elmwood Ave., Buffalo NY 14207. (716)874-5819. Fax: (716)874-2775. Art Director: Alan Friedman. Estab. 1981. Produces greeting cards and stationery. "We produce silkscreened greeting cards – seasonal and everyday – to a high-end design-conscious market."
Needs: Approached by 20 freelance artists/year. Works with 3-4 freelance artists/year. Buys 30-40 images/year. Prefers artists with experience in hard-separated art. Uses freelance artists mainly for greeting card design. Considers all 2-dimensional media. Looking for sophisticated, classic or contemporary styles. Needs computer-literate feelancers for design. Freelancers should be familiar with QuarkXPress, Adobe Illustrator or Adobe Photoshop. Produces material for all holidays and seasons. Submit seasonal material 6-8 months in advance; Christmas, 1 year in advance.
First Contact & Terms: Send query letter with brochure, résumé, SASE, photographs, photostats and slides. Samples are filed or returned if requested. Reports back within 1 month. Art Director will contact artist for portfolio review if interested. Portfolio should include color roughs, final art, photographs and transparencies. Originals are returned at job's completion. Pays royalties of 5% of production at wholesale. Rights purchased vary according to project.
Tips: "We are most interested in artists familiar with hand-separated process and with the assets and limitations of screenprinting."

HALLMARK CARDS, INC., P.O. Box 419580, Drop 216, Kansas City MO 64141-6580. Contact: Carol King for submission agreement and guidelines; include SASE, no samples. Not currently soliciting new freelance artists or designs. Works on assignment only. Samples cannot be reviewed without submission agreement. Buys all rights.
Needs: Limited needs for general/humor illustration and surface design. Product formats range from paper items such as greeting cards, puzzles and giftwrap to gift items.

Tips: "Hallmark has a large and talented creative staff. Freelance designers must show professional experience, exceptional originality and technical skill."

THE HAMILTON COLLECTION, 4810 Executive Park Ct., Jacksonville FL 32216-6069. (904)279-1300. Artist Liaison, Product Development: Kathryn McGoldrick; Senior Art and Production Director for commercial art/advertising: Linda Olsen. Direct marketing firm for collectibles: limited edition art, plates, sculpture, dolls, jewelry and general gifts. Clients: general public, specialized lists of collectible buyers and retail market.
Needs: Approached by 100 freelance artists/year. Works with 5 freelancers in creative department and 75-100 in product development each year. Assigns 400-500 jobs to freelancers/year. Only local artists with 3 years of experience used for mechanical work. For illustration and product design, "no restrictions on locality, but must have *quality* work and flexibility regarding changes." Uses freelancers for advertising mechanicals, brochure illustration and mechanicals, and product design and illustration. Needs fine art for plates. Needs computer-literate freelancers for production.
First Contact & Terms: Send query letter with samples. Fine art will be returned (must include a SASE or appropriate package with sufficient postage). Samples not filed are returned only if requested by artist. Reports within 6-8 weeks. Call or write for appointment to show portfolio. Artist should follow-up with letter after initial query. Sometimes requests work on spec before assigning a job. Pays for design by the hour, $10-50 or by the project, $100-1,500. Pays for illustration by the project, $1,000-5,000. Pays for mechanicals by the hour, $20 average. Sometimes interested in buying second rights (reprint rights) to previously published work "for product development in regard to collectibles/plates; artwork must be suitable for cropping to a circular format."
Tips: Prefers conservative, realistic style. "We aggressively seek out new talent for our product development projects through every avenue available. Attitude and turnaround time are important. Be prepared to offer sketches on speculation. We may take longer to decide, but our needs are steady. This is a strong market (collectibles) that has continued its growth over the years, despite economic slumps."

H&L ENTERPRISES, 1844 Friendship Dr., El Cajon CA 92020. (619)448-0883. Fax: (619)448-7935. Operations Vice President: Carol Lorsch. Estab. 1978. Produces posters, novelty and humorous signs.
Needs: Approached by 25 freelance artists/year. Works with 4 freelancers/year. Prefers artists with experience in art for silkscreen process. Must have cartoon-like style and imagination in illustrating humorous slogans. Works on assignment only. Uses freelancers mainly for product illustration. Looking for simple, coloring-book cartoon style. Artwork must be in proportion to 8½×11.
First Contact & Terms: Send query letter with tearsheets and sketches. Samples are returned. Reports back within 5 days. "Be sure to provide phone number." Art Director will contact artist for portfolio review if interested. Artist should follow-up with call after initial query. Requests work on spec before assigning a job. Originals are not returned. Pays average flat fee of $25-75 for illustration/design; royalties are negotiable. Negotiates rights purchased. Considers buying second rights (reprint rights) to previously published work.
Tips: Finds artists through word of mouth and artists' reps. "We're not interested in fine art. Interested in quick-sketch illustrations of humorous sayings. Don't use scanners to copy others' work and plagiarize it."

‡HERITAGE COLLECTION, (formerly Allison Greetings), 79 Fifth Ave., New York NY 10003. (212)647-1000. Fax: (212)647-0188. Director: Douglas Jones. Estab. 1988. Produces greeting cards, gift bags, gift wrap, mugs, placemats, etc., for the African-American.
Needs: Approached by 20-30 freelance artists/year. Works with 3-5 freelance artists/year. Buys 40-80 new freelance designs and illustrations/year. Uses freelance artists mainly for card art and verse. Considers all media. Produces material for all holidays and seasons, birthdays and Kwanzaa. Submit seasonal material 1 year in advance.
First Contact & Terms: Send query letter with SASE, tearsheets, photographs, photocopies and photostats. Samples are filed or are returned by SASE. Reports back within 1 month. Call for appointment to show portfolio of original/final art, color tearsheets. Originals are returned at job's completion. Pays 5% royalty; $250 per card, plus royalty. Buys all rights.

‡HIGH RANGE GRAPHICS, 365 N. Glenwood, P.O. Box 3302, Jackson WY 83001. President: Jan Stuessl. Estab. 1989. Produces T-shirts. "We produce screen-printed garments for the resort market. Subject matter includes, but is not limited to, skiing, climbing, hiking, biking, fly fishing, mountains, out-of-doors, nature and rafting. We do designs for kids, college age, and 'youthful at any age' men and women. Some designs incorporate humorous text."
Needs: Approached by 20 freelance artists/year. Works with 10 freelancers/year. Buys 10-20 designs and illustration/year. Prefers artists with experience in screen printing. Uses freelancers mainly for T-shirt ideas and artwork and color separations. Prefers artwork 10-12 wide × 12-16 tall. Needs computer-literate freelancers for design and illustration. 33% of freelance work demands knowledge of Aldus FreeHand.
First Contact & Terms: Send query letter with résumé, SASE, photocopies and photographs. Samples are filed or are returned by SASE if requested by artist. Reports back within 2 months. Company will contact for portfolio review if interested. Portfolio should include b&w thumbnails, roughs and final art. Originals

Don't Overlook the Collectibles Market

Flip through a *TV Guide*, decorating magazine or Sunday newspaper supplement and you will notice full-page spreads advertising limited edition collectibles. Whether it's a plate featuring Scarlett O'Hara or Jean-Luc Picard, a sculpture of an English cottage, or a porcelain doll, each will find a treasured place in a collector's home. And each represents an opportunity for freelance artists.

The Hamilton Collection, along with companies such as The Franklin Mint and The Bradford Exchange, is a leader in this multi-million dollar industry. Based in Florida, it is best known for its popular plate collections, and also produces dolls, jewelry, sculpture, canvas transfer prints, ornaments, music boxes and other products, each a potential market for freelance artists, according to Melanie Hart, senior vice president of product development.

The Hamilton Collection works with illustrators and fine artists to create the images used in its plate collections. The company plans to test at least 100 plate programs next year and will work with about 85 artists.

When most artists think of publishing, they think first of print publication, but plate publication offers similar exposure. There is some crossover between the plate and print market, but plate buyers tend to be more conservative than print buyers. A large number are female, age 40 and over, and they tend to have a higher than average disposable income. They usually collect a series of plates, which means artists can build a strong following in the field.

"The market is changing rapidly," says Hart. "We're looking at more open, fresher styles — and less traditional. (Yet) styles are generally realistic. Wildlife in particular must be near photorealism with lots of detail and color. We're looking for dramatic images." In addition to realistic works, a few of the company's plate collections have featured impressionistic work and cartoon styles.

Popular images include Native Americans, wildlife, animals (especially kittens and puppies) and sports images. "Sports have been an exciting area," says Hart. "Licensing is a big issue in sports, but it is never necessary for artists to obtain the license. The company will secure rights." Concepts are often developed inhouse, but sometimes a look in an artist's portfolio will generate an idea for a series. Yet, finding all the images needed for an entire collection in an artist's portfolio almost never happens. "We usually work in series of eight or more and it's unusual to find eight images already created. We may look at twelve and find five we can use. We'll then ask the artist to paint three more.

"Continuity is very important," Hart says. "The artist must be able to deliver finished art on a regular basis. Ideally, they'll be able to finish a painting in four to six weeks." Work must fit into a circular format, so artists should design work with a circular crop. On the other hand, it's in the artist's interest to create a rectangular image so it can be transferred to other formats such as prints. If an existing image does not fit the circular format, but would make a great plate,

the company may ask the artist to add to the painting or a computer may be used to extend the painting out to the edge of the plate. In both cases, the artist will be given a chance to see and approve additions to her work.

The company usually buys plate rights and a first option on other uses, but they will negotiate. Above all, Hart says, they try to be fair to artists. Usually artists are paid an advance against royalties and if it turns out that the initial images do not do well when test-marketed, the artist still receives the advance and rights are released. Royalties for new artists range from 25 to 50 cents per plate. The exception to this arrangement is in the case of licensed products. For products in which the artist does not own the license rights, the company pays a flat fee and work is created on a work-for-hire basis.

Artists interested in breaking into the collectibles market, should attend at least one of the major plate shows, such as the ones held in South Bend, Indiana; Secaucus, New Jersey; and Anaheim, California each year. Also look in collector's magazines such as *Collector's Mart* and visit local shops. "Often there are shows sponsored by the stores and these are great places to see the products and meet the artists.

"This is a commercial market. You must be motivated to work with us and not let attitude and ego get in the way. Artists used to having total control need to develop flexibility in this market. It's a matter of mutual respect and trust," Hart says.

—*Robin Gee*

This dramatic portrait, Captain Jean-Luc Picard, *was painted by Thomas Blackshear for the Hamilton Collection. It was the premiere plate in his* Star Trek The Next Generation 5th Anniversary Commemorative *collection.*

are returned at job's completion. Pays by the project, $300 minimum; royalties of 5%. Negotiates rights purchased.

Tips: "Familiarize yourself with screen printing and T-shirt art that sells. Know how to do color separations that are production friendly. Designs should evoke an emotional connection for retail customers with their vacation experience or activity. Ink colors should work on several shirt colors. We must have creative new ideas for same old subject matter."

HOME INTERIORS & GIFTS, 4550 Spring Valley Rd., Dallas TX 75244. (214)386-1000. Fax: (214)233-8825. Artist Representative: Robbin Allen. Art Director: Louis Bazar. Estab. 1957. Produces decorative framed art in volume to public by way of shows in the home. "H.I.& G. is a direct sales company. We sell nationwide with over 35,000 consultants in our sales force. We work with artists to design products for our new product line yearly. We work with some publishers now, but wish to work with more artists on a direct basis."

Needs: Approached by 75 freelance artists/year. Works with 25-30 freelancers/year. "We carry approximately 450-500 items in our line yearly." Prefers artists with knowledge of current colors and the decorative art market. "We give suggestions but we do not dictate exacts. We would prefer the artists express themselves through their individual style. We will make correction changes that will enhance each piece for our line." Uses freelance artists mainly for artwork to be framed (oil and watercolor work mostly). Also for calligraphy. Considers oil, watercolor, acrylic, pen & ink, pastels, mixed media. "We sell to middle America for the most part. Our art needs to be traditional with a sense of wholesomeness to it. For example: a hunter with dog, but no gun. We sell Victorian, country, landscapes, still life, wildlife. Art that tells a story. We also sell a mild contemporary." Produces material for Father's Day, Halloween, Christmas, Easter, graduation, Thanksgiving, Mother's Day. Submit seasonal material 10 months in advance.

First Contact & Terms: Send query letter with résumé, SASE, photographs, slides and transparencies. Samples are filed or are returned by SASE. Art Director will contact artist for portfolio review if interested. Portfolio should include color slides, photographs. Requests work on spec before assigning a job. Pays royalties. Royalties are discussed on an individual basis. Buys reprint rights.

Tips: Finds artists through word of mouth, magazines, artists' submissions, sourcebooks and visiting artist's exhibitions. "This is a great opportunity for the artist who is willing to learn our market. Paint for women because women are our customers. Paintings need softness in form — not rugged and massive/strong or super dark. Jewel tones are great for us. Study Monét — good colors there. Our art demands are unique. The artist will work with our design department to stay current with our needs."

HURLIMANN ARMSTRONG STUDIOS, Box 1246, Menlo Park CA 94026. (415)325-1177. Fax: (415)324-4329. Managing General Partner: Mary Ann Hurlimann. Estab. 1987. Produces greeting cards and enclosures, fine art folders, stationery, portfolios and pads.

Needs: Approached by 60 freelance artists/year. Works with 6 freelancers/year. Buys 16 designs/year. Considers watercolor, oil and acrylic. No photography. Prefers rich color, clear images, no abstracts. "We have some cards that use words as the central element of the design." Not interested in computer-generated art. Prefers 10 × 14 final art.

First Contact & Terms: Send query letter with slides. Samples are not filed and are returned by SASE if requested by artist. Art Director will contact artist for portfolio review if interested. Originals are returned at job's completion. Requests work on spec before assigning a job. Pays by the project, $250-300; royalties of 5% or fixed fee. Buys all rights.

Tips: "Send good quality slides and photos of your work."

IGPC, 10th Floor, 460 W. 34th St., New York NY 10001. (212)869-5588. Contact: Art Department. Agent to foreign governments. "We produce postage stamps and related items on behalf of 40 different foreign governments."

Needs: Approached by 50 freelance artists/year. Works with 75-100 freelance illustrators and designers/year. Assigns several hundred jobs to freelancers/year. Prefers artists within metropolitan New York or tri-state area. Must have excellent design and composition skills and a working knowledge of graphic design (mechanicals). Artwork must be focused and alive (4-color) and reproducible to stamp size (usually 4 times up). Works on assignment only. Uses artists for postage stamp art. Prefers airbrush, acrylic and gouache (some watercolor and oil OK).

First Contact & Terms: Send samples. Reports back within 5 weeks. Art Director will contact artist for portfolio review if interested. Portfolio should contain "4-color illustrations of realistic, tight flora, fauna, technical subjects, autos or ships. Also include reduced samples of original artwork." Sometimes requests work on spec before assigning a job. Pays by the project, $1,000-4,000. Consider government allowance per project when establishing payment.

Tips: "Artists considering working with IGPC must have excellent drawing abilities in general or specific topics, i.e., flora, fauna, transport, famous people, etc.; sufficient design skills to arrange for and position type; the ability to create artwork that will reduce to postage stamp size and still hold up with clarity and perfection. Must be familiar with printing process and print call-outs. Generally, the work we require is realistic art. In some cases, we supply the basic layout and reference material; however, we appreciate an

artist who knows where to find references and can present new and interesting concepts. Initial contact should be made by phone for appointment, (212)629-7979."

‡**INNOVATIVE ICONS INCORPORATED,** Suite 6, 3065 McCall Dr., Atlanta GA 30340. (404)457-9089. Fax: (404)458-4508. Art Director: Kate Taylor. Produces invitations and announcements—birth, wedding, baby showers, wedding showers, birthdays, all age, all occasion parties: Christmas, Halloween, New Year.
Needs: Approached by 30 freelance artists/year. Works with 15 freelance artists/year. Buys 150 freelance designs and illustrations/year. Uses freelance artists mainly for border designs. Considers anything but oil based media. Needs computer-literate freelancers for design. Freelancers should be familiar with QuarkX-Press, Aldus FreeHand or Adobe Illustrator. Produces material for Halloween, Christmas, graduation, birthdays, Valentine's Day, Hannukkah, Thanksgiving and New Year. Submit seasonal material 9 months in advance.
First Contact & Terms: Send query letter with résumé and photocopies. Samples are filed. Reports back to the artist only if interested. Art Director will contact artist for portfolio review if interested. Portfolio should include b&w and color thumbnails, rough, final art and photographs. Originals are not returned. Pays $150 total buyout/border. Buys all rights.

‡**INSPIRATIONART & SCRIPTURE,** P.O. Box 5550, Cedar Rapids IA 52406. (319)365-4350. Fax: (319)366-2573. Division Manager: Lisa Edwards. Estab. 1993. Produces greeting cards, posters and calendars. "We create and produce jumbo-sized (24×36) posters targeted at pre-teens (10-14), teens (15-18) and young adults (18-30). A Christian message is contained in every poster. Some are fine art and some are very commercial. We prefer very contemporary images."
Needs: Approached by 350-500 freelance artist/year. Works with 60-80 freelancers/year. Buys 80-100 designs and illustrations/year. Christian art only. Uses freelance artists mainly for posters and greeting cards. Considers all media. Looking for "something contemporary or unusual that appeals to teens or young adults." Produces material for Christmas, Valentine's Day, Mother's Day, Father's Day, Easter, graduation, Thanksgiving, New Year's, birthdays and everyday. Submit seasonal material 9-12 months in advance.
First Contact & Terms: Send query letter with photographs, slides, SASE, photocopies and transparencies. Samples are filed or are returned by SASE. Reports back within 3-4 weeks. Company will contact artist for portfolio review if interested. Portfolio should include color roughs, final art, photographs and transparencies. "We need to see the artist's range. It is acceptable to submit 'secular' work, but we also need to see work that is Christian-inspired." Originals are returned at job's completion. Pays by the project, $50-500. Rights purchased vary according to project.
Tips: "The better the quality of the submission, the better we are able to determine if the work is suitable for our use (slides are best). The more complete the submission (e.g., design, art layout, scripture, copy), the more likely we are to purchase the work. We do accept traditional work, but are looking for work that is more commercial and hip (think MTV with values)."

■**INTERCONTINENTAL GREETINGS LTD.,** 176 Madison Ave., New York NY 10016. (212)683-5830. Fax: (212)779-8564. Creative Marketing Director: Robin Lipner. Sells reproduction rights on a per country, per product basis. Licenses and syndicates to 4,500-5,000 publishers and manufacturers in 50 different countries. Products include greeting cards, calendars, prints, posters, stationery, books, textiles, heat transfers, giftware, china, plastics, toys and allied industries, scholastic items and giftwrap.
Needs: Approached by 500-700 freelance artists/year. Assigns 400-500 jobs and 1,500 designs and illustrations/year from freelance artists. Buys illustration/design mainly for greeting cards and paper products. Also buys illustration for giftwrap, calendars, giftware and scholastic products. Uses traditional as well as humorous and cartoon-style illustrations. Accepts airbrush, watercolor, colored pencil, acrylic, pastel, marker and computer illustration. Prefers "clean work in series format. All card subjects are considered. 20% of freelance work demands knowledge of Adobe Illustrator, Aldus FreeHand or Photoshop.
First Contact & Terms: Send query letter and/or résumé, tearsheets, slides, photographs and SASE. Request portfolio review in original query. Artist should follow-up after initial query. Portfolio should include color tearsheets and photographs. Pays for original artwork by the project. Pays 20% royalties upon sale of reproduction rights on all selected designs. Contractual agreements made with artists and licensing representatives; will negotiate reasonable terms. Provides worldwide promotion, portfolio samples (upon sale of art) and worldwide trade show display.

Market conditions are constantly changing! If you're still using this book and it is 1996 or later, buy the newest edition of Artist's & Graphic Designer's Market *at your favorite bookstore or order directly from Writer's Digest Books.*

Tips: Finds artists through word of mouth, self-promotions, visiting artist's exhibitions and artists' reps. "Perhaps we'll see more traditional/conservative subjects and styles due to a slow economy. More and more of our clients need work submitted in series form, so we have to ask artists for work in a series or possibly reject the odd single designs submitted. Make as neat and concise a presentation as possible with commercial application in mind. Artists often send too few samples, unrelated samples or sloppy, poor quality reproductions. Show us color examples of at least one finished piece as well as roughs."

THE INTERMARKETING GROUP, 29 Holt Rd., Amherst NH 03031. (603)672-0499. President: Linda L. Gerson. Estab. 1985. Licensing agent for greeting cards, stationery, calendars, posters, paper tableware products, tabletop, dinnerware, giftwrap, eurobags, giftware, toys, needle crafts. The Intermarketing Group is a full service merchandise licensing agency representing artist's works for licensing with companies in consumer goods products including the greeting card, giftware, toy, housewares, needlecraft and apparel industries.
Needs: Approached by 100 freelance artists/year. Works with 10 freelance artists/year. Licenses works as developed by clients. Prefers artists with experience in full-color illustration. Uses freelancers mainly for tabletop, cards, giftware, calendars, paper tableware, toys, bookmarks, needlecraft, apparel, housewares. Will consider all media forms. "My firm generally represents highly illustrated works, characters and humorous illustrations for direct product applications. All works are themed." Prefers 5×7 or 8×10 final art. Produces material for all holidays and seasons and everyday. Submit seasonal material 6 months in advance.
First Contact & Terms: Send query letter with brochure, tearsheets, photostats, résumé, photographs, slides, SASE, photocopies and transparencies. Samples are not filed and are returned by SASE. Reports back within 3 weeks. Artist should follow-up with letter after initial query. Originals are returned at job's completion. Requests work on spec before assigning a job. Pays royalties of 3-10%. Buys all rights. Considers buying second rights (reprint rights) to previously published work.
Tips: Finds new artists "mostly by referrals and via artist submissions. I do review trade magazines, attend art shows and other exhibits to locate suitable clients. Companies today seem to be leaning towards the tried and true traditional art approach. Economic times are tough so companies are selective in their licenses."

‡KEM PLASTIC PLAYING CARDS, INC., Box 137, Scranton PA 18504. (717)343-4783. Vice President: Mark D. McAleese. Estab. 1937. Produces plastic playing cards. Manufactures high-quality durable cards and markets them worldwide to people of all ages, ethnic backgrounds, etc. Special interest is young people.
Needs: Buys 1-3 designs/illustrations/year. Prefers "artists who know composition and colors." Buys freelance design/illustrations mainly for playing cards. Also uses artists for calligraphy. Considers watercolor, oil and acrylics. Seeks "good composition with vivid, bouncing colors and color contrasts, always in good taste." Prefers 5½×7. Produces material for all holidays and seasons.
First Contact & Terms: Send query letter with brochure and slides. Samples are not filed and are returned. Reports back within 1 week. To show portfolio, mail roughs, final reproduction/product, slides, tearsheets, photostats and color. Originals are returned at job's completion. Pays $500-1,000/illustration. Buys first or one-time rights; negotiates rights purchased.
Tips: "Call Mark D. McAleese at (800)233-4173."

KOGLE CARDS, INC., 1498 S. Lipan St., Denver CO 80223-3411. President: Patty Koller. Estab. 1982. Produces greeting cards.
Needs: Approached by 500 freelance artists/year. Buys 250 designs and 250 illustrations/year. Works on assignment only. Considers all media for illustration. Prefers 5×7 or 10×14 final art. Produces material for Christmas and all major holidays plus birthdays; material accepted year-round.
First Contact & Terms: Send slides. Samples not filed are returned only if SASE included. Reports back within 4 weeks. To show portfolio, mail color and b&w photostats and photographs. Originals are not returned. Pays royalties of 5%. Buys all rights.

L.B.K. CORP., 7800 Bayberry Rd., Jacksonville FL 32256-6893. (904)737-8500. Fax: (904)737-9526. Art Director: Barbara McDonald. Estab. 1940. "Three companies feed through L.B.K.: NAPCO and INARCO are involved with manufacturing/distributing for the wholesale floral industry; First Coast Design produces fine giftware." Clients: wholesale.
 ● L.B.K. Corp. has a higher-end look for their floral market products. They are doing very little decal, mostly dimensional pieces.
Needs: Works with 15 freelance illustrators and designers/year. 50% of work done on a freelance basis. Prefers local artists for mechanicals for sizing decals; no restrictions on artists for design and concept. Works on assignment only. Uses freelance artists mainly for mechanicals and product design. "Background with a seasonal product such as greeting cards is helpful. 75% of our work is very traditional and seasonal. We're also looking for a higher-end product, an elegant sophistication."
First Contact & Terms: Send résumé, tearsheets, slides, photostats, photographs, photocopies and transparencies. Samples are filed or returned by SASE if requested by artist. Reports back in 2 weeks. Artist should follow-up with letter after initial query. Portfolio should include samples which show a full range of illustration style. Sometimes requests work on spec before assigning a job. Pays for design by the project, $25 and up. Pays for illustration by the hour, $15; or by the project, $100-250; pays for mechanicals by the

hour, $15. Buys all rights. Considers buying second rights (reprint rights) to previously published work.
Tips: Finds artists through word of mouth and artists' self-promotions. "We are very selective in choosing new people."

LANG COMPANIES, Lang Graphics, Main Street Press, Bookmark and Delafield Stamp Company, 514 Wells St., Delafield WI 53018. (414)646-2211. Fax: (414)646-2224. Product Development: Deborah Nelson. Estab. 1982. Produces high quality linen-embossed greeting cards, stationery, calendars, gift bags and rubber stamps.
Needs: Approached by 300 freelance artists/year. Works with 40 freelance artists/year. Buys 600 freelance designs and illustrations/year. Uses freelancers mainly for card and calendar illustrations. Considers watercolor and oil. No photography. Looking for traditional and non-abstract country, folk and fine art styles. Produces material for Christmas, Hanukkah, birthdays and everyday. Submit seasonal material 6 months in advance.
First Contact & Terms: Send query letter with SASE and brochure, tearsheets, photostats, photographs, slides, photocopies or transparencies. Samples are filed or are returned by SASE if requested by artist. Reports back within 6 weeks. "Please do not send originals." Originals are returned at job's completion if requested. Pays royalties based on wholesale sales. Rights purchased vary according to project.
Tips: "Research the company and submit a compatible piece of art. Be patient awaiting a response. A phone call often rushes the review and work may not be seriously considered."

LOVE GREETING CARDS, INC., 1717 Opa Locka Blvd., Opa Locka FL 33054-4221. (305)685-5683. Fax: (305)685-0903. Vice President: Norman Drittel. Estab. 1984. Produces greeting cards, posters and stationery. "We produce cards for the 40- to 60-year-old market, complete lines and photography posters."
● This company has found a niche in targeting middle-aged and older Floridians. Keep this audience in mind when developing card themes for this market. One past project involved a line of cards featuring Florida's endangered wildlife.
Needs: Works with 2 freelance artists/year. Buys 20 designs and illustrations/year. Prefers artists with experience in greeting cards and posters. Also buys illustrations for high-tech shopping bags. Uses freelancers mainly for greeting cards. Considers pen & ink, watercolor, acrylic, oil and colored pencil. Seeks a contemporary/traditional look. Prefers 5×7 size. Produces material for Hanukkah, Passover, Rosh Hashanah, New Year, birthdays and everyday.
First Contact & Terms: Send query letter, brochure, résumé and slides. Samples are filed or are returned. Reports back within 10 days. Call or write for appointment to show portfolio of roughs and color slides. Originals are not returned. Pays average flat fee of $150/design. Buys first or one-time rights.
Tips: "Most of the material we receive from freelancers is of poor quality. We use about 5% of submitted material. We are using a great deal of animal artwork and photographs."

‡LUCY & COMPANY, 13701 42nd NE, Seattle WA 98125. (206)775-8826. Art Director: Noelle Rigg. Estab. 1977. Produces greeting cards, posters, giftwrap, stationery, calendars, plush, and children's books. "Our designs are mostly florals, angels and teddy bears. We direct our products to girls and women of all ages."
Needs: Approached by 50 freelance artists/year. Works with 5 freelance artists/year. Uses freelance artists mainly for greeting cards, catalog/brochure design, books, new product mock-ups. Also uses freelance artists for calligraphy, P-O-P displays, paste-up and product design. Prefers final art at least 8×10. 50% of freelance work demands knowledge of Aldus PageMaker, QuarkXPress, Aldus FreeHand, Adobe Illustrator or Adobe Photoshop. Produces material for Christmas, Valentine's Day, Mother's Day, Father's Day, Easter, Graduation, Thanksgiving, New Year, Halloween, birthdays and everyday. Submit seasonal material 10 months in advance.
First Contact & Terms: Send query letter with brochure, résumé, SASE, tearsheets, photographs and photocopies. "No slides or transparencies, please." Samples are filed and returned by SASE if requested by artist. Reports back to the artist only if interested. Portfolio review not required. Originals are returned at job's completion. Pays by the hour, $7.50 minimum; by the project, $50. Rights purchased vary according to project.
Tips: "Warmer, homey, almost country designs (nostalgic) are becoming more popular now."

MALENA PRODUCTIONS, INC., P.O. Box 14483, Ft. Lauderdale FL 33302. (305)492-9923. Fax: (305)776-1551. President: Helena Steiner-Hörnsteyn. Estab. 1985. Produces greeting cards, stationery, T-shirts and dolls; "high-end quality products for US and international market."
Needs: Approached by 1,000 artists/year. Works with 4-6 artists/year. Prefers artists with "new ideas and 'looks'." Works on assignment only. Seldom uses freelance artists. Produces material for Christmas and the seasons. Submit seasonal material 6-8 months in advance.
First Contact & Terms: Send query letter. Reports back in 3-4 weeks with SASE. Portfolio review not required. Originals are not returned at job's completion unless requested. Sometimes requests work on spec before assigning a job. Payment varies according to project. Rights purchased vary according to project.
Tips: "I see ahead the introduction of smaller cards and more adventurous gift/party supplies."

THE MAYPOLE, TOO! INC., 324 W. Jackson Ave. E., Oxford MS 38655. Phone/Fax: (601)234-9517. Owner: Chris Bernet. Estab. 1983. Produces predominantly child-themed greeting cards, stationery and enclosure cards. "We manufacture greeting cards for high-end stationery stores and children's boutiques. We specialize in birth announcements."
Needs: Approached by 30-50 freelance artists/year. Works with 0-10 freelancers/year. Uses freelancers mainly for developing new products. Also for calligraphy. Looking for all-occasion cards, birth announcements and party invitations. "20% larger than final product is best size" for final art. Produces material for Christmas and everyday. Submit seasonal material 3-6 months in advance.
First Contact & Terms: Send query letter with brochure, résumé, photographs and slides. Samples are filed and are returned. Reports back within 15 days. Art Director will contact artist for portfolio review if interested. Portfolio should include final art. Originals are returned at job's completion. Pays by the project, $200-1,000 or pays royalties of 2-5%. Negotiates rights purchased.

‡FRANCES MEYER, INC., 104 Coleman Blvd., Savannah GA 31408. (912)748-5252. Fax: (912)748-8378. Stationery Manager: Katherine Trosdal. Estab. 1979. Produces giftwrap, stationery and party supplies. "We produce a number of items for the gift and party industry as well as an ever-growing number of stationery-related products. Our products are directed to consumers of all ages. We have everything from birth announcements to shower and wedding invitations."
Needs: Works with 5-6 freelance artists/year. Commissions 100 freelance illustrations and designs/year. Works on assignments only. Uses freelancers mainly for stationery-related products. "Most of our artists work in either watercolor or acrylic. We are open, however, to artists who work in other media." Looking for "everything from upscale and sophisticated adult theme-oriented paper items, to fun, youthful designs for birth announcements, baby and youth products. Diversity of style, originality of work, as well as technical skills are a few of our basic needs." Produces material for Christmas, graduation, Thanksgiving (fall), New Year's, Halloween, birthdays, everyday, weddings, showers, new baby, etc. Submit seasonal material 2-3 months in advance.
First Contact & Terms: Send query letter with tearsheets, slides, SASE, photocopies, transparencies and "as much information as is necessary to show diversity of style and creativity." Samples are not filed and are returned by SASE if requested by artist. Reports back within 2-3 weeks. Company will contact artist for portfolio review if interested. Originals are returned at job's completion. Pays royalty (varies).
Tips: "Generally, we are looking to work with a few talented and committed artists for an extended period of time. Our outside artists are given ample coverage in our catalog as we tend to show collections of each design. We do not 'clean out' our line on an annual basis just to introduce new product. If an item sells, it will remain in the line. Punctuality concerning deadlines is a necessity."

MIXEDBLESSING, D-5, 352 Central Park Ave, Scarsdale NY 10583. (914)723-3414. President: Elise Okrend. Estab. 1990. Produces interfaith greeting cards combining Jewish and Christian images for all ages.
Needs: Approached by 10 freelance artists/year. Works with 2-3 freelancers/year. Buys 20 designs and illustrations/year. Prefers artists with whimsical style. Works on assignment only. Uses freelancers mainly for card illustration. Considers watercolor, pen & ink and pastel. Prefers final art 5×7. Produces material for Christmas and Hanukkah. Submit seasonal material 10 months in advance.
First Contact & Terms: Send query letter with brochure and photocopies. Samples are filed. Reports back only if interested. Artist should follow-up with letter after initial query. Originals are returned at job's completion. Sometimes requests work on spec before assigning a job. Pays average flat fee of $150 for illustration/design. Buys all rights.
Tips: Finds artists through visiting art schools. "I see growth ahead for the industry."

■NALPAC, LTD., 8700 Capital, Oak Park MI 48237. (313)541-1140. Fax: (313)544-9126. President: Ralph Caplan. Estab. 1971. Produces coffee mugs and T-shirts for gift and mass merchandise markets.
Needs: Approached by 10-15 freelance artists/year. Works with 2-3 freelancers/year. Buys 70 designs and illustrations/year. Works on assignment only. Considers all media. Needs computer-literate freelancers for design, illustration and production. 60% of freelance work demands computer skills.
First Contact & Terms: Send query letter with brochure, résumé, SASE, photographs, photocopies, slides and transparencies. Samples are filed or are returned by SASE if requested by artist. Reports back within 1 month. Call for appointment to show portfolio. Usually buys all rights, but rights purchased may vary according to project. Pays for design and illustration by the hour $10-25; or by the project $40-500, or offers royalties of 4-10%.

NCE, NEW CREATIVE ENTERPRISES INC., 5481 Creek Rd., Cincinnati OH 45242. (513)891-1172. Fax: (513)891-1176. Design & Art Director: Dave J. Griffiths. Estab. 1979. Produces low-medium priced giftware and decorative accessories. "We sell a wide variety of items ranging from magnets to bird feeders. Our typical buyer is female, age 30-50."
Needs: Approached by 5-10 freelance artists/year. Works with 2-5 freelancers/year. Buys 10-50 designs and illustrations/year. Prefers artists with experience in giftware/decorative accessory design, concept development and illustration and concept sketching skills. Most often needs ink or marker illustration. Seeks heart-

warming and whimsical designs and illustrations using popular (Santa, Easter Bunny, etc.) or unique characters. Final art must be mailable size. Needs computer-literate freelancers for design, illustration and production. 50% of work demands knowledge of Aldus PageMaker and Adobe Illustrator. Produces material for Christmas, Valentine's Day, Easter, Thanksgiving and Halloween. Submit seasonal material 10 months in advance.

First Contact & Terms: Send query letter with tearsheets, photographs, photocopies, photostats, slides and transparencies. Samples are filed and are returned by SASE if requested by artist. Reports back within 2-3 weeks. Call for appointment to show portfolio or mail appropriate materials. Portfolio should include thumbnails, roughs, finished art samples, b&w and color tearsheets, photographs, slides and dummies. Originals are returned at job's completion. Pays average flat fee of $75 for illustration/design; or by the hour, $7-9. Rights purchased vary according to project.

Tips: "Familiarity and experience with the industry really helps, but is not imperative. Yard and garden decoration/accessories are very popular right now."

THOMAS NELSON, INC.—MARKINGS, P.O. Box 141000, Nashville TN 37214. (615)889-9000. Fax: (615)391-3166. Creative Director: Ann Cummings. Gift book publisher and producer of stationery products. Specializes in baby, children, feminine, sports and kitchen-related subjects. 85-90% require freelance illustration; 50% require freelance design. Book catalog free by request.

Needs: Approached by 50-100 freelance artists/year. Works with 5-15 illustrators and 5-15 designers/year. Assigns 10-20 design and 10-20 illustration jobs/year. Uses freelancers mainly for covers, borders and spots. Needs computer-literate freelancers for design. 50% of freelance work demands knowledge of QuarkXPress or Aldus FreeHand. Works on assignment only.

First Contact & Terms: Send query letter with brochure, résumé, tearsheets and photocopies. Samples are filed or are returned. Reports back to the artist only if interested. Request portfolio review in original query. Portfolio should include thumbnails, finished art samples, color tearsheets and photographs. Whether originals returned to the artist depends on contract. Sometimes requests work on spec before assigning a job. Interested in buying second rights (reprint rights) to previously published work. "Payment varies due to complexity and deadlines."

Tips: Finds artists through word of mouth, magazines, artists' submissions/self-promotions, sourcebooks, agents, visiting artist's exhibitions, art fairs and artists' reps. "The majority of our mechanical art is executed on the computer with discs and lazer runouts given to the engraver instead of paste up boards."

THE NELSON LINE, Suite 6, 102 Commerce Dr., Moorestown NJ 08057. (609)778-4801. Fax: (609)778-4725. Owner: Eli Nelson. Estab. 1987. Produces greeting cards and giftwrap of "art-oriented images and children's sophisticated (not cutesy) designs."

Needs: Approached by 20 freelance artists/year. Works with 1-2 freelancers/year. Buys 10-20 designs and illustrations/year. Uses freelancers mainly for greeting cards. Considers any media. Looking for sophisticated Christmas images and animals and bright color in children's images. Prefers 5 × 7 final art. Produces material for Christmas, Valentine's Day, Mother's Day, Hanukkah, Rosh Hashanah, birthdays and everyday. Submit seasonal material 6 months in advance.

First Contact & Terms: Send query letter with photostats, photographs, SASE and photocopies. Samples are not filed and are returned by SASE if requested by artist. Reports back within 2-3 weeks. Pays average flat fee of $150. Rights purchased vary according to project.

Tips: Notes a "rising popularity of ethnic art, naive art and folk art."

NEW ENGLAND CARD CO., Box 228, Route 41, West Ossipee NH 03890. (603)539-5095. Owner: Harold Cook. Estab. 1980. Produces greeting cards and prints of New England scenes.

Needs: Approached by 75 freelance artists/year. Works with 10 freelancers/year. Buys more than 24 designs and illustrations/year. Prefers artists with experience in New England art. Considers oil, acrylic and watercolor. Looking for realistic styles. Prefers art proportionate to 5 × 7. Produces material for all holidays and seasons. "Submit all year."

First Contact & Terms: Send query letter with SASE, photographs, slides and transparencies. Samples are filed or are returned. Reports back within 2 months. Artist should follow-up after initial query. Payment negotiable. Rights purchased vary according to project; but "we prefer to purchase all rights."

Tips: "Once you have shown us samples, follow up with new art."

‡NEW YORK GRAPHIC SOCIETY, P.O. Box 1469, Greenwich CT 06836. (203)661-2400. Fax: (203)661-2480. Creative Director: Cynthia Costello. Estab. 1925. Produces posters, reproductions and limited editions.

Needs: Approached by hundreds of freelance artists/year. Works with 5-10 freelance artists/year. Buys 5-10 freelance designs and illustrations/year. Works on assignment only. Uses freelance artists mainly for reproductions. Considers oil, watercolor, acrylic, pastel and photography. Looking for landscapes, florals, abstracts and impressionism. Produces material for Christmas. Submit seasonal material 6 months in advance.

First Contact & Terms: Send query letter with brochure, résumé, SASE, tearsheets and slides. Samples are not filed and are returned by SASE. Art Director will contact artist for portfolio review if interested. Originals

are returned at job's completion. Sometimes requests work on spec before assigning a job. Pays royalties. Buys reprint rights.
Tips: Finds artists through word of mouth, magazines, artists' submissions/self-promotions, artist's exhibitions and art fairs.

■**NOVEL TEE DESIGNS AND GREETINGS,** 141 Chinquapin Orchard, Yorktown VA 23693. Contact: Art Director. Estab. 1985. Manufacturer and distributor of imprinted greeting cards, T-shirts, sweatshirts, aprons and nightshirts for retail shops. Also produces tourist-oriented, ski resort, beach/surf, seasonal and cartoon/ humorous designs. Clients: Gift shops, surf shops and department stores.
Needs: Approached by 50-100 freelance artists/year. Works with 50-100 illustrators and 25 designers/year. Assigns 50 jobs to freelancers/year. Prefers artists with experience in silkscreen printing, art and design. Works on assignment only. Uses freelancers mainly for apparel graphic designs. "We are looking for designs that will appeal to women ages 18-40 and men ages 15-40. We also need ethnic designs; greeting card designs featuring blacks, cartoons, humor; detailed and graphic designs." Needs computer-literate freelancers for illustration. 15% of freelance work demands knowledge of Adobe Illustrator or Aldus FreeHand.
First Contact & Terms: Send query letter with brochure showing art style or résumé, tearsheets, SASE and photostats. Samples are filed or are returned only if requested by artist. Art Director will contact artist for portfolio review if interested. Portfolio should include thumbnails, roughs, final reproduction/product and tearsheets. Requests work on spec before assigning a job. Pays for design and illustration by the project, $200 average. Negotiates rights purchased.
Tips: Finds artists through self-promotions and trade shows. "Artists should have past experience in silk-screening art. Understand the type of line work needed for silkscreening and originality. We are looking for artists who can create humorous illustrations for a product line of T-shirts. Fun, whimsical art sells in our market. Graphic designs are also welcome. Have samples of rough through completion."

■**OATMEAL STUDIOS,** Box 138, Rochester VT 05767. (802)767-3171. Fax: (802)767-9890. Creative Director: Helene Lehrer. Estab. 1979. Publishes humorous greeting cards and notepads, creative ideas for everyday cards and holidays.
Needs: Approached by approximately 300 freelance artists/year. Buys 100-150 designs and illustrations/ year. Considers all media. Produces seasonal material for Christmas, Mother's Day, Father's Day, Easter, Valentine's Day and Hanukkah. Submit art in May for Christmas and Hanukkah; in January for other holidays.
First Contact & Terms: Send query letter with slides, roughs, printed pieces or brochure/flyer to be kept on file; write for artists' guidelines. "If brochure/flyer is not available, we ask to keep one slide or printed piece; color or b&w photocopies also acceptable for our files." Samples returned by SASE. Reports in 3-6 weeks. No portfolio reviews. Sometimes requests work on spec before assigning a job. Negotiates payment.
Tips: "We're looking for exciting and creative, humorous (not cutesy) illustrations for our everday lines. If you can write copy and have a humorous cartoon style all your own, send us your ideas! We do accept work without copy too. Our seasonal card line includes traditional illustrations, so we do have a need for non-humorous illustrations as well."

‡**STANLEY PAPEL DESIGNS,** #100, 17337 Ventura Blvd., Encino CA 91316. (818)789-9119. Fax: (818)789-9171. Director of Product Development: Joy Tangarone. Estab. 1955. Produces stationery, giftwrap, paper tableware, mugs, musical, totebags, keyrings, magnets, ceramic tabletop ensembles and picture frames. "Stanley Papel is a product development agency creating fine illustrated art, social and personal expression graphics and novelty impulse products for major giftware firms. The designs and products are directed to consumers ages 18-70 worldwide."
Needs: Approached by 150 freelance artists/year. Works with 50 freelance artists/year. Buys 500 freelance designs and illustration/year. Prefers artists with experience in giftware, paper and party goods and 3-D molded gifts. Uses freelancers mainly for illustration and graphic designs. Also for P-O-P displays and 3-D tabletop ensembles. Considers watercolor, gouache, acrylic, computer graphics and pen & ink. Looking for "colorful graphics with outstanding use of typestyles as well as crisp watercolor illustrations, either photoreal-ism or decorative styles." Needs computer-literate freelancers for design. 33% of freelance work demands knowledge of QuarkXPress, Aldus FreeHand, Adobe Illustrator or Adobe Photoshop. Produces material for

The solid, black square before a listing indicates that it is judged a good first market by the Artist's & Graphic Designer's Market editors. Either it offers low payment, pays in credits and copies, or has a very large need for freelance work.

Christmas, Valentine's Day, Mother's Day, graduation, Halloween, birthdays and St. Patrick's Day. Submit seasonal material 1 year in advance.

First Contact & Terms: Send query letter with tearsheets, résumé, slides and color photocopies. Samples are filed or are returned by SASE if requested by artist. Reports back within 6 weeks. Company will contact artist for portfolio review if interested. Portfolio should include color final art, tearsheets and transparencies. Originals are returned at job's completion. Pays by the project, $150-1,000. Rights purchased vary according to project.

Tips: "We review artists quarterly. All projects are assigned to freelance artists. We prefer to work with artists who have some experience in giftware. The final products are given as gifts so artists should keep in mind the 'me-to-you' reason to buy products with their designs."

PAPEL FREELANCE, INC., 2530 US Highway 130, CN 9600, Cranbury NJ 08512. (609)395-0022, ext. 205. Art Department Manager: Lori Farbanish. Estab. 1955. Produces everyday and seasonal giftware items: mugs, photo frames, magnets, molded figurines, candles and novelty items. Paper items include memo pads, gift bags, journals.

Needs: Approached by about 125 freelance artists/year. Buys 250 illustrations/year. Uses artists for product design, illustrations on product, calligraphy, paste-up and mechanicals. "Very graphic, easy to interpret, bold, clean colors, both contemporary and traditional looks as well as juvenile and humorous styles." Produces material for Halloween, Christmas, Valentine's Day, Easter, St. Patrick's Day, Mother's Day, Father's Day and everyday lines: graduation, wedding, back to school.

First Contact & Terms: Send query letter with brochure, résumé, photostats, photocopies, slides, photographs and tearsheets to be kept on file. Samples not filed are returned by SASE if requested. Art Director will contact artist for portfolio review if interested. Portfolio should include final reproduction/product and b&w and color tearsheets, photostats and photographs. Originals are not returned. Sometimes requests work on spec before assigning a job. Pays by the project, $125 and up; or royalties of 3%. Buys all rights.

Tips: "I look for an artist with strong basic drawing skills who can adapt to specific product lines with a decorative feeling. It is an advantage to the artist to be versatile and capable of doing several different styles, from contemporary to traditional looks, to juvenile and humorous lines. Send samples of as many different styles as you are capable of doing well. Quality and a strong sense of color and design are the keys to our freelance resource. In addition, clean, accurate inking and mechanical skills are important to specific jobs as well. Update samples over time as new work is developed. New ideas and 'looks' are always welcome."

THE PAPER COMPANY™, 731 S. Fidalgo St., Seattle WA 98108. Contact: Design Manager. Estab. 1979. Manufacturer of fine contemporary stationery and related products. "We produce a wide array of designs from sophisticated florals to simple, fun graphics and everything in between."

Needs: Prefers to work with 8 freelance artists and in-house design staff. Buys approximately 40 designs/ year. Produces material for everyday and Christmas. "There are no restrictions to media usage, however please note that we do not use cartoon illustration/design."

First Contact & Terms: Send a query letter including previous work assignments/experience with printed samples and/or color photocopies to indicate style. Reports in 1 month. Art Director will contact artist for portfolio review if interested. Sometimes requests work on spec before assigning a job. Samples are returned upon request. No phone calls accepted. Pays flat fee rate, $150-$600; no licensing considerations.

Tips: Finds artists through submissions and word of mouth. "This is a constantly changing field; new products, new trends, etc. Imprintables will be making a huge impact shortly (if not already)."

‡✽PAPERPOTAMUS PAPER PRODUCTS INC., Box 310, Delta, British Columbia V4K 3Y3 Canada. (604)270-4580. Fax: (604)270-1580. Director of Marketing: George Jackson. Estab. 1988. Produces greeting cards for women ages 18 to 60. "We have also added a children's line."

Needs: Works with 8-10 freelance artists/year. Buys 75-100 illustrations from freelance artists/year. Also uses artists for P-O-P displays, paste-up and inside text. Prefers watercolor, but will look at all media that is colored; no b&w except photographic. Seeks detailed humorous cartoons and detailed nature drawings i.e. flowers, cats. "No studio card type artwork." Prefers 5¼ × 7¼ finished art work. Produces material for Christmas, Valentine's Day, Easter and Mother's Day; submit 18 months before holiday. Normally works with an artist to produce an entire line of cards but will put selected work into existing or future lines and possibly develop line based on success of the selected pieces.

First Contact & Terms: Send query letter with brochure, résumé, photocopies and SASE. Samples are not filed and are returned by SASE only if requested by artist. Reports back within 2 months. Call or write to schedule an appointment to show a portfolio, or mail roughs and color photographs. Original artwork is not returned to the artist after job's completion. Pays average flat fee of $100/illustration or royalties of 3-5%. Prefers to buy all rights, but will negotiate rights purchased. Company has a 20 page catalog you may purchase by sending $4 with request for artist's guidelines. Please do not send IRC's in place of SASE.

Tips: "Know your market! Have a sense of what is selling well in the card market. Learn about why people buy cards and why they buy certain types of cards for certain people. Understand the time frame necessary to produce a good card line."

PAPILLON INTERNATIONAL GIFTWARE INC., 40 Wilson Rd., Humble TX 77338. (713)446-9606. Fax: (713)446-1945. Vice President Marketing: Michael King. Estab. 1987. Produces greeting cards, decorative accessories, home furnishings and Christmas ornaments. "Our product mix includes figurines, decorative accessories, Christmas ornaments and decor and greeting cards. We use freelance artists primarily for greeting card illustration, catalog design and P-O-P display design."
Needs: Approached by 20 freelance artists/year. Works with 4-6 freelancers/year. Buys 4-6 designs and illustrations/year. Prefers local artists only. Works on assignment only. "We are looking for illustrations appealing to classic and refined tastes for our cards and Christmas ornaments." Prefers 10×14. Needs computer-literate freelancers for design and illustration. 60% of work demands knowledge of Aldus Page-Maker, Adobe Illustrator and Photoshop. Produces material for Christmas, Valentine's Day, Thanksgiving and Halloween. Submit seasonal material 1 year in advance.
First Contact & Terms: Send query letter with brochure, SASE, tearsheets, photographs, photocopies, photostats and slides. Samples are filed and are returned by SASE if requested by artist. Reports back within 6-8 weeks. To show portfolio, mail roughs, color slides and tearsheets. Originals returned at job's completion. Pays by the project, $400 average. Negotiates rights purchased.

PHILADELPHIA T-SHIRT MUSEUM, 235 N. 12th St., Philadelphia PA 19107. (215)625-9320. Fax: (215)625-0740. President: Marc Polish. Estab. 1972. Produces T-shirts and sweatshirts. "We specialize in printed T-shirts and sweatshirts. Our market is the gift and mail order industry, resort shops and college bookstores."
Needs: Works with 6 freelancers/year. Designs must be convertible to screenprinting. Produces material for Christmas, Valentine's Day, Mother's Day, Father's Day, Hanukkah, graduation, Halloween, birthdays and everyday.
First Contact & Terms: Send query letter with brochure, tearsheets, photographs, photocopies, photostats and slides. Samples are filed and are returned. Reports back with 2 weeks. To show portfolio, mail anything to show concept. Originals returned at job's completion. Pays royalties of 6%. Negotiates rights purchased.
Tips: "We like to laugh. Humor sells. See what is selling in the local mall or department store."

‡PICKARD CHINA, 782 Pickard Ave., Antioch IL 60002. (708)395-3800. Fax: (708)395-3827. Director of Marketing: Henry A. Pickard. Estab. 1893. Manufacturer of fine china dinnerware, limited edition plates and collectibles. Clients: upscale specialty stores, department stores, direct mail marketers, consumers and collectors. Current clients include Cartier, Tiffany & Co., Marshall Field's, Bradford Exchange, Hamilton Mint, U.S. Historical Society.
Needs: Assigns 2-3 jobs to freelance artists/year. Uses freelance artists mainly for china patterns and plate art. Prefers designers for china pattern development with experience in home furnishings. Tabletop experience is a plus. Wants painters for plate art who can paint people and animals well—"Rockwellesque" portrayals of life situations. Prefers any medium with a fine art or photographic style. Works on assignment only.
First Contact & Terms: Send query letter with brochure showing art style or résumé and color photographs, tearsheets, slides or transparencies. Samples are filed or are returned if requested. Art Director will contact artist for portfolio review if interested. Pays royalties of 2-3%. Negotiates rights purchased. Interested in buying second rights (reprint rights) to previously published work.

PLUM GRAPHICS INC., Box 136, Prince Station, New York NY 10012. (212)966-2573. Contact: Yvette Cohen. Estab. 1983. Produces greeting cards. "They are full-color, illustrated, die-cut; fun images for young and old."
Needs: Buys 12 designs and illustrations/year. Prefers local artists only. Works on assignment only. Uses freelancers for greeting cards only. Considers oil, acrylic, airbrush and watercolor (not the loose style). Looking for representational and tight-handling styles. Prefers animal themes.
First Contact & Terms: Send query letter with photocopies or tearsheets. Samples are filed or are returned by SASE if requested by artist. Reports back to the artist only if interested. "We'll call to view a portfolio." Portfolio should include final art and color tearsheets. Originals are returned at job's completion. Sometimes requests work on spec before assigning a job. Pays average flat fee of $300 for illustration/design. Pays an additional fee if card is reprinted. Buys all rights. Considers buying second rights (reprint rights) to previously published work; "depends where it was originally published."
Tips: Finds artists through word of mouth, artists' submissions and sourcebooks. "I suggest that artists look for the cards in stores to have a better idea of the style. They are sometimes totally unaware of Plum Graphics and submit work that is inappropriate."

THE POPCORN FACTORY, 13970 W. Laurel Dr., Lake Forest IL 60045. Vice President, Merchandising and Marketing: Nancy Hensel. Estab. 1979. Manufacturer of popcorn cans and other gift items sold via catalog for Christmas, Valentine's Day, Easter and year-round gift giving needs.
Needs: Works with 6 freelance artists/year. Assigns up to 20 freelance jobs/year. Works on assignment only. Uses freelancers mainly for cover illustration, can design, fliers and ads. Occasionally uses artists for advertising, brochure and catalog design and illustration. 10% of work demands knowledge of QuarkXPress.
First Contact & Terms: Send query letter with brochure. Samples are filed. Reports back within 1 month. Write for appointment to show portfolio, or mail finished art samples and photographs. Pays for design by

the project, $500-2,000. Pays for illustration by the project, $500-1,500. Considers complexity of project, skill and experience of artist, and turnaround time when establishing payment. Buys all rights.

Tips: "Send classic illustration, graphic designs or a mix of photography/illustration. We can work from b&w concepts—then develop to full 4-color when selected."

This detail of a mug design by Jacquelyn Frerichs, which appeared in Potpourri Press's Christmas line, was originally done as a greeting card for another company. The artist added elements such as an additional snowman and a rabbit on a saucer to create a complete design for the 3¹/8 × 9³/4 space.

POTPOURRI PRESS, 6210 Swiggett Rd., Greensboro NC 27419. Mailing address: Box 19566, Greensboro NC 27410. (910)852-8961. Fax: (910)852-8975. Director of New Product Development: Janet Pantuso. Estab. 1968. Produces paper products including bags, boxes, stationery and tableware; tins; stoneware items; and collectible figurines for gift shops, the gourmet shop trade and department stores. Targets women age 25 and older.

Needs: Buys 10-20 freelance designs/year and 10-20 freelance illustrations/year. "Our art needs are increasing. We need artists who are flexible and able to meet deadlines." Works on assignment only. Uses freelancers for calligraphy, mechanicals and art of all kinds for product reproduction. Prefers watercolor, acrylic and marker. Also needs mechanical work. Seeking traditional, seasonal illustrations for Christmas introductions and feminine florals for everyday. Submit seasonal material 1-2 years in advance.

First Contact & Terms: Send query letter with résumé and tearsheets, slides or photographs. Samples not filed are returned by SASE. Art Director will contact artist for portfolio review if interested. Pays average flat fee of $300; or pays by the project, $1,000-5,000 average. Buys all rights.

Tips: Finds artists through word of mouth, magazines, artists' submissions/self-promotions, sourcebooks, agents, visiting artist's exhibitions, art fairs and artists' reps. "Our audience has remained the same but our products are constantly changing as we continue to look for new products and discontinue old products. I often receive work from artists that is not applicable to our line. I prefer that artists learn more about the company before submitting work."

PRATT & AUSTIN COMPANY, INC., 642 S. Summer St., Holyoke MA 01040. (413)532-1491. Fax: (413)536-2741. President: Bruce Pratt. Art Director: Lorilee Costello. Estab. 1931. Produces greeting cards, stationery and calendars. "Our market is the modern woman at all ages. Design must be pretty, cuddly and elicit a positive response." Using more recycled paper products and endangered species designs.

Needs: Approached by 50 freelance artists/year. Works with 20 freelancers/year. Buys 100-150 designs and illustrations/year. Uses freelancers mainly for concept and finished art. Also for calligraphy. Produces material for Christmas, birthdays, Mother's Day and everyday. Submit seasonal material 1½ years in advance.

First Contact & Terms: Send query letter with tearsheets, slides and transparencies. Samples are filed or are returned by SASE if requested. Art Director will contact artist for portfolio review if interested. Portfolio should include thumbnails, roughs, color tearsheets and slides. Pays by the hour, $20-30; or by the project, $200-1,000 average; or royalties of 1-5%. Rights purchased vary according to project. Interested in buying second rights (reprint rights) to previously published work.

Tips: Finds artists through artists' submissions and agents. "It is imperative that freelancers submit seasonal/holiday designs 18 months in advance."

PRETTY PAPER COMPANY, Dept. AM, 900 W. Academy St., Cherryville NC 28021. (704)435-4570. Fax: (704)435-4579. Creative Director: Phyllis Watson. Estab. 1981. Produces greeting cards, stationery, die-cut pads, pads with designs, calendars, planners, mugs, tins, address and blank books, note holders and gift baskets.
Needs: Approached by 5 artists/year. Works with 20 artists/year. Buys up to 50 designs and illustrations/ year. Prefers "artists compelled to do their best consistently with deep understanding of color and regard for deadlines. Should be pleasant to work with." Works on assignment only. Uses freelancers for color illustration, calligraphy, mechanicals on computer, illustration and border designs. Considers watercolor, pastel, scratchboard, woodcut, oil, colored pencil, mixed media. "If it's exquisite or clever, we'll consider it. We like dramatic, graceful, and/or delicate florals, tropicals, classic, Victorian, impressionistic or fairly detailed and realistic styles." Needs computer-literate freelancers for design and production. 5-10% of freelance work demands knowledge of Aldus PageMaker or Adobe Illustrator. Produces material for all holidays and seasons. Submit seasonal material 18 months in advance.
First Contact & Terms: Send query letter with brochure, résumé, SASE, tearsheets, photographs, photocopies, photostats, slides, color copies, thumbnails and roughs; "we are interested in seeing evolution of thought process." No originals. Samples are filed or are returned by SASE if requested by artist. Art Director will contact artist for portfolio review if interested. Portfolio should include thumbnails, roughs, color: copies, photostats, tearsheets, photographs and slides. Originals are returned at job's completion if specifically agreed upon. Requests work on spec before a assigning job. Pays average flat fee of $300 for illustration/ design; by the project, $100-300 average. Buys all rights.
Tips: "Give a professional presentation of your work."

THE PRINTERY HOUSE OF CONCEPTION ABBEY, Conception MO 64433. Fax: (816)944-2582. Art Director: Rev. Norbert Schappler. Estab. 1950. Publishes religious greeting cards. Specializes in religious Christmas and all-occasion themes for people interested in religious, yet contemporary, expressions of faith. "Our card designs are meant to touch the heart. They feature strong graphics, calligraphy and other appropriate styles."
Needs: Approached by 75 freelance artists/year. Works with 25 freelancers/year. Uses freelancers for product illustration. Prefers acrylic, pastel, cut paper, oil, watercolor, line drawings, serigraphs and classical and contemporary calligraphy. Looking for dignified styles and solid religious themes. Produces seasonal material for Christmas and Easter "as well as the usual birthday, get well, sympathy, thank you, etc. cards of a religious nature. Creative general message cards are also needed." Strongly prefers calligraphy to type style.
First Contact & Terms: Send query with brief résumé and a few samples representative of your art style and skills. Non-returnable samples preferred—or else samples with SASE. Reports back usually within 3 weeks. To show portfolio, mail appropriate materials only after query has been answered. "In general, we continue to work with artists once we have accepted their work." Pays flat fee of $150-300 for illustration/ design. Usually buys exclusive reproduction rights for a specified format; occasionally buys complete reproduction rights.
Tips: "Abstract or semi-abstract background designs seem to fit best with religious texts. Color washes and stylized designs are often appropriate. Remember our specific purpose of publishing greeting cards with a definite Christian/religious dimension but not piously religious. It must be good quality artwork. We sell mostly via catalogs so artwork has to reduce well for catalog." Sees trend towards "more personalization and concern for texts."

PRODUCT CENTRE-S.W. INC./THE TEXAS POSTCARD CO., Box 860708, Plano TX 75086. (214)423-0411. Fax: (214)578-0592. Art Director: Susan Grimland. Produces greeting cards, posters, melamine trays, coasters and postcards. Themes range from nostalgia to art deco to pop/rock for contemporary buyers.
Needs: Buys 100 designs from freelance artists/year. Uses freelancers for P-O-P display, paste-up and mechanicals. Considers any media, but "we do use a lot of acrylic/airbrush designs." Prefers contemporary styles. Final art must not be larger than 8×10. "Certain products require specific measurements. We will provide these when assigned."
First Contact & Terms: Send résumé, business card, slides, photostats, photographs, photocopies and tearsheets to be kept on file. Samples not filed are returned only by request with SASE including return insurance. Reports within 4 months. Originals are not returned. Call or write for appointment to show portfolio. Pays by the project, $100-200. Buys all rights.
Tips: "Artist should be able to submit camera-ready work and understand printer's requirements. The majority of our designs are assigned. No crafty items or calligraphy. No computer artwork."

PRODUCT CONCEPT CONSULTING, INC, 3334 Adobe Court, Colorado Springs CO 80907. (719)632-1089. Fax: (719)632-1613. President: Susan Ross. Estab. 1986. New product development agency. "We work with a variety of companies in the gift and greeting card market in providing design, new product development and manufacturing services."
Needs: Works with 20-25 freelance artists/year. Buys 400 designs and illustrations/year. Prefers artists with 3-5 years experience in gift and greeting card design. Works on assignment only. Buys freelance designs and illustrations mainly for new product programs. Also for calligraphy, P-O-P display and paste-up. Considers all media. Needs computer-literate freelancers for design and production. 25% of freelance work demands

knowledge of Adobe Illustrator, QuarkXPress or Aldus FreeHand. Produces material for all holidays and seasons.
First Contact & Terms: Send query letter with résumé, tearsheets, photostats, photocopies, slides and SASE. Samples are filed or are returned by SASE if requested by artist. Reports back within 1 week. To show portfolio, mail color and b&w roughs, final reproduction/product, slides, tearsheets, photostats and photographs. Originals not returned. Pays average flat fee of $250; or pays by the project, $250-2,000. Buys all rights.
Tips: "Be on time with assignments." Looking for portfolios that show commercial experience.

PUNCH ENTERPRISES INC., Suite 200, 5661 Columbia Pike, Falls Church VA 22041. (703)931-4860. Fax: (703)671-5805. President: David Black. Estab. 1987. Produces novelty items for ages 5-adult.
Needs: Approached by 10 freelance artists/year. Works with 2 freelancers/year. Buys 2 designs and illustrations/year. Prefers artists with experience in package design and P-O-P display. Works on assignment only. Needs computer-literate freelancers for design and illustration.
First Contact & Terms: Send query letter with résumé, SASE and photocopies. Samples are filed. Reports back to the artist only if interested. To show portfolio, mail finished art samples and color photographs. Originals are not returned. Pays by the project, $300-5,000. Buys all rights.

QUALITY ARTWORKS, INC., 2262 North Penn Rd., P.O. Box 369, Hatfield PA 19440-0369. Creative Director: Linda Tomezsko Morris. Estab. 1985. Manufacturer/distributor producing bookmarks, blank books, bookplates, stationery and scrolls. Subject matter ranges from classic, traditional to contemporary, fashion-oriented. Clients: bookstores, card and gift shops and specialty stores.
Needs: Works with 20 freelance artists/year. Needs 100-200 designs/year. Considers any medium. Artists must be able to work within a narrow vertical format (bookmarks). Works on assignment only. Uses freelancers for product illustration.
First Contact & Terms: Send query letter with tearsheets, slides and/or printed pieces. Samples are filed or are returned only if requested by artist with SASE. Art Director will contact artist for portfolio review if interested. Portfolio should include roughs, original/final art, product samples, tearsheets, slides or color prints. Pays for illustration $50-400; or royalties of 6%. Considers skill and experience of artist, how work will be used and rights purchased when establishing payment.
Tips: "We are looking for creative, fresh looks with strong color and design. Study our product and the market. Design with the consumer in mind. You must also have an understanding of the 4-color printing process."

RECO INTERNATIONAL CORPORATION, Collector's Division, Box 951, 138-150 Haven Ave., Port Washington NY 11050. (516)767-2400. Manufacturer/distributor of limited editions, collector's plates, lithographs and figurines. Sells through retail stores and direct marketing.
Needs: Works with freelance and contract artists. Uses freelancers or artists under contract for plate and figurine design and limited edition fine art prints. Prefers romantic and realistic styles.
First Contact & Terms: Send query letter and brochure to be filed. Write for appointment to show portfolio. Art Director will contact artist for portfolio review if interested. Negotiates payment. Considers buying second rights (reprint rights) to previously published work.
Tips: "We are very interested in new artists. We go to shows and galleries, and receive recommendation from arists we work with."

RECYCLED PAPER GREETINGS INC., (formerly Recycled Paper Products), 3636 N. Broadway, Chicago IL 60613. Fax: (312)281-1697. Art Director: Melinda Gordon. Publishes greeting cards, adhesive notes, buttons and mugs.
 ● Sandra Boynton pioneered this company with her unique style and outlook. This company, which began as a tiny grass-roots organization, has grown to become a leading trendsetter in the industry.
Needs: Buys 1,000-2,000 freelance designs and illustrations. Considers b&w line art and color–"no real restrictions." Looking for "great ideas done in your own style with messages that reflect your own slant on the world." Prefers 5 × 7 vertical format for cards; 10 × 14 maximum. "Our primary interest is greeting cards." Produces seasonal material for all major and minor holidays including Jewish holidays. Submit seasonal material 18 months in advance; everyday cards are reviewed throughout the year.
First Contact & Terms: Send SASE for artist's guidelines. "I don't want slides or tearsheets–I am only interested in work done for our products." Reports in 2 months. Portfolio review not required. Originals returned at job's completion. Sometimes requests work on spec before assigning a job. Pays average flat fee of $250 for illustration/design with copy. Some royalty contracts. Buys all rights.
Tips: "Remember that a greeting card is primarily a message sent from one person to another. The art must catch the customer's attention, and the words must deliver what the front promises. We are looking for unique points of view and manners of expression. Our artists must be able to work with a minimum of direction and meet deadlines. There is a renewed interest in the use of recycled paper–we have been the industry leader in this for 22 years."

RED FARM STUDIO, 1135 Roosevelt Ave., Box 347, Pawtucket RI 02861. (401)728-9300. Fax: (401)728-0350. Contact: Creative Director. Estab. 1955. Produces greeting cards, giftwrap and stationery. Specializes in nautical and traditional themes and fine watercolors. Approached by 150 freelance artists/year. Works with 20 freelancers/year. Buys 200 freelance design and illustrations/year. Uses freelancers for greeting cards, notes, Christmas cards. Considers watercolor. Looking for accurate, detailed, realistic work. Produces material for Christmas, Mother's Day, Father's Day, Easter, birthdays and everyday.
First Contact & Terms: First send query letter and #10 SASE to request art guidelines. Submit slides, transparencies, photographs, SASE. "Do not send sketches." Samples not filed are returned by SASE. Art Director will contact artist for portfolio review if interested. Originals not returned. Pays flat fee of $250-300 for illustration/design; or pays by the project, $200-300. Buys all rights.
Tips: "We are interested in realistic, fine art watercolors of traditional subjects like nautical scenes, flowers, birds, shells and landscapes. No photography."

REEDPRODUCTIONS, Suite B, 2175 Francisco Blvd., San Rafael CA 94901. (415)456-8267. Partner/Art Director: Susie Reed. Estab. 1978. Produces celebrity postcards, key rings, magnets, address books, etc.
Needs: Approached by 20 artists/year. Works with few artists/year. Prefers local artists with experience. Works on assignment only. Artwork used for paper and gift novelty items. Also for paste-up and mechanicals. Prefers color or b&w photorealist illustrations of celebrities.
First Contact & Terms: Send query letter with brochure or résumé, tearsheets, photostats, photocopies or slides and SASE. Samples are filed or are returned by SASE. Art Director will contact artist for portfolio review if interested. Portfolio should include color or b&w final art, final reproduction/product, slides, tearsheets and photographs. Originals are returned at job's completion. Payment negotiated at time of purchase. Considers buying second rights (reprint rights) to previously published work.
Tips: "We specialize in products related to Hollywood memorabilia."

REGENCY & CENTURY GREETINGS, 1500 W. Monroe St., Chicago IL 60607. (312)666-8686. Fax: (312)243-0590. Art Director: David Cuthbertson. Estab. 1921. Publishes Christmas cards, traditional and some religious.
Needs: Approached by 300 freelance artists/year. Buys 150 freelance illustrations and designs/year. Prefers airbrush, watercolor, acrylic, oil and calligraphy. Prefers traditional themes. Submit seasonal art 8 months in advance.
First Contact & Terms: Send query letter with relevant, current samples. Art Director will contact artist for portfolio review if interested. Originals can be returned to artist at job's completion. Requests work on spec before assigning a job. Pays average flat fee of $300. **Pays on acceptance.** Buys exclusive Christmas card reproduction rights. Interested in buying second rights (reprint rights) to previously published artwork.
Tips: Finds artists through magazines and art fairs. "Request artist's guidelines to become familiar with the products and visit stationery shops for ideas. Portfolio should include published samples. Traditional still sells best in more expensive lines, but will review contemporary designs for new lines." Sees an "increased need for Christmas/holiday cards appropriate for businesses to send their customers."

RENAISSANCE GREETING CARDS, Box 845, Springvale ME 04083. (207)324-4153. Fax: (207)324-9564. Art Director: Janice Keefe. Estab. 1977. Publishes greeting cards; "current approaches" to all-occasion cards, seasonal cards, Christmas cards including nostalgic themes. "Alternative card company with unique variety of cards for all ages and situations."
Needs: Approached by 400-500 artists/year. Buys 250 illustrations/year. Full-color illustrations only. Produces materials for all seasons and holidays and everyday. Submit art 18 months in advance for fall and Christmas material; approximately 1 year in advance for other holidays.
First Contact & Terms: Request artist's guidelines, include SASE. To show portfolio, mail color copies, tearsheets, slides or transparencies. Packaging with sufficient postage to return materials should be included in the submission. Reports in 2 months. Originals are returned to artist at job's completion. Sometimes requests work on spec before assigning a job. Pays for design by the project, $125-300 advance on royalties or flat fee, negotiable.
Tips: Finds artists mostly through artists' submissions/self-promotions. "Currently interested in humorous concepts and illustration. Start by sending a small (10-12) sampling of 'best' work, preferably color copies or slides (with SASE for return). Indicate if the work shown is available or only samples. We're doing more designs with special effects like die-cutting and embossing."

THE ROSENTHAL JUDAICA COLLECTION, by Rite Lite, 260 47th St., Brooklyn NY 11220. (718)439-6900. Fax: (718)439-5197. Vice President Product Design: Rochelle Stern. Estab. 1948. Manufacturer and distributor of a full range of Judaica ranging from mass-market commercial goods to exclusive numbered pieces. Clients: department stores, galleries, gift shops, museum shops and jewelry stores.
Needs: Approached by 40 freelance artists/year. Works with 4 freelance designers/year. Works on assignment only. Uses freelance artists mainly for new designs for Judaic giftware. Prefers ceramic and brass. Also uses artists for brochure and catalog design, illustration and layout and product design. Needs computer-literate freelancers for design. 20% of freelance work demands computer skills.

First Contact & Terms: Send query letter with brochure or résumé, tearsheets and photographs. Do not send originals. Samples are filed. Reports back only if interested. Portfolio review not required. Art Director will contact artist for portfolio review if interested. Portfolio should include original/final art and color tearsheets, photographs and slides. Pays flat fee of up to $500 for illustration/design; or royalties of 5%. Buys all rights. "Works on a royalty basis."
Tips: Finds artists through word of mouth.

‡**ST. ARGOS CO., INC.,** 11040 W. Hondo Pkwy., Temple City CA 91780. (818)448-8886. Fax: (818)579-9133. Manager: Roy Liang. Estab. 1987. Produces greeting cards, Christmas decorations, paper boxes, tin boxes, bags, puzzles, cards and giftwrap.
Needs: Approached by 3 freelance artists/year. Works with 2 freelance artists/year. Buys 3 freelance designs and illustrations/year. Prefers artists with experience in Victorian or country style. Uses freelance artists mainly for design. Produces material for all holidays and seasons. Submit seasonal material 6 months in advance.
First Contact & Terms: Send query letter with résumé and slides. Samples are filed. Art Director will contact artist for portfolio review if interested. Portfolio should include color samples. Originals are not returned. Pays royalties of 7.5%. Negotiates rights purchased.

SALUDOS, USA, Box 2445, Danbury CT 06813. (203)744-1977. Creative Art Director: Secundino Paulino. Estab. 1992. "Produces greeting cards directed toward the Hispanic/American market. Cards are produced with bilingual messages for everyday and seasonal uses for ages 18-50. We prefer colorful, festive, upbeat, emotional work."
Needs: Approached by 35-45 artists/year. Works with 15 freelancers/year. Buys 50-75 designs and illustrations. Prefers artists with "strong communication talents who complete projects on time." Works on assignment only. Uses freelancers mainly for illustration. Also for calligraphy. Considers pastel, watercolor, colored pencil, oil, acrylic, mixed media, photography, graphics. Must be proportional to 5×7. Produces material for friendship, birthday, get well, Mother's Day, Father's Day, graduation, Christmas, Three Kings Day, general and religious.
First Contact & Terms: Send query letter with SASE, tearsheets, photographs, color photocopies, slides and transparencies. Samples are filed and are returned by SASE if requested by artist. Samples without SASE will not be returned. Art Director will contact artist for portfolio review if interested. Do not send originals. Negotiates rights purchased. Originals are returned at job's completion. Sometimes requests work on spec before assigning a job. Pays average flat fee of $150 for illustration/design; by the hour, $8-10; by the project, $100-200; or royalties of 15%. Interested in buying second rights (reprint rights) to previously published work.
Tips: Finds artists through submissions, word of mouth and reps. "Send résumé only if available. We favor artists with varied styles capable of working in various media, whose work is classy, colorful, festive, emotional, upbeat, expressive."

SARUT INC., 107 Horatio, New York NY 10014. (212)691-9453. Fax: (212)691-1077. Vice President Marketing: Frederic Rambaud. Estab. 1979. Produces museum quality science and nature gifts. "Marketing firm with 6 employees. 36 trade shows a year. No reps. All products are exclusive. Medium- to high-end market."
Needs: Approached by 4-5 freelance artists/year. Works with 4 freelancers/year. Uses freelancers mainly for new products. Seeks contemporary designs. Produces material for all holidays and seasons.
First Contact & Terms: Samples are returned. Reports back within 2 weeks. Write for appointment to show portfolio. Rights purchased vary according to project.
Tips: "We are looking for concepts. Products not automatically graphics."

‡**SCANDECOR INC.,** 430 Pike Rd., Southampton PA 18966. (215)355-2410. Creative Director: Lauren B. Harris. Produces posters, calendars and greeting cards.
Needs: Looking for cute and trendy designs mainly for posters for boys, girls and teens. Prefers illustrations and airbrush work.
First Contact & Terms: Samples not filed are returned by SASE. Artist should follow-up after initial query. Art Director will contact artist for portfolio review if interested. Portfolio should include color slides, photostats and photographs. Originals are sometimes returned at job's completion. Requests work on spec before assigning a job. Negotiates rights purchased.
Tips: Finds artists through magazines, submissions, gift shows and art fairs. "In the future more manufacturers will have to target superstores and become competitive in the global environment. My guess is there will be smaller groups of large manufacturing to serve the superstores and more specialization for others in the small gift market."

SCHMID, 55 Pacella Park Dr., Randolph MA 02368. (617)961-3000. Fax: (617)986-8168. Product Development: Elizabeth Hazelton. Estab. 1930. Manufacturer and distributor producing giftware such as music boxes, figurines and picture frames in earthenware, porcelain and resin. Clients: gift shops, department stores, jewelry stores, specialty shops and catalogs.

Needs: Assigns 30-60 jobs/year. Prefers artists with experience in giftware or greeting card design. Works on assignment only. Uses freelancers mainly for product design. "We assign concept art and freelancer is responsible for pencil roughs and sometimes color once pencil concept is approved."

First Contact & Terms: Send query letter with photocopies and other nonreturnable samples. Samples are filed or are returned by SASE only if requested by artist. Art Director will contact artist for portfolio review if interested. Portfolio should include roughs, final art, color and b&w tearsheets. Pays for design and illustration by the project. Considers complexity of project and how work will be used when establishing payment. Buys all rights.

Tips: Finds artists through artists' submissions/self-promotions, art fairs and word of mouth. "A 'greeting card style' is a plus. We are looking for illustrators who can portray figures and/or animals, suitable for 3-D production. It is helpful if you explain how your work would fit into the 3-D gift industry or our company. We would appreciate being sent pieces we can keep on file. Tearsheets of what you already have on the market give us a good idea of where to utilize your talents."

■**SCOTT CARDS INC.**, Box 906, Newbury Park CA 91319. (805)498-2777. President: Larry Templeman. Estab. 1985. Produces greeting cards for contemporary adults of all ages.

Needs: Buys 75 freelance designs/year. "We will double that amount this year if submissions warrant." Prefers pen & ink. Looking for "hard-edged cartoons appealing to sophisticated adults. We like humorous, sensitive and romantic messages aimed at modern adult relationships: single, married, friends, work, etc. No rhymed verse. Heavy emphasis on birthdays."

First Contact & Terms: Send query letter with brochure or photocopies and SASE. Samples are filed or are returned by SASE. Reports back within 4 months. Portfolio review not required. Pays minimum flat fee of $50 for cartoons, design and illustration." Buys all rights.

Tips: Finds artists first through word of mouth and then through publications. "New ways to say 'I love you' always sell if they aren't corny or too obvious. Humor helps, especially if it twists. We are looking for nontraditional sentiments that are sensitive, timely and sophisticated. Our cards have a distinct flavor, so before submitting your work, write for our guidelines and samples brochure. We see good growth ahead for the industry."

*****SECOND NATURE, LTD.**, 10 Malton Rd., London, W105UP England. (01)960-0212. Art Director: David Roxburgh. Produces greeting cards and giftwrap. "High-end, higher-priced product mainly for women 15-40 years old."

Needs: Prefers interesting new contemporary but commercial styles. Produces material for Christmas, Valentine's Day, Mother's Day, and Father's Day. Submit seasonal material 18 months in advance.

First Contact & Terms: Send query letter with brochure showing art style. Samples not filed are returned only if requested by artist. Reports back within 2 months. Call or write for appointment to show portfolio. Originals are not returned at job's completion. Pays $300 for illustration/design. Negotiates rights purchased.

Tips: "We are interested in all forms of paper engineering."

■**SHERRY MFG. CO., INC.**, 3287 NW 65th St., Miami FL 33147. Fax: (305)691-6132. Art Director: Jeff Seldin. Estab. 1948. Manufacturer of silk-screen T-shirts with beach and mountain souvenir themes. Label: Sherry's Best. Clients: T-shirt retailers. Current clients include Walt Disney Co., Club Med and Kennedy Space Center.

Needs: Approached by 50 freelance artists/year. Works with 15 freelance designers and illustrators/year. Assigns 350 jobs/year. Prefers artists that know the T-shirt market and understand the technical aspects of T-shirt art. Prefers colorful graphics or highly stippled detail. Needs computer-literate freelancers for design and illustration. 25% of freelance work demands knowledge of Adobe Illustrator, Aldus FreeHand, Photoshop, Typestyler or Stratavision.

First Contact & Terms: Send query letter with brochure showing art style or résumé, photostats and photocopies. Samples are not filed and are returned only if requested. Art Director will contact artist for portfolio review if interested. Portfolio should include thumbnails, roughs, original/final art, final reproduction/product and color tearsheets, photostats and photographs. Sometimes requests work on spec before assigning a job. Pays average flat fee of $250. Considers complexity of project, skill and experience of artist, and volume of work given to artist when establishing payment. Buys all rights.

Tips: "Know the souvenir T-shirt market and have previous experience in T-shirt art preparation. Some freelancers do not understand what a souvenir T-shirt design should look like. Send sample copies of work with résumé to my attention."

SMART ART, P.O. Box 661, Chatham NJ 07928. (201)635-1690. President: Barb Hauck-Mah. Vice President: Christine Hauck. Estab. 1992. Produces greeting cards, stationery, photo frame cards and invitations. "Smart Art creates pen & ink cards with a warm, gentle humor. We contribute a portion of all profits to organizations dedicated to helping our nation's kids."

• Smart Art no longer requires computer design skills.

Needs: Approached by 40-50 freelance artists/year. Works with 12 freelancers/year. Buys 50-75 illustrations/year. Prefers artists with experience in children's book illustration. Works on assignment only. Uses freelanc-

ers for card design/illustration and photography. Considers watercolor and pen & ink. Produces material for most holidays and seasons, plus birthdays and everyday. Submit seasonal material 10-12 months in advance.
First Contact & Terms: Send query letter with tearsheets, photocopies, résumé and SASE. Samples are filed or returned by SASE. Reports back within 6-8 weeks. Portfolio review not required. Sometimes requests work on spec before assigning a job. Originals are returned at job's completion. Pays royalties of 4%. Negotiates rights purchased.
Tips: Finds artists through word of mouth and trade shows.

SPENCER GIFTS, INC., 6826 Black Horse Pike, Pleasantville NJ 08232. (609)645-5526. Fax: (609)645-8062. Art Director: James Stevenson. Estab. 1965. Retail gift chain located in approximately 500 malls in 43 states.
• Products offered by this chain include posters, T-shirts, games, mugs, novelty items, cards and 14k jewelry. Visit a store if you can to get a sense of what they offer.
Needs: Assigns 12-20 freelance jobs/year. Prefers artists with professional experience in advertising. Uses artists for illustration (hard line art, fashion illustration, airbrush). Needs computer-literate freelancers for illustration. 20% of freelance work demands knowledge of Aldus FreeHand, Adobe Illustrator and Photoshop.
First Contact & Terms: Send query letter with nonreturnable samples of previously published work including phone number where you can be reached during business hours. Art Director will contact artist for portfolio review if interested. Pays flat fee of $500. Will contact only upon job need. Considers buying second rights (reprint rights) to previously published work.
Tips: Finds artists through sourcebooks. "Send examples of airbrush art."

‡STUART HALL CO., INC., Box 419381, Kansas City MO 64141. Director of Advertising and Art: Judy Riedel. Produces stationery, school supplies and office supplies.
Needs: Approached by 30 freelance artists/year. Buys 40 freelance designs and illustrations/year. Artist must be experienced—no beginners. Works on assignment only. Uses freelance artists for design, illustration, calligraphy on stationery, notes and tablets, and paste-up and mechanicals. Considers pencil sketches, rough color, layouts, tight comps or finished art; watercolor, gouache, or acrylic paints are preferred for finished art. Avoid fluorescent colors. "All art should be prepared on heavy white paper and lightly attached to illustration board. Allow at least one inch all around the design for notations and crop marks. Avoid bleeding the design. In designing sheet stock, keep the design small enough to allow for letter writing space. If designing for an envelope, first consult us to avoid technical problems."
First Contact & Terms: Send query letter with résumé, tearsheets, photostats, slides and photographs. Samples not filed are returned by SASE. Reports only if interested. Art Director will contact artist for portfolio review if interested. Portfolio should include roughs, original/final art, final reproduction/product, color, tearsheets, photostats and photographs. Originals are not returned. "Stuart Hall may choose to negotiate on price but generally accepts the artist's price." Buys all rights.
Tips: Finds artists primarily through word of mouth.

SUN HILL INDUSTRIES, INC., 48 Union St., Stamford CT 06906. Fax: (203)356-9233. Creative Director: Nancy Mimoun. Estab. 1977. Manufacturer of Easter egg decorating kits, Halloween novelties (the Giant Stuff-A-Pumpkin®) and Christmas items. Produces only holiday material. Clients: discount chain and drug stores and mail-order catalog houses. Clients include K-Mart, Walmart, Walgreens and Caldor.
Needs: Approached by 10 freelance artists/year. Works with 2-3 illustrators and 1-2 designers/year. Assigns 5-6 freelance jobs/year. Works on assignment only. Uses freelancers for product and package design, rendering of product and model-making. Prefers marker and acrylic. Needs computer-literate freelancers for design and presentation. 70% of freelance work demands knowledge of Aldus PageMaker, QuarkXPress and Adobe Illustrator.
First Contact & Terms: Send query letter with brochure and résumé. Samples are filed or are returned only if requested by artist. Reports back only if interested. Pays by the hour, $25 minimum; or by the project, $250 minimum. Considers complexity of project and turnaround time when establishing payment. Buys all rights.
Tips: "Send all information; don't call. Include package designs; do not send mechanical work."

SUNRISE PUBLICATIONS INC., Box 4699, Bloomington IN 47402. (812)336-9900. Fax: (812)336-8712. Administrative Assistant, Creative Services Dept.: Mary McClain. Estab. 1974. Produces greeting cards, posters, writing papers and related products.
Needs: Approached by 300 artists/year. Works with 200 artists/year. Buys 400 designs and illustrations/year. Uses freelancers mainly for greeting card illustration. Also for calligraphy. Considers any medium. Looking for "highly detailed, highly rendered illustration, but will consider a range of styles." Also looking for photography and surface design. 2% of freelance work demands computer skills. Produces material for all holidays and seasons and everyday. Reviews seasonal material year-round.
First Contact & Terms: Send query letter with SASE, tearsheets, photographs, photocopies, photostats, slides and/or transparencies. Samples are not filed and are returned by SASE. Reports back within 2 weeks for queries regarding status; submissions returned within 3 months. Art Director will contact artist for portfo-

lio review if interested. Portfolio should include color tearsheets, photographs and/or slides (duplicate slides or transparencies, please; *not* originals). Originals are returned at job's completion. Pays flat fee, $350 minimum. Negotiates rights purchased. Considers buying second rights (reprint rights) to previously published work.
Tips: Finds artists through word of mouth, magazines, artists' submissions/self-promotions, sourcebooks, agent, visiting artists' exhibitions, art fairs and artists' reps.

SUNSHINE ART STUDIOS, INC., 45 Warwick St., Springfield MA 01102. (413)781-5500. Contact: Art Director. Estab. 1921. Produces greeting cards, stationery, calendars and giftwrap which are sold in own catalog, appealing to all age groups.
Needs: Works with 100-125 freelance artists/year. Buys 200-250 freelance designs and illustrations/year. Prefers artists with experience in greeting cards. Works on assignment only. Uses freelancers mainly for greeting cards, giftwrap and stationery. Also for calligraphy. Considers gouache, watercolor and acrylic. Looking for "cute animals, florals and traditional motifs." Prefers art 4½×6½ or 5×7. Produces material for Christmas, Easter, birthdays and everyday. Submit seasonal material 6-8 months in advance.
First Contact & Terms: Send query letter with brochure, résumé, SASE, tearsheets and slides. Samples are filed or are returned by SASE if requested by artist. Reports back to the artist only if interested. Portfolio should include finished art samples and color tearsheets and slides. Originals not returned. Pays by the project, $250-400. Buys all rights.

SUPER-CALLI-GRAPHICS, 425 E. Hyde Park, Inglewood CA 90302. (310)677-4171. Fax: (310)677-4911. Owner: Marcia Miller. Estab. 1978. Produces stationery and trendy desk accessories and gifts for children and teenagers.
Needs: Works with 12 freelance artists/year. Buys 100 freelance designs and illustrations/year. Prefers local artists only. Works on assignment only. Uses freelancers mainly for design and paste-up. Also for mechanicals. Needs computer-literate freelancers for design, illustration and production. Looking for "colorful, modern, trendy" work. Produces material for Christmas, Valentine's Day, Easter and Halloween. Submit seasonal material 1 year before holiday.
First Contact & Terms: Send query letter with photocopies. Samples are filed and are not returned. Reports back to the artist only if interested. To show portfolio, mail appropriate color materials. Originals are not returned. Pays by the hour, $10-25; or by the project, $100 minimum. Buys all rights.

‡CURTIS SWANN, Division of Burgoyne, Inc., 2030 E. Byberry Rd., Philadelphia PA 19116. (215)677-8000. Fax: (215)677-6081. Contact: Creative Director. Produces greeting cards. Publishes everyday greeting cards based on heavily embossed designs. Style is based in florals and "cute" subjects.
Needs: Works with 10 freelancers/year. Buys 20 designs and illustrations. Prefers artists with experience in greeting card design. Considers designs and media that work well to enhance embossing. Produces material for everyday designs as well as Christmas, Valentine's, Easter, Mother's and Father's Day. Accepts work all year round.
First Contact & Terms: Send query letter with slides, transparencies, photocopies and SASE. Samples are filed. Creative Director will contact artist for portfolio review if interested. Sometimes requests work on spec before assigning a job. Payment depends on project. Buys first rights or all rights.

A SWITCH IN ART, GERALD F. PRENDERVILLE, INC., P.O. Box 246, Monmouth Beach NJ 07750. (908)389-4912. Fax: (908)389-4913. President: G.F. Prenderville. Estab. 1979. Produces decorative switch plates. "We produce decorative switch plates featuring all types of designs including cats, animals, flowers, kiddies/baby designs, birds, etc. We sell to better gift shops, museums, hospitals, specialty stores with large following in mail order catalogs."
Needs: Approached by 4-5 freelance artists/year. Works with 2-3 freelancers/year. Buys 30-50 designs and illustrations/year. Prefers artists with experience in card industry and cat rendering. Seeks cats and wildlife art. Prefers 8×10 or 10×12. Produces material for Christmas and everyday. Submit seasonal material 6 months in advance.
First Contact & Terms: Send query letter with brochure, tearsheets and photostats. Samples are filed and are returned. Reports back within 2-3 weeks. Pays by the project, $75-300. Interested in buying second rights (reprint rights) to previously published artwork.
Tips: Finds artists mostly through word of mouth. "Be willing to accept your work in a different and creative form that has been very successful. We seek to go vertical in our design offering to insure continuity. We are very easy to work with and flexible. Cats have a huge following among consumers but designs must be realistic."

TLC GREETINGS, 615 McCall Rd., Manhattan KS 66502. Fax: (913)776-4041, ext. 232. Creative Director: Michele Johnson. Estab. 1986. Produces stationery and gift items, plus figurines and collectibles.
 • TLC uses a variety of designs, and is continually expanding with new styles. Also expanding to cater to male audience and the college market.

Needs: Works with 8 freelance artists/year. Buys 20 designs/year. Works on assignment only. Open to any media. "Our cards are 5×7; can work with larger size."

First Contact & Terms: Send query letter with brochure, photocopies and SASE. Samples are filed or are returned by SASE. Art Director will contact artist for portfolio review if interested. Portfolio should include slides, tearsheets and photostats. Sometimes requests work on spec before assigning a job. Pays average flat fee of $300 or royalties of 5% for illustration/design. Negotiates rights purchased.

Tips: Artists "see our name in *Artist's & Graphic Designer's Market* and trade publications; we also find them through word of mouth. We're looking for unique, unpublished illustrations. Send clear copies for our files. Don't send too much. Party invitations seem to be a popular line."

After reading about West Graphics in Artist's & Graphic Designer's Market, Jerry King submitted a few samples including "Joan's Wish." The image was originally rendered in pen & ink, then scanned into a Macintosh for colorization in Adobe Photoshop by Brian Fearon of West Graphics. The artist was paid a flat fee against 5% royalties for his men-bashing design. Inside copy reads "Hope this year is a lucky one!!"

VAGABOND CREATIONS INC., 2560 Lance Dr., Dayton OH 45409. (513)298-1124. Art Director: George F. Stanley, Jr. Publishes stationery and greeting cards with contemporary humor. 99% of artwork used in the line is provided by staff artists working with the company.

Needs: Works with 4 freelance artists/year. Buys 30 finished illustrations/year. Prefers local artists. Seeking line drawings, washes and color separations. Material should fit in standard size envelope.

First Contact & Terms: Query. Samples are returned by SASE. Reports in 2 weeks. Submit Christmas, Mother's Day, Father's Day, Valentine's Day, everyday and graduation material at any time. Originals are returned only upon request. Payment negotiated.

Tips: "Important! Important! Currently we are *not* looking for additional freelance artists because we are very satisfied with the work submitted by those individuals working directly with us. We do not in any way wish to offer false hope to anyone, but it would be foolish on our part not to give consideration. Our current artists are very experienced and have been associated with us for in some cases over 30 years."

‡WARNER PRESS, INC., 1200 E. Fifth St., Anderson IN 46018. (317)644-7721, ext. 217. Fax: (317)649-3664. Art Manager: Roger Hoffman. Estab. 1884. Produces greeting cards, posters, stationery, calendars, church bulletins and supplies. Warner Press is the publication board of the Church of God. "We produce products for the Christian market including greeting cards, calendars and posters. Our main market is the Christian bookstore, but we are expanding into general market with some items. We provide products for all ages."

Needs: Approached by 50 freelance artists/year. Works with 35-40 freelance artists/year. Buys 600 freelance designs and illustrations/year. Prefers artists with experience in greeting cards, posters, calendars, books and giftware—must adhere to deadline and produce quality work. Works on assignment only. Uses freelance artists for all products—cards, coloring books, calendars, stationery, etc. Also uses freelance artists for calligraphy. "We use local Macintosh artists with own equipment capable of handling 50 megabyte files in Photo-

Shop, FreeHand and QuarkXPress." Considers all media and photography. Looking for bright florals, sensitive still lifes, landscapes, wildlife, birds, seascapes; all handled with bright or airy pastel colors. Needs computer-literate freelancers for production. 100% of production work demands knowledge of QuarkXPress, Aldus FreeHand, Adobe Illustrator or Adobe Photoshop. Produces material for Father's Day, Mother's Day, Christmas, Easter, graduation, birthdays, Valentine's Day and everyday. Submit seasonal 18 months in advance.

First Contact & Terms: Send query letter with brochure, tearsheets and photocopies. Samples are filed and are not returned. Reports back within 1 month. Art Manager will contact artist for portfolio review if interested. Portfolio should include b&w and color final art, tearsheets, photographs and transparencies. Originals are not returned. Pay by the project, $250-350. Pays for calligraphy pieces by the project. Buys all rights (occasionally varies).

Tips: "Subject matter must be appropriate for Christian market. We prefer palettes of brights colors as well as clean, pretty pastels for greeting cards and calendars. Dramatic palettes work in our poster line."

WEST GRAPHICS, #7, 385 Oyster Point Blvd., San Francisco CA 94080. (800)648-9378. Fax: (415)588-5552. Contact: Production Department. Estab. 1980. "West Graphics is an alternative greeting card company offering a diversity of humor from 'off the wall' to 'tastefully tasteless.' Our goal is to publish cards that challenge the limits of taste and keep people laughing." Produces greeting cards, postcards, note pads and gift bags.

Needs: Approached by 100 freelance artists/year. Works with 40 freelancers/year. Buys 150 designs and illustrations/year. Uses freelancers mainly for illustration. "All other work is done inhouse." Considers all media. Looking for outrageous contemporary illustration and "fresh new images on the cutting edge." Prefers art proportionate to finished vertical size of 5×7, no larger than 10×14. Produces material for all holidays and everyday (birthday, get well, love, divorce, congratulations, etc.) Submit seasonal material 1 year in advance.

First Contact & Terms: Send query letter with résumé, SASE, tearsheets, photocopies, photostats, slides and transparencies. Samples should relate to greeting card market. Samples are not filed and returned by SASE if requested by artist. Reports back within 6 weeks. Company will contact artist for portfolio review if interested. Portfolio should include thumbnails, roughs, photostats, color tearsheets, photographs, slides, dummies and samples of printed work if available. Rights purchased vary. Pays by the project, $100-350, or offers royalties of 5%.

Tips: "We welcome both experienced artists and those new to the greeting card industry. Develop art and concepts with an occasion in mind such as birthday, etc. Our most successful cards humorously capture the contradiction between innocence and that which surprises, shocks or insults. Your target should be issues that women care about: men, children, relationships, sex, religion, aging, success, money, crime, health, etc. Increasingly, there is a younger market and more cerebral humor. Greeting cards are becoming a necessary vehicle for humorously communicating genuine sentiment that is uncomfortable to express personally."

WILLIAMHOUSE-REGENCY, INC., 28 W. 23rd St., New York NY 10010. Executive Art Director: Nancy Boecker. Estab. 1955. Produces wedding invitations and announcements, Christmas cards and stationery.

Needs: Approached by 30 freelance artists/year. Works with 10 freelancers/year. Buys 50 designs and illustrations/year. "Prefers artists with experience in our products and techniques (including foil and embossing)." Uses freelancers mainly for design and illustration of wedding invitations. Also for calligraphy. Considers all media. Produces material for personalized Christmas, Rosh Hashanah, New Year, graduation, wedding invitations and birth announcements. Submit seasonal material 1 year in advance.

First Contact & Terms: Send query letter with SASE. Samples are not filed and are returned by SASE. Reports back within 3 weeks. Artist should follow-up with letter after initial query. Portfolio should include roughs and dummies. Pays average flat fee of $150/design. Buys reprint rights or all rights.

Tips: "Send in any roughs or copies of finished ideas you have, and we'll take a look. Write for specs on size first (with SASE) before submitting any material. In wedding invitations, we seek a non-greeting card look. Have a look at what is out there."

CAROL WILSON FINE ARTS, INC., Box 17394, Portland OR 97217. (503)283-2338 or 281-0780. Contact: Gary Spector. Estab. 1983. Produces greeting cards, posters and stationery from contemporary to nostalgic. "Currently we are actively looking for unusual humor to expand our contemporary humor line. We want cards that will make people laugh out loud! Another category we also wish to expand is fine arts."

Needs: Approached by hundreds of artists/year. Uses artists for product design and illustration of greeting cards. Considers all media. Prefers humorous cartoons and fine art. Produces material for Christmas, Valentine's Day and Mother's Day. Submit seasonal material preferably 1 year in advance.

First Contact & Terms: Send query letter with résumé, business card, tearsheets, photostats, photocopies, slides and photographs to be kept on file. No original artwork on initial inquiry. Write for an appointment to show portfolio or for artist's guidelines. "All approaches are considered, but we prefer to see ideas that are applicable to specific occasions, such as birthday, anniversary, wedding, new baby, etc. We look for artists with creativity and ability." Samples not filed are returned by SASE. Reports within 2 months. Negotiates return of original art after reproduction. Payment ranges from flat fee to negotiated royalties.

Tips: "We are seeing an increased interest in romantic fine-arts cards and very elegant products featuring foil, embossing and die-cuts."

Greeting Cards, Gift Items and Paper Products/ '94-'95 changes

The following companies were listed in the 1994 edition but do not have listings in this edition. The majority did not respond to our request to update their listings. If a reason was given for a company's exclusion, it appears in parentheses after the company's name.

Africa Card Co. Inc.
American Greetings Corporations
Amscan Inc.
Beach Product
Bonita Pioneer Packaging
Chicago Computer and Light, Inc.
Clay Art
Create-A-Craft
Design Design, Inc.
Earth Card, Inc.
Earth Care Paper Inc.
Encore Studios, Inc.
Enesco Corporation
Epic Products Inc.
Fairchild Art/Fairchild Phoenix
Fantazia Marketing Corp.
Fisher-Price
Freedom Greetings
Freline, Inc.

Gallery Graphics
Glitterwrap, Inc.
The Great Northwestern Greeting Seed Company
Greetwell
Jan Hagara Collectibles, Inc. (per request)
Hampshire Pewter Company
H&L Enterprises
idesign Greetings, inc.
Jillson & Roberts, Inc.
Kipling Cartoons & Creative Dare Devils
Lookinglass, Inc.
Montgomery Publishing, Agency & Studio
Mug Shanty
Namemaker Corp.
New Deco, Inc.
Norse Products
North East Marketing Systems

(NEMS)
Ooz & Oz, Inc.
P.S. Greetings, Inc.
Painted Hearts & Friends
Pangaea Ltd.
Paper Impressions
Paper Magic Group Inc.
Paper Moon Graphics, Inc.
Paramount Cards, Inc.
Passerine Press, Publishers
Quincrafts Corporation
Russ Berrie and Company
Securitag Corp.
TLC Greetings
Tristopher's Greeting Cards Inc.
U.S. Allegiance, Inc (per request)
Vintage Images
Xsend-Trix Cards

Magazines

This section offers one of the best and most consistent markets for freelance art. Magazines have cartoon and illustration needs that must be filled. The best proof of this fact is as close as your nearest newsstand. The colorful publications competing for your attention are chock-full of interesting illustrations, cartoons and caricatures. Magazines are generally published on a monthly or bimonthly basis, requiring art directors to constantly be on the lookout for dependable artists who can deliver on deadline quality artwork with a particular style and focus.

Art that illustrates a story in a magazine or newspaper is called editorial illustration. You'll notice that term as you browse through the listings. Art directors look for the best visual element to hook the reader into the story. In some cases this is a photograph, but often, especially in stories dealing with abstract ideas or difficult concepts, an illustration makes the story more compelling. A whimsical illustration sets the tone for a humorous article and a caricature might dress up a short feature about a celebrity.

Attractive art won't be enough to grab a magazine assignment. Your work must convey the tone and content of a writer's article. Good illustrators accomplish this whether their style is realistic or they specialize in simple line drawings. Even though you may be versatile, impress art directors with your proficiency in a certain style. It's easier for them to think in terms of "the guy who does the frantic wiggly line drawings," or "the woman who does the realistic portraits," than somebody whose talents are all over the map.

Targeting your approach

The key to success in the magazine arena is matching and adapting your style and subject matter to appropriate publications. Art directors work to achieve a chemistry between artist and magazine, creating a relationship in which the artwork and editorial content complement each other.

Consumer magazines, in the broadest sense of the term, appeal to the public at large, while trade publications focus on an audience involved in a particular profession. But in light of the current movement toward specialization, it's more important than ever to look beyond these classifications and study the unique personalities of individual magazines before submitting samples. Magazine art directors expect prospective freelancers to understand their publication's focus and audience, and they expect any samples submitted to reflect this understanding.

Before submitting, research the market by visiting a newsstand or library. If you can't find a magazine, check the listing in *Artist's & Graphic Designer's Market* to see if sample copies are available. Keep in mind that many magazines also provide artists' guidelines in exchange for a SASE.

Once you've identified some magazines you'd like to approach, study them closely, taking note of the styles and themes they prefer. Many magazines have distinct visual personalities and consequently may be reluctant to experiment with work unlike that which they already use. Also, keep in mind that not all magazines use color work.

While virtually all publication design is Mac-generated, illustration is more subjective. Some art directors prefer electronic illustration, while others buy only hand-rendered work. If you are a computer artist you'll want to check for specifics before submitting.

Submitting samples

It's fairly standard practice to mail nonreturnable samples along with a brief cover letter of introduction. Some art directors like to see a résumé; some don't. If you are a designer, a well-designed résumé can serve as a testimony to your creative talent. Send a résumé if you think it will build a stronger case for you. Always include a self-addressed, stamped envelope large enough to accommodate your samples, but indicate that the director is welcome to keep samples on file.

Persistence pays off in this field if your work is good, your attitude professional and your target market appropriate. Don't be afraid to send in new samples as you acquire tearsheets and do new work. This reminds the art director that you're still interested in the publication and are available for assignments. Remember, however, to check the magazine's masthead for staff changes before submitting new material.

Some art directors still conduct portfolio reviews, although this practice has become somewhat antiquated. Check individual listings for information about whether such reviews are conducted. For more information on portfolios and sample packages, turn to page 20.

Fees

Many designers and illustrators do editorial work because of the creative freedom it affords. But the sacrifice for this freedom is sometimes in the payment. Rates for editorial work are generally lower than those for advertising and packaging work.

Even so, it's hard to put a price on magazine work. Fees vary widely, depending on the assignment, rights purchased, experience of the freelancer and on the magazine's budget. Widely circulated publications often boast large pay scales, while those with smaller circulations — particularly literary or "little" magazines — sometimes pay only in copies. Keep in mind, however, that there are advantages to publishing in small magazines, despite their low payment. They're often more open to experimental work and to new artists. Such markets have been highlighted with a solid black box in this section. Also note that the term "**pays on acceptance**" appears in boldface within the listings. For more information on setting fees, turn to page 11.

A note about sourcebooks

On this year's new listing questionnaires, we asked art directors how they found artists for their publications. Although we were aware of the various directories and sourcebooks used by art directors, we did not realize the extent of their use. If an art director uses creative directories or sourcebooks we have included this information under the Tips subhead. The term "sourcebooks" as used in the listings, refers to the various creative directories published each year which showcase the work of photographers, illustrators and cartoonists. Some of the popular annual talent directories like *The Creative Black Book*, *The American Showcase* and *RSVP* carry paid advertisements, costing several thousand dollars per page, bought by illustrators and/or agents. Other annuals, like the *Print Regional Design Annual* and *Communication Art Illustration Annual* feature award winners of various competitions. Art directors frequently turn to these publications when looking for artists with interesting styles. In listings where the art director reports use of these publications, be aware that your competition is stiff, but do not let that deter you in your marketing plans. A great submission package will put your work in front of art directors and will be kept in their frequently referred to files. For more information on creative directories see Successful Self-Promotion on page 15.

‡■**ABERRATIONS**, P.O. Box 460430, San Francisco CA 94146-0430. Art Director: Eric Turowski. Estab. 1992. Monthly science fiction/fantasy/horror magazine aimed at an adult readership. Circ. 1,500. Originals returned at job's completion. Sample copies available for $3.50 plus 98¢ postage. Art guidelines available for SASE with first-class postage.

• *Aberrations* was recently purchased by a new publisher and Art Director Eric Turowski is "looking forward to working with a new crop of artists."

Illustrations: Approached by 58 illustrators/year. Buys 9-22 illustrations/issue. Works on assignment only. Prefers science fiction, fantasy, horor story illustrations. Considers pen & ink, watercolor, collage, airbrush, acrylic, marker, colored pencil, oil, charcoal, mixed media, pastel, "just about anything that's *camera-ready*." Send query letter with photocopies. Samples are filed. Reports back to the artist only if interested. "Mail a portfolio of 3-6 photocopies for our files." Pays on publication; $25 for b&w or color cover; $7 for b&w inside. Buys first rights.

Tips: Finds artists through submissions and queries. "We are mainly interested in pulp-styled b&w illustrations for the interior of the magazine. Covers are done with spot colors (no more than 3), so separations are required. Mail your samples *flat*. Tell us the kind of work you like to do, and what you don't like to do. We are eager to work with new artists, and we aren't hard to please. Also, we prefer camera-ready art, or as close to it as you are able. I tend to assign the art for several issues at a time, so don't be discouraged if I don't get back to you right away."

‡**ABORIGINAL SCIENCE FICTION**, Box 2449, Woburn MA 01888-0849. Editor: Charles C. Ryan. Estab. 1986. Quartery science fiction literary magazine for adult science fiction readers; b&w with 4-color cover; "straightforward design, with illustrations usually given full-page bleeds." Circ. 14,000. Sample copy $4.95; art guidelines for SASE with 1 first-class stamp.

Cartoons: Approached by 100 cartoonists/year. Buys 4-8 cartoons/year from freelancers. Prefers science fiction, science and space themes, unique styles. Prefers single panel or double panel with or without gagline, b&w line drawings, b&w washes and color washes. Send query letter with roughs. Samples are filed or are returned by SASE. Reports back within 2-3 months. Pays $25, b&w. Buys first rights or nonexclusive reprint rights.

Illustrations: Approached by 200 illustrators/year. Buys 40-48 illustrations/year from freelancers. Works on assignment only. Prefers science fiction, science and space themes. "Generally, we prefer art with a realistic edge, but surrealistic art will be considered." Prefers b&w drawings/paintings. Send query letter with photocopies and SASE. Samples are filed or are returned by SASE. Reports back within 2 months. Portfolio review not required. Pays on publication $350 color, cover; $125 b&w, inside. Buys first rights.

■**ACCENT ON LIVING**, Box 700, Bloomington IL 61702. Fax: (309)378-4420. Editor: Betty Garee. Estab. 1956. Quarterly magazine with emphasis on success and ideas for better living for the physically handicapped. 5×7 b&w with 4-color cover. Original artwork returned after publication if requested. Sample copy $2.

• Also publishes books for physically disabled adults under Cheever Publishing.

Cartoons: Approached by 30 cartoonists/year. Buys approximately 12 cartoons/issue. Receives 5-10 submissions/week from freelancers. Interested in seeing people with disabilities in different situations. Send finished cartoon samples and SASE. Reports in 2 weeks. **Pays on acceptance;** $20 b&w; $35 full page. Buys first-time rights (unless specified).

Illustrations: Approached by 20 illustrators/year. Uses 3-5 freelance illustrations/issue. Works on assignment only. Provide samples of style to be kept on file for future assignments. Samples not filed are returned by SASE. Reports in 2 weeks. **Pays on acceptance;** $35 for b&w cover; $75 for color cover; $35 for b&w and color inside. Buys first time rights.

‡**ADVENTURE CYCLIST**, 150 E. Pine, Missoula MT 59802. (406)721-1776. Fax: (406)721-8754. Art Director: Greg Siple. Estab. 1974. Published 9 times a year. A journal of adventure travel by bicycle. Circ. 26,000. Originals returned at job's completion. Sample copies available. Needs computer-literate freelancers for design, illustration and production. 50% of freelance work demands computer knowledge of QuarkXPress or Aldus FreeHand.

Illustrations: Buys 1 illustration/issue. Works on assignment only. Send query letter with transparencies. Samples are not filed and are returned. Reports back within 1 month. Publication will contact artist for portfolio review if interested. Portfolio should include color photocopies. Pays on publication; $150 for color cover; $50 for color inside. Buys one-time rights.

■**THE ADVOCATE**, 301A Rolling Hills Park, Prattsville NY 12468. (518)299-3103. Art Editor: C.J. Karlie. Estab. 1987. Bimonthly b&w literary tabloid. "*The Advocate* provides aspiring artists, writers and photographers the opportunity to see their works published and to receive byline credit toward a professional portfolio so as to promote careers in the arts." Circ. 12,000. "Good quality photocopy or stat of work is acceptable as a submission." Sample copies available for the cost of $3. Art guidelines for SASE with first-class postage.

Cartoons: Open to all formats except color washes. Send query letter with SASE and submissions for publication. Samples are not filed and are returned by SASE. Reports back within 2-6 weeks. Buys first rights. Pays in contributor's copies.

Illustrations: Buys 10-15 illustrations/issue. Considers pen & ink, charcoal, linoleum-cut, woodcut, lithograph, pencil. Also needs editorial and entertainment illustration. Send query letter with SASE and artwork submissions. No simultaneous submissions. Samples are not filed and are returned by SASE. Portfolio review not required. Reports back within 2-6 weeks. Buys first rights. Pays in contributor's copies.

Tips: Finds artists through submissions and from knowing artists and their friends. "Please remember SASE for return of materials. We hope to continue publishing 6 times per year and will need 10-15 illustrations per issue."

AGING TODAY, 833 Market St., San Francisco CA 94103. (415)974-9619. Fax: (415)882-4280. Editor: Paul Kleyman. Estab. 1979. "*Aging Today* is the bimonthly b&w newspaper of The American Society on Aging. It covers news, public policy issues, applied research and developments/trends in aging." Circ. 12,000. Accepts previously published artwork. Originals returned at job's completion if requested. Sample copies available. Art guidelines not available.

Cartoons: Approached by 25 cartoonists/year. Buys 1-2 cartoons/issue. Prefers political and social satire cartoons; single, double or multiple panel with or without gagline, b&w line drawings. Send query letter with brochure and roughs. Samples returned by SASE if requested by artist. Reports back to the artist only if interested. Buys one-time rights. Pays $15-25 for b&w.

Illustrations: Approached by 5 illustrators/year. Buys 1 illustration/issue. Works on assignment only. Prefers b&w line drawings and some washes. Considers pen & ink. Needs editorial illustration. Send query letter with brochure, SASE and photocopies. Samples are not filed and are returned by SASE if requested by artist. Reports back to the artist only if interested. Artist should follow-up with call and/or letter after initial query. Buys one-time rights. Pays on publication; $25 for b&w cover; $25 for b&w inside.

Tips: "Send brief letter with 2 or 3 applicable samples. Don't send hackneyed cartoons that perpetuate ageist stereotypes."

■**THE AGUILAR EXPRESSION,** Box 304, Webster PA 15087. (412)379-8019. Editor/Publisher: Xavier F. Aguilar. Estab. 1989. Biannual b&w literary magazine/newsletter. Circ. 150. Accepts previously published artwork. Originals not returned. Sample copies available for the cost of $5. Art guidelines for SASE with first-class postage.

Illustrations: Approached by 5-10 illustrators/year. Buys 1-2 illustrations/issue. Considers pen & ink. Also needs creative illustrations with 1 line caption. Send query letter with SASE and photocopies. Samples are not filed and are returned by SASE if requested by artist. Reports back within 1 month. Portfolio review not required. Sometimes requests work on spec before assigning job. Acquires one-time rights. No payment. Artist receives 1 copy and byline.

Tips: Finds artists through artist's submissions.

■**AIM,** Box 20554, Chicago IL 60620. (312)874-6184. Editor-in-Chief: Ruth Apilado. Managing Editor: Dr. Myron Apilado. Estab. 1973. 8½×11 b&w quarterly with 2-color cover. Readers are those "wanting to eliminate bigotry and desiring a world without inequalities in education, housing, etc." Circ. 7,000. Sample copy $4; artist's guidelines for SASE. Reports in 3 weeks. Previously published, photocopied and simultaneous submissions OK. Receives 12 cartoons and 4 illustrations/week from freelancers.

Cartoons: Buys 10-15 cartoons/year. Uses 1-2 cartoons/issue. Prefers education, environment, family life, humor in youth, politics and retirement; single panel with gagline. Especially needs "cartoons about the stupidity of racism." Send samples with SASE. Reports in 3 weeks. Buys all rights on a work-for-hire basis. Pays on publication; $5-15 for b&w line drawings.

Illustrations: Uses 4-5 illustrations/issue; half from freelancers. Prefers pen & ink. Prefers current events, education, environment, humor in youth, politics and retirement. Provide brochure to be kept on file for future assignments. Samples not returned. Reports in 1 month. Prefers b&w for cover and inside art. Buys all rights on a work-for-hire basis. Pays on publication; $25 for b&w cover illustrations.

Tips: "We could use more illustrations and cartoons with people from all ethnic and racial backgrounds in them. We also use material of general interest. Artists should show a representative sampling of their work and target the magazine's specific needs. Nothing on religion."

■**AMELIA,** 329 E St., Bakersfield CA 93304. (805)323-4064. Editor: Frederick A. Raborg, Jr. Estab. 1983. Quarterly magazine. Also publishes 2 supplements—*Cicada* (haiku) and *SPSM&H* (sonnets) and illustrated postcards. Emphasizes fiction and poetry for the general review. Circ. 1,250. Accepts some previously published material from illustrators. Original artwork returned after publication if requested with SASE. Sample copy $7.95; art guidelines for SASE.

Cartoons: Buys 3-5 cartoons/issue for *Amelia*. Prefers sophisticated or witty themes (see Ford Button's, Earl Engleman's and Vahan Shirvanian's work). Prefers single panel b&w line drawings and washes with or without gagline (will consider multipanel on related themes). Send query letter with finished cartoons to be kept on file. Material not filed is returned by SASE. Reports within 1 week. Usually buys first rights. **Pays on acceptance;** $5-25 for b&w. Occasionally uses captionless cartoons on cover; $50 b&w; $100 color.

Illustrations: Buys 80-100 illustrations and spots/year for *Amelia*; 24-30 spots for *Cicada*; 15-20 spots for *SPSM&H* and 50-60 spots for postcards. Considers all themes. "No taboos, except no explicit sex; nude

studies in taste are welcomed, however." Prefers pen & ink, pencil, watercolor, acrylic, oil, pastel, mixed media and calligraphy. Send query letter with résumé, photostats and/or photocopies to be kept on file. Unaccepted material returned immediately by SASE. Reports in 1 week. Portfolio should contain "one or two possible cover pieces (either color or b&w), several b&w spots, plus several more fully realized b&w illustrations." Buys first rights or one-time rights (prefers first rights). **Pays on acceptance**; $50 for b&w, $100 for color, cover; $5-25 for b&w, inside. "Spot drawings are paid for on assignment to an issue."
Tips: "In illustrations, it is very difficult to get excellent nude studies. Everyone seems capable of drawing an ugly woman; few capture sensuality, and fewer still draw the nude male tastefully. (See male nudes we've used by Susan Moffett and Miguel Angel Reyes for example.)"

‡AMERICA WEST AIRLINES MAGAZINE, Suite 240, 7500 N. Dreamy Draw Dr., Phoenix AZ 85020. Art Director: Mary Velgos. Estab. 1986. Monthly inflight magazine for fast-growing national airline; 4-color, "conservative design. Appeals to an upscale audience of travelers reflecting a wide variety of interests and tastes." Monthly. Circ. 125,000. Accepts previously published artwork. Original artwork is returned after publication. Sample copy $3. Needs computer-literate illustrators familiar with Photoshop, Adobe Illustrator, Quark XPress and Aldus FreeHand.
Illustrations: Approached by 100 illustrators/year. Buys illustrations mainly for spots, columns and feature spreads. Buys 5 illustrations/issue from freelancers. Uses freelance artwork mainly for features and columns. Works on assignment only. Prefers editorial illustration in airbrush, mixed media, colored pencil, watercolor, acrylic, oil, pastel, collage and calligraphy. Send query letter with color brochure showing art style and tearsheets. Looks for the "ability to intelligently grasp idea behind story and illustrate it. Likes crisp, clean colorful styles." Samples are filed. Does not report back. Publication will contact artist for portfolio review if interested. Sometimes requests work on spec before assigning job. Buys on publication one-time rights. Pays $75-250, b&w; $150-500, color, inside. "Send lots of good-looking color tearsheets that we can keep on hand for reference. If your work interests us we will contact you."
Tips: "In your portfolio show examples of editorial illustration for other magazines, good conceptual illustrations and a variety of subject matter. Often artists don't send enough of a variety of illustrations; it's much easier to determine if an illustrator is right for an assignment if I have a complete grasp of the full range of his abilities. Send high-quality illustrations and show specific interest in our publication." Does not want to see "photocopies—makes artwork and artist look sloppy and unprofessional."

AMERICAN BREWER MAGAZINE, Box 510, Hayward CA 94543. (510)538-9500 (mornings). Publisher: Bill Owens. Estab. 1985. Quarterly trade journal in b&w with 4-color cover focusing on the micro-brewing industry. Circ. 4,000. Accepts previously published artwork. Original artwork returned after publication. Sample copies for $5. Phone for art guidelines. Needs computer-literate freelancers for illustration. 80% of freelance work demands knowledge of Aldus PageMaker.
Cartoons: Approached by 6-8 cartoonists/year. Buys 2 cartoons/issue. Prefers themes related to drinking or brewing handcrafted beer; single panel. Send query letter with roughs. Samples not filed are returned. Reports back within 2 weeks. Buys reprint rights. Pays $25-50 for b&w.
Illustrations: Approached by 6-10 illustrators/year. Buys 2 illustrations/issue. Works on assignment only. Prefers themes relating to beer, brewing or drinking; pen & ink. Send query letter with photocopies. Samples are not filed and are returned. Reports back within 2 weeks. Pays $200 for color cover. Buys reprint rights.
Tips: "I prefer to work with San Francisco Bay area artists."

■AMERICAN FITNESS, Suite 200, 15250 Ventura Blvd., Sherman Oaks CA 91403. (818)905-0040. Editor-at-Large: Peg Jordan. Managing Editor: Rhonda J. Wilson. Bimonthly magazine emphasizing fitness, health and exercise "for sophisticated, college-educated, active lifestyles." Circ. 26,000. Accepts previously published material. Original artwork returned after publication. Sample copy $1.
Cartoons: Approached by 12 cartoonists/month. Buys 1 cartoon/issue. Material not kept on file is returned if requested. Buys one-time rights. Pays $35.
Illustrations: Approached by 12 illustrators/month. Assigns 4-6 illustrations/issue. Works on assignment only. Prefers "very sophisticated" 4-color line drawings. Send query letter with thumbnails, roughs or brochure showing art style. Reports back within 2 months. Acquires one-time rights.
Tips: "Excellent source for never-before-published illustrators who are eager to supply full-page lead artwork."

AMERICAN LIBRARIES, 50 E. Huron St., Chicago IL 60611. (312)280-4216. Fax: (312)440-0901. Senior Editor: Tom Gaughan. Senior Editor of Design: Edie McCormick. Estab. 1907. Monthly professional 4-color journal of the American Library Association for its 55,000 members, providing independent coverage of news and major developments in and related to the library field. Circ. 55,000. Original artwork returned at job's completion. Sample copy $5. Art guidelines available.
Cartoons: Approached by 15 cartoonists/year. Buys no more than 1 cartoon/issue. Prefers themes related to libraries. Send query letter with brochure and finished cartoons. Samples are filed. Does not report on submissions. Buys first rights. Pays $35-50 for b&w.

Illustrations: Approached by 20 illustrators/year. Buys 1-2 illustrations/issue. Works on assignment only. Send query letter with brochure, tearsheets and résumé. Samples are filed. Does not report on submissions. To show a portfolio, mail tearsheets, photostats, photographs and photocopies. Portfolio should include broad sampling of typical work with tearsheets of both b&w and color. Buys first rights. **Pays on acceptance**; $75-150 for b&w and $250-300 for color, cover; $75-150 for b&w and $150-250 for color, inside.
Tips: "I suggest inquirer go to a library and take a look at the magazine first." Sees trend toward "more contemporary look, simpler, more classical, returning to fewer elements."

AMERICAN MOTORCYCLIST, American Motorcyclist Association, Box 6114, Westerville OH 43081-6114. (614)891-2425. Executive Editor: Greg Harrison. Managing Editor: Bill Wood. Circ. 190,000. Monthly 4-color for "enthusiastic motorcyclists investing considerable time and money in the sport." Sample copy $1.50.
Cartoons: Buys 1-2 cartoons/issue. Receives 5-7 submissions/week. Interested in "single panel gags about motorcycling." Prefers to receive finished cartoons. Must include SASE. Reports in 3 weeks. Buys all rights on a work-for-hire basis. Pays on publication; $15 minimum for b&w washes.
Illustrations: Buys 1-2 illustrations/issue, almost all from freelancers. Receives 1-3 submissions/week. Interested in motorcycling themes. Send query letter with résumé and tearsheets to be kept on file. Samples returned by SASE. Reports in 3 weeks. Buys first North American serial rights. Pays on publication; $150 minimum for color cover; $30-100 for b&w and color inside.

AMERICAN MUSCLE MAGAZINE, Box 6100, Rosemead CA 91770. Art Director: Michael Harding. Monthly 4-color magazine emphasizing bodybuilding, exercise and professional fitness. Features general interest, historical, how-to, inspirational, interview/profile, personal experience, travel articles and experimental fiction (all sports-related). Circ. 301,420. Accepts previously published material. Original artwork returned after publication.
Illustrations: Buys 5 illustrations/issue. Send query letter with résumé, tearsheets, slides and photographs. Samples are filed or are returned. Reports back within 1 week. Buys first rights, one-time rights, reprint rights or all rights. **Pays on acceptance**.
Tips: "Be consistent in style and quality."

THE AMERICAN SPECTATOR, Box 549, Arlington VA 22216-0549. (703)243-3733. Fax: (703)243-6814. Managing Editor: Wladyslaw Pleszczynski. Production Manager: Thomas G. Neubert. Monthly political, conservative, newsworthy literary magazine. "We cover political topics, human interest items and book reviews." Circ. 258,000. Original artwork returned after publication. Sample copies and art guidelines available.
Illustrations: Uses 5-10 illustrations/issue. Interested in "realism with a comic twist." Works on assignment only. Prefers pen & ink, watercolor, acrylic, colored pencil, oil and pastel. Samples are filed or returned by SASE. Reports back on future assignment possibilities. Provide résumé, brochure and tearsheets to be kept on file for future assignments. No portfolio reviews. Reports in 2 weeks. Buys first North American serial rights. Pays on publication; $500 minimum for 4-color line drawings on cover; $100 minimum for b&w line drawings inside.

‡**AMERICAN WOMAN MOTORSCENE**, 2830 Santa Monica Blvd., Santa Monica CA 90404. (310)829-0012. Fax: (310)453-8850. Editor-in-Chief: Courtney Caldwell. Estab. 1988. Bimonthly automotive and recreational motorsports magazine for today's active women. Feature oriented for women of achievement. Circ. 100,000. Accepts previously published artwork. Originals returned at job's completion only if requested. Sample copies available for 9 × 12 SASE and 10 first-class stamps. Art guidelines not available. Needs computer-literate freelancers for illustration. 20% of freelance work demands computer knowledge of QuarkXPress or Aldus PageMaker.
Cartoons: Approached by 3-5 cartoonists/year. Prefers women in automotive—"classy, no bimbo stuff"; single/double panel humorous cartoons with gaglines. Send query letter with roughs and finished cartoons. Samples are filed. Reports back within 1 month with SASE or if interested. Rights purchased vary according to project. Pays $50 for b&w.
Illustrations: Approached by 3-5 illustrators/year. Works on assignment only. Prefers women of achievement. Open/flexible to all media. Send query letter with résumé, SASE, tearsheets and photocopies. Samples are filed or are returned by SASE if requested by artist. Reports back within 1 month with SASE. Publication will contact artist for portfolio review if interested. Portfolio should include b&w tearsheets, roughs, photocopies, final art and photographs. Rights purchased vary according to project. Pays on publication; $50 minimum for b&w inside.
Tips: Finds artists through submissions, *Artist's & Graphic Designer's Market*. "Must have knowledge of cars, trucks, motorcycles, hot rods and how today's women think!"

‡**ANIMALS**, 350 S. Huntington Ave., Boston MA 02130. (617)522-7400. Fax: (617)522-4885. Contact: Jim Grisanzio. Estab. 1868. "*Animals* is a national bimonthly 4-color magazine published by the Massachusetts Society for the Prevention of Cruelty to Animals. We publish articles on and photographs of wildlife, domestic animals, conservation, controversies involving animals, animal-welfare issues, pet health and pet care." Circ. 90,000. Original artwork usually returned after publication. Sample copy $2.95.

This image of a baboon was one of several by Mary King which accompanied an article in Animals *entitled "Spare Parts or Spare the Animal." King had about a week and a half to complete the illustrations which were rendered in oils, and sought to portray "dreamlike peacefulness" in the finished product.*

Illustrations: Approached by 1,000 illustrators/year. Works with 5 illustrators/year. Buys 5 or less illustrations/year from freelancers. Uses artists mainly for spots. Prefers pets or wildlife illustrations relating to a particular article topic. Prefers pen & ink, then airbrush, charcoal/pencil, colored pencil, watercolor, acrylic, oil, pastel and mixed media. Needs editorial and medical illustration. Send query letter with brochure or tearsheets. Samples are filed or are returned by SASE. Reports back within 1 month. Publication will contact artist for portfolio review if interested. Portfolio should include color roughs, original/final art, tearsheets and final reproduction/product. Negotiates rights purchased. Pay up to $300, color, cover; up to $150, b&w, $200, color, inside. **Pays on acceptance.**
Tips: "In your samples, include work showing animals, particularly dogs and cats or humans with cats or dogs. Show a representative sampling."

APPALACHIAN TRAILWAY NEWS, Box 807, Harpers Ferry WV 25425. (304)535-6331. Fax: (304)535-2667. Editor: Judith Jenner. Emphasizes the Appalachian Trail for members of the Appalachian Trail Conference. 5 issues/year; 4 issues b&w, 1 issue color. Circ. 26,000. Sometimes accepts previously published material. Returns original artwork after publication. Sample copy $3 (no SASE); art guidelines for SASE with first-class postage.
Illustrations: Buys 2-5 illustrations/issue. Prefers pen & ink, charcoal/pencil, colored pencil, watercolor, acrylic, oil, pastel and calligraphy. Original artwork must be related to the Appalachian Trail. Send query letter with samples to be kept on file. Prefers photostats, photocopies or tearsheets as samples. Samples not filed are returned by SASE. Reports within 2 months. Negotiates rights purchased. **Pays on acceptance;** $25-200, b&w, occasional color. Also buys 1-2 cartoons/year; pays $25 and up.
Tips: Finds most artists through references, word of mouth and samples received through the mail.

AQUARIUM FISH MAGAZINE, P.O. Box 6050, Mission Viejo CA 92690. (714)855-8822. Fax: (714)855-3045. Editor: Edward Bauman. Estab. 1988. Monthly magazine covering fresh and saltwater and marine aquariums and garden ponds. Circ. 75,000. Accepts previously published artwork. Originals are returned at job's completion. Sample copies available for $4. Art guidelines for SASE with first-class postage.

Cartoons: Approached by 30 freelance cartoonists/year. Buys 6 cartoons/issue. Themes should relate to aquariums and ponds. Send query letter with finished cartoon samples. Samples are filed. Reports back within 1 month. Buys one-time rights. Pays $35 for b&w, $50 for color.

Illustrations: Approached by 5 freelance illustrators/year. Buys 4 illustrations/issue. Works on assignment only. Considers pen & ink, watercolor, air brush and colored pencil. Send query letter with photocopies. Samples are filed or returned by SASE. Reports back within 1 month. Portfolio review not required. Buys one-time rights. Pays on publication; $50-100 for b&w and $100-200 for color inside.

‡**ARMY MAGAZINE**, 2425 Wilson Blvd. Arlington VA 22201. (703)841-4300. Art Director: Patty Zukerowski. Estab. 1950. Monthly trade journal dealing with current and historical military affairs. Also covers military doctrine, theory, technology and current affairs from a military perspective. Circ. 115,000. Originals returned at job's completion. Sample copies available for $2.25. Art guidelines available.

Cartoons: Approached by 5 cartoonists/year. Buys 1 cartoon/issue. Prefers military, political and humorous cartoons; single or double panel, b&w washes and line drawings with gaglines. Send query letter with brochure and finished cartoons. Samples are filed or are returned by SASE if requested by artist. Reports back to the artist only if interested. Buys one-time rights. Pays $50 for b&w.

Illustrations: Approached by 10 illustrators/year. Buys 1-3 illustrations/issue. Works on assignment only. Prefers military, historical or political themes. Considers pen & ink, airbrush, acrylic, marker, charcoal and mixed media. Send query letter with brochure, résumé, tearsheets, photocopies and photostats. Samples are filed or are returned by SASE if requested by artist. Publication will contact artist for portfolio review if interested. Portfolio should include b&w and color tearsheets, photocopies and photographs. Buys one-time rights. Pays on publication; $300 minimum for b&w, $500 minimum for color cover; $50 for b&w, $75 for color inside.

ART BUSINESS NEWS, 19 Old Kings Hwy. S., Darien CT 06820-4526. (203)656-3402. Monthly trade journal emphasizing the business of selling art and frames, trends, new art editions, limited editions, posters and framing supplies. Features general interest, interview/profile and technical articles. Circ. 30,000. Original artwork returned after publication. Sample copy $5.

● *Art Business News* no longer accepts cartoons.

Illustrations: Approached by 30 illustrators/year. Works on assignment only. Send query letter with brochure showing art style and tearsheets. Samples are filed or are returned. Reports back within weeks. Write for appointment to show portfolio or mail color and b&w tearsheets and photographs. Buys one-time rights. Pays $100 for b&w cover; $200 for color inside.

ART DIRECTION, 6th Floor, 10 E. 39th St., New York NY 10016. (212)889-6500. Fax: (212)889-6504. Editor: Dan Barron. Estab. 1949. Monthly 4-color trade magazine that emphasizes advertising for art directors. Circ. 9,091. Accepts previously published artwork. Original work not returned after publication. Sample copy $4.50. Art guidelines available.

Illustrations: Receives 7 illustrations/week from freelancers. Uses 2-3 illustrations/issue. Works on assignment only. Interested in themes that relate to advertising. Needs editorial illustration. Send query letter with brochure showing art styles. Samples are not filed and are returned only if requested. Reports in 3 weeks. Portfolio of tearsheets may be dropped off every Monday-Friday. Sometimes requests work on spec before assigning job. Negotiates rights purchased. Pays on publication; $350 for color cover.

Tips: "Must be about current advertising."

‡**ARTHRITIS TODAY MAGAZINE**, 1314 Spring St. NW, Atlanta GA 30309-2858. (404)872-7100. Fax: (404)872-9559. Art Director: Deb Gaston. Estab. 1987. Bimonthly consumer magazine. "*Arthritis Today* is the official magazine of the Arthritis Foundation. It is an award-winning publication that provides the most comprehensive and reliable source of information about arthritis research, care and treatment. It is written both for people with arthritis and those who care about them." Circ. 500,000. Originals returned at job's completion. Sample copies available. Art guidelines not available. Needs computer-literate freelancers for production. 20% of freelance work demands computer knowledge of Adobe Illustrator, QuarkXPress or Adobe Photoshop.

Illustrations: Approached by 10-20 illustrators/year. Buys 2-6 issues/year. Works on assignment only. Considers watercolor, collage, airbrush, acrylic, colored pencil, mixed media and pastel. Send query letter with brochure, tearsheets, photostats, slides (optional) and transparencies (optional). Samples are filed. Publication will contact artist for portfolio review if interested. Portfolio should include color tearsheets, photostats,

The double dagger before a listing indicates that the listing is new in this edition. New markets are often more receptive to freelance submissions.

photocopies, final art and photographs. Buys one-time rights. **Pays on acceptance;** $700 for color cover; $75 for b&w, $100 for color inside.

Tips: Finds artists through sourcebooks, other publications, word of mouth, artists' submissions. "No limits on areas of the magazine open to freelancers. 2-3 departments, each issue use spot illustrations. Submit tearsheets for consideration. No cartoons."

THE ARTIST'S MAGAZINE, 1507 Dana Ave., Cincinnati OH 45207. Editor: Mary Magnus. Monthly 4-color magazine emphasizing the techniques of working artists for the serious beginning, amateur and professional artist. Circ. 275,000. Occasionally accepts previously published material. Returns original artwork after publication. Sample copy $2 with SASE and 50¢ postage.
 ● Sponsors annual contest. Send SASE for more information. Also publishes an annual one-shot issue called *Watercolor Magic.*
Cartoons: Contact Mary Magnus, editor. Buys 2-3 "top-quality" cartoons/issue. Most cartoons bought are single panel finished cartoons with or without gagline – b&w line drawings and washes. "We're also on the lookout for color, multipanel (4-6 panels) work with a theme to use on our 'P.S.' page. Any medium." All cartoons should be artist-oriented, appeal to the working artist and should not denigrate art or artists. Avoid cliché situations. For single panel cartoon submissions, send cover letter with 4 or more finished cartoons. For "P.S." submissions, query first with roughs and samples. Material not filed is returned only by SASE. Reports within 1 month. Buys first North American serial rights. **Pays on acceptance;** $65 and up for b&w single panels; $200 and up for "P.S." work.
Illustrations: Contact Jeff Borisch, art director. Buys 2-3 illustrations/issue. Works on assignment only. Send query letter with brochure, résumé and samples to be kept on file. Prefers photostats or tearsheets as samples. Samples not filed are returned by SASE. Buys first rights. **Pays on acceptance.** "We're also looking for b&w spots of art-related subjects. We will buy all rights, $15-25 per spot."

‡ARTS INDIANA, #701, 47 S. Pennsylvania, Indianapolis IN 46204-3622. (317)632-7894. Fax: (317)632-7966. Editor: Hank Nuwer. Estab. 1979. Monthly arts magazine. Circ. 10,000. Sample copies available for $4. Art guidelines not available. Needs computer-literate freelancers for presentation. 25% of freelance work demands computer knowledge of Aldus PageMaker.
Cartoons: Approached by 5-10 cartoonists/year. Buys 2 cartoons/issue. Prefers arts-related (all arts) and humorous cartoons; single panel b&w washes and line drawings with or without gaglines. Send query letter with roughs and finished cartoons. Samples are not filed. Reports back within 3 days. Buys one-time rights. Pays $35 for b&w.
Illustrations: Approached by 5-10 illustrators/year. Buys 2 illustrations/issue. Prefers any line drawings for illustrating columns. Considers pen & ink. Send query letter with SASE and photocopies. Reports back within 3 days. Portfolio review not required. Buys one-time rights. Pays on publication; $25-35 per line drawing.
Tips: "Finds artists through submissions and our solicitation."

ISAAC ASIMOV'S SCIENCE FICTION MAGAZINE, 1540 Broadway, New York NY 10036. (212)354-6500. Fax: (212)697-1567. Art Director: Terri Czeczko. Estab. 1977. Monthly b&w with 4-color cover magazine of science fiction and fantasy. Circ. 100,000. Accepts previously published artwork. Original artwork returned at job's completion. Sample copies available. Art guidelines for SASE with first-class postage.
Illustrations: Approached by 60 illustrators/year. Buys 10 illustrations/issue. Works on assignment only. Considers pen & ink, airbrush, watercolor, acrylic and oil. Send query letter with tearsheets. Views portfolios on Tuesdays of each week. Samples are sometimes filed or are returned by SASE if requested by artist. Reports back only if interested. Rights purchased vary according to project. Pays $1,200 for color cover; $100 for b&w.

ASPCA ANIMAL WATCH, 424 E. 92nd St., New York NY 10128. (212)876-7700 (ext. 4441). Visual Arts Editor: Dave McMichael. Estab. 1960. Quarterly company magazine. Circ. 90,000. Accepts previously published artwork. Original artwork returned at job's completion.
Cartoons: Approached by 20-25 cartoonists/year. Buys 3 cartoons/issue. Prefers animal-related themes or styles. Send brochure, roughs and photocopies. Samples are filed. Rights purchased vary according to project. Pays $75-100.
Illustrations: Approached by 20 illustrators/year. Buys 3 illustations/issue. Prefers animal-related themes or styles. Considers all media. Send photocopies. Samples are filed. Reports back within 2 weeks. Rights purchased vary according to project. Pays on publication; $150 for color cover; $75 for b&w and $100 for color inside.

■ASSOCIATION OF COLLEGE UNIONS-INTERNATIONAL, 400 E. Seventh St., Bloomington IN 47405. (812)332-8017. Fax: (812)333-8050. Art Director: Ann Vest. Estab. 1914. Professional education association journal. "Covers multicultural issues, creating community on campus, union and activities programming, managing staff, union operation, professional development and student development." Needs computer-literate freelancers with knowledge of CorelDraw for illustration.

• Also publishes hardcover and trade paperback originals. See listing in Book Publishers section for more information.

Illustrations: Works on assignment only. Considers pen & ink, pencil, and computer illustration. Send query letter with tearsheets, photographs, and color transparencies of college student union activities. Samples are filed. Reports back to artist only if interested. Negotiates rights purchased.

Tips: "We are a volunteer-driven association. Most people submit work on that basis."

ATLANTIC CITY MAGAZINE, Box 2100, Pleasantville NJ 08232-1324. (609)272-7907. Fax: (609)272-7910. Art Director: Michael L.B. Lacy. Estab. 1979. 4-color monthly that emphasizes the growth, people and entertainment of the Atlantic City/South Jersey region for residents and visitors. Circ. 50,000.

Illustrations: Approached by 1,000 illustrators/year. Works with 20 illustrators/year. Buys 36 illustrations/year. Uses artists for spots, department and feature illustration. Uses mainly 4-color and some b&w. Works on assignment only. Send query letter with brochure showing art style, tearsheets, slides and photographs to be kept on file. Call or write for appointment to show a portfolio, which should include printed samples final reproduction/product, color and b&w tearsheets and photographs. Buys first rights. Pays on publication; $250 for b&w and $500 for color cover; $125 for b&w and $225 for color inside.

Tips: "We are looking for intelligent, reliable artists who can work within the confines of our budget and time frame. Deliver good art and receive good tearsheets. We are produced completely electronically and have more flexibility with design. Now illustrators who can work with and provide electronic files are a plus."

AUTOMOBILE MAGAZINE, Dept. AM, 120 E. Liberty, Ann Arbor MI 48104. (313)994-3500. Art Director: Lawrence C. Crane. Estab. 1986. Monthly 4-color "automobile magazine for up-scale life-styles." Traditional, "imaginative" design. Circ. 600,000. Original artwork is returned after publication. *Art guidelines specific for each project.*

Illustrations: Buys illustrations mainly for spots and feature spreads. Works with 5-10 illustrators/year. Buys 2-5 illustrations/issue. Works on assignment only. Considers airbrush, mixed media, colored pencil, watercolor, acrylic, oil, pastel and collage. Needs editorial and technical illustrations. Send query letter with brochure showing art style, résumé, tearsheets, slides, photographs and transparencies. Show automobiles in various styles and media. "This is a full-color magazine, illustrations of cars and people must be accurate." Samples are returned only if requested. "I would like to keep something in my file." Reports back about queries/submissions only if interested. Request portfolio review in original query. Portfolio should include final art, color tearsheets, slides and transparencies. Buys first rights and one-time rights. Pays $900 for color cover; $200 and up for color inside. Pays up to $2,000 depending on size of illustration.

Tips: Finds artists through mailed samples. "Send samples that show cars drawn accurately with a unique style and imaginative use of medium. We are experiencing record month after record month; we are the third fastest growing magazine in America."

AUTOMUNDO, #204, 525 NW 27th Ave., Miami FL 33125. (305)541-4198. Fax: (305)541-5138. Editor: Jorge Koechlin. Estab. 1982. Monthly 4-color Spanish automotive magazine. Accepts previously published artwork. Originals returned at job's completion. Sample copies and art guidelines available.

Cartoons: Approached by 2 cartoonists/year. Buys 1 cartoon/issue. Prefers car motifs. Prefers cartoons without gagline. Send query letter with brochure and roughs. Samples are filed. Reports back to the artist only if interested. Rights purchased vary according to project. Pays $10 for b&w cartoons.

Illustrations: Publication will contact artist for portfolio review if interested. Portfolios may be dropped off every Monday. Needs editorial illustrations.

AWARE COMMUNICATIONS, INC., (formerly *DIR Communications*), 2720 NW Sixth St., Gainesville FL 32609-2992. (904)331-8422. Vice President-Creative: Scott M. Stephens. Estab. 1984. Quarterly, semi-annual, annual 4-color company magazines and posters for Fortune 100 companies. Circ. 500,000 to 6.5 million. Needs computer-literate freelancers for design and production. 30% of freelance work demands knowledge of CorelDraw and Ventura. Original artwork is not returned.

Cartoons: Approached by 3 comic book style cartoonists/year. Prefers Marvel Comic style—sports, health, fitness. Samples are filed and not returned. Reports back to the artist only if interested. Buys all rights. Pays $250, color.

Illustrations: Approached by 10 illustrators/year. Buys 40 illustrations/year. Works on assignment only. Needs editorial, medical and technical illustration. Prefers comic book and realistic styles; very graphic and educational. Considers airbrush, acrylic, oil and colored pencil. Send query letter with brochure, tearsheets and photostats. Samples are filed or returned by SASE if requested by artist. Publication will contact artist for portfolio review if interested. Portfolio should include printed samples, color tearsheets, photostats, photographs, slides and photocopies. Buys all rights. Sometimes requests work on spec before assigning job. **Pays on acceptance;** $1,500 for color cover; $200 for color inside.

Tips: "Have a universal appealing style. We deal with medical and educational publications, so abstract images and style will not be considered." Must be able to illustrate people and be anatomically accurate.

‡AXIOS, The Orthodox Journal, 30-32 Macaw Ave., Belmopan, Belize. 501-8-23284. Editor: Daniel Gorham. Monthly 2-color newsletter emphasizing "challenges in ethics and theology, some questions that return to haunt one generation after another, old problems that need to be restated with new urgency. *Axios* tries to present the 'unthinkable' " from an Orthodox Catholic viewpoint. Circ. 10,506. Accepts previously published material, simultaneous submissions. Original artwork returned after publication. Sample copy $2. Needs computer-literate freelancers for design, illustration, production and presentation. 25% of freelance work demands computer literacy in Ventrua and Microsoftword.
Illustrations: Buys 5-10 illustrations/issue from freelancers. Prefers bold line drawings, seeks icons, b&w; "no color *ever*; uses block prints—do not have to be religious, but must be *bold*!" Send query letter with brochure, résumé, business card or samples to be kept on file. Samples not filed are returned by SASE. Publication will contact artist for portfolio review if interested. Portfolio should include final reproduction/product and b&w. Buys one-time rights. **Pays on acceptance**; $50 for b&w, $150 for color, cover; $40 for b&w, $100 for color inside.
Tips: "Realize that the Orthodox are *not* Roman Catholics, nor Protestants. We do not write from those outlooks. Though we do accept some stories about those religions, be sure *you* know what an Orthodox Catholic is. Know the traditional art form—we prefer line work, block prints, linocuts."

✒B.C. OUTDOORS, 202-1132 Hamilton St., Vancouver, British Columbia V6B 2S2 Canada. (604)687-1581. Editor: Karl Bruhn. 4-color magazine, emphasizing fishing, hunting, RV camping, wildlife/conservation. Published 8 times/year. Circ. 40,000. Original artwork returned after publication unless bought outright. Free sample copy. Prefers inquiring freelancers to be familiar with Adobe Illustrator and QuarkXPress.
Cartoons: Approached by more than 10 cartoonists/year. Buys 1-2 cartoons/issue. Should pertain to outdoor recreation: fishing, hunting, camping and wildlife in British Columbia. Format: single panel, b&w line drawings with or without gagline. Prefers finished cartoons. Include SAE (nonresidents include IRC). Reports in 2 weeks. Pays $50 for b&w. Buys one-time rights.
Illustrations: Approached by more than 10 illustrators/year. Buys 16-20 illustrations/year. Interested in outdoors, creatures and activities as stories require. Format: b&w line drawings and washes for inside and color washes for inside and cover. Works on assignment only. Samples returned by SAE (nonresidents include IRC). Reports back on future assignment possibilities. Arrange personal appointment to show portfolio or send samples of style. Subject matter and the art's quality must fit with publication. Reports in 2-6 weeks. Buys first North American serial rights or all rights on a work-for-hire basis. **Pays on acceptance**; $175 for full-page b&w; $225 for color inside; partial page, $75 DPS.

‡✒THE BABY CONNECTION NEWS JOURNAL, Drawer 13320, San Antonio TX 78213-0320. Art Director: G.M. Boyd. Illustrations Department, Chairman: Leanna Garcia. Estab. 1986. Publications for new and expectant families with emphasis on infant development, maternity issues, parenting humor, bonding and infant care. Circ. 45,000-60,000. Accepts previously published artwork. Originals are not returned. Sample copies available for $3.75. Art guidelines not available.
• *The Baby Connection* is one of several magazines and journals published by Baby's Mart, a retail baby store and educational center. They also publish *Pitter Patter Chatter, The Smarter Baby Club Newsletter* and *Baby Facts—Fax.* This organization needs a steady supply of cartoons and illustrations.
Cartoons: Approached by 15-30 cartoonists/year. Buys 4-16 cartoons/issue. Cartoons on maternity issues: stages of pregnancy; expectant father in various humorous situations; new dad/new mom humorous situations; cartoons of babies crawling, sitting, laying, eating, fussing, happy. Prefers political and humorous cartoons; single, double or multiple panel, b&w line drawings with or without gaglines. Send query letter with finished cartoons and personal biography. Samples are filed. "Please allow up to 6 months if necessary." Reports back to the artist only if interested. Buys one-time rights.. Pays $10 for b&w.
Illustrations: Approached by 12-20 illustrators/year. Buys 6-12 cartoons/issue. Prefers illustrations of babies either humorous or the "oh how cute—how adorable—oh how sweet" type, pregnant moms, expectant dads, new moms, new fathers, drawings of a baby's room, crib, nursery items, medical illustrations or any topic on pregnancy or birthing. Considers pen & ink and marker. Send query letter with SASE, tearsheets, photocopies and biography. Samples are filed. Reports back within 6 months. Portfolio review not required. Buys one-time rights. Pays on publication; $10 for b&w inside.
Tips: "We absolutely encourage all new artists we come in contact with. We do hunderds of brochures for our products and classes each year which all require *lots* of art. Do not call us. Your best chances are to follow our guidelines stated here, have a little patience, take a chance with your own style of creativity and remember we are open to most anything! All submissions should include a brief, personable biography of the artist as we like our readers to get a glimpse into our contributors' personal details—think of something out of the ordinary about yourself, your life, your work, your outlook!"

‡THE BACKSTRETCH, 19899 W. Nine Mile Rd., Southfield MI 48075-3960. (810)354-3232. Fax: (810)354-3157. Editor-in-Chief/Publisher: Harriet H. Dalley. Estab. 1962. Bimonthly trade journal. "Covers topics of importance and interest to thoroughbred trainers and owners, other industry personnel; and racing fans. The editorial focus is on issues and trends in the industry; personality profiles; historical, business and vet

topics." Circ. 12,000. Accepts previously published artwork. Originals are not returned. Sample copies and art guidelines available.

Cartoons: Approached by 4-6 cartoonists/year. Send query letter with roughs. Samples are filed. Reports back within 2-3 months. Buys one-time rights. Pays $25 for b&w, $35 for color.

Illustrations: Approached by 4-6 illustrators/year. Buys 2-3 illustrations/year. Works on assignment only. Prefers contemporary, realistic art related to thoroughbred training and racing. Considers pen & ink, watercolor, airbrush, acrylic, marker, colored pencil, oil, charcoal and pastel. Send query letter with résumé, tearsheets, photographs, slides, transparencies. Samples are not filed and are returned by SASE if requested by artist. Reports back within 2-3 months. Publication will contact artist for portfolio review if interested. Portfolio should include b&w and color roughs. Buys one-time rights. Pays on publication; $250 for color cover; $25 for b&w, $35 for color inside.

■**BAD HAIRCUT**, P.O. Box 2827, Olympia WA 98502. Editors/Publishers: Kim and Ray Goforth. Estab. 1987. Literary magazine. "We focus on politics, human rights and environmental themes in a unique blend of poetry, fiction, essays, interview and art." Irregular intervals between issues. Circ. 2,000. Accepts previously published artwork. Original artwork returned at job's completion. Sample copies for $4. Art guidelines free for SASE with first-class postage.

Cartoons: Approached by 4 cartoonists/year. Buys 0-5 cartoons/issue. Prefers progressive politics; single panel. Send query letter with finished cartoons. Samples are not filed and are returned by SASE. Reports back within 2 weeks. Buys first rights. Pays $5 for b&w.

Illustrations: Approached by 4 illustrators/year. Buys 0-5 illustrations/issue. Needs editorial illustration. Prefers progressive politics; pen & ink and charcoal. Send query letter with résumé, SASE and photocopies. Samples are not filed and are returned by SASE. Reports back within 2 weeks. Buys first rights. Pays on publication; $10 for b&w cover; $5 for color inside.

Tips: "Read an issue. Get a feel for what we're trying to do."

‡**BAJA TIMES**, Box 5577, Chula Vista CA 91912. 01152-661-21244. Editor: John W. Utley. Estab. 1978. Emphasizes Baja California, Mexico for tourists, other prospective visitors and retirees living there. Monthly tabloid, b&w with 4-color cover. Circ. 65,000. Accepts previously published material. Original artwork returned after publication. Sample copy and art guidelines for $9 × 12$ or larger SAE with 4 first-class stamps.

Cartoons: Approached by 8-12 cartoonists/year. Buys 1 cartoon/issue. All must be Baja California-oriented. Prefers single panel with gagline. Send query letter with sample of finished cartoons to be kept on file. Material not filed returned by SASE. Reports within 1 month. Buys first time rights. Pays $25 for b&w; on publication.

Tips: Finds cartoonists through submissions.

■**BALL MAGAZINE**, Box 775, Northampton MA 01061. (413)584-3076. Senior Editor: Douglas M. Kimball. Estab. 1992. Semi-annual b&w with 4-color cover literary magazine. "Committed to an editorial policy that frees artists to do what interests *them*. We print all work of quality without apology for content. We aim specifically for the 18- to 30-year-old age group." Circ. 2,000-10,000. Originals returned at job's completion. Art guidelines available for SASE with first-class postage.

Cartoons: Buys 2-6 cartoons/issue. Prefers irreverent, political, sexual themes. Send query letter with roughs. Samples are filed and returned by SASE if requested by artist. Reports back within 2 weeks. Rights acquired vary according to project. Pays in copies only. "May offer cash for exceptional work."

Illustrations: Buys 3-6 illustrations/issue. "*Ball Magazine* is open to all styles but prefers artists or illustrators who take risks in both content and style." Considers all media. No query letter, just send tearsheets, photographs, photocopies, and slides. Samples are filed or returned by SASE if requested by artist. Publication will contact artist for portfolio review if interested. Rights acquired vary according to project. Pays on publication; $100 for color cover; copies for b&w inside.

Tips: "A lot of cartoonists/illustrators ask me what I'm looking for which to me is all wrong. I prefer to see work first, then talk. I want work from people who are following their own instincts. The entire 'professionalism' movement is the most disturbing element of the freelance art industry. Too much polish and salesmanship and not enough talent make for dull work."

■**BALLAST QUARTERLY REVIEW**, 2022 X Ave., Dysart IA 52224-9767. Contact: Art Director. Estab. 1985. Quarterly literary and graphic design magazine. "*Ballast* is an acronym for Books Art Language Logic Ambiguity Science and Teaching. It is a journal of verbal and visual wit. Audience consists mainly of designers, illustrators, writers and teachers." Circ. 600. Accepts previously published artwork. Originals returned at job's completion. Sample copies available for 2 first-class stamps.

Illustrations: Approached by 50 illustrators/year. Publishes 6 illustrations/issue. Preferred themes are metamorphosis (one thing evolving into another) and visual puns. Seeks b&w line art—no halftones. Send query letter with photocopies. Samples are sometimes filed or returned by SASE if requested by artist. Reports back to the artist only if interested. No portfolio reviews. Payment is 5-10 copies of issue.

Tips: Finds artists through books, magazines, word of mouth, other illustrators.

BALLOON LIFE MAGAZINE, 2145 Dale Ave., Sacramento CA 95815. (916)922-9648. Fax: (916)922-4730. Editor: Tom Hamilton. Estab. 1985. Monthly 4-color magazine emphasizing the sport of ballooning. "Contains current news, feature articles, a calendar and more. Audience is sport balloon enthusiasts." Circ. 4,000. Accepts previously published material. Original artwork returned after publication. Sample copy for SASE with $2 postage. Needs computer illustrators familiar with Aldus PageMaker, Adobe Illustrator, Adobe Photoshop, Colorit, Pixol Paint Professional, and Aldus FreeHand.
Cartoons: Approached by 20-30 cartoonists/year. Buys 1-2 cartoons/issue. Seeks gag, editorial or political cartoons, caricatures and humorous illustrations. Prefers single panel b&w line drawings with or without gaglines. Send query letter with samples, roughs and finished cartoons. Samples are filed or returned. Reports back within 2 weeks. Buys first rights. Pays on publication; $25 for b&w and $25-40 for color.
Illustrations: Approached by 10-20 illustrators/year. Buys 1-3 illustrations/year. Send query letter with business card and samples. Samples are filed or returned. Reports back within 2 weeks. Publication will contact artist for portfolio review if interested. Buys first rights. Pays on publication; $50 for color cover; $25-40 for b&w or color inside.
Tips: "Know what a modern hot air balloon looks like! Too many cartoons reach us that are technically unacceptable."

‡BALLS & STRIKES SOFTBALL, 2801 NE 50th St., Oklahoma City OK 73111. (405)424-5266. Fax: (405)424-3855. Editor-in-Chief: Ronald A. Babb. Estab. 1933. Monthly sports consumer magazine emphasizing amateur and Olympic softball. Circ. 310,000. Originals returned at job's completion. Sample copies and art guidelines available. Needs computer-literate freelancers for illustration. 50% of freelance work demands computer knowledge of Aldus PageMaker, Adobe Illustrator, QuarkXPress, Adobe Photoshop or Aldus FreeHand.
Cartoons: Approached by 2 cartoonists/year. Buys 1 cartoon/issue. Only sports-softball single panel cartoons. Send query letter with roughs. Samples are not filed and are returned by SASE if requested by artist. Reports back to the artist only if interested. Buys first rights. Pays $50-100 for b&w.
Illustrations: Approached by 2 illustrators/year. Sports-softball only. Considers pen & ink, watercolor, collage, airbrush, acrylic, marker, colored pencil, oil, charcoal, mixed media and pastel. Send query letter with tearsheets and photostats. Samples are not filed and are returned by SASE if requested by artist. Publication will contact artist for portfolio review if interested. Portfolio should include b&w and color roughs and tearsheets. Buys first rights. Pays on publication; $350 for color cover; $50 for b&w, $100 for color inside.

‡BALTIMORE JEWISH TIMES, 2104 N. Charles St., Baltimore MD 21218. (301)752-3504. Art Director: Robyn Katz. Weeky b&w tabloid with 2-color cover emphasizing special interests to the Jewish community for largely local readership. Weekly. Circ. 20,000. Accepts previously published artwork. Returns original artwork after publication, if requested. Sample copy available.
Illustrations: Approached by 50 illustrators/year. Buys 4-6 illustrations/issue from freelancers. Works on assignment only. Prefers high-contrast, b&w illustrations. Send query letter with brochure showing art style or tearsheets and photocopies. Samples not filed are returned by SASE. Reports back if interested. To show a portfolio, mail appropriate materials or write/call to schedule an appointment. Portfolio should include original/final art, final reproduction/product and color tearsheets and photostats. Buys first rights. Pays on publication; $200 for b&w, cover and $300 for color, cover; $50-100 for b&w, inside.
Tips: Finds artists through word of mouth, self-promotion and sourcebooks. Sees trend toward "more freedom of design integrating visual and verbal."

‡BALTIMORE MAGAZINE, 16 S. Calvert St., Baltimore MD 21202. (410)752-7375. Fax: (410)625-0280. Art Director: Claude Skelton. Estab. 1908. Monthly city magazine featuring news, profiles and service articles. Circ. 50,000. Originals returned at job's completion. Sample copies available for $2.05/copy. Art guidelines not available. Needs computer-literate freelancers for illustration and production. 10% of freelance work demands computer knowledge of QuarkXPress or Aldus FreeHand.
Illustrations: Approached by 60 illustrators/year. Buys 4 illustrations/issue. Works on assignment only. Considers all media, depending on assignment. Send query letter with brochure. Samples are filed. Publication will contact artist for portfolio review if interested. Buys one-time rights. Pays on publication; 60 days after invoice.
Tips: Finds artists through sourcebooks, publications, word of mouth, artists' submissions. All art is freelance—humorous front pieces, feature illustrations, etc. Does not use cartoons.

BARTENDER MAGAZINE, Box 158, Liberty Corner NJ 07938. (908)766-6006. Fax: (908)766-6607. Editor: Jackie Foley. Estab. 1979. Quarterly 4-color trade journal emphasizing restaurants, taverns, bars, bartenders, bar managers, owners, etc. Circ. 145,000. Needs computer-literate designers familiar with QuarkXPress and Adobe Illustrator.
Cartoons: Approached by 10 cartoonists/year. Buys 3 cartoons/issue. Prefers bar themes; single panel. Send query letter with finished cartoons. Samples are filed. Buys first rights. Pays on publication; $50 for b&w and $100 for color cover; $50 for b&w and $100 for color inside.

Illustrations: Approached by 5 illustrators/year. Buys 1 illustration/issue. Works on assignment only. Prefers bar themes. Considers any media. Send query letter with brochure. Samples are filed. Negotiates rights purchased. Pays on publication; $500 for color cover.

‡**BAY WINDOWS**, 1523 Washington St., Boston MA 02118. (617)266-6670. Editor: Jeff Epperly. Estab. 1981. A weekly newspaper "targeted to politically-aware lesbians, gay men and other political allies publishing non-erotic news and features"; b&w with 2-color cover. Circ. 46,000. Accepts previously published artwork. Original artwork returned after publication. Sample copies available. Art guidelines not available. Needs computer illustrators familiar with Aldus PageMaker or Aldus FreeHand.
Cartoons: Approached by 25 freelance cartoonists/year. Buys 1-2 freelance cartoons/issue. Buys 50 freelance cartoons/year. Preferred themes include politics and life-styles. Prefers double and multiple panel, political and editorial cartoons with gagline, b&w line drawings. Send query letter with roughs. Samples are returned by SASE if requested by artist. Reports back to the artist within 6 weeks only if interested. Rights purchased vary according to project. Pays on publication; $75-100 for b&w only.
Illustrations: Approached by 60 freelance illustrators/year. Buys 1 freelance illustration/issue. Buys 50 freelance illustrations/year. Artists work on assignment only. Preferred themes include politics—"humor is a plus." Considers pen & ink and marker drawings. Send query letter with photostats and SASE. Samples are filed. Reports back within six weeks only if interested. Portfolio review not required. Rights purchased vary according to project. Pays on publication; $100-125 for cover; $75-100 for b&w inside.

BEND OF THE RIVER® MAGAZINE, 143 W. 3rd St., P.O. Box 39, Perrysburg OH 43552. Fax: (419)874-1466. Editor-in-Chief: R. Lee Raizk. Monthly b&w magazine with "folksy" design for local history enthusiasts. Circ. 4,500. Previously published and photocopied submissions OK. Sample copy $1.30.
● This publication has an "old fashioned, antique" look. Not a market for illustrators.
Cartoons: Approached by 5-10 cartoonists/year. Buys 12 cartoons/issue. Interested in early Americana, cowboys, antiques, turn-of-the-century people; single panel with gagline. Include SASE. Buys first North American serial rights or all rights on a work-for-hire basis. Pays $5-10 for b&w line drawings. Wants to see "cartoons that are funny."
Tips: Query if sending anything except cartoons.

THE BERKELEY MONTHLY, 1301 59th St., Emeryville CA 94608. (510)658-9811. Fax: (510)658-9902. Art Director: Andreas Jones. Estab. 1970. Consumer monthly tabloid; b&w with 4-color cover. Editorial features are general interests (art, entertainment, business owner profiles) for an upscale audience. Circ. 75,000. Accepts previously published artwork. Originals returned at job's completion. Sample copies and art guidelines for SASE with first-class postage. No nature or architectural illustrators. Needs computer-literate freelancers for design. 100% of freelance design work demands knowledge of Aldus PageMaker, QuarkXPress or Aldus FreeHand.
Cartoons: Approached by 75-100 cartoonists/year. Buys 3 cartoons/issue. Prefers single panel, b&w line drawings; "any style, extreme humor." Send query letter with finished cartoons. Samples are filed or returned by SASE if requested by artist. Reports back to the artist only if interested. Buys one-time rights. Pays $35 for b&w.
Illustrations: Approached by 150-200 illustrators/year. Buys 2 illustrations/issue. Prefers pen & ink, watercolor, acrylic, colored pencil, oil, charcoal, mixed media and pastel. Send query letter with résumé, SASE, tearsheets, photocopies and slides. Samples are filed or returned by SASE if requested by artist. Reports back only if interested. Write for appointment to show portfolio, which should include thumbnails, roughs, b&w tearsheets and slides. Buys one-time rights. Pays $100-200 for b&w inside. Pays 30 days after publication.

■✿**BEST OF THE MIDWEST'S SCIENCE FICTION, FANTASY & HORROR**, 2419 Klein Place, Regina, Saskatchewan S4V 1M4 Canada. (306)789-2419. Illustration Coordinator: Cathy Buburuz. Estab. 1990. Annual trade paperback of science fiction, fantasy and horror. "This anthology of science fiction, fantasy and horror stories with illustrations serves to showcase and promote the artistry of both new and established talent. Artists are given accepted stories to illustrate." Circ. 10,000. Accepts previously published artwork "if previously printed with selected story." Art guidelines and sample copies available from Brian Smart, Fiction Editor, ESA Publications, Route 1, Box 118AA, Archie MO 64725. Send $10.95 and SASE with first-class postage. "We have published the work of only one computer artist but would like to receive samples from others."
Illustrations: Approached by 15 illustrators; "I would like a wider range of artists to submit samples of their work." Buys 25 illustrations/issue. Prefers science fiction, fantasy and horror themes. "Interior illustrations are b&w but we do use color on the cover." Send query letter with samples of work in any medium (preferably b&w) with SAE and IRCs (foreign postage *cannot* be used in Canada). Samples are filed. Reports back within 1 month. To show a portfolio, mail appropriate materials. "Include name, address and telephone number on the reverse side of *all* submissions." Buys first rights. Pays on publication, $100 for color cover; ¼ of 1% net profits from sales in which illustration appears for b&w inside plus 1 contributor's copy.
Tips: "Send several samples of your best science fiction, fantasy and horror related art . . . when I receive a story suited to your art style, you will be notified by letter and sent the story for illustration. Illustrating is

an extremely competitive business. If it's not your best, please don't send it to us. Send as many art samples as you want. It is to your advantage to show a wide range of your talent. All art is kept on file and is not returned unless the artist includes sufficient postage and requests that the samples be returned. Illustrating for a small press magazine is a great way for beginning artists to create and add to their portfolios."

BETTER HEALTH MAGAZINE, 1384 Chapel St., New Haven CT 06511. (203)789-3973. Fax: (203)789-4053. Assistant Editor: Nora King. Estab. 1979. Bimonthly, 4-color "consumer health magazine." Circ. 140,000. Accepts previously published artwork. Original artwork returned at job's completion. Sample copies available for $1.25. Art guidelines not available. 25% of freelance work demands knowledge of Aldus PageMaker, Photoshop, QuarkXPress, Aldus FreeHand, Adobe Illustrator or Color Studio.
Illustrations: Approached by 100 illustrators/year. Buys 4 illustrations/issue. Works on assignment only. Considers watercolor, collage, airbrush, acrylic, marker, colored pencil, oil, charcoal, mixed media, pastel and computer illustration. Send query letter with tearsheets. Samples are filed. Reports back only if interested. Call or write for appointment to show a portfolio, or mail appropriate materials. Portfolio should include rough, original/final art, color tearsheets, photostats, photographs and photocopies. Buys first rights. **Pays on acceptance;** $600 for color cover; $500 for color inside.

BEVERAGE WORLD MAGAZINE, 150 Great Neck Rd., Great Neck NY 11021. (516)829-9210. Desktop Publishing Manager: Paul Leone. Editor: Larry Jabbonsky. Monthly magazine covering beverages (beers, wines, spirits, bottled waters, soft drinks, juices) for soft drink bottlers, breweries, bottled water/juice plants, wineries and distilleries. Circ. 33,000. Accepts simultaneous submissions. Original artwork returned after publication if requested. Sample copy $2.50.
Illustrations: Buys 3-4 illustrations/issue from freelancers. Works on assignment only. Send query letter with photostats, slides or tearsheets to be kept on file. Write for appointment to show portfolio. Reports only if interested. Negotiates rights purchased. **Pays on acceptance;** $350 for color cover; $50-100 for b&w inside. Uses color illustration for cover, usually b&w for spot illustrations inside.
Tips: "We prefer to work with Macintosh graphic and layout artists."

BEVERLY HILLS [213], #307, 9465 Wilshire Blvd., Beverly Hills CA 90212-2602. (310)275-7916. Art Director: John Buse. Estab. 1983. Weekly tabloid focusing on Hollywood premiers, reviews, fashion, movie stars. Features celebrity cover stories. Circ. 50,000. Accepts previously published artwork. Originals are returned at job's completion. Sample copies and art guidelines available.
Cartoons: Approached by 2-3 freelance cartoonists/year. Prefers b&w line drawings. Send query letter with brochure. Samples are filed. Reports back only if interested. Rights purchased vary according to project. Payment varies.
Illustrations: Works on assignment only. Prefers pen & ink, colored pencil and pastel. Send query letter with brochure, résumé and photographs. Samples are filed. Reports back only if interested. To show a portfolio, mail appropriate materials. Rights purchased vary according to project. Pays on publication.

BICYCLING MAGAZINE, Dept. AM, 33 E. Minor St., Emmaus PA 18098. (215)967-5171. Art Director: Ken Palumbo. 10 published/year. Original artwork is returned after publication.
Illustrations: Buys illustrations mainly for spots, feature spreads, technical and maps. Buys 8 illustrations/issue. Works on assignment only. Send query letter with tearsheets, photocopies, slides, photographs and transparencies. Samples are filed or returned only if requested. Reports back about queries/submissions only if interested. Call for appointment to show portfolio. Buys one-time rights.

BIRD WATCHER'S DIGEST, Box 110, Marietta OH 45750. (614)373-5285. Editor: Mary B. Bowers. Bimonthly magazine covering birds and bird watching for "bird watchers and birders (backyard and field; veteran and novice)." Circ. 90,000. Previously published material OK. Original work returned after publication. Sample copy $3.
Cartoons: Buys 1-3 cartoons/issue. Interested in themes pertaining to birds and/or bird watchers. Single panel b&w line drawings with or without gagline. Send roughs. Samples returned by SASE. Reports in 2 months. Buys one-time rights or reprint rights. Pays $20 on publication.

■**BLACK BEAR PUBLICATIONS**, 1916 Lincoln St., Croydon PA 19021-8026. Editor: Ave Jeanne. Associate Editor: Ron Zettlemoyer. Estab. 1984. Publishes semiannual b&w magazine emphasizing social, political, ecological and environmental subjects "for mostly well-educated adults." Circ. 500. Also publishes chapbooks. Accepts previously published artwork. Art guidelines for SASE with first-class postage. Current copy $5 postpaid in US.
Illustrations: Works with 12 illustrators/year. Buys 20 illustrations/issue. Prefers collage, woodcut, pen & ink. Send samples with SASE, résumé and photocopies. Samples not filed returned by SASE. Portfolio review not required. Reports within 10 days. Acquires one-time rights or reprint rights. Pays in copies, on publication, for the magazine. Pays cash on acceptance for chapbook illustrators. Chapbook illustrators are contacted for assignments. Average pay for chapbook illustrators is $35 for one-time rights.

Tips: Finds artists through word of mouth and artists' submissions. "Be familiar with our needs. We work in b&w only and prefer samples digest size. If we are interested, we won't let you know without a SASE."

BLACK WARRIOR REVIEW, Box 2936, University of Alabama, Tuscaloosa AL 35487. (205)348-4518. Editor: Leigh Ann Sackrider. Biannual 4-color literary magazine publishing contemporary poetry, fiction and nonfiction by new and established writers. Circ. 2,000. Accepts previously published artwork. Original artwork is returned at job's completion. Sample copy $6. Art guidelines not available.
Illustrations: Approached by 4 illustrators/year. Buys 2 illustrations/issue. Themes and styles vary. Needs editorial illustration. Considers pen & ink, airbrush, watercolor, acrylic, oil, collage and marker. Send query letter with photocopies. Samples are not filed and are returned. Reports back in 1 month. Pays on publication; $100 for b&w or color cover; $50 for b&w or color inside.
Tips: "Look at the magazine."

‡THE B'NAI B'RITH INTERNATIONAL JEWISH MONTHLY, B'nai B'rith, 1640 Rhode Island Ave. NW, Washington DC 20036. (202)857-6645. Editor: Jeff Rubin. Estab. 1886. Specialized magazine published 8 times a year, focusing on issues of interest to the Jewish family. Circ. 200,000. Originals returned at job's completion. Sample copies available for $5. Art guidelines not available.
Illustrations: Approached by 100 illustrators/year. Buys 1-2 illustrations/issue. Works on assignment only. Considers pen & ink, colored pencil, mixed media, watercolor, acrylic, oil, pastel, collage, marker, charcoal. Send query letter with brochure and SASE. Samples are filed. Reports back only if interested. Request portfolio review in original query. Portfolio should include final art, color, tearsheets and published work. Buys one-time rights. **Pays on acceptance;** $400 for color cover; $50 for b&w, $100 for color inside.
Tips: Finds artists through word of mouth and artists' submissions. "Have a strong and varied portfolio reflecting a high degree of professionalism. Illustrations should reflect a proficiency in conceptualizing art—not just rendering. Will not be held responsible for unsolicited material."

‡BONE & FLESH, Box 349, Concord NH 03302. (603)225-0521. Editor: Lester Hirsh. Estab. 1988. Semiannual b&w with 2-color cover literary magazine. "*Bone & Flesh* publishes highly crafted poetry, prose and essays for a literate audience. Our readers are interested in small press and alternative media." Publishes chapbooks irregularly. Circ. 300. Accepts previously published artwork. Original artwork is returned at job's completion. Sample copy $5. Art guidelines for SASE with first-class postage.
Illustrations: Approached by 15-20 freelance illustrators/year. Buys 6-8 freelance illustrations/issue. Considers pen & ink. Send query letter with photocopies. Request portfolio review in original query. Samples are not filed and are returned by SASE if requested. Publication will contact artist for portfolio review if interested. Negotiates rights acquired. Pays in copies.
Tips: "See a sample copy prior to sending work to decide if we are an appropriate outlet for your work. *Bone & Flesh* is a 'homespun' publication, usually photocopied from typeset. We have published artwork by Wayne Hogan, Kathryn Gauthier, Martin Filipovisk and Fleur Byers, among others."

BOSTONIA MAGAZINE, 10 Lenox St., Brookline MA 02146. (617)353-9711. Art Director: Douglas Parker. Estab. 1900. Quarterly 4-color magazine emphasizing "innovative ideas and excellence in writing" for graduates of the university and those interested in quality writing. Circ. 145,000. Original artwork returned to artist after publication. Sample copies $2.50.
Cartoons: "Would be interested in creative ideas appropriate for highly educated audience." Send photocopies of unpublished work regularly. Do not send originals. Samples are filed. Reports back within weeks only if interested. Buys first rights. Pays $200.
Illustrations: Buys 25 illustrations/issue. Works with 150-200 illustrators/year. Works on assignment only. Send résumé, tearsheets, photostats, photocopies, slides and photographs. Samples are filed. Reports back within weeks only if interested. Portfolio should include color and b&w thumbnails, roughs, final art, tearsheets, final reproduction/product, photostats, photographs and slides. Buys first rights. "Payment depends on final use and size." **Pays on acceptance.**
Tips: "Portfolio should include plenty of tearsheets/photocopies as handouts. Don't phone; it disturbs flow of work in office. No sloppy presentations. Show intelligence and uniqueness of style." Prefers original illustrations "meant to inform and elucidate."

‡BOW & ARROW MAGAZINE, Box 2429, Capistrano Beach CA 92624. (714)493-2101. Fax: (714)240-8680. Editorial Director: Roger Combs. Emphasizes bowhunting and bowhunters. Bimonthly. Original artwork returned after publication.
Cartoons: Buys 2-3 cartoons/issue; all from freelancers. Prefers single panel, with gag line; b&w line drawings. Send finished cartoons. Material not kept on file returned by SASE. Reports within 2 months. Buys first rights. **Pays on acceptance;** $10-15, b&w.
Illustrations: Buys 1-2 illustrations/issue; all from freelancers. Prefers live animals/game as themes. Send samples. Prefers photographs or original work as samples. Especially looks for perspective, unique or accurate use of color and shading, and an ability to clearly express a thought, emotion or event. Samples returned by

SASE. Reports in 2 months. Portfolio review not required. Buys first rights. **Pays on acceptance**; $100 for color cover; $30 for b&w inside.

BOWLING MAGAZINE, 5301 S. 76th St., Greendale WI 53129. (414)423-3232. Fax: (414)421-7977. Editor: Bill Vint. Estab. 1933. Bimonthly 4-color magazine covering the sport of bowling in its many facets. Circ. 140,000. Sample copies for 9×12 SAE with $1.21 postage. Art guidelines for SASE with first-class postage. **Illustrations:** Approached by 12 illustrators/year. Buys 1-2 illustrations/issue. Works on assignment only. Send query letter with tearsheets, SASE and photocopies. Samples are filed or are returned by SASE if requested by artist. Reports back within 10 days. Rights purchased vary according to project. **Pays on acceptance**; $250-500 for color cover; $75-250 for color inside; $25-75 b&w spot art (instructional themed material). **Tips:** "Have a thorough knowledge of bowling. We have a specific interest in instructional materials that will clearly illustrate bowling techniques."

‡BREAKING IN, P.O. Box 89147, Atlanta GA 30312. (404)524-7359. Publisher: Ed Hampton. Estab. 1992. Monthly magazine showcases cartoonists who are interested in being syndicated. Circ. 1,000. Accepts previously published artwork. Originals sometimes returned. Sample copies available for $9. Art guidelines available.
Cartoons: Approached by 500 cartoonists/year. Buys 1 cartoon/issue. Prefers single and multiple panel with gagline, dealing with cartooning/syndication from the cartoonists' point of view. Samples are filed or returned by SASE if requested by artist. Reports back within 1 month. Rights purchased vary according to project. Pays $50 for b&w and $300-500 for color (cover only).
Illustrations: Buys 1 illustration/issue. Works on assignment only. Send query letter with SASE and tearsheets or call. Samples are filed and are returned by SASE. Reports back within 1 month only if interested. Rights purchased vary according to project. Pays on publication; $300-500 for color cover.

BRIDE'S MAGAZINE, Dept. AM, Condé-Nast Publications, 140 E. 45th St., New York NY 10017. (212)880-8530. Art Director: Phyllis Cox. Assistant to the Art Director: Mary Catherine McCooey. Estab. 1934. Bimonthly 4-color; "classic, clean, sophisticated design style." Original artwork is returned after publication. Sample copies for SAE with first-class postage.
Cartoons: "We have not printed cartoons thus far, but would like to in the future (funny cartoons)."
Illustrations: Buys illustrations mainly for spots and feature spreads. Buys 5-10 illustrations/issue. Works on assignment only. Considers pen & ink, airbrush, mixed media, colored pencil, watercolor, acrylic, collage and calligraphy. Needs editorial illustrations. Send query letter with brochure, tearsheets, photocopies and slides. In samples or portfolio, looks for "graphic quality, conceptual skill, good 'people' style; lively, young, but sophisticated work." Samples are filed. Publication will contact artist for portfolio review if interested. Portfolios may be dropped off every Monday-Thursday and should include color and b&w final art, tearsheets, slides, photostats, photographs and transparencies. Buys one-time rights or negotiates rights purchased. Pays on publication; $250-350 for b&w or color inside.
Tips: Finds artists through word of mouth, magazines, artists' submissions/self-promotions, sourcebooks, artists' agents and reps, attending art exhibitions. Sections most open to illustrators are "Something New" (a short subject page with 4-color art); also needs illustrations to accompany feature articles such as "Wedding Nightmare" and "Honeymoon Hotline," travel section features (color).

BRIGADE LEADER, Box 150, Wheaton IL 60189. (708)665-0630. Estab. 1960. Art Director: Robert Fine. Quarterly 2-color magazine for Christian men leading boys in Brigade. Circ. 11,000. Accepts previously published artwork. Original artwork returned after publication if requested. Sample copy for $1.50 and large SASE; artist's guidelines for SASE.
Cartoons: Approached by 30 cartoonists/year. Buys 1 cartoon/issue. Interested in sports, nature and youth themes; single panel with gagline. Include SASE. Buys first rights only. Pays on publication $25-35 for b&w cartoons.
Illustrations: Approached by 45 illustrators/year. Buys 2-4 illustrations/issue. Uses freelancers mainly for editorial illustrations. Prefers editorial illustration in pen & ink, airbrush, pencil and watercolor. Interested in masculine subjects (sports, camping, out of doors, family). Provide business card and photocopies to be kept on file. Works on assignment only. Pays on publication; $150 and up for b&w cover; $100-200 for inside.
Tips: "We like to see original concepts and well-executed drawings. We need more work on sports and father-son activities."

BUCKMASTERS WHITETAIL MAGAZINE, 1020 Monticello Court, Montgomery AL 36117. (205)271-3337. Fax: (205)244-6523. Vice President of Production: Dockery Austin. Estab. 1987. Magazine covering whitetail deer hunting. Seasonal – 6 times a year. Circ. 250,000. Accepts previously published artwork. Originals are not returned. Sample copies and art guidelines available. Needs computer-literate freelancers for design and illustration. 80% of freelance work demands knowledge of Adobe Illustrator, QuarkXPress, Photoshop or Aldus FreeHand.

Cartoons: Approached by 5 freelance cartoonists/year. Buys 1 cartoon/issue. Send query letter with brochure and photos of originals. Samples are filed or returned by SASE. Reports back within 3 months. Rights purchased according to project. Pays $25 for b&w.

Illustrations: Approached by 5 freelance illustrators/year. Buys 1 illustration/issue. Works on assignment only. Considers all media. Send query letter with brochure, SASE, tearsheets, photographs and slides. Samples are filed or are returned by SASE if requested. Reports back within 3 months. Call or write for appointment to show portfolio. Portfolio should include final art, slides and photographs. Rights purchased vary according to project. **Pays on acceptance;** $500 for color cover; $150 for color inside.

‡BUILDINGS MAGAZINE, 427 Sixth Ave. SE, Cedar Rapids IA 52406. (319)364-6167. Fax: (319)364-4278. Graphic Designer/Art Director: Ellsa Geneser. Estab. 1906. Monthly trade journal; magazine format; "information related to current approaches, technologies and products involved in large commercial facilities." Circ. 42,000. Original artwork not returned at job's completion. Sample copies available. Art guidelines not available.

Illustrations: Works on assignment only. Considers all media, themes and styles. Send query letter with brochure, tearsheets and photocopies. Samples are filed. Publication will contact artist for portfolio review if interested. Portfolio should include thumbnails, b&w/color tearsheets. Rights purchased vary according to project. **Pays on acceptance;** $350 for color cover; $75 for color inside.

Tips: Finds artists through word of mouth and submissions. "Show us a variety of work (styles), if available."

‡BUSINESS NH MAGAZINE, Suite 201, 404 Chestnut St., Manchester NH 03101-1831. (603)626-6354. Fax: (603)626-6359. Art Director: Nikki Bonenfant. Estab. 1982. Monthly magazine with focus on business, politics and people of New Hampshire. Circ. 13,000. Accepts previously published artwork. Originals returned at job's completion. Sample copies free for 9×12 SASE and 5 first-class stamps. Art guidelines not available. Needs computer-literate freelancers for design, illustration and production. 10% of freelance work demands computer knowledge of Adobe Illustrator or QuarkXPress.

Illustrations: Approached by 4 illustrators/year. Buys 1-4 illustrations/year. Works on assignment only. Prefers bold, contemporary graphics. Considers pen & ink, airbrush, colored pencil and computer generated illustration. Send query letter with résumé and tearsheets. Samples are filed or are returned by SASE if requested by artist. Publication will contact artist for portfolio review if interested. Portfolio should include b&w and color thumbnails, tearsheets, slides and final art. Buys one-time rights and reprint rights. Pays on publication; $50 for b&w, $75 for color inside.

Tips: Art Director hires freelancers mostly to illustrate feature stories and for small icon work for departments. Does not use cartoons.

BUSINESS TRAVEL NEWS, 1515 Broadway., New York NY 10036. (212)626-2531. Fax: (212)944-7144. Art Director: Teresa Carboni. Estab. 1985. Biweekly, 4-color trade journal covering "business (not leisure) travel: meetings, conventions, costs, travel planning." Circ. 52,000. Accepts previously published artwork. Originals are returned at job's completion.

• This magazine now covering more serious topics such as cost-cutting and job loss.

Illustrations: Approached by 50 illustrators/year. Buys 2 illustrations/issue. All styles and themes welcome. Prefers pen & ink, watercolor, collage, airbrush, acrylic, marker, colored pencil, oil, mixed media, pastel and computer art. Send query letter with tearsheets, photographs and photocopies. Samples are filed and are not returned. Reports back only if interested. Buys one-time rights. **Pays on acceptance;** $200 for b&w, $500 for color cover; $200 for b&w and color inside.

Tips: "Send me your best samples, be flexible to work with, meet deadlines."

BUTTERICK CO., INC., 161 Avenue of the Americas, New York NY 10013. (212)620-2500. Art Director: Renna Franco. Associate Art Director: Robin Read. Estab. 1968, magazine; 1867, catalog. Quarterly magazine and monthly catalog. "*Butterick Magazine* is for the home sewer, providing fashion and technical information about our newest sewing patterns through fashion illustration, photography and articles. The Butterick store catalog is a guide to all Butterick patterns, shown by illustration and photography." Magazine circ. 350,000. Catalog readership: 9 million worldwide. Originals are returned at job's completion.

Illustrations: Approached by 30 freelance illustrators/year. Buys 4-6 illustrations for each magazine issue; 120 fashion figures for each catalog. "We have 2 specific needs: primarily fashion illustration in a contemporary yet realistic style, mostly depicting women and children in full-length poses for our catalog. We are also interested in travel, interior, light concept and decorative illustration for our magazine." Considers watercolor and gouache for catalog art; all other media for magazine. Send query letter with tearsheets and color photocopies and promo cards. Samples are filed or are returned by SASE if requested by artist. Does not report back, in which case the artist should call soon if feedback is desired. Portfolio drop off every Monday or mail appropriate materials. Portfolio should include final art, tearsheets, photostats, photocopies and large format transparencies. Rights purchased vary according to project. **Pays on acceptance;** $250-1,200 inside (depending on job).

Tips: "Send non-returnable samples several times a year—especially if style changes. We like people to respect our portfolio drop-off policy. Repeated calling and response cards are undesirable. One follow-up call by illustrator for feedback is fine."

‡**CAMPUS LIFE**, 465 Gundersen Dr., Carol Stream IL 60188. Art Director: Tom Moraitis. Assistant Art Director: Doug Johnson. Monthly 4-color publication for high school and college students. "Though our readership is largely Christian, *Campus Life* reflects the interests of all kids—music, activities, photography and sports." Circ. 120,000. Original artwork returned after publication. "No phone calls, please. Send mailers." Uses freelance artists mainly for editorial illustration. Needs computer-literate freelancers for illustration. 10% of freelance work demands computer literacy in Aldus FreeHand and Adobe Illustrator.
Cartoons: Approached by 50 cartoonists/year. Buys 100 cartoons/year from freelancers. Uses 3-8 single-panel cartoons/issue plus cartoon features (assigned) on high school and college education, environment, family life, humor through youth and politics; applies to 13-18 age groups; both horizontal and vertical format. Prefers to receive finished cartoons. Reports in 4 weeks. **Pays on acceptance**; $50, b&w; $75, color.
Illustrations: Approached by 175 illustrators/year. Works with 10-15 illustrators/year. Buys 2 illustrations/issue, 50/year from freelancers. Styles vary from "contemporary realism to very conceptual." Works on assignment only. Send promos or tearsheets. Please no original art transparencies or photographs. Samples returned by SASE. Publication will contact artist for portfolio review if interested. Buys first North American serial rights; also considers second rights. **Pays on acceptance;** $75-350, b&w; $350-500, color, inside.
Tips: "I like to see a variety in styles and a flair for expressing the teen experience. Keep sending a mailer every couple of months."

‡✷**CANADIAN DIMENSION (CD)**, 707-228 Notre Dame Ave., Winnipeg, Manitoba R3R 1N7 Canada. (204)957-1519. Fax: (204)943-4617. Office Manager: Yvonne Block. Estab. 1963. Bimonthly consumer magazine published "by, for and about activists in the struggle for a better world, covering women's issues, aboriginal issues, the enrivonment, labour, etc." Circ. 2,600. Accepts previously published artwork. Originals returned at job's completion. Sample copies available for $2. Art guidelines available for SASE with first-class postage.
Cartoons: Approached by 10 cartoonists/year. Buys 4 cartoons/issue. Prefers political and humorous cartoons. Send query letter with roughs. Samples are filed or returned by SASE if requested by artist. Buys one-time rights. Pays $30 for b&w.
Illustrators: Approached by 5 illustrators/year. Buys 6 illustrations/year. Send query letter with brochure and SASE. Samples are filed or returned by SASE if requested by artist. Publication will contact artist for portfolio review if interested. Buys one-time rights. Pays on publication; $100 for b&w cover; $30 for b&w inside.
Tips: Finds artists through word of mouth and artists' submissions.

CAREER PILOT MAGAZINE, 4959 Massachusetts Blvd., Atlanta GA 30337. (404)997-8097. Fax: (404)997-8111. Graphic Designer: Kellie Frissell. Estab. 1983. "Monthly aviation information magazine covering beginning pilot to retirement. Articles relate to business, lifestyle, health and finance." Circ. 14,000. Accepts previously published artwork. Originals returned at job's completion. Sample copies available (free postage). Art guidelines available. Interested in both computer-generated and conventional illustrations.
Illustrations: Approached by 30 illustrators/year. Buys 4 illustrations/issue. Main subjects: training/education, health, lifestyle, finance (one or two/year with an airplane/subject). Open to various media including photographic illustration, 3-D, paper sculpture, etc. Send query letter with brochure, résumé, tearsheets, photocopies, photostats, slides and transparencies. "No phone calls please." Samples are filed or returned if requested. Reports back to the artist only if interested. Buys one-time rights. Pays net 30 days on receipt of invoice. $200 for b&w, $300 for color, full page; $100 for b&w, $200 for color, spot illustration.
Tips: "Please use discretion when choosing samples to send. *Career Pilot* is a fairly conservative, professional publication."

‡**CAREERS AND COLLEGES**, 989 Sixth Ave., New York NY 10018. (212)563-4688. Fax: (212)967-2531. Art Director: Michael Hofmann. Estab. 1980. Quarterly 4-color educational magazine. "Readers are college-bound high school juniors and seniors. Besides our magazine, we produce educational publications for outside companies." Quarterly. Circ. 500,000. Accepts previously published artwork. Original artwork is returned at job's completion. Sample copy for SASE with first-class postage. Art guidelines not available.
• This publication has a fresh new design.
Illustrations: "We're looking for contemporary, upbeat, sophisticated illustration. All techniques are welcome." Send query letter with appropriate material. Portfolio review not required. "Please do not call. Will call artist if interested in style." Buys one-time rights. Pays $950, color, cover; $100, b&w spots, $350, color departments, $400-800, color, inside; within 8 weeks of delivery of final art.

■**CAROLINA QUARTERLY**, Greenlaw Hall CB 3520, University of North Carolina, Chapel Hill NC 27599. Editor: Amber Vogel. Triquarterly "emphasizing literature for libraries and readers all over the US who are interested in contemporary poetry and fiction." Magazine is "perfect-bound, finely printed, b&w with 1-

color cover." Circ. 1,300. Send only clear copies of artwork. Sample copy $5 (includes postage and handling). Art guidelines free for SASE with first-class postage.

Cartoons: Approached by 5 cartoonists/year.

Illustrations: Uses artists for covers and inside illustrations. Approached by 10 illustrators/year. Buys up to 10 illustrations/issue. Prefers small b&w sketches. Send query letter with samples. Prefers b&w prints. Reports within 2 months. Acquires first rights.

Tips: "Bold, spare images often work best in our format. Look at a recent issue to get a clear idea of content and design."

■**CAT FANCY**, Fancy Publications Inc., Box 6050, Mission Viejo CA 92690. (714)855-8822. Editor: Debbie Phillips-Donaldson. Monthly 4-color magazine for cat owners, breeders and fanciers; contemporary, colorful and conservative. Readers are men and women of all ages interested in all phases of cat ownership. Circ. 303,000. No simultaneous submissions. Sample copy $5.50; artist's guidelines for SASE. Needs computer-literate freelancers for charts and graphs in QuarkXPress or Adobe Illustrator.

Cartoons: Buys 12 cartoons/year. Seeks single, double and multipanel with gagline. Should be simple, upbeat and reflect love for and enjoyment of cats. "Central character should be a cat." Send query letter with photostats or photocopies as samples and SASE. Reports in 2-3 months. Buys first rights. Pays on publication; $35 for b&w line drawings.

Illustrations: Buys 2-5 b&w spot illustrations/issue. Article illustrations assigned. Portfolio review not required. Pays $20 for spots; $50-100 for b&w illustrations; $200-300 for color illustrations; more for packages of multiple illustrations. Needs editorial, medical and technical illustration and images of cats.

Tips: "We need cartoons with an upbeat theme and realistic illustrations of purebred and mixed-breed cats. Please review a sample copy of the magazine before submitting your work to us."

‡■**CATHOLIC FORESTER**, Box 3012, 355 W. Shuman Blvd., Naperville IL 60566-7012. (708)983-4920. Editor: Dorothy Deer. Estab. 1883. Magazine. "We are a fraternal insurance company but use general-interest articles, art and photos. Audience is middle-class, many small town as well as big-city readers, patriotic, somewhat conservative distributed nationally." Bimonthly 4-color magazine. Circ. 150,000. Accepts previously published material. Original artwork returned after publication if requested. Sample copy for 9×12 SASE with 3 first-class stamps.

Cartoons: Approached by more than 50 cartoonists/year. Buys 6-7 cartoons/issue from freelancers. Considers "anything *funny* but it must be clean." Prefers single panel with gagline; b&w line drawings. Material returned by SASE if requested. Reports within 3 months; "we try to do it sooner." Buys one-time rights or reprint rights. **Pays on acceptance**; $25, b&w.

Illustration: Needs editorial illustration. Portfolio review not required. Publication will contact artist for portfolio review if interested. Requests work on spec before assigning job. Pays $25 for b&w, $100-200 for color inside.

Tips: Finds artists mostly through word of mouth.

■**CATS MAGAZINE**, P.O. Box 290037, Port Orange FL 32129. (904)788-2770. Fax: (904)788-2710. Editor: Tracey Copeland. Estab. 1945. Monthly 4-color magazine for cat enthusiasts of all types. Circ. 150,000. Sample copies free for SASE with $2 first-class postage. Art guidelines available. Uses freelance artists mainly for inside art. Freelancers should be familiar with Painter, Photoshop, Illustrator or Freehand.

Illustrations: Buys 10-12 illustrations/year. Prefers "cats" themes. Considers pen & ink, watercolor, oil and other media. Send query letter with SASE and samples. Samples are filed for 2 years. Publication will contact artist for portfolio review if interested. Requests work on spec before assigning job. Illustrators are commissioned based on samples in files.

Tips: Finds artists through artists' submissions and sourcebooks. "Artwork should show cats in a realistic manner or have editorial significance."

CHEMICAL ENGINEERING, 1221 Avenue of Americas, New York NY 10020. (212)512-3377. Fax: (212)512-4762. Art Director: M. Gleason. Estab. 1903. Monthly 4-color trade journal featuring chemical process, industry technology, products and professional career tips. Circ. 80,000. Accepts previously published artwork. Original artwork returned at job's completion. Sample copies available. "Illustrators should review any issue for guidelines."

• Now also publishes environmental engineering supplement three times/year. Needs cover illustrations.

Illustrations: Approached by 1,000+ illustrators/year. Buys 200 illustrations/year. Works on assignment only. Prefers technical information graphics in all media, including computer art. 50% freelance work demands knowledge of QuarkXPress, Aldus Freehand, Adobe Illustrator or Photoshop. Send query letter with samples and SASE. Samples are filed or are returned by SASE if requested by artist. Reports back only if

interested. To show a portfolio, mail appropriate representative materials. Buys first rights, one-time rights or reprint rights. Pays on publication; $150-200 for color inside.
Tips: "Have a style and content appropriate to the business of engineering, and fit within our limited budget."

CHEMICAL ENGINEERING PROGRESS, 345 E. 47th St., New York NY 10017. (212)705-7966. Art Director: Mark Montgomery. Technical trade magazine published by the American Institute of Chemical Engineering. Needs computer-literate freelancers for design and illustration. 100% of freelance work demands knowledge of Adobe Illustrator, QuarkXPress, Photoshop and Aldus FreeHand.
Illustrations: Approached by 20 illustrators/year. Works on assignment only. Needs technical and editorial illustration. Send query letter with tearsheets. Samples are filed. Publication will contact artist for portfolio review if interested. Artist should follow up with a call or letter after original query. Reports back to the artist only if interested. Pays $600 cover; $300 for b&w, $450 for color inside. Buys first or one-time rights.

CHESAPEAKE BAY MAGAZINE, 1819 Bay Ridge Ave., Annapolis MD 21403. (410)263-2662. Fax: (410)267-6924. Art Director: Christine Gill. Estab. 1972. Monthly 4-color magazine focusing on the boating environment of the Chesapeake Bay—including its history, people, places and ecology. Circ. 35,000. Original artwork returned after publication. Sample copies free for SASE with first-class postage. Art guidelines available. "Please call."
Cartoons: Approached by 12 cartoonists/year. Prefers single panel, b&w washes and line drawings with gagline. Cartoons are nautical humor or appropriate to the Chesapeake environment. Send query letter with finished cartoons. Samples are filed. Reports back to the artist only if interested. Buys one-time rights. Pays $25-30 for b&w.
Illustrations: Approached by 12 illustrators/year. Buys 2-3 technical and editorial illustrations/issue. Considers pen & ink, watercolor, collage, acrylic, marker, colored pencil, oil, charcoal, mixed media and pastel. Usually prefers watercolor or oil for 4-color editorial illustration. "Style and tone are determined by the artist after he/she reads the story." Send query letter with résumé, tearsheets and photographs. Samples are filed. Reports back only if interested. Publication will contact artist for portfolio review if interested. Portfolio should include "anything you've got." No b&w photocopies. Buys one-time rights. "Price decided when contracted." Pays $50-175 for b&w inside; $75-275 for color inside.
Tips: "Our magazine design is relaxed, fun, oriented toward people having fun on the water. Style seems to be loosening up. Boating interests remain the same. But for the Chesapeake Bay—water quality and the environment are more important to our readers than in the past. Colors brighter. Send tearsheets or call for an interview—we're always looking."

‡CHIC MAGAZINE, Suite 300, 9171 Wilshire Blvd., Beverly Hills CA 90210. (310)858-7100. Art Director: John Berado. Estab. 1976. Monthly magazine "which contains fiction and nonfiction; sometimes serious, often humorous, Sex is the main topic, but any sensational subject is possible." Circ. 50,000. Originals returned at job's completion. Sample copies available for $6. Art guidelines not available.
Illustrations: Approached by 15 illustrators/year. Buys 2 illustrations/issue. Works on assignment only. Prefers themes: sex/eroticism, any and all styles. Considers all media. Send query letter with tearsheets, photographs and photocopies. Samples are filed. Artist should follow up with call and/or letter after initial query. Publication will contact artist for portfolio review if interested. Portfolio should include b&w and color slides and final art. Buys all rights. **Pays on acceptance;** $600 for color inside.
Tips: Finds artists through word of mouth, mailers and submissions. "We use artists from all over the country, with diverse styles, from realistic to abstract. Must be able to deal with adult subject matter and have no reservations concerning explicit sexual images. We want to show these subjects in new and interesting ways."

CHICAGO LIFE MAGAZINE, Box 11311, Chicago IL 60611-0311. Publisher: Pam Berns. Estab. 1984. Bimonthly lifestyle magazine. Circ. 60,000. Accepts previously published artwork. Original artwork returned at job's completion. Sample copy for SASE with $1.75 postage. Art guidelines not available.
Cartoons: Approached by 25 cartoonists/year. Buys 2 cartoons/issue. Prefers sophisticated humor; b&w line drawings. Send query letter with photocopies of finished cartoons. Samples are filed or are returned by SASE if requested. Reports back only if interested. Buys one-time rights. Pays $20.
Illustration: Approached by 30 illustrators/year. Buys 3 illustrations/issue. Prefers "sophisticated, avant-garde or fine art. No 'cute' art, please." Considers all media. Send SASE, slides and photocopies. Samples are filed or returned by SASE. Reports back within 3 weeks. Buys one-time rights. **Pays on acceptance;** $30 for b&w and color inside.

‡✴CHICKADEE, Suite 500, 179 John St., Toronto, Ontario M5T 3G5 Canada. (416)868-6001. Fax: (416)868-6009. Art Director: Tim Davin. Estab. 1979. 10 issues/yr. Children's science & nature magazine. Chickadee is a "hands-on" science and nature publication designed to entertain and educate 3-9 year-olds. Each issue contains photos, illustrations, an easy-to-read arrival story, a craft project, puzzles, a science experiment, and a pullout poster. Circ. 150,000 in North America. Originals returned at job's completion. Sample copies available. Art guidelines not available. Needs computer-literate freelancers for illustration. Freelancers should be familiar with Adobe Illustrator, CorelDRAW or Adobe Photoshop.

Illustrations: Approached by 500-750 illustrators/year. Buys 3-7 illustrations/issue. Works on assignment only. Prefers animals, children, situations and fiction. All styles, loaded with humor but not cartoons. Realistic depictions of animals and nature. Considers all media and computer art. No b&w illustrations. Send query letter with tearsheets. Samples are filed or returned by SASE if requested by artist. Publication will contact artist for portfolio review if interested. Portfolio should include final art, tearsheets and photocopies. Buys all rights. Pays within 30 days of invoice; $450 for color cover; $650 for color/double page spread.

Tips: Finds artists through sourcebooks, word of mouth, artists' submissions as well as looking in other magazines to see who's doing what. "Please become familiar with the magazine before you submit. Ask yourself whether your style is appropriate before spending the money on your mailing."

■**CHILD LIFE**, 1100 Waterway Blvd., Box 567, Indianapolis IN 46206. (317)636-8881. Art Director: Janet K. Moir. Estab. 1921. 4-color magazine for children 9-11. Monthly, except bimonthly January/February, April/ May, July/August and October/November. Sample copy $1.25.

 ● Also publishes *Children's Digest*.

Illustrations: Approached by 200 illustrators/year. Works with 30 illustrators/year. Buys approximately 50 illustrations/year on assigned themes. Especially needs health-related (exercise, safety, nutrition, etc.) themes, and stylized and realistic styles of children 9-11 years old. Uses freelance art mainly with stories, recipes and poems. Send query letter with brochure showing art style or résumé and tearsheets, photostats, photocopies, slides, photographs and SASE. Especially looks for an artist's ability to draw well consistently. Reports in 2 months. Portfolio review not required. Buys all rights. Pays $275 for color cover. Pays for inside illustrations by the job, $70-155 (4-color), $60-120 (2-color), $35-90 (b&w). Pays within 3 weeks prior to publication date. "All work is considered work for hire."

Tips: Finds artists through artist submission, occasionally through a sourcebook. "Artists should obtain copies of current issues to become familiar with our needs. I look for the ability to illustrate children in group situations and interacting with adults and animals, in realistic styles. Also use unique styles for occasional assignments – cut paper, collage or woodcut art. No cartoons, portraits of children or slick airbrushed advertising work."

■**CHILDREN'S DIGEST**, 1100 Waterway Blvd., Box 567, Indianapolis IN 46206. (317)636-8881. Fax: (317)637-0126. Art Director: Janet K. Moir. 4-color magazine with special emphasis on health, nutrition, safety and exercise for preteens. Published 8 times/year. Sample copy $1.25; art guidelines for SASE.

 ● Also publishes *Child Life*.

Illustrations: Approached by 200 illustrators/year. Works with 40 illustrators/year. Buys 15-20 illustrations/ issue. Uses freelance art mainly with stories, articles, poems and recipes. Works on assignment only. Send query letter with brochure, résumé, samples and tearsheets to be kept on file. Portfolio review not required. Prefers photostats, slides and good photocopies as samples. Samples returned by SASE if not kept on file. Reports within 2 months. Buys all rights. Pays $275 for color cover; $35-90 for b&w, $60-120 for 2-color, $70-155 for 4-color inside. Pays within 3 weeks prior to publication date. "All artwork is considered work for hire."

Tips: Finds artists through artist submission and sourcebooks. Likes to see situation and storytelling illustrations with more than 1 figure. When reviewing samples, especially looks for artist's ability to bring a story to life with illustrations and to draw well consistently. No advertising work, cartoon styles or portraits of children. Needs realistic styles and animals.

■**CHILDREN'S PLAYMATE**, Box 567, Indianapolis IN 46206. (317)636-8881. Art Director: Marty Jones. 4-color magazine for ages 6-8. Special emphasis on entertaining fiction, games, activities, fitness, health, nutrition and sports. Published 8 times/year. Original art becomes property of the magazine and will not be returned. Sample copy $1.25.

Illustrations: Uses 25-30 illustrations/issue; buys 10-20 from freelancers. Interested in editorial, medical, stylized, humorous or realistic themes; also food, nature and health. Considers pen & ink, airbrush, charcoal/ pencil, colored pencil, watercolor, acrylic, oil, pastel, collage, multimedia and computer illustration. Works on assignment only. Send sample of style; include illustrations of children, families, animals – targeted to children. Provide brochure, tearsheet, stats or good photocopies of sample art to be kept on file. Samples returned by SASE if not filed. Artist should follow up with call or letter. Also considers b&w camera-ready art for puzzles, such as dot-to-dot, hidden pictures, crosswords, etc. Buys all rights on a work-for-hire basis. Payment varies. Pays $275 for color cover; up to $155 for color and $90 for b&w inside, per page.

Tips: "Finds artists through artists' submissions/self-promotions. Become familiar with our magazine before sending anything. Don't send just 2 or 3 samples. I need to see a minimum of 8 pieces to determine that the artist fits our needs. Looking for samples displaying the artist's ability to interpret text, especially in fiction for ages 6-8. Illustrators must be able to do their own layout with a minimum of direction."

■**THE CHRISTIAN CENTURY**, 407 S. Dearborn, Chicago IL 60605. (312)427-5380. Fax: (312)427-1302. Production Coordinator: Matthew Giunti. Estab. 1888. Religious magazine; "a weekly ecumenical magazine with a liberal slant on issues of Christianity, culture and politics." Circ. 35,000. Accepts previously published artwork. Original artwork returned at job's completion. Art guidelines for SASE with first-class postage.

Cartoons: Buys 1 cartoon/issue. Prefers religious themes. Line art works best on newsprint stock. Seeks single panel, b&w line drawings and washes. Send query letter with finished cartoons. Samples are filed or are returned by SASE if requested by artist. Reports back within 3 weeks. Buys one-time rights. Pays $25 for b&w; $50 for cover.

Illustrations: Approached by 40 illustrators/year. Buys 30 illustrations/year. Works on assignment only. Needs editorial illustration with "religious, specifically Christian themes and styles that are inclusive, i.e., women and minorities depicted." Considers pen & ink and charcoal. Send query letter with tearsheets. Portfolio review not required. Samples are filed or returned by SASE. Reports back within 1 month. Buys one-time rights. Pays on publication; $100 for b&w cover; $50 for b&w inside.

CHRISTIAN HOME & SCHOOL, 3350 E. Paris Ave. SE, Grand Rapids MI 49512. (616)957-1070. Fax: (616)957-5022. Senior Editor: Roger W. Schmurr. Emphasizes current, crucial issues affecting the Christian home for parents who support Christian education. Half b&w, half 4-color magazine; b&w with 4-color cover; published 6 times/year. Circ. 53,000. Original artwork returned after publication. Sample copy for 9 × 12 SASE with 4 first-class stamps; art guidelines for SASE with first-class postage. Finds most artists through references, portfolio reviews, samples received through the mail and artist reps.

Cartoons: Prefers family and school themes. Pays $50 for b&w.

Illustrations: Buys approximately 2 illustrations/issue. Prefers pen & ink, charcoal/pencil, colored pencil, watercolor, collage, marker and mixed media. Prefers family or school life themes. Works on assignment only. Send query letter with résumé, tearsheets, photocopies or photographs. Show a representative sampling of work. Samples returned by SASE. Publication will contact artist if interested in portfolio review. Buys first rights. Pays on publication; $175 for b&w full page inside; $250 for 4-color.

THE CHRISTIAN READER, Dept. AM, 465 Gundersen Dr., Carol Stream IL 60188. (708)260-6200. Fax: (708)260-0114. Art Director: Rai Whitlock. Estab. 1963. Bimonthly general interest magazine. "A digest of the best in Christian reading." Circ. 250,000. Accepts previously published artwork. Originals returned at job's completion. Sample copies and art guidelines for SASE with first-class postage.

Cartoons: Buys 3 cartoons/issue. Prefers home, family, church life and general interest. Send query letter with samples of published work. Samples are filed or returned by SASE. Reports back to artist only if interested. Buys one-time rights. Pays $45 for reprint; $75 originals.

Illustrations: Buys 12 illustrations/issue. Works on assignment only. Prefers family, home and church life. Considers all media. Samples are filed or returned by SASE if requested by artist. Reports back only if interested. To show a portfolio, mail appropriate materials. Buys one-time rights. **Pays on acceptance**; $150 for b&w, $250 for color inside.

Tips: "Send samples of your best work, in your best subject and best medium. We're interested in fresh and new approaches to traditional subjects and values."

THE CHRISTIAN SCIENCE MONITOR, Mailstop P-214, 1 Norway St., Boston MA 02115. (617)450-2361. Fax: (617)450-7575. Design Director: John Van Pelt. Estab. 1910. International 4-color daily newspaper. Originals returned at job's completion. Needs computer-literate freelancers for design and illustration. Freelancers should be familiar with Adobe Illustrator, QuarkXPress and Photoshop.

Cartoons: Prefers international news, commentary and analysis cartoons. Pays $75 for b&w cartoons; $150 for color cartoons.

Illustrations: Approached by 30-40 illustrators/year. Buys 100-150 illustrations/year. Works on assignment only. Needs editorial illustration. Prefers local artists with color newspaper experience. Uses freelancers mainly for opinion illustration. Send query letter with brochure, photocopies and photostats. Samples are filed. Publication will contact artist for portfolio review if interested. Buys one-time rights and national syndication rights. Pays $200 for color.

Tips: Finds artists through artists' submissions and other publications.

‡**THE CHURCH HERALD**, 4500 60th St. SE, Grand Rapids MI 49512-9642. (616)698-7071. Estab. 1837. Monthly magazine. "The official denominational magazine of the Reformed Church in America." Circ. 105,000. Accepts previously published artwork. Originals returned at job's completion. Sample copies available for $2. Art guidelines not available.Needs computer-literate freelancers for illustration.

Illustrations: Buys 2 illustrations/issue. Works on assignment only. Considers pen & ink, watercolor, collage, marker and pastel. Send query letter with brochure and tearsheets. Samples are filed. Reports back to the artist only if interested. Portfolio review not required. Buys one-time rights. Pays on publication; $300 for color cover; $150 for b&w, $200 for color inside.

THE CHURCHMAN'S HUMAN QUEST, 1074 23rd Ave. N., St. Petersburg FL 33704. (813)894-0097. Editor: Edna Ruth Johnson. Magazine is b&w with 2-color cover, conservative design. Published 6 times/year. Circ. 10,000. Original artwork returned after publication. Sample copy available.

Cartoons: Buys 2-3 cartoons/issue. Interested in religious, political and social themes. Prefers to see finished cartoons. Include SASE. Reports in 1 week. **Pays on acceptance**; $7.

Illustrations: Buys 2-3 illustrations/issue. Interested in themes with "social implications." Prefers to see finished art. Provide tearsheet to be kept on file for future assignments. Include SASE. Reports in 1 week. Pays $320 for color cover; $280 for b&w.

Tips: "Read current-events news so you can apply it humorously."

■**CICADA**, 329 E St., Bakersfield CA 93304. (805)323-4064. Editor: Frederick Raborg. Estab. 1984. A quarterly literary magazine "aimed at the reader interested in haiku and fiction related to Japan and the Orient. We occasionally include excellent Chinese and other Asian poetry forms and fiction so related." Circ. 600. Accepts previously published artwork. Originals returned at job's completion. Sample copies available for the cost of $4.50. Art guidelines for SASE with first-class postage.

Cartoons: Approached by 50-60 cartoonists/year. Buys 2 cartoons/issue. Prefers the "philosophically or ironically funny. Excellent cartoons without gaglines occasionally used on cover." Prefers single panel b&w washes and line drawings with or without gagline. Send good photocopies of finished cartoons. Samples are filed or returned by SASE. Reports back within 2 months. Buys first rights. Pays $10 for b&w; $15 if featured. **Pays on acceptance.**

Illustrations: Approached by 150-175 illustrators/year. Buys 2 illustrations/issue. Prefers Japanese or Oriental, nature themes in pen & ink. Send query letter with photostats of finished pen & ink work. Samples are filed or returned by SASE. Reports back within 2 months. Portfolio review not required. Buys first rights and one-time rights. Pays $15-20 for b&w cover; $10 for b&w inside. Pays on publication for most illustrations "because they are dictated by editorial copy."

Tips: Finds artists through market listings and artists' submissions.

CINCINNATI MAGAZINE, 409 Broadway, Cincinnati OH 45202. (513)421-4300. Art Director: Tom Hawley. Estab. 1960. Monthly 4-color lifestyle magazine for the city of Cincinnati. Circ. 30,000. Accepts previously published artwork. Original artwork returned at job's completion. Art guidelines not available.

Cartoons: Approached by 20 cartoonists/year. Buys 4 cartoons/issue. "There are no thematic or stylistic restrictions." Prefers single panel b&w line drawings. Send query letter with finished cartoons. Samples are filed or returned with SASE. Reports back within 2 months. Buys one-time rights or reprint rights. Pays $25.

Illustrations: Approached by 20 illustrators/year. Buys 6 illustrations/issue from local freelancers. Works on assignment only. Send query letter with tearsheets and/or photocopies. Samples are filed or returned by SASE if requested by artist. Reports back only if interested. Buys one-time rights or reprint rights. **Pays on acceptance;** $250 for color cover; $85 for b&w; $135 for color inside.

CIRCLE K MAGAZINE, 3636 Woodview Trace, Indianapolis IN 46268. (317)875-8755. Fax: (317)879-0204. Art Director: Dianne Bartley. Estab. 1968. Kiwanis International's youth magazine for (college age) students emphasizing service, leadership, etc. Published 5 times/year. Circ. 14,000. Originals returned at job's completion. Sample copies available.

Illustrations: Approached by more than 30 illustrators/year. Buys 1-2 illustrations/issue. Works on assignment only. Needs editorial illustration. "We look for variety." Send query letter with tearsheets. Samples are filed. Publication will contact artist for portfolio review if interested. Portfolio should include tearsheets and slides. **Pays on acceptance:** $100 for b&w and $250 for color cover; $50 for b&w and $150 for color inside.

‡■**CITY LIMITS**, 40 Prince St., New York NY 10012. (212)925-9820. Fax: (212)966-3407. Senior Editor: Jill Kirschenbaum. Estab. 1976. Monthly urban affairs magazine covering issues important to New York City's low- and moderate-income neighborhoods, including housing, community development, the urban environment, crime, public health and labor. Circ. 10,000. Originals returned at job's completion. Sample copies free for 9 × 12 SASE and 4 first-class stamps.

● Plans to publish more cartoons in the future. Would like to see more submissions.

Cartoons: Buys 5 cartoons/year. Prefers N.Y.C. urban affairs — social policy, health care, environment and economic development. Prefers political cartoons; single, double or multiple panel b&w washes and line drawings with or without gaglines. Send query letter with finished cartoons and tearsheets. Samples are filed. Reports back within 1 month. Buys first rights and reprint rights. Pays $35-50 for b&w.

Illustrations: Buys 1-2 illustrations/issue. Must address urban affairs and social policy issues, affecting low and moderate income neighborhoods, primarily in New York City. Considers pen & ink, watercolor, collage, airbrush, charcoal, mixed media and anything that works in b&w. Send query letter with tearsheets. Samples are filed. Reports back within 1 month. Request portfolio review in original query. Portfolio should include b&w thumbnails, final art and tearsheets. Buys first rights and reprint rights. Pays on publication; $50-100 for b&w cover; $35-50 for b&w inside. "Our production schedule is tight, so publication is generally within 2 weeks of acceptance, as is payment."

Tips: Finds artists through other publications, word of mouth and submissions. "Make sure you've seen the magazine before you submit. Our niche is fairly specific."

‡**CLASSIC AUTO RESTORER**, P.O. Box 6050, Mission Viejo CA 92690. (714)855-8822. Fax: (714)855-3045. Editor: Brian Mertz. Estab. 1989. Monthly consumer magazine with focus on collecting, restoring and enjoy-

Samuel Trudel was commissioned by City Limits *to illustrate a story about the growing independence of the five boroughs of New York City. The artist was going for a clear metaphor for the separating boroughs, and came up with "a clean, sophisticated design with a strong editorial feel," says Editor Jill Kirschenbaum.*

ing classic cars. Circ. 85,000. Accepts previously published artwork. Originals returned at job's completion. Sample copies available for $5.50. Art guidelines not available. Needs computer-literate freelancers for illustration. 20% of freelance work demands knowledge of Adobe Illustrator or QuarkXPress.

Illustrations: Approached by 5-10 illustrators/year. Buys 2-3 illustrations/issue. Prefers technical illustrations and cutaways of classic/collectible automobiles through 1972. Considers pen & ink, watercolor, airbrush, acrylic, marker, colored pencil, oil, charcoal, mixed media and pastel. Send query letter with SASE, slides, photographs and photocopies. Samples are filed or returned by SASE if requested by artist. Reports back to the artist only if interested. Buys one-time rights. Pays on publication; $300 for color cover; $35 for b&w, $100 for color inside.

Tips: Finds artists through submissions. Areas most open to freelance work are technical illustrations for feature articles and renderings of classic cars for various sections.

■**CLEANING BUSINESS,** 1512 Western Ave., Box 1273, Seattle WA 98111. (206)622-4241. Fax: (206)622-6876. Publisher: Bill Griffin. Submissions Editor: Jim Saunders. Quarterly magazine with technical, management and human relations emphasis for self-employed cleaning and maintenance service contractors. Circ. 6,000. Prefers first publication material. Simultaneous submissions OK "if to noncompeting publications." Original artwork returned after publication if requested by SASE. Sample copy $3.

Cartoons: Buys 1-2 cartoons/issue. Must be relevant to magazine's readership. Prefers b&w line drawings.

Illustrations: Buys approximately 12 illustrations/issue including some humorous and cartoon-style illustrations. Send query letter with samples. Samples returned by SASE. Buys first publication rights. Reports only if interested. Pays for design by the hour, $10-15. Pays for illustration by the project, $3-15. Pays on publication.

Tips: "Our budget is extremely limited. Those who require high fees are really wasting their time. We are interested in people with talent and ability who seek exposure and publication. Our readership is people who work for and own businesses in the cleaning industry. If you have material relevant to this specific audience, we would definitely be interested in hearing from you."

CLEARWATER NAVIGATOR, 112 Market St., Poughkeepsie NY 12603. (914)454-7673. Fax: (914)454-7952. Graphics Coordinator: Nora Porter. Bimonthly b&w newsletter emphasizing sailing and environmental matters for middle-upper income Easterners with a strong concern for environmental issues. Circ. 8,000. Accepts previously published material. Original artwork returned after publication. Sample copy free with SASE.

Cartoons: Buys 1 cartoon/issue. Prefers editorial lampooning – environmental themes. Prefers single panel b&w line drawings with gaglines. Send query letter with samples of style to be kept on file. Material not filed is returned only if requested. Reports within 1 month. Publication will contact artist for portfolio review if interested. Buys first rights. Pays on publication, negotiable rate, for b&w.

Illustrations: Buys editorial and technical illustration of nature subjects. Pays $100 for b&w, $150 for color cover; $75 for b&w, $100 for color inside.

Tips: Finds artists through word of mouth, artists' submissions and attending art exhibitions. Sees "greater and greater specialization" in the magazine field.

CLEVELAND MAGAZINE, Dept. AM, Suite 730, 1422 Euclid Ave., Cleveland OH 44115. (216)771-2833. Fax: (216)781-6318. Contact: Gary Sluzewski. Monthly city magazine, b&w with 4-color cover, emphasizing local news and information. Circ. 50,000. Uses computer-literate freelancers for illustration. 40% of freelance work demands knowledge of QuarkXPress, Aldus FreeHand or Photoshop.

Illustrations: Approached by 100 illustrators/year. Buys 5-6 editorial illustrations/issue on assigned themes. Sometimes uses humorous illustrations. Send query letter with brochure showing art style or samples. Call or write for appointment to show portfolio, which should include printed samples, final reproduction/product, color tearsheets and photographs. Pays $300 for b&w, $400 for color cover; $200 for b&w, $250 for color inside.

Tips: "Artists used on the basis of talent. We use many talented college graduates just starting out in the field. We do not publish gag cartoons but do print editorial illustrations with a humorous twist. Full page editorial illustrations usually deal with local politics, personalities and stories of general interest. Generally, we are seeing more intelligent solutions to illustration problems and better techniques. The economy has drastically affected our budgets; we pick up existing work almost completely as opposed to commissioning illustrations."

COBBLESTONE, THE HISTORY MAGAZINE FOR YOUNG PEOPLE, Cobblestone Publishing, Inc., 7 School St., Peterborough NH 03458. (603)924-7209. Fax:(603)924-7380. Art Director: Ellen Klempner-Beguin. Assistant Art Director: Lisa Brown. Monthly magazine emphasizing American history; features nonfiction, supplemental nonfiction, fiction, biographies, plays, activities and poetry for children ages 8-14. Circ. 38,000. Accepts previously published material and simultaneous submissions. Sample copy $3.95 with 8×10 SASE. Material must relate to theme of issue; subjects and topics published in guidelines for SASE. Freelance work demands knowledge of Adobe Illustrator and Photoshop.

 • Other magazines published by Cobblestone include *Calliope* (world history), *Faces* (cultural anthropology) and *Odyssey* (science). All for kids ages 8-15.

Illustrations: Buys 1-2 illustrations/issue. Prefers historical theme as it pertains to a specific feature. Works on assignment only. Send query letter with brochure, résumé, business card and b&w photocopies or tearsheets to be kept on file or returned by SASE. Write for appointment to show portfolio. Buys all rights. Pays on publication; $10-125 for b&w, $20-210 for color inside. Artists should request illustration guidelines.

Tips: "Study issues of the magazine for style used. Send samples and update samples once or twice a year to help keep your name and work fresh in our minds."

■**COLLEGE BROADCASTER MAGAZINE**, 71 George St., Providence RI 02912-1824. (401)863-2225. Fax: (401)863-2221. Publisher/Executive Director: Glenn Gutmacher. Estab. 1989. Bimonthly 2-color trade journal; magazine format; "for college radio and television stations, communication and film depts.; anything related to student station operations or careers in electronic media." Circ. 2,000 copies. Accepts previously published artwork. Original artwork is returned at job's completion if requested upon submission. Sample copies available for SASE with first-class postage. Art guidelines not available. Needs computer literate freelancers for illustration; should be familiar with Aldus PageMaker, Aldus FreeHand and Photoshop.

Cartoons: Approached by 1-3 cartoonists/year. Publishes 3-5 cartoons/year. Prefers "funky, alternative or media industry, MTV or political style (relating to a media issue)"; single panel b&w line drawings and washes with gagline. Contact only through artist rep. Send query letter with finished cartoons. Samples are filed. Reports back to the artist only if interested. Pays 5 copies. Buys one-time rights.

Illustrations: Approached by 1-3 freelance illustrators/year. Needs editorial and technical illustrations. Prefers all "cartoons and funky covers." Considers pen & ink and marker. Contact through artist rep or send query letter with tearsheets and photographs. Samples are filed. Reports back only if interested. Publication will contact artist for porfolio review if interested. Portfolio should include photocopies. Buys one-time rights. Pays 5 copies.

Tips: "Be aware of what's happening in the media industry, especially what's hot in college radio and/or TV. Keep it topical."

COLLISION® MAGAZINE, Box M, Franklin MA 02038. (508)528-6211. Editor: Jay Kruza. Cartoon Editor: Brian Sawyer. Monthly magazine with an audience of new car dealers, auto body repair shops and towing companies. Articles are directed at the managers of these small businesses. Circ. 16,000. Prefers original material but may accept previously published material. Sample copy $4. Art guidelines for SASE with first-class postage.
Cartoons: Buys 3 cartoons/issue. Prefers themes that are positive or corrective in attitude. Prefers single panel b&w line drawings with gagline. Send rough versions or finished cartoons. Reports back in 2 weeks or samples returned by SASE. Buys all rights and reprint rights. Pays $10/single panel b&w line cartoon.
Illustrations: Buys about 2 illustrations/issue based upon a 2-year advance editorial schedule. Send query letter which includes phone number and time to call, with brochure, tearsheets, photostats, photocopies, slides and photographs. Samples are returned by SASE. "We prefer clean pen & ink work but will use color." Reports back within 15-30 days. "**Pays on acceptance** for assigned artwork ranging from $25 for spot illustrations up to $200 for full-page material."

COMMON LIVES/LESBIAN LIVES, Box 1553, Iowa City IA 52244. Contact: Editorial Collective. Quarterly magazine emphasizing lesbian lives for all ages, races, nationalities and sizes. Perfect-bound, 128 pages, b&w with color cover. Circ. 2,000. "All submissions sent to the Lesbian Herstory Archives." Sample copy $5.
Cartoons: Approached by 5-8 cartoonists/year. Prefers lesbian themes. Prefers vertical format 5½×8½ page. Reports within 4 months.
Illustrations: Approached by 10-20 illustrators/year. Style of Sudie Rakusin and Tee Corrine. Prefers lesbian themes. Prefers vertical format 5½×8½ page. Must be camera ready. No multiple submissions. Maximum of 5 pieces at one time. Graphic work is *not* returned. B&w only, mail flat, not folded. Reports back within 4 months. Portfolio review not required.
Tips: Accepts work by lesbians only.

‡COMMONWEAL, 15 Dutch St., New York NY 10038. (212)732-0800. Contact: Editor. Estab. 1924. Public affairs journal. "Journal of opinion edited by Catholic lay people concerning public affairs, religion, literature and all the arts;" b&w with 2-color cover. Biweekly. Circ. 18,000. Original artwork is returned at the job's completion. Sample copies for SASE with first-class postage. Guidelines for SASE with first-class postage.
Cartoons: Approached by 20-40 cartoonists/year. Buys 3-4 cartoons/issue from freelancers. Prefers simple lines and high-contrast styles. Prefers single panel, with or without gagline; b&w line drawings. Send query letter with finished cartoons. Samples are filed or are returned by SASE if requested by artist. Reports back within 2 weeks. Buys first rights. Pays $8.50 for b&w.
Illustrations: Approached by 20 illustrators/year. Buys 3-4 illustrations/issue, 60/year from freelancers. Prefers high-contrast illustrations that "speak for themselves." Prefers pen & ink and marker. Send query letter with tearsheets, photographs, SASE and photocopies. Samples are filed or returned by SASE if requested by artist. Reports back within 2 weeks. To show a portfolio, mail b&w tearsheets, photographs and photocopies. Buys first rights. Pays $25 for b&w cover; $10 for b&w inside on publication.

CONFETTI MAGAZINE, 1401 Lunt Ave., Elk Grove Village IL 60007. (708)437-6604. Fax: (708)437-6618. Art Directors: Jennifer Goland and Jean Bartz. Estab. 1988. "*Confetti* is a bimonthly trade journal addressed to working professionals in the graphic arts business. Our readers include other artists and designers, art directors, creative directors, production managers and publishing executives. Our magazine goes into ad agencies, publishing houses, design studios, creative departments of corporations, and TV and record companies. We are an information source and an idea book, presenting articles on both traditional and computer-generated art that will stimulate and inspire the creative mind. We are looking for work that is a cut above the ordinary." Circ. 15,500. Accepts previously published artwork. Orginals returned at job's completion. Sample copies and art guidelines available. Needs computer-literate freelancers for illustration.
Illustrations: Approached by approximately 300 illustrators/year. Considers all media, including computer-generated illustrations. Send query letter with brochure, résumé, tearsheets, photocopies and photostats. Samples are filed and returned by SASE if requested by artist. Reports back to the artist only if interested. Write for appointment to show a portfolio. Do not send unsolicited portfolios. Portfolio should include b&w

tearsheets and slides, color photostats and photocopies, final art and photographs.

Tips: "Be familiar with quality of art. *Confetti* is a professional art publication and shows only top quality art. Hobbyists need not apply. There is currently a trend to produce computer art even when this may not be the best medium for the artist. *Confetti* looks for work with good personal style. We accept innovative, fresh computer or traditional art. Because our magazine goes to art and creative directors who purchase art, we do not ordinarily pay for work. An appearance in *Confetti* frequently leads to work from sources among our readers. Artists whose work is of sufficient interest and quality may become the subject of features. On occasion we also barter for conceptual art."

‡CONFRONTATION: A LITERARY JOURNAL, English Department, C.W. Post, Long Island University, Brookville NY 11548. (516)299-2391. Editor: Martin Tucker. Estab. 1968. Semiannual literary magazine devoted to the short story and poem, for a literate audience open to all forms, new and traditional. Circ. 2,000. Sample copies available for $3. Art guidelines not available. 20% of freelance work demands computer skills.

Illustrations: Approached by 10-15 illustrators/year. Buys 2-3 illustrations/issue. Works on assignment only. Considers pen & ink and collage. Send query letter with SASE and photocopies. Samples are not filed and are returned by SASE. Reports back within 1-2 months only if interested. Portfolio review not required. Rights purchased vary according to project. Pays on publication; $50-100 for b&w, $100-250 for color cover; $25-50 for b&w, $50-75 for color inside.

CONSERVATORY OF AMERICAN LETTERS, Box 298, Thomaston ME 04861. (207)354-0753. Editor: Bob Olmsted. Estab. 1986. Quarterly Northwoods journal emphasizing literature for literate and cultured adults. Original artwork returned after publication. Sample copy for SASE with first-class postage.

Cartoons: Pays $5 for b&w cartoons.

Illustrations: Approached by 30-50 illustrators/year. "Very little illustration used. Find out what is coming up, then send something appropriate. Unsolicited 'blind' portfolios are of little help." Portfolio review not required. Buys first rights, one-time rights or reprint rights. **Pays on acceptance**; $5 for b&w, $30 for color cover; $5 for b&w, $30 for color inside.

■CONSTRUCTION EQUIPMENT OPERATION AND MAINTENANCE, Construction Publications, Inc., Box 1689, Cedar Rapids IA 52406. (319)366-1597. Editor-in-Chief: C.K. Parks. Estab. 1948. Bimonthly b&w tabloid with 4-color cover. Concerns heavy construction and industrial equipment for contractors, machine operators, mechanics and local government officials involved with construction. Circ. 67,000. Original artwork not returned after publication. Free sample copy.

Cartoons: Buys 8-10 cartoons/issue. Interested in themes "related to heavy construction industry" or "cartoons that make contractors and their employees 'look good' and feel good about themselves"; single panel. Send finished cartoons and SASE. Reports within 2 weeks. Buys all rights, but may reassign rights to artist after publication. Pays $20 for b&w. Reserves right to rewrite captions.

‡CONTACT ADVERTISING, Box 3431, Ft. Pierce FL 34948. (407)464-5447. Editor: Herman Nietzche. Estab. 1971. Publishes 26 national and regional magazines and periodicals covering adult oriented subjects and alternative lifestyles. Circ. 1 million. Sample copies available. Art guidelines free for SASE with first-class postage.

● Some titles of publications are *Swingers Today* and *Swingers Update*. Publishes cartoons and illustrations (not necessarily sexually explicit) which portray relationships of a non-traditional number of partners.

Cartoons: Approached by 9-10 cartoonists/year. Buys 3-4 cartoons/issue. Prefers sexually humorous cartoons. Send query letter with finished cartoons. Samples are filed or returned by SASE if requested by artist. Reports back within 30 days. Rights purchased vary according to project. Pays $15 for b&w.

Illustrations: Approached by 9-10 illustrators/year. Buys 2-4 illustrations/issue. Prefers pen & ink drawings to illustrate adult fiction. Considers pen & ink. Send query letter with photostats. Samples are filed or are returned by SASE if requested by artist. Reports back within 30 days. Publication will contact artist for portfolio review if interested. Portfolio should include final art. Rights purchased vary according to project. Pays $15-35 for b&w inside.

Tips: Finds artists through word of mouth, referrals and submissions.

■DAVID C. COOK PUBLISHING CO., 850 N. Grove Ave., Elgin IL 60120. (312)741-2400. Director of Design Services: Randy R. Maid. Publisher of magazines, teaching booklets, visual aids and film strips. For Christians, "all age groups."

Cartoons: Approached by 250 cartoonists/year. Pays $50 for b&w; $65 for color.

Illustrations: Buys about 30 full-color illustrations/week. Send tearsheets, slides or photocopies of previously published work; include self-promo pieces. No samples returned unless requested and accompanied by SASE. Works on assignment only. **Pays on acceptance:** $550 for color cover; $350 for color inside. Considers complexity of project, skill and experience of artist and turnaround time when establishing payment. Buys all rights. Originals can be returned in most cases.

Tips: "We do not buy illustrations or cartoons on speculation. We welcome those just beginning their careers, but it helps if the samples are presented in a neat and professional manner. Our deadlines are generous but must be met. We send out checks as soon as final art is approved, usually within 2 weeks of our receiving the art. We want art radically different from normal Sunday School art. Fresh, dynamic, the highest of quality is our goal; art that appeals to preschoolers to senior citizens; realistic to humorous, all media."

‡**COUNTRY AMERICA**, 1716 Locust St., Des Moines IA 50309-3023. (515)284-2135. Fax: (515)284-3035. Art Director: Ray Nenbauer. Estab. 1989. Consumer magazine "emphasizing entertainment and lifestyle for people who enjoy country life and country music." Monthly 4-color magazine. Circ. 1,000,000. Art guidelines not available.
Illustrations: Approached by 10-20 illustrators/year. Buys 1-2 illustrations/issue, 10-15 illustrations/year from freelancers on assignment only. Contact through artist rep or send query letter with brochure, tearsheets, slides and transparencies. Samples are filed. Reports back only if interested. Call or write to schedule an appointment to show a portfolio, which should include original/final art, tearsheets and slides. Buys all rights. **Pays on acceptance.**

‡**COUNTRY JOURNAL**, 6405 Flank Dr., Harrisburg PA 17105. Art Director: David Siegfried. Estab. 1974. Consumer magazine that is "the authoritative resource on rural life, providing practical advice for the country dweller. Readership aimed to middle and upper income levels." Bimonthly 4-color magazine. Circ. 200,000. Original artwork is returned after publication. Sample copies available for $4. Art guidelines available for SASE.
Illustrations: Buys illustrations mainly for departments and feature spreads. Buys 8-16 illustrations/issue. Works on assignment only. Considers pen & ink, mixed media, colored pencil, oils, pastels, collage, charcoal pencil, woodcuts and scratchboard. Send query letter with brochure showing art style, tearsheets, photostats, photocopies, photographs and transparencies. Looks for "ability with human form, architectural and technical illustration (but not high-tech styles)." Samples are filed. Samples not filed are returned only if requested and accompanied by SASE. Reports back about queries/submissions only if interested. Write to schedule an appointment to show a portfolio which should include original/final art, tearsheets and transparencies. Pays $500 color cover. Pays $125 for b&w; $225 for color inside ¼ page on publication.
Tips: The best advice for an illustrator is "to examine the magazine. Present samples appropriate to our style. Artists who exemplify this style include James Needham, Malcolm Wells and Frank Fretz."

‡**CRAFTS 'N THINGS**, Suite 1000, 701 Lee St., Des Plaines IL 60016-4570. (708)297-7400. Fax: (708)297-8328. Editorial Director: Julie Stephani. Estab. 1975. General crafting magazine published 10 times yearly. Circ. 305,000. Originals returned at job's completion. Sample copies available. Art guidelines free for SASE with first-class postage.
• *Crafts 'n Things* is a "how to" magazine for crafters. The magazine is open to crafters submitting designs and step-by-step instruction for projects such as Christmas ornaments, cross-stitched pillows, stuffed animals and quilts. They do not buy cartoons and illustrations.
Tips: Finds artists through submissions. "Our designers work freelance. Our projects mainly include needlework, painting, dolls, florals/naturals, glueing, etc. Call or write for submission guidelines.

■**CREATIVE CHILD & ADULT QUARTERLY**, The National Association for Creative Children and Adults, 8080 Spring Valley, Cincinnnati OH 45236. Publisher: Professor Ann Fabe Isaacs. Editor: Dr. Wallace D. Draper. Emphasizes creativity in *all* its applications for parents, teachers, students, administrators in the professions. Quarterly. Original artwork returned after publication if SASE is enclosed. Sample copy $10.
Cartoons: Uses 1 cartoon/issue. Prefers single panel; b&w line drawings. Send samples of style or finished cartoons to be kept on file. Material not kept on file is returned by SASE. Reports within weeks. Pays in copies on publication.
Illustrations: Uses various number of illustrations/issue, including some humorous and cartoon-style illustrations. Send query letter and original work. Samples returned by SASE. Reports within weeks. Pays in copies of publication.

‡**CURRENTS**, 212 W. Cheyenne Mountain Blvd., Colorado Springs CO 80906. (719)579-8759. Fax: (719)576-6238. Editor: Greg Moore. Estab. 1979. Quarterly magazine with emphasis on kayaking, rafting or river canoeing and conservation of rivers. Circ. 10,000. Originals returned at job's completion. Sample copies available for $1. Art guidelines available.
Cartoons: Prefers humorous cartoons; single panel b&w line drawings. Send query letter with finished cartoons. Samples are filed or are returned by SASE if requested by artist. Reports back to the artist only if interested. Negotiates rights purchased. Pays $30-60 for b&w.
Illustrations: Send query letter with SASE, tearsheets and photographs, Samples are filed or returned by SASE if requested by artist. Publication will contact artist for portfolio review if interested. Portfolio should include b&w final art, tearsheets and photographs. Negotiates rights purchased. Pays on publication; $30-60 for b&w inside.

‡**DAKOTA COUNTRY**, Box 2714, Bismark ND 58502. (701)255-3031. Publisher: Bill Mitzel. Estab. 1979. *Dakota Country* is a monthly hunting and fishing magazine, with readership in North and South Dakota. Features stories on all game animals and fish and outdoors. Basic 3-column format, b&w and 2-color with 4-color cover, feature layout. Circ. 13,200. Accepts previously published artwork. Original artwork is not returned after publication. Sample copies cost $2.
Cartoons: Likes to buy cartoons in volume. Prefers outdoor themes, hunting and fishing. Prefers multiple or single cartoon panels with gagline; b&w line drawings. Send query letter with samples of style. Samples not filed are returned by SASE. Reports back regarding queries/submissions within 2 weeks. Negotiates rights purchased. **Pays on acceptance;** $10-20, b&w.
Illustrations: Portfolio review not required. Pays $20-25 for b&w inside.
Tips: "Always need good-quality hunting and fishing line art and cartoons."

■**DAKOTA OUTDOORS**, P.O. Box 669, Pierre SD 57501-0669. (605)224-7301. Fax: (605)224-9210. Editor: Kevin Hipple. Managing Editor: Rachel Engbrecht. Estab. 1978. Monthly outdoor magazine covering hunting, fishing and outdoor pursuits in the Dakotas. Circ. 7,500. Accepts previously published artwork. Original artwork is returned at job's completion. Sample copies and art guidelines for SASE with first-class postage.
Cartoons: Approached by 10 cartoonists/year. Buys 1-2 cartoons/issue. Prefers outdoor, hunting and fishing themes. Prefers cartoons with gagline. Send query letter with appropriate samples and SASE. Samples are not filed and are returned by SASE. Reports back within 1-2 months. Rights purchased vary according to project. Pays $5 for b&w.
Illustrations: Approached by 2-10 illustrators/year. Buys 1 illustration/issue. Prefers outdoor, hunting/fishing themes, depictions of animals and fish native to the Dakotas. Prefers pen & ink. Send query letter with SASE and copies of line drawings. Reports back within 1-2 months. To show a portfolio, mail "high-quality line art drawings." Rights purchased vary according to project. Pays on publication; $5-25 for b&w.
Tips: "We especially need line-art renderings of fish, such as walleye."

DATAMATION, Dept. AM, 275 Washington St., Newton MA 02158. (617)558-4221. Fax: (617)630-3930. Senior Art Director: Chris Lewis. Associate Art Director: Dave Gordon. Bimonthly trade journal; magazine format, "computer journal for corporate computing professionals worldwide." Circ. 200,000. Accepts previously published artwork. Original artwork is returned at job's completion. Sample copies available. Art guidelines not available.
Cartoons: Approached by 60 cartoonists/year. Buys 2 cartoons/issue. Prefers "anything with a computer-oriented theme; people in businesses; style: horizontal cartoons"; single panel, b&w line drawings and washes. Send query letter with finished cartoons. "All cartoons should be sent **only** to Andrea Ovans, Assistant Managing Editor." Samples are not filed and are returned by SASE. Reports back within 1 month. Buys first rights. Pays $125 for b&w.
Illustrations: Approached by 100-200 illustrators/year. Buys 1-2 illustrations/issue. Works on assignment only. Open to most styles. Considers pen & ink, watercolor, collage, airbrush, acrylic, marker, colored pencil, mixed media and pastel. Send query letter with non-returnable brochure, tearsheets and photocopies. Samples are filed and are not returned. Does not report back. To show a portfolio, mail b&w/color tearsheets, photostats and photocopies. Buys first rights. **Pays on acceptance;** $150 for b&w, $1,000 for color inside.
Tips: "Send non-returnable samples only by mail; do not wish to meet and interview illustrators."

‡**DAUGHTERS OF SARAH**, 2121 Sheridan Rd., Evanston IL 60201-3298. (708)866-3882. Art Director: Kari Sandhaas. Estab. 1974. Quarterly literary magazine with focus on religious/social justice/Christian feminist theology. Audience is Christian and feminist. Supports ordination of women and inclusive language for God. Circ. 5,000. Accepts previously published artwork. Originals are returned at job's completion. Sample copies available for $3.50. Art guidelines free for SASE with first-class postage.
Cartoons: Approached by 12 cartoonists/year. Prefers feminist themes. "We have a different theme each quarter." Prefers humorous cartoons; single panel b&w line drawings with gagline. Send query letter with brochure. Samples are not filed and are returned by SASE. Reports back within 1 month. Buys one-time rights. Pays $30 for b&w.
Illustrations: Approached by 10 illustrators/year. Buys 4 illustrations/issue. Works on assignment only. Prefers Christian feminist themes. Considers pen & ink. Send query letter with brochure. Samples are not filed and are returned by SASE. Reports back within 1 month. Portfolio review not required. Buys one-time rights. Pays on publication; $30 for b&w cover, $30 for b&w inside.
Tips: Finds artists through artists' submissions, word of mouth. Each quarterly issue has a different theme. Artists should send for list of future themes and guidelines. "Please have some understanding of Christian

For a list of markets interested in humorous illustration, cartooning and caricatures, refer to the Humor Index at the back of this book.

feminism. Do not send generic religious art—it is usually not relevant to our themes. Please do not send more than 1 or 2 samples."

DC COMICS INC., Dept. AM, 1325 Avenue of the Americas, New York NY 10010. (212)636-5400. Group Editor-Creative Services: Neal Pozner. Monthly 4-color comic books for ages 7-25. Circ. 6,000,000. Original artwork is returned after publication.
Illustrations: Buys 22 comic pages/title each month. Works on assignment only. Send query letter with résumé and photocopies. Do not send original artwork. Samples not filed are returned if requested and accompanied by SASE. Reports back within 2 months. Buys all rights. **Pays on acceptance.**
Tips: "Work should show an ability to tell stories with sequential illustrations. Single illustrations are not particularly helpful, since your ability at storytelling is not demonstrated."

‡DEAD OF NIGHT MAGAZINE, Suite 228, 916 Shaker Rd., Longmeadow MA 01106-2416. Editor: Lin Stein. Estab. 1989. Semi-annual (April and October) magazine which "offers variety to fans of horror, fantasy, mystery, science fiction and vampire-related fiction." Circ. 1,000. Sample copies available for $5. Art guidelines available for SASE with first-class postage.
Illustrations: Approached by 20 illustrators/year. Buys 5-10 illustrations/year. Considers pen & ink and marker. Send query letter with SASE and dark, unfolded photocopies. Samples are filed. Reports back within 6 weeks. Portfolio review not required. Buys first rights. Pays on publication; $25 for b&w cover; $10 for b&w inside.
Tips: Finds artists through market listings, advertising and flier mailings. "Artist should read a sample to get a feel for the type of fiction we publish. Since we do not usually assign art (except for the occasional cover) but instead, choose story illustrations from available samples, knowing our "slant" is vital. Study the magazine!"

DEALER BUSINESS, P.O. Box 2006, 6633 Odessa Ave., Van Nuys CA 91406. (818)997-0644. Fax: (818)997-1058. Art Director: Chris Gallison. Estab. 1966. *"Dealer Business* (formerly *Auto Age* magazine) is a monthly national trade magazine that reaches virtually every new car and truck dealership in the United States, with heavy emphasis on business subjects." Circ. 30,000. Accepts previously published artwork (if stock). Samples copies available. Art guidelines are not available.
Illustrations: Approached by 10-15 illustrators/year. Buys 3-4 illustrations/issue. Prefers realism—business situations, people/cars. Some stylization depending on concept. Concepts usually involve business problems, themes, etc. Prefers pen & ink, watercolor, airbrush, acrylic, oil and mixed media. Send query letter with brochure, tearsheets, photocopies and photostats. Samples are filed. Reports back to the artist only if interested. To show a portfolio, mail tearsheets, slides, photostats, photocopies and transparencies (4×5 or 8×10). Buys all rights. Pays on publication; $650 for color cover. Fees for inside illustration depend on size and b&w or color.

DEC PROFESSIONAL, 101 Witmer Rd., Horsham PA 19044. (215)957-1500. Fax: (215)957-1081. Art Director: Al Feuerstein. Estab. 1982. Monthly 4-color trade journal for users of digital equipment company computers. Circ. 100,000. Sample copies available. Art guidelines not available. Needs computer-literate freelancers for illustration. 10% of freelance work demands knowledge of Aldus PageMaker, Aldus FreeHand, Adobe Illustrator or Photoshop.
Illustrations: Approached by 15-20 illustrators/year. Buys 1 illustration/issue. Works on assignment only. Prefers computer-related themes and styles. Considers watercolor, collage, airbrush, colored pencil and computer art. Send query letter with tearsheets. Samples are filed. Reports back only if interested. To show a portfolio, write to schedule an appointment. Portfolio should include printed samples, tearsheets and slides. Pays on publication; $800-1,000 for color cover.
Tips: "Being a computer trade magazine—we are constantly changing the way we do things based on the up-to-date hardware/software we receive regularly."

DECORATIVE ARTIST'S WORKBOOK, 1507 Dana Ave., Cincinnati OH 45207. Art Director: Scott Finke. Estab. 1987. "A step-by-step bimonthly decorative painting workbook. The audience is primarily female; slant is how-to." Circ. 89,000. Does not accept previously published artwork. Original artwork is returned at job's completion. Sample copy available for $4.65. Art guidelines not available.
Cartoons: Approached by 5-10 cartoonists/year. Buys 10-15 cartoons/year. Prefers themes and styles related to the decorative painter; single panel b&w line drawings with and without gagline. Send query letter with finished cartoons. Samples are not filed and are returned by SASE if requested by artist. Reports back within 1 month. Buys first rights. Pays $50 for b&w.
Illustrations: Approached by 100 illustrators/year. Buys occasional illustration; 3-4/year. Works on assignment only. Prefers realistic and humorous themes and styles. Prefers pen & ink, watercolor, airbrush, acrylic, colored pencil, mixed media and pastel. Send query letter with brochure, tearsheets and photocopies. Samples are filed. Reports back to the artist only if interested. To show a portfolio mail slides. Buys first rights or one-time rights. Pays on publication; $100 for b&w, $200 for color inside.

DELAWARE TODAY MAGAZINE, 3 Christina Centre, Suite 1204, 201 N. Walnut St., Wilmington DE 19801. Fax: (302)656-5843. Art/Design Director: Ingrid Hansen-Lynch. Monthly 4-color magazine emphasizing regional interest in and around Delaware. Features general interest, historical, humorous, interview/profile, personal experience and travel articles. "The stories we have are about people and happenings in and around Delaware. Our audience is middle-aged (40-45) people with incomes around $79,000, mostly educated. We try to be trendy in a conservative state." Circ. 25,000. Original artwork returned after publication. Sample copy available. Needs computer-literate freelancers for illustration.

Cartoons: Works on assignment only. Do not send gaglines; accepts b&w line drawings, b&w and color washes. Send query letter with samples of style. Do not send folders of pre-drawn cartoons. Samples are filed. Reports back only if interested. Buys first rights or one-time rights. Pays $75 for small, $100 for large.

Illustrations: Buys approximately 3-4 illustrations/issue. "I'm looking for different styles and techniques of editorial illustration!" Works on assignment only. Open to all styles. Send query letter with résumé and 3-4 samples. Samples are filed. Publication will contact artist for portfolio review if interested. Portfolio should include printed samples and color and b&w tearsheets and final reproduction/product. Buys first rights or one-time rights. Pays on publication; $200-400 for color cover; $75-125 for b&w or color inside.

Tips: Finds artists through artists' submissions and self-promotions.

DIABLO MAGAZINE, Suite 200, 2520 Camiro Diablo, Walnut Creek CA 94596. (510)943-1111. Fax: (510)943-1045. Art Director: Laura Cirolia. Estab. 1980. Monthly city magazine covering Contra Costa lifestyle and politics. Circ. 65,000. Original artwork is returned at job's completion. Sample copies available.

Illustrations: Approached by 3-50 freelance illustrators/year. Buys 15 freelance illustrations/issue. Works on assignment only. Considers all media. Send query letter with photocopies. Samples are filed. Reports back to the artist only if interested. Call for appointment to show portfolio of final art and tearsheets and slides. Buys one-time rights. Pays 60 days after publication; $150-450.

DISCOVERIES, 6401 The Paseo, Kansas City MO 64131. (816)333-7000. Editor: Latta Jo Knapp. Estab. 1974. Weekly 4-color story paper; "for 8-10 year olds of the Church of the Nazarene and other holiness denominations. Material is based on everyday situations with Christian principles applied." Circ. 30,000. Originals are not returned at job's completion. Sample copies for SASE with first-class postage. Art guidelines not available.

Cartoons: Approached by 15 cartoonists/year. Buys 52 cartoons/year. "Cartoons need to be humor for children—not about them." Spot cartoons only. Prefers artwork with children and animals; single panel. Send finished cartoons. Samples not filed are returned by SASE. Reports back in 6-8 weeks. Buys all rights. Pays $15 for b&w.

Illustrations: Approached by 30-40 illustrators/year. Buys 52 illustrations/year. Works on assignment only. Needs cover illustrations. Considers watercolor, acrylic and other mediums on request. Send query letter with brochure and résumé. Samples are filed. Reports back only if interested. Request portfolio review in original query. To show a portfolio, mail tearsheets. Buys all rights. **Pays on acceptance;** $75 for color, $40 for b&w cover.

Tips: Finds artists through artists' submissions/self-promotion and word of mouth. No "fantasy or science fiction situations or children in situations not normally associated with Christian attitudes or actions. Our publications require more full-color artwork than in the past."

‡DOG FANCY, Box 6050, Mission Viejo CA 92690. Editor: Kim Thornton. Estab. 1970. Monthly 4-color magazine for dog owners and breeders of all ages, interested in all phases of dog ownership. Circ. 200,000. Simultaneous submissions and previously published work OK. Sample copy for $5.50; artist's guidelines with SASE.

Cartoons: Buys 30 cartoons/year from freelancers; single panel. "Central character should be a dog." Mail finished art. Send SASE. Prefers photostats or photocopies as samples. Reports in 6 weeks. Buys first rights. Pays on publication; $35, b&w line drawings. "Our best cartoonists are very familiar with dogs and show the humor in dogs' natural behaviors or extrapolate those behaviors to human situations: i.e., a dog sitting on a street corner with a sign that says, 'Will work for food and love.'"

Illustrations: Buys 10 illustrations/year from freelancers, mainly for spot art and article illustration. Prefers local artists. Works on assignment only. Publication will contact artist for portfolio review if interetsed. Buys one-time rights. Pays on publication; $20 for spot, $35-100 for b&w, $100-300 for color illustrations. Needs editorial and medical illustrations.

Tips: Finds artists through word of mouth and artists' submissions/self-promotion. "Spot illustrations are used in nearly every issue. I need dogs in action (doing just about anything) and puppies. Please send a selection that we can keep on file. Drawings should be scaled to reduce to column width (2¼")."

‡DOLL COLLECTOR'S PRICE GUIDE, 306 E. Parr Rd., Berne IN 46711. (219)589-8741. Fax: (219)589-8093. Editor: Cary Raesner. Quarterly consumer magazine featuring information for collectors and investors on identifying, and pricing collectible dolls in every medium. Circ. 43,985. Accepts previously published artwork. Originals not returned. Sample copies available for $2. Art guidelines not available.

Cartoons: Approached by 2-3 cartoonists/year. Buys 1-4 cartoons/year. Prefers doll collecting; single panel with gagline. Send query letter with finished cartoons. Samples are filed or returned by SASE. Reports back to the artist only if interested. Buys all rights. Pays $25 for b&w.

DOLPHIN LOG, The Cousteau Society, Suite 402, 870 Greenbrier Circle, Chesapeake VA 23320. (804)523-9335. Editor: Elizabeth Foley. Bimonthly 4-color educational magazine for children ages 7-13 covering "all areas of science, natural history, marine biology, ecology, and the environment as they relate to our global water system." 20-pages, 8 × 10 trim size. Circ. 80,000. Sample copy for $2 and 9 × 12 SASE with 75¢ postage; art guidelines for letter-sized SASE with first-class postage.
Illustrations: Buys approximately 4 illustrations/year. Uses simple, biologically and technically accurate line drawings and scientific illustrations. "*Never* uses art that depicts animals dressed or acting like people. Subjects should be carefully researched." Prefers pen & ink, airbrush and watercolor. Send query letter with tearsheets and photocopies or brochure showing art style. "No portfolios. We review only tearsheets and/or photocopies. No original artwork, please." Samples are returned upon request with SASE. Reports within 1 month. Buys one-time rights and worldwide translation rights for inclusion in other Cousteau Society publications and the right to grant reprints for use in other publications. Pays on publication; $25-200 for color inside.
Tips: "We usually find artists through their submissions/promotional materials and in sourcebooks. Artists should first request a sample copy to familiarize themselves with our style. Send only art that is both water-oriented and suitable for children."

‡■THE ECONOMIC MONITOR, P.O. Box 2268, Winter Park FL 32790-2268. (407)4548. Fax: (407)629-0762. Editor: Stephen Combs. Estab. 1992. Quarterly magazine emphasizing national economic policy and the benefits of capitalism. Circ. 500. Accepts previously published artwork. Originals returned at job's completion. Sample copies for 52¢ postage. Art guidelines not available.
Cartoons: Approached by 2-3 cartoonists/year. Prefers political cartoons (others will be considered). Send query letter with roughs or finished cartoons. Samples are not filed. Reports back within 2 weeks. Buys one-time rights. Pays $10-15 for b&ws, plus copies.
Tips: "We promote free market, limited government, low taxes, maximum individual freedom and a concern for the environment. We are a not-for-profit magazine that is a forum for new writers and cartoonists. We would like to see more illustrations with articles."

‡■EIDOS: Sexual Freedom & Erotic Entertainment for Women, Men and Couples, Box 96, Boston MA 02137-0096. (617)262-0096. Editor: Brenda L. Tatelbaum. Estab. 1984. Quarterly b&w tabloid emphasizing erotica and erotic entertainment for women and men; grassroots, counter-cultural, alternative "look". Quarterly. Original artwork returned after publication. Needs computer-literate freelancers for design and production. "If we can receive camera-ready material, it cuts our costs."
Cartoons: "We look for 'humorous' cartoons that make critical comments on political/cultural/social issues of the day related to sexuality, 1st Amendment, freedom, etc." Approached by 12 cartoonists/year. Pays contributor copy and byline.
Illustrations: Approached by 30 illustrators/year. Works with 12-15 artists/year. Buys 12-15 illustrations/year from freelancers. Uses freelancers for editorial art and photography; pasteup/design. Send query letter with résumé, tearsheets, photostats and photographs. Samples are filed or are returned by SASE. Reports back within 2 months. Portfolio review not required. Acquires first rights. Pays contributor copy and byline.
Tips: Finds artists through word of mouth, artists' submissions/self-promotions and sourcebooks. "We look for sensuous, sensitive, sophisticated erotica depicting mutually respectful sexuality and images of the human form. Alternative to commercial mainstream magazines." More often publishes images of men and couples. "We do not want to see stereotypical images and language (cartoons); lack of sexually explicit detail (art and photography); lack of bold b&w contrast."

ELECTRICAL APPARATUS, Barks Publications, Inc., Suite 1016, 400 N. Michigan Ave., Chicago IL 60611-4198. (312)321-9440. Fax: (312)321-1288. Contact: Cartoon Editor. Estab. 1948. Monthly 4-color trade journal emphasizing industrial electrical/mechanical maintenance. Circ. 16,000. Original artwork not returned at job's completion. Sample copy $4. Art guidelines not available.
Cartoons: Approached by several cartoonists/year. Buys 3-4 cartoons/issue. Prefers themes relevant to magazine content; with gagline. "Captions are typeset in our style." Send query letter with roughs and finished cartoons. "Anything we don't use is returned." Reports back within 2-3 weeks. Buys all rights. Pays $15-20 for b&w and color.
Illustrations: "We have staff artists so there is little opportunity for freelance illustrators, but we are always glad to hear from anyone who believes he or she has something relevant to contribute."

‡THE ELECTRON, 1776 E. 17th, Cleveland OH 44114. (216)781-9400. Fax: (216)781-0331. Managing Editor: Denise M. Zakrajsek. Bimonthly newspaper published for the students of the Cleveland Institute of Electronics. Each issue deals with a different aspect of electronics. Circ. 25,000. Accepts previously published artwork. Sample copies available. Art guidelines not available but "please call."

Cartoons: Approached by 20 cartoonists/year. Buys 4-6 cartoons/issue. Prefers electronics related humorous cartoons; single panel b&w line drawings with or without gagline. Send query letter with brochure or roughs. Samples are filed. Reports back to the artist only if interested. Rights purchased vary according to project.
Tips: Finds artists through artists' submissions. "Please submit only cartoons related to electronics. Send for editorial calendar. If possible, cartoons may be related to future topics."

ELECTRONICS NOW, 500-B Bi-County Blvd., Farmingdale NY 11735. (516)293-3000. Fax: (516)293-3115. Editor: Brian Fenton. Estab. 1939. Monthly b&w magazine with 4-color emphasizing electronic and computer construction projects and tutorial articles; practical electronics for technical people including service technicians, engineers and experimenters in TV, hi-fi, computers, communications and industrial electronics. Circ. 171,679. Previously published work OK. Free sample copy. Needs computer-literate freelancers for illustration.
Cartoons: Approached by 20-25 cartoonists/year. Buys 70-80 cartoons/year on electronics, computers, communications, robots, lasers, stereo, video and service; single panel. Send query letter with finished cartoons. Samples are filed or are returned by SASE. Reports in 1 week. Buys first or all rights. **Pays on acceptance;** $25 minimum, b&w washes.
Illustrations: Approached by 10 illustrators/year. Buys 3 illustrations/year. Works on assignment only. Needs editorial and technical illustration. Preferred themes or styles depend on the story being illustrated. Considers airbrush, watercolor, acrylic and oil. Send query letter with tearsheets and slides. Samples are filed or are returned by SASE. Publication will contact artist for portfolio review if interested. Portfolio should include roughs, tearsheets, photographs and slides. Buys all rights. **Pays on acceptance;** $400 for color cover $100 for b&w inside.
Tips: Finds artists through artists' submissions/self-promotion. "Artists approaching *Electronics Now* should have an innate interest in electronics and technology that shows through in their work."

EMPLOYEE SERVICES MANAGEMENT MAGAZINE, NESRA, Suite 2211, York Rd., Oak Brook IL 60521-2371. (708)368-1820. Fax: (708)368-1286. Editor: Cynthia Helson. B&w with 4-color cover emphasizing the field of employee services and recreation for human resource professionals, employee services and recreation managers and leaders within corporations, industries or units of government. Published 10 times/year. Circ. 6,500. Accepts previously published material. Returns original artwork after publication. Sample copy for SASE with 72¢ postage; art guidelines for SASE with first-class postage. 70% of freelance work demands knowledge of Aldus PageMaker or Adobe Illustrator.
Cartoons: "Looking for very clean line cartoons focusing on workplace issues." Pays $50 for b&w.
Illustrations: Approached by 5-10 illustrators/year. "We usually use watercolors, colorful images which portray issues in the business environment (i.e., stress, travel plans, fitness/wellness, etc.)." Buys 0-1 illustration/issue. Works on assignment only. Send query letter with résumé and tearsheets or photographs to be kept on file. Samples not filed are returned only if requested. Reports within 1 month. Buys one-time rights. **Pays on acceptance;** $100-200 for b&w, $300-400 for color covers; $50 for b&w; $100 for color inside.
Tips: Looking for "illustrations with clean lines in bright colors pertaining to human resources issues. I like to be surprised; 'typical' illustrations bore me. Computer compatability dictates who I work with."

ENVIRONMENT, 1319 18th St. NW, Washington DC 20036. (202)296-6267, ext. 236. Fax: (202)296-5149. Graphics/Production Manager: Jennifer Crock. Estab. 1958. Emphasizes national and international environmental and scientific issues. Readers range from "high school students and college undergrads to scientists, business and government leaders and college and university professors." Black & white magazine with 4-color cover; "relatively conservative" design. Published 10 times/year. Circ. 12,500. Original artwork returned after publication. Sample copy $6.75; cartoonist's guidelines available.
Cartoons: Buys 1-2 cartoons/issue. Receives 5 submissions/week. Interested in single panel line drawings or b&w washes with or without gagline. Send finished cartoons and SASE. Reports in 2 months. Buys first North American serial rights. Pays on publication; $35 for b&w cartoon.
Illustrations: Buys 2-10/year. Uses illustrators mainly for cover design, promotional work, feature illustration and occasional spot illustrations. Send query letter, brochure, tearsheets and photocopies. Publication will contact artist for portfolio review if interested. Portfolio should include printed samples. Pays $350 for b&w or color cover; $100 for b&w, $200 for color inside.
Tips: "Regarding cartoons, we prefer witty or wry comments on the impact of humankind upon the environment. Stay away from slapstick humor." For illustrations, "we are looking for an ability to communicate complex environmental issues and ideas in an unbiased way."

‡■EQUILIBRIUM¹⁰, Box 162, Golden CO 80402-0162. Graphic Coordinator: Gary Eagle. Estab. 1984. Monthly magazine emphasizing equilibrium: balance, opposites and antonyms for all ages. Accepts previously published material.
Cartoons: Buys 200 cartoons/year. Buys 12 cartoons/issue from freelancers. Accepts any format. Send query letter with samples and finished cartoons. Samples not filed are returned by SASE. Reports back within 3 months. Rights purchased vary. Pays on publication; $10-50, color.

Illustrations: Works with 50 illustrators/year. Buys 10 illustrations/issue from freelancers. Send query letter with brochure and samples. Samples are filed or are returned by SASE. Reports back within 3 months. Negotiates rights purchased. Pays on publication; $50, b&w, cover.
Tips: "Letters and queries arriving at our office become the property of our firm and may be published 'as is'."

‡EVANGELIZING TODAY'S CHILD, Box 348, Warrenton MO 63383-0348. (314)456-4321. Fax: (314)456-2078. Art Director: Kevin Williamson. Estab. 1942. Bimonthly magazine for Sunday school teachers, Christian education leaders and children's workers in every phase of Christian ministry for children 4-11. Circ. 22,000. Accepts previously published artwork "if we are informed." Sample copies available. Art guidelines for SASE with first-class postage.
Illustrations: Approached by 10-15 illustrators/year. Buys 8 illustrations/issue. Works on assignment only. Prefers bright, clean, realistic art with child appeal, sometimes Bible figures or contemporary and historical people. Needs to be clear from distance of 8-15 ft. for teaching purpose. Considers all media. Send query letter with tearsheets, photographs, photocopies, color photostats, slides and transparencies. Samples are filed or returned by SASE if requested by artist. Reports back to the artist only if interested. Portfolio review not required. Buys all rights (negotiable). Pays on publication. Pays $200 for color inside.
Tips: Finds artists through submissions, word of mouth, personal contacts. "Realism, lively color and action are key items we look for. An understanding of Christian themes is very helpful. Computer knowledge helpful, but not essential."

EXECUTIVE FEMALE, 30 Irving Place, New York NY 10003. (212)477-2200. Art Director: Adriane Stark. Estab. 1978. Association magazine for National Association for Female Executives, 4-color. "Get ahead guide for women executives, which includes articles on managing employees, personal finance, starting and running a business." Circ. 200,000. Accepts previously published artwork. Original artwork is returned after publication.
Illustrations: Buys illustrations mainly for spots and feature spreads. Buys 7 illustrations/issue. Works on assignment only. Send samples (not returnable). Samples are filed. Responds only if interested. Buys first or reprint rights. Pays on publication; $100-800.

‡FAMILY CIRCLE, Dept. AM, 110 Fifth Ave., New York NY 10011. (212)463-1000. Art Director: Doug Turshen. Circ. 7,000,000. Supermarket-distributed publication for women/homemakers covering areas of food, home, beauty, health, child care and careers. 17 issues/year. Does not accept previously published material. Original artwork returned after publication. Sample copy and art guidelines not available.
Cartoons: No unsolicited cartoon submissions accepted. Reviews in office first Wednesday of each month. Buys 1-2 cartoons/issue. Prefers themes related to women's interests from a feminist viewpoint. Uses limited seasonal material, primarily Christmas. Prefers single panel with gagline, b&w line drawings or washes. Buys all rights. **Pays on acceptance;** $325. Contact Jim Chambers, (212)463-1000, for cartoon query only.
Illustrations: Buys 20 illustrations/issue from freelancers. Works on assignment only. Provide query letter with samples to be kept on file for future assignments. Prefers slides or tearsheets as samples. Samples returned by SASE. Reports only if interested. Prefers to see finished art in portfolio. Submit portfolio on "portfolio days," every Wednesday. All art is commissioned for specific magazine articles. Buys all rights on a work-for-hire basis. **Pays on acceptance.**

FAMILY MOTOR COACHING, 8291 Clough Pike, Cincinnati OH 45244. (513)474-3622. Editor: Pamela Wisby Kay. Estab. 1963. Monthly 4-color magazine emphasizing travel by self-contained motor home for families who own and enjoy the recreational use of such vehicles. Circ. 95,000. Original artwork returned after publication, "if requested." Sample copy $2.50; art guidelines available with SASE.
Cartoons: Uses 1-5 cartoons/issue. Themes "must pertain to motor-homing, RV life-style, travel or the outdoors. No trailers or tents." Prefers single panel b&w line drawings and washes with or without gagline. Send finished cartoons. Samples returned by SASE. Reports in 4-6 weeks. Buys first rights. Pays on publication; $20 for b&w.

FASHION ACCESSORIES, 65 W. Main St., Bergenfield NJ 07621. (201)384-3336. Fax: (201)384-6776. Publisher: Sam Mendelson. Estab. 1951. Monthly trade journal; tabloid; emphasizing costume jewelry and accessories—wholesale level. Publishes both 4-color and b&w. Circ. 8,000. Accepts previously published artwork. Original artwork is returned to the artist at the job's completion. Sample copies for $3. Art guidelines not available. Needs computer-literate freelancers for illustration. Freelance work demands knowledge of QuarkXPress.
Cartoons: Pays $75 for b&w cartoons.
Illustrations: Works on assignment only. Needs editorial illustration. Prefers mixed media. Send query letter with brochure and photocopies. Samples are filed. Reports back within 2 weeks. Portfolio review not required. Rights purchased vary according to project. **Pays on acceptance;** $100 for b&w, $150 for color cover; $100 for b&w, $100 for color inside.

‡FATE MAGAZINE, 84 S. Walsasha St., St. Paul MN 55106-0383. (612)291-1970. Fax: (291)-1908. Art Director: Christopher Wells. Estab. 1903. New Age consumer magazine. Circ. 125,000. Accepts previously published artwork. Originals returned at job's completion. Sample copies available. Art guidelines available for SASE with first-class postage. Need computer-literate freelancers for design and illustration. 5-10% of freelance work demands computer knowledge of Adobe Illustrator, QuarkXPress or Adobe Photoshop.

• Published by Llewellyn Publications which also publishes New Age books, card decks and kits.

Cartoons: Buys 2-3 cartoons/year. Prefers serious, some fun but not exaggerated; single panel b&w washes and line drawings. Send query letter with finished cartoons and photocopies. Samples are filed or returned by SASE. Reports back within 2 weeks.

Illustrations: Approached by 150 illustrators/year. Buys 3-25 illustrations/issue. Works on assignment only. Prefers b&w, pen & ink wash. Considers all media. Send query letter with SASE, photocopies and slides. Samples are filed or are returned by SASE. Publication will contact artist for portfolio review if interested. Portfolio should include b&w and color tearsheets, roughs, photocopies and photographs. Negotiates rights purchased. **Pays on acceptance;** $200 for b&w, $700 for color cover; $25 for b&w, $70 for color inside.

Tips: Finds artists through submissions, any other art resources. Especially needs artwork focusing on New Age, Celtic, fantasy, occult, *real* monsters (Big Foot, Loch Ness, gnomes, fairies, etc.). "Send SASE if material is to be returned at all."

FFA NEW HORIZONS, Box 15160, Alexandria VA 22309. (703)360-3600. Fax:(703)360-5524. Associate Editor: Lawinna McGary. Publication of the National FFA Organization. Estab. 1953. Bimonthly magazine; 4-color. Circ. 450,000. Buys all rights. Pays on acceptance. Sample copy available.

Cartoons: Approached by 25 cartoonists/year. Buys 30 cartoons/year on FFA or assigned themes. Receives 10 cartoons/week. Reports in 3 weeks. Pays $20, cartoons; more for assignments.

Illustrations: Approached by 20 illustrators/year. "We're looking for fresh, exciting illustrations. Normally, we assign illustrations for specific stories." Send query letter with tearsheets or photocopies. Publication will contact artist for portfolio review if interested. Portfolio should include final reproduction/product, tearsheets and photostats. Negotiates payment.

Tips: Wants to see "b&w line art; several pieces to show style and general tendencies; printed pieces." Does not want to see "slides of actual 4-color original art." Sees "a glut of poor computer graphics. It all looks the same."

FIFTY SOMETHING MAGAZINE, 8250 Tyler Blvd., Mentor OH 44060. (216)974-9594. Fax: (216)974-1004. Editor: Linda L. Lindeman. Estab. 1990. Bimonthly magazine; 4-color. "We cater to the fifty-plus age group with upbeat information, feature stories, travel, romance, finance and nostalgia." Circ. 25,000. Accepts previously published artwork. Original artwork is returned at the job's completion. Sample copies for SASE, 10 × 12, with $1 postage.

Cartoons: Approached by 50 cartoonists/year. Buys 3 cartoons/issue. Prefers funny issues on aging. Prefers single panel b&w line drawings with gagline. Send query letter with brochure, roughs and finished cartoons. Samples are filed. Reports back only if interested. Buys one-time rights. Pays $10, b&w and color.

Illustrations: Approached by 50 illustrators/year. Buys 2 illustrations/issue. Prefers old-fashioned, nostalgia. Considers all media. Send query letter with brochure, photographs, photostats, slides and transparencies. Samples are filed. Reports back only if interested. To show a portfolio, mail thumbnails, printed samples, b&w photographs, slides and photocopies. Buys one-time rights. Pays on publication; $25 for b&w, $100 for color cover; $25 for b&w, $75 for color inside.

‡■FIGHTING WOMAN NEWS MAGAZINE, 6741 Tung Ave. W., Theodore AL 36582. Owner/Editor: Debra Pettis. Estab. 1975. Quarterly magazine relating to women in the martial arts, featuring articles on self defense, book reviews, stories and poetry. Circ. 5,000. Accepts previously published artwork. Originals returned at job's completion. Sample copies available for $3.50. Art guidelines not available. Needs computer-literate freelancers. 80% of freelance work demands knowledge of Aldus PageMaker or anything IBM compatible.

Cartoons: Approached by 1 cartoonist/year. Prefers martial arts, self defense, etc. Prefers humorous cartoons; b&w line drawings with gagline. Send query letter with finished cartoons. Samples are filed or are returned by SASE. Reports back within 1 week. Acquires first rights. Pay in copies of magazine.

Illustrations: Prefers self defense, martial arts. Considers pen & ink and anything that will reproduce well in b&w. Send query letter with brochure, SASE and photocopies. Samples are filed or are returned by SASE. Reports back within 1 week. Publication will contact artist for portfolio review if interested. Portfolio should

A bullet introduces comments by the editor of Artist's & Graphic Designer's Market indicating special information about the listing.

include b&w thumbnails and photocopies. Rights acquired vary according to project. Pays on publication copies of magazine.

■**THE FINAL EDITION**, Box 294, Rhododendron OR 97049. (503)622-4798. Fax: (503)622-4994. Editor: Michael P. Jones. Estab. 1985. Monthly b&w investigative journal that deals "with a variety of subjects—environment, wildlife, crime, etc. for professional and blue collar people who want in-depth reporting." Circ. 1,500. Accepts previously published material. Original artwork is returned after publication. Art guidelines for SASE with 1 first-class stamp. 50% of freelance work demands computer skills.
Cartoons: Buys 1-18 cartoons/issue. Prefers single, double, multipanel, b&w line drawings, b&w or color washes with or without gagline. Send query letter with samples of style, roughs or finished cartoons. Samples are filed or returned by SASE. Reports back within 2 weeks only if SASE is sent. Acquires one-time rights. Pays in copies.
Illustrations: Buys 10 illustrations/issue. Works with 29 illustrators/year. Prefers editorial, technical and medical illustration in pen & ink, airbrush, pencil, marker, calligraphy and computer illustration. Send query letter with brochure showing art style or résumé and tearsheets, photostats, photocopies, slides or photographs. Samples not filed are returned by SASE. Reports back within 2 months, "depending upon work load." Cannot return phone calls because of large volume." Request portfolio review in original query. Portfolio should include thumbnails, roughs, printed samples, final reproduction/product, color or b&w tearsheets, photostats and photographs. Acquires one-time rights. Pays in copies.
Tips: Finds artists primarily through sourcebooks and also through word of mouth. "We are really looking for artists who can sketch covered wagons, pioneers, Native Americans and mountain men. Everything is acceptable just as long as it doesn't advocate sex and violence and destroying our environment. This year there will be a lot of illustrations depicting social justice issues. Also we will need more illustrators this year."

‡**FIRST HAND MAGAZINE**, P.O. Box 1314, Teaneck NJ 07666. (201)836-9177. Fax: (201)836-5055. Estab. 1980. Monthly consumer magazine emphasizing gay erotica. Circ. 60,000. Originals returned at job's completion. Sample copies available for $5. Art guidelines for SASE with first-class postage.
Cartoons: Approached by 10 cartoonists/year. Buys 5 cartoons/issue. Prefers gay male themes—erotica; humorous; single panel b&w line drawings with gagline. Send query letter with finished cartoons. Samples are not filed and are returned by SASE. Reports back within 6 weeks. Buys all rights. Pays $20 for b&w.
Illustrations: Approached by 30 illustrators/year. Buys 12 illustrations/issue. Prefers gay male erotica. Considers pen & ink, airbrush, marker, colored pencil and charcoal. Send query letter with photostats. Samples are not filed and are returned by SASE. Reports back within 6 weeks. Portfolio review not required. Buys first rights. Pays on publication; $50 for b&w inside.

■**FISH DRUM MAGAZINE**, 626 Kathryn Ave., Santa Fe NM 87501. Editor: Robert Winson. Estab. 1988. "*Fish Drum* is an eclectic ('funky to slick') literary magazine, including poetry, prose, interviews, essays, scores and b&w art. We've upgraded the production of the magazine, and are now larger, perfect bound, offset printed." Publishes 1-2 issues yearly. Circ. 500. Original artwork returned at the job's completion. Sample copies available for $3.
Cartoons: "We have accepted and published a few cartoons, though we aren't offered many. Cartoons need to be literary, underground, Buddhist or political." Prefers single, multiple panel and b&w line drawings. Send query letter with finished cartoons. Samples are not filed and are returned by SASE if requested. Reports back within 2 weeks. Acquires one-time rights. Pays in copies.
Illustrations: Prefers abstract, humorous or emotional art. Prefers any b&w offset-reproducible media. Send query letter with SASE and photocopies. Samples are not filed and are returned by SASE. Reports back within 2 weeks. Portfolio review not required. Acquires one-time rights. Pays in copies.
Tips: "We're interested in original, personal, arresting art and have a bias toward non-mainstream New Mexico artists, underground and abstract art."

FLING INTERNATIONAL, Relim Publishing Co., 550 Miller Ave., Mill Valley CA 94941. (415)383-5464. Editor: Arv Miller. Quarterly emphasizing sex for men ages 18-34. Sample copy $5.
Cartoons: Prefers sexual themes. "The female characters must be pretty, sexy and curvy and extremely chesty. Styles can be cartoony or semi-realistic." **Pays on acceptance;** $30 for b&w, $50-100 for color.

■**FLORAL & NURSERY TIMES**, P.O. Box 8470, 436 W. Frontage Rd., Northfield IL 60093. (708)441-0300. Fax: (708)441-0308. Editor: Barbara Gilbert. Estab. 1979. Trade journal; tabloid format; 2-color with 4-color cover; serving the horticulture trade including retail florists, wholesalers, growers and manufacturers. Circ. 17,500. Accepts previously published artwork. Original artwork returned at job's completion. Sample copies available for SASE with first-class postage. Art guidelines not available.
Cartoons: Approached by 3-4 cartoonists/year. Buys 15-24 cartoons/year. Prefers single panel with gagline. Send query letter with finished cartoons. Samples are not filed and are returned by SASE. Reports back within 2 weeks. Buys all rights. Pays $10 for b&w.
Illustrations: Needs editorial illustration. Portfolio review not required. Requests work on spec before assigning job. Pays $10 for b&w inside.

Tips: Finds artists through artists' submissions.

FOOD & SERVICE, Box 1429, Austin TX 78767. (512)472-3666. Editor: Julie Sherrier. Art Director: Neil Ferguson. Estab. 1940. Official trade publication of Texas Restaurant Association. Seeks illustrations (but not cartoons) dealing with business problems of restaurant owners and food-service operators, primarily in Texas, and including managers of clubs, bars and hotels. Published 11 times/year. Circ. 6,500. Simultaneous submissions OK. Originals returned after publication. Sample copy for SASE.
Illustrations: Works with 15 illustrators/year. Buys 36-48 illustrations/year from freelancers. Uses artwork mainly for covers and feature articles. Seeks high-quality b&w or color artwork in variety of styles (airbrush, watercolor, pastel, pen & ink, etc.). Seeks versatile artists who can illustrate articles about food-service industry, particularly business aspects. "Humor is a plus; we seldom use realistic styles." Works on assignment only. Query with résumé, samples and tearsheets. Publication will contact artist for portfolio review if interested. Pays $250-300 for color cover; $150-250 for b&w, $200-275 for color inside. Negotiates rights and payment upon assignment.
Tips: Finds artists through artists' submissions and occasionally other magazines. "In a portfolio, show samples of color work and tearsheets. Common mistakes made in presenting work include sloppy presentation and typos in cover letter or résumé. Request a sample of our magazine (include a 10 × 13 SASE), then send samples that fit the style or overall mood of our magazine. We do not run illustrations or photos of food, so don't send or create samples specific to a food theme. We are a business issues magazine, not a food publication."

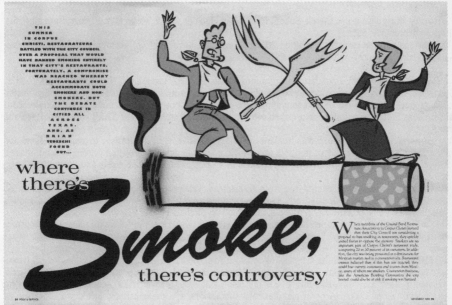

To accompany an article in Food & Service on "the rather heavy topic" of smokers' vs. nonsmokers' rights in restaurants, Art Director Neil Ferguson wanted a "lighthearted, fun illustration that didn't really take sides." Edd Patton's distinctive, contemporary style fit the bill. The ink drawing was shot on clear film, then back-painted with acrylics.

FORBES MAGAZINE, 60 Fifth Ave., New York NY 10011. (212)620-2200. Art Director: Everett Halvorsen. Established 1917. Biweekly business magazine. Circ. 765,000. Reader-friendly design for adults, usually over 40. Art guidelines not available. Does not use previously published illustrations nor cartoons with punchlines. Requires witty, intelligent, contemporary but understandable ideas. Contacted by 100 illustrators a year. Buys 5-6 illustrations per issue. "The method and material does not matter as long as the artwork will fit and be separated on a drum scanner." **Pays on acceptance.** Up to $2,500 for a cover assignment and an average of $450 to $600 for an inside illustration. Less if it is a spot and more if the art runs larger than two columns. "Discuss the fee with art director when you are contacted about doing an assignment."
Tips: "Address samples or portfolios to Everett Halvorsen. Call before leaving a portfolio to make sure the art director is available. Besides the art director, *Forbes* has 4 associate art directors who make assignments.

It is helpful if you address by name those you want to contact. Look at the masthead if you can. Send printed samples or photocopies. Samples are filed if they are interesting and returned only if requested, otherwise they are discarded. We don't report back unless we have an assignment or wish we had. It's preferrable and advantageous to leave your portfolio, to allow those art directors who are available to look at your work. We discourage appointments but if circumstance required a meeting, call Roger Zapke, the Deputy Art Director."

FOREIGN SERVICE JOURNAL, 2101 E St. NW, Washington DC 20037. (202)338-4045. Contact: Managing Editor. Estab. 1924. Monthly magazine emphasizing foreign policy for foreign service employees; 4-color with design in *"Harpers'* style." Circ. 11,000. Returns original artwork after publication.
Cartoons: Occasionally buys cartoons from freelancers. Write or call for appointment to show portfolio. Portfolio should include "political cartoons and conceptual ideas/themes." Buys first rights. Pays on publication; $100 and up, b&w.
Illustrations: Works with 6-10 illustrators/year. Buys 20 illustrations/year from freelancers. Needs editorial illustration. Uses artists mainly for covers and article illustration. Works on assignment only. Publication will contact artist for portfolio review if interested. Buys first rights. Pays on publication; $500 for color cover; $100 and up for b&w inside.
Tips: Finds artists through sourcebooks.

FRONT PAGE DETECTIVE, RGH Publications, 20th Floor, 460 W. 34th St., New York NY 10001. Fax: (212)947-6727. Editor-in-chief: Rose Mandelsberg. For "mature adults—law enforcement officials, professional investigators, criminology buffs and interested laymen"; b&w with 2-color cover. Published 7 times a year.
Cartoons: Must have crime theme. Submit finished art. Include SASE. Reports in 10 days. Buys all rights. **Pays on acceptance;** $25.
Tips: "Make sure the cartoons submitted do not degrade or ridicule law enforcement officials. Omit references to supermarkets/convenience stores."

‡FUTURIFIC MAGAZINE, Foundation for Optimism, Apt. T3, 150 Haven Ave., New York NY 10032-1139. Publisher: B. Szent-Miklosy. Monthly b&w publication emphasizing future-related subjects for highly educated, upper income leaders of the community. Circ. 10,000. Previously published material and simultaneous submissions OK. Original artwork returned after publication. Sample copy for SASE with $3 postage and handling.
Cartoons: Buys 5 cartoons/year from freelancers. Prefers positive, upbeat, futuristic themes; no "doom and gloom." Prefers single, double or multiple panel with or without gagline, b&w line drawings. Send finished cartoons. Samples returned by SASE. Reports within 4 weeks. Will negotiate rights and payment. Pays on publication.
Illustrations: Buys 5 illustrations/issue from freelancers. Prefers positive, upbeat, futuristic themes; no "doom and gloom." Send finished art. Samples returned by SASE. Reports within 4 weeks. To show a portfolio, walk in. Negotiates rights and payment. Pays on publication.
Tips: "Only optimists need apply. Looking for good, clean art. Interested in future development of current affairs, but not science fiction."

THE FUTURIST, Dept. AM, Suite 450, 7910 Woodmont Ave., Bethesda MD 20814. (301)598-6414. Art Director: Mariann Seriff. Managing Editor: Cynthia Wagner. Emphasizes all aspects of the future for a well-educated, general audience. Bimonthly b&w magazine with 4-color cover; "fairly conservative design with lots of text." Circ. 30,000. Accepts simultaneous submissions and previously published work. Return of original artwork following publication depends on individual agreement.
Illustrations: Approached by 50-100 illustrators/year. Buys 3-4 illustrations/issue. Needs editorial illustration. Uses a variety of themes and styles "usually b&w drawings, often whimsical. We like an artist who can read an article and deal with the concepts and ideas." Works on assignment only. Send samples or tearsheets to be kept on file. Publication will contact artist for portfolio review if interested. Rights purchased negotiable. **Pays on acceptance;** $500-750 for color cover; $75-350 for b&w, $200-400 for color inside.
Tips: "When a sample package is poorly organized, poorly presented—it says a lot about how the artists feel about their work." Sees trend toward "moving away from realism; highly stylized illustration with more color."

GALLERY MAGAZINE, Dept. AM, 401 Park Ave. S., New York NY 10016. (212)779-8900. Creative Director: Jana Khalifa. Emphasizes "sophisticated men's entertainment for the middle-class, collegiate male; monthly 4-color with flexible format, conceptual and sophisticated design." Circ. 375,000. Accepts previously published artwork. Interested in buying second rights (reprint rights) to previously published artwork. Needs computer-literate freelancers for production. 100% of freelance work demands knowledge of QuarkXPress and Adobe Illustrator.
Cartoons: Approached by 100 cartoonists/year. Buys 3-8 cartoons/issue. Interested in sexy humor; single, double or multiple panel, color and b&w washes, b&w line drawings with or without gagline. Send finished

cartoons. Enclose SASE. Contact; J. Linden. Reports in 1 month. Buys first rights. Pays on publication; $75 for b&w, $100 for color.

Illustrations: Approached by 300 illustrators/year. Buys 60 illustrations/year. Works on assignment only. Needs editorial illustrations. Interested in the "highest creative and technical styles." Especially needs slick, high-quality, 4-color work. Send flier, samples and tearsheets to be kept on file for possible future assignments. Prefers prints over transparencies. Samples returned by SASE. Publication will contact artist for portfolio review if interested. Negotiates rights purchased. Pays on publication; $350 for b&w, $800 for color inside.

Tips: Finds artists through artists' submissions and sourcebooks. A common mistake freelancers make is that "often there are too many samples of literal translations of the subject. There should also be some conceptual pieces."

GAME & FISH PUBLICATIONS, 2250 Newmarket Pkwy., Marietta GA 30067. (404)953-9222. Fax: (404)933-9510. Graphic Artist: Allen Hansen. Estab. 1975. Monthly b&w with 4-color cover. Circ. 500,000 for 30 state-specific magazines. Original artwork is returned after publication. Sample copies available.

Illustrations: Approached by 50 illustrators/year. Buys illustrations mainly for spots and feature spreads. Buys 1-8 illustrations/issue. Considers pen & ink, watercolor, acrylic and oil. Send query letter with photostats and photocopies. "We look for an artist's ability to realistically depict North American game animals and game fish or hunting and fishing scenes." Samples are filed or returned only if requested. Reports back only if interested. Portfolio review not required. Buys first rights. Pays $25 and up for b&w, $75-100 for color, inside. Pays 2½ months prior to publication.

Tips: Does not want to see cartoons.

GENRE, #1, 8033 Sunset Blvd., Los Angeles CA 90046. (213)896-9778. Publisher: Richard Settles. Estab. 1990. Bimonthly magazine covering fashion, travel and lifestyle for gay men. Circ. 100,000. Originals returned at job's completion. Sample copies free for SASE with first-class postage. Art guidelines not available. Needs computer-literate freelancers for design, illustration and production. Freelancers should be familiar with QuarkXPress or Photoshop.

Cartoons: Approached by 10 cartoonists/year. Prefers gay humor. Send query letter with finished cartoon samples. Samples are filed. Reports back only if interested. Buys all rights.

Illustrations: Approached by 10 freelance illustrators/year. Buys 1 illustration/issue. Works on assignment only. Considers all media. Send query letter with brochure and résumé. Samples are filed. Reports back only if interested. To show a portfolio, mail roughs, tearsheets. Buys all rights. Pays on publication; up to $100 inside.

‡GENT, Dugent Publishing Corp., Suite 600, 2600 Douglas Rd., Coral Gables FL 33134-6125. Publisher: Douglas Allen. Editor: Bruce Arthur. Managing Editor: Nye Willden. For men "who like big-breasted women." 96 pages 8½×11, 4-color. Sample copy $3.

Cartoons: Buys humor and sexual themes; "major emphasis of magazine is on large D-cup-breasted women. We prefer cartoons that reflect this slant." Mail cartoons. Buys first rights. Pays $75, b&w spot drawing; $100, page.

Illustrations: Buys 3-4 illustrations/issue from freelancers on assigned themes. Submit illustration samples for files. Portfolio should include "b&w and color, with nudes/anatomy." Buys first rights. Pays $125-150, b&w; $300, color.

Tips: "Send samples designed especially for our publication. Study our magazine. Be able to draw erotic anatomy. Write for artist's guides and cartoon guides *first*, before submitting samples, since they contain some helpful suggestions."

♣GEORGIA STRAIGHT, 2nd Floor, 1235 W. Pender St., Vancouver, British Columbia V6E 2V6 Canada. (604)681-2000. Fax: (604)681-0272. Managing Editor: Charles Campbell. Estab. 1967. A weekly tabloid; b&w with 2-color cover. An urban news and entertainment paper for educated adults 18 to 45 years of age. Circ. 100,000. Accepts previously published artwork. Originals are returned at job's completion. Sample copies free for SASE with first-class postage. Would like inquiring freelancers to be familiar with QuarkXPress, Aldus FreeHand or Adobe Illustrator.

Cartoons: Approached by 50 cartoonists/year. Buys 4-5 cartoons/issue. Prefers intelligent satire with cultural/lifestyle bent. Prefers single panel, b&w line drawings and washes, with or without gagline. Send query letter with photocopies of finished cartoons. Samples are filed. Reports back to the artist only if interested. Buys one-time rights. Pays on publication; $35 and up for b&w.

Illustrations: Approached by 20 illustrators/year. Buys 2 illustrations/issue. Works on assignment only. Send query letter with samples. Samples are filed. Reports back only if interested. To show a portfolio, mail photostats. Buys one-time rights. Pays on publication; $200 for b&w cover; $125 and up for b&w inside.

Tips: "Be able to deliver good work on a 7-day turnaround."

‡GIRLS' LIFE, 4517 Hartford Rd., Baltimore MD 21214-9989. (410)254-9200. Fax: (410)254-0991. Art Director: Jean Baer. Estab. 1993. Monthly consumer magazine for 7- to 14-year-old girls. Originals sometimes

Leveling the Playing Field for Women Cartoonists

"I'm in the beginning of what I consider a good strong push in the field of women's cartooning," Roz Warren says. "The fact that my books sell so well is an indicator that there is an audience for women's humor."

Roz Warren

Warren, a feminist lawyer-turned-humorist, has edited five collections of cartoons—by women only—for The Crossing Press. Her first anthology, *Women's Glib*, sparked a sequel, *Women's Glibber*, and Warren plans to release a new edition in the series every year or so. She's also put together several collections of cartoons on single themes, and has begun her own press, Laugh Lines, to publish women's humor, including collections from individual cartoonists.

When she quit practicing law to become a full-time mom, Warren got the idea to compile a humor collection. "I'd been clipping and saving humor for years, and it occurred to me that it would be great to have a collection of nothing but really terrific women's humor. I was in a position where I had the time to do that."

At the project's inception, Warren had about a third of *Women's Glib* collected. She placed calls for submission in some women's magazines, and the word rapidly spread that someone was looking for cartoons by women because there was so little market for them. She's received submissions from Australia, New Zealand, Scotland, Ireland, Israel and Croatia.

Presently, Warren gets work from more than 200 women cartoonists, and continues to discover talent daily. "By and large, the cartoonists I work with are women who have day jobs and cartoon because it comes from their hearts. There are very few women cartoonists who make a living from their art—probably less than ten. But there are damn few men making a living at it. Charles Schulz is the exception rather than the rule."

According to Warren, stand-up comedy is light years ahead of cartooning when it comes to having one's work noticed, especially for women. "It's not because Roseanne Arnold or Brett Butler is funnier than a cartoonist," she says. "But they take their work directly to the audience, and cartoonists have to go through middlemen—and they're usually men."

Case in point, your local newspaper's comics page. "The perception is that women's cartooning is a special interest," Warren says. "So if there is one strip by a woman, they've fulfilled their obligation. Where as they don't consider men's special interest. They figure 'Oh, that's reality—we all care about what

men are doing.' "

So with the publication of her books, Warren has created an opportunity for women to have their work seen. Editors of *Glamour*, *Mademoiselle* and *Ms.* consult Warren and she puts them in touch with the women in her collections. Warren thinks this is an important step in getting women cartoonists the recognition they deserve, as women's magazines—*Ms.* included—continue to publish mostly cartoons by men.

"I ultimately think that when we're all dealing on a level playing field, editors should use the cartoon that best expresses what they want to get across and they should be blind to whether or not it's by a male or female," she says. "Given the fact that currently the playing field is not at all level, these magazines are starting to realize that it's part of their job to help women get their work out."

While Warren's books are a great place for new cartoonists to get exposure, there are criteria for what she publishes. "I'm a feminist, but that doesn't mean every cartoon has to address a feminist issue," she explains. "What I like is something that puts a new spin on things, makes you think in a slightly different way. It has to make me laugh. It has to be something inoffensive."

For instance, Warren will not consider cartoons on dieting or catching a man; work making fun of gays and lesbians, the disabled, overweight people; ageist and racist material. Anything else Warren receives is considered, and she recommends other markets for quality work she can't use. But she can't stress enough how tough the market is.

"I'm in a position to compare what it's like for cartoonists, for poets, for writers, for essayists, for performance artists, and I think cartooning is definitely the toughest. In terms of recognition, in terms of reaching your audience—in terms of everything. And it's getting better extremely slowly."
—*Alice P. Buening*

Work by cartoonist Stephanie Piro appearing in Women's Glib *caught the eye of several magazine editors including* Glamour's. *One of her cartoons was reprinted in the magazine's January 1993 issue. There was so much interest in Piro's work, that Laugh Lines Press published the first collection of her cartoons,* Men! Ha!

"I like the concept of "Men"... It's the reality I have problems with..."

returned at job's completion. Sample copies available. Art guidelines not available. Sometimes needs computer literate freelancers for illustration. 20% of freelance work demands computer knowledge of Adobe Illustrator, QuarkXPress or Adobe Photoshop.

● This is a new magazine published by The Avalon Hill Game Co. At the time *Artist's & Graphic Designer's Market* went to press, *Girls' Life* was still formulating guidelines and payment policies for cartoons and illustrations.

Illustrations: Prefers anything pertaining to 7- to 14-year-old girls. Considers pen & ink, watercolor, airbrush, acrylic and mixed media. Send query letter with SASE, tearsheets, photographs, photocopies, photostats, slides and transparencies. Samples are filed or are returned by SASE if requested by artist. Publication will contact artist for portfolio review if interested. Portfolio should include tearsheets, slides, photostats, photocopies, final art and photographs. Buys first rights. Pays on publication.
Tips: Finds artists through artists' submissions.

GLASS FACTORY DIRECTORY, Box 2267, Hempstead NY 11557. (516)481-2188. Manager: Liz Scott. Annual listing glass manufacturers in US, Canada and Mexico.
Cartoons: Receives an average of 1 submisson/week. Buys 5-10 cartoons/issue. Cartoons should pertain to glass manufacturing (flat glass, fiberglass, bottles and containers; no mirrors). Prefers single and multiple panel b&w line drawings with gagline. Prefers roughs or finished cartoons. Send SASE. Reports in 1-3 months. Buys all rights. **Pays on acceptance**; $25.
Tips: "Learn about making glass of all kinds. We rarely buy broken glass jokes. There *are* women working in glass plants."

‡GOLD AND TREASURE HUNTER MAGAZINE, 27 David Rd., P.O. Box 47, Happy Camp CA 96039. (916)493-2029. Fax: (916)493-2095. Managing Editor: Janice Trombetta. Estab. 1988. Bimonthly magazine featuring "true, fictional and how-to" stories about people worldwide discovering gold, treasure and outdoor adventure. "Provides excellent family recreational opportunities!" Circ. 50,000. Accepts previously published artwork. Published originals and artwork are not returned. Sample copies for #10 SASE with first-class postage. Art guidelines not available.
Cartoons: Approached by 3 cartoonists/year. Buys 1 cartoon/issue. Prefers gold mining, metal detecting, treasure hunting. Prefers humorous cartoons; b&w line drawings with gagline. Send query letter with roughs and finished cartoons. Samples are filed. Reports back within 4-6 weeks. Buys first rights. Pays $10-25 for b&w.
Illustrations: Approached by 3 illustrators/year. Buys 5-7 illustrations/year. Considers pen & ink and charcoal. Send query letter with brochure, résumé, SASE, tearsheets and photocopies. Samples are filed. Reports back within 4-6 weeks. Portfolio review not required. Buys first rights. Pays on publication; $10-25 for b&w inside.
Tips: Finds artists through word of mouth and artists' submissions. Area most open to freelancers is the fiction section.

GRAPHIC ARTS MONTHLY, 249 W. 17th St., New York NY 10011. (212)463-6834. Editor: Roger Ynostroza. Managing Editor: Michael Karol. Monthly 4-color magazine for management and production personnel in commercial and specialty printing plants and allied crafts. Design is "direct, crisp and modern." Circ. 94,000. Sample copy $10.
Cartoons: Approached by 25 cartoonists/year. Buys 15 cartoons/year on printing, layout, paste-up, typesetting and proofreading. They should be single panel, sophisticated and illustrate story; no captions. To show portfolio, mail art and SASE. Reports in 3 weeks. Buys first rights. **Pays on acceptance**; $125 for b&w.
Illustrations: Approached by 120 illustrators/year. Needs editorial and technical illustration that "conveys the tone of the copy in style of Tom Bloom." Portfolio may be dropped off. Portfolio should include "good, recent work. Also any printed cards to keep for our files." Artist always follow-up with a call or letter. Pays $125 for color inside; $1,200 for color cover.

‡GRAY AREAS, P.O. Box 808, Broomall PA 19008-0808. Publisher: Netta Gilboa. Estab. 1991. Quarterly magazine examining gray areas of law and morality in the fields of music, law, technology and popular culture. Accepts previously published artwork. Originals not returned. Sample copies available for $6. Art guidelines not available. Needs computer-literate freelancers for design and illustration. 50% of freelance work demands knowledge of Aldus PageMaker or CorelDRAW.
Cartoons: Approached by 5 cartoonists/year. Buys 2-5 cartoons/issue. Prefers "illegal subject matter" humorous cartoons; single, double or multiple panel b&w line drawings. Send query letter with brochure, roughs, photocopies or finished cartoons. Samples are filed. Reports back within 1 week only if SASE provided. Buys one-time rights.
Illustrations: Works on assignment only. "Illegal subject matter like sex, drugs, computer criminals." Considers "any media that can be scanned by a computer." Send query letter with SASE and photocopies. Samples are filed. Reports back within 1 week only if SASE enclosed. Portfolio review not required. Buys one-time rights. Pays on publication; $500 for color cover; negotiable b&w.

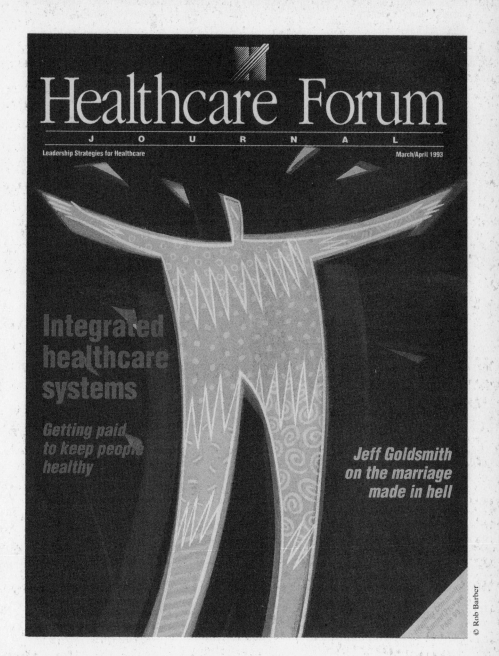

© Rob Barber

This cover image was created by Rob Barber for Healthcare Forum Journal. Barber rendered a " 'patchwork' human figure, symbolizing the whole person — from organs to emotions" for an issue on integrated healthcare systems. "Rob can take an idea and create a very simple, graphic image that conveys the idea," says Art Director Bruce Olson.

Tips: "Most of the artists we use have approached us after seeing the magazine. All sections are open to artists. We are only interested in art which deals with our unique subject matter. Please do not submit without having seen the magazine. We have a strong 1960s style. Our favorite artists include Robert Crumb and Rick Griffin. We accept all points of view in art, but only if it addresses the subject we cover. Don't send us animals, statues or scenery."

‡**GUIDEPOSTS MAGAZINE**, 16 E. 34th St., New York NY 10016. (212)251-8127. Fax: (212)684-0679. Art Director: Lawrence A. Laukhuf. Estab. 1945. Monthly nonprofit inspirations, consumer magazine. *Guideposts* is a "practical interfaith guide to successful living. Articles present tested methods for developing courage, strength and positive attitudes through faith in God." Circ. 4,000,000. Sample copies and guidelines are available.
Illustrations: Buys 3-5 illustrations/issue. Works on assignment only. Prefers realistic, reportial. Considers watercolor, collage, airbrush, acrylic, colored pencil, oil, mixed media and pastel. Send query letter with SASE, tearsheets, photographs, slides and transparencies. Samples are returned by SASE if requested by artist. To arrange portfolio review artist should follow up with call after initial query. Portfolio should include color transparencies 8×10. Buys one-time rights. **Pays on acceptance.**
Tips: Finds artists through sourcebooks, other publications word of mouth, artists' submissions and society of illustrators shows. Sections most open to freelancers are illustrations for action/adventure stories. "Do your homework as to our needs. At least see the magazine!"

‡**GULF COAST MEDIA**, Suite 5, 886 110th Ave. N., Naples FL 33963. (813)591-3431. Fax: (813)591-3938. Art Director: Crystel A. Fox. Estab. 1989. Publishes chamber's annuals promoting area tourism as well as books; 4-color and b&w; design varies. Accepts previously published artwork. Originals are returned at job's completion. Sample copies for SASE with first-class postage. Needs computer-literate freelancers for production. 100% of freelance work demands computer literacy in Aldus PageMaker and Aldus FreeHand.
Illustrations: Works on assignment only; usage of illustration depends on client. Needs editorial illustration, maps and charts. Preferred themes depend on subject; watercolor, collage, airbrush, acrylic, marker, color pencil, mixed media. Send query letter with brochure, tearsheets, photographs and photocopies. Samples are filed. Reports back only if interested. Publication will contact artist for portfolio review if interested. Portfolio should include roughs and original/final art. Buys first rights, one-time rights or reprint rights. **Pays on acceptance;** $250 for b&w, $250 for color, cover; $35 for b&w, $250 for color, inside; $50 for color spot art.
Tips: "Our magazine publishing is restricted to contract publications, such as Chamber of Commerce publications, playbills, collateral materials. All of our work is located in Florida, mostly southwest Florida, therefore everything we use will have a local theme."

HEALTHCARE FORUM JOURNAL, 830 Market St., San Francisco CA 94102. (415)421-8810. Fax: (415)421-8837. Art Director: Bruce Olson. Estab. 1936. Bimonthly trade journal for healthcare executive administrators, a publication of the Healthcare Forum Association. Circ. 25,000. Accepts previously published artwork. Originals are returned at job's completion. Sample copies available.
Illustrations: Approached by 15-20 illustrators/year. Buys 3-5 illustrations/issue. Works on assignment only. Preferred styles vary, usually abstract and painterly; watercolor, collage, acrylic, oil and mixed media. Send query letter with SASE, tearsheets, photostats and photocopies. Samples are filed and returned by SASE if requested by artist. Reports back only if interested. Buys one-time rights. **Pays on acceptance;** $600-700 for color cover; $350 for b&w, $500 for color inside.

HEART DANCE, 473 Miller Ave., Mill Valley CA 94941-2941. Fax: (415)383-7500. Editor: Randy Peyser. Estab. 1990. Monthly New Age magazine. "The Bay Area's largest events calendar for contemporary human awareness, spirituality and well-being. Features workshops, classes, groups, getaways and special events." Circ. 50,000. Accepts previously published artwork. Original artwork is returned with SASE at job's completion. Sample copies and art guidelines available.
Cartoons: Approached by 15-20 cartoonists/year. Buys 1-4 cartoons/issue. New Age, spiritual and cosmic themes preferred; any format acceptable; must be b&w. Send query letter with finished cartoons. Samples

are filed or are returned by SASE if requested by artist. Reports back within 1 month. Buys one-time rights. Pays $10 for b&w.
Illustrations: Approached by 40 illustrators/year. Buys 4 illustrations/issue. Prefers New Age, cosmic, positive, light and heartfelt themes and styles. Prefers pen & ink. Send query letter with SASE and photocopies. Samples are filed or are returned by SASE if requested by artist. Reports back within 1 month. Buys one-time rights. Pays on publication; $25 for cover, $10 for inside, b&w.

‡HEARTLAND BOATING MAGAZINE, P.O. Box 1067, Martin TN 38237-1067. (901)587-6791. Fax: (901)587-6893. Editor: Molly Lightfoot Blom. Estab. 1988. Specialty magazine published 7 times per year devoted to power (cruisers, houseboats) and sail boating enthusiasts throughout middle America. The content is both humorous and informative and reflects "the challenge, joy and excitement of boating on America's inland waterways." Circ. 15,000. Occasionally accepts previously published artwork. Originals are returned at job's completion. Sample copies available for $4. Art guidelines for SASE with first-class postage. Needs computer-literate freelancers for design and illustration. 50% of freelance work demands computer knowledge of Adobe Illustrator, QuarkXPress or Adobe Photoshop.
Cartoons: Approached by 10-12 cartoonists/year. buys 0-1 cartoons/issue. Prefers boating; single panel without gaglines. Send query letter with roughs. Samples are filed or returned by SASE if requested by artist. Reports back within 2 months. Negotiates rights purchased. Pays $30 for b&w.
Illustrations: Approached by 2-3 illustrators/year. Buys 2-3 illustrations/issue. Works on assignment only. Prefers boating related. Considers pen & ink. Send query letter with SASE and tearsheets. Samples are filed or returned by SASE if requested by artist. Reports back within 2 months. Portfolio review not required. Negotiates rights purchased. Pays on publication. Pays $30 for b&w inside.
Tips: Finds artists through artists' submissions.

‡■HEAVEN BONE, Box 486, Chester NY 10918. (914)469-9018. Editor: Steve Hirsch. Estab. 1987. Biannual literary magazine emphasizing poetry, fiction, essays reflecting spiritual/mystical and transformational concerns. Black-and-white with a "contemporary, esoteric design, eccentric but clean, well, mostly. . . ." Circ. 1,000. Accepts previously published artwork. Original artwork is returned after publication if requested. Sample copies $6. Art guidelines for SASE with first-class postage. Needs computer illustrators familiar with Adobe Illustrator, QuarkXPress and Aldus FreeHand.
Cartoons: Approached by 5-7 cartoonists/year. Just beginning to use b&w cartoons. Cartoons appearing in magazine are "humorous, spiritual, esoteric, ecologically and politically astute." Pays in 2 copies of magazine, unless other arrangements made.
Illustrations: Approached by 25-30 illustrators/year. Buys illustrations mainly for covers and feature spreads. Buys 2-7 illustrations/issue, 4-14/year from freelancers. Considers pen & ink, mixed media, watercolor, acrylic, oil, pastel, collage, markers; charcoal, pencil and calligraphy. Send query letter with brochure showing art style, tearsheets, photostats, photocopies and photographs. Samples should be esoteric, spiritual, Buddhist/Hindu and expansive. Samples are not filed and are returned by SASE. Reports back about queries/submissions within 3 months. To show a portfolio, mail b&w tearsheets, slides, photostats and photographs. Buys first rights. Pays in 2 copies of magazine.
Tips: "Please see sample issue before sending unsolicited portfolio."

HIGHLIGHTS FOR CHILDREN, 803 Church St., Honesdale PA 18431. (717)253-1080. Fax: (717)253-0179. Art Director: Rosanne Guararra. Cartoon Editor: Kent Brown. Monthly 4-color magazine for ages 2-12. Circ. 3,000,000.
Cartoons: Buys 2-4 cartoons/issue. Receives 20 submissions/week. Interested in upbeat, positive cartoons involving children, family life or animals; single or multiple panel. Send roughs or finished cartoons and SASE. Reports in 4-6 weeks. Buys all rights. **Pays on acceptance**; $20-40 for line drawings. "One flaw in many submissions is that the concept or vocabulary is too adult, or that the experience necessary for its appreciation is beyond our readers. Frequently, a wordless self-explanatory cartoon is best."
Illustrations: Buys 30 illustrations/issue. Works on assignment only. Prefers "realistic and stylized work; upbeat, fun, more graphic than cartoon." Pen & ink, colored pencil, watercolor, marker, cut paper and mixed media are all acceptable. Discourages work in fluorescent colors. Send samples of style and flier to be kept on file. Send SASE. Request portfolio review in original query. Publication will contact artist for portfolio review if interested. Buys all rights on a work-for-hire basis. **Pays on acceptance**; $1,025 for color front and back covers; $50-500 for color inside. "We are always looking for good hidden pictures. We require a picture that is interesting in itself and has the objects well hidden. Usually an artist submits pencil sketches. In no case do we pay for any preliminaries to the final hidden pictures." Submit hidden pictures to: Jody Taylor.
Tips: "We have a wide variety of needs, so I would prefer to see a representative sample of an illustrator's style or styles."

HISTORIC PRESERVATION NEWS, 1785 Massachusetts Ave. NW, Washington DC 20036. (202)673-4042. Fax: (202)673-4172. Art Director: Jeff Roth. Estab. 1961. Monthly association newspaper; "a benefit of membership in the National Trust for Historic Preservation." Circ. 225,000. Original artwork returned after publication. Sample copies available for $2 plus SASE. Art guidelines not available.

Illustrations: Approached by more than 100 illustrators/year. Buys 1 illustration/issue. Works on assignment only. Considers all media. Send query letter with brochure, tearsheets and photostats. Samples are filed. Reports back to the artist only if interested. To show a portfolio, mail thumbnails, tearsheets, slides, roughs and photographs. Buys one-time rights. **Pays on acceptance;** $100-200 for b&w inside.
Tips: "Do not show us a variety of styles or techniques; show us the style or technique that you do best."

ALFRED HITCHCOCK MYSTERY MAGAZINE, Dell Magazines Fiction Group, 1540 Broadway, New York NY 10036. (212)354-6500. Art Director: Terri Czeczko. Emphasizes mystery fiction; b&w with 4-color cover.
Illustrations: Works with 25 illustrators/year. Buys 80 illustrations/year. Uses artwork for covers, interiors and spots. Publication will contact artist for portfolio review if interested. Portfolio may be dropped off every Tuesday. Buys first rights. **Pays on acceptance;** $1,200 for cover illustrations; $150 for b&w inside; minimum $150 for line drawings.

HOME EDUCATION MAGAZINE, Box 1083, Tonasket WA 98855. (509)486-1351. Managing Editor: Helen Hegener. Estab. 1983. "We publish one of the largest magazines available for home schooling families." Desktop bimonthly published in 2-color; b&w with 4-color cover. Circ. 7,200. Original artwork is returned after publication upon request. Sample copy $4.50. Art guidelines for SASE with first-class postage.
Cartoons: Approached by 20-30 cartoonists/year. Buys 1-2/year. Style preferred is open, but theme must relate to home schooling. Prefers single, double or multiple panel b&w line drawings and washes with or without gagline. Send query letter with samples of style, roughs and finished cartoons, "any format is fine with us." Samples are filed or returned by SASE if requested. Reports back regarding queries/submissions within 3 weeks. Buys reprint rights, one-time rights or negotiates rights purchased. **Pays on acceptance;** $5-15 for b&w.
Illustrations: Approached by 100 illustrators/year. Buys illustrations mainly for spots and feature spreads. Buys 10-12 illustrations/issue. Considers pen & ink, mixed media, markers, charcoal pencil or any good sharp b&w or color media. Send query letter with tearsheets, photocopies or photographs. "We're looking for originality, clarity, warmth. Children, families and parent-child situations are what we need." Samples are filed or are returned by SASE if requested. Publication will contact artist for portfolio review if interested. Buys one-time rights, reprint rights or negotiates rights purchased. **Pays on acceptance;** $5-20 for b&w.
Tips: Finds artists primarily through artists' submissions and self-promotions. "Most of our artwork is produced by staff artists. We receive very few good cartoons."

‡HOME TIMES, 3676 Collin Dr., West Palm Beach FL 33406. (407)439-3509. Editor and Publisher: Dennis Lombard. Estab. 1988. Weekly conservative local newpaper tabloid with some national distribution. Circ. 15,000. 3 sample issues available for $1 and 9 × 12 SASE and 4 stamps. Art guidelines not available.
Cartoons: Approached by 20 cartoonists/year. Buys 8-10 cartoons/issue. Prefers conservative politics, family life, warm family humor. Prefers political cartoons; single and multiple panel b&w line drawings. Send query letter with finished cartoons. Samples are filed or returned by SASE. Buys one-time rights. Pays $5 for b&w.
Tips: Finds artists through submissions. Does not generally buy illustrations, but about 8-10 cartoons an issue. "Read the paper to understand the editorial slant."

HONOLULU MAGAZINE, 36 Merchant St., Honolulu HI 96813. (808)524-7400. Art Director: Teresa J. Black. "Monthly 4-color city/regional magazine reporting on current affairs and issues, people profiles, lifestyle. Readership is generally upper income (based on subscription). Contemporary, clean, colorful and reader-friendly" design. Original artwork is returned after publication. Sample copies for SASE with first-class postage. Needs computer-literate freelancers for design and production. 15% of freelance work demands knowledge of QuarkXPress.
Illustrations: Buys illustrations mainly for spots and feature spreads. Buys 1-3 illustrations/issue. Works on assignment only. Prefers airbrush, colored pencil and watercolor. Considers pen & ink, mixed media, acrylic, pastel, collage, charcoal, pencil and calligraphy. Send query letter with brochure showing art style. Looks for local subjects, conceptual abilities for abstract subjects (editorial approach) – likes a variety of techniques. Looks for strong b&w work. Samples are filed or are returned only if requested. Reports back only if interested. Write to schedule an appointment to show a portfolio which should include original/final art and color and b&w tearsheets. Buys first rights or one-time rights. Pays on publication; $400-500 for color cover; $300-600 for color inside.
Tips: Finds artists through word of mouth, magazines, artists' submissions, attending art exhibitions. "Needs both feature and department illustration – best way to break in is with small spot illustration."

‡HORSE ILLUSTRATED, P.O. Box 6050, Mission Viejo CA 92690. (714)855-8822. Associate Editor: Moira C. Harris. Estab. 1975. Monthly consumer magazine providing "information for responsible horse owners." Circ. 180,000. Originals are returned after job's completion. Sample copies available for $4. Art guidelines for SASE with first-class postage.
Cartoons: Approached by 200 cartoonists/year. Buys 1 or 2 cartoons/issue. Prefers satire on horse ownership ("without the trite clichés"); single panel b&w line drawings with gagline. Send query letter with brochure, roughs and finished cartoons. Samples are not filed and are not returned or are returned by SASE if requested

by artist. Reports back within 6 weeks. Buys first rights and one-time rights. Pays $35 for b&w.
Illustrations: Approached by 60 illustrators/year. Buys 1 illustration/issue. Prefers realistic, mature line art, pen & ink spot illustrations of horses. Considers pen & ink. Send query letter with brochure, SASE, tearsheets, photocopies and photostats. Samples are not filed and are returned by SASE if requested by artist. Reports back within 6 weeks. Portfolio review not required. Buys first rights or one-time rights. Pays on publication; $35 for b&w inside.
Tips: Finds artists through artists' submissions. "We only use spot illustrations for breed directory and classified sections. We do not use much, but if your artwork is within our guidelines, we usually do repeat business."

HORTICULTURE MAGAZINE, 98 N. Washington St., Boston MA 02114. (617)742-5600. Illustration Editor: Sarah Schwartz. Estab. 1904. Monthly magazine for all levels of gardeners (beginners, intermediate, highly skilled). "*Horticulture* strives to inspire and instruct people who want to garden." Circ. 290,000. Originals are returned at job's completion. Art guidelines are available.
Illustrations: Approached by 75 freelance illustrators/year. Buys 10 illlustrations/issue. Works on assignment only. Prefers tight botanicals; garden scenes with a natural sense to the clustering of plants; people; hands and "how-to" illustrations. Considers all mediums. Send query letter with brochure, résumé, SASE, tearsheets, slides. Samples are filed or returned by SASE. Publication will contact artist for portfolio review if interested. Buys one-time rights. Pays 3 weeks after project completed. Payment depends on complexity of piece.
Tips: "Finds artists through word of mouth, magazines, artists' submissions/self-promotions, sourcebooks, artists' agents and reps, attending art exhibitions. "I always go through the sourcebook and request portfolio materials if a person's work seems appropriate and is impressive."

■**HOUSEWIFE-WRITERS FORUM,** P.O. Box 780, Lyman WY 82937. (307)786-4513. Publisher: Diane Wolverton. Estab. 1988. Bimonthly 2-color magazine "for and by women (and men) who share a commitment to writing while juggling home life and family responsibilities." Circ. 1,000-1,500. Accepts previously published artwork. Originals are returned at job's acceptance. ("We make copies for use.") Sample copies available for $3. Art guidelines free for SASE with first-class postage.
Cartoons: Approached by 25 cartoonists/year. Buys 1-2 cartoons/issue. Prefers family, writing, housewife-writers; single panel, with gagline about writing and juggling family life. Send finished cartoons. Samples are not filed and are returned. Reports back within 2 months if SASE enclosed. Portfolio review not required. Buys first rights and reprint rights. Pays $2 for b&w.
Illustrations: Works on assignment only. Prefers family and writing themes in pen & ink, charcoal. Send query letter with photocopies. Samples are filed. Reports back to the artist only if interested. Buys first rights and reprint rights. Pays $2 for b&w. **Pays on acceptance.**
Tips: "Send us samples and a letter telling a little about the artist."

HOW, The Bottomline Design Magazine, 1507 Dana Ave., Cincinnati OH 45207. Associate Art Director: Scott Finke. Estab. 1985. Bimonthly trade journal covering "how-to and business techniques for graphic design professionals." Circ. 35,000. Original artwork returned at job's completion. Sample copy $8.50. Art guidelines not available.
• Sponsors annual conference for graphic artists. Send SASE for more information.
Illustrations: Approached by 100 illustrators/year. Buys 2 illustrations/issue. Works on assignment only. Considers all media, including photography and computer illustration. Send query letter with brochure, tearsheets, photocopies and transparencies. Samples are filed or are returned by SASE if requested. Reports back only if interested. To show a portfolio, mail slides. Buys first rights or reprint rights. Pays on publication; $500 for color cover; $50 for b&w; $150-400 for color inside.

HSUS NEWS, 700 Professional Dr., Gaithersburg MD 20814. Art Director: Theodora T. Tilton. Estab. 1954. Quarterly 4-color magazine focusing on Humane Society news and animal protection issues. Circ. 450,000. Accepts previously published artwork. Originals are returned at job's completion.
Illustrations: Buys 1-2 illustrations/issue. Works on assignment only. Themes vary. Send query letter with samples. Samples are filed or returned. Reports back within 1 month. To show a portfolio, mail appropriate materials. Portfolio should include printed samples, b&w and color tearsheets and slides. Buys one-time rights and reprint rights. **Pays on acceptance;** $250 for b&w, $400 for color cover; $150 for b&w, $300 for color inside.

‡■**THE HUMOROUS VEIN,** P.O. Box 725, Lawrenceville GA 30246-0725. (404)339-3038. Editor: Stephen C. Watts. Estab. 1994. Bimonthly humor magazine, newsletter format. Offbeat humor publication "targeted towards deranged persons in their teens through twenties, featuring short stories, essays, and cartoons." Originals are returned. Sample copies available for $1.95. Art guidelines for SASE with first-class postage.
Cartoons: Approached by 60 cartoonists/year. Buys 6-10 cartoons/issue. Prefers offbeat, unpredictable humor. Prefers humorous cartoons; single panel b&w line drawings with gagline. Send query letter with finished cartoons. Samples are not filed and are returned by SASE if requested by artist. Reports back within 6

weeks. Buys first rights. **Pays on acceptance**; $1 for b&w, 2 copies of newsletter upon publication.
Tips: Finds artists through submissions and word of mouth. "Send camera-ready line art; we cannot use photocopies although these are acceptable as inquiries only. We are looking for unusual, offbeat humor, but we don't accept material that depicts graphic sexual references or racism."

HUMPTY DUMPTY'S MAGAZINE, Box 567, Indianapolis IN 46206. (317)636-8881. Art Director: Lawrence Simmons. A health-oriented children's magazine for ages 4-7; 4-color; simple and direct design. Published 8 times a year. Circ. 300,000. Originals are not returned at job's completion. Sample copies available for $1.25 Art guidelines available for SASE.
Illustrations: Approached by 300-400 illustrators/year. Buys 20 illustrations/issue. Works on assignment only. Preferred styles are mostly cartoon and some realism. Considers any media as long as finish is done on scannable (bendable) surface. Send query letter with slides, photocopies, tearsheets and SASE. Samples are filed or returned by SASE if not kept on file. Reports back only if interested. To show a portfolio, mail color tearsheets, photostats, photographs and photocopies. Buys all rights. Pays on publication; $275 for color cover; $35-90 for b&w and $70-155 for color inside.

IDEALS MAGAZINE, Box 148000, Nashville TN 37214. (615)231-6740. Fax: (615)231-6750. Editor: Lisa Thompson. 4-color magazine, published 8 times/year, emphasizing poetry and light prose. Accepts previously published material. Sample copy $4.
Illustrations: Buys 6-8 illustrations/issue. Uses freelance artists mainly for flowers, plant life, wildlife and people. Prefers seasonal themes rendered in a nostalgic style. Prefers pen & ink, airbrush, colored pencil, oil, watercolor and pastel. Send query letter with brochure showing art style or tearsheets. Samples not filed are returned by SASE. Do not send originals or slides. Buys artwork outright. Pays on publication.
Tips: "In submissions, target our needs as far as style is concerned, but show representative subject matter. Artists should be familiar with our magazine before submitting samples of work."

ILLINOIS ENTERTAINER, 2250 E. Devon, Des Plaines IL 60018. (708)298-9333. Fax: (708)298-7973. Editor: Michael C. Harris. Estab. 1975. Sleek consumer/trade-oriented monthly entertainment magazine focusing on local and national alternative music. Circ. 80,000. Accepts previously published artwork. Originals are not returned. Sample copies for SASE with first-class postage. Art guidelines not available.
Illustrations: Approached by 1-5 freelance illustrators/year. Works on assignment only. Publication will contact artist for portfolio review if interested. Buys first rights. Pays on publication; $20 for b&w.
Tips: Finds artists through word of mouth and submissions. "Send some clips and be patient."

ILLINOIS MEDICINE, Suite 700, 20 N. Michigan Ave., Chicago IL 60602. (312)782-1654. Fax: (312)782-2023. Managing Editor: Carla Nolan. Estab. 1989. Biweekly 4-color company tabloid published for the physician members of the Illinois State Medical Society featuring nonclinical socio-economic and legislative news; conservative design. Circ. 20,000. Accepts previously published artwork. Illustrations are returned at job's completion. Sample copies available.
Cartoons: Approached by 20 cartoonists/year. Buys 1 cartoon/issue. Prefers medical themes—geared to physicians; single panel, b&w washes and line drawings with gagline. Send query letter with finished cartoons. Samples are not filed and are returned. Reports back within 2 months. Buys one-time rights. Pays $50 for b&w, $100 for color.
Illustrations: Approached by 10 illustrators/year. Buys 1 illustration/issue. Works on assignment only. Preferred themes are medical or governmental; pen & ink, watercolor, charcoal and pastel. Send query letter with brochure, tearsheets, photostats or photographs. Samples are filed. Publication will contact artist for portfolio review if interested. Artist should follow up with call or letter. Portfolio should include roughs, printed samples, b&w and color tearsheets, photostats and photographs. Buys one-time rights. **Pays on acceptance**; $500 for b&w, $800-1,000 for color.
Tips: Finds artists mostly through artists' self-promotions.

‡IN TOUCH FOR MEN, 13122 Saticoy St., North Hollywood CA 91605-3402. (818)764-2288. Fax: (818)764-2307. Editor: Doug DiFranco. Estab. 1973. Monthly magazine. "*In Touch* is an erotic magazine for gay men that explores all aspects of the gay community (sex, art, music, film, etc.)." Circ. 60,000. Accepts previously published work (very seldom). Originals returned after job's completion. Sample copies and art guidelines available. Needs computer-literate freelancers for illustration.
● This magazine is open to working with illustrators who create work on computers and transfer it via modem. Final art must be saved in a Macintosh-readable format.
Cartoons: Approached by 10 cartoonists/year. Buys 1-2 cartoons/issue. Prefers humorous, gay lifestyle related (not necessarily sexually explicit in nature); single and multiple panel b&w washes and line drawings with gagline. Send query letter with finished cartoons. Samples are filed. Reports back within 1 month. Buys one-time rights. Pays $50 for b&w, $100 for color.
Illustrations: Approached by 10 illustrators/year. Buys 3-5 illustrations/issue. Works on assignment only. Prefers open-minded, lighthearted style. Considers all types. Send query letter with résumé, tearsheets, photocopies and slides. Samples are filed. Reports back within 2 weeks. Publication will contact artist for

portfolio review if interested. Portfolio should include b&w and color final art. Usually buys one-time rights or vary according to project. **Pays on acceptance.** Pays $50 for b&w inside, $100 for color inside.

Tips: "Most artists in this genre will contact us directly, but we get some through word-of-mouth and occasionally we will look up an artist whose work we've seen and interests us. Areas most open to freelancers are 4-color illustrations for erotic fiction stories, humorous illustrations and stand-alone comic strips/panels depicting segments of gay lifestyle. Understanding of gay community and lifestyle a plus."

‡**INCOME OPPORTUNITIES,** 1500 Broadway, New York NY 10036-4015. (212)642-0600. Contact: Ron Kuliner. Estab. 1956. Monthly consumer magazine for small business investors. Circ. 400,000. Accepts previously published artwork. Originals returned at job's completion. Sample copies available. Art guidelines not available. Needs computer-literate freelancers for illustration. 5% of freelance work demands knowledge of QuarkXPress.

Cartoons: Approached by 10 cartoonists/year. Buys 4 cartoons/issue. Prefers light outlines with b&w and color washes. Send query letter with brochure. Samples are filed. Reports back to the artist only if interested. Buys first rights. Pays $100 for b&w, $250 for color.

Illustrations: Approached by 10 illustrators/year. Buys 10 illustrations/issue. Works on assignment only. Prefers money oriented art. Considers watercolor and airbrush. Send query letter with brochure, tearsheets and photocopies. Samples are filed. Reports back to the artist only if interested. To arrange portfolio review artist should follow up with call and letter after initial query. Portfolio should include tearsheets, final art and photographs. Buys first rights. Pays on publication; $1,500 for color cover; $250 for color inside.

Tips: Finds artists through sourcebooks like *American Showcase*, also through artists' submissions. Mostly hires artists for humorous illustrations for the departments. "Send mailing cards."

INSIDE, 226 S. 16th St., Philadelphia PA 19102. (215)893-5797. Editor: Jane Biberman. Estab. 1979. Quarterly. Circ. 70,000. Accepts previously published artwork. Interested in buying second rights (reprint rights) to previously published work. Original artwork returned after publication.

Illustrations: Buys several illustrations/issue from freelancers. Buys 40 illustrations/year. Prefers color and b&w drawings. Works on assignment only. Send samples and tearsheets to be kept on file. Samples not kept on file are not returned. Call for appointment to show portfolio. Reports only if interested. Buys first rights. **Pays on acceptance;** minimum $500 for color cover; minimum $150 for b&w, $200 for color inside. Prefers to see sketches.

Tips: Finds artists through artists' promotional pieces, attending art exhibitions, artists' requests to show portfolio.

‡**INTERNATIONAL DOLL WORLD,** 306 E. Parr Rd., Berne IN 46711. (219)589-8740. Editor: Cary Raesner. Bimonthly consumer journal that provides information on doll collecting, restoration and crafting; 4-color. Circ. 54,122. Accepts previously published artwork. Original artwork is sometimes returned after publication. Sample copies $2. Art guidelines not available.

Cartoons: Approached by 2-3 cartoonists/year. Buys 2-3 cartoons/year from freelancers. Prefers themes on doll collecting. Prefers single panel with gagline. Send finished cartoons. Samples are filed. Samples not filed are returned by SASE. Reports back regarding queries/submissions only if interested. Negotiates rights purchased. **Pays on acceptance;** $25 b&w.

Illustrations: Approached by 14-15 illustrators/year. Buys illustrations mainly for feature spreads and paper dolls. Buys 2 illustrations/issue. Considers mixed media, colored pencil, watercolor, acrylic, oil and pastel. Send query letter with tearsheets, slides, photographs and transparencies. Looks for realistic technique. Samples are filed or are returned by SASE if requested. Reports back about queries/submissions within 2 weeks. Call or write to schedule an appointment to show a portfolio which should include color original/final art, slides, photographs and transparencies. Negotiates rights purchased. **Pays on acceptance;** $35-150 for color inside.

Tips: "The best way for an illustrator to break into our publication is to send paper dolls. Don't send them on paper that produces a blurry line."

‡■**INTERNATIONAL INSIDER,** P.O. Box 43685, Detroit MI 48243-0685. Editor-in-Chief: Mr. Shannon Roxborough. Estab. 1993. Bimonthly magazine emphasizing Eastern and Western health and healing methods for the body, mind and spirit. Circ. 50,000. Accepts previously published artwork. Originals returned at job's completion if SASE is enclosed. Sample copies available for $5. Art guidelines for SASE with first-class postage. Needs computer-literate freelancers for illustration. 10% of freelance work demands computer

The double dagger before a listing indicates that the listing is new in this edition. New markets are often more receptive to freelance submissions.

knowledge of Aldus PageMaker, Adobe Illustrator, Adobe Photoshop, Aldus FreeHand or Aldus Page-Maker.

Cartoons: Approached by 50 cartoonists/year. Buys 6 cartoons/issue. Prefers humorous cartoons; b&w and color washes and b&w line drawings. Send query letter with SASE. Samples are not filed and are returned by SASE. Reports back within 2 month. Buys first rights. Pays $20 for b&w, $30 for color.

Illustrations: Approached by 50 illustrators/year. Buys 12 illustrations/issue. Considers pen & ink, watercolor, collage, airbrush, acrylic, marker, colored pencil and oil. Send query letter with SASE and photographs. Samples are not filed and are returned by SASE. Reports back within 2 months. Publication will contact artist for portfolio review if interested. Portfolio should include b&w and color photographs of art work. Buys all rights. **Pays on acceptance;** $50 for b&w, $60 for color cover; $30 for b&w, $40 for color inside.

Tips: "Unpublished artists are encouraged to submit material. Please include sufficient postage for material to be returned."

‡■**THE INTERNATIONAL SADDLERY AND APPAREL JOURNAL,** P.O. Box 3039, Berea KY 40403-3039. (606)986-4644. Fax: (606)986-1770. Editor: Pamela R. Harrell. Estab. 1987. Monthly trade journal; magazine format; business publication for the equine trade. Features information on horse and rider equipment and supplies, not horses. "Our readers are retail businesses." Circ. 10,000. Accepts previously published artwork. Original artwork is returned at job's completion. Sample copies for $4. Art guidelines for SASE with first-class postage.

Cartoons: Reports back within 2 months. Buys first rights. Pays $35 for b&w.

Illustrations: Approached by 5-10 freelance illustrators/year. Buys 1-2 freelance illustrations/year. Prefers business themes (sometimes equine-related). Send query letter with appropriate samples and SASE. Samples are filed or are returned by SASE if requested by artist. Reports back within 2 months. Portfolio review not required. Buys first rights. Pays on publication; $35 for b&w.

Tips: Finds artists through artists' submissions/self-promotions. "We use cartoons on floppy disk services also."

‡■**INTERRACE,** P.O. Box 12048, Atlanta GA 30355-2048. (409)364-9590. Fax: (404)364-9965. Associate Publisher: Gabe Grosz. Estab. 1989. Consumer magazine published 8 times/year. "Magazine of interracial/multi-racial/biracial theme for couples and people. Reflects the lives and lifestyles of interracial couples and people." Circ. 25,000. Accepts previously published artwork. Originals are returned at job's completion with SASE if requested. Sample copies available for $2 and 9×12 SASE. Guidelines available for SASE with first-class postage.

• *Interrace* spawned *Biracial Child* magazine ("the only one if its kind in the US") in 1994 for parents of mixed-race children, interracial stepfamilies and transracial adoption. This new publication is in need of illustrators. Submit to above address.

Cartoons: Approached by 10 cartoonists/year. Buys 10 cartoons/year. Prefers interracial couple/family, multiracial people themes; any format. Send query letter with roughs or finished cartoons. Samples are filed or are returned by SASE if requested. Reports back if interested within 1 month. Negotiated rights purchased. Pays $10 for b&w, $15 for color.

Illustrations: Approached by 20 illustrators/year. Uses 2-3 illustrations/issue. Prefers interracial couple/family, multiracial people themes. Considers pen & ink, airbrush, colored pencil, mixed media, watercolor, acrylic, pastel, collage, marker and charcoal. Send query letter with résumé and photocopies. Samples are filed or are returned by SASE if requested. Reports back if interested within 1 month. Request portfolio review in original query. Artist should follow-up with letter after initial query. Portfolio should include photocopies and any samples; "it's up to the artist." Negotiates rights purchased. Pays on publication; $75 for b&w or color cover; $15 for b&w, $20 for color inside.

Tips: Finds artists through submissions. "We are looking for artwork for interior or cover that is not only black and white couples/people, but all mixtures of black, white, Asian, Native American, Latino, etc."

■**IOWA WOMAN,** Box 680, Iowa City IA 52244. (319)987-2879. Editor: Marianne Abel. Estab. 1979. Quarterly b&w with 4-color cover literary magazine. "A magazine for every woman who has a mind of her own and wants to keep it that way, with fine literature and visual art by women everywhere." Circ. 2,400. Accepts previously published artwork. Originals are returned at job's completion. Sample copies $6. Art guidelines for SASE with first-class postage. Needs computer-literate freelancers for illustration. Amount of freelance work demanding computer skills varies. Freelancers should be familiar with QuarkXPress.

Cartoons: Approached by 2 cartoonists/year. "Have bought none yet, but we would use 10 cartoons/year." Preferred theme/style is narrative, political and feminist "without male-bashing"; single, double and multiple panel b&w line drawings with or without gagline. Send query letter with roughs, finished cartoons and SASE. Samples are filed or are returned by SASE if requested. Reports back within 1 month. Buys first rights. Pays $15 and 2 copies.

Illustrations: Approached by 30 illustrators/year. Buys 6 illustrations/issue. Prefers images of nature, incidental sketches and scenes; pen & ink, watercolor, collage, mixed media, b&w photos. Send query letter with tearsheets or slides, letter of introduction, SASE and photocopies. Samples are filed or returned by

SASE if requested. Reports back within 1 month. Portfolio review not required. Buys first rights. Pays $15 for b&w inside; $50 for color cover.

Tips: "We consider Iowa (or former Iowa) women artists only for the cover; women artists from everywhere else for inside art. We prefer to work on assignment, except for cartoons."

JACK AND JILL, Box 567, 1100 Waterway Blvd., Indianapolis IN 46206. (317)636-8881. Fax: (317)637-0126. Art Director: Edward F. Cortese. Emphasizes entertaining articles written with the purpose of developing the reading skills of the reader. For ages 7-10. Monthly except bimonthly January/February, April/May, July/August and October/November. Magazine is 32 pages, 4-color and 16 pages, b&w. The editorial content is 50% artwork. Buys all rights. Original artwork not returned after publication (except in case where artist wishes to exhibit the art; art must be available to us on request). Sample copy $1.25.

• This magazine is published by Children's Better Health Institute. Other magazines by this organization include *Turtle, Humpty Dumpty, Children's Playmate, Child Life, Children's Digest,* and *U.S. Kids.*

Illustrations: Approached by more than 100 illustrators/year. Buys 25 illustrations/issue. Uses freelance artists mainly for cover art, story illustrations and activity pages. Interested in "stylized, realistic, humorous illustrations for mystery, adventure, science fiction, historical and also nature and health subjects." Style of Len Ebert, Les Gray, Fred Womack, Phil Smith and Clovis Martin. Prefers editorial illustration in mixed media. Works on assignment only. Send query letter with brochure showing art style and résumé, tearsheets, photostats, photocopies, slides and photographs to be kept on file; include SASE. Publication will contact artist for portfolio review if interested. Portfolio should include printed samples, tearsheets, b&w and 2-color pre-separated art. Pays $275 cover, $155 full page, $100 ½ page, $70 spot for 4-color. For 4-color pre-separation art pays $190 full page, $115 ½ page and $80 spot. Pays $120 full page, $90 ½ page, $60 spot for 2-color. Pays $90 full page, $60 ½ page, $35 spot for b&w. Buys all rights on a work-for-hire basis. On publication date, each contributor is sent two copies of the issue containing his or her work.

Tips: Finds artists through artists' submissions and self-promotion pieces. Portfolio should include "illustrations composed in a situation or storytelling way, to enhance the text matter. I do not want to see samples showing *only* single figures, portraits or landscapes, sea or air."

JACKSONVILLE TODAY, Suite 300, 1650 Prudential Dr., Jacksonville FL 32207. (904)396-8666. Creative Director: Jan Gaunder. Estab. 1983. City/regional lifestyle magazine covering Florida's First Coast. 10 times/yearly. Circ. 25,000. Accepts previously published artwork. Originals returned at job's completion. Sample copies available for $5 (includes postage). Art guidelines for SASE with first-class postage. Needs computer-literate freelancers for production. Freelancers should be familiar with QuarkXPress, FreeHand and Photoshop.

Illustrations: Approached by 50 illustrators/year. Buys 4 illustrations/issue. Prefers editorial illustration with topical themes and sophisticated style. Send tearsheets. Samples are filed and are returned by SASE if requested. Reports back within 2-4 weeks. Request portfolio review in original query. Publication will contact artist for portfolio review if interested. Portfolio should include b&w and color tearsheets and slides. Buys all rights. Pays on publication; $800 for color cover; $175 for b&w, $200 for color inside.

Tips: Finds artists through illustration annuals. "We are very interested in seeing new talent—people who are part of the breaking trends."

THE JAMES WHITE REVIEW, P.O. Box 3356, Butler Quarter Station, Minneapolis MN 55403. (612)339-8317. Publisher: Phil Willkie. Estab. 1983. Quarterly b&w literary magazine. "The Lambda award-winning gay men's literary quarterly." Circ. 4,000. Accepts previously published artwork. Original artwork is returned at job's completion. Sample copies available for $3. Art guidelines not available.

Cartoons: Pays $25 for b&w cartoons.

Illustrations: Approached by 20 illustrators/year. Buys 8-10 illustrations/issue. Interested in all types of work by emerging and established gay artists. All media welcome. Send query letter with résumé, SASE, photographs, slides. Samples are not filed and are returned by SASE. Publication will contact artist for portfolio review if interested. Portfolio should include b&w photographs and slides. Buys first rights or one-time rights. Pays on publication; $25 for b&w cover, $25 for b&w inside; maximum of $50/artist per issue.

Tips: "We are interested in seeing work in any media by emerging and established gay artists. Please send copies and not the originals. We are not responsible for lost or damaged artwork."

■**JAPANOPHILE**, Box 223, Okemos MI 48864. (517)349-1795. Editor: Earl R. Snodgrass. Quarterly emphasizing cars, bonsai, haiku, sports, etc. for educated audience interested in Japanese culture. Circ. 600. Accepts previously published material. Original artwork not returned at job's completion. Sample copy $4; art guidelines for SASE.

Cartoons: Approached by 7-8 cartoonists/year. Buys 1 cartoon/issue. Prefers single panel b&w line drawings with gagline. Send finished cartoons. Material returned only if requested. Reports only if interested. Buys all rights. Pays on publication; $5 for b&w and color.

Illustrations: Buys 1-5 illustrations/issue. Needs humorous editorial illustration. Prefers sumie or line drawings. Send photostats or tearsheets to be kept on file if interested. Samples returned only if requested.

Reports only if interested. Buys all rights. Pays on publication; $5 for b&w and color cover; $5 for b&w inside.

Tips: Would like cartoon series on American foibles when confronted with Japanese culture.

JAZZIZ, 3620 NW 43rd St., Gainesville FL 32606. (904)375-3705. Fax: (904)375-7268. Art Director: Torne White. Estab. 1982. Bimonthly magazine covering "all aspects of adult-oriented music with emphasis on instrumental and improvisatory styles: jazz, blues, classical, world beat, sophisticated pop; as well as audio and video." Circ. 120,000. Accepts previously published artwork. Originals returned at job's completion.

● Also publishes *Play* magazine.

Illustrations: Approached by 100-200 illustrators/year. Buys 1-5 illustrations/issue. Works on assignment only. Prefers mixed media. Send query letter with résumé, tearsheets and samples. Samples are filed or returned by SASE if requested by artist. Reports back only if interested. Call or write for appointment to show portfolio, which should include thumbnails, roughs and color tearsheets and photographs. Rights vary according to project. Pays on publication; $75 for b&w, $150 for color inside.

Tips: "Send an inventive promotion piece and show work you have done along with concept/reasons for the piece. Strong use of color, texture and space is important. I think there is a higher awareness of fine art now and freelance artists should be pushing the limits between illustration and fine art."

‡JEWISH WEEKLY NEWS, P.O. Box 1569, Springfield MA 01101-1569. (413)739-4771. Publisher: Kenneth White. Estab. 1945. Weekly regional journal of news, arts, and opinion serving the Jewish communities of western Massachusetts. Circ. 3,000. Accepts previously published artwork. Originals returned at job's completion. Sample copies available for 9 × 12 SASE and 65¢ postage. Art guidelines available for SASE and first-class postage. Needs computer-literate freelancers for illustration. Freelancers should be familiar with Adobe Illustrator or QuarkXPress.

Cartoons: Prefers political humor within a Jewish context. Prefers political and humorous cartoons; single panel. Send query letter with brochure. Samples are filed or are returned by SASE if requested by artist. Reports back within 2 months. Buys one-time rights. Pays $5-10 for b&w.

Illustrations: Buys 3-5 illustrations/year. Considers pen & ink. Send query letter with brochure, tearsheets and photocopies. Samples are filed. Reports back within 2 months. Portfolio review not required. Pays on publication; $10-20 for b&w cover. Buys one-time rights.

Tips: Sections most open to freelancers are special sections on Jewish life-cycle events.

JOURNAL OF ACCOUNTANCY, Harborside 201 Plaza III, Jersey City NJ 07311. (201)938-3450. Art Director: Jeryl Ann Costello. Monthly 4-color magazine emphasizing accounting for certified public accountants; corporate/business format. Circ. 350,000. Accepts previously published artwork. Original artwork returned after publication. Needs computer-literate freelancers for design and illustration of charts and graphs. 35% of freelance work demands knowledge of Adobe Illustrator, QuarkXPress and Aldus FreeHand.

Illustrations: Approached by 200 illustrators/year. Buys 2-6 illustrations/issue. Prefers business, finance and law themes. Prefers mixed media, then pen & ink, airbrush, colored pencil, watercolor, acrylic, oil and pastel. Works on assignment only. Send query letter with brochure showing art style. Samples not filed are returned with SASE. Portfolio should include printed samples, color and b&w tearsheets. Buys first rights. Pays on publication; $1,200 for color cover; $200-600 for color (depending on size) inside.

Tips: Finds artists through artists' submissions/self-promotions, sourcebooks and magazines. "I look for indications that an artist can turn the ordinary into something extraordinary, whether it be through concept or style. In addition to illustrators, I also hire freelancers to do charts and graphs. In portfolios, I like to see tearsheets showing how the art and editorial worked together."

‡JOURNAL OF ASIAN MARTIAL ARTS, 821 W. 24th St., Erie PA 16502-2523. (814)455-9517. Fax: (814)838-7811. Publisher: Michael A. DeMarco. Estab. 1991. Quarterly journal covering all historical and cultural aspects of Asian martial arts. Interdisciplinary approach. College-level audience. Circ. 5,000. Accepts previously published artwork. Sample copies available for $10. Art guidelines for SASE with first-class postage. Needs computer-literate freelancers for illustration. Freelancers should be familiar with Aldus PageMaker.

Illustrations: Buys 60 illustrations/issue. Prefers b&w wash; brush-like Oriental style; line. Considers pen & ink, watercolor, collage, airbrush, marker and charcoal. Send query letter with brochure, résumé, SASE and photocopies. Samples are filed. Reports back within 4-6 weeks. Publication will contact artist for portfolio review if interested. Portfolio should include b&w roughs, photocopies and final art. Buys first rights and reprint rights. Pays on publication; $100 for b&w cover, $25-100 for b&w inside.

Tips: "Usually artists hear about or see our journal. We can be found in bookstores, libraries, or in listings of publications. Areas most open to freelancers are illustrations of historic warriors, weapons, castles, battles – any subject dealing with the martial arts of Asia. If artists appreciate aspects of Asian martial arts and/or Asian culture, we would appreciate seeing their work and discuss the possibilities of collaboration."

JOURNAL OF HEALTH EDUCATION, 1900 Association Dr., Reston VA 22091. Editor: Patricia Lyle. Estab. 1970. "Bimonthly trade journal for school and community health professionals, keeping them up-to-date on issues, trends, teaching methods, and curriculum developments in health." Conservative; b&w with 4-color

cover. Circ. 10,000. Original artwork is returned after publication if requested. Sample copies available. Art guidelines not available. Needs computer-literate freelancers for design, illustration and production. 70% of freelance work demands knowledge of Aldus PageMaker, Adobe Illustrator, QuarkXPress and Aldus FreeHand.
Illustrations: Approached by 50 illustrators/year. Buys 6 illustrations/year. Uses artists mainly for covers. Wants health-related topics, any style; also editorial and technical illustrations. Prefers watercolor, pen & ink, airbrush, acrylic, oil and computer illustration. Works on assignment only. Send query letter with brochure showing art style or photostats, photocopies, slides or photographs. Samples are filed or are returned by SASE. Publication will contact artist for portfolio review if interested. Portfolio should include color and b&w thumbnails, roughs, printed samples, photostats, photographs and slides. Negotiates rights purchased. **Pays on acceptance;** $45 for b&w; $250-500 for color cover.

THE JOURNAL OF LIGHT CONSTRUCTION, RR 2, Box 146, Richmond VT 05477. (802)434-4747. Fax: (802)434-4467. Art Director: Theresa Emerson. Monthly magazine emphasizing residential and light commercial building and remodeling. Focuses on the practical aspects of building technology and small-business management. Circ. 45,000. Accepts previously published material. Original artwork is returned after publication. Sample copy free. Needs computer-literate freelancers for design and production. 80% of freelance work demands knowledge of QuarkXPress and Adobe Photoshop.
Illustrations: Buys 10 illustrations/issue. "Lots of how-to technical illustrations are assigned on various construction topics." Send query letter with brochure, résumé, tearsheets, photostats or photocopies. Samples are filed or are returned only if requested by artist. Reports back within 2 weeks. Call or write for appointment to show portfolio, which should include printed samples, final reproduction/product and b&w tearsheets. Buys one-time rights. **Pays on acceptance;** $500 for color cover; $75 for b&w inside.
Tips: "Write for a sample copy. We are unusual in that we have drawings illustrating construction techniques. We prefer artists with construction and/or architectural experience."

JUDICATURE, Suite 1600, 25 E. Washington, Chicago IL 60602. Contact: David Richert. Estab. 1917. Journal of the American Judicature Society. Black-and-white bimonthly with 2-color cover and conservative design. Circ. 15,000. Accepts previously published material. Original artwork returned after publication. Sample copy for SASE with $1.44 postage. Needs computer-literate freelancers for design. 100% of freelance work demands knowledge of Aldus PageMaker, and Aldus FreeHand.
Cartoons: Approached by 10 cartoonists/year. Buys 1-2 cartoons/issue. Interested in "sophisticated humor revealing a familiarity with legal issues, the courts and the administration of justice." Send query letter with samples of style and SASE. Reports in 2 weeks. Buys one-time rights. Pays $35 for unsolicited b&w cartoons.
Illustrations: Approached by 20 illustrators/year. Buys 1-2 illustrations/issue. Works on assignment only. Interested in styles from "realism to light humor." Prefers subjects related to court organization, operations and personnel. Send query letter with brochure showing art style and SASE. Publication will contact artist for portfolio review if interested. Portfolio should include roughs and printed samples. Wants to see "b&w and the title and synopsis of editorial material the illustration accompanied." Buys one-time rights. Negotiates payment. Pays $250 for color cover; $250 for b&w full page, $175 for b&w half page inside.
Tips: "Show a variety of samples, including printed pieces and roughs."

‡JUGGLER'S WORLD, Box 443, Davidson NC 28036. (704)892-1296. Fax: (704)892-2499. Editor: Bill Giduz. Estab. 1981. Quarterly magazine publishing news, features and how-to information on juggling and jugglers. Circ. 3,500. Accepts previously published artwork. Originals not returned. Sample coies free for 9 × 12 SASE and 5 first-class stamps. Art guidelines available for SASE with first-class postage.
Cartoons: Approached by 15 cartoonists/year. Buys 2 cartoons/issue. Prefers cartoons about juggling. Prefers humorous cartoons; single panel with gagline. Send query letter with roughs and finished cartoons. Samples are not filed and are not returned. Reports back within 1 week. Buys one-time rights. Pays $15 for b&w.

KALEIDOSCOPE: International Magazine of Literature, Fine Arts, and Disability, 326 Locust St., Akron OH 44302. (216)762-9755. Editor-in-Chief: Darshan Perusek. Estab. 1979. Black and white with 4-color cover. Semiannual. "Elegant, straightforward design. Unlike medical, rehabilitation, advocacy or independent living journals, explores the experiences of disability through lens of the creative arts. Specifically seeking work by artists with disabilities. Work by artists without disabilities must have a disability focus." Circ. 1,500. Accepts previously published artwork. Sample copy $4. Guidelines with SASE.
Illustrations: Freelance art occasionally used with fiction pieces. More interested in publishing art that stands on its own as the focal point of an article. Approached by 15-20 artists/year. Do not send originals. Prefers high contrast, b&w glossy photos, but will also review color photos or 35mm slides. Include sufficient postage for return of work. Samples are not filed. Publication will contact artist for portfolio review if interested. Acceptance or rejection may take up to a year. Pays $25-100 plus two copies. Rights return to artist upon publication.
Tips: Finds artists through artists' submissions/self-promotions and word of mouth. "Inquire about future themes of upcoming issues. Considers all mediums, from pastels to acrylics to sculpture. Must be high quality art."

■**KALLIOPE, a journal of women's art**, 3939 Roosevelt Blvd., Jacksonville FL 32205. (904)387-8211. Editor: Mary Sue Koeppel. Estab. 1978. Literary b&w triannual which publishes an average of 18 pages of art by women in each issue. "Publishes poetry, fiction, reviews, and visual art by women and about women's concerns; high-quality art reproductions; visually interesting design." Circ. 1,200. Accepts previously published "fine" artwork. Original artwork is returned at the job's completion. Sample copy for $7. Art guidelines available.

Cartoons: Approached by 1 cartoonist/year. Uses 1 cartoon/issue. Topics should relate to women's issues. Send query letter with roughs. Samples are not filed and are returned by SASE. Reports back within 2 months. Rights acquired vary according to project. Pays 1 year subscription or 3 complimentary copies for b&w cartoon.

Illustrations: Approached by 35 fine artists/year. Buys 18 photos of fine art/issue. Looking for "excellence in fine visual art by women (nothing pornographic)." Send query letter with résumé, SASE, photographs (b&w glossies) and artist's statement (50-75 words). Samples are not filed and are returned by SASE. Reports back within 2 months. Rights acquired vary according to project. Pays 1 year subscription or 3 complimentary copies for b&w cover or inside.

Tips: Seeking "excellence in theme and execution and submission of materials. Previous artists have included Louise Fishman, Nancy Azara, Rhonda Roland Shearer and Lorraine Bodger. We accept 3-6 works from a featured artist."

KASHRUS Magazine — The Periodical for the Kosher Consumer, Box 204, Brooklyn NY 11204. (718)336-8544. Fax: (718)336-8550. Editor: Rabbi Wikler. Estab. 1980. Bimonthly b&w magazine with 2-color cover which updates consumer and trade on issues involving the kosher food industry, especially mislabeling, new products and food technology. Circ. 10,000. Accepts previously published artwork. Original artwork is returned after publication. Sample copy $2.

Cartoons: Buys 2 cartoon/issue. Pays $25-35 for b&w. Seeks "kosher food and Jewish humor."

Illustrations: Buys illustrations mainly for covers. Works on assignment only. Prefers pen & ink. Send query letter with photocopies. Reports back about queries/submissions within 7 days. Request portfolio review in original query. Portfolio should include tearsheets and photostats. Pays $75-100 for b&w cover; $50 for b&w inside.

Tips: Finds artists through artists' submissions and self-promotions. "Send general food or Jewish food- and travel-related material. Do not send off-color material."

■**KENTUCKY LIVING**, Box 32170, Louisville KY 40232. Fax: (502)459-3209. Editor: Gary Luhr. 4-color monthly emphasizing Kentucky-related and general feature material for Kentuckians living outside metropolitan areas. Circ. 385,000. Accepts previously published material. Original artwork returned after publication if requested. Sample copy available. All artwork is solicited by the magazine to illustrate upcoming articles. Freelancers should be familiar with Aldus PageMaker.

Cartoons: Approached by 10-12 cartoonists/year. Pays $30 for b&w.

Illustrations: Buys occasional illustrations/issue. Works on assignment only. Prefers b&w line art. Send query letter with résumé and samples. Samples not filed are returned only if requested. Reports within 2 weeks. Buys one-time rights. **Pays on acceptance**; $50 for b&w inside.

✷**KEY PACIFIC PUBLISHERS**, (formerly *Where Victoria*), Dept. AM, 3rd Floor, 1001 Wharf St., Victoria, British Columbia V8W 1T6 Canada. (604)388-4324. Fax: (604)388-6166. Art Director: Patricia Weber. Estab. 1977. Annual tourist magazines, travel trade manuals and conference planners featuring general information on shopping and attractions for the tourist market. Accepts previously published artwork. Original artwork returned to artist at the job's completion. Sample copies and art guidelines available.

Illustrations: Approached by 10 illustrators/year. Buys 20 illustrations/year. Prefers life-style and scenic themes and realistic styles; usually used in shopping or dining listings section. Considers watercolor and acrylic. Send query letter with tearsheets, photographs, slides and transparencies. Samples are filed. Publication will contact artist for portfolio review if interested. Portfolio should include tearsheets, photographs and slides. Buys first, one-time or reprint rights. Sometimes requests work on spec before assigning job. Payment negotiable on publication.

Tips: Finds artists usually through art exhibitions and word of mouth.

The solid, black square before a listing indicates that it is judged a good first market by the Artist's & Graphic Designer's Market *editors. Either it offers low payment, pays in credits and copies, or has a very large need for freelance work.*

KEYBOARD MAGAZINE, Suite #100, 411 Borel Ave., San Mateo CA 94402. (415)358-9500. Fax: (415)358-9527. Art Director: Richard Leeds. Estab. 1975. Monthly 4-color magazine focusing on keyboard and electronic instruments, technique, artist interviews, etc. Circ. 100,000. Original artwork is returned at job's completion. Sample copies and art guidelines not available.
Illustrations: Approached by 15-20 illustrators/year. Buys 2 illustrations/issue. Works on assignment only. Prefers conceptual, "outside, not safe" themes and styles. Considers pen & ink, watercolor, collage, airbrush, acrylic, mixed media and pastel. Send query letter with brochure, tearsheets, photographs, photocopies, photostats, slides and transparencies. Samples are filed. Reports back only if interested. Publication will contact artist for portfolio review if interested. Portfolio should include printed samples and tearsheets. Buys first rights. Pays on publication; $100-250 for b&w, $100-500 for color inside.

‡KID CITY MAGAZINE, 1 Lincoln Plaza, New York NY 10023. Art Director: Michele Weisman. For ages 6-10.
Illustrations: Approached by 1,000 illustrators/year. Buys 100 illustrations/year from freelancers. Query with photocopied samples. Buys one-time rights. **Pays on acceptance**; $300 minimum for b&w full page, $400 for color full page, $600 for color spread.
Tips: A common mistake freelancers make in presenting their work is "sending samples of work too babyish for our acceptance."

KIPLINGER'S PERSONAL FINANCE MAGAZINE, 1729 H St. NW, Washington DC 20006. (202)887-6416. Contact: Susan Borkenhagen. Estab. 1937. A monthly 4-color magazine covering personal finance issues including investing, saving, housing, cars, health, retirement, taxes and insurance. Circ. 1,300,000. Originals are returned at job's completion. Sample copies available.
Cartoons: Pays $500 for color cartoons.
Illustrations: Approached by 1,000 illustrators/year. Buys 15 illustrations/issue. Works on assignment only. Looking for original conceptual art. Interested in editorial illustration in new styles, including computer illustration. Send query letter with tearsheets and photocopies. Samples are filed or are returned by SASE if requested by artist. Publication will contact artist for portfolio review if interested. Portfolio should include tearsheets. Buys first rights. **Pays on acceptance.**
Tips: "Send us high-caliber original work that shows creative solutions to common themes."

■KITE LINES, Box 466, Randallstown MD 21133-0466. Fax: (410)922-4262. Publisher/Editor: Valerie Govig. Quarterly 4-color magazine emphasizing kites for the adult enthusiast only. Circ. 13,000. Original artwork returned after publication. Sample copy $5.50. Art guidelines available.
Cartoons: Buys 1 cartoon/year. Prefers single panel; b&w or color drawings—kites only. Send finished cartoons. Samples are filed or are returned by SASE. Reports back within 1 month only if interested. Buys first rights. Pays $15-30 for b&w; $20-35 for color.
Illustrations: Buys 2-3 illustrations/year. Works on assignment primarily. Needs editorial illustration and technical drawings of kites. Send query letter with brochure showing art style or photocopies. Samples are filed or returned by SASE. Reports back within 1 month only if interested. Portfolio review not required. Buys first rights. Pays $15-30 for b&w; $20-35 for color inside. "We often pay in the form of subscriptions, kite books, etc."
Tips: Finds artists through word of mouth. "Illustrations in *Kite Lines* are so closely related to an article that, if they are not provided by the author, they are assigned to meet a very specific need. Strong familiarity with kites is absolutely necessary. Good technical drawings of kite plans (for kitemaking) are needed as part of articles with instructions for building kites. (In other words, a 'package,' with article, is needed.) We often do computer re-drawing from rough originals but are open to assistance with these re-drawings."

LACMA PHYSICIAN, Box 3465, Los Angeles CA 90051-1465. Managing Editor: Janice M. Nagano. Estab. 1871. Trade magazine; b&w with 4-color cover and some 4-color editorial inside. "We present news and features of socioeconomic and political interest to physicians, as well as information of, for and about the Los Angeles County Medical Association (LACMA) and its members." Published 20 times/year. Circ. 10,000. Originals are returned at job's completion. Sample copies available.
Illustrations: Approached by 30-50 illustrators/year. Buys 1-2 illustrations/issue. Works on assignment only. Prefers pen & ink, airbrush, marker or other, "depending on assignment." Send query letter with nonreturnable samples. Samples are filed. Reports back to the artist only if interested. Buys first rights. **Pays on acceptance**; $700 for color cover; $200 for b&w, $350 for color inside.
Tips: Finds artists through artists' submissions and sourcebooks.

LADYBUG, the Magazine for Young Children, Box 300, Peru IL 61354. Associate Art Director: Suzanne Beck. Estab. 1990. Monthly 4-color magazine emphasizing children's literature and activities for children, ages 2-7. Design is "geared toward maximum legibility of text and basically art-driven." Circ. 120,000. Accepts previously published material. Original artwork returned after publication. Sample copy $4; art guidelines for SASE.

Illustrations: Approached by 600-700 illustrators/year. Works with 40 illustrators/year. Buys 200 illustrations/year. Examples of artists used: Marc Brown, Cyndy Szekeres, Rosemary Wells, Tomie de Paola, Diane de Groat. Uses artists mainly for cover and interior illustration. Prefers realistic styles (animal, wildlife or human figure); occasionally accepts caricature. Works on assignment only. Send query letter with brochure, samples and tearsheets to be kept on file, "if I like it." Prefers photostats and tearsheets as samples. Samples are returned by SASE if requested. Publication will contact artist for portfolio review if interested. Portfolio should show a strong personal style and include "several pieces that show an ability to tell a continuing story or narrative." Does not want to see "overly slick, cute commercial art (i.e., licensed characters and overly sentimental greeting cards)." Buys reprint rights. Pays on publication; $750 for color cover; $250 for color full page.
Tips: "Has a need for artists who can accurately and attractively illustrate the movements for finger-rhymes and songs and basic informative features on nature and 'the world around you.' Multi-ethnic portrayal is also a *very* important factor in the art for *Ladybug*."

LAW PRACTICE MANAGEMENT, Box 11418, Columbia SC 29211-1418. (803)754-3563. Managing Editor/Art Director: Delmar L. Roberts. 4-color trade journal for the practicing lawyer. Estab. 1975. Published 8 times/year. Circ. 22,234. Previously published work rarely used. Needs computer-literate freelancers for illustration. 15% of freelance work demands computer skills.
Cartoons: Primarily interested in cartoons "depicting situations inherent in the operation and management of a law office, e.g., operating computers and other office equipment, interviewing, office meetings, lawyer/office staff situations, and client/lawyer situations. We use 2-4 cartoons/issue. Cartoons depicting courtroom situations are not applicable to an office management magazine." Send cartoons for consideration. Reports in 3 months. Usually buys all rights. **Pays on acceptance;** $50 for all rights.
Illustrations: Uses inside illustrations and, rarely, cover designs. Pen & ink, watercolor, acrylic, oil, collage and mixed media used. Currently uses all 4-color artwork. Send query letter with résumé. Reports in 3 months. Usually buys all rights. Pays on publication; $250-300 for color cover; $75-125 for b&w, $150-250 for 4-color inside.
Tips: "There's an increasing need for artwork to illustrate high-tech articles on technology in the law office. (We have 2 or more such articles each issue.) We're especially interested in computer graphics for such articles."

‡LISTEN MAGAZINE, 55 W. Oak Ridge Dr., Hagerstown MD 21740. (301)791-7000. Editor: Lincoln Steed. Monthly magazine for teens with specific aim to educate against alcohol and other drugs and to encourage positive life choices. Circ. 50,000. Accepts previously published artwork. Originals returned at job's completion. Sample copies available. Art guidelines for SASE with first-class postage. Needs computer-literate freelancers for design and illustration. 10% of freelance work demands computer knowledge of CorelDRAW, QuarkXPress and Aldus PageMaker.
Cartoons: Buys 1 cartoon/issue. Prefers single panel b&w washes and line drawings. Send query letter with brochure and roughs. Samples are filed. Reports back to the artist only if interested. Buys reprint rights. Pays $30 for b&w, $150 for color.
Illustrations: Approached by 50 illustrators/year. Buys 6 illustrations/issue. Works on assignment only. Considers all media. Send query letter with brochure, SASE and photostats. Samples are filed or are returned by SASE. Publication will contact artist for portfolio review if interested. Buys reprint rights. **Pays on acceptance;** $200 for b&w, $400 for color cover; $100 for b&w, $200 for color inside.

LOG HOME LIVING, Suite 101, 4451 Brookfield Corporate Dr., Chantilly VA 22021. (800)826-3893 or (703)222-9411. Fax: (703)222-3209. Art Director: Randy Pope. Estab. 1989. Bimonthly 4-color magazine "dealing with the aspects of buying, building and living in a log home. We emphasize upscale living (decorating, furniture, etc.)." Circ. 125,000. Accepts previously published artwork. Samples copies not available. Art guidelines available. Needs computer-literate freelancers for design and production. 20% of freelance work demands knowledge of QuarkXPress, Adobe Illustrator and Photoshop.
Cartoons: Prefers playful ideas about logs and living and wanting a log home.
Illustrations: Buys 2 illustrations/issue. Works on assignment only. Prefers editoral illustration with "a strong style—ability to show creative flair with not so creative a subject." Considers watercolor, airbrush, colored pencil and pastel. Send query letter with brochure, if possible, tearsheets and photocopies. Samples are filed. Publication will contact artist for portfolio review if interested. Portfolio should include thumbnails, roughs, printed samples, or color tearsheets. Buys all rights. **Pays on acceptance;** $50 for b&w, $200 for color inside.
Tips: Finds artists through artists' submissions/self-promotions, sourcebooks.

For a list of markets interested in humorous illustration, cartooning and caricatures, refer to the Humor Index at the back of this book.

‡**LONG ISLAND UPDATE**, 151 Alkier St., Brentwood NY 11717. (516)435-8890. Fax: (516)435-8925. Editor: Cheryl A. Meglio. Estab. 1990. Monthly consumer magazine which covers events, entertainment and other consumer issues for general audience, ages 21-40, of Long Island area. Circ. 58,000. Originals returned at job's completion. Sample copies available. Art guidelines not available.
Illustrations: Approached by 25-30 illustrators/year. Buys 1 illustration/issue. Considers watercolor. Send query letter with résumé and tearsheets. Samples filed. Reports back within 7 weeks. Portfolio review not required. Buys first rights. Pays on publication; $25 for color inside.
Tips: Area most open to freelancers is illustrations for humor page.

LONGEVITY, 1965 Broadway, New York NY 10023. (212)496-6100. Art Director: Carveth Kramer. Estab. 1988. Monthly 4-color lifestyle publication with a practical guide to the art and science of staying young. Reaches women readers ages 25 to 50 years old. "This is not a magazine for the elderly." Accepts previously published artwork. Originals are returned at job's completion. Sample copies and art guidelines not available.
Illustrations: Approached by 100 freelance illustrators/year. Buys 5-10 illustrations/issue. "Artists should come up with good solutions to problems." Needs editorial, technical and medical illustration. Send query letter with tearsheets, photographs, photocopies and slides. Samples are filed and are not returned. Publication will contact artist for portfolio review if interested. Portfolio should include tearsheets, slides, photostats and photographs. Buys first rights. Pays on publication; $1,500 for color cover.

THE LOOKOUT, 8121 Hamilton Ave., Cincinnati OH 45231. (513)931-4050. Art Coordinator: Richard Briggs. Weekly 4-color magazine for conservative Christian adults and young adults. "We work with basic 2- or 3-column grids, but flexible." Circ. 120,000. Original artwork not returned after publication, unless requested. Sample copy and art guidelines available for 50¢. Needs computer-literate freelancers for illustration. Freelancers should be familiar with Adobe Illustrator, QuarkXPress or Aldus FreeHand.
Cartoons: Prefers cartoons on family life and religious/church life; mostly single panel. Pays $35 for b&w; $70 for color.
Illustrations: Buys 1-3 illustrations/issue. Interested in "adults, families, interpersonal relationships; also, graphic treatment of titles." Works on assignment only. Send query letter with brochure, flier or tearsheets to be kept on file. Reporting time varies. Request portfolio review in original query. Buys all rights but will reassign. **Pays on acceptance**; $200 for b&w cover; $150 for b&w, $200 for color inside.
Tips: Finds artists through word of mouth, other magazines and self-promotions. "We use a variety of styles, but mainly realistic and impressionistic. The design of magazine is conservative, in that we are not avant-garde in design—but we're not always locked in a standard grid."

■**LUNA VENTURES**, Box 398, Suisun CA 94585. Editor: Paul Doerr. Publishes several monthly newsletters including *Enhanced Reality*, emphasizing created lifestyles like Renaissance Faires, Society for Creative Anachronism, muzzle-loaders, paint-ball, beach bums, fencing and blades, western and fastdraw, D&D and gamers. *Investigator*, covering serial killers and rapists, missing children and persons, mutilation, cult, conspiracy, crime and treason. *Live & Love*, covering polygamy, line families and similar topics. *Simple Living*, emphasizing homesteading, survival, living in small boats and RVs, treasure and prospecting and individual tactics. *Unknown*, covering all the oddities, like UFO, ESP, Bigfoot, cults, monsters' appearances and disappearances, psychic, unsolved mysteries, etc. Accepts previously material. Original artwork not necessary. Sample copy $3 for microfiche, $2 for paper. Art guidelines available for SAE with first-class postage. Pays in copy of issue and percentage of sales.
Tips: "New or nonprofessional artists welcomed."

‡**THE LUTHERAN**, 8765 W. Higgins Rd., Chicago IL 60631. (312)380-2540. Art Director: Jack Lund. Estab. 1988. Monthly general interest magazine of the Evangelical Lutheran Church in America; ¼ 4-color and ¾ 2-color, "contemporary" design. Circ. 850,000. Previously published work OK. Original artwork returned after publication on request. Free sample copy for 9 × 12 SASE and 5 first-class stamps. Cartoon guidelines available. Needs computer-literate freelancers for illustration. Freelancers should be familiar with Adobe Illustrator, QuarkXPress or Adobe Photoshop.
Cartoons: Approached by 100 cartoonists/year. Buys 2 cartoons/issue from freelancers. Interested in humorous or thought-provoking cartoons on religion or about issues of concern to Christians; single panel b&w washes and line drawings with gaglines. Prefers finished cartoons. Send query letter with photocopies or finished cartoons and SASE. Reports usually within 2 weeks. Buys one time rights. Pays on publication; $25-100 for b&w line drawings and washes.
Illustrations: Buys 6 illustrations/year from freelancers. Works on assignment. Send samples of style to keep on file for future assignments. Buys all rights on a work-for-hire basis. Samples returned by SASE if requested. Portfolio review not required. Pays on publication; $400 for color cover; $150-350 for b&w, $400 for color inside.
Tips: Finds artists mainly through artists' submissions. "Include your phone number with submission. Send samples that can be retained for future reference."

THE LUTHERAN JOURNAL, 7317 Cahill Rd., Edina MN 55439. Contact: J.W. Leykom. 2- and 4-color family magazine for Lutheran Church members, middle aged and older. Accepts previously published artwork. Free sample copy.
Illustrations: Seasonal 1-, 2- or full-color covers. Needs editorial illustration. Portfolio review not required. Pays on publication; $15 for b&w inside. Buys one-time rights.

MADE TO MEASURE, 600 Central Ave., Highland Park IL 60035. (312)831-6678. Publisher: William Halper. Semiannual trade journal emphasizing manufacturing, selling of uniforms, career clothes, men's tailoring and clothing. Magazine distributed to retailers, manufacturers and uniform group purchasers. Circ. 24,000. Art guidelines available.
Cartoons: Buys 15 cartoons/issue. Prefers themes relating to subject matter of magazine; also general interest. Prefers single panel b&w line drawings with or without gagline. Send query letter with samples of style or finished cartoons. Any cartoons not purchased are returned. Reports back. Buys first rights. **Pays on acceptance;** $30-50 for b&w.

■**MAGIC CHANGES,** P.O. Box 658, Warrenville IL 60555. (708)416-3111. Editor: John Sennett. Estab. 1978. B&w annual with 4-color cover emphasizing fantasy and poetry for "college students, housewives, teachers, artists and musicians. Themes: 'Art: The Last Gasp of a Lost Grasp,' 'The Order of the Celestial Otter,' 'State of the Arts,' 'Time,' 'Music,' and 'Skyscraper Rats.' A magical musical theme pervades." B&w with 2- or 4-color cover, 8½×11 or 5½×8½ format. Circ. 500. Accepts previously published material. Originals are returned after publication. Sample copy $5; make check payable to John Sennett. Art guidelines for SASE. Uses freelance artists for cover and inside art.
Cartoons: Approached by 20 cartoonists/year. Buys 2 cartoons/issue. Cartoons appearing should look like "a cross between Fabulous Furry Freak Bros. and Doonesbury." Likes art in the style of Mary Bohdanowicz. Considers space, art, animals and street activity themes. Prefers single, double or multipanel b&w line drawings with or without gagline. Send query letter with finished cartoons. Material returned by SASE. Reports within 6-8 weeks. Acquires first rights. Pays $10 for b&w.
Illustrations: Approached by 50 illustrators/year. Buys 10 illustrations/year. Considers city, wilderness, bird, space and fantasy themes. Prefers pen & ink, then charcoal/pencil and computer illustration. Send query letter with samples. Samples are returned by SASE. Reports within 2 months. To show portfolio, mail final art or final reproduction/product. Acquires first rights. Pays $15 for b&w, $20 for color cover; $5 for b&w or color inside.
Tips: Finds artists through artists' submissions. "Target your drawings to our themes. Mix otters, music and stars."

■**MAINSTREAM, Magazine of the Able-Disabled,** 2973 Beech St., San Diego CA 92102. (619)234-3138. Managing Editor: William G. Stothers. Estab. 1975. B&w magazine with 4-color cover "serving active, upscale men and women with disabilities, with emphasis on disability rights." Published 10 times/year. Circ. 18,200. Originals are returned at job's completion. Sample copy available for $4.50. Art guidelines not available.
Cartoons: Approached by 5-6 cartoonists/year. Prefers themes and styles that say "disability *can* be funny to disabled people." Prefers b&w line drawings, single panel. Send query letter with brochure and finished cartoons. Samples are filed or are returned by SASE if requested by artist. Reports back within 2 months. Negotiates rights purchased. Pays $35 for b&w.
Illustrations: Approached by 5-6 illustrators/year. Buys few illustrations/year. Works on assignment only. Considers pen & ink. Send query letter with brochure, tearsheets, SASE and photocopies. Samples are filed or are returned by SASE if requested by artist. Reports back within 2 months. To show portfolio, mail photocopies. Requests work on spec before assigning a job. Negotiates rights purchased. Pays on publication; $35 for b&w.

MALIBU COMICS, 26707 W. Agoura Rd., Calabasas CA 91302. (818)878-4900. Contact: Submissions Editor. Estab. 1986. Comic book publisher. 25 titles/month. 100% require freelance illustration. Originals are returned at job's completion. Book catalog available for $1.
Illustrations: Approached by 500 and works with 200 artists/year. "We publish more than 7,000 pages of comic book art (super hero, action, adventure) annually." Send query letter with SASE, tearsheets, photocopies, photostats, slides and transparencies. Samples are filed or are returned by SASE. Request portfolio review in original query. Reports back within 6-8 weeks. Negotiates rights purchased.
Tips: "We get dozens of submissions a week through the mail. We also meet many artists at comic book conventions throughout the country. Some artists come to us through agents. We also look for established comic book artists with track records in the industry. As with any creative field, there are more qualified people than there is work available. We are not interested in seeing completed stories of your original characters. We want to see samples of comic book story pages utilizing our characters, or other super-heroes. Do not send us art that slavishly imitates the style of popular comic book artists. Look carefully at what we publish."

■**MANAGEMENT ACCOUNTING**, 10 Paragon Dr., Montvale NJ 07645. (201)573-6269. Editor: Robert F. Randall. Estab. 1919. Monthly 4-color with a 3-column design emphasizing management accounting for management accountants, controllers, chief accountants and treasurers. Circ. 85,000. Accepts simultaneous submissions. Originals are returned after publication. Sample copy free for SASE.
Cartoons: Approached by 15 cartoonists/year. Buys 12 cartoons/year. Prefers single panel b&w line drawings with gagline. Topics include office, financial, business-type humor. Send finished cartoons. Material not kept on file is returned by SASE. Reports within 2 weeks. Buys one-time rights. **Pays on acceptance;** $25 for b&w.
Illustrations: Approached by 6 illustrators/year. Buys 1 illustration/issue.
Tips: No sexist cartoons.

‡**MARTIAL ARTS TRAINING**, 24715 Avenue Rockefeller, Valencia CA 91380-9018. (805)257-4066. Fax: (805)257-3028. Editor: Doug Jeffrey. Estab. 1980. Bimonthly magazine on martial arts training. Circ. 25,000-35,000. Originals are returned at job's completion. Sample copies available. Art guidelines available.
Cartoons: Approached by 1 cartoonist/year. Prefers martial arts training; single panel with gagline. Send query letter with roughs and finished cartoons. Samples are not filed and are returned by SASE. Reports within 1 month. Buys all rights.

MEDICAL ECONOMICS MAGAZINE, Five Paragon Dr., Montvale NJ 07645. (201)358-7200. Director of Design Administration: Donna DeAngelis. Estab. 1909. "Bimonthly 4-color trade journal, contemporary, with more of a consumer than a trade publication look; for those interested in the financial and legal aspects of running a medical practice." Circ. 182,000. Accepts previously published material. Originals are returned at job's completion. Uses freelance artists for "all editorial illustration in the magazine." Needs computer-literate freelancers for illustration and production. 25% illustration and 100% production freelance work demands knowledge of QuarkXPress, Adobe Illustrator and Photoshop.
Cartoons: Approached by more than 50 cartoonists/year. Buys 10-12 cartoons/issue. Prefers editorial illustration with medically related themes. Prefers single panel b&w line drawings and washes with gagline. Send query letter with finished cartoons. Send cartoons to the attention of Helen McKenna. Material not filed is returned by SASE. Reports within 2 months. Buys all rights. Pays $100 for b&w.
Illustrations: Approached by more than 100 illustrators/year. Works with more than 30 illustrators/year. Buys 100 illustrations/year. Prefers all media including 3-D illustration. Needs editorial and medical illustration that varies, "but is mostly on the conservative side." Works on assignment only. Send query letter with résumé and samples. Samples not filed are returned by SASE. Reports only if interested. Publication will contact artist for portfolio review if interested. Buys one-time rights. **Pays on acceptance;** $900-1,300 for color cover; $200-600 for b&w, $250-800 for color inside.

‡**THE MEETING MANAGER**, Suite 5018, 1950 Stemmons Freeway, Dallas TX 75207. (214)746-5222. Fax: (214)746-5248. Art Director: Denise Blessing. Estab. 1972. Association publication sent to members of the meeting planning industry, 4-color; conservative, colorful design. Monthly. Circ. 14,000. Accepts previously published artwork. Originals are returned at job's completion if requested beforehand. Sample copies for $3.
Cartoons: Prefers business cartoons (example: *The New Yorker* style). Pays $50 for b&w, $100 for color.
Illustrations: Approached by 5 freelance illustrators/year. Buys 3 freelance illustrations/year. Works on assignment only. Needs editorial and technical illustration. Prefers professional, business art; airbrush and acrylic. Send query letter with brochure, tearsheets and nonreturnable samples. Samples are filed. Reports back only if interested. Publication will contact artist for portfolio review if interested. Portfolio should include original/final art, tearsheets and photographs. Requests work on spec before assigning a job. Rights purchased vary according to project. **Pays on acceptance** or on publication; $200 for b&w, $400 for color cover; $100 for b&w, $200 for color inside.
Tips: "Send best samples of nonreturnable work. When an artist is matched with a specific assignment, they will be contacted."

MEMCO NEWS, Box 1079, Appleton WI 54912. Editor: Richard F. Metko. Quarterly trade magazine emphasizing "welding applications performed with Miller Electric equipment. Readership ranges from workers in small shops to metallurgical engineers." Circ. 44,000. Previously published material and simultaneous submissions OK. Originals are not returned.

METRO NEWSPAPER, 550 S. 1st St., San Jose CA 95113. (408)298-8000. Fax: (408)298-0602. Contact: Editor. Estab. 1985. A general interest urban alternative weekly newspaper covering local politics, entertainment and lifestyle. Circ. 80,000. Accepts previously published artwork. Original artwork is returned at job's completion. Sample copies for $3. Art guidelines not available.
Cartoons: Approached by dozens of cartoonists/year. Buys less than 10 cartoons/year. Prefers sophisticated humor. Send query letter with finished cartoons. Samples are filed or returned by SASE. Reports back within 2 months. Buys one-time rights. Pays $25 for b&w.
Illustrations: Approached by dozens of illustrators/year. Buys 25 illustrations/year. Works on assignment only. Send query letter with SASE. Samples are filed or returned by SASE. Reports back within 2 months.

To show portfolio, mail appropriate materials, then call. Buys one-time rights. Pays on publication; rates vary.

Tips: Finds artists through word of mouth. "Exhibit versatility, work fast, be flexible. Review publication to see what we've run in the past."

METROSPORTS MAGAZINE, 695 Washington St., New York NY 10014. (212)627-7040. Fax: (212)242-3293. Publisher: Miles Jaffe. Estab. 1986. Monthly tabloid, b&w with 4-color cover. Features multiple recreational sports coverage: New York metro and Boston markets in separate editions. Circ. 130,000. Accepts previously published artwork. Originals are returned at job's completion. Art guidelines for SASE with first-class postage. Needs computer-literate freelancers for design. 50% of freelance work demands knowledge of Aldus PageMaker, Aldus FreeHand or Adobe Illustrator.

Cartoons: Approached by 4-5 cartoonists/year. Preferred theme is recreational (not team) sports. Send query letter with brochure and roughs. Samples are filed. Reports back only if interested. Negotiates rights purchased. Pays $50 for b&w.

Illustrations: Approached by 4 illustrators/year. Prefers line drawings, pen & ink and marker. Send query letter with photographs or photocopies. Samples are filed. To show portfolio, mail photocopies. Buys one-time rights. Pays on publication; $10 for b&w inside.

Tips: "We look for charm, wit, originality."

‡MID-AMERICAN REVIEW, English Dept., Bowling Green State University, Bowling Green OH 43403. (419)372-2725. Editor-in-Chief: George Looney. Estab. 1980. Twice yearly literary magazine publishing "the best contemporary poetry, fiction, essays, and work in translation we can find. Each issue includes poems in their original language and in English." Circ. 700. Originals are returned at job's completion. Sample copies available for $5. Art guidelines not available.

Illustrations: Approached by 1-2 illustrators/year. Buys 1 illustration/issue. Considers pen & ink, watercolor, collage, charcoal and mixed media. Send query letter with brochure, SASE, tearsheets, photographs and photocopies. Samples are filed or are returned by SASE if requested by artist. Reports back within 3 months. Portfolio review not required. Buys first rights. Pays on publication. Pays $50 for b&w or color.

Tips: "*MAR* only publishes artwork on its cover. We like to use the same artist for one volume (two issues)."

‡MIDNIGHT ZOO, P.O. Box 8040, Walnut Creek CA 94596-8040. (510)682-9662. Fax: (510)682-9706. Managing Editor: Elizabeth Martin-Burk. Estab. 1990. Quarterly literary magazine featuring science fiction, fantasy and horror. Circ. 300. Accepts previously published artwork. Originals are returned at job's completion. Sample copies available for $7 postpaid. Art guidelines for SASE with first-class postage. Needs computer-literate freelancers for design, illustration, production and presentation. 10% of freelance work demands computer skills.

Cartoons: Prefers science fiction, fantasy or horror; political and humorous cartoons, single, double or multiple panel b&w line drawings. Send query letter with finished cartoons samples only. Samples are filed or are returned by SASE. Reports back within 2 months. Acquires one-time rights. Pays copies only.

Illustrations: Prefers science fiction, fantasy and horror. Considers b&w only, pen & ink, collage, marker, charcoal and mixed media. Send query letter with SASE, tearsheets and samples. Samples are filed or are returned by SASE. Reports back within 2 months. Portfolio review not required. Acquires one-time rights. Pays on publication. Pays $40 for b&w cover; pays copies only for b&w inside.

MILITARY LIFESTYLE MAGAZINE, Suite 710, 4800 Montgomery Lane, Bethesda MD 20814. Fax: (301)718-7652. Design Director: Judi Connelly. Estab. 1969. Emphasizes active-duty military life-styles for military families; 4-color; "open, lively, colorful but fairly traditional in design." Published 10 times/year. Circ. 530,000. Original artwork returned after publication. Sample copy for $1.50. Needs computer-literate freelancers for illustration. 25% of freelance work demands knowledge of Photoshop, QuarkXPress or Aldus FreeHand.

Illustrations: Approached by 30-35 illustrators/year. Buys 2-6 illustrations/issue. Uses artists mainly for features. Theme/style depends on editorial content. Works on assignment only. Send brochure and business card to be kept on file. Accepts photostats, recent tearsheets, photocopies, slides, photographs, etc., as nonreturnable samples. Samples returned only if requested. Reports only if interested. Buys first rights. Pays on publication; $200-600 depending on size published for cover and inside.

■MILITARY MARKET MAGAZINE, Springfield VA 22159-0210. (703)750-8676. Editor: Larry Moffi. Monthly 4-color trade magazine emphasizing "the military's PX and commissary businesses for persons who manage and buy for the military's commissary and post exchange systems; also aimed at manufacturers, brokers and distributors"; contemporary design. Circ. 12,000. Simultaneous submissions OK. Original artwork not returned after publication.

Cartoons: Approached by 25 cartoonists/year. Buys 2 cartoons/issue. Interested in themes relating to "retailing/buying of groceries or general merchandise from the point of view of the store managers and workers." Prefers single panel b&w line drawings with or without gagline. Send finished cartoons. Samples returned by SASE. Reports in 6 months. Buys all rights. **Pays on acceptance;** $25 for b&w.

Tips: Finds artists through word of mouth. "We use freelance cartoonists only—*no* other freelance artwork." Do not "send us military-oriented cartoons. We want retail situations *only. No* bimbo cartoons."

MILLER FREEMAN, INC., 600 Harrison St., San Francisco CA 94107. (415)905-2200. Fax: (415)905-2236. Graphics Operations Manager: Amy R. Brokering. Publishes 50 monthly 4-color business and special-interest consumer magazines serving the paper, travel, retail, real estate, sports, design, forest products, computer, music, electronics and medical markets. Circ. 20,000 to 150,000. Returns original artwork after publication. Needs computer-literate freelancers for design and illustration. 50% of freelance work demands knowledge of QuarkXPress, Adobe Illustrator or Photoshop.
Illustrations: Approached by 200 illustrators/year. Uses freelancers mainly for illustration of feature articles. Needs editorial, technical and medical illustration. Buys numerous illustrations/year. Works on assignment only. Send query letter with printed samples to be kept on file. Do not send photocopies or original work. Samples not filed are returned by SASE. Reports back only if interested. No phone queries, please. Negotiates rights purchased. **Pays on acceptance.**

■**MODERN DRUMMER,** 870 Pompton Ave., Cedar Grove NJ 07009. (201)239-4140. Editor-in-Chief: Ronald Spagnardi. Art Director: Scott Bienstock. Monthly magazine for drummers, "all ages and levels of playing ability with varied interests within the field of drumming." Circ. 95,000. Previously published work OK. Original artwork returned after publication. Sample copy for $3.95.
Cartoons: Buys 3-5 cartoons/year. Interested in drumming themes; single and double panel. Prefers finished cartoons or roughs. Include SASE. Reports in 3 weeks. Buys first North American serial rights. Pays on publication; $5-25. "We want strictly drummer-oriented gags."

‡**MODERN MATURITY,** Dept. AM, 3200 E. Carson, Lakewood CA 90712. (213)496-2277. Art Director: James H. Richardson. Estab. 1956. Bimonthly 4-color magazine emphasizing health, lifestyles, travel, sports, finance and contemporary activities for members 50 years and over. Circ. 21 million. Previously published work OK. Originals are returned after publication. Sample copy available for SASE.
Illustrations: Approached by 200 illustrators/year. Buys 8 freelance illustrations/issue. Works on assignment only. Considers watercolor, collage, oil, mixed media and pastel. Samples are filed "if I can use the work." Reports back to the artist only if interested. Publication will contact artist for portfolio review if interested. Portfolio should include original/final art, tearsheets, slides and photocopies. Buys first rights. **Pays on acceptance**; $1,000 for b&w; $2,000 for color cover; $2,000 for color inside, full page.
Tips: "We generally use people with a proven publications editorial track record. I request tearsheets of published work when viewing portfolios."

‡**MUSHING,** P.O. Box 149, Ester AK 99725-0149. Phone/Fax: (907)479-0454. Publisher: Todd Hoener. Estab. 1988. Bimonthly "yearround, international magazine for all dog-driving sports, from sledding to skijoring to weight pulling to carting to packing. We seek to educate and entertain." Circ. 10,000. Originals are returned at job's completion. Sample copies available for $4. Art guidelines available for SASE with first-class postage.
Cartoons: Approached by 10 cartoonists/year. Buys 1 cartoon/issue. Prefers humorous cartoons; single panel b&w line drawings with gagline. Send query letter with roughs. Samples are not filed and are returned by SASE if requested by artist. Reports back with 1-6 months. Buys first rights and reprint rights. Pays $25 for b&w and color.
Illustrations: Approached by 10 illustrators/year. Buys 0-1 illustrations/issue. Prefers simple; healthy, happy sled dogs; some silhouttes. Considers pen & ink and charcoal. Send query letter with SASE and photocopies. Samples are returned by SASE if requested by artist. Reports back within 1-6 months. Portfolio review not required. Buys first rights. Pays on publication; $130 for color cover; $25 for b&w, $25 for color inside.
Tips: Finds artists through artists' submissions. "Be familiar with sled dogs and sled dogs sports. We're most open to using freelance illustrations with articles on dog behavior, adventure stories, health and nutrition."

‡**MY FRIEND,** 50 St. Paul's Ave., Boston MA 02130-3491. (617)522-8911. Art Director: Sr. Mary Joseph, FSP. Estab. 1979. Monthly Catholic magazine for kids containing information, entertainment, and Christian formation for young people ages 6-12. Circ. 14,000. Originals returned at job's completion. Sample copies free for 9×12 SASE with $1 postage. Art guidelines for SASE with first-class postage.
Illustrations: Approached by 60 illustrators/year. Buys 6 illustrations/issue. Works on assignment only. Prefers humorous, realistic portrayals of children. Considers pen & ink, watercolor, airbrush, acrylic, marker, colored pencil, oil, charcoal, mixed media and pastel. Send query letter with brochure, résumé, SASE, tearsheets, photographs, photocopies and photostats. Samples are filed or are returned by SASE if requested by artist. Reports back to the artist only if interested. Portfolio review not required. Rights purchased vary according to project. **Pays on acceptance**; $200 for color cover; $100, full page b&w and color inside.

This sorrowful illustration by Irwin Rosenhouse accompanied an article in NA'AMAT Woman entitled "For My Father," about the daughter of a Holocaust survivor who attends a reunion of the survivors of her father's hometown in Poland. Editor Judith Sokoloff feels that Rosenhouse captured in the faces the mood of the article.

‡**NA'AMAT WOMAN**, 200 Madison Ave., New York NY 10016. (212)725-8010. Fax: (212)447-5187. Editor: Judith Sokoloff. Estab. 1926. Jewish women's magazine published five times yearly, covering a wide variety of topics that are of interest to the Jewish community, affiliated with NA'AMAT USA (a nonprofit organization). Originals are returned at job's completion. Sample copies available for $1.
Cartoons: Approached by 5 cartoonists/year. Buys 4-5 cartoons/year. Prefers political cartoons; single panel b&w line drawings. Send query letter with brochure and finished cartoons. Samples are filed or are returned by SASE if requested by artist. Reports back to the artist only if interested. Rights purchased vary according to project. Pays $75 for b&w.
Illustrations: Approached by 10 illustrators/year. Buys 1-3 illustrations/issue. Works on assignment only. Considers pen & ink, collage, marker and charcoal. Send query letter with tearsheets. Samples are filed or are returned by SASE if requested by artist. Reports back to the artist only if interested. Publication will contact artist for portfolio review if interested. Portfolio should incldue b&w tearsheets and final art. Rights purchased vary according to project. Pays on publication. Pays $150 for b&w cover; $75-100 for b&w inside.
Tips: Finds artists through sourcebooks, publications, word of mouth, artists' submissions. "Give us a try! We're small, but nice."

NAILS, 2512 Artesia Blvd., Redondo Beach CA 90278. (310)376-8788. Fax: (310)798-2472. Art Director: Robina Mann. Estab. 1983. Monthly 4-color trade journal; "seeks to educate readers on new techniques and products, nail anatomy and health, customer relations, chemical safety, salon sanitation and business." Circ. 55,000. Originals are not returned at job's completion. Sample copies available. Art guidelines vary. Needs computer-literate freelancers for design, illustration and production. 30% of freelance work demands knowledge of QuarkXPress, Adobe Illustrator or Photoshop.
Cartoons: Prefers cartoons on "cities or caricatures, comic strip style if any." Payment depends on size and style of job.

Illustrations: Approached by 30 illustrators/year. Buys 2 illustrations/issue. Works on assignment only. Needs editorial and technical illustration; charts and sport art. Prefers "bright, upbeat styles." Interested in all media. Send query letter with brochure and tearsheets. Samples are filed. Reports back within 1 month or artist should follow-up with call. Call for an appointment to show a portfolio of tearsheets and transparencies. Buys all rights. **Pays on acceptance;** $200 (depending on size of job) for b&w and color inside.
Tips: Finds artists through self-promotion and word of mouth. "Professional presentation of artwork is important."

THE NATION, 72 Fifth Ave., New York NY 10011. (212)242-8400. Associate Editor: Micah Sifry. Estab. 1865. "We are a weekly journal of left/liberal political opinion, covering national and international affairs, literature and culture." Circ. 100,000. Originals are returned after publication upon request. Sample copies available. Art guidelines not available.
Illustrations: Approached by 50 illustrators/year. Buys illustrations mainly for spots and feature spreads. Buys 3-4 illustrations/issue. Works with 25 illustrators/year. Works on assignment only. Considers pen & ink, airbrush, mixed media and charcoal pencil, b&w only. Send query letter with tearsheets and photocopies. "On top of a defined style, artist must have a strong and original political sensibility." Samples are filed or are returned by SASE. Reports back only if interested. Call for appointment to show portfolio, or mail appropriate materials. Buys first rights. Pays $150 for b&w cover; $75 for b&w inside.

‡NATIONAL BUSINESS EMPLOYMENT WEEKLY, P.O. Box 300, Princeton NJ 08543-0300. (609)520-7311. Fax: (609)520-4309. Art Director: Larry Nanton. Estab. 1981. Weekly newspaper covering job search and career guidance for middle-senior level executives. Circ. 33,000. Originals returned at job's completion.
Cartoons: Buys 1 cartoon/issue. Prefers humorous material on all phases of job hunting; single panel b&w washes and line drawings with or without gagline. Send query letter with finished cartoons. Samples are not filed and are returned by SASE. Reports back to the artist only if interested. Buys first rights. Pays $50 for b&w.
Illustrations: Approached by 12 illustrators/year. Buys 2 illustrations/issue. Works on assignment only. Prefers b&w images and designs of people in all stages of the job search. Considers pen & ink, watercolor, airbrush and pencil. Send query letter with tearsheets. Samples are filed. Reports back to the artist only if interested. Portfolio review not required. Buys one-time rights and reprint rights. Pays on publication; $100 for b&w inside.
Tips: "If you're happy with your drawing ability and style and it shows in your work (not just your samples), I'll be happy with it, too!"

NATIONAL DRAGSTER, Suite 101, 2220 E. Alosta Ave., Glendora CA 91740. Fax: (818)335-6651. Art Director: Jill Flores. Estab. 1959. Drag Racing b&w tabloid with 4-color cover and newspaper style design distributed to 80,000 association (NHRA) members. "The nation's leading drag racing weekly." Circ. 80,000. Accepts previously published artwork. Originals are not returned after publication. Sample copies available. Art guidelines not available.
Cartoons: Buys 5-10 cartoons/year. Prefers drag racing theme. Prefers single panel b&w line drawings and washes with gagline. Send query letter with samples of style. Samples are filed. Reports back only if interested. Negotiates rights purchased. Pays on publication; minimum $50 for b&w.
Illustrations: Buys illustrations mainly for spots. Buys 10-20 illustrations/year. Style is creative image, line or wash, sometimes humorous, style of Don Weller. Computer art OK. Needs editorial and technical illustration. Prefers drag racing oriented pen & ink. Considers airbrush, mixed media and markers. Send query letter with brochure showing art style, tearsheets, photostats and photocopies. Looks for realistic automotive renderings. Samples are filed. Reports back only if interested. Publication will contact artist for portfolio review if interested. Portfolio should include printed copies, tearsheets, photostats and photographs. Negotiates rights purchased. Pays on publication; $100 for b&w inside.
Tips: Send "concept drawings, drag racing illustrations (actual cars, cut-aways, etc.)."

NATIONAL GARDENING, 180 Flynn Ave., Burlington VT 05401. (802)863-1308. Fax: (802)863-5962. Art Director: Linda Provost. Estab. 1980. Bimonthly magazine "specializing in edible and ornamental gardening; environmentally conscious; fun and informal but accurate; a gardener-to-gardener network." 4-color design is "crisp but not slick, fresh but not avant-garde—colorful, informative, friendly, practical." Circ. 200,000. Sometimes accepts previously published artwork. Original artwork returned after publication. Sample copies available. Art guidelines not available. Needs computer-literate freelancers for illustration 5% of freelance work demands knowledge of Adobe Illustrator, QuarkXPress or Aldus FreeHand.
Illustrations: Approached by 200 illustrators/year. Buys 10 illustrations/issue. Works on assignment only. Needs editorial and technical illustration. Preferred themes or styles "range from botanically accurate how-to illustrations to less literal, more interpretive styles. See the magazine. We use all media." Style of Kim Wilson Eversz, Andrea Eberbach, Amy Bartlett Wright. Send query letter with brochure, SASE, tearsheets, photostats and slides. Samples are filed or returned by SASE if requested. Reports back only if interested "i.e. ready to assign work." Publication will contact artist for portfolio review if interested. Portfolio should

include "your best work in your best form." Buys one-time rights. **Pays within 30 days of acceptance; $50-350 for b&w, $100-700 for color inside.**
Tips: Finds artists through artists' submissions/self-promotion and *American Showcase*.

NATIONAL REVIEW, 150 E. 35th St., New York NY 10016. (212)679-7330. Contact: Art Director. Emphasizes world events from a conservative viewpoint; bimonthly b&w with 4-color cover, design is "straight forward – the creativity comes out in the illustrations used." Originals are returned after publication. Uses freelance artists mainly for illustrations of articles and book reviews, also covers.
Cartoons: Buys 15 cartoons/issue. Interested in "light political, social commentary on the conservative side." Send appropriate samples and SASE. Reports in 2 weeks. Buys first North American serial rights. Pays on publication; $50 for b&w.
Illustrations: Buys 15 illustrations/issue. Especially needs b&w ink illustration, portraits of political figures and conceptual editorial art (b&w line plus halftone work). "I look for a strong graphic style; well-developed ideas and well-executed drawings." Style of Tim Bower, Jennifer Lawson, Janet Hamlin, Alan Nahigian. Works on assignment only. Send query letter with brochure showing art style or tearsheets and photocopies. No samples returned. Reports back on future assignment possibilities. Call for an appointment to show portfolio of final art, final reproduction/product and b&w tearsheets. Include SASE. Buys first North American serial rights. Pays on publication; $100 for b&w inside; $500 for color cover.
Tips: "Tearsheets and mailers are helpful in remembering an artist's work. Artists ought to make sure their work is professional in quality, idea and execution. Recent printed samples alongside originals help. Changes in art and design in our field include fine art influence and use of more halftone illustration." A common mistake freelancers make in presenting their work is "not having a distinct style, i.e. they have a cross sample of too many different approaches to rendering their work. This leaves me questioning what kind of artwork I am going to get when I assign a piece."

NATIONAL TRIAL LAWYER MAGAZINE, 212 E. Vine St., Millville NJ 08332. (609)825-9099. Fax: (609)825-5959. Editor: Brad X. Terry. 2-color bimonthly trade journal with 4-color cover. Independent open forum of communication for the plaintiffs bar. Circ. 15,000. Originals are returned at job's completion. Sample copies and art guidelines free for SASE with first-class postage.
Cartoons: Buys 1 cartoon/issue. Prefers legal themes; single panel b&w drawings with gagline. Send query letter with finished cartoons. Samples are filed. Reports back within 2 weeks. Rights purchased vary according to project. Pays $30 for b&w.
Illustrations: Prefers offbeat, satirical style; legal themes. Prefers pen & ink. Send query letter with résumé. Samples are filed. Reports back within 2 weeks. Portfolio review not required, but portfolio should include final art, b&w photocopies. Rights purchased vary according to project. Pays on publication; $350 for b&w, $500 for color.

‡NEGATIVE CAPABILITY, 62 Ridgelawn Dr. E., Mobile AL 36608-6116. (205)343-6163. Publisher: Sue Walker. Estab. 1981. Literary journal with focus on the arts; published three times a year. Circ. 1,000. Originals are returned at job's completion. Sample copies available for $5. Art guidelines available.
Cartoons: Prefers b&w line drawings. Send query letter with finished cartoons. Samples are filed or are returned by SASE if requested by artist. Reports back within 1 month. Buys first rights.
Illustrations: Considers pen & ink. Send query letter with photographs and photocopies. Samples are filed and are returned by SASE if requested by artist. Reports back within 1 month. Portfolio review not required. Artist should follow up with call and/or letter after initial query. Portfolio should include b&w tearsheets, slides, photocopies and photographs.

NETWORK WORLD, 161 Worcester Rd., The Meadows, Framingham MA 01701. (508)875-6400. Fax: (508)820-3467. Art Director: Susan Slater. Weekly 4-color tabloid with "conservative but clean computer graphics intensive (meaning lots of charts)." Accepts previously published artwork. Interested in buying second rights (reprint rights) to previously published artwork. Emphasizes news and features relating to the communications field. Originals are returned after publication. Needs computer-literate freelancers for design and illustration. 10% of freelance work demands knowledge of Aldus FreeHand.
Illustrations: Themes depend on storyline. Works on assignment only. Send query letter with brochure and photocopies to be kept on file. Publication will contact artist for portfolio review if interested. Reports only if interested. Buys first rights. **Pays on acceptance;** $175 and up for b&w, $300 and up for color inside; $1,000 for color cover.
Tips: "All of our in-house charts and graphics are done on the Mac. But most freelance illustration is not done on the Mac. My need for freelance artists to do illustration has actually increased a bit. Use 1-3 illustrations per week on average."

NEVADA, Suite 200, 1800 Hwy. 50 E., Carson City NV 89710. (702)687-6158. Fax: (702)687-6159. Estab. 1936. Bimonthly magazine "founded to promote tourism in Nevada." Features Nevada artists, history, recreation, photography, gaming. Traditional, 3-column layout with large (coffee table type) 4-color photos. Circ. 130

million. Accepts previously published artwork. Originals are returned to artist at job's completion. Sample copies for $1.50. Art guidelines available.
Cartoons: Prefers 4-color cartoons for humor pieces. Pays $40 for b&w, $60 for color.
Illustrations: Approached by 25 illustrators/year. Buys 2 illustrations/issue. Works on assignment only. Send query letter with brochure, résumé and slides. Samples are filed. Reports back within 2 months. To show portfolio, mail 20 slides and bio. Buys one-time rights. Pays $125 for color cover; $20 for b&w, $50 for color inside.

NEW AGE JOURNAL, 42 Pleasant St., Watertown MA 02172. (617)787-2005. Art Director: Linda Koury. Emphasizes alternative life-styles, holistic health, ecology, personal growth, human potential, planetary survival. Bimonthly. Circ. 190,000. Accepts previously published material and simultaneous submissions. Originals are returned after publication by request. Sample copy $3.
Illustrations: Buys 60-90 illustrations/year. Works on assignment only. Send tearsheets, slides or promo pieces. Samples returned by SASE if not kept on file. Portfolio may be dropped off. Pays $1,000 for color cover; $400 for color inside.
Tips: Finds artists through sourcebooks and reps. "I prefer to see tearsheets or printed samples."

■**THE NEW CRUCIBLE,** DeYoung Press, Rt. 1, Box 76, Stark KS 66775. (316)754-3203. Publisher: Mary DeYoung. Estab. 1964. Magazine covering free thought, philosophy, environmental concerns and atheist topics.
 ● Also publishes hardcover originals and reprints. Uses 2 freelancers/year for jacket/cover illustration.
 Book catalog available for $2. This is a good market if you want to build your portfolio.
Cartoons: Approached by 10 cartoonists/year. Prefers political and environmental themes. Send query letter with SASE and samples. Samples are filed and are returned by SASE if requested by artist. Reports back to the artist only if interested. Rights acquired vary according to project. Pays in copies.

‡■**NEW LETTERS,** 5100 Rockhill Rd., University of Missouri, Kansas City MO 64110. Quarterly "innovative" literary magazine with an international scope; b&w with 2-color cover. Sample copy $4.
Illustrations: Uses camera-ready spot drawings, line drawings and washes; "any medium that will translate well to the 6×9 b&w printed page." Also needs cover designs. Submit art. Must include SASE for return of work. Reports in 2-8 weeks. Buys all rights. Pays $5 maximum for pen & ink, line drawings and washes.
Tips: "Fewer pieces of freelance art being accepted; we consider only work of the highest quality. Artwork does not necessarily have to relate to content."

‡■**the new renaissance,** 9 Heath Rd., Arlington MA 02174. Editor: Louise T. Reynolds. Art Editor: Olivera Sajkovic. Estab. 1968. Biannual (spring and fall) magazine emphasizing literature, arts and opinion for "the general, literate public"; b&w with 2-color cover, 6×9. Circ. 1,600. Originals are returned after publication if SASE is enclosed. Sample copy available. Current issue $8.50 US, $9 foreign. (US dollars only.)
Cartoons: Approached by 20-32 freelance artists/year. Pays $15-30 for b&w. Very few used in any given year.
Illustrations: Buys 6-8 illustrations/issue from freelancers and "occasional supplementary artwork (2-4 pages)." Works mainly on assignment. Send résumé, samples, photos and SASE. No slides. Samples not filed are returned by SASE. Reports within 2-4 months. Publication will contact artist for portfolio review if interested, "but only if artist has enclosed SASE." Portfolio should include roughs, b&w photographs and SASE. Buys one-time rights. Pays after publication; $25-30 for b&w.
Tips: "Only interested in b&w. We want artists who have an understanding of what is involved in illustrating a 'quality' (or 'serious' or 'literary') piece of fiction (or, occasionally, a poem) and for this we suggest they study the illustrations we have used in the past. We are receiving work that is appropriate for a newsletter, newsprint or alternative-press magazines; *tnr* takes a classicist position in the arts—we want our work to hold up and we need work that shows an understanding of our audience. We don't consider anything that is submitted without a SASE. No postcards, please. Artists should buy a back issue ($5.00 or $6.75) so they can see the kind of fiction we publish and the type of illustrations that we need."

THE NEW REPUBLIC, 1220 19th St. NW, Washington DC 20036. (202)331-7494. Assistant Editor: Amy Knox Sheffer. Estab. 1914. Weekly political/literary magazine; political journalism, current events in the front section, book reviews and literary essays in the back; b&w with 4-color cover. Circ. 95,000. Original artwork returned after publication. Sample copy for $3.50. Needs computer-literate freelancers for illustration. 15% of freelance work demands computer skills.
Illustrations: Approached by 400 illustrators/year. Buys up to 5 illustrations/issue. Uses freelancers mainly for cover art. Works on assignment only. Prefers caricatures, portraits, 4-color, "no cartoons." Style of Vint Lawrence. Considers airbrush, collage and mixed media. Send query letter with tearsheets. Samples returned by SASE if requested. Publication will contact artist for portfolio review if interested. Portfolio should include color photocopies. Rights purchased vary according to project. Pays on publication; up to $600 for color cover; $250 for b&w and color inside.

Vint Lawrence, who has been drawing for The New Republic for more than 20 years, was given three days to produce this pen & ink drawing to accompany an article on the Kennedy family and reviews of several books. Lawrence sold the original illustration of the Kennedy brothers. The work is also sold in prints.

■**NEW WRITER'S MAGAZINE**, Box 5976, Sarasota FL 34277. (813)953-7903. Editor/Publisher: George J. Haborak. Estab. 1986. Bimonthly b&w magazine. Forum "where all writers can exchange thoughts, ideas and their own writing. It is focused on the needs of the aspiring or new writer." Rarely accepts previously published artwork. Original artwork returned after publication if requested. Sample copies for $3. Art guidelines not available.

Cartoons: Approached by 2-3 cartoonists/year. Buys 1-3 cartoons/issue. Prefers cartoons "that reflect the joys or frustrations of being a writer/author"; single panel b&w line drawings with gagline. Send query letter with samples of style. Samples are sometimes filed or returned if requested. Reports back within 1 month. Buys first rights. Pays on publication; $10 for b&w.

Illustrations: Buys 1 illustration/issue. Works on assignment only. Prefers line drawings. Considers watercolor, mixed media, colored pencil and pastel. Send query letter with brochure showing art style. Samples are filed or returned if requested by SASE. Reports within 1 month. To show portfolio, mail tearsheets. Buys first rights or negotiates rights purchased. Pays on publication. Payment negotiated.

■**NEXT PHASE**, 33 Court St., New Haven CT 06511. (203)772-1697. Editor: Kim Means. Estab. 1989. Triannual literary magazine with "trend-setting design. *Next Phase* features quality fiction and artwork by undiscovered artists and writers. Environmental and humane topics preferred." Circ. 1,000. Accepts previously published work. Originals are returned at job's completion. Sample copies available for $3. Art guidelines free for SASE with first-class postage.

Cartoons: Prefers b&w cartoons tightly illustrated and dealing with environmental or social issues. Pays 3 contributors copies.

Illustrations: Approached by 30 illustrators/year. Buys 6 illustrations/issue. Open to computer-generated (Mac) artwork. Prefers pen & ink, watercolor, collage, airbrush and mixed media. Needs editorial illustration. Send query letter with SASE, tearsheets, photographs, photocopies and photostats. Samples are filed. Reports back within 3 weeks. Portfolio review not required. Requests work on spec before assigning a job. Pays 3 contributor copies.

Tips: Will not respond to submission unlsess SASE is included.

‡■**NORTH AMERICAN HUNTER/NORTH AMERICAN FISHERMAN**, 12301 Whitewater Dr., Minnetonka MN 55343. (612)936-9333. Fax: (612)936-9755. Art Director: Mark Simpson. Estab. 1978 (*N.A. Hunter*) and 1988 (*N.A. Fisherman*). Bimonthly consumer magazines. *North American Hunter* and *Fisherman* are the official publications of the North American Hunging Club and the North American Fishing Club. Circ. 600,000 and 400,000. Accepts previously published artwork. Originals are returned at job's completion. Sample copies available. Art guidelines for SASE with first-class postage. Needs computer-literate freelancers for illustration. 20% of freelance work demands computer knowledge of Adobe Illustrator, QuarkXPress, Adobe Photoshop or Aldus FreeHand.

Cartoons: Approached by 20 cartoonists/year. Buys 3 cartoons/issue. Prefers humorous work portraying outdoorsmen in positive image; single panel b&w washes and line drawings with or without gagline. Send query letter with brochure. Samples are filed. Does not report back. Buys one-time rights.
Illustrations: Approached by 40 illustrators/year. Buys 3 illustrations/issue. Prefers illustrations that portray wildlife and hunting and fishing in an accurate and positive manner. Considers pen & ink, watercolor, airbrush, acrylic, colored pencil, oil, charcoal, mixed media and pastel. Send query letter with brochure, tearsheets, résumé, photographs and slides. Samples are filed. Does not report back. Portfolio review not required. Rights purchased vary according to project. **Pays on acceptance.**

‡■NORTH AMERICAN WHITETAIL MAGAZINE, 2250 Newmarket Pkwy., Marietta GA 30076. (404)953-9222. Fax: (404)933-9510. Editorial Director: Ken Dunwoody. Estab. 1982. Consumer magazine; "designed for serious hunters who pursue whitetailed deer." 8 issues/year. Circ. 160,000. Accepts previously published artwork. Original artwork is returned at job's completion. Sample copies available for $3. Art guidelines not available.
Illustrations: Approached by 30 freelance illustrators/year. Buys 1-2 freelance illustrations/issue. Works on assignment only. Considers pen & ink and watercolor. Send query letter. Samples are filed or are returned by SASE if requested by artist. Reports back only if interested. To show a portfolio, mail appropriate materials. Rights purchased vary according to project. Pays 10 weeks prior to publication; $25 and up for b&w, $75 and up for color inside.

NOTRE DAME MAGAZINE, 415 Main Bldg., Notre Dame IN 46556. (219)631-4630. Art Director: Don Nelson. Estab. 1971. Quarterly 4-color university magazine for Notre Dame alumni and friends. Circ. 115,000. Accepts previously published artwork. Original artwork returned after publication. Sample copies and art guidelines not available.
Illustrations: Approached by 40 illustrators/year. Buys 5 illustrations/issue. Works on assignment only. Looking for "accomplished, experienced editorial artists only." Tearsheets, photostats, photographs, slides and photocopies OK for samples. Samples are filed "if they are good" or are returned by SASE if requested. "Don't send submissions—only tearsheets and samples." To show portfolio, mail published editorial art. Buys first rights. Pays $275-2,000.
Tips: "We have very high standards; if you are a beginning illustrator without professional training we are probably not interested in seeing your work."

‡NOW AND THEN, Box 70556 ETSU, Johnson City TN 37614-0556. (615)929-5348. Fax: (615)929-5348. Editor: Pat Arnow. Estab. 1984. Magazine covering Appalachian issues and arts, published three times a year. Circ. 1,000. Accepts previously published artwork. Originals are returned at job's completion. Sample copies available for $4.50. Guidelines available. Needs computer-literate freelancers for illustration. Freelancers should be familiar with Aldus FreeHand or Aldus PageMaker.
Cartoons: Approached by 25 cartoonists/year. Prefers Appalachia issues, political and humorous cartoons; b&w washes and line drawings. Send query letter with brochure, roughs and finished cartoons. Samples not filed and are returned by SASE if requested by artist. Reports back within 4 months. Buys one-time rights. Pays $15 for b&w.
Illustrations: Approached by 3 illustrators/year. Buys 1-2 illustrations/issue. Prefers Appalachia, any style. Considers b&w or 2-color pen & ink, collage, airbrush, marker and charcoal. Send query letter with brochure, SASE and photocopies. Samples are not filed and are returned by SASE if requested by artist. Reports back within 4 month. Publication will contact artist for portfolio review if interested. Portfolio should include b&w tearsheets, slides, final art and photographs. Buys one-time rights. Pays on publication; $25-50 for b&w cover.
Tips: Area most open to freelancers is magazine cover. "We have special theme issues, illustrations have to have something to do with theme. Write for guidelines, enclose SASE."

NUGGET, Dugent Publishing Co., Suite 600, 2600 Douglas Rd., Coral Gables FL 33134. Editor: Christopher James. Illustration Assignments: Nye Willden. 4-color "electic, modern" magazine for men and women with fetishes. Published 8 times/year.
Cartoons: Buys 5 cartoons/issue. Receives 50 submissions/week. Interested in "funny fetish themes." B&w only for spots and for page. Prefers to see finished cartoons. Include SASE. Reports in 2 weeks. Buys first North American serial rights. Pays $75 for spot drawings; $125 for full page.
Illustrations: Buys 2 illustrations/issue. Interested in "erotica, cartoon style, etc." Works on assignment only. Prefers to see samples of style. Send brochure, flier or other samples to be kept on file for future assignments. No samples returned. Publication will contact artist for portfolio review if interested. Buys first North American serial rights. Pays $200 for b&w.
Tips: Finds artists through artists' submissions/self-promotion. Especially interested in "the artist's anatomy skills, professionalism in rendering (whether he's published or not) and drawings which relate to our needs." Current trends include "a return to the 'classical' realistic form of illustration, which is fine with us because we prefer realistic and well-rendered illustrations."

NURSEWEEK, 1156-C Aster Ave., Sunnyvale CA 94086. (408)249-5877. Fax: (408)249-8204. Art Director: Young Kim. *"Nurseweek* is a biweekly 4-color tabloid mailed free to registered nurses in Los Angeles and Orange counties, the greater San Francisco Bay Area and Sacramento (total circ. approximately 80,000), and bimonthly to every RN in California (more than 210,000). *Nurseweek* provides readers with nursing-related news and features that encourage and enable them to excel in their work and that enhance the profession's image by highlighting the many diverse contributions nurses make. In order to provide a complete and useful package, the publication's article mix includes late-breaking news stories, news features with analysis (including in-depth bimonthly special reports), interviews with industry leaders and achievers, continuing education articles, career option pieces (Spotlight, Entrepreneur, Dear Elly), lifestyle features (After Hours) and reader dialogue (Letters, Commentary, First Person)." Sample copy $3. Art guidelines not available. Needs computer-literate freelancers for production. 90% of freelance work demands knowledge of Quark, PhotoShop, Adobe Illustrator, Ventura/CorelDraw.
Cartoons: Approached by 20 cartoonists/year. Buys 1 cartoon/issue. Cartoons must portray positive image of nurses. Prefers single panel, b&w washes, color washes or b&w line drawings with gaglines. Send query letter with finished cartoon samples. Samples are not filed and are returned by SASE. Reports back within 1 month. Buys first rights. Pays $25 for b&w, $50 for color.
Illustrations: Approached by 10 illustrators/year. Buys 1 illustration/year. Prefers pen & ink, watercolor, airbrush, marker, colored pencil, mixed media and pastel. Needs medical illustration. Send query letter with brochure, tearsheets, photographs, photocopies, photostats, slides and transparencies. Samples are not filed and are returned by SASE if requested by artist. Publication will contact artist for portfolio review if interested. Portfolio should include final art samples, photographs. Buys all rights. Pays on publication; $150 for b&w, $250 for color cover; $100 for b&w, $175 for color inside.
Tips: Finds artists through sourcebooks.

THE OFFICIAL PRO RODEO SOUVENIR PROGRAM, Suite 205, 4565 Hilton Pkwy., Colorado Springs CO 80907. (719)531-0177. Fax: (719)531-0183. Director Publication Marketing: Mary Ellen Davis. Estab. 1973. An annual 4-color souvenir program for PRCA rodeo events. "This magazine is purchased by rodeo organizers, imprinted with rodeo name and sold to spectators at rodeo events." Circ. 400,000. Originals are returned at job's completion. Sample copies available. Art guidelines not available.
Illustrations: Buys 1 freelance illustration/year for the cover. Works on assignment only. "We assign a rodeo event—50%-art, 50%-photos." Considers all media. Send query letter with brochure, résumé, SASE, tearsheets, photographs and photocopies. Samples are filed. Publication will contact artist for portfolio review if interested. Buys one-time rights. Pays on publication; $250 for color cover.
Tips: Finds artists through artists' submissions/self-promotion, sourcebooks, artists' agents and reps and attending art exhibitions. "Know about rodeos and show accurate (not necessarily photo-realistic) portrayal of event. Artwork is used on the cover about 50 percent of the time. Freelancers get more work now because our office staff is smaller."

‡OHIO MAGAZINE, 62 E. Broad St., Columbus OH 43215. (614)461-5083. Art Director: Brooke Wenstrup. Monthly publication emphasizing feature material of Ohio "for an educated, urban and urbane readership"; 4-color; design is "clean, with white-space." Circ. 90,000. Previously published work OK. Original artwork returned after publication. Sample copy $2.50. Needs computer-literate freelancers for design, illustration and production. 20% of freelance work demands knowledge of Adobe Illustrator, QuarkXPress, Adobe Photoshop or Aldus FreeHand.
Cartoons: Approached by 2 cartoonists/year. Buys 2 cartoons/year. Prefers b&w line drawings. Send brochure. Samples are filed or are returned by SASE. Reports back within 1 month. Buys one-time rights. Pays $50 for b&w and color.
Illustrations: Approached by 70 illustrators/year. Buys 2 illustrations/issue. Works on assignment only. Considers pen & ink, watercolor, collage, acrylic, marker, colored pencil, oil, mixed media and pastel. Send brochure, SASE, tearsheets and slides. Samples are filed or are returned by SASE. Reports back within 1 month. Request portfolio review in original query. Portfolio should include b&w and color tearsheets, slides, photostats, photocopies and final art. Buys one-time rights. **Pays on acceptance**; $350 for b&w, $350 for color cover; $75-350 for b&w, $100 for color inside.
Tips: Finds artists through artists' submissions and gallery shows. "Using more of a fine-art style to illustrate various essays—like folk-art style illustrators. Please take time to look at the magazine if possible before submitting."

‡OKLAHOMA TODAY MAGAZINE, 401 Will Rogers Bldg., Oklahoma City OK 33105. (405)521-2496. Fax: (405)521-3992. Editor: Jeanne Devlin. Estab. 1956. Bimonthly regional, upscale consumer magazine focusing on all things that define Oklahoma and interest Oklahomans. Circ. 41,000. Accepts previously published artwork. Originals are returned at job's completion. Sample copies and art guidelines available. Needs computer-literate freelancers for design, illustration, production and presentation. 20% of freelance work demands knowledge of Aldus PageMaker, Adobe Illustrator and Adobe Photoshop.
Cartoons: Buys 1 cartoon/issue. Prefers humorous cartoons focusing on Oklahoma, oil, cowboys or Indians with gagline. Send query letter with roughs. Samples are filed. Reports back within days if interested; months

if not. Buys one-time rights. Pays $50 minimum for b&w, $75 minimum for color.

Illustrations: Approached by 24 illustrators/year. Buys 2-3 illustrations/issue. Considers pen & ink, watercolor, collage, airbrush, acrylic, marker, colored pencil, oil, charcoal and pastel. Send query letter with brochure, résumé, SASE, tearsheets and slides. Samples are filed. Reports back within days if interested; months if not. Portfolio review required if interested in artist's work. Portfolio should include b&w and color thumbnails, tearsheets and slides. Buys one-time rights. Pays $200-500 for b&w, $200-750 for color cover; $50-500 for b&w, $75-750 for color inside.

Tips: Finds artists through sourcebook, other publications, word of mouth, artists' submissions and artist reps. Illustrations to accompany short stories and features are most open to freelancers. "Read the magazine; have a sense of the 'New West' spirit and do an illustration or cartoon that exhibits your understanding of *Oklahoma Today*."

ON OUR BACKS, 526 Castro St., San Francisco CA 94114. (415)861-4723. Photo Editor: Heather Findlay. Estab. 1984. A b&w with 4-color cover bimonthly magazine, covering lesbian sexuality. "One of our specialties is lesbian erotic photography." Accepts previously published artwork. Originals are returned at job's completion upon request with SASE. Submission guidelines available. Needs computer-literate freelancers for design and production. 10% of freelance work demands knowledge of Aldus PageMaker, Aldus FreeHand, Photoshop or Quark.

Cartoons: Needs lesbian/sex humor. "We will accept a variety of styles." Pays $25 for b&w.

Illustrations: Send query letter with photocopies. Samples are filed or are returned by SASE. Publication will contact artist for portfolio review if interested. Rights purchased vary according to project. Pays 30 days after publication; $30 for b&w inside.

Tips: Finds artists through artists' submissions/self-promotion, sourcebooks, artists' agents and reps, attending art exhibitions, other publications, press releases and public listings. "Lesbian sex photography is a pioneer effort, and we are constantly trying to enlarge our scope and possibilties. We explore a variety of sexual styles; and nudity, per se, is not necessarily the focus. An erotic, and often emotional interpretation is. In general, we want a diversity of lesbians and intriguing themes that touch on our gay experience in a sexy and convincing manner. We will be going monthly and glossy."

‡ONLINE ACCESS MAGAZINE, #310, 900 N. Franklin St., Chicago IL 60610. (312)573-1700. Fax: (312)573-0520. Editor-in-Chief: Kathryn McCabe. Estab. 1986. Monthly consumer magazine focusing on online computer services. "Magazine that makes modems work." Circ. 70,000. Accepts previously published artwork. Sample copies and art guidelines not available. Needs computer-literate freelancers for illustration.

Illustrations: Approached by 10 illustrators/year. Buys 8 illustrations/issue. Prefers colorful computer-related artwork. Considers pen & ink, watercolor, collage, airbrush, acrylic, marker, colored pencil, oil and mixed media. Send query letter with tearsheets. Samples are filed. Publication will contact artist for portfolio review if interested. Portfolio should includ b&w and color tearsheets. Buys reprint rights. **Pays on acceptance**; $500 for color cover; $100 for color inside.

OPEN COMPUTING MAGAZINE, (formerly *Unixworld Magazine*), 1900 O'Farrell St., San Mateo CA 94403. (415)513-6800. Art Director: Joe Sikoryak. Estab. 1984. Monthly trade magazine. "*Open Computing* is a business-oriented computer magazine with practical articles aimed at the business user as well as more technical readers." Circ. 95,000. Originals are returned at job's completion.

Illustrations: Buys 4-6 illustrations/issue. Works on assignment only. Prefers "less realistic, more expressive and stylistic" color work. Send query letter with tearsheets and photocopies. Samples are filed or are returned by SASE if requested by artist. Reports back to the artist only if interested. Buys first rights. Pays on publication.

‡OPTIONS, P.O. Box 470, Port Chester NY 10573. Contact: Wayne Shuster. Estab. 1981. Bimonthly consumer magazine featuring erotic stories and letters, and informative items for gay and bisexual males and females. Circ. 60,000. Accepts previously published artwork. Originals are returned at job's completion. Sample copies available for $3.50 and 6×9 SASE with first-class postage.

Cartoons: Approached by 10 cartoonists/year. Buys 5 cartoons/issue. Prefers well drawn b&w, ironic, humorous cartoons; single panel b&w line drawings with or without gagline. Send query letter with finished cartoons.

Samples are not filed and are returned by SASE if requested by artist. Reports back within 3 weeks. Buys all rights. Pays $20 for b&w.

Illustrations: Approached by 2-3 illustrators/year. Buys 2 illustrations/issue. Prefers gay male sexual situations. Considers pen & ink, airbrush b&w only. Also buys color or b&w slides (35mm) of illustrations. Send query letter with tearsheets, photocopies, slides and transparencies. Samples are not filed and are returned by SASE if requested by artist. Reports back to the artist only if interested. Portfolio review not required. Buys all rights. Pays on publication; $50 for b&w inside.

Tips: Finds artists through artists' submissions.

OREGON QUARTERLY, (formerly *Old Oregon*), 5228 University of Oregon, Eugene OR 97403-5228. (503)346-5047. Fax: (503)346-2220. Editor: Tom Hager. Estab. 1919. Quarterly 4-color alumni magazine. "The Northwest perspective. Regional issues and events as addressed by UO faculty members and alumni." Circ. 95,000. Accepts previously published artwork. Originals are returned at job's completion. Sample copies available for SASE with first-class postage.

Illustrations: Approached by 25 illustrators/year. Buys 1 illustration/issue. Prefers story-related themes and styles. Interested in all media. Send query letter with résumé, SASE and tearsheets. Samples are filed unless accompanied by SASE. Reports back only if interested. Buys one-time rights. Portfolio review not required. **Pays on acceptance**; $250 for b&w, $500 for color cover; $100 for b&w, $250 for color inside.

Tips: Finds artists through submissions.

ORLANDO MAGAZINE, #300, 422 W. Fairbanks Ave., Winter Park FL 32789. (407)539-3939. Fax: (407)539-0533. Art Director: Mike Havekotte. Estab. 1946. "We are a 4-color monthly city/regional magazine covering the Central Florida area—local issues, sports, home and garden, business, entertainment and dining. Circ. 35,000. Accepts previously published artwork. Originals are returned at job's completion. Sample copies available. Art guidelines not available.

Illustrations: Buys 3-4 illustrations/issue. Works on assignment only. Needs editorial illustration. Send postcard, brochure or tearsheets. Samples are filed and are not returned. Reports back to the artist only if interested with a specific job. Portfolio review not required. Buys first rights, one-time rights or all rights (rarely). Pays on publication; $400 for color cover; $200-250 for color inside.

Tips: "Send appropriate samples. Most of my illustration hiring is via direct mail. The magazine field is still a great place for illustration."

THE OTHER SIDE, 300 W. Apsley St., Philadelphia PA 19144. (215)849-2178. Fax: (605)335-0368. Editor: Mark Olson. Art Director: Cathleen Benberg. "We are read by Christians with a radical commitment to social justice and a deep allegiance to biblical faith. We try to help readers put their faith into action." Publication is ¾ b&w, ¼ color with 4-color cover. Published 6 times/year. Circ. 14,000. Accepts previously published artwork. Sample copy available for $4.50.

Cartoons: Approached by 20-30 cartoonists/year. Buys 12-15 cartoons/year on current events, human interest, social commentary, environment, economics, politics and religion; single and multiple panel. Pays on publication; $25 for b&w line drawings. "Looking for cartoons with a radical political perspective."

Illustrations: Approached by 40-50 illustrators/year. Especially interested in original artwork (editorial illustrations) in color and b&w. Send query letter with tearsheets, photocopies, slides, photographs and SASE. Reports in 6 weeks. Photocopied and simultaneous submissions OK. Publication will contact artist for portfolio review if interested. Portfolio should include roughs, final reproduction/product and photographs. Sometimes requests work on spec before assigning a job. Pays within 1 month of publication; $50-100 for 4-color; $30-75 for b&w line drawings inside.

Tips: "We're looking for illustrators who share our perspective on social, economic and political issues."

‡OUR SUNDAY VISITOR, 200 Noll Plaza, Huntington IN 46750. (219)356-8400. Fax: (219)356-8472. Estab. 1912. Weekly magazine which focuses on Catholicism. Audience is mostly older, conservative; adhere to the teachings of the magisterium of the church. Circ. 120,000. Accepts previously published artwork. Originals are returned at job's completion. Sample copies available. Art guidelines not available.

Illustrations: Approached by 7-8 illustrators/year. Buys 10-12 illustrations/year. Works on assignment only. Preferred themes are religious and social issues. Considers pen & ink, watercolor, collage, airbrush, acrylic, marker, colored pencil, oil, charcoal, mixed media and pastel. Send query letter with photographs. Samples are filed. Portfolio review not required. Buys first rights. Pays on publication; $250 for b&w, $400 for color cover; $150 for b&w, $250 for color inside.

OUTDOOR AMERICA MAGAZINE, Level B, 1401 Wilson Blvd., Arlington VA 22209. Fax: (703)528-1836. Editor: Michael E. Diegel. Estab. 1922. Quarterly 4-color magazine emphasizing conservation and outdoor recreation (fishing, hunting, etc.) for sportsmen/sportswomen and conservationists. "There is an increasing emphasis on up-to-date graphics and design." Circ. 50,000. Original artwork returned after publication. Sample copy available for $1.50.

Cartoons: Approached by 100 cartoonists/year. Pays $50 for b&w; payment varies for color.

Illustrations: Approached by 150 illustrators/year. Buys 10 illustrations/year. Usually commissions original work. Send query letter with résumé, photocopied samples or tearsheets, and list of where previously published to be kept on file. Samples not filed are returned upon request. Publication will contact artist for portfolio review if interested. Buys one-time rights. Pays on publication; $50-75 for b&w and $50-160 for color inside.

Tips: Finds artists usually through word of mouth or self-promotion. "I'll look at anything, but it has to grab me with style, originality and/or humor within two seconds. Most of our illustration enhances specific articles. I like ironic humor and a bold and original style. Send samples that will convince me you have that sort of vision—no deer, raccoons or other cute pen & inks."

OUTSIDE MAGAZINE, 1165 N. Clark St., Chicago IL 60610. (312)951-0990. Fax: (312)664-5397. Design Director: John Askwith. Estab. 1977. Monthly 4-color magazine with "clean, active, classic, service-oriented design. America's leading active lifestyle magazine." Circ. 450,000. Art guidelines for SASE with first-class postage. Needs technical illustration of maps and graphs and occasional computer-literate freelancers for design, illustration and information graphics. Freelancers should be familiar with Adobe Illustrator, QuarkXPress or Photoshop.

Illustrations: Approached by 150-200 illustrators/year. Buys 150 illustrations/year. Works on assignment only. Prefers contemporary editorial styles. Needs maps. Considers watercolor, collage, airbrush, acrylic, colored pencil, oil, mixed media and pastel. Send query letter with brochure, tearsheets or slides. Most samples are filed. Those not filed will be returned by SASE. Publication will contact artist for portfolio review if interested. Portfolio should include original/final art, tearsheets and slides. Buys one-time rights. Pays on publication; $750 average for color inside.

Tips: Finds artists through sourcebooks and word of mouth. "Establish target publications. Maintain contact through update mailings until assignment is received. Always get as many tearsheets from a job as you can. I think portfolios will be on disks in the future." Seeks contemporary, figurative/scenic images in photography and illustration.

***■OVERSEAS!,** Kolpingstr 1, H 69181 Leimen, Germany. Editor: Greg Ballinger. Estab. 1973. "*Overseas!* is the leading lifestyle magazine for the US military stationed throughout Europe. Primary focus is on European travel, with regular features on music, sports, video, audio and photo products." 4-color. Sample copy for SAE and 4 IRCs; art guidelines for SAE and 1 IRC.

Cartoons: Prefers single and multiple panel cartoons. "Always looking for humorous, offbeat cartoons on travel, being a tourist in Europe and working in the US military. Looking more for *National Lampoon* or *New Yorker*-style cartoons/humor than a *Saturday Evening Post*-type cartoon. Anything new, different or crazy is given high priority." Don't query; send nonreturnable photocopies. Pays $30 for b&w cartoon.

‡OWNER-MANAGER MAGAZINE, 67 Wall St., New York NY 10305. (212)323-8056. Publisher: V. Ricasio. Estab. 1992. Bimonthly magazine "for owner-managers who want to know more than how to run a business." Circ. 30,000. Accepts previously published artwork. Originals are returned at job's completion. Sample copies for #10 SASE with first-class postage. Art guidelines not available. Needs computer-literate freelancers for design and production. 30% of freelance work demands knowledge of Aldus PageMaker, QuarkXPress or Adobe Photoshop.

Illustrations: Approached by 10 illustrators/year. Buys 1-2 illustrations/issue. Works on assignment only. Considers pen & ink and mixed media. Send query letter with SASE and photocopies. Samples are filed or are returned. Reports back within 2 months. Publication will contact artist for portfolio review if interested. Portfolio should include b&w and color samples of work. Buys first rights and one-time rights. Pays on publication; $300 for b&w, $500 for color cover; $50 for b&w, $250 for color inside.

Tips: Finds artists through word of mouth.

✹■PACIFIC YACHTING MAGAZINE, 202-1132 Hamilton St., Vancouver, British Columbia V6B 2S2 Canada. (604)687-1581. Fax: (604)687-1925. Editor: John Shinnick. Estab. 1968. Monthly 4-color magazine focused on boating the west coast of Canada. Power/sail cruising only. Circ. 25,000. Accepts previously published artwork. Original artwork returned at job's completion. Sample copies available for $3. Art guidelines not available.

Cartoons: Approached by 12-20 cartoonists/year. Buys 1-2 cartoons/issue. Prefers boating themes; single panel b&w line drawings with gagline. Send query letter with brochure and roughs. Samples are filed or are returned by SASE if requested by artist. Reports back within 1 week. Buys one-time rights. Pays $25-50 for b&w.

The asterisk before a listing indicates that the market is located outside the United States and Canada.

Illustrations: Approached by 25 illustrators/year. Buys 6-8 illustrations/year. Prefers boating themes. Considers pen & ink, watercolor, airbrush, acrylic, colored pencil, oil and charcoal. Send query letter with brochure. Samples are filed or are returned by SASE if requested by artist. Reports back within 1 week only if interested. Call for an appointment to show portfolio. Portfolio should include all appropriate samples related to boating on the West Coast. Buys one-time rights. Pays on publication; $300-500 for color cover; $50-100 for b&w and $200-300 for color inside.
Tips: "Know boating well enough to communicate to the experienced boater. Know and love my magazine."

‡**PALO ALTO WEEKLY,** 703 High St., Palo Alto CA 94301. (415)326-8210. Estab. 1979. Semiweekly newspaper. Circ. 45,000. Accepts previously published artwork. Originals returned at job's completion. Sample copies available. Rarely needs computer-literate freelancers for production. Freelancers should be familiar with Adobe Illustrator, QuarkXPress or Aldus FreeHand.
Illustrations: Buys 20-30 illustrations/year. Works on assignment only. Considers all media. Send query letter with brochure, résumé, SASE, tearsheets, photographs, photocopies, photostats, slides and transparencies. Samples are filed. Publication will contact artist for portfolio review if interested. Pays on publication; $150 for b&w, $175 for color cover; $75 for b&w, $100 for color inside.
Tips: Most often uses freelance illustration for covers and cover story, especially special section covers such as restaurant guides. "We call for artists' work in our classified ad section when we need some fresh work to look at. We like to work with local artists."

PARADE MAGAZINE, 750 Third Ave., New York NY 10017. (212)573-7187. Director of Design: Ira Yoffe. Photo Editor: Miriam White. Weekly emphasizing general interest subjects. Circ. 37 million (readership is 73 million). Original artwork returned after publication. Sample copy and art guidelines available.
 • Magazine syndicated to newspapers nationwide. Sponsors annual photography contest with Eastman Kodak.
Illustrations: Uses varied number of illustrations/issue. Works on assignment only. Send query letter with brochure, résumé, business card and tearsheets to be kept on file. Call or write for appointment to show portfolio. Reports only if interested. Buys first rights, or occasionally all rights.
Tips: "Provide a good balance of work."

■**PARAPLEGIA NEWS,** Suite 180, 2111 E. Highland Ave., Phoenix AZ 85016-4702. (602)224-0507. Fax: (602)224-0500. Art Director: Susan Robbins. Estab. 1947. Monthly 4-color magazine emphasizing wheelchair living for wheelchair users, rehabilitation specialists. Circ. 27,000. Accepts previously published artwork. Original artwork not returned after publication. Sample copy free for large-size SASE with $1.45 postage. 50% of freelance work demands knowledge of QuarkXPress, PhotoShop or Adobe Illustrator.
 • Publication has changed from contemporary to conservative design.
Cartoons: Buys 3 cartoons/issue. Prefers line art with wheelchair theme. Prefers single panel b&w line drawings with or without gagline. Send query letter with finished cartoons to be kept on file. Write for appointment to show portfolio. Material not kept on file is returned by SASE. Reports only if interested. Buys all rights. **Pays on acceptance;** $10 for b&w.
Illustrations: Works with 1 illustrator/year. Buys 1 illustration/year from freelancers. Needs editorial and medical illustration "well executed and pertinent." Prefers wheelchair living or medical and financial topics as themes. Send query letter with brochure showing art style or tearsheets, photostats, photocopies and photographs. Samples not filed are returned by SASE. Publication will contact artist for portfolio review if interested. Portfolio should include final reproduction/product, color and b&w tearsheets, photostats, photographs. Negotiates payment ("usually around $250") and rights purchased.

PEDIATRIC ANNALS, 6900 Grove Rd., Thorofare NJ 08086. (609)848-1000. Managing Editor: Mary L. Jerrell. Monthly 4-color magazine emphasizing pediatrics for practicing pediatricians. "Conservative/traditional design." Circ. 33,000. Considers previously published artwork. Original artwork returned after publication. Sample copies available.
Illustrations: Prefers "technical and conceptual medical illustration which relate to pediatrics." Considers watercolor, acrylic, oil, pastel and mixed media. Send query letter with tearsheets, slides and photographs to be kept on file. Publication will contact artist for portfolio review if interested. Buys one-time rights or reprint rights. Pays $250-600 for color cover.
Tips: Finds artists through artists' submissions/self-promotions and sourcebooks. "Illustrators must be able to treat medical subjects with a high degree of accuracy. We need people who are experienced in medical illustration, who can develop ideas from manuscripts on a variety of topics, and who can work independently (with some direction) and meet deadlines. Non-medical illustration is also used occasionally. We deal with medical topics specifically related to children. Include color work, previous medical illustrations and cover designs in a portfolio. Show a representative sampling of work."

■**PENNSYLVANIA MAGAZINE,** Box 576, Camp Hill PA 17001-0576. (717)761-6620. Editor-in-Chief: Albert Holliday. Estab. 1981. "Bimonthly magazine for college-educated readers, ages 35-60, interested in Pennsylvania history, travel and personalities." Cir. 40,000. Query with samples. Include SASE. Reports in 3 weeks.

Previously published, photocopied and simultaneous submissions OK. Buys first serial rights. **Pays on acceptance** for assigned art. Sample copy for $2.95.
Cartoons: Buys 5-10 cartoons/year. Must be on Pennsylvania topics. Pays $25-50.
Illustrations: Buys 25 illustrations/year on history and travel-related themes. Pays $100 for cover; $25-50 for b&w or color inside.

‡**PENNSYLVANIA SPORTSMAN**, Box 90, Lemoyne PA 17043. (717)761-1400. Publisher: Lou Hoffman. Managing Editor: Sherry Ritchey. Estab. 1959. Regional 4-color magazine featuring "outdoor spots, hunting, fishing, where to go, what to do, how to do it." 8 issues per year. Circ. 67,000. Original artwork is returned after publication. Sample copies available for $2. Art guidelines for SASE with first-class postage.
Cartoons: Buys 10 cartoons/year. Prefers hunting and fishing themes. Prefers single panel with gagline, b&w line drawings. Send query letter with samples of style. Samples are filed. Samples not filed are returned by SASE. Reports back regarding queries/submissions within 2 weeks. Buys one-time rights. **Pays on acceptance**; $10, b&w.
Illustrations: Buys editorial illustrations mainly for covers and feature spreads. Buys 2 or 3 illustrations/issue. Considers pen & ink and acrylics. Send query letter with brochure showing art style or tearsheets. Samples are filed. Samples not filed are returned by SASE. Publication will contact artist for portfolio review if interested. Portfolio should include slides. Requests work on spec before assigning job. Pays $150 for color cover. Buys one-time rights.
Tips: "Features needed in these areas: deer, turkey, bear, trout and bass. Buys little in way of illustrations-mainly photography."

■**PERSIMMON HILL**, 1700 NE 63rd St., Oklahoma City OK 73111. (405)478-6404. Fax: (405)478-4714. Director of Publications: M.J. Van Deventer. Estab. 1963. Quarterly 4-color journal of Western heritage "focusing on both historical and contemporary themes. It features nonfiction articles on notable persons connected with pioneering the American West; art, rodeo, cowboys, flora and animal life; or other phenomena of the West of today or yesterday. Lively articles, well written, for a popular audience. "Contemporary design follows style of *Architectural Digest* and *European Travel and Life*." Circ. 15,000. Original artwork returned after publication. Sample copy for $7. Art guidelines for SASE with first-class postage. Needs computer-literate freelancers for presentation. 50% of freelance work demands knowledge of Aldus PageMaker.
Illustrations: Approached by 75-100 illustrators/year. Buys 5 illustrations/issue. Works on assignment only. Prefers Western-related themes and pen & ink sketches. Send query letter with résumé, SASE, photographs or slides and transparencies. Samples are filed or returned by SASE if requested. Publication will contact artist for portfolio review if interested. Portfolio should include original/final art, photographs or slides. Buys first rights. Requests work on spec before assigning job. Pays $50 for b&w, $300 for color cover; $150 for color inside.
Tips: Finds artists through word of mouth and artists' submissions. "We are a museum publication. Most illustrations are used to accompany articles. Work with our writers, or suggest illustrations to the editor that can be the basis for a freelance article or a companion story. More interest in the West means we have to provide more contemporary photographs and articles about what people in the West are doing today."

PET BUSINESS, 5400 NW 84th Ave., Miami FL 33166. Editor: Elizabeth McKey. A monthly 4-color news magazine for the pet industry (retailers, distributors, manufacturers, breeders, groomers). Circ. 17,000. Accepts previously published artwork. Sample copy $3.
Cartoons: Interested in pet-related themes; single panel. Include SASE. Pays on publication; $10.
Illustrations: Occasionally needs illustration for business-oriented cover stories. Portfolio review not required. Pays on publication; $200.
Tips: "Send 2 or 3 samples and a brief bio, only."

‡**PHANTASM**, Suite 1346, 235 E. Colorado Blvd., Pasadena CA 91101. Editor and Publisher: J.F. Gonzales. Estab. 1990. Quarterly horror fiction magazine. Circ. 1,000. Sometimes accepts previously published artwork. Originals returned at job's completion. Sample copies available for $4.95. Art guidelines for SASE with first-class postage.
Cartoons: Approached by 4-8 cartoonists/year. Buys 1-2 cartoons/issue. Prefers weird and black humor; single, double or multiple panel with or without gagline. Send query letter with roughs and finished cartoons. Samples are filed or are returned by SASE. Reports back within 2 months. Buys first rights. Pays $5 for b&w.
Illustrations: Approached by 10 illustrators/year. Buys 6-8 illustrations/issue. Works on assignment only. Prefers horrific, surrealism. Considers pen & ink, oil, airbrush and pencil. Send query letter with résumé, SASE, tearsheets, photographs, photocopies and slides. Samples are filed or are returned by SASE if requested by artist. Publication will contact artist for portfolio review if interested. Portfolio should include b&w thumbnails, tearsheets, slides, final art and photographs. Buys first rights. **Pays on acceptance**; $25-50 for b&w cover; $5-15 for b&w inside.
Tips: Finds artists through word of mouth and submissions. "We are a small publication and tend to use the same artists each issue, but will use someone new if their work impresses us. Be original, be familiar with

other artists of this genre (horror)—Michael Whelan, J.K. Potter, Alan Clark, etc. Illustrations are done by assignment to illustrate the fiction we publish. We usually ask for 1 illustration per story. Illustration usually reflects some mood/theme of piece."

PHYSICIAN'S MANAGEMENT, 7500 Old Oak Blvd., Cleveland OH 44130. (216)243-8100. Fax: (216)891-2683. Editor-in-Chief: Robert A. Feigenbaum. Art Director: Louanne Senger. Monthly 4-color magazine emphasizing business, practice management and legal aspects of medical practice for primary care physicians. Circ. 120,000.
Cartoons: Receives 50-70 cartoons/week. Buys 10 cartoons/issue. Themes typically apply to medical and financial situations "although we do publish general humor cartoons." Prefers camera-ready, single and double panel b&w line drawings with gagline. Uses "only clean-cut line drawings." Send cartoons with SASE. **Pays on acceptance**; $80.
Illustrations: Approached by 5 illustrators/year. Buys 2-4 illustrations/issue. Accepts b&w and color illustrations. All work done on assignment. Send a query letter to editor or art director first or send examples of work. Publication will contact artist for portfolio review if interested. Fees negotiable. Buys first rights.
Tips: Finds artists through word of mouth, magazines, artists' submissions/self-promotions, sourcebooks, agents and reps and attending art exhibitions. "First, become familiar with our publication. Cartoons should be geared toward the physician—not the patient. No cartoons about drug companies or medicine men. No sexist cartoons. Illustrations should be appropriate for a serious business publication. We do not use cartoonish or comic book styles to illustrate our articles. We work with artists nationwide."

PICTURE PERFECT, Box 15760, Stanford CT 06901. (203)967-9952. Fax: (203)975-1119. Publisher: Andres Aquino. Estab. 1989. Monthly 4-color photography magazine covering fashion, commercial travel, beauty photography and illustration. Circ. 140,000. Original artwork returned at job's completion. Sample copy $4. Needs computer-literate freelancers for design. 5-10% of freelance work demands knowledge of Aldus PageMaker.
Cartoons: Pays $15 for b&w cartoons.
Illustrations: Buys 5 illustrations/issue. Prefers computer generated images. Considers pen & ink, airbrush and mixed media. Send query letter with tearsheets, photostats and SASE. Samples are filed or returned by SASE if requested by artist. Reports back within 3 weeks. Portfolio review not required. Rights purchased vary according to project. Pays on publication; $25 for b&w, $35 for color spot fillers.
Tips: "Review the material and editorials covered in our magazine. Your work should have excellent visual impact. We are photography oriented."

‡■**THE PINEHURST JOURNAL**, P.O. Box 360747, Milpitas CA 95036-0747. (510)440-9259. Editor: Michael K. McNamara. Estab. 1990. Quarterly literary magazine of original, distinctive fiction, nonfiction, poetry and essays. "Readers are primarily 25 to 70, college educated and discerning." Circ. 225. Accepts previously published artwork. Originals returned at job's completion. Sample copies available for $5. Art guidelines for SASE with first-class postage.
Illustrations: Approached by 5 illustrators/year. Buys 8-10 illustrations/issue. Prefers styles b&w original line art, generic subjects for illustration of stories. Considers pen & ink. Send query letter with SASE and reproducible photocopies. Samples are filed or are returned by SASE if requested by artist. Reports back within 6 weeks. Portfolio review not required. Buys one-time rights. Pays on publication; $5-10 for b&w cover; contributor copy for b&w inside.
Tips: Finds artists through artists' submissions. "What we seek is distinctive artwork on speculation for future use as story/poem illustration and cover art. Artwork must reproduce well by both printing and photocopying. We do very little fantasy, science fiction, or horror and no formula western, romance or young adult."

PLANNING, American Planning Association, 1313 E. 60th St., Chicago IL 60637. (312)955-9100. Editor and Associate Publisher: Sylvia Lewis. Art Director: Richard Sessions. Monthly b&w magazine with 4-color cover for urban and regional planners interested in land use, housing, transportation and the environment. Circ. 30,000. Previously published work OK. Original artwork returned after publication, upon request. Free sample copy and artist's guidelines available.
Cartoons: Buys 2 cartoons/year on the environment, city/regional planning, energy, garbage, transportation, housing, power plants, agriculture and land use. Prefers single panel with gaglines ("provide outside of cartoon body if possible"). Include SASE. Reports in 2 weeks. Buys all rights. Pays on publication; $50 minimum for b&w line drawings.
Illustrations: Buys 20 illustrations/year on the environment, city/regional planning, energy, garbage, transportation, housing, power plants, agriculture and land use. Send roughs and samples of style with SASE. Reports in 2 weeks. Buys all rights. Pays on publication; $250 maximum for b&w drawings cover; $100 minimum for b&w line drawings inside.
Tips: "Don't send portfolio." No "corny cartoons. Don't try to figure out what's funny to planners. All attempts seen so far are way off base."

PLAY MAGAZINE, 3620 NW 43rd St., Gainesville FL 32606. (904)375-3705. Fax: (904)375-7268. Art Director: Torne White. "A quarterly 4-color magazine for parents covering quality entertainment and educational products for children: music, video, audio, toys, computers, books, interactive technologies of all sorts, as well as feature stories on entertainers and family interest topics." Circ. 100,000. Accepts previously published artwork. Originals are returned at job's completion.

Illustrations: Approached by 50-100 illustrators/year. Buys 4-8 illustrations/issue. Works on assignment only. Considers mixed media. Send query letter with résumé, tearsheets and samples. Samples are filed and are returned by SASE if requested by artist. Publication will contact artist for portfolio review if interested. Portfolio should include thumbnails, roughs, color tearsheets and photographs. Rights purchased vary according to project. Sometimes requests work on spec before assigning job. Pays on publication; $75-150.

POCKETS, Box 189, 1908 Grand Ave., Nashville TN 37202. (615)340-7333. Editor: Janet McNish. Devotional magazine for children 6 to 12. 4-color with some 2-color. Monthly except January/February. Circ. 75,000. Accepts previously published material. Original artwork returned after publication. Sample copy for SASE with 4 first-class stamps.

Illustrations: Approached by 50-60 illustrators/year. Uses variety of styles; 4-color, 2-color, flapped art appropriate for children. Realistic fable and cartoon styles. Accepts tearsheets, photostats and slides. Also open to more unusual art forms: cut paper, embroidery, etc. Samples not filed are returned by SASE. Reports only if interested. Buys one-time or reprint rights. **Pays on acceptance:** $50-550 depending on size.

Tips: "Decisions made in consultation with out-of-house designer. Send samples to our designer: Chris Schechner, Suite 207, 3100 Carlisle Plaza, Dallas, TX 75204."

‡■POOR KATY'S ALMANAC, P.O. Box 3031, Anaheim CA 92803-3031. Art Director: Ms. Valentine Lawson. Estab. 1992. Bimonthly literary magazine for taxi cab drivers and passengers. "We promote letter-writing as a hobby (especially commendation letters). Our philosophy is to put cab drivers in the mood to share their optimism with the people they encounter so as to create a domino effect." Circ. 500. Accepts previously published artwork. Sample copies free for 6×9 SASE and 3 first-class stamps or available for $2. Art guidelines for SASE with first-class postage. Needs computer-literate freelancers for design, illustration, production and presentation. 50% of freelance work demands computer skills.

Cartoons: Approached by 2 cartoonists/year. Buys 1 cartoon/issue. Prefers humor, optimism, cab drivers, letter-writers, dispatchers, police officers (positive image), political; single, double or multiple panel, b&w and color washes and b&w line drawings with or without gagline. Send query letter with brochure, roughs, finished cartoons or photocopies. Samples are filed or are returned by SASE if requested by artist. Reports back within 3 months. Rights purchased vary according to project. Pays $1 for b&w, $2 for color.

Illustrations: Buys 1 illustration/issue. Preferred themes are Americana, cab drivers, western, mystery, "Dick and Jane," coloring book spots (for kids), dot-to-dot artwork, hidden pictures, "Don't drink and drive—take a cab." Also needs postcard and envelope art. Considers pen & ink, watercolor, collage, airbrush, acrylic, marker, colored pencil, charcoal, mixed media and pastel. Send query letter with SASE, tearsheets, photocopies, photostats. Samples are filed or are returned by SASE if requested by artist. Reports back within 3 months. Must include SASE or postcard for reply. Portfolio review not required. Publication will contact artist for portfolio review if interested. Negotiates rights purchased. Rights purchased vary according to project. **Pays on acceptance** for color; pays on publication for b&w; $1 for b&w, $2 for color cover; $1 for b&w, $2 for color inside.

Tips: Finds artists through artists' submissions, word of mouth. "Get a copy of our publication, and our guidelines. Then submit, including mini biography and minimum required payment. Most open to freelancers for story illustrations (on assignment); cartoon strips; coloring-book panels to go with our "Katy the Checker Cab" character; "From My Taxi" column by guest cab drivers (current or retired). We're compiling a catalog of gift items and need taxi-related art and graphics."

■POPULAR ELECTRONICS, 500 B Bi-County Blvd., Farmingdale NY 11735. (516)293-3000. Editor: Carl Laron. Monthly 4-color magazine emphasizing hobby electronics for consumer and hobby-oriented electronics buffs. Circ. 87,287. Original artwork not returned after publication. Sample copy free.

Cartoons: Approached by over 20 cartoonists/year. Buys 3-5 cartoons/issue. Prefers single panel b&w line drawings and b&w washes with or without gagline. Considers a diversity of styles and subjects: electronics, radio, audio, video. Send finished cartoons. "We purchase and keep! Unused ones returned." Samples are returned. Portfolio review not required. Reports within 2 weeks. Buys all rights. Pays $25 for b&w.

■POTATO EYES, Box 76, Troy ME 04987. (207)948-3427. Co-Editor: Carolyn Page. Estab. 1988. A biannual literary magazine; b&w with 2-color cover. Design features "strong art showing rural places, people and objects in a new light of respect and regard. Focuses on the Appalachian chain from the Laurentians to Alabama but not limited to same. We publish people from all over the US and Canada." Circ. 800. Original artwork returned at job's completion. Sample copies available: $5 for back issues, $6 for current issue.

Illustrations: Prefers detailed pen & ink drawings or block prints, primarily realistic. No cartoons. Send query letter with photocopies. Samples are filed and are not returned. Reports back within 2 months. Acquires

© 1992 Potato Eyes

Potato Eyes *used this pen & ink cover illustration by Chana Dickerson to symbolize "the down-to-earth, rural quality" of the magazine. According to Leroy Zarucchi of The Potato Eyes Foundation, the magazine's audience liked the cover. "We think it helped in subscription renewals."*

one-time rights. Requests work on spec before assigning job. Pays on publication; $25 and up for b&w cover. Inside illustrations are paid for in contributor's copies.

Tips: "Our *Artist's & Graphic Designer's Market* listing has sent us dozens of artists. The rest have come through word of mouth or our magazine display at book fairs. We plan to utilize more b&w photography to complement the b&w artwork. An artist working with quill pens and a bottle of India ink could do work for us. A woodcarver cutting on basswood using 19th-century tools could work for us. Published artists include Joe McLendon, Tom Staley, Lynn Holt and Sushanna Cohen. Two of our artists were nominated for 'Editor's Choice III' awards in 1991." Also publishes yearly *The Nightshade Short Story Reader*, same format, and 10 poetry chapbooks.

■**POWER AND LIGHT**, 6401 The Paseo, Kansas City MO 64131. (816)333-7000, ext. 2243. Fax: (816)333-4439. Editor: Beula Postlewait. Editorial Assistant: Melissa Hammer. Estab. 1992. "*Power and Light* is a weekly 8 page, 2- and 4-color story paper that focuses on the interests and concerns of the preteen (11-12 year old). We try to connect what they learn in Sunday School with their daily lives." Circ. 38,000. Originals are not returned. Sample copies and art guidelines free for SASE with first-class postage.

Cartoons: Buys 1 cartoon/issue. Prefers humor for the preteen; single panel b&w line drawings with gagline. Send query letter with brochure, roughs and finished cartoon samples. Samples are filed or are returned by SASE if requested. Reports back within 90 days. Buys all rights. Pays $15 for b&w.

Illustrations: Buys 1 illustration/issue. Works on assignment only. Should relate to preteens. Considers airbrush, marker and pastel. Send query letter with brochure, résumé, SASE, photographs and photocopies. Request portfolio review in original query. Samples are filed. Reports back only if interested. Artist should follow up with letter after initial query. Portfolios may be dropped off every Monday-Thursday. Portfolio should include roughs, final art samples, b&w, color photographs. Buys all rights. Sometimes requests work on spec before assigning job. Pays on publication; $40 for b&w cover and inside; $75 for color cover and inside.

Tips: Finds artists through artists' submissions. "Send a résumé, photographs or photocopies of artwork and a SASE to the office. A follow-up call is appropriate within the month. Adult humor is not appropriate."

‡❋■**PRAIRIE JOURNAL TRUST**, P.O. Box 61203 Brentwood P.O., Calgary, Alberta T2L 2K6 Canada. Estab. 1983. Biannual literary magazine. Circ. 600. Sample copies available for $6. Art guidelines for SAE with IRCs only.

Illustrations: Approached by 8 illustrators/year. Buys 5 illustrations/issue. Considers b&w only. Send query letter with photocopies. Samples are not filed and are returned by SASE if requested by artist. Reports back within 6 months. Portfolio review not required. Acquires first rights. Pays honorarium for b&w cover.
Tips: Canadian freelancers preferred.

■**PRAIRIE SCHOONER**, 201 Andrews Hall, University of Nebraska, Lincoln NE 68588-0334. (402)472-3191. Fax: (402)472-9771. Editor: Hilda Raz. Business Manager: Pam Weiner. Estab. 1927. Quarterly b&w literary magazine with 2-color cover. "*Prairie Schooner*, now in its 68th year of continuous publication, is called 'one of the top literary magazines in America,' by *Literary Magazine Review*. Each of the 4 issues contains short stories, poetry, book reviews, personal essays, interviews or some mix of these genres. Contributors are both established and beginning writers. Readers live in all states in the US and in most countries outside the US." Circ. 3,200. Original artwork is returned after publication. "We rarely have the space or funds to reproduce artwork in the magazine but hope to do more in the future." Sample copies for $3.50.
Illustrations: Approached by 1-5 illustrators/year. Uses freelancers mainly for cover art. "Before submitting, artist should be familiar with our cover and format, 6×9, black and one color or b&w, vertical images work best; artist should look at previous issues of *Prairie Schooner*. Portfolio review not required. We are rarely able to pay for artwork; have paid $50 to $100."
Tips: Finds artists through word of mouth. "We're trying for some 4-color covers."

■**PRIMAVERA**, Box #37-7547, Chicago IL 60637. (312)324-5920. Contact: Editorial Board. Estab. 1974. Annual b&w magazine with 4-color cover emphasizing art and literature for readers interested in contemporary literature and art which reflect the experiences of women. Includes a wide variety of styles of fiction, poetry, photographs, line drawings, paintings. Circ. 1,000. Original artwork returned after publication. Sample copy $5; art guidelines available for SASE.
Cartoons: Original line drawings of great visual interest and impact. Pays in contributor's copies.
Illustrations: Works with 5 illustrators/year. Would like to buy 15 illustrations/year. "We are open to a wide variety of styles and themes depicting experiences of women. Work must be in b&w with strong contrasts and should not exceed 5×7. Send finished art. Reports in 2 months. "If the artist lives in Chicago, she may call us for an appointment." Publication will contact artist for portfolio review if interested. Acquires first rights. "We pay in 2 free copies of the issue in which the artwork appears."
Tips: Finds artists through attending exhibitions. "It's a good idea to take a look at a recent issue. Artists often do not investigate the publication and send work which may be totally inappropriate. We publish a wide variety of artists. We have increased the number of graphics per issue. Send us a *variety* of prints. It is important that the graphics work well with the literature and the other graphics we've accepted. Our decisions are strongly influenced by personal taste and work we know has already been accepted. Will consider appropriate cartoons and humorous illustrations."

‡✳■**PRISM INTERNATIONAL**, Department of Creative Writing, U.B.C., Buch E462—1866 Main Mall, Vancouver, British Columbia V6T 1Z1 Canada. (604)822-2514. Executive Editor: Gregory Nyte. Estab. 1959. Quarterly literary magazine. "We use cover art for each issue." Circ. 1,200. Original artwork is returned to the artist at the job's completion. Sample copies for $5.
Illustrations: Approached by 20 illustrators/year. Buys 1 cover illustration/issue. "Most of our covers are full color; however, we try to do at least 1 b&w cover/year." Send query letter with photographs. Most samples are filed. Those not filed are returned by SASE if requested by artist. Reports back within 3 months. Portfolio review not required. Buys first rights. Pays on publication; $150.
Tips: Finds artists through word of mouth and going to local exhibits.

‡**PROCEEDINGS**, U.S. Naval Institute, 118 Maryland Ave., Annapolis MD 21402-5035. (301)268-6110. Art Director: LeAnn Bauer. Monthly b&w magazine with 4-color cover emphasizing naval and maritime subjects. "*Proceedings* is an independent forum for the sea services." Design is clean, uncluttered layout, "sophisticated." Circ. 110,000. Accepts previously published material. Sample copies and art guidelines available.
Cartoons: Buys 23 cartoons/year from freelancers. Prefers cartoons assigned to tie in with editorial topics. Send query letter with samples of style to be kept on file. Material not filed is returned if requested by artist. Reports within 1 month. Negotiates rights purchased. Pays $25-50 for b&w, $50 for color.
Illustrations: Buys 1 illustration/issue. Works on assignment only. Needs editorial and technical illustration. "Like a variety of styles if possible. Do excellent illustrations and meet the requirement for military appeal." Style of Tom Freeman, R.G. Smith and Mark McCandlish. Prefers illustrations assigned to tie in with editorial topics. Send query letter with brochure, résumé, tearsheets, photostats, photocopies and photographs. Samples are filed or are returned only if requested by artist. Artist should follow up after initial query. Publication will contact artist for portfolio review if interested. Negotiates rights purchased. Sometimes requests work on spec before assigning job. Pays $50, b&w, $50-75, color, inside; $150-200, color cover. "Contact us first to see what our needs are."
Tips: "Magazines such as *Proceedings* that rely on ads from defense contractors will have rough going in the future."

PROFESSIONAL AGENT, 400 N. Washington St., Alexandria VA 22314. (703)836-9340. Fax: (703)836-1279. Editor: Alan Prochoroff. Monthly 4-color magazine for independent insurance agents and other affiliated members of the American Agency System. Circ. 30,000. Original artwork returned after publication. Free sample copy.
Illustrations: Buys 3-5 illustrations/issue from freelancers. Prefers "sophisticated, conceptual, stylized" editorial illustrations in watercolor, acrylic and all other media. Provide published samples to be kept on file for future assignments. Publication will contact artist for portfolio review if interested. Buys first-time North American rights. Pays $900 for color cover (includes additional inside placement); $500 for color inside.
Tips: "Collaborative, conceptual approach often required. Include with your sample, clips of published pieces, a list of former clients, award-winning pieces and tearsheets. No fine art paintings (landscapes, still lifes, etc.). Samples can be returned with SASE. Prefers to see a representative sampling and to work with established artists and illustrators familiar with magazine publishing. Almost 100% of our illustrations are done by freelancers."

THE PROGRESSIVE, 409 E. Main St., Madison WI 53703. Art Director: Patrick JB Flynn. Estab. 1909. Monthly b&w plus 4-color cover. Circ. 40,000. Free sample copy and art guidelines.
Cartoons: Prefers political cartoons. Pays $50 for b&w.
Illustrations: Works with 50 illustrators/year. Buys 12 b&w illustrations/issue. Needs editorial illustration that is "smart, bold, expressive." Style of Sue Coe, Henrik Drescher, Frances Jetter, David McLimans. Works on assignment only. Send query letter with tearsheets and/or photocopies. Samples returned by SASE. Reports in 1 month. Portfolio review not required. Pays $400 for cover; $200 for b&w line or tone drawings/ paintings inside. Buys first rights.
Tips: Do not send original art. Send direct mail samples, a postcard or photocopies and appropriate return postage. "The successful art direction of a magazine allows for personal interpretation of an assignment."

PUBLIC CITIZEN, Suite 610, 2000 P St. NW, Washington DC 20036. (202)833-3000. Editor: Peter Nye. Contact: Lauren Marshall. Bimonthly magazine emphasizing consumer issues for the membership of Public Citizen, a group founded by Ralph Nader in 1971. Circ. 150,000. Accepts previously published material. Returns original artwork after publication. Sample copy available with 9 × 12 SASE with first-class postage.
Illustrations: Buys up to 10 illustrations/issue. Prefers contemporary styles in pen & ink; uses computer illustration also. "I use computer art when it is appropriate for a particular article." Send query letter with samples to be kept on file. Samples not filed are returned by SASE. Reports only if interested. Buys first rights or one-time rights. Pays on publication; $300 for 3-color cover; $50-200 for b&w or 2-color inside.
Tips: "Frequently commissions more than 1 spot per artist. Also, send several keepable samples that show a range of styles and the ability to conceptualize."

PUBLISHERS WEEKLY, Dept. AM, 4th Floor, 249 W. 17th St., New York NY 10011. (212)645-9700. Art Director: Karen E. Jones. Weekly magazine emphasizing book publishing for "people involved in the creative or the technical side of publishing." Circ. 50,000. Original artwork is returned to the artist after publication.
Illustrations: Buys 75 illustrations/year. Works on assignment only. "Open to all styles." Send query letter with brochure or résumé, tearsheets, photostats, photocopies, slides and photographs. Samples are not returned. Reports back only if interested. To show a portfolio, mail appropriate materials. **Pays on acceptance;** $200 for b&w, $350 for color inside.

‡QUEEN OF ALL HEARTS, 26 S. Saxon Ave., Bay Shore NY 11706. (516)665-0726. Fax: (516)665-4349. Managing Editor: Rev. Roger Charest. Estab. 1950. Bimonthly Roman Catholic magazine on Marian theology and spirituality. Circ. 4,500. Accepts previously published artwork. Sample copy available. Art guidelines not available.
Illustrations: Buys 1 or 2 illustrations/issue. Works on assignment only. Prefers religious. Considers pen & ink and charcoal. Send photographs. Samples are not filed and are returned by SASE if requested by artist. Does not report. Portfolio review not required. Buys one-time rights. **Pays on acceptance.**
Tips: Area most open to freelancers is illustration for short stories. "Be familiar with our publication."

■ELLERY QUEEN'S MYSTERY MAGAZINE, 1540 Broadway, New York NY 10036. (212)782-8532. Editor: Janet Hutchings. Emphasizes mystery stories and reviews of mystery books.
Cartoons: "We are looking for cartoons with an emphasis on mystery, crime and suspense."
Illustrations: Prefers line drawings. All other artwork is done inhouse. Reports within 3 months. **Pays on acceptance;** $25 minimum for line drawings.

■QUILT WORLD, 306 E. Parr Rd., Berne IN 46711. Editor: Sandra L. Hatch. Bimonthly 4-color magazine with "folksy design." Concerns patchwork and quilting. Previously published work OK. Original artwork not returned after publication. Sample for $3.
Cartoons: Approached by 10 cartoonists/year. Buys 2 cartoons/issue. Uses themes "poking gentle fun at quilters." Send finished cartoons. Reports in 3 weeks if not accepted. "I hold cartoons I can use until there is space." Buys all rights. Pays $15 on acceptance and/or publication.

Tips: Needs computer-literate freelancers for quilt design. Freelancers should be familiar with QuarkXPress or Aldus FreeHand and Word. "We do most of our own graphics by computer."

RACQUETBALL MAGAZINE, 1685 W. Vintah, Colorado Springs CO 80904-2921. (719)635-5396. Fax: (719)635-0685. Director of Communications/Editor: Linda Mojer. Bimonthly publication of The American Amateur Racquetball Association. "Distributed to members of AARA and industry leaders in racquetball. Focuses on both amateur and professional athletes." Circ. 50,000. Accepts previously published artwork. Originals returned at job's completion. Sample copies and art guidelines available. Needs computer-literate freelancers. Freelancers should be familiar with Aldus PageMaker.
Cartoons: Needs editorial illustration. Prefers racquetball themes. Send query letter with roughs. Samples are filed. Reports back within 2 months. Publication will contact artist for portfolio review if interested. Negotiates rights purchased. Pays $50 for b&w, $50 for color (payment negotiable).
Illustrations: Approached by 5-10 illustrators/year. Usually works on assignment. Prefers racquetball themes. Send query letter with samples. Samples are filed. Publication will contact artist for portfolio review if interested. Negotiates rights purchased. Pays on publication; $200 for color cover; $50 for b&w, $50 for color inside (all fees negotiable).

R-A-D-A-R, 8121 Hamilton Ave., Cincinnati OH 45231. Editor: Margaret Williams. Weekly 4-color magazine for children 3rd-6th grade in Christian Sunday schools. Original artwork not returned after publication.
Cartoons: Buys 1 cartoon/month on animals, school and sports. "We want cartoons that appeal to children — but does not put down any group of people; clean humor." Prefers to see finished cartoons. Reports in 1-2 months. **Pays on acceptance;** $17.50.
Illustrations: Buys 5 or more illustrations/issue. "Art that accompanies nature or handicraft articles may be purchased, but almost everything is assigned." Send tearsheets to be kept on file. Samples returned by SASE. Publication will contact artist for portfolio review if interested. Buys all rights on a work-for-hire basis. Sometimes requests work on spec before assigning job. Pays $150 for full-color cover; $70 for inside.
Tips: Finds artists through word of mouth, artists' submissions and self-promotion.

RADIANCE, The Magazine for Large Women, P.O. Box 30246, Oakland CA 94604. (510)482-0680. Publisher/Editor: Alice Ansfield. Estab. 1984. Quarterly magazine "for women *all* sizes of large — encouraging them to live fully *now*." Circ. 8,000. Accepts previously published artwork. Original artwork returned at job's completion. Sample copy for $3.50. Art guidelines not available.
Cartoons: Approached by 200 cartoonists/year. Buys 1-2 cartoons/issue. Wants empowering messages for large women, with humor and perspective on women's issues; double or multiple panel b&w or 2-color line drawings with gagline. Send query letter with brochure, roughs and finished cartoons. Samples are filed or are returned by SASE if requested by artist. Buys one-time rights. Pays $25-100 for b&w.
Illustrations: Approached by 200 illustrators/year. Buys 1-2 illustrations/issue. Works on assignment only. Considers pen & ink, watercolor, charcoal and mixed media. Send query letter with appropriate samples — whatever works! Samples are filed or are returned by SASE if requested by artist. Buys one-time rights. Pays on publication; $100-200 for color cover; $25-100 for b&w inside.
Tips: "Read our magazine. Find a way to help us with our goals and message."

■RAG MAG, Box 12, Goodhue MN 55027. Contact: Beverly Voldseth. Estab. 1982. Semiannual (fall and spring) b&w magazine emphasizing poetry, graphics, fiction and reviews for small press, writers, poets and editors. Circ. 300. Accepts previously published material. Send no original work. Sample copy $6.
Cartoons: Approached by 4-5 cartoonists/year. Acquires 2 cartoons/issue. Any theme or style. Prefers single panel or multiple panel b&w line drawings with gagline. Send only finished cartoons. Material returned in 2 months by SASE if unwanted. Reports within 2 months. Acquires first rights. Pays in copies only.
Illustrations: Approached by up to 12 illustrators/year. Acquires 6 illustrations/issue. Any style or theme. Send camera-ready copy (3-6 pages of your best work). Samples and responses returned only by SASE. Reports within 1 month. Portfolio review not required. Acquires first rights. Pays in copies.
Tips: "I choose artwork for its own appeal — just as the poems and short stories are. I only take what's ready to be used on receipt. I return what I don't want. I don't hold a lot in my files because I think artists should be sending their artwork around. And even if I like someone's artwork very much, I like to use new people. I do not want to see anything portraying violence or putting down a group."

REAL PEOPLE MAGAZINE, 16th Floor, 950 3rd Ave., New York NY 10022. (212)371-4932. Fax: (212)838-8420. Editor: Alex Polner. Estab. 1988. 4-color and some b&w, digest-sized. "Bimonthly 4-color and b&w entertainment magazine featuring celebrities and show business articles, profiles for men and women ages 35 and up." Circ. 125,000. Original artwork returned after publication. Sample copy for $3.50 plus postage. Art guidelines not available.
Illustrations: Buys 1-2 color illustrations/issue and 1-3 b&w/issue. Works on assignment only. Theme or style depends on the article. Prefers pen & ink, watercolor, acrylic and collage with strong concept and/or sense of humor. Send query letter with tearsheets. Samples are filed. Artist should follow up after initial

query. Publication will contact artist for portfolio review if interested. Buys one-time rights. Pays on publication; $50-100 for b&w, $200-300 for color inside.
Tips: "We are using more illustration recently."

‡**REFORM JUDAISM**, 838 Fifth Ave., New York NY 10021-7046. (212)249-0100. Managing Editor: Joy Weinberg. Estab. 1972. Quarterly magazine. "The official magazine of the Reform Jewish movement. It covers development within the movement and interprets world events and Jewish tradition from a Reform perspective." Circ. 295,000. Accepts previously published artwork. Originals returned at job's completion. Sample copies available for $3.50. Art guidelines not available. 5% of freelance work demands computer skills.
Cartoons: Prefers political themes tying into editorial coverage. Send query letter with finished cartoons. Samples are filed. Reports back within 3-4 weeks. Buys first firghts, one-time rights and reprint rights. Pays $50 for b&w, $75 for color.
Illustrations: Buys 8-10 illustrations/issue. Works on assignment. Send query letter with brochure, résumé, SASE and tearsheets. Samples are filed. Reports pack within 3-4 weeks. Publication will contact artist for portfolio review if interested. Portfolio should include tearsheets, slides and final art. Rights purchased vary according to project. **Pays on acceptance.** Pays $600 for color cover; $150-200 for b&w, $250-400 for color inside.
Tips: Finds artists through sourcebooks and artists' submissions.

‡**RELIX MAGAZINE**, P.O. Box 94, Brooklyn NY 11229. (718)258-0009. Fax: (718)692-4345. Publisher: Toni Brown. Estab. 1974. Bimonthly consumer magazine emphasizing the Grateful Dead and psychedelic music. Circ. 50,000. Does not accept previously published artwork. Sample copies or art guidelines not available.
Cartoons: Approached by 20 cartoonists/year. Prefers Grateful Dead related humorous cartoons, single or multiple panel b&w line drawings. Send query letter with finished cartoons. Samples are not filed and are returned by SASE if requested by artist. Reports back to the artist only if interested. Pays $25-75 for b&w, $100-200 for color. Buys all rights.
Illustrations: Approached by 100+ illustrators/year. Buys multiple illustrations/issue. Prefers Grateful Dead related. Considers pen & ink, airbrush and marker. Send query letter with SASE and photostasts. Samples are not filed and are returned by SASE if requested by artist. Reports back to the artist only if interested. Portfolio review not required. Buys all rights. Pays on publication. Pays $100-500 for color cover; $25-75 for b&w, $75-150 for color inside.
Tips: Finds artists through word of mouth. "Looking for skeleton artwork—happy, not gorey."

∎**RENOVATED LIGHTHOUSE**, P.O. Box 340251, Columbus OH 43234-0251. Editor: R. Allen Dodson. Estab. 1986. Irregular 72-page literary magazine; "quality literary work by amateurs and professionals." Circ. 200. Originals not returned to artist. Sample copy (current) $4; (back) $3.75; contributor copies $3.50. Art guidelines for SASE with first-class postage (52¢).
Cartoons: "We need cartoon fillers." Prefers "dry humor, subtle sometimes, often political, but not necessarily timely, more a signpost of the times." Pays one copy of issue.
Illustrations: Approached by 36 illustrators/year. "We use one artist/issue. This artist is required to provide: 1) an unpublished original drawing (5.5×8.5) of a lighthouse, preferably, for the cover; 2) 3-4 unpublished or previously published works for the gallery column, 3) a biographical sketch for inclusion in the gallery, 4) 2-4 illustrations of a story in the same issue. We aim for a publication that belongs in the library, not a periodical to throw away after reading it." Prefers "disk submissions. Artwork must be retrievable into Word Perfect for Windows 6.0." Considers pen & ink. Send query letter with SASE and photocopies. Samples are filed. Reports back within 1 month. To show a portfolio, mail b&w tearsheets and photocopies. Rights purchased vary according to project. Pays $20/issue.
Tips: "Publications are suffering at the hands of computer entertainment much as what happened with the advent of TV. Eventually, all magazines will have to be on disk. Tell us whether the work is a submission, to be filed or to be returned."

THE REPORTER, Women's American ORT, 315 Park Ave. S., New York NY 10010. (212)505-7700. Fax: (212)674-3057. Editor: Dana B. Asher. Estab. 1966. Quarterly organization magazine for Jewish women emphasizing issue, lifestyle, education. *The Reporter* is the magazine of Women's ORT, a membership organization supporting a worldwide network of technical and vocational schools. Circ. 110,000. Original artwork returned at job's completion. Sample copies for SASE with first-class postage.
Illustrations: Approached by 25 illustrators/year. Buys 2 illustration/issue. Works on assignment only. Prefers contemporary art. Considers pen & ink, mixed media, watercolor, acrylic, oil, charcoal, airbrush, collage and marker. Send query letter with brochure, résumé, tearsheets, photographs, photocopies, photostats and slides. Samples are filed or returned by SASE if requested by artist. Reports back to the artist only if interested. Rights purchased vary according to project. Pays on publication; $150 for color cover; $50 for b&w, $75 for color inside.

‡**RESIDENT AND STAFF PHYSICIAN**, 80 Shore Rd., Port Washington NY 11050. (516)883-6350. Executive Editor: Anne Mattarella. Monthly publication emphasizing hospital medical practice from clinical, educa-

tional, economic and human standpoints. For hospital physicians, interns and residents. Circ. 100,000.

Cartoons: Buys 3-4 cartoons/year from freelancers. "We occasionally publish sophisticated cartoons in good taste dealing with medical themes." Reports in 2 weeks. Buys all rights. **Pays on acceptance;** $25.

Illustrations: "We commission qualified freelance medical illustrators to do covers and inside material. Artists should send sample work." Send query letter with brochure showing art style or résumé, tearsheets, photostats, photocopies, slides and photographs. Call or write to schedule an appointment to show a portfolio, which should include color and b&w final reproduction/product and tearsheets. **Pays on acceptance;** $700, color, cover; payment varies for inside work.

Tips: "We like to look at previous work to give us an idea of the artist's style. Since our publication is clinical, we require highly qualified technical artists who are very familiar with medical illustration. Sometimes we have use for nontechnical work. We like to look at everything. We need material from the *doctor's* point of view, *not* the patient's."

RHODE ISLAND MONTHLY, 18 Imperial Place, Providence RI 02903. (401)421-2552. Fax: (401)831-5624. Art Director: Donna Chludzinski. Estab. 1988. Monthly 4-color magazine which focuses on life in Rhode Island. Provides the reader with in-depth reporting, service and entertainment features and dining and calendar listings. Circ. 28,000. Accepts previously published artwork. Sample copies available for $1. Art guidelines not available.

Illustrations: Approached by 20 freelance illustrators/year. Buys 1-2 illustrations/issue. Works on assignment and sometimes on spec. Considers all media. Send query letter with SASE, tearsheets, photographs and slides. Samples are filed. Request portfolio review in original query. Publication will contact artist for portfolio review if interested. Portfolio should include b&w and color tearsheets. Buys one-time rights. Sometimes requests work on spec before assigning job. Pays on publication; $150 for b&w, $250+ for color inside, depending on the job.

Tips: Finds artists through word of mouth, artists' submissions, self-promotion and sourcebooks. "Ninety-five percent of our visual work is done by photographers. That's what works for us. We are glad to file illustration samples and hire people with appropriate styles at the appropriate time. I need to look at portfolios quickly. I like to know the illustrator knows a little bit about *RI Monthly* and has therefore edited his/her work down to a manageable amount to view in a short time."

RIP OFF PRESS, INC., Box 4686, Auburn CA 95604. (916)885-8183. Fax: (916)885-8219. Editor in Chief: Kathe Todd. Estab. 1969. Publishes adult and underground, mostly b&w comic books and graphic novels. Titles include *Fabulous Furry Freak Brothers*, *The Magical Nymphini* and *Those Annoying Post Bros*. Genres: X-rated humor and fantasy, horror, science fiction and social parodies. Themes: social commentary and alternative lifestyles. "We publish 'underground' comix. Prefer submissions to be intelligent, well-written and well-drawn—preferring realistic illustration over minimalistic or 'cartoony' styles. X-rated submissions should be non-violent and involve consenting adults only. We publish up to fifty 32-page comic books yearly, circulation range 3,000-15,000 per title." Original artwork returned after publication. Send $1 for catalog listing retail prices. Art guidelines for SASE with first-class postage.

Cartoons: Works with 8-20 different cartoonists/year. Prefers vertical pages in correct proportion for comic book format (standard comic trim size is 6⅝ × 10¼). Send query letter with letter-size photocopies of representative pages or stories. Enclose SASE if reply is desired. Samples are filed "depending on possible future use." Samples not filed are returned by SASE provided envelope and postage are adequate for the purpose. Buys North American comic rights and first refusal on subsequent collections. Creator retains copyright and all subsidiary rights. Option fee paid on execution of contract, with title to be announced for publication on receipt of completed manuscript. Publication is contingent on obtaining sufficient pre-publication orders from distributors to cover costs of production. Pays 10% of cover on net copies sold, 30 days after publication.

Tips: Looks for "knowledge of successful rendering techniques for b&w line reproduction; ability to use comic narrative techniques well; knowledge of and facility with anatomy, backgrounds and perspective. No pencil-only pages, straight superhero comics or manuscripts over 32 pages or work which shows a complete ignorance of repro techniques."

‡RIVER STYX, 14 S. Euclid, St. Louis MO 630108. (314)361-0043. Editor: Jennifer Tabin. Estab. 1975. *River Styx* is a tri-annual, not-for-profit literary arts organization that produces a multiculturally-oriented, internationally distributed literary arts journal that features poetry, fiction, essays, interviews and visual art. Does not accept previously published artwork. Originals returned at job's completion. Sample copies available for $7. Art guidelines for SASE with first-class postage.

- Does not buy cartoons and illustrations per se, but features the work of fine artists in its pages.

ROANOKER MAGAZINE, 3424 Brambleton Ave., Roanoke VA 24018. Art Director: Starr Alldredge Howard. Estab. 1974. Monthly general interest magazine for the city of Roanoke, Virginia and the Roanoke valley. Circ. 10,000. Originals are not returned. Art guidelines not available.

Illustrations: Approached by 20-25 freelance illustrators/year. Buys 5-10 illustrations/year. Works on assignment only. Send query letter with brochure, tearsheets and photocopies. Samples are filed. Reports back

only if interested. No portfolio reviews. Buys one-time rights. Pays on publication; $100 for b&w or color cover; $75 for b&w or color inside.
Tips: "Please *do not* call or send any material that needs to be returned."

‡**ROBB REPORT**, One Acton Place, Acton MA 01720. (508)263-7749. Fax: (508)263-0722. Design Director: Ilse Stryjewski. Monthly 4-color consumer magazine "for the affluent lifestyle, featuring exotic cars, investment, entrepreneur, boats, etc." Circ. 50,000. Accepts previously published artwork. Original artwork is returned at job's completion. Sample copies not available. Art guidelines for SASE with first-class postage.
Cartoons: Prefers upscale lifestyle cartoons. Send query letter with finished cartoons. Samples are filed. Reports back only if interested. Buys one-time rights. Pays $150 for b&w, $250 for color.
Illustrations: Approached by 50 freelance illustrators/year. Buys 5 freelance illustrations/year. Send query letter with tearsheets, photographs, slides and transparencies. Samples are filed. Portfolio should include b&w and color tearsheets, slides and photographs. Buys one-time rights. Sometimes requests work on spec before assigning job. Payment varies; within 60-90 days of acceptance.

ROCK PRODUCTS, 29 N. Wacker Dr., Chicago IL 60606. (312)726-2802. Fax: (312)726-2574. Art Director: Bryan O. Bedell. Estab. 1894. Monthly 4-color trade journal. Circ. 30,000. Accepts previously published artwork. Needs computer-literate freelancers for illustration. 75% of freelance work demands knowledge of Adobe Illustrator.
Cartoons: "We use very few cartoons. They would need to be industry-related."
Illustrations: Approached by 20 illustrators/year. Buys 5 illustrations/year. Works on assignment only. Looking for realistic, technical style. Send query letter with brochure and samples or slides. Samples are filed or are returned by SASE if requested by artist. Publication will contact artist for portfolio review if interested. Portfolio should include thumbnails, roughs, final art, b&w and color tearsheets. Rights purchased vary according to project. Pays $300 for color cover; $100 for b&w, $200 for color inside.
Tips: Finds artists through word of mouth and self-promotion. Prefers local artists. "Get lucky, and approach me at a good time. A follow-up call is fine. Few people ever call after they send material. This may not be true of most AD's, but I prefer a somewhat casual, friendly approach. Also, being 'established' means nothing. I prefer to use new illustrators as long as they are professional and friendly."

✱■**ROOM OF ONE'S OWN**, Box 46160, Station D, Vancouver, British Columbia V6J 5G5 Canada. Contact: Editor. Estab. 1975. Quarterly literary journal. Emphasizes feminist literature for women and libraries. Circ. 700. Original artwork returned after publication if requested. Sample copy for $7; art guidelines for SAE (nonresidents include 3 IRCs).
Cartoons: "Cartoons need to be "feminist, affirmative and simple." Pays $25 and up, b&w and color.
Illustrations: Buys 3-5 illustrations/issue from freelancers. Prefers good b&w line drawings. Prefers pen & ink, then charcoal/pencil and collage. Send photostats, photographs, slides or original work as samples to be kept on file. Samples not kept on file are returned by SAE (nonresidents include IRC). Reports within 6 months. Buys first rights. Pays $25-50, b&w, color; on publication.
Tips: "Artwork usually appears on the cover only."

‡**THE ROTARIAN**, 1560 Sherman Ave., Evanston IL 60201. Editor: Willmon L. White. Art Director: P. Limbos. Estab. 1911. Monthly 4-color publication emphasizing general interest, business and management articles. Service organization for business and professional men and women, their families, and other subscribers. Accepts previously published artwork. Sample copy and editorial fact sheet available.
Cartoons: Approached by 14 cartoonists/year. Buys 5-8 cartoons/issue from freelancers. Interested in general themes with emphasis on business, sports and animals. Avoid topics of sex, national origin, politics. Send query letter to Cartoon Editor, Charles Pratt, with brochure showing art style. Reports in 1-2 weeks. Buys all rights. **Pays on acceptance**; $75.
Illustrations: Approached by 8 illustrators/year. Buys 10-20 illustrations/year; 7 or 8 humorous illustrations year from freelancers. Uses freelance artwork mainly for covers and feature illustrations. Buys assigned themes. Most editorial illustrations are commissioned. Send query letter to Art Director with brochure showing art style. Artist should follow-up with a call or letter after initial query. Portfolio should include keyline paste-up, original/final art, final reproduction/product, color and photographs. Sometimes requests work on spec before assigning job. Buys all rights. **Pays on acceptance**; payment negotiable, depending on size, medium, etc, $800-1,000, color, cover; $200-700 color, inside; full page.
Tips: "Preference given to area talent." Conservative style and subject matter.

‡**ROUGH NOTES**, 1200 N. Meridian, P.O. Box 564, Indianapolis IN 46204. Publications Production Manager: Evelyn Egan. Estab. 1878. Monthly 4-color magazine with a contemporary design. Does not accept previously published artwork.
Cartoons: Buys 3-5 cartoons/issue on property and casualty insurance, automation, office life (manager/subordinate relations) and general humor. No risqué material. Receives 30-40 cartoons/week from freelance artists. Submit art the third week of the month. Include SASE. Reports in 1 month. Buys all rights. Prefers 5×8 or 8×10 finished art. **Pays on acceptance**; $20, line drawings and halftones.

Tips: "Do not submit sexually discriminating materials. I have a tendency to disregard all of the material if I find any submissions of this type. Send several items for more variety in selection. We would prefer to deal only in finished art, not sketches."

RUNNER'S WORLD, 33 E. Minor St., Emmaus PA 18098. (610)967-5171. Fax: (610)967-7725. Art Director: Ken Kleppert. Estab. 1965. Monthly 4-color with a "contemporary, clean" design emphasizing serious, recreational running. Circ. 470,000. Accepts previously published artwork "if appropriate." Returns original artwork after publication. Sample copy available. Needs computer-literate freelancers. 30% of freelance work demands knowledge of Adobe Illustrator, QuarkXPress or Aldus FreeHand.
Illustrations: Approached by hundreds of illustrators/year. Works with 25 illustrators/year. Buys average of 6 illustrations/issue. Needs editorial, technical and medical illustrations. "Styles include tightly rendered human athletes, caricatures and cerebral interpretations of running themes. Also, *RW* uses medical illustration for features on biomechanics." Style of David Suter, Tom Bloom, John Segal, Enos. Prefers pen & ink, airbrush, charcoal/pencil, colored pencil, watercolor, acrylic, oil, pastel, collage and mixed media. Works on assignment only. Send samples to be kept on file. (Prefers tearsheets.) Publication will contact artist for portfolio review if interested. Pays $300 and up for color inside. Buys one-time international rights. "No cartoons or originals larger than 11×14."
Tips: Finds artists through word of mouth, magazines, artists' submission/self-promotion, sourcebooks, artists' agents and reps, and attending art exhibitions. Portfolio should include "a maximum of 12 images. Show a clean presentation, lots of ideas and few samples. Don't show disorganized thinking. Portfolio samples should be uniform in size."

RUTGERS MAGAZINE, Alexander Johnston Hall, New Brunswick NJ 08903. Fax: (908)932-8412. Art Director: Joanne Dus-Zastrow. Estab. 1987. Quarterly 4-color general interest magazine covering research, events, art programs, etc. that relate to Rutgers University; "conservative design." Readership consists of alumni, parents of students and University staff. Circ. 110,000. Accepts previously published artwork. Original artwork is returned after publication. Sample copies available. Needs computer-literate freelancers for illustration. 10% of freelance work demands computer literacy in QuarkXPress or Aldus FreeHand.
Illustrations: Buys illustrations mainly for covers and feature spreads. Buys 4 illustrations/issue, 16 illustrations/year. Considers mixed media, watercolor, pastel and collage. Send query letter with brochure. "Show a strong conceptual approach." Editorial illustration "varies from serious to humorous, conceptual to realistic." Samples are filed. Publication will contact artist for portfolio review if interested. Buys one-time rights. Pays on publication; $800-1,000 for color cover; $100-800 for color inside.
Tips: Finds artists through sourcebooks and artists' submissions. "Open to new ideas. See a trend away from perfect realism in illustration. See a willingness to experiment with type in design."

‡SACRAMENTO MAGAZINE, 4471 D Street, Sacramento CA 95819. (916)452-6200. Fax: (916)452-6061. Art Director: Rebecca McKee. Estab. 1975. Monthly consumer lifestyle magazine with emphasis on home and garden, health features and stories of local interest. Circ. 20,000. Accepts previously published artwork. Originals returned to artist at job's completion. Sample copies available. Art guidelines not available. Needs computer-literate freelancers for design. 10% of freelance work demands computer knowledge of Aldus PageMaker, Adobe Photoshop or Aldus FreeHand.
Cartoons: Buys 1 cartoon/issue. Prefers humorous cartoons; b&w line drawings. Call for appointment or send postcard that adequately represents artists style. Samples are not filed. Returned by SASE if requested by artist. Pays $35 for b&w. Buys one-time rights.
Illustrations: Buys 1-2 illustrations/issue. Works on assignment only. Considers collage, airbrush, acrylic, colored pencil, oil, charcoal, mixed media and pastel. Send query letter with tearsheets and photocopies. Samples are filed and are not returned. Does not report back. Artist should call for appointment or send samples of published work that adequately represents artists style. Publication will contact artist for portfolio review if interested. Portfolio should include b&w and color tearsheets, slides, final art and photographs. Buys one-time rights. Pays on publication. Pays $350 for b&w/color cover; $200 for b&w, $250 for color inside.
Tips: Finds artists through artists' submissions and sourcebooks. Sections most open to freelancers are departments and some feature stories. "We have a regular cartoonist."

SACRAMENTO NEWS & REVIEW, 2210 21st St., Sacramento CA 95818. (916)737-1234. Fax: (916)737-1437. Art Director: Don Button. Estab. 1989. "An award-winning alternative b&w with 4-color cover newsweekly for the Sacramento area. We combine a commitment to investigative and interpretive journalism with coverage of our area's growing arts and entertainment scene." Circ. 90,000. Occasionally accepts previously published artwork. Originals returned at job's completion. Sample copies and art guidelines available.
Cartoons: Approached by 100 cartoonists/year. Buys 6 cartoons/issue. Prefers political and off-beat single panel, b&w line drawings. Send query letter with copies. Samples are filed. Reports back to the artist only if interested. Rights purchased vary according to project. Pays $15 for b&w.
Illustrations: Approached by 50 illustrators/year. Buys 1 illustration/issue. Works on assignment only. For cover art, needs themes that reflect content. Send query letter with tearsheets. Samples are filed. Publication

will contact artist for portfolio review if interested. Portfolio may be dropped off every Monday-Saturday. Portfolio should include mail tearsheets, slides, photocopies and photographs. Buys first rights. **Pays on acceptance**; $100 for b&w and $150 for color cover; $50 for b&w inside.
Tips: Finds artists through artists' submissions.

THE ST. LOUIS JOURNALISM REVIEW, 8380 Olive Blvd., St. Louis MO 63132. (314)991-1699. Contact: Charles L. Klotzer. Monthly magazine featuring critiques of primarily St. Louis but also national media — print, broadcasting, TV, cable, advertising, public relations and the communication industry. Circ. 5,000.
Cartoons: Subject should pertain to the news media; preferably local. Query with samples. Include SASE. Reports in 4-7 weeks. Pays on publication; $15-25.
Illustrations: Query with samples and SASE. Reports in 4-6 weeks. Pays on publication; $15-25 (negotiable) for b&w illustrations pertaining to the news media (preferably local).

■**SALT LICK PRESS**, #15, 1416 N.E. 21st Ave., Portland OR 97232-1507. Editor/Publisher: James Haining. Published irregularly. Circ. 1,000. Previously published material and simultaneous submissions OK. Original artwork returned after publication. Sample copy for $6.
Illustrations: Buys 2 illustrations/issue. Interested in a variety of themes. Send brochure showing art style or tearsheets, photostats, photocopies, slides and photographs. Publication will contact artist for portfolio review if interested. Samples returned by SASE. Reports in 1 month. Buys first rights. Sometimes requests work on spec before assigning job. Pays in copies.

‡**SALT WATER SPORTSMAN**, 280 Summer St., Boston MA 02210-1126. (617)439-9977. Fax: (617)439-9357. Art Director: Chris Powers. Estab. 1939. Monthly consumer magazine describing the how-to and where-to of salt water sport fishing in the US, Caribbean and Central America. Circ. 140,000. Accepts previously published artwork. Originals returned at job's completion. Sample copies for 8½ × 11 SASE and 6 first-class stamps. Art guidelines available for SASE with first-class postage. Needs computer-literate freelancers for illustration. 10% of freelance work demands computer skills.
Illustrations: Buys 4-5 illustrations/issue. Works on assignment only. Considers pen & ink, watercolor, acrylic and charcoal. Send query letter with tearsheets, photocopies and transparencies. Samples are not filed and are returned by SASE if requested by artist. Publication will contact artist for portfolio review if interested. Portfolio should include b&w and color tearsheets and final art. Buys first rights. **Pays on acceptance.** Pays $50 for b&w, $100 for color inside.
Tips: Finds artists mostly through artists' submissions. Areas most open to freelancers are how-to, semi-technical drawings for instructional features and columns; occasional artwork to represent fishing action or scenes. "Look the magazine over carefully to see the kind of art we run — focus on these styles."

SANTA BARBARA MAGAZINE, Suite H, 226 E. Canon Perdido St., Santa Barbara CA 93101. (805)965-5999. Art Director: Kimberly Kavish. Estab. 1975. Quarterly 4-color magazine with classic design emphasizing Santa Barbara culture and community. Circ. 12,000. Original artwork returned after publication if requested. Sample copy for $3.50.
 ● Also publishes *Pasadena Magazine* which has the same illustration needs and policies.
Illustrations: Approached by 20 illustrators/year. Works with 2-3 illustrators/year. Buys about 1-3 illustrations/year. Uses freelance artwork mainly for departments. Works on assignment only. Send query letter with brochure, résumé, tearsheets and photocopies. Reports back within 6 weeks. To show a portfolio, mail b&w and color art, final reproduction/product and tearsheets; will contact if interested. Buys first rights. **Pays on acceptance:** approximately $275 for color cover; $175 for color inside. "Payment varies."
Tips: "Be familiar with our magazine."

SATELLITE ORBIT, Suite 600, 8330 Boone Blvd., Vienna VA 22182. (703)827-0511. Fax: (703)356-6179. Contact: Art Director. Monthly 4-color magazine emphasizing satellite television industry for home satellite dish owners and dealers. Design is "reader friendly, with small copy blocks — large TV listing section." Circ. 350,000. Accepts previously published material. Original artwork returned after publication. 25% of freelance work demands Adobe Illustrator or Photoshop.
Illustrations: Buys 2-5 illustrations/issue. Needs "inventive, clearly drawn spots that get the point across." Style of John Cuneo, Gil Eisner, Joe Murray, Seymour Chwast. Needs editorial illustration. Works on assignment only. Send query letter with tearsheets, photocopies, slides and photographs. Samples not filed are returned only if requested. Reports within 1 month. Portfolio review not required. Negotiates rights purchased and payment. Pays on publication; $450 for b&w, $1,500 for color cover; $150 for b&w, $250 for color inside.
Tips: Finds artists through sourcebooks and self-promotions. "I usually only use spot illustration work. Black-and-white work usually gets overlooked and I don't like to see uninventive poorly-drawn stuff. I predict the magazine field will be electronic within 10 years with moving video clips."

SCIENCE FICTION CHRONICLE, Box 022730, Brooklyn NY 11202-0056. (718)643-9011. Fax: (718)643-9011. Editor/Publisher: Andrew Porter. Estab. 1979. Monthly magazine/trade journal covering science fiction,

fantasy and horror; includes news, letters, reviews, market reports, etc. Black and white with 4-color cover. Circ. 6,000. Accepts previously published work. Sample copies for 9 × 12 SASE with $1.21 first-class postage. **Illustrations:** Uses illustration for covers only. Approached by 20-40 illustrators/year. Prefers science fiction and fantasy themes. Considers airbrush and acrylic. Send query letter with transparencies or slides only. Samples are not filed and are returned by SASE. Reports back within 6-8 weeks. Portfolio review not required. Buys one-time or reprint rights. Pays on publication; $125 for color cover.

THE SCIENCE TEACHER, 1840 Wilson, Arlington VA 22201-3000. (7033)243-7100. Fax: (703)243-7177. Design Editor: Kim Alberto. Estab. 1958. Monthly education association magazine; 4-color with "somber, but not boring" design."A journal for high school science teachers, science educators and secondary school curriculum specialists." Circ. 27,000. Accepts previously published work. Original artwork returned at job's completion. Sample copies and art guidelines available. Needs computer-literate freelancers for illustration. 5% of freelance work demands knowledge of Aldus PageMaker or Aldus FreeHand.
Cartoons: Approached by 6 cartoonists/year. Buys 0-1 cartoon/issue. "Science or education humor is all we publish but cartoons must not be insulting or controversial. Animal testing, dissection, and creatinism or Darwinism cartoons will not be published." Prefers single panel b&w line drawings or b&w washes with or without gagline. Send query letter with non-returnable samples. Reports back to the artist if interested. Buys one-time rights. Pays $35 for b&w.
Illustrations: Approached by 75 illustrators/year. Buys 2 illustrations/issue. Works on assignment only. Considers pen & ink, airbrush, collage and charcoal; b&w only. Need conceptual pieces to fit specific articles. Send query letter with tearsheets and photocopies. Samples are filed. Publication will contact artist for portfolio review if interested. Portfolio should include b&w final art. Buys one-time rights. Pays on publication; $50 for b&w inside, full page.
Tips: Prefers experienced freelancers with knowledge of the publication. "I have found a very talented artist through his own self-promotion, yet I also use a local sourcebook to determine artists' styles before calling them in to see their portfolios."

‡SCUBA TIMES MAGAZINE, 14110 Perdido Key Dr., Pensacola FL 32507. (904)492-7805. Fax: (904)492-7807. Art Director: Trisha Russell. Bimonthly magazine for scuba enthusiasts. Originals returned at job's completion. Editorial schedule is available. 5% of freelance work demands computer knowledge of CorelDRAW.
Cartoons: Approached by 2 cartoonists/year. Buys 0-1 cartoon/issue. Prefers humorous cartoons, single panel b&w and color washes with gagline. Send query letter with finished cartoons. Samples are filed. Reports back to the artist only if interested. Pays $25 for b&w/color.
Illustrations: Approached by 10 illustrators/year. Buys 0-1 illustration/issue. Considers all media. Send query letter with SASE, tearsheets, photostats and slides. Samples are filed. Publication will contact artist for portfolio review if interested. Portfolio should include b&w and color tearsheets, slides and final art. Buys one-time rights. Pays on publication. Pays $125 for color cover; $25-125 for b&w/color inside.
Tips: Finds artists through artist's submissions and word of mouth. "Be familiar with our magazine. Show us you can draw divers and their gear. Our readers will catch even the smallest mistake. Also a good thing to try would be to get an old issue and pick a story from either the advanced diving journal or the departments that we used a photo and show us how you would have used your art instead. This will show us your ability to conceptualize and your skill as an artist."

SEA MAGAZINE, Box 17782 Cowan, Irvine CA 92714. Art Director: Jeffrey Fleming. Estab. 1908. Monthly 4-color magazine emphasizing recreational boating for owners or users of recreational powerboats, primarily for cruising and general recreation; some interest in boating competition; regionally oriented to 13 western states. Circ. 60,000. Accepts previously published artwork. Return of original artwork depends upon terms of purchase. Sample copy for SASE with first-class postage.
• Also needs freelancers fluent in Quark and PageMaker for production.
Illustrations: Approached by 20 illustrators/year. Buys 10 illustrations/year mainly for editorial. Prefers pen & ink. Also considers airbrush, watercolor, acrylic and calligraphy. Send query letter with brochure showing art style. Samples are returned only if requested. Publication will contact artist for portfolio review if interested. Portfolio should include tearsheets and cover letter indicating price range. Negotiates rights purchased. Pays on publication; $50 for b&w; $225 for color inside (negotiable).
Tips: "We will accept students for portfolio review with an eye to obtaining quality art at a reasonable price. We will help start career for illustrators and hope that they will remain loyal to our publication."

 The double dagger before a listing indicates that the listing is new in this edition. New markets are often more receptive to freelance submissions.

‡■THE SENSIBLE SOUND, 403 Darwin Dr., Snyder NY 14226. Publisher: John A. Horan. Editor: Karl Nehring. Quarterly publication emphasizing audio equipment for hobbyists. Circ. 9,200. Accepts previously published material and simultaneous submissions. Original artwork returned after publication. Sample copy for $2.
Cartoons: Uses 4 cartoons/year. Prefers single panel, with or without gagline; b&w line drawings. Send samples of style and roughs to be kept on file. Material not kept on file is returned by SASE. Reports within 1 month. Negotiates rights purchased. Pay rate varies; on publication.

SHAREWARE MAGAZINE, 1030-D E. Duane Ave., Sunnyvale CA 94086. (408)730-9291. Fax: (408)730-2107. Art Director: Debbie Mize. Estab. 1988. Bimonthly consumer 4-color magazine featuring software (called shareware) for the IBM PC and compatibles, and the Macintosh computers; includes reviews, new releases, author interviews, for beginners to programmers. Design is "colorful, sharp and clean." Circ. 75,000. Accepts previously published artwork. Original artwork ownership is negotiable. Sample copies available. Art guidelines not available. Needs computer-literate freelancers for design, illustration, production and presentation. 50% of freelance work demands computer literacy in Adobe Illustrator or Corel Draw.
Cartoons: Prefers single panel, computer-related. Pays $10 for b&w.
Illustrations: Approached by 50 illustrators/year. Buys up to 6 illustrations/year from freelancers. Work is on assignment only. Considers any media. Needs editorial. Send a query letter with brochure and tearsheets to be kept on file. Publication will contact artist for portfolio review if interested. Buys rights or reprint rights. Sometimes requests work on spec before assigning job. Pay is negotiable depending on what is required. **Pays on acceptance.**
Tips: "We need strong designs to attract readers at the newsstands. Cartoon submissions also welcome."

■SHEEP! MAGAZINE, W. 2997 Markert Rd., Helenville WI 53137. (414)593-8385. Fax: (414)593-8384. Estab. 1980. A monthly tabloid covering sheep, wool and woolcrafts. Circ. 15,000. Accepts previously published work. Original artwork returned at job's completion. Sample copies available.
Cartoons: Approached by 30 cartoonists/year. Buys 6-8 cartoons/issue. Considers all themes and styles. Prefers single panel with gagline. Send query letter with brochure and finished cartoons. Samples are returned. Reports back within 3 weeks. Buys first rights or all rights. Pays $15-25 for b&w; $50-100 for color.
Illustrations: Approached by 10 illustrators/year. Buys 5 illustrations/year. Works on assignment only. Considers pen & ink, colored pencil, watercolor. Send query letter with brochure, SASE and tearsheets. Samples are filed or returned. Reports back within 3 weeks. To show a portfolio, mail thumbnails and b&w tearsheets. Buys first rights or all rights. **Pays on acceptance:** $45-75 for b&w, $75-150 for color cover; $45-75 for b&w, $50-125 for color inside.
Tips: "Demonstrate creativity and quality work. We're eager to help out beginners."

‡SHOFAR, 43 Northcote Dr., Melville NY 11747. (516)643-4598. Publisher: Gerald H. Grayson. Estab. 1984. Monthly magazine emphasizing Jewish religious educations published October through May—double issues December/January and April/May. Circ. 15,000. Accepts previously published artwork. Originals returned at job's completion. Sample copies free for 9×12 SASE and 3 first-class stamps. Art guidelines available.
Illustrations: Buys 3-4 illustrations/issue. Works on assignment only. Send query letter with tearsheets. Reports back to the artist only if interested. Pays on publication. Pays $25-100 for b&w, $50-150 for color cover.

SIGNS OF THE TIMES, 1350 N. King's Rd., Nampa ID 83687. (208)465-2500. Fax: (208)465-2531. Art Director: Merwin Stewart. A monthly Seventh-day Adventist 4-color publication that examines contemporary issues such as health, finances, diet, family issues, exercise, child development and spiritual growth. "We attempt to show that Biblical principles are relevant to everyone." Circ. 240,000. Accepts previously published artwork "whenever a need for existing art arises, but it's not frequent." Original artwork returned to artist after publication. Art guidelines available.
● No longer publishes cartoons.
Illustrations: Buys 6-10 illustrations/issue. Works on assignment only. Prefers contemporary "realistic, stylistic, or humorous styles (but not cartoons)." Considers any media. Call or send query letter with nonreturnable samples. "Tearsheets or color photos (prints) are best, although color slides are acceptable." Samples are filed or are returned only if requested by artist. Publication will contact artist for portfolio review if interested. Buys first-time North American publication rights. **Pays on acceptance** (30 days); approximately $700 for color cover; $100-300 for b&w, $500-700 for color inside. Fees negotiable depending on needs and placement, size, etc. in magazine.
Tips: Finds artists through artists' submissions, sourcebooks, and sometimes by referral from other art directors. "Most of the magazine illustrations feature people. Approximately 20 visual images (photography as well as artwork) are acquired for the production of each issue, half as b&w, half in color, and the customary working time frame is three weeks. Quality artwork and timely delivery are mandatory for continued assignments. It is customary for us to work with highly-skilled and dependable illustrators for many years."

‡**THE SILVER WEB,** P.O. Box 38190, Tallahassee FL 32315. Publisher/Editor: Ann Kennedy. Estab. 1989. Semi-annual literary magazine. Subtitled "A Magazine of the Surreal." Circ. 1,000. Accepts previously published artwork. Originals returned at job's completion. Sample copies available for $5.75. Art guidelines for SASE with first-class postage.
Illustrations: Approached by 10-15 illustrators/year. Buys 15-20 illustrations/issue. Prefers works of the surreal, horrific or bizarre images, but not traditional horror/fantasy (dragons or monsters are not desired). Considers pen & ink, collage, charcoal and mixed media, all only in b&w. Send query letter with SASE. Samples are filed or are returned by SASE if requested by artist. Reports back within 1 week. Publication will contact artist for portfolio review if interested. Rights purchased vary according to project. **Pays on acceptance.** Pays $25 for b&w cover; $10 for b&w inside.

■**SILVERFISH REVIEW,** Box 3541, Eugene OR 97403. (503)344-5060. Editor/Publisher: Rodger Moody. Estab. 1979. Semiannual literary magazine that publishes poetry, fiction, translations, essays, reviews, interviews and poetry chapbooks. Published December and July. Circ. 750. Sample copies available for $4, regular issue; $5, chapbook; plus $2 for postage.
Illustrations: Buys 1 freelance illustration/issue. Prefers pen & ink and charcoal. Send query letter with photocopies. Samples are filed. Reports back within 1 month. To show a portfolio, mail photocopies. Buys one-time rights. Pays $25-40 for b&w cover or inside.

‡■**THE SINGLE PARENT,** 401 N. Michigan Ave., Chicago IL 60611-4267. (312)644-6610. Editor: Mercedes M. Vance. Estab. 1958. Emphasizes family life in all aspects—raising children, psychology, divorce, remarriage, etc.—for all single parents and their children; quarterly 2-color magazine with 4-color cover. Circ. 80,000. Accepts simultaneous submissions and occasionally, previously published material. Original artwork not returned.
Cartoons: Prefers cartoons with single parent family/singles themes.
Illustrations: Prefers working with desktop/computer art IBM or Macintosh (encapsulated postscript filed, or scanned images). Please send photostats or hardcopy with diskette. Art non-returnable.
Tips: *The Single Parent* does not usually pay for photographs or illustration, however welcomes art from those who wish to become contributing illustrators.

■**SINISTER WISDOM,** Box 3252, Berkeley CA 94703. Contact: Art Director. Estab. 1976. Literary magazine. Triannual multicultural lesbian feminist journal of arts and politics, international distribution; b&w with 2-color cover. Design is "tasteful with room to experiment. Easy access to text is first priority." Circ. 3,500. Accepts previously published artwork. Original artwork returned at job's completion. Sample copies available for $6.25. Art guidelines for SASE with first-class postage. 20% of freelance work demands computer skills in Aldus PageMaker, Adobe Illustrator or Aldus FreeHand.
Cartoons: Approached by 15 cartoonists/year. Buys 0-2 cartoons/issue. Prefers lesbian/feminist themes, any style. Prefers single panel, b&w line drawings. Send query letter with roughs. Samples are filed or returned by SASE. Reports back within 9 months. Buys one-time rights. Pays 2 copies upon publication.
Illustrations: Approached by 30-75 illustrators/year. Buys 6-15 illustrations/issue. Prefers lesbian themes, images of women, abstraction and fine art. Considers any media for b&w reproduction. Send query letter with SASE, photographs, photocopies and photostats. Samples are filed or returned by SASE. Reports back within 9 months. Does not review portfolios. Buys one-time rights. Pays on publication; 2 copies; "will pay for production or lab costs."
Tips: "Read it and note the guidelines and themes of upcoming issues. We want work by lesbians only."

SKYDIVING MAGAZINE, 1725 N. Lexington Ave., DeLand FL 32724. (904)736-4793. Fax: (904)736-9786. Designer: Sue Clifton. Estab. 1979. "Monthly magazine on the equipment, techniques, people, places and events of sport parachuting." Circ. 10,100. Originals returned at job's completion. Sample copies and art guidlines available.
Cartoons: Approached by 10 cartoonists/year. Buys 2 cartoons/issue. Prefers skydiving themes; single panel, with gagline. Send query letter with roughs. Samples are filed. Reports back within 2 weeks. Buys one-time rights. Pays $25 for b&w.

■**THE SMALL POND MAGAZINE OF LITERATURE,** Box 664, Stratford CT 06497. Editor: Napoleon St. Cyr. Estab. 1964. Emphasizes poetry and short prose. Readers are people who enjoy literature—primarily college-educated. Usually b&w or 2-color cover with "simple, clean design." Published 3 times/year. Circ. 300. Sample copy for $3; art guidelines for SASE.
Illustrations: Receives 50-75 illustrations/year. Acquires 1-5 illustrations/issue. Uses freelance artwork mainly for covers, centerfolds and spots. Prefers "line drawings (inside and on cover) which generally relate to natural settings, but have used abstract work completely unrelated. Fewer wildlife drawings and more unrelated-to-wildlife material." Send query letter with finished art or production-quality photocopies, 2×3 minimum, 8×11 maximum. Include SASE. Publication will contact artist for portfolio review if interested. Pays 2 copies of issue in which work appears. Buys copyright in copyright convention countries.

Tips: Finds artists through artists' submissions and self-promotion. "Need cover artwork, but inquire first or send for sample copy." Especially looks for "smooth clean lines, original movements, an overall impact. Don't send a heavy portfolio, but rather 4-6 black-and-white representative samples with SASE. Don't send your life's history and/or a long sheet of credits. Work samples are worth a thousand words."

‡**SOAP OPERA UPDATE MAGAZINE**, 270 Sylvan Ave., Englewood Cliffs NJ 07632. (201)569-6699 ext. 226. Fax: (201)569-2510. Art Director: Catherine McCarthy. Estab. 1988. Bi-weekly consumer magazine geared toward fans of soap operas and the actors who work in soaps. It is "the only full-size, all color soap magazine in the industry." Circ. 700,000. Originals are not returned. Sample copies and art guidelines available.
Illustrations: Approached by 100 illustrators/year. Buys 1 or 2 illustrations/issue. Works on assignment only. Prefers illustrations showing a likeness of an actor/actress in soap operas. Considers any and all media. Send query letter with tearsheets. Samples are filed. Publication will contact artist for portfolio review if interested. Portfolio should include color tearsheets and final art. Buys all rights usually. Pays on publication. Pays up to $200 for color inside.
Tips: Finds artists through word of mouth. Areas most open to freelancers are caricatures of actors in storyline related illustration in the "Reader's Notes/Editors Notes" section. "Please send self-promotion cards along with a letter if you feel your work is consistent with what we publish."

‡**SOAP OPERA WEEKLY**, 45 W. 25th St., New York NY 10010. (212)645-2100. Creative Director: S. Rohall. Estab. 1989. Weekly 4-color consumer magazine; tabloid format. Circ. 600,000-700,000. Original artwork returned at job's completion. Sample copies not available.
Cartoons: Prefers cartoons with gagline, color washes. Send query letter with brochure. Samples are filed. Reports back only if interested. Buys one-time rights. Pays $200, color.
Illustrations: Approached by 50 freelance illustrators/year. Works on assignment only. Send query letter with brochure and soap-related samples. Samples are filed. Request portfolio review in original query. Publication will contact artist for portfolio review if interested. Portfolio should include original/final art. Buys first rights. **Pays on acceptance;** $1,500 for color cover; $750 for color, full page.

■**SOCIAL POLICY**, 25 W. 43rd St., New York NY 10036. (212)642-2929. Managing Editor: Audrey Gartner. Estab. 1970. Emphasizes the human services—education, health, mental health, self-help, consumer action, voter registration, employment. Quarterly magazine for social action leaders, academics and social welfare practitioners. Black & white with 2-color cover and eclectic design. Circ. 5,000. Accepts simultaneous submissions. Original artwork returned after publication. Sample copy for $2.50.
Illustrations: Approached by 12 illustrators/year. Works with 6 illustrators/year. Buys 6-8 illustrations/issue. Accepts b&w only, illustration "with social consciousness." Prefers pen & ink and charcoal/pencil. Send query letter and tearsheets to be kept on file. Call for appointment to show portfolio, which should include b&w final art, final reproduction/product and tearsheets. Reports only if interested. Buys one-time rights. Pays on publication; $100 for cover; $25 for b&w inside.
Tips: When reviewing an artist's work, looks for "sensitivity to the subject matter being illustrated."

SOLIDARITY MAGAZINE, Published by United Auto Workers, 8000 E. Jefferson, Detroit MI 48214. (313)926-5291. Editor: David Elsila. Four-color magazine for "1.3 million member trade union representing US workers in auto, aerospace, agricultural-implement, public employment and other areas." Contemporary design.
Cartoons: Carries "labor/political" cartoons. Pays $75 for b&w, $125 for color.
Illustrations: Works with 10-12 illustrators/year for posters and magazine illustrations. Interested in graphic designs of publications, topical art for magazine covers with liberal-labor political slant. Especially needs illustrations for articles on unemployment and economy. Looks for "ability to grasp publication's editorial slant." Send query letter with résumé, flier and/or tearsheet. Samples are filed. Pays $300 for b&w, $500 for color cover; $200 for b&w, $300 for color inside; $75 for small b&w spot illustration; $400+ for small pamphlet design.

■**SOUTH CAROLINA WILDLIFE**, Box 167, Columbia SC 29202. (803)734-3972. Editor: John Davis. Art Director: Linda Laffitte. Bimonthly 4-color magazine covering wildlife, water and land resources, outdoor recreation, natural history and environmental concerns. Circ. 70,000. Accepts previously published artwork.
• *South Carolina Wildlife* is low-key, relying on photos and art to attract/support editorial content.
Illustrations: Uses 5-10 illustrations/issue. Interested in wildlife art; all media; b&w line drawings, washes, full-color illustrations. "Particular need for natural history illustrations of good quality. They must be technically accurate." Subject matter must be appropriate for South Carolina. Prefers to see printed samples or slides of work, which will be filed with résumé. *Please note that samples will not be returned.* Publication will contact artist for portfolio review if interested. Sometimes requests work on spec before assigning job. Payment is negotiable. Acquires one-time rights.
Tips: Finds artists through word of mouth, magazines, artists' submissions/self-promotion, books and publications other than magazines. "We are interested in unique illustrations—something that would be impossible to photograph. Make sure proper research has been done and that the art is technically accurate."

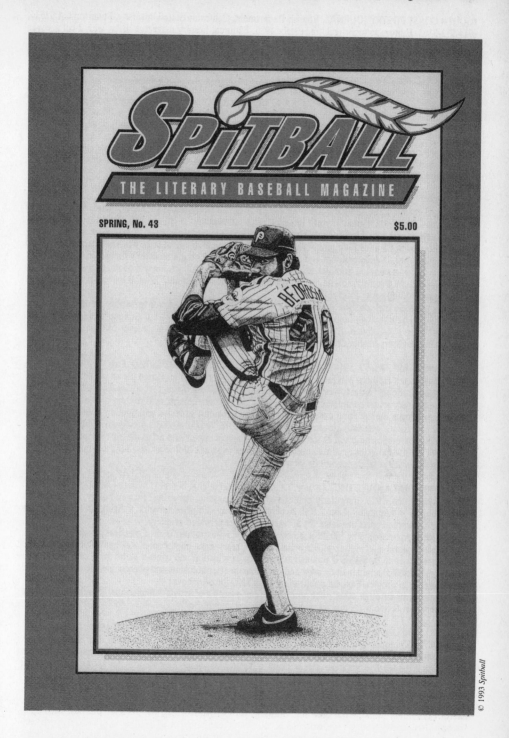

Donnie Pollard, illustrator of this pen & ink drawing, first did a piece for Mike Shannon, editor of Spitball, when he was in the Air Force. "I found Spitball in Artist's & Graphic Designer's Market," he says. "When I got out of the service, I got in touch with Mike, and things took off from there." Today, Pollard serves as Art Director for the magazine.

■**SOUTH COAST POETRY JOURNAL**, English Department, California State University, Fullerton CA 92634. (714)773-3163. Editor: John Brugaletta. Estab. 1986. Biannual literary magazine. B&w with 2-color cover journal size, 60 pages. "We publish some of the best poetry being written today. Among our subscribers are some of the finest libraries in the US. Readership tends to be active in all of the arts." Circ. 400. Accepts previously published artwork. Original artwork returned after publication. Sample copy for $3.50. Art guidelines for SASE with first-class postage.

Illustrations: Approached by 4-5 illustrators/year. Buys 12-15 illustrations/issue. Prefers sketches of objects and details from everyday life. Considers pen & ink, charcoal, pencil and any line art in b&w. Send query letter with SASE, photocopies, slides and photographs. "We are mainly interested in fillers, but are happy to look at work as large as 3×5 or work that can be reduced to that." Samples are not filed and are returned by SASE. Publication will contact artist for portfolio review if interested. Buys one-time rights. Sometimes requests work on spec before assigning job. Pays 2 copies of magazine.

Tips: Finds artists through artists' submissions/self-promotion and attending art exhibitions. "Send 4 to 6 photocopies of pages from your sketch book. Work must produce clear PMTs."

‡**SOUTHERN LIVING**, (formerly *Southern Accents*), 2100 Lakeshore Dr., Birmingham AL 35209. (205)877-6347. Art Director: Lane Gregory. Monthly 4-color magazine emphasizing interiors, gardening, food and travel. Circ. 2,000,000. Original artwork returned after publication.

Illustrations: Approached by 30-40 illustrators/year. Buys 2 illustrations/issue from freelancers. Uses freelance artists mainly for illustrating monthly columns. Works on assignment only. Prefers watercolor, colored pencil or pen & ink. Needs editorial and technical illustration. Send query letter with brochure showing art style or résumé and samples. Samples returned only if requested. Publication will contact artist for portfolio review if interested. Portfolio should include b&w and color tearsheets and slides. Buys one-time rights. **Pays on acceptance**; $300, b&w; $500 color, inside.

Tips: In a portfolio include "four to five best pieces to show strengths and/or versatility. Smaller pieces are much easier to handle than large. Its best not to have to return samples but to keep them for reference files." Don't send "too much. It's difficult to take time to plow through mountains of examples." Notices trend toward "lighter, fresher illustration."

‡**SOUTHWEST ART**, #1440, 5444 Westheimer, Houston TX 77056. (713)850-0990. Fax: (713)850-1314. Editor-in-Chief: Susan Hallsten McGarry. Estab. 1971. Monthly consumer magazine for art collectors interested in the representational fine arts west of the Mississippi River. The editorial core of *Southwest Art* is interviews with contemporary artists complemented by articles that explore the historical context of western American art. Columns focus on changing events in western art museums, galleries and auction houses, along with reviewing past trends and activities in the marketplace. Circ. 70,000. Accepts previously published artwork. Original transparencies returned at job's completion. Sample copies and art guidelines available.

● Does not use cartoons or illustrations, but features the work of fine artists. Send query letter with 35mm slides for possible feature or interview.

‡**THE SPIRIT THAT MOVES US**, P.O. Box 720820, Jackson Heights NY 11372-0820. (718)426-8788. Editor: Morty Sklar. Estab. 1975. Irregularly published literary magazine featuring "fiction, poetry, essays and art on any subject, in any style." Circ. 2,000. Accepts previously published artwork. Originals returned at job's completion. Sample copies available for $5. Art guidelines provided at query.

Illustrations: Approached by 100 illustrators/year. Buys 15 illustrations/issue. Considers pen & ink, airbrush, acrylic and oil. Send query letter with brochure, SASE, tearsheets, photocopies and photostats. Samples are filed or are returned by SASE if requested by artists. Publication will contact artist for portfolio review if interested. Portfolio should include b&w and color tearsheets, photostats and photocopies. Rights purchased vary according to project. Pays on publication. Pays $100 for b&w cover.

Tips: Finds artists through other publications, word of mouth and artists' submissions. "Send what you love best. Query first to see what our themes and time frames might be."

■**SPITBALL, The Literary Baseball Magazine**, 6224 Collegevue Place, Cincinnati OH 45224. (513)541-4296. Editor: Mike Shannon. Quarterly 2-color magazine emphasizing baseball exclusively, for "well-educated, literate baseball fans." Sometimes prints color material in b&w on cover. Returns original artwork after publication if the work is donated; does not return if purchases work. Sample copy for $1; art guidelines for SASE with first-class postage.

● This mag is starting up a regular feature called "Brushes on Baseball" which profiles individual artists. Now running a contest to solicit artists for this column.

Cartoons: Prefers single panel b&w line drawings with or without gagline. Prefers "old fashioned *Sport Magazine/New Yorker* type. Please, cartoonists. . . . make them funny, or what's the point!" Query with samples of style, roughs and finished cartoons. Samples not filed are returned by SASE. Reports back within 1 week. Negotiates rights purchased. Pays $10, minimum.

Illustrations: "We need three types of art: cover work, illustration (for a story, essay or poem) and filler. All work must be baseball-related; prefers pen & ink, airbrush, charcoal/pencil and collage. Sometimes we assign the cover piece on a particular subject; sometimes we just use a drawing we like. Interested artists

GET YOUR WORK INTO THE RIGHT BUYERS' HANDS!

You work hard... and your hard work deserves to be seen by the right buyers. But with the constant changes in the industry, it's not always easy to know who those buyers are. That's why you'll want to keep up-to-date and on top with the most current edition of this indispensable market guide.

Totally Updated Each Year

Keep ahead of the changes by ordering *1996 Artist's & Graphic Designer's Market* today. You'll save the frustration of getting your work returned in the mail, stamped MOVED: ADDRESS UNKNOWN. And of NOT submitting your work to new listings because you don't know they exist. All you have to do to order the upcoming 1996 edition is complete the attached order card and return it with your payment or credit card information. Order now and you'll get the 1996 edition at the 1995 price—just $23.99—no matter how much the regular price may increase! *1996 Artist's & Graphic Designer's Market* will be published and ready for shipment in September 1995.

Keep on top of the fast-changing industry and get a jump on selling your work with help from the *1996 Artist's & Graphic Designer's Market*. Order today! You deserve it!

Turn over for more books to help you sell your work ➡

More Great Books to Help You Get Ahead!

NO POSTAGE
NECESSARY
IF MAILED
IN THE
UNITED STATES

BUSINESS REPLY MAIL
FIRST CLASS MAIL PERMIT NO. 17 CINCINNATI OHIO

POSTAGE PAID BY ADDRESSEE

WRITER'S DIGEST BOOKS
1507 DANA AVENUE
CINCINNATI OH 45207-9965

should write to find out needs for covers and specific illustration." Buys 3 or 4 illustrations/issue. Send query letter with b&w illustrations or slides. Target samples to magazine's needs. Samples not filed are returned by SASE. Reports back within 1 week. Negotiates rights purchased. **Pays on acceptance;** $100 for color cover; $20-40 b&w inside. Needs short story illustration.

Tips: "Usually artists contact us and if we hit it off, we form a long-lasting mutual admiration society. Please, you cartoonists out there, drag your bats up to the *Spitball* plate! We like to use a variety of artists."

‡SPORTS CAR INTERNATIONAL, #5, 42 Digital Dr., Novato CA 94949. Art Director: Henry Rasmussen. Estab. 1986. Monthly entertainment publication for the exotic and classic sports car enthusiast. Printed "four-color on glossy stock, we are America's premier sports car magazine." Circ. 75,000. Original artwork is returned after publication.

Illustrations: Works with 6-8 illustrators/year. Works on assignment only. Prefers pen & ink, airbrush and watercolor. Send query letter with brochure showing art style. Looks for originality, movement and color. Samples are filed. Reports back about queries/submissions only if interested. Portfolio should include tearsheets, slides, photographs and transparencies. Buys first rights.

‡SPORTS 'N SPOKES, Suite 180, 2111 E. Highland Ave., Phoenix AZ 85016-4702. (602)224-0500. Fax: (602)224-0507. Art and Production Director: Susan Robbins. Bimonthly consumer magazine with emphasis on sports and recreation for the wheelchair user. Circ. 15,000. Accepts previously published artwork. Sample copies for 11 × 14 SASE and $1.45 postage. Art guidelines not available. Needs computer-literate freelancers for illustration. 50% of freelance work demands computer knowledge of Adobe Illustrator, QuarkXPress or Adobe Photoshop.

Cartoons: Approached by 10 cartoonists/year. Buys 3-5 cartoons/issue. Prefers humorous cartoons; single panel b&w line drawings with or without gagline. Send query letter with finished cartoons. Samples are filed or returned by SASE if requested by artist. Reports back within 3 months. Buys all rights. Pays $10 for b&w.

Illustrations: Approached by 5 illustrators/year. Buys 1 illustration/year. Works on assignment only. Considers pen & ink, watercolor and computer-generated. Send query letter with résumé and tearsheets. Samples are filed or returned by SASE if requested by artist. Reports back to the artist only if interested. Publication will contact artist for portfolio review if interested. Portfolio should include color tearsheets. Buys one-time rights and reprint rights. Pays on publication. Pays $250 for color cover; $25 for color inside.

Tips: Finds artists through word of mouth. Areas most open to freelancers are illustrations to establish theme for survey of lightweight-wheelchair manufacturers.

STEREOPHILE, 208 Delgado, Sante Fe NM 87501. (505)982-2366. Fax: (505)989-8791. Production Director: Reb Willard. Estab. 1962. Monthly magazine. "We're the oldest and largest subject review high-end audio magazine in the country, approx. 220 pages/month." Circ. 60,000. Accepts previously published artwork. Original artwork not returned at job's completion.

Cartoons: Send query letter with appropriate samples. Reports back only if interested. Rights purchased vary according to project. Pays $200 for b&w and color inside; $900 for cover.

Illustrations: Approached by 50 illustrators/year. Buys 3-5 illustrations/issue. Works on assignment only. Interested in all media. Send query letter with brochure and tearsheets. Samples are filed. Reports back only if interested. Portfolio should include original/final art, tearsheets or other appropriate samples. Rights purchased vary according to project. Pays on publication; $900 for color cover; $150-350 for b&w and color inside.

Tips: "Be able to turn a job in 3 to 5 days and have it look professional. Letters from previous clients to this effect help."

STL MAGAZINE: THE ART OF LIVING IN ST. LOUIS, 6996 Millbrook Blvd., St. Louis MO 63130. (314)726-7685. Fax: (314)726-0677. Creative Director: Suzanne Griffin. Art Director: Kathy Sewing. Estab. 1991. Company magazine of KETC/Channel 9. Monthly 4-color magazine and program guide going to over 50,000 members of Channel 9, a PBS station. Age group of members is between ages 35 and 64, with a household income of $50,000 average. Circ. 52,000. Accepts previously published artwork. Originals returned at job's completion. Sample copies available. Art guidelines not available. Needs computer-literate freelancers for design and production. 20% of freelance work demands computer knowledge of Adobe Illustrator, QuarkXPress or Photoshop.

Illustrations: Buys 2 illustrations/issue. Works on assignment only. Looking for unusual and artistic approaches to story illustration. Considers pen & ink, collage, acrylic, colored pencil, oil, mixed media and pastel. Send query letter with brochure, SASE, tearsheets, photographs and photocopies. Samples are filed or returned by SASE. Publication will contact artist for portfolio review if interested. Portfolio should include final art samples, color tearsheets and slides. Rights purchased vary according to project. **Pays on acceptance;** $300 for color cover; $75 for b&w, $100 for color inside.

Tips: Finds artists through word of mouth, magazines, artists' submissions/self-promotion and artists' agents and reps. Send printed samples of work to Creative or Art Director. There is no point in cold calling if we have no visual reference of the work. We have a limited budget, but a high circulation. We offer longer deadlines, so we find many good illustrators will contribute."

■**STONE SOUP, The Magazine by Children**, P.O. Box 83, Santa Cruz CA 95063. (408)426-5557. Editor: Gerry Mandel. Bimonthly 4-color magazine with "simple and conservative design" emphasizing writing and art by children through age 13. Features adventure, ethnic, experimental, fantasy, humorous and science fiction articles. "We only publish writing and art by children through age 13. We look for artwork that reveals that the artist is closely observing his or her world." Circ. 24,000. Original artwork is returned after publication. Sample copies available for $3. Art guidelines for SASE with first-class postage.
Illustrations: Buys 8 illustrations/issue. Prefers complete and detailed scenes from real life. Send query letter with photostats, photocopies, slides and photographs. Samples are filed or are returned by SASE. Reports back within 1 month. Buys all rights. Pays on publication; $25 for color cover; $8 for b&w or color inside.
Tips: "We accept artwork by children only, through age 13."

‡**STRAIGHT**, 8121 Hamilton Ave., Cincinnati OH 45231. (513)931-4050. Fax: (513)931-0994. Editor: Carla J. Crane. Estab. 1950. Weekly Sunday school take-home paper for Christian teens ages 13-19. Circ. 45,000. Sample copies for #10 SASE with first-class postage. Art guidelines for SASE with first-class postage.
Illustrations: Approached by 40-50 illustrators/year. Buys 50-60 illustrations/issue. Prefers realistic and cartoon. Considers pen & ink, watercolor, collage, airbrush, colored pencil and oil. Send query letter with brochure and tearsheets. Samples are filed. Reports back to the artist only if interested. Portfolio review not required. Buys all rights. **Pays on acceptance.** Pays $250 for color cover; $150 for color inside.
Tips: Finds artists through artists' submissions, other publications and word of mouth. Areas most open to freelancers are "realistic and cartoon illustrations for our stories and articles."

■**THE STRAIN**, Box 330507, Houston TX 77233-0507. (713)738-4887. Articles Editor: Alicia Adler. Estab. 1987. Monthly literary magazine and interactive arts publication. "The purpose of our publication is to encourage the interaction between diverse fields in the arts and (in some cases) science." Circ. 1,000. Accepts previously published artwork. Original artwork is returned to the artist at the job's completion. Sample copy for $5 plus 9×12 SAE and 7 first-class stamps.
Cartoons: Send photocopies of finished cartoons with SASE. Samples not filed are returned by SASE. Reports back within "2 years on submissions." Buys one-time rights or negotiates rights purchased.
Illustrations: Buys 2-10 illustrations/issue. "We look for works that inspire creation in other arts." Send work that is complete in any format. Samples are filed "if we think there's a chance we'll use them." Those not filed are returned by SASE. Publication will contact artist for portfolio review if interested. Portfolio should include final art or photographs. Negotiates rights purchased. Pays on publication; $10 for b&w, $5 for color cover; $10 for b&w, $5 for color inside.

‡**STUDENT LEADERSHIP JOURNAL**, P.O. Box 7895, Madison WI 53707-7895. (608)274-9001. Fax: (608)274-7882. Editor: Jeff Yourison. Estab. 1988. Quarterly nonprofit organizational journal. "Offers training, encouragement and news to college-age student leaders of Christian fellowship groups, specifically those affiliated with InterVarsity. Circ. 8,000. Originals returned at job's completion. Sample copies available for $3. Art guidelines not available. Needs computer-literate freelancers for illustration and production. 50% of freelance work demands computer knowledge of CorelDRAW or QuarkXPress.
Cartoons: Approached by 2-4 cartoonists/year. Buys 2-3 cartoons/issue. Prefers campus-related, cultural commentary; humorous insight; single and multiple panel b&w line drawings with gagline. Send query letter with brochure, roughs and past clips or tearsheets. Samples are filed or returned by SASE if requested by artist. Reports back to the artist only if interested. Rights purchased vary according to project. Pays $50 for b&w.
Illustrations: Approached by 1-2 illustrators/year. Buys 1-3 illustrations/year. Works on assignment only. Prefers scratchboard, line drawings, "some computer-generated stuff" that is generally symbolic; illustrative of key moods and themes. Considers pen & ink and scratchboard. Send query letter with brochure, SASE, tearsheets and photocopies. Samples are filed or returned by SASE if requested by artist. Publication will contact artist for portfolio review if interested. Portfolio should include thumbnails and tearsheets. Rights purchased vary according to project. Pays on publication. Pays $100-150 for b&w cover; $50-75 for b&w inside.
Tips: Finds artists through "our designer, who knows a lot of beginning artists. Cartoonists are found by sheer luck, or pursued once we see good work. Please try to understand our university audience. They are sophisticated yet young, fragile and occasionally cynical or suspicious. We strive for empathy and support, helping students to look at themselves with insight and humor."

■**SUMMIT: THE MOUNTAIN JOURNAL**, 1221 May St., Hood River OR 97031. Art Director: Adele Hammond. Estab. 1990. Literary magazine. Circ. 30,000. Sample copies for SASE with first class postage and $6. Art guidelines for SASE with first-class postage.
Cartoons: Approached by 5 cartoonist/year. Buys 3-5 cartoons/year. Prefers single panel, b&w washes and line drawings. Send query letter with finished cartoons. Samples are filed. Reports back within 3 weeks. Buys one-time rights. Pays $50 for b&w.

Illustrations: Approached by 10 illustrators/year. Buys 5-10 illustrations/issue. Considers pen & ink, watercolor, collage, colored pencil, oil, charcoal, mixed media and pastel. Send query letter with résumé and tearsheets. Samples are filed. Reports back with 3 weeks. Call for appointment to show portfolio. Portfolio should include final art, tearsheets photographs and slides. Buys one-time rights. Pays on publication; $50-200 for b&w and color inside.

Tips: "Study the magazine for its spirit and focus. Only illustrations/cartoons relating to mountains will be considered."

THE SUN, 107 N. Roberson, Chapel Hill NC 27516. (919)942-5282. Editor: Sy Safransky. Monthly magazine of ideas. Circ. 20,000. Accepts previously published material. Original artwork returned after publication. Sample copy for $3.50. Art guidelines for SASE with first-class postage.

Cartoons: "We accept very few cartoons." Material not kept on file is returned by SASE. Reports within 3 months. Buys first rights. Pays $25 plus copies and subscription.

Illustrations: Send query letter with samples. Needs illustrations that reproduce well in b&w. Accepts abstract and representational work. Samples not filed are returned by SASE. Reports within 3 months. Buys one-time rights. Pays on publication; $25 and up for inside; $50 for cover; plus copies and subscription.

‡TAMAQUA, C120, Parkland College, 2400 W. Bradley Ave., Champaign IL 61820-1899. (217)351-2217. Fax: (217)351-2581. Editor-in-Chief: Bruce Morgan. Estab. 1989. A literary/arts magazine published twice yearly for a literary audience. "Our only guiding rule is to publish the best fiction, poetry, nonfiction, and art that we receive." Circ. 1,800. Sample copies available for $6. Art guidelines for SASE with first-class postage.

Illustrations: Approached by 50-150 illustrators/year. Buys 18-32 illustrations/issue. No restrictions on themes, style or media. Send query letter with SASE, tearsheets, photographs, slides and transparencies. Samples are filed. Reports back within 4 months. Request portfolio review in original query. Publication will contact artist for portfolio review if interested. Portfolio should include b&w and color tearsheets, slides, final art and photographs. Rights purchased vary according to project. Pays on publication; $20-50 for b&w cover; $10-20 for b&w/color inside.

Tips: Finds artists through recommendations from artists, critics, curators, etc. "Nothing replaces knowledge of the market; hence study *Tamaqua* and/or similar publications, to discern the difference between good, solid, intelligent literature/art and that which is not."

TAMPA BAY MAGAZINE, 2531 Landmark Dr., Clearwater FL 34621. (813)791-4800. Editor: Aaron Fodiman. Estab. 1986. Bimonthly local lifestyle magazine with upscale readership. Circ. 35,000. Accepts previously published artwork. Sample copy available for $4.50. Art guidelines not available.

Cartoons: Approached by 30 cartoonists/year. Buys 6 cartoons/issue. Prefers single panel color washes with gagline. Send query letter with finished cartoon samples. Samples are not filed and are returned by SASE if requested. Buys one-time rights. Pays $15 for b&w, $20 for color.

Illustrations: Approached by 100 illustrators/year. Buys 5 illustrations/issue. Prefers happy, stylish themes. Considers watercolor, collage, airbrush, acrylic, marker, colored pencil, oil and mixed media. Send query letter with photographs and transparencies. Samples are not filed and are returned by SASE if requested. To show a portfolio, mail color tearsheets, slides, photocopies, finished samples and photographs. Buys one-time rights. Pays on publication; $150 for color cover; $75 for color inside.

‡■TAMPA REVIEW, The University of Tampa, 19F, Tampa FL 33606-1490. Editor: Richard Mathews. Estab. 1988. Biannual literary magazine. "*Tampa Review* publishes outstanding works of poetry, fiction, nonfiction and art from the US and abroad." Circ. 500. Black and white with 4-color cover, text pages single 6″ wide columns in Palatino. Art presented on single pages, usually full page. "We prefer vertical works to fill page." Accepts previously published artwork. Original artwork is returned at job's completion. Sample copy for $5. Art guidelines available.

Illustrations: Buys 6 freelance illustrations/issue. Prefers contemporary work. Considers pen & ink, acrylic, oil, charcoal, photography, mixed media. Send query letter with résumé, SASE, photographs, slides or PMTs January through March. Submissions are held through April, then returned by SASE if requested by artist. Reports back within 3 months if interested. Portfolio review not required. Buys one-time rights. Pays $10 for color, cover; $10 for b&w.

Tips: "Send us high quality work sharply reproduced. We use museum-quality art, often working directly through museums and art galleries, but welcome submissions from artists."

‡TECHNICAL ANALYSIS OF STOCKS & COMMODITIES, 4757 California Ave. SW, Seattle WA 98116-4499. (206)938-0570. Publisher: Jack K. Hutson. Estab. 1982. Monthly traders' magazine for stocks, bonds, futures, commodities, options, mutual funds. Circ. 40,000. Accepts previously published artwork. Sample copies available for $5. Art guidelines for SASE with first-class postage. Needs computer-literate freelancers for production. 10% of freelance work demands computer knowledge of Aldus PageMaker or Adobe Photoshop.

Cartoons: Approached by 10 cartoonists/year. Buys 1 cartoon/issue. Prefers humorous cartoons, single panel b&w line drawings with gagline. Send query letter with finished cartoons. Samples are filed or are returned

by SASE if requested by artist. Reports back within 3 weeks. Buys one-time rights or reprint rights. Pays $30 for b&w.

Illustrations: Approached by 25 illustrators/year. Buys 6 illustrations/issue. Works on assignment only. Send query letter with brochure, tearsheets, photographs, photocopies, photostats, slides. Samples are filed or are returned by SASE if requested by artist. Reports back within 3 weeks. Publication will contact artist for portfolio review if interested. Portfolio should include b&w and color tearsheets, slides, photostats, photocopies, final art and photographs. Buys one-time rights and reprint rights. Pays on publication; $160 for color cover; $70 for b&w, $120 for color inside.

Tips: Areas most open to freelancers are caricatures with market charts or computers.

© 1993 Ismael Roldan

After researching newsstands and reading Artist's & Graphic Designer's Market,
Ismael Roldan created a 9×12 full-color mailer to send to prospective markets.
Through this self-promotion, he was commissioned to create an illustration for a
short piece in Tennis magazine about Las Vegas, Andre Agassi's hometown, renaming
two streets after the star.

TENNIS, Dept. AM, 5520 Park Ave., Trumbull CT 06611. (203)373-7000. Art Director: Lori Wendin. For young, affluent tennis players. Monthly. Circ. 750,000.

Illustrations: Works with 15-20 illustrators/year. Buys 50 illustrations/year. Uses artists mainly for spots and openers. Works on assignment only. Send query letter with tearsheets. Mail printed samples of work. **Pays on acceptance;** $400-800 for color.

Tips: "Prospective contributors should first look through an issue of the magazine to make sure their style is appropriate for us."

‡TEXAS CONNECTION MAGAZINE, P.O. Box 541805, Dallas TX 75354-1805. (214)951-0316. Fax: (214)951-0349. Editor: Nanci Drewer. Estab. 1988. Monthly adult magazine. Circ. 25,000. Originals returned at job's completion. Sample copies available for $10. Art guidelines available for SASE with first-class postage.

Cartoons: Buys 4-6 cartoons/issue. Prefers adult; single panel b&w washes and line drawings with gagline. Send query letter with finished cartoons. Samples are filed or not filed at artist's request. Samples are returned. Reports back to the artist only if interested. Buys first rights. Pays $25 for b&w.

Illustrations: Approached by 12 illustrators/year. Buys 12 illustrations/issue. Prefers adult. Send query letter with photocopies. Samples are not filed or are returned. Publication will contact artist for portfolio review

if interested. Portfolio should include b&w and color photocopies and final art. Buys one-time rights. Pays on publication; $50 for b&w, $100 for color inside.

Tips: Finds artists through artists' submissions. Areas most open to freelancers are "adult situations normally—some editorial and feature illustrations."

■**THE TEXAS OBSERVER,** 307 W. Seventh, Austin TX 78701. (512)477-0746. Contact: Editor. Estab. 1954. Biweekly b&w magazine emphasizing Texas political, social and literary topics. Circ. 10,000. Accepts previously published material. Returns original artwork after publication. Sample copy for SASE with postage for 2 ounces; art guidelines for SASE with first-class postage.

Cartoons: "Our style varies; content is political/satirical or feature illustrations." Also uses caricatures.

Illustrations: Buys 4 illustrations/issue. Needs editorial illustration with political content. "We only print b&w, so pen & ink is best; washes are fine." Send photostats, tearsheets, photocopies, slides or photographs to be kept on file. Samples not filed are returned by SASE. Reports within 1 month. Request portfolio review in original query. Buys one-time rights. Pays on publication; $50 for b&w cover; $25 for inside.

Tips: "No color. We use mainly local artists usually to illustrate features. We also require a fast turnaround."

■**THEDAMU ARTS MAGAZINE,** 13217 Livernois, Detroit MI 48238-3162. (313)931-3427. Publisher: David Rambeau. Estab. 1970. Monthly b&w "general adult multi-disciplinary urban arts magazine." Circ. 1,000. Accepts previously published artwork. Send copies only. Sample copies and art guidelines for SASE with first-class postage.

Cartoons: Approached by 5-10 cartoonists/year. "We do special cartoon issues featuring a single artist like a comic book (40-80, 8×11 horizontal drawings) with adult, urban, contemporary themes with a storyline that can be used or transferred to video and would fill 7 tab pages and a cover." Prefers b&w or color line drawings. Send query letter with 3-6 cartoons. Reports back within 3 months only if interested. Buys one-time rights usually, but rights purchased sometimes vary according to project. Pays $25 for b&w and color.

Tips: Finds artists through word of mouth and other magazines. "We're the first or second step on the publishing ladder for artists and writers. Submit same work to others also. Be ready to negotiate. I see electronic computer bulletin board magazines ahead. More small (500-1,000 copies) magazines given computer advances, linkages with video, particularly with respect to cartoons."

‡**THEMA,** Box 74109, Metairie LA 70033-4109. (504)568-6268. Editor: Virginia Howard. Estab. 1988. Triquarterly. Circ. 300. Sample copies are available for $8. Art guidelines for SASE with first-class postage. Needs computer-literate freelancers for illustration. Freelancers should be familiar with CorelDRAW.

● Each issue of *Thema* is based on a different, unusual theme, such as "Is it a Fossil, Higgins?" Upcoming themes and deadlines include "Three by a Tremor Tossed" (November, 1994); "Laughter on the Steps" (March 1, 1995); "A Solitary Clue" (July 1, 1995) and "Jogging on Ice" (November 1, 1995).

Cartoons: Approached by 10 cartoonists/year. Buys 1 cartoon/issue. Preferred themes are specified for individual issue (see Tips). Prefers humorous cartoons; b&w line drawings without gagline. Send query letter with finished cartoons. Samples are filed or are returned by SASE if requested by artist. Buys one-time rights. Pays $10 for b&w.

Illustrations: Approached by 10 illustrators/year. Buys 1 illustration/issue. Preferred themes are specified for target issue (see Tips). Considers pen & ink. Send query letter with SASE. Samples are returned by SASE if requested by artist. Portfolio review not required. Buys one-time rights. **Pays on acceptance;** $10 for b&w inside.

Tips: Finds artists through word of mouth. "Generally, artwork goes on the left-hand page facing the first story. It should try to depict the theme for that issue. With more sumbissions, we would expand the use of art throughout the journal. Request list of upcoming themes (with SASE) before submitting work. Submit b&w renderings only."

‡■**THIS: A SERIAL REVIEW,** 6600 Clough Pike, Cincinnati OH 45244-4090. Fine Arts Editor: Phillip Roberto. Estab. 1994. Triquarterly literary/arts journal. Sample copies available for $7. Art guidelines available for SASE with first-class postage.

Cartoons: Prefers all formats. Send query letter with roughs and finished cartoons. Samples are not filed and are returned by SASE. Reports back within 3 months. Negotiates rights acquired.

Illustrations: Approached by 40 illustrators/year. Considers all media. Send query letter with SASE, tearsheets, photographs, photocopies, photostats, slides and transparencies. Samples are returned by SASE. Reports back within 3 months. Publication will contact artist for portfolio review if interested. Negotiates rights acquired. Pays on publication 2 copies of issue in which illustration appears.

Tips: "*THIS* is a new literary journal. We seek all types of illustration for possible inclusion."

THRASHER, 1303 Underwood Ave., San Francisco CA 94124. (415)822-3083. Fax: (415)822-8359. Contact: Managing Editor. Estab. 1981. Monthly 4-color magazine. "*Thrasher* is the dominant publication devoted to the latest in extreme youth lifestyle, focusing on skateboarding, snowboarding, new music, videogames, etc." Circ. 200,000. Accepts previously published artwork. Originals returned at job's completion. Sample copies

for SASE with first-class postage. Art guidelines not available. Needs computer-literate freelancers for illustration. Freelancers should be familiar with Adobe Illustrator or Photoshop.

Cartoons: Approached by 100 cartoonists/year. Buys 2-5 cartoons/issue. Prefers skateboard, snowboard, music, youth-oriented themes. Send query letter with brochure and roughs. Samples are filed and are not returned. Reports back to the artist only if interested. Rights purchased vary according to project. Pays $50 for b&w, $75 for color.

Illustrations: Approached by 100 illustrators/year. Buys 2-3 illustrations/issue. Prefers themes surrounding skateboarding/skateboarders, snowboard/music (rap, hip hop, metal) and characters and commentary of an extreme nature. Prefers pen & ink, collage, airbrush, marker, charcoal, mixed media and computer media (Mac format). Send query letter with brochure, résumé, SASE, tearsheets, photographs and photocopies. Samples are filed. Publication will contact artist for portfolio review if interested. Portfolio should include b&w and color tearsheets, photocopies and photographs. Rights purchased vary according to project. Negotiates payment for covers. Sometimes requests work on spec before assigning job. Pays on publication; $75 for b&w, $100 for color inside.

Tips: "Send finished quality examples of relevant work with a bio/intro/résumé that we can keep on file and update contact info. Artists sometimes make the mistake of submitting examples of work that are inappropriate to the content of the magazine. Buy/borrow/steal an issue and do a little research. Read it. Desktop publishing is now sophisticated enough to replace all high-end prepress systems. Buy a Mac. Use it. Live it."

‡■**TODAY'S FIREMAN,** Box 875108, Los Angeles CA 90087. Editor: Don Mack. Estab. 1960. Quarterly b&w trade tabloid featuring general interest, humor and technical articles and emphasizing the fire service. "Readers are firefighters—items should be of interest to the fire service." Circ. 10,000. Accepts previously published material. Original artwork is not returned after publication.

Cartoons: Buys 12 cartoons/year from freelancers. Prefers fire-service oriented single panel with gagline; b&w line drawings. Send query letter with samples of style, roughs or finished cartoons. Reports back only if interested. Buys one-time rights. Pays $4.

TOLE WORLD, 1041 Shary Circle, Concord CA 94518. (510)671-9852. Editor: Judy Swager. Estab. 1977. Bimonthly 4-color magazine with creative designs for decorative painters. "*Tole* incorporates all forms of craft painting including folk art. Manuscripts on techniques encouraged." Circ. 100,000. Accepts previously published artwork. Original artwork returned after publication. Sample copies and art guidelines available.

Cartoons: Buys 3-6 cartoons/year. Prefers simple, tasteful, traditional, jocular. Prefers single, double or multiple panel b&w line drawings and washes with or without gagline. Send roughs. Samples are not filed and are returned only by SASE. Reports back regarding queries/submissions within 1 month. Buys first rights. Pays $25 for b&w.

Illustrations: Buys illustrations mainly for step-by-step project articles. Buys 8-10 illustrations/issue. Prefers acrylics and oils. Considers alkyds, pen & ink, mixed media, colored pencil, watercolor and pastels. Needs editorial and technical illustration. Send query letter with photographs. Samples are not filed and are returned. Reports back about queries/submissions within 1 month. Pays $150 for color cover; $25-100 b&w, $150 for color inside.

Tips: "Submissions should be neat, evocative and well-balanced in color scheme with traditional themes, though style can be modern."

‡■**TQ,** Suite 137, 2845 W. Airport Freeway, Irving TX 75062. (214)570-7599. Art Director: Rebekah Lyon. "Our main purpose is to help Christian teens live consistently for Christ, and to help them grow in their knowledge of the Bible and its principles for living"; 4-color monthly magazine, "lively, fun design." Circ. 50,000. Accepts previously published artwork. Original artwork returned after publication. Free sample copy. Needs computer-literate freelancers for illustration. 10% of freelance work demands computer literacy in Adobe Illustrator or Aldus FreeHand.

Cartoons: Managing Editor: Chris Lyon. Buys 2-3 cartoons/issue from freelancers. Receives 4 submissions/week from freelancers. Interested in wholesome offbeat humor for teens; prefer cartoons with teens as main characters; single panel. Prefers to see finished cartoons. Reports in 6 weeks. Buys first rights on a work-for-hire basis. Pays $25, b&w; $50, color cartoons.

Illustrations: Some illustrations purchased on assignment only. Needs illustration for fiction stories, comedic with teen appeal. Submit samples with query letter. Artist should follow up with letter after initial query. Publication will contact artist for portfolio review if interested. Sometimes requests work on spec before assigning job. Pays $500 for color cover; $250 for color inside.

‡■**TRADITION,** Box 438, Walnut IA 51577. (712)366-1136. Editor-in-Chief/Art Director: Robert Everhart. "For players and listeners of traditional and country music. We are a small bimonthly nonprofit publication and will use whatever is sent to us. A first-time gratis use is the best way to establish communication." Circ. 2,500. Previously published work OK. Sample copy $1 to cover postage and handling.

Cartoons: Buys 1 cartoon/issue from freelancers on country music; single panel with gagline. Receives 10-15 cartoons/week from freelance artists. To show a portfolio, mail roughs. Pays on publication; $5-15, b&w line drawings.

Illustrations: Buys 1 illustration/issue from freelancers on country music. Query with résumé and samples. Send SASE. Buys one-time rights. Pays on publication; $5-15, b&w line drawings, cover; $5-15, b&w line drawings, inside. Reports in 1 month.

Tips: "We'd like to see an emphasis on traditional country music."

TRAINING Magazine, The Human Side of Business, 50 S. Ninth St., Minneapolis MN 55402. (612)333-0471. Fax: (612)333-6526. Art Director: Jodi Boren Scharff. Estab. 1964. Monthly 4-color trade journal covering job-related training and education in business and industry, both theory and practice. Audience: training directors, personnel managers, sales and data processing managers, general managers, etc. "We use a variety of styles, but it is a business-looking magazine." Circ. 51,000. Sample copies for SASE with first-class postage. Art guidelines not available.

Cartoons: Approached by 20-25 cartoonists/year. Buys 1-2 cartoons/issue. "We buy a wide variety of styles. The themes relate directly to our editorial content, which is training in the workplace." Prefers single panel, b&w line drawings or washes with and without gagline. Send query letter with brochure and finished cartoons. Samples are filed or are returned by SASE if requested by artist. Reports back within 1 month. Buys first rights or one-time rights. Pays $25 for b&w.

Illustrations: Buys 6-8 illustrations/issue. Works on assignment only. Prefers themes that relate directly to editorial content. Styles are varied. Considers pen & ink, airbrush, mixed media, watercolor, acrylic, oil, pastel and collage. Send query letter with brochure, résumé, tearsheets, photocopies and photostats. Samples are filed or are returned by SASE if requested by artist. Reports back to the artist only if interested. Call or write for appointment to show portfolio, which should include final art and b&w and color tearsheets, photostats, photographs, slides and photocopies. Buys first rights or one-time rights. **Pays on acceptance:** $500 and up for color cover; $75-200 for b&w, $200-250 for color inside.

Tips: "Show a wide variety of work in different media and with different subject matter. Good renditions of people are extremely important."

■**TRANSITIONS ABROAD: The Magazine of Overseas Opportunities**, 18 Hulst Rd., Box 1300, Amherst MA 01004. Editor: Clayton A. Hubbs. Bimonthly b&w magazine with 2-color cover emphasizing "educational, low-budget and special interest overseas travel for those who travel to learn and to participate." Circ. 15,000. Accepts previously published artwork. Original artwork returned after publication. Sample copy for $3.50; art guidelines for SASE.

Illustrations: Buys 3 illustrations/issue. Especially needs illustrations of American travelers and natives in overseas settings (work, travel and study). Send roughs to be kept on file. Samples not filed are returned by SASE. Reports in 1 month. Request portfolio review in original query. Buys one-time rights. Pays on publication; $25-100 for b&w line drawings, $100 for color, inside; $30-150 for b&w washes, $250 color, cover.

Tips: "There is more interest in travel which involves interaction with people in the host country, with a formal or informal educational component. We usually commission graphics to fit specific features. Inclusion of article with graphics increases likelihood of acceptance. Study the publication and determine its needs."

‡**TRIQUARTERLY**, 2020 Ridge Ave., Evanston IL 60208-4302. (708-491-3490. Fax: (708)467-2096. Editor: Reginald Gibbons. Estab. 1964. Triquarterly literary magazine, "dedicated to publishing writing and graphics which are fresh, adventureous, artistically challenging and never predictable." Circ. 5,000. Originals returned at job's completion. Sample copies for $4. Art guidelines not available.

Illustrations: Approached by 3-4 illustrators/year. Considers only work that can be reproduced in b&w as line art or screen for pages; all media; 4-color for cover. Send query letter with SASE, tearsheets, photographs, photocopies and photostats. Samples are filed or are returned by SASE. Reports back within 3 months (if SASE is supplied). Publication will contact artist for portfolio review if interested. Portfolio should include b&w and color thumbnails, tearsheet, slides, photostats, photocopies, final art and photographs. Buys first rights. Pays on publication; $300 for b&w/color cover; $30 for b&w inside.

■**TRUE WEST/OLD WEST**, Box 2107, Stillwater OK 74076. (405)743-3370. Editor: John Joerschke. Monthly/quarterly b&w magazine with 4-color cover emphasizing American Western history from 1830 to 1910. For a primarily rural and suburban audience, middle-age and older, interested in Old West history, horses, cowboys, art, clothing and all things Western. Circ. 30,000. Accepts previously published material and considers some simultaneous submissions. Original artwork returned after publication. Sample copy for $2. Art guidelines for SASE.

Illustrations: Approached by 75 illustrators/year. Buys 5-10 illustrations/issue (2 or 3 humorous). "Inside illustrations are usually, but not always, pen & ink line drawings; covers are Western paintings." Send query letter with samples to be kept on file; "We return anything on request. For inside illustrations, we want samples of artist's line drawings. For covers, we need to see full-color transparencies." Publication will contact artist for portfolio review if interested. Buys one-time rights. Sometimes requests work on spec before assigning job. Pays $100-150 for color transparency for cover; $20-50 for b&w inside. "**Pays on acceptance for new artists, on assignment for established contributors.**"

Tips: "We think the mainstream of interest in Western Americana has moved in the direction of fine art, and we're looking for more material along those lines. Our magazine has an old-fashioned Western history

design with a few modern touches. We use a wide variety of styles so long as they are historically accurate and have an old-time flavor."

TURTLE MAGAZINE FOR PRESCHOOL KIDS, 1100 Waterway Blvd., Box 567, Indianapolis IN 46206. (317)636-8881. Art Director: Bart Rivers. Estab. 1979. Emphasizes health, nutrition, exercise and safety for children 2-5 years; 4-color. Published 8 times/year. Original artwork not returned after publication. Sample copy for $1.25; art guidelines for SASE. Needs computer-literate freelancers familiar with Aldus FreeHand and Photoshop for illustrations.
Illustrations: Approached by 100 illustrators/year. Works with 20 illustrators/year. Buys 15-30 illustrations/issue. Interested in "stylized, humorous, realistic and cartooned themes; also nature and health." Works on assignment only. Send query letter with résumé, photostats or good photocopies, slides and tearsheets. Samples are filed or are returned by SASE. Reports only if interested. Portfolio review not required. Buys all rights. Pays on publication; $275 for cover; $80-190 for pre-separated 4-color, $70-155 for 4-color, $60-120 for 2-color; $35-90 for b&w inside.
Tips: Finds most artists through samples received in mail. "Familiarize yourself with our magazine and other children's publications before you submit any samples. The samples you send should demonstrate your ability to support a story with illustration."

TWINS MAGAZINE, Suite 155, 6740 Antioch, Merriam KS 66204. (913)722-1090. Fax: (913)722-1767. Art Director: Cindy Himmelberg. Estab. 1984. Bimonthly 4-color international magazine designed to give professional guidance to multiples, their parents and professionals who care for them. Circ. 55,000. Sample copies available. Art guidelines for SASE with first-class postage.
Cartoons: Pays $25 for b&w, $50 for color.
Illustrations: Approached by 10 illustrators/year. Buys 10 illustrations/issue. Works on assignment only. Prefers children (twins) in assigned situations. Considers watercolor, airbrush, acrylic, marker, colored pencil and pastel. Send query letter with résumé, tearsheets, photocopies, slides. Samples are filed or returned by SASE if requested by artist. Request portfolio in original query. Reports back to the artist only if interested. Portfolio should include final art, color tearsheets, photographs and photocopies. Buys all rights. Pays on publication; $100 for color cover; $75 for color inside.
Tips: Finds artists through artists' submissions.

‡2 AM MAGAZINE, Box 6754, Rockford IL 61125-1754. Publisher: Gretta M. Anderson. Estab. 1986. Quarterly literary magazine featuring stories and reviews, primarily horror, science fiction and fantasy. Circ. 1,200. Originals returned at job's completion. Sample copies available for $4.95 and $1.16 postage. Art guidelines for SASE with first-class postage.
Illustrations: Approached by 30 illustrators/year. Buys 5 illustrations/issue. Works mostly on assignment. Considers pen & ink, airbrush, marker, charcoal and mixed media. Send query letter with SASE, photographs, photocopies, slides and transparencies—"whatever is convenient." Samples are filed or are returned by SASE if requested by artist. Reports back within 3 months. Publication will contact artist for portfolio review if interested. Portfolio should include b&w photocopies. Buys first rights. **Pays on acceptance;** $20 for b&w cover; $8 for b&w inside.
Tips: Finds artists through artists' submissions. "Interior art most open to new artists, chosen by story and samples on file. Only publishes b&w line art. Looking for uniqueness and polish."

‡VEGETARIAN JOURNAL, P.O. Box 1463, Baltimore MD 21203-1463. (410)366-8343. Editor: Debra Wasserman. Estab. 1982. Bimonthly nonprofit vegetarian magazine that examines the health, ecological and ethical aspects of vegetarianism. "Highly educated audience including health professionals." Circ. 27,000. Accepts previously published artwork. Originals returned at job's completion upon request. Sample copies available for $3.
Cartoons: Approached by 4 cartoonists/year. Buys 1 cartoon/issue. Prefers humorous cartoons; single panel b&w line drawings. Send query letter with roughs. Samples are not filed and are returned by SASE if requested by artist. Reports back within 2 weeks. Rights purchased vary according to project. Pays $25 for b&w.
Illustrations: Approached by 20 illustrators/year. Buys 6 illustrations/issue. Works on assignment only. Prefers strict vegetarian food scenes (no animal products). Considers pen & ink, watercolor, collage, charcoal and mixed media. Send query letter with photostats. Samples are not filed and are returned by SASE if requested by artist. Reports back within 2 weeks. Portfolio review not required. Rights purchased vary according to project. **Pays on acceptance;** $25 for b&w/color inside.
Tips: Finds artists through word of mouth and job listings in art schools. Areas most open to freelancers are recipe section and feature articles. "Review magazine first to learn our style. Send query letter with photocopy sample of line drawings of food."

‡■VELONEWS, 1830 N. 55th St., Boulder CO 80301. (303)440-0601. Fax: (303)444-6788. Art Director: Charles Chamberlin. Estab. 1972. Consumer magazine; tabloid format; timely coverage of bicycle racing (no tours, triathlons or fun rides). Occasional features on people and subjects related to racing. Published 8

times/year. Circ. 45,000. Original artwork returned at job's completion. Sample copies available for $6. Art guidelines not available.

Cartoons: Approached by 5-10 freelance cartoonists/year. Buys 1 freelance cartoon/issue. Prefers "pointed commentary on issues relating to bicycle racing"; single panel with gagline, b&w washes. Send query letter with finished cartoons. Samples are filed or are returned by SASE. Reports back only if interested. Buys one-time rights. Pays $35, b&w, $75, color.

Illustrations: Approached by 10-20 freelance illustrators/year. Works on assignment only. Considers pen & ink, watercolor, marker and color pencil. Send query letter with SASE and photocopies. Samples are filed or are returned by SASE. Reports back only if interested. To show a portfolio, mail roughs and b&w photocopies. Buys one-time rights. Pays on publication; $40, b&w, $70, color, cover; $40, b&w, $70, color, inside.

Tips: "Our stock in trade is timeliness, so an artist must be willing to work quickly. Knowledge of the sport of bicycle racing is essential. We have plenty of interview features, so a good caricaturist could break in without much difficulty."

VENTURE, Box 150, Wheaton IL 60189. (708)665-0630. Art Director: Robert Fine. Estab. 1959. Bimonthly 2-color magazine for boys 10-15. "Our aim is to promote Christian values and awareness of social and ethical issues." Circ. 20,000. Accepts previously published artwork. Original artwork returned after publication. Sample copy $1.85 with large SASE; art guidelines for SASE.

Cartoons: Send to attention of cartoon editor. Approached by 20 cartoonists/year. Buys 1-3 cartoons/issue on nature, family life, sports, school, camping, hiking. Prefers single panel with gagline. Send finished cartoons. Include SASE. Reports in 1 month. Buys first-time rights. **Pays on acceptance**; $30 minimum.

Illustrations: Approached by 50 illustrators/year. Buys 3-4 illustrations/issue. Subjects include education, nature, family life, sports and camping; b&w only. Works on assignment only. Send business card, tearsheets and photocopies of samples to be kept on file for future assignments. Samples returned by SASE. Publication will contact artist for portfolio review if interested. Buys one-time rights. Pays on publication; $100 minimum for b&w cover; $85-185 for b&w inside.

VERMONT MAGAZINE, P.O. Box 288, 14 School St., Bristol VT 05443. (802)453-3200. Fax: (802)453-3940. Art Director: Elaine Bradley. Estab. 1989. Bimonthly regional publication "aiming to explore what life in Vermont is like: its politics, social issues and scenic beauty." Circ. 50,000. Accepts previously published artwork. Original artwork returned at job's completion. Sample copies and art guidelines for SASE with first-class postage.

Illustrations: Approached by 100-150 illustrators/year. Buys 2-3 illustrations/issue. Works on assignment only. "Particularly interested in creativity and uniqueness of approach." Considers pen & ink, watercolor, colored pencil, oil, charcoal, mixed media and pastel. Send query letter with tearsheets, "something that I can keep." Materials of interest are filed. Publication will contact artist for portfolio review if interested. Portfolio should include final art and tearsheets. Buys one-time rights. Considers buying second rights (reprint rights) to previously published work. Pays $800 for color cover; $250 for b&w, $600 for color inside depending on assignment and size.

Tips: Finds artists mostly through submissions/self-promos and from other art directors. "Please send me a personalized note that indicates you've seen our magazine and you think your artwork would fit in; give reasons. Handwritten and informal is just fine. We will continue to see lean times in the magazine field. Assignment fees for most magazines will probably stay where they are for awhile and contributors who are unwilling to work in this tough market will probably lose jobs. In return, art directors will begin to give illustrators more creative freedom."

VETTE MAGAZINE, 299 Market St., Saddle Brook NJ 07662. (201)488-7171. Fax: (201)712-9899. Editor-in-Chief: D. Randy Riggs. Art Director: Kathleen Miller. Estab. 1976. Monthly 4-color magazine "devoted exclusively to the Corvette automobile and the hobby of Corvetting." Circ. 60,000. Original artwork returned after publication. Art guidelines not available.

Cartoons: Approached by 5 cartoonists/year. Prefers spot illustrations and humorous drawings about Corvettes or the Corvette industry. Pays $75 for b&w, $100 for color.

Illustrations: Buys illustrations mainly for spots and feature spreads. Buys 1-2 illustrations/issue. Needs editorial illustration. Works on assignment only. Considers pen & ink, airbrush, colored pencil, watercolor, acrylic, oil, pastel, marker and charcoal/pencil. Send query letter with brochure, tearsheets, photostats and photocopies. Samples not filed are returned only if requested. Publication will contact artist for portfolio review if interested. Buys first rights. Requests work on spec before assigning job. **Pays on acceptance**; $150 for b&w, $500 for color inside. "Black and white, pen & ink, spot drawings of Corvettes are encouraged. Humorous drawings are also accepted."

Tips: Finds artists through artists' submissions/self-promotions. The best way to break in is to send "spot illustrations for fillers. Major art is assigned according to articles. Label back of art with name and address. Send no originals."

VICA JOURNAL, 14001 James Monroe Hwy., Box 3000, Leesburg VA 22075. (703)777-8810. Fax: (703)777-8999. Editor: Tom Hall. Estab. 1965. Quarterly tabloid, b&w with 4-color cover and center spread. "*VICA*

Journal helps high school and post-secondary students learn about careers, educational opportunities and activities of VICA chapters. VICA is an organization of 250,000 students and teachers in trade, industrial, technical and health occupations education." Circ. 250,000. Accepts previously published artwork. Originals returned at job's completion (if requested). Sample copies available. Art guidelines not available. Needs computer-literate freelancers for design and illustration. Freelancers should be familiar with Aldus Page-Maker or Aldus FreeHand.

Illustrations: Approached by 4 illustrators/year. Works on assignment only. Prefers positive, youthful, innovative, action-oriented images. Considers pen & ink, watercolor, collage, airbrush and acrylic. Send query letter with photographs, photocopies and photostats. Samples are filed. Portfolio should include printed samples, b&w and color tearsheets and photographs. Rights purchased vary according to project. **Pays on acceptance;** $400 for color cover; $150 for b&w and $200 for color inside.

Tips: "Send samples or a brochure. These will be kept on file until illustrations are needed. Don't call! Fast turnaround helpful. Due to the unique nature of our audience, most illustrations are not re-usable; we prefer to keep art."

VIDEOMAKER MAGAZINE, Box 4591, Chico CA 95927. (916)891-8410. Fax: (916)891-8443. Art Director: Janet Souza. Monthly 4-color magazine for video camera users with "contemporary, stylish yet technical design." Circ. 150,000. Accepts previously published artwork. Original artwork returned at job's completion. Sample copies are available. Art guidelines not available. Needs computer-literate freelancers for illustration. 75% of freelance work demands knowledge of Aldus PageMaker, Adobe Illustrator or Aldus FreeHand.

Cartoons: Prefers technical illustrations with a humorous twist. Pays $30 for b&w, $800 for color.

Illustrations: Approached by 30 illustrators/year. Buys 3 illustrations/issue. Works on assignment only. Likes "illustration with a humorous twist." Considers pen & ink, airbrush, colored pencil, mixed media, watercolor, acrylic, oil, pastel, collage, marker and charcoal. Send query letter with photocopies. Samples are filed. Publication will contact artist for portfolio review. Portfolio should include thumbnails, tearsheets and photographs. Negotiates rights purchased. Sometimes requests work on spec before assigning job. Pays on publication; $30-800 for b&w, $50-1,000 for color inside. Needs editorial and technical illustration.

Tips: Finds artists through artists' submissions/self-promotions. "Read a previous article from the magazine and show how it could have been illustrated. The idea is to take highly technical and esoteric material and translate that into something the layman can understand. Since our magazine is mostly designed on desktop, we are increasingly more inclined to use computer illustrations along with conventional art. We constantly need people who can interpret our information accurately for the satisfaction of our readership."

‡■VIDEOMANIA, P.O. Box 47, Princeton WI 54968-0047. Editor/Publisher: R. Katerzynske. Estab. 1981. Bimonthly tabloid slanted for the home entertainment enthusiast. Circ. 5,000. Originals returned at job's completion. Sample copies available for $2.50. Art guidelines for SASE with first-class postage. Needs computer-literate freelancers for illustration.

Cartoons: Approached by 10 cartoonists/year. Prefers free hand—video related; b&w line drawings. Send query letter and finished cartoons. Samples are filed. Reports back within 1 month. Negotiates rights acquired. Pays negotiable contributor copies, by-lines, subscription, free ads.

Illustrations: Approached by 10 illustrators/year. Works on assignment only. Preferred themes free hand, video related. Send query letter with SASE and photocopies. Samples are filed. Reports back within 1 month. Publication will contact artist for portfolio review if interested. Portfolio should include b&w final art. Negotiates rights purchased. Pays on publication.

Tips: Finds artists through artists' submissions. Areas most open to freelancers are covers and video-related art. "Don't expect to get rich off of us. However we are more readily open to new artists."

VIRGINIA TOWN & CITY, P.O. Box 12164, Richmond VA 23241. (804)649-8471. Fax: (804)343-3758. Editor: Christine Everson. Estab. 1965. Monthly b&w magazine with 4-color cover for Virginia local government officials (elected and appointed) published by nonprofit association. Circ. 5,000. Accepts previously published artwork. Originals returned at job's completion. Sample copies available. Art guidelines not available.

Cartoons: "Currently none appear, but we would use cartoons focusing on local government problems and issues." Pays $25, b&w.

Illustrations: Publication will contact artist for portfolio review if interested. Rights purchased vary according to project. **Pays on acceptance;** $50-75 for b&w and $55 for color cover; $25-45 for b&w and $35 for color inside.

Tips: "We occasionally need illustrations of local government services. For example, police, firefighters, education, transportation, public works, utilities, cable TV, meetings, personnel management, taxes, etc. Usually b&w. Illustrators who can afford to work or sell for our low fees, and who can provide rapid turnaround should send samples of their style and information on how we can contact them."

Always enclose a self-addressed, stamped envelope (SASE) with queries and sample packages.

■VISIONS—INTERNATIONAL, THE WORLD OF ILLUSTRATED POETRY, Black Buzzard Press, 1110 Seaton Lane, Falls Church VA 22046. Editors: Bradley R. Strahan, Brad Ross and Shirley Sullivan. Emphasizes literature and the illustrative arts for "well educated, very literate audience, very much into art and poetry." Published 3 times/year. Circ. 750. Original artwork returned after publication *only if requested*. Sample copy for $3.50 (latest issue $4.50); art guidelines for SASE.
Illustrations: Approached by 40-50 illustrators/year. Acquires approximately 21 illustrations/issue. Needs poetry text illustration. Works on assignment only. Representational to surrealistic and some cubism. Black and white only. Send query letter with SASE and samples that clearly show artist's style and capability; no slides or originals. Samples not filed are returned by SASE. Reports within 2 months. Portfolio review not required. Acquires first rights. "For information of releases on artwork, please contact the editors at the above address." Pays in copies or up to $10.
Tips: "Finds new artists through our editor or people submitting samples. Don't send slides. We might lose them. We don't use color, anyway. No amateurs, because of computer publishing we'll be seeing more and more fly-by-night amateurs."

VOCATIONAL EDUCATION JOURNAL, 1410 King St., Alexandria VA 22314. (703)683-3111. Fax: (703)683-7424. Managing Editor: K. Leftwich. Estab. 1924. Monthly 4-color trade journal. "We publish articles on teaching for educators in the field of vocational education." Circ. 45,000. Accepts previously published artwork. Originals returned at job's completion. Sample copies with 9×11 SASE and first-class postage. Art guidelines not available. Needs computer-literate freelancers for illustration.
Cartoons: "We rarely use cartoons." Pays $100 for b&w, $200-300 for color.
Illustrations: Approached by 10 illustrators/year. Buys 6-8 illustrations/year. Works on assignment only. Considers pen & ink, watercolor, colored pencil, oil and pastel. Send query letter with brochure and photographs. Samples are filed. Reports back within 3 weeks. Portfolio review not required. Rights purchased vary according to project. Sometimes requests work on spec before assigning job. Pays on publication; $600-800 for color cover; $100 for b&w, $250 for color inside.

‡WASHINGTON FLYER MAGAZINE, Suite 111, 11 Canal Center Plaza, Alexandria VA 22314. (703)739-9292. Fax: (703)683-2848. Art Editor: Laurie McLaughlin. Estab. 1989. Bimonthly 4-color consumer magazine. "In-airport publication focusing on travel, transportation, trade and communications for frequent business and pleasure travelers." Circ. 150,000. Accepts previously published artwork. Original artwork is returned to the artist at the job's completion. Sample copies available. Art guidelines not available. Needs computer-literate freelancers for illustration. 20% of freelance work demands computer knowledge of QuarkXPress, Aldus FreeHand or Adobe Illustrator.
Illustrations: Approached by 100 illustrators/year. Buys 3 freelance illustrations/issue. Needs editorial illustration—"clear, upbeat, sometimes serious, positive, bright." Works on assignment only. Considers all media. Send query letter with brochure, tearsheets, photostats, photographs, slides, SASE, photocopies and transparencies. Samples are filed. Publication will contact artist for portfolio review if interested. Portfolio should include color tearsheets, photostats, photographs, slides and color photocopies. Buys reprint rights or all rights. **Pays on acceptance**; $600 for color cover; $250 for color inside.
Tips: "We are very interested in reprint rights."

WASHINGTON PHARMACIST, Suite 101, 1420 Maple Ave. SW, Renton WA 98055-3196. (206)228-7171. Fax: (206)277-3897. Publications Director: Sheri Ray. Estab. 1959. Bimonthly association trade magazine, b&w with 2- and 4-color covers, emphasizing pharmaceuticals, professional issues and management for pharmacists. Circ. 2,000. Accepts previously published artwork. Sample copies available.
Cartoons: Approached by 15 cartoonists/year. Buys fewer than 5 cartoons/year. Themes vary. Send query letter with brochure and roughs. Samples are filed. Reports back only if interested. Rights purchased vary according to project. Pays $15 minimum for b&w.
Illustrations: Approached by 15 illustrators/year. Buys 0-5 illustrations/year. Prefers pen & ink. Send query letter with brochure and photocopies. Publication will contact artist for portfolio review if interested. Rights purchased vary according to project. **Pays on acceptance**; $25 minimum cover, $15 minimum inside.
Tips: Finds artists through artists' submissions and word of mouth.

‡THE WATER SKIER, 799 Overlook Dr., Winter Haven FL 33884-1679. (813)324-4341. Fax: (813)325-8259. Editor: Greg Nixon. Estab. 1950. Bimonthly association publication covering both competitive and recreational water skiing. Circ. 35,000. Originals not returned. Sample copies available. Art guidelines not available. Needs computer-literate freelancers for illustration. 75% of freelance work demands computer knowledge of Aldus PageMaker, Adobe Photoshop or Aldus FreeHand.
Cartoons: Approached by 2 cartoonists/year. Send query letter with brochure and finished cartoons. Samples are filed. Reports back to the artist only if interested. Buys first rights.
Illustrations: Approached by 20 illustrators/year. Buys 1-2 illustrations/issue. Works on assignment only. Prefers specific to waterskiing. Considers pen & ink, watercolor and charcoal. Send query letter with résumé and tearsheets. Samples are filed. Publication will contact artist for portfolio review if interested. Portfolio

should include b&w and color tearsheets, photostats, photocopies, final art and photographs. Buys first rights. Pays on publication.

‡WEEKLY READER/SECONDARY, Weekly Reader Corp., 245 Long Hill Rd., Middletown CT 06457. (203)638-2420. Fax: (203)346-5964. Contact: Mike DiGiorgio. Estab. 1928. Educational newspaper, magazine, posters and books. *Weekly Reader* and *Secondary* periodicals have a newspaper format. The *Weekly Reader* emphasizes news and education for children 4-14. The philosophy is to connect students to the world. Publications are 4-color or 2-color; b&w with 4-color or 2-color cover. Design is "clean, straight-forward." Accepts previously published artwork. Original artwork is returned at job's completion. Sample copies are available.
Cartoons: Approached by 10 cartoonists/year. Prefers contempory, humorous line work. Preferred themes and styles vary according to the needs of the story/articles; single panel. Send query letter with printed samples. Samples filed or are returned by SASE if requested by artist. Rights purchased vary according to project. Pays $75, b&w; $250-300, color (full page).
Illustrations: Needs editorial, technical and medical illustration. Style should be "contemporary and age level appropriate for the juvenile audience. Style of Janet Hamlin, Janet Street, Joe Locco, Joe Klein and Mas Mianot." Approached by 60-70 illustrators/year. Buys more than 50/week, 2,600 illustrations/year from freelancers. Works on assignment only. Prefers pen & ink, airbrush, colored pencil, mixed media, watercolor, acrylic, pastel, collage and charcoal. Send query letter with brochure, tearsheets, slides, SASE and photocopies. Samples are filed or are returned by SASE if requested by artist. Request portfolio review in original query. Artist should follow up with letter after initial query. Pays $250, b&w, $300, color, cover; $250, b&w, $300, color, inside. Payment is usually made within 3 weeks of receiving the invoice.
Tips: Finds artists through artists' submissions/self-promotions, sourcebooks, agents and reps. "Our primary focus is the children's marketplace; figures must be drawn well if style is realistic. Art should reflect creativity and knowledge of audience's sophistication needs. Our budgets are tight and we have very little flexibility in our rates. We need artists who can work with our budgets. Still seeking out artists of all styles – professionals!"

‡WESTART, P.O. Box 6868, Auburn CA 95604-6868. (916)885-0969. Editor: Martha Garcia. Estab. 1962. Semimonthly art magazine. *WestArt* serves fine artists and craftspeople on the West Coast. Readership includes art patrons, libraries, galleries and suppliers. It features news about current and upcoming gallery exhibitions, and covers painting, ceramics, sculpture, photography, and related visual arts activities. The "Time to Show" section lists fine art competitions, as well arts and crafts shows and festivals. Circ. 5,000. Originals returned at job's completion. Sample copies and art guidelines available.
● Does not buy cartoons or illustrations, but features the work of fine artists whose work is shown on the West Coast.
Tips: All art published by *WestArt*, including cartoons and illustrations, must be included in current or upcoming West Coast exhibitions. Artists should send for a free sample copy of *WestArt* and art guidelines before submitting any information or art work. When submitting information and artwork, a SASE is required for a response.

‡WESTERN TALES MAGAZINE, P.O. Box 33842, Granada Hills CA 91394. Publisher: Dorman Nelson. Estab. 1993. Quarterly magazine featuring Western fiction and poetry. Circ. 5,000. Originals returned at job's completion. Sample copies available for $6. Art guidelines available.
Cartoons: Approached by 10 cartoonists/year. Buys 2 cartoons/issue. Prefers Western/Native American genre humorous cartoons; single panel b&w line drawings with gagline. Send query letter with roughs or finished cartoons. Samples are not filed and are returned by SASE. Reports in 2 months. Buys first rights. Pays $10-50 for b&w.
Illustrations: Approached by 10-15 illustrators/year. Buys 30 illustrations/issue. Prefers Western genre – animals, 1800s depictions, horse oriented. Considers pen & ink, watercolor and collage. Send query letter with SASE and photocopies. Samples are not filed and are returned by SASE. Reports back within 2 months. Artist should follow up with call and/or letter after initial query. Portfolio should include b&w and color roughs and final art. Buys first rights. Pays on publication; $250 for color cover.
Tips: Finds artists through word of mouth, art galleries and art shows. Work most open to freelancers is art for color cover, b&w pen & ink or brush watercolor in reference to stories and poetry.

‡THE JAMES WHITE REVIEW, P.O. Box 3356, Butler Quarter Station, Minneapolis MN 55403. (612)339-8317. Editor: Phil Willkie. Estab. 1983. Quarterly gay men's literary magazine. Circ. 4,500. Accepts previously published artwork. Originals returned at job's completion. Sample copies available for $3. Art guidelines available for SASE with first-class postage.
Cartoons: Approached by 5 cartoonists/year. Buys 1 cartoon/issue. Send query letter with finished cartoons. Reports back within 3 months. Buys first rights. Pays $25 for b&w.
Illustrations: Approached by 25 illustrators/year. Buys 12 illustrations/issue. Considers pen & ink and charcoal. Send query letter with photographs, photostats, slides and transparencies. Samples are returned by SASE. Reports back within 3 months. Portfolio review not required. Publication will contact artist for portfolio review if interested. Buys first rights. **Pays on acceptance.** Pays $50 for b&w cover; $50 for b&w inside.

WILDFIRE, P.O. Box 199, Devon PA 19333. (610)352-8882. Editor: Judith Trustone. Black and white magazine with 4-color cover emphasizing nature, Native American values, spirituality and new art topics. "We promote Native American spirituality, earth awareness, ecology, natural childbirth/raising, sexuality and relationships, alternative lifestyles, earth changes and prophecy." Circ. 50,000. Accepts previously published material. Original artwork returned to artist after publication. Sample copies $5.
Cartoons: Approached by 10-15 cartoonists/year. Buys 2 cartoons/issue. Prefers themes featuring nature vs. technology or gender issues or earth changes, "non-sarcastic." Prefers b&w line drawings or b&w washes. Send samples of style. Samples are filed or are returned by SASE if requested by artist. Reports back within 1 month. Buys first rights. Pays $20 (varies) for b&w.
Illustrations: Approached by 10-15 illustrators/year. Needs illustrations to accompany features and news bites. Send query letter with brochure. Samples are filed or are returned only if requested by artist. Publication will contact artist for portfolio review if interested. Portfolio should include b&w tearsheets. Requests work on spec before assigning job. Buys first rights. Pays $35 for b&w (variable).
Tips: Finds artists through word of mouth, freelance submissions and personal contacts.

WILSON LIBRARY BULLETIN, 950 University Ave., Bronx NY 10452. (212)588-8400. Editor: Grace Anne DeCandido. Art Director: Lynn Amos. Emphasizes the issues and the practice of library science; 4-color. "We showcase one full-page color illustration per issue." Published 10 times/year. Circ. 13,500. Free sample copy. Uses freelance artists mainly for cartoons and feature articles. Needs computer-literate freelancers for illustration. 10% of freelance work demands knowledge of Adobe Illustrator or Photoshop.
Cartoons: Approached by 25-30 cartoonists/year. Buys 2-3 cartoons/issue on education, publishing, reading, technology and libraries; single panel with gagline. Mail finished art samples and SASE. Reports back only if interested. Buys first rights. Pays on publication; $100 for b&w line drawings and washes.
Illustrations: Approached by 20-30 illustrators/year. Buys 1-2 illustrations/issue. Works on assignment only. Send query letter, business card and samples to be kept on file. Do not send original work that must be returned. Publication will contact artist for portfolio review if interested. Buys first rights. Pays on publication; $400 for color cover; $300 for color washes; $100-200 for b&w line drawings and washes inside; $25 for spot drawings.
Tips: Finds artists through self-promotion, "including a business reply postcard is helpful." Artist should have "knowledge of our publication and its needs."

‡WIN, P.O. Box 56722, Sherman Oaks CA 91413. (818)845-0325. Art Director: Cecil Suzuki. A monthly 4-color consumer magazine. "The only magazine in the country devoted to all aspects of legal gambling." Accepts previously published artwork. Original artwork returned at job's completion.
Cartoons: Buys 5-12 freelance cartoons/year. Must be gambling related, hip/insider gags. Prefers single panel, with gagline, b&w line drawings, color washes. Send query letter with finished cartoons. Samples are filed or returned by SASE if requested by artist. Reports back to the artist only if interested. Buys first rights. Pays $25/cartoon.
Illustrations: Buys 1-2 freelance illustrations/issue. Works on assignment only. Prefers a contemporary look. Considers pen & ink, watercolor, collage, airbrush, acrylic, color pencil and mixed media. "Send query letter with non-returnable promotional materials; we can't guarantee return of originals or slides." Samples are filed. Publication will contact artist for portfolio review if interested. Portfolio should include b&w and color tearsheets and slides. Buys first rights. Pays $200 color, cover; pays $100, color, inside.

WINES & VINES, 1800 Lincoln Ave., San Rafael CA 94901. (415)453-9700. Fax: (415)453-2517. Editor: Philip E. Hiaring. Monthly 4-color magazine emphasizing the grape and wine industry in North America for the trade—growers, winemakers, merchants. Circ. 4,200. Accepts previously published material. Original artwork not returned after publication.
Illustrations: Send query letter to be kept on file. Reports within 1 month. Buys first rights. **Pays on acceptance:** $50-100 for color cover; $15 for b&w inside.

■WISCONSIN REVIEW, Box 158, Radford Hall, University of Wisconsin-Oshkosh, Oshkosh WI 54901. (414)424-2267. Editor: Troy Schoultz. Triquarterly review emphasizing literature (poetry, short fiction, reviews) and the arts. Black and white with 4-color cover. Circ. 2,000. Accepts previously published artwork. Original artwork returned after publication "if requested." Sample copy for $2; art guidelines available for SASE.
Illustrations: Uses 5-10 illustrations/issue. "Cover submissions can be color, size 5½×8½ or smaller or slides. Submissions for inside must be b&w, size 5½×8½ or smaller unless artist allows reduction of a larger

For a list of markets interested in humorous illustration, cartooning and caricatures, refer to the Humor Index at the back of this book.

size submission. We are primarily interested in material that in one way or another attempts to elucidate, explain, discover or otherwise untangle the manifestly complex circumstances in which we find ourselves in the 1990s." Provide samples and tearsheets with updated address and phone number to be kept on file for possible future assignments. Send query letter with roughs, finished art or samples of style. Samples returned by SASE. Reports in 5 months. Pays in 2 contributor's copies.

Tips: Finds artists mainly through sourcebooks, "but hopefully through word of mouth by artists who made it in."

WISCONSIN TRAILS, Box 5650, Madison WI 53705. (608)231-2444. Production Manager: Nancy Mead. 4-color publication concerning travel, recreation, history, industry and personalities in Wisconsin. Published 6 times/year. Circ. 35,000. Previously published and photocopied submissions OK. Art guidelines for SASE.

Illustrations: Buys 6 illustrations/issue. "Art work is done on assignment, to illustrate specific articles. All articles deal with Wisconsin. We allow artists considerable stylistic latitude." Send samples (photocopies OK) of style to be kept on file for future assignments. Indicate artist's favorite topics; name, address and phone number. Include SASE. Publication will contact artist for portfolio review if interested. Buys one-time rights on a work-for-hire basis. Pays on publication; $50-350 for inside.

Tips: Finds artists through magazines, artists' submissions/self-promotions, artists' agents and reps and attending art exhibitions.

‡■WOMEN'S GLIB™, Box 259, Bala Cynwyd PA 19004. Editor: Roz Warren. Estab. 1991. Quarterly anthologies of cartoons, by women, and books that highlight the best contemporary women's humor (humor by women). Circ. 20,000. Accepts previously published artwork. Originals are not returned. Sample copies available for $10 payable to Roz Warren (not Women's Glib). Art guidelines for SASE with first-class postage.

● For insights on the world of women's cartooning, see the Insider Report featuring Roz Warren earlier in this section.

Cartoons: Approached by 1,000 cartoonists/year. Buys 100-200 cartoons/issue. Prefers feminist humorous cartoons. Send query letter with finished cartoons. Samples are filed or returned by SASE if requested by artist. Reports back within 5 days. Buys one-time rights. Pays $10-20 for b&w.

Illustrations: Approached by 50 illustrators/year. Buys 5 illustrations/issue. Works on assignment only. Send query letter. Samples are filed. Reports back within 5 days. Portfolio review not required. Buys one-time rights. Pays on publication; $20 for b&w.

Tips: Finds artists through word of mouth and calls for submissions in journals and magazines. "Almost all the work I use is freelance. Women's Glib is a terrific break-in market. In each book I publish many women for the first time. I use work by women only. Please take a look at one of the prior books in this series before submitting work. They are available at your local bookstore or library or may be ordered directly from my publisher by phoning 1-800-777-1048."

WORDPERFECT MAGAZINE and WORDPERFECT FOR WINDOWS MAGAZINE, 270 W. Center St., Orem UT 84057-4683. (801)226-5555. Fax: (801)226-8804. Assistant Art Director: Don Lambson. Estab. 1989. Monthly 4-color consumer magazine for WordPerfect users (nearly 10,000,000 in the US). Circ. 250,000. Accepts previously published artwork. Originals and 10 tearsheets returned at job's completion.

Illustrations: Approached by 100 illustrators/year. Buys 15 Illustrations/issue. Works on assignment only. Prefers conceptual work in any style or medium. Send query letter with tearsheets and photocopies. Samples filed or returned by SASE if requested. Publication will contact artist for portfolio review if interested. Portfolio should include color tearsheets and finished art samples. Buys one-time rights. **Pays on acceptance;** $1,500 for color cover; $800 for color inside.

Tips: Finds artists through *Showcase*, *Workbook* and self-promotions. "In the future, increased availability of stock illustrations will result in extra reimbursement for quality conceptual illustrations."

WORKBENCH, K.C. Publishing, Inc., Suite 300, 700 W. 47th St., Kansas City MO 64112. Executive Editor: Robert N. Hoffman. Estab. 1957. Bimonthly 4-color magazine for woodworkers and do-it-yourselfers. Circ. 750,000. Needs computer-literate freelancers for design and illustration. 50% of freelance work demands knowledge of Aldus PageMaker, Adobe Illustrator or QuarkXPress.

Cartoons: Buys 15 cartoons/year. Interested in woodworking and do-it-yourself themes; single panel with gagline. Submit samples with SASE. Reports in 1 month. Buys all rights, but may reassign rights to artist after publication. **Pays on acceptance;** $40 minimum for b&w line drawings.

Illustrations: Works with 10 illustrators/year. Buys 100 illustrations/year. Artists with experience in the area of technical drawings, especially house plans, exploded views of furniture construction, power tool and appliance cutaways, should send SASE for sample copy and art guidelines. Style of Eugene Thompson, Don Mannes and Mario Ferro. Publication will contact artist for portfolio review if interested. Sometimes requests work on spec before assigning job. Pays $50-1,200 for b&w, $100-1,500 for color inside.

Tips: "We have cut back on the number of stories purchased, though not necessarily the amount of art."

WORLD TRADE, Suite 450, 500 Newport Center Dr., Newport Beach CA 92660. (714)640-7070. Fax: (714)640-7770. Photo Editor: Craig Peterson. Estab. 1988. Bimonthly 4-color trade journal; "read by upper management, presidents and CEOs of companies with international sales." Circ. 37,000. Accepts previously published artwork. Original artwork is returned to artist at job's completion. Sample copies and art guidelines not available. Needs computer-literate freelancers for illustration. 20-30% of freelance work demands computer skills.
Cartoons: Prefers business/social issues. "We have a staff cartoonist." Samples are filed. Reports back to the artist only if interested. Buys first rights or reprint rights.
Illustrations: Approached by 15-20 illustrators/year. Buys 2-3 illustrations/issue. Works on assignment only. "We are open to all kinds of themes and styles." Considers pen & ink, colored pencil, mixed media and watercolor. Send query letter with brochure and tearsheets. Samples are filed. Reports back to the artist only if interested. Portfolio review not required. Buys first rights or reprint rights. Pays on publication; $350 for color cover; $200 for color inside.
Tips: "Send an example of your work. We prefer previous work to be in business publications. Artists need to understand we work from a budget to produce the magazine and budget controls are closely watched during recessions."

WRITER'S DIGEST, 1507 Dana Avenue, Cincinnati OH 45207. Art Director: Daniel T. Pessell. Senior Editor: Tom Clark (for cartoons). Monthly magazine emphasizing freelance writing for freelance writers. Circ. 250,000. Original artwork returned after publication. Sample copy for $3.
 • Cartoons submitted are also considered for inclusion in annual *Writer's Yearbook.*
Cartoons: Buys 3 cartoons/issue. Theme: the writing life. Needs cartoons that deal with writers and the trials of writing and selling their work. Also, writing from a historical standpoint (past works), language use and other literary themes. Prefers single panel with or without gagline. Send finished cartoons. Material returned by SASE. Reports back within 1 month. Buys first rights or one-time rights. **Pays on acceptance;** $50-85 for b&w.
Illustrations: Buys 5 illustrations/month. Theme: the writing life. Prefers b&w line art primarily. Works on assignment only. Send nonreturnable samples to be kept on file. Accepts photocopies as samples. Buys one-time rights. **Pays on acceptance;** $400-500 for color cover; $50-350 for inside b&w.
Tips: "We're also looking for b&w spots of writing-related subjects. We will buy all rights; $15-25 per spot."

■**WRITER'S GUIDELINES: A Roundtable for Writers and Editors,** Box 608, Pittsburg MO 65724. Managing Editor: Susan Salaki. Estab. 1988. "We want cartoons reflecting various attitudes now existing between editors and writers." Circ. 1,000. Sample copies available for $4. Art guidelines available for SASE with first-class postage.
Cartoons: Buys 2 cartoons/issue. Prefers satire. All cartoons should reflect the theme of "writers seeking publication or editors seeking publishable material." Prefers single panel b&w line drawings with gagline. Send query letter with finished cartoons. (Send photocopies only.) Reports back within 1 month. Buys one-time rights. Pays up to $25 for quality cartoons.
Tips: "When a cartoonist sends in her or his work, we often buy all the cartoons we can from that artist. If our readers like the work, we try to buy even more from that artist."

WRITER'S YEARBOOK, 1507 Dana Ave., Cincinnati OH 45207. Submissions Editor: Angela Terez. Annual publication emphasizing writing and marketing techniques, business topics for writers and writing opportunities for freelance writers and people getting started in writing. Original artwork returned with 1 copy of the issue in which it appears. Sample copy $6.25. Affiliated with *Writer's Digest.* Cartoons submitted to either publication are considered for both.
Cartoons: Uses 3-6 cartoons in yearbook. "All cartoons must pertain to writing—its joys, agonies, quirks. All styles accepted, but high-quality art is a must." Prefers single panel, with or without gagline, b&w line drawings or washes. Send finished cartoons. Samples returned by SASE. Reports in 1-2 months. Buys first North American serial rights for one-time use. **Pays on acceptance;** $50 minimum for b&w.
Tips: "A cluttery style does not appeal to us. Send finished, not rough art, with clearly typed gaglines. Cartoons without gaglines must be particularly well executed."

‡■**WY'EAST HISTORICAL JOURNAL,** P.O. Box 294, Rhododendron OR 97049. (503)622-4798. Fax: (503)622-4798. Publisher: Michael P. Jones. Estab. 1994. Quarterly historical journal. "Our readers love history and nature, and this is what we are about. Subjects include America, Indians, fur trade, Oregon Trail, etc., with a focus on the Pacific Northwest." Circ. 2,500. Accepts previously published artwork. Originals returned at job's completion if accompanied by SASE. Sample copies and art guidelines for SASE with first-class postage. Needs computer-literate freelancers for illustration. 50% of freelance work demands computer skills.
Cartoons: Approached by 50 cartoonists/year. Buys 6 cartoons/issue. Prefers Northwest Indians, Oregon Trail, wildlife; single panel. Send query letter with brochure, roughs and finished cartoons. Samples aare filed or are returned by SASE. Reports back within 2 weeks. Buys reprint rights. Pays in copies.
Illustrations: Approached by 100 illustrators/year. Buys 10 illustrations/issue. Prefers Northwest Indians, Oregon Trail, fur trade, wildlife. Considers pen & ink, airbrush and charcoal. Send query letter with brochure,

Win Magazine Assignments with Fresh Ideas

There is one subject every person can relate to. Most can't get enough of it. Throughout history men have cheated, lied, even killed for it. It's not love, sex or power, but it can buy all three: money. We all try to acquire it; some know how to invest it; but Beth Ceisel, art director of *Your Money* magazine, must continuously find new and interesting ways to illustrate it.

Beth Ceisel

Hers is a common plight for art directors whose publications have a specific focus—whether it be finance, books, animals or ice hockey. The illustrators who can successfully come up with fresh ideas for portraying the magazine's specialty are the ones who will get assignments. And *Your Money* has its own distinct style and voice, as with any magazine, making it essential to study a few copies before submitting.

Your Money uses scores of charts, graphs and illustrations to explain information provided in an article. "Because of who our readers are, we're trying to make things more accessible to the average person," Ceisel says. "We feel we have a responsibility to make financial information as easy as possible for the reader to grasp." Using artwork, she can put complex information into a palatable format for her readers.

All of *Your Money*'s charts are Mac-generated and done out of house. Ceisel has a number of artists she uses repeatedly (including a few on staff at *USA Today*). "I'm always looking for new people, but the need for chart artists is not as great as the need for conceptual illustrations."

Ceisel chooses new talent from the scads of submissions received daily. And while she's not necessarily looking for finance pieces, the content of submissions is a consideration. Just as it's probably not to an artist's benefit to submit political cartoons to *National Dragster* or caricatures of rock stars to *Log Home Living*, work from a children's illustrator, for example, won't make it past Ceisel's first cut. "It just won't fit in with our style."

In a submission, Ceisel wants to see tearsheets and finished pieces from illustrators. She looks for overall strong conceptual ability, but there's no single quality she seeks in a freelancer. The style and mood needed change with each article. "Sometimes we get redundancy in headlines from issue to issue, where they use the word 'cut,' for example, because it's such a dramatic image, and the illustrations focus on that word. We need different styles of illustration so we don't have redundancy in the artwork as well."

When choosing freelance illustrators to tackle financial issues, one might think an artist must be familiar with, if not well-versed in, the subject. Ceisel, however, takes the opposite approach. Money knowledge is not a criterion for her freelancers. "If an illustrator doesn't have that knowledge, he or she is approaching the piece from a reader's standpoint," she says.

"When I pick an illustrator, I'm looking for a certain kind of mood, rather than someone whose style will fit exactly how we visualize the finished illustration. I'm looking for someone who's got a strong sensibility and likes what they're doing. I don't try to put artists in a position where they're trying to conform to what works for us."

After Ceisel assigns an illustration, the work goes through an approval process for general concept, but she likes to keep the interpretation loose. "I don't want to hinder creativity. If an illustrator has a completely different idea for a piece, I'd love to see it. And nine times out of ten the idea will make it through the approval process."

Persistence, says Ceisel, is a good quality in freelancers looking for work in a market flooded with submissions. "I could get work that I think is great, but it may slip through the cracks because of the volume of submissions I get. You just can't retain that much in your brain library. But if somebody persists and stands out, I'm more likely to give them a try.

"Illustrators have a function for us—they have to say something and they have to be accessible to people and talk to people. The bottom line to me is the quality of the magazine. If we work together on that and have the same focus, we can produce a good product."
—*Alice P. Buening*

Adam Niklewicz had about two weeks to complete this illustration to accompany an article on small company stocks and funds enjoying a bull market in the April/May 1993 issue of Your Money. The artist, who rendered the piece in acrylics, was paid $800 for the job.

résumé, SASE, tearsheets, photographs, photocopies, photostats, slides and transparencies. Samples are filed or are returned by SASE if requested by artist. Reports back within 2 weeks. Publication will contact artist for portfolio review if interested. Portfolio should include b&w and color thumbnails, tearsheets, slides, roughs, photostats, photocopies, final art and photographs. Buys first rights. Pays in copies.

Tips: Uses freelancers for "feature articles in need of illustrations. However, we will consider doing a feature on the artist's work." Finds artists through submissions, sourcebooks and word of mouth. "They find us. Send us a good selection of your samples, even if they are not what we are looking for. Once we see what you can do, we will give an assignment."

YELLOW SILK: Journal of Erotic Arts, Box 6374, Albany CA 94706. (510)644-4188. Publisher: Lily Pond. Estab. 1981. Quarterly magazine emphasizing "erotic literature and arts for well educated, highly literate readership, generally personally involved in arts field." Circ. 16,000. Returns original artwork after publication. Sample copy for $7.50.

Cartoons: Buys 12 cartoons/year. Acquires 0-3 cartoons/issue. Prefers themes involving human relationships and/or sexuality. " 'All persuasions; no brutality' is editoral policy. Nothing tasteless." Accepts any cartoon format. Send query letter with finished cartoons or photocopies. Include phone number, name and address on each sample. Material is filed or is returned by SASE with correct stamps, no meters. Reports only if SASE included. Buys first or reprint rights. Negotiates payment plus 3 copies. Pays on publication.

Illustrations: Acquires 10-20 illustrations/issue by 1 artist if possible. Considers "anything in the widest definitions of eroticism except brutality, bondage or S&M. We're looking for work that is beautiful, artistic. We are really fine arts as opposed to illustration. No pornography. All sexual persuasions represented." Prefers acrylic, then pen & ink, watercolor, oil, pastel, collage and mixed media. Send originals, photocopies, slides, photostats, good quality photographs. Color and b&w examples in each submission are preferred. Include name, address and telephone number on all samples. Samples not filed are returned by SASE. Reports back within 3 months. Buys first rights or reprint rights. Negotiates payment plus copies. Pays on publication.

Tips: "Artistic quality is of equal or higher importance than erotic content. There are too many people doing terrible work thinking it will sell if it's sexual. Don't send it to me! Disturbingly, hard-edge S&M images seem more frequent. Don't send us those, either !!"

‡YOGA JOURNAL, 2054 University Ave., Berkeley CA 94704-1082. (510)841-9200. Fax: (510)644-3101. Art Director: Nancy Terzian. Estab. 1975. Bimonthly consumer magazine emphasizing health, consciousness, yoga, holistic healing, transpersonal psychology, body work and massage, martial arts, meditation and Eastern spirituality. Circ. 70,000. Originals returned at job's completion. Sample copies available. Art guidelines not available.

Illustrations: Approached by 50 illustrators/year. Buys 8 illustrations/issue. Works on assignment only. Considers all media. Send query letter with any reproductions. Samples are filed. Publication will contact artist for portfolio review if interested. Buys one-time rights. **Pays on acceptance**; $500 for color cover; $100 for b&w, $125 for color inside.

Tips: Finds artists through word of mouth and artists' submissions.

‡YOU! MAGAZINE, Suite 102, 29800 Agoura Rd., Agoura Hills CA 91301-1118. (818)991-1813. Fax: (818)991-2024. Entertainment Editor: A.J. Merrifield. Estab. 1986. Magazine for Catholic and Christian high school and college youth, published 10 times yearly. Circ. 375,000. Originals are not returned. Sample copies available for $2.98. Art guidelines for SASE with first-class postage. Needs computer-literate freelancers for design and illustration. 50% of freelance work demands computer knowledge of Adobe Illustrator, QuarkX-Press, Adobe Photoshop or Aldus FreeHand.

Cartoons: Approached by 30-40 cartoonists/year. Buys 2 cartoons/issue. Prefers Catholic youth, political and humorous cartoons; single or multiple panel b&w line drawings. Send query letter with brochure, roughs and finished cartoons. Samples are filed. Reports back to the artist only if interested. Rights purchased vary according to project. Pays $50 for b&w, $60 for color.

Illustrations: Approached by 100 illustrators/year. Buys 20 illustrations/issue. Prefers spiritual themes. Considers pen & ink, watercolor, collage, airbrush, acrylic, marker, oil, charcoal, mixed media, pastel and computer art. Send query letter with brochure, résumé, SASE, tearsheets, photographs, photocopies, slides and transparencies. Samples are filed. Request portfolio review in original query. Publication will contact artist for portfolio review if interested. Portfolio should include b&w thumbnails, tearsheets, slides, roughs, photocopies, final art and photographs. Rights purchased vary according to project. Pays on publication; $70 for b&w, $80 for color inside.

Tips: Finds artists through sourcebooks, other publications, word of mouth and artists' submissions.

‡YOUR HEALTH, 5401 NW Broken Sound Blvd., Boca Raton FL 33487. (407)997-7733. Fax: (407)997-9210. Photo Editor: Judy Browne. Estab. 1960. Biweekly health and fitness magazine for the general public. Circ. 50,000. Accepts previously published artwork. Originals returned at job's completion. Sample copies and art guidelines available.

Cartoons: Approached by 30 cartoonists/year. Buys 10 cartoons/year. Prefers health and fitness humorous cartoons; b&w line drawings. Send query letter with roughs. Samples are filed. Reports back within 1 month. Buys one-time rights. Pays $50 for b&w/color.

Illustrations: Approached by 5 illustrators/year. Buys 2 illustrations/issue. Prefers health and fitness themes. Considers all media but prefers pen & ink or colored pencil. Send query letter with tearsheets, photographs and photocopies. Samples are filed. Reports back within 1 month. Publication will contact artist for portfolio review if interested. Portfolio should include any samples. Buys one-time rights. Pays on publication; $100 for b&w, $150 for color inside.

Tips: Finds artists through other publications. Features and departments are both open to freelancers.

‡**YOUR HEALTH & FITNESS,** 60 Revere Dr., Northbrook IL 60062-1563. (708)205-3000. Fax:(708)564-8197. Supervisor of Art Direction: Kristi Johnson Simkins. Estab. 1978. Quarterly consumer magazine and company magazine. *"Your Health & Fitness* is a magazine that allows clients to customize up to 8 pages. Clients consist of hospitals, HMOs and corporations." Circ. 600,000. Accepts previously published artwork. Originals are returned at job's completion. Sample copies available. Guidelines not available. Needs computer-literate freelancers for design and illustration. 70% of freelance work demands knowledge of Adobe Illustrator, QuarkXPress, Adobe Photoshop and Aldus Freehand.

Cartoons: Approached by 12 cartoonists/year. Buys 1 cartoon/issue. Prefers humorous health, fitness and food cartoons; single panel, b&w line drawings with gaglines. Send query letter with finished cartoons. Samples are filed or are returned. Reports back to the artist only if interested. Buys one-time or reprint rights. Pays $150 for b&w, $200 for color.

Illustrations: Approached by 200 illustrators/year. Buys 6 illustrations/issue. Works on assignment only. Prefers exercise, fitness, psychology, drug data, health cost, first aid, diseases, safety and nutrition themes; any style. Considers pen & ink, watercolor, collage, airbrush, acrylic, oil, mixed media and pastel. Send query letter with tearsheets, photostats, photographs, slides, photocopies and transparencies. Samples are filed or are returned. Reports back to the artist only if interested. Publication will contact artist for portfolio review if interested. Portfolio should include b&w and color tearsheets and sildes. But one-time or reprint rights. Pays on publication; $500 for color cover; $150 for b&w, $250 for color inside.

Tips: "Fast Facts" section of magazine is most open to freelancers; uses health- or fitness-related cartoons. Finds artists through sourcebooks and submissions.

YOUR MONEY MAGAZINE, 5705 N. Lincoln Ave., Chicago IL 60659. (312)275-3590. Art Director: Beth Ceisel. Estab. 1980. Bimonthly 4-color personal finance magazine. "Provides useful advice on saving, investing and spending. Design is accessible and reader-friendly." Circ. 400,000. Original artwork returned after publication. Art guidelines for SASE with first-class postage. Needs computer-literate freelancers for illustration, charts/graphs. 25% of freelance work demands computer literacy in Aldus, FreeHand or Adobe Illustrator.

Illustrations: Buys 10-12 illustrations/issue. Works on assignment only. Editorial illustration is used based upon specific needs of an article, therefore style, tone and content will vary. Send query letter with brochure, tearsheets, photocopies and/or promotional pieces. Samples not filed are returned by SASE. Publication will contact artist for portfolio review if interested. Buys first rights or one-time rights. Sometimes requests work on spec before assigning job. Pays $300-1,000 for b&w, $300-1,000 for color and b&w cover; $300-1,100 for color inside.

Tips: Finds artists through other magazines, submissions and sourcebooks. "Show only your best work. Include tearsheets in portfolio. Computers will take over the magazine field. Typography will become a lost art!"

■**ZUZU'S PETALS QUARTERLY,** P.O. Box 4476, Allentown PA 18105. (215)821-1324. Editor: T. Dunn. Estab. 1992. Quarterly literary magazine. "We are a journal of the written and visual arts providing a forum for postmodern creativity." Circ. 300. Accepts previously published artwork. Original artwork is returned at job's completion. Sample copies for $5. Art guidelines not available.
 • This quarterly plans to expand its page count.

Cartoons: Approached by 50 cartoonists/year. Buys 1 cartoon/issue. Prefers edgy, post modern cartoons with a literary focus.

Illustrations: Prefers offbeat, "alternative" work. Submit portfolio by mail. Portfolio should include b&w photographs, photocopies. Buys one-time rights.

Tips: Finds artists through magazines and word of mouth. "We prefer b&w artwork. Be as creative as you feel! We will consider artist-created b&w computer art in a PCX format."

Magazines/'94-'95 changes

The following publications were listed in the 1994 edition, but do not have listings in this edition. The majority did not respond to our request to update their listings. If a reason was given for a magazine's exclusion, it appears in parentheses after the name of the magazine.

Abyss
Alaska Business Monthly
The American Atheist
American Careers
American Health
American Music Teacher
Aqua-Field Publications
Arizona Literary Review
Aspen Magazine
Ballast Quarterly Review
The Barrelhouse
Bassmaster Magazine
Bay Area Parent/Bay Area Baby
Body, Mind and Spirit
Both Sides Now
Business & Commercial Aviation
Business Atlanta
California Business
The California Fire Service
Canadian Pharmaceutical Journal (too many submissions)
Career Focus
Career Woman
Careers and Majors Magazine
The Cartoonist Exchange (not accepting additional cartoonists)
CD Review
CED
The Chronicle of the Horse
Cinefantastique
Classic Toy Trains
Cleveland Now® and Now®-Magazine
Clubhouse
The Columbus Single Scene
Concrete Products
Conde Nast Traveler
The Consultant Pharmacist
The Cool Traveler Magazine
Coping
Creem Magazine
Cricket
The Dairyman
Dark Tome
Decor (no longer uses cartoons)
Detroit Free Press Magazine
Detroit Monthly Magazine
Discover
Discovery (per request)
Entrepreneur Magazine
Esquire
Europe
Evangel
Event
Executive Report
Expecting Magazine
Express (per request)
Fantagraphic Books
Fiction International
Field & Stream Magazine

Finescale Modeler
First Visit
Florida Keys Magazine
Florida Leader Magazine
Florist
Flower & Garden
Folio
For Seniors Only, For Graduates Only
Fordham University
Foundation News
Golf Illustrated
Golf Journal
Good Old Days
Grand Rapids Magazine
Group Publishing
Guide for Expectant Parents
Gulfshore Life Magazine
Hawaii Magazine
Heartland USA
The Herb Quarterly
High Performance Pontiac
Hobson's Choice
Home & Condo Magazine
Home Office Computing
Hopscotch
Hospital Practice
inCider Magazine
Income Plus
Independent Living
The Independent Weekly
Inside Texas Running
International Bowhunter
Iowa Municipalities
Islands
Journal of the West
Kiwanis
Lacrosse Magazine
Lady's Circle
Leisure World
Los Angeles Magazine
Magical Blend
Main Line Magazine
Management Review
Masters Agency
Michigan Out of Doors
Middle Eastern Dancer
Moment
Moving Forward
National Enquirer
National Geographic
New Living
New Mystery Magazine
The New Yorker
Northeast Outdoors
Northern California Home & Garden
The Northern Logger & Timber Processor
The Northwest Palate (too many submissions)
Omni
The Optimist Magazine
Orange Coast Magazine

Oregon River Watch
Organic Gardening
Outdoor Canada
Outdoor Life Magazine
Pacific Press Publishing Assoc.
Paint Horse Journal
Palm Beach Life
Phi Delta Kappan
Pictopia
Popular Science
The Practical Homeowner
Praying
Premiere Magazine
The Presbyterian Record
Private Pilot
Product Managment Today
Professional Tool & Equipment News and Bodyshop Tool & Equipment News
Psychology Today
Public Utilities Fortnightly
Rapport
Redbook Magazine
Reprographics & Design
The Resident
The Retired Officer
San Jose Studies
The Saturday Evening Post
Science News
Screen Actor
Seafood Leader
Seek
Shepherd Express
Short Fiction by Woman
Show Biz News and Model News
Software Managment News (does not need artwork)
Soldiers Magazine
Sonoma Business Magazine
Steppingout Arts Magazine
Student Lawyer
Tikkun Magazine
Training & Development
Travel & Leisure
Travel Mexico Events
Varbusiness
Video Games & Computer Entertainment
Vista USA
Vogue Patterns
The Washington Opera
The Washington Post
Westways
Wildlife Art News
Wildlife Conservation/Bronx Zoo
Windsurfing Magazine
Wings West Magazine
Wisconsin Resaurateur
Woman Bowler
Wonder Time
Working Mother Magazine
YM

Record Companies

The $10 billion recording industry is a burgeoning market for freelance designers and illustrators that is dominated by a handful of major multi-national organizations. "The big six"—Polygram, Warner, Thorn-EMI, BMG, MCA and Sony—take in more than 90% of industry sales. But there are thousands of independent labels. Some are thriving, others struggling, but they are a big part of the industry. And you'll find the "indies" are great places to start when looking for freelance assignments.

Kim Champagne, senior art director for Warner Bros. Records, advises freelancers to impress record companies with outstanding portfolios. Nominated for a 1994 Grammy Award for a CD cover design, Champagne provides more insight into the music industry as our Insider Report subject on page 610.

What art directors look for

Designers and illustrators looking to break into the music arena will find art directors like Champagne searching for quality. Record companies are looking for artists who are familiar with the various CD formats. Labels also turn to outside creatives for display design, promotional materials, collateral pieces or video production.

It's also not unusual for an art director to work with several freelancers on one project. For example, one person might handle typography, another illustration, a photographer is sometimes used and a designer can be hired for layout. So whether you're right out of school or have 20 years under your belt, if your stuff is fresh, the market is ripe for picking.

It will benefit you to keep up with new technology within the music industry. The digital compact cassette (DCC) and the mini-disk, for instance, have entered the arena to compete with CD and cassette sales. At press time, full-length CDs are leading sales with a healthy 60.8 percent of the market. Ultimately, the consumer will determine the winning format.

But how does this affect freelance artists? When it comes to the aforementioned disks, designers must meet the challenges of displaying essential information within smaller parameters. The design of the CD booklet has evolved into an art form and is already much more sophisticated than the design of album covers or cassette packaging. Strategies must run the gamut from wilder, attention-grabbing graphics to simple, less-cluttered designs. With smaller packaging, record labels also need more creative merchandise displays to attract buyers in retail stores.

Landing and negotiating the assignment

Spencer Drate, author of the book *Rock Art*, published by PBC International, has freelanced in the music industry for 15 years and worked on projects for the Ramones, the Pretenders and David Byrne. Drate advises artists to enter the industry by freelancing for small independent labels. Be sure your portfolio includes quality samples. It doesn't matter if the work is of a different genre—quality is key. Get the name of the art director or creative director from the listings in this section and send a cover letter that asks for a portfolio review. If you are not contacted within a couple of weeks, make a polite follow-up call to the office manager. (Most art directors prefer not to be called directly. If they are interested, they will call.)

Another route of entry is through management companies who work for recording artists. They represent musicians in the many facets of their business, one being control over the artwork used in releases. Follow the steps already listed to get a portfolio review. Lists of management companies can be found in *Songwriter's Market* published by Writer's Digest Books and the *Recording Industry Sourcebook* published by Ascona Group, Inc.

Once you nail down an assignment, get an advance and a contract. Independent labels usually provide an advance and payment in full when a project is done. When negotiating a contract, ask for a credit line on the finished piece and samples for your portfolio.

You don't have to live in one of the recording capitals to land an assignment, but it does help to familiarize yourself with the business. Visit record stores and study the releases of various labels. Ask to see any catalogs or promotional materials the store may have received from the companies you're interested in. Read music industry trade magazines, like *Spin, Rolling Stone, Ray Gun* and *Billboard*. Along with Drate's book you might want to check *Packaging & Graphics* by Ken Pfeifer, a Rockport Book.

■**AFTERSCHOOL PUBLISHING COMPANY**, P.O. Box 14157, Detroit MI 48214. (313)571-0363. President: Herman Kelly. Estab. 1978. Produces 4 CDs and tapes: rock & roll, jazz, rap, R&B, soul, pop, classical, folk, educational, country/western, dance and new wave. Recent releases: *Throw The D*, by Two Live Crew and *Get Serious*, by Cut N Move.
Needs: Produces 1 soloist/year. Works with 10 designers and 10 illustrators/year. Prefers professional artists with experience in all forms of the arts. Uses artists for CD cover design, tape cover design and illustration, brochure design, advertising design and illustration and posters. Needs computer-literate freelancers for production. 25% of freelance work demands computer skills.
First Contact & Terms: Send query letter with brochure, résumé, SASE and appropriate samples. Samples are filed or are returned by SASE. Reports back within 2-4 weeks. Requests work on spec before assigning a job. To show a portfolio, mail roughs, printed samples, b&w/color tearsheets, photographs, slides and transparencies. Pays by the project. Negotiates rights purchased. Interested in buying second rights (reprint rights) to previously published work.
Tips: Finds artists through Michigan Council for the Arts' Artist Directory and Detroit Arts Council.

‡**ALEAR RECORDS**, Rt. 2, Box 114, Berkeley Springs WV 25411. (304)258-2175. Owner: Jim McCoy. Estab. 1973. Produces tapes and albums: country/western. Past releases: "The Taking Kind," by J.B. Miller; "If I Throw away My Pride," by R.L. Gray; and "Portrait of a Fool," by Kevin Wray.
Needs: Produces 12 soloists and 6 groups/year. Works with 3 visual artists/year. Works on assignment only. Uses artists for CD cover design and album/tape cover illustration.
First Contact & Terms: Send query letter with résumé and SASE. Samples are filed. Reports back within 1 month. To show a portfolio, mail roughs and b&w samples. Pays by the project, $50-250.

***ALPHABEAT**, Box 12 01, 97862 Wertheim/Main West Germany 9342-841 55. Owner: Stephan Dehn. A&R: Marga Zimmerman. Produces CDs, tapes and albums: R&B, soul, dance, rap, pop, new wave, electronic and house; solo and group artists.
Needs: Uses artists for CD and album/tape cover design and illustration; brochure design and illustration; catalog design, illustration and layout; direct mail packages; advertising design and illustration.
First Contact & Terms: Send query letter with brochure, tearsheets, photostats, résumé, photographs, slides, SASE, photocopies and IRCs. Samples are returned by SAE with IRCs. To show a portfolio, mail appropriate materials. Payment depends on product. Rights purchased vary according to project.

‡**AMERICATONE INTERNATIONAL—U.S.A.**, 1817 Loch Lomond Way, Las Vegas NV 89102-4437. (702)384-0030. Fax: (702)382-1926. President: Joe Jan Jaros. Estab. 1983. Produces CDs and tapes: rock & roll, jazz, pop, progressive, classical, country/western and rap by solo artists and groups. Recent releases: "Dick Shearer and His Stan Kenton Spirit," by Dick Shearer; "It's Magic," by Alex Bradley.
Needs: Produces 10 solo artists and 3 groups/year. Uses artists for direct mail packages and posters.
First Contact & Terms: Samples are returned by SASE. Reports back to artist within 2 months only if interested. To show a portfolio, mail appropriate materials.

■**THE AMETHYST GROUP LTD.**, 273 Chippewa Dr., Columbia SC 29210-6508. Contact: Management. Produces rock and roll, dance, soul, R&B; solo artists. Past releases: "Silhouette" and "New Fire Ceremony."

Needs: Produces 3 soloists and 5 groups/year. Uses artists for album cover and brochure design, direct mail packages and promotional materials. Prefers b&w or color, abstract designs.

First Contact & Terms: Send query letter with résumé and samples. Samples are returned by SASE. Reports back within 2 months. Write to show a portfolio, which should include b&w photographs. Pays by the project, $25 minimum. Considers available budget and rights purchased when establishing payment. Negotiates rights purchased. Must sign release forms.

Tips: "Be realistic and practical. Remember that b&w is the industry standard; color is used a great deal with major companies. Express talent, not hype; be persistent. Always include proper postage for any reply and/or return of materials. Give us an idea of how you expect to be paid and/or credited."

‡ANTELOPE PUBLISHING, 23 Lover's Lane, Wilton CT 06897. (203)834-9884. President: Tony Lavorgna. Estab. 1982. Produces CDs and tapes: jazz and middle of the road by solo artists and groups. Recent releases: "Somewhere Near," by Jeri Brown; "All-Star Bebop," by Swing Fever.

Needs: Produces 1 solo artist and 1 group/year. Works with 2 visual artists/year. Works on assignment only. Uses artists for CD cover design and illustration; tape cover design and illustration; brochure illustration; direct mail packages and poster.

First Contact & Terms: Send query letter with brochure, résumé, photocopies, photographs, tearsheets. Samples are filed. Reports back to the artist only if interested. To show portfolio, mail b&w final art. Pays for design by the project. Negotiates rights purchased.

Tips: "Start with a small company where more attention will be received."

APON RECORD COMPANY, INC., Steinway Station, Box 3082, Long Island City NY 11103. (212)721-8599. President: Andre M. Poncic. Produces classical, folk, pop and video tapes from eastern Europe.

Needs: Produces 20 records/year. Works with 20 designers and 20 illustrators/year. Uses artists for album cover design and illustration, catalog illustration and layout, posters.

First Contact & Terms: Works on assignment only. Send brochure and samples to be kept on file. Write for art guidelines. Samples not filed are returned by SASE. Reports to the artist within 60 days only if interested. Considers available budget when establishing payment. Purchases all rights.

ART ATTACK RECORDINGS/MIGHTY FINE RECORDS, 3305 North Dodge Blvd., Tucson AZ 85716. (602)881-1212. President: William Cashman. Produces rock & roll, country/western, jazz, pop, R&B; solo artists. Recent releases: *Joe Rush*, by Joe Rush; *Empathy*, by Penny Netz.

Needs: Produces 4 albums/year. Works with 1-2 designers and 1-2 illustrators/year for CD and album/tape cover design and illustration; catalog design and layout; advertising design, illustration and layout; posters.

First Contact & Terms: Works on assignment only. Send query letter with brochure, business card, tearsheets or photographs to be kept on file. Samples not filed are returned by SASE only if requested. Reports only if interested. Write for appointment to show portfolio. Original artwork not returned to artist. Pays for design by the hour, $15-25; by the project, $100-500. Pays for illustration by the project, $100-500. Considers complexity of project and available budget when establishing payment. Purchases all rights. Sometimes interested in buying second rights (reprint rights) to previously published artwork.

AVC ENTERTAINMENT INC., Suite 200, 6201 Sunset Blvd., Los Angeles CA 90028. (213)461-9001. Fax: (213)962-0352. President: James Warsinske. Estab. 1989. Produces CDs and tapes: rock & roll, R&B, soul, dance, rap and pop by solo artists and groups. Recent releases: *Let It Be Right*, by Duncan Faure; *Knowledge to Noise*, Madrok; *Push Harder*, 7th Stranger; *Psycho Love Child*, by Psycho Love Child.

Needs: Produces 2-6 soloists and 2-6 groups/year. Uses 4-10 visual artists for CD and album/tape cover design and illustration; brochure design and illustration; catalog design, layout and illustration; direct mail packages; advertising design and illustration. Needs computer-literate freelancers for design and illustration. 50% of freelance work demands knowledge of Aldus PageMaker, Adobe Illustrator, QuarkXPress, Adobe Photoshop.

First Contact & Terms: Send query letter with SASE, tearsheets, photographs, photocopies, photostats, slides and transparencies. Samples are filed. Reports back within 1 month. To show portfolio, mail roughs, printed samples, b&w and color photostats, tearsheets, photographs, slides and transparencies. Pays by the project, $100-1,000. Buys all rights.

Tips: "Get your art used commercially, regardless of compensation. It shows what applications your work has."

The double dagger before a listing indicates that the listing is new in this edition. New markets are often more receptive to freelance submissions.

AZRA INTERNATIONAL, Box 459, Maywood CA 90270. (213)560-4223. Fax: (213)560-1240. President: D.T. Richards. Estab. 1981. Produces CDs: rock & roll, classical and New Age. Recent releases: *It's For You*, by Omicron and *Color of the Sun*, by Dan James.
Needs: Produces 6 CDs/year. Works with 6 designers and 6 illustrators/year. Uses artists for CD and album/tape cover design and illustration.
First Contact & Terms: Send query letter with SASE. Samples are not filed and are returned by SASE. Reports back within 2 weeks. Call for appointment to show portfolio, which should include b&w and color photographs. Sometimes requests work on spec before assigning a job. Pays by the project, $100-1,000. Buys one-time rights. Interested in buying second rights (reprint rights) to previously published work.
Tips: Finds new artists through submissions. Would like it if artists would "offer to use something from their portfolios at a lower rate. There is a need for creative artwork for 3-D packaging or pop-up packaging. Our company is opening a division for this new work."

‡**AZTLAN RECORDS**, P.O. Box 5672, Buena Park CA 90622-5672. (714)826-7151. Manager: Carmen Ortiz. Estab. 1986. Produces CDs and tapes: alternative and ethnic. Recent releases: "Der Kirchenwasser," by Angel of the Odd.
Needs: Produces 1 solo artist or group/year. Work with 1 visual artist/year. Prefers artists with experience in b&w inks. Works on assignment only. Uses artists for CD cover and tape cover illustration. Needs computer-literate freelancers for illustration. Freelancers should be familiar with Aldus PageMaker.
First Contact & Terms: Send query letter with SASE. Samples are filed and are returned by SASE if requested by artist. Reports back to the artist only if interested. To show portfolio, mail appropriate materials. "Send best representation of your work." Pays for design by the project. Rights purchased vary according to project.

BAL RECORDS, Box 369, LaCanada CA 91012. (818)548-1116. President: Adrian P. Bal. Estab. 1965. Produces 4-6 rpm (singles): rock & roll, jazz, R&B, pop and country/western. Recent releases include: "Chilly Bones," by Marge Calhoun; "You're A Part of Me," and "You and Me," by Paul Richards.
Needs: Produces 2-4 soloists and 1 or 2 groups/year. Uses 1-3 artists/year for direct mail packages.
First Contact & Terms: Samples are not filed and are returned by SASE. Reports back ASAP. Portfolio review requested if interested in artist's work. Sometimes requests work on spec before assigning a job.
Tips: Finds new artists through submissions. "I don't like the abstract designs."

■**B-ATLAS & JODY RECORDS**, 2557 E. 1st St., Brooklyn NY 11223. (718)339-8047. Vice President/A&R Director: Vincent Vallis. Vice President/Sales: Ron Alexander. Estab. 1979. Produces CDs, tapes and albums: rock & roll, jazz, rap, R&B, soul, pop, country/western and dance. Releases include: "Where Did Our Love Go," by Demetrius Dollar Bill; "Alone," by Alan Whitfield; "Master Plan," by Keylo; "Our Lives," by Alan J. Whitfield, Jr.
Needs: Produces 20 soloists and 10 groups/year. Works with 5 visual artists/year on assignment only. Uses artists for CD cover design and illustration; brochure illustration.
First Contact & Terms: Send query letter with SASE and photocopies. Samples are filed. Reports back to the artist only if interested. To show a portfolio, mail photographs. Pays by the project, $50-100. Rights purchased vary according to project.

‡**BEACON RECORDS**, P.O. Box 3129, Peabody MA 01961. (603)893-2200. Fax: (603)893-9441. Principal: Tony Ritchie. Estab. 1992. Produces CDs and tapes: folk, Celtic, alternative by solo artists and groups. Recent releases: "Of Age," by Aztec Two-Step; "Were You At The Rock," by Aine Minogue.
Needs: Produces 10-15 solo artists and groups/year. Work with 2-3 visual artists/year. Prefers artists with experience in music industry graphics. Uses artists for CD cover design and illustration; tape cover design and illustration; brochure design and illustration; catalog design, illustration and layout; direct mail packages; advertising design and illustration; and posters. Needs computer-literate freelancers for design, illustration and production. 75% of freelance work demands computer skills.
First Contact & Terms: Send query letter with brochure and samples. Samples are filed. Reports back to the artist only if interested. Write for appointment to show portfolio which should include b&w and color final art and photographs. Pays for design, by the project. Buys all rights.

*****BIG BEAR RECORDS**, P.O. Box, Birmingham B16 8UT England. (021)454-7020. Fax: (21)454-9996. Managing Director: Jim Simpson. Produces CDs and tapes: jazz, R&B. Recent releases: *Side-Steppin*, by Bruce Adams/Alan Barnes Quintet and *Live at Bonnie Scotts, Birmingham*, by King Pleasure & The Biscuit Boys.
Needs: Produces 8-10 records/year. Works with 4-6 illustrators/year. Uses artists for album cover design and illustration. Needs computer-literate freelancers for illustration.
First Contact & Terms: Works on assignment only. Send query letter with photographs or photocopies to be kept on file. Samples not filed are returned only by SAE (nonresidents include IRC). Negotiates payment. Considers complexity of project and how work will be used when establishing payment. Purchases all rights. Interested in buying second rights (reprint rights) to previously published work.

‡**BLACK DIAMOND RECORDS INCORPORATED,** P.O. Box 8073, Pittsburg CA 94565. (510)980-0893. Fax: (510)458-0915. Art Management: B.D.R. Art Dept. Estab. 1988. Produces tapes, CDs and vinyl 12-inch and 7-inch records: jazz, pop, R&B, soul, rap by solo artists and groups. Recent releases: "Make Love to Me," by Della; "Where U From," by C-Max; "U Sold Me," by Jerry J; "Mobsters," by Mobsters.
Needs: Produces 2 solo artists and 3 groups/year. Works with 2 visual artists/year. Prefers artists with experience in album cover and insert design. Uses artists for CD cover design and illustration; tape cover design and illustration; direct mail packages; advertising design and illustration; and posters. Needs computer-literate freelancers for production. 85% of freelance work demands knowledge of Aldus PageMaker, Aldus FreeHand.
First Contact & Terms: Send query letter with résumé. Samples are filed and are returned. Reports back within 3 months. Write for appointment to show portfolio that includes b&w roughs and photographs. Pays for design by the hour, $100; by the project, $100. Rights purchased vary according to project.
Tips: "Be creative, be patient, be assertive, be on time."

‡**BLAIR VIZZION MUSIC,** Suite 5, 1315 Simpson Rd., N.W., Atlanta GA 30314. (404)642-2645. Managing Director: Willie W. Hunter. Estab. 1989. Produces pop, R&B, soul by solo artists and groups. Recent releases: "Rockin You Tonight" and "Anytime Anyplace," by Gary Adkins.
Needs: Produces 4 solo artists and 1 group/year. Works on assignment only. Uses artists for CD cover illustration; tape cover design; advertising illustration; posters. Needs computer-literate freelancers.
First Contact & Terms: Send query letter with résumé, photographs and SASE. Samples are returned. Reports back within 2 months. To show portfolio, mail b&w and color roughs and photographs. Pays for design by the project. Rights purchased vary according to project.

BLASTER BOXX HITS, 519 N. Halifax Ave., Daytona Beach FL 32118. (904)252-0381. Fax: (904)252-0381. C.E.O.: Bobby Lee Cude. Estab. 1978. Produces CDs, tapes and albums: rock & roll, R&B, folk, educational, country/western and marching band music. Recent releases: "Blow Blow Stero" and "Shot In The Dark," by Zonky Honky.
Needs: Produces 6 CDs and tapes/year. Works on assignment only. Uses artists for CD cover design and illustration.
First Contact & Terms: Send query letter with appropriate samples. Samples are filed. Reports back within 1 week. To show a portfolio, mail thumbnails. Sometimes requests work on spec before assigning a job. Pays by the project. Buys all rights.

‡**BOUQUET-ORCHID ENTERPRISES,** P.O. Box 1335, Norcross GA 30091. (404)798-7999. President: Bill Bohannon. Estab. 1972. Produces CDs and tapes: rock & roll, country, pop and contemporary Christian by solo artists and groups. Recent releases: *Blue As Your Eyes*, by Adam Day and *Take Care Of My World*, by Bandoleers.
Needs: Produces 6 soloists and 4 groups/year. Works with 8-10 artists/year. Works on assignment only. Uses artists for CD and tape cover design; brochure design; direct mail packages; advertising illustration. Needs computer-literate freelancers for design and illustration. 25% of freelance work demands knowledge of Aldus PageMaker, Adobe Illustrator and QuarkXPress.
First Contact & Terms: Send query letter with brochure, SASE, résumé and samples. "I prefer a brief but concise overview of an artist's background and works showing the range of his talents." Include SASE. Samples are not filed and returned by SASE if requested by artist. Reports within 1 month. To show a portfolio, mail b&w and color tearsheets and photographs. Pays for design by the project, $100-500. Rights purchased vary according to project.
Tips: "Keep being persistent in sending out samples of your work and inquiry letters as to needs. Always strive to be creative and willing to work within guidelines, as well as budgets."

BOVINE RECORD COMPANY, Unit 54, 14700 Front Beech Rd., Panama City Beach FL 32413. President: Jack Moorhouse. Estab. 1977. Produces CDs and tapes: rock & roll, country/western by solo artists. Recent releases: *A Retrospective* and *Greatest Hits Vol. II,* by John Moorhouse.
Needs: Produces 2 albums/year. Works with 2 designers and 2 illustrators/year. Prefers local artists on assignment only. Uses artists for album/tape cover illustration and design; brochure illustration; direct mail packages; advertising design; posters. Needs computer-literate freelancers for design, illustration, production and presentation. 10% of freelance work demands computer skills in Aldus FreeHand.
First Contact & Terms: Send query letter with brochure, SASE and photographs. Samples are filed or are returned by SASE. Reports within 2 months. To show a portfolio, mail b&w and color photographs. Pays for design or illustration by the hour, $25-40.

Tips: "I'm noticing that titles and even artists' names are often hidden and one has to look hard at the product to find the artist's name."

‡**BRIARHILL RECORDS,** 3484 Nicolette Dr., Crete IL 60417. (708)672-6457. President/A&R Director: Danny Mack. Estab. 1984. Produces tapes, CDs and records: pop, gospel, country/western, polka, Christmas by solo artists and groups. Recent releases: "Jesus is The Reason for the Season," by Danny Mack (Christmas); "After All," by Danny Mack and Debbie Rodriguez (country duet).
Needs: Produces 2-5 solo artists/year. Work with 2 visual artists/year. Prefers artists with experience in album covers. Works on assignment only. Uses artists for CD cover design and illustration; tape cover design and illustration; brochure design; and advertising illustration. 20% of freelance work demands knowledge of Adobe Illustrator.
First Contact & Terms: Send query letter with photocopies and SASE. Samples are filed and are not returned. Reports back within 3 weeks. To show portfolio, mail photostats. Pays for design by the project, $100 minimum. Buys all rights.
Tips: "Especially for the new freelance artist, get acquainted with as many recording studio operators and show your work. Ask for referrals. They can be a big help in getting you established locally."

‡**BROKEN RECORDS INTERNATIONAL,** 305 S. Westmore Ave., Lombard IL 60148. (708)916-6874. Fax: (708)916-6928. President: Roy Bocchieri. Estab. 1985. Produces 2 CDs and tapes/year: rock & roll and dance. Recent releases: *Hallowed Ground* and *Immortal,* by Day One.
Needs: Works with 1 freelance designer, 1 freelance illustrator/year. Requests work on spec before assigning a job. Uses artists for CD and album/tape cover design and illustration; brochure, catalog and advertising design and illustration; catalog layout; direct mail packages; and posters.
First Contact & Terms: Send query letter with brochure. Samples are filed or are not returned. Reports back only if interested. To show a portfolio, mail appropriate materials. Requests work on spec before assigning a job. Pay is determined by the work needed. Rights purchased vary according to project.

BSW RECORDS, Box 2297, Universal City TX 78148. (210)659-2338. Fax: (210)659-2557. President: Frank Willson. Estab. 1987. Produces tapes and albums: rock & roll, country/western by solo artists. Releases 8 CDs/tapes each year. Recent releases: *Pure Country,* by Rusty Doherty; *From The Heart* by Candee Land.
Needs: Produces 25 soloists and 5 groups/year. Works with 4-5 freelance designers, 4-5 freelance illustrators/ year. Uses 3-4 artists/year for CD cover design; album/tape cover and brochure design and illustration; direct mail packages; advertising design and illustration; and posters. 25% of freelance work demands knowledge of Aldus FreeHand.
First Contact & Terms: Send query letter with SASE. Samples are filed. Reports back within 1 month. To show portfolio, mail photographs. Requests work on spec before assigning a job. Pays by the project. Buys all rights. Sometimes interested in buying second rights (reprint rights) to previously published work.
Tips: Finds new artists through submissions, self-promotion.

‡**CASH PRODUCTIONS, INC. (RECORDING ARTIST DEVELOPMENT CORPORATION),** 744 Joppa Farm Rd., Joppatowne MD 21085. Phone/Fax: (410)679-2262. President/CEO: Ernest W. Cash. Estab. 1987. Produces CDs and tapes: country/western by solo artists and groups. Recent releases: "Family Ties," by The Short Brothers.
Needs: Produces 8-10 solo artists and 8-10 groups/year. Works with 10-12 visual artists/year. Works only with artist reps. Works on assignment only. Uses artists for CD cover design and illustration; brochure design; catalog design and layout; direct mail packages; advertising design; posters. Needs computer-literate freelancers for design, illustration and presentation. 20% of freelance work demands computer skills.
First Contact & Terms: Send query letter with résumé. Samples are filed. Reports back to the artist only if interested. To show portfolio, mail final art. Pays for design by the project. "Price will be worked out with rep or artist." Buys all rights.

■**CASTLE RECORDS,** P.O. Box 1130, Tallevast FL 34270-1130. (813)351-3253. Fax: (813)351-3253. Vice President: Bob Francis. Estab. 1964. Produces CDs, tapes and albums: rock & roll, R&B, jazz, soul, dance and pop. Recent releases: *Nasty As They Wanna Be,* by Nasty Boys; "The Ultimate Male," by Noelle.
Needs: Produces 3-4 soloists and 6-10 groups/year. Works with 3-4 freelance designers, 3-4 freelance illustrators/year for CD and album/tape cover illustration; catalog illustration; posters; artist and label logos.

How to Use Your **Artist's & Graphic Designer's Market** *offers suggestions for understanding and using the information in these listings. Read this and other articles in the front of this book for important business tips.*

First Contact & Terms: Send query letter with tearsheets, résumé, photographs and SASE. Samples are filed or are returned by SASE. Reports back within 2 weeks. To show a portfolio, mail b&w and color photographs. Sometimes requests work on spec before assigning a job. Pays by the hour, $7.50-15; by the project, $100-2,500. Interested in buying second rights (reprint rights) to previously published work. Rights purchased vary according to project.

Tips: Finds new artists through *Artist's & Graphic Designer's Market* and referrals.

‡CAT'S VOICE PRODUCTIONS, P.O. Box 564, Newburyport MA 01950. (508)463-3028. Owner: Tom Reeves. Estab. 1982. Produces tapes, CDs and multimedia: rock & roll, R&B, progressive, folk, country/western, New Age. Recent releases: "Hot, Moist, Pink & Stinky," by The Mangled Ducklings; "One Groove At A Time," by Cleanshot.

Needs: Produces 4 solo artists and 18 groups/year. Works with 2-4 visual artists/year. Prefers artists with experience in album and rock media. Works on assignment only. Uses artists for CD cover design and illustration; tape cover design and illustration; brochure design and illustration; catalog design, illustration and layout; direct mail packgaes; advertising and illustration; posters. Needs computer-literate freelancers for design, illustration, production and presentation. 100% of freelance work demands knowledge of Aldus PageMaker, QuarkXPress, Aldus FreeHand, Adobe Illustrator, Adobe Photoshop and Claris Works.

First Contact & Terms: Send query letter with résumé, photographs and SASE. Samples are filed and are returned by SASE if requested by artist. Reports back within 1 month. Write for apointment to show portfolio or mail appropriate materials that include b&w final art and photographs. Pays for design by the hour, $15-75; by the project, $125-500; by the day, $200-400. Buys all rights.

***CELESTIAL SOUND PRODUCTIONS,** 23 Selby Rd. E. 113LT, London England. 081503-1687. Managing Director: Ron Warren Ganderton. Produces rock & roll, classical, soul, country/western, jazz, pop, R&B by group and solo artists. Recent releases: "I'm in Love" and "Find A Way Out."

Needs: Works with "many" artists/year for album cover, advertising and brochure design and illustration; posters.

First Contact & Terms: Send query letter with brochure showing art style or send résumé, business card and photographs to be kept on file "for a reasonable time." Samples not filed are returned by SASE only if requested. Reports within 5 days. Call for appointment to show portfolio, which should include roughs, color and b&w photographs. Original artwork returned after job's completion. Pays by the project. Considers available budget, how work will be used and rights purchased when establishing payment. Buys all rights, reprint rights or negotiates rights purchased.

Tips: "We are searching for revolutionary developments and those who have ideas and inspirations to express in creative progress."

‡CHATTAHOOCHEE RECORDS, 15230 Weddington St., Sherman Oaks CA 91411. (818)788-6863. Fax: (310)472-5568. A&R: André Duval. Estab. 1958. Produces CDs and tapes: rock & roll, pop by groups. Recent releases: "Don't Touch it Let it Drip," by Cream House.

Needs: Produces 1-2 groups/year. Works with 1 visual artist/year. Prefers local artists only. Works on assignment only. Uses artists for CD cover design and illustration; tape cover design and illustration; advertising design and illustration; posters. 50% of freelance work demands knowledge of Adobe Illustrator.

First Contact & Terms: Send query letter with brochure, résumé and photographs. Samples are filed and are not returned. Reports back to the artist only if interested. To show portfolio, mail final art and photographs. Pays for design by the project. Rights purchased vary according to project.

CHERRY STREET RECORDS, INC., P.O. Box 52681, Tulsa OK 74152. (918)742-8087. President: Rodney Young. Estab. 1991. Produces CDs and tapes: rock & roll, R&B, country/western, soul, folk by solo and group artists. Past releases: *Blue Dancer*, by Chris Blevins and *Tulsa Style*, by Brad Absher.

Needs: Produces 2 soloists/year. Works with 2 designers and 2 illustrators/year. Prefers artists with experience in CD and cassette design. Works on assignment only. Uses artists for CD cover design and illustration, album/tape cover illustration; catalog design; and advertising illustration. Needs computer-literate freelancers for design, illustration, production and presentation. 50-75% of freelance work demands computer skills.

First Contact & Terms: Send query letter with SASE. Samples are filed or are returned by SASE. Reports back only if interested. Write for appointment to show portfolio which should include printed samples, b&w and color photographs. Pays by the project, $50-1,000. Buys all rights.

Tips: "Compact disc covers and cassettes are small. Your art must get consumer attention."

***COMMA RECORDS & TAPES,** Box 2148, D-63243, Neu Isenburg Germany. 06102-51065. Fax: 06102-52696. Contact: Marketing Department. Estab. 1972. Produces CDs, tapes and albums: rock & roll, R&B, classical, country/western, soul, folk, dance, pop by group and solo artists.

Needs: Produces 70 soloists and 40 groups/year. Uses 10 artists/year for CD and album/tape cover and brochure design and illustration; posters.

First Contact & Terms: Send query letter with brochure, tearsheets, photostats, photographs, SASE, photocopies and transparencies. Samples are not filed and are returned by SASE if requested by artist. Reports

back to the artist only if interested and SASE enclosed. To show a portfolio, mail copies of final art and b&w photostats, tearsheets, photographs and transparencies. Payment negotiated. Buys first rights and all rights.

CORNELL ENTERTAINMENT GROUP, Suite 210, 907 Baltimore St., Mobile AL 36605-4653. (205)690-5495. President: Antonio Pritchett. Estab. 1987. Produces CDs and tapes: rock & roll, R&B, pop, progressive by group and solo artists. Recent releases: *To The Groove*, by Da Force; *Get Back Up*, by Messenger and *Serve The Lord*, by the Chatmans.
Needs: Uses artists for CD and tape cover design and illustration; advertising design and illustration; direct mail packages; and posters. Needs computer-literate freelancers for production and presentation. 10% of work demands knowledge of Photoshop.
First Contact & Terms: Send query letter with tearsheets, résumé, photographs, photocopies and SASE. Samples are filed or returned by SASE if requested. Reports back within 3-4 weeks. Call or write for appointment to show portfolio of roughs, final art, b&w and color photostats, tearsheets and photographs. Pays by the hour, $7-15; by the project, $50-2,800; by the day, $50-$400. Rights purchased vary according to project.

■**COWBOY JUNCTION FLEA MARKET & PUBLISHING CO.,** Highway 44 and Junction 490, Lecanto FL 34461. (904)746-4754. Secretary: Elizabeth Thompson. Estab. 1957. Produces tapes, albums and CDs: country/western and bluegrass. Recent releases: *I Love Miss America*, *Alabama* and *Desert Storm*, by Buddy Max.
Needs: Produces 3 albums/year; soloists and groups. Uses 12 artists/year for album/tape cover illustration and design; and direct mail packages.
First Contact & Terms: Send query letter with SASE. Samples are not filed and are returned by SASE. Portfolio review not required. Requests work on spec before assigning a job.
Tips: "Display at Cowboy Junction Flea Market on Tuesday or Friday; come to our Country/Western—Bluegrass Music Show Saturday at 2 pm and show us and all involved your works." Closed July and August.

‡**CREATIVE NETWORK INC.,** (formerly Nicoletti Productions Inc.), Box 2818, Newport Beach CA 92663. (714)494-0181. Fax: (714)494-0982. President: J. Nicoletti. Estab. 1976. Produces CDs, tapes and albums: rock & roll, jazz, rap, group artists, rhythm and blues, soul, pop, folk, country/western, dance and solo artists. Releases include: *Soldier's Eyes*, by Joseph Nicoletti; *Let's Put the Fun Back in Rock'n'Roll*, by Fabian, Frankie Avalon, Bobby Rydell; *Those Funky Kind of Guys*, by Eliza Lorenz.
Needs: Produces 3 soloists/year. Works with 10 visual artists/year. Uses artists for all design, illustration and layout work.
First Contact & Terms: Send query letter with tearsheets, photostats, résumé, SASE, photographs, slides, photocopies and transparencies—Present "a clean package of your best work." Samples are filed. Reports back within 3 weeks. Call to schedule an appointment to show a portfolio, or mail appropriate materials, which should include "whatever you need to show." Payment negotiated. Negotiates rights purchased.
Tips: Finds new artists through artists' submissions/self-promotional material.

■**CRS ARTISTS,** 724 Winchester Rd., Broomall PA 19008. (215)544-5920. Fax: (215)544-5921. Administrative Assistant: Caroline Hunt. Estab. 1981. Produces CDs, tapes and albums: jazz and classical by solo artists and compilations. Recent releases: *Excursions* and *Albumleaf*.
Needs: Produces 20 CDs/year. Works with 4 designers and 5 illustrators/year on assignment only. Needs computer-literate freelancers for design and presentation. 50% of freelance work demands knowledge of Windows/Wordstar.
First Contact & Terms: Send query letter with brochure, résumé, photographs and photocopies. Samples are filed or are returned by SASE if requested by artist. Reports back within 1 month only if interested. Call for appointment to show portfolio or mail roughs, b&w tearsheets and photographs. Requests work on spec before assigning a job. Pays by the project. Buys all rights; negotiable.
Tips: Finds new artists through *Artist's & Graphic Designer's Market*.

‡**CYMBAL RECORDS,** P.O. Box 27410, Las Vegas NV 89126. (702)735-8175. Owner: David Johnson. Estab. 1984. Produces CDs and tapes: rock & roll, jazz, pop, R&B, soul, classical and folk by solo artists and groups. Recent releases: "I Need Your Love," by David Wilkerson; "Hand Prints," by Ben Sher.
Needs: Produces 4 solo artists/year. Works on assignment only. Uses artists for CD cover design and illustration; tape cover design and illustration; catalog design; advertising design and illustration; and posters.
First Contact & Terms: Send query letter with résumé and SASE. Samples are not filed and are returned by SASE. Reports back within 1 month. To show portfolio, mail b&w samples. Pays for design by the project. Rights purchased vary according to project.

‡**DIRECT FORCE PRODUCTIONS,** Box 255, Roosevelt NY 11575. (516)867-3585. President: Ronald Amedee. Estab. 1989. Produces CDs and tapes: rock and roll, jazz, rap, rhythm and blues, soul, pop, country/western by group and solo artists. Recent releases: *Direct Force*, by Rono Amedee; and *Love Force Unlimited*, by Paco Julliano.

Needs: Produces 25 albums/year; soloists and groups. Works with 15 freelance designers and 10 freelance illustrators/year. Prefers artists with experience in the music field. Uses artists for CD cover design; album/tape cover design and illustration; advertising design; posters. Needs computer-literate freelancers for design and illustration. 10% of freelance work demands computer literacy in QuarkXPress or Adobe Illustrator.
First Contact & Terms: Send query letter with résumé and photographs. Samples are filed or are returned. Reports back within 15 days. Call to schedule an appointment to show a portfolio or mail appropriate materials: original/final art and b&w and color samples. Sometimes requests work on spec before assigning a job. Pays for design and illustration by the project, $200-1,500. Rights purchased vary according to project.

‡DOC HOLIDAY PRODUCTIONS, 10 Luanita Lane, Newport News VA 23606. (804)930-1814. Fax (804)930-1814. President: Doc Holiday. Estab. 1971. Produces CDs and tapes: rock & roll, R&B, soul, country/western, rap by solo artists and groups. Recent releases: "Cajun Baby," by Hank Williams Jr. and Doug Kershaw; "Don't Mess With My Toot Toot," by Fats Domino and Doug Kershaw.
Needs: Produces 30-40 solo artists and 15-20 groups/year. Work with 3-5 visual artists/year. Works on assignment only. Uses artists for CD cover design and illustration; tape cover design and illustration; brochure design; catalog design; and posters. 25% of freelance work demands computer skills.
First Contact & Terms: Send query letter with brochure, résumé, photocopies, photographs and tearsheets. Samples are filed. Reports back within 2 weeks only if interested. To show portfolio, mail b&w and color final art, tearsheets and photographs. Pays for design by the project. Buys first rights, one-time rights or all rights.

DRAGON STREET RECORDS, INC., P.O. Box 670714, Dallas TX 75367-0714. (214)750-4584. Fax: (214)369-5972. President/Art Director: David Dennard. Estab. 1989. Produces CDs and tapes: rock and roll, pop and alternative/commercial. Recent releases: *Six*, by The Nixons; *Bill*, by Tripping Daisy; and *Buick Men*, by Hagfish.
Needs: Produces 6 groups/year. Works with 3-6 designers and 2-4 illustrators/year. Prefers artists with experience in cutting-edge graphic layouts and visuals. Also prefers PC or Mac-based artists with color scanning and 4-color output experience. Works on assignment only. Uses artists for CD cover design and illustration, album/tape cover design; catalog and advertising design; posters; and merchandising materials design (T-shirts, stickers, etc.). Needs comptuer-literate freelancers for design, illustration and production. 85% of freelance work demands computer skills in QuarkXPress, Photoshop or Streamliner.
First Contact & Terms: Send query letter with résumé and any appropriate materials. Samples are filed or are returned by SASE if requested by artist. Reports back only if interested. Call for appointment to show portfolio which should include original/final art, photostats, photographs and slides. Pays by the project, $350-1,000. "Most projects are by bid." Rights purchased vary according to project.
Tips: "As the image area decreases on new formats, high-impact, attention-getting graphics will be essential in the retail arena of record stores."

‡DREAMBOX MEDIA (E.A.R.S., INC.), Box 8132, Philadelphia PA 19101. (215)328-1619. General Manager: Jim Miller. Estab. 1986. Produces CDs and tapes: jazz by groups. Recent releases: "Tunnel Vision," by Reverie; "Street Blues," by "Father" John D'Amico.
Needs: Produces 3 groups/year. Works with 2 visual artists/year. Works only with artists reps. Prefers local artists with experience in graphics. Works on assignment only. Uses artists for CD cover design and illustration; tape cover design and illustration; brochure design and illustration; catalog design; direct mail packages; advertising design and illustration; posters; and logo designs. Needs computer-literate freelancers for design and production. 100% of freelance work demands knowledge of Aldus FreeHand and MacPAINT.
First Contact & Terms: Contact only through artist agent. Samples are filed. Reports back to artist only if interested within 6 months. To show portfolio, mail color final art, tearsheets and transparencies. Pays for design by the project, $300-600. Rights purchased vary according to project.

EMPEROR OF EMPERORS, P.O. 3387, Fontana CA 92334-3387. (909)355-2372. Producer: Stephen V. Mann. Estab. 1979. Produces CDs, tapes, feature films, videos and commercials: produces all types of music. Recent releases: *All Souled Out*, by Krishnautix, music by artists from Peru and India as well as motion picture soundtracks.
Needs: Produces 200 soloists and 50 groups/year. Uses 15-20 visual artists/year. Prefers multi-talented artists. Works on assignment only. Uses artists for CD, tape, brochure and advertising design and illustration; catalog design, illustration and layout; direct mail packages and posters. Needs computer-literate freelancers for design, illustration, production and presentation. 70% of work demands knowledge of Aldus PageMaker, QuarkXPress, Aldus FreeHand, Adobe Illustrator and Photoshop.
First Contact & Terms: Send query letter with brochure, résumé, photographs and slides. Samples are filed. Reports back only if interested. Write for appointment to show portfolio of final art and color photographs, slides and transparencies. Requests work on spec before assigning a job. Pays by the project, $250-350 for illustration and design. Sometimes interested in buying second rights (reprint rights) to previously published work, or as edited. Rights purchased vary according to project.
Tips: Finds new artists through word of mouth, artists' submissions.

‡**EMZEE RECORDS**, P.O. Box 3213, S. Farmingdale NY 11735. Phone/Fax: (516)420-9169. President: Dawn Kendall. Estab. 1983. Produces tapes, CDs and vinyl: rock & roll, jazz, pop, R&B, folk, country/western and rap by solo artists and groups. Recent releases: "X-Quisite Contrast," by ZALE; "Memories of You," by Tony Novarro.

Needs: Produces 25 solo artists and 20 groups/year. Works with 15 visual artists/year. Prefers artists with experience in music industry. Works on assignment only. Uses artists for CD cover design and illustration; tape cover design and illustration; brochure illustration; catalog design, illustration and layout; direct mail packages; posters. Needs computer-literate freelancers for design and illustration. 50% of freelance work demands knowledge of Aldus PageMaker, Adobe Illustrator, Adobe Photoshop, Aldus FreeHand.

First Contact & Terms: Send query letter with brochure, résumé, photostats, transparencies, photocopies, SASE and tearsheets. Samples are filed and are returned by SASE. Reports back within 3 weeks. To show portfolio, mail b&w and color thumbnails, tearsheets, photostats and transparencies. Pays for design by the project, $500-10,000. Rights purchased vary according to project.

Tips: "Network with musicians, record companies."

ETHEREAN MUSIC/ELATION ARTISTS, #510, 9200 W. Cross Dr., Littleton CO 80123-2225. (303)973-8291. Fax: (303)973-8499. Contact: Chad Darnell. Estab. 1988. Produces 4-10 CDs and tapes/year: jazz and new age/Native American. Recent releases: *Saxafaction*, by Bryan Savage; *Mayan Dream*, by Tee'el and Dik Darnell.

Needs: Produces 2-6 soloists and 2-6 groups/year. Works with 1 designer and 1 illustrator/year for CD and tape cover design and illustration. Needs computer-literate freelancers for illustration. 80% of freelance work demands knowledge of QuarkXPress, Adobe Illustrator and Photoshop.

First Contact & Terms: Send query letter with brochure, résumé, photostats and photocopies. "No original artwork." Samples are filed or are returned by SASE if requested. Reports back only if interested. Write for appointment to show portfolio. Sometimes requests work on spec before assigning a job. Pays for design by the project, $200-1,000. Pays for illustration by the hour, $100-500. Rights purchased vary according to project.

Tips: Finds new artists through word of mouth. "Network with groups like NAIRD-NAPRA, etc. Send out a lot of letters and pray! Many labels do work inhouse."

FARR MUSIC AND RECORDS, Box 1098, Somerville NJ 08876. (201)722-2304. Contact: Candace Campbell. Produces CDs, tapes and albums: rock & roll, dance, soul, country/western, folk and pop by group and solo artists.

Needs: Produces 12 records/year by 8 groups and 4 soloists. Works with 12 designers and 20 illustrators/year. Uses artists for album cover design and illustration; brochure and catalog design; advertising design and illustration; and posters.

First Contact & Terms: Send query letter with résumé, tearsheets, photostats, photocopies, slides and photographs to be kept on file. Samples not filed are returned by SASE. Reports within 3 weeks. To show a portfolio, mail roughs, final reproduction/product and color photographs. Original art returned to the artist. Pays for design by the hour, $30-150; pays for illustration by the hour, $130-150. Buys first rights or all rights.

FINER ARTS RECORDS/TRANSWORLD RECORDS, Suite 115, 2170 S. Parker Rd., Denver CO 80231. (303)755-2546. Fax: (303)755-2617. President: R. Bernstein. Produces CDs and tapes: rock & roll, dance, soul, country/western, jazz, pop and R&B by group and solo artists. Recent releases: *Miracles and Dreams*, original cast recording and *Israel, Oh Israel* by the Leningrad Philharmonic Orchestra.

Needs: Produces 3 CDs, tapes/year. Works with 1-2 designers and 1-2 illustrators/year. Uses artists for album cover design and illustration; and posters. Needs computer-literate freelancers for production. 50% of freelance work demands knowledge of Aldus PageMaker.

First Contact & Terms: Send query letter with brochure showing art style or résumé and tearsheets, photostats and photocopies. Samples are filed or returned only if requested. Reports back only if interested. Write for appointment to show portfolio. Negotiates pay by the project, $500 minimum. Considers complexity of project, available budget and turnaround time when establishing payment. Negotiates rights purchased.

‡**1ST COAST POSSE RECORDS/HALLWAY INTERN'L RECORDS**, 8010 International Village Dr., Jax FL 32211. Eastern Office: (904)765-8276. Western Office: (213)295-2588. East Creative Director: Ron "Cosmos" Hall. West Creative Director: Al Money. Estab. 1990. Produces VHS videotapes, CDs tapes and 12″ singles: jazz, R&B, rap, world/New Age by solo artists and groups. Recent releases: "Tales of the Buffalo Soldiers," by Al Hall, Jr. and Cosmos Dwellers; and "U Ain't Know," by Eli D/H_{II}O.

Needs: Produces 2-4 solo artists and 4 groups/year. Works with 2-3 visual artists/year. Works on assignment only. Uses artists for CD cover design and illustration; tape cover design and illustration; brochure design and illustration; catalog design; direct mail packages; advertising design; and posters. Needs computer-literate freelancers for design, illustration, production. 25% of freelance work demands computer skills.

First Contact & Terms: Send query letter with brochure, résumé and photocopies. Samples are filed. Reports back to the artist only if interested. To show portfolio, mail appropriate materials. Pays for design by the

project, by negotiated contract. Rights purchased vary according to project.

Tips: "Be different; be bold; work should be vivid enough to get attention—the product will take it from there!"

■**FMG GRAPHICS**, Dept. AM, Suite 300, 4041 MacArthur Blvd., Newport Beach CA 92660. (714)660-3888. Fax: (714)660-3899. Estab. 1985. Produces CDs and tapes: rock & roll, R&B, soul, dance, rap, pop by solo and group artists—"gospel artists only."

Needs: Produces 8 soloists and 10 groups/year. Works with 10 artists/year with experience in "MacIntosh DTP—electronic pre-press." Works on assignment only. Uses artists for CD and album/tape cover design and illustration; brochure design and illustration; catalog design, illustration and layout; advertising design and illustration; and posters.

First Contact & Terms: Send query letter with tearsheets, résumé, photographs, slides, SASE, photocopies and transparencies. Samples are filed or are returned by SASE. Reports back only if interested. Call for appointment to show portfolio which should include thumbnails, b&w tearsheets, photographs, slides, transparencies 4×5 or smaller. Pays by the project, $300-1,500. Rights purchased vary according to project.

‡**FOLK ERA RECORDS, DIVISION OF AZTEC CORP.**, 705 S. Washington St., Naperville IL 60540. (708)305-0823. Fax: (708)305-0782. Vice President: Mike Fleischer. Estab. 1983. Produces CDs and tapes: folk, country/western, bluegrass by solo artists and groups. Recent releases: "In the Heat Of The Summer," by Kim and Reggie Harris; "Rising In Love," by David Roth.

Needs: Produces 3-9 solo artists and 3-9 groups/year. Prefers local artists with experience in CD and cassette cover design. Works on assignment only. Uses artists for CD cover design and illustration; tape cover design and illustration. Needs computer-literate freelancers for design and production. 33⅓% of freelance work demands knowledge of QuarkXPress.

First Contact & Terms: Send query letter with brochure, photostats, photocopies, tearsheets. Samples are not filed and are returned by SASE if requested by artist. Reports back to the artist only if interested in 6-12 weeks. Write for appointment to show portfolio that includes b&w and color roughs, final art and tearsheets. Pays for design by the project, $100-1,000. Negotiates rights purchased.

Tips: "Find a local artist or group and 'volunteer' to do a cover design. That gives the artist a sample to show to prospective clients."

‡**GENESEE RECORDS INC.**, 100 Chicago, Litchfield MI 49252. (517)542-2400. Estab. 1984. Produces tapes: gospel, country/western. Recent releases: "Rollin Road" and "Suntan Motion" by Country Express.

Needs: Produces 2-4 solo artists and 1 group/year. Works with 1 visual artist/year. Prefers local artists only. Uses artists for tape cover design and illustration; and posters.

‡**GOLDBAND RECORDS**, P.O. Box 1485, Lake Charles LA 70602. (318)439-8839 or (318)439-4295. Fax: (318)491-0994. President: Eddie Shuler. Estab. 1944. Produces CDs and tapes: rock & roll, jazz, R&B, progressive, folk, gospel, country/western, cajun, zydeco. Recent releases: *Cajun Troubadour*, by Jo'el Sonnier; *Making Love In Chicken Koop*, by Willis Prudhomme; *Mel 'Love Bug' Pellerin*, by Mel Pellerin (Watermelon Rock); *Hackberry Ramblers* featuring Linda Dodd LaPointe (Cajun French).

Needs: Produces 3 groups/year. Uses artists for CD cover design and direct mail packages. Needs computer-literate freelancers for design.

First Contact & Terms: Send query letter with brochure and résumé. Samples are filed and are returned by SASE if requested by artist. Reports back to the artists only if interested. Call to show portfolio of roughs and photographs. Pays for design by the project. Negotiates rights purchased.

HARD HAT RECORDS AND CASSETTE TAPES, 519 N. Halifax Ave., Daytona Beach FL 32118-4017. (904)252-0381. Fax: (904)252-0381. CEO: Bobby Lee Cude. Produces rock & roll, country/western, folk and educational by group and solo artists. Publishes high school/college marching band arrangements. Releases include: *Broadway USA!!* and "Done It All," by Frederick-the-Great.

• Also owns Blaster Boxx Hits.

Needs: Produces 6-12 records/year. Works with 2 designers and 1 illustrator/year. Works on assignment only. Uses artists for album cover design and illustration; advertising design; and sheet music covers. Prefers promotional material look "modern, up-to-date, on the cutting edge" and that cover designs fit the music style. Needs computer-literate freelancers for design. 60% of freelance work demands computer skills in Photoshop.

First Contact & Terms: Send query letter with brochure to be kept on file one year. Samples not filed are returned by SASE. Reports within 2 weeks. Write for appointment to show portfolio. Sometimes requests work on spec before assigning a job. Pays by the project. Buys all rights.

Always enclose a self-addressed, stamped envelope (SASE) with queries and sample packages.

‡❋**HICKORY LANE RECORDS**, Box 2275, Vancouver, British Columbia V6B 3W5 Canada. (614)465-1408. President: Chris Michaels. Estab. 1985. Produces CDs and tapes: rock & roll, pop, folk, gospel, country/western. Recent releases: "Country Drives Me Wild," by Chirs Michaels; "For Her and the Roses," by Steve Blake Montihue; "Until Now," by Steve Mitchell and Chris Michaels.
Needs: Produces 5 solo artists and 2 groups/year. Works with 13 visual artists/year. Works on assignment only. Uses artists for CD cover design and illustration; tape cover design and illustration; brochure design and illustration; advertising designing and illustration; posters. Needs computer-literate freelancers for design. 25% of freelance work demands knowledge of Aldus PageMaker, Adobe Illustrator, QuarkXPress, Adobe Photoshop, Aldus FreeHand.
First Contact & Terms: Send query letter with brochure, résumé, photostats, transparencies, photocopies, photographs, SASE and tearsheets. Samples are filed and are returned by SASE if requested by artist. Reports back within 6 weeks. Call or write for appointment to show portfolio of b&w and color roughs, final art, tearsheets, photostats, photographs, transparencies and computer disks. Pays for design by the project, $250-650. Negotiates rights purchased.

‡**HOLLYROCK RECORDS**, C-300, 16776 Lakeshore Dr., Lake Elsinore CA 92530. (909)699-3338. Fax: (909)699-0533. A&R: D. Paton. Estab. 1985. Produces CDs and tapes: rock & roll, pop, country/western by solo artists and groups. Recent releases: "Gett Outta Town," by Linda Rae and Breakheart Pass; "Headline News," by Brett Duncan.
Needs: Produces 4 solo artists and 3-5 groups/year. Works with 3-5 visual artists/year. Works only with artist reps. Prefers local artists with experience in music covers. Uses artists for CD cover design and illustration; tape cover design and illustration; and direct mail packages. Needs computer-literate freelancers for design, illustration, production and presentation. 50% of freelance work demands knowledge of Aldus PageMaker and Adobe Photoshop.
First Contact & Terms: Send query letter with brochure, résumé, photostats, photographs. Samples are filed and are returned by SASE. Reports back in 1 month. Write for appointment to show portfolio of b&w and color thumbnails and photographs. Pays for design by the project. Buys all rights.

HOTTRAX RECORDS, 1957 Kilburn Dr., Atlanta GA 30324. (404)662-6661. Publicity and Promotion: Teri Blackman. Estab. 1975. Produces CDs and tapes: rock & roll, R&B, country/western, jazz, pop and blues/novelties by solo and group artists. Recent releases: *Poor Man Shuffle*, by The Bob Page Project and *Hurricane Warning*, by Roger Hurricane Wilson.
Needs: Produces 2 soloists and 4 groups/year. Works with 2-4 visual artists/year. Prefers artists with experience in multimedia—mixing art with photographs—and caricatures. Uses artists for CD and tape cover design and illustration; catalog and advertising design and illustration; and posters. Needs computer-literate freelancers for design and illustration. 25% of freelance work demands knowledge of Aldus PageMaker, Adobe Illustrator and Photoshop.
First Contact & Terms: Send query letter with samples (color photocopies OK). Some samples are filed. If not filed samples are not returned. Reports back only if interested. Pays by the project, $100-1,000. Buys all rights.

INSTINCT RECORDS, #502, 26 West 17th St., New York NY 10011. (212)727-1360. Label Manager: Gerald Helm. Estab. 1989. Produces CDs and tapes: disco, pop, dance and techno. Recent releases: *Plasticity*, by Cabaret Voltaire and *Ambient*, by Moby.
Needs: Works with 10 visual artists/year. Releases 30 CDs, tapes each year. Prefers local artists and Macintosh-based designers only. Artists work on assignment only. Uses artists for CD cover, tape cover and advertising design and illustration. Needs computer-literate freelancers for design, illustration and production. 90% of freelance work demands knowledge of QuarkXPress, Adobe Illustrator and Photoshop.
First Contact & Terms: Send query letter with SASE. Samples are returned by SASE if requested. Reports back only if interested. Call for appointment to show portfolio of thumbnails, roughs, final art and color slides. Requests work on spec before assigning a job. Pays by the hour, $25 minimum; or by the project, $400 minimum. Rights purchased vary according to project.

J & J MUSICAL ENTERTAINMENT, Suite 434, 156 Fifth Ave., New York NY 10010. (212)691-5630. Fax: (212)645-5038. President: Jeneane Claps. Estab. 1979. Produces CDs, tapes and albums: jazz and rap. Recent releases: *Textile*, by Freeway Fusion and *Summer Set*, by Jeneane.
Needs: Produces 4 soloists and 2 groups/year. Prefers local artists only. Works on assignment only. Uses artists for CD cover design and illustration; album/tape cover illustration; brochure design; catalog design, illustration and layout; direct mail packages; advertising illustration; and posters.
First Contact & Terms: Send query letter with brochure, résumé and SASE. Samples are not filed and are returned by SASE if requested by artist. Reports back within 6 weeks. Write for appointment to show portfolio or mail thumbnails, b&w and color photostats, tearsheets and photographs. Pays by the project. Buys first rights or all rights.

‡■**JAY JAY,** NE 35 62nd St., Miami FL 33138. (305)758-0000. President: Walter Jagiello. Produces CDs and tapes: country/western, jazz and polkas. Recent releases: *Donna I Really Wanna*, by Li'l Wally and *Great Polka Hits*, by Mil-Ed Duo-Kuta and Li'l Wally.
Needs: Produces 7 CDs, tapes and albums/year. Works with 3 freelance designers and 2 illustrators/year. Works on assignment only. Uses artists for album cover design and illustration; brochure design; catalog layout; advertising design, illustration and layout; and posters. Sometimes uses artists for newspaper ads. Knowledge of midi-music lead sheets helpful for freelancers.
First Contact & Terms: Send brochure and tearsheets to be kept on file. Call or write for appointment to show portfolio. Samples not filed are returned by SASE. Reports within 2 months. Requests work on spec before assigning a job. Pays for design by the project, $20-50. Considers skill and experience of artist when establishing payment. Purchases all rights.

JAZZAND, 12 Micieli Place, Brooklyn NY 11218. (718)972-1220. Proprietor: Rick Stone. Estab. 1984. Produces CDs and tapes: jazz. Past releases: *Far East*, by Rick Stone Quartet and *Blues for Nobody*, by Rick Stone.
Needs: Produces 1 soloist and 1 group/year. Works with 2 designers/year. Prefers local artists with experience in cover and poster design. Works on assignment only. Uses artists for CD and album/tape cover design and illustration; brochure and catalog design and layout; direct mail packages; advertising design; and posters. Needs computer-literate freelancers for design and production. 20% of freelance work demands computer skills in Aldus PageMaker, Adobe Illustrator or Photoshop.
First Contact & Terms: Send query letter with résumé, tearsheets and photocopies. Samples are filed. Reports back within 1 month. Call for appointment to show portfolio or mail appropriate materials, including tearsheets and photographs. Pays by the project, $150-750.
Tips: "Get to know people at labels, producers, etc. Establish *personal* contacts; even if someone can't use your services right now, 6 months from now they may be in need of someone. People in the music business tend to move around frequently to other record companies, agencies, etc. If you've developed a good rapport with someone and they leave, find out where they've gone; the next company they work for might hire you."

KIMBO EDUCATIONAL, 10 N. 3rd Ave., Long Branch NJ 07740. Production Manager: Amy Laufer. Educational record/cassette company. Produces 8 records and cassettes/year for schools, teacher supply stores and parents. Primarily early childhood physical fitness, although other materials are produced for all ages.
Needs: Works with 3 freelance artists/year. Prefers local artists on assignment only. Uses artists for ads; catalog design; album, cassette, CD covers; and flier designs. Helpful if artist has experience in the preparation of album jackets or cassette inserts.
First Contact & Terms: "It is very hard to do this type of material via mail." Write or call for appointment to show portfolio. Prefers photographs or actual samples of past work. Reports only if interested. Pays for design and illustration by the project, $200-500. Considers complexity of project and budget when establishing payment. Buys all rights.
Tips: "The jobs at Kimbo vary tremendously. We produce material for various levels—infant to senior citizen. Sometimes we need cute 'kid-like' illustrations and sometimes graphic design will suffice. A person experienced in preparing an album cover would certainly have an edge. We are an educational firm so we cannot pay commercial record/cassette art prices."

LAMBSBREAD INTERNATIONAL RECORD COMPANY/LBI, Box 328, Jericho VT 05465. (802)899-3787. Creative Director: Robert Dean. Estab. 1983. Produces CDs, tapes and albums: R&B, reggae. Recent release: *Reggae Mood*, by Lambsbread.
Needs: Produces 2 soloists and 2 groups/year. Works with 3 designers and 2 illustrators/year. Works on assignment only. Uses artists for CD cover design; album/tape cover design and illustration; catalog design; direct mail packages; advertising design; and posters. Needs competent freelancers for design, illustration, production and presentation. 70% of freelance work demands computer skills.
First Contact & Terms: Send query letter with brochure, tearsheets, résumé, photographs, SASE and photocopies. Samples are filed. Reports back only if interested. To show a portfolio, mail thumbnails, roughs, photostats and tearsheets. Sometimes requests work on spec before assigning a job. Payment negotiated by the project. Buys all rights or negotiates rights purchased according to project.
Tips: "Become more familiar with the way music companies deal with artists. Also check for the small labels which may be active in your area. The technology is unreal regarding computer images and graphics. So don't over price yourself right out of work."

‡**LANDMARK COMMUNICATIONS GROUP,** Box 1444, Hendersonville TN 37077. President: Bill Anderson Jr. Estab. 1980. Produces CDs, albums and tapes: country/western and gospel. Releases include: *You Were Made for Me*, by Skeeter Davis and *Talkin' Bout Love*, by Gail Score.
Needs: Produces 6 soloists and 2 groups/year. Works with 2-3 freelance designers and illustrators/year. Works on assignment only. Uses artists for CD cover design and album/tape cover illustration.
First Contact & Terms: Send query letter with brochure. Samples are filed. Reports back within 1 month. Portfolio should include tearsheets and photographs. Rights purchased vary according to project.

‡**LBJ PRODUCTIONS**, 8608 W. College St., French Lick IN 47432. (812)936-7318. Executive Producer: Larry B. Jones. Estab. 1989. Produces tapes, CDs, records, posters: rock & roll, gospel, country/western by solo artists and groups. Recent releases: "First Time Out," by Borrowed Time; "Do You Feel the Same," by Desert Reign.
Needs: Produces 5-6 solo artists and 2-3 groups/year. Works with 1-2 visual artists/year. Prefers local artists only with experience in music industry. Works on assignment only. Uses artists for CD cover design and illustration; tape cover design and illustration; brochure design; advertising design and illustration; posters. Needs computer-literate freelancers for design and production. 50% of freelance work demands knowledge of Aldus PageMaker, Adobe Illustrator; Adobe Photoshop.
First Contact & Terms: Send query letter with résumé, photocopies, SASE and tearsheets. Samples are filed and are returned by SASE if requested by artist. Reports back within 6 weeks. Call for appointment to show portfolio of b&w thumbnails, final art and tearsheets. Pays for design by the project, $75-500. Rights purchased vary according to project.

PATTY LEE RECORDS, 6034 Graciosa Dr., Hollywood CA 90068. (213)469-5431. Contact: Susan Neidhart. Estab. 1986. Produces CDs and tapes: New Orleans rock & roll, jazz, folk, country/western, cowboy poetry and eclectic by solo artists. Recent releases: *Alligator Ball*, by Armand St. Martin and *Horse Basin Ranch*, by Timm Daughtry.
Needs: Produces 4-5 soloists/year. Works with 1 designer and 2 illustrators/year. Works on assignment only. Uses artists for cover designs, sign designs, brochure design and posters.
First Contact & Terms: Send query letter. Samples are filed or are returned by SASE. Reports back only if interested. For appointment to show a portfolio, mail appropriate letter. "Do not send anything other than an introductory letter." Payment varies. Rights purchased vary according to project.
Tips: Finds new artists through word of mouth, magazines, artists' submissions/self-promotional material, sourcebooks, artist's agents and reps and design studios. "Our label is small but growing. The economy has not affected our need for artists."

***LEMATT MUSIC LTD./Pogo Records Ltd./Swoop Records/Grenouille Records/Zarg Records/Lee Sound Productions/R.T.F.M./Lee Music Ltd./Check Records/Value For Money Productions**, % Stewart House, Hill Bottom Rd., Sands, IND, EST, Highwycombe, Buckinghamshire England. (0630)647374. Fax: (0630)647612. Manager, Director: Ron Lee. Produces CDs, tapes and albums: rock & roll, dance, country/western, pop, and R&B by group and solo artists. Recent releases: "Savior of Love" and *American Girl*, by Hush.
Needs: Produces 25 CDs, tapes/year. Works with 3-4 freelance designers, 3-4 freelance illustrators/year. Works on assignment only. Uses a few cartoons and humorous and cartoon-style illustrations where applicable. Uses artists for album cover design and illustration; advertising design, illustration and layout; and posters. Needs computer-literate freelancers for design, illustration and presentation. 30% of freelance work demands knowledge of computers.
First Contact & Terms: Send query letter with brochure, résumé, business card, slides, photographs and videos to be kept on file. Samples not filed are returned by SASE (nonresidents send IRCs). Reports within 3 weeks. To show portfolio mail final reproduction/product and photographs. Original artwork sometimes returned to artist. Payment negotiated.
Tips: Finds new artists through artists' submissions and design studios.

‡**LIMITED POTENTIAL RECORDS**, P.O. Box 268586, Chicago IL 60626. President: Mike Potential. Estab. 1987. Produces tapes, CDs and 7" vinyl: rock & roll, pop by groups. Recent releases: "Screen Kiss," by OO OO WA; "I Am One," by Smashing Pumpkins.
Needs: Produces 5-10 groups/year. Works with 2-3 visual artists/year. Prefers artists with experience in 4-color album, CD, tape art. Works on assignment only. Uses artists for CD cover design; tape cover design and illustration; catalog design and layout; direct mail packages; advertising illustration; and posters. Needs computer-literate freelancers. 75% of freelance work demands knowledge of QuarkXPress, Adobe Photoshop, Corel Draw.
First Contact & Terms: Send query letter with résumé and tearsheets. Samples are filed and are returned by SASE if requested by artist. Reports back within 1 month. To show portfolio, mail b&w and color final art and tearsheets. Pays for design by the project, $50-1,000. Rights purchased vary according to project.
Tips: "As with everything in the music biz, its all who you know! Start befriending people in bands—do a lot of work designing fliers and such, and be prepared to work cheap, or to work for free to start off. There are lots of artists trying to break in, and not a lot of cash at that level!"

 The asterisk before a listing indicates that the market is located outside the United States and Canada.

LITTLE RICHIE JOHNSON AGENCY, Box 3, Belen NM 87002. (505)864-7442. Fax: (505)864-7442. General Manager: Tony Palmer. Produces tapes and albums: country/western. Recent releases: *At His Best*, by Albert Young Eagle and *She's Back*, by Myrna Lorrie.
Needs: Produces 5 soloists and 2 groups/year. Works with "a few" designers and illustrators/year on assignment only. Prefers local artists only. Uses artists for album/tape cover design and advertising design.
First Contact & Terms: Send query letter with brochure showing art style or photographs. Samples are filed or are returned by SASE only if requested. Reports back only if interested. To show a portfolio, mail photographs. Pays for design and illustration by the project. Considers complexity of project and available budget when establishing payment. Rights purchased vary according to project.

LSR RECORDS, 81 N. Forest, Rockville Centre NY 11570. (516)764-6315. Fax: (516)764-6200. Production Manager: Alan Mann. Estab. 1980. Produces CDs, 7" and LPs: alternative rock. Recent releases: *Godspeed The Punchline*, by Truman's Waters and *Babe The Blue Ox*.
Needs: Produces 50-100 CDs, tapes/year. Prefers local artists only with experience in Mac System 7, Quark, Illustrator, Photoshop and Typestyler. Uses artists for catalog and advertising design; computer "paste-up" and separations from 4-color process. Needs computer-literate freelancers for design and production. 100% of freelance work demands computer skills.
First Contact & Terms: Send query letter with résumé. Samples are filed or returned by SASE if requested. Reports back only if interested. Pays by the hour, $10-18; or by the project, $50-200. Buys all rights.
Tips: "Sell yourself to *bands* on independent labels to gain experience."

LUCIFER RECORDS, INC., Box 263, Brigantine NJ 08203. (609)266-2623. President: Ron Luciano. Produces pop, dance and rock & roll.
Needs: Produces 2-12 records/year. Experienced artists on assignment only. Uses artists for album cover design; brochure design, illustration and layout; catalog design; direct mail packages; advertising layout, design and illustration; and posters.
First Contact & Terms: Send query letter with résumé, business card, tearsheets, photostats or photocopies. Reports only if interested. Original art sometimes returned to artist. Write to show a portfolio, or mail tearsheets and photostats. Pays by the project. Negotiates pay and rights purchased.

M.O.R. RECORDS, 17596 Corbel Court, San Diego CA 92128. (619)485-1550. Fax: (619)485-1883. President/Owner: Stuart L. Glassman. Estab. 1980. Produces CDs and tapes: jazz and pop. Releases include: *A Passion For The Piano*, by Zach Davids; *The Hour Of Love*, by Dennis Russell.
Needs: Produces 3 CDs, tapes/year. Prefers artists with experience in pop/M.O.R. music. Uses artists for CD cover design and tape cover illustration.
First Contact & Terms: Send query letter with résumé. Samples are filed. Reports back within 2 months. Portfolio should include thumbnails. Sometimes requests work on spec before assigning a job. Pays by the project. Rights purchased vary according to project.
Tips: "Clean lines are in; erotic, exotic covers/designs are out. No more 'comic book' covers."

‡JIM McCOY MUSIC, Rt. 2 Box 114, Berkeley Springs WV 25411. (304)258-9381. Owner: Bertha McCoy. Estab. 1972. Produces CDs and tapes: country/western. Recent releases: "Mysteries of Life," by Carroll County Ramblers.
Needs: Produces 12 solo artists and 10 groups/year. Works on assignment only. Uses artists for CD cover design and illustration; tape cover illustration.

MAGGIE'S MUSIC, INC., Box 4144, Annapolis MD 21403. (410)268-3394. Fax: (410)267-7061. President: Maggie Sansone. Estab. 1984. Produces CDs and tapes: folk music of British Isles, Ireland and America. Recent releases include: *Whispering Stones*, by Al Petteway; *Ancient Noels*, by Maggie Sansone and Ensemble Galilei.
Needs: Produces 3-4 albums/year. Works with 2 designers and 2 illustrators/year. Prefers artists with experience in album covers, Celtic and folk art. Works on assignment only. Uses artists for CD and album/tape cover design and illustration; brochure design and illustration; catalog design, illustration and layout. Needs computer-literate freelancers for design and production. 50% of freelance work demands knowledge of PageMaker Designer.
First Contact & Terms: Send query letter with color and b&w samples, brochure. Samples are filed. Reports back only if interested. Portfolio review requested if interested in artists' work. Requests work on spec before assigning a job. Pays for design by the hour, $30-60. Pays for illustration by the project, $500-1,000. Sometimes interested in buying second rights (reprint rights) to previously published work, or as edited. Buys all rights.

‡MCI ENTERTAINMENT GROUP, Suite 830, 10 Universal City, Universal City CA 91608. (818)506-8533. Fax: (818)506-8534. Director: Maxx Diamond. Estab. 1979. Produces CDs and tapes: rock & roll, jazz, pop, R&B, soul, gospel, country/western by solo artists and groups. Recent releases: "Young & In Love," by I.B. Phyne; "Shakedown," by The Band Aka.

Needs: Produces 2 solo artists and 5 groups/year. Works with 3 visual artists/year. Works on assignment only. Uses artists for CD cover design and illustration; tape cover design and illustration; brochure design and illustration; catalog design, illustration and layout; direct mail packages; advertising design and illustration; posters. Needs computer-literate freelancers for design. 75% of freelance work demands knowledge of Aldlus PageMaker, Adobe Photoshop, Aldus FreeHand.
First Contact & Terms: Send query letter with SASE. Samples are not filed and are returned by SASE. Reports back within 6 weeks. Write for appointment to show portfolio which should include b&w and color thumbnails, roughs, photographs. Pays for design by the hour, $10-40. Negotiates rights purchased.

‡■MIA MIND MUSIC, Suite 4B, 500½ E. 84th St., New York NY 10028. (212)861-8745. Fax: (212)439-9109. Producer: Steven Bemtzel. Assistant Producer: Ashley Wilkes. Produces tapes, CDs, DAT, demos, records: rock & roll, pop, R&B, soul, progressive, folk, gospel, rap, alternative by solo artists and groups. Recent releases: "Shake," by Madonna/Otto von Wernherr; *Jade-Maid to Order*, by Ashley.
Needs: Produces 15 solo artists and 5 groups/year. Works with 12 visual artists/year. Prefers artists with experience in rock/pop art. Works on assignment only. Uses artists for CD cover design and illustration; tape cover design and illustration; brochure design and illustration; direct mail packages; advertising design; posters. Needs computer-literate freelancers. 75% of freelance work demands knowledge of Adobe Illustrator, Adobe Photoshop, Performer Paint Box.
First Contact & Terms: Send query letter with brochure, résumé, photocopies, photographs. Samples are filed. Reports back within 15 days. Call to show portfolio of b&w and color final art and photographs. Pays for design by the project, $50-500. Rights purchased vary according to project.

‡MIGHTY RECORDS, Rockford Music Publishing Co.—BMI, Stateside Music Publishing Co.—BMI, Stateside Music Co.—ASCAP, Suite 6-D, 150 West End Ave., New York NY 10023. (212)873-5968. Manager: Danny Darrow. Estab. 1958. Produces CDs and tapes: jazz, pop, country/western by solo artists. Recent releases: "Impulse," and "Dooms Day," by Danny Darrow.
Needs: Produces 1-2 solo artists/year. Works on assignment only. Uses artists for CD cover design and illustration; tape cover design and illustration; brochure design and illustration; catalog design and layout; advertising design and illustration; posters.
First Contact & Terms: Send query letter with SASE. Samples are not filed and are returned by SASE if requested by artist. Reports back within 1 week. To show portfolio, mail photocopies with SASE. Pays for design by the project. Rights purchased vary according to project.

MILES AHEAD RECORDS, P.O. Box 35449, Los Angeles CA 90035. (310)281-8599. A&R: Lermon Horton. Estab. 1968. Produces CDs, tapes and albums: R&B, dance, urban contemporary.
Needs: Produces 8 soloists and 4 groups/year. Works with 12 artists/year with experience in recording and stage. Uses artists for CD cover design; album/tape cover illustration; direct mail packages; advertising design and illustration; and posters.
First Contact & Terms: Send query letter with résumé, photographs and SASE. Samples are filed or are returned by SASE if requested by artist. Reports back within 3 weeks. To show a portfolio, mail b&w and color photographs. Payment and rights negotiated.

MIRAMAR PRODUCTIONS, 200 2nd Ave., Seattle WA 98119. (206)284-4700. Fax:(206)286-4433. Production Manager: David Newsom. Estab. 1984. Produces CDs, tapes and videos: rock & roll, R&B, jazz, progressive and adult contemporary by solo and group artists. Recent releases: *Imaginaria*, by Gary Powell; *Robert Vaughn and the Dead River Angels*; and *220 Volt Live*, by Tangerine Dream.
Needs: Produces 5 soloists and 5 groups/year. Works with 10 visual artists/year. Works on assignment only. Uses artists for CD and tape cover design and illustration; brochure and advertising design and illustration; posters; and videotape packaging. Needs computer-literate freelancers for design, illustration, production and presentation. 90% of freelance work demands knowledge of QuarkXPress, Aldus FreeHand, Adobe Illustrator and Photoshop.
First Contact & Terms: Send query letter with brochure, tearsheets, résumé and photocopies. Samples are filed. Reports back only if interested. Write for appointment to show portfolio of b&w and color photostats, tearsheets, photographs, slides and printed pieces. Pays by the project. Rights purchased vary according to project.

‡NEW EXPERIENCE RECORDS/GRAND SLAM RECORDS, P.O. Box 683, Lima OH 45802. (419)228-0691. President: James Milligan. Estab. 1989. Produces tapes, CDs and records: rock & roll, jazz, pop, R&B, soul, folk, gospel, country/western, rap by solo artists and groups. Recent releases: *Denied*, by Richard Bamberger; "Pure Heart," by Group T.M.C. (gospel).
Needs: Produces 5-10 solo artists and 4-6 groups/year. Works with 2-3 visual artists/year. Works with artist reps. Prefers artists with experience in album cover design. "Will consider other ideas." Works on assignment only. Uses artists for CD cover design and illustration; tape cover design and illustration; brochure design; catalog layout; advertising design; posters. Needs computer-literate freelancers for design and production. 50% of freelance work demands knowledge of Aldus PageMaker.

First Contact & Terms: Send query letter with brochure, résumé, photocopies, photographs, SASE and tearsheets. Samples are filed. Reports back within 6 weeks. Artist should follow up with letter or phone call. Call or write for appointment to show portfolio of b&w roughs, final art and photographs. Pays for design by the project, $250-500. Buys one-time rights or reprint rights.

‡**NEW SOUTH RECORDS**, P.O. Box 250013, Atlanta GA 30325. (404)352-2263. Contact: Production Director. Estab. 1994. Produces CDs and tapes: rock & roll, jazz, pop, R&B, soul, progressive, classical, folk by solo artists and groups.
Needs: Uses artists for CD cover design and illustration; tape cover design and illustration; and posters.
First Contact & Terms: Send query letter with brochure, résumé, photocopies and SASE. Samples are filed and are returned by SASE. Reports back within 3 months. Write for appointment to show portfolio. Pays for design by the project. Rights purchased vary according to project.

‡**NORTH STAR RECORDS INC.**, 95 Hathaway, Providence RI 02907. (401)788-8400. Fax: (401)785-8404. Vice President: Paul Mason. Estab. 1985. Produces CDs and tapes: jazz, classical, folk, traditional, contemporary, world beat, New Age by solo artists and groups. Recent releases: *Eveningtide*, by Bruce Foulke; *Broadway Openings*, by Dick Johnson & Swingshift.
Needs: Produces 5 solo artists and 5 groups/year. Works with 4 visual artists/year. Prefers artists with experience in CD and cassette cover design. Works on assignment only. Uses artists for CD cover design and illustration; tape cover design and illustration; brochure design and illustration; catalog design, illustration and layout; direct mail packages. Needs computer-literate freelancers for design and presentation. 10% of freelance work demands knowledge of Aldus PageMaker.
First Contact & Terms: Send query letter with brochure. Samples are filed. Reports back to the artist only if interested. To show portfolio, mail color roughs and final art. Pays for design by the project, $500-1,000. Buys first rights, one-time rights or all rights.

NUCLEUS RECORDS, Box 111, Sea Bright NJ 07760. President: Robert Bowden. Produces albums and tapes: country/western, folk and pop. Recent releases: "Oh How I Missed You" and "Selfish Heart," by Bob Bowden.
Needs: Produces 2 records/year. Artists with 3 years' experience only. Works with 1 designer and 2 illustrators/year on assignment only. Uses artists for album cover design. 10% of freelance work demands computer literacy in Adobe Illustrator and Photoshop.
First Contact & Terms: Send query letter with résumés, printed samples and photographs. Write for appointment to show a portfolio, which should include photographs. Samples are returned. Sometimes requests work on spec before assigning a job. Pays for design by the project, $150-200. Pays for illustration by the project, $125-150. Reports within 1 month. Originals returned after job's completion. Considers skill and experience of artist when establishing payment. Buys all rights.
Tips: Finds new artists through artists' submissions and design studios.

ONE STEP TO HAPPINESS MUSIC, % Jacobson & Colfin, P.C., 156 Fifth Ave., New York NY 10010. (212)691-5630. Fax: (212)645-5038. Attorney: Bruce E. Colfin. Produces CDs, tapes and albums: reggae by group and solo artists. Past release: "Make Place for the Youth," by Andrew Tosh.
Needs: Produces 1-2 soloists and 1-2 groups/year. Works with 1-2 artists/year on assignment only. Uses artists for CD and album/tape cover design and illustration.
First Contact & Terms: Send query letter with brochure, résumé and SASE. Samples are filed or returned by SASE if requested by artist. Reports back within 6-8 weeks. Call or write to schedule an appointment to show a portfolio, which should include tearsheets. Pays by the project. Rights purchased vary according to project.

‡**ORINDA RECORDS**, P.O. Box 838, Orinda CA 94563. (510)833-7000. A&R Director: H. Balk. Produces CDs and tapes: jazz, pop, classical by solo artists and groups.
Needs: Works with 6 visual artists/year. Works on assignment only. Uses artists for CD cover design and illustration; tape cover design and illustration.
First Contact & Terms: Send query letter with photocopies. Samples are filed and are not returned. Reports back to the artist only if interested. Write for appointment to show portfolio of b&w and color photographs. Pays for design by the project. Rights purchased vary according to project.
Tips: "Keep current."

‡**PINEWOOD PRODUCTIONS/BAYPORT RECORDS**, P.O. Box 5241, Chesapeake VA 23324. (804)627-0957. Producer: Bill Johnson. Estab. 1954. Produces tapes and vinyl records: soul, gospel, blues by solo artists and groups.
Needs: Uses artists for tape cover design; brochure design and illustration; catalog illustration; direct mail packages; advertising design.
First Contact & Terms: Send query letter with photographs, information. Samples are not filed and are returned by SASE if requested by artist. Reports back within 1 month. Write for appointment to show

portfolio of color photographs. Buys one-time rights; rights purchased vary according to project.

PLANKTON RECORDS, 236 Sebert Rd., Forest Gate, London E7 ONP England. (081)534-8500. Senior Partner: Simon Law. Produces CDs and tapes: rock and roll, R&B, funk and gospel by solo & group artists. Recent releases: *Outstanding Claims*, by Fresh Claim; and *The Celebration Club Session*, by Out of Darkness.
Needs: Produces 2 soloists and 2 groups/year. Works with 1 designer and 1 illustrator/year. "We usually work with a freelance visual artist if he or she is connected to and sympathetic with the recording artist." Works on assignment only. Uses artists for album cover design and illustration. 50% of freelance work demands knowledge of QuarkXPress or Adobe Illustrator.
First Contact & Terms: Send query letter with brochure. Samples not filed are returned by SASE and IRC. Reports back within 2 months. Portfolio review requested if interested in artist's work. Sometimes requests work on spec before assigning a job. Pays for design and illustration by the project, $200-300. Considers available budget when establishing payment. Buys reprint rights.
Tips: "All the products that we release have a Christian bias, regardless of musical style. This should be borne in mind before making an approach."

THE PRESCRIPTION CO., 70 Murray Ave., Port Washington NY 11050. (516)767-1929. President: D. F. Gasman. Estab. 1976. Produces CDs, tapes and albums; rock & roll, pop, folk, country/western by group and solo artists. Releases include: "You Came In" and "Rock and Roll Blues," by Medicine Mike.
Needs: Works on assignment only. Uses artists for all types of design and illustration.
First Contact & Terms: Send query letter with brochure, résumé and "whatever it takes to demonstrate talent." Samples are filed and are not returned. Reports back only if interested. To show a portfolio, mail b&w and color photostats and photographs. Payment depends on nature of project. Rights purchased vary according to project.

R.E.F. RECORDING CO./FRICK MUSIC PUBLISHING CO., 404 Bluegrass Ave., Madison TN 37115. (615)865-6380. Contact: Bob Frick. Produces CDs and tapes: country/western and gospel. Releases include: "He Sat Where You Sit," by Teresa Ford and "I Come Into Your Presence," by Donna LaPierre.
Needs: Produces 30 records/year; works with 10 groups artists/year. Works on assignment only.
First Contact & Terms: Send résumé and photocopies to be kept on file. Write for appointment to show portfolio. Samples not filed are returned by SASE. Reports within 10 days only if interested.

‡RAGE-N-RECORDS, #3, 212 N. 12th St., Philadelphia PA 19107. (215)977-9777. Fax: (215)496-9321. Creative Director: Vincent Kershner. Estab. 1984. Produces CDs and tapes: rock & roll, pop, R&B, blues by solo artists and groups. Recent releases: "It's A Tough Town," by The Cutaways!; "Reindeer Games," by Pat Godwin.
Needs: Produces 10 solo artists and 10 groups/year. Works with 5-10 visual artists/year. Prefers artists with experience in rock & roll designs. Works on assignment only. Uses artists for CD cover design and illustration; tape cover illustration; and posters.
First Contact & Terms: Samples are not filed and are returned by SASE if requested by artist. Does not report back. Artist should follow up. Call for appointment to show portfolio. Pays for design by the project.

■RAINFOREST RECORDS, INC., Suite 110, 8855 SW Holly Ln., Wilsonville OR 97070. Director: Ray Woods. Estab. 1990. Produces CDs, tapes and albums: rock & roll, rap and industrial/avant-garde. Recent release: *Live at Laurelthirst* (CD compilation).
Needs: Produces 1 soloist and 5 groups/year. Works with 6 designers and 3 illustrators/year. Prefers artists with experience in album and music-related design. Prefers local artists who know the recording group. Works on assignment only. Uses artists for CD and album/tape cover design and illustration; advertising design and illustration; and fliers. Needs computer-literate freelancers for design and production.
First Contact & Terms: Send query letter with tearsheets or photocopies; SASE; and letter of intent and experience. Samples are filed or are returned by SASE if requested by artist. Reports back only if interested. To show a portfolio, mail thumbnails, roughs, printed samples and b&w tearsheets and photographs. Pays by the project, $500 maximum. Buys all rights.
Tips: "Be willing to contribute art for line credit only. I'm not kidding. After you establish yourself, you can offer services at a price. But until then there are hundreds of artists who'll work for free, especially for a small music company."

The solid, black square before a listing indicates that it is judged a good first market by the Artist's & Graphic Designer's Market *editors. Either it offers low payment, pays in credits and copies, or has a very large need for freelance work.*

■**RAPP PRODUCTION, INC./R.R.R. MUSIC,** Suite 204, 23 Music Square E., Nashville TN 37203. Contact: Beverly Bell. 1422 Meadowrue, East Lansing MI 48823. Estab. 1964. Produces CDs, tapes and albums: rock & roll, R&B, classical, country/western, jazz, soul, folk, disco, rap, pop and Christian by solo and group artists. Past release: "Legends Never Die," by Bill Scarbrough.
Needs: Produces 10-20 soloists and 10-20 groups/year. Works with 10-20 artists/year. Works with artist and reps. Uses artists for CD and album/tape cover design and illustration; brochure design and illustration; catalog design, illustration and layout; direct mail packages; advertising design and illustration; and posters. Needs computer-literate freelancers for design, illustration, production and "sometimes" presentation. 50% of freelance work demands knowledge of Aldus PageMaker, QuarkXPress, Aldus FreeHand, Adobe Illustrator and other Macintosh programs.
First Contact & Terms: Send query letter with brochure, résumé, SASE, tearsheets, photographs, photocopies, photostats and transparencies. Samples are filed or are returned by SASE if requested by artist. Reports back to the artist only if interested. To show a portfolio, mail "best introductions or lasting impressions." Pays for design by the hour, $20-40; by the project, $50 minimum. Pays for illustration by the project, $100 minimum; by the day, $50 minimum. Rights purchased vary according to project and on value of use.

RE-BOP RECORDS, 31 Hebert Rd., Montpelier VT 05602-4320. Partner: Stephen McArthur. Produces tapes: folk, children's and R&B by solo and group artists. Releases: "Live At The Smithsonian," (video) by Ella Jenkins and *Daddy's Lullabies*.
Needs: Produces 5-10 soloists/year. Works with 3-4 designers and 3-4 illustrators/year. Uses artists for album cover design and illustration.
First Contact & Terms: Send query letter with résumé, tearsheets, photostats and photocopies. Samples are filed or are not returned. Reports back within 2 months only if interested. Pays for design by the hour, $30-50; pays for illustration by the project, $300-800. Negotiates rights purchased.
Tips: "Our concentration is on children's projects, book and tape projects, country and adult contemporary."

RELATIVITY RECORDS, 187-07 Henderson Ave., Hollis NY 11423. (718)217-3600. Fax: (718)464-9510. Art Director: David Bett. Estab. 1979. Produces CDs and tapes: rock & roll, jazz, rap, pop and heavy metal. Recent releases: *Jaundice*, by Lucy's Fur Coat; *Street Level*, by The Beatnuts; and *Peter Frampton*, by Peter Frampton.
Needs: Produces 30-50 groups/year. Works with 1-2 designers and 10-20 illustrators/year. Prefers artists with experience in "anything from underground comic-book art to mainstream commercial illustration." Works on assignment only. Uses artists for CD and album cover, brochure and catalog illustration; posters; logo art; and lettering. Helpful to have knowledge of QuarkXPress, Aldus FreeHand, Adobe Illustrator or Photoshop (Adobe). Style and tone for design includes "the full spectrum of styles."
First Contact & Terms: Send promotional piece, slides, tearsheets or photostats. Samples are filed or returned with SASE. Reports back only if interested. Call or write to show portfolio, which should include color and b&w slides or transparencies or printed samples. Pays by the project, $500-3,500. Considers complexity of project, available budget and rights purchased when establishing payment. Rights purchased vary according to project.
Tips: "We seek creative people with imagination. Avoid the obvious"

‡**RISING STAR RECORDS,** 710 Lakeview Ave. NE, Atlanta GA 30308. (404)872-1431. Fax: (404)872-3108. Promotions Manager: Kevin Berg. Estab. 1987. Produces CDs, tapes and print music: jazz and New Age by solo artists and groups. Recent releases: "Breaking the Rules," by Pruett & Davis; *Seashore Solitude*, by various artists.
Needs: Produces 2-3 solo artists and 2-3 groups/year. Works with 2 visual artists/year. Prefers local artists with experience in album designs. Works on assignment only. Uses artists for CD cover design and illustration; tape cover design and illustration; advertising design and illustration. Needs computer-literate freelancers for design, illustration, production and presentation. 100% of freelance work demands knowledge of Aldus PageMaker and Mac system.
First Contact & Terms: Send query letter with résumé, photocopies and SASE. Samples are filed and are returned by SASE if requested by artist. Reports back within 2 months. To show portfolio, mail roughs and photographs. Pays for design by the project, $500-1,000.

ROCK DOG RECORDS, P.O. Box 3687, Hollywood CA 90028-9998. (213)661-0259. President, A&R and Promotion: Gerry North. Estab. 1987. Produces CDs and tapes: rock & roll, R&B, dance, New Age, contemporary instrumental and music for film, TV and video productions.
Needs: Produces 2-3 soloists and 2-3 groups/year. Works with 5-6 illustrators/year. Prefers artists with experience in album art. Uses artists for CD and album/tape cover design and illustration; direct mail packages; ad design; and posters. Needs computer-literate freelancers for illustration. 50% of freelance work demands computer skills.
First Contact & Terms: Send query letter with photographs and photocopies. Samples are filed or are returned by SASE. Reports back within 2 weeks. To show portfolio, mail photocopies. Sometimes requests work on spec before assigning a job. Pays for design by the project, $50-500. Pays for illustration by the

project, $50-500. Interested in buying second rights (reprint rights) to previously published work.
Tips: Finds new artists through submission from artists who use *Artist's & Graphic Designer's Market*. "Be open to suggestions; follow directions."

RRRECORDS, 151 Paige St., Lowell MA 01852. (508)454-8002. Contact: Ron. Estab. 1984. Produces CDs, tapes and albums: experimental, electronic and avant-garde.
Needs: Produces 10 soloists and 10 groups/year. Uses 20 artists/year for CD and album/tape cover design and illustration; and magazine illustration.
First Contact & Terms: Send query letter with résumé, SASE and appropriate samples. Samples are filed. Reports back only if interested. To show a portfolio, mail thumbnails, roughs, final art and b&w and color photostats. Pays by the project, negotiable. Negotiates rights purchased.

‡LONNY SCHONFELD & ASSOC./G-TOWN RECORDS, (formerly Texas Star International), Box 460086, Garland TX 75046. (214)497-1616. President: Lonny Schonfeld. Estab. 1988. Produces CDs and tapes: rock & roll, pop, educational and country/westerns by group artists. Recent releases: "Jingle Bell Rock," by Bobby Priestley; "Let it Snow, Let it Snow, Let it Snow," by Donna Priestley; "Loneliness," by Randy Stout.
Needs: Produces 2 soloists and 2 groups/year. Works with 3-4 freelance designers, 2 freelance illustrators/year. Prefers artists with experience in logos, advertising and children's art. Uses artists for CD cover design; album/tape cover design and illustration; brochure design; direct mail packages; advertising design; and posters.
First Contact & Terms: Send query letter with SASE, photographs and other samples of work. Samples are filed or are returned by SASE if requested by artist. Reports back within 10 days. To show a portfolio, mail original/final art and photographs. Requests work on spec before assigning a job. Pays for design by the project, $100 minimum. Pays for illustration by the project, $50 minimum. Buys all rights. Rights purchased vary according to project.
Tips: Finds new artists through artists' submissions. "Be original—if we wanted someone else's style, we would hire them."

‡SHORE RECORDS, P.O. Box 161, Hazlet NJ 07730. (908)888-1846. Fax: (908)888-1846. Director of A&R: Paul A. Bonanni. Estab. 1991. Produces CDs and tapes: rock & roll, pop, progressive, country/western. Recent releases: *Monroes*, by Monroes TRI-State's Best Unsigned Artists by compilation of various local bands.
Needs: Produces 1-2 solo artists and 1-2 groups/year. Works with 1 visual artist/year. Prefers local artists with experience in MAC computers/illustration. Works on assignment only. Uses artists for CD cover design and illustration; tape cover design and illustration; advertising design and illustration; and posters. 75% of freelance work demands computer skills.
First Contact & Terms: Send query letter with brochure, résumé, photographs and SASE. Samples are filed and are returned by SASE. Reports back to the artist only if interested within 6-8 months. To show portfolio, mail portfolio of photographs. Pays for design by the project, based on what type of project and details involved to produce album cover. Rights purchased vary according to project.

SIRR RODD RECORD & PUBLISHING COMPANY, 2453 77th Ave., Philadelphia PA 19150-1820. President: Rodney J. Keitt. Estab. 1985. Produces disco, soul, jazz, pop, R&B by group and solo artists. Past releases: *Fashion & West Oak Lane Jam*, by Klassy K; and *The Essence of Love/Ghetto Jazz*, by Rodney Jerome Keitt.
Needs: Produces 2 soloists and 3 groups/year. Works with 1 artist/year on assignment only. Uses artists for album cover design and illustration; direct mail packages; advertising design and illustration; and posters.
First Contact & Terms: Send query letter with résumé, photostats, photocopies and slides. Samples are filed and are not returned. Reports back within 2 months. Write to show a portfolio, which should include color thumbnails, roughs, final reproduction/product, photostats and photographs. Pays by the project, $100-3,500. Buys reprint rights or negotiates rights purchased.
Tips: "Treat every project as though it were a major project. Always request comments and criticism of your work."

‡SLAMDEK RECORD COMPANY, (formerly Slamdek/Scramdown), Box 43551, Louisville KY 40253. Fax: (502)244-8694. Submissions Analyst: Matilda Pfenstemeyer or Mark Brickey. Estab. 1986. Produces CDs, tapes and DATs: rock and roll, alternative rock, hardcore, punk rock. Recent releases: "Blurry," by Hopscotch Army; "If the Spirits are Willing," by Endpoint; and "Memphis Sessions," by Slambang Vanilla Featuring Jesus Rosebud.
Needs: Produces 5-10 groups/year. Works with 1-3 freelance designers and illustrators/year. Prefers artists with experience in color and photograph integration. Works on assignment only. Uses artists for CD cover design and illustration; album/tape cover design and illustration; brochure design and illustration; catalog design, illustration and layout; advertising design and illustration; posters and promotional holographs.
First Contact & Terms: Send query letter with SASE, tearsheets and photographs. Samples are filed. To show a portfolio, mail color tearsheets and photographs. Payment varies. Rights purchased vary according to project.

‡**THE SONIC GROUP, LTD.,** 15 Gloria Lane, Fairfield NJ 07006. (201)575-7460. Fax: (204)575-8629. President: Mark Berry. Estab. 1984. Produces CDs and tapes: progressive and alternative metal. Recent releases: "Love Chain," by Voivod; "Dead Reciloning," by Clutter.
Needs: Produces 5 solo artists and 2-3 groups/year. Works with 2-3 visual artists/year. Works only with artist reps. Works on assignment only. Uses artists for CD cover design and posters.
First Contact & Terms: Contact only through artists agent. Samples are filed and are returned by SASE. Does not report back. To show portfolio, mail portfolio of roughs, final art and photographs. Pays for design by the project. Buys all rights.

‡**SOUND ACHIEVEMENT GROUP, INC.,** P.O. Box 24625, Nashville TN 37202. (615)883-2600. Fax: (615)885-7353. A&R Director: Royce Gray. Estab. 1985. Produces CDs, tapes and videos: gospel by solo artists and groups. Recent releases: "Another Alternative," by Jeff Deyd; "Tapestry of Praise," by Darla McFabben.
Needs: Produces 6 solo artists and 8 groups/year. Works with 3 visual artists/year. Prefers local artists only. Works on assignment only. Uses artists for CD cover design and illustration; tape cover design and illustration; advertising design. Needs computer-literate freelancers for design. 40% of freelance work demands knowledge of Corel Draw.
First Contact & Terms: Send query letter with brochure and SASE. Samples are not filed and are returned by SASE. Reports back to the artist only if interested Call for appointment to show portfolio of b&w and color samples. Pays for design by the project, $50-400. Buys all rights.

‡**STARCREST PRODUCTIONS,** 209 Circle Hills Dr., Grand Forks ND 58201. (701)772-6831. President: George Hastings. Produces country, pop and gospel music. Past release: "North Dakota Country Centennial Album," by Mary Joyce.
Needs: Produces 5 records/year, all of which have cover/jackets designed and illustrated by freelance artists. Works with 1 freelance designer and illustrator/year. Uses artists for jacket and brochure design; and print ad illustration.
First Contact & Terms: Send query letter, samples and SASE. Reports in 2 months. Negotiates pay based on amount of creativity required.

STARDUST RECORDS/WIZARD RECORDS, Drawer 40, Estill Springs TN 37330. Contact: Col. Buster Doss, Box 13, Estill Springs TN 37330. (615)649-2577. Produces CDs, tapes and albums: rock & roll, folk, country/western. Recent releases: *Movin' Out, Movin' Up, Movin' On*, by "Danny Boy" Squire and *Rainbow of Rocks*, by Larry Johnson.
Needs: Produces 12-20 CDs and tapes/year. Works with 2-3 designers and 1-2 illustrators/year on assignment only. Uses artists for CD and album/tape cover design and illustration; brochure design; and posters.
First Contact & Terms: Send query letter with brochure, tearsheets, résumé and SASE. Samples are filed. Reports back within 1 week. Call for appointment to show a portfolio, which should include thumbnails, b&w photostats. Pays by the project, $300. Buys all rights.
Tips: Finds new artists through *Artist's & Graphic Designer's Market*.

‡**STATUE RECORDS,** 2810 McBain St., Redondo Beach CA 90278. (310)371-5686. Fax: (310)542-9858. Estab. 1982. Produces CDs and tapes: rock & roll, pop, R&B, classical, gospel, country/western and rap by solo artists and groups.
Needs: Uses artists for CD cover design and illustration; tape cover design and illustration; brochure design and illustration; catalog design and layout.

‡**T.O.G. MUSIC ENTERPRISES,** 2107 S. Oakland St., Arlington VA 22204. (703)685-0199. President: Ted Graca. Estab. 1988. Produces CDs, tapes, CD-ROM and movies: rock & roll, jazz, pop, R&B, soul, progressive, classical, folk, gospel, country/western, rap, fusion and novelty by solo artists and groups. Recent releases: *Street Flava*, by City Life; *All I Want For Christmas*, by various artists.
Needs: Produces 5 solo artists and 40 groups/year. Works with 6 visual artists/year. Uses artists for CD cover design and illustration; tape cover design and illustration; brochure design and illustration; catalog design, illustration and layout; direct mail packages; advertising design and illustration; posters and video packaging and design. Needs computer-literate freelancers for design, illustration, production and presentation. Freelancers should be familiar with Aldus PageMaker, Adobe Illustrator, QuarkXPress, Adobe Photoshop, Aldus Freehand, Corel Draw 4.0, Adobe Premiere, Director, Morph.
First Contact & Terms: Send query letter with résumé and SASE. "State what you would like to happen in the relationship; what are your expectations?" Samples are filed and are returned by SASE if requested by artist. Reports back within 2 weeks. To show portfolio, mail b&w and color thumbnails, roughs, final art, tearsheets, photographs, transparencies, slides or photostats with résumé and SASE. Pays for design by the project, $25-1,000. Rights purchased vary according to project.
Tips: "Be willing to work on spec or to share in the success of a project rather than expecting upfront monies."

INSIDER REPORT

Opportunities Grow As CD Packaging Shrinks

Kim Champagne, senior art director for Warner Bros. Records, Los Angeles, is a prime example of how a creative, hailing from anywhere in the world, can break into designing music packages freelance or fulltime. Her story is a blueprint for those interested in this exciting, creative and expanding field.

After graduating from the Alberta College of Art (Canada), Champagne headed to L.A. Her first gig was a one-and-a-half year stint for a local marketing firm doing mostly print collateral for the television industry. It was like many starting positions—long hours and low pay—but it gave her valuable hands-on experience and paved an in-road. "It was a lousy first job but I gained a lot of experience and was given a lot of responsibility," says Champagne.

Kim Champagne

After a while, she developed an interest in album cover art. Determined to break into the market, she made as many contacts as possible in the industry by networking at industry events. At one event, she met Jeri Heiden, art director for Warner Bros. She later showed Heiden her work, who evidently liked what she saw. When freelance help was needed around the art department, Heiden called Champagne. She's still there today, and loving it.

Champagne says there are different routes a designer can take—the best and the simplest is direct contact. Send a letter of introduction followed by arranging to drop off or mail your portfolio. Then it's time to wait for the call.

"We look at a lot of portfolios. They get put on a table (which is always full) and everybody who needs to see them does. If the book is exceptional, we'll call and have them come in. There are no particular styles (We're looking for)." Rather, the overall quality of the designer's work is judged. So if you've been designing brochures for land deals in the Sahara, as long as it was a quality piece, don't fret. "We're just looking for really talented people."

Champagne seeks out both traditional and computer-influenced artists. However, at crunch time, the computer artist may have an advantage because of faster turnaround time. As for the software of choice at Warner, you'll find QuarkXPress, Adobe Photoshop, Aldus FreeHand and Adobe Illustrator.

At Warner, a project is assigned to an art director who works with the artist directly, sometimes even working from an idea presented by the recording artist. It's then up to the art director to hire freelancers on a use-as-needed basis. As one would guess, communication, diplomacy and initiative must be strong suits.

"These aren't prerequisites, but certainly everybody appreciates working with

someone who is professional," says Champagne. And, as with most design work, there is a strict budget; while this varies in size, it must be strictly adhered to. Deadlines are also strict.

And do you wonder what it is like to work in that small format? A CD booklet measures only 4¾ inches, but Champagne says you must consider the whole package. There is the booklet, which often folds out, a back panel, and the CD itself. This adds up to a lot of visual space for the artist to work in and Champagne says that is what is so exciting. "CDs are, in a lot of ways, more fun than doing LPs because there are more places to put art (which forces) you to think of everything at once. It's more of a complete package; it has a rhythm."

If taking on a project of this stature frightens you, relax. Champagne says there are a million ways a project can be divvied up. Sometimes a whole CD package will be assigned to one designer; sometimes it's just the typography.

Along with CD packaging, designers sometimes get an opportunity to work on merchandising that almost always accompanies a project. Work of this nature includes point-of-purchase displays in retail stores such as product holders, fliers, posters, laser disks, business collateral and T-shirts.

Champagne, in just six short years, has reached a higher level. She's designed packages for The Red Hot Chili Peppers, Aerosmith, ZZ Top and Dwight Yoakam, among others. In 1994 she was nominated for a Grammy for special packaging for singer Paul Westerberg's CD, *14 Songs*. Champagne loves the industry because of its freedom. "The bottom line is that everybody wants a package that looks good. There is a lot of freedom in terms of who I work with and how the project is handled. It's professional in a casual sense."

— *Neil Burns*

Art Director Kim Champagne was nominated for a 1993 Grammy Award for compact disk package design for her work on Paul Westerberg's CD, 14 Songs.

MICK TAYLOR MUSIC, % Jacobson & Colfin, P.C., 156 Fifth Ave., New York NY 10010. (212)691-5630. Fax: (212)645-5038. Attorney: Bruce E. Colfin. Estab. 1985. Produces CDs, tapes and albums: rock & roll, R&B by solo and group artists. Recent releases: "Stranger in This Town," by Mick Taylor (MAZE Records).
Needs: Produces 1 soloists and 1-2 groups/year. Works with 2-3 artists/year on assignment only. Uses artists for CD cover design and illustration; and album/tape cover design and illustration.
First Contact & Terms: Send query letter with brochure, résumé, SASE. Samples are filed or returned by SASE if requested. Reports back within 6-8 weeks. Call or write for appointment to show portfolio, which should include tearsheets. Pays by the project. Rights purchased vary according to project.

***TOP RECORDS,** 4, Galleria del Corso, Milano Italy. (02)76021141. Fax: 0039/2/76021141. Estab. 1975. Produces CDs, tapes, albums: rock and roll, rap, R&B, soul, pop, folk, country/western, disco; solo and group artists. Past releases *Il Cuore E' Nudo. . .E I Pesci Cantano*, by Ivan Cattaneo; "Goes Country," by Tina Turner and recordings by Rosanna Iratelo.
Needs: Produces 5 soloists and 5 groups/year. Works with 2 artists/year on assignment only.
First Contact & Terms: Send query letter with brochure. Samples are filed but not returned, if not expressly demanded and with costs to be charged to the artists. Reports back within 1 month. Call for appointment to show portfolio or mail appropriate materials. Portfolio should include original/final art and photographs. Buys all rights.

‡TOUCHE RECORDS CO., P.O. Box 96, El Cerrito CA 94530. (510)524-4937. Fax: (510)524-9577. Executive Vice President: James Bronson, Jr. Estab. 1955. Produces CDs, tapes and LPs: jazz, soul, R&B and rap. Recent releases: *Said Same Person*, by William Richard "Smiley" Winters.
Needs: Produces 1-10 solo artists/year. Works on assignment only. Uses artists for CD cover design and illustration; tape cover illustration; brochure design and illustration; catalog design, illustration and layout; direct mail packages; advertising design and illustration; and posters.
First Contact & Terms: Send query letter with brochure, résumé, photocopies and tearsheets. Samples are filed. Reports back within 10 days. To show portfolio, mail portfolio of roughs. Pays for design by the project. Buys all rights.

■TREND® RECORDING AND DISTRIBUTING CO., Box 201, Smyrna GA 30081. (404)432-2454. President: Tom Hodges. Produces CDs and tapes: soul, country, pop, R&B, middle-of-the-road music and jazz. Recent releases: *Heartbreak Road*, by Charles and Nancy Cole; *Sons of the South*, by Shawn Spencer.
Needs: Produces 6 records/year by 1 group and 2 soloists. Works with 7 designers and 6 illustrators/year. Freelancers design and illustrate 1 cover/jacket per year. Needs computer-literate freelancers for production. 25% of freelance work demands knowledge of QuarkXPress.
First Contact & Terms: Send query letter with samples. Samples are not filed and are returned by SASE. Send brochure or samples that can be kept on file for future reference. Include SASE. Reports in 4 weeks. Portfolio review not required. Sometimes requests work on spec before assigning a job. Pays $20-1,000. Negotiates pay by the project, based on amount of creativity required and how the work will be used. Buys reprint rights. Sometimes interested in buying second rights (reprint rights) to previous published work.
Tips: Finds new artists through sourcebooks. Looking for "originality."

‡TYPETOKEN RECORDS, 1211 Arlington Place, Warrensburg MO 64093. (816)747-5578. Media Director: Phil Easter. Estab. 1990. Produces CDs: ambient, industrial, electronic, experimental by music groups. Recent releases: *Industrial Icon*, by Stone Glass Steel; *House of Garbar*, by Death In Arcadia.
Needs: Produces 1-3 groups/year. Works with 3 visual artists/year. Prefers artists with experience in CD cover illustration and photography. Works on assignment only. Uses artists for CD cover design and illustration. Needs computer-literate freelancers for design and illustration. 25% of freelance work demands knowledge of Aldus PageMaker.
First Contact & Terms: Send query letter with résumé, photocopies, photographs and slides. Samples are filed and are not returned. Reports back within 1-2 months. To show portfolio, mail b&w and color roughs and photographs. Pays for design by the project. Rights purchased vary according to project.
Tips: "Focus only on the genres that inspire and interest you. Study the artwork and design used within those genres. Start small with independent artists and labels. Don't pass up opportunities for good exposure and promotion. Ask questions. Take risks. Experiment."

VARESE SARABANDE RECORDS, 13006 Saticoy St., N. Hollywood CA 91605. (818)764-1172. Fax: (818)765-7801. Vice President: Robert Townson. Estab. 1978. Produces CDs and tapes: film music soundtracks. Recent releases: *Basic Instinct*, by Jerry Goldsmith; *The Player*, by Thomas Newman; and *Terminator 2: Judgment Day* by Brad Fiedel.
Needs: Works on assignment only. Uses artists for CD and tape cover illustration.
First Contact & Terms: Send query letter with photostats, slides and transparencies. Samples are filed. Reports back only if interested. Pays by the project.
Tips: "Be familiar with the label's output before approaching them."

WARLOCK RECORDS, INC., 19 W. 21st St., New York NY 10010. (212)979-0808. Fax: (212)979-0897. Executive Vice President: Diana Lemchak. Estab. 1986. Produces CDs, tapes and albums: rhythm and blues, jazz, rap and dance. Recent releases: *Sax Appeal*, by Kim Waters; *Love Can't Wait*, by Lil Suzy; and *Ya Rollin' Doo Doo*, by Doo Doo Brown.
Needs: Produces 5 soloists and 12-15 groups/year. Works with 5 visual artists/year. Prefers artists with experience in record industry graphic art and design. Works on assignment only. Uses artists for CD and album/tape cover design; posters; and advertising design. Seeking artists who both design and produce graphic art, to "take care of everything, including typesetting, stats, etc."
First Contact & Terms: Send query letter with brochure, résumé, photocopies and photostats. Samples are filed and are not returned. "I keep information on file for months." Reports back only if interested; as jobs come up. Call to schedule an appointment to show a portfolio, or drop off for a day or half-day. Portfolio should include photostats, slides and photographs. Pays by the project, $50-1,000. Rights purchased vary according to project.
Tips: "Work for a low fee from one or two companies to gain experience in the recording industry and then remain loyal to them—you'll get experience and great recommendations."

WARNER BROS. RECORDS, 3300 Warner Blvd., Burbank CA 91505. (818)953-3361. Fax: (818)953-3232. Art Dept. Assistant: Michelle Barish. Produces the artwork for CDs, tapes and sometimes albums: rock & roll, jazz, rap, R&B, soul, pop, folk, country/western by solo and group artists. Releases include: *Automatic for the People*, by R.E.M. and *Erotica*, by Madonna. Releases approximately 300 total packages/year.
Needs: Works with freelance art directors, designers, photographers and illustrators on assignment only. Uses freelancers for CD and album tape cover design and illustration; brochure design and illustration; catalog design, illustration and layout; advertising design and illustration; and posters. Needs computer-literate freelancers for design and production. 100% of freelance work demands knowledge of Aldus Page-Maker, QuarkXPress, Aldus FreeHand, Adobe Illustrator or Photoshop.
First Contact & Terms: Send query letter with brochure, tearsheets, résumé, slides and photographs. Samples are filed or are returned by SASE if requested by artist. Reports back to the artist only if interested. Submissions should include roughs, printed samples and b&w and color tearsheets, photographs, slides and transparencies. Do not submit original artwork. "Any of these are acceptable." Pays by the project.
Tips: "Send a portfolio—we tend to use artists or illustrators with distinct/stylized work—rarely do we call on the illustrators to render likenesses; more often we are looking for someone with a conceptual or humorous approach."

WATCHESGRO MUSIC BMI—INTERSTATE 40 RECORDS, 9208 Spruce Mountain Way, Las Vegas NV 89134. (702)363-8506. President: Eddie Lee Carr. Estab. 1975. Produces CDs, tapes and albums: rock & roll, country/western and country rock. Releases include: "The Old Cowboy," by Don Williams; "What About Us," by Scott Ellison; and "Eldorado," by Del Reeves.
Needs: Produces 8 soloists/year. Works with 3 artists/year for CD and album/tape cover design and illustration; and videos.
First Contact & Terms: Send query letter with photographs. Samples are filed or are returned by SASE. Reports back within 1 week only if interested. To show portfolio, mail b&w samples. Pays by the project. Negotiates rights purchased.

‡**YOUNG COUNTRY RECORDS/PLAIN COUNTRY RECORDS/NAPOLEON COUNTRY RECORDS**, P.O. Box 5412, Buena Park CA 90620. (909)371-2973. Owner: Leo J. Eiffert, Jr. Estab. 1968. Produces tapes and records: gospel and country/western by solo artists and groups. Recent releases: "The Singing Housewife," by Pam Bellows; "Little Miss Candy Jones," by Johnny Horton; "My Friend," by Leo J. Eiffert, Jr.
Needs: Produces 7 solo artists and 3 groups/year. Works with 40-60 visual artists/year. 10% of freelance work demands computer skills.
First Contact & Terms: Send query letter with tearsheets. Samples are filed. Reports back within 3-4 weeks. To show portfolio, mail b&w and color samples. Pays for design by the project, $150-500. Buys all rights.

‡**ZYLON DISCS**, P.O. Box 39A16, Los Angeles CA 90039. Artist Relations: Richard Barron. Estab. 1986. Produces CDs and tapes: rock & roll, R&B, folk and alternative by solo artists and groups. Recent releases: "Where's Mary," by Blood Beach; "The 12th Hour," by The Zodiac Club; "Rocks," by Straight Jacket; and "No One Gets Out Alive," by Lucrecia.

Needs: Produces 1-2 solo artists and 1-2 groups/year. Works with 10-15 visual artists/year. Prefers local artists only. Uses artists for advertising design and illustration. 2% of freelance work demands knowledge of Adobe Illustrator and Adobe Photoshop.

First Contact & Terms: Send query letter with résumé. Samples are filed. Reports back to the artist only if interested. Portfolio should include tearsheets and photostats. Pays for design by the hour, $35-65; by the project; by the day. Buys reprint rights.

Record Companies/'94-'95 changes

The following record companies were listed in the 1994 edition but do not have listings in this edition. The majority did not respond to our request to update their listings. If a reason was given for a company's exclusion, it appears in parentheses after the company's name.

A&M Records (too many submissions)
Alpha International Record Co.
Arista Records
B.G.S. Productions Ltd.
Baby Sue
Bizz-e Productions
Black & Blue Records
Blue Rock'it Records
Bold 1 Records
Bread'n Honey Records Inc.
Business Development Consultants
Cadet Records
Calvert Street Records
Capitol Management
Capricorn Records
Chapman Recording Studios
Cimirron/Rainbird Records, Inc.
A Company Called W

Copperchase Productions, Inc.
Cosmotone Records
Creole Records Ltd.
Curtiss Records
DOVentertainment
Earth Beat
Finkelsten Management Co. Ltd./True North Records
Globeart, Inc.
GM Recordings
Grass Roots Productions
GRP Records
Hula Records
K-Tel International
Lamon Records Inc.
Jack Lynch Music Group/Nashville Country Productions
Mechanic Records, Inc.
Motown Record Co., L.P.
Narada Productions, Inc.
Northeastern Records
Original Cast Records; Broad

way Hollywood Video Productions
Play Records, Inc.
Pro Sound Studios/Napu Records International
Quality Records
Record Company of the South
Record Masters, Inc.
Rhythms Productions
Robbins, Inc.
Rockit Records, Inc.
San Francisco Sound
Shaky Publishing Co.
Shining Eagle Records (per request)
SOR (Step One Records)
Sphemusations
Terlock Records/Susan Records
Tom Thumb Music
Velvet Production Co.
Welk Music Group

Syndicate/Clip Art Firms

Next time you pick up the Sunday comics to settle in for a visit with Cathy, Marmaduke, Broom-Hilda, Mary Worth or Calvin and Hobbs, check out the incredibly small print next to the copyright symbol within each comic strip. If you squint, you'll note it's not followed by the artist's name, but by one of the many syndicates that sell cartoons to newspapers. So, if you're a cartoonist, dreaming of seeing your characters in the funny papers, you must first sell the idea to a syndicate.

The syndicate business is one of the hardest to break into. Even the great Jules Feiffer had a hard time attracting their attention (see this section's Insider Report on page 622). There are an overwhelming number of aspiring cartoonists competing for a very limited number of jobs. And these are jobs that don't open up often. Editors are always reluctant to drop a long-established strip for a new one, as such action often results in a deluge of reader complaints. Consequently, big name cartoonists like Jim Davis and Gary Larson are pretty much set for life.

What is encouraging, however, is that some newspapers have expanded their comics sections in recent years in an attempt to boost sagging circulation rates. Many are trying to win the loyalty of younger readers or more targeted audiences. As a result, some new features have been added to papers in recent years—particularly ethnic strips and games and quizzes for school-age children.

Furthermore, as the economy recovers and ad spending picks up, some publications are beginning to increase editorial pages. More pages will mean more space for syndicated features. And the wealth of new magazines cropping up should prove to be fertile ground for syndicated material as well.

How syndicates operate

Syndicates basically act as agents for cartoonists, selling comic strips, panels and editorial cartoons to newspapers and magazines. Newspaper features can be daily, daily and Sunday, Sunday only, or weekly (with no day specified). Magazine features are usually monthly or bimonthly. The syndicate edits, promotes and distributes the cartoonist's work, and keeps careful records of sales in exchange for a cut of the profits. Some syndicates also handle merchandising of licensed products, such as mugs, T-shirts and calendars.

Selling to syndicates is not an easy task, but it is achievable. Most syndicates say they're looking for a "sure thing," a feature in which they'll feel comfortable investing the more than $25,000 needed for promotion and marketing. Work worthy of syndication must be original, saleable and timely, and characters must have universal appeal in order to attract a diversity of readers.

Keep in mind that to succeed in the syndicate market, you have to be more than a fabulous cartoonist. You must also be a good writer and stay in touch with current events and public concerns. Cartooning is an idea business just as much as it is an art business—and the art won't sell if the idea isn't there in the first place.

How to approach a syndicate

If you're an editorial cartoonist, you'll need to start out selling your cartoons to a base newspaper (probably in your hometown) and build up some clips before ap-

proaching a syndicate. Submitting published clips will prove to the syndicate that you have established a loyal following and are able to produce cartoons on a regular basis. Once you've built up a good collection of clips, submit at least 12 photocopied samples of your published work along with a brief cover letter.

Strips are handled a bit differently. Since they usually originate with the syndicate, it's not always necessary for them to have been previously published. Some syndicates even prefer to "discover" new strip artists and introduce them fresh to newspapers.

To submit a strip idea, send a brief cover letter that summarizes your idea, along with a character sheet (this shows your major characters along with their names and a description of each), and 24 strip samples on 8½ × 11 paper. By sending four weeks worth of samples, you'll show the syndicate that you're capable of rendering consistent characters, and that your idea is a lasting one. Don't ever submit originals; always make photocopies of your work and send those. It's OK to make simultaneous submissions to various syndicates.

Payment and contracts

Should you be one of the lucky few to be picked up by a syndicate, the amount you earn will depend on the number of publications in which your work appears and the size of those publications. Whereas a top strip such as Garfield may be in as many as 2,000 papers worldwide, it takes a minimum of about 60 interested newspapers to make it worthwhile and profitable for a syndicate to distribute a strip.

Newspapers pay in the area of $10-15 a week for a daily feature. Your payment will be a percentage of gross or net receipts. Contracts usually involve a 50/50 split between the syndicate and the cartoonist. Magazine rates, however, tend to vary a bit more. Check the listings in this section for more specific information about terms of payment.

Before signing a contract with a syndicate, be sure you understand the terms and are comfortable with them. The most favorable contracts will offer the following:
- Creator ownership of the strip and its characters.
- Periodic evaluation of the syndicate's performance.
- A five-year contract without automatic renewal.
- A percentage of gross, instead of net, receipts.

Self-syndication

An alternative to consider is self-syndication. Self-syndicated cartoonists retain all rights to their work and keep all profits, but they also have to act as their own salespeople, sending packets to newspapers and other likely outlets. This requires developing a mailing list, promoting the strip (or panel) periodically, and developing a pricing, billing and collections structure. If you're a good businessperson and have the required time and energy, this might be the route for you.

Clip art

Clip art firms provide their clients—individuals, associations and businesses—with camera-ready illustrations, cartoons, spot drawings, borders and dingbat symbols.

YOURS FREE!

Get this inspiring "Guide to More Creative Painting" FREE with your paid subscription.

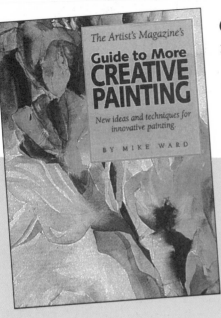

The Artist's Magazine's
Guide to More CREATIVE PAINTING
New ideas and techniques for innovative painting.

BY MIKE WARD

Inside, you'll discover how to use your unique background and innermost feelings to generate new, exciting ideas for your artwork. How to rely on special warm-up techniques and the right timing to make the most of your creative "flow." And how to experiment with *your* personal style— trying out different mediums to create a variety of effects, using new materials in unconventional ways, liberating yourself by indulging in a few "painting no-no's"... and much more!

Subscribe today and this invaluable guide is yours free!

INTRODUCTORY SUBSCRIPTION SAVINGS

Yes! Start my subscription to *The Artist's Magazine* at the low introductory rate of just $19 for 12 monthly issues. **I save $16 off the newsstand price!**

☐ Payment enclosed. Please send my FREE "Guide to More Creative Painting" immediately.

☐ Bill me and send my free guide upon payment.

Name _____

Address _____ Apt. _____

City _____ State_____ Zip _____

* Outside U.S. add $10 (includes GST in Canada) and remit in U.S. funds.
Allow 4-6 weeks for first-issue delivery. Newsstand rate: $35.40.

Mail this card today! No postage needed.

SAVE $16 OFF THE NEWSSTAND PRICE!

TYAM1

More detailed instruction and how-to information than any other magazine for artists!

You'll find practical features like these in every issue of *The Artist's Magazine*:

- **Step-by-step instruction**—Whether it's capturing crisp details in watercolor, painting sensuous realism in oils, or photographing your paintings, you'll find clear, detailed directions in every issue.

- **Interviews with top professional artists**—Their tips and techniques can be applied to any level of skill to develop personal style, fresh ideas and inspiration.

- **Monthly reports on materials, methods and publications for artists**—If there's a new product or technique that can benefit your work, you'll read about it first in *The Artist's Magazine*.

- **Up-to-the-minute market information**—How and where to show and sell art, plus news of regional and national competitions and more than 1,300 workshops.

Mail the post-paid card below to start your subscription today!

Some clip art books can be purchased in bookstores, but clients who are frequent users normally subscribe to a service and receive collections by mail once a month on disk or in booklet format. Clip art is used in a variety of capacities, from newsletters to brochures to advertisements and more. In subscribing to a clip art service, clients buy the right to use the artwork as frequently as they wish.

Most clip art is black and white representational line art, rendered in a realistic or stylized manner. However, many firms are now offering a few special color reproductions with each monthly package. Collections usually fall into certain subject areas, such as animals, food, clothing or medicine. Most clip art firms keep track of consumer demands and try to offer images that cover current topics and issues. For example, many have begun to market more images with multicultural and environmental themes.

Artists cannot retain rights to work sold as clip art, since clip art is, by nature, virtually copyright free. Consequently, name credits are rarely given, although some firms will allow inclusion of a small monogram or logo alongside the artwork. Payment rates aren't astronomical, but there are advantages to working with clip art firms. For example, most give long lead times, which allow freelancers to work projects into their schedules at their convenience. Moreover, clip art businesses tend to pay in a very timely manner (some within 10 days of invoice).

■**ALLIED FEATURE SYNDICATE**, P.O. Drawer 48, Joplin MO 64802-0048. (417)673-2860. Fax: (417)673-4743. Editor: Robert Blanset. Estab. 1940. Syndicate serving 50 outlets: newspapers, magazines, etc.
• Allied Features is the only agency syndicating cartoons solely geared toward electronics. Also owns separate syndicates for environmental, telecommunications, space and medical instruments fields.
The same company also owns 4 newspapers: *Circuit News*, *Circuit Assembly*, *ENN* and *The Lead Trader*.
Needs: Approached by 100 artists/year. Buys from 10 or more freelance artists/year. Introduces 25-50 new strips/year. Recent introductions include Outer Space by Ken Muse and Shuttlebutt by James Wright. Considers comic strips, gag cartoons, caricatures, editorial/political cartoons. Considers single, double or multiple panel b&w line drawings, b&w washes and color washes, with or without gagline. Prefers creative works geared toward business, the Space Program, electronics, engineering and environmental topics.
First Contact & Terms: Sample package should include cover letter, photocopies and finished cartoon samples. One sample of each should be included. Samples are filed or are returned by SASE if requested by artist. Does not report back. Portfolio review requested if interested in artist's work. Pays on publication flat fee of $10-25. Buys first rights. Interested in buying second rights (reprint rights) to previously published artwork. Offers automatic renewal. Syndicate owns original art and the characters. "This is negotiable with artist. We always negotiate."

AMERICAN INTERNATIONAL SYNDICATE, 1324½ N. 3rd St., St. Joseph MO 64501. (816)279-9315. Fax: (816)279-9315. Executive Director: Gerald A. Bennett. Estab. 1987. Syndicate serving 54 daily-weekly newspapers. Art guidelines available for SASE with appropriate postage.
Needs: Approached by 500 artists/year. Buys from 5 freelance artists/year. Introduces 5 new strips/year. Considers comic strips, gag cartoons, computer features and spot drawings. Recent introductions include The Best Years by Ed Heckman and Fun Film Facts by Jim Books. Prefers single and multiple panel, b&w line drawings and washes with gagline. Prefers modern updated features on sports, family, business and environment-education themes. Also uses freelance artists for puzzles and games, science features or nature-type features. Maximum size of artwork 2½×7 (strip); 5×5 (panel).
First Contact & Terms: Sample package should include cover letter, roughs, tearsheets, finished cartoons (2) and SASE. 8-12 samples should be included. Samples are filed or returned by SASE if requested by artist. Reports back within 1 month. Portfolio review not required. Pays 50% of gross income. Pays on

The solid, black square before a listing indicates that it is judged a good first market by the Artist's & Graphic Designer's Market *editors. Either it offers low payment, pays in credits and copies, or has a very large need for freelance work.*

"receipt of money." Buys all rights. Minimum length of contract 2 years. Offers automatic renewal. Artist owns original art and characters.

Tips: Finds artists through artist's submissions. "I would love to see a strip on a female in congress with day-to-day mishaps. Would also like to see computer features or comic strips."

■**ART PLUS REPRO RESOURCE,** P.O. Box 4710, Sarasota FL 34230-4710. (813)925-7754. Publisher: Wayne Hepburn. Estab. 1983. Clip art firm serving about 6,000 outlets, primarily churches, schools, associations and ministries.

 • This clip art firm works 12 months ahead of publication, pays within 60 days of acceptance. Accepts any seasonal material at any time. Has been using more digitized and computer images. They will furnish a list of topics needed for illustration.

Needs: Buys 40-60 cartoons and 500-1,000 freelance illustrations/year. Prefers illustrations and single panel cartoons and b&w line art with gagline. Maximum size is 7×10 and must be reducible to 20% of size without losing detail. "We need very graphic material." Prefers religious, educational and seasonal themes. Needs computer literate artists with knowledge of IBM-CorelDraw 4.0 .CDR/.CGM/.PCX/.TIF MAC-TIFF/Adobe Photoshop.

First Contact & Terms: Send photocopies. Samples not filed are returned by SASE. Guidelines, catalog and sample available for 9×12 SAE with 4 first-class stamps. Reports back within 2 months. Portfolio review not required. **Pays on acceptance;** $15 for cartoons; $15-40 for spot or clip art. Buys all rights.

Tips: Finds artists through *Artist's & Graphic Designer's Market.* "All our images are published as clip art to be reproduced by readers in their bulletins and newsletters for churches, schools, associations, etc. We need art for holidays, seasons and activities; new material every 3 months. We want single panel cartoons, not continuity strips. We're currently looking for people images, ethnic and mixed races."

‡**BENNETT PUBLISHING,** 3400 Monroe Ave., Rochester NY 14618. (716)381-5450. President: Lois B. Bennett. Estab. 1978. Clip art firm serving schools. Guidelines not available.

Needs: Approached by 20 artists/year. Buys from 1 artist/year. Considers illustrations, spot drawings. Prefers educational themes.

First Contact & Terms: Sample package should include cover letter, résumé. "We contact artist when needed." **Pays on acceptance.** Buys all rights. Syndicate owns original art and characters.

BLACK CONSCIENCE SYNDICATION, INC., Dept. AM, 21 Bedford St., Wyandanch NY 11798. (516)491-7774. President: Clyde R. Davis. Estab. 1987. Syndicate serving regional magazines, schools, daily newspapers and television.

Needs: Considers comic strips, gag cartoons, caricatures, editorial or political cartoons, illustrations and spot drawings. Prefers single, double or multipanel cartoons. "All material must be of importance to the Black community in America and the world." Especially needs material on gospel music and its history. "Our new format is a TV video magazine project. This half hour TV program highlights our clients' material. We are accepting ½" tapes, 2 minutes maximum. Tape must describe the artist's work and provide brief bio of the artist. Mailed to 25 different Afrocentric publications every other month."

First Contact & Terms: Send query letter with résumé, tearsheets and photocopies. Samples are filed or are returned by SASE only if requested by artist. Reports back within 2 months. Portfolio review not required. Pays on publication; 50% of net proceeds. Considers client's preferences when establishing payment. Buys first rights.

Tips: "All material must be inspiring as well as informative. Our main search is for the truth."

ASHLEIGH BRILLIANT ENTERPRISES, 117 W. Valerio St., Santa Barbara CA 93101. (805)682-0531. Art Director: Ashleigh Brilliant. Estab. 1967. Syndicate and publisher. Outlets vary. "We supply a catalog and samples for $2 plus SASE."

Needs: Considers illustrations and complete word and picture designs. Prefers single panel. Maximum size of artwork 5½×3½, horizontal only.

First Contact & Terms: Samples are returned by SASE if requested by artist. Reports back within 2 weeks. **Pays on acceptance;** minimum flat fee of $50. Buys all rights. Syndicate owns original art.

Tips: "Our product is so unusual that freelancers will be wasting their time and ours unless they first carefully study our catalog."

How to Use Your Artist's & Graphic Designer's Market *offers suggestions for understanding and using the information in these listings. Read this and other articles in the front of this book for important business tips.*

CAROL BRYAN IMAGINES, THE LIBRARY IMAGINATION PAPER, 1000 Byus Dr., Charleston WV 25311. Editor: Carol Bryan. Estab. 1978. Syndicates clip art for 3,000 public and school libraries. Sample issue $1.
Needs: Buys 6-15 freelance illustrations/issue. Considers gag cartoons, illustrations and spot drawings. Prefers single panel; b&w line drawings. Prefers library themes—"not negative towards library or stereotyped (example: showing a spinster librarian with glasses and bun)." Prefers subjects dealing with "today's libraries—fax mediums, computers, equipment—good-looking librarians—upbeat ideas. It's a more-than-books-world now—it's the complete information place. Need more focus on school library items."
First Contact & Terms: Send query letter with tearsheets, photocopies and finished cartoons. Send no more than 6 samples. Samples are filed or are returned by SASE. Reports back within 3 weeks. Pays on publication; flat fee of $25. Buys one-time or reprint rights.
Tips: "Seeing a sample issue is mandatory—we have a specific, very successful style. Your style may blend with our philosophy. Need great cartoons that libraries can publish in their newsletters. We are interested in seeing more cartoons about the school library, fun and upbeat; and cartoons which show the latest, trendiest library activities and more of a multicultural consideration when drawing figures."

CHRONICLE FEATURES, Suite 1011, 870 Market St., San Francisco CA 94102. (415)777-7212. Comics Editor; Jean A. Arnold. Syndicate serving 1,600 daily, weekly and monthly newspapers, occasionally magazines. Guidelines available for #10 SASE.
Needs: Approached by 2,000 artists/year. Introduces 1 or 2 new strips/year. Considers comic strips and panels. "We have no preferred format, as long as the work is stellar and has a style all its own. We do not need spot drawings, caricatures or editorial/political cartoons. We already have artists covering these areas." Maximum size of artwork $8\frac{1}{2} \times 11$; must be reducible to standard newspaper strip/panel size.
First Contact & Terms: Sample package should include cover letter, photocopies and SASE large enough to return response and/or work. 24 samples should be included. Samples are not filed and are returned by SASE only if requested by artist, otherwise not returned. Reports back within 6 weeks. To show a portfolio, mail appropriate materials. Pays 50% of gross income. Buys all rights. Minimum length of contract 5 years. Artist owns the original art and characters.
Tips: "Please send all inquiries by mail. We prefer to minimize telephone contact, as it interrupts the flow of our work."

‡**CITY NEWS SERVICE**, Box 39, Willow Springs MO 65793. (417)469-2423. President: Richard Weatherington. Estab. 1969. Editorial service providing editorial and graphic packages for magazines.
Needs: Buys from 12 or more freelance artists/year. Considers caricature, editorial cartoons and tax and business subjects as themes; considers b&w line drawings and shading film.
First Contact & Terms: Send query letter with résumé, tearsheets or photocopies. Samples should contain business subjects. "Send 5 or more b&w line drawings, color drawings, shading film or good line drawing editorial cartoons." Does not want to see comic strips. Samples not filed are returned by SASE. Reports within 4-6 weeks. To show a portfolio, mail tearsheets or photostats. Pays 50% of net proceeds; pays flat fee of $25 minimum. "We may buy art outright or split percentage of sales."
Tips: "We have the markets for multiple sales of editorial support art. We need talented artists to supply specific projects. We will work with beginning artists. Be honest about talent and artistic ability. If it isn't there then don't beat your head against the wall."

‡**COMIC ART THERAPY SERVICES**, P.O. Box 7981, Corpus Christi TX 78415. (512)850-2930. Fax: (512)857-2424. Art Director: Pedro Moreno. Comic Editor: James Rodriguez. Advertising Manager: Liz Fernandez. Estab. 1993. Syndicate serving 100 newspapers, magazines, churches and newsletters. Guidelines available for $10 (check or money order).
Needs: Approached by 200 cartoonists and 100 artists/year. Buys from 25 cartoonists and 10 artists/year. Introduces 25 new strips/year. Considers comic strips, editorial political cartoons, gag cartoons, illustrations, caricatures, spot drawings, b&w Sunday strips. Prefers single or multiple panel b&w line drawings with or without gagline. Prefers work that is humorous especially to children. (No offensive and degrading material.) Also uses artists for book covers, illustrations. Artwork must be reducible to 65% of original size.
First Contact & Terms: Sample package should include cover letter, résumé, tearsheets and finished cartoons (like the reduced copies newspaper comics). 6-12 samples should be included. Samples are not filed and are returned by SASE. Reports back within 1-2 weeks. To show portfolio, mail final art. Pays 50% of gross income on publication. Negotiates rights purchased. Minimum length of contract is 36 months. Artist owns original art and characters.
Tips: Include reduced copies (like the newspaper page), 6-12 cartoons, a $10 fee (check or money order) and a résumé and if possible a b&w photo.

‡**COMMUNITY PRESS SERVICE**, P.O. Box 639, Frankfort KY 40602. (502)223-1736. Editor: Gail Combs. Estab. 1990. Syndicate serving 200 weekly and monthly periodicals.
Needs: Approached by 15-20 cartoonists and 30-40 artists/year. Buys from 8-10 cartoonists and 4-5 freelance artists/year. Introduces 1-2 new strips/year. Considers comic strips. Prefers single panel b&w line drawings with or without gagline. Maximum size of artwork $8\frac{1}{2} \times 11$; must be reducible to 50% of original size.

First Contact & Terms: Sample package should include cover letter, finished cartoons, photocopies. 5-10 samples should be included. Samples are filed. Reports back within 2 months. Call for appointment to show portfolio of b&w final art. **Pays on acceptance.** Buys all rights. Offers automatic renewal. The artist owns characters. Syndicate owns original art.

CREATORS SYNDICATE, INC., 5777 W. Century Blvd., Los Angeles CA 90045. (310)337-7003. President: Richard S. Newcombe. Executive Vice President: Anita Tobias. Estab. 1987. Serves 2,400 daily newspapers, weekly and monthly magazines worldwide.
Needs: Buys from 100 writers and artists/year. Considers comic strips, gag cartoons, caricatures, editorial or political cartoons and "all types of newspaper columns."
First Contact & Terms: Send query letter with brochure showing art style or résumé and "anything but originals." Samples are not filed and are returned by SASE. Reports back within 2 months. Write for appointment to show a portfolio, which should include tearsheets and photostats. Pays 50% of net proceeds. Considers saleability of artwork and client's preferences when establishing payment. Negotiates rights purchased.

‡DREAM MAKER SOFTWARE, #16, 925 W. Kenyon Ave., Englewood CO 80110. (303)762-1001. Fax: (303)762-0762. Art Director: David Sutphin. Estab. 1986. Clip art firm, computer software publisher serving homes, schools, businesses, publishers, designers, ad agencies. Guidelines available for #10 SASE.
Needs: Approached by 6 cartoonists/year. Considers gag cartoons, illustrations, spot drawings, "all work suitable for publication as clip art."
First Contact & Terms: Sample package should include cover letter. 8-12 samples should be included. Samples are not filed and are returned by SASE. Reports back to the artist in 1 month only if interested. Call for appointment to show portfolio of b&w final art. Pays 5-10% of gross income or $10-50 flat fee on publication. Rights purchased vary according to project.

DYNAMIC GRAPHICS INC., 6000 N. Forest Park Dr., Peoria IL 61614-3592. (309)688-8800. Art Director: Frank Antal. Distributes to thousands of magazines, newspapers, agencies, industries and educational institutions.
• Dynamic Graphics is a clip art firm and publisher of *Step-by-Step Graphics* magazine. 99% of all artwork sold as clip art is done by freelancers. Uses illustrators from all over the world.
Needs: Works with 30-40 artists/year. Prefers illustration, graphic design and elements; primarily b&w, but will consider some 2- and full-color. "We are currently seeking to contact established illustrators capable of handling b&w and highly realistic illustrations of contemporary people and situations."
First Contact & Terms: Submit portfolio with SASE. Reports within 1 month. Buys all rights. Negotiates payment. **Pays on acceptance.**
Tips: "Concentrate on mastering the basics in anatomy and figure illustration before settling into a 'personal' or 'interpretive' style!"

■FILLERS FOR PUBLICATIONS, 7015 Prospect Place NE, Albuquerque NM 87110. (505)884-7636. President: Lucie Dubovik. Distributes to magazines and newspapers.
Needs: Buys 72 pieces/year from freelancers. Considers single panel, 4×6 or 5×7 cartoons on current events, education, family life, retirement, factory and office themes; clip art and crossword puzzles. Inquire for subject matter and format.
First Contact & Terms: Send query letter with samples of style and SASE. Samples are returned. Reports in 3 weeks. Previously published and simultaneous submissions OK. Buys first rights. **Pays on acceptance;** $7 for cartoons and line drawings; $25/page of clip art.
Tips: Does not want to see comic strips.

✱FOTO EXPRESSION INTERNATIONAL, Box 1268, Station "Q", Toronto, Ontario M4T 2P4 Canada. (416)841-1065. Fax: (416)841-2283. Director: M.J. Kubik. Serving 35 outlets.
Needs: Buys from 80 artists/year. Considers b&w and color single, double and multiple panel cartoons, illustrations and spot drawings.
First Contact & Terms: Send query letter with brochure showing art style or résumé, tearsheets, slides and photographs. Samples not filed are returned by SASE. Reports within 1 month. To show a portfolio, mail final reproduction/product and color and b&w photographs. Pays on publication; artist receives percentage. Considers skill and experience of artist and rights purchased when establishing payment. Negotiates rights purchased.

The double dagger before a listing indicates that the listing is new in this edition. New markets are often more receptive to freelance submissions.

Tips: "Quality and content are essential. Résumé and samples must be accompanied by a SASE or, out of Canada, International Reply Coupon is required."

FUTURE FEATURES SYNDICATE, Suite 117, 1923 Wickham Rd., Melbourne FL 32935. Creative Director: Jerry Forney. Estab. 1989. Syndicate markets to 1,000 daily newspapers. "Follow standard newspaper guidelines."
Needs: Approached by 400 freelance artists/year. Introduces 3-4 new strips/year. Considers comic strips, gag cartoons, editorial/political cartoons, humorous strips featuring animals and contemporary drawing styles and clip art. Recent introductions include Scratch That by Gregory Barrington and Tyrannosaurus Rick by Brad Yung. Prefers single, double and multiple panel with or without gagline; b&w line drawings. Prefers "unpublished, well designed art, themed for general newspaper audiences." Maximum size of artwork 8½×11 panel, 5×20 strip: must be reducible to 25% of original size.
First Contact & Terms: Sample package should include cover letter, photocopies and a short paragraph stating why you want to be a syndicated cartoonist. 12 samples should be included. Samples are filed or are returned by SASE. Reports back within 1 month. Portfolio review not required, but portfolio should include original/final art. Pays on publication; 50% of gross income. Buys first rights. Minimum length of contract is 2 years. Artist owns original art; syndicate owns characters.
Tips: Finds artists through submissions, word-of-mouth. "Keep trying new and inventive concepts. Make sure work is unique with outstanding characters and original settings. Don't get discouraged by rejection. We want quality work that can be maintained. If you have the ability we will work with you to promote it."

GRAPHIC NEWS BUREAU, gabriel graphics, Box 38, Madison Square Station, New York NY 10010. (212)254-8863. Cable: NOLNOEL. Director: J.G. Bumberg. Custom syndications and promotions to customized lists of small dailies, suburbans and selected weeklies.
Needs: Represents 4-6 artists/year, preferably within easy access. No dogmatic, regional or pornographic themes. Uses single panel cartoons, illustrations, halftones in line conversions and line drawings.
First Contact & Terms: Send query letter only. Reports within 4-6 weeks. Specifics on request with SASE. Provide 3×5 card to be kept on file for possible future assignments.
Tips: A new, added service provides for counselling and conceptualizing in graphics/management/communications ". . . when printing is an integral part of the promotion, product, service."

HEALTH CARE PR GRAPHICS, Division of Solution Resources, Inc., Suite 1, 1121 Oswego St., Liverpool NY 13088. (315)451-9339. Editor: Eric Roberts. Estab. 1981. Clip art firm. Distributes monthly to hospitals and other health care organizations.
Needs: Uses illustration, drawings and graphic symbols for use in brochures, folders, newsletters, etc. Prefers sensitive line illustrations, spot drawings and graphics related to health care, hospitals, nurses, doctors, patients, technicians and medical apparatus. Also buys cartoons. Needs computer literate artist with knowledge of Photoshop, Quark, Adobe.
First Contact & Terms: Experienced illustrators only, preferably having hospital exposure or access to resource material. Works on assignment only. Send query letter, résumé, photostats or photocopies to be kept on file. "Send 10 to 20 different drawings which are interesting and show sensitive, caring people." Does not want to see "color illustration or styles that cannot be reproduced easily." Samples returned by SASE if not kept on file. Reports within 1 month. Original art not returned at job's completion. Buys all rights. **Pays on acceptance**; pays flat rate of $30-100 for illustrations or negotiates payment according to project.
Tips: Finds artists through submissions, word of mouth. "We are looking to establish a continuing relationship with freelance graphic designers and illustrators. Illustration style should be serious, sensitive and somewhat idealized. Send enough samples to show the variety (if any) of styles you're capable of handling. Indicate the length of time it took to complete each illustration or graphic, and/or remuneration required. Practice drawing people's faces. Many illustrators fall short when drawing people."

HISPANIC LINK NEWS SERVICE, 1420 N St. NW, Washington DC 20005. (202)234-0737. Fax: (202)234-4090. Editor: Jonathan J. Higuera. Syndicated column service to 100 newspapers and a newsletter serving 1,300 subscribers: "movers and shakers in the Hispanic community in US, plus others interested in Hispanics."
Needs: Buys from 20 artists/year. Considers single panel cartoons; b&w, pen & ink line drawings. Introductions include In the Dark by Clyde James Aragon and Editorial by Alex Gonzalez. Work should have a Hispanic angle; "most are editorial cartoons, some straight humor."
First Contact & Terms: Send query letter with résumé and photocopies to be kept on file. Samples not filed are returned by SASE. Reports within 3 weeks. Portfolio review not required. **Pays on acceptance**; $25 flat fee (average). Considers clients' preferences when establishing payment. Buys reprint rights and negotiates rights purchased. "While we ask for reprint rights, we also allow the artist to sell later."
Tips: Interested in seeing more cultural humor. "While we accept work from all artists, we are particularly interested in helping Hispanic artists showcase their work. Cartoons should offer a Hispanic perspective on current events or a Hispanic view of life."

INSIDER REPORT

What To Do When They Say "No"

Jules Feiffer

If you've ever labored for hours perfecting your work, studied the markets, followed submission guidelines to the letter, and waited patiently for the mail to deliver the good news, only to receive a few polite rejections, do what cartoonist Jules Feiffer did. Win a Pulitzer Prize.

Feiffer tried for years to sell his cartoons, packaging them carefully and sending them to magazines and syndicates. Time and again he was advised that if his style was just a bit more like William Steig or Saul Steinberg or some other successful cartoonist, he could get published. Back at his drawing board he'd alter a line here and a character's expression there, trying to make his unconventional style conform. "In essence I tried very hard at becoming a hack, imitating other artists' styles," says Feiffer, "but I failed miserably at it." Discouraged, Feiffer came to a radical decision. "I had to opt for quality. It was my final shot."

The only publication that gave Feiffer any encouragement was a then fledgling four-page tabloid called *The Village Voice*. The editor accepted Feiffer's submission, but with one hitch—the struggling paper couldn't afford to pay contributors. What the paper *could* offer Feiffer was a consistent forum for his cartoons, freedom to create them as he saw fit, and a valuable opportunity to grow as an artist. Eventually it lead him to the coveted Pulitzer Prize for Editorial Cartooning in 1986.

In the first few months of the weekly feature, which began in 1956, Feiffer's drawing style changed so much from week to week that a casual reader might have thought the work was by different cartoonists. But in six months a solid style began to emerge. Soon readers picked up *The Voice* to catch Feiffer's cast of characters: the long limbed modern dancer in the black leotard, bounding, leaping and crawling from frame to frame of Feiffer's drawings; Bernard, a young urban liberal given to anxiety attacks; and over the years, Eisenhower, Kennedy, Johnson, Nixon, Ford, Carter, Reagan, Bush and Bill Clinton. The strip was revolutionary in both form and content. Feiffer's people didn't speak in bubbles like the other cartoon characters, and his pen satirized difficult subjects—relationships, politics, war and prejudice.

Though the paper did not pay Feiffer for eight years, the decision to contribute a weekly strip was one of the most profitable moves in his career. *The Village Voice* put Feiffer's work where it could be seen. Its popularity brought offers from syndicates, and his cartoons were later syndicated in more than 100 papers.

As a result, collections of Feiffer's work were published and assignments with national magazines such as *Playboy*, *The New Yorker* and *Newsweek* followed. He was offered the chance to write his first play, which led to ventures into novel and screenwriting.

"You can't be passive, feel sorry they don't appreciate how good you are and just sulk. Don't wait for luck to find you. Get out there and give yourself a chance to *meet* luck. If the big magazines and syndicates won't give you a chance, there are tiny newspapers around the country that will publish your work and you can do things that nobody's ever done before. Most of them pay very little, but it gets your work out there where it can be seen."

Feiffer believes strongly that success doesn't show up until you've survived some blows. Accustom yourself to failure and learn how to deal with it, he says. "When young people—particularly bright, ambitious and talented young people—can't live up to their expectations, they think they are no good. What they don't realize is that failure is organic and part of your life and it will happen and will happen often. It is something to greet and get through. There are enough people out there whose job it is to frustrate you, to turn you down, to reject you. Don't do their job for them."

Surviving is easier if you get excited about what you're doing. "You've got to fall in love with your work," says Feiffer, whose current passion is writing and illustrating children's books. He's just published *The Man in the Ceiling*, about a boy cartoonist, and is working on a fairy tale. When a retrospective of his strips and drawings was unveiled at a Los Angeles gallery last fall, Feiffer shrugged off comparisons to Lautrec. "I just keep on doing what interests me and mix it up with what pays the rent."

—*Mary Cox*

Reprinted with permission of Jules Feiffer

"Me, Me, Me, Me, Me . . ." *one of Jules Feiffer's favorites among his own cartoons, first appeared in* **The Village Voice.** *It can be found in Jules Feiffer's* **America, From Eisenhower to Reagan,** *a collection of the cartoonist's work published by A.A. Knopf, Inc.*

JODI JILL FEATURES, Suite 321, 1705 14th St., Boulder CO 80302. Art Editor/President: Jodi Jill. Estab. 1983. Syndicate serving "hundreds" of newspapers, magazines, publications. Art guidelines not available.
Needs: Approached by 250 artists/year. "Tries to average 10 new strips per year." Considers comic strips, editorial/political cartoons and gag cartoons. "Looking for silly, funny material, not sick humor on lifestyles or ethnic groups." Recent introductions include From My Eyes by Arnold Peters and Why Now? by Ralph Stevens. Prefers single, double and multiple panel and b&w line drawings. Needs art, photos and columns that are visual puzzles. Maximum size of artwork 8½×11.
First Contact & Terms: Sample package should include cover letter, résumé, tearsheets, finished cartoons and photocopies. 6 samples should be included. Samples are not filed and are returned by SASE if requested by artist. Portfolio review requested if interested in artist's work. Reports back within 1 month. Portfolio should include b&w roughs and tearsheets. **Pays on acceptance;** 40-50% of net proceeds. Negotiates rights purchased. Minimum length of contract is 1 year. The artist owns original art and characters.
Tips: Finds artists "by keeping our eyes open and looking at every source possible. Would like to see more puzzles with puns in their wording and visual effects that say one thing and look like another. We like to deal in columns. If you have a visual puzzle column we would like to look it over. Some of the best work is unsolicited."

‡A.D. KAHN, INC., 35336 Spring Hill, Farmington Hills MI 48331. (810)355-4100. Fax: (810)356-4344. President/Editor: David Kahn. Estab. 1960. Syndicate serving daily and weekly newspapers, monthly magazines. Art guidelines not available. Recent introductions include Zoolies (captionless cartoon).
Needs: Approached by 24-30 freelance artists/year. Represents from 1-2 freelance artists/year. Introduces 1-2 new strips/year. Considers comic strips, editorial/political cartoons, gag cartoons, puzzles/games.
First Contact & Terms: Sample package should include material that best represents artist's work. Files samples of interest; others returned by SASE if requested by artist. Does not report back, in which case the artist should call for results. Pays 50% of net proceeds. Negotiates rights purchased according to project. The artist owns original art and characters.

KING FEATURES SYNDICATE, 235 E. 45th St., New York NY 10017. (212)455-4000. Comics Editor: Jay Kennedy. Estab. 1915. Syndicate servicing 3,000 newspapers. Guidelines available for #10 SASE.
• This is one of the oldest, most established syndicates in the business. It runs such classics as Blondie, Hagar, Dennis the Menace and Beetle Bailey and such contemporary strips as Zippy the Pinhead and Ernie. If you are interested in selling your cartoons on an occasional rather than fulltime basis, refer to the listings for The New Breed and Laff-A-Day (also run by King Features).
Needs: Approached by 6,000 artists/year. Introduces 3 new strips/year. Considers comic strips and single panel cartoons. Prefers humorous single or multiple panel, and b&w line drawings. Maximum size of artwork 8½×11. Comic strips must be reducible to 6½″ wide; single panel cartoons must be reducible to 3½″ wide.
First Contact & Terms: Sample package should include cover letter, character sheet that names and describes major characters and photocopies of finished cartoons. "Résumé optional but appreciated." 24 samples should be included. Returned by SASE. Reports back within 6 weeks. Pays 50% of net proceeds. Rights purchased vary according to project. Artist owns original art and characters. Length of contract and other terms negotiated.
Tips: "We look for a uniqueness that reflects the cartoonist's own individual slant on the world and humor. If we see that slant, we look to see if the cartoonist is turning his or her attention to events that other people can relate to. We also very carefully study a cartoonist's writing ability. Good writing helps weak art, better than good art helps weak writing."

LAFF-A-DAY, %King Features Syndicate, 235 E. 45th St., New York NY 10017. (212)455-4000. Contact: Laff-A-Day Editors. Estab. 1936. Syndicated feature. "Showcases single panel gag cartoons with a more traditional approach."
Needs: Reviews 3,000 cartoons/year. Buys 312 cartoons/year. Maximum size of artwork 8½×11. Must be reducible to 3½″ wide.
First Contact & Terms: "Submissions should include 10-25 single panel cartoons per batch. Cartoons should be photocopied 1 per page and each page should have cartoonist's name and address on back. All submissions must include SASE large enough and with enough postage to return work. No original art." Reports back within 6 weeks. **Pays on acceptance;** flat fee of $50.

LEW LITTLE ENTERPRISES, INC., P.O. Box 5318, Bisbee AZ 85603-5318. (602)432-8003. Editor: Lew Little. Estab. 1986. Syndicate serving all daily and weekly newspapers. Guidelines available for legal SAE with 1 first-class stamp.
Needs: Approached by 300-400 artists/year. Buys from 1-2 artists/year. Introduces 1-2 new strips/year. Considers comic strips, editorial/political cartoons and gag cartoons. Prefers single or multiple panel with gagline.
First Contact & Terms: Sample package should include cover letter, résumé, roughs and photocopies of finished cartoons. Minimum of 12 samples should be included. Samples are not filed and are returned by SASE. Reports back within 6 weeks. To schedule an appointment to show a portfolio mail final reproduction/product, b&w roughs, tearsheets and SASE. Pays on publication; negotiable percentage of net proceeds.

Negotiates rights purchased. Minimum length of contract 5 years. Offers automatic renewal. Artist owns original art and syndicate owns characters during the contract term, after which rights revert to artist.
Tips: Does not want to see "bulky portfolios or elaborate presentations."

LOS ANGELES TIMES SYNDICATE, 218 S. Spring St., Los Angeles CA 90012. (213)237-7987. General Manager: Steven Christensen. (213)237-3213.
Needs: Comic strips, panel cartoons and editorial cartoons. "We prefer humor to dramatic continuity and general illustrations for political commentary. We consider only cartoons that run 6 or 7 days/week. Cartoons may be of any size, as long as they're to scale with cartoons running in newspapers." (Strips usually run approximately 6¹/₁₆×2; panel cartoons 3⅛×4; editorial cartoons vary.)
First Contact & Terms: Submit photocopies or photostats of 24 dailies. Submitting Sunday cartoons is optional; if you choose to submit them, send at least four. Reports within 2 months. Include SASE. Buys all rights. Pays flat fee of $50-150.
Tips: Finds artists through word of mouth, submissions, newspapers. "Don't imitate cartoons that are already in the paper. Avoid linework or details that might bleed together, fade out or reproduce too small to be seen clearly. We hardly ever match artists with writers or vice versa. We prefer people or teams who can do the entire job of creating a feature."

This image is just one of the thousands — from Art Deco to high tech — available from Metro Creative Graphics' ImageBase® Electronic Clip Art collection. The art, purchased outright from freelancers, is sold in packages of at least 100 in 18 categories. Metro also offers a package of 2,000 images on CD-ROM.

METRO CREATIVE GRAPHICS, INC., 33 W. 34th St., New York NY 10001. (212)947-5100. Fax: (212)714-9139. Contact: Prasuna Tanchuk. Estab. 1910. Creative graphics/art firm. Distributes to 6,000 daily and weekly paid and free circulation newspapers, schools, graphics and ad agencies and retail chains.
Needs: Buys from 100 freelance artists/year. Considers all styles of illustrations and spot drawings; b&w and color line art preferred. Special emphasis on computer generated art for Macintosh. Send floppy disk samples using Adobe Illustrator, Aldus Freehand or Fractal Design Painter. Prefers all categories of themes associated with retail, classified, promotion and advertising. Also needs covers for special-interest tabloid section.
First Contact & Terms: Send query letter with brochure, photostats, photocopies, slides, photographs or tearsheets to be kept on file. Samples not kept on file returned by SASE. Reports only if interested. Works

on assignment only. **Pays on acceptance**; flat fee of $25-1,000. Considers skill and experience of artist, saleability of artwork and clients' preferences when establishing payment.

Tips: "Show a variety of styles and ability. Especially interested in drawings of people in realistic situations. If specialty is graphic design, think how you would use samples in advertising. Current popular themes include healthcare, religion, computer equipment (desktop publishing) and business symbols. Cartoons for syndication, most editorial art and oil paintings not considered."

MIDWEST FEATURES INC., P.O. Box 9907, Madison WI 53715-0907. (608)274-8925. Editor/Founder: Mary Bergin. Estab. 1991. Syndicate serving daily/weekly newspapers and other Wisconsin/Midwest publications. Guidelines not available.

Needs: Approached by dozens of artists/year. Buys from 2-3 artists/year. Artists most likely to get 1-shot assignments. Considers comic strips, editorial/political cartoons and illustrations. Prefers single panel and b&w line drawings without gagline. Emphasis on Wisconsin/Midwest material is mandatory.

First Contact & Terms: Sample package should include cover letter, résumé, tearsheets and 8½ × 11 photocopies. "No originals!" 6 samples should be included. Samples are filed. Reports back to the artist only if interested or if artist sends SASE. Pays on publication; 50% of gross income. Rights purchased vary according to project. Minimum length of contract one year for syndication work. Offers automatic renewal. Artist owns original art and characters.

Tips: "Do not send originals. Phone calls are not appreciated."

■**NATIONAL NEWS BUREAU,** Box 43039, Philadelphia PA 19129. (215)546-8088. Editor: Harry Jay Katz. Syndicates to 300 outlets and publishes entertainment newspapers on a contract basis.

Needs: Buys from 500 freelance artists/year. Prefers entertainment themes. Uses single, double and multiple panel cartoons, illustrations; line and spot drawings.

First Contact & Terms: To show a portfolio, send samples and résumé. Samples returned by SASE. Reports within 2 weeks. Returns original art after reproduction. Send résumé and samples to be kept on file for future assignments. Negotiates rights purchased. Pays on publication; flat fee of $5-100 for each piece.

THE NEW BREED, %King Features Syndicate, 235 E. 45th St., New York NY 10017. (212)455-4000. Contact: The New Breed Editors. Estab. 1989. Syndicated feature.

• "The New Breed showcases single panel gag cartoons done by cartoonists with a contemporary or wild sense of humor. The New Breed is a place where people can break into newspaper syndication without making a commitment to producing a comic on a daily basis. The feature is intended as a means for King Features to encourage and stay in touch with promising cartoonists who might one day develop a successful strip for regular syndication."

Needs: Reviews 30,000 cartoons/year. Buys 500 cartoons/year. Maximum size of artwork 8½ × 11; must be reducible to 3½ wide.

First Contact & Terms: "Submissions should include 10-25 single panel cartoons per batch. The cartoons should be photocopied one per page and each page should have cartoonist's name and address on back. All submissions must include SASE large enough and with enough postage to return work. Do not send originals." Reports back within 6 weeks. **Pays on acceptance**; flat fee of $50. Buys first worldwide serial rights.

‡**NEW ENGLAND MOTORSPORTS/INTERNATIONAL MOTORSPORTS SYNDICATES,** 84 Smith Ave., Stoughton MA 02072. (617)344-3827. Estab. 1988. Syndicate serving 15 daily newspapers, motorsports trade weeklies. Art guidelines not available.

Needs: Considers sports pages material. Prefers single panel, motorsports motif. Maximum size 1 column.

First Contact & Terms: Sample package should include cover letter and 1 sample. Samples are filed. Reports back within 1 week. To show a portfolio, mail original/final art. **Pays on acceptance**; flat fee of $5 fee. Syndicate owns original art and characters.

OCEANIC PRESS SERVICE, Suite 106, 1030 Calle Cordillera, San Clemente CA 92673-6234. (714)498-7227. Fax: (714)498-2162. Manager: Helen J. Lee. Estab. 1957. Syndicates to 300 magazines, newspapers and subscribers in 30 countries. Guidelines $2 with SASE.

• Singer Media Corp. owns this syndicate. See listing for Singer Media in this section for more information.

Needs: Buys several hundred pieces/year from artists. Considers cartoon strips (single, double and multiple panel) and illustrations in *The New Yorker* or *Playboy* style. Recent introductions include Verizontal by Magila and Sex, by Engleman for the world market. Prefers camera-ready material (tearsheets or clippings). Cartoonist who exemplifies tone and style we want is "Booth, Adam Lasalvy (French). Recently published work covering: pop music, entertainment, business management. Themes published include sex cartoons, family, inflation, juvenile activity cartoons, and covers for paperbacks (color transparencies). Interested in unusual sports cartoons. "No graphic sex or violence. Pokes fun at established TV shows. Bad economy sparks interest in how-to articles with b&w line drawings. People like to read more about celebrities, but it has to have a special angle, not the usual biographic run-of-the-mill profile. I'd like to see a good cartoon book on Sherlock Holmes, on Hollywood, on leading TV shows."

First Contact & Terms: Send query letter with photostats and samples of previously published work. Accepts tearsheets and clippings, no originals. Portfolio review not required. Send SASE. Reports within 1 month. Pays 50% of gross income. Interested in buying second rights (reprint rights) to previously published artwork.
Tips: "We're looking for more color work for manufacturers of toys and textiles. We'd also like to see specialized topics, not general."

■**REPORTER, YOUR EDITORIAL ASSISTANT**, 7015 Prospect Place, NE, Albuquerque NM 87110. (505)884-7636. Editor: George Dubow. Syndicates to newspapers and magazines for secondary level schools and colleges.
Needs: Considers single panel cartoons on teenage themes.
First Contact & Terms: Mail art and SASE. Reports in 3 weeks. Buys first rights. Originals returned to artist only upon request. Pays $5-10.
Tips: Does not want to see comic strips.

SAM MANTICS ENTERPRISES, P.O. Box 77727, Menlo Park CA 94026. (415)854-7872. President: Carey Cook. Estab. 1988. Syndicate serving schools, weekly newspapers. Guidelines not available.
Needs: Approached by 12 artists/year. Considers comic strips and educational text. Prefers multiple panel and b&w line drawings. Prefers themes relating to educational training and vocabulary. Maximum size of artwork 11 × 17; must be reducible to 65% of original size.
First Contact & Terms: Sample package should include cover letter, photocopies of finished cartoons. 20 samples should be included. Samples not filed and are returned by SASE if requested by artist. Reports back within 1 month. To show portfolio, mail tearsheets. Pays on publication. Rights purchased vary according to project. The artist owns original art and characters.
Tips: Finds artists through submission. "Including self-promotional materials is encouraged because they show certainty of artist and describe flexibility which may not be obvious in the submission. Focus is on educational-art ideas. We try to make learning fun!"

SINGER MEDIA CORP., Unit #106, 1030 Calle Cordillera, San Clemente CA 92673-6234. (714)498-7227. Fax: (714)498-2162. Executive Vice President: Katherine Han. Syndicates to 300 worldwide magazines, newspapers, book publishers and poster firms. Geared toward the family, business management. Artists' guidelines $2.
 • Oceanic Press Service is also run by this company. This syndicate provides a list of subjects they're interested in covering through cartoons. Ask for this list when you write for guidelines.
Needs: Syndicates several hundred pieces/year. Considers single, double and multiple panel cartoon strips; family, children, juvenile activities and games themes. Especially needs business, outer space and credit card cartoons of 3-4 panels. Cartoonists who exemplify tone and style we want are Shirvanian, Stein, Day. Recent introductions include Golf by Lo Linkert and Fantastic Facts by Fred Treadgold. Prefers to buy reprints or clips of previously published material. Prefers color cartoons.
First Contact & Terms: To show a portfolio, send query letter with tearsheets. Show 10-12 samples. "Prefer to see tearsheets or camera ready copy or clippings. No computer-generated art." Include SASE. Reports within 2-3 weeks. Returns cartoons to artist at job's completion if requested at time of submission with SASE. Licenses reprint or all rights; prefers foreign reprint rights. Do not send originals. Pays 50% of gross income. Pays a $5-200 flat fee/cartoon.
Tips: "Current daily needs: phone answering machines, credit card, job hunting, computers, fax, technology, golf, baseball, women executives (positive), lay offs, world trade. Good cartoonists show more than 2 people talking. They give detailed backgrounds. More sophisticated people are needed. Study *The New Yorker*'s cartoons. We have opened up worldwide markets."

STATON GRAPHICS, P.O. Box 618, Winterville GA 30683-0618. President: Bill Staton. Syndicates almost exclusively to weekly newspapers. Art guidelines available for #10 SASE.
Needs: Approached by 100 cartoonists/year. Buys from 1-2/year. Introduces 1-2 new strips/year. Considers comic strips, gag cartoons and editorial/political cartoons.
First Contact & Terms: Sample package should include minimum of 12 photocopied samples. Samples not filed are returned by SASE. Pays 50% of gross income at time of sale. Rights purchased vary according to project. Artist owns original art and characters.
Tips: Finds artists through word of mouth, sourcebooks. Also offers critique service for $15 fee. "Avantegarde cartoons are hot now, but I feel they're a fad. Longevity of subject is one of the keys to success. Be original and funny!"

TEENAGE CORNER INC., 70-540 Gardenia Court, Rancho Mirage CA 92270. President: Mrs. David J. Lavin. Syndicates rights.

Needs: Prefers spot drawings and illustrations.
First Contact & Terms: Send query letter and SASE. Reports within 1 week. Buys 1-time and reprint rights. Negotiates commission. Pays on publication.

Bound & Gagged

By Dana Summers

Bound & Gagged, the latest hilarious strip created by cartoonist Dana Summers, is syndicated by Tribune Media Services. Summers, who began his career freelancing for weekly Massachusetts' newspapers, has been an editorial cartoonist for The Orlando Sentinel *since 1982, and is co-creator of the successful strip* The Middletons.

‡T/MAKER COMPANY, 1390 Villa St., Mountain View CA 94041. (415)962-0195. Fax: (415)962-0201. Contact: Click Art. Estab. 1984. Clip art firm serving thousands of retail outlets, catalog sales. Guidelines not available.
Needs: Approached by hundreds of cartoonists and artists/year. Buys from dozens of cartoonists and artists/year. Considers illustrations, caricatures, spot drawings. Prefers b&w line drawings.
First Contact & Terms: Sample package should include cover letter, résumé, tearsheets, photostats. Samples are filed. Reports back to the artist only if interested. To show portfolio, mail appropriate b&w and color materials. Rights purchased vary according to project. Minimum length of contract is "forever."

TRIBUNE MEDIA SERVICES, INC., Suite 1500, 435 N. Michigan Ave., Chicago IL 60611. (312)222-4444. Editor: Michael A. Silver. Syndicate serving daily and Sunday newspapers. Recent introductions include Bound & Gagged (strip) by Dana Summers, Dave (strip) by David Miller, Pluggers (comic panel) by Jeff Macnelly, Bottom Liners (comic panel) by Eric and Bill Teitelbaum. "All are original comic strips, visually appealing with excellent gags."
Needs: Seeks comic strips and newspaper panels. Prefers original comic ideas, with excellent art and timely, funny gags; original art styles; inventive concepts; crisp, funny humor and dialogue.
First Contact & Terms: Send query letter with résumé and photocopies. Sample package should include 2-3 weeks of daily strips or panels. Samples not filed are returned only if SASE is enclosed. Reports within 4-6 weeks. Pays 50% of net proceeds.

‡UNITED CARTOONIST SYNDICATE, P.O. Box 7081, Corpus Christi TX 78415. (512)850-2930. Fax: (512)857-2424. Art Director: Pedro Moreno. Comic Director: Jerry Cardona. Estab. 1975. Syndicate serving 100 magazines, newspapers, newsletters, church publications. Comic guidelines available for $10 (check or money order).
Needs: Approached by 200 cartoonists and 100 artists/year. Buys from 25 cartoonists and 10 artists/year. Introduces 25 new strips/year. Considers comic strips, editorial political cartoons, gag cartoons, illustrations, caricatures, spot drawings, Sunday strips. Prefers single or multiple panel b&w line drawings. Prefers humorous material that will not be offensive to the general audience. Also uses artists for book covers, illustrations. Artwork must be reducible to 65% of original size.
First Contact & Terms: Sample package should include cover letter, résumé, tearsheets, finished cartoons, copies reduced to newspaper comics size. 6-12 samples should be included. Samples are not filed and are returned by SASE. Reports back within 1-2 weeks. To show portfolio, mail appropriate materials including final art. Pays on publication; 50% of gross income. Negotiates rights purchased. Artist owns original art and characters.

Tips: "Include comic strips/panels geared to family entertainment. Features with a résumé of artist and a b&w photo of artist (optional)."

UNITED MEDIA, 200 Park Ave., New York NY 10166. Director of Comic Art: Sarah Gillespie. Estab. 1978. Syndicate servicing US and international newspapers. Guidelines available for SASE. "United Media consists of United Feature Syndicate and Newspaper Enterprise Association. Submissions are considered for both syndicates. Duplicate submissions are not needed."
Needs: Introduces 2-4 new strips/year. Considers comic strips and single, double and multiple panels. Recent introductions include 9 Chickweed Lane by Brooke McEldowney, Committed by Michael Fry. Prefers pen & ink. Maximum size of artwork: 8½ × 11.
First Contact & Terms: Send cover letter, résumé, finished cartoons and photocopies. Include 36 dailies; "Sundays not needed in first submissions." Do not send "oversize submissions or concepts but no strip." Samples are not filed and are returned by SASE. Reports back within 3 months. "Does not view portfolios." UFS pays 50% of net proceeds. NEA pays flat fee, $500 and up a week. Buys all rights. Minimum length of contract 5 years and 5 year renewal. Automatic renewal. 50/50 ownership of art; syndicate owns characters.
Tips: "Send copies, but not originals. Do not send mocked-up licensing concepts." Looks for "originality, art and humor writing. Be aware of long odds; don't quit your day job. Work on developing your own style and humor writing. Worry less about 'marketability' — that's our job."

WASHINGTON POST WRITERS GROUP, 1150 15th St. NW, Washington DC 20071-9200. (202)334-6375. Editorial Director: Alan Shearer. Estab. 1973. Syndicate serving over 1,000 daily, Sunday and weekly newspapers in US and abroad. Art guidelines available for SASE and necessary postage.
Needs: Approached by 1,000 prospective cartoonists and columnists/year. Introduces 1-2 new features/year. Recent introductions include Cheap Thrills Cuisine by Lombardo & Bui, a weekly recipe strip for food pages, features zany Chef Peppi. Prefers single and multiple panel and b&w line drawings. Does not handle 1-time material.
First Contact & Terms: Sample package should include cover letter, résumé, tearsheets, photostats and photocopies, but "lists of publications that carry artist's material are most important." 15-20 samples should be included. Samples are not filed and are returned by SASE. Reports back within 3 weeks. "No original artwork, please." Payment is contract negotiated. Pays 50% of gross income for syndication agreement. Buys all rights. Minimum length of contract varies.
Tips: Submissions should be "sophisticated and well-drawn, but we are open-minded. The Writers Group has always been a small syndicate, and plans to remain so."

WHITEGATE FEATURES SYNDICATE, 71 Faunce Dr., Providence RI 02906. (401)274-2149. Talent Manager: Eve Green. Estab. 1988. Syndicate serving daily newspapers and magazines. Introduced Dave Berg's Roger Kaputnik.
Needs: "We're planning on 6 or more strips next year. Do one now." Considers comic strips, gag cartoons, editorial/political cartoons, illustrations and spot drawings; single, double and multiple panel. Work must be reducible to strip size. Also needs artists for advertising and publicity.
First Contact & Terms: Send cover letter, résumé, tearsheets, photostats and photocopies. Include about 12 strips. To show a portfolio, mail tearsheets, photostats, photographs and slides; include b&w. Pays 50% of net proceeds upon syndication. Negotiates rights purchased. Minimum length of contract 5 years (flexible). Artists owns original art; syndicate owns characters (negotiable).
Tips: Include in a small sample package "info about yourself, tearsheets of previous work, notes about the strip and enough samples to tell what it is. Please don't write asking if we want to see; just send samples." Looks for "good writing, strong characters, good taste in humor. No hostile comics. We like people who have been cartooning for a while and have been printed. Try to get published in local newspapers first."

Syndicates/Clip Art/'94-'95 changes

The following companies were listed in the 1994 edition but do not have listings in this edition. The majority did not respond to our request to update their listings. If a reason was given for exclusion, it appears in parentheses after the company's name.

Adventure Feature Syndicate
Art & Stuff (ceased publication)
Cartoon Media
Dear Newspapers
Editors Press Service, Inc.

F.A.C.
Paula Royce Graham
Graphic Arts Communications
Loeleen-Durck Creations/Leonard Bruce Designs (not taking submissions)

Minority Features Syndicate, Inc.
Page 1 News
The Southman Syndicate
Studio Advertising Art
Universal Press Syndicate

Resources

Artists' Reps

Throughout *Artist's & Graphic Designer's Market*, we've been stressing the importance of promoting and marketing your work. What if you are so busy *creating* work you don't have time to promote it? Many artists have found leaving the promotion to an artist's rep allows them more time to devote to the creative process. In exchange for actively promoting an artist's career, the representative receives a percentage of the artist's sales (usually 25-30%).

Because of the growing number of artists choosing representation as an option, we decided to add artists' reps to our resources section. The listings include fine art and commercial artists' reps (for illustrators). Reps concentrate on either the commercial or fine art markets, rarely both. Very few reps handle designers.

Reps are responsible for presenting your artwork to the right people so that it sells. Fine art reps promote the work of fine artists, sculptors, craftspeople and fine art photographers to galleries, museums, corporate art collectors, interior designers and art publishers. Commercial art reps help illustrators obtain assignments from advertising agencies, publishers, corporations, magazines and other art buyers; negotiate contracts; and handle billing and collection of invoices.

An artist's rep will often work with an illustrator to help bring a portfolio up-to-speed. The rep might recommend purchasing an advertisement in one of the many creative directories such as *American Showcase* or *Creative Illustrator* so that your work will be seen by hundreds of art directors or advise advertising in a fine arts magazine. Expect to make an initial investment in costs for duplicate portfolios and mailings.

Getting representation isn't as easy as you might think. Reps are very choosy about who they will represent, not just in terms of talent, but in terms of marketability and professionalism. They have extensive knowledge of various markets, trends and prices. A rep will only take on talent she believes in and knows will sell.

Start by approaching a rep with a brief query letter and direct mail piece, if you have one. If you do not have a flier or brochure, send photocopies or (duplicate) slides along with a self-addressed, stamped envelope. Check the listings in this section for more specific submission information.

The Society of Photographers and Artists Representatives (SPAR) is an organization for professional representatives. SPAR members are required to maintain certain standards and follow a code of ethics. For more information on the group, write to SPAR, Suite 1166, 60 E. 42nd St., New York NY 10165, phone (212)779-7464.

One final note: artists' reps are hired to sell artwork. Artists' advisors, on the other hand, are consultants hired by artists to advise them on marketing strategies. Advisors usually work short term and are paid hourly rates. They advertise in arts magazines, or find clients through word of mouth. Some write books on the subject and/or offer marketing seminars. So if you feel you aren't ready to contract with a rep, you might want to seek out an advisor who can help get your career rolling.

ADMINISTRATIVE ARTS, INC., P.O. Box 547935, Orlando FL 32854-1266. President: Brenda B. Harris. Fine art advisor. Estab. 1983. Registry includes 1,000 fine artists (includes fine art crafts). Markets include: architects; corporate collections; developers; private collections; public art.
Handles: Fine art. "We prefer artists with established regional and national credentials. We also review and encourage emerging talent."
Terms: "Trade discount requested varies from 15-50% depending on project and medium. Submissions must include: 1) complete résumé; 2) artist's statement or brief profile; 3) labeled slides (artist's name, title of work, date, medium, image size and *retail price*); 4) availability of works submitted."
How to Contact: For first contact, send cover letter, résumé, profile, labeled slides (including pricing), tearsheets, copies of reviews, etc. and SASE. Reports in 1-3 weeks.
Tips: "Artists are generally referred by their business or art agent, another artist or art professional, educators, or art editors who know our firm. A good impression starts with a cover letter and a well organized, typed résumé. *Always place your name and slide identification on each slide.* Make sure that slides are good representations of your work. Know your retail and net pricing and the standard industry discounts. Invite the art professional to visit your studio. To get placements, be cooperative in getting art to the art professional when and where it's needed."

ALBRECHT & JENNINGS ART ENTERPRISES, 3546 Woodland Trail, Williamsburg MI 49690. (616)938-2163. Contact: Tom Albrecht. Fine art representative. Estab. 1991. Represents 60 fine artists (includes 15 sculptors). Staff includes Tom Albrecht, Karen Jennings. Specializes in Michigan and Midwest art, especially by emerging artists. Markets include: corporate collections; private collections.
Handles: Fine art.
Terms: Agent receives 40% commission. Advertising costs are paid by representative. For promotional purposes, talent must provide slides and photographs of artwork, and up-to-date résumés.
How to Contact: For first contact, send query letter, résumé, bio, slides, photographs and SASE. Reports in 2 weeks. After initial contact, call for appointment to show portfolio of slides and photographs.
Tips: Obtains talent "by referral from other artists, looking at galleries, and solicitation."

AMERICAN ARTISTS, REP. INC., #1W, 353 W. 53rd St., New York NY 10019. (212)582-0023. Fax: (212)582-0090. Commercial illustration representative. Estab. 1930. Member of SPAR. Represents 30 illustrators. Markets include: advertising agencies; corporations/client direct; design firms; editorial/magazines; paper products/greeting cards; publishing/books; sales/promotion firms.
Handles: Illustration, design.
Terms: Rep receives 30% commission. "All portfolio expenses billed to artist." Advertising costs are split: 70% paid by talent; 30% paid by representative. "Promotion is encouraged; portfolio must be presented in a professional manner — 8×10, 4×5, tearsheets, etc." Advertises in *American Showcase, Creative Black Book, RSVP, The Workbook,* Medical and Graphic Artist Guild publications.
How to Contact: For first contact, send query letter, direct mail flier/brochure, tearsheets. Reports in 1 week if interested. After initial contact, drop off or mail appropriate materials for review. Portfolio should include tearsheets, slides.
Tips: Obtains new talent through recommendations from others, solicitation, conferences.

JACK ARNOLD FINE ART, 5 E. 67th St., New York NY 10021. (212)249-7218. Fax: (212)249-7232. Contact: Jack Arnold. Fine art representative. Estab. 1979. Represents 15 fine artists (includes 1 sculptor). Specializes in contemporary graphics and paintings. Markets include: galleries; museums; private collections; corporate collections.
Handles: Looking for contemporary impressionists and realists.
Terms: Agent receives 50% commission. Exclusive area representation preferred. No geographic restrictions. To be considered, talent must provide color prints or slides.
How to Contact: For first contact, send bio, photographs, retail prices and SASE. Reports in days. After initial contact, drop off or mail in portfolios of slides, photographs.
Tips: Obtains new talent through referrals.

ART EMOTION CORP., 24 E. Piper Lane, Prospect Heights IL 60070. (708)459-0209. Contact: Gerard V. Perez. Estab. 1977. Represents 45 fine artists. Specializes in "selling to art galleries." Markets include: corporate collections; galleries; interior decorators.
Handles: Fine art.
Terms: "We buy for resale." Exclusive area representation is required. For promotional purposes talent must provide slides, color prints, "any visuals." Advertises in *Art News, Decor, Art Business News.*
How to Contact: For first contact, send tearsheets, slides, photographs and SASE. Reports in 1 month, only if interested. "Don't call us — if interested, we will call you." Portfolio should include slides, photographs.
Tips: Obtains new talent "through recommendations from others and word of mouth."

ART SOURCE L.A., INC., Suite 555, 11901 Santa Monica Blvd., Los Angeles CA 90025. (310)479-6649. Fax: (310)479-3400. Contact: Francine Ellman. Fine art representative. Estab. 1980. Member of Architectural

Design Council. Represents 10 photographers, 30 fine artists (includes 4 sculptors). Specializes in fine art consulting and curating; creative management, exhibition and design. Markets include: architects; corporate collections; developers; public space galleries; interior designers; museums; private collections; publishing/books; film industry.

Handles: Fine art, fine photography.

Terms: Agent receives commission, amount varies. Exclusive area representation required in some cases. No geographic restrictions. "We request artists or photographers to submit a minimum of 10 slides/visuals, résumé and SASE. Advertises in *Art News, Artscene, Art in America, Blue Book, Gallery Guide, Visions, Art Diary*.

How to Contact: For first contact, send résumé, bio, slides or photographs and SASE. Reports in 1-2 months. After initial contact, "we will call to schedule an appointment" to show portfolio of original art, slides, photographs.

Tips: Obtains new talent through recommendations, artists' submissions and exhibitions.

ARTCO INCORPORATED, 3148 RFD Cuba Rd., Long Grove IL 60047. (708)438-8420. Fax: (708)438-6464. Contact: Sybil Tillman. Fine art representative. Estab. 1970. Member of International Society of Appraisers. Represents 60 fine artists. Specializes in contemporary artists' originals and limited edition graphics. Markets include: architects; art publishers; corporate collections; galleries; private collections.

Handles: Fine art.

Terms: "Each commission is determined mutually. For promotional purposes, I would like to see original work or transparencies." No geographic restrictions. Advertises in newspapers, magazine, etc.

How to Contact: For first contact, send query letter, résumé, bio, slides, photographs or transparencies. Reports in 2 weeks. After initial contact, call for appointment to show portfolio of original art, slides, photographs.

Tips: Obtains new talent through recommendations from others, solicitation, conferences, advertising.

ARTIST DEVELOPMENT GROUP, 27 Circuit Dr., Edgewood RI 02905-3712. (401)785-2770. Fax: (401)785-2773. Contact: Rita Campbell. Represents photography, fine art, graphic design, as well as performing talent to advertising agencies, corporate clients/direct. Staff includes Rita Campbell, Marvin Lerman. Estab. 1982. Member of Rhode Island Women's Advertising Club. Markets include: advertising agencies; corporations/client direct.

Handles: Illustration, photography.

Terms: Rep receives 20-25% commission. Advertising costs are split: 50% paid by talent; 50% paid by representative. For promotional purposes, talent must provide direct mail promotional piece; samples in book for sales meetings.

How to Contact: For first contact, send résumé, bio, direct mail flier/brochure. Reports in 3 weeks. After initial contact, drop off or mail in appropriate materials for review. Portfolios should include tearsheets, photographs.

Tips: Obtains new talent through "referrals as well as inquiries from talent exposed to agency promo."

ARTISTS ASSOCIATES , 3788 Mill St., Shrub Oak NY 10588. (212)755-1365. Fax: (212)755-1987. Contact: Bill Erlacher. Commercial illustration representative. Estab. 1964. Member of Society of Illustrators, Graphic Artists Guild, AIGA. Represents 11 illustrators. Markets include: advertising agencies; corporations/client direct; design firms; editorial/magazines; paper products/greeting cards; publishing/books; sales/promotion firms.

Handles: Illustration, fine art, design.

Terms: Rep receives 25% commission. Advertises in *American Showcase, RSVP, The Workbook, Society of Illustrators Annual*.

How to Contact: For first contact, send direct mail flier/brochure.

ARTISTS INTERNATIONAL, 320 Bee Brook Rd., Washington CT 06777-1911. (203)868-1011. Fax: (203)868-1272. Contact: Michael Brodie. Commercial illustration representative. Estab. 1970. Represents 20 illustrators. Specializes in children's books. Markets include: advertising agencies; design firms; editorial/magazines; licensing.

Handles: Illustration only.

Terms: Rep receives 30% commission. No geographic restrictions. Advertising costs are split: 70% paid by talent; 30% paid by representative. For promotional purposes, talent must provide 2 portfolios. Advertises in *American Showcase*. "We also have our own full-color brochure, 24 pages."

How to Contact: For first contact, send slides, photocopies and SASE. Reports in 1 week. After initial contact, drop off or mail appropriate materials for review. Portfolio should include slides, photostats.

Tips: Obtains new talent through recommendations from others, solicitation, conferences, *Literary Market Place*, etc. "SAE with example of your work; no résumés required."

ASCIUTTO ART REPS., INC., 1712 E. Butler Circle, Chandler AZ 85225. (602)899-0600. Fax: (602)899-3636. Contact: Mary Anne Asciutto. Children's illustration representative. Estab. 1980. Member of SPAR, Society

of Illustrators. Represents 20 illustrators. Specializes in children's illustration for books, magazines, posters, packaging, etc. Markets include: publishing/packaging/advertising.

Handles: Illustration only.

Terms: Rep receives 25% commission. No geographic restrictions. Advertising costs are split: 75% paid by talent; 25% paid by representative. For promotional purposes, talent should provide "prints (color) or originals within an 11 × 14 size format."

How to Contact: Send a direct mail flier/brochure, tearsheets, photocopies and SASE. Reports in 2 weeks. After initial contact, send appropriate materials if requested. Portfolio should include original art on paper, tearsheets, photocopies or color prints of most recent work. If accepted, materials will remain for assembly.

Tips: In obtaining representation "be sure to connect with an agent that handles the kind of accounts you (the artist) *want*."

CAROL BANCROFT & FRIENDS, P.O. Box 959, Ivy Hill Rd., Ridgefield CT 06877. (203)438-8386. Fax: (203)438-7615. Owner: Carol Bancroft. Promotion Manager: Chris Tuqeau. Illustration representative for children's publishing. Estab. 1972. Member of SPAR, Society of Illustrators, Graphic Artists Guild. Represents 25 illustrators. Specializes in illustration for children's publishing—text and trade; any children's-related material.

Handles: Illustration for children of all ages. Looking for multicultural artists and fine artists wishing to get into publishing.

Terms: Rep receives 25-30% commission. Advertising costs are split: 75% paid by talent; 25% paid by representative. For promotional purposes, talent must provide "flat copy (not slides), tearsheets, promo pieces, good color photocopies, etc.; 10 pieces or more is best; narrative scenes and children interacting." Advertises in *RSVP*.

How to Contact: For contact, "call Chris for information or send samples and SASE." Reports in 1 month.

Tips: Obtains new talent through solicitation and recommendation.

SAL BARRACCA ASSOC. INC., 381 Park Ave. S., New York NY 10016. (212)889-2400. Fax: (212)889-2698. Contact: Sal Barracca. Commercial illustration representative. Estab. 1988. Represents 23 illustrators. "90% of our assignments are book jackets." Markets include: advertising agencies; publishing/books.

Handles: Illustration.

Terms: Rep receives 25% commission. Exclusive area representation is required. Advertising costs are split: 75% paid by talent; 25% paid by representative. For promotional purposes "portfolios must be 8 × 10 chromes that are matted. We can shoot original art to that format at a cost to the artist. We produce our own promotion and mail out once a year to over 16,000 art directors."

How to Contact: For first contact, send direct mail flier/brochure, tearsheets and SASE. Reports in 1 week; 1 day if interested. After initial contact, drop off or mail in appropriate materials for review. Portfolio should include tearsheets, slides.

Tips: Obtains new talent from artists sending samples of their work. "Make sure you have at least 3 years of working on your own so that you don't have any false expectations from an agent."

CECI BARTELS ASSOCIATES, 3286 Ivanhoe, St. Louis MO 63139. (314)781-7377. Fax: (314)781-8017. Contact: Ceci Bartels. Commercial illustration and photography representative. Estab. 1980. Member of SPAR, Graphic Artists Guild, ASMP. Represents 20 illustrators and 3 photographers. "My staff functions in sales, marketing and bookkeeping. There are 7 of us. We concentrate on advertising agencies and sales promotion." Markets include: advertising agencies; corporations/client direct; design firms; publishing/books; sales/promotion firms.

Handles: Illustration, photography. "Illustrators capable of action with a positive (often realistic) orientation interest us as well as conceptual styles."

Terms: Rep receives 30% commission. Advertising costs are split: 70% paid by talent; 30% paid by representative "after sufficient billings have been achieved. Artists pay 100% initially. We need direct mail support and advertising to work on the national level. We welcome 6 portfolios/artist. Artist is advised not to produce multiple portfolios or promotional materials until brought on." Advertises in *American Showcase, Creative Black Book, RSVP, The Workbook, CIB*.

How to Contact: For first contact, send query letter, direct mail flier/brochure, tearsheets, slides, SASE, portfolio with SASE or promotional materials. Reports if SASE enclosed. After initial contact, drop off or mail appropriate materials for review. Portfolio should include tearsheets, slides, photographs, 4 × 5 transparencies. Obtains new talent through recommendations from others; "I watch the annuals and publications."

NOEL BECKER ASSOCIATES, 150 W. 55th St., New York NY 10019. (212)764-1988. Contact: Noel Becker. Commercial illustration and photography representative. Estab. 1975. Member of Graphic Artists Guild. Represents 2 photographers. Specializes in fashion. Markets include corporations/client direct.

Handles: Illustration, photography.

Terms: Agent receives 25-30% commission. Advertising costs are paid by talent. For promotional purposes, talent must provide direct mail piece.

How to Contact: For first contact, send direct mail flier/brochure, photocopies. After initial contact, call for appointment to show portfolio of tearsheets, photographs.

BARBARA BEIDLER INC., #506, 648 Broadway, New York NY 10012. (212)979-6996. Fax: (212)505-0537. Contact: Barbara Beidler. Commercial illustration and photography representative. Estab. 1986. Represents 1 illustrator, 5 photographers, 2 fashion stylists. Specializes in fashion, still life, locations, life style, portraits. Markets include: advertising agencies; catalog agencies; corporations/client direct; design firms; editorial/magazines; publishing/books; sales/promotion firms.
How to Contact: For first contact, send direct mail flier/brochure. After initial contact, write for appointment to show portfolio of tearsheets, slides.
Tips: Obtains new talent through recommendations from others.

BERENDSEN & ASSOCIATES, INC., 2233 Kemper Lane, Cincinnati OH 45206. (513)861-1400. Fax: (513)861-6420. President: Bob Berendsen. Commercial illustration, photography, graphic design representative. Estab. 1986. Represents 24 illustrators, 4 photographers, 4 designers/illustrators. Specializes in "high-visibility consumer accounts." Markets include: advertising agencies; corporations/client direct; design firms; editorial/magazines; paper products/greeting cards; publishing/books; sales/promotion firms.
Handles: Illustration, photography. "We are always looking for illustrators that can draw people, product and action well. Also, we look for styles that are unique."
Terms: Rep receives 25% commission. Charges "mostly for postage but figures not available." No geographic restrictions. Advertising costs are split: 75% paid by talent; 25% paid by representative. For promotional purposes, "artist must co-op in our direct mail promotions, and sourcebooks are recommended. Portfolios are updated regularly." Advertises in *RSVP, Creative Illustration Book, The Ohio Source Book* and *American Showcase*.
How to Contact: For first contact, send query letter, résumé, tearsheets, slides, photographs, photocopies and SASE. Reports in weeks. After initial contact, drop off or mail appropriate materials for review. Portfolios should include tearsheets, slides, photographs, photostats, photocopies.
Tips: Obtains new talent "through recommendations from other professionals. Contact Bob Berendsen for first meeting."

BERNSTEIN & ANDRIULLI INC., 60 E. 42nd St., New York NY 10165. (212)682-1490. Fax: (212)286-1890. Contact: Sam Bernstein. Commercial illustration and photography representative. Estab. 1975. Member of SPAR. Represents 54 illustrators, 16 photographers. Staff includes Tony Andriulli; Howard Bernstein; Fran Rosenfeld; Judy Miller; Leslie Nusblatt; Molly Birenbaum; Craig Hoberman; Susan Wells; Helen Goon; Libby Edwards. Markets include: advertising agencies; corporations/client direct; design firms; editorial/magazines; paper products/greeting cards; publishing/books; sales/promotion firms.
Handles: Illustration and photography.
Terms: Rep receives a commission. Exclusive career representation is required. No geographic restrictions. Advertises in *American Showcase, Creative Black Book, The Workbook, New York Gold, Creative Illustration Book; Berstein & Andriulli International Illustration.*
How to Contact: For first contact, send query letter, direct mail flier/brochure, tearsheets, slides, photographs, photocopies. Reports in 1 week. After initial contact, drop off or mail appropriate materials for review. Portfolio should include tearsheets, slides, photographs.

SAM BRODY, ARTISTS & PHOTOGRAPHERS REPRESENTATIVE, 15 W. Terrace Rd., Great Neck NY 11021-1513. (212)758-0640; (516)482-2835. Fax: (516)482-2835-999. Contact: Sam Brody. Commercial illustration and photography representative and broker. Estab. 1948. Member of SPAR. Represents 4 illustrators, 3 photographers, 2 designers. Markets include: advertising agencies; corporations/client direct; design firms; editorial/magazines; publishing/books; sales/promotion firms.
Handles: Illustration, photography, design, "great film directors."
Terms: Agent receives 25-30% commission. Exclusive career representation is required. Advertising costs are split: 75% paid by talent; 25% paid by representative. For promotional purposes, talent must provide 8 × 10 transparencies (dupes only) with case, plus back-up advertising material, i.e., cards (reprints—*Black Book*, etc.) and self-promos. Advertises in *Creative Black Book*.
How to Contact: For first contact, send bio, direct mail flier/brochure, tearsheets. Reports in 3 days or within 1 day if interested. After initial contact, call for appointment or drop off or mail in appropriate materials for review. Portfolio should include tearsheets, slides, photographs.
Tips: Obtains new talent through recommendations from others, solicitation. In obtaining representation, artist/photographer should "talk to parties he has worked with in the past year."

BROOKE & COMPANY, 4323 Bluffview, Dallas TX 75209. (214)352-9192. Fax: (214)350-2101. Contact: Brooke Davis. Commercial illustration and photography representative. Estab. 1988. Represents 10 illustrators, 2 photographers. "Owner has 18 years experience in sales and marketing in the advertising and design fields."

Terms: No information provided.
How to Contact: For first contact, send bio, direct mail flier/brochure, "sample we can keep on file if possible" and SASE. Reports in 2 weeks. After initial contact, write for appointment to show portfolio or drop off or mail portfolio of tearsheets, slides or photographs.
Tips: Obtains new talent through referral or by an interest in a specific style. "Only show your best work. Develop an individual style. Show the type of work that you enjoy doing and want to do more often. Must have a sample to leave with potential clients."

PEMA BROWNE LTD., HCR Box 104B, Pine Rd., Neversink NY 12765. (914)985-2936. Fax: (914)985-7635. Contact: Pema Browne or Perry Browne. Commercial illustration representative. Estab. 1966. Represents 12 illustrators. Specializes in general commercial. Markets include: advertising agencies; editorial/magazines; all publishing areas; children's picture books.
Handles: Illustration. Looking for "professional and unique" talent.
Terms: Rep receives 30% commission. Exclusive area representation is required. For promotional purposes, talent must provide color mailers to distribute. Representative pays mailing costs on promotion mailings.
How to Contact: For first contact, send query letter, direct mail flier/brochure and SASE. Reports in 2 weeks if interested. After initial contact, drop off or mail appropriate materials for review. Portfolios should include tearsheets and transparencies or good color photocopies.
Tips: Obtains new talent through recommendations. "Be familiar with the marketplace."

BRUCK AND MOSS ASSOCIATES, 333 E. 49th St,. New York NY 10017. (212)980-8061 or (212)982-6533. Fax: (212)832-8778 or (212)674-0194. Contact: Eileen Moss or Nancy Bruck. Commercial illustration representative. Estab. 1978. Represents 12 illustrators. Markets include: advertising agencies; corporations/client direct; design firms; editorial/magazines; publishing/books; sales/promotion firms; direct marketing.
Handles: Illustration.
Terms: Rep receives 30% commission. Exclusive representation is required. No geographic restrictions. Advertising costs are split: 70% paid by talent; 30% paid by representative. For promotional purposes, talent must provide "4×5 transparencies mounted on 7×9 black board. Talent pays for promotional card for the first year and for trade ad." Advertises in *American Showcase* and *The Workbook*.
How to Contact: For first contact, send tearsheets, "if sending slides, include SASE." After initial contact, drop off or mail in appropriate materials for review. Portfolios should include tearsheets. If mailing portfolio include SASE or Federal Express form.
Tips: Obtains new talent through referrals by art directors and art buyers, mailings of promo card, source books, art shows, *American Illustration* and *Print Annual*. "Make sure you have had experience repping yourself. Don't approach a rep on the phone, they are too busy for this. Put them on a mailing list and mail samples. Don't approach a rep who is already repping someone with the same style."

CHIP CATON ARTIST REPRESENTATIVE, 15 Warrenton Ave., Hartford CT 06105. (203)523-4562. Fax: (203)231-9313. Contact: Chip Caton. Commercial illustration, commercial photography representative. Estab. 1986. Member of SAR, Graphic Artists Guild. Represents 24 illustrators and 5 photographers. Markets include: advertising agencies; corporations/client direct; design firms; editorial/magazines; sales/promotion firms.
Handles: Illustration, photography.
Terms: Rep receives 25% commission. Exclusive area representation is required. Advertising costs are split: 75% paid by talent; 25% paid by representative. For promotional purposes, talent must provide portfolio case and appropriate representation of work. Advertises in *American Showcase*, *The Workbook*, *California Image*.
How to Contact: For first contact, send query letter, tearsheets, slides, photographs, photocopies and SASE. Reports in 2 weeks if interested. After initial contact, call for appointment to show portfolio.
Tips: Obtains new talent through referrals from clients, artist's queries.

CAROL CHISLOVSKY DESIGN INC., 853 Broadway, New York NY 10003. (212)677-9100. Fax: (212)353-0954. Contact: Carol Chislovsky. Commercial illustration representative. Estab. 1975. Member of SPAR. Represents 20 illustrators. Markets include: advertising agencies; design firms; editorial/magazines; publishing/books.

Handles: Illustration.

Terms: Rep receives 30% commission. Advertising costs are split: 70% paid by talent; 30% paid by representative. For promotional purposes, talent must provide direct mail piece. Advertises in *American Showcase, Creative Black Book* and sends out a direct mail piece.

How to Contact: For first contact, send direct mail flier/brochure. Portfolio should include tearsheets, slides, photostats.

Tips: Obtains new talent through solicitation.

WOODY COLEMAN PRESENTS INC., 490 Rockside Rd., Cleveland OH 44131. (216)661-4222. Fax: (216)661-2879. Contact: Woody. Creative services representative. Estab. 1978. Member of Graphic Artists Guild. Represents illustration, photography, models and talent. Markets include: advertising agencies; corporations/client direct; design firms; editorial/magazines; paper products/greeting cards; publishing/books; sales/promotion firms; public relations firms.

Handles: Illustration, photography, models and talent through a full-color, modem-accessible database open 24 hours every day.

Terms: Rep receives 25% commission. Advertising costs are split: 75% paid by talent; 25% paid by representative. For promotional purposes, talent must provide "all portfolios in 4×5 transparencies." Advertises in *American Showcase, Creative Black Book, The Workbook,* other publications.

How to Contact: For first contact, send query letter, tearsheets, slides, SASE. Reports in 7 days, only if interested. Portfolio should include tearsheets, 4×5 transparencies.

Tips: "Solicitations are made directly to our agency. Concentrate on developing 8-10 specific examples of a single style exhibiting work aimed at a particular specialty, such as fantasy, realism, Americana or a particular industry such as food, medical, architecture, transportation, film, etc." Specializes in "quality service based on being the 'world's best listeners.' We know the business, ask good questions and simplify an often confusing process. We are truly representative of a 'service' industry."

CONRAD REPRESENTS . . ., #5, 2149 Lyon St., San Francisco CA 94185. (415)921-7140. Contact: James Conrad. Commercial illustration and photography representative. Estab. 1984. Member of SPAR, Society of Illustrators, Graphic Artists Guild. Represents 25 illustrators, 6 photographers. Markets include: advertising agencies; corporate art departments; graphic designers and publishers of books; magazines, posters; calendars and greeting cards.

Handles: Illustration, photography.

Terms: Rep receives 25% commission. Exclusive regional or national representation is required. No geographic restrictions. For promotional purposes, talent must provide a portfolio "and participate in promotional programs."

How to Contact: For first contact, send samples. Follow up with phone call.

CORCORAN FINE ARTS LIMITED, INC., 2341 Roxboro Rd., Cleveland OH 44106. (216)397-0777. Fax: (216)397-0222. Contact: James Corcoran. Fine art representative. Estab. 1986. Member of NOADA (Northeast Ohio Dealers Association); ISA (International Society of Appraisers). Represents 5 photographers, 11 fine artists (includes 3 sculptors). Staff includes Meghan Wilson (gallery associate); Bill Haak (office administrator); James Corcoran (owner/manager). Specializes in representing high-quality contemporary work. Markets include: architects; corporate collections; developers; galleries; interior decorators; museums; private collections.

Handles: Fine art.

Terms: Agent receives 50% commission. Exclusive area representation is required. Advertising costs are "decided case by case."

How to Contact: For first contact send a query letter, résumé, bio, slides, photographs, SASE. Reports back within 1 month. After initial contact, drop off or mail appropriate materials for review. Portfolio should include slides, photographs.

Tips: Usually obtains new talent by solicitation.

CORNELL & MCCARTHY, 2-D Cross Hwy., Westport CT 06880. (203)454-4210. Fax: (203)454-4258. Contact: Merial Cornell. Children's book illustration representative. Estab. 1989. Member of SCBWI. Represents 30 illustrators. Specializes in children's books: trade, mass market, educational.

Handles: Illustration.

Terms: Agent receives 25% commission. Advertising costs are split: 75% paid by talent; 25% paid by representative. For promotional purposes, talent must provide 10-12 strong portfolio pieces relating to children's publishing.

How to Contact: For first contact, send query letter, direct mail flier/brochure, tearsheets, photocopies and SASE. Reports in 1 month. After initial contact, call for appointment or drop off or mail appropriate materials for review. Portfolio should include original art, tearsheets, photocopies.

Tips: Obtains new talent through recommendations, solicitation, conferences. "Work hard on your portfolio."

CORPORATE ART ASSOCIATES, LTD., Suite 402, 270 Lafayette St., New York NY 10012. (212)941-9685. Director: James Cavello. Art consultant and curator. Sales, lease and rentals; special exhibitions. Estab. 1987. Markets include: advertising agencies; corporations; design firms; sales/promotion firms; architects; developers; galleries; interior decorators; private collections; hospitals/health care centers; TV/motion picture productions.
Handles: Fine art, illustration, photography.
Terms: Agent receives 20% commission. No geographic restrictions. Advertising costs are paid by talent.
How to Contact: For first contact, send query letter, résumé, tearsheets, 5 slides, photographs, color photocopies and SASE.
Tips: Obtains new talent through recommendations from others.

CVB CREATIVE RESOURCE, 1856 Elba Circle, Costa Mesa CA 92626. (714)641-9700. Fax: (714)641-9700. Contact: Cindy Brenneman. Commercial illustration, photography and graphic design representative. Estab. 1984. Member of SPAR, ADDOC. Specializes in "high-quality innovative images." Markets include: advertising agencies; corporations/client direct; design firms.
Handles: Illustration. Looking for "a particular style or specialized medium."
Terms: Rep receives 30% commission. Exclusive area representation is required. Advertising costs are split: 70% paid by talent; 30% paid by representative, "if rep's name and number appear on piece." For promotional purposes, talent must provide promotional pieces on a fairly consistent basis. Portfolio should be laminated. Include transparencies or cibachromes. Images to be shown are mutually agreed upon by talent and rep.
How to Contact: For first contact, send slides or photographs. Reports in 2 weeks, only if interested. After initial contact, call for appointment to show portfolio of tearsheets, slides, photographs, photostats.
Tips: Obtains new talent through referrals. "You usually know if you have a need as soon as you see the work. Be professional. Treat looking for a rep as you would looking for a freelance job. Get as much exposure as you can. Join peer clubs and network. Always ask for referrals. Interview several before settling on one. Personality and how you interact will have a big impact on the final decision."

LINDA DE MORETA REPRESENTS, 1839 Ninth St., Alameda CA 94501. (510)769-1421. Fax: (510)521-1674. Contact: Linda de Moreta. Commercial illustration and photography representative; also portfolio and career consultant. Estab. 1988. Represents 4 illustrators, 4 photographers. Markets include: advertising agencies; corporations/client direct; design firms; editorial/magazines; paper products/greeting cards; publishing/books; sales/promotion firms.
Handles: Illustration, photography.
Terms: Rep receives 25% commission. Exclusive representation requirements vary. Advertising costs are split: 75% paid by talent; 25% paid by representative. Materials for promotional purposes vary with each artist. Advertises in *The Workbook, The Creative Black Book, Bay Area Creative Sourcebook*.
How to Contact: For first contact, send direct mail flier/brochure, tearsheets, slides, photocopies, photostats and SASE. "Please do *not* send original art. SASE for any items you wish returned." Responds to any inquiry in which there is an interest. Portfolios are individually developed for each artist and may include tearsheets, prints, transparencies.
Tips: Obtains new talent through client and artist referrals primarily, some solicitation. "I look for a personal vision and style of illustration or photography combined with professionalism, maturity and a willingness to work hard."

SHARON DODGE AND ASSOCIATES , #202, 1201 First Ave. S., Seattle WA 98132. (206)622-7035. Fax: (206)622-7041. Contact: Sharon or Elaine. Commercial illustration and photography representative. Estab. 1985. Member of Graphic Artists Guild, AIGA. Represents 16 illustrators, 4 photographers. Specializes in advertising primarily, with some publishing work. Markets include: advertising agencies; corporations/client direct; design forms; editorial/magazines; publishing/books.
Handles: Illustration, computer illustration. "Interested in artists on the edge of technology."
Terms: Rep receives 25-30% commission. Exclusive area representation is required. For promotional purposes, talent must provide 11×14 mounted transparencies "or flat art mounted in cases furnished by us." Advertises in *American Showcase, Creative Black Book, The Workbook* and *Archive*.
How to Contact: For first contact, send tearsheets. Reports in 1 month, only if interested.
Tips: Obtains new talent through recommendations from others, solicitation, conferences. "Make direct phone contact after sending materials."

DWYER & O'GRADY, INC., P.O. Box 239, Mountain Rd., East Lempster NH 03605. (603)863-9347. Fax: (603)863-9346. Contact: Elizabeth O'Grady. Agents for children's picture book artists and writers. Estab. 1990. Member of Society of Illustrators, Graphic Artists Guild, SCBWI, ABA. Represents 26 illustrators and 12 writers. Staff includes Elizabeth O'Grady, Jeffrey Dwyer. Specializes in children's picture books and occasionally young adult novels. Markets include: publishing/books.
Handles: Illustrators and writers of children's books. "Favor realistic and representational work for the older age picture book. Artist must have full command of the figure and facial expressions."

Terms: Rep receives 15% commission. Additional fees are negotiable. Exclusive area representation is required (world rights). Advertising costs are paid by representative. For promotional purposes, talent must provide both color slides and prints of at least 20 sample illustrations depicting the figure with facial expression.
How to Contact: When making first contact, send query letter, slides, photographs and SASE. Reports in 1½ month. After initial contact, call for appointment and drop off or mail in appropriate materials for review. Portfolio should include slides, photographs.
Tips: Obtains new talent through "referrals from people we trust and personal search."

ELLIOTT/OREMAN ARTISTS' REPRESENTATIVES, 265 Westminster Rd., Rochester NY 14607. (716)244-6956. Fax: (716)244-0307. Contact: Shannon Elliott. Commercial illustration, photography and animation representative. Estab. 1983. Represents 10 illustrators, 1 photographer and 1 animator. Markets include: advertising agencies; corporations/client direct; design firms; editorial/magazines; paper products/greeting cards; publishing/books; architectural firms.
Handles: Illustration. Looking for computer animation.
Terms: For promotional purposes, talent must have a tearsheet, which will be combined with others in a sample folder.
How to Contact: For first contact, send query letter, tearsheets, slides. "I will call to schedule an appointment, if interested."
Tips: Obtains new talent through recommendations from others, solicitation.

FREELANCE HOTLINE, INC., Suite 405, 311 First Ave. N., Minneapolis MN 55401. (612)341-4411. Fax: (612)341-0229. Contact: Elisa Soper. Commercial illustration, graphic design, desktop and keyline artists representative. Estab. Chicago 1987, Minneapolis 1992. Member of AIGA. Specializes in desktop and keyline artists. Markets include: advertising agencies; corporations/client direct; design firms; sales/promotion firms.
Handles: Illustration, design, desktop publishing/graphic arts. Artists should have "2 years professional desktop and/or keylining experience (Mac, IBM platforms)."
Terms: Have set fee and pay rate. Exclusive area representation is required in Twin Cities Metro and surrounding areas. Independent contractor pays no fees. "All talent have their own portfolios, etc. Freelance Hotline also has a portfolio." Advertises in *Creative Black Book, Gold Book*, magazines, newspapers, *MacChicago, Computer User Format*, etc.
How to Contact: For first contact, send query letter, résumé, bio, direct mail flier/brochure (samples not necessary). Reports in 2 weeks (always contacted, qualified or not). After initial contact, Freelance Hotline calls to set up appointment to test desktop/keyline skills, followed by portfolio review. Portfolio should include thumbnails, roughs, original art, tearsheets, slides, photographs, photostats, photocopies (variety of materials, concept to print). After testing and portfolio review, 3 professional references are checked.
Tips: Obtains new talent through Yellow Pages, magazines, newspapers, conferences, seminars, Macshows, Gold/Black books, etc.

ROBERT GALITZ FINE ART/ACCENT ART, 166 Hilltop Court, Sleepy Hollow IL 60118. (708)426-8842. Fax: (708)426-8846. Contact: Robert Galitz. Fine art representative. Estab. 1985. Represents 100 fine artists (includes 2 sculptors). Specializes in contemporary/abstract corporate art. Markets include: architects; corporate collections; galleries; interior decorators; private collections.
Handles: Fine art.
Terms: Agent receives 25-40% commission. No geographic restrictions; sells mainly in Chicago, Illinois, Wisconsin, Indiana and Kentucky. For promotional purposes talent must provide "good photos and slides." Advertises in monthly art publications and guides.
How to Contact: For first contact, send query letter, slides, photographs. Reports in 2 weeks. After initial contact, call for appointment to show portfolio of original art.
Tips: Obtains new talent through recommendations from others, solicitation, conferences. "Be confident, persistent. Never give up or quit."

DENNIS GODFREY REPRESENTING ARTISTS, Suite 6E, 231 W. 25th St., New York NY 10001. Phone/Fax: (212)807-0840. Contact: Dennis Godfrey. Commercial illustration representative. Estab. 1985. Represents 6 illustrators. Specializes in publishing. Markets include: advertising agencies; corporations/client direct; design firms; publishing/books.

How to Use Your **Artist's & Graphic Designer's Market** *offers suggestions for understanding and using the information in these listings. Read this and other articles in the front of this book for important business tips.*

Handles: Illustration.
Terms: Rep receives 25% commission. Prefers exclusive area representation in NYC/Eastern US. Advertising costs are split: 75% paid by talent; 25% paid by representative. For promotional purposes, talent must provide mounted portfolio (at least 20 pieces), as well as promotional pieces. Advertises in *The Workbook*.
How to Contact: For first contact, send tearsheets. Reports in 2 weeks, only if interested. After initial contact, write for appointment to show portfolio of tearsheets, slides, photographs, photostats.
Tips: Obtains new talent through recommendations from others, occasionally by solicitation.

DAVID GOLDMAN AGENCY, #918, 41 Union Square W., New York NY 10003. (212)807-6627. Contact: David Goldman. Commercial illustration representative. Estab. 1980. Represents 12 illustrators. Specializes in "finding unique, highly stylized talents for exclusive North American representation, emphasizing licensing markets." Markets include: advertising agencies; corporations/clients direct; design firms; editorial/magazines; paper products/greeting cards; publishing/books; sales/promotion firms; apparel; puzzles; mugs; CD-ROMs; TV production companies.
Handles: Illustration. Looking for "unique conceptual illustrators not working on computers who are serious about building a long-term career in illustration."
Terms: Rep receives 25% commission. Exclusive area representation is required in North America. "I look for a dedicated hard working team player. I must like the person, the rest will always follow . . ." Advertises in *American Showcase, Corporate Showcase, Eurolink*.
How to Contact: "I prefer to meet illustrator personally when in New York. We do not answer queries." After initial contact, call for appointment to show portfolio of best representation of illustrator's body of work.
Tips: Obtains new talent through "recommendations, magazines (where I'll like a style and locate the illustrator) and appointments in our office. I look for a great person behind the work, someone art directors and designers will enjoy communicating with."

BARBARA GORDON ASSOCIATES LTD., 165 E. 32nd St., New York NY 10016. (212)686-3514. Contact: Barbara Gordon. Commercial illustration and photography representative. Estab. 1969. Member of SPAR, Society of Illustrators, Graphic Artists Guild. Represents 9 illustrators, 1 photographer. "I represent only a small, select group of people and therefore give a great deal of personal time and attention to the people I represent."
Terms: No information provided. No geographic restrictions in continental US.
How to Contact: For first contact, send direct mail flier/brochure. Reports in 2 weeks. After initial contact, drop off or mail appropriate materials for review. Portfolio should include tearsheets, slides, photographs; "if the talent wants materials or promotion piece returned, include SASE."
Tips: Obtains new talent through recommendations from others, solicitation, conferences, etc. "I have obtained talent from all of the above. I do not care if an artist or photographer has been published or is experienced. I am essentially interested in people with a good, commercial style. Don't send résumés and don't call to give me a verbal description of your work. Send promotion pieces. *Never* send original art. If you want something back, include a SASE. Always label your slides in case they get separated from your cover letter. And always include a phone number where you can be reached."

BARB HAUSER, ANOTHER GIRL REP, P.O.Box 421443, San Francisco CA 94142-1443. (415)647-5660. Fax: (415)285-1102. Estab. 1980. Represents 10 illustrators and 1 photographer. Markets include: primarily advertising agencies and design firms; corporations/client direct.
Handles: Illustration and photography.
Terms: Rep receives 25-30% commission. Exclusive representation in the San Francisco area is required. No geographic restrictions.
How to Contact: For first contact, send direct mail flier/brochure, tearsheets, slides, photographs, photocopies and SASE. Reports in 3-4 weeks. Call for appointment to show portfolio of tearsheets, slides, photographs, photostats, photocopies.

SCOTT HULL ASSOCIATES, 68 E. Franklin S., Dayton OH 45459. (513)433-8383. Fax: (513)433-0434. Contact: Scott Hull or Frank Sturges. Commercial illustration representative. Estab. 1981. Represents 20 illustrators.
Terms: No information provided.
How to Contact: Contact by sending slides, tearsheets or appropriate materials for review. Follow up with phone call. Reports within 2 weeks.
Tips: Obtains new talent through solicitation.

JEDELL PRODUCTIONS, INC., 370 E. 76th St., New York NY 10021. (212)861-7861. Contact: Joan Jedell. Commercial photography representative. Estab. 1969. Member of SPAR. Specializes in photography. Markets include: advertising agencies.

Handles: Photography, fine art.
How to Contact: After initial contact, drop off or mail in portfolio of photographs. For returns, include SASE or Federal Express number.

KASTARIS & ASSOCIATES, 3301a S. Jefferson, St. Louis MO 63118. (314)773-2600. Fax: (314)773-6406. Commercial illustration representative. Estab. 1987. Represents 16 illustrators and 2 photographers. Markets include: advertising agencies; design firms; editorial/magazines; publishing/books; sales/promotion firms.
Handles: Illustration.
Terms: Rep receives 25% commission. Exclusive area representation is negotiable. Advertising costs are split: 75% paid by talent; 25% paid by representative. Talent "must have at least 3,000 promotional tearsheets; must advertise with my firm; must provide 4×5 transparencies for portfolio." Advertises in *American Showcase, The Workbook.*
How to Contact: For first contact, send direct mail flier/brochure, tearsheets and SASE if you want sampler back. Reports in 1 month if interested. After initial contact, call for appointment.
Tips: "Show one style only. Have a strong portfolio that includes images of people, products, animals, food and typography."

PEGGY KEATING, 30 Horatio St., New York NY 10014. (212)691-4654. Contact: Peggy Keating. Commercial illustration representataive. Estab. 1969. Member of Graphic Artists Guild. Represents 7 illustrators. Specializes in fashion illustration (men, women, children, also fashion-related products). Markets include: advertising agencies; corporations/client direct; editorial/magazines; sales/promotion firms; "mostly pattern catalog companies and retail."
Handles: "Fashion illustration, but only if top-drawer."
Terms: Rep receives 25% commission. Exclusive area representation is required. For promotional purposes, talent must provide "strong sample material that will provide an excellent portfolio presentation." Advertises by direct mail.
How to Contact: For first contact, send tearsheets, photocopies. Reports in days, only if interested. After initial contact, drop off or mail appropriate materials for review. Portfolio should include thumbnails, roughs, original art, tearsheets, slides, photographs, photostats, photocopies. "It might include all or one or more of these materials. The selection and design of the material are the important factor."
Tips: Obtains new talent through "recommendations from others, or they contact me directly. The talent must be first-rate. The field has diminished and the competition is fierce. There is no longer the tolerance of not yet mature talent, nor is there a market for mediocrity."

KIRCHOFF/WOHLBERG, ARTISTS REPRESENTATION DIVISION (II), #525, 866 United Nations Plaza, New York NY 10017. (212)644-2020. Fax: (212)223-4387. Director of Operations: John R. Whitman. Estab. 1930s. Member of SPAR, Society of Illustrators, AIGA, Associaton of American Publishers, Bookbuilders of Boston, New York Bookbinders' Guild. Represents over 50 illustrators. Artist's Represenative: Elizabeth Ford (juvenile and young adult trade book and textbook illustators). Specializes in juvenile and young adult trade books and textbooks. Markets include: publishing/books.
Handles: Illustration and photography (juvenile and young adult). Please send all correspondence to the attention of Elizabeth Ford.
Terms: Rep receives 25% commission. Exclusive representation to book publishers is usually required. Advertising costs paid by representative ("for all Kirchoff/Wohlberg advertisements only"). "We will make transparencies from portfolio samples; keep some original work on file." Advertises in *American Showcase, Art Directors' Index, Society of Illustrators Annual,* children's book issue of *Publishers Weekly.*
How to Contact: For first contact, send query letter, "any materials artists feel are appropriate." Reports in 4-6 weeks. "We will contact you for additional materials." Portfolios should include "whatever artists feel best represents their work. We like to see children's illustration in any style."

BILL AND MAURINE KLIMT, 7-U, 15 W. 72nd St., New York NY 10023. (212)799-2231. Contact: Bill or Maurine. Commercial illustration representative. Estab. 1978. Member of Society of Illustrators, Graphic Artists Guild. Represents 14 illustrators. Specializes in paperback covers, young adult, romance, science fiction, mystery, etc. Markets include: advertising agencies; corporations/client direct; design firms; editorial/magazines; paper products/greeting cards; publishing/books; sales/promotion firms.
Handles: Illustration.
Terms: Rep receives 25% commission, 30% commission for "out of town if we do shoots. The artist is responsible for only their own portfolio. We supply all promotion and mailings other than the publications." Exclusive area representation is required. No geographic restrictions. Advertising costs are split: 75% paid

Always enclose a self-addressed, stamped envelope (SASE) with queries and sample packages.

by talent; 25% paid by representative. For promotional purposes, talent must provide 4×5 or 8×10 mounted transparencies. Advertises in *American Showcase, RSVP*.
How to Contact: For first contact, send direct mail flier/brochure, and "any image that doesn't have to be returned unless supplied with SASE." Reports in 5 days. After initial contact, call for appointment to show portfolio of professional, mounted transparencies.
Tips: Obtains new talent through recommendations from others and solicitation.

ELLEN KNABLE & ASSOCIATES, INC. , 1233 S. LaCienega Blvd., Los Angeles CA 90035. (310)855-8855. (310)657-0265. Contact: Ellen Knable, Kathee Toyama. Commercial illustration, photography and production representative. Estab. 1978. Member of SPAR, Graphic Artists Guild. Represents 6 illustrators, 5 photographers. Markets include: advertising agencies; corporations/client direct; design firms.
Terms: Rep receives 25-30% commission. Exclusive West Coast/Southern California representation is required. Advertising costs split varies. Advertises in *The Workbook*.
How to Contact: For first contact, send query letter, direct mail flier/brochure and tearsheets. Reports within 2 weeks. Call for appointment to show portfolio.
Tips: Obtains new talent from creatives/artists. "Have patience and persistence!"

CLIFF KNECHT–ARTIST REPRESENTATIVE, 309 Walnut Rd., Pittsburgh PA 15202. (412)761-5666. Fax: (412)261-3712. Contact: Cliff Knecht. Commercial illustration representative. Estab. 1972. Represents 15 illustrators, 1 design firm, 2 fine artists. Markets include: advertising agencies; corporations/client direct; design firms; editorial/magazines; paper products/greeting cards; publishing/books; sales/promotion firms.
Handles: Illustration.
Terms: Rep receives 25% commission. No geographic restrictions. Advertising costs are split: 75% paid by the talent; 25% paid by representative. For promotional purposes, talent must provide a direct mail piece. Advertises in *American Showcase* and *Graphic Artists Guild Directory of Illustration*.
How to Contact: For first contact, send résumé, direct mail flier/brochure, tearsheets, slides. Reports in 1 week. After initial contact, call for appointment to show portfolio of original art, tearsheets, slides, photographs.
Tips: Obtains new talent directly or through recommendations from others.

SHARON KURLANSKY ASSOCIATES, 192 Southville Rd., Southborough MA 01772. (508)872-4549. Fax: (508)460-6058. Contact: Sharon Kurlansky. Commercial illustration representative. Estab. 1978. Represents 9 illustrators. Markets include: advertising agencies; corporations/client direct; design firms; editorial/magazines; paper products/greeting cards; publishing/books; sales/promotion firms.
Handles: Illustration.
Terms: Rep receives 25% commission. Exclusive area representation is required. Advertising costs are split: 75% paid by talent; 25% paid by representative. "Will develop promotional materials with talent. Portfolio presentation formatted and developed with talent also." Advertises in *American Showcase, The Creative Illustration Book* under artist's name.
How to Contact: For first contact, send direct mail flier/brochure, tearsheets, slides and SASE. Reports in 1 month if interested. After initial contact, call for appointment to show portfolio of tearsheets, photocopies.
Tips: Obtains new talent through various means.

L.A. ART EXCHANGE, 2451 Broadway, Santa Monica CA 90404. (310)828-6866. Fax: (310)828-2643. Contact: Jayne Zehngut. Fine art representative. Estab. 1987. Member of Professional Picture Framers Assoc. Represents 20 fine artists. "We deal with retail, wholesale and corporate accounts." Markets include: corporations/client direct; design firms; architects; corporate collections; developers; galleries; interior decorators.
Handles: Fine art, photography, design.
Terms: No information provided. Exclusive area representation is "preferred." No geographic restrictions.
How to Contact: For first contact, send résumé, bio, slides, photographs and SASE. Reports in 1 week. After initial contact, write for appointment or drop off or mail in appropriate materials for review.
Tips: Obtains new talent through "advertising in *Decor* magazine and *Art Business News* and local newspapers. Primary businesses are custom picture framing; fine art and poster sales; art consulting (corporate and residential)."

FRANK & JEFF LAVATY & ASSOCIATES, Suite 212, 217 E. 86th St., New York NY 10028-3617. (212)427-5632. Commercial illustration and fine art representative. Represents 15 illustrators.
Handles: Illustration.
Terms: No information provided.
How to Contact: For first contact, send query letter, direct mail flier/brochure, tearsheets, slides and SASE. Reports in 1 week. After initial contact, call for appointment to show portfolio of tearsheets, 8×10 or 4×5 transparencies.
Tips: Obtains new talent through solicitation. "Specialize! Your portfolio must be focused."

NELDA LEE INC., 2610 21st St., Odessa TX 79761. (915)366-8426. Fax: (915)550-2830. President: Nelda Lee. Vice President: Cory Ricot. Fine art representative. Estab. 1967. Senior member of American Society of Appraisers, President of Texas Association of Art Dealers. Represents 50-60 artists (includes 4 sculptors). Markets include: corporate collections; developers; galleries; interior decorators; museums; private collections.
Handles: Fine art, illustration.
Terms: Agent receives 40-50% commission. Exclusive area representation is required. No geographic restrictions. Advertising costs are paid by representative. Advertises in *Texas Monthly*, *Southwest Art*, local TV and newspapers.
How to Contact: For first contact, send query letter and photographs ("include phone number"). Reports in 10 days. After initial contact, call for appointment to show portfolio of original art and photographs.
Tips: Obtains new talent through "direct contact from talent. Don't give up. Keep contacting—about every six months to a year."

LEIGHTON & COMPANY, 4 Prospect St., Beverly MA 01915. (508)921-0887. Fax: (508)921-0223. Contact: Leighton O'Connor. Commercial illustration and photography representative. Estab. 1986. Member of Graphic Artists Guild, ASMP. Represents 8 illustrators and 3 photographers. Markets include: advertising agencies; corporations/clients direct; design firms; editorial/magazines; publishing/books.
Handles: Illustration, photography. "Looking for photographers and illustrators who can create their work on computer."
Terms: Rep receives 25% commission. Advertising costs are split: 75% paid by talent; 25% paid by representative. For promotional purposes, "talent is required to supply me with 6×9 color mailer(s). Photographers and illustrators are required to supply me with laminated portfolios as well as two 4×5 color transparency portfolios." Advertises in *Creative Illustration*, *Graphic Artist Guild Directory of Illustration*.
How to Contact: For first contact, send query letter, direct mail flier/brochure, tearsheets and SASE. Reports in 1 week if interested. After initial contact, drop off or mail in appropriate materials with SASE for review. Portfolio should include tearsheets, slides, photographs.
Tips: "My new talent is almost always obtained through referrals. Occasionally, I will solicit new talent from direct mail pieces they have sent to me. It is best to send work first, i.e., tearsheet or direct mail pieces. Only send a portfolio when asked to. If you need your samples returned, always include a SASE. Follow up with one phone call. It is very important to get the correct spelling and address of the representative. Also, make sure you are financially ready for a representative, having the resources available to create a portfolio and direct mail campaign."

LESLI ART, INC., Box 6693, Woodland Hills CA 91365. (818)999-9228. Contact: Stan Shevrin. Fine art representative. Estab. 1965. Represents 28 fine artists. Specializes in "artists painting in oil or acrylic, in the manner of the impressionists. Also represent illustrators whose figurative work can be placed in art galleries."
Terms: Negotiable.
How to Contact: For first contact, send bio, slides, photographs and SASE. Reports in 2 weeks.
Tips: Obtains new talent through "reviewing portfolios. Artists should show their most current works and state a preference for subject matter and medium."

JIM LILIE ARTIST'S REPRESENTATIVE , #706, 110 Sutter St., San Francisco CA 94104. (415)441-4384. Fax: (415)395-9809. Commercial illustration and photography representative. Estab. 1977. Represents 7 illustrators, 1 photographer. Markets include: advertising agencies; design firms.
Handles: Illustration.
Terms: Rep receives 25% commission. Exclusive area representation is required. Advertising costs are split: 75% paid by talent; 25% paid by representative. For promotional purposes, talent must provide portfolio of either transparencies or laminated pieces: 8×10. Advertises in *American Showcase* and *Creative Black Book*.
How to Contact: For first contact send direct mail flier/brochure, tearsheets and SASE. Portfolio should include tearsheets, photocopies.
Tips: Obtains new talent through recommendations from others.

JOHN LOCKE STUDIOS, INC., 15 E. 76th St., New York NY 10021. (212)288-8010. Fax: (212)288-8011. Associate Representative: Eileen McMahon. Commercial illustration representative. Estab. 1943. Represents 21 illustrators. "Noted for representing high profile European and American artists—Folon, Gorey, Searle, Francois, Sis, etc." Markets include: advertising agencies; corporations/client direct; design firms; editorial/magazines; paper products/greeting cards; publishing/books; sales/promotion firms.
Handles: Illustration. "When we look for new talent, which is rare, it must be work that is extremely individualistic, not totally realistic, humorous—the work of a mature artist."
Terms: Rep receives 25% commission. Exclusive area representation is required. Advertising costs are split: 50% paid by talent; 50% paid by representative. For promotional purposes, talent must send "tearsheets for portfolio using 11×14 sheets, any published books or specialty packages/pieces to include with portfolio; slides." Advertises in *American Showcase*, *The Workbook*, *New York Gold*; "rarely advertise in directories—most promotion-direct mail, now."

How to Contact: For first contact, send query letter. Reports in 2 weeks; an appointment is then determined.
Tips: Obtains new talent through "recommendations and our own solicitation; watch European publications for artists who are making their mark. With us, not pushing too hard is the best advice. Recommendation from known art director, designer, editor extremely helpful. Show a small sample of really first-rate work."

LONDON CONTEMPORARY ART, 729 Pine Crest, Prospect Heights IL 60070. (708)459-3990. Contact: Nancy Rudin. Fine art representative. Estab. 1977. Represents 45 fine artists. Specializes in "selling to art galleries." Markets include: galleries; corporate collections; interior decorators.
Handles: Fine art.
Terms: Publisher of original art. Exclusive representation is required. For promotional purposes talent must provide slides, color prints, "any visuals." Advertises in *Decor, Art Business News, Art & Antiques, Preview, Sunstorm.*
How to Contact: For first contact, send tearsheets, slides, photographs and SASE. Reports in 1 month, only if interested. "Don't call us – if interested, we will call you." Portfolio should include slides, photographs.
Tips: Obtains new talent through recommendations from others and word of mouth.

PETER & GEORGE LOTT, 60 E. 42nd St., New York NY 10165. (212)953-7088. Commercial illustration representative. Estab. 1958. Member of Society of Illustrators, Art Directors Club. Represents 15 illustrators. Markets include: advertising agencies; corporations/client direct; design firms; editorial/magazines; publishing/books; sales/promotion firms; "all types fashion and beauty accounts (men's, women's, children's, still life and accessories).
Handles: Illustration. "As a general rule, we're interested in any kind of saleable commercial art."
Terms: Rep receives 25% commission. No geographic restrictions. Advertises in *American Showcase, Creative Black Book, The Workbook* and other publications.
How to Contact: For first contact, "call to drop off portfolio."
Tips: "Check with us first to make sure it is a convenient time to drop off a portfolio. Then either drop it off or send it with return postage. The format does not matter, as long as it shows what you can do and what you want to do."

MARTHA PRODUCTIONS, INC., Suite C, 11936 W. Jefferson, Culver City CA 90230. (310)390-8663. Fax: (310)390-3161. Contact: Martha Spelman. Commercial illustration and graphic design representative. Estab. 1978. Member of Graphic Artists Guild. Represents 25 illustrators. Staff includes Jennifer Broughton (assignment illustration), Martha Spelman (artist representative), Kristins Powell (artist representative). Specializes in b&w and 4-color illustration. Markets include: advertising agencies; corporations/client direct; design firms; editorial/magazines; paper products/greeting cards.
Handles: Illustration.
Terms: Rep receives 30% commission. Exclusive area representation is required. No geographic restrictions. Advertising costs are split: 70% paid by talent; 30% paid by representative. For promotional purposes, talent must provide "a minimum of 12 images, 4×5 transparencies of each. (We put the transparencies into our own format.) In addition to the transparencies, we require 4-color promo/tearsheets and participation in the biannual Martha Productions brochure." Advertises in *The Workbook, Single Image.*
How to Contact: For first contact, send query letter, direct mail flier/brochure, tearsheets, slides and SASE (if materials are to be returned). Reports only if interested. After initial contact, drop off or mail in appropriate materials for review. Portfolio should include tearsheets, slides, photographs, photostats.
Tips: Obtains new talent through recommendations and solicitation.

MATTELSON ASSOCIATES LTD., 37 Cary Road, Great Neck NY 11021. (212)684-2974. Fax: (516)466-5835. Contact: Judy Mattelson. Commercial illustration representative. Estab. 1980. Member of SPAR, Graphic Artists Guild. Represents 3 illustrators. Markets include: advertising agencies; corporations/client direct; design firms; editorial/magazines; paper products/greeting cards; publishing/books; sales/promotion firms.
Handles: Illustration.
Terms: Rep receives 25-30% commission. Exclusive area representation is required. No geographic restrictions. Advertising costs are split: 75% paid by talent; 25% paid by representative. For promotional purposes, talent must provide c-prints and tearsheets, custom-made portfolio. Advertises in *American Showcase, RSVP.*
How to Contact: For first contact, send direct mail flier/brochure, tearsheets and SASE. Reports in 2 weeks, if interested. After initial contact, call for appointment to show portfolio of tearsheets, c-prints.
Tips: Obtains new talent through "recommendations from others, solicitation. Illustrator should have ability to do consistent, professional-quality work that shows a singular direction and a variety of subject matter. You should have a portfolio that shows the full range of your current abilities. Work should show strong draftsmanship and technical facility. Person should love her work and be willing to put forth great effort in each assignment."

MEDIA GALLERY/ENTERPRISES, 145 W. Fourth Ave., Garnett KS 66032-1313. (913)448-5813. Contact: Robert Cugno. Fine art representative. Estab. 1963. Number of artists and sculptors represented varies. Specializes in clay – contemporary and modern. Markets include: galleries; museums; private collections.

Handles: Fine art, clay.
Terms: Agent receives 40-60% commission. For promotional purposes, talent must provide photos and slides.
How to Contact: For first contact, send bio, slides, SASE. Reports in 1-2 weeks. After initial contact, drop off or mail in appropriate materials for review.
Tips: Obtains new talent through recommendations from other artists, collectors, art consultants and gallery directors.

VICKI MORGAN ASSOCIATES, 194 Third Ave., New York NY 10003. (212)475-0440. Contact: Vicki Morgan. Commercial illustration representative. Estab. 1974. Member of SPAR, Graphic Artists Guild, Society of Illustrators. Represents 12 illustrators. Markets include: advertising agencies; corporations/client direct; design firms; editorial/magazines; paper products; publishing/books; sales/promotion firms.
Handles: Illustration. "Fulltime illustrators only."
Terms: Rep receives 25-30% commission. Exclusive area representation is required. No geographic restrictions. Advertising costs are split: 75% paid by talent; 25% paid by representative. "We require samples for 3 duplicate portfolios; the presentation form is flexible." Advertises in *American Showcase*.
How to Contact: For first contact, send any of the following: direct mail flier/brochure, tearsheets, slides with SASE. "If interested, we keep on file and consult these samples first when considering additional artists. No drop-off policy."
Tips: Obtains new talent through "recommendations from artists I represent and mail solicitation."

THE NEIS GROUP, 11440 Oak Dr., Shelbyville MI 49344. (616)672-5756. Fax: (616)672-5757. Contact: Judy Neis. Commercial illustration and photography representative. Estab. 1982. Represents 30 illustrators, 7 photographers. Markets include: advertising agencies; design firms; editorial/magazines; publishing/books.
Handles: Illustration, photography.
Terms: Rep receives 25% commission. Advertising costs are split: 75% paid by talent; 25% paid by representative. Advertises in *The American Showcase*.
How to Contact: For first contact, send direct mail flier/brochure, tearsheets, photographs. Reports in 5 days. After initial contact, drop off or mail appropriate materials for review. Portfolio should include tearsheets, photographs.
Tips: "I am mostly sought out by the talent. If I pursue, I call and request a portfolio review."

THE NEWBORN GROUP, 135 E. 54th St., New York NY 10022. (212)421-0050. Fax: (212)421-0444. Owner: Joan Sigman. Commercial illustration representative. Estab. 1964. Member of SPAR, Society of Illustrators, Graphic Artists Guild. Represents 10 illustrators. Markets include: advertising agencies; design firms; editorial/magazines; publishing/books.
Handles: Illustration.
Terms: Rep receives 25% commission. Exclusive area representation is required. Advertising costs are split: 75% paid by talent; 25% paid by representative. Advertises in *American Showcase*, *The Workbook*, *Directory of Illustration*.
How to Contact: For first contact, send query letter, direct mail flier/brochure. Reports in 2-3 weeks. Do not send portfolio.
Tips: Obtains new talent through recommendations from other talent or art directors.

PACIFIC DESIGN STUDIO, P.O. Box 1396, Hilo HI 96721. (808)935-6056. Fax: (808)966-7232. Contact: Francine H. Pearson. Commercial illustration and photography representative. Also handles fine art, graphic design and is an illustration and photography broker. Estab. 1980. Represents 6 illustrators, 4 photographers, 2 designers, 12 fine artists (includes 3 sculptors). "This is a small 3-person office." Specializes in "art and design of the Hawaiian Islands, the Big Island in particular." Markets include advertising agencies, editorial/magazines, paper products/greeting cards, T-shirt manufacturers and resorts.
Handles: Illustration, photography, fine art. Looking for "underwater artists, ocean and sea life artists, Pacific Rim artists, Hawaiiana design."
Terms: Rep receives 15-20% commission. Charges for "real costs of freight, etc., which come off the top of a sale." Exclusive area representation is "preferred, but not required." For promotional purposes, "transparencies are required, full-color tearsheet or mailer is preferred; artist must have minimum of 12 pieces for sale."
How to Contact: For first contact, send query letter, résumé, bio, direct mail flier/brochure, tearsheets, slides and SASE. Reports in 2 weeks, only if interested, "depending on what is sent for first contact." After initial contact, write for appointment to show portfolio or drop off or mail portfolio of original art, slides, photographs, transparencies.
Tips: Obtains new talent through studio visits, recommendations, client and architect references, local news and print media. "Send only your best work and be patient. Good representation requires good timing and creativity as well as client contacts."

THE PENNY & STERMER GROUP, Suite 2D, 19 Stuyvesant Oval, New York NY 10009-2021. (212)505-9342. Fax: (212)505-1844. Contact: Carol Lee Stermer. Commercial illustration representative. Estab. 1975.

Member of Graphic Artists Guild. Represents 9 illustrators, animation artist. Specializes in illustration for packaging. Markets include: advertising agencies; corporations/client direct; design firms; editorial/magazines; paper products/greeting cards; publishing/books; sales/promotion firms.
Handles: Illustration. Looking for highly conceptual artists and established food packaging artists.
Terms: Rep receives 25-30% commission. Artists billed for portfolio supplies and bulk mailings. Advertising costs are split: 70-75% paid by talent; 30-25% paid by representative. For promotional purposes, talent must provide direct mail pieces. Advertises in *American Showcase, Creative Black Book, RSVP, The Workbook*.
How to Contact: For first contact, send nonreturnable promos, direct mailers, etc. Reports only if interested. After initial contact, "I'll call." Portfolio should include tearsheets, 4×5 or 8×10 chromes.

CHRISTINE PRAPAS/ARTIST REPRESENTATIVE, 8402 SW Soods Creek Court, Portland OR 97219. (503)246-9511. Fax: (503)246-6016. Contact: Christine Prapas. Commercial illustration and photography representative. Estab. 1978. Member of AIGA. "Promotional material welcome."

PUBLISHERS' GRAPHICS, 251 Greenwood Ave., Bethel CT 06801. (203)797-8188. Fax: (203)798-8848. Commercial illustration representative for juvenile markets. Estab. 1970. Member of Graphic Artists Guild, Author's Guild Inc.. Staff includes Paige C. Gillies (President, selects illustrators, develops talent); Susan P. Schwarzchild (sales manager). Specializes in children's book illustration. Markets include: design firms; editorial/magazines; paper products/greeting cards; publishing/books; sales/promotion firms.
Handles: Illustration.
Terms: Rep receives 25% commission. Exclusive area representation is required. For promotional purposes, talent must provide original art, proofs, photocopies "to start. The assignments generate most sample/promotional material thereafter unless there is a stylistic change in the work." Advertises in *Literary Market Place*.
How to Contact: For first contact, send résumé, photocopies and SASE. Reports in 6 weeks. After initial contact, "We will contact them. We don't respond to phone inquiries." Portfolios should include original art, tearsheets, photocopies.
Tips: Obtains new talent through "clients recommending our agency to artists. We ask for referrals from our illustrators. We receive submissions by mail."

GERALD & CULLEN RAPP, INC., 108 E. 35th St., New York NY 10016. (212)889-3337. Fax: (212)889-3341. Contact: John Knepper (illustration); Donna Petrizzo (photography). Commercial illustration, photography and graphic design representative. Estab. 1945. Member of SPAR, Society of Illustrators, Graphic Artists Guild. Represents 32 illustrators, 2 photographers, 1 designer. Markets include: advertising agencies; corporations/client direct; design firms; editorial/magazines; paper products/greeting cards; publishing/books; sales/promotion firms.
Handles: Illustration, photography.
Terms: Rep receives 25-30% commission. Exclusive area representation is required. No geographic restrictions. Split of advertising costs is negotiated. Advertises in *American Showcase, New York Gold, The Workbook,* and *CA, Print, Art Director* magazines. "Conducts active direct mail program."
How to Contact: For first contact, send query letter, direct mail flier/brochure. Reports in 1 week. After initial contact, call for appointment to show portfolio of tearsheets, slides.
Tips: Obtains new talent through recommendations from others, solicitations.

REDMOND REPRESENTS, 7K Misty Wood Circle, Timonium MD 21093. (410)666-1916. Contact: Sharon Redmond. Commercial illustration and photography representative. Estab. 1987. Markets include: advertising agencies; corporations/client direct; design firms.
Handles: Illustration, photography.
Terms: Rep receives 30% commission. Exclusive area representation is required. No geographic restrictions. Advertising costs and expenses are split: 50% paid by talent; 50% paid by representative. For promotional purposes, talent must provide a small portfolio (easy to Federal Express) and at least 6 direct mail pieces (with fax number included). Advertises in *American Showcase, Creative Black Book*.
How to Contact: For first contact, send photocopies. Reports in 2 weeks. After initial contact, representative will call talent to set an appointment.
Tips: Obtains new talent through recommendations from others, advertising in "black book," etc. "Even if I'm not taking in new talent, I do want *photocopies* sent of new work. You never know when an ad agency will require a different style of illustration/photography and it's always nice to refer to my files."

KERRY REILLY: REPS, 1826 Asheville Place, Charlotte NC 28203. Phone/Fax: (704)372-6007. Contact: Kerry Reilly. Commercial illustration and photography representative. Estab. 1990. Represents 16 illustrators, 3 photographers. Markets include: advertising agencies; corporations/client direct; design firms; editorial/magazines.
Handles: Illustration, photography. Looking for computer graphics, freehand, etc.
Terms: Rep receives 25% commission. Exclusive area representation is required. No geographic restrictions. Advertising costs are split: 75% paid by talent; 25% paid by representative. For promotional purposes, talent

must provide at least 2 pages printed leave-behind samples. Preferred format is 9 × 12 pages, portfolio work on 4 × 5 transparencies. Advertises in *American Showcase.*

How to Contact: For first contact, send direct mail flier/brochure or samples of work. Reports in 2 weeks. After initial contact, call for appointment to show portfolio or drop off or mail tearsheets, slides, 4 × 5 transparencies.

Tips: Obtains new talent through recommendations from others. "It's essential to have printed samples — a lot of printed samples."

RIDGEWAY ARTISTS REPRESENTATIVE, 712 Terminal Rd., Lansing MI 48906. (517)321-2777. Fax: (517)321-2815. Contact: Edwin Bonnen. Commercial illustration and photography representative. Estab. 1984. Member of AAF, AIGA. Represents 3 illustrators, 1 photographer. Markets include: advertising agencies; corporations/client direct; design firms; editorial/magazines.

Handles: Illustration, photography, fine art. "We are primarily looking for individuals who have developed a distinctive style, whether they be a photographer or illustrator. Photographers must have an area they specialize in. We want artists who are pros in the commercial world; i.e., working with tight deadlines in sometimes less than ideal situations. We would consider a fine artist looking for commercial outlet if it was a good fit."

Terms: Rep receives 25% commission in the state of Michigan, 35% out of state. Exclusive area representation is required. Advertising costs are split: 75% paid by talent; 25% paid by representative. For promotional purposes, talent must provide portfolio of laminated color prints. "Direct mail is primary method of advertising; use of sourcebooks is secondary."

How to Contact: For first contact, send query letter, bio, direct mail flier/brochure. Reports in 3 weeks, only if interested. After initial contact, call for appointment to show portfolio of photographs.

Tips: Obtains talent through recommendations, sourcebooks and solicitations.

ROSENTHAL REPRESENTS, 3443 Wade St., Los Angeles CA 90066. (213)390-9595. Fax: (213)306-6878. Commercial illustration representative and licensing agent for artists who do advertising, entertainment, action/sports, children's humorous, storyboard, animal, graphic, floral, realistic, impressionistic and game packaging art. Estab. 1979. Member of SPAR, Society of Illustrators, Graphic Artists Guild, Women in Design and Art Directors Club. Represents 100 illustrators, 3 photographers, 2 designers and 5 fine artists. Specializes in game packaging, personalities, licensing, merchandising art and storyboard artists. Markets include: advertising agencies; corporations/client direct; paper products/greeting cards; sales/promotion firms; licensees and manufacturers.

Handles: Illustration.

Terms: Rep receives 25-30% as a rep; 40% as a licensing agent. Exclusive area representation is required. No geographic restrictions. Advertising costs are paid by talent. For promotion purposes, talent must provide 1-2 sets of transparencies (mounted and labeled), 10 sets of slides of your best work (labeled with name on each slide), 1-3 promos. Advertises in *American Showcase, Creative Black Book* and *The Workbook.*

How to Contact: For first contact, send direct mail flier/brochure, tearsheets, slides, photocopies, photostats and SASE. Reports in 1 week. After initial contact, call for appointment to show portfolio of tearsheets, slides, photographs, photocopies.

Tips: Obtains new talent through seeing their work in an advertising book or at an award show.

RICHARD SALZMAN, 716 Sanchez St., San Francisco CA 94114. (415)285-8267. Fax: (415)285-8268. Contact: Richard Salzman. Commercial illustration representative. Estab. 1982. Member of SPAR, Graphic Artists Guild, AIGA, SFCA, WADC. Represents 14 illustrators. Markets include: advertising agencies; corporations/client direct; design firms; editorial/magazines; publishing books.

Handles: Illustration. "We're always looking for visionaries and are also interested in digital art or other 'new' media."

Terms: Rep receives 30% commission. Exclusive area representation in US is required. Advertising costs are split: 70% paid by talent; 30% paid by representative. "We share promotional costs." Charges for "portfolios. Talent is required to pay cost of the portfolio (6 copies) created by the representative." Advertises in *American Showcase, The Workbook* and *Creative Illustration Book.*

How to Contact: For first contact, send tearsheets, slides, photocopies. After initial contact, call for appointment to show portfolio.

Tips: "We receive 20 to 30 solicitors a week. We sign an average of 1 new artist a year. Solicit to reps the way you would to a client or art director."

How to Use Your Artist's & Graphic Designer's Market *offers suggestions for understanding and using the information in these listings. Read this and other articles in the front of this book for important business tips.*

TRUDY SANDS & ASSOCIATES, 1350 Chemical St., Dallas TX 75207. (214)905-9037. Fax: (214)905-9038. Contact: Trudy Sands. Commercial illustration and photography representative. Estab. 1984. Member of AIGA. Represents 7 illustrators, 1 photographer. Markets include: advertising agencies; corporations/client direct; design firms; editorial/magazines; publishing/books.
Handles: Illustration.
Terms: Rep receives 25% commission. Charges 75% of Federal Express bills. Exclusive area representation is required. 25% of advertising costs is paid by representative when billing 10,000 or more a year. For promotional purposes, talent must provide "4 mailers a year with rep's name and phone number. Two new portfolio pieces a month. Certain format agreed upon by rep and illustrator." Advertises in *RSVP, The Workbook, Japanese Sourcebook.*
How to Contact: For first contact, send direct mail flier/brochure. Reports in 1 month if interested. After initial contact, call for appointment to show portfolio of 4×5 transparencies or laminated photocopies.
Tips: Obtains new talent through direct mail or sourcebooks. "Have an interesting style. Good promo pieces. Be willing to advertise. Don't expect reps to call you back long distance. Ask art directors which reps they like."

JOAN SAPIRO ART CONSULTANTS, 4750 E. Belleview Ave., Littleton CO 80121. (303)793-0792. Fax: (303)721-1401. Fax: (303)290-9204. Contact: Joan Sapiro or Jennifer Kalin. Art consultants. Estab. 1980. Specializes in "corporate art with other emphasis on hospitality and health care."
Handles: All mediums of artwork and all prices if applicable for clientele.
Terms: "50/50. Artist must be flexible and willing to ship work on consignment. Also must be able to provide sketches, etc. if commission piece involved." No geographic restrictions.
How to Contact: For first contact, send résumé, bio, direct mail flier/brochure, tearsheets, slides, photographs, price list—net (wholesale) and SASE. Reports in 2 weeks. After initial contact, drop off or mail in appropriate materials for review. Portfolios should include tearsheets, slides, price list and SASE.
Tips: Obtains new talent through recommendations, publications, travel and research.

FREDA SCOTT, INC., 244 Ninth St., San Francisco CA 94103. (415)621-2992. Fax: (415)621-5202. Contact: Wendy Fuchs or Freda Scott. Commercial illustration and photography representative. Estab. 1980. Member of SPAR. Represents 10 illustrators, 6 photographers. Markets include: advertising agencies; corporations/client direct; design firms; editorial/magazines; paper products/greeting cards; publishing/books; sales/promotion firms.
Handles: Illustration, photography.
Terms: Rep receives 25% commission. No geographic restrictions. Advertising costs are split: 75% paid by talent; 25% paid by representative. For promotional purposes, talent must provide "promotion piece and ad in a directory. I also need at least 3 portfolios." Advertises in *American Showcase, Creative Black Book, The Workbook.*
How to Contact: For first contact, send direct mail flier/brochure, tearsheets and SASE. If you send transparencies, reports in 1 week, if interested. "You need to make follow up calls." After initial contact, call for appointment to show portfolio of tearsheets, photographs, 4×5s or 8×10s.
Tips: Obtains new talent sometimes through recommendations, sometimes solicitation. "If you are seriously interested in getting repped, keep sending promos—once every 6 months or so. Do it yourself a year or two until you know what you need a rep to do."

SEIFFER & ASSOCIATES, 19 Stony Hill Rd., Bethel CT 06801. (203)794-9550. Fax: (203)794-9054. Contact: Wendy Seiffer. Licensing agency. Estab. 1987. "We license artwork to be reproduced on posters and prints, collectible plates, apparel, mugs, music boxes, puzzles, cards, calendars and other gift and stationery items. We're a full-scale licensing agency specializing in fine art. Collectibles and apparel are our strongest areas. Posters and stationery products are our next strongest areas. Our licensed products are featured at The Nature Company, Spiegel, L.L. Bean and at fine shops world-wide. Our clients include Turner Publications, Lenox, The Danbury Mint, The Franklin Mint." Staff includes Wendy Seiffer, President (marketing); Barbara Chriswell (artist relations); Deb Serkin (Director of Creative Services); John Seiffer, Vice President (international sales, operations, contracts).
Handles: Fine art and exceptional illustration. Looking for "colorful, well-executed and realistic or photorealistic work. Purely decorative is fine as well."
Terms: Agent receives 50% commission. Exclusive worldwide representation is standard. For promotional purposes, "great visuals are essential. Photographs or tearsheets and reproduction-quality transparencies (supplied by the artist) are required."
How to Contact: For first contact, send résumé, comprehensive portfolio (no originals) and SASE. Reports in 2 months. Portfolio should include at least 12-24 images presenting a wide range of work.
Tips: "Have great visuals—at least 12-24 images to show consistency. Include a bio/artist's statement. For successful licensing, artist should have a healthy inventory of work, including work done in series. Reproduction quality transparencies (4×5 or bigger) are required."

SIMPATICO ART & STONE, 1221 Demaret Lane, Houston TX 77055-6115. (713)467-7123. Contact: Billie Blake Fant. Fine art broker/consultant/exhibitor. Estab. 1973. Specializes in unique fine art, sculpture and Texas domestic stone furniture, carvings, architectural elements. Market includes: corporate; institutional and residential clients.
Handles: Looking for unique fine art and sculpture not presently represented in Houston, Texas.
Terms: Standard commission. Exclusive area representation required.
How to Contact: For first contact, send query letter, résumé, slides.
Tips: Obtains new talent through travel, publications, exhibits and referrals.

SOLDAT & ASSOCIATES, Suite 1008, 307 N. Michigan, Chicago IL 60601. (312)201-9662. Fax: (312)201-9664. Contact: Rick Soldat. Commercial illustration and photography representative. Estab. 1990. Member of SPAR. Represents 4 illustrators, 4 photographers. Markets include: advertising agencies; corporations/client direct; design firms; publishing/books; sales/promotion firms.
Handles: Illustration, photography.
Terms: Rep receives 25-30% commission. Charges for postage, shipping, long-distance travel. Exclusive area representation in the Midwest is required. Advertising costs are split: 75% paid by talent; 25% paid by representative. For promotional purposes, talent must provide "a promo for direct mail and other purposes." Advertises in *The Workbook* and *Chicago Talent Sourcebook*.
How to Contact: For first contact, send query letter, tearsheets. Reports in 1 week. After initial contact, call for appointment to show portfolio of original art, tearsheets, slides, photographs.
Tips: Obtains new talent through "recommendations from others, talent search, talent calling us directly."

DANE SONNEVILLE ASSOC. INC., P.O. Box 155, 285 Aycrigg, Passaic NJ 07055. Phone/Fax: (201)472-1225. Contact: Dane. Commercial illustration, photography and graphic design representative, illustration or photography broker, paste up, printing, hair and make up, all type stylists, computer image artists, writers. Estab. 1971. Represents 20 illustrators, 10 photographers and 10 designers. Specializes in "resourcefulness and expeditious service." Markets include: advertising agencies; corporations/client direct; design firms; editorial/magazines; publishing/books; sales/promotion firms.
Handles: Illustration, photography, design, writing, all creative support personnel.
Terms: Rep receives 25% commission. Advertising costs are paid by talent. For promotional purposes, talent must provide unlimited promo pieces (to leave behind). Advertises in *American Showcase, Creative Black Book, RSVP, The Workbook*.
How to Contact: For first contact, send résumé, direct mail flier/brochure, tearsheets. Reports in 1 week if interested. After initial contact, call for appointment to show portfolio of original art, tearsheets, slides, photographs.
Tips: Obtains new talent through recommendations from others. "Knock on every door."

SULLIVAN & ASSOCIATES, 3805 Maple Ct., Marietta GA 30066. (404)971-6782. Fax: (404)973-3331. Contact: Tom Sullivan. Commercial illustration, commercial photography and graphic design representative. Estab. 1988. Member of Creative Club of Atlanta, Atlanta Ad Club. Represents 14 illustrators, 7 photographers and 7 designers, including computer graphic skills in illustration/design/production and photography. Staff includes Tom Sullivan (sales, talent evaluation, management), Debbie Sullivan (accounting, administration). Specializes in "providing whatever creative or production resource the client needs." Markets include: advertising agencies, corporations/client direct; design firms; editorial/magazines; publishing/books; sales/promotion firms.
Handles: Illustration, photography. "Open to what is marketable; computer graphics skills."
Terms: Rep receives 25% commission. Exclusive area representation in Southeastern US is required. Advertising costs are split: 75-100% paid by talent; 0-25% paid by representative. "Negotiated on individual basis depending on: (1) length of time worked with; (2) area of representation; (3) scope of exclusive representation." For promotional purposes, talent must provide "direct mail piece, portfolio in form of 8½×11 (8×10 prints) pages in 22-ring presentation book." Advertises in *American Showcase, The Workbook*.
How to Contact: For first contact, send bio, direct mail flier/brochure; "follow up with phone call." Reports in 2 weeks if interested. After initial contact, call for appointment to show portfolio of tearsheets, photographs, photostats, photocopies, "anything appropriate in nothing larger than 8½×11 print format."
Tips: Obtains new talent through referrals and direct contact from creative person. "Have direct mail piece or be ready to produce it immediately upon reaching an agreement with a rep. Be prepared to immediately put together a portfolio based on what the rep needs for that specific market area."

PHILIP M. VELORIC, ARTIST REPRESENTATIVE, 128 Beechtree Dr., Broomall PA 19008. (215)356-0362. Fax: (215)353-7531. Contact: Philip M. Veloric. Commercial illustration representative. Estab. 1963. Member

Always enclose a self-addressed, stamped envelope (SASE) with queries and sample packages.

of Art Directors Club of Philadelphia. Represents 22 illustrators. "Most of my business is from textbook publishing, but not all of it." Markets include: advertising agencies; design firms; publishing/books; collectibles.

Handles: Illustration. "Artists should be able to do (and have samples to show) all ethnic children (getting ages right; tell a story; develop a character); earth science, life and physical science; some trade books also."
Terms: Rep receives 25% commission. Exclusive area representation is required. Advertising costs are split: 75% paid by talent; 25% paid by representative. Advertises in *RSVP*.
How to Contact: For first contact, call. After initial contact, call for appointment to show portfolio of original art, tearsheets, photocopies, laser copies.
Tips: Obtains new talent through recommendations from others.

WARSHAW BLUMENTHAL, INC., 104 E. 40th St., New York NY 10016. (212)867-4225. Fax: (212)867-4154. Contact: Andrea Warshaw. Commercial illustration representative. Estab. 1988. Member of SPAR. Represents 26 illustrators. "We service the ad agencies in offering high-tech storyboard, comp art and animatic art for testing. Currently looking for finished artists. We also represent comp artists, letterers, Letters' and a Macintosh computer artist who animates on the system."
Terms: No information provided.
How to Contact: For first contact, send résumé, direct mail flier/brochure, photocopies. Reports in 2 days. After initial contact, call for appointment or drop off or mail portfolio of "finished-looking animatic art and/or a reel."
Tips: Obtains new talent through word of mouth and recommendations.

THE WEBER GROUP, 125 W. 77th St., New York NY 10024. (212)799-6532. Fax: (212)874-9488. Contact: Tricia Weber. Commercial illustration representative. Estab. 1984. Represents 7 illustrators. Specializes in advertising illustration, publishing and design firm work. Markets include: advertising agencies; corporations/client direct; design firms; editorial/magazines; book publishers.
Handles: Illustration.
Terms: Rep receives 25% commission. Advertising costs are split: 75% paid by talent; 25% paid by representative. For promotional purposes, talent must provide "a portfolio (transparencies or color prints to be determined after meeting) of 10-15 quality pieces; advertise in at least 1 top directory once a year and participate in direct mail with group." Advertises in *American Showcase, The Workbook*.
How to Contact: For first contact, send tearsheets, slides, photographs, photocopies or photostats. Reports in 2 weeks. "Will return anything if requested." After initial contact, drop off or mail appropriate materials for review. Portfolio should include tearsheets, slides and/or photographs. "Good quality reproductions are necessary to show care about presentation."
Tips: Usually referred by other reps, art buyers, art directors. Attends shows to see new talent. "My job as a rep is to seek new talent, and see who is out there with an exciting 'new' style (new approach to an old style). Presentation is important. 'Neat,' but not necessarily in the traditional sense of the word, is important."

DAVID WILEY, Suite 1161, 870 Market St., San Francisco CA 94102. (415)989-2023. Fax: (415)989-6265. Contact: David Wiley. Commercial illustration and photography representative. Estab. 1984. Member of AIP (Artists in Print). Represents 7 illustrators, 1 photographer. Specializes in "reliability and quality!"
Terms: No information provided.
How to Contact: For first contact, send direct mail flier/brochure, tearsheets, slides, photographs, and SASE ("very important"). Will call back, if requested, within 48 hours. After initial contact, call for appointment or drop off appropriate materials. Portfolio should include, roughs, original art, tearsheets.
Tips: Obtains new clients through creative directory listings and direct mail.

DEBORAH WOLFE LTD., 731 N. 24th St., Philadelphia PA 19130. (215)232-6666. Fax: (215)232-6585. Contact: Deborah Wolfe. Commercial illustration representative. Estab. 1978. Represents 25 illustrators. Markets include: advertising agencies; corporations/client direct; design firms; editorial/magazines; publishing/books.
Handles: Illustration.
Terms: Rep receives 25% commission. Advertises in *American Showcase* and *Creative Black Book*.
How to Contact: For first contact, send direct mail flier/brochure, tearsheets, slides. Reports in 3 weeks.
Tips: "Artists usually contact us through mail or drop off at our office. If interested, we ask to see more work (including originals)."

Organizations

Organizations provide a myriad of services and opportunities to assist artists with business and professional development. These benefits come in many forms: support services, hotlines, seminars, workshops, conferences, advocacy programs, legal advice, publications, referral services, and even group insurance plans. Many organizations offer funding opportunities as well. (You will find grant information highlighted in bold within the listings.) Some of the larger organizations, such as the Graphic Artists Guild and Society of Illustrators, have built enough solidarity to influence industry standards regarding payment and copyright protection.

To find out about other artists' organizations, refer to the Gale *Encyclopedia of Associations* in your local library.

‡AESTHETIC REALISM FOUNDATION, 141 Greene St., New York NY 10012. (212)777-4490. Fax: (212)777-4426. Executive Director: Margot Carpenter. Estab. 1973. This not-for-profit educational foundation teaches Aesthestic Realism, the philosophy founded in 1941 by the American poet and critic Eli Siegel based on this principle "The world, art, and self explain each other: each is the aesthetic oneness of opposites."
Offerings: Holds weekly public seminars, classes in the visual arts, poetry, music, acting and more. Artists may submit work for exhibition in the Terrain Gallery.

‡EDWARD F. ALBEE FOUNDATION, 14 Harrison St., New York NY 10013. (212)226-2020. Foundation Secretary: David Briggs. Residency program for visual artists and writers.
Offerings: Offers one-month residency at the William Flanagan Memorial Creative Persons Center (The Barn) in Montauk, Long Island NY. Information and application forms are available on request. **Offers**

One example of the way arts organizations touch the lives of artists and the public is in facilitating partnerships to create public art projects like this memorial to blues guitarist Stevie Ray Vaughan in Austin, Texas. The memorial was funded by private contributions, the city provided design support and Austin's Art in Public Places Program located a site for the sculpture. The Vaughan family selected sculptor Ralph Helmick of Newton, Massachusetts to create the memorial.

Reprinted with permission of Ralph Helmick. Photograph © Martha Peters

Foundation Residency to provide a private, peaceful atmosphere in which artists can work. For information contact: David Briggs, Foundation Secretary. **Awards 24 residencies/year (summer season only); no cash awards.** Deadline for application: April 1 (postmark). Interested artists should send for application form.

ALTERNATIVE WORKSITE/BEMIS CENTER FOR CONTEMPORARY ARTS, 724 S. 12th St., Omaha NE 68102. (402)341-7130. Fax: (402)341-9791. Executive Director: Ree Schonlau. Assistant Director: Karen Frank. Estab. 1981. "We provide well-equipped studios, living spaces and a monthly stipend to visual artists who are awarded residencies here. The artists come from across the United States and all over the world to work within a supportive community of like-minded people. The Bemis is housed in a renovated factory building on the fringe of downtown Omaha. It is a unique opportunity made possible through the efforts of a nonprofit organization of art people established in 1981."

Membership: Open to all visual artists anywhere in the world. "Artists must submit an application form, 10 slides of work completed in the last two years, a résumé, reviews or other support material, the application fee of $25, and a large self-addressed envelope for return of slides. A rotating jury of professional artists and curators select from the pool of applicants once a year.

Offerings: Accepted artists are granted residencies for periods of 2-6 months. There is a monthly stipend of $200; studios and living accommodations are rent-free. Write for application. Deadline: March 1st. Also has small alternative gallery space for experimental works. Recently acquired ownership of nearby warehouse (to be expanded into a new facility when funds allow).

‡AMERICAN CENTER FOR DESIGN, Suite 500, 233 E. Ontario, Chicago IL 60611. (312)787-2018. Fax: (312)649-9518. Estab. 1927. "A national association of design professionals, educators and students. In addition to promoting excellence in design practice, it serves as a national center for the accumulation and dissemination of information regarding the role and value of design."

Membership: Membership available. "Open to those individuals engaged in the practice, direction, or instruction of design; those engaged in an allied profession in the active support of the American Center for Design's objectives; businesses or institutions which support activities or education in design." Yearly dues: Student, $60; Apprentice (any individual who has graduated from a design school within the last two years), $85; Regular, Full or Associate, $140. Write or call for membership information.

Offerings: Sponsors several national conferences and curated design exhibitions throughout year. Design student conference and regularly scheduled presentations by recognized designers. Publishes annual *Design Journal*; *Statements*, a collection of interviews, articles and book reviews published 3 times per year; *Creative Registry*, a monthly publication listing employment opportunities; and *100 Show Annual*, a catalog of winning entries from the 100 Show. Also publishes a directory listing member names, titles, work addresses and phone numbers.

AMERICAN SOCIETY OF ARCHITECTURAL PERSPECTIVISTS, 320 Newbury St., Boston MA 02115. (617)846-4766. President Emeritus: Frank M. Costantino. Estab. 1986.

Purpose: Nonprofit business organization promoting the professional interest of architectural illustrators and establishing a communication network among members throughout the US, Canada, Japan, England and other countries. Approximate current membership: 400.

Membership: Open to architectural illustrators, architects, students and other related professionals. Professional practitoners of architectural delineation preferred. Full membership, $135; overseas professional, $150. Student membership $35. Write for membership information.

Offerings: Two meetings/year. Annual touring exhibition. Awards Hugh Ferriss Memorial Prize. Publishes full-color, five-year retrospective book (Van Nostrand Reinhold and ASAP). Also publishes exhibition catalog of winning entries and a quarterly newsletter. Membership benefits include national/international listings, contract format, pricing guidelines, tax information and contact with foreign renderers associations. Seminars, lectures and demonstrations offered at fall convention and during year. Regional activities coordinated by Advisory Councillors in most major cities.

AMERICAN SOCIETY OF ARTISTS, INC., P.O. Box 1326, Palatine IL 60078. (312)751-2500 or (708)991-4748. Membership Chairman: Helen Del Valle. Estab. 1972. National professional membership organization of fine artists (has a crafts division of American Artisans.)

Membership: Juried membership available—a limited number of members in each category and media are accepted. Juried via slides/photos with application for membership. Yearly dues: $20 initiation fee, $50 dues. Write and send #10 SASE for membership information. "Be sure to state media you work in."

Offerings: Sponsors about 25 shows/year and lecture and demonstration service. If a member qualifies for participation in this, they are "booked" for lectures, demos, workshops and seminars for various groups (they present them). Awards include honorary membership and certificates of appreciation. Publishes quarterly *A.S.A. Artisan*, which includes show and exhibition listings and information for and about members; *Art Lovers Bulletin*, listing of art and craft shows held in Illinois by various organizations. Other services include supplies, publicity and access to other benefits including insurance, credit union, etc.

‡AMERICAN SOCIETY OF AVIATION ARTISTS, 1805 Meadowbrook Heights Rd., Charlottesville VA 22901. (804)296-9771. Fax: (804)293-5185. Executive Secretary: Luther Y. Gore. Estab. 1986. "An organization to promote high standards in aviation art and to encourage artists to record, celebrate and interpret aviation/aerospace history."
Membership: Membership available. Open to practicing artists, collectors, gallery owners, curators. Currently has 300 members. Yearly dues: artists $85, associates $35. Call or write for membership information.
Offerings: Offers annual forum with lectures, workshops, demonstrations; annual juried and unjuried exhibitions; annual "best in show" awards. Publishes brochure, newsletter (quarterly), book (color) of members' works, occasional guides. **Sponsors annual juried exhibition to encourage high standards in the art.** For information contact: Luther Gore, Executive Secretary. Requirements: artist and artist fellow members must be engaged in production and sale of aviation/aerospace art. Interested artists should send for application form. Applications require two sets of five 35 mm slides showing recent work. "We're the premier aviation art society in US; an association with recognized artists is an invaluable aid to young artists."

‡ARAB AMERICAN CULTURAL FOUNDATION—ALIF GALLERY, 1204 32st St. NW, Washington DC 20007. (202)337-9670. Fax: (202)337-1574. Director: Ms. Lama Dajani. Estab. 1978. "The AACF was established in Washington DC. It is a nonprofit, tax-exempt organization dedicated to further the appreciation of Arab art and culture in America by presenting excellence in the arts—Alif Gallery swerves as the Foundation's exhibition center and headquarters, and it is the only gallery in America specializing in contemporary Arab art."
Membership: Membership available. Open to all. Currently has 150 members. Yearly dues: donation of minimum $25 and up to $10,000. Call or write for membership information.
Offerings: The Foundation offers exhibition, workshops, consultation services, slide library, book signing receptions, gallery talks, lectures, film showings and presentation of concerts and performing arts. Produces catalogs related to each event it sponsors and curates. Offers insurance and covers the expenses of promotion, installation and the opening reception. "The Foundation provides a unique service of presenting Arab related multi-disciplinary programs."

‡ART ASSOCIATION OF HARRISBURG, 21 N. Front St., Harrisburg PA 17101. (717)236-1432. Fax: (717)236-6631. President/Sales Gallery Manager: Carrie Wissler-Thomas. Estab. 1926. "The Art Association of Harrisburg promotes the visual arts through exhibitions and education. AAH maintains a year-round art school for students of all ages and skill levels, and we mount 10 in-house exhibitions annually as well as 36 shows in community locations per year. We also maintain a Sales Gallery wherein members' artwork is offered for sale on a consignment basis."
Membership: Membership available. Open to anyone. Currently has 800 members. Yearly dues: $30, basic membership (higher patron levels available). Call or write for membership information.
Offerings: "We offer 30 classes per each of our four annual semesters, all taught by professional artists. We hold 10 in-house exhibitions annually, including 2 membership, 1 school, 1 juried and 6 invitational shows. We offer members' works for sale in our Sales Gallery on a consignment basis, with a 33% commission. We also hold shows of members' works in 9 community locations." Publishes a bimonthly newsletter. Member artists have the opportunity to exhibit one piece in each of the 2 annual membership shows, also can place works in Sales Gallery. Affiliated with the Harrisburg Allied Arts Fund. "AAH is the oldest, most established art group in the area and we provide excellent exhibition opportunities for artists in all levels of their careers. Our Sales Gallery has a good track record of sales to area corporations."

‡THE ART CENTER, MOUNT CLEMENS, MI, 125 Macomb Place, Mount Clemens, MI 48043. (810)469-8666. Fax: (810)469-4529. Executive Director: Jo-Anne Wilkie. Estab. 1969. "The purpose of The Art Center is primarily educational, to foster and develop interest in the visual arts by providing quality exhibitions, and by conducting classes, sponsoring tours, and generally serving as a resource center for both the public and the artists."
Membership: Membership available. Open to everyone. Currently has 400 members. Yearly dues: $25, Individual; $35, Family; $50, Sponsor. Call or write for membership information.
Offerings: "Corporate sponsors and the Arts Foundation of Michigan provide awards for exhibiting artists. Exhibits include statewide open competitive, juried, invitational, student shows, and student-faculty shows of The Art Center, Special Events include the month-long Holiday Fair, which changes ethnic focus each year, the Mount Clemens Art Fair, which takes place over Mother's Day Weekend. Classes are offered for adults and children in painting, drawing, sculpture, ceramics and crafts." The Art Center holds the Michigan Annual Juried Art Exhibit, open to all artists. There are also opportunities for solo or small group invitational exhibits. Offers classes for adults and children in a variety of media, tours to major Museum Exhibits, lectures.

‡ART IN GENERAL, 79 Walker, New York NY 10013. (212)219-0473. Fax: (212)219-0511. Contact: Gallery Coordinator. Estab. 1981. "Art in General is a nonprofit arts organization providing 3,500 sq. ft. of exhibition space in lower Manhattan, focusing on the development of contemporary art through its presentation—art that is often under-represented in larger museum and commercial gallery structures."

Offerings: "We publish an annual book which describes every exhibition for the year, including biographies of all artists involved." Accepts submissions for exhibitions. "We offer lectures, performances, readings, and workshops but we are primarily a gallery space."

‡**ART INFORMATION CENTER,** Suite 412, 280 Broadway, New York NY 10007. (212)227-0282. Director: Dan Concholar. Estab. 1959. "A networking referral service for fine art, with a staff of 1, interns and volunteers." **Membership:** Open to professional fine artists and dealers. $10 fee to place slides, data in information bank for artists; consultations by appointment. Write or call for membership information.

ART LEAGUE OF HOUSTON, 1953 Montrose Blvd., Houston TX 77006. (713)523-4053. Executive Director: Linda Haag Carter. Estab. 1953. "Organization to inform the public through support of the visual arts, outreach programs. Supports emerging and underexposed artists with alternative space and recognizes Texas artists through exhibitions and the Arts Registry of Texas."
 • An exhibition space is offered to members, see listing in Galleries section.
Membership: Membership available. Open to all. Yearly dues: Golden Pallette, $5,000 or more; Benefactor, $1-4,999; Individual, $25; Sponsor, $100-999; Patron, $50-99; Student, $20; Husband & Wife, $40; Retired, $10. Write or call for membership information.
Offerings: Holds one exhibition every month, openings the first Thursday of each month. Offers classes in painting, drawing, sculpting, photography, jewelry, metalsmithing, ceramics and children's classes. In addition, the Art League offers a combination of workshops in the above disciplines and publishes a bimonthly newsletter, *Art League of Houston* and a membership directory. **Holds 3 juried exhibitions yearly. Awards a total of $1,500.** Requirements: must be a laegue member. The Art League of Houston provides the administrative support for art instructors to teach art to children detained in the juvenile detention centers in the Harris County area, offers the Oasis program for senior citizens who are interested in art, and also offers an art class to people with AIDS, at no cost to the student.

‡**ART ON THE MOVE TOURS, INC.,** 1171 Linden Ave., Highland Park IL 60035. (708)432-6265. Fax: (708)433-6265. President: Joan Arenberg. Estab. 1986. Conducts tours visiting museums, galleries, artists' studios and private collections regularly in Chicago area and selected US destinations.
Membership: No membership required. Artists should contact president if they are interested in studio visits from groups exploring and learning about visual arts—or if they wish to travel on art-related tours.

THE ART STUDIO, INC., 720 Franklin, Beaumont TX 77701. (409)838-5393. Executive Director: Greg Busceme. Estab. 1984. An alternative artist space, currently 20 artists strong.
Membership: Membership available. Open to all. Yearly dues: minimum, $15; Regular, $30; Sustaining, $50; Patron, $100; Sponsor, $250. Call or write for membership information. Applicants for space or exhibition must send slides and résumé. No deadline.
Offerings: No meetings for members but conducts monthly meetings for artists. Holds monthly exhibitions of artists in the region. Offers workshops and classes commensurate with need or request. Sponsors The Art Studio, Inc. Membership Show (juried). Publishes a newsletter, *Studio Ink.* Offers a special program, Outreach, to low-income kids.

ARTISTS IN PRINT, Suite 530, 665 3rd St., San Francisco CA 94107. (415)243-8244. Fax: (415)495-3155. President: Patti Mangan. Estab. 1974. A nonprofit resource/support center for the local graphic arts community with more than 500 members.
Membership: Membership available. Open to all. Yearly dues: $45, individual; $25, student. Write or call for membership information.
Offerings: Holds monthly roundtable discussions and portfolio review sessions (reviews done by local art directors). Sponsors Al Hayes' Advertising Portfolio Class twice a year (15 week fairly demanding course). Offers job referrals, workshops, career counseling, resource library and health insurance. Publishes *In Brief,* a quarterly newsletter and *Directory of Talent,* a database of artists that goes to all Bay area employers who list in the job file.

‡**ARTS & SCIENCE COUNCIL—CHARLOTTE/MECKLENBURG, INC.,** Suite 250, 227 W. Trade St., Charlotte NC 28202. (704)372-9667. Fax: (704)372-8210. President: Michael Marsicano. Estab. 1959. "A multi-faceted private nonprofit organization that raises funds for cultural organizations, provides planning to ensure the long-term health of the cultural community and provides technical services to cultural organizations."
Membership: Open to cultural groups (they may apply for affiliate status).
Offerings: Offers Emerging Artist Grants and Arts-in-Education Grants to local public schools, artists and arts organizations that team up to bring the arts into the classroom. Publishes a quarterly newsletter. **Gives Emerging Artist Grants to further the careers of developing artists.** For information contact: David Sensi, Grants Officer. Requirements: Applicants must live in Mecklenburg, Cabarrus, Gaston, Iredell, Lincoln or Union counties in North Carolina or York County, South Carolina; must be at least 18-years-old and not enrolled in an undergraduate or graduate degree program. **Awarded 31 grants in 1993-94 totalling $28,500. Average grant: $1,000; length October-June.** Deadline for application: early fall (exact date varies each year).

Interested artists should send for applications, available from the Arts & Science Council or from arts councils in the other six participating counties. Affiliated with Mint Museum of Art, Spirit Square Center for the Arts, Afro-American Cultural Center, Community School of the Arts, Light Factory Photographic Arts Center.

ARTS EXTENSION SERVICE, Division of Continuing Education, 604 Goodell Bldg., University of Massachusetts, Amherst MA 01003. (413)545-2360. Fax: (413)545-3351. Special Projects Coordinator: Pam Korza. Estab. 1973. "AES is a national arts service organization which has worked to achieve access to and integration of the arts in communities through continuing education for artists, arts organizations and community leaders. Our services include consulting, teaching, publishing, arts programming and research."
Membership: Not a membership organization.
Offerings: "AES's award-winning Artist in Business workshops have been presented across the country with the sponsorship of local and state arts agencies and artist organizations. AES provides consulting services for artists and arts and can help artist organizations assess their organizational missions. Our Artist Business Library helps artists find information on the business of art and pursuing a career as an artist." Two of AES's workshops are Planning Your Marketing Strategy and Basic Artist Business Practices. Publishes 10 softbound books such as *Fairs & Festivals*, *The Artist in Business* and *Going Public: A field guide to developments in art in public places*. **Sponsors New England Film and Video Festival—various awards to recognize independent and student Film and Video makers in the New England region.** For information contact: Pam Korza, Director. The competition is open to independent media artists who are rsidents of Maine, Vermont, New Hampshire, Connecticut, Massachusetts and Rhode Island. Students attending New England colleges and universities may enter. Students who are attending a college or university outside of New England who have permanent resident status in a New England state are also invited to enter. 35mm, 16mm, Super 8 and video formats are eligible. Works must have been completed within the past two years. **Gives approximately 20 awards with an approximate $6,000 total annually.** Deadline for application: late January. Contact Arts Extension Service for information. Affiliated with the University of Massachusetts, Amherst.

‡ARTS FOUNDATION OF MICHIGAN, Suite 2164, 645 Griswold, Detroit MI 48226. (313)964-2244. Executive Director: Kimberly Adams. Estab. 1966. "AFM is an independent funding organization that fosters participation and investment by corporations, foundations and individuals to support the creative spirit and encourage excellence in the arts in Michigan."
Offerings: Provides Creative Artist Grants, scholarships to select art schools in Michigan, competition grants, Grant writing technical assistance and other special programs from time-to-time. Publishes *Artist Update Newsletter*. **Offers Creative Artist Grant to fund significant, original new work by individual artists.** For information contact: Kim Adams, Executive Director. Requirement: Michigan residents only; no students. **Awards 38 grants $122,200. Average grant: $500-5,600; length: 1 year.** Deadline for application: varies each year. Interested artists should call or write for application. "This is *not* a fellowship program but rather a project grant—be clear and specific about what is to be accomplished."

‡ARTS MIDWEST, Suite 310, 528 Hennepin Ave., Minneapolis MN 55403. (612)341-0755. Fax: (612)341-0902. Public Relations: Karen R. Nelson. Estab. 1985. "Arts Midwest is a regional organization which provides funding training, and publications to Illinois, Indiana, Iowa, Michigan, Minnesota, North Dakota, Ohio, South Dakota, and Wisconsin."
Offerings: Arts Midwest funding opportunities include: Dance on Tour, Meet the Composer/Midwest, Jazz Satellite Touring Fund, Performing Arts Touring Fund, NEA Visual Artist Fellowships, Artworks Fund, Jazz Master Awards, Cultural Development Fund and Minority Arts Administration Fellowships. We also sponsor the annual Midwest Arts Conference, a booking event for presenters and artists. Arts Midwest offers a quarterly *Midwest Jazz*, a bimonthly *Inform* newsletter, a 5-part *Insights on Jazz* series, an *Applause!* directory of performing artists a *Jazz Masters Journal*, application booklets and other special interest arts publication. **Offers performing arts and visual arts grants. "Arts Midwest translates human and financial resources into enriching arts experiences for Midwestern residents."** For information contact: Bobbi Morris, Director of Funding. Grants are primarily available to organizations and individuals within the nine-state Midwest region. Nonprofit and/or professional status usually required. **Arts Midwest awards an average of 300 grants totaling $760,000 yearly. Average grant: $300-5,000.** Deadlines for application: mostly in fall or spring—call for specific program deadlines. Interested artists should contact Arts Midwest for guidelines, application forms, and technical assistance.

ARTS ON THE PARK, INC., 115 N. Kentucky Ave., Lakeland FL 33801-5044. (813)680-2787. Executive Director: Dudley Uphoff. Estab. 1979. Community Art Center with shows, competitions, concerts and publications to encourage area artists, writers, performers.
Membership: Membership available. Open to artists and the arts public. Yearly dues: Regular, $35; Senior, $25. Write or call for membership information.
Offerings: Holds receptions monthly and one annual meeting in September. Sponsors continuous exhibitions and competitions for area artists. Offers art classes, life studio, video workshops and monthly author workshops. Sponsors awards and contest for artists. Publishes a newsletter, calendar, annual poets anthology and

quarterly literary magazine. Also offers monthly concerts and jams for folk performers.

ARTSPACE, INC., 201 E. Davie St., Raleigh NC 27601. (919)821-2787. Executive Director: Ann Tharrington. Estab. 1986. Center for the visual and performing arts in downtown Raleigh. "Artspace has more than 100 artist members, 26 studios open to the public, 2 galleries, (one of which doubles as a theatre space) and a restaurant."
Membership: Artists are juried into the association. Juries are held in March and September. Submit 10 slides, slide narrative, letter of intent, current résumé, SASE and $20 jury fee for Phase I. Phase II involves presenting original work. Regular membership, $45. Write or call for membership information.
Offerings: Holds quarterly meetings, and 10 exhibits/year in 2 galleries. Offers fall, winter, spring and summer classes. "Purchase awards and Merit awards are offered for juried artists' and Association member shows. Also sponsors statewide competitions in various media and themes. Artspace is a popular meeting place for businesses, civic organizations and private parties." Publishes *Artspace Artists Association Directory*.

ARTSWATCH, 2337 Frankfort Ave., Louisville KY 40206. (502)893-9661. Contact: Jan Graves. Estab. 1986. A small avante-garde organization devoted to local and regional exploration of the visual and performance arts.
 ● Membership is increasing considerably.
Membership: Open to all. Artist, $10; individual, $15; family, $25; supporting, $100; friend, $250; patron, $500. Membership is available; write/call for membership information.
Offerings: "We do a variety of events each month around Louisville." Holds collaborative workshops for performing and visual arts. Offers a wide variety of awards and contests. Special programs include workshops for abused children, Elderarts, and more. Performance artists and visual artists are encouraged to submit proposals for review.

‡ASSOCIATED ARTISTS OF WINSTON-SALEM, 226 N. Marshall St., Winston-Salem NC 27101. (910)722-0340. Executive Director: Rosemary H. Martin. Estab. 1956. "Associated Artists' goals are to conduct and promote activities which support the awareness, enjoyment and appreciation of fine art, with a special emphasis on education. AAWS encourages the creative talent of individual artists, from novice to professional."
Membership: Membership available. Open to artists and art appreciators. Currently has 375 members. Yearly dues: $28-Associate; $40-Exhibiting (discounts for students/sr. citizens—see brochure). Call or write for membership information.
Offerings: "AAWS sponsors one regional (Southeastern) competition, two national competitions, and 9-10 local shows annually. We sponsor various lectures, trips and workshops throughout the year." Publishes *Artefacts*, a bi-monthly newsletter; an annual yearbook/directory; and catalogs for 3 major competitions. **Offers Henley Southeastern Spectrum competition to recognize top-notch artwork by Southeastern artists.** For information contact: Rosemary H. Martin, Executive Director. Must submit 2-D work (paintings, drawings, printmaking) by Southeastern artists. **Awards $16,000-18,000 in cash and purchase awards (varied from year to year). Average award amount: $500.** Deadline for application: varies from year to year—slides due circa February 15-March 15. Send for prospectus. "We sponsor 12-13 shows annually in our galleries in the historic Sawtooth Building." Offers lectures by visiting jurors/artists, artists' studios tours; local, regional, national and international art-related trips; occasional workshops in various media. "We are a funded member agency of The Arts Council of Winston-Salem and Forsyth County. We don't deny exhibition opportunities to anyone—all can take part, whether novice or professional. Our volunteer program offers unique opportunities for fellowship with artists and art patrons alike."

‡ASSOCIATION FOR VISUAL ARTISTS (AVA), Suite 30, 615 Lindsay St., Chattanooga TN 37403. (615)265-4282. Fax: (615)265-5233. Director: Christy Mitchell. Estab. 1986. "AVA is a nonprofit organization dedicated to the promotion and support of original visual art and its creators. AVA produces a variety of programs, workshops and art exhibitions for its members and for the Chattanooga Community."
Membership: Membership available. Open to artists, non-artists, supporters of arts. Currently has 609 members. Yearly dues: $20 and up. Call or write for membership information.
Offerings: AVA offers workshops, exhibitions, lectures and competitions and often collaborates with other arts organizations and universities to bring artist scholars to the community. Prints a quarterly newsletter and is in the process of producing a directory of artists and galleries. AVA is a funded member of Allied Arts of Greater Chattanooga. "We get the artists in touch with the community and the community in touch with the artists."

‡ASSOCIATION OF COMMUNITY ARTS AGENCIES OF KANSAS (ACAAK), P.O. Box 1363, Salina KS 67402-1363. (913)825-2700. Executive Director: Ellen Morgan. Estab. 1973. "A statewide assembly of community arts agencies/organizations, ACAAK fosters excellence in the arts for the benefit of all Kansans."
Membership: Membership available. Open to all. Currently has 180 arts agencies/organizations, 300 individual members. Yearly dues: $10-1,000. Call or write for membership information.
Offerings: "We offer technical assistance/support through telephone, written communications, on-site visits, consultations; professional growth development through a variety of workshops/conferences/seminars; facili-

tated board retreats, strategic/long range planning; resource library of books/ACAAK developed materials available for loan on various aspects of the administration of nonprofit organizations; Kansas Artists' Postcard series competition and exhibits. Publishes *Update*, a monthly technical information piece for member organizations, and *Ensemble*, a quarterly newsletter which covers state/regional/national news. **Sponsors Kansas Artists' Postcard Series to honors exceptional Kansas artists.** For information contact: Regan Blanchard, Program Coordinator. Requirements: must be a Kansas resident, artwork must be original, no textiles or photography, image must be 4¼×6″. **Gives 26 awards totaling $3,000.** Deadline for application: June 1-every year. Interested artists should call or write for guidelines. Winners of Kansas Artists' Postcard Series form exhibit that tours 5 state area.

ATLANTIC CENTER FOR THE ARTS, INC., 1414 Art Center Ave., New Smyrna Beach FL 32168. (904)427-6975 or (800)393-6975. Fax: (904)427-5669. Executive Director: Suzanne Fetscher. Grants Specialist: Ann Brady. Estab. 1980. Interdisciplinary artists in residence facility, located on 67 acres. Provides an informal work environment for accomplished and creative artists from all disciplines to work with outstanding Master Artists.
Membership: Membership available. Open to all. Yearly dues: Individual, $25; Family, $50; One Hundred Plus, $100; Patron, $1,000. Write or call for membership information.
Offerings: Offers gallery exhibits by resident artist and informal performances and readings. Also offers artists' residencies 5-6 times a year with three Master Artists (1994 Master artist was painter Alex Katz). Publishes a tri-monthly calendar and bulletin from annual Ethics of Change forum. Special programs include art workshops for adults and summer series for children. **Offers scholarship awards for artists accepted into residency programs.** For information, artists should contact: Jim Frost, Program Assistant. Artists must first be accepted by Master Artist with whom they wish to work. Then they must submit scholarship application form. Eligibility is determined by financial need/available funds. **Average grant $600; length 3-week residency.** Deadline for application: varies, call or write for application materials and then, if accepted, complete scholarship application form. Florida artists of renown are invited to exhibit at an in-town community facility, Harris House of Atlantic Center for the Arts.

ATLATL, Suite 104, 2303 N. Central Ave., Phoenix AZ 85004. (602)253-2731. Executive Director: Carla A. Roberts. Estab. 1977. "Atlatl is a national Native American arts service organization that promotes the vitality of Native American arts."
Membership: Membership available: Yearly dues: begin at $25. Write or call for membership information.
Offerings: Sponsors touring art exhibitions. Offers workshops and technical assistance to Native American artists. Publishes quarterly *Native Arts Update*, and bulletins as needed between quarters. Also published *Directory of Native American Performing Artists* (available for $5 plus postage). Maintains a registry of Native American artists. Sponsors national conference Native Arts Network on biennial cycle.

‡BLOOMINGTON ART CENTER, 10206 Penn Ave. S., Bloomington MN 55431. (612)887-9667. Fax: (612)887-9644. Executive Director: Susan Anderson. Estab. 1976. "Our organization is a community art center which gives opportunities for emerging artists to exhibit and the public to view art, and teaches quality classes and workshops to children and adults."
Membership: Membership available. Open to anyone interested. Currently has 500 members. Yearly dues: $20 Individual; $35 Household. Call or write for membership information.
Offerings: Offers workshops and classes for children and adults (from beginning to advanced); 3 exhibition spaces—each has six shows a year with a total of 18 shows through the Art Center a year; exhibition opportunities to artists in a 5 state area—North and South Dakota, Iowa, Wisconsin and Minnesota—chosen by peer group one year in advance; one members juried exhibit a year. Publishes a quarterly catalog, brochure on buying original artwork, booklet on school artist residencies, brochure about Bloomington Art Center and announcements to exhibits—18 a year. "We have three exhibit spaces: Art Center gallery, Bloomington City Hall and local bank lobby." Provides insurance to cover exhibits in art center gallery. "We offer high quality classes to people of all levels of ability; we show quality artwork of all kinds by emerging regional professional artists."

‡BLUE STAR ART SPACE, 116 Blue Star, San Antonio TX 78204. (210)227-6960. Director: Jeffrey Moore. Estab. 1986.
Membership: Membership available. Yearly dues: $30 individual; $50 family; $250 patron; $1,000 exhibition sponsor (other levels of membership available). Call or write for membership information.
Offerings: Blue Star has 10,000 sq. ft. of exhibition space. Offers lectures throughout the year in relation to current exhibition.

‡BRANDYWINE WORKSHOP, 1520-22 Kater St., Philadelphia PA 19146. (215)546-3657. President: Allan L. Edmunds. Estab. 1972. A nonprofit visual arts institution dedicated to promoting printmaking as a fine art.
Membership: Membership available. Open to art lovers of all races, ages and cultures. Write for membership information.

Offerings: Holds exhibitions; "prints produced at Brandywine travel nationally and internationally." Offers visiting artist fellowship program, application required for 1-2 week sessions. Publishes a newsletter, *Brandywine Brief*, and an art journal, *Brandywine Papers*. Offers intern training, neighborhood beautification, lecture series and print sales. Developer of the Firehouse Art Center, a visual arts complex on South Broad Street in Philadelphia, which houses galleries, archives and the visual technologies center.

***BRITISH AMERICAN ARTS ASSOCIATION,** 116 Commercial St., London E1 6NF United Kingdom. (071)247-5385. Fax: (071)247-5256. Executive Director: Jennifer Williams. Estab. 1978. "Arts service organization providing information and advice to artists and arts administrators working in transatlantic cultural exchange. BAAA is not a grant giving organization." Membership is not currently available.
Offerings: Occasional workshops on varied subjects. Publishes newsletter and other materials on international cultural exchange.

‡BRONX COUNCIL ON THE ARTS, 1738 Hone Ave., Bronx NY 10461. (718)931-9500. Fax: (718)409-6445. Executive Director: Bill Aguado. Estab. 1962. "The Bronx Council on the Arts is the officially designated cultural agency of Bronx County. Our mission has always been to encourage and nurture the community's interest and participation in the arts, and the professional development of artists and art organizations."
Membership: Membership available. Open to all. Currently has 750 members. Yearly dues: $10-25. Call or write for membership information.
Offerings: "We offer several grants for individual artists and/or organizations with arts programs." "We publish 2 items: bi-monthly calendars of events that are occuring in the Bronx, and a monthly listing of opportunities called *Arts Update*." **Offers BRIO (Bronx Recognises Its Own) to assist artists in their development and get them out into the community.** For information contact: Edwin Pagan, Arts Services Associate. Requirements: must be a Bronx resident; no students. **Awards 40 grants – 10 at $1,500; 30 at $250; length: 1 year.** Deadline for application: March 1. Call or write to receive an application. "We have a Studio Fellowship Program; 3 winners get free studio space. We have relationships with and give grants to many local visual arts organizations. We are an effective liason with many organizations of different types, both in the Bronx and throughout the region."

CALIFORNIA CONFEDERATION OF THE ARTS, 2nd Floor, 704 O St., Sacramento CA 95814. (916)447-7811. Fax: (916)447-7891. Associate Director: Ken Larsen. Estab. 1976. "The Confederation, with 1,000 organizational and individual members, serves as an advocate for a wide range of state arts programs and legislation."
Membership: Membership available. Open to all. Write or call for membership information.
Offerings: Holds 2 major meetings: Arts Day and Congress of the Arts. Offers workshops, seminars, and awards. "We have initiated multi-year broad-based statewide campaigns for arts in education and cultural equity. Our quarterly newsletter, the *California Arts Advocate*, offers a 16-24 page comprehensive overview of arts and politics as they affect everyone in California."

‡CHESHIRE FINE ART, INC., 265 Sorghum Mill Dr., Cheshire CT 06410. Phone/Fax: (203)272-0114. Contact: Linda Ladden. Estab. 1983. Handles "research and promotion of New England Regional Art and Artists and authorship of articles about some artists."
Offerings: "We give presentations and classes free of charge." Published articles in *Fine Arts Trader*, *New England Antiques Journal*, and many other antique publications; and periodic articles about Cape Ann and New England artists. Also published *Emile Gruppe, Artist & Man* booklet written by Linda Ladden. Works closely with Rockport Art Association, Rockport MA, for one-man retrospective exhibitions on past members of Rockport Art Association.

CHICAGO ARTISTS' COALITION, 5 W. Grand Ave., Chicago IL 60610. (312)670-2060. Executive Director: Arlene Rakoncay. Estab. 1974. An artist-run, nonprofit service organization for visual artists. "Our purpose is to create a positive environment in which artists can live and work. Our primary objectives are improved benefits, services and networking opportunities for artists, education of the general public regarding the value of the visual arts, and protection of artists from unfair business practices and censorship."
Membership: Membership available. Open to all visual artists. Currently has 2,700 members. Yearly dues: Regular, $30; Student, $18; Seniors, $20. Write or call for membership information.
Offerings: Holds monthly program meetings with slide presentations or panel discussions, plus an annual tax and recordkeeping workshop and an annual business of art conference. Publishes monthly 16-page newspaper, *Chicago Artists' News*, and artists' reference materials: *Artists' Gallery Guide*, *Bookkeeping for Artists* and *Yellow Pages for Artists*. Other services include health insurance plans (also available for artists in Indiana, Iowa, Michigan, Missouri, Wisconsin and Illinois), a fine art insurance plan for works of art, a job referral

service, slide registry, discounts at art supply stores, a resource center, an emergency assistance program and a national credit union.

CHICANO HUMANITIES AND ARTS COUNCIL, 4136 Tejon St., Denver CO 80211. (303)477-7733. Fax: (303)433-3660. Executive Director: Rick Manzanares. Estab. 1979. Nonprofit organization that promotes and preserves Chicano/Latino art, culture and humanities.
Membership: Membership available. Yearly dues: Regular or full, $20; Student, $10; Family, $25. Write or call for membership information.
Offerings: Conducts annual meetings and monthly board meetings plus monthly exhibits with varying themes, and workshops on literary arts, artists rights, etc. Sponsors contest for volunteer of the month and volunteer of the year. Offers internships for college students as well as art education classes. Publishes *CHAC Reporter* (includes artist watch, art events, opportunities, awards and honors). Also provides opportunity for artist exchanges and makes referrals. CHAC has exhibition space available (contact for more information).

‡CITIZEN EXCHANGE COUNCIL, 4th Floor, 12 W. 31 St., New York NY 10001. (212)643-1985. Fax: (212)643-1996.
Offerings: Publishes a quarterly newsletter, *Communiqué*. **Offers Arts Link Collaborative Project Grants to US artists to travel the former Soviet Union and Central/Eastern Europe to pursue projects; Artslink Residencies to fund US Arts organizations wishing to host an artist from the region in 5-week residency.** For information contact: Claudia Stillwell, Program Coordinator. Requirements: must be US artist or US nonprofit organization; curators, scholars, critics, students and student or recreational amateur groups are *not eligible*. **Awards 25-30 grants for US artists; 20 for East-side artists; 15-20 for US host organizations. Average grant: $4,000.** Deadline for application: February 15, 1994. Interested artists should contact Citizen Exchange Council for application.

‡CITY OF CINCINNATI, HUMAN SERVICES DIVISION, Room 158, 801 Plum St., Cincinnati OH 45202. (513)352-1592. Fax: (513)352-5241. Human Services Analyst: Carolyn Gutjahr. Arts grant programs estab. 1989. "The City has a grant program to provide support for emerging and established artists; to encourage excellence and professionalism in the arts and development of new work; to encourage access to the arts for Cincinnati residents and to encourage through the arts an understanding among diverse cultures in Cincinnati."
Offerings: Offers grants for individual artists and workshop for grant application process. Publishes an arts calendar, including events and exhibitions of grant recipients, which is sent monthly to the Mayor and Members of Cincinnati City Council, the City Manager, and the Members of the Cincinnati Arts Allocation Committee. **Offers City of Cincinnati individual artist grants for either operating support, funding ongoing artistic activities, or project support, funding a one-time short-term artistic activity.** For information contact: Carolyn Gutjahr, Human Services Analyst. Requirements: Applicant must be a legal resident of the City of Cincinnati. Previous grant recipients must have completed reporting requirement. **Awards no set number of grants** (historically between 20-35, about 50% of eligible applications). **Grant range $400-2,200 maximum request $3,000. Average grant: $1,500; length: 12 months, September 15-September 15.** Deadline for application: February 15. Interested artists should call (513)352-1595 for Grant Application distribution locations. "A public presentation of funded work is required to take place at a site within the limits of the City of Cincinnati during the grant period. Grants are also available for small arts organizations. A workshop is offered for the grant application process. Technical assistance and information handouts are available.

‡CITYARTS, Suite 911, 225 Lafayette St., New York NY 10012. (212)966-0377. Fax: (212)966-0551. Executive Director: Tsipi Ben-Haim. Estab. 1968. "We are a pioneering nonprofit arts organization dedicated to the creation of public art in all media, but particularly murals. We maintain a slide file of artists who wish to make public art. Artists should be professional sculptors or painters who wish to work with and in the community to be included in the slide file."
 ● Cityarts completed a mural based on an Alice Walker poem and she attended the ribbon cutting ceremony.
Offerings: Holds public art or exhibition demonstrating past projects. Sometimes issues competitive calls for artists for specific projects. Send SASE with request for artist application. Provides slides for rental or purchase that document the creative process, public art works through the years, and murals around the

world. Published a catalog, *The Creative Process* ($7 and postage); and a pamphlet *We Care and Dare* (available with SASE). Occasionally sponsors an artist in residence. Has a resource file and counseling service for artists by appointment.

‡**CLAIREMONT ART GUILD**, % Art Scene Gallery, 4150 Mission Blvd., San Diego CA 92117. (619)483-2740. Manager: Hope Wilts. Estab. 1954. "The purpose of the Clairemont Art Guild shall be for the advancement of creative arts in the community and individual growth through association with the Guild."
Membership: Membership available. Open to everyone—artists and people who want to support the arts. Currently has 165 members. Yearly dues: $20. Call or write for membership information to Inga Scott, 4541 Hubbard Ave., San Diego CA 92117. (619)278-3820.
Offerings: Offers monthly demos, lectures and critiques and outside exhibitions. "We maintain the Art Scene Gallery. We have a judged and juried show every year. We give art awards to college students and 8th graders yearly. We are now working on our '40th Anniversary gift' an art wall/fountain project for the South Clairemont Recreation Center. We also run Art in the Rough Gallery for local artists who are *not* in the Guild. We have receptions in both Galleries every other month." **Holds Clairemont juried show to promote the arts.** For information contact: Hope Wilts, Manager. Requirements: show (held November every year) is open to all artists in San Diego county. **Awards up to $1,500 in juried show.** Deadline for application: November 1. Holds various workshops during the year. Has a liason with Mesa Community College. "We are a wonderful group of artists who like to learn and grow with each other."

COALITION OF WOMEN'S ART ORGANIZATIONS, 123 E. Beutel Rd., Port Washington WI 53074. (414)284-4458. President: Dorothy Provis. Estab. 1977. "We are a national advocacy organization and have a membership of 10,000 plus individuals and organizations, such as Chicago Artists' Coalition and National Women's Caucus for Art."
Membership: Membership available. Open to "anyone in the arts community who wishes to keep abreast of proposed national legislation and other issues that affect artists." Yearly dues: Organizations, $25; Individuals, $10. Write for membership information.
Offerings: Annual meeting at the College Art Association conference. Holds panels at Women's Caucus for Art and/or College Art Association conference held in February each year. Publishes *CWAO NEWS*, a monthly, to keep members informed of salient information: proposed federal arts legislation, arts at issue, women's art issues, etc.

COLORADO CALLIGRAPHERS' GUILD, Box 6746, Denver CO 80206. Contact: Secretary. Estab. 1978. Educational group. Approximate membership: 175.
Membership: Membership available. Open to anyone. Yearly dues: Regular, $20. Write for membership information.
Offerings: Holds quarterly meetings. Sponsors open and juried shows of calligraphy. Gives afternoon and 2-day workshops. Publishes *Inkcetera*, triannual newsletter. Also publishes a directory listing members.

‡**COLORADO COUNCIL ON THE ARTS**, 750 Pennsylvania St., Denver CO 80203-3699. (303)894-2617. Fax: (303)894-2615. Associate Director: Daniel Salazar. Estab. 1967. State Art Agency.
Offerings: Offers a full range of support for the arts in Colorado, from traditional folk artists to major art institutions. Publishes annual report and *Colorado Artist Newsletter* (monthly). **Offers COVisions Recognition Awards & Project Grants to acknowledge outstanding accomplishment in folk, media, visual and performing arts and literature. Supports innovative projects of high artistic merit.** For information contact: Daniel Salazar, Associate Director. Requirements: Colorado artists only. **Awards 32 grants, $160,000 yearly. Average grant: $4,000; length: 1 year.** Deadline for applicaton: folk, media and performing—October 15; visual—November 15; literature—December 15; project grants—June 15. Send for application form.

COMMUNICATING ARTS GROUP OF SAN DIEGO, INC., Suite F, 3108 Fifth Ave., San Diego CA 92103. (619)295-5082. Fax: (619)295-3822. Administrator: Ms. Sydney Cleaver. Estab. 1950. A networking group for those in the graphic art field.
Membership: Regular or full and Corporate memberships available. Open to professionals and students in graphic arts as well as related fields. Write or call for membership information.
Offerings: Holds monthly meetings, trade shows and exhibitions. Sponsors "the best contest of advertising/editorial art done in San Diego County." Publishes monthly newsletter, *Glimpse*, and an annual showbook, *Creative Show*. Publishes a directory of members for members only. Special programs include the Creative Show San Diego, a golf outing and a beach party. Also offers health insurance plan to members.

‡**COMMUNITY FINE ARTS CENTER**, 400 C, Rock Springs WY 82901. (307)362-6212. Fax: (307)382-4640. Director: Gregory Gaylor. Estab. 1966. "We curate a permanent collection of American Art original paintings dated 1892-present, belonging to the Rock Springs High School-School District #1. Includes paintings by Norman Rockwell, Rufino Tamayo, Edward Chavez, Elliot Orr, Loren McGiver, etc. We exhibit artists nationwide as well as area/regional artists."

Offerings: "We offer Youth Art Month for local school district; 1-3 workshops per year by regional working artists; Summer Art Camp for grades 4-6; Art Mobile which carries paintings from permanent collections by prominent artists to area school districts. Publishes Community Fine Arts Center Catalog. "We have 100 running ft. of wall exhibition space and approximately 2,000 sq. ft. of floor space. We give tours to regional area art museums and artists' lofts/studios—Denver, Salt Lake City." Affiliated with Rock Springs School District #1, the city of Rock Springs and Sweetwater County.

‡**CONNECTICUT VOLUNTEER LAWYERS FOR THE ARTS (CTVLA),** Connecticut Commission on the Arts, 227 Lawrence St., Hartford CT 06106. (203)566-4770. CTVLA Coordinator: Linda Dente. Estab. 1974. "Pro bono lawyer association made up of about 200 attorneys throughout Connecticut. The purpose of the CTVLA is to supply free legal help to Connecticut artists and arts organizations."
Membership: Eligibility requirements for artists to receive free legal help are: (1) The artist must be a Connecticut resident; (2) The artist's legal problem must relate to his/her work as an artist; or in the case of arts organizations, the problem must relate directly to the organization; (3) The artist must qualify financially by meeting standards set by the Connecticut Bar Association Committee on Arts and the Law. No fee or type of membership. Services are available; write or call about eligibility.
Offerings: "We provide benefits to artists, not to our members. We host conferences and workshops dealing with arts concerns and the law. These conferences are aimed at increasing artists' awareness of the laws pertaining to them."

‡**COUPEVILLE ARTS CENTER/PALETTES PLUS,** P.O. Box 171, Coupeville WA 98239. (206)678-3396. Fax: (206)678-7420. Director: Judy Lynn. Estab. 1987. "Our purpose is to 'enhance the arts learning experience.' We are a nonprofit organization producing workshops in painting, photography and fiber arts."
Membership: Membership available. Open to all. Currently has 325 members. Yearly dues: $25 General; $50 Sustaining; $75 Family; $100-249 Patron. Call or write for membership information.
Offerings: "Palettes Plus are workshops in visual arts, watercolor, oil, mixed media, colored pencil, paper-making, drawing and screen printing during the months of June, July, August, October and January. The Coupeville Arts Center is located on magnificent Whidbey Island Washington. We publish workshop brochures, an arts center brochure and periodic newsletters." **Offers scholarships to college and high school students to increase arts education.** For information contact: Judy Lynn, Director; Karen Erbland, Office Manager. Requirements: students only. **Average grant: $300; length: 1 week workshop.** Deadline for application: varies. Interested artists should send portfolio to CAC with return postage.

‡**CREATIVE ARTS GUILD,** 520 W. Waugh St., Dalton GA 30720. (706)278-0168. Fax: (706)278-6996. Executive Director: Ann Treadwell. Estab. 1963. Community arts agency specializing in the visual and performing arts. "The mission of the organization is to recognize, stimulate, encourage, and popularize creative excellence in the arts for the benefit of everyone in the community."
Membership: Membership available. Open to individuals, families and businesses. Currently has 1,094 members. Yearly dues: $15 senior citizens; $25 families/individuals; $100 businesses. Call or write for membership information.
Offerings: Offers a variety of visual arts, music and dance classes for children and adults; exhibition opportunities in both CAG galleries which change exhibits approximately every six weeks; a Performing Arts Live Series of performances by performing artists; a series of noontime concerts which are free to the public; variety of other programs, classes, concerts, exhibitions and special projects throughout the community; a large fall Festival of Arts and Crafts and a National Fiber Arts Competition/Exhibition. "We publish a newsletter each month; a calendar of events three times a year and other brochures and fliers for special projects; and class brochures about six times a year." **Sponsors Fall Festival of Arts and Crafts/National Fiber Arts Competition/Exhibition.** For information contact: Ann Treadwell, Executive Director. Requirements: all artists above the age of 18 are eligible to apply to be included in the Fall Festival of Arts and Crafts and the National Fiber Arts Competition/Exhibition. Has two galleries—one large space and one smaller auxiliary gallery. Send slides and résumés in care of Gallery Coordinator. "We are affiliated with the Georgia Council for the Arts, National Association of Local Arts Agencies, Georgia Association of Community Arts Agencies, Georgia Citizens for the Arts, etc."

‡**CREATIVE GROWTH ART CENTER,** 355 24th St., Oakland CA 94612. (510)836-2340. Fax: (510)836-2349. Executive Director: Irene Brydon. Gallery Manager: Bonnie Haight. Estab. 1974. Creative Growth Art Center is a nonprofit art studio/gallery for artists with disabilities—the gallery features the work of NAIVE, NAIF or outsider artists.

The double dagger before a listing indicates that the listing is new in this edition. New markets are often more receptive to freelance submissions.

Membership: Membership available. Open to all. Currently has 350 members. Yearly dues: $35. Call or write for membership information.
Offerings: Offers ongoing gallery exhibitions, gift shop for crafts, lectures and workshop. Publishes a newsletter, gallery announcements and occasional catalogs. Offers exhibition space for artists with disabilities and artist lectures and workshops. "Receives support from many other galleries and corporations. One of the country's leading organizations for artists with disabilities."

‡CROWLEY ART ASSOCIATION, 22 N. Parkerson, P.O. Box 2003, Crowley LA 70527-2003. (318)783-3747. Gallery Coordinator: Jean Oubre. Estab. 1976. Association to promote, support, encourage and advance the visual arts, crafts, artist and craftsmen in the area.
Membership: Membership available. Open to everyone. Currently has 220 members. Yearly dues: $10. Call or write for membership information.
Offerings: Holds monthly meetings, monthly programs, juried art shows, children's workshops, adult workshops, etc. Publishes monthly newsletters, yearbooks. CAA sponsors "The Gallery" which offers exhibition space. "Our organization is fun and informative and we give artists a chance to showcase their work."

‡DILLMAN'S CREATIVE ARTS FOUNDATION, Box 98, Lac Du Flambeau WI 54538. (715)588-3143. President: Dennis Robertson. Estab. 1978. DCAF was established to promote artistic development, act as a resource for cultural activity and provide art scholarships.
Offerings: Offers workshop scholarships to help cover workshop instruction. Awards up to 30 scholarships; $100 value a year depending on available funds. Average grant: $100; length: 5 teaching days. Deadline for application: May 1. Interested artists should request an application. All art leagues are offered a scholarship to be used for fund raising, etc. Offers exhibition space at Dillman's Lodge and local clinic. Send for brochure of workshops available. All workshops are in one location; a student has the opportunity for 24 hour studio time, instruction, meals, accommodations and sports recreation.

DUTCHESS COUNTY ARTS COUNCIL, 39 Market St., Poughkeepsie NY 12601. (914)454-3222. Fax: (914)454-6502. Executive Director: Sherre Wesley. Estab. 1964. "An arts service organization with a membership of 40 cultural organizations and 470 individuals. DCAC seeks to establish the Mid-Hudson Valley Region as one of the premier locations for high quality cultural activities in New York State."
Membership: "Membership is encouraged among artists and cultural organizations, educators and schools, professionals, nonprofit groups and all individuals interested in the arts." Yearly dues: Benefactor, $250; Donor, $150; Patron, $100; Supporter, $50; Contributor, $35; Friend, $25. Write or call for membership information.
Offerings: Holds annual membership meeting; other meetings are on an as-needed basis. "DCAC's technical assistance workshops cover a broad range of topics, such as graphics techniques, advocacy, grant writing, marketing and financial management." County Executive Arts Awards are given to individuals and institutions who contribute significantly to the artistic vitality of Dutchess County. Publishes *ARTSCENE*, a quarterly newsletter providing news and information about DCAC and regional arts issues and activities. *The Artists Skills Bank* lists regional artists by specialities and skills and the *Arts-in-Education Registry* lists artists and cultural organizations which sponsor or participate in educational programs. Other services include raising and regranting funds to support the arts programming of artists and cultural groups.

‡THE ELIZABETH FOUNDATION FOR THE ARTS, P.O. Box 2670, New York NY 10036. (212)956-6633. Fax: (212)956-6633. Director: Jane Stephenson. Estab. 1991. A not-for-profit foundation established to provide financial assistance to artists.
Offerings: Offers grants program for individuals in the visual arts. For information contact: J. Stephenson, Director. Requirements: professionals only with at least 6 years experience working primarily in painting, drawing, sculpture, print making or mixed media. **Awarded 13 grants, totaling $101,000 in 1992. Average grant: $8,000; length: maximum 1 year.** Deadline for application: May 1 (postmark). Interested artists should write for application form and guidelines. Offers 1 or more studio spaces in New York City for internationally selected artists.

‡FARMINGTON VALLEY ARTS CENTER, 25 Arts Center Lane, Avon CT 06001. (203)678-1867. Executive Director: Betty Friedman. Estab. 1972. "An Arts Center where 40 visual artists work in studios, 1,500 students take art classes, and the home of the Fisher Galley Shop featuring the finest in American craft."
Membership: Membership available. Open to all. Currently has 750 members. Yearly dues: $20-250. Write for membership information.
Offerings: Offers visual arts classes, gallery and shop and 20 studios for artists to rent (professional). "We're the only arts center of our size and scope in the region. A mecca for visual artists."

‡FRIENDSHIP ART WORKSHOPS, 1340 Neans Dr., Austin TX 78758. (512)834-9129. President: Patrick Conway. Estab. 1988. "We provide the highest level of art instruction in exotic locations at an easily affordable price."

Offerings: "We offer art workshops in Guadalajara, Chapala and Ajijic, Mexico featuring master artist instructors. Students are also introduced to the art and culture of Mexico." Offers summer and winter art "get-aways" which combine instruction with visits to museums, studios, theaters, etc. Contact for more information.

‡GEORGIA COUNCIL FOR THE ARTS, Suite 115, 530 Means St., Atlanta GA 30318-5793. (404)651-7926. Fax: (404)651-7922. Visual Arts Manager: Richard Waterhouse. Estab. 1976. "The Georgia Council for the Arts, a state agency, is designed to encourage excellence in the arts, to support its many forms of expression, and to make the arts available to all Georgians."
Offerings: Provides Individual Artist Grants to Georgia artists and the Artist-in-Education (AIE) Program (contact at (404)651-7931) which provides 3-18 week residencies in Georgia schools. Publishes annual *Individual Artists Guide to Programs*. **Offers Individual Artists' Grant Program to provide income for artists whose work demonstrates artistic merit and whose careers will potentially benefit from the completion of a project.** For information contact: Richard Waterhouse, Visual Arts Manager. Requirements: must be a resident of Georgia for at least one year; cannot be degree credit student at time of application or during the funding period. **Awards for fiscal year 1994: 81 total and 57 in Visual Arts for a total of $117,500. Average grant: $2,500; length: 1 year (July 1, 1995-June 30, 1996).** Deadline for application: April 1, 1995. Interested artists should call or write the Georgia Council for the Arts for grant guidelines after October 15, 1994. Grants Managers offer Individual Artist Grant Seminars during February 1995. Offers 2 exhibition spaces—Carriage Works Gallery and Governor's Office Exhibiton Series.

‡ADOLPH & ESTHER GOTTLIEB FOUNDATION, INC., 380 W. Broadway, New York NY 10012. (212)226-0581. Fax: (212)226-0584. Grants Manager: Jenny Gillis. Estab. 1976. "The Adolph and Esther Gottlieb Foundation is a nonprofit corporation registered with the State of New York. The Foundation was established according to provisions in the will of Adolph Gottlieb in order to award financial assistance to mature, creative painters, sculptors and printmakers. We provide financial suppport to individual artists who have shown a lifetime commitment to their art."
Offerings: Sponsors Individual Support Program and Emergency Assistance Program. Requirements: Both programs are for painters, sculptors and printmakers; each program has a maturity requirement and financial need element. **Awards in 1993: 49 emergency grant awards totalling $246,460 and 10 Individual Support grants of $20,000 each.** Deadline for application to Individual Support program: December 15. Interested artists should write to the foundation.

GRAPHIC ARTISTS GUILD, 11 W. 20th St., New York NY 10011-3704. (212)463-7730. Fax: (212)463-8779. Executive Director: Paul Basista. Estab. 1967. "A national union dedicated to uniting in its membership all persons engaged in the graphic arts professions, improving industry standards and improving the economic and social conditions of professional artists, designers and other creators of visual communication."
 • The Graphic Artists Guild, known simply as "The Guild" in design circles, publishes an excellent, frequently updated reference book, *Graphic Artists Guild Handbook, Pricing & Ethical Guidelines*, considered the most official overview of current pricing practices.
Membership: Membership available. Open to all professional graphic artists. At least 51% of income must be derived from artwork for full membership. Yearly dues: Regular or full, $110, $150, $195, $245; Associate, $105; Student, $55; One-time initiation fee, $25. Write or call for membership information.
Offerings: Holds monthly meetings at chapter levels. The first National Conference was in June 1992. Also sponsors activities at other conferences. Offers professional education geared toward business issues. Publishes *Graphic Artists Guild Handbook, Pricing & Ethical Guidelines*, *Graphic Artists Guild Directory of Illustration*, *National Guild News* (quarterly), and chapter *Updates*. Other services include legislative advocacy on health and copyright issues, legal and accounting referrals, insurance plans, a placement center, job referral network, a professional education program and artist-to-artist hotline. "The guild spearheaded 'Artists United for Universal Healthcare' to lobby for enactment of universal single payer health system. Also represents traditionally employed artists and designers for the purpose of collectively bargaining wages, hours and other conditions of work."

‡VIRGINIA A. GROOT FOUNDATION, P.O. Box 1050, Evanston IL 60204-1050. Estab. 1988. "We give grants to artists working in ceramic sculpture and sculpture." **Offers Virginia A. Groot Foundation Grant.** Requirements: must be age 21 and above, no students, ceramic sculpture and sculpture artists only. **Awards vary from year to year, usually $25,000 (one) and several smaller grants. Average grant length: 1 year.** Deadline for application: March 1. Interested artists should send SASE for an application form.

A bullet introduces comments by the editor of Artist's & Graphic Designer's Market *indicating special information about the listing.*

THE GUILD OF NATURAL SCIENCE ILLUSTRATORS, Box 652, Ben Franklin Station, Washington DC 20044. (301)309-1514. Administrative Assistant: Leslie Becker. Estab. 1968. A nonprofit organization for educational and professional scientific illustrators.
Membership: Membership available. Open to students, professional artists and individuals interested in the field of scientific illustration. "Potential members must have an interest in scientific illustration as a career and/or be employed in our field or an allied field; i.e., curator, instructor or exhibit (museum) worker." Yearly dues: regular or full membership, $40. Write for membership information.
Offerings: Holds meetings every month, except June, July and August. Sponsors 1 annual exhibit at the national meeting and a permanent traveling exhibit. Offers quarterly weekend workshops in Washington DC and a summer workshop for 2 weeks out of town. Awards are given at the national meeting. Publishes annual journal of scientific illustration and 10 newsletters/year. Publishes *Creative Source Directory* of members' work every 3 years.

‡**INDIANA ARTS COMMISSION,** Room 072, 402 W. Washington St., Indianapolis IN 46204. (317)232-1268. Fax: (317)232-5595. Director of Programs: Julie Murphy. Estab. 1969. "The Indiana Arts Commission is a state agency. As public catalyst, partner, and investor, the IAC serves the citizens of Indiana by funding, encouraging, promoting and expanding all the arts."
Offerings: Offers Arts in Education program which places professional artists in educational settings throughout Indiana in cooperation with the National Endowment for the Arts. Also sponsors the Visiting Artists Program to offer children and adults introductory arts experiences in an educational setting, providing funding to artists through funded sites for educational programs (up to $2,000). **Offers Individual Artist Fellowship (IAF) grants to assist artists with activities significants to their professional growth and recognition, or with the creation or completion of a project.** For information contact: IAC office. Requirements: must have lived in Indiana for one year preceding date of application. Craft, design, media, visual and visual folk artists are eligible to apply in odd-numbered years. Applicants must not have received a total of $10,000 through previous IAC fellowships. **Awards 20-25 fellowships/year. Awards fellowships of $5,000 each to professional artists; $2,000 each to emerging artists.** Average grant (1993): $3,576. Deadline for application: April 1. Also provides funding for projects sponsored by nonprofit organizations.

‡**INTERNATIONAL SOCIETY OF COPIER ARTISTS,** 800 West End Ave., New York NY 10025. (212)662-5533. Director: Louise Neaderland. Estab. 1981. "There are 110 contributing artist members and 40 institutional subscribers to the *I.S.C.A. Quarterly* of original xerographic art. The purpose is to promote the use of the copier as a creative tool and educate the public through exhibitions, lectures, slide shows and workshops."
Membership: Membership avilable. Open to artists who use the copier as a creative tool to make prints and book works. Applicant must submit 3 slides or samples of their Xerographic work. If accepted, annual membership fee is $30 in the Continental U.S. and $40 for foreign members. Each artist will receive four and must contribute work to at least two issues of the *I.S.C.A. Quarterly* in each year. Subscriptions are available for $90 per year (US) or $110 outside the US. Write or call for membership information.
Offerings: Board of directors meets once each year. Offers the traveling exhibition ISCAGRAPHICS of Xerographic prints and book works. Keeps major archives of related works. Holds workshops, lectures and slide shows on using the copier as a creative tool to produce prints and artists' books. Publishes *I.S.C.A. Directory of Xerographic Print and Bookmakers.*

‡**INTERNATIONAL SOCIETY OF MARINE PAINTERS,** P.O. Box 13, Oneco FL 34264. (813)758-0802. Fax: (813)755-1042. President: Jerry McClish. Estab. 1974. "We promote painting the marine scene. Exhibitions are held each year in museums or large art centers. No entry fee is charged and no ribbons or prizes are awarded."
Membership: Membership available. Open to associates with an interest in marine painting. Currently has 300 members. Yearly dues: $10 Associate; $20 Professional. Call or write for membership information.
Offerings: Offers workshops and museum grade exhibitions. Publishes a catalog of artist memberships and a quarterly newsletter, *Seascaper.* "We hold exhibitions at quality art centers and museums and an annual artist's breakfast yearly in Gloucester, MA. We are an international organization with members from several countries, Australia through Europe."

‡**IOWA ARTS COUNCIL,** Capitol Complex, 600 E. Locust, Des Moines IA 50319-0290.
Offerings: Offers artist mini grants and artist project grants to support artist projects and professional development opportunities. For information contact: Bruce Williams, Director of Creative Artist and Visual Arts. Requirements: Must be an Iowa resident, 18 years of age or older and not a student. **Awards 20-30 large artist project grants, 30-50 artist mini grants totaling $85,000. Average grant amount: $400 for mini; $3,000 for large project; length: 1 year.** Deadline for application: mini grants–6 weeks before beginning; large grants–January. Interested artists should send for application.

‡**THE JAPAN FOUNDATION,** 39th Floor, 152 W. 57th St., New York NY 10019. (212)489-0299. Fax: (212)489-0409. Program Assistant: Pensri Ho. Estab. 1972. "The Japan Foundation is a nonprofit organization whose objective is to promote international cultural exchange and mutual understanding between Japan and other

countries through the exchange of persons, support of Japanese studies, support of Japanese-language instruction, and arts-related exchanges."

Offerings: Offers Artists Fellowship Program to provide artists and specialists in the arts with the opportunity to pursue creative projects in Japan and to meet and consult with their Japanese counterparts. Requirements: Projects must be within the disciplines of humanities or the social sciences and must be related in substantial part to Japan. American citizens, American citizens temporarily residing abroad, permanent residents of the United States and those residing in the United States who are neither US citizens nor permanent residents are eligible. Japanese nationals, except those who have permanent residency in the United States, are not eligible to apply. **Awarded in '93/'94—5 awards totaling $115,484. Average grant length: 1-6 months.** Deadline for application: December 1. Interested artists should send for application available in September. "It is a very competitive and involved application process if does *not* facilitate arrangements in Japan. Affiliation in Japan is *required* and must be secured by applicant. There should be a valid reason for going to Japan, i.e., joint projects with Japanese artists, etc."

KANSAS CITY ARTISTS COALITION, 201 Wyandotte, Kansas City MO 64105. (816)421-5222. Executive Director: Janet Simpson. Estab. 1976. A nonprofit, visual arts organization that promotes contemporary art and artists; membership includes 500 plus artists and supporters.
Membership: Membership available. Open to all. Yearly dues: Regular, $40; Friend, $50; Patron, $100 and up; Forum only $20. Write or call for membership information.
Offerings: Holds solo, group, juried professional exhibitions at KCAC Gallery monthly. Sponsors various workshops in art and business, grant writing and slide taking. Publishes *Forum Magazine*, a visual arts journal. Also offers lectures, performance and installation arts. **Awards granted through juried exhibitions.**

KANSAS VOLUNTEERS FOR THE ARTS, % Susan Whitfield-Lungren, Box 780227, Wichita KS 67278-0227. (316)733-0791. Acting Director: Susan Whitfield-Lungren. Estab. 1987. Referral and information service for artists and arts organizations; not a membership organization.
Offerings: Has workshops and seminars on subjects such as contracts, copyright and taxes.

‡KENTUCKY FOUNDATION FOR WOMEN, 1215 Heyburn Building, Louisville KY 40202. (502)562-0045. Assistant to the Director: Pat Buster. Organization "to support Kentucky women who use the arts for social change—specifically, for equality for all women regardless of age, class, sexual preference or color.
Offerings: Publishes literary magazine, *The American Voice*. **Offers KFW Grants Program to promote social change through the arts; grants are given for feminist visual and performing artists, writers, filmmakers, feminist scholars.** For information contact: Pat Buster, Assistant to the Director. Requirements: Applicants must be residents of Kentucky or of area immediately adjacent to Kentucky in Indiana, Ohio, West Virginia or Tennessee. **Awards vary; "in 1993 we gave 28 grants totaling $148,000." Average grant: $4,000; length: 1 year.** Deadline for application: October 1. Interested artists should send for application form and guidelines. Visual and performing artists applications considered in odd-numbered years; writers and filmmakers considered in even-numbered years.

‡JOHN MICHAEL KOHLER ARTS CENTER, 608 New York Ave., P.O. Box 489, Sheboygan WI 53082-0489. (414)458-6144. Fax: (414)458-4473. Publicity Administrator: Patti Glaser-Martin. Contemporary, visual and performing arts center devoted to encouraging and supporting innovative explorations in the arts.
Membership: Membership available. Open to all. Currently has 1,300 members. Yearly dues: $25 individual; $35 family. Call or write for membership information.
Offerings: Offers temporary exhibitions of contemporary art and residency program. Publishes a bi-monthly newsletter and exhibition catalogs. **Offers Arts/Industry residency program to facilitate collaboration between art and industry.** For information contact: Lynne Shumow, Arts/Industry Coordinator. Deadline for application: August 1 of year preceding desired residency. Interested artists should call for application form.

LACE (LOS ANGELES CONTEMPORARY EXHIBITIONS), 6522 Hollywood Blvd., Hollywood CA 90028. (213)957-1777. Fax: (213)957-9025. Exhibitions Coordinator: Jinger Heffner. Performance/Video Coordinator: Tom Dennison. Estab. 1978. Nonprofit, multi-disciplinary arts organization.
Membership: Membership available. Open to all. Yearly dues: Regular, $35, $50, $100, $250; $20 for low-income, physically challenged, students, seniors. Write or call for membership information.
Offerings: "Benefits of membership include bimonthly calendar of events, discounts for performances, advance notice on competitions, etc." Holds 5 exhibitions/year, performances most weekends and 5-6 video exhibitions/year. Offers grant workshops, annual benefit art auction, symposia and workshops in concert with exhibitions. Sponsors competitions, 1 or 2 times a year. **Offers Artists' Projects Grants, a program "to support new projects which push the bounderies of contemporary art and challenge traditional formats."** Requirements: California and Hawaii residents only; no students. **Awards 6-8 grants totaling approximately $30,000/year. Average grant: $2,500-5,000; length: 1 year.** Holds open studio tours and other outside events. Also has a bookstore, a visual art gallery, performance theater and a video lounge. Each space is programmed by a curitorial committee. Please send SASE for guidelines.

Order Form

Start my 1-year subscription to **HOW** and send me the next 6 issues for just $39...a savings of more than $13 off the newsstand price. It's like getting an extra issue free!

☐ **Payment enclosed**

☐ **Bill me** **Charge my** ☐ Visa ☐ MC

Exp._____

Signature_____

NAME _____

COMPANY _____

JOB TITLE_____

ADDRESS _____

CITY_____STATE_____ZIP_____

IMPORTANT! Please take a moment to complete the following information.

Type of company (choose one):
1 ☐ Advertising agency 3 ☐ Design studio
4 ☐ Graphic arts vendor 2 ☐ Company
7 ☐ Educational institution 63 ☐ Other
(specify): _____

In Canada add $15 (includes GST); overseas add $22; airmail add $65. Remit in U.S. funds. Newsstand rate $52.90. Allow 4-6 weeks for first issue delivery.

Job title/occupation is (choose one):
16 ☐ Owner/management 22 ☐ Creative director 12 ☐ Art director/designer
13 ☐ Advertising/marketing staff
25 ☐ Instructor 19 ☐ Student
63 ☐ Other (specify):_____

SAVE MORE THAN $13!

HOW
THE BOTTOMLINE DESIGN MAGAZINE

T3AM2

‡LACHENMEYER ARTS CENTER, 700 S. Little St., P.O. Box 586, Cushing OK 74023. Director: Rob Smith. Estab. 1984. "We are a nonprofit fine arts center offering art classes to all ages. We also offer art shows and organize an annual arts festival. We have an art resource library and studio equipment available to the public."
Membership: Membership available. Open to anyone. Yearly dues: none.
Offerings: "We offer occasional workshops, 8-week art classes four times a year and 3 or 4 art shows a year. We publish four schedules a year containing our listings of shows, workshops and classes." Offers individual and group shows, classes and workshops. We are funded by the O.H. and Hattie Mae Lachenmeyer Development Trust. "The cost of our classes is a bargain."

LAWYERS FOR THE CREATIVE ARTS, Suite 411, 213 W. Institute Place, Chicago IL 60610. (312)944-2787. In Illinois (800)525-ARTS. Fax: (312)944-2195. Executive Director: Debra L. Quentel. Estab. 1972. Offers legal assistance and education to artists and arts organizations. Services available in English and Spanish.
Membership: Membership available. Assistance is available to all Illinois artists and arts organizations. Yearly dues: Individual, $20; Group, $100.
Offerings: Offers workshops and seminars. Topics include copyright for film/video and not-for-profit incorporation. Provides legal information over the telephone. Publishes *Copyright Basics for the Visual Artist* and many other publications. "Please contact for a publication list."

‡LINCOLN ARTS, 540 F St., P.O. Box 1166, Lincoln CA 95648. (916)645-9713. Arts Administrator: Angela Tahti. Estab. 1986. Organization "to support and promote affordable and accessible arts programs and services in the Lincoln area."
Membership: Membership available. Open to anyone interested. Currently has 400 members. Yearly dues: $10 individual; $20 family; $25 business/corporate. Call or write for membership information.
Offerings: Publishes bimonthly newsletter (for our members); books—*Wester Placer County According to History*, by G. Logan (Vols. I & II); *Feats of Clay: The Pottery & The City of Lincoln*, by history committee. **Sponsors Feats of Clay®, a national juried competition and celebratory exhibition of contemporary ceramic art.** For information contact: Dick Ketelle, Feats Chairman. **Grants vary as does funding—our purpose/ focus is arts in education and multicultural technical assistance. Average grant: $200.** Interested artists should contact for information or potential inclusion in Artists for Schools Residency Catalog. Offers classes and workshops—call for schedule. "We are an independent nonprofit organization with a gallery. We're located in a town of 7,900—our organization is doing remarkable things and our Feats of Clay® show draws national attention."

‡THE LOONIES (A Humor Salon), P.O. Box 20443, Oakland CA 94620. (510)451-6248. Contact: Barry Gantt. Estab. 1978. "We provide an informal and comfortable gathering place for writers, artists and creative types engaged in professional humor."
Membership: Membership available. (Not really "members" but affiliates) Open to all. Currently has 350 members. Yearly dues: none. Write for membership information (must send a long SASE).
Offerings: Offers ongoing networking salons—"that's all we do, so this is useful only for people who live in the Bay Area and environs." Publishes a flier announcing each meeting.

‡LOUISVILLE VISUAL ART ASSOCIATION "Louisville's contemporary visual arts center," 3005 Upper River Rd., Louisville KY 40207. (502)896-2146. Fax: (502)896-2148. Executive Director: John Begley. Estab. 1909. "Our mission is 'to foster an appreciation of today's visual art.'"
Membership: Membership available. Open to anyone. Currently has 2,200 members. Yearly dues: $10-500. Call or write for membership information.
Offerings: "We offer some cash awards for juried shows, 300 classes, consultation services, exhibition services, slide registries, and we act as fiscal agent to NEA Grant recipients." Publishes Visual Art Review, a quarterly newsletter. **Sponsors "Water Tower Annual" competition and "Showcase" competition.** For information contact: Al Gorman, Curator. Requirements: must live within 250 miles of Louisville; for Showcase: must not have exhibited the piece within the last 2 years in Louisville, must not have been in Showcase last 2 years. **Average award: $100.** Interested artists should send for prospectus; ask for info about both shows. Offers more than 300 classes annually. Affiliated with Louisville's "Fund for the Arts" foundation "We're Louisville's oldest and foremost contemporary art organization. We also have a sales and rental gallery located in downtown Louisville's Galleria Mall where we accept work on consignment and maintain an artist slide registry. For more information call gallery manager Joyce Emery at (502)581-1445."

‡LOWER EAST SIDE PRINTSHOP, INC., 59-61 E. 4th St., New York NY 10003. (212)673-5390. Director: Mary Ann Wadden. Estab. 1968. Not-for-profit organization providing printmaking facilities, instruction and printing services to artists of all ages.
Membership: Not a membership organization. Activities are open to any artist interested in printmaking with varying levels of experience. Write or call for membership information.
Offerings: Offers a variety of workshops—silkscreen, monoprint, photo processes, etching and lithography, a poster program for other nonprofits and affiliated individuals. "We also provide affordable printing facilities

for individual artists through the Artist Workspace Program and fund small/unique edition projects for artists in the Special Editions Program."

‡THE MACDOWELL COLONY, INC., 100 High St., Peterborough NH 03458. (603)924-3886. Fax: (603)924-9142. Contact: Admissions Coordinator. Estab. 1907. "MacDowell is the oldest and largest artist colony in the U.S. providing writers, composers, visual artists, photographers, printmakers, architects and filmmakers a place where they may work uninterrupted. Interdisciplinary and collaborating artists are welcome."
Offerings: Pubilshes a newsletter and an annual report. **Offers artist residency.** For information contact: Admissions Coordinator. Requirements: talent is the only criteria for admission. **Awards about 200 residencies annually including room and board and use of private studio. Length of residency: up to 2 months.** Deadline for application: January 15, April 15, September 15. Interested artists should send for application form.

‡MAIN LINE ART CENTER, Old Buck Rd. & Lancaster Ave., Haverford PA 19041. (610)525-0272. Director: Judy Herman. Estab. 1937. Nonprofit educational art center devoted to teaching and exhibiting visual arts.
Membership: Membership available. Open to anyone. Currently has 900 members. Yearly dues: adults $30. Call or write for membership information.
Offerings: Offers workshops and classes in all visual arts areas; exhibition opportunities with cash prizes for many shows. Publishes a newsletter and a brochure of classes. Offers ample gallery space for juried/curated exhibits. Offers 5 sessions of workshops and classes annually. "We're a community art center where emerging artists can gain recognition for their work."

‡MAINE CRAFTS ASSOCIATION, P.O. Box 228, Deer Isle Maine 04627. (207)348-9943. Executive Director: Carolyn A. Hecker. The Maine Crafts Association is a nonprofit membership organization open to anyone with an interest in craft. Its purpose is to advance interest in and appreciation for crafts and Maine craftspeople by representing and promoting the highest quality in contemporary and traditional work.
Membership: Membership available. Open to anyone. Currently has 800 members. Yearly dues: range from $20 (citizens and students); $1,000 (sponsors). Call or write for membership information.
Offerings: Offers workshops, seminars, exhibitions, slide registry, library, resource and referral services, teacher registry, members' shop, Portland Craft Show (annual juried craft fair). Publishes bimonthly newsletter, *Maine Cultural Guide.* Offers workshops to enhance technical skills as well as business and marketing practices. Offers health and liability insurance plans. "MCA strives hard to be a strong advocate for the craft artist—heightening public awareness and making important connections."

‡MARYLAND LAWYERS FOR THE ARTS, INC., 2nd Floor, 218 W. Saratoga St., Baltimore MD 21201-3528. (410)752-1633. Executive Director: Delma Wickham-Smith. Estab. 1985. Primarily provides free legal assistance to income-eligible Maryland artists and arts organizations. Referral fees: $20 individual, $50 group or organization, $100 nonprofit incorporation.
Membership: Membership available. Open to anyone interested in the arts. Yearly dues: $20 artist; $35 individual; $50 organization; $15 student; $100 corporation. Write or call for membership information.
Offerings: Arts & Entertainment Law Resource Library, seminars and speakers' bureau. Publishes a newsletter/arts entertainment law journal. Offers assistance with copyright, contracts and other issues affecting arts and entertainment law.

‡MASSACHUSETTS DIVISION OF FISHERIES & WILDLIFE, One Rabbit Hill Rd., Westboro MA 01581. (508)792-7270. Fax: (508)792-7275. Chief, Information & Education: Ellie Horwitz. Estab. 1865.
Offerings: Holds 2 competitions: Waterfowl Stamp Contest and Archery and Primitive Firearms Stamp Contest. For information contact: Ellie Horwitz, Chief, Information & Education. Deadline for application: waterfowl stamp—July 31; archery stamp—May 31. Interested artists should send for regulations.

‡MICHIGAN GALLERY, 2661 Michigan St., Detroit MI 48216. (313)961-7867. Executive Director: Carl Kamulski. Estab. 1973.
Purpose: "Promotes the visual and performing arts, and when possible, the literary arts in Michigan."
Membership: Membership available. Open to all. Yearly dues: Associate, $25; affiliate, $75; student, $25. Write or call for membership information.
Offerings: Holds monthly board meetings and semiannual general meetings. Holds 18-24 exhibitions of local, national and international artists. Offers 120 workshops and seminars/year on subjects such as raku, bronze pour, life drawing. Publishes *MG Quarterly*, a monthly newsletter. Sponsors 36 performances/year—poets, bands, dance. **Offers awards or contest through exhibition underwriters such as art materials manufacturers and corporations.**

MICHIGAN GUILD OF ARTISTS AND ARTISANS, 118 N. Fourth Ave., Ann Arbor MI 48104. (313)662-3382. Director: Mary C. Strope. Estab. 1971. "A nonprofit membership organization of artists, providing marketing, educational and other services to individual artists and crafts persons."

Membership: Membership available. Open to all artists and artisans in the US and Canada. Yearly dues: $45. Write or call for membership information.
Offerings: Holds monthly meetings for board and committees. Exhibitions are held in a member gallery in downtown Ann Arbor. Offers educational workshops and referrals, eligibility for low cost health insurance and discounts on craft magazines, car rental, motels, art supplies. Now offering wholesale referral program. Holds 3 (juried) art fairs, a 3-day workshop featuring Bruce Baker and a workshop on the business of being an artist. Publishes bimonthly *Limited Editions* newsletter and the *Guild Membership Directory*.

MIDWEST WATERCOLOR SOCIETY, 111 W. Washington Blvd., Lombard IL 60148. No central office; for general information call (708)629-0443. Estab. 1976. Organization "to preserve the integrity of transparent watercolor by sponsoring an annual juried national exhibition at a midwestern museum, and an annual workshop. Members, no entry fee; non-members, $15. Submit 2 slides. Limit one acceptance. Three show acceptances within 10 years qualifies artist to receive MWS letters.
Membership: Membership available. Open to anyone 18 or older in the US and Canada. Yearly dues: $25, brings newsletter, no entry fee, show catalog, voting rights, advance registration for annual workshop. Dues 12/31-12/31, no pro-rating; life membership $300. Payable from October 1 to December 31. Send $25 check payable to MWS, to Cathy Paprocki, Membership—635 E. Stark Dr., Palatine IL 60067. Prospectus for upcoming national show available January 1, send SASE to Fortunato, MWS, 249 N. Martin St., Palatine IL 60067.
Offerings: Sponsors annual juried national show of transparent watercolor only to be held at Neville Public Museum, Green Bay, WI; July 15-September 24, 1995 and July 20-September 22, 1996. Holds awards banquet and demo by workshop instructor. **Gives approximately $5,000 in awards,** Skyledge $1,000. Annual 5 day workshop in conjunction with show opening, by nationally known painter, open to nonmembers.

***NATIONAL ASSOCIATION FOR THE VISUAL ARTS,** P.O. Box 60, Potts Point, New South Wales, 2011 Australia. (02)368-1900. Fax: (02)358-6909. Contact: Artists Unit. Estab. 1983. National advocacy and lobbying organization for the visual arts.
Membership: Membership available. Open to all involved in the visual arts. Yearly dues: Regular or full, $A27; Associate, $A20. Write or call for membership information.
Offerings: Publishes the *Nava Newsletter*, *Professional Practice Kits*, *Money for Visual Artists*. Offers research programs and publishes directory entitled *Who's Who of Australian Visual Artists*.

‡NATIONAL ASSOCIATION OF ARTISTS' ORGANIZATIONS, Suite 611, 918 F St. NW, Washington DC 20004. (202)347-6350. Fax: (202)347-7376. Executive Director: Helen M. Brunner. Estab. 1982. "A national nonprofit service organization dedicated to serving, promotion and protecting artists' organizations. Artists' organizations are the primary presenters and supporters at new and evolving work in the visual, performing, media, literary and interdisciplinary arts."
Membership: Membership available. Open to artists' organizations, related art organizations, artists, art professionals from every region of the US. Currently has more than 650 members. Yearly dues: vary with type of membership. Call or write for membership information.
Offerings: NAAO publishes a detailed directory of its membership every two years. The most recent directory also includes a critical assessment of the field and its evolution, NAAO also publishes *Bulletin* a bimonthly newsletter which is included in membership, free once to non-members. *Organizing Artists: A Document and Directory of the National Association of Artists' Organizations*, is also included in membership and is $25 for non-members.

‡NEW ENGLAND FOUNDATION FOR THE ARTS, #801, 678 Massachusetts Ave., Cambridge MA 02139. (617)492-2914. Fax: (617)876-0702. Contemporary Arts Coordinator: BJ Larson. Estab. 1976. A regional organization developing the arts in New England with funding from the National Endowment for the Arts, the 6 New England state arts agencies and leading corporations and foundations.
Offerings: "The New England Foundation for the Arts offers support for artists of all disciplines through 2 grant programs for visual artists, apprenticeship programs for traditional artists, a touring roster for performing artists, a national jazz network, sponsorship of conferences and workshops for technical assistance to artists, and ongoing research on arts policy issues." Publishes *Directory of Native American Artists*, *Artists Trust Newsletter*, *Annual Report Guide to Programs* and *Jazz Radio Newsletter*. **Offers Artists' Projects: New Forms, Regional Fellowships in the Visual Arts; to offer direct or financial support for new artists projects and recognition for consistant excellent work of serious artists.** For information contact: BJ Larson, Contemporary Arts Coordinator. Requirements: must be residents of Connecticut, Maine, Massachusetts, Rhode Island, New Hampshire or Vermont at time of application; not available to students, or recipients of a NEA fellowship since 1984; **Average grant: $2,000-5,000.** Deadline for application: "usually in the spring." Interested artists should send for application forms. "NEFA is a valuable information resource for artists."

‡NEW JERSEY STATE COUNCIL ON THE ARTS, CN 306, Trenton NJ 08625. (609)292-6130. Fax: (609)989-1440. Grants Coordinator: Steven R. Runk. Estab. 1966. "Agency of New Jersey state government supporting the arts through fellowships, grants, programs and services to artists, arts organizations and arts projects."

Offers: Fellowship support, Organization Grants (arts organizations/projects) and Artists in Education — artist residencies. Publishes *Report to the Field*, a quarterly newsletter. **Offers fellowship support to provide artists with support to continue producing new work.** Contact: Steven R. Runk, Grants Coordinator. Must be New Jersey resident; no high school or college students in an undergraduate, matriculated program; cannot be a recipient in past three years. **Awards 65-75 awards/year; annual amount varies $400,000-500,000/ year. Average grant $500-12,000; length: 1 year.** Deadline for application: December 15 annually. Interested artists should request application, complete and return with specified support material.

‡**NEW MEXICO ARTISTS' ASSOCIATION,** Suite 239B, 1801 Rodeo Rd., Santa Fe NM 87505. (505)982-5639. Fax: (505)473-4718. Director: Winona Garmhausen, Ph.D. Estab. 1987. Organization "to provide quality arts instruction on a private basis to persons wishing to study with a Santa Fe artist."
Membership: Membership available. Open to qualified Santa Fe artists. Currently has 52 members. Yearly dues: none. Call or write for membership information.
Offerings: "We offer qualified Santa Fe area artists the opportunity to share their expertise with a wide range of artist/students and thereby supplement their incomes and broaden their base of domestic and foreign exposure."

‡**NEW YORK FOUNDATION FOR THE ARTS,** 155 Avenue of the Americas, New York NY 10013. (212)366-6900, ext. 212. Fax: (212)366-1778. Director of Communications: David Green. Estab. 1971.
Offerings: Publishes *FYI,* a quarterly newsletter of practical information (subscription, $5). **Offers fellowships to enable artists to complete work and residencies in schools.** For information contact: Mark Bradford (fellowships), Anne Holder (residencies). Requirements: must be resident of New York State. **Awards 120 $7,000 fellowships and gives 65-70 grants to schools for residencies.** Deadline for fellowship application: October 18. Interested artists should send for application. Offers seminars. Operates Arts Wire, a national online communications network for the arts community.

‡✹**NEWFOUNDLAND & LABRADOR ARTS COUNCIL,** P.O. Box 98, St. John's, Newfoundland A1C 5H5 Canada. (709)726-2212. Fax: (709)726-0619. Executive Director: Randy Follett. Estab. 1980. The Newfoundland and Labrador Arts Council is a nonprofit organization whose purpose is to foster the arts of the province by carrying on financial assistance programs and by working with government and the community for development in the arts. **Offers Project/Sustaining Grants. Sustaining Grants are available to professional arts organizations to provide assistance towards their administrative costs with a guaranteed minimum grant for a three-year period. Project Grants support production costs, operating costs, travel costs and study costs relating to a specific project to be undertaken by an artist, arts group or organization.** For information contact: NLAC office. Requirements: must be 18 years of age; must be Canadian citizen or landed immigrant; must have been a resident of Labrador or Newfoundland for minimum of 1 year at time of application. **Awards 135 Project Grants totaling $193,479. Average grant: $1,500. Length: varies.** Deadline for application: April 15, September 15, January 15. Interested artists should send for application.

‡**NORTHWOOD UNIVERSITY ALDEN B. DOW CREATIVITY CENTER,** 3225 Cook Rd., Midland MI 48640-2398. (517)837-4478. Fax: (517)837-4468. Executive Director: Carol B. Coppage. Estab. 1978. "The Alden B. Dow Creativity Center offers four fellowships each summer for individuals in any field or profession, including the arts, humanities and sciences, who wish to pursue an innovative project or creative idea."
Offerings: Offers Alden B. Dow Creativity Center Fellowship Awards. "This Fellowship allows each Fellow the freedom to pursue his/her own creative, innovative project through independent, non-scheduled study." Requirements: The program structure requires the maturity to work independently and live cooperatively. Foreign citizens must demonstrate ability to communicate in written and spoken English. **Awards include travel to and from Midland, Michigan, room and board, plus a $750 stipend to be applied to project materials and/or personal expenses. Average grant length: 8 weeks.** Deadline for application: December 31.

NOVA (New Organization for the Visual Arts), Suite 410, 4614 Prospect Ave., Cleveland OH 44103. (216)431-7500. Executive Director: Janus Small. Estab. 1972. Provides professional support through year-round services, special programs and advocacy for professional visual artists and friends of the arts.
Membership: Open to all. Write or call for membership information.
Offerings: Offers workshops and seminars on topics such as art marketing, censorship, legal and business questions and other topics of concern to visual artists. Publishes *NOVA Quarterly,* newsletter; *Artist as a Self-Employed Person* (Vols. I, II and III); and *Presenting Art: Practical Guidelines for Artist and Exhibit Sponsors.* Offers Northeastern Ohio Artists' Slide Registry and Artists' Information Resources.

OCEAN STATE LAWYERS FOR THE ARTS (OSLA), Box 19, Saunderstown RI 02874-0019. (401)789-5686. Executive Director: David M. Spatt, Esq. Estab. 1984. Rhode Island affiliate of the nationwide Volunteer Lawyers for the Arts network providing free and reduced fee legal counsel to artists and arts organizations, as well as lectures, seminars and workshops.
Offerings: "Counsel only offered on questions of law regarding arts and entertainment, i.e. copyright, contract, etc." Offers workshops on such topics as copyrights, contracts and collection of overdue accounts.

Publishes *OSLA Arts & Laws*, quarterly newsletter providing legal information of interest to artists, entertainers and arts organizations.

ORGANIZATION OF INDEPENDENT ARTISTS, Suite 402, 19 Hudson St., New York NY 10013. (212)219-9213. Fax: (212)219-9216. Estab. 1976. "A nonprofit organization providing artists with exhibition opportunities in public spaces throughout New York City—OIA also provides artists with a range of support services designed to help get their work out to the public." Represents emerging and mid-career artists. Interested in emerging artists. "We have about 1,000 artists in our slide registry." Sponsors 15 shows/year. Average display time 1 month. Office is open Tuesday, 1-7; Wednesday, Thursday and Friday, 1-5.
Membership: Membership available. Open to all professional artists and affiliates. Currently has 652 members. Yearly dues: $30. Call or write for membership information.
Offerings: Sponsors artist curated exhibitions in public spaces, Warren Tanner Memorial Art Fund; active slide registry of members work; Resource Center Slide Night for members; Eye on Art Program (where collectors and critics visit private collections, alternative spaces and OIA member artists' studios); mailing list service—mailing list on sale of 1,100 names of press, critics, professionals, galleries, corporate collectors. There is an annual fee of $30 to be in the slide registry, but artists need not be in the registry to be in the exhibitions. Publishes quarterly newsletter (*OIA NEWSLETTER*) and Eye on IA brochure.

‡**PALENVILLE INTERARTS COLONY**, P.O. Box 59, Palenville NY 12463. (212)254-4614. Director: Joanna Sherman. Estab. 1983. Artist colony.
Offerings: Offers studio space, living space and meals for 1-8 weeks. Some residencies are subsidized. Most artists pay something. Beautiful, secluded, Catskill Mountains. Multi-disciplinary. Requirements: open to emerging and established artists of all disciplines, including performance, visual and literary arts. Deadline for application: April 1. Interested artists should send for application. Offers dance studio, theater, 5 visual arts studios, 4 writers spaces.

‡**PASTEL SOCIETY OF AMERICA**, 15 Gramercy Park S., New York NY 10003. (212)533-6931. President: Flora B.Giffuni. Estab. 1972. The Pastel Society of America is a professional association of elected artists who all work in the Pastel medium. Their aims are to set standards of excellence, and to encourage the use of Pastel; to establish separate Pastel categories in major art exhibitions, with jurors qualified to evaluate Pastels, and prizes commensurate with the quality of work; to focus attention on the renaissance of Pastel, and educate the public regarding the permanence and beauty of the medium.
Membership: Membership available. Open to artists working with soft pastels. Currently has 600 members. Yearly dues: $40, Full Membership; $30, Associate.
Call (Wednesday-Friday, 10-5) or write for membership information.
Offerings: Offers awards and scholarships; ongoing classes in pastel yearround; a slide registry of members' work for referral; yearly open exhibition in September at the National Arts Club. Publishes *Pastelagram* (newsletter) twice a year in January and June. **Awards scholarships to further the study of pastels.** For information contact: Flora Giffuni, President. Requirements: must work in soft pastels. **Awards 30 scholarships (as well as awards) totaling $20,000. Average grant length: 1-2 weeks.** Deadline for application: April. Interested artists should contact Christina Debarry, Chairman, Scholarship—Pastel Society of America. Gives yearly exhibition in Grand Gallery at National Arts Club and various museums. Offers workshops in September; classes year round. Gives discounts on pastels and paper to members. "We're the largest and oldest pastel society in US."

‡❋**PEI COUNCIL OF THE ARTS**, P.O. Box 2234, 94 Great George St., Charlottetown, Prince Edward Island C1A 8B9 Canada. (902)368-4410. Fax: (902)368-4418. Executive Director: Judy MacDonald. Estab. 1974. Organization "to promote the enjoyment of, participation in and accessibility to the Arts, for all people throughout the province."
Membership: Membership available. Open to everyone. Yearly dues: $15. Call or write for membership information.
Offerings: Offers a resource center, rental space, artists' network, promotion, funding assistance and special activities such as speakers and seminars. Publishes a monthly art calendar and a quarterly newsletter. **Offers grants to assist both individuals and organizations working in any of the art disciplines.** For information contact: Libby Sears, Promotions Assistant. Requirements: must be a Canadian citizen or landed immigrant and a resident of PEI for 6 of the last 12 months. **Maximum grant amount: $3,000 individual; $6,000 organization; $1,000 travel/study.** Deadlines for application: April 30, September 15, December 15. Interested artists should send for application.

‡**PENNSYLVANIA WATERCOLOR SOCIETY**, P.O. Box 626, Mechanicsburg PA 17020. Estab. 1979. Nonprofit organization "to promote the art of watercolor to artists and general public, to expose watercolor to the public."
Membership: Membership available. Open to all watercolorists. Currently has 500 members. Yearly dues: $20. Has associate members and accredited members (who must be accepted into 2 PWS juried shows within 8 years). Write for membership information.

Offerings: Offers yearly national juried exhibition; member non-juried exhibit workshops; video and slide library for members; educational facilities. Publishes a quarterly newsletter. Sponsors national juried watercolor exhibition to attract top watercolorists. Show held in a different college, university or gallery each year in Pennsylvania. For information contact: Lyn Marsh, Exhibit Chair. Requirements: all watermedia, under plexi-glass. Interested artists should send for information. Holds 5-day spring watercolor workshop. "Our exhibitions are top-notch and accreditation is valued."

‡**PINELLAS COUNTY ARTS COUNCIL**, 400 Pierce Blvd., Clearwater FL 34616. (813)464-3327. Fax: (813)464-4608. Support Services Director: Joyce Barnett. Estab. 1976. "Designated the official local arts agency of Pinellas County, The Arts Council is dedicated to establishing the arts as a vital part of the county's infrastructure through the growth and development of programs and services to the arts, government and the community at large."
Membership: Membership available. Open to anyone. Yearly dues: $25. Call or write for membership information.
Offerings: Publishes *Florida Festivals, Who, What, When, Where*, a 16-month listing of all arts and craft shows in state of Florida; updated annually; includes listings from September-December of following year. Includes contact name/address; date of show and entry deadline; entry fees; prize money; show location; artistic media accepted.

‡**PRINTED MATTER, INC.**, 77 Wooster St., New York NY 10012. (212)925-0325. Fax: (212)925-0464. Director: David Dean. Estab. 1976. Organization to foster the dissemination, appreciation and understanding of artists' publications.
Membership: Membership available. Open to all. Yearly dues: $50 and up. Call for membership information.
Offerings: Offers distribution and retailing of artists' publications. Sponsors events, exhibition, a reading room. Publishes events listings and catalogs.

PUBLIC ART WORKS, Box 150435, San Rafael CA 94915-0435. (415)457-9744. Estab. 1979. A small nonprofit organization that commissions artists to create works for public spaces.
● Note that Public Art Works does not buy or fund completed artwork.
Membership: Commission competitions are open to all professional artists working in media appropriate to large scale (usually outdoor) artworks (both temporary and permanent installations). Write/call to be included on competitions mailing list.
Offerings: Publishes annual catalog and newsletters. Sponsors education and community outreach programs.

‡**RESOURCES & COUNSELING FOR THE ARTS**, 429 Landmark Center, 75 W. Fifth St., St. Paul MN 55102. (612)292-4381. Fax: (612)292-4515. Manager of Artists' Services: Chris Osgood. Estab. 1978. "Nonprofit arts service with a 4-person staff. RCA is a source of information, training and affordable counseling for artists on the business and career aspects of the arts."
Membership: Not a membership organization. "Fee for service is currently $20/hour of counseling." Write or call for information.
Offerings: Gives a quarterly series of workshops, including grantwriting, copyright, marketing for artists, career planning, tax preparations. Publishes *Guide to Grants for Minnesota Artists*; *Guide to Exhibition and Gallery Spaces in Minnesota*; *Artwork: Opportunities in Arts Administration*; *Handbook For Minnesota Artists*. Offers one-to-one business counseling. "RCA administers The Dayton Hudson Artist Loan Fund, a revolving low-interest loan Fund For Twin Cities area artists."

‡**ROCKEFELLER FOUNDATION/BELLAGRO STUDY & CONFERENCE CENTER**, 420 Fifth Ave., New York NY 10016. (212)852-8431. **Offers a residency program.** Requirements: Established artists only—no students, no beginners. **Pays room and board.** Interested artists should send for brochure for more information.

‡**ST. TAMMANY ART ASSOCIATION**, 129 N. New Hampshire, Covington LA 70433. (504)892-8650. Director: Don Marshall. Estab. 1958. Organization "to support and promote education and communication through the language of the arts."
Membership: Membership available. Open to all. Currently has 800 members. Yearly dues: $20 individual; $30 family. Call for membership information.
Offerings: Offers changing exhibitions of contemporary artists; annual arts festival; classes for adults and children; educational outreach programs on African Art and Native American Art. Publishes *Art Pages*, a newsletter. Studio space is available. Gives regular workshops in crafts; sponsors artist forum lecture series. "We provide a showcase for professional artists in the region and numerous programs for public schools."

‡**SALEM ART ASSOCIATION**, 600 Mission St. SE, Salem OR 97302. (503)581-2228. Executive Director: David Cohen. Estab. 1939. "The Salem Art Association is a nonprofit community organization dedicated to furthering the creation, understanding and appreciation of art, to collect, preserve and present works of art, to support and encourage artists, to encourage broad public participation in and enjoyment of art, art educa-

tion, and historical programs, and the preservation of local history as it relates to the Bush House Museum and the Bush family."

Membership: Membership available. Open to all. Currently has 1,200 members. Yearly dues: $25 individual or artist; $30 family; $125 business. Write for membership information.

Offerings: "The Salem Art Association has two exhibition galleries and a sales gallery. Exhibits are changed monthly. SAA offers classes for beginners and advanced students in ceramics, weaving, spinning, painting, drawing and more. Children's classes are also available. SAA runs a tri-county arts-in-education program, an historic mansion museum, and puts on the Salem Art Fair & Festival each year. Membership offers a 10% discount on gallery purchases and classes, SAA publications and free admission to Bush House Museum as well as other Salem Historic Houses." Publishes biannual newsletter, monthly exhibit announcements and quarterly class schedules. "Membership supports our year round exhibition and education programs. It is an opportunity to support and be involved in the arts at a community level."

‡**SAN LUIS OBISPO ART CENTER,** 1010 Broad St., P.O. Box 813, San Luis Obispo CA 93406. (805)543-8562. Executive Director: Carol Dunn. Estab. 1958. "A membership-based visual arts center with a mission to provide and promote ongoing diversity of visual arts experience through education, inspiration, expression and interaction."

Membership: Membership available. Open to all. Currently has 750 members. Yearly dues: individual $20; participating artist fee $10. Write for membership information.

Offerings: Offers ongoing exhibition opportunities for artist members; regional artists call for entries for major Gray Wing Gallery Shows; Guest Artist Lecture Series; demonstrations and workshops monthly; adult and children's art classes and special annual events promoting artists. Publishes monthly newsletter; each of the five artist groups also print monthly or bimonthly newsletters. **Sponsors high school competition to grant scholarship money to junior or senior high school students based on artistic merit.** For information contact: Carol Dunn, Executive Director. Requirements: must be high school junior or seniors and show portfolio. **Awards 6 scholarships totaling $1,100.** Deadline for application: May 7. Interested artists should send for application. "We're a unique art center with a base of artist members as the core."

SECOND STREET GALLERY, 201 Second St. NW, Charlottesville VA 22902. (804)977-7284. Director: Sarah Sargent. Estab. 1973. "A nonprofit arts organization that serves the artistic community and the public at large through exhibitions of contemporary art by regional and national emerging and established artists. Sponsors education programs and workshops."

Membership: Membership available. Open. Write or call for membership information.

Offerings: Holds exhibitions of contemporary art. Offers workshops on grant writing and artist seminars. Sponsors juried shows, such as Recent American Works on Paper. Publishes a quarterly newsletter, *The Second Glance,* and special exhibition catalogs. Also offers The Photography Review and Sunday Night Reading Series.

THE SOCIETY FOR CALLIGRAPHY & HANDWRITING, Box 31963, Seattle WA 98103. Contact: Secretary. Estab. 1975. "To promote interest and knowledge in the artform of beautiful lettering."

• A sponsor of "Soundings" the 16th annual International Calligraphy Conference, to be held in 1996.

Membership: Membership available. Approximate current membership: 150. Yearly dues: $20. Write for membership information.

Offerings: Conducts monthly meetings, sponsors 1 exhibition/year and 3-4 workshops/year. Publishes newsletter 3 times/year and membership directory, available only to members.

SOCIETY OF ILLUSTRATORS OF LOS ANGELES, 116 The Plaza Pasadena, Pasadena CA 91101. (818)952-SILA (7452). Director: Monica Heath. Estab. 1955. Organization "to maintain and advance the highest standards of professionalism in illustration in the service of the communities of art and humanities."

Membership: Membership available. Open to illustrators and persons allied to illustration. Regular member applications must undergo a portfolio review. Yearly dues: Regular, $100; Associate, $100; Intermediate, $42.50-72.50; Student, $30. Write or call for membership information.

Offerings: Holds monthly meetings. Sponsors Illustration West exhibition. Presents awards at Illustration West. Conducts benefit surveys. Organizes workshops or seminars. Publishes *Medium.* "We are able to supply a list of illustrators based on their specialties." **Offers SILA student scholarship awards to fund students in illustration careers.** Contact Monica Heath, Executive Director. Must be a student full time – illustration majors in their junior year; apply through school department head.

‡**SOCIETY OF PUBLICATION DESIGNERS,** Suite 721, 60 E. 42nd St., New York NY 10165. (212)983-8585. Fax: (212)983-6043. Director: Bride Whelan. Estab. 1966.

Membership: Membership available. Open to anyone interested in the publication design field. Yearly dues: Individual, $175; Corporate membership available. Call or write for membership information.

Offerings: Holds monthly Speakers Evenings featuring graphic artists and art directors of special interest to publication industry; annual black tie awards gala at the New York Public Library; publication design

competition (call for entries in January and exhibition of award-winning entries in September at Art Directors Club, NY). Publishes *Grids*, a monthly newsletter and *Publication Design Annual*, winners of annual competitions. Sponsors photography and illustration portfolio shows for young editorial artists. Membership list of 2,000 names is available for $150.

‡SOUTHERN ARTS FEDERATION (SAF), Suite 400, 181 14th St. NE, Atlanta GA 30309. (404)874-7244. Fax: (404)873-2148. Visual & Media Arts Coordinator: Lisa Richmond. Estab. 1975. "Nonprofit, regional arts agency dedicated to providing leadership and support to affect positive change in all art forms throughout the South."
Membership: Open to state arts councils.
Offerings: Offers annual SAF/NEA Retional Visual Arts Fellowships, in painting, drawing, works on paper, artists' books, sculpture, crafts and photography. Catalogs of fellowship recipients' work appear in major national pubilcation such as *American Craft*, *Sculpture* and *Aperture*. **Offers Regional Visual Arts Fellowship to encourage artistic development and bring recognition to southern artists of merit.** For information contact: Lisa Richmond, Visual & Media Arts Coordinator. Requirements: must be resident of Alabama, Florida, Georgia, Kentucky, Louisiana, Mississippi, North Carolina, South Carolina or Tennessee; no students. **Awards 30 grants at $5,000 ($150,000 total awarded); length: 1 year.** Deadline for application: January. Interested artists should write for application form.

‡SUBURBAN FINE ARTS CENTER, 777 Central Ave., Highland Park IL 60035. (708)432-1888. Executive Director: Ann Rosen. Estab. 1960. "We are an independent, not-for-profit organization. We endeavor to further develop community understanding and awareness of the visual arts. We focus on an extensive arts education curriculum for artists and art students of all ages. We host monthly exhibits in our gallery and in the Highland Park City Hall Rotunda Gallery."
Membership: Membership available. Open to everyone. Currently has 800 members. Yearly dues: $15 senior; $25 individual; $35 Family. Call for membership information.
Offerings: Offers exhibitions, either group or individual shows on a monthly basis. "We have teaching opportunities in a 10 week class session or on our Saturday workshop series, (2-4 hour sessions). We publish a quarterly class brochure, a biannual newsletter, monthly exhibit opening announcements. Artist should submit slides of their work along with an artist statement to our gallery committee for review. We have an extensive list of workshops, classes, exhibit competitions and lectures; please call or write for further information. We provide exhibition possibilities, teaching opportunities, slide registry of members' slides, classes and artist resource center."

‡SUMTER GALLERY OF ART, P.O. Box 1316, Sumter SC 29151 or 421 N. Main St. Sumter SC 29150. (803)775-0543. Executive Director: Mary Jane Caison. Estab. 1969. "The object of the Sumter Gallery of Art shall be to promote the visual arts and to increase and diffuse the knowledge and appreciation thereof; to maintain in the City of Sumter a Gallery of Art; to collect, to preserve and to exhibit objects of artistic interest to the public."
Membership: Membership available. Open to everyone. Currently has 350 members. Yearly dues: $25 Individual; $40 Family; $100 Patron; $250 State-of-the-Art; $500 Benefactor; $1,000 Angel. Call or write for membership information.
Offerings: Offers 9-10 temporary visual arts exhibits a year; two permanent collections of works by Elizabeth White; a touchable exhibit for the blind and visually impaired; exhibition galleries; art school and gift shop housed in the Elizabeth White house which is listed on the National Register of Historic Places; exhibition and sales opportunities for artists; and a thriving volunteer program. Nonprofit organization. Publishes a quarterly newsletter. Exhibiting artists are chosen by committee. Offers a 9 month art school; 1 week art camp; workshops (1 day) offered throughout year. Affiliated with the Sumter Artists Guild (sister organization). "Few museums exist in towns the size of Sumter which offer such comprehensive programs. Support is sought and needed from art patrons everywhere."

TEXAS ACCOUNTANTS & LAWYERS FOR THE ARTS, 1540 Sul Ross, Houston TX 77006. (713)526-4876. Contact: Program Director. Estab. 1979. "TALA provides free legal and accounting services to arts organizations and low-income artists in Texas."
Membership: Membership available. Open to all. Artists' net income must not exceed $15,000. Problem must be art-related. Yearly dues: Organization, $25; Artist, $20. Call or write for membership information.
Offerings: Holds art-related legal/accounting seminars (tax, copyright, etc.) on a regular basis. Publishes *Art Law and Accounting Reporter* (quarterly journal) and seven booklets on art-related legal or accounting matters. Other services include estate planning for artists and arts and resolution services.

‡TEXAS SCULPTURE ASSOCIATION, 2360 Laughlin Dr., Dallas TX 75228-6841. (817)458-7590. President: Jerry Daniel. Estab. 1983. "Nonprofit organization to provide sculptors opportunities to exhibit, learn and share artistic visions with the general public and to promote sculpture and develop more public awareness of sculpture."

Membership: Membership available. Open to any person, artist, gallery, institution or company. Currently has 200 members. Yearly dues: $30 Active; $20 Student; up to $1,000 Associate. For membership information call Jerry Daniel, (817)458-7590 or write Beth Brown, Membership, 5110 Vickery Blvd., Dallas, TX 75214.
Offerings: Sponsors Annual Member's Show—Trammell Crow Center, Dallas; Annual juried exhibits—Plaza Of The Americas Gallery, Dallas; annual Outdoor Sculpture Competition—State Fair of Texas at Dallas Civic Garden Center (other exhibits, tours, workshops set with annual calendar). Publishes *T.S.A. News*, a newsletter, six times a year, member's show catalog and directory and catalogs of various juried exhibits. Awards cash and honorariums in selected exhibits (amounts vary). For information contact: Annie Davis, Board of Director—Programs/Workshops (214)437-3250.

© 1985 Reynaldo Hernández

Reynaldo Hernández painted "Tribute to a United Community" to enhance the United Community Center in Milwaukee, an organization serving the city's Hispanic community. The outdoor mural showcases activities and services of the center, showing "the colorful cultural diversity and unity of the Hispanic community, emphasizing the importance of culture and education."

TOLEDO VOLUNTEER LAWYERS FOR THE ARTS, Suite 1523, 608 Madison Ave., Toledo OH 43604. (419)255-3344. Executive Director: Arnold N. Gottlieb. Estab. 1988. Offers legal services to individuals and organizations on art related issues. Membership not available.
Offerings: No meetings. Offers periodic seminars on legal rights and responsibilities, taxation, contracts, copyrights, etc. Other services include a lending library.

‡**TOPEKA & SHAWNEE COUNTY PUBLIC LIBRARY GALLERY OF FINE ARTS,** 1515 W. 10th, Topeka KS 66611-1374. (913)231-0527. Fax: (913)233-2055. Gallery Director: Larry Peters. Estab. 1873. Organization "to promote the visual arts within the community and county (especially contemporary arts) for the enjoyment and entertainment of the public."
Membership: Membership available. Open to anyone. Currently has 2,000 members. Yearly dues: various categorits. Write for membership information.
Offerings: Sponsors Topeka Competition for originality and excellence of art. For information contact: Larry Peters, Gallery Director. Requirements: must be resident of Kansas, Oklahoma, Colorado, Iowa, Missouri or Nebraska. **Awards 6-8 prizes totaling $2,000. Average award: $150-200.** Interested artists should

send for application form. Holds 8-9 changing shows per year. Offers insurance. Affiliated with the Topeka & Shawnee County Public Library.

‡TOUCHSTONE CENTER FOR CRAFTS, R.D. 1, Box 60, Farmington PA 15437. (412)329-1370. Executive Director: Julie K. Greene. Estab. 1972. "Residential arts facility whose mission is to advance excellence in arts and crafts through week-long and weekend workshops featuring master level artists from all across the US."
Membership: Membership available. Open to anyone interested in supporting the arts. Currently has 569 members. Yearly dues: range from individual ($20) to corporate ($200). Call or write for membership information.

‡TULSA ARTISTS' COALITION, Box 3515, Tulsa OK 74101. (918)838-7893. Editor: Janice McCormick. Estab. 1985. A coalition of approximately 65 multi-disciplinary contemporary artists and art supporters.
Membership: Membership available. Open to artists—visual, theatrical performers, writers, musicians, dancers—and art supporters. "Although others are not excluded, members tend to be emerging artists working in non-traditional forms." Yearly dues: Individual, $25; family, $35. Write for membership information.
Offerings: Holds monthly meetings. Sponsors exhibitions and performances: Embellishments—wearable art, performance show and sale are semi-regular; Annual Creations (late November/early December)—visual arts for sale; Phoenix Project—features performance art. Uptown Underground—a weekly series of poets and performers (actors, imrov and musicians) presenting original work, in a coffeehouse environment, features open mike. Irregularly presents workshops depending on members' concerns. Publishes *The Eidotrope*, a monthly newsletter containing artist opportunities, arts events in Tulsa, reviews of current shows, performances and exhibits. Also has an artist's resource library. Holds monthly gallery shows in TAC's "Alternatives" Gallery. Opened new performance space in June 1993. Gives Members' Annual Art Auction and Membership party.

‡UNITED COMMUNITY CENTER/GALLERY OF THE AMERICAS, 1028 S. Ninth, Milwaukee WI 53204. (414)384-3100. Artistic Director: Elma G. Radke. Estab. 1970. Organization "to serve the Hispanic community of Milwaukee through a host of various educational, health and social programs."
Membership: Membership available. Open to general community. Call or write for membership information.
Offerings: "We publish a quarterly newsletter, a calender of events brochure and recently we've completed our first art exhibition catalog." Offers a 30×40' exhibition space and auditorium with seating. Gallery tours, lectures, workshops, and art classes are featured attractions. Offers insurance coverage for participants of art exhibitions. "We've conducted collaborative events with various institutions throughout the Milwaukee area. The cultural arts department functions to provide Hispanic culture, awareness and self esteem."

‡UTAH ARTS COUNCIL, 617 E. South Temple, Salt Lake City UT 84102. (801)533-5895. Artist's Services: Tay Haines. Estab. 1880s. A state arts agency. Programs include visual arts, folk arts, funding resources, literary arts, design arts, arts in education, artists services.
Membership: Open to Utah residents only.
Offerings: UAC Annual Conference offers artist's workshops. **Offers Artist Grants, $500; Visual Arts Fellowships (2/year), $5,000 cash; literary publication prize, $500.** Requirements: must be Utah resident for one year; professionals only. Interested artists should send for application form.

VAGA (VISUAL ARTISTS & GALLERIES ASSOCIATION), 45th Floor, 1133 Avenue of the Americas, New York NY 10036. Executive Director: Robert Panzer. (212)840-1805. Fax: (212)840-1925. Estab. 1976. "An artists' membership society and copyright collective, licensing reproduction rights in the US and worldwide through affiliates worldwide."
Membership: Membership available. Open to artists, galleries and art consultants. Yearly dues: New, $75; Renewal, $50; Estate, $100; Estate Renewal, $75; Gallery, $300. Call or write for information.
Offerings: Protects artists' copyrights and provides advice concerning copyright and artists' rights issues. Provides art licensing and reproduction rights clearance and royalties collection for artists. "VAGA is a member of CISAC, an international council of copyright societies, and through VAGA's affiliations, members are promoted and protected worldwide." Provides lobbying power to ensure that the legal rights of artists remain protected. Promotes members works for reproduction. Maintains a slide library of fine art for licensing purposes. Maintains dialogue with galleries, museums, publishers and other art related businesses concerning art issues.

‡VERMONT COUNCIL ON THE ARTS, Drawer 33, 136 State St., Montpelier VT 05633-6001. (802)828-3291. Estab. 1964. "The VCA is the state arts agency. Our mission is to advance the arts in Vermont for the benefit of all."
Membership: Membership available. Open to anyone. Currently has 1,300 members. Yearly dues: vary. Call or write for membership information.

Offerings: Offers fellowships, artist development grants, project grants, Slide Bank Touring and Arts in Education Roster. Publishes *Artsletter*, a newsletter including opportunity listings (bimonthly), an Annual Report and Artist Register Handbook. **Offers a fellowship to recognize exceptional work by Vermont artists.** For information contact: Grants Officer. Must be a Vermont resident, 18 or older; no students. **Awards approximately 8 fellowships at $3,500 each, totaling $28,000; length: 1 year.** Deadline for application: March 1. Interested artists should request handbook with guidelines and application. Project grants and artist development grants are also available. The VCA maintains a roster of performing artists for touring and artists to work in the schools. Offers occasional technical assistance workshop on marketing, grant writing, increasing access, etc. "The VCA is a strong advocate for artists and arts issue on the state and national level."

‡**VERMONT STATE CRAFT CENTER AT FROG HOLLOW,** 1 Mill St., Middlebury VT 05753. (802)388-3177. Marketing: Linda Baker. Estab. 1971. "The Vermont State Craft Center at Frog Hollow is a nonprofit visual arts organization dedicated to promoting awareness and excellence of fine crafts and hand-made art through education, advocacy and exhibition."
Membership: Membership available. Open to anyone. Currently has 600 members. Yearly dues: $25-100. Call or write for membership information.
Offerings: Holds exhibitions, classes (scholarships available) and workshops. Publishes a newsletter (3 times a year). Sponsors one national show a year and several exhibitions for Vermont artists. Offers craft classes and workshops for all ages and skill levels. Must be Vermont resident to be an exhibitor.

‡**VERY SPECIAL ARTS NEVADA (VSAN),** 200 Flint St., Reno NV 89501. (702)329-1401. Fax: (702)329-1328. Executive Director: M.E. Horan. Estab. 1986. "We provide hands-on visual and performing art programs for populations with special needs and the general public."
Offerings: VSAN hires professional artists who can conduct hands-on workshops with children and adults with special needs and the general public. Publishes a quarterly newsletter. Affiliated with Very Special Arts in Washington DC.

‡**VOLCANO ART CENTER,** P.O. Box 104, Hawaii National Park HI 96718. (808)967-8222. Fax: (808)967-8512. Executive Director: Marilyn Nicholson. Estab. 1974. "Nonprofit educational institution located within Hawaii Volcanoes National Park, with the purpose of promoting, developing and perpetuating the artistic and cultural heritage of Hawaii's people and environment through activities in the visual, literary and performing arts."
Membership: Membership available. Open to everyone. Currently has 750 members. Yearly dues: $25-500. Call or write for membership information.
Offerings: Maintains a fine arts and crafts gallery featuring the work of member artists. Exhibits change monthly. Offers classes and workshops in visual, performing and literary arts. Presents musical concerts and theater productions. Hosts many special events. Publishes *Volcano Gazette* bi-monthly; sent to members and available at distribution points on the island of Hawaii. Operates a multi-roomed exhibition space and gallery. Offers classes, workshops, lectures and demonstrations in visual, literary and performing arts. Operates gallery under a cooperative agreement with the National Park Service. "Our focus is on art inspired by or reflective of the unique volcanic/rainforest region."

VOLUNTEER LAWYERS FOR THE ARTS, Sixth Floor, 1 E. 53rd St., New York NY 10022. (212)319-2787. Executive Director: Daniel Y. Mayer, Esq. Estab. 1969. VLA operates a legal hotline for any artist or arts organization that needs quick answers to arts-related questions. Call (212)319-2910. "Organization to provide the low-income arts community with free legal assistance and education. Conferences and publications provide artists and arts organizations with easy-to-understand information on art law issues. Also works to protect artists' rights. Referrals available to volunteer lawyer organizations nationwide."
Membership: Membership available. Open to VLA volunteer lawyers. Yearly dues: Associate, $50. Sustainer, $100; Special Member, $150. Call or write for information.
Offerings: Members receive invitations to special events, conferences, workshops; access to VLA Arts Law Library; discounts on publications; subscriptions to *Columbia-VLA Journal for Law and the Arts*; and discounts on seminars.

‡**WAKE VISUAL ARTS ASSOCIATION,** 112 E. Hargett St., Raleigh NC 27601. (919)828-7834. Executive Director: Deborah Hancock. Estab. 1980. "A nonprofit art organization and gallery that sponsors exhibitions, workshops, lectures, classes, receptions and other events."
Membership: Membership available. Open to all. Currently has 400 members. Yearly dues: $45 artist; $20 student, $25 supporting; up to $500 Benefactor. Call or write for membership information.
Offerings: Offers life drawing workshop as well as additional announced workshops. Publishes *Expressions*, a monthly newsletter containing information about gallery events, member achievements and other pertinent information for members. All members may exhibit work for all shows. Offers workshops in life drawing and photography; critiques, lectures and receptions. Work is insured when on exhibit. Offers discount for supplies. We give aspiring, emerging and professional artists opportunities.

‡**WASHINGTON SCULPTORS GROUP,** 2909 Brandywine St. NW, Washington DC 20028. (202)686-5285. President: Joan Danziger. Estab. 1983. "A service organization for sculptors, designed to promote awareness of sculpture."
Membership: Membership available. Open to anyone with an interest in sculpture. Currently has 280 members. Yearly dues: Regular, $30. Call or write for membership information.
Offerings; Holds regular meetings 9-10 months/year. Exhibition commitee holds 2 exhibits/year. Offers an occasional artist apprenticeship program. Publishes a list of members of the Washington Sculptors Group.

‡**WESTERN STATES ARTS FEDERATION (WESTAF),** 236 Montezuma Ave., Santa Fe NM 87501. (505)988-1166. Fax: (505)982-9207. Contact: Visual Arts Program. Estab. 1974. "Western States Arts Federation is a private not-for-profit corporation serving as a regional consortium of the western state arts agencies of Alaska, Arizona, California, Colorado, Idaho, Montana, Nevada, New Mexico, Oregon, Utah, Washington and Wyoming. It promotes artists and arts organizations through national programs and special programs and services designed to support the unique regional needs of the vast and varied West."
Offerings: Gives organizational support for presentation of WESTAF/NEA regional fellowship recipients for US nonprofit organizations. Distributes catalog of fellowship work, free to US nonprofits, for sale to others. Publishes *Technical Production Handbook; Building for the Arts*; *Artjob*; WESTAF's biweekly newsletter (subscription) of professional opportunities in the arts. **Awards WESTAF/NEA Regional Fellowships for Visual Artist to honor outstanding artistic achievement by artists living and working in the WESTAF region, to recognize exceptional work that is an expression of contemporary ideas.** Contact: Visual Arts Program, WESTAF. Requirements: an applicant must be a professional artist, a citizen or legal resident of the United States, and a resident of the region served by WESTAF from the application deadline (March 10) through the panel review period (May 31). NEA fellowship recipients (in last 4 years) and full-time students pursuing college or university degrees are not eligible. **Awards 30 fellowships, $5,000 each. Average grant: $5,000.** Deadline for application: March 1. Interested artists should call or write WESTAF in September of the year before you want to apply. **Organizational support grants are made to US nonprofits (up to $1,000 per artist) to exhibit or otherwise present the work of fellowship recipients.** Holds "It's Easy Seminars," technical assistance to New Mexico artists in art business and marketing.

WOMEN IN DESIGN/CHICAGO, Suite 2400, 400 W. Madison, Chicago IL 60606. (312)648-1874. President: Susan Emanuel. Estab. 1977. A locally based, nonprofit organization. "We focus on the goals and interests of women designers and women in design related professions." Promotes greater recognition of women's contributions to design.
Membership: Membership available. Open to anyone. Currently has 400 members. Yearly dues: Regular, $50; Corporate, $160; Patron, $400; Student/Retired, $25. Call or write for information.
Offerings: Sponsors monthly programs. Publishes bimonthly newsletter and annual membership directory. *Job Source* listings published monthly; call or write for application; available free to members, fee for nonmembers. Provides information on professional issues, women's political agendas and issues, and advancements in technology. Sponsors Woman of the Year Award and Friend of Women in Design award.

‡**WOMEN IN DESIGN/LOS ANGELES,** 1875 Oak Tree Dr., Los Angeles CA 90041. (213)251-3737. Contact: Membership Chairperson. Estab. 1977. Professional organization of 250 designers, artists, illustrators, art directors and others.
Membership: Membership available. Open to professionals and students, "those interested in our networking, educational programs and special events." Currently has 150 members. Yearly dues: Regular, $65; Student, $30. Call or write for membership information.
Offerings: Holds 2 meetings/month. Holds hands-on studio visits, networking potlucks and biannual seminar on career-building techniques. Frequent design competitions for materials publicizing events and organization. Publishes *Women in Design Network. Women in Design/LA Directory* includes members' names, addresses, phones, specialties. Special programs include Portfolio Night, Résumé Night.

WOMEN IN THE ARTS FOUNDATION, INC., % R. Crown, 1175 York Ave., New York NY 10021. (212)751-1915. Executive Coordinator: Roberta Crown. Estab. 1971. "WIA is working to overcome discrimination against women artists. Through meetings, newsletters, education programs, negotiations with museums, galleries and collectors, WIA works to change outdated concepts and attitudes regarding women as professional artists. WIA has provided opportunities for women to exhibit work and has addressed unfair jurying practices. We also provide information about networking to help women function effectively as professional artists."
Membership: Membership available. Open to women in the visual arts, or those interested in the arts. Regular membership, $40. Call or write for membership information.
Offerings: Conducts monthly meetings. Sponsors approximately 3-4 exhibitions a year and monthly workshops. Newsletter published quarterly—$9/yearly ($15 institutions).

‡**WOMEN IN THE DIRECTOR'S CHAIR,** #202, 3435 N. Sheffield, Chicago IL 60657. (312)281-4988. Fax: (312)281-4999. Program Director: Dalida Maria Benfield. Estab. 1980. "Not-for-profit media arts organiza-

tion dedicated to exhibiting and promoting films and videos by women who reflect a diversity of cultures and experiences."

Membership: Membership available. Open to anyone. Yearly dues: Full, $25; Student, $15; Two-year-full, $40. Call or write for membership information.

Offerings: "There are regularly scheduled meetings which allow members to discuss their ideas, show works in progress and obtain feedback and creative support from peers." Hosts the International Women Film and Video Festival. "Members are entitled to discounts on special screenings, seminars and workshops." Publishes newsletter providing members with information on upcoming events, news, etc.

WOMEN'S STUDIO WORKSHOP, Box 489, 722 Binnewater Rd., Rosendale NY 12472. (914)658-9133. Executive Director: A.E. Kalmbach. Estab. 1974. A not-for-profit educational studio (printmaking, book arts, letterpress, papermaking, darkrooms).
Membership: Membership available. Open to all. Regular or Full, $35. Send SASE for membership information and application guidelines.
Offerings: Holds intensive week-long and weekend workshops in all aspects of printmaking, papermaking and bookarts. **Awards grants for book artists to come and work in residence (with stipend) or simply to produce a new work.** Gives competitive fellowships for reduced fee studio rentals and student internships. Studios are available year-round for artists projects.

‡**WYOMING ARTS COUNCIL,** 2320 Capitol Ave., Cheyenne WY 82002. (307)777-7742. Fax: (307)777-5499. Director: John Coe. Estab. 1967. "The mission of the Wyoming Arts Council is to enhance Wyoming's quality of life and thus its long-term cultural and economic strength by encouraging and supporting diversity, access, vitality and excellence in the arts."
Membership: Open to Wyoming residents.
Offerings: Offers fellowships in visual arts, literature and performing arts, given once a year; individual artist project grants; organization grants to nonprofits; artist Registry Slide Bank for residents of Wyoming; Wyoming Arts Council Gallery, exhibits Wyoming artists; Arts in Education artist residencies. Publishes *All Arts Newsletter* 10 times a year; Fellowship Exhibition catalog published every two years; Annual Report published yearly. **Awards fellowship in visual arts, literature and peforming arts to encourage individuals in their work.** For information contact: Wyoming Arts Council Office. Requirements: Wyoming Arts Council programs and grants are designated for residents only and nonprofit organizations in the state. **Awarded $383, 661 in 1993. Average grant: 1 year.** Deadlines for application: February 15, March 1, August 1, September 1. Interested artists should call Arts Council Office and indicate if they are individual or applying for an organization. Contact individual program managers for area of interest. Offers Wyoming Arts Council Gallery to show living and working artists in Wyoming only. Holds Artspeak Conference with emphasis for individual artists once a year. Affiliated with the Parks & Cultural Division of the Commerce Department of the State of Wyoming."If an artist lives in Wyoming, the Arts Council provides valuable resources, contacts to organizations in and out of the state."

Organizations/'94-'95 changes

The following organizations were listed in the 1994 edition but do not have listings in this edition. They did not respond to our request to update their listings.

American Institute of Graphic Arts (AIGA)
American Society of Architectural Perspectivists
Art Directors Club of

Cincinnati
ASMP Chicago Midwest Center
Association of Hispanic Art (AHA), Inc.

Center for Safety in the Arts
Detroit Artists Market
San Diego Lawyers for the Arts
Seattle Design Association
Society of Newspaper Design

Publications of Interest

Artist's & Graphic Designer's Market recommends the following publications as valuable sources that will help in your freelancing efforts, assist you in staying informed of market trends, or provide you with additional names and addresses of art buyers. A few offer advertising opportunities for artists. Most are available either in a library or bookstore or from the publisher.

Directories

AMERICAN SHOWCASE, *14th Floor, 915 Broadway, New York NY 10010. (212)673-6600. Annual hardcover directory of illustrators. Most often used by art directors and artist representatives to find new talent.*

ART NOW GALLERY GUIDE, *97 Grayrock Rd., P.O. Box 5541, Clinton NJ 08809. (908)638-5255. Monthly guide listing galleries by region. Also publishes international guide.*

AUDIO VIDEO MARKETPLACE, *R.R. Bowker, A Reed Reference Publishing Co., 121 Chanlon Rd., New Providence NJ 07974. (908)464-6800. Annual directory listing audiovisual companies and related services.*

CREATIVE BLACK BOOK, *Black Book Marketing, Inc., 866 Third Ave., New York NY 10022. (212)702-9700. Annual directory listing illustrators, photographers, printers and service houses. Also publishes regional directories.*

CREATIVE ILLUSTRATION BOOK, *Black Book Marketing, Inc., 866 Third Ave., New York NY 10022. (212)702-9700. Annual directory of illustration.*

ENCYCLOPEDIA OF ASSOCIATIONS, *Gale Research Co., 835 Penobscot Building, Detroit MI 48226-4094. (313)961-2242. Annual directory listing active organizations.*

FINE ART INDEX, *International Art Reference, 159 W. Burton Place, Chicago IL 60610. (312)335-8219. Biannual hardcover directory listing national and international contemporary fine artists and galleries.*

GRAPHIC ARTISTS GUILD'S DIRECTORY OF ILLUSTRATION, *Serbin Communications, 511 Olive St., Santa Barbara CA 93101. (805)963-0439. Annual directory of illustration.*

LITERARY MARKET PLACE, *R.R. Bowker, A Reed Reference Publishing Co., 121 Chanlon Rd., New Providence NJ 07974. (908)464-6800. Annual directory listing book publishers and related services.*

O'DWYER'S DIRECTORY OF PUBLIC RELATIONS FIRMS, *J.R. O'Dwyer Company, Inc., 271 Madison Ave., New York NY 10016. (212)679-2471. Annual directory listing PR firms, indexed by specialties.*

RSVP, *The Directory of Illustration and Design, P.O. Box 314, Brooklyn NY 11205. (718)857-9267. Annual directory in which designers and illustrators can advertise their services. Most often used by art directors seeking new talent.*

STANDARD DIRECTORY OF ADVERTISING AGENCIES (The Redbook), *National Register Publishing, A Reed Reference Publishing Co., 121 Chanlon Rd., New Providence NJ 07974. (908)464-6800. Annual directory listing advertising agencies.*

STANDARD RATE AND DATA SERVICE (SRDS), *3004 Glenview Rd., Wilmette IL 60091. (708)256-6067. Monthly directory listing magazines, plus their advertising rates and related information.*

Magazines

ADVERTISING AGE, *Crain Communications, 740 N. Rush St., Chicago IL 60611. (312)649-5200. Weekly trade tabloid covering the ad industry.*

ADWEEK, *Adweek Magazines, 1515 Broadway, New York NY 10036. (212)536-5336. Weekly advertising and marketing magazine. Also publishes annual directory of ad agencies.*

ART CALENDAR, *P.O. Box 199, Upper Fairmont MD 21867. (410)651-9150. Monthly magazine listing galleries, juried shows, percent-for-art programs, scholarships and art colonies, plus other art-related articles.*

ART IN AMERICA, *Brant Publications, Inc., 575 Broadway, New York NY 10012. (212)941-2800. Monthly magazine covering national and international news and issues relating to the fine art world. Also publishes annual Guide to Museums, Galleries and Artists (August issue).*

THE ARTIST'S MAGAZINE, *F&W Publications, Inc., 1507 Dana Ave., Cincinnati OH 45207. (513)531-2222. Monthly magazine for fine artists, illustrators and cartoonists. Features how-to articles on techniques and business issues.*

ARTNEWS, *Artnews Associates, 48 W. 38th St., New York NY 10018. (212)398-1690. Magazine published 10 times/year covering the latest issues in national and international fine art, plus reviews and other feature articles.*

ARTWEEK, *Suite 520, 12 S. First St., San Jose CA 95113. (408)279-2293. Biweekly magazine covering fine art issues, galleries and other events on the West Coast.*

BILLBOARD, *1515 Broadway, New York NY 10036. (212)536-5055. Weekly magazine covering the music industry.*

COMMUNICATION ARTS, *Box 10300, 410 Sherman Ave., Palo Alto CA 94303. Magazine published 8 times/year covering design, illustration and photography.*

DECOR, *Commerce Publishing Co., 330 N. 4th St., St. Louis MO 63102. (314)421-5445. Monthly trade magazine for gallery owners and gallery directors. Also publishes an annual buyers' guide directory.*

EDITOR & PUBLISHER, *The Editor & Publisher Co. Inc., 11 W. 19th St., New York NY 10011. (212)675-4380. Weekly magazine covering latest developments in journalism and newspaper production. Publishes annual directory issue listing syndicates and another directory listing newspapers.*

FOLIO, *Cowles Business Media, Box 4949, 911 Hope St., Stamford CT 06907-0949. (203)358-9900. Biweekly magazine featuring trends in magazine circulation, production and editorial.*

GIFTWARE NEWS, *Talcott Communications Corp., 3405 Empire State Bldg., New York NY 10118. (212)629-0819. Monthly trade magazine covering the giftware and paper products industry.*

GREETINGS MAGAZINE, *Mackay Publishing Corp., 309 Fifth Ave., New York NY 10016. (212)679-6677. Monthly trade magazine covering the greeting card and stationery industry.*

HOW, *F&W Publications, Inc., 1507 Dana Ave., Cincinnati OH 45207. (513)531-2222. Monthly magazine for graphic design professionals.*

PARTY & PAPER RETAILER, *4Ward Corp., 70 New Canaan Ave., Norwalk CT 06850. (203)845-8020. Monthly magazine covering the giftware and paper products industry.*

PRINT, *RC Publications, 9th Floor, 104 Fifth Ave., New York NY 10011. (212)463-0600. Bimonthly magazine focusing on creative trends and technological advances in illustration, design, photography and printing. Also publishes Regional Design Annual featuring the year's best in design and illustration.*

PUBLISHERS WEEKLY, *Cahners Publishing Co., 249 W. 17th St., New York NY 10011. (212)463-6758. Weekly trade magazine covering industry trends and news in book publishing, book reviews and interviews.*

SOUTHWEST ART, *CBH Publishing, Suite 1440, 5444 Westheimer, Houston TX 77056. (713)850-0990. Monthly magazine covering fine arts in the Southwest.*

STEP-BY-STEP GRAPHICS, *Dynamic Graphics Inc., 6000 N. Forest Park Dr., Peoria IL 61614. (800)255-8800. Bimonthly magazine featuring step-by-step demonstrations for electronic designers and illustrators.*

UPPER & LOWER CASE (U & lc), *International Typeface Corp., 866 Second Ave., New York NY 10017. (212)371-0699. Quarterly publication covering the latest in typography and issues relating to type designers.*

Glossary

Acceptance (payment on). The artist is paid for his work as soon as the buyer decides to use it.

Adobe Illustrator®. Drawing and painting software.

Adobe PhotoShop®. Photo manipulation program.

Advance. Amount paid to an artist before beginning work on an assigned project. Often paid to cover preliminary expenses.

Airbrush. Small pencil-shaped pressure gun used to spray ink, paint or dye to obtain gradated tonal effects.

Aldus Freehand. Illustration software.

Aldus PageMaker. Page layout software.

Art director. In commercial markets, the person responsible for choosing and purchasing artwork and supervising the design process.

Biennially. Occurring once every two years.

Bimonthly. Occurring once every two months.

Biweekly. Occurring once every two weeks.

Book. Another term for a portfolio.

Buy-out. The sale of all reproduction rights (and sometimes the original work) by the artist; also subcontracted portions of a job resold at a cost or profit to the end client by the artist.

Calligraphy. The art of fine handwriting.

Camera-ready. Art that is completely prepared for copy camera platemaking.

Capabilities brochure. A brochure, similar to an annual report, outlining for prospective clients the nature of a company's business and the range of products or services it provides.

Caption. See gagline.

CD-ROM. Compact disc read-only memory; non-erasable electronic medium used for digitized image and document storage and retrieval on computers.

Collateral. Accompanying or auxiliary pieces, such as brochures, especially used in advertising.

Color separation. Photographic process of separating any multi-color image into its primary component parts (cyan, magenta, yellow and black) for printing.

Commission. 1) Percentage of retail price taken by a sponsor/salesman on artwork sold. 2) Assignment given to an artist.

Comprehensive. Complete sketch of layout showing how a finished illustration will look when printed; also called a comp.

Copyright. The exclusive legal right to reproduce, publish and sell the matter and form of a literary or artistic work.

Consignment. Arrangement by which items are sent by an artist to a sales agent (gallery, shop, sales rep, etc.) for sale with the understanding the artist will not receive payment until work is sold. A commission is almost always charged for this service.

Direct-mail package. Sales or promotional material that is distributed by mail. Usually consists of an outer envelope, a cover letter, brochure or flyer, SASE, and postpaid reply card, or order form with business reply envelope.

Dummy. A rough model of a book or multi-page piece, created as a preliminary step in determining page layout and length. Also, a rough model of a card with an unusual fold or die cut.

Edition. The total number of prints published of one piece of art.

Elhi. Abbreviation for elementary/high school used by publishers to describe young audiences.

Environmental graphic design (EGD). The planning, designing and specifying of graphic elements in the built and natural environment; signage.

Estimate. A ballpark figure given to a client by a designer anticipating the final cost of a project.

Etching. A print made by the intaglio process, creating a design in the surface of a metal or other plate with a needle and using a mordant to bite out the design.

Exclusive area representation. Requirement that an artist's work appear in only one outlet within a defined geographical area.

Finished art. A completed illustration, mechanical, photo, or combination of the three that is ready to go to the printer. Also called camera-ready art.

Gagline. The words printed with a cartoon (usually directly beneath); also called a caption.

Gouache. Opaque watercolor with definite, appreciable film thickness and an actual paint layer.

Halftone. Reproduction of a continuous tone illustration with the image formed by dots produced by a camera lens screen.

IRC. International Reply Coupon; purchased at the post office to enclose with artwork sent to a foreign buyer to cover his postage cost when replying.

Keyline. Identification of the positions of illustrations and copy for the printer.

Kill fee. Portion of the agreed-upon payment the artist receives for a job that was assigned, started, but then canceled.

Layout. Arrangement of photographs, illustrations, text and headlines for printed material.

Lithography. Printing process based on a design made with a greasy substance on a limestone slab or metal plate and chemically treated so image areas take ink and non-image areas repel ink.

Logo. Name or design of a company or product used as a trademark on letterheads, direct mail packages, in advertising, etc., to establish visual identity.

Mechanicals. Paste-up or preparation of work for printing.

Multimedia. A generic term used by advertising, public relations and audiovisual firms to describe productions involving more than one medium to create a variety of visual effects. Also, a term used to reflect the varied inhouse capabilities of an agency.

Naif. Native art of such cultures as African, Eskimo, Native American, etc., usually associated with daily life.

Offset. Printing process in which a flat printing plate is treated to be ink-receptive in image areas and ink-repellent in non-image areas. Ink is transferred from the printing plate to a rubber plate, and then to the paper.

Overlay. Transparent cover over copy, on which instruction, corrections or color location directions are given.

Panel. In cartooning, the boxed-in illustration; can be single panel, double panel or multiple panel.

Paste-up. Procedure involving coating the backside of art, type, Photostats, etc., with rubber cement or wax and adhering them in their proper positions to the mechanical board. The boards are then used as finished art by the printer.

Photostat. Black & white copies produced by an inexpensive photographic process using paper negatives; only line values are held with accuracy. Also called stat.

PMT. Photomechanical transfer; Photostat produced without a negative.

P-O-P. Point-of-purchase; in-store marketing display which promotes a product.

Print. An impression pulled from an original plate, stone, block screen or negative; also a positive made from a photographic negative.

Production artist. In the final phases of the design process, the artist responsible for mechanicals, paste up, and sometimes the overseeing of printing.

QuarkXPress. Page layout program.

Query. Letter to an art director or buyer eliciting interest in a work you want to illustrate or sell.

Quotation. Set fee proposed to a client prior to commencing work on a project.

Rendering. A drawn representation of a building, interior, etc., in perspective.

Retail. To sell directly to the consumer.

Roughs. Preliminary sketches or drawings.

Royalty. An agreed percentage paid by the publisher to the artist for each copy of the work sold.

SASE. Self-addressed, stamped envelope.

Self-publishing. In this arrangement, the artist coordinates and pays for printing, distribution and marketing of his/her own artwork and in turn keeps all ensuing profits.

Semiannual. Occuring twice a year.

Semimonthly. Occurring twice a month.

Semiweekly. Occuring twice a week.

Serigraph. Silkscreen; method of printing in which a stencil is adhered to a fine mesh cloth stretched over a wooden frame. Paint is forced through the area not blocked by the stencil.

Simultaneous submissions. Submission of the same artwork to more than one potential buyer at the same time.

Speculation. Creating artwork with no assurance that the buyer will purchase it or reimburse expenses in any way; referred to as work on spec.

Spot drawing. Small illustration used to decorate a page of type, or to serve as a column ending.

Storyboard. Series of panels which illustrate a progressive sequence or graphics and story copy of a TV commercial, film or filmstrip. Serves as a guide for the eventual finished product.

Tabloid. Publication whose format is an ordinary newspaper page turned sideways.

Tearsheet. Published page containing an artist's illustration, cartoon, design or photograph.

Thumbnail. A rough layout in miniature.

Transparency. A photographic positive film such as a color slide.

Type spec. Type specification; determination of the size and style of type to be used in a layout.

Velox. Photoprint of a continuous tone subject that has been transformed into line art by means of a halftone screen.

VHS. Video Home System; a standard videotape format for recording consumer-quality videotape, most commonly used in home videocassette recording and portable camcorders.

Video. General category comprised of videocassettes and videotapes.

Wash. Thin application of transparent color or watercolor black for a pastel or gray tonal effect.

Wholesale. To sell (usually in large quantities) to an outlet for resale rather than directly to the consumer.

Humor Index

If you are a cartoonist, caricaturist or humorous illustrator, this index will help you narrow your search for appropriate markets. The companies listed here have indicated an interest in humorous material. Use this index as a preliminary step in researching markets, then be sure to check individual listings for more specific information about each market's needs and submission requirements.

A

Aboriginal Science Fiction
Accent on Living
Advance Advertising Agency
Advocate, The
Aging Today
Aim
Allen And Company, Patricia
Allied Feature Syndicate
Amberley Greeting Card Co.
American Brewer Magazine
American Fitness
American International Syndicate
American Libraries
American Motorcyclist
American Woman Motorscene
Anderson Studio, Inc.
Appalachian Trailway News
Aquarium Fish Magazine
Army Magazine
Art Business News
Art Plus Repro Resource
Artist's Magazine, The
Arts Indiana
ASPCA Animal Watch
Automundo
Aware Communications, Inc.

B

B.C. Outdoors
Baby Connection News Journal, The
Backstretch, The
Bad Haircut
Baja Times
Ball Magazine
Balloon Life Magazine
Balls & Strikes Softball
B&A Design Group
Bartender Magazine
Bay Windows
Bend of the River® Magazine
Berkeley Monthly, The
Beverly Hills [213]

Bird Watcher's Digest
Black Conscience Syndication, Inc.
Blate Associates, Samuel R.
Bostonia Magazine
Bow & Arrow Magazine
Breaking In
Bride's Magazine
Brigade Leader
Brilliant Enterprises, Ashleigh
Bryan Imagines, The Library Imagination Paper, Carol
Buckmasters Whitetail Magazine
Business Travel News

C

Campus Life
Canadian Dimension (CD)
Carolina Quarterly
Caroll Publishing, J.F.
Cas Associates
Cat Fancy
Catholic Forester
CCC Publications
Chesapeake Bay Magazine
CHIC Magazine
Chicago Life Magazine
Chickadee
Children's Playmate
Christian Century, The
Christian Home & School
Christian Reader, The
Christian Science Monitor, The
Chronicle Features
Churchman's Human Quest, The
Cicada
Cincinnati Magazine
City Limits
City News Service
Class Publications, Inc.
Cleaning Business
Clearwater Navigator

General Index

D

F

I

J

M

More Great Books
for Your Art and Graphic Design!

1995 Interview Personalities

Portrait Artist: Phil Ruxton

Cynthia Janet White
Fine Artist
Page 268

Kim Champagne
Record Company Art Director
Page 610